ENCYCLOPEDIA OF
Nineteenth-Century Photography

ENCYCLOPEDIA OF
Nineteenth-Century Photography

VOLUME 2
J–Z
INDEX

John Hannavy
EDITOR

Routledge
Taylor & Francis Group
New York London

Routledge
Taylor & Francis Group
270 Madison Avenue
New York, NY 10016

Routledge
Taylor & Francis Group
2 Park Square
Milton Park, Abingdon
Oxon OX14 4RN

© 2008 by Taylor & Francis Group, LLC
Routledge is an imprint of Taylor & Francis Group, an Informa business

Printed in the United States of America on acid-free paper
10 9 8 7 6 5 4 3 2 1

International Standard Book Number-13: 978-0-415-97235-2 (Hardcover)

Library of Congress Cataloging-in-Publication Data

Encyclopedia of nineteenth-century photography / John Hannavy, ed.
 p. cm.
 Includes bibliographical references and index.
 ISBN 0-415-97235-3 (978-0-415-97235-2 : alk. paper)
 1. Photography--Encyclopedias. I. Hannavy, John.

TR9.H25 2007
770.3--dc22
 2007018144

Visit the Taylor & Francis Web site at
http://www.taylorandfrancis.com

and the Routledge Web site at
http://www.routledge.com

Contents

Board of Advisors

Contributors

Fabio Adler
William R Alschuler
Jan Altmann
Jenny Ambrose
Saskia Asser
Quentin Bajac
Etelka L Baji
Inga Lára Baldvinsdóttir
Gordon Baldwin
Julia Ballerini
Stephen Bann
Tony Bannon
Peter Barberie
Martin Barnes
Paulette E. Barton
Sarah Bassnett
Geoffrey Batchen
Jordon Bear
William B. Becker
Carlo Benini
Terry Bennett
Hans Bjelkhagen
Carolyn Bloore
Helene Bocard
Mattie Boom
Nuno Borges de Araujo
Rita Bott
Laure Boyer
Steve Brace
Marta Braun
Elizabeth Brayer
Leslie K Brown
François Brunet
Bill Buchanan
Gail Buckland
David Burder
Matthew Butson

Ron Callender
John Cameron
Denis Canguilhem
Elisa Canossa
Justin Carville
Claudia Cavatorta
Milan Chlumsky
Laura Claudet
David Coleman
J.T.H. Connor
Alistair Crawford
Isobel Crombie
Lee Ann Daffner
Laurie Dahlberg
Malcolm Daniel
Kathleen Davidson
Daniel M. Davis
Lynn Ann Davis
Dominique de Font-Réaulx
Hans de Herder
Catherine De Lorenzo
Robert Deane
Michelle Anne Delaney
Margaret Denny
Frances Dimond
Marcy Dinius
Sebastian Dobson
Deidre Donohue
Jocelyne Dudding
Isabelle Duquenne
Steve Edwards
Elizabeth Edwards
Alan Elliott
Bruce T Erickson
Anne-Marie Eze
John Falconer
Jennifer Farrell

CONTRIBUTORS

Richard G. Ferguson
Roberto A Ferrari
Caroline Fieschi
Orla Fitzpatrick
Roy Flukinger
Klára Fogarasi
Colin Ford
Diane Forsberg
Karen Fraser
Rolf Fricke
John Fuller
Luke Gartlan
Bill Gaskins
Jerome Ghesquière
Debbie Gibney
Sabrina Gledhill
Renata Golden
Jenny Gotwals
Bryan Green
Alan Greene
Kristen Gresh
Maren Gröning
Beth Ann Guynn
Michael Hallett
Jo Hallington
Anthony Hamber
Stacy Hand
John Hannavy
Colin Harding
Russell Harris
Janice Hart
Richard Haw
Mark Haworth-Booth
Karen Reed Hellman
Sylvie Henguely
Heinz K Henisch
Bridget Henisch
Stephen Herbert
Lynn Herbert
Robert Hirsch
Katherine Hoffman
Hanne Holm-Johnsen
Kathleen Stewart Howe
Kuei-ying Huang
Philip Jackson
Steven Jacobs
David L Jacobs
Carol M Johnson
Martyn Jolly
Steven F. Joseph
Sarah Kennel
Károly Kincses
Hope Kingsley
Stephanie Klamm
Erhard Koppensteiner

Andrea Korda
Michele Krainik
Cliff Krainik
Andrea Kunard
Michelle Lamunière
Amélie Lavin
Luce Lebart
Astrid Lechner
Mathilde Leduc-Grimaldi
Danielle Leenaerts
Sophie Leighton
Ian Leith
Brian Liddy
Alexey Loginov
Bobbi London
William Main
Bernard Marbot
Caroline Marten
David Mattison
Michael Maunder
Philippe Maurice
Carol Mavor
Sarah McDonald
Chris McGlone
Terresa McIntosh
Pamela Meyer
Stephen Monteiro
Keith Moore
Richard Morris
Alison Morrison Low
Francis Morrone
Vanda Morton
Jeffrey Murray
Luis Nadeau
Roger Neill
Caryn E. Neumann
Gael Newton
Petra Notenboom
Ken Orchard
Engin Ozendes
Tim Padfield
Silvia Paoli
Lori Pauli
Charlene Peacock
Julia Peck
Maria Antonella Pelizzari
Michele Penhall
Marion Perceval
Carolyn Peter
Christen Petersen
Steven Petersen
Phiphat Phongraphiphon
Nuno de Avelar Pinheiro
Stephen C. Pinson
Erika Piola

Ibolya-Csengel Plank
John Plunkett
Michael Pritchard
Phillip Prodger
Warwick Reeder
Pierre-Lin Renié
Yolanda Retter
Kate Rhodes
Kimberly Rhodes
Par Rittsel
Pam Roberts
Edmund Robertson
Andrew Rodger
Hans Rooseboom
Naomi Rosenblum
Donald A Rosenthal
Deac Rossell
Stephanie Roy
David Rudd Cycleback
Tom Ruffles
Rolf Sachsse
Marcel Glen Safier
Diana Saldana
Britt Salvesen
Gary Sampson
John Sawkill
Janice Schimmelman
Savannah Schroll
Charles Schwartz
Joan M. Schwartz
Rebecca Senf
Nancy M Shawcross
Julie Sheldon
Becky Simmons
Roddy Simpson
Colleen Skidmore
Graham Smith
Tim Smith
Meredith Soles
Will Stapp

Lindsey Stewart
David Stone
Jacek Strzalkowski
Paula Summerly
Ian Sumner
Johan M Swinnen
Frédérique Taubenhaus
John Taylor
Roger Taylor
Maureen Taylor
Sarah Templeton
Friedrich Tietjen
Milanka Todiã
Carole Troufléau
Aliki Tsirgialou
Raymond Turley
Peter Turner
Jannie Uhre Ejstrud
Anneke van Veen
John Vignoles
Karl Volkmar
Andrea Volpe
Steven Wachlin
Diane Waggoner
John Ward
Michael Ware
Roger C. Watson
Sarah Weatherwax
David Webb
Christopher Webster
Maxim Weintraub
Francine Weiss
Larry West
Sarah Wheeler
Renate Wickens
Kelley Wilder
Linda Wisniewski
Bob Zeller
Annalisa Zox-Weaver

Alphabetical List of Entries

Thematic List of Entries

Companies

Agfa
Alinari, Fratelli
Autotype Fine Art Company
Bassano, Alexander
Bausch & Lomb
Bonfils, Fèlix, Marie-Lydie Cabanis, and Adrien
Britannia Works Co. (Ilford Ltd)
Brogi, Giacomo, Carlo and Alfredo
Bruckmann Verlag, Friedrich
Caldesi, Leonida & Montecchi
Chevalier, Vincent & Charles Louis
D'Alessandri, Fratelli
Dallmeyer, John Henry & Thomas Ross
Downey, William Ernest, Daniel, & William Edward
Elliott, Joseph John & Fry, Clarence Edmund
Frith & Co
Goerz, Carl Paul
Goupil & Cie
Hering, Henry & Co.
Hills, Robert and John Henry Saunders
Kodak
Lafayette (James Stack Lauder)
Lambert & Co., G.R.
Lemercier, Lerebours and Bareswill
Leon, Moyse & Levy, Issac; Ferrier, Claude-Marie; and Charles Soulier
London Stereoscopic Company
Marion and Company
Maull & Co. (Maull & Fox, Maull & Polyblank)
Mawson & Co
Mayer & Pierson
Murray, Richard and Heath, Vernon
Negretti and Zambra
Neurdein Frères
Notman, William & Sons
Ottewill, Thomas & Co.

Photoglob Zurich/Orell Fussli & Co.
Platinotype Co. (Willis & Clements)
Ross, Andrew & Thomas
Rouch, William White
Scovill & Adams
Smith, Beck & Beck
Taylor, A. & G.
Underwood, Bert and Elmer
Watson, William & Sons
Whatman, James & Co.
Zangaki Brothers

Formats

Cabinet Cards
Card Formats: Minor Formats
Cartes-de-Visite
Cased Objects
Lantern Slides
Mounting, Matting, Passe-Partout, Framing, Presentation
Photographic Jewelry
Postcard

National and Regional Surveys

Africa
Africa, North
Arctic and Antarctic
Argentina
Australia
Belgium
Brazil
Canada
Central America and the Caribbean
Ceylon
Chile
China
Cuba

Photographers, Inventors, Patrons, and Critics

THEMATIC LIST OF ENTRIES

THEMATIC LIST OF ENTRIES

Processes (General)

Introduction

The *Encyclopedia of Nineteenth-Century Photography* is a unique publication, one that is an essential reference work for anyone interested in the medium of photography. This text is the result of diligent primary research by many of the world's leading researchers and writers on the subject. Their scholarship has revealed many long established 'facts' to be fictions, established the role of many hitherto unrecorded figures, measured the achievements of many of the leading practitioners against contemporary critical appraisal of their work, and placed the history of photography's first century within a social and economic context. What these researches have produced is a reference work of significant scholarship that in addition to standing as a critical work of reference, offers many highly perceptive essays that significantly develop current critical debate on the role, the nature, and the merits of nineteenth century photography.

We have devoted considerable space to key figures like Daguerre, Talbot, Fenton, Herschel, Brady and others to place their achievements in context. Similarly, major inventors, manufacturers, organisations, and supporters of the medium have been examined in extended essays. In its totality the encyclopedia contains 1197 entries: 610 major entries of 1000 to 5000 words, and an additional 587 shorter entries on minor and emerging figures; together these provide readers an expansive history of nineteenth century photography. This text ranges from shorter 200 word entries that provide snapshots of photographic figures and other key elements of nineteenth century photography to large, 5,000 word entries that provide detailed, analytical scholarship for our readers.

The encyclopedia offers a number of access points to information. Photography's history can be explored by date, by named image-maker, by area, or by process to name but four, with each of these themes offering a fresh perspective on the history of the medium.

How to Use This Book

The *Encyclopedia of Nineteenth-Century Photography* contains **both alphabetical and thematic tables of contents** for easy reference. These sections allow researchers to quickly and easily locate topics of interest or a group of similar entries under a specific theme. **See Also**s at the end of many entries provide cross-references to guide the reader to associated entries. Readers also have the pleasure of viewing the **197 images** placed throughout this work to aid their understanding of nineteenth-century photography. Included as well with every major entry is a **Further Reading** section in which authors have listed referenced texts or other works giving additional content on that topic. A thorough, analytical **index** increases the ease of navigating these two volumes.

National and Regional Surveys allow readers geographically oriented access, enabling them to learn about location-specific issues—from the overly humid conditions of South Asia to the arid environment of Egypt. These sections provide a fresh framework by which to read, separating true history from the conventional western-oriented understanding of history that has dominated photographic historiography for a century.

Societies, Groups, Institutions, and Exhibitions offer a unique view of the popularisation of photography and its encouragement by local and national groups and organisations, and show how exhibitions were used to draw together photographers from other countries. In these entries short- and long-term interest groups and exhibitions are discussed from conception to either their conclusion or present day. These discussions often include the photographers and patrons who were critically involved in the success of these groups and of photography in the nineteenth century. Readers will see a global interconnectedness emerge from these entries as the histories of these groups are revealed.

Publications looks at both illustration- and word-based texts. Word-based publications often focus primarily on the art and science of photography itself. Necessary to a comprehensive understanding of the appeal of photography in the nineteenth century is that illustration-based publications provided not just images of foreign lands to people who could not afford to travel, but they created images for discussion, research, and further review as well. The emergence of the photographic press served not only as a means of disseminating information for the practical application of photography but also for its chemistry, techniques, processes, and equipment. The photographic press also functioned as a platform for the publication of criticism and debate. Through these increasingly widely-read journals, problems concerning the manipulation of early processes were often resolved through readers' letter pages.

Photographers, Inventors, Patrons, and Critics, the most conventional of the texts' themes, offer the reader extended biographies of leading names in the development of the art and science of photography. The figures located under this section have often contributed critically to the success and proliferation of photography internationally; however, this section includes minor figures as well whose involvement were nonetheless important in the development of photography.

Although there is both an alpha and thematic table of contents, the entries are sequenced alphabetically, ensuring that the information contained in these volumes can be accessed easily by the reader. This encyclopedia offers a total overview of the history of photography's first century. Many of the earliest encyclopedias served as compilations of photographic history and practice for the benefit of the working photographer in pre-Great War Britain and America, however this encyclopedia is a comprehensive reference work on photography's first century for the benefit of a growing body of not just photographic historians, academics, professionals, and enthusiasts worldwide but students as well. Primary amongst our requisites for this encyclopedia was that it be the reference work we would want students and upcoming scholars to use in researching photographic history.

A century ago photographic history was the pursuit just a few. Very few eminent photographers of the day were interested in the work of their antecedents, a notable example being Alvin Langdon Coburn, , who was fascinated by the work of early Scottish photographers David Octavius Hill and Robert Adamson, and the Scottish amateur Dr Thomas Keith. Today however a much wider body of people—including photographic historians, nonspecialists, and students—seek to develop a deeper understanding of photography's history to place it within the wider context that this encyclopedia provides.

Readers can also explore the history of the companies, devices and techniques that were invented, developed, and marketed by individuals and companies such as Bausch & Lomb, R & J Beck, Jonathan Fallowfield, Kodak, J Lancaster, Marion & Co, Ross, Voigtlander, and Alfred Watkins all of which are discussed in detail in the entries that follow. The breadth of this encyclopedia's list of entries reaches not just the science or art of photography, but also the practicality of it. For instance, between the announcement of the daguerreotype and the end of the nineteenth century, the weight of a camera had been reduced from more than one hundred pounds to just a few pounds, and the total equipment a photographer needed to carry on location had been reduced from enough to fill a small carriage to less than would fill a small knapsack. These entries narrate the progression and evolution of photography for the historian, constructing a dynamic, fundamental understanding of photography starting from kitchen-sink chemistry where each photographer was exclusively responsible for the manufacture of his or her sensitive materials, to the beginning of mass manufacturing towards the end of the century. These discussions highlight the emergence of companies like Kodak and Agfa, which were already firmly established in the industry as the nineteenth century drew to a close and which would later dominate the twentieth century.

It has often been said that at the time of the introduction of the first viable photographic processes, photography was a solution in search of a problem. Although the inventors of the medium were confident in their predictions of the huge potential of photography, none could have foreseen the range of applications, and the innumerable approaches and styles that would emerge before the end of the nineteenth century. Nor could anyone have foreseen the number of processes that would be introduced, or predict the success of some and the failure of others. Those applications, approaches, styles, and processes, minor as well as major, are explored and discussed within the pages that follow, as are their photographic inventors, supporters, and exponents. This comprehensive text provides researchers with this material in an easy-to-navigate, meticulously organized reference work.

This *Encyclopedia of Nineteenth-Century Photography* encompasses the enormous range and depth of nineteenth century photography, both art and science. There are many entries on major and minor figures whose achievements have previously been under-reported, providing readers with a much fuller history than was available hitherto. This is the first comprehensive reference work to introduce and celebrate these obscure,

misremembered photographers, and clarify enduring confusion over names. For example there were three photographers operating under the name William Bell, all of whom were in the forefront of nineteenth century American photography. Our contributors have clearly identified all three and separated their achievements. Similar diligence has been applied all the entries to ensure the histories included herein are thoughtful, useful, and clear, and that they establish an accurate nineteenth century photographic history.

Photography's first century is one of invention and innovation, intense debate and the development of an increasingly sophisticated visual language. The academic study of photographic history is a surprisingly young subject, despite the fact that over a century and a half has passed since its first published history. It is one of photographic history's failings that some of the misinterpretations that are bound to be present in any early attempt to document a history have remained unchallenged for so long. That many such misunderstandings have been replicated from one book to another, and are now repeated on countless websites, underlines the importance of a publication as exhaustive as the *Encyclopedia of Nineteenth-Century Photography*. This text contains explorations and discussions by leading theorists, historians, and critics of the innovations, and the debates and implications of photography in the nineteenth century. These contributors have painstakingly researched these topics to simplify and delineate these issues for our readers. The commissioning of leading experts to research and compile this encyclopedia, with many of them offering fresh and often challenging readings of the subject, has made this text essential reading.

As mentioned earlier, one of the strengths of this encyclopedia is the inclusion of many figures whose contribution to the development of the medium have been unacknowledged, but yet another is the commitment of the writers to return to primary source material and review many of the assumptions and misconceptions in the history of the subject. Because of this return to primary material several of the 'facts' published in many past works have been revealed as misunderstandings based on only partial information. An example is the discovery of hand-written patents in the Scottish and Irish Patents Offices, negating the widely published assertion that Richard Beard did not patent the daguerreotype in either country, which scholars have often cited as an explanation for why there were in the 1840s more daguerreotypists in Scotland than in England. That he patented the process throughout Great Britain, but apparently did not enforce his patent rights except in England and Wales, opened up new understanding and interpretation of his career included in his entry in this text.

Furthermore, the encyclopedia's scope encompasses more than just American, Great Britain, and France to include countries not often thoroughly discussed in photo-historical texts. The history of photography contained in this encyclopedia is the product of a photo- instead of Anglo- or Euro-centric approach, and one that encompasses extended accounts of the emergence of photography in many areas of the world including Russia, China, Japan, Central and South America, Africa, and the Ottoman Empire and also offers biographies of leading figures in each of these areas. These countries and regions have been covered in depth to establish a history of photography's expansive influence upon, and importance in, cultures throughout the world. Researchers using this text will read entries by authorities based in the countries about which they are writing, introducing them to many photographers whose work will now be recognized to be as important as some of the image-makers whose place in the pantheon of photographic history is already established.

Although photography existed in its own right worldwide, photography's inventors were predominantly from France, Britain, and America, and as such, these nations were primarily responsible for the dissemination of the medium. British and French travellers and military personnel played a pivotal role in taking photography to Asia, Africa, and the Antipodes, with American photographers taking the medium to South America and the Pacific.

These travellers introduced photography to the first generation of indigenous practitioners in each country, many of whose achievements are published within this text for the first time. As local photographers matured in their understanding of the medium, and developed their own locally relevant aesthetic—often drawn from national trends and styles in painting the exhibitions they organised, and the societies and groups they established, developed their own national momentum. Essays mapping the emergence of these exhibitions, institutions, and organisations are crucial in establishing the contexts within which the first and second generations of photographers operated.

The diversity of perspectives provided for readers includes the exploration of the role played by major and minor figures in the emergence of historical and critical writing on photography, from Henry Snelling to Helmut Gernsheim. Documented as well are accounts of pioneering advocates of the medium who understood the importance of the photograph as historical artefact. Key amongst those advocates are the early collectors, whose understanding of the importance of collecting visual material then ensured that the available evidence of photography's history would be as rich as it is today. Thus readers will find entries for those who established the collection at the South Kensington Museum, now

the Victoria & Albert Museum—and those who initiated the collecting of photographs at the Library of Congress and elsewhere.

Our enduring impressions of the nineteenth century including the Crimean War, the American Civil War, and other mid-century conflicts are informed by the images offered by surviving photographs. These images were often constrained by the limitations of available processes and technology, by the photographers' interpretation of contemporary sensibilities and by the photographers' recognition that sales of the resulting images had to conform to the tastes of the purchaser. When with an understanding of their time, however, these images serve as valid historical documentation from which anyone reading this text can gain not only a more intimate knowledge of these events, but also of how responsive photography was in certain circumstances.

Just as influential in dictating the nature and content of photographs of news and current affairs were the constraints placed on mid-nineteenth century photographers by the nature of the processes they were using. The inability of the medium to capture action resulted in an abundance of staged portraits. Thus, in offering a real understanding of the images produced during the nineteenth century, we have sought in compiling *The Encyclopedia of Nineteenth-Century Photography* to present factual material within its contemporary nineteenth century context. Reading mid-Victorian images with a twenty-first century mindset is to misunderstand much of what is to be seen.

The publication of both the *Encyclopedia of Nineteenth-Century Photography* and the companion three-volume *Encyclopedia of Twentieth-Century Photography*, document the magnitude of nineteenth century photographers' vision, and the extent to which their early predictions for photography have been achieved and surpassed. These two texts present in a set of reference books what will become the standard sources of students for years to come. These volumes will also by their breadth and content undoubtedly drive further photo-historical research in many of those areas of study.

Acknowledgments

In bringing this project to completion, I am indebted to the vision of the original editor, Pamela Roberts, and to the Advisory Board made up of leading academics and curators worldwide, who established the basic principles of the project and drew up the original list of entries. I have deviated only slightly from their list, adding a few emerging figures as the project progressed. To realise their vision required the scholarship of the many leading authorities on nineteenth century photography who have written the entries, and the many collections from which the illustrations have generously been made available.

The contributions of many people have been equally crucial in completing this project and we owe them each, individually, a debt of gratitude for their perseverance. To name but a few, I am especially indebted to Ron Callender, Alistair Crawford, Malcolm Daniel, Anthony Hamber, Michael Hallett, Colin Harding, Kathleen Stewart Howe, Gael Newton, Michael Pritchard, Pam Roberts, Larry Schaaf, Graham Smith, and Mike Ware for their knowledge and their advice, and for their generosity with their time in helping me unravel some of the complexities of identification, and helping me to find authoritative writers for many of the more challenging entries that have significantly expanded the boundaries of published knowledge. That we have found accomplished researchers adds to the integrity of the project. Special thanks to Mark Georgiev, Acquisitions Editor, and also to Beth Renner, Development Editor at Routledge, who has had the unenviable task of keeping track of all the assignments, cajoling writers who missed their deadlines, liaising with me every step along the way, and helping us get back on track needed.

Despite its trials, this has been one of the most rewarding projects with which I have been involved. During it, I have had the pleasure of meeting and discussing photographic history with countless remarkable people. The highs have been very high, but the lows would have been a lot lower without the support and encouragement of my wife, Kath.

JOHN HANNAVY

J

JACKSON, WILLIAM HENRY
(1843–1942)

The photographs which earned William Henry Jackson an important place in photographic and American history were made in the last quarter of the nineteenth century, but he continued an active life well into the next century with his images reaching an ever wider audience through color post cards, publications, and exhibitions. Unlike other pioneer photographers of the West, Jackson became a living legend.

Born in Keeseville, New York, on April 4, 1843, Jackson credited his mother with providing watercolor instruction and with introducing him to Chapman's *American Drawing Book*. Following school graduation in 1858, he became a retoucher and colorist for a Troy photographic studio, and two years later he was similarly employed in Rutland, Vermont.

With the onset of the Civil War, Jackson enlisted in a Vermont regiment and served as a staff artist. Honorably discharged in 1863, he returned to the Rutland studio, but the following year he became a studio artist in Styles' Gailery in Burlington, Vermont. Here, his cultural horizons broadened, but a broken engagement resulted in an abrupt departure for New York, where he and two buddies then headed westward toward Montana silver mines. He drove oxen, worked as a farm hand in Utah, and unsuccessfully sought work in California before abandoning the mining quest to head eastward. After driving wild horses to Julesburg, Wyoming, and boarding them on a freight train to Omaha, Nebraska, he found a job in that city as a colorist in the Hamilton Gallery. With help from his father, he bought out this photographic studio along with the competitor in 1867, and the next year he formed Jackson Brothers, Photographers, with his brother Ed.

Realizing that studio work was not his forte, Jackson photographed both landscapes and Native Americans as he followed the route of the yet unfinished Union Pacific Railroad in 1868. He used the cumbersome wet plate process.

The Union Pacific and the Central Pacific tracks finally met at Promontory Point, Utah, on May 10, 1869, but Jackson was in Omaha that day marrying Mollie Greer. Dr. Ferdinand V. Hayden, Director of the U. S. Geological and Geographical Survey saw Jackson's work, and the following year included him, without salary, on the 1870 expedition along the Old Oregon Trail through Wyoming.

Hayden, like fellow surveyor and geologist Clarence King, followed John Ruskin's aesthetics, so he viewed Jackson's detailed work as both scientific document and artistic statement. Painter Sanford Gifford was also with the Survey. For the 1870 Wyoming expedition, Jackson used a whole plate ($6\frac{1}{2}$" × $8\frac{1}{2}$") camera, and photographed both views and Native Americans, as Hayden wanted records of what was wrongly believed to be a vanishing people. Jackson usually photographed Indians in a straight-forward manner, though sometimes with studio props. His later photographs of the Moquis pueblo show the native people in their environment.

Some of Jackson's most memorable photographs were made on the 1871 expedition to Yellowstone. Accompanying the party was the painter Thomas Moran, who like Gifford, influenced Jackson's photography. Jackson photographed the geysers and hot springs with a stereoscopic camera and with an 11" × 14" camera (imperial plate size). One of the legends surrounding Jackson was that the Yellowstone photographs swayed legislators to vote in favor of making this area the first National Park. Howard Bossen, however, has effectively demonstrated that Jackson's photographs were but one factor in a powerful lobbying effort to preserve these lands.

Salaried since 1871, Jackson remained with the Hayden projects until the Survey was disbanded in

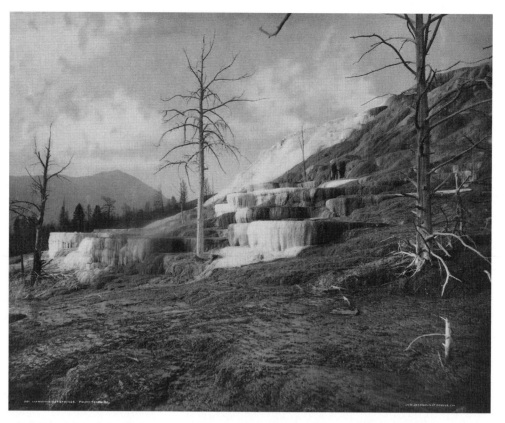

Jackson, William Henry.
Mammoth Hot Springs,
Pulpit Terraces.
*The Metropolitan Museum
of Art, Rogers Fund, 1874
(1974.530) Image © The
Metropolitan Museum of Art.*

1879. During this time he made Mountain of the Holy Cross, in 1873, a photograph which Moran used for a painting. For the Philadelphia Centennial Exposition of 1876, Hayden placed Jackson in charge of the Survey's exhibition, which included his photographs and his clay models of cliff dwellings based on his exploration the previous year in the Mancos Canyon and Canyon de Chelly.

With the end of the Survey, Jackson left Washington, D.C. in 1879, and moved to Denver, Colorado, where he formed the Jackson Photographic Company. Meanwhile, western railroads sought tourists and settlers on their routes and recognized the persuasive power of dramatic landscape photographs. Beginning in 1881, Jackson worked for numerous lines as an "official railroad photographer," and depicted landscape and trains in picturesque and sublime settings. He now used the new dry plate process, and much of his work involved mammoth plates (18" × 22").

This western railroad photography led to the Baltimore & Ohio railroad's P. G. Pangborn hiring Jackson in 1892, to photographs along that company's route. The photographs were shown at the World's Columbian Exposition in Chicago in 1893, where Jackson was commissioned to photograph the architecture.

Pangborn then organized The World Transportation Commission and hired Jackson to photograph a tour that included Egypt, India, China, and Russia. Jackson was away from his business and family for 17 months, during which time he also supplied *Harper's Weekly* with photographs and articles.

Returning from the arduous tour, Jackson found his business foundering, and he sold out to the Photochrom Company in 1897, to become a salaried director and part owner of the parent company, The Detroit Publishing Company. Jackson continued to actively photograph until 1903, when managerial duties precluded extensive travel. The Photochrom Company failed in 1924, and Jackson retired.

In 1936, Jackson painted murals for the U. S. Department of the Interior in Washington, D. C. That same year Henry Ford acquired 40,000 of his negatives for the Edison Institute in Dearborn, Michigan. By this time Jackson's camera of choice had shifted from the 20" × 24" plate camera used on the 1875 expedition to a 35 mm Leica. By 1939, he was using Kodachrome film.

Jackson also produced a series of romanticized watercolor paintings based on his original sketches, photographs, and recollections. When 97, he published an autobiography, *Time Exposure,* which Peter Hales found "heavily embellished," but which Douglas Waitley claimed had "a scrupulous regard for accuracy..."

Shortly after a fall, Jackson died on 30 June 1942, in New York City at age 99.

JOHN FULLER

Biography

Born, Keeseville, New York, 1843. Retoucher and artist in Troy, New York studio, 1857; similar job in Rutland, Vermont, 1860. Civil War volunteer 1861–63; returned to Rutland studio. Artist in Burlington, Vermont studio, 1 864. Left New York City l 866, for West; various jobs including builwhacking. Formed Jackson Brothers, Photographers, 1867. Married Mollie Greer in 1869, and photographed Wyoming. "Official Photographer," for F. V. Hayden and U.S. Geological and Geographical Survey, 1870–1879. Moved to Washington in 1872, wife died in childbirth. Married Emilie Painter, 1873. Photographed members of Ute tribe, 1874. Organized Survey's exhibit, Philadelphia Centennial, 1876. Founded The Jackson Photographic Co., Denver, Colorado, 1879,' work began as "official railroad photographer." Incorporated as W. H. Jackson Photograph and Publishing Co., 1883. Exhibited and photographed World's Columbia Exposition, Chicago, 1893. World Transportation Commission tour with *Harper's Weekly* assignments, 1894–1896. Part owner, The Detroit Publishing Go. Photographed actively until 1903-, retired from the Detroit Publishing Co., 1924. Mural commission from Department of the Interior, 1936, paintings for National Park Service in 1937. Honorary Fellow, Royal Photographic Society, 1938. Watercolors completed for Oregon Trail Association., 1939. Published autobiography, *Time Exposure,* 1940. Honorary degree from University of Wyoming (Laramie), 1941. Died, New York City, 30 June 1942.

Group Exhibitions

1876 Centennial Exposition, Philadelphia, Pennsylvania. Awarded several medals 1889 Jubilee Exhibition, Berlin, Germany. Highest Honors.
1895 Calcutta (India) Photographic Exhibition. Bronze Medal 1902 Traveling exhibition in Santa Fe Railway private car.
1936 Exhibition of Jackson Collection, Denver Public Library.
1942 "Photographs of the Civil War and the American Frontier," Museum of Modern Art, New York City.

Selected Works

"156 Mountain of the Holy Cross," 1875.
"Cañon of the Rio Las Animas," ca. 1882.
"1068 Grand Cañon of the Colorado," ca. 1892.
"573 The Choonbatty Loop on the East Bengal Railway in the Himalayas," 1895, "1091 Mammoth Hot Springs on Gardiner's River (Wyoming), after 1880 "296 View from Tequa Towards Moqui," 1875.

See also: Landscape; and Ruskin, John.

Further Reading

Bossen, Howard, "A Tall Tale Retold," *Studies in Visual Communication,* vol/ 8, no. 1, Winter, 1982, 98–109.
Hafen, Leroy, *The Diaries of William Henry Jackson,* Glendale, CA: Arthur H. Clarke, 1959.
Hales, Peter B., *William Henry Jackson and the Transformation of the American Landscape,* Philadelphia: Temple University, 1988.
Jackson, Clarence S., *Picture Maker of the Old West,* William H. Jackson, New York: C. Scribner's Sons, 1947/
Jackson, William H. and Howard R. Driggs, *Pioneer Photographer,* Yonkers-on- Hudson, NYk: World Book Co., 1929.
Jackson, William H., *Time Exposure* (1940), Tucon, AZ: The Patrice Press, 1994.
Naef, Weston and James N. Wood, *Era of Exploration: The Rise of Landscape Photography in the American West, 1860–1885,* Buffalo, NY: Albright-Knox Gallery, 1975.
Newhall, Beaumont and Diane E. Edkins, *William Henry Jackson,* Dobbs Ferry, NY, 1974.
Waitley, Douglas, *William Henry Jackson: Framing the Frontier,* Missoula, MT, Mountain Press, 1998.

JAMES, HENRY (1803–1877)
English, patron, officer of the Royal Engineers (Lieutenant 1831, Captain 1846, Colonel 1857, Director General Ordnance Survey 1854–75)

Throughout his career, Colonel Sir Henry James was a proponent of photography as an adjunct to the mission of the Royal Engineers and the Ordnance Survey Office, both in the work of surveying and mapping and resultant publications. He pioneered the use of photography as a method for reproducing maps and plans and established a studio at the Ordnance Survey offices in Southampton where maps, plans, and documents were photographically reproduced. In 1859 he published *Account of Methods Employed for the Reduction of Plans by Photography.* Later he claimed the invention of a photo-mechanical technique, photo-zincography, which was developed by two men under his command at the Ordnance Survey Office in Southampton, England, and at first, starting in 1859, simply a method of preparing a photo-lithographic transfer and applying it to a zinc plate, afterwards printed from. Direct prints from negatives were then made on the zinc plates. Photozincography may refer to a line or a half-tone process. His first successful photozincograph was a reproduction of an etching in 1859. Sir Henry James read a paper to the British Association "On photozincography" in September 1861.

James also saw the utility of photography in field work and ordered the inclusion of photographic documentation in many of the Office's surveys: *Ordnance*

Survey of Jerusalem (1864); *Ordnance Survey of Sinai Peninsula* (1869); *Plans and Photographs of Stonehenge and of Turusachan in the Island of Lewis* (1867); and *Notes on the Great Pyramid of Egypt and the Cubits Used in Its Design* (1869). In addition he oversaw the production of a photographic facsimile of the *Domesday Book* or ancient record of the Survey of English lands, ordered in 1086 by William the Conqueror. This was the first systematic geographic record in England. Under his leadership, photography was an integral component of mapping and surveying accomplished by one of the nineteenth century's most influential forces for exploration.

KATHLEEN HOWE

JANSSEN, PIERRE JULES CÉSAR (1824–1907)
French astronomer, inventor, and photographer

Janssen studied the solar spectrum and developed a spectrohelioscope in 1868. In 1867 he concluded that water vapor was present in the atmosphere of Mars. He also discovered an unknown spectral line in the Sun in 1868 and later shared that information with Norman Lockyer, who was credited with the discovery of helium. Janssen was the first to note the granular appearance of the Sun, and published a monumental solar atlas in 1904. Janssen taught Mathematics and Physics and was appointed as correspondent to India to observe the total eclipse of the Sun in 1868. His first contribution to scientific photography was proof, using a spectroscope, that the solar prominences are gaseous. He also discovered the chromospheres, a type of gaseous envelope of the Sun. The French government appointed him director of the Astrophysics Observatory in Meudon, France, where he resided for about 30 years. Janssen studied mainly the Sun, publishing an atlas with almost 6000 pictures of its surface.

The convention of photography confronts Janssen with the given world, with what one can find in the real world and what the camera may register in its fragmentary vision of time and space. The photographer merely decides when, where and how to do it, which seriously limits the author in the possibilities of creation based on some direct way of shaping the image. In a certain sense, the images had always been there—the task of Janssen is only to spot and register it, which does not seem much. But the history of photography proves that one can perform enormous tasks in this seemingly narrow field. For Janssen himself as a player in the history of photography is photography a creative tool that is composed of repeatedly undertaken attempts at transgression, attempts of going beyond the urely

documentary relation between the image and its object. Transgressing this basic feature of photography was for Janssen a fascinating challenge.

Janssen was born in Paris, in 22 February 1824. He became handicapped by a childhood. Pierre Jules César Janssen studied mathematics and physics at the faculty of sciences at the university of Paris. He taught at the lyceum Charlemagne in 1853, and in the school of architecture 1865-71, but his energies were mainly devoted to various scientific missions entrusted to him He became very quickly fascinated with the spectroscopic work of Gustav Kirchhoff and Robert Bunsen. Under their influence, the young man began his search on the solar spectrum in 1862 and showed in particular that certain lines of the spectrum are due to the steam of the Earth's atmosphere. He studied the work of John William Draper, who took a photograph of the moon in 1840. His son, Henry Draper, later became the first person to photograph the Orion Nebula in 1880, which was essentially the first deep sky photograph.

In 1857–58, he worked in Peru on the determination of the magnetic equator and in 1861–62 and 1864, he studied telluric absorption in the solar spectrum in Italy and Switzerland.

In 1867 he conducted optical and magnetic experiments at the Azores, successfully observing both transits of Venus, the first in 1874 in Japan, and the second of the 1882 transit at Oran in Algeria. He took part in a long series of solar eclipse expeditions, e.g., to Trani (1867), Guntoor (1868), Algiers (1870), Siam (1875), the Caroline Islands (1883), and to Alcosebre in Spain (1905).

At the Azores (1867) he examined magnetic and topographical conditions. In 1868 Janssen went to India to observe a total eclipse of the Sun. He was unable to correlate certain lines in the solar spectrum with wavelengths of any known elements. English scientist Norman Lockyer made the same discovery of a new, unknown element and reported it simultaneously to the French Academy of Sciences.

An intrepid traveler in spite of his infirmity, Janssen traveled to Peru, Italy, Switzerland, Algeria (which he reached in a balloon from Paris besieged by the Prussian army in 1870) and finally to Guntur, India.

At this great Indian eclipse of 1868 he demonstrated the gaseous nature of red prominence, and devised a method of observing it under ordinary daylight conditions. One main purpose of his spectroscopic inquiries was to answer the question whether the Sun contained oxygen or not. An indispensable preliminary was the virtual elimination of oxygen-absorption in the Earth's atmosphere, and his bold project of establishing an observatory on the top of Mont Blanc was prompted by a perception of the advantages to be gained by re-

ducing the thickness of air through which observations would be made. This observatory, the foundations of which were fixed in the snow that covers the summit to a depth of ten meters, was built in September 1893, and Janssen, in spite of his sixty-nine years, made the ascent and spent four days taking observations. On August 18 1868 of that same year, while observing an eclipse of the Sun in India, he noticed a bright yellow line with a wavelength of 587.49 nm in the spectrum of the chromospheres of the Sun. Janssen was at first ridiculed since no element had ever been detected in space before being found on Earth. On October 20 of the same year, English astronomer Norman Lockyer also observed the same yellow line in the solar spectrum and concluded that it was caused by an unknown element after unsuccessfully testing to see if it were some new type of hydrogen. Since it was near the Fraunhofer D line he later named the new line D3, distinguishing it from the nearby D1 and D2 doublet lines of sodium. He and English chemist Edward Frankland named the element after the Greek word for the Sun god, Helios, and, assuming it was a metal, gave it an -ium ending (a mistake that was never corrected).

Janssen belonged to this group of photographers for whom even considering the respect they have for the medium nd their awareness of tit limits a purely technical relation is not enough. Janssen created his world for registration himself, subordinating its images to certain manual manipulations because of the need to manifest his own creativity.

In 1874, the French government proposed Janssen is the director of a new observatory intended for astronomical physics. He accepted the offer and chose the site of Meudon for observatory and in 1876, he collected the remarkable series of solar photographs for his great Atlas de photographies solaires (1904). The first volume of the Annales de l'observatoire de Meudon was published by him in 1896. Astrophotography is a specialized type of photography that entails making photographs of astronomical objects in the night sky such as planets, stars, and deep sky objects such as star clusters and galaxies. Astrophotography was used to reveal objects that are too faint to observe with the naked eye, as both film and digital cameras can accumulate and sun photons over long periods of time. Astrophotography posed challenges that were distinct from normal photography, because most subjects were usually quite faint and often small in angular size.

Janssen later became director of the observatory on Mont Blanc. His photographer's of the mountains has interested for the way in which it has involved two main paradigms of historical method, whose results have come together in a very fruitful and complementary manner.

I refer on the one hand, to the concept of the photograph as in effect a container for data from which evidence may be deduced, a classic approach to photographic history; and on the other, to a view of the photograph which owes more to archeology, and pays attention tot the nature of what is to be found with it, irrespective of whether or not there is any primarily photographic connection. However, it depends on each perceiver's sensibility and imagination how broad and interesting the visual world of Janssen might seem. He died at Meudon by Paris on the 23rd of December 1907.

JOHAN SWINNEN

See also: France; Astronomy; Topographical Photography; Science.

Further Reading

Eder, Josef Maria, *History of Photography*, New York: Dover Publications, 1972.

Frizot, Michel (ed.), *Nouvelle Histoire de la Photographie*, Paris: Bordas, 1994.

Gernsheim, Helmut and Alison, *The origins of photography*, London: Thames and Hudson, 1982.

Heilbrun, Françoise (ed.), *L'invention d'un regard (1839–1918)*, Paris: Musée d'Orsay/Bibliothèque nationale, 1989.

Launay, Françoise, *Dans les champs des étoiles, les photographes et le ciel 1850–2000*, Paris: Musée d'Orsay, 2000.

Le Rider, Georges, *Une invention du XIXe siècle, expressionet technique, la photographie, collection de la société française de photographie*, Paris: Bibliothèque Nationale, 1976.

Lemagny Jean-Claude, Sayag, Alain, *L'invention d'un art*, Paris: Centre Georges Pompidou, 1989.

Sipley, Louis Walton, *Photography's Great Inventors*, Philadelphia: American Museum of Photography, 1965.

JAPAN

When Daguerre made his historic announcement to the French Academy of Sciences in 1839, Japan had been officially closed to the outside world for two hundred years and was not to be opened to foreign trade for another twenty. News of scientific progress in the West only came to Japan as a result of the exclusive trading privileges that the Kingdom of the Netherlands enjoyed with the Shogun's government, and it is a striking testimony to the persistence and dedication of contemporary Japanese scholars of Western learning—or *rangaku* ('Dutch Learning')—that the first camera was imported into Japan in 1843. This was in response to an order made through the Dutch trading post in Nagasaki by a local merchant, Ueno Toshinojô, and it is typical of the numerous false starts that bedeviled the advent of photography in Japan that the daguerrian apparatus was unaccountably sent back and Ueno was not to see his purchase again until it was finally returned to

Nagasaki in 1848. Various new words were minted by Japanese scholars and lexicographers to describe the new technology, ranging from the direct transliterations into Japanese syllabic script such as *dageriyoteipu* to more elegant coinages employing Chinese characters, such as *ineikyô* ('Shadow-printing Mirror'). By the mid-1860s, however, the classical expression *shashin* (literally 'Copying Truth'), which had hitherto been used to describe a genre of Chinese-influenced painting, gained the widest currency, and to this day remains the Japanese word for photograph and photography.

The first Japanese photographers operated for the most part in a theoretical vacuum, and although many were able to acquire the necessary equipment and supplies, all of them had to struggle to apply the hard-won book knowledge they acquired through translations of Dutch textbooks to compensate for their lack of practical experience. Early researches into photography also required the support of those feudal lords who had a profound interest in Western Learning. Ueno's camera was acquired in 1848 by Shimazu Nariakira, lord of the powerful Satsuma domain, who duly commanded two of his clan scholars, Kawamoto Kômin and Matsuki Kôan, to experiment with the apparatus. Although Kawamoto studied enough Western writings on the daguerreotype process to publish the first Japanese photographic manual in 1854, success evaded the Satsuma scholars for many years, and it was only in 1857 that two other retainers of the clan, Ichiki Shirô and Ujuku Hikoemon, succeeded in taking a daguerreotype likeness of their lord, thus achieving the joint distinction of being the first Japanese to take a photograph. Other domains also conducted research into photography, such as Mito, Fukuoka and Kaga. Even after the arrival of foreign photographers in Japan after 1859, daimyo patronage was of great help to many Japanese photographers, the most famous being Ueno Hikoma, son of Toshinojô, who after learning the wet-collodion from a Western photographer visiting Nagasaki, persuaded the daimyo of the Tsu domain to sponsor his further photographic studies in Edo during 1860–61. In 1862 Ueno published the first guide in Japanese to the wet-collodion process and returned to Nagasaki to open the first commercial studio in the port.

It was through the agency of a Western photographer, however, that the first known photographs were taken in Japan. In 1854, Eliphalet Brown Jnr., a daguerrean from New York, arrived in Japan as part of Commodore Perry's mission to open up the country to foreign trade, and his contribution to the visual record of the mission was later incorporated in lithographic form into the official account published by order of the United States Congress. Less fortunate was Lieutenant Aleksandr Feodorovich Mozhaiskii, who also took daguerreotypes during a parallel Russian expedition to Japan, but whose work was lost before he even left Japan when his ship was destroyed in a tidal wave in 1855. Brown and Mozhaiskii were the first of a wave of foreign photographers who came to Japan over the following decade. Most were amateur photographers who were usually more preoccupied with the business which had brought them to Japan, whether as members of early diplomatic missions, officers serving on the naval vessels which provided them with transport and protection, merchants, or missionaries. Those who came to Japan before 1860 with the specific object of photographing the country and its people were in a minority, such as the American artist Edward Meyer Kern, who visited Japan as part of a hydrographic survey of the North Pacific undertaken by the United States Navy between 1853 and 1856, and the Swiss photographer Pierre Joseph Rossier, who visited Japan on at least two occasions in 1859 and 1860 to take photographs for the London photographic firm Negretti and Zambra.

The first professional photographer who actually took up residence in Japan was the American Orrin Eratus Freeman (1830–1866), who appears to have arrived in Yokohama early in 1860, followed by William Saunders in 1862 and Charles Parker and Felice Beato in 1863. Freeman, who had previously operated an ambrotype studio in Shangahi, taught photography to one Ukai Gyokusen, who later bought his teacher's camera and photographic equipment and went on to establish his own studio in Edo in 1861, thus becoming the first Japanese commercial photographer. Several Japanese photographers served an apprenticeship of sorts with foreign photographers. The most famous was perhaps Kusakabe Kimbei, who worked as an assistant to Felice Beato and possibly Baron von Stillfried as well. By 1881, Kusakabe was operating his own studio in Yokohama and quickly emerged as a major producer of photographs of landscapes and costume studies for the souvenir trade. This route was not always easy. Stillfried, who also taught Usui Shûsaburô and Futami Asakura, soon realized that he was training up future business rivals and sought to limit the extent of his instruction accordingly.

Others preferred to study abroad in order to master techniques not yet current in Japan. Okamoto Keizô, who later succeeded to the name of Suzuki Shinichi II, went to San Francisco in 1879 to study photographic retouching at the studio of Isaac West Taber, and after his return to Japan in 1880 enjoyed considerable success as the first practitioner of the technique. Ogawa Kazumasa spent the years 1882–83 in Boston intensively studying dry-plate photography, carbon printing and collotype printing, and by 1890 had established himself as the foremost photographic publisher in Japan.

Technologically, most of the nineteenth century was taken up with catching up with photographic developments in the West, and the five decades between the

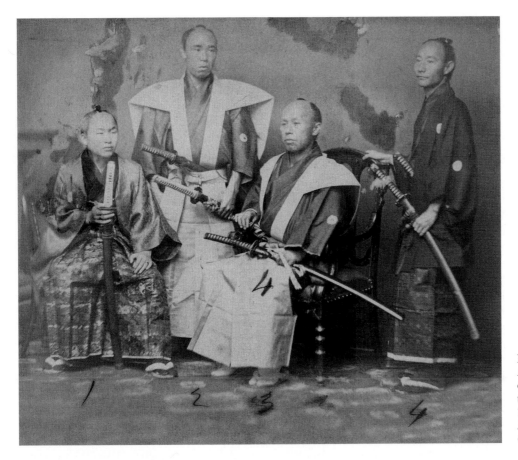

Brady, Mathew and Alexander Gardner. Members of the First Japanese Mission to the United States. *The J. Paul Getty Museum, Los Angeles © The J. Paul Getty Museum.*

first documented use of a camera by a Japanese in 1848 and the election of Ogawa Kazumasa as a Fellow of the Royal Photographic Society in 1895 were characterized by the steady closing of the time lag between photographic innovation in the West and its adoption in Japan. Many of the first Japanese students of photography in the 1850s struggled to master the daguerreotype process at a time when it was being rendered obsolescent in Europe and the United States by the collodion wet plate process. As contact with foreign photographers became more frequent following the opening of selected Japanese ports for trade in 1859, up-to-date technical instruction became available and the wet-collodion process enjoyed widespread usage in Japan until the end of the nineteenth century. Even as late as 1896, ambrotypes, encased in distinctive paulownia wooden boxes, remained popular as a cheap method of securing a portrait, and its American equivalent, the tintype, was never adopted. Similarly, many photographers continued to use wet-collodion negatives even after dry-plates began to be imported into Japan in the early 1880s. Indeed, the arrival of the first dry-plates in Japan proved to be something of a false start. In March 1879, little over one year after the British inventor Joseph Swan had perfected his process of manufacturing pre-sensitized negatives, free samples from the Mawson and Swan

works were being circulated among selected Japanese commercial photographers. The new technology did not catch on, and most photographers, after experimenting unsuccessfully with the unfamiliar plates, continued as before. The first successful application of the process in Japan—by a Japanese photographer at least—did not occur until May 1883, when the Tokyo photographer Esaki Reiji photographed the controlled explosion of a torpedo during a naval review in the Sumida River. This memorable image served as both an advertisement for Esaki's self-claimed status as a *hayatori shashinshi*, and an encouragement to other photographers. One immediate benefit to the Esaki studio was a sudden increase in demand from parents for portraits of their children, who could now be photographed with greater ease, and by his own estimate in the following three years Esaki produced over 3,000 negatives of infants aged under 15 months old. Nevertheless, Japanese adherence to the wet-collodion process remained widespread for the remainder of the 1880s, partly as a result of the irregular quality of imported dry plates and partly of habit, and for a time even those photographers who used the new plates made a habit of taking second exposures with wet-plates as a form of insurance policy. Eventually, in 1888, the photographic supplier Konishi began to import Marion dry-plates on a regular basis and their reliability ensured

the final acceptance of the dry-plate process in Japan. Several attempts were made by domestic manufacturers to produce dry plates, but by the end of the nineteenth century most Japanese photographers still preferred to use imported plates.

In other respects, Japanese photography made quick progress following the overthrow of the Tokugawa shogunate and the establishment of a new government in the name of the Meiji Emperor (the so-called 'Meiji Restoration') in 1868.

Several branches of the new Japanese government showed an interest in the medium of photography. The Imperial Household Office commissioned Uchida Kuichi in January 1872 to take the first official photographic portrait of the Emperor Meiji (the resulting portrait, which showed the Emperor in traditional Japanese court dress, was subsequently deemed inappropriate to the image of Japan as a modern country and a second sitting had to be arranged with Uchida in October 1873, this time with the Emperor wearing a Western-style uniform). Uchida's favored position with the imperial household was further confirmed in May 1872 when he was ordered to accompany the Emperor on his seven-week tour of Western Japan, and photograph the places visited by the imperial party. By the time of Uchida's untimely death in February 1875, the court's patronage of photography had declined and remained low-key for the remainder of the Meiji Era, and although later photographers such as Maruki Riyô received occasional commissions from the imperial household, none were able to repeat Uchida's success, and the Emperor Meiji was never officially photographed again.

The official patronage of photography was more conspicuous and consistent among those departments most closely connected with Japan's modernization during the nineteenth century. The *Kaitakushi*, or Hokkaidô Colonization Office, began employing photographers after 1871 to document the development of Japan's northernmost island, and the first to benefit from this government largesse were Tamoto Kenzô, who had opened a studio in the treaty port of Hakodate in 1866, and the Yokohama-based photographer Baron Raimund von Stillfried, whose portfolio of photographs taken in Hokkaidô in the fall of 1872 was included among the exhibits sent to Austria in the following year as part of Japan's official contribution to the Vienna International Exposition. The Kaitakushi continued to allocate a large part of its budget to photographic commissions until its affairs were wound up in 1882 following a financial scandal.

After a slow start, the Army Ministry also took a regular interest in photography. In 1874, the Tokyo photographers Matsuzaki Shinji and Kumagai Shin were permitted to accompany the army on its first overseas expedition to Taiwan, and in 1876, Yokoyama

Matsusaburo was appointed lecturer in photography at the Military Academy in Tokyo. Initially, the army used photography mainly as an adjunct to map-making and the documentation of Japan's nineteenth century conflicts was entrusted instead to civilian photographers who had either been specifically contracted for the purpose, such as Ueno Hikoma and Tomishige Rihei during the Satsuma Rebellion of 1877, or who had volunteered for the task, as was the case with Matsuzaki and Kumagai during the Taiwan Expedition of 1874 and Count Kamei Koreaki at the outbreak of war with China in 1894. This latter conflict gave rise to a proposal within the General Staff for the creation of a dedicated unit of army photographers, and both the Sino-Japanese War (1894–95) and Russo-Japanese War (1904–05) were documented by a combination of an army photographic unit and teams of civilian photographers authorized by the General Staff.

Although officially supported documentary photography served largely to record Japan's present, the Ministry of Education showed itself to be just as concerned in recording the past. In 1872, Yokoyama Matsusaburô conducted a survey across western Japan, photographing temples and their treasures.

A significant step towards the creation of a photography community in Japan took place in June 1889 when the first Japanese photographic association, the Nihon Shashinkai ('Photographic Society of Japan') was established in Tokyo, with the *Shashin Shimpô* functioning as its official organ. Within four years, its membership had grown from its original 56 founding members to 171 professional and amateur photographers. In May 1893 the Society hosted the first international photographic exhibition in Japan. The exhibition, at which 296 art photographs by members of the London Camera Club were displayed, was organized by William K. Burton, a professor of sanitary engineering at the Imperial University in Tokyo, who was serving as the Society's secretary and was himself a member of the Club. The exhibition attracted numerous visitors, including the Empress Haruko, and had enormous impact, introducing both Japanese photographers and the Japanese public at large to the best amateur photographic work being produced in the West at that time, and some historians date the beginning of *geijutsu shashin*, the Japanese equivalent of Pictorialism, from this event. Despite its role in popularizing photography, the *Nihon Shashinkai* by no means monopolized the subsequent wave of amateur interest. In June 1893, disagreements within the *Nihon Shashinkai*, fueled by the excitement generated by the exhibition, led a trio of photographers consisting of Ogura Kenji, Aritô Kintarô and the flamboyant Kajima Seibei to establish a rival association, the *Dai Nihon Shashin Himpyôkai* ('Greater Japan Photographic Critique Society'). The organization held regular bimonthly meetings, at which

photographs were judged by secret ballot, and quickly established an extensive regional network and its own journal in June 1894. Nevertheless, the Society, which changed its name in May 1897 to the *Dai Nihon Shashin Kyôkai* (Greater Japan Photography Association), never quite lost its elitist tone, the social composition of its membership, which was dominated by members of the upper class as much as professional photographers, serves as a reminder that by the end of the nineteenth century photography was still not yet within the reach of ordinary Japanese. Both associations appear to have ceased their activities at the end of the 1890s, when their financial backer Kajima went bankrupt, although at the same time other amateur photographic associations were being established on a local level across Japan and its growing empire, and by 1902, photographers in Tokyo, Osaka, Kyoto, Kobe and even Taiwan had formed their own organizations.

It was the rise of the amateur photographer in the 1890s that gave permanence to the photographic journals that had begun springing up sporadically in Japan two decades before. Japan's first photographic journal, the elegantly named *Datsuei Yawa* ('Night Conversations Fleeing from the Shadows') was published in 1874 by the Tokyo-based photographer Kitaniwa Tsukuba but lasted for only three issues. It fell into limbo for six years until another Tokyo publisher took up the baton in April 1880 and reissued it under the new name of *Shashin Zasshi* ('Photographic Magazine'). Despite extending its circulation beyond the Tokyo area, the new journal lasted for only seven issues and ceased publication in 1881. In the following year, another Tokyo photographer, Futami Asakuma, established the *Shashin Shimpô* ('Photographic News'), which lasted for 18 issues and almost two years until it folded in July 1884. In February 1889, the title was resurrected by Ogawa Kazumasa and proved more lasting under his custodianship. By the fall of September 1896, no fewer than four photographic journals were in existence, including the *Shashin Shimpô* and the *Shashin Geppô* ('Monthly Photographic Journal'), which had been established in February 1894 by Konishi Rokuhei, a prominent photographic supplier (the present-day Konica). Both journals would continue publication until December 1940.

By 1900, Japanese photography had not only closed the technological gap with the West but had also established itself as part of Japan's modernisation. There is perhaps no better contemporary statement of where Japanese photography stood on the eve of the twentieth century than William K. Burton's assessment delivered to the readers of *The Practical Photographer* in September 1896:

'It is not too much to say that, till about eight years ago, the technical difficulties that the Japanese photographer had to contend against were so great, that his attention was taken up with these alone, and that he had no superfluous mind or energy left to grapple with the artistic side of the subject… It will probably not be generally granted that the photography of the Japanese of the present day is up to the level of the best Occidental photography, so far as artistic merit is concerned, but if the present rate of improvement be maintained, what is to be looked for twenty years hence, or it may be fifty, or even a hundred? I for one would not be surprised to see Japan excel all other countries in the matter of photography as an art.'

SEBASTIAN DOBSON

See also: Brown Jr, Eliphalet; Ueno Hikoma; Kern, Edward Meyer; Rossier, Pierre, Negretti and Zambra; Beato, Antonio; von Stillfried und Ratenitz, Baron Raimund; Wet Collodion Negative; and Swan, Sir Joseph Wilson.

Further Reading

Bennett, Terry, *Early Japanese Images*, Tokyo: Charles E. Tuttle Co. Ltd, 1996.

Kinoshita Naoyuki, *Nihon no Shashinka 1—Ueno Hikoma to Bakumatsu no shashinkatachi*, Tokyo: Iwanami Shoten, 1997.

Kinoshita Naoyuki, *Nihon no Shashinka 2—Tamoto Kenzô to Meiji no shashinkatachi*, Tokyo: Iwanami Shoten, 1999.

'Photography and Photographers in Japan' (Japanese Double Number): *The Practical Photographer*, vol. VII, no. 81, September 1896.

Sharf, Frederic A., Dobson, Sebastian & Morse, Anne Nishimura, *Art and Artifice, Japanese Photographs of the Meiji Era*, Boston: Museum of Fine Art, 2004.

Tokyo Metropolitan Museum of Photography, *The Advent of Photography in Japan*, Tokyo & Hakodate: Tokyo Metropolitan Museum of Photography, Tokyo, in association with Hakodate Museum of Art, 1997.

Tucker, Anne Wilkes, Friis-Hansen, Dana, Kaneko Ryuichi, and Takeba, Joe,: *The History of Japanese Photography*, New Haven, CT and London: Yale University Press in association with The Houston Museum of Fine Art, 2003.

JENNINGS, WILLIAM NICHOLSON (1860–1946)
American photographer

William Nicholson Jennings, a Philadelphia commercial photographer, was born on 16 November 1860 in Yorkshire, England to wool merchants William Jennings and Sara Ann Palmer Nicholson. An aerial and progress photographer, an active member of the Franklin Institute, and one of the founders of the American Museum of Photography, Jennings took up photography as a hobby, using his camera as a scientific tool to capture the world's first picture of lightning on 2 September 1882. From 1885–1896 he worked as a Pennsylvania Railroad photographer, documenting construction sites and damaged infrastructure, including the wreckage

caused by the Johnstown Flood of 1889. In 1893 Jennings successfully shot the first four panoramic, aerial photographs of Philadelphia from a free floating balloon. In 1896 he assisted inventor and photographer, Frederick E. Ives, with the development of Kromskop color photography and opened a Kromskop sales studio in Philadelphia in 1899. After the failure of the business in the early 1900s, Jennings operated a commercial studio taking post card pictures and high-angle progress photographs of Philadelphia buildings. In the 1910s Jennings was appointed official photographer during World War I by the U.S. government to document military camps and railroad construction. Actively working as a photographer until retirement from his studio in 1936, Jennings died on 9 September 1946.

LINDA WISNIEWSKI

JEUFFRAIN, PAUL (1809–1896)
French photographer

One knows few things about Paul Jeuffrain, and the biographical material available to draw a clear portrait of him is very short.

Paul Jeuffrain, son of Augustin Jean Jeuffrain and of Marie Crémière, was born in Tours (France) on 5 March 1809. He was 9 years old when his family settled in Louviers. In 1818, Jeuffrain mad his début in the local textile industry. Indeed, the father immediately began to work as a cloth's manufacturer and mill owner for the Poitevin et Thévin factory, which took later, in 1828, the name of Viollet-Jeuffrain, and later on, in 1858, became Jeuffrain and Co. In 1829, Paul had not joined the family industry yet, as the military archives prove it, mentioning his presence in Paris as a proofreader. Though many sources allocate to him a career of naval officer, some others maintain on the contrary that he would have been exempted from military service for frailty of constitution. As Michel Nattier has noted, Jeuffrain has probably travelled for a while in the merchant navy. This is particularly interesting in that it reveals already the young man's taste for exotism and travelling, taste that has not failed afterwards, and was closely connected in his practising of photography.

But, in 1834, Paul Jeuffrain, aged 25, had come back to Louviers, as mentionned in the trade register, where he is marked as being a cloth manufacturer. Associated to his own brother Augustin and married to his cousin Aurélie Crélière, he took the family business over, which, quite flourishing, ensured a comfortable life for him.

One does not know much more about his professional or private life, because remarkably little information about this period has survived. On the other hand, he has passed on to posterity some splendid calotypes,

realised during two journeys, one in Italy in 1852, the other in Algeria in 1856.

But how did he arrive to calotype? In spite of any certainty, it is possible however to make some assumptions, for instance in concern with the role played by his career in the textile industry. Because the fact of being part of this milieu, in full expansion, in full technical revolution, has for an evidence made him sensitive to the notions of progress, invention, to the world's unfolding industrialization, and particularly to the increasing part of machines and modern technical devices. The nascent photography was completely in such dynamics; during those first years, it was still especially of the concern of inventors keen on science and art, rich enough to engage in the long and expensive operations required by the photographic protocol. Jeuffrain is one of those, bourgeois half artist, half inventor, his comfortable social position seeming to have allowed him to venture to the pleasures and experimentations of the new born invention. New born indeed, since Jeuffrain's first photos date back to 1849, as revealed by the album conserved in Paris by the *Société française de photographie* (all the images, that is to say this album and the travel negatives had been given to the Société by Jeuffrain's son. The only genuine positives are those of the album), album he made all by himself, combining his own images with those of others great users of the new medium: prints from Hippolyte Bayard, among which some of Louviers dated 1851, proofs of a probable meeting between the two men before 1855; also prints from Roger Fenton, member of the Photographic Society (1853). This album, like those realized at the same period by Hippolyte Bayard or Victor Regnault, clearly attests the climate of emulation, of exchanges, of friendly and fruitful meetings between photographers. It is all the same difficult to understand the kind of relationships Jeuffrain might have had with others amateur calotypists before 1855, even if this album's existence tends to prove he had already met or been in touch with some of them, french and british (Fenton, who was a student in the painter Delaroche's studio between 1841 and 1843, by the side of Charles Nègre, Henri Le Secq and Gustave Le Gray, could have met Jeuffrain during his stay in Paris in winter 1851–1852). In 1852 he took his first travelling photographs, in Naples (his second "photographic journey," in Algeria, dates, as for it, from 1856), but he was not a member of the *Société Héliographique* at that time. It is only in 1855 that he became a member of the *Société française de photographie*, created on 15 november 1854 after the dissolution of the *Société héliographique*, and remained untill he died in 1896. However, he joined on the invitation of the new society itself, since it proposed him in 1855 becoming a founder member, which testifies that his works were known and appreciated in the closed circle of photography's

pionneers. Besides, while he was tooking photographs in Naples in 1852, others were practising elsewhere in Italy. Indeed, the Cafè Greco in Rome was since 1850 a place for meetings and exchanges between French, English and Italian calotypists. Maybe Jeuffrain had met some of them while travelling.

Jeuffrain's place in the history of primitive photography is difficult to understand since informations are rare, and one can only conjecture. He seems to have stayed in the background—his photos for instance have never been shown in the numerous exhibitions of the Société française de photographie—and in the same time, to have really shared the desires and research of the period, the dreams of improving and testing the possibilities of the new invention.

To take an active part in this history implied an experimental standpoint, standpoint that Jeuffrain seemed to have adopted from a technical point of view as well as iconographic or aesthetic. His various experiments of processes, on different papers, on glass, as his few publications concerning technical points prove well such an investment. But the aesthetic concerns appear to have got the upper hand, since he quickly chose the exclusive use of calotype. Paper gives images a finish close to drawing, a *sfumato* effect, which make photography a fine art object. As some of his contemporary calotypists, Jeuffrain seems to have been very early conscient of a specificity of the medium, and thus, of photographic images themselves. His calotypes from Italy and Algeria reveal a new approach of reality, a more analytic vision of the world, and in the same time, a taste for the picturesque, for compositions tinged with nostalgic poetry, where the slightness of light and the silence of desert spaces sometimes border on oddness. So has he photographed italian squares and Algerian streets without any human presence, dramatized by the chiaroscuro plays and the hazy halo peculiar to calotype. Jeuffrain's attitude fits in perfectly with a climate of craze for exotism, travelling, linked to a renewed interest in past and archeology.

He has otherwise taken some beautiful portraits, men and women, alone or in group. But above all what is perhaps the most striking in all these images, is the recurrence of a nearly spectral motif: many of them indeed record the trace of a movement—that of a body moving too fast for the long exposure of calotype, or of boats in a bay—imposing a ghostly dimension, which can not only be attributed to the hazards of the shot, but is rather the sign of a curiosity for a peculiar photographic effect, and a peculiar aesthetic.

Jeuffrain died in 1896, leaving his son caretaker of his posterity. As far as one can judge, all his production is contained in those few hundred photographs; as for the rest—private life or others works—it stays a complete mystery, the same which radiates from some of his images, as the sign or signature of a secret personnality.

AMÉLIE LAVIN

Biography

Paul Jeuffrain was born in Tours (France) on 5 March 1809. He might have been travelling for a while in the merchant navy, then in 1834, he came back to Louviers to work as a cloth manufacturer. Associated to his own brother Augustin, he took the direction of the cloth' family factory, "les Etablissements Jeuffrain." He married his cousin Aurélie Crémière in 1834, but she died a few month after the wedding. He married again twice, once with Elisa Alphonsine Lefort, then in 1856 with Victorine Anna Thenon. He began with photography around 1849, and made then two journeys in Italy and Algeria in 1852 and 1856, from which he took back some beautiful calotypes. Founding member of the *Société française de photographie*, created in 1854, he has never been part of the numerous exhibitions organized there. Nevertheless remained he a member of the society until his death in 1896, society which conserves all his calotypes and his *Album* since 1914.

See also: Calotype and Talbotype; Société française de photographie; and Société héliographique française.

Further Reading

Paul Jeuffrain, *Fabricant de drap à Louviers, 1809–1896. Voyages photographiques* (exhibition catalogue), Louviers: Musée de Louviers, 2001.

Michel Frizot, "Un dessin automatique. La vérité du calotype," in *Nouvelle Histoire de la Photographie*, Paris: Bordas, 1994.

André Rouillé, "L'exploration photographique du monde," in *Histoire de la photographie*, Paris: Larousse-Bordas, 1998.

Jean-Claude Gautrand, *Le temps des pionniers. A travers les collections de la Société française de photographie*, col. Photo Poche, no. 30, Paris: Centre National de la Photographie, 1987.

André Jammes, Eugenia Parry Janis, *The Art of French Calotype*, Princeton, NJ: Princeton University Press, 1983.

Christiane Roger, Roméo Martinez, *I calotipi della societa francese di fotographia 1840–1880*, Venise: Marsilio editori, 1981.

JOCELYN, LADY FRANCES (1820–1880)
Aristocratic British woman photographer

Lady Frances Elizabeth Cowper was born in England in 1820, the youngest daughter of Earl and Lady Emelia Cowper. The Earl died in 1837 when Frances was 17 and two years later her mother married Viscount Palmerston who was to become Prime Minister of England. The Palmerston residences of Broadlands, Panshanger and Cambridge House became the setting for major social

and political gatherings that also served, as Lady Palmerston noted, "to amuse Fanny [Lady Frances]."

Queen Victoria took considerable interest in the Palmerston family and invited Lady Frances to be one of twelve young women to carry her wedding train in 1840. The following year Lady Frances herself was married to Viscount Jocelyn, the eldest son of the 3rd Earl of Roden, who had recently returned from military service in India and China. After their marriage, Viscountess Jocelyn continued to be associated with the Royal Court and was appointed an Extra Woman of the Bedchamber in 1842. Four years later the Jocelyns moved to Northern Ireland to Viscount Jocelyn's ancestral estate. They had six children before the Viscount contracted cholera in 1854 when stationed at the Tower of London and died. Following his death Viscountess Jocelyn and her children returned to England to live with her mother.

In 1858 Viscountess Jocelyn began to take photographs. It is possibly that she learnt the skill from Lord Dudley de Ros, a member of the Royal Court and amateur photographer who took portraits of the Royal Family and court circle, including Viscountess Jocelyn. Other photographers of her acquaintance included Dr Ernst Becker, who had instructed the Royal Family on photography in the 1850s, and Graham Vivian, a family friend who was a member of the Photographic Society and visited and photographed the Palmerstons in 1858. By 1861 Jocelyn had joined the Photographic Society of London and accompanied the Queen and Prince Albert to a view an exhibition there that same year. In 1862 she had developed enough confidence in her own work to submit several landscape photographs of the grounds of Broadlands to the International Exhibition, London where she received a honourable mention for "artistic effect." She continued her involvement with photographic associations until the late 1860s with one of her works included in a group Amateur Photographic Association album in 1867.

However, the main outlet for Jocelyn's talents was in the private not public arena. In common with other aristocratic amateur women photographers, such as Lady Milles and Lady Filmer, Jocelyn carefully assembled photographic albums with her own and commercially bought photographs. The impetus to create such albums may have come, at least in part, from the enthusiasm of Queen Victoria who had a well-known passion for assembling and viewing albums of photographs. A few of the aristocratic women of the Royal circle, Jocelyn included, extended this practice to include inventive photographic montages often incorporating watercolour and drawing. As the audience for these albums was presumably limited to friends and family considerable creative freedom existed when constructing and manipulating family and personal narratives. Their work also differs from mainstream nineteenth century practice in its lack of concern for the 'integrity' of the photographic image which is cut up and over-painted where desired and for their disruption of conventional notions of authorship with the frequent use of commercial photographs as the raw material for their own designs.

In the 1860s and 1870s, Jocelyn created at least six large photographic albums that operate at the nexus of creative expression, personal biography and social history. In one of her major albums (held by the National Gallery of Australia, Canberra), Jocelyn's arrangement of photographs of her family and their homes establishes the continuity and solidity of aristocratic family life. This view is established, in part, through the placement of photographic portraits of family members in hand drawn designs that emphasise permanence and interconnectedness—such as diamond and honeycomb shapes. Jocelyn also frequently includes flowers carefully selected for their symbolic language such as filial devotion and love.

While these portrait montages are largely assembled from commercial photographs, Jocelyn's albums also include her own photographs. The NGA album contains a discrete section titled, "Bygone Hours by the Viscountess Jocelyn," in which Jocelyn and her children pose on the terrace and enclosed courtyard of her house at St Leonards. There is little spontaneity about these images with the participants adopting carefully rehearsed postures as they read, embroider or spin wool. The sense of stasis in these domestic tableaux is reminiscent of the work of her contemporary, Viscountess Hawarden, who similarly created scenes within enclosed domestic spaces.

Jocelyn also created inventive and, at times, whimsical montages constructed from her own and others photographs. In one image she place photographs of babies and young children in a hand-drawn tree, complete with nests, thus playing on the notion of the family tree. Other album pages are more formal and show her inventive design sense with motifs including jewellery, Japanese screens, letters with photographic 'stamps,' and a stained glass window design comprising portraits of men in naval uniform and small head of women mimicking carved gargoyles. Often these album pages are only partially completed suggesting that the process of assembling albums was a lengthy and thoughtful one.

Writer Eugenia Parry Janis has noted "the psychological directness" of collage work produced by aristocratic women photographers and a number of Jocelyn's photographs appear to refer to her own life. In the 1870s her family was dogged by tragedy with all six of Jocelyn's children eventually dying of tuberculosis. A sense of personal vulnerability is apparent from one of her most intriguing collages, a hand-drawn archery

target in which Jocelyn has positioned herself as the "bulls-eye" surrounded but not hit by arrows.

By the mid 1870s, Jocelyn's interest in photography seems to have diminished and she spent much of this time travelling to various English and French seaside resorts with her children in search of health. However, all of her children were to die before Jocelyn's own death in Cannes, France on 24 March 1880.

ISOBEL CROMBIE

Biography

Viscountess Jocelyn (nee Cowper) was born in England in 1820. After the death of her father in 1837 her mother married Viscount Palmerston, one of Queen Victoria's closest advisers. Lady Frances was a bridesmaid at the Queen's wedding in 1840 and was appointed Extra Woman of the Bedchamber in 1842. Lady Frances married Viscount Jocelyn in 1841 and they moved to his family estate in Northern Ireland. They had six children before the Viscounts' death in 1854. Viscountess Jocelyn began to photograph in 1858. She became a member of the Photographic Society of London in 1861 and the Amateur Photographic Association in the 1860s. In 1862 she received an honourable mention for her landscape photographs from the International Exhibition, London. However the main arena for her photographic work was her private albums, where she placed her own and commercially produced photographs. Jocelyn frequently constructed montages of these photographs, hand decorating them with watercolour and drawings. She died in France in 1880.

See also: Hawarden, Viscountess Clementina Elphinstone.

Further Reading

Batchen, Geoffrey, "Vernacular Photographies," in *History of Photography,* vol. 23, no. 3, Autumn 2000, 262–271.

Crombie, Isobel, "The Work and Life of Viscountess Jocelyn: Private Lives," in *History of Photography,* vol. 22, no., Spring 1998, 40–51.

Haworth-Booth, Mark, *Photography: An Independent Art, Photographs from the Victoria and Albert Museum 1839–1996,* London: V&A Publications, 1997.

Janis, Eugenia Parry, "Her Geometry" in Sullivan, Constance, *Women Photographers,* New York: Abrams, 1990.

Lever, Trensham (ed.), *The Letters of Lady Palmerston,* London: Murray, 1957.

Williams, Val, *Women Photographers: The Other Observers 1900 to Present,* London: Virago, 1986.

JOCELYN, WILLIAM NASSAU (1832–92)
British amateur photographer

William Nassau Jocelyn took the first dateable photographs in Tokyo and the first wet plate collodian photographs in Japan. In 1857, Lord Elgin had been appointed to head a British mission to China. During a break in negotiations, Elgin headed over to Japan and spent most of August, 1858 concluding a Treaty with that country, before returning to China. Jocelyn, an amateur photographer and member of the British aristocracy, joined the Mission in Shanghai on July 28th, 1858, just three days before it left for Japan. His appointment was as assistant secretary and official photographer; he succeeded a Robert Morrison who had held the position since April 1857. Jocelyn took photographs of the Japanese Commissioners who had negotiated the Treaty in Edo (Tokyo) in August 1858. He also used the Government's photographic apparatus when the Mission returned to China. Around ten of Jocelyn's photos from the Mission have survived, seven of China and three of Japan. They can be found in the print room of the Victoria & Albert Museum, London. All are in poor condition with significant fading and/or defects. No research appears to have been done on Jocelyn's life and details are very sketchy.

TERRY BENNETT

JOHNSON, WALTER ROGERS (1794–1852)

Walter Rogers Johnson was Professor of Physics and Chemistry in the Medical College at the University of Pennsylvania when he returned to America from Europe having acquired a complete daguerreotype apparatus—probably from Giroux in Paris.

The newspaper *United States Gazette* carried a report of his acquisition on October 22, 1839, and he had begun experiments with the apparatus by early November, marking him as one of America's first daguerreotypists. Recent research suggests he may have successfully made portraits before the end of 1839. By January 1840 he was giving public lectures on the process in Philadelphia, illustrated with his own daguerreotypes of local landmarks. In the *United States Gazette,* on January 31, 1840, Johnson announced that he would exhibit "various samples of the art produced in this city [Philadelphia], including landscapes, interior views, statuary and objects in natural history." A fine whole plate daguerreotype by Johnson, from February 1840, survives in the Smithsonian Collection, showing a laterally reversed view of the Merchants' Exchange in the city, the construction of which had been completed only four years earlier.

Surprisingly, given his initial enthusiasm for the medium, Johnson appears to have abandoned photography completely before 1843, devoting the remainder of his life to his scientific interests.

He died in Philadelphia in 1852.

JOHN HANNAVY

JOHNSTON, FRANCES BENJAMIN (1864–1952)

In her Obituary in *Time* magazine in 1952, Frances Benjamin Johnston was remembered as a 'onetime news photographer who had an inside track to the White House because of her friendships with Presidents Harrison, McKinley, and Theodore Roosevelt… With a box-like camera given to her by George Eastman in 1887, she snapped such shots as McKinley on the eve of his assassination.' McKinley died in 1901 actually only 17 minutes after she had taken the photograph, and by that time Johnston, already widely recognised as an accomplished photographer, would have been using much more sophisticated equipment.

Born in Grafton, West Virginia, on 15th January 1864, she studied art in Paris in 1883 to 1884 before returning to America to continue her studies in Washington.

Her photographic output throughout the late 19th and early 20th centuries was wide ranging and embraced portraiture and documentary, architectural, and even subterranean photography in the caves of Kentucky.

An accomplished writer as well as a photographer, she produced many influential articles about architecture, photography, and photographers, over a career lasting more than fifty years. Amongst those, a series on the foremost women photographers of the period in America, published in the *Ladies Home Journal* in 1901–1902, included essays on Gertrude Käsebier, Eva Watson-Schultz, and others.

JOHN HANNAVY

JOHNSTON, JOHN DUDLEY (1868–1955)

John Dudley Johnston is remembered both for his influence on the sesssionist movement in Britain and as architect of the Royal Photographic Society collection. Revered during the first years of the 20th century for subtle depths of his gum platinum prints—such as the minimalist *Valley of the Dragon* (1909), Johnston was an influential member of the Linked Ring and associated with foremost photographers of the period in both the USA and Europe.

Johnston was born on 23 April 1868 at 42 Arnold Street, Toxteth Park, Liverpool. He was the son of John Glynn Johnston, a general merchant and his wife Laura Dudley, by whose former surname he was known. Dudley Johnston was the eldest of six children. The family stayed briefly in central Liverpool before moving on to Seaforth and in 1877 to "Inglewood," Sandon Park, Wavertree—on the outskirts of Liverpool. Johnston left school in 1883 to become a company clerk in Liverpool and by 1901 he was established as a merchant in India Rubber with Messrs Heilbut, Symons & Co at 9 Rumford Street. He married Edith Maud Barker in 1897 and set up home at 76 Huskisson Street in central Liverpool, where he lived for 14 years. Before his marriage, Johnston, an able clarinet player, was very active in the Liverpool Orchestral Society and later played with the Halle orchestra. He was the Liverpool correspondent for *London Musical Courier* through which he developed many contacts in other parts of the country. He resigned as correspondent in 1897—much to the regret of the Editor. Johnston was becoming deeply interested in photography inspired particularly by a trip to Norway in 1893, which he recorded with a camera.

Already a giant of the northern photography movement before he moved to London, Johnston exhibited at the Northern Photographic Exhibition at the Walker Art Gallery in 1904. The first Northern Exhibition had been held in 1901 and subsequently exhibitions were held every three years in Liverpool, Manchester or Leeds. With its rotating venues, trade display and evening lantern lectures, the Northern was considered the most comprehensive of the pre-First World War exhibitions. It was to become a national beacon for pictorial photographers with exhibitors such as Horsley Hinton, Charles Job, Chas Inston, Alex Keighley, F.J. Mortimer and Frederick Evans and, latterly, Hoppe and Dührkoop.

Johnston became increasingly active in the Northern exhibitions and with the instigating institution, the Liverpool Amateur Photographic Association—one of the oldest photographic organisations in Britain. Johnston's own work was revered not only for its impressionistic technique and exploitation of innovative photographic process, but also for his vision in capturing the solid monumentality, civic pride and industry of the north. For example, in *Liverpool an Impression* (1911), a horse drawn carriage disappears into the fog at the side of the Royal Insurance Company's building—contemporarily considered the most important example of commercial architecture in Liverpool, while *Manchester—an Impression* (1906) reveals a sublime beauty in a canalised river closed in by waterside mills and scaffolding. At the tiem of the 1907 exhibition, Johnston was a member of the Exhibition Committee and Vice President of Liverpool Amateur Photographic Association, by 1911, he had risen to become President and also Chair of the Northern Exhibition Committee. He was elected to the Linked Ring in 1907 in which he rapidly became active and influential. As with music, he networked beyond the three cities of the Northern Exhibition and not just to London: George Good, photographer and author of *A History of the Liverpool Amateur Photographic Association* (1953) recalled how Johnston took a party of Liverpool photographers south to meet a group of Birmingham photographers and observed 'a memorable collection of photographic talent indeed'.

In 1911 Johnston made a career move to London. On his arrival, he immediately involved himself with

the Royal Photographic Society of which he had been a member since 1907. He participated actively in exhibitions and the organisation of the society—he was twice president from 1923–25 and 1929–31. Exhibition labels on the reverse of some of his prints in the RPS collection evidence the breadth of his work and also provide an itinerary of early 20th century exhibitions. His sensitively lit nudes and portraits of the late 1920s recall the meeting with his second wife Florence and a move from process to pattern. The role of pattern is particularly noticeable in *Snow Roofs* (1923) and in other snow scenes of the same period and, later, in scenes such as *Arabesque* (1940), a dappled, sunlight, open market made from an elevated viewpoint.

Of equal, if not greater importance, is Johnston's role in revolutionising the collecting policy of the RPS. He believed that it was vital to the study of photography to be aware of what had gone before. In 1923, as President of the RPS, he initiated the role of curator. By his own account, he built up the collection of photographs from about 100 prints to 1500 prints. The strengths of the collection are based on his personal contacts, his search for knowledge of the process of photography, his dedication to the society and his continued involvement in collecting. His vision for the collection was to dominate the next 50 years: his collecting policy and stewardship of the collection was continued into the 1970s by Florence Johnston.

After his retirement from business, Johnston embarked on a history of the RPS. *Story of the Royal Photographic Society* was not just an account of the Society, it was a history of photography—an exploration of the fifteen years before his own birth. Johnston continued to maintain a high profile through his ongoing enlargement and care of the RPS collection and because of his popular lectures—Switzerland, Bavaria and Italy, a lecture tour on the Grand Canyon- always illustrated by his own, widely admired series of slides.

Dudley Johnston died in Paddington, London in 1955.

CAROLYN BLOORE

See also: Royal Photographic Society; Dührkoop, Rudolf and Minya; Evans, Frederick H.; and Brotherhood of the Linked Ring.

Further Reading

Cox, Bertrand, *Pictorial Photography of J. Dudley Johnston 1905–1940*, London: Royal Photographic Society, 1952.

Dudley Johnston Archive, RPS Collection at NMPFT.

Harker, Margaret, *The Linked Ring*, London: Royal Photographic Society, Heineman, 1979.

RPS Collection (prints) at NMPFT.

Taylor, John with Bloore, Carolyn, *Pictorial Photography in Britain 1900–1920*, Arts Council of Great Britain and RPS, 1978.

JOLY DE LOTBINIÈRE, PIERRE-GUSTAVE GASPARD (1798–1865)

Pierre-Gustave Gaspard Joly de Lotbinière was a merchant, landowner, traveller, daguerreotypist; born Geneva, Switzerland, 1798; died, Paris, France, 1865. In 1828, Swiss-born Pierre-Gustave Gaspard Joly, a wine merchant from the Epernay region of France, married Julie-Christine Chartier, heiress of the seigneury of Lotbinière, on the south shore of the St. Lawrence, not far from Quebec City. In August 1839, he was in Paris about to embark on the Grand Tour, and like others was caught up in the "daguerreotypomania" that followed the disclosure of Daguerre's process. Equipped by Paris optician N.-M.P. Lerebours to take daguerreotypes on his travels, Joly de Lotbinière became the first to photograph the Parthenon in early October 1839. He then continued to Egypt where he travelled from Alexandria as far as the First Cataract in company with fellow traveller-daguerreotypists Horace Vernet, the Orientalist painter and Director of the French Academy in Rome, and Frédéric Goupil-Fesquet, his nephew. His journal and an annotated list of daguerreotypes taken on his travels indicates he took more than forty daguerreotypes in Egypt and another twenty-six in Jaffa, Jerusalem, Damascus, and Baalbek before returning to Paris by way of Rhodes and Turkey. His original plates are not known to have survived; however, five of his daguerreotype views of Greece, Egypt, and Syria were published as engravings in Lerebours' *Excursions daguerriennes* which appeared in instalments between 1840 and 1844; others were engraved for Hector Horeau's *Panorama d'Égypte et de Nubie*, published in Paris in 1841.

JOAN M. SCHWARTZ

JOLY, JOHN (1857–1933)
Inventor

John Joly was born in Bracknagh, Offaly, Ireland on 1 November 1857. His father John Plunket Joly was Rector of Clonsat (Offaly) and came from an influential family of French descent. His mother Julia, Comtesse de Lusi was born in Castlejordan, Meath. After his father's death in 1858 Joly's family moved to Dublin where his education was entrusted to a tutor, John Charles Mahon. His formal education began at the Protestant Rathmines School in 1872. He spent a year in France for health reasons prior to his entrance into Trinity College Dublin in 1876. He was conferred a Bachelor of Engineering in 1882. After graduation he was appointed to the College's Engineering Department where he was to gain a reputation as an inventor of scientific instruments.

In the late 1880s he became interested in the application of photography to the various sciences and to astronomy in particular. He was a member of the

Photographic Society of Ireland from 1890. Joly was commissioned by Arthur Rimbaud, Director, Dunsink Observatory, County Dublin, to design camera shutters which would overcome the difficulties associated with stellar photography. On 18 November 1891 his findings in this area were read to the foremost scientific research body in Ireland, the Royal Dublin Society, of which he was a Fellow and later President. His other early publications on photography included an examination of the effect of temperature upon the sensitiveness of photographic plates.

Yet it was within the field of colour photography that he was to produce his most innovative work. Joly's process followed on from earlier research undertaken by James Clerk Maxwell, André Louis Ducos du Hauron, Charles Cros and Frederick Ives. Maxwell and others had already experimented with additive processes based upon the principle that all the colours of light can be made by combining different proportions of the three primary colours. However, none of the previous solutions had resulted in a colour image which could be observed without the assistance of a viewing apparatus. Joly announced his process in the *Photographic Times* of 23 November 1894 and patented it in the same year. His method required only a single filter and was the first screen plate process to be made commercially available. Essentially, it involved the scoring of a series of fine coloured lines onto a single glass plate through which the image could then be taken. After development and reversal of the photographic plate it was viewed through a similar filter and resulted "in vivid colour with all the realism and relief conferred by colour and colour perspective."

Joly gave a more detailed account of his discovery in a paper read to the Royal Dublin Society on 26 June 1895. In it, he referred to Hermann W. Vogel's work on the sensitising of photographic emulsions to the green and yellow portions of the spectrum and to Ives's images which consisted of three superimposed colours. Lithographic reproductions of Joly's process appeared alongside the published paper. An additional note refers to the early work of du Hauron and the fact that in 1869 he had suggested the use of a lined screen similar to that used by Joly. The note infers that du Hauron's suggestions were not acted upon as his theory of colour was flawed. In 1894, Joly's process received coverage in the French periodical *Les Inventions nouvelles* and was noted and acknowledged by du Hauron in the *Photo-Revue Africaine* on 1 April and 15 May 1895. In the same year Joly was to exhibit his colour photographs at the Royal Dublin Society whilst a group of American businessmen established the *Natural Colour Photo Co.* in Great Brunswick Street, Dublin, with a view to producing the screens commercially.

Unfortunately Joly was to encounter legal difficulties as an American, James W. McDonough, of Chicago, had arrived upon a similar process which involved the coating of a plate with coloured particles of powdered glass. As a result of these legal problems Joly was required to visit the United States in September 1895 and again in March and July of 1896. McDonough whose process was patented in England in 1892 also manufactured his plates commercially. However, his method was expensive to produce and his firm the *International Color Photo Company* went bankrupt.

Likewise, Joly's process did not achieve the widespread acceptance which he had hoped for. He encountered technical difficulties which hampered commercial production of the screens and the failure to produce colour prints on paper limited their appeal. The first truly successful commercial colour process, the Autochrome, did not appear until 1907. It was invented by August and Louis Lumière in 1903 and was also a three colour additive process. The mosaic screen was made of minute grains of starch which had been dyed and strewn onto a plate. Its success was partly due to the commercial strategies employed by the brothers and the excellent results which were achieved by their factory produced plates.

Joly did not lose interest in photography and was to apply for over 40 photography related patents in Britain, the United States and France during the period 1868–1903. He was President of the Photographic Society of Ireland from 1902–1903. On 11 February 1896 he exhibited his X-ray photographs, the first such taken in Ireland, to the Dublin University Experimental Association. This interest was the foundation of his work on radiation. In 1897 he was appointed Professor of Geology and Mineralogy in Trinity College, Dublin a post which he was to hold for 36 years. In 1914 he developed a method of radium therapy which was subsequently used for cancer treatment around the world. He continued to publish widely in the fields of botany, mineralogy, geology and experimental physics. He also worked to improve conditions for the students to whom he gave weekly lantern slide shows until his death on 8 December 1933.

The National Library of Ireland holds over half of the extant Joly slides in its Photographic Archive. Many of the 306 slides depict botanical specimens but other subjects include landscapes, printed advertisements and portraits. Joly material is also held by the Science Museum, London; the Physics Department, Trinity College, Dublin and the Kodak Museum, Harrow, London.

ORLA FITZPATRICK

Biography

Joly the scientist, educator and photographer was born in Bracknagh, County Offaly, Ireland in 1857. His father John Plunket Joly, Rector of Clonsat (Offaly) came from

an influential family of French origins whilst his mother Julia, Comtesse de Lusi was born in Castlejordan, Meath of German extraction. His relations included the Royal Astronomer, Charles Jasper Joly and Jasper Robert Joly, a founder of the National Library of Ireland. He was educated in Trinity College, Dublin from 1876 to 1882 where he was to remain as a lecturer, professor and fellow for the rest of his life. He became interested in the application of photography to the various sciences and to astronomy in particular in the late 1880s. However, he was to make his greatest contribution to the field of colour photography. His additive process which was patented in 1894 was the first successful method of producing colour from a single plate. Although his method was supplanted by the Lumière Brothers Autochrome process he was to retain an interest in photography. He continued to publish widely in the fields of botany, mineralogy, geology and experimental physics making a considerable contribution to the field of radiation treatment. He died in Dublin on 8 December 1933 and is buried in Mount Jerome Cemetery, Dublin.

See also: Maxwell, James Clerk; du Hauron, André Louis Ducos; Cros, Charles Emile Hortensius; and Ives, Frederick Eugene.

Further Reading

Chandler, Eddie, *Photography in Ireland: The Nineteenth Century*, Dublin: Edmund Burke Publisher, 2001.

"Death of Dr. John Joly. Many-sided man of science. Pioneer of radium treatment. His great service to geology," in *The Irish Times*, 9 December 1933, 9–10 (Obituary notice).

Henchy, P., "The Joly Family, Jasper Robert Joly and the National Library," in *Irish University Review*, 7, 1977, 184–198.

Isler-de Jongh, Ariane, "The Origins of Colour Photography Scientific, Technical and Artistic Interactions," in *History of Photography*, vol. 18, no. 2, Summer 1994, 111–119.

Joly, John, "On a method of photography in natural colours," in *Scientific Transactions of the Royal Dublin Society*, Series 2, 1896, 127–138.

Marder, William and Estelle, "Louis Ducos du Hauron (1837–1920)," in *History of Photography*, vol. 18, no. 2, Summer 1994, 134–139.

Ní Dhuibhne, Éilis, "Photographs" in *Treasures from the National Library of Ireland*, edited by Noel Kissane, Dublin: The Boyne Valley Honey Company, 1994.

Nudds, John R., "The Life and Work of John Joly (1857–1933)," in *Irish Journal of Earth Sciences*, vol. 8 no. 1, 1986, 81–94.

Rouse, Sarah, *Into the Light: An Illustrated Guide to the Photographic Collections in the National Library of Ireland*, Dublin: National Library of Ireland, 1998.

JONES, CALVERT RICHARD (1804–1877)
British painter and photographer

Calvert Richard Jones was born in Swansea, South Wales on 4 December 1802 the eldest of five children. He had two brothers and two sisters. His father, also named Calvert Richard Jones, and mother, Prudence, lived at Veranda, a house in Singleton Park, Swansea. About 1813 the family moved to the nearby Heathfield House. As part of the landed gentry of South Wales, Jones's father was active in civic affairs. The young Jones was educated at Oriel College, Oxford where he gained a first class degree in mathematics in 1823. While at Oxford he became a close friend of Christopher (Kit) Rice Mansel Talbot, first cousin of William Henry Fox Talbot. In 1824 Jones and Kit travelled to the Mediterranean to purchase works of art. In 1829 Jones took holy orders to take up position as rector of Loughor, a small town near Penllergaer, Wales and as lay rector of St Mary's Swansea. As a rector he performed the marriage ceremony of his friend Kit and Lady Charlotte Butler in 1835. Jones abandoned his ecclesiastical profession at the time of his first marriage on 25 July 1837 to Anne Harriet who bore their only child, Christina Henrietta Victoria Games.

Jones became a talented musician as well as a skilled draughtsman and painter in watercolour and oils. It is believed that the artist Samuel Prout gave him instruction and that he was acquainted with the marine painters John Wichelo and George Chambers and members of the Old Watercolour Society. Jones' drawings and paintings dating from the 1830s show landscapes and figures but he favoured marine subjects made around Swansea, especially ships beached or in dry harbour. The controlled and precise nature of these works suggests the use of an optical drawing aid such as a *camera lucida* or *camera obscura* though there is no evidence to prove this. However, it is clear that Jones later applied to photography the artistic methods of composition, and some of the same subject matter, that he had dealt with as a draftsman.

In February 1839 Jones learned of the photogenic drawing and calotype process through Fox Talbot's correspondence with his cousin Emma and her husband John Dillwyn Llewelynwho were friends and neighbours of Jones in South Wales. Writing to Talbot, his cousin Charlotte Traherne noted, "Mr Calvert Jones is quite wild about it and I dare say by this time is making experiments in Swansea himself." (Buckman, 21). Notwithstanding his enthusiasm for Talbot's discovery, Jones was also quick to respond to the announcement of the daguerreotype process that he also learned between 1840 and 1841. The only known example by him is a fine view of Margam castle (1841), built in 1830 by Kit Talbot (National Library of Wales). However, Jones was keen to use calotypes on his travels since the paper used was lighter than the copper daguerreotype plates and easier to prepare in advance. Talbot's patent had become available in February 1841 and by May Jones had written to Talbot wanting details. By June, Jones was practising it Italy but with limited success due to technical difficulties.

Sometime between 1841 and 1843 Jones met and photographed in Paris with Hippolyte Bayard who had independently discovered a method of forming a positive image on paper (through Jones, Bayard and Talbot were eventually introduced to each other and their respective pioneering processes). Jones persevered independently with Talbot's process until 1845 when he renewed regular correspondence with him in which Jones asked for tuition. Talbot responded by asking him on a photographic excursion to York. Jones followed up with a trip just outside London making views of Hampton Court taken on his own. The same year, he was also invited to Talbot's Reading Establishment. With renewed enthusiasm and improved technical expertise he planned an extensive photographic tour of the Mediterranean in the company of Kit Talbot and Kit's ailing wife, Lady Charlotte. Talbot hoped to gain a stock of foreign views through Jones's excursion. Paper was prepared for him at the Reading Establishment. In November 1845 he travelled to France and Malta where he experienced difficulty in obtaining essential photographic supplies locally and on order from Britain. While in Malta he was visited by the Reverend George Bridges whom he instructed in the calotype process. The trip was suddenly disrupted by the death of Lady Charlotte. However, Jones continued in 1846 to Sicily, Naples, Pompeii, Rome and Florence, returning to Britain by early June with numerous negatives.

Jones was by this time encountering financial difficulty and was anxious to sell his new negatives to Talbot. Many of his prints were made available through Talbot's Reading Establishment. However, by 1846 the venture was becoming unprofitable. Impressed by Jones's skills, Talbot asked him to manage premises in London in the hope of making a new start in a more prominent location. Jones refused but the business was eventually taken on by Talbot's assistant Nicolaas Henneman to become the Regent Street Studios. Talbot and Jones remained on good terms and his prints continued to be sold at Regent Street. Despite his hopes—and Talbot's endorsement of his work—none of Jones's pictures appeared in *The Pencil of Nature*. He continued to make photographs while travelling and views survive from France, Belgium, Italy and Ireland and in numerous British locations especially Ilfracombe, Bath, Bristol, Cardiff and Swansea.

Jones's interest in the technical advancement of calotype photography is evidenced in his correspondence with Talbot that shows how the process was refined through Jones's observations. Jones's prints reveal his experimentation with varnishing (to prevent fading), retouching and hand colouring. He was also one of the first photographers to make use of the panoramic format or 'joiners' and 'double or treble views' as he called them. In 1853 he presented a paper *On a Binocular Camera* (*Journal of the Photographic Society*, Volume 1, 1854, pp. 60-61) to the Photographic Society of London of which he was one of the first members. By the early 1850s, the calotype had been largely superseded by the introduction of glass negatives and albumen prints. Jones's last known correspondence with Talbot is from 1853.

After his father's death in 1847 Jones had gained financial independence, took ownership of Heathfield House and become involved in related business affairs and local politics largely to the exclusion of photography. He also took up a household in Brussels where his wife died in 1856. He is not known to have made any photographs after that time though he continued to paint. Jones' second marriage was to Portia Jane Smith in 1858. They had two daughters. Thereafter the family lived at Bath with frequent visits to the continent. Jones' first daughter died on 29 June 1877 shortly before her father who died at Lansdown Crescent, Bath on 7 November 1877. He was buried in Swansea at St. Mary's church.

Calvert Jones's important contribution to the development of photography is now being realised after many years of neglect following his death. He was one of the few Britons to have produced a substantial body of calotypes in Britain and abroad. His marine studies were made at a time of major transition in shipping from sail to steam and are of significant historic worth. Similar historical value can be placed upon his variety of architectural studies taken from his preferred oblique angle or as a detailed partial view. His figure studies within architectural settings and environmental portraits are unique to Jones as a photographer during the period in which he was working (and it may be noted that Jones himself likely appears in many of his own photographs). However, his most significant contribution to the early development of photography lay in his ability to fuse technical skill with artistic training, intentions and results. Jones revealed his understanding of both the simplicity and challenge of photography as an artistic medium, when he wrote to Talbot: "The best artists, to whom I have shown specimens, have been perfectly enchanted, especially with details and foregrounds and as nature is infinite, so is the supply which I could furnish: the great point being to select the proper subjects from a proper position." (Letter to W.H.F Talbot, June 9, 1846, quoted in Buckman, 29).

MARTIN BARNES

Biography

Calvert Richard Jones was born in Swansea, South Wales on 4 December 1802, the eldest of five children. The family were part of the landed gentry of the area. The young Jones was attended Oriel College, Oxford

where he gained a first class degree in mathematics in 1823. In 1829 he took holy orders to take up positions as a rector in Wales. He abandoned his ecclesiastical profession at the time of his first marriage in 1837 to Anne Harriet who bore their only child. Jones became a skilled draughtsman and painter in watercolour and oils. In 1839 he learned of the calotype process through Fox Talbot's correspondence with his relatives who were friends and neighbours of Jones in South Wales. Between 1840 and 1841 he also learned the daguerreotype process. However, Jones extensively used the calotype on his travels from 1841 to 1845 photographing locally in Wales and other parts of Britain and in Italy, France, Belgium and Malta. He corresponded regularly with Talbot who sold Jones's prints through his Reading Establishment. Jones took ownership of the family estates after his father's death in 1847 and became involved in business and local affairs largely to the exclusion of photography. He also took up a household in Brussels where his wife died in 1856. He is not known to have made any photographs after that time. Jones's second marriage was to Portia Jane Smith in 1858. They had two daughters. Thereafter, the family lived at Bath with frequent visits to the continent. Jones's first daughter died on 29 June 1877 shortly before her father who died at Lansdown Crescent, Bath on 7 November 1877. He was buried in Swansea at St. Mary's church.

Collections

National Museum of Photography Film and Television, Bradford.
National Maritime Museum.
National Library of Wales.
V&A.

See also: Bayard, Hippolyte; Llewelyn, John Dillwyn; and Talbot, William Henry Fox.

Further Reading

Buckman, Rollin, with an introduction by John Ward, *The photographic work of Calvert Richard Jones*, London: Science Museum (Great Britain). H.M.S.O, 1990.
Bishop, William, "Calvert the Calotypist," *The British Journal of Photography*, 1 August 1991, 10–11.
Cox, Julian, "Photography in South Wales 1840–60: This beautiful art," in *History of Photography*, vol.15, Autumn 1991, 160–70.
Lassam, Robert E. and Gray, Michael, *The Romantic era: Reverendo Calvert Richard Jones 1804–1877, Reverendo George Wilson Bridges 1788-1863 William Robert Baker di Bayfordbury 1810–1896: il lavoro di tre fotografi inglesi svolto in Italia nel 1846–1860, usando il procedimento per Calotipia(Talbotipia)*, Florence: Museo di Storia della Fotografia Fratelli Alinari, 1988.
Meical Jones, Iwan, "Calvert Richard Jones: The earlier work," *History of Photography*, vol. 15, Autumn 1991, 174–9.
Painting, David. *Swansea's place in the history of photography*, Swansea: Royal Institution of South Wales, 1982.
Smith, Graham. "Calvert Jones in Florence," *History of Photography*, vol. 20, spring 1996, 4–41.

JONES, GEORGE FOWLER (1819–1905)
English photographer and architect

Being both an architect and a photographer is not uncommon but Fowler Jones remains exceptional and he notably encompasses every process from paper, glass and nitrate between the 1840s and 1900.

Born in Aberdeen and trained under William Wilkins and Sydney Smirke he practised in York from 1846: his views of the city were among the first but he continued another 50 years [using the ceroline paper negative process] frequently revisiting Scotland.

2100 well documented negatives at the National Media Museum cover domestic and ecclesiastic structures across northern England, Scotland and Ireland. His amateur eye is professionally informed by an architectural vision so his work is distinctive compared with commercial, picturesque or quick progress work. He unusually includes new as well as old buildings with singular well documented devotion—yet his only exhibition was posthumous. Neither did he publish yet his son did produce a series of drawings of York clearly deriving from photographic originals. Architectural commissions and views in Ireland prove he was active there as early as 1845 so his travels need investigation.

English Victorian architect-photographers usually fall into the amateur or dilettante categories and by the 1870s most architects utilized professional architectural photographers like Bedford Lemere so Fowler Jones stands outside the norm.

IAN LEITH

JONES, HENRY CHAPMAN (1854–1932)
English chemist and author

The scientist Henry Chapman Jones was engaged in wide-ranging studies concerned with the chemistry of photography, and for many years was a regular contributor of informed scientific opinion on the emerging study of the workings of the photographic process.

He was born in London and later studied at the Royal School of Mines. In 1879, he was elected a Fellow of the Royal College of Chemistry.

Amongst his many contributions to the photographic press was a memorial lecture delivered to the Royal Photographic Society in 1920 on the work of Sir William de Wiveleslie Abney, whom he had known during his lifetime.

He was in regular correspondence with Hurter and

Driffield throughout the period of their important research into the understanding of the relationships between sensitivity, exposure and development.

Of significance is an article published in *Photography* in 1890, disputing several assertions made by H&D in their 1890 paper. This led to a heated debate with Driffield, culminating in a rift between the two men, and the publication in *The Photographic Journal* of Jones's paper 'Density ratios as affected by development,' which sought to disprove a central canon of H&D's work.

An Introduction to the Science & Practice of Photography by Henry Chapman Jones was published by Iliffe & Sons in 1888, and had reach a third edition by 1900.

JOHN HANNAVY

JUHL, ERNST (1850–1915)
Collector and curator

Ernst Wilhelm Juhl, born on December 10, 1850, one of five children, in Hamburg, Germany was to have a significant influence as collector and supporter of experiments in photography in the late nineteenth and early twentieth centuries. Juhl attended high school in Hamburg and then went on to study engineering at the Technische Hochschule in Hannover. A sketchbook with technical drawings from those student years is in the collection of the Hamburg Museum für Kunst and Gewerbe.

Following his studies, Juhl returned to Hamburg and tried without too much success to found two companies. With independent income, however, Juhl was able to marry Johanna Julie Auguste Jacoby, (Henny), the grandniece of the composer Richard Wagner. The couple had three children, a son Ernst Carl, and two daughters, Hertha and Isle.

Being well-educated, Juhl spoke several languages, enjoyed traveling and entertaining a variety of people at his home. A number of artists came to gatherings at the Juhl home, and Juhl began collecting paintings and drawings from Hamburg artists who were experimenting in modernist styles. Among those works he collected early were those of Ernst Eitner and Arthur Illies.

From the late 1890s onward, Juhl expanded his personal library to include a number of valuable art books catalogues, and portfolios. Of particular interest was a 1903 portfolio, "*Heliogravuren nach Gummidrucken von Mitgliedern der Gesellschaft.*" Unfortunately many of Juhl's books and graphic works were destroyed during World War II when a bomb hit Juhl's son's house.

Through Juhl's influence and interests, Hamburg became one of the most important cities in Europe to foster the growth and development of photography. It is ironic that Juhl took very few photographs himself, but felt the medium to be a powerful and significant one for the nineteenth and twentieth centuries. He promoted the founding of the "Amateurphotographen-Vereins" and then the "Gesellschaft zur Förderung der Amateur-Photographie" (Society for the Promotion of the Art Photography).

From 1893 to 1903 with the Society for the Promotion of Art Photography, Juhl organized ten international-photographic exhibitions at the Hamburg Kunsthalle. These exhibits honored photography as an art, and had a strong influence on the photography of the Art Nouveau or *Jugendstil* period.

In 1903 the tenth, and last Annual International Exhibition of Art Photography at the Hamburg Kunsthalle, made Hamburg a focal point for experiments in Jugendstil photography. Juhl, as President of the Art Association and the Society for the Promotion of Art Photography, invited amateur and professional photographers from throughout the globe. Among them was the well-known professional photographer Nicola Perscheid from Leipzig. (Perscheid moved to Berlin in 1965.) Perscheid exhibited two large-scale allegorical wall images, entitled "Mower" and "Shepherd," as well as eight portraits. The large scale portraits are still preserved in Dresden.) Among the portraits were those such as *Portraits of His Majesty the Emperor in Hunting Dress, H.M. King George of Saxony* and *Professor Max Klinger.* (Max Klinger had recently completed the large-scale sculpture of a Zeus-like Beethoven for the opening of the Vienna Secession building in 1902.)

Not only did Juhl help organize significant art and photographic exhibitions, but he also served as a juror or commissioner for various exhibits in other major European cities: in Amsterdam (1895), Haarlem (1896), Berlin (1896), Oxford (1901), Turin (1902), Lille (1903), and Dresden (1909). He was also made an honorable member at a number of the new emerging photography clubs that sponsored photography as a valid art from—i.e., The Photo Club of Paris, the Camera Club of Vienna, and the Belgian Photography Association.

Further, Juhl, as a well respected Hamburg citizen, was able to encourage museums and private individuals to collect contemporary photography. Juhl also exerted influence by writing various articles on the new photography and serving as art director of the *Photographische Rundschau*, a position which he had to give up in 1902, because he had so enthusiastically supported the new Impressionist work of the young photographer, Edward Steichen, whose photographs had begun to look much like paintings. For some, who expected, and wished photography to retain its documentary status, Juhl's attitude and support for such experiments, was inappropriate and unacceptable.

Juhl's artist judgment, however, was largely respected and in 1908 he was commissioned to direct the organiza-

tion and planning of a "State Photographic Collection" by the Senate of Hamburg. Many of the pictures for the collection were taken by Minya Diéz-Dührkoop, the daughter of the well-known photographer, Rudolph Dührkoop (1848–1918), and Anton Joachim Christian Bruhn, who was initially a carpenter but made photography his primary profession about 1900. Bruhn's photographs of Hamburg are strong atmospheric images, many of which depict the working class of a major port city. From 1908 to 1912 over one thousand 18x24 cm. photographs were taken under Juhl's direction.

Ninety of these were put together in a portfolio in 1912. The mayor of Hamburg at the time, Dr. Johann Heinrich Burchard, was also very supportive of this project. Burchard unfortunately died a month before the project's completion. The bound portfolio, however, was dedicated to Burchard's memory. The collection was titled, "Ernst Juhl, Hamburg and the Hamburg Landscape," photographed by the Commission of the Free and Hanseatic City of Hamburg. Copies were made of the portfolio in two different editions, one bound in parchment, the other bound in a half-linen binding. Copies were for sale and used as gifts for Hamburg citizens who contributed special services to the city. The photographs taken for this project, in general, emphasized the pictorial and artistic, rather than pure documentary qualities.

Juhl's own private photography collection began in earnest, probably about 1893. His collection began to particularly expand in 1899 after he purchased a number of calotypes from James Craig Arman and work from David Octavius Hill, Robert Adamson, and Julia Margaret Cameron. A special exhibit of Juhl's collection was held in Berlin from May 8-June 30, 1910 at the Kunstgewerbe Museum. Juhl's collection, now in Hamburg's *Museum für Kunst and Gewerbe,* and Berlin contains examples of quality work from photographers working throughout the world at the turn of the century. Major names, such as Stieglitz, Steichen, Käsebier, Hofmeister, Kühn, etc. who were experimenting with various photographic techniques and content imagery, fighting for the role of photography as a significant art form, are to be seen in the collection. Due to financial difficulties for Juhl's widow, Henny, the collection was sold after Juhl's death.

Ernst Juhl died on August 16, 1915. In a commemorative statement, Dr. Willi Warstatt wrote, "Er war seiner der bedeutendesten Freunde und Forderer der Kunstlerischen Photographie, und sein Tod wird nicht nur in Deutschland, sondern auch über die Grenzen unseres Vaterlandes hinaus Anteilnahme und Trauer erregen." ("He was one of the most meaningful friends and supporters of art photography, and his death will evoke sympathy and grief not only in Germany, but far past the borders of our fatherland.")—Quoted in Rudi-

ger Joppien, *Eine Schöne und auf dem Kontinent wohl einzige Sammlung*; *Die Sammlung Ernst Juhl* (Hanburg, Museum für Kunst und Gewerbe, 1989, 21.)

KATHERINE HOFFMAN

Biography

Ernst Juhl was born on December 10, 1850, one of five children in Hamburg, Germany. He attended the Gymnasium in Hamburg and the Technische Hochschule in Hannover, studying engineering. His attempts to work in business were somewhat unsuccessful, and following marriage to Johanna Julie Auguste Jacoby (Henny) and starting a family, Juhl became much more interested in the arts and photography. From 1893–1903 he, with the Society for the Promotion of Art Photography, which he had started, organized ten international art photography exhibitions at the Hamburg Kunsthalle. In 1902 he was forced to give up the art direction of the "Photographische Rundschau." From 1908–1912 Juhl directed the planning and organization of a State Photographic Collection by the Senate of Hamburg. He died on August 16, 1915.

See also: Photo-Club de Paris; *Photographische Rundschau*; and Dührkoop, Rudolf and Minya.

Further Reading

Evers, Bernd, *Kunst in der Bibliothek.* Berlin: Akademie Verlag, 1994.

Juhl, Ernst, and Margret Kruse, *Kunstphotographie um 1900: die Sammlung Ernst Juhl.* Hamburg: Museum für Kunst und Gewerbe Hamburg, 1989.

Juhl, Ernst, *Camera-Kunst: eine internationale Sammlung von Kunst-photographien der Neuzeit.* Berlin: G. Schmidt, 1903.

——, *Das Lichtbild als Kunstwerk.* Hamburg, 1897.

——, *Internationale Kunst-Photographen.* Hamburg, 1900.

——, *Hamburg—Land und Leute der Niederelbe, Aufgenommen im Auftrag der Freien und Hansestadt Hamburg.* Hamburg, 1912.

JÚNIOR, CHRISTIANO (1832–1902)

José Christiano de Freitas Henriques Júnior was born in Portugal, in the small island of Flores, Azores archipelago, in 1832. He is known for his work in Brazil, Argentina and other South American countries. Nothing is known about his first years in Portugal where he remains unknown, he is not even mentioned in the only *Portuguese History of Photography*, written by a fellow Azorean. Even on his small island, his memory seems to be lost. Following the path of many of his fellow countrymen, he migrated to Brazil in 1855. His photographic activities started in Maceio, northeast Brazil, in the early 1860's. He went to Rio de Janeiro in 1863, where as a partner of several photographic studios, he

made some of his best known work: The *carte-de-visite* of negro slaves. These were sold as a souvenir mainly to the visiting or returning Europeans. These were a complement of a successful business as a portrait photographer. His next step led him to establish his business in Mercedes, Uruguay, and in 1867 in Buenos Aires. At that time he managed studios in three South American countries. In his Buenos Aires studio in Florida Street of Buenos Aires he photographed landowners, politicians, diplomats, the core of the Argentinean society, including the presidents: Pelegrini; Mitre, Sarmiento. In the 1870s he established a studio run by his son, José Virginio Freitas Henriques for photographing children, a difficult task in the wet collodium time. He earned a gold medal in the Cordoba National exhibition in 1871. In Argentina, as in Brazil he completed his successful portrait work with photographs of the growing city of Buenos Aires, the local costumes and other Argentinean cities. His children's studio was destroyed by a fire in 1875. He sold his studio to Witcomb in 1878, and a year latter started touring Argentina publishing photographic albums of Argentinean provinces. He retired from his photographic activity in 1883. He died in Asunción Paraguay in 1902.

NUNO DE AVELAR PINHEIRO

Exhibitions

Buenos Aires, 2002, Fundación Antorchas.

A Colecção do Imperador, Fotografia Brasileira e Estrangeira do Século XIX, Museu Nacional de Belas. Artes, 1997, Arquivo Fotográfico da Câmara Municipal de Lisboa.

K

KARELIN, ANDREY OSIPOVICH
(1837–1906)
Professional photographer, artist

Andrey Osipovich Karelin was born in 1837 in the Tambov region. He was the illegitimate child of a peasant woman and a landlord. During his childhood Karelin demonstrated an inclination for painting, and at the age of ten wanted to be a master of iconic painting. The local landlord recognized his talent and in 1857, sent him to St. Petersburg Academy of Art. At the Academy, he studied with future famous artists such as I. Kramskoy, K. Makovsky and others. In the course of his studying, Karelin received two silver medals for his works.

Karelin began as a retoucher in a photographic studio and later chose to experiment with photography. Upon graduating the Academy in 1864 and receiving the qualification of an "independent artist," Karelin left St. Petersburg. In the summer he went to Nizhny Novgorod's fair and chose to stay there to work in the studio of M. Nastjukov, one of the first photo-chronographer in the Volga area.

In 1869 Karelin opened a studio of his own in Nizhny Novgorod. The photographer made portraits and multi-figured genre scenes. At first he used wet collodion, but then switched to bromgelatine plates with dimensions of 50 × 60 cm. The more perfect optical shape of the lens allowed him to achieve considerable depth of focus in his multi-figured compositions. The decisive factor affecting the scene was the light and the layout of his photos which were derived from the laws of academic painting that he studied in the Academy of Arts.

In 1870 the gentlefolks' leader of Nizhny Novgorod requested that Karelin and the well-known Russian landscape painter I. Shishkin create an album comprised of images within Nizhny Novgorod, its neighborhood, and photos of the nationalities inhabiting the region. The prints were water-colored by Shishkin and Karelin themselves. The exemplary album was presented to the Emperor Alexander II.

From 1870 to 1880, Karelin created a most interesting "Art Album of Photos from Life," which contained his studio genre pictures. The photographer photographed idyllic family life where everyone in his pictures were preoccupied with something appropriate. Some were depicted playing musical instruments while others read. Karelin was in constant search for a more effective means of expression. He experimented with sitters, costumes, and worked on composition by taking several pictures of the same scene. His primary concern in arranging the scene was to make all the elements of the composition interactive. Karelin loved to use windows as the background for his photos, thus demonstrating his mastery in lighting, making the sitters' features and the photographs' details visible through exemplifying the light and shadow of the photograph. Karelin experimented with the role of property by photographing unique objects from everyday life that he had in his varied collection, which he had been gathering for quite a while.

All the works in the album were in accordance with the laws of academic painting. Even the scenes donated to charity bore no pathos of exposure of social inequity and characteristics of injustice, which were often found in the works by peredvizhniks. Karelin tried to make photo-images less documentary by employing the method suggested by Russian photographer A. Denier. Karelin made a wide use of this technique especially in the works of considerable size, thus obtaining a soft image without needing to retouch it. M. Dmitriev, a photographer, wrote of Karelin's works: "He was the first to show how to photo groups of sitters in a studio so as to fix marvelous effects of sunlight and make the poses of sitters dainty and noble. His works were always

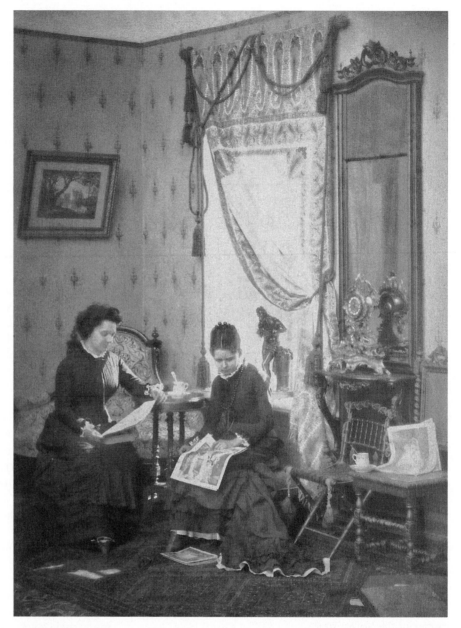

Karelin, Andrey Osipovich.
Conversation in the Salon.
From the Art Album of Photos from Life 1870–1880s. Private Collection: Alexei Loginov.

marked by high artistry and more to it by elaborate and subtle technical efficiency." In 1876 Karelin was given the honorary title of photographer of the Emperor's Academy of Arts. In the 1870s he worked the Nizhny Novgorod fair from his studio. Karelin successfully exhibited his works at photo-exhibitions at home and abroad. In 1873, he took part in the sixth International exhibition of pictorial photography in Vena, and in 1876 he won the silver medal at a Special exhibition of the French photography society in Paris. He also won a bronze medal at the centennial Exhibition held in Philadelphia in 1876 to mark the centenary of the foundation of the United States of America. The photograhs that he exhibited at the Edinburgh Photographic Society's Exhibition in 1876 and 1877 were very well received, and Karelin was awarded a gold medal and a diploma.

In 1878 Karelin became a member of the French national academy of arts and was given a diploma from the French photography society and a gold medal at the eighth World exhibition in Paris.

Even though Karelin was very successful with photography, he never stopped painting. For more then 30 years he worked as the head and teacher of a drawing and painting school that, since pedagogy was of great importance to Karelin, gave free lessons for all students. The school had 30 to 40 students of all ages. In 1886 he, along with other local artists, organized a provincial art exhibition in Nizhny Novgorod. Some of his students such as M. Dmitriev, S. Solovjev and his son A. Karelin later became famous. Karelin's activities were not just confined to Nizhny Novgorod. In fact, he created portraits for and was friendly with people from all over

Russia. He was acquainted with scientists, musicians, writers, and artists such as D. Mendeleev, I. Kramskoy, I. Repin, and many more.

In 1886 Karelin issued his album "Views of Nizhny Novgorod." In this ablum he returned to landscape photography. The most remarkable of them were his panoramic views of the city and the Volga River. These photos were done by means of a landscape objective from the top of the highest bank of the river. The depth of space is, as a rule, highlighted by placing something in the foreground, the effect of which is strengthened by an aerial perspective. The album also comprised landscapes of city streets, monuments of architecture, separate buildings and fragments of buildings. And again Karelin built the composition of these photographs in accordance to the norms and rules of academic painting. His choice of positioning is the reason why his photographs came out so elaborately.

Karelin's creative works were widely acknowledged not only by specialists in photography, but also by the intelligentsia. His works immensely influenced the process of development of photography in Russia. In 1895 Karelin became a fellow member of the Russian photography society in Moscow, and in 1896 he became its honored member. In 1897 he was elected as a fellow member of the Emperor society of natural science, anthropology and ethnography. Finally, in 1903 at an International photography exhibition in St. Petersburg, his last ever, he won a silver medal.

In the course of his life, Karelin never stopped his altruistic activities. He died in 1906 in Nizhny Novgorod. His obituary ran as follows: "He was the first to prove by all his numerous photo sketches that art and photography are very closely connected. He proved that the fantasy of a photo-artist, his dainty taste in choosing the plot for his works might be realized through photography."

In the USSR the photo report became the main trend of the official photography, causing Karelin's work to be forgotten. Many contemporary photographers, including the commercial photographers, are more often using and developing Karelin's methods to achieve the maximum expression of the image by arranging the composition and the artificial lighting.

ALEXEI LOGINOV

Biography

Andrey Osipovich Karelin was born on July 4, 1837, in the village of Selezny in the Tambov region. He studied at the St. Petersburg Academy of Arts from 1857 to 1864. In 1869 he opened his studio in Nizhny Novgorod. He made photo–portraits and views of the city. In 1870 together with landscape painter Shishkin he created the album "Nizhny Novgorod." From 1870 to 1880 he

created his "Art Album of Photos from Life" which comprised studio genre scenes of idyllic family life. He took part in and won prizes at numerous exhibitions. He taught painting in Nizhny Novgorod for everyone and he took an active part in the Artistic culture of the city. He created a large gallery of portraits of Russian scientists, writers, musicians, artists and public figures. In 1886 he issued the album "Views of Nizhny Novgorod," and thus returned to landscape photography. Karelin died in 1906 in Nizhny Novgorod.

Further Reading

Morozov, S., *Artistic Photography*, M. Planeta, 1986, 416 pp.

Osipovich Karelin, Andrey, *Creative Legacy*, edited by A. Semenov, M. Kchorev, and Nizhny Novgorod, Volgo-Vyat Publishing House, 1990, 288 pp.

Russische photographie 1840–1940, Berlin, Ars Nicolai, 1993.

Russian Photograph,. The Middle of the 19th—the Beginning of the 20th Century. Chief editor N. Rakchmanov, M. Planeta, 1996, 344 pp.

Loginov, A, *Russian Pictorial Photography/ Pictorial Photography in Russia. 1890s–1920,* Art-Rodnik, 2002, 10–29.

Loginov, A. Horoshilov, *The Masterpieces of the Photography from Private Collections. Russian Photography 1849–1918.* Punctum 2003, 176 pp.

KARGOPOULO, BASILE (VASILI) (1826–1886)
Ottoman Greek photographer

Basile Kargopoulo opened his studio on Grand' Rue de Péra in the Ottoman capital Istanbul in 1850, and opened a second studio in partnership with E. Foscolo in the city of Edirne, then a major army base.

Kargopoulo was particularly renowned for his panoramas of Istanbul, scenes of the city and the Bosphorus, and photographs of royal palaces. He kept a large wardrobe of costumes in his studio for young men who wanted to dress up for their photographs. He became well known for his series of Istanbul types, including fishermen, greengrocers, and street vendors, such as *simit* (bagel) and sherbet sellers, sold as mounted 6 × 9 cm prints. Today these photographs are important documents recording life in 19th century Istanbul.

Kargopoulo was appointed royal photographer to Sultan Abdulmecid (1823–1861, r. 1839–1861), and was private photographer to Sultan Murad V (1840–1904, r. 1876) When Sultan Abdülhamid II (1842–1918 r. 1876–1909) came to the throne, Kargopoulo's appointment as royal photographer was rescinded because he did not take down the photograph of Murad V on his studio wall, but shortly later, he was reinstated.

ENGIN OZENDES

KÄSEBIER, GERTRUDE (1852–1934)
American photographer

Gertrude Käsebier came to photography relatively late in life and was soon among the most esteemed photographic portraitists of her day, successful both artistically and commercially. From the end of 1897 for the next thirty years, she operated a prominent portrait studio in New York City. Her work was vigorously championed by Alfred Stieglitz following their meeting in 1898, but within a decade, the two had begun to fall out over aesthetic and practical differences. Indeed, throughout her career, she maintained a determined independence, frequently holding what she termed "heretical views" with regard to prevailing commercial and artistic trends.

Married and the mother of three, Käsebier first made photographs using her family as a subject in 1885. In 1889, at the age of thirty-seven, she enrolled in the Pratt Institute in Brooklyn to study painting. Following her course of study she turned to artistic photography and, in early 1894, submitted the winning photograph to a juried contest in the *Quarterly Illustrator*. This prompted criticism from her painting masters for her involvement both with photography and with the illustrated press. In spring of 1894, she traveled to Europe, producing a series of photographs of French peasants, reminiscent of the paintings of Jean-François Millet, which she subsequently published in the *Monthly Illustrator*. In Germany, she undertook a brief apprenticeship with a chemist in order to learn the chemical basis of photography, before returning to New York in 1895.

Käsebier launched herself into professional portrait photography in 1896. After apprenticing with a commercial photographer, she opened her own studio in Manhattan in the winter of 1897–1898. Her style of portraiture dispensed with conventional props, focusing on softly lit heads against dark backgrounds. In addition to her fashionable clientele, she began photographing Plains Indians from Buffalo Bill's Wild West Company in April 1898, producing a series of remarkably intimate character studies.

Käsebier quickly made a name for herself as a pictorial photographer. In June 1898, she introduced herself to Stieglitz, leading figure in the Camera Club of New York. At the 1898 Photographic Salon of Philadelphia, with Stieglitz on the jury, Käsebier exhibited her recent work and gave a lecture on the need for an artistic approach to portraits emphasizing simplicity, naturalness, and directness. She recommended that artistically trained women take up "modern photography" as a "vocation" (Käsebier, 86).

Blurring distinctions between artistic and commercial photography, Käsebier charged a premium for her portraits and favored the fine platinum print over the popular gelatin silver print. Stieglitz enthusiastically exhibited her photographs at the Camera Club in February 1899, and in April featured them in *Camera Notes*. At the 1899 Philadelphia Salon, Käsebier served on the jury, alongside Clarence H. White and Fred Holland Day, and received praise for *The Manger*, a luminous image of a gauze-draped Madonna with child. British actress Ellen Terry would famously buy this picture for $100, an unheard-of sum for a photograph at the time.

At the 1900 Philadelphia Salon, Käsebier achieved critical acclaim for *Blessed Art Thou Among Women* (1899), an allegorical photograph of a young girl crossing a threshold into public life. Also in 1900, her work was exhibited abroad in Paris and London. In October, she and British photographer Carine Cadby became the first women elected into the elite Brotherhood of the Linked Ring. At this time, Käsebier began a series of portraits for the illustrated magazine *World's Work*, photographing such eminent figures as author Mark Twain and educator Booker T. Washington. She was achieving success simultaneously on three fronts: commercially in her portrait practice, artistically in exhibitions and photography journals, and publicly in the illustrated press.

Following a stay with Eduard Steichen in Paris in the summer of 1901, Käsebier became an ardent practitioner of the gum bichromate printing process. Subsequently, she both alternated and combined platinum and gum printing techniques in her work, experimenting with different versions of the same image. Her prints might feature crisp photographic detail or moody handling of the emulsion, depending on the situation.

In 1902, Stieglitz included Käsebier as a founding member of the Photo-Secession, and in January 1903, he devoted the first issue of the Photo-Secession's deluxe journal, *Camera Work*, to her work. In 1905, several pastoral images by Käsebier, among them, *Happy Days* (1903), were featured in *Camera Work* 10 and exhibited at Stieglitz's newly opened Little Galleries of the Photo-Secession.

The theme of women's emotional experience recurs throughout Käsebier's work. In 1902 she produced *Portrait of Miss N.*, a frankly erotic depiction of the young showgirl Evelyn Nesbit poised seductively with an open pitcher tipped toward the viewer, symbolically suggesting the girl's entry into sexual life. Two years later, Käsebier's wrenching portrait of the poet Agnes Lee, entitled *Heritage of Motherhood*, depicted a grieving mother in a bleak landscape.

The emphasis on depth of feeling in Käsebier's photographs led to divergent assessments of her work in 1907. An article by Mary Fanton Roberts (pseudonym Giles Edgerton) in the April issue of *Craftsman* praised Käsebier's investigation of "Photography as an Emotional Art." In response, Charles H. Caffin, previously a strong supporter of Käsebier, wrote a stinging satire,

published in *Camera Work* 20 (October 1907), of the self-indulgent "emotional artist." The privileged role of intuition in pictorial photography was beginning to give way to a more detached, modernist photographic aesthetic.

By 1909, Käsebier's relations with Stieglitz had grown strained over her identification with professionalism and his with non-commercialism (Michaels, 130). In 1910, in the wake of Stieglitz's International Exhibition of Pictorial Photography, tension erupted over financial matters relating to the sale of her works (Michaels, 136). Stieglitz, meanwhile, was turning his attention away from pictorial photography in favor of the machine aesthetic and modern art. In 1911, he asked for a pledge of loyalty to the new direction that the Photo-Secession was taking under his leadership; Käsebier refused. When Clarence H. White, himself an ex-Secessionist, founded the Pictorial Photographers of America in 1916, he made Käsebier honorary vice president

From the start of her career in the mid-1890s, Käsebier's critical fortunes had risen and fallen rather precipitously. What at first seemed bold and daring in her work came, in light of trends away from pictorial photography after 1910, to seem conservative (Tighe, 98). After her death in 1934, decades of relative invisibility followed. In the 1970s, however, concurrent reevaluations of pictorial photography and the neglected history of women artists led to a revival of interest in Käsebier's life and work. Subsequently, in the late 1990s, her innovative portraits of Native Americans drew renewed attention to her exceptional career.

STEPHEN PETERSEN

Biography

Gertrude Käsebier was born Gertrude Stanton in Fort Des Moines, Iowa (now Des Moines, the state capitol), on 18 May 1852, to a family of Quaker heritage. From the age of eight to twelve she, along with her parents, John W. Stanton and Muncy Boone Stanton, and younger brother Charles, lived in the Colorado Territory, where her father sought his fortune in the gold rush. After finding success in mining operations, he and his family moved east in 1864, settling in Brooklyn, New York. Käsebier attended Moravian Seminary for Young Ladies in Bethlehem, Pennsylvania, from 1868 to 1870. In 1874 she married Eduard Käsebier, a German immigrant and shellac importer six years her senior. Living first in Brooklyn and later in New Jersey, the Käsebiers raised three children before Gertrude decided to pursue a career as a painter, returning to Brooklyn to study at the Pratt Institute from 1889 to 1895. Turning in 1896 to a profession in photography, she apprenticed with Brooklyn portrait photographer Samuel H. Lifshey. Following her apprenticeship she operated a highly regarded portrait studio in New York for thirty years, before physical ailments forced her retirement. A member of the Brotherhood of the Linked Ring from 1900–1909 and of the Photo-Secession from 1902–1912, she knew and exhibited with all of the major pictorial photographers. Käsebier died on 13 October 1934 in New York City at the age of 82. Her husband predeceased her by twenty-five years. Early in her career, she published her photographs in many journals and magazines including *The Monthly Illustrator*, *The World's Work*, *Everybody's Magazine*, *Ladies' Home Journal*, and *Harper's Bazaar*. Major exhibitions during Käsebier's lifetime included the Philadelphia Photographic Salon, Pennsylvania Academy of Fine Arts, 1898, 1899, 1900; The New School of American Photography, curated by F. Holland Day, Royal Photographic Society, London, 1900; American Pictorial Photography Organized by the Photo-Secession, National Arts Club, New York, 1902; and the International Exhibition of Pictorial Photography, Albright Art Gallery, Buffalo, 1910.

See also: Brotherhood of the Linked Ring; Gum Print; Pictorialism; Platinum Print; Portraiture; and Stieglitz, Alfred.

Further Reading

Bunnell, Peter C., "Gertrude Käsebier" in *Arts in Virginia*, vol. 16, no. 1 (Fall 1975), 2–15, 40.
Caffin, Charles H., *Photography as a Fine Art*, facsimile edition of 1901 original, Hastings-on-Hudson, New York: Morgan and Morgan, 1971.
Homer, William Innes., *A Pictorial Heritage: The Photographs of Gertrude Käsebier*. Wilmington, DE: Delaware Art Museum, 1979 (exhibition catalogue).
Hutchinson, Elizabeth, "When the 'Sioux Chief's Party Calls': Käsebier's Indian Portraits and the Gendering of the Artist's Studio" in *American Art*, vol. 16, no. 12 (Summer 2002), 40–65.
Käsebier, Gertrude, "Studies in Photography (1898)" in *A Photographic Vision: Pictorial Photography, 1889–1923*, edited by Peter C. Bunnell. Salt Lake City: Peregrine Smith, 1980, 84–86.
Michaels, Barbara, *Gertrude Käsebier: The Photographer and her Photographs*,.New York: Harry N. Abrams, 1992.
Tighe, Mary Ann, "Gertrude Käsebier Lost and Found" in *Art in America*, vol. 65, no. 2 (March–April 1977), 94–98.
Tucker, Anne. *The Woman's Eye*. New York: Alfred A. Knopf, 1973.

KEELER, JAMES EDWARD (1857–1900)

The American astronomer James Edward Keeler was born in La Salle, Illinois, and during an extended period of illness in his teens, developed a passion for astronomy. After completing his bachelors degree at John Hopkins University, he studied for two years in Europe—at Berlin and Heidelberg—and subsequently

was appointed to the staff of the Allegheny Observatory in Pittsburgh in 1884.

By 1888 he had been appointed as astronomer at the newly completed Lick Observatory in California, where he stayed for three years conducting a wide range of spectrographic experiments with the observatory's refracting telescope, before returning to the Allegheny to take up the position of Professor of Astronomy and Astrophysics.

He returned to the Lick Observatory as Director in 1898, and set about applying himself to the photography of every nebula listed in Sir William Herschel's catalogues of 1786, 1789 and 1802—two and a half thousand in number. He photographed over half of them, and in the process discovered many more.

For his photographic recordings, he used the Observatory's 36-inch f/5.7 Crossley Reflecting Telescope, imported from England where it had previously been used by A. A. Common in his garden observatory in Ealing, London. The exposure for each plate was between three and four hours.

Keeler died in San Francisco in 1900 at the age of only 42, his photographic project far from complete.

JOHN HANNAVY

KEENE, RICHARD (1825–1894)
English

Richard Keene was born in London on May 15th 1825 and his family moved to Derby in 1825 where his father managed a silk mill.

Keene was apprenticed to local printers Thomas Richardson and Sons, later moving to their London offices. He later worked for publishers and booksellers Simpkin Marshall and Co.

He returned to Derby in 1851, married Mary Barrow and set up as a printer, publisher and bookseller at 24 Irongate.

Becoming interested in photography, he started making local views which he sold commercially and exhibited 16 architectural views at the 1862 London International Photographic Exhibition.

He was known for his high quality portrait, landscape and architectural studies which he produced as albumen, gelatin silver and platinum prints. He also specialised in producing photographs on ceramic. Keene published several books about Derbyshire, was official photographer to the Midland Railway Company until 1883 and a member of the local archaeological society.

Keene was a member of the Photographic Society of Great Britain and was elected to membership of The Linked Ring on 26th July 1892 with the pseudonym 'Master Printer,' the link name reflecting the quality of his photographic printing skills.

Keene died at his home in Radbourne Street, Derby in 1894, leaving five sons and three daughters.

IAN SUMNER

KEIGHLEY, ALEXANDER (1861–1947)
English photographer

Although the son of a wealthy worsted mill owner, of High Hall, Stretton, Yorkshire, Keighley had to work his way up, from shop floor sweeper to managing director. Interested in oil and watercolour painting, the influence of Henry Peach Robinson allowed him to combine these interests into photography in 1883, then he joined the Bradford Photographic Society. In 1887, with 12 prints, he was awarded first prize by Peter Henry Emerson in the *Amateur Photography* competition (Alfred Stieglitz came second). Yet Emerson lamented Keighley's sharp focus and then later criticised him for becoming a 'gum sploger.' In the end Keighley adopted the manner of soft focus Impressionism and became a leading Pictorialist with many solo exhibitions in London, USA and throughout Europe. Invited member of the Linked Ring Brotherhood 1892, Fellow of the Royal Photographic Society 1912, Honorary Fellow 1924. Often he used a quarter plate camera, without a view finder, permanently set at 10 yards and covered in a bag so that he could surreptitiously photograph people, often on his travels abroad where the majority of his photographs were made. The negatives were then made into full plate positives, then manipulated using combination printing, pencil and dyes, then enlarged onto 16 × 20" or 20 × 24" glass negatives for contact printing with carbon. In his time, his photographs were highly praised as "lyrical," "poetic," the "poetry of romance," but they have not survived well. Now they would be regarded as "sentimental," "unreal," but his reputation suffers, like many of his time, in that only the same few images are ever reproduced.

ALISTAIR CRAWFORD

KEITH, THOMAS (1827–1895)
British surgeon and amateur photographer

Dr. Thomas Keith's appreciation of light, and his ability to recognise its potential for powerful visual statements is evident in his small but significant body of early paper photography. Working only when working pressures permitted, he produced over two hundred architectural and landscape views.

His subject matter embraced the Closes and Wynds of Edinburgh's Old Town, wooded highland landscapes, and the romantic ruins of Iona Abbey and his last dated negatives were taken in September 1856. With his preferred soft or diffuse light, his use of angular shadows

created powerful and dynamic images. At a time when the chemical and technical manipulation of processes occupied the minds of early photographers, Keith was concerned with controlling and exploiting the lighting conditions he found in mid-Victorian Scotland. In a paper presented to the Photographic Society of Scotland in 1856, he said

> If you were to ask me to what circumstance more than another I attribute my success, I should say, not to any peculiarity whatever in my manipulation, or to any particular strength of the solutions I employ, but entirely to this, that I never expose my papers unless the light is first-rate. This I have now made a rule, and nothing ever induces me from it; and I may safely say that since I attended to this I have never had a failure. (Keith, "Dr. Keith's Paper on the Waxed Paper Process" in Photographic Notes vol. 1 no. 8, 17, July 1856, 101–104)

His family had several early associations with photography. As a founder member of the Free Church of Scotland, his father, the Reverend Alexander Keith, had been photographed by David Octavius Hill and Robert Adamson for inclusion in Hill's painting "The Signing of the Deed of Demission at Tanfield." Thomas's brother Alexander, also a clergyman, was also photographed by Hill and Adamson. His older brother George Skene Keith, an amateur daguerreotypist, travelled to the Holy Land in 1844 and 1845 and produced daguerreotype views from which engravings were made for the 1848 edition of his father's book *Evidence of the Truth of the Christian Religion.*

Keith's practical engagement with photography spanned no more than five years. His earliest dated images were taken in 1854, his last in 1856. As some unspecified examples of his salted paper prints were reportedly exhibited in Aberdeen in 1853, it can be assumed that he had first experimented with photography no later than the summer of 1852. He intimated his decision to give up photography in 1857, almost certainly due to increasing pressures on his time as a medical practitioner. There is no evidence that he took any photographs in that year. He did, however, continue to exhibit his work for several years after.

Keith's medium of choice was Gustave le Gray's Waxed Paper Process, a process ideally suited to the constraints placed on his photography by the demands of his profession.

For the practice of photography to be possible, he needed a process which permitted him to prepare his negative materials in advance, and process them some time after exposure. Despite the ascendancy of the Wet Collodion process, Waxed Paper was ideally suited to the time-constrained amateur. With it, Keith pre-waxed and prepared his paper negative materials at least a day in advance, and developed them overnight. Thus freed from collodion's requirements of location processing,

Keith could operate with lightweight and easily transportable equipment, and respond quickly to lighting conditions. His reasons for selecting the Waxed Paper Process are all contained and clearly expressed within the text of his 1856 lecture.

That lecture, to the Photographic Society of Scotland on 10th June 1856, is one of the most significant explications of the Waxed Paper Process. In it he underlines the importance of the quality of the prevailing light—the feature which marks Keith's photography out as exceptional. Turning necessity to his advantage, he learned how to exploit the soft long shadows of early morning and late afternoon.

> I am almost always sure of clear mornings soon after sunrise, and most of my negatives have been taken before 7 in the morning or after 4 in the afternoon. The light then is much softer, the shadows are larger and the halftints in your pictures are more perfect, and the lights more agreeable. (Keith, "Dr. Keith's Paper on the Waxed Paper Process" in *Photographic Notes* vol. 1 no. 8, 17 July 1856, 101–104)

By the time of his invitation to deliver that key lecture, Keith's reputation as a photographer was already considerable. The images he displayed at the meeting were "greatly admired, and were considered by the Society to be the finest yet produced."

He was an early member of the Society, serving on its Council from 1856 until 1858, although he seldom attended meetings. He did, however, exhibit regularly, and images of Iona Abbey, taken in early September 1856, were hung in the Society's first Exhibition in 1857, to considerable acclaim. He exhibited in both 1858 and 1859, his last contribution being to an exhibition in Aberdeen where his work was shown alongside photographs by his friend John Forbes White with whom he had collaborated on several of his photographic expeditions.

Since their creation, Keith's photographs have had many admirers, including Alvin Langdon Coburn, who made prints from selected original negatives and exhibited them at the Royal Photographic Society in 1914, almost sixty years after they had been taken. Coburn included Keith as one of the "Old Masters of Photography," describing his work as being "as good as Hill's." He arranged for a selection of prints to be shown in New York's Ehrich Gallery, and again in Buffalo in the following year. He eventually acquired some of the negatives, later bequeathing them to George Eastman House. Miller and art collector, John Forbes White was also included as one of Coburn's "Old Masters."

Keith's reputation was further embedded by Helmut Gernsheim's inclusion of his work in the 1951 exhibition *Masterpieces of Victorian Photography* at the Victoria and Albert Museum in London.

The major holding of his work—predominantly Waxed Paper negatives—is the Hurd Bequest in Edinburgh Central Library.

JOHN HANNAVY

Biography

Thomas Keith was born in St. Cyrus, Aberdeenshire, Scotland, in May 1827, one of seven sons of the Reverend Alexander Keith. He studied art in Aberdeen, before becoming one of the last medical apprentices in Edinburgh, and subsequently serving as a junior member of Sir James Young Simpson's team working on anaesthetics—his brother George Skene Keith was Simpson's assistant. After qualification, and a residency at Edinburgh Infirmary, he moved to Turin as House Surgeon in the British Embassy, returning to Edinburgh in 1851. By the time he took up photography, he was in general practice with his brother George. He later pioneered several important procedures in ovarian surgery, and his hobby always took second place to his career as a doctor, surgeon and gynaecologist. His close and lasting friendship with Joseph Lister was sustained by a shared belief in the importance on cleanliness in the operating theatre, and he was one of the first to introduce Lister's antiseptic techniques in his work. In his obituary, celebrating an eminent career in medicine, the only reference to photography concerned his knowledge of glass—ironic for a master of the paper negative! He died in 1895 as a result of health problems exacerbated by sustained exposure to large quantities of early antiseptics.

See also: Waxed Paper Negative Processes.

Further Reading

Hannavy, John, *Thomas Keith's Scotland—the work of a Victorian Amateur Photographer.*, Edinburgh: Canongate, 1981.

Minto, C. S., *Thomas Keith, 1827–1895, Surgeon and Photographer, the Hurd Bequest*, Edinburgh: Edinburgh Corporation Libraries and Museums Committee, 1966.

Minto, C. S., *John Forbes White, Miller, Collector, Photographer 1831–1904*, Edinburgh: Edinburgh Corporation Libraries and Museums Committee, 1970.

Schaaf, Larry J., *Sun Pictures Catalogue Six: Dr. Thomas Keith and John Forbes White*, New York: Kraus, 1993.

Keith, Thomas, "Dr. Keith's Paper on the Waxed Paper Process" in *Photographic Notes* vol. 1 no. 8, 1856, 101–104.

Hannavy, John, "Thomas Keith at Iona" in *History of Photography*, vol. 2, 1, 29–33. London: Taylor & Francis, 1978.

KERN, EDWARD MEYER (1823–863)

The youngest of three Philadelphia-born, artistically-minded brothers who all took part in important ventures of American exploration in the mid-19th century, Edward Meyer Kern was probably the boldest, and,

although primarily a draughtsman, the only one to practice photography—in the form of daguerreotypes. Indeed, he used a daguerreotype apparatus on several important American naval expeditions to the Far East and thereby helped introduce the process in a number of locations in Asia and the Pacific area.

Though his actual photographic output was still largely unknown or unidentified, and though most holdings of his work consisted exclusively of sketches, drawings and maps of the American West, Edward "Ned" Kern was a significant figure in the development of photography, for at least two reasons. First, he was part of an important cultural and professional transition, which saw the novelty of photography gradually penetrate the tradition of scientific drawing in American exploration, albeit only timidly at first. Second, after 1853 Kern was a pioneer spreading photography to the Far East and, as such, a representative of the process of technological modernization, which in many parts of the world was associated with the advent of photography.

Kern's involvement in photography, however, had been slow in developing. As was the case with most of the artists, draughtsmen and scientists who took part in the ambitious U.S. government program of exploration of the American West before 1860, Kern did not at first seem interested in the daguerreotype process as an adjunct to scientific exploration. From 1845 to 1851, instead, he worked exclusively as a pencil artist and topographer on several surveys of the American West, notably under the leadership of John Charles Frémont, and often in company with his brothers Benjamin and Richard Kern, the latter being regarded as the most gifted artist of the trio.

Frémont, it is true, had experimented with the daguerreotype as early as 1842, and he did hire a daguerreotypist on his 1853 expedition, but this was rather an exception in the U.S.; at any rate, claims that Edward Kern was once employed as daguerreotypist by Frémont are not substantiated by survey records or private archives. Although his sketching style might be regarded as theatrical and almost naive, Kern was in fact a prime example of the American explorers' typically Romantic and highly productive commitment to the hand and the eye; along with the prolonged dominance of the impractical daguerreotype process, this explains why until 1860 photography remained largely alien to the practice of U.S. military engineers, who instead favored tried-and-true methods closely associating topography and draughtsmanship.

After breaking his connection to Frémont on account of the latter's brash methods, Kern indeed continued to work with brush and pencil on various Western surveys until 1851-52, reaching a degree of fame in Philadelphia with several exhibitions of Western sketches and illustrations of botany and Indian subjects. Without a doubt,

through his stays in California and his experiences in exploration, this skilled and adventurous artist-scientist must have learned about the daguerreotype before 1853. In 1853, however, when Kern did take up the process, it was not to go back once again to the American West with the Army's topographical surveys, to which he lost both his brothers between 1849 and 1853—killed by Indians—but to leave American soil and take to the sea.

That year Kern enrolled as artist and daguerreotypist on the U.S. Navy's North Pacific Expedition, and before sailing went to New York especially to gain instruction in the process at the Anthonys' firm. The North Pacific Expedition, which was to remain at sea until 1855, was a large-scale venture, intended to provide a scientific complement to the famous, more strategically-minded expedition of Commodore Matthew Perry, which had just forced the "opening" of Japan to the West and had itself included daguerreotypist Eliphalet Brown. The Ringgold-Rodgers expedition ended up covering a huge area in the South and North Pacific, exploring naval routes and describing coastal areas from Australia to China, along the Japanese coasts, and even north to Kamtchatka and Siberia; it was prolonged by another Navy survey of sea routes between California and China in 1857–1860, on which Kern was also engaged as artist and daguerreotypist.

Although few or none of the many images that he produced on these historic ventures have surfaced so far (one probable exception being a view of the American cemetery at the Gyokusen-Ji Temple in Shimoda, Japan, which is held at the George Eastman House and was exhibited in Tokyo in 1992), it is known from written sources that Kern made daguerreotypes, as well as sketches, on the coasts of China, Japan, Siberia, and on various islands such as Hawaii and Okinawa. Indeed, as historian of American exploration William H. Goetzmann has written, "perhaps even more than Brown of Perry's expedition, Kern introduced photography to the Far East" (*New Lands, New Men*, 350). In Japan especially, it appears that the introduction of photography by Brown, Kern and others heralded made visible, the advent of Western culture, its technology, its particular form of realism, and its commercialism, which were to be adopted quickly and efficiently.

It is certainly worth noting that whereas the U.S. Army's engineers refrained from resorting to a technology that they tended to view as ill-suited to their needs and even tainted with a kind of charlatanism, the U.S. Navy made a point of displaying and exporting this same technology—along with telegraphy, clocks, and railroads—to the potential markets and dominions of the Pacific, as if the daguerreotype had most concretely embodied the supposed superiority of Western culture. In this early episode of globalization, Edward Kern was merely an agent, but in hindsight he appears as a prime illustration of the fundamental link between American expansion, technological modernity, and the appeal of the sun-picture.

FRANÇOIS BRUNET

Biography

Edward Meyer Kern was born in Philadelphia in 1823, the youngest of a genteel family that also produced an art teacher and two other artist-explorers, Benjamin Jordan (1818–1849) and Richard Hovenden (1821–1853). Having exhibited in Philadelphia as early as 1841, "Ned" Kern participated in several surveys of the American West: in 1845 with John Charles Frémont's third expedition and his "conquest of California"; in 1848, again with Frémont, through the central Rocky Mountains, this time along with Benjamin and Richard (Ben was eventually killed on this expedition); in 1849 on a military raid against the Navajos, and in 1850-1851 for topographical work in New Mexico. From 1853 to 1855 Edward joined, as artist-daguerreotypist, Lieutenant Cadwalader Ringgold's North Pacific Expedition, later commanded by Lieutenant John Rodgers; from 1857 to 1860, he was daguerreotypist to Lieutenant John M. Brooke's survey of sea routes in the Central Pacific. Once back in the U.S., and after another stint with Frémont, Edward Kern returned to Philadelphia and taught art. He died of epilepsy in 1863.

See also: Brown Jr., Eliphalet.

Further Reading

"Early Works of Photography," exhibition catalogue, Tokyo: Metropolitan Museum of Photography, 1992.

Goetzmann, William H. and Goetzmann, William N., *The West of the Imagination,* New York and London: Norton, 1986.

Goetzmann, William H., *New Lands, New Men: America and the Second Great Age of Discovery*, New York: Penguin, 1987.

Hine, Robert V., *In the Shadow of Frémont: Edward Kern and the Art of Exploration, 1845-1860*, Norman: University of Oklahoma Press, 1982.

Lamar, Howard R., ed., *The Reader's Encyclopedia of the American West*, New York: Harper & Row, 1977.

Mulligan, Therese, and Wooters, David, *Photography from 1839 to Today*, Rochester, NY: George Eastman House, Cologne: Taschen, 1999.

Taft, Robert, *Artists and Illustrators of the Old West, 1850–1900*, Princeton, NJ: Princeton University Press, 1953.

Yale University, Beinecke Rare Book and Manuscript Library, Yale Collection of Western Americana, Edward Meyer Kern and Richard H. Kern Papers, WA MSS S-2395.

KERRY, CHARLES (1857–1928)
Australian photographer and studio owner

Charles Henry Kerry was born on Bobundra Station, near Bombala, NSW in 1857, the son of grazier Samuel

Kerry and Margaret Blay. As a teenager he accompanied a travelling photographer, then at 17 he worked for Alexander H. Lamartiniere in a studio at 308 George St, Sydney, eventually becoming a partner in the business. Lamartiniere left the business in debt around 1883 but Kerry managed to resurrect it, providing portraiture which he eventually delegated to staff while he photographed an increasing array of landscape views, social events and bush life. In the 1886 he formed a partnership with C. D. Jones that capitalised on the dry plate process. In 1888 Kerry began using magnesium flashlight, put to use inside the Jenolan Caves and 10 years later he used electric flashlight. Kerry and his employed photographers made regular trips throughout New South Wales during the 1890s executing private and government commissions and building a massive stock of landscape views. In 1895 the NSW Government requested Kerry photograph the state's Aborigines. In 1898 new four level premises were opened at 310 George St. In 1903 the firm started producing postcards and it quickly became one of Australia's larger postcard publishers. Kerry left the business in the hands of his nephew in 1913 to pursue mining interests and it closed in 1917. Kerry died in 1928 in North Sydney.

MARCEL SAFIER

Holdings: State Library of New South Wales, Sydney; Powerhouse Museum, Sydney; State Library of Victoria, Melbourne; National Library of Australia, Canberra.

KILBURN, BENJAMIN WEST (1827–1909) AND EDWARD (1830–1884)
Stereoscopic photographers and publishers

Benjamin and Edward Kilburn were the sons of Josiah and Emily Bonney Kilburn. Josiah managed a machine and iron foundry in Littleton, New Hampshire. Benjamin, the oldest child, was born on 10 December 1827. His brother Edward was born on 27 February 1830. In 1843 both children began a three-year apprenticeship at an iron foundry in Fall River, Massachusetts. After their apprenticeship they returned to Littleton to work with their father.

Littleton is located in northern New Hampshire, on the western edge of the White Mountains. Its popularity as a tourist destination dates to the middle of the nineteenth century. The area offered spectacular scenery and hiking, fishing, and hunting opportunities, as well as resort hotels for relaxing and dining.

In the mid-1850s Edward Kilburn learned photography from O.C. Bolton, one of the early White Mountain photographers. Edward pursued photography as a pastime while he established a match factory and later sold Grover and Baker sewing machines. Both broth-

ers enlisted in the Civil War. In 1865 they formed a stereographic view partnership, known as the Kilburn Brothers, which would grow to dominate the field of stereo publishing. Stereo views are two photographs mounted side-by-side that appear three-dimensional when placed in a viewer called a stereoscope. Collecting stereo views was a craze of the middle-class in the mid to late nineteenth century. People acquired stereo views of tourist spots that they had visited as well as exotic locales that they would only experience through the wonder of the stereoscope.

Although Edward was initially the firm's primary photographer, Benjamin quickly took over this important duty. Early views concentrated on the White and Franconia Mountains. In spite of their rural location, Kilburn Brothers's views were sold around the country. In 1866 the *Littleton Gazette* reported that: "... the Kilburn Brothers with their new instrument for taking Stereoscopic [sic] views ... are being extensively circulated throughout the United States, and are pronounced by the most useful critics to be equal if not superior to any others published in the United States."

After only two years of business the firm was selling views internationally. In 1867 the Kilburn Brothers built a factory on Main Street in Littleton. In addition to the production areas, a sales shop occupied the front room.

The Kilburn Brothers used assembly line techniques in the production of their stereo views. The firm employed predominantly women who were responsible for a variety of duties including sensitizing the albumen paper, and hand cutting and pasting the prints. Men worked as printers, photographers, and in managerial positions. Over the years, the number of employees fluctuated, reaching a peak in 1904 when the company employed more than 100 people. They worked ten hour days from 7 a.m. to 5 p.m.

In December 1873 the Kilburn Brothers moved into a new and bigger factory on Cottage Street in Littleton. This building had a southern exposure along its length, providing more natural light for the printing operation. At this time, the company produced between 1400 and 1800 stereo views a day. A dozen views cost approximately $2.00.

Despite the company's success, Edward retired in February 1875 at the age of forty-five. In retirement he gave a series of magic lantern shows featuring views from the Kilburn Brothers's inventory and planted a large orchard. He died in 1884.

Benjamin continued to run the stereo company, changing its name to the B.W. Kilburn Company. One of the company's specialties was views of the cog railroad run by the Mount Washington Steam Railway Company. Kilburn documented the development of the railroad, and a series of his views appeared in the

21 August 1869 issue of *Harper's Weekly*. By tilting the camera, many of his stereo views exaggerate steep angle of the track making the descent look vertiginous. With other views, Kilburn carefully composed his photographs, often emphasizing the foreground to enhance the three-dimensional qualities of the stereo views. In addition to his views of New England, Benjamin made stereo views in Virginia, Bermuda, Mexico, Canada, and Europe. He photographed events, such as Grover Cleveland's inauguration, and acquired the exclusive rights to produce stereo views of the 1893 World's Columbian Exposition in Chicago and the California Midwinter Exposition. Other popular subjects sold by the firm were the Johnstown, Pennsylvania flood, the Boxer Rebellion, the Boer War, and the Spanish-American War.

One of the company's foremost photographers was Percival Graham. He joined the firm in the 1870s and photographed extensively at the 1901 Pan American Exposition held in Buffalo, New York. James M. Davis also worked as a photographer and distributor for the company.

The firm used several cameras including a Henry Clay stereo view camera and an American Optical Company camera that used a tripod. In an effort to eliminate the use of a tripod, Benjamin designed a "gun camera." The camera was mounted on a gun stock that rested on the photographer's shoulder.

In addition to their own inventory of negatives, Kilburn also bought negatives from other photographers. In 1881 he purchased the negatives and rights to a large collection by Boston stereo manufacturer John Soule, which included views of Niagara and Yosemite.

The studio produced both standard sized stereo views and larger cabinet sized stereos. Most views were pasted to buff mounts. Yellow, orange, and gray mounts were also used. Their stereo views were available for purchase in the company's sales room, and at local stores, hotels, and tourist sites, such as the Mount Washington Railway gift shop. College students were employed in the summer to sell stereo views door-to-door in the Northeastern and Midwestern United States. In the 1870s the company issued catalogs listing their views. Orders could also be placed by mail.

In the United States, the Kilburn firm was both the largest producer of stereo views and in operation for the longest period of time-forty-four years. The exact date of Benjamin Kilburn's retirement is unknown. In 1901 he sustained a stroke which left him disabled until his death in 1909. In 1910 the Kilburn negatives and equipment were sold to their former agent James Davis, and later to one of their main competitors, the Keystone View Company.

Kilburn's negatives and logbooks are in the collection of the California Museum of Photography. The Little-ton New Hampshire Public Library holds thousands of Kilburn stereo views.

CAROL JOHNSON

Biography

Benjamin Kilburn (1827–1909) married Caroline Burnham on 16 November 1853. They had one daughter named Elizabeth. On 25 May 1857 Edward Kilburn (1830–1884) married Adaline Owen, a local schoolteacher. Their union produced one child, a daughter named Emily. In 1862 both brothers enlisted in the Civil War, and served through 1864 in New Hampshire's 13th Regiment, Company D. In 1865 the Kilburn Brothers stereo company began operation. It became the most prominent stereo view company in the world. Their views were exhibited at the 1876 Philadelphia Centennial exhibition. In 1909 when the company ceased operations their inventory included nearly 100,000 glass stereo negatives.

See also: Stereoscopy.

Further Reading

Hepburn, Freeman, "Not Quite on the Level Stereo-The Mt. Washington Cog Railway," in *Stereo World* 13, no. 1 (March/April 1986): 8–14.

McShane, Linda, *"When I wanted the Sun to Shine" Kilburn and Other Littleton, New Hampshire Stereographers*, Littleton, NH: Sherwin Dodge, 1993.

Southall, Thomas, "White Mountain Stereographs and the Development of a Collective Vision," in *Points of View: The Stereograph in America-A Cultural History*, Rochester, NY: Visual Studies Workshop Press in collaboration with the Gallery Association of New York State, 1979.

KILBURN, WILLIAM EDWARD (1818–1891), AND DOUGLAS THOMAS (c. 1812–1871)
English photographers

The brothers Douglas and William Kilburn were born in London, the sons of Thomas Kilburn and Catherine Ward.

William Kilburn was working as a professional photographer before. 1846 and his photographs of a Chartist Rally in London in 1848 brought his work to the attention of Prince Albert, from whom he later received several commissions, styling himself 'Photographist to Her Majesty and His Royal Highness Prince Albert'.

Kilburn exhibited a series of 'photographic miniatures (daguerreotypes) at the 1851 Great Exhibition, but finest daguerreotypes were produced between 1852 and 1855, at his studio at 234 Regent Street London. His use of light, and skilful tinting was remarkable. From 1856 he exclusively used collodion.

Douglas Kilburn, a watercolorist and photographer, emigrated to Australia before 1847. After having arranged for William to send equipment and materials from England, he was the first to make daguerreotypes of Aboriginal people of the Yarra Yarra tribe in Victoria in 1847 which were used as basis of illustrations in William Westgarth's *Australia Felix* (Edinburgh 1848). He operated a daguerreotype studio in Collins Lane, Melbourne, from May 1848—only the second professional photographic establishment in the city.

He returned briefly to Britain in 1850 where he was married, before returning to Australia and settling in Hobart, Tasmania—where he was the first to demonstrate stereoscopic photography in 1853. He eventually turned his attention to politics and became an MP in the Tasmanian parliament.

JOHN HANNAVY

KIMBEI, KUSAKABE; See KUSAKABE KIMBEI

KINDER, JOHN (1818–1903)
English artist and photographer

The Rev. John Kinder (1818–1903) was ordained in the Anglican Church after attending Cambridge University. He came to Auckland, in 1855 where he took up a teaching post at the Church of England Grammar School. In the tradition of well educated English gentlemen, he made several sketching tours in the North Island during term breaks. Around 1860, after taking lessons in photography from an Auckland professional photography Hartley Webster, he completed a series of stereoscopic views which of Auckland. As he grew in confidence as a photographer, he took to using a large format view camera which yielded a series of topographical views. About this time, his photography became something of an *aide memoir* for his watercolours. He was a brilliant draftsman and was well aware of all the effects that could be obtained by perceptive selection of subject and rendering. His intense commitment to photography ended in 1872 as other matters demanded his attention. Kinder obviously considered photography as being on an equal footing with his watercolours, exhibiting them as he did along with his watercolours at exhibitions staged by the Auckland Arts Society.

WILLIAM MAIN

KING, HENRY (1855–1923)
Austrailian photographer

Henry King was born in 1855 in Swanage, Dorset, the son of William and Eliza King. He arrived in Sydney, Australia as a toddler aboard the *Kate* in 1856. He started in photography in 1873 working for the studio of J. Hubert Newman. King opened a studio at 330 George St., Sydney, in partnership with William Joseph Slade in 1879. They moved to 316 George St the following year then Slade left to set up in Newcastle. King worked by himself thereafter initially producing *carte de visite* portraits, but with time he began to specialise in landscapes, rivalling the work of Charles Kerry. King travelled extensively in New South Wales and Queensland to photograph landscapes and to document the Aboriginal population. In addition to enlargements, King produced many lantern slides and stereoviews including series featuring the Jenolan Caves and views around Sydney and environs. King was active in the NSW Photographic Society and always encouraged amateurs. He worked from a variety of George St addresses until 1920 and died following an operation 23 May 1923. In 1929 bookseller James Tyrrell acquired several thousand of King's glass plate negatives that are now in the Powerhouse Museum, Sydney.

MARCEL SAFIER

Holdings: State Library of New South Wales, Sydney; Powerhouse Museum, Sydney; Macleay Museum, University of Sydney, Sydney; State Library of Victoria, Melbourne; National Library of Australia, Canberra.

KING, HORATIO NELSON (1828–1905)
English photographer

The career of H. N. King spans the first sixty years of photographic history and also encompasses a wide range of formats and subjects. Starting in Bath in the 1850s he ingeniously combined the roles of local theatrical impresario with taking portraits of celebrities visiting this fashionable resort.

Moving to London he inherited more than 1000 negatives taken by the photographer Vernon Heath and by the late 1870s he had transferred his scope and operations to the Goldhawk Road in West London becoming an important topographical and architectural specialist competing with Francis Frith, James Valentine, and George Washington Wilson. This business was underpinned by his longstanding connections with the Royal family: in his reminiscences he mentions visiting Windsor Castle over 250 times to create what must be one of the most extensive records of royal residence including Buckingham Palace, St. James' Palace and other properties.

King claimed to have been the first to introduce photographs in railway carriages having been granted two first class tickets for six months by the Great Western Railway. This must link with his catalogue of over 7000

mainly British views including stereo cards and lantern slides—which also includes over 150 views of India.

IAN LEITH

KINNEAR, CHARLES GEORGE HOOD (1832–1894)
Schottish photographer and inventor

The Honourable C. G. H. Kinnear was active in photographic circles, particularly in Scotland, from the mid-1850s until the early-1890s and was described as 'the inventor of the modern form of camera bellows'.

Kinnear was a founding member of the Photographic Society of Scotland from 1856 until it was wound up in 1873 and held various offices with the Society including Honorary Secretary from 1856–1860 and Vice President. He was also a founder member of the Edinburgh Photographic Exchange Club from 1859 and, later, a member of the Edinburgh Photographic Society. He exhibited widely in Scotland. He published several articles in the photographic press including reports of his photographic travels and exhibited his work between 1856–1864.

His principal contribution was a design of camera which he described in 1857. A report was published in the *Journal of the Photographic Society* in February 1858. Kinnear's camera had tapered bellows which allowed each fold to collapse within the previous larger fold when closed. The design was based on Captain Fowkes' camera which had straight bellows, but Kinnear claimed his design was stronger and more suited to travelling. It also cost about £4 or half the price of the Fowkes camera which it quickly superseded. The original camera was for 12½ × 10½ inch paper negatives and was built for Kinnear by Bell of Potterrow, Edinburgh. The camera was 15½ × 13 × 3½ inches when closed and weighed 13lbs. The design was taken up by the principal London camera makers such as Ottewill, Bland & Co, Rouch and Meagher and Improved Kinnear cameras were advertised from the early 1860s.

Kinnear's original design was a little awkward with the back section needing to be screwed on to the baseboard and the lens board required mounting on to the front standard. Camera makers improved and adapted the basic design while keeping the innovative bellows arrangement. Over time the means of focusing was changed from an endless rod screw from the camera's back to a side-turned rack and pinion and refinements such as swing-backs, rising fronts and reversible and fixed backs were added. The refined design, principally through the work of McKellen in the 1880s, became the *de facto* standard plate camera until the early twentieth century. Kinnear died aged 63 on 5 November 1894.

MICHAEL PRITCHARD

KINSEY, DARIUS REYNOLD (1869–1945)
American photographer

Darius Reynold Kinsey was born on July 23, 1869, in Maryville, Missouri. In 1889 he and his family moved to Snoqualmie, Washington Territory. After learning photography from a Mrs. Spalding in Seattle around 1890, Darius spent five years photographing for the Seattle and Lake Shore Railroad Company. He formed a brief partnership with his brother Clark, but Clark and another brother Clarence moved to the Yukon Territory, Canada, during the Klondike Gold Rush, forming the Kinsey & Kinsey photography business in Grand Forks. Married in 1896, Darius' wife Tabitha (d. 1963) worked in the darkroom. Their first studio, opened in 1897, was in Sedro-Woolley, Washington. In 1906 they relocated to Seattle and Darius gave up portrait work, devoting himself over the next three decades to photographing logging activities in the Pacific Northwest, a passion shared by his brother and competitor Clark between 1913 and 1945. Darius worked with stereoscopic, panoramic, and large format cameras, including a 20 × 24 inch camera. Only an injury at age 71 stopped his career. The Whatcom Museum of History and Art, Bellingham, Washington, acquired the Darius Kinsey collection (over 4,700 negatives and several hundred prints) in January 1979. The University of Washington also holds 151 Darius Kinsey prints, along with his brother Clark's negative collection.

DAVID MATTISON

KIRCHNER, JOHANNA FREDERIKA DORIS (EMMA) (1830–1909)
European photographer and studio owner

Emma Kirchner was one of the few female European photographers of the 19th century. A portrait made around 1855 by the first female daguerreotypist of Germany, Bertha Wehnert-Beckmann (Leipzig 1815–1901), discovered in 2004, showed a young Emma Kirchner. It only proved that they knew each other, but doesn't prove that Kirchner was her pupil. The proof that Kirchner already worked as a photographer in Leipzig, was shown at the back of her oldest picture made after her arrival in Holland which marks *"Emma Kirchner—Zuiderstraat."*

After the death of her father, Emma's mother took care of the tailor shop he left her and Emma, not yet three years old and baby Maria. Mother and daughter Emma ran the shop with very little help.

Kirchner never married but had daughter Dorice with the Leipzig Publisher Rudolph Loës and two daughters (one of whom died after a few days) with Commissionaire Carl August Bretschneider.

Kirchner immigrated 1863 to Delft in the Netherlands with her mother and daughter Dorice. Kirchner started the photographic firm with Frederik Gräfe, husband of her sister Marie, and from there photos where signed "*E. Kirchner & Co-Zuiderstraat 179.*" At the firm, Emma Kirchner was the professional photographer and Gräfe still a gunsmith until 1872.

May 9, 1871, Gräfe fired Kirchner and announced that he would work alone at number 136 at the same street, on May 19, Kirchner announced that she worked alone in the old studio.

In 1875 her daughter Dorice (1852–1939) married Henri de Louw (1851–1944) with whom Kirchner worked almost a year as '*Henri de Louw & Emma Kirchner.*'

Unfortunaly Kirchner never left any written documents, which makes her life more mysterious.

From 1876 until 1899 Kirchner made her best work, mostly *carte-de-visite* and *cabinet pictures* portraits of Citizens in and around Delft by albumin-style. May 1899 Johan van Doorne took over her studio.

Kirchner moved to The Hague and in 1903 to Amsterdam where she died at the house of composer Bernard Zweers (1854–1924), who was married to her granddaughter Dora (1876–1959).

Kirchner was not only a highly educated emancipated woman, but the only women photographer in Delft until almost the end of the 20th century. She was the only photographer in the Netherlands to work alone for such a long period of time without any pupils, compared to other female photographers, who worked with their husbands or pupils.

PETRA NOTENBOOM

KLIČ, KAREL VÁCLAV (1841–1926)

Perhaps surprisingly, for someone whose contribution to the printed image was so significant, some considerable confusion results from reading the published accounts of Klič's life. He is variously described as being Czech, German and Austrian.

Karel Václav Klič was born in Hostinne, in the foothills of the Krkonose Mountains in the present-day Czech Republic. The town has long been a centre for paper-making. His artistic talents showed early in his life, and he was admitted as a student at the Art Academy in Prague in 1855 when aged only 14. Apparently unwilling to conform, he was expelled after only a few months, only returning to complete his studies some years later.

Klič, also known as Karl Wenzel Klietsch—the German/Austrian version of his name—had a varied career —working as a draughtsman and as a painter for a time, before leaving Prague. He was also an accomplished cartoonist and illustrator, and found outlets for his work in many newspapers. Records show that he worked in

Prague and Brno (Moravia) and Budapest before opening a photographic studio in Vienna, Austria.

It was probably Klič's experience in newspaper illustration which led him to revisit the idea of developing a photo-mechanical printing process—an idea first explored and brought to fruition, albeit crudely, by Henry Fox Talbot in the 1850s.

It was while he was working in Vienna that Karl Klič developed the process for which he is remembered —photogravure. His first successful prints were exhibited at the annual exhibition of the Vienna Photographic Society in October 1879 and drew much admiration, although the secretive Klič did not reveal any details of his methodology. Further prints were exhibited at the following year's exhibition in November 1880. With hindsight, much of the credit for the process must go to Talbot whose photoglyphic engraving process had produced a similar if rather less refined result more than twenty years earlier, but Klič's innovations made it work much more effectively. Whereas Talbot's work had largely remained experimental, Klič's process became the first widely used mass-production process for photographic images, offering the permanence of a pigment-based image at a cost which was only a fraction, in both time and money, of that associated with the Woodburytype or with carbon printing.

In 1880 and 1881, several of his prints were reproduced in the Austrian photographic journal *Photographische Korrespondenz*, and also in 1881, a photogravure portrait of Mungo Ponton was published in Britain in *The Yearbook of Photography and Photographic News Almanac*. This portrait, provisionally dated 1870-1879 may have been taken by Klič.

The process was used to great artistic effect by, amongst others, Peter Henry Emerson in the 1880s for publications such as *Pictures of East Anglian Life*, published in 1888.

Alfred Steiglitz started to use the process in the 1880s, ands some of the finest examples of photogravure printing can be found on the pages of *Camera Work* published by Steiglitz in the early years of the twetieth century.

T & R Annan of Glasgow, whose *Old Closes and Streets* had originally been produced in carbon two decades earlier, produced editions in photogravure in 1900. Thomas Annan and his son James Craig Annan had learned the intricacies of gravure printing directly from Klič in Vienna in 1883.

Klič had experimented with zinc etching processes in the 1870s before his quest for the ideal photomechanical printing process led him to what became photogravure. His earliest proposals embraced ideas drawn both from Talbot's experimental process of 1858, and from the carbon printing process, at the height of its popularity in the 1870s.

A copper plate was coated with a resin and then a bichromated gelatin tissue similar to that used in carbon printing. After exposure, the unhardened bichromated gelatin could be removed and the plate etched. The etched plate was then inked—the ink being held within the etched areas to depths dependant upon the tonal density of the image—and printed on a flatbed printing press. No 'screen' was necessary, and the process was capable of rendering a considerable tonal range. This process is now known as 'grain gravure' to distinguish it from the later screen-based process.

But Klič's vision extended well beyond the production of single sheet-fed prints, and in 1895 he and his collaborator Samuel Fawcett developed rotogravure. It would appear that Klič and Fawcett had been working, independently, towards the development of a rotary intaglio printing process, and that their collaboration brought the process to a successful conclusion. Klič was, by the early 1890s, resident in England.

At some point c.1890 Klič made contact with the Storey Brothers in Lancaster, a firm of calico printers where, according to company records, Fawcett was already employed. By 1895 Klič, Fawcett and the Storeys had established the Rembrandt Intaglio Printing Company to exploit the new rotogravure process. Fawcett had been working on a design for a rotary press for textile printing, and Klič's rotary photogravure expertise proved the catalyst. It was at Klič's suggestion that the company moved from printing textiles to printing high quality gravures of paper. Their *Burlington Art Miniatures* were a significant commercial success, and for several years they led the world in high quality gravure printing, still closely guarding the details of their techniques. Eventually, of course, other companies caught up with them, and instigated technical improvements to the process.

By 1897 Klič was technical director of the company, but in that year he left England and returned to Vienna, leaving the operation of the Rembrandt Intaglio Printing Company to Fawcett. He returned briefly in 1906—by which time he had perfected a close-registered three-colour gravure process using a fine half-tone screen—but he spent much of the remainder of his life in Vienna where he died on November 16th 1926.

JOHN HANNAVY

See also: Talbot, William Henry Fox; Annan, Thomas; Stieglitz, Alfred; Emerson, Peter Henry; and Photogravure.

Further Reading

Albert, K., *Karl Klietsch*, Vienna, 1927
Coe, Brian, and Howarth-Booth, Mark, *A Guide to Early Photographic Processes*, London: Victoria & Albert Museum, 1983

Denison, Herbert: *A Treatise on Photogravure in Intaglio by the Talbot-Klič Process*, London: Iliffe & Sons, 1895. (Reprinted in 1974 by the Visual Studies Workshop, Rochester)

KLUMB, REVERT HENRY (1837–c. 1886)

Born in Berlin, Germany in 1837, Revert Henry (Henrique) Klumb began working in Brazil in the early 1850s. After running the studio of French photographer and lithographer Paul Theodore Robin, he worked for a painter, François René Moreaux. In 1855, he opened his own studio and pioneered stereoscopy in Rio de Janeiro. Emperor Pedro II appointed him Imperial Photographer on August 24, 1861. Around that time, Klumb opened a studio in Petrópolis, the emperor's mountain retreat. After moving there in 1865, he lectured at the Imperial Academy of Fine Arts and tutored Princess Isabel, the Emperor's daughter. In 1872, he published an illustrated road guide on Brazil's first highway, between Petrópolis and Juiz de Fora, Minas Gerais. Renowned for his landscapes and bold use of close-ups when photographing plants in Princess Isabel's gardens, he exhibited his works at the Petrópolis Horticultural Exposition in 1875. After that, Klumb and his wife, Hermelinda Barreto, went to live in Bahia and had two daughters there. By 1886, they were in Paris, from where he wrote to Empress Teresa Christina begging her to help him and his family return home. His patroness agreed, but he died shortly thereafter, possibly en route to Brazil.

SABRINA GLEDHILL

KNUDSEN, KNUD (1832–1915)
Norwegian landscape photographer

Knud Knudsen was born in Odda, Norway. He came from a family of country merchants, but got interested in photography quite early. He probably worked as an assistant to Marcus Selmer from 1857, before he started his own studio in Bergen in 1864. His business grew to one of the biggest in the country, catering to Norwegians and tourists alike and selling thousands of images.

His motives are mainly landscapes and documentation of the rapidly vanishing rural culture from which he came. Knudsen was the first to systematically photograph the whole of Norway, but with emphasis on the Vest coast. In spite of some composition elements inspired from painting, his images show us a skilled photographer who uses photographic elements to the full. Up to 1882 Knudsen used the wet plate and his darkroom tent is sometimes to be seen in his images. He developed an understanding for the special quality of the collodion process and produced images that are full of contrast and detail in the dark parts. To solve the difficult problem with exposure time for light and dark surfaces

Knudsen often made two exposures. One can therefore find different landscapes with the same sky. Knudsen retired in 1898 and left his business to a relative.

The University of Bergen possesses the biggest collection of images, both negatives and positives, after him.

HANNE HOLM-JOHNSEN

KOCH, ROBERT (1843–1910)

Heinrich Hermann Robert Koch was born on December 11, 1843, in Clausthal, a small mining city in the Harz Mountains of Lower Saxony (Niedersachsen). Robert's father, Herrmann Koch, was a mining administrator who eventually became head of the mine. Robert's mother, Mathilde Biewend, was actually her husband's grandniece. Koch died on 27 May 1910 at Baden–Baden, a victim of a serious heart attack.

From positions as a country doctor, experimenting on microbes in his spare time, he moved to Berlin and eventually went on to become—together with his great French rival Louis Pasteur—the founder of bacteriology.

His articles about bacteriological methods—including culture media, microscopic plate technique, and specimen staining procedures—held great significance for the history of photomicrography.

In 1877 Koch published the first photomicrographs of bacteria ever, producing collotypes of such quality, they set the standard for decades.

To produce the wet collodion negatives K. used state-of-the-art equipment such as the first focus free oil-immersion lenses and the new Abbe condensor, named after its inventor Ernst Abbe, an optical consultant for the Carl Zeiss Company in Jena.

For Koch himself photography was of eminent importance for scientific practice, especially in the field of microbiology, because "(t)he photosensitive plate represents the microscopic image more reliably than the retina of the eye" (Koch 1877, 408). "The photographic picture might be more relevant occasionally than the specimen under the microscope itself" (Koch 1881, 11).

Koch also made extensive use of photography during his several excursions, mainly to Africa, to study tropical medicine between 1883 and 1907. As well as serving as private souvenirs the photographs were made as medical documents, anthropological illustrations, or visual tools in "parasitological" research.

JAN ALTMANN

KODAK

In 1888, reviewing a new camera that had just come on the market, made by an American company formed just a few years earlier, *The British Journal of Photography* wrote: 'What, in the name of all that is photographic, is the Kodak…? Just over twenty years later, Bernard

E. Jones in his *Cyclopaedia of Photography*, published in 1911 knew precisely what "Kodak" was: "A trade name which is so familiar that many suppose it to apply to all hand cameras…" This rapid transformation from unknown novelty to household word is one of the most remarkable episodes not only in the evolution of photography but in modern business history. The success of Kodak was down to the vision, industry, commercial awareness and determination of one man—George Eastman.

George Eastman (1854–1932) was born in Waterville, New York. From a modest family background—his father died when George was eight—he soon learnt the value of industry and thrift. Aged fourteen, he left school to work as an errand boy for a local insurance company, earning three dollars a week. Some idea of his character can be gleaned from the fact that, even as a teenager, he kept meticulous account books, noting every item of income and expenditure. By 1872 he had managed to save over $1,000. In 1874 he joined the Rochester Savings Bank as a bookkeeper. Still only twenty, he now took over all his family's financial responsibilities.

Despite his work and family commitments, young George still found time to pursue leisure interests, in particular, photography. In 1877 his account book reveals that he bought a photographic outfit for $49 and began to take lessons in wet collodion photography with a local photographer, George Monroe. He soon became absorbed in his new hobby, spending all his free time taking photographs or studying photographic magazines to improve his technique and knowledge. In 1878, he came across an article in *The British Journal of Photography* describing Charles Bennett's improved method for making gelatine emulsions by 'ripening' them to greatly improve their sensitivity. Eastman began to experiment with coating his own plates at home, often working through the night. By the end of the year, he was getting consistently successful results and began to consider making plates for sale. In 1879, frustrated by the tedious and slow process of coating plates individually by hand, he devised a plate-coating machine, consisting of a roller and a trough of warmed emulsion, which he patented in England, America and several European countries.

In 1880, just three years after he had first taken up photography, Eastman rented the third floor of a building in Rochester, New York and began the commercial manufacture of dry plates. He invested all his own savings in the enterprise but he also got financial backing from Colonel Henry A. Strong, a well-off whip manufacturer, who, with his wife, lodged with the Eastmans. Strong invested $1,000 and, crucially, gave George the benefit of his long business experience. On 1 January, 1881, the Eastman Dry Plate Company was formed, supplying plates to the leading American photographic

supply house, E. & H.T. Anthony. Later that year, Eastman resigned from his job in the bank and devoted himself full-time to his new enterprise. After surviving some early setbacks, the business prospered.

In 1883, the Company moved to larger premises in State Street, Rochester and the following year the business became a corporation, changing its name to the Eastman Dry Plate and Film Company. The change of name reflected the development of a new product, Eastman Negative Paper, which Eastman had devised in partnership with a camera maker, William H. Walker. Using paper as a negative support revived an idea from the earliest days of photography. Gelatine emulsion coated paper, however, was much more sensitive than earlier paper processes and offered a potentially attractive alternative to heavy and fragile glass plates. At first, special adapters enabled sheets of Eastman Negative Paper to be used in conventional plate holders. However, to fully exploit the possibilities of his negative paper, Eastman and Walker also devised a rollholder which attached to the back of a standard plate camera and contained a roll of negative paper sufficient for twenty four exposures. The paper was advanced after each exposure by turning a key. Rollholders were not a new idea. In 1854, Spencer and Melhuish took out a British patent for a device in which sheets of negative paper were gummed together and wound on rollers and in 1875 Leon Warnecke introduced a more sophisticated version which held a one hundred exposure roll of tissue coated with a dry collodion emulsion. These early rollholders, however, were not commercially successful—mainly because of imperfections of the sensitised paper. The Eastman Walker rollholder combined precision of manufacture with negative paper that was both sensitive and easy to manipulate and enjoyed some popularity.

Soon after the rollholder came on the market in 1885, Eastman announced an improvement on his paper negative film, which he called "American Film." This consisted of a paper base coated with a layer of soluble gelatine, then a layer of collodion and, finally, a gelatine emulsion. After exposure and processing, the film could be soaked in warm water, dissolving the soluble gelatine so that the image-bearing layer could be stripped off and laid on glass for printing. American, or "stripping" film as it was also known, combined the lightness and flexibility of paper with the transparency of glass but it was a comparatively difficult material to use.

To sell his range of plates, rollholders and negative papers, Eastman looked beyond North America to the lucrative European market. In May, 1885 an International Inventions Exhibition was held in London's Albert Hall. William Walker brought over some rollholders and exhibited them under the title "Apparatus for the production of negatives in the photographic camera from continuous rolls of paper." They won a silver medal form

the exhibition judges and received favourable reviews in the British photographic press. Encouraged by this success, Walker returned to London later that year to open the company's first foreign office, at 13 Soho Square. European sales were promoted by the appointment of "sole agents"—one of the best-known being Paul Nadar, son of the famous French photographer, "Nadar."

Eastman's next move was to combine the concept of the rollholder and paper negative film with a hand-held or "detective" camera. In 1886 he took out a joint patent with Franklin M. Cossitt for a box-form hand camera designed to be used with either a rollholder or conventional plates. Despite the manufacturing experience gained from production of rollholders, manufacturing a camera proved to be both difficult and costly. By June 1887, only fifty had been completed. Eastman decided to cut his losses and sold them off to a Philadelphia photographic dealer, W. H. Walmsey, for $50 each. Only one example is known to have survived, and is in the Smithsonian Institution in Washington.

Undeterred, Eastman immediately began work another camera, putting into practice the lessons he had learned and devising a camera in which for the first time, the rollholder was an integral part of the design. This time he got it right. In October 1887, he wrote: "I believe I have got the little rollholder breast camera perfected." The "rollholder breast camera" was put on the market in June 1888 under a more succinct and memorable name—"The Kodak." In 1920, Eastman described how he had come up with the name:

> The letter "K" had been a favourite with me—it seems a strong, incisive sort of letter. It became a question of trying out a great number of combinations of letters that made words starting and ending with 'K.' The word 'Kodak' is the result. To the British Patent Office he wrote: 'This is not a foreign name or word; it was constructed by me to serve a definite purpose. It has the following merits as a trade-mark word: First, it is short. Second, it is not capable of mispronunciation. Third, it does not resemble anything in the art and cannot be associated with anything else in the art.

The Kodak camera initiated a revolution in photography that was to quickly transform it into a truly democratic pastime within the range of everyone, regardless of income or technical knowledge. Extremely simple to use, it reduced taking a photograph to three simple actions: 1. Pull the string. 2. Turn the key. 3. Press the button. The camera itself did not embody any great technical advances; it was not even the first camera designed solely to take roll-film. The most revolutionary aspect wasn't in fact the camera, but Eastman's concept of separating the act of picture-*taking* from that of picture-*making*. The Kodak was sold already loaded with film for 100 exposures. After this had been exposed, the entire camera was returned to the factory for the film

to be unloaded, developed and printed. The reloaded camera was then returned to its owner, together with a set of prints. The Kodak system was summed up by Eastman's famous advertising slogan—"You Press the Button, We do the Rest." For the first time, anyone (as long as they could afford the 5 guineas which the Kodak cost) could become a photographer.

Originally, "Kodak" was used only as a name for Eastman's detective camera; only later did it become generally adopted as a designation for the company's products. The success of the Kodak can be gauged from the fact that in May 1892, the company formally changed its American name to the Eastman Kodak Company. In Britain, the Eastman Photographic Materials Company had been set up in 1889 to manufacture and sell Eastman's products outside North and South America. From 1891, at their new factory in Harrow, they manufactured film and paper and developed and printed customers films. In 1898, reflecting the change which had already taken place in America, the British company changed its name to Kodak Limited. By this date, other European companies had been established, wholly owned by the British Company— Kodak Gmbh in Germany in 1896, Eastman Kodak S.A.F. in France in 1897. Belgium, Holland and Austria/Hungary followed in 1899, then Russia and Australia in 1900 and Italy in 1901. By the outbreak of the First World War, Kodak had offices and branches all over the world.

The introduction of a range of Kodak cameras, the successful manufacture of flexible celluloid rollfilm and, later, daylight loading film cartridges, transformed the company's fortunes. What had been a comparatively successful photographic manufacturer now became a worldwide business phenomenon. By the mid-1890s, over one hundred thousand Kodak cameras had been sold and the pace of growth showed no signs of slowing down. The word Kodak entered popular usage as a verb as well as a noun as people carrying Kodaks "Kodaked" everything in sight. As early as 1890, *Photography* magazine had correctly prophesied: "The word will very likely develop verbal, adjectival and adverbial forms as "'I am going to Kodak,' 'This is a Kodak negative,' 'This picture looks Kodakky'." Other manufacturers, too, were eager to seize on the popularity of the Kodak name but Eastman jealously guarded the integrity of his trade name and the company stamped down hard on any perceived misuse. In 1898, for example, the company obtained an injunction against the Kodak Cycle Co Ltd., preventing them from using the name Kodak in connection with any of their products. Similar court cases took place all over the world. As the company's advertisements repeatedly reminded customers: "If it isn't an Eastman, it isn't a Kodak."

The revolution begun in 1888 with the introduction of the Kodak, took another giant step forward in 1900

with the appearance of the Brownie camera. With the Kodak, Eastman had attempted, in his own words to: "...furnish anybody, man, woman or child, who has sufficient intelligence to point a box straight and press a button...with an instrument which altogether removes from the practice of photography the necessity for...any special knowledge of the art." With the Brownie camera, costing just five shillings (one dollar), the financial as well as the technical constraints on photography were finally removed. One hundred thousand Brownies were sold in 1900 alone.

In creating and satisfying a huge, previously untapped, market for popular photography Eastman was to create one of the biggest business empires the world had ever seen. All over the world, the word Kodak became as instantly recognisable as that other great symbol of American commercial imperialism, Coca-Cola. In 1898, *Commerce* magazine predicted: "The year 1888 will rank in the annals of photography as the date of the introduction of the Kodak." The passage of one hundred years has only served to reinforce this prediction.

COLIN HARDING

See also: Camera Design 6: Kodak 1888–1900; and Eastman, George.

Further Reading

Ackerman, Carl W., *George Eastman*, Houghton Mifflin,1930.

Brayer, Elizabeth, *George Eastman*; Johns Hopkins University Press, 1996.

Collins, Douglas, *The Story of Kodak*, Harry N. Abrams, 1990.

Jenkins, Reese V., *Images and Enterprise: Technology and the American Photographic Industry, 1839 to 1925*, Johns Hopkins University Press, 1975.

KOREA

By the mid-nineteenth century the Yi Dynasty had ruled Korea since 1392 and a policy of 'no contact' with foreigners had been adopted. A Russian fleet visited the port of Wonsan in 1856 and tried in vain to open a dialogue with the local officials. In 1866 the still deeply conservative regime became concerned over the increasing number of Christian converts and instituted a wholesale massacre. A number of French priests were also killed and, as a result, seven French warships sailed to Kanghwa Island, close to Seoul. When negotiations broke down, the French looted Kanghwa city but were driven off after suffering significant casualties. The same year an American ship, the USS *General Sherman*, tried to open commercial relations. Misunderstandings arose, and when the ship became grounded in the shallow Taedong River, all on board were massacred and the ship was burnt.

Taking stock: Did any of these events give rise to photographic opportunities? The writer has seen one *carte de visite* portrait, from a Shanghai Chinese stu-

dio, of what appears to be a French priest together with other Koreans—presumably escapees from the 1866 persecution. The writer also has in his collection several *cartes de visite* of French origin, which show portraits of unkempt-looking Koreans probably photographed on board a ship. The 1866 French-Korean conflict strongly suggests itself.

In May, 1871 Admiral Rodgers led a fleet of five ships to Kanghwa with the dual purpose of enquiring about the attack on the *General Sherman* and of opening trade relations. Felix Beato was the expedition's photographer. When the American diplomacy failed, Beato was able to photograph the conflict of the 10th and 11th of June—including the carnage inside the captured forts. Beato had gone across to Shanghai by 28th June, and on the 30th June, with the American fleet still in Korea, Beato advertised in the *Shanghai News Letter* the sale of his photograph albums of the conflict! Beato did not believe in wasting time. Albums of the conflict are exceptionally rare, but one example is held by the Library of Congress, another is in the writer's collection.

In September of the same year, John Thomson was on a photographic tour of China and had reached Peking. There he encountered a few Koreans who were part of a mission to China and were on the point of leaving. Thomson was just in time to secure one portrait of two of the officials which is reproduced in his monumental 1873–1874 work, *Illustrations of China and its Peoples*.

In 1874, the American photographer D.R. Clark was in the Far East to photograph the Transit of Venus. He subsequently published a stereoview series in 1875, *Asiatic and Tropical Views,* and included were five views of Korean interest. Clark had photographed a Korean emigrant community living in Vladivostok and the first view, *Natives of Corea,* which is now in the writer's collection, would appear to be the earliest-known photograph to include Korean women.

In 1876, a Korean embassy in Tokyo was photographed, examples of which are in the writer's collection. A fine group of photographs of an 1880 mission to Japan are held by the *Russian Geographical Society*, St. Petersburg. A photograph of an 1883 mission to the United States is in the *Peabody Essex Museum*.

At this time, photographic activity amongst Koreans themselves started to emerge. The first professional Korean photographer was Kim Yong-Won who was a member of both the 1876 and 1880 embassies to Japan. He was helped by a Japanese photographer, Honda Shunosuke, and Kim set up a studio in Korea in 1883. In 1884, both Ji Un-Young, who had studied photography in Japan, and Hwang Chul opened studios. However, no photographs appear to have survived, and there is precious little documentary evidence concerning the activities of these three pioneers.

All three had to contend with widespread ignorance and suspicion of photography. Rumors persisted that photographic chemicals were the residue from cooked local children! Hwang Chul's studio suffered regular stoning. The new technology was also associated with the unpopular Japanese, and the general hostility resulted in all three studios being closed down and destroyed in 1884.

Not surprisingly, these early photographers had confined themselves to portraiture, which they could practise in relative safety. Kim Kyu-Jin, an artist who went to Japan to study photography around 1895, was appointed the first official photographer at the Korean Court, but none of his photographs have been positively identified.

In the final few years of the nineteenth century, photography was given a boost when the King issued an ordinance banning the wearing of the traditional male topknot. Many Koreans wished to preserve an image of what they looked like before complying and photo studios suddenly experienced unprecedented demand. But Korean sources, so far as the writer understands, have yet to positively identify any photograph, taken by a Korean, prior to 1920.

By the late-1880s, however, a succession of amateur Western photographers had photographed the country. The talented amateur and American diplomat, George Foulk (1856–1893) took a number of photographs, examples of which survive in American institutions. In 1883 the American, Percival Lowell, travelled to Korea and in a book which he published in 1885, included twenty-five of his own photographs. The first professional Japanese photographers in Korea seem to have been Honda Shunosuke, and a Kameya Teijiro who died in Korea in 1885 following the setting up of his studio at around this time. Nothing much is known about either of them.

A large part of the Sino-Japanese War of 1894–1895 was fought on Korean soil and photographs were taken by, amongst others, the French artist and cartoonist Georges Bigot (1860–1927), many of whose photographs can be seen at *Kawasaki City Museum*, Japan and John Alfred Vaughan, an engineer on HMS *Undaunted*. Examples of his work are in the writer's collection.

Because Korean photography was so late in getting started, virtually all surviving work is represented in albumen or silver print. Photographic formats include stereoviews, *cabinet, cartes de visite,* and lantern slides. All nineteenth-century photography of Korea is rare, and what there is exists mainly outside Korea.

TERRY BENNETT

See also: Beato, Felice; and Thomson, John.

Further Reading

Bennett, Terry, *Korea Caught In Time*, Reading: Garnet Publishing, 1997.

Choi Injin, Park Juseok, and Lee Kyungmin, *History of Korean Photography*, Seoul: The Research Institute The History of Photography, 1998. Exhibition Catalogue. Korean text.

Cho P'ang-Haeng, *Yi-Dynasty through Pictures*, Volumes 1 and 2, Seoul: Somuntang, 1994. Korean text.

Chung Sung-Kil, *Korea One Hundred Years Ago: Photographs (1871–1910),* Seoul: Korea Information Cultural Center, Seoul, 1989. Korean text.

Kwon Jong-Wook, *A Study on the activity of Japanese photographers in the early history of Korean photography,* in *Bulletin of The Japan Society for Arts and History of Photography,* vol. 14, no. 1, 2005 (text in Japanese).

Oh Ki-Kwon (ed.), *100 Years of Korean History in photographs 1876–1976,* Seoul: Dong-A Ilbo, 1978. Korean text.

Underwood, Peter A., Moffett, Samuel H., and Sibley, Norman R., *First Encounters: Korea 1880–1910,* Seoul: Dragon's Eye Graphics, 1982.

Yi Hon, *Independence Movement through Pictures*, Volume 1, Seoul: Somuntang, 1987. Korean Text.

KOTZSCH, CARL FRIEDRICH AUGUST (1836–1910)
German photographer

Carl Friedrich August Kotzsch was born Sept. 20, 1836, in Loschwitz near Dresden. Working in his father's vineyard he received only a basic formal education. From 1853, the Kotzsch house was host to a colony of artists, mostly students of the well-known graphic artist Ludwig Richter. Around 1860 August Kotzsch began to draw and take photographs. From 1861, August Kotzsch was known as professional photographer in Loschwitz. Around 1870 he began with the production of still life photographs of common fruits like apples, grapes, and quinces, which were placed on simple plates and shelves. Nothing is known about the reasons why he took up these forms of photography hitherto completely alien to the medium except for industrial products. Roughly fifty of these still lifes were produced within a comparatively short time, always using a shadowy daylight—exactly the way Karl Blossfeldt did with his widely acclaimed plant images forty years later. The stunning quality of these still lifes exceed his good quality as a travel and landscape photographer. Curiously enough, these images were recovered from obscurity in the 1980s. After 1895, there is no photograph known from his studio. On October 23, 1910, August Kotzsch died in Loschwitz which he never left farther than walking distance.

ROLF SACHSSE

KRASZNA-KRAUSZ, ANDOR (1904–1989)

The twentieth century career of the photographic publisher Andor Kraszna-Krausz had a decisive impact on the revival of interest in nineteenth century photography, but just how his own interest in the medium came about remains obscure. When setting out in Great Britain in the late 1930s to establish the Focal Press, the imprint that by the 1960s would become the world's largest and most esteemed publishing house for books about photography, film and television, he often reminded people that he had had a long career in Germany working for the Continent's largest specialist photography publisher, Wilhelm Knapp in Leipzig. And this was perfectly true, as far as it went. What remained unsaid was that his experience with Knapp was almost exclusively in Berlin as the film critic and then editor of the leading moving picture trade paper *Die Filmtechnik* from 1925 to 1936. With strong domestic film production dominated by the Universum Film, A. G. (UFA) studios and significant interchange with American producers in Hollywood, Weimar Berlin was, arguably, at the time the leading centre for film criticism and film theory, where Kraszna-Krausz published in parallel with writers like Herbert Ihering, Siegfried Kracauer and Rudolf Arnheim. His lengthy, detailed analyses of films by F. W. Murnau, Fritz Lang, E. A. Dupont, Viktor Sjöström, G. W. Pabst, Charles Chaplin, John Ford, Vslevod Pudovkin, Fred Niblo and others were mixed on Kraszna-Krausz's rich palette with equally incisive notices of documentaries, experimental productions, and animated films. He regularly supplemented his reviews and interviews for *Die Filmtechnik* with intense editorials decrying impersonal commercial productions, the dominance of the star system, and the exorbitant production costs of films, while arguing in other essays on behalf of socially relevant, culturally significant filmmaking and examining the contributions of technicians to the art of filmmaking. But apart from reviews of a few books which included photography, such as Laszlo Moholy-Nagy's *Malerei, Photographie, Film* (Painting, Photography, Film) of 1926, there is little evidence in these years of the passion for photography with which Kraszna-Krausz launched his second career in Britain.

Established in 1938, Kraszna-Krausz's Focal Press at first relied heavily on his former contacts in Germany. Two of Focal's first titles, *Snaps of Children and How to Take Them* along with *A Good Picture Every Time,* both by Alex Strasser, were translations of works published earlier by Knapp in Germany, who also printed the books for the new British publisher. The 1939 title *Phototips on Children: The Psychology, the Technique and the Art of Child Photography* was written by Kraszna-Krausz's longstanding colleague in film criticism, Rudolf Arnheim, together with his wife Mary Arnheim, undoubtedly as they passed through Britain on their way to distinguished new careers in America. One of the earliest books from the press, *The All-in-One Camera Book* by E. Emanuel and F. L. Dash, was a solid success, ultimately running to some 81 editions and remaining in print until the early 1990s. Perhaps encouraged by the

substantive if not yet secure financial platform provided by this book, or perhaps beginning to express the fondness for and sympathy with the culture and history of his adopted country that would become so prominent throughout the remainder of his life, Kraszna-Krausz in the early 1940s began to publish large-format picture books on nineteenth century photography.

Gallery of Immortal Portraits (1940) and *Victorian Photography* (1942) featured works of William Henry Fox Talbot, David Octavius Hill, Julia Margaret Cameron, Roger Fenton, Frank M. Sutcliffe, and others, selected from the permanent collection of the Royal Photographic Society by Alex Strasser and introduced by texts from Kraszna-Krausz. Most importantly, these books reproduced original prints, at a time when 19th century photography was principally known from copy prints that over decades had gradually become more and more "modern" in the sense that they attempted to show the quality of Victorian images through printing them with current techniques. Just how radical these publications were at the time is hard to imagine now given the roll-call of eminent pioneers they brought out of the RPS archive, once-forgotten photographers who are today honoured, studied, collected and many times republished. Comprising volumes 1 and 2 of the *Classics of Photography*, a nascent series cut short by wartime limits on paper supplies, the publications were accompanied by Kraszna-Krausz's own very defensive texts that beg his readers to understand the primitive and awkward photographic technology used in the past, to excuse the photographers' subservience to styles of painting already *passé* when the photographs were made, and to recognise that modern photography had successfully avoided the *cul-de-sac* that trapped the Victorians.

It would seem that Kraszna-Krausz, a committed modernist and advocate of democratic values in both photography and moving pictures, was in these essays beginning to work out for the first time his relationship to the history of photography and to its legacy. After warning his readers that the Victorian photographers had struggled gallantly with crude and undeveloped tools, what Kraszna-Krausz celebrates is their spirit of amateur adventurousness, along with their curiosity and freedom to experiment which in his view saved photography from the habitual and miserly commercialism of the professional studios. Here, Kraszna-Krausz repeats his conviction that honest amateurism was always to be more valued than formulaic professionalism, a view that was also a theme of much of his film criticism in the late 1920s. The idealism that Kraszna-Krausz found in the Victorian photographers was also a fundamental tenet of his new publishing firm, which was committed to providing access for every intelligent reader to modern technical work in filmmaking and photography at the

highest level, clearly explained and concisely delivered. By producing unvarnished albums of classic Victorian photography untainted by romantic visions of the past, Andor Kraszna-Krausz allowed a new generation to see their work directly and to recognize the innate qualities which made it a mirror of its period.

DEAC ROSSELL

Biography

Born on 15 January 1904 in Szombathely, Hungary, to Adolf and Irén (Rosenberger) Krausz, Andor Kraszna-Krausz added the unidentified "Kraszna" to his name sometime before 1925, although in that year he experimented with spelling his name in several signed articles as "Kraszna-Krauß," "Kraszna-Kraus," and "Kraszna-Krausz." Little is known about his youth and early education; he was reputed to be an eager photographer from the age of twelve, to have studied law at the University of Budapest, emigrating to Germany in the early 1920s and followed up an intense interest in photography and film at Munich University. By 1925 he was in Berlin, working as a journalist for professional film magazines to which he contributed film reviews, commentary, interviews and occasional book reviews. Appointed in September, 1925, the chief film critic of the trade journal *Die Filmtechnik* published by the specialist photography house of Wilhelm Knapp in Halle, he became the magazine's editor in January 1926 and oversaw every biweekly issue until the summer of 1936, when he left Knapp and Germany, ultimately settling in the United Kingdom. In 1938 Kraszna-Krausz established his own publishing enterprise in London, Focal Press, which became the world's largest photographic publishers, issuing both practical handbooks and books on specialist techniques in photography, film, and television, issuing some 1,500 titles over its first half century. Kraszna-Krausz oversaw every aspect of book production at the Focal Press, which continues today, until he retired in 1978 at the age of seventy-four. He was awarded the Kulturpreis of the German Photographer's Association in 1979, made an honorary fellow of the Royal Photographic Society and the British Kinematograph Society, and established a foundation in 1984 to support research in and award a book prize for photography and film, which upon his death in 1989 received the bulk of his estate.

Further Reading

Chittock, John, "A Very Personal Reflection on Andor Kraszna-Krausz," 22 July 1997, unpublished typescript, prepared for the Hungarian Museum of Photography, Budapest.

——, "Dr Andor Kraszna-Krausz Hon FRPS, Hon FBKS," in, *BJP* (1990) x:x.

Die Filmtechnik. Zeitschrift für alle technischen und künstlerischen

Fragen des gesamten Filmwesens [Film Technology. The journal for all technical and artistic questions of the film industry], 1. Jg. 1925—11. Jg. 1936, *passim*.

Graham, Gordon, "'Only a link in the chain,' a tribute to a great publisher," in, *The Bookseller*, December 1, 1979, 2454.

Spiess, Eberhard, "Andor Kraszna-Kraus, 12.1.1904–24.12.1989," in, *epd Film*, (1990) 5:12.

Strasser, Alex, *Gallery of Immortal Portraits* (London: Focal Press, 1941).

Strasser, Alex, *Victorian Photography* (London: Focal Press, 1942).

KRONE, HERMANN (1827–1916)

Hermann Krone lived most of his life in Dresden, and spent it in pursuits that ranged over photographic experimentation; being a photographer for solar eclipse and transit of Venus expeditions; teaching photography, photo printing processes and art in schools and private lessons; portraiture; and travel photography including stereo images (some of which are held at George Eastman House). He made attempts to get copyright for photographers, did extensive public lecturing on a wide range of scientific and photographic subjects, and created publications which most famously includes a unique *Historisches Lehrmuseum fur Photographie* (Historical Didactic Museum of Photography), actually a group of large pages devoted to documenting many of the photo processes that were or became known in his time. This document was recently published in book form (1998), including all the paper pages, but omitting a small number of glass plate color images and about 900 glass negatives. Krone's teaching and production reputation were international.

The color plates are spectra made by Lippmann's process. Krone was one of the early experimenters in this process and was the first to publish trials of it that omitted the mercury mirror (1892). Instead, the light reflected from the emulsion-air interface interferes with the incoming light. The resulting image has color less saturated than that in the original technique, which used a mercury mirror in contact with the emulsion to create a stronger reflection. Krone's work in this area anticipated Rothe's better-known results by about a decade.

WILLIAM R. ALSCHULER

Further Reading

Hesse, W., *Historisches Lehrmuseum fur Photographie: Experiment. Kunst. Massenmedium*, Historical Didactic Museum of Photography: Experiment. Art. Mass Medium. Dresden: Verlag der Kunst, 1998.

Krone, H., *Farbenphotogramme von Spectren*, in *Annalen der Physik*, Wiedemans, vol. 46, 426–430, 1892.

KRUGER, JOHAN FRIEDRICH CARL (FRED) (1831–1888)
German landscape photographer and studio owner

Fred Kruger was born on 18 April 1831 in Berlin. He emigrated to Australia in the early 1860s to join his brother's furniture business and later took it over as sole proprietor. In 1866 upon selling the furniture business he became a cabinet maker but also opened a photographic studio in Carlton, Victoria. Kruger was recognised at international exhibitions for his landscape photographs but also photographed the civil progress, scenic views and Botanic Gardens of Geelong, Ballarat and Queenscliff, Victoria extensively. In 1868 he was commissioned to photograph the Aboriginal Cricket Team that toured Australia and which played at Lords. In 1877–1888 he photographed the Aborigines at the Coranderrk Aboriginal Mission Station at the request of the Victorian Board for the Protection of Aborigines; "Badger's Creek, Coranderrk (Aborigines Fishing)" (State Library of Victoria) notably depicts Aboriginal subjects at leisure in the landscape. After settling in Geelong, he received a further commission at Coranderrk in 1883 for physiognomic studies. Kruger's photographs were available individually or presented in albums and were regularly used in the illustrated press. Commissions remained a source of income from property owners and in 1886 the Victorian government requested photographs of the Yan Yean waterworks. Kruger died in Surrey Hills, Melbourne, on 15 February 1888.

JULIA PECK

KÜHN, HEINRICH (1866–1944)
Austrian photographer

(Carl Christian) Heinrich Kühn was born on February 25, 1866, to wealthy parents in Dresden. He studied medicine and natural science in Freiburg in Breisgau. Due to health problems he moved to Innsbruck/Tirol. In the Camera Club Vienna, which he joined in 1895, he became acquainted with Hugo Henneberg and Hans Watzek. Kühn is considered an internationally well-known representative of the Austrian Pictorialismus. Numerous personal contacts and connections to the international scene marked his activities. Kühn was friends with Alfred Stieglitz and over three decades lasting exchanges of letters marked their friendship (1899 to 1931). In 1896 he was accepted as a member in the Linked Ring Brotherhood London. The portraits of his children was emphasised in his work. He worked intensively with the technology of the autochrome. After

the loss of his fortune, Kühn operated a private studio in his house. In 1914 he established a photography school in Innsbruck, which had to be closed one year later due to the continuing First World War. The design of a soft-drawing lens named "Imagon," the publication of two photo books about the technology and aesthetics of photography, as well as numerous publications in specialized magazines marked his activity in the 1920s and 1930s. Kühn died on September 14, 1944, in Birgitz/Tirol.

ASTRID LECHNER

KUICHI, UCHIDA; See UCHIDA KUICHI

KUSAKABE KIMBEI (1841–1932)
Japanese photographer and studio owner

Kusakabe Kimbei was one of the most successful photographers in nineteenth-century Japan, operating a studio in Yokohama from where he produced, for foreign residents and tourists, beautifully decorated albums of handcolored albumen prints of both scenery and *genre* subjects. As a result, Kusakabe is better known today in the West than in Japan and usually by his first name, Kimbei, which he used no doubt because it was easier for foreigners to pronounce. Born into a family of textile merchants in Kofu, Yamanashi Prefecture, Kusakabe left home at eighteen to become an artist in Yokohama. Some time in the 1860s he joined Felix Beato, initially to assist in the handcoloring of photographs, but than as a studio assistant. He subsequently worked with Baron Raimund Von Stillfried-Ratenicz. Kusakabe opened his own Yokohama studio in 1880 and was adept at cultivating foreign patronage—no doubt his time with Beato and Stillfried would have helped in this respect. Becoming a Christian in 1885 would also not have harmed his business and, by the end of the century, he operated the largest studio in Japan. Retiring in 1914 he spent his later years painting. By 1930 his health had worsened and he moved to Ashiya City where he died in 1932.

TERRY BENNET

L

LACAN, ERNEST (1828–1879)
French editor and critic

Although Ernest Lacan never practiced photography, he was a central voice in the international photographic community during the second half of the 19th century. As editor and writer for the two leading French photography journals, *La Lumière* [*The Light*] and *Le Moniteur de la Photographie* [*The Monitor of Photography*], from 1851 to 1879 Lacan helped shape the terms of the debate around photographic practice and theory as he strove to articulate photography's cultural significance.

Lacan was born in Paris, France, in 1828, the son of Auguste Théophile Lacan and Marie Josèphe Monodé Devassaux. He studied painting under the artist Léon Cogniet and apprenticed in his studio in the 1840s. Cogniet was a highly regarded history painter with a strong interest in photography and Lacan later credited Cogniet's enthusiasm for stirring his own interest in the new medium. It was with Cogniet's encouragement that in 1849 Lacan first envisioned creating a photography journal, after having decided to give up painting for writing.

In 1851 it was another painter and member of the Société Héliographique, Jules-Claude Ziégler, who helped Lacan start *La Lumière,* which first appeared on 9 February under the photography society's auspices. When the society dissolved several months later, photography supplier Alexis Gaudin bought the weekly and appointed Lacan secretary (i.e., manager), then editor-in-chief.

As Europe's first photography journal, *La Lumière* achieved a significant readership in France and internationally, and throughout the 1850s Lacan used its pages to cover technological advances and historical issues, as well as to promote photography within the greater intellectual and artistic community. Dedicated to "Fine Arts, Heliography and Sciences," it sought a broad audience of artists, scientists and scholars as it centered on photography but also encompassed other, carefully chosen topics like the annual Paris Salon.

In his writings and editorial policy, Lacan fought fiercely to defend photography against what he saw as a common misconception that "imagination and artistic feeling play no part in the results." While he exalted photography's many applications, he sought to downplay its commercial reputation, taking pains to distinguish the medium's "amateurs," "artists," and "savants" from the legions of "simple photographers" who toiled in the portrait trade.

Throughout the first half of the 1850s, Lacan wrote regular photography reviews for the journal, addressing the work of some of the most important photographers of the epoch, including Charles Nègre, Roger Fenton, Edouard Baldus, and Olympe Aguado. While Lacan's colleague, the critic Francis Wey, wrote more generally for the journal on the aesthetics of photography and art, Lacan's reviews mapped out photography's artistic terrain by analyzing specific works with a scrutiny of form and a depth of commentary previously reserved for the other arts. He was among the first to claim that photography had its own schools and styles, and although he believed these initially derived from the different photographic processes, he was convinced that photography "permits each [artist] to take—according to his tastes and the nature of his talent— a different path."

Lacan was reluctant to situate photography squarely within the fine arts, but he saw it as closely related to them rather than an inferior substitute, and his reviews would contribute to securing the photograph's place as an aesthetic object. Even if he never ventured to incorporate its most obvious characteristics— like its reproducibility or mechanical means—into his assessments,

his criticism was exceptional in challenging the limits of what could be considered artistry by including works beyond the scope of other critics. In reviewing the images of English asylum patients taken by Dr. Hugh Welch Diamond, for example, Lacan boldly declared that they "can be ranked, in their execution, among the most beautiful photographic productions."

Given his links to Parisian art circles, Lacan played host to regular photography salons in his Paris home in the 1850s. These informal gatherings bolstered the French photographic community, especially during the crucial period between the dissolution of the Société héliographique in 1851 and the founding of the Société française de la photographie in 1854. Open to an eclectic mix of photographers, writers and other artists, his salons usually included displays of recent photographs made by guests, thereby helping to reinforce the link between photography and aesthetic discourse.

In 1856 Lacan published *Esquisses Photographiques* [Photographic Sketches], a collection of several of his *La Lumière* reviews as well as articles he had written elsewhere on photography's origins and uses. The book was a turning point in Lacan's career, as he would thereafter concentrate his writing more on technical innovations and business reporting. He also took on numerous outside projects, like contributing introductions to books on photography by Claude-Félix Abel Niepce de Saint-Victor (1855) and Alphonse Louis Poitevin (1862), editing a popular weekly, *Le Moniteur Universel* [The Universal Monitor], becoming scientific editor of *La Vie Moderne* [The Modern Life] (1859) and serving as French correspondent for *The Photographic News* in London.

At the end of 1860, after disagreements with Gaudin, Lacan left *La Lumière* to co-found a competing journal, *Le Moniteur de la Photographie,* with Paul Liesegang, German publisher of *Photographisches Archiv* [Photographic Archive]. Subtitled "International Journal of the Progress of the New Art," the fortnightly periodical first appeared on 15 March 1861. Primarily addressed at professional photographers, Lacan augmented the editorial staff by inviting respected commercial photographers and printers like Antoine Claudet, Louis Désiré Blanquart-Evrard and André-Adolphe-Eugène Disdéri to contribute articles. Lacan wrote a regular column, reported on technical matters and detailed new applications of photography in fields like criminal investigation and military strategy.

While he continued to review major photography exhibitions like that held at the Universal Exposition, Lacan was less concerned with individual photographers or styles. Perhaps reflecting his journal's stronger commercial slant, he expounded on aesthetic trends within the medium as a whole and often attributing these to technological innovations rather than personal creativity.

In 1870, Liesegang left *Le Moniteur de la Photographie* and Lacan became sole proprietor. He fell gravely ill in the summer of 1878 but continued writing and editing up to his death the following January. His longtime colleague, Léon Vidal, succeeded him as editor and the journal remained in print under various owners until 1914.

Although the writings of other early critics of photography—like Charles Baudelaire and Lady Elizabeth Eastlake—have received greater attention, Lacan's work as a whole provides a comprehensive view of the evolving attitudes and aims that marked photography's first decades. His versatility and energy, not to mention his enduring faith in photography's benefits to society, were rarely matched in his lifetime.

STEPHEN MONTEIRO

Biography

Emmanuel Ernest Auguste Lacan was born in Paris, France in 1828 to Auguste Théophile Lacan and Marie Josèphe Monodé Devassaux. He studied painting under Léon Cogniet and apprenticed in Cogniet's studio in the 1840s. He worked as a librarian before turning to journalism in 1851, helping found the photography journal, *La Lumière,* where he was editor and a regular contributor until 1860. He published a collection of his photography writings, *Esquisses Photographiques* (1856), and contributed to several books on photography. He also published poetry and fiction, including *Le Mort de l'Archevêque de Paris* [The Death of the Archbishop of Paris] (1849) and *Les Petites Gens* [The Little People] (1870). He edited and wrote for *Le Moniteur Universel* from the 1850s through the 1870s, was scientific editor for *La Vie Moderne* (1859), and contributed to other journals published by the Société des Publications Périodiques. He was also a correspondent for *The Photographic News.* Lacan co-founded the weekly journal *Le Moniteur de la Photographie* in 1861, which he published until his death. He was married to Camille Valentine Salle and died in Paris on 18 January, 1879.

See also: Société Héliographique Française; Nègre, Charles; Fenton, Roger; Baldus, Édouard; Aguado de las Marismas, Comte Olympe-Clemente-Alexandre-Auguste and Vicomte Onesipe-Gonsalve; Wey, Francis; Diamond, Hugh Welch; Société Française de Photographie; Niépce de Saint-Victor, Claude Félix Abel; Poitevin, Alphonse Louis; Liesegang, Paul Eduard; Antoine Claudet, Blanquart-Evrard, Louis-Désiré; Disdéri, André-Adolphe-Eugène; Baudelaire, Charles; and Rigby, Lady Elizabeth Eastlake.

Further Reading

Lacan, Ernest, *Esquisses Photographiques,* Paris: Grassart, 1856; second edition, Paris: J.M. Place, 1987.

Lacan, Ernest (ed.), *La Lumière,* Marseille: Jeanne Laffitte, 1995.

Rouillé, André, *La photographie en France, Textes & Controverses: une anthologie 1816–1871* [Photography in France, Texts and Controversies: an anthology, 1816–1871], Paris, Macula, 1989.

Hermange, Emmanuel, "'La Lumière' et l'invention de la critique photographique (1851–1860)" ["La Lumière" and the invention of photography criticism (1851–1860)], *Etudes Photographiques,* 1, 1996, 89–108.

LAFAYETTE, JAMES (JAMES STACK LAUDER) (1853–1923)

James Stack Lauder (1853–1923), photographer, under the name James Lafayette, was born in Dublin on 22 January 1853, the eldest son in the family of six sons and four daughters of Edmund Stanley Lauder (1824–1891), photographer, and his wife Sarah Stack (1828–1913). Edmund was a pioneering and successful photographer who had opened a daguerreotype studio in Dublin in 1853.

In 1880 James Stack Lauder founded his own photography studio, using for the first time the professional name of James Lafayette "late of Paris" and naming his studio variously "Jacques Lafayette," "J. Lafayette," and "Lafayette" as an indication of his artistic training in the City of Lights. He was joined in the new business by his three brothers, all of whom were experienced photographers who had worked in their father's studio. In 1884 he was elected member of the Photographic Society of Great Britain, and thereafter his entries in the multitudinous photographic competitions around Britain and in Europe started winning him medals for "exceptionally fine portraits."

By 1885, the studio's output was praised in print by the Photographic Society of Great Britain as "very beautiful, being distinguished for delicacy of treatment..." and Lafayette's early experiments with hand-colouring produced images that were described as "permanent carbon photographs painted in water-colour on porcelain," and the new specialist photographic press waxed generally lyrical over the fine quality of "Monsieur Lafayette's" portraiture. His work was noted to be of the highest technical excellence. His poses were graceful and good, the flesh was rendered as flesh and the folds of the drapery were rich and effective in the "Rembrandt style." As well as producing a number of faux rustic and cloying images of mother and child in the high Victorian style, Lafayette registered many idylls for copyright at Stationers' Hall. A typical image of this genre, half photograph, half line drawing, made as late as June 1894 has elements of highly sanitised fully-clothed Victorian eroticism depicting, in Lauder's own words, a "group of two figures, girl on ladder gathering apple blossom, man under tree receiving same in his hat, called 'Blossoming Hopes.'"

During the World's Columbian Exposition of 1893, held in Chicago, the foremost German professor of photography, H.W. Vogel, described a portrait of Lafayette's work as the "grandest photographs... He shows great skill in finely arranged single pictures and groups. A suspended angel, almost life-size and taken from life, is remarkable." This floating angel could be considered a rudimentary beginning of special effects photography and it was not until decades later that an employee divulged that the image had been made by photographing the subject lying down on a large sheet of glass over a painted background, so adjusted and so illuminated as to give the proper idea of perspective and the draperies having been arranged on the surface of the glass to give the impression of flight.

In the studio's commercial portraits, Lafayette followed the recipe well-tested from the early days of the daguerreotype when having an image made of oneself suddenly became affordable and no longer the preserve of active patrons of painters. As the subjects of portraits became democratised, the commercial photographer faced the situation of having to make flattering photographs of people who had no experience of sitting for a portrait and Lafayette's art of posing and skill in cropping the prints from his 12" × 15" glass negatives engendered both commercial success and, on 6 March 1887, the grant of a Royal Warrant as "Photographer to Her Majesty at Dublin."

The Royal Warrant, which was subsequently renewed by King Edward VII and George V, conferred enormous prestige, and the style and title of "Photographer Royal" on the studio advertising and promotional literature, proved extremely useful in attracting new clients. The business expanded rapidly in the 1890s. Studios were established in Glasgow (1890), Manchester (1892), and with the expected business bulge in Jubilee year (1897) a branch was opened on London's fashionable Bond Street. Subsequently another studio was established in Belfast (1900). In 1898 all the Lauder family businesses were incorporated and shares in the newly established Lafayette Ltd. were floated on the Stock Exchange.

Lafayette's commercial success coincided with developments in the half-tone printing process, which resulted in the proliferation of illustrated weekly magazines. The firm was one of the first to recognize the opportunities offered by syndicating photographs and portraits of his favourite subjects—"some of the great ladies of the land"—were published in such great numbers as full page covers in *The Queen, The Tatler,* and *Chic, inter alia,* that *The Lady's Realm* in 1900 stated outright: "It is well-nigh impossible to open any

magazine or paper which contains portraits of present-day celebrities without seeing at least one reproduction of a photograph by the well-known Lafayette house [with its] 'special Lafayette silver process'." By 1897, the fame of his portraits of the great society beauties, such as the Countess of Warwick, Daisy Princess of Pless, and Queen Alexandra, led the critic Levin Carnac (pseudonym of the author George Chetwynd Griffith-Jones) to muse in *Pearson's Magazine* in 1897 that it was "Lafayette's blissful lot to photograph more of the most beautiful and distinguished women of Europe than anyone else." The male was not forgotten and portraits of distinguished men and from society, the stage, and politics appeared prominently in the various new publications, frequently providing the frontispiece and setting the tone for the publication.

The sale of photographic postcards had also become big business, and certain images by Lafayette, such as Queen Alexandra in her Doctor of Music robes, registered for copyright on 28 April 1885, sold over eighty thousand copies by 1900. The Lafayette range of postcards included many images of the British royal family as well as luminaries of the stage, including a seminal series of Sarah Bernhardt as Hamlet from her London season of 1899.

On 2 July 1897, to mark Queen Victoria's Diamond Jubilee, Louisa, Duchess of Devonshire (1832–1911), one of London's foremost political hostesses, held a costume ball with around seven hundred guests ranging from royalty down to aristocracy and a commission went out to Lafayette, who had opened a studio on London's fashionable Bond Street with "patent fog-clearing equipment" earlier that year, to set up a tent in the garden to photograph the guests in costume during the Ball. This would have been a formidable commission for James Stack Lauder, and evidence from the extant negatives shows that he had transported from the Bond Street studio a variety of backdrops and props and, of course, photographic equipment. His remit was to photograph guests who would be in costumes ranging from mythological and ancient Greek down to renaissance and oriental characters. In order to capture the sense of event and location, the studio prepared a new backdrop representing the very lawn and gardens of Devonshire House complete with statuary. Approximately 162 negatives exist from this event, many of which were published by the Duchess of Devonshire in a private album and which represent the studio's largest output from a single photographic session. A copy of this album is held by the National Portrait Gallery, London.

The Lafayette studio, which survived the vicissitudes of World War I and Irish Independence, finally closed in 1952—the Lauder family having been in the business continuously from 1853. A storeroom of negatives, possibly representing the press archive of the studio, was discovered in the attic of a building in Fleet Street in 1968 during building works. The archive was eventually handed to the Victoria & Albert Museum, London, which kept 3,500 glass plate and celluloid negatives dating from 1885 to c 1937. The rest of the collection, consisting of circa forty thousand nitrate negatives from the 1920s to the early 1950s, was given to the National Portrait Gallery.

During the heyday of the Lafayette studio, the ranks of sitters included most of the British royal family, many European royalties, a significant number of maharajas, and official visitors from the Far East. The quality of the studio's portraiture peaked between 1897 and 1920 and was an inspiration to the following generation of photographers, who were more willing to experiment with new styles of lighting and posing. Of the thousands of images credited to Lafayette and which are recognisably portraits in the Lafayette style, only 649 photographs registered for copyright before 1912 bear the signature of James Lauder as author.

James Stack Lauder died at the Hôpital St. Jean, Bruges on 20 August 1923.

RUSSELL HARRIS

Further Reading

Beaton, Cecil, *British Photographers*, London, William Collins, 1944.

——, *My Bolivian Aunt: A Memoir*, London, Weidenfeld & Nicolson, 1971.

——, *My Royal Past by Baroness von Bülop née Princess Theodora Louise Alexina Ludmilla Sophie von Eckermann-Waldstein*, London, Batsford, 1939.

British Journal of Photography, 6 December 1895.

Brown, Julie K., *Contesting Images: Photography and the World's Columbian Exposition*, Tucson and London, University of Arizona Press, 1994.

Copyright Records, Public Record Office, Kew, COPY 1/413.

Devee, Sunity, Maharani of Cooch Behar, *The Autobiography of an Indian Princess*, John Murray, London, 1921.

Devonshire House Fancy Dress Ball, July 2 1897: A Collection of Portraits in Costume of Some of the Guests, privately printed, 1899.

Dimond, Frances, *Developing the Picture: Queen Alexandra and the Art of Photography*, London, Royal Collection Publications, 2004.

Harris, Russell, "The Devonshire House Ball as Photographed by Monsieur Lafayette," in the *European Royal History Journal*, XLIV, May 2005.

——, "The Great Commercial Photographic Studios of London" in *The European Royal History Journal*, XXXVII, February 2004

——, "The Lafayette Project," in *Durbar, Journal of the Indian Military Collectors Society*, volume 9, no. 1.

——, *Maharajas at the Lafayette Studio*, New Delhi, Roli Books, 2005.

——, *Maharajas at the London Studios*, New Delhi, Roli Books, 2001.

——, "Portretele unei Regine: Regina Maria în imagini inedite" in *Magazin Istoric*, XXXVIII, New Series, no. 11(452), Bucharest, November 2004.

——, "Royal Images held in the Lafayette Archive at the Victoria

and Albert Museum" in *The European Royal History Journal*, XXXVI, December 2003.

Meadows, Jane, "Lauder, James Stack (1853–1923)," *Oxford Dictionary of National Biography*, 2004.

Koch, W. John, *Daisy of Pless 1873–1943: A Discovery,* Edmonton, W. John Koch Publishing, 2002.

"J. Lafayette—Photographer Royal, 30, Westmoreland Street," *Industries of Dublin*, Dublin, 1888.

Levitt, Sarah, *Fashion in Photographs 1880–1900*, London, Batsford 1991.

Munn, Geoffrey C., *Tiaras: A History of Splendour*, Woodbridge, Antique Collectors' Club, 2001.

Murphy, Sophia, *The Duchess of Devonshire's Ball,* London, Sidgwick & Jackson, 1984.

Newhall, Beaumont, *The History of Photography*, London, Secker & Warburg, 1982.

Pearson's Magazine, "Photography as a Fine Art," vol. III, no. 15, March 1897.

Pepper, Terence, *High Society: Photographs 1897–1914,* London, National Portrait Gallery, 1998.

Photographic News, 14 January 1898.

Photographic Society of Great Britain, Exhibition Catalogue, November 27th, 1885.

Pritchard, Michael, *Directory of London Photographers 1841–1908*, Watford, PhotoResearch, 1994.

Portraiture by Lafayette, London, promotional brochure, c. 1904,

Rohatgi, Pauline, *Portraits in the India Office Library and Records*, London, British Library, 1983.

Vogel, H.W., "Letter from Germany: The Chicago World's Fair," A*nthony's Photographic Bulletin 24* (Nov. 11, 1893).

The World Coronation Visitors' Supplement, 18 June 1902.

LAI AFONG (active 1850s–1890s)

Although almost nothing is known about his personal life, Lai Afong will probably be remembered as the most significant Chinese photographer of the nineteenth century. Afong, as he preferred to be known, opened his first studio in Hong Kong in around 1859 and continued to operate it until ca. 1900. He assiduously cultivated foreign clientele, employing a succession of foreign assistants such as William Lentz and D.K. Griffith to help him do so. John Thomson spoke highly of his work in his 1875 book, *The Straits of Malacca, Indo-China & China*: "…a man of cultivated taste, and imbued with a wonderful appreciation of art…his pictures, besides being extremely well executed, are remarkable for their artistic choice of position." By the 1870s Afong's advertisements proclaimed him as photographer: "By appointment to H.E. Sir Arthur Kennedy, Governor of Hong Kong, and H.I.H. The Grand Duke Alexis of Russia." He accumulated an impressive portfolio of views from all over China claiming, in 1897, to have more than any other Far-Eastern studio. Apart from his excellent portraiture, he is known for his dramatic views of the 1874 Hong Kong Typhoon and for an exquisite album of Foochow scenery, a copy of which is held by the *Scottish National Portrait Gallery*, Edinburgh.

TERRY BENNETT

LAMBERT & CO., G.R. (1867–1918)
German-born, commercial photographers of Singapore and Malaya

The first known mention of Singapore photographers, G.R. Lambert and Company, was an advertisement (dated 10th April 1867) that appeared in a May edition of the *Singapore Daily Times* announcing the opening of a "Photographic Establishment" at 1 High Street.

The island of Singapore, which lies off the Southern tip of the Malay Peninsula, was established by Sir Stamford Raffles and became a trading post under the East India Company in 1819. It was incorporated with Penang and Malacca to form the Straits Settlements in 1826 and came under British colonial rule in 1867, the same year as Lambert's announcement.

Lambert was a German from Dresden and may of been connected with the Lambert Brothers' carriage makers, undertakers, and masons, who were well established in Singapore.

It appears that at some time after his initial advertisement Lambert returned to Europe, it is not clear whether his first studio failed or not, but another announcement ten years later (in May 1877) told of his return to Singapore, with a studio at 30 Orchard Road (opposite Lambert Brothers' Carriage Works). Interestingly, this advertisement stated that photographs [portraits] were taken daily 7a.m.–11am. It was probably too warm for portraiture after this time. The Orchard Road premises had previously been briefly occupied by another German photographer, G.A. Schleeselmann, who, in turn, had purchased the negatives of former occupant and fellow countryman, Henry Schuren.

By 1878 Lambert had moved studio again, this time to 430 Orchard Road, where he advertised a new collection of Singapore 'views and types.' Lambert visited Siam (Thailand) in late 1879 and returned in February 1880 after being appointed official photographer to the King of Siam.

In fact Lambert & Co. were to become the "official" photographers of South East Asia; they recorded major royal and political visits, government buildings, plus social and sporting events, along with formal portraits of ministers and merchants.

Lambert's studio portraits were mainly comprised of commissioned studies depicting European merchants and their families, as well as local dignitaries. However, there was another body of work that showed native or racial types and these more exotic studies were aimed at the tourist market

In the early and mid 1880s much of the Singapore studios' output by was undertaken by manager, J.C. Van Es and assistant Alexander Koch, who became a partner in 1886. Around this time Lambert himself seems to have returned to Europe leaving the running of the business in the trusted hands of Van Es and Koch.

In 1886 the main studio moved again, this time to number 186 Orchard Road, where they stayed until ca.1902. The firm also operated other studios at 1B and 3A Orchard Road and also at Gresham House in Battery Road. By the early 1900's Lambert and Co. had become the leading photographers in South East Asia, with operators creating landscape and portrait photographs in Borneo, Malaya, Sarawak, Sumatra, Thailand, and elsewhere.

As well as several studios in Singapore, Lambert & Co. had bases in other parts of South East Asia. Heinrich Ernst, Charles Blum, H. Kunz (and others) operated the Lambert studios at Deli and Medan in Sumatra. Photographers H. Stafhell and Charles J. Kleingrothe both worked as assistants to Lambert in Sumatra before setting up on their own as Kleingrothe & Stafhell in 1889. There were also other branch offices situated in Kuala Lumpur and Bangkok.

It is not known which photographers made which "Lambert" images, at least forty different managers, assistants, and photographers were known to have worked for Lambert & Co. at one time or another. Furthermore, negatives and prints by other operators were regularly bought and sold when studios closed or photographers moved overseas.

Considering the number and differing experience of staff employed, the work produced by the company was generally of a high standard and always technically competent, which was quite an achievement considering that the location work was invariably undertaken in hot and humid tropical conditions.

The pictures produced were largely aimed at the European market and documented the rapidly changing face of Singapore, which was constantly growing in size and importance during the end of the 19th and early 20th Centuries. The images produced in remoter areas, often showing local inhabitants, are the most interesting and exotic. The groups were carefully chosen and posed but no attempt was made to document poverty-stricken natives, commercial considerations being prerequisite.

Lambert's operators recorded the growth in trade throughout the area; coffee and rubber plantations, tobacco farms, mines and shipping were all well documented and the resulting images helped promote South East Asia as an attractive place in which to invest.

The images produced by the company were initially produced as albumen prints and later gelatin-silver, and were often gold toned, which helped maintain their color. Later still, platinotype prints were offered. Titles and reference numbers were added to the glass negatives in a variety of styles and the later prints were sometimes embossed with an oval company blindstamp.

By the end of the century, the company had started producing postcards, over 250 views were on offer and reportedly a quarter of a million were sold annually.

The market for photographs was changing, visitors were choosing cheaper postcards over larger and expensive studies and Lambert & Co. started catering for the emerging amateur photographic market, offering cameras, film, and processing facilities. By 1902 the studio at 186 Orchard Road was closed and Gresham House succumbed in 1910. By 1911 the operation was in liquidation and the business was confined to premises at 3A Orchard Road. A succession of managers were brought in, the final one being H. Nugent Buckeridge, who later formed his own photographic business, which lasted until the Second World War. By 1918 Lambert & Co. were, briefly, back at 186 Orchard Road, however the business was in trouble and finally closed the same year. Tastes were changing and with the world's economy in decline, the market for high-quality, expensive prints had ended.

IAN CHARLES SUMNER

Biography

G.R. Lambert, born Dresden, Germany (dates unknown). Part of a large German business community in Singapore. Opened photographic studio in Singapore April 1867 (which may have closed shortly after) returned to Europe, returned to Singapore 1877, and created chain of studios throughout South East Asia. Returned to Europe ca.1886, leaving the operation in the hands of managers. Maintained an interest in the business until ca.1910. Firm ceases trading 1918.

See also: Advertising of Photographic Products; Advertising Uses of Photography; and Koch, Robert.

Further Reading

Falconer, John, *A Vision of the Past. A History of Early Photography in Singapore and Malaya. The Photographs of G.R. Lambert & Co., 1880–1910.* Times Editions, Singapore. 1987.
Collection: Cambridge University Library: Royal Commonwealth Society Library, photograph collection of the British Association of Malaysia and Singapore, BAM.

LAMPREY, JOHN (active 1860s–1870s)

John Lamprey was Librarian of the Royal Geographical Society and Assistant Secretary of the Ethnological Society of London. Very little is known of him, however his photographic legacy is the system for the production of anthropometric photographs which he published in the *Journal of the Ethnological Society* in 1869. The system was devised for use to both anthropologists and artists for the "comparison of measurement of individuals by some common standard." In poses that refer back to traditional visual modes of mapping the body which had developed since the seventeenth century, the figure was arranged in both full face and in profile poses, with ad-

ditional head studies, in front of the background screen divided into two inch square by means of silk threads. The idea was that the measurements of the body could be read off the scaled photograph so: "the anatomical structure of a good academy figure or a model of six feet can be compared with a Malay of four feet height in height."

Although Lamprey himself is often attributed with the photographs himself, it would appear that he only facilitated them on behalf of the Ethnological Society. Indeed it is not known precisely if he initiated the system or was merely acting on instructions, nor is it clear how subjects were recruited, although a number appear to have been seaman. However the fact the President of the Ethnological Society, the distinguished Darwinian biologist, Thomas Huxley, initiated his own system within months of the publication of Lamprey's system, and with no reference to the latter, suggests that as science the scheme was found wanting in some way. The photographs themselves appear to have been taken for the Ethnological Society by Henry Evans, described as photographer and scientific instrument maker. Evans was prosecuted for the sale of indecent photographs in March 1870, a high-profile case which raised the question of the boarderline between science and pornography. It has often been assumed that the photographs probably commissioned by Lamprey were part of this prosecution. "Men of Science" (probably senior members of the Ethnological Society) petitioned on Evans' behalf, as did artists whom he was supplying with model photographs, including Rossetti and Burne-Jones, but to no avail. Although it was clearly stated that the "scientific" photographs were not those that were the subject of the prosecution, there is another set of photographs in existence, using the same models which are of more questionable intent and are not amongst the sets commonly found in anthropological collections. As Evans' whole stock, including the anthropometric photographs and studies by O. Rejlander, was burned, after his conviction, we shall probably never know.

None the less the system was quite influential, largely because it was one of the few instructions in the field to be published. For instance it resonates through the black and white chequered background used by Portman and Molesworth for their 1894 anthropometric studies of the Andamanese and some Lamprey-system photographs were reproduced in Carl Dammann's *Anthropologisch-Ethnologiches Album in Photographien* (1873–74). The photographs have become iconic of nineteenth century racial beliefs and have been published widely in post-colonial critical studies and art works, for instance Faisal Abdu' Allah' s untitled installation for "The Impossible Science of Being" (Photographers Gallery, London, 1995).

ELIZABETH EDWARDS

See also: Dammann, Carl and Frederick

Further Reading

Lamprey, J.H., "On a method of measuring the human form for the use of students of ethnology," *Journal of the Ethnological Society of London* (1869) 1:84–85.

LANCASTER, JAMES & SONS (1830–1955)
English photography studio

James Lancaster established his business in Birmingham as a spectacle maker and optician in 1830. The company became J Lancaster and Son around 1876 and in 1905 it became a limited company. It ceased trading circa 1955.

W. J. Lancaster (died 18 September 1925) was the driving force behind the company's rapid expansion into photographic equipment from the early 1870s leading one obituary to describe him as "the pioneer of amateur photography." This was achieved by the adoption of a system of production reported on by George E. Brown in 1930: "The great output of his apparatus was organised on a system which I do not think has been imitated on a similar scale in the photographic trade. He had no factory in the ordinary sense. In Birmingham there have always been a vast number of individual workshops…and all making for Lancaster."

The system of using out-workers to produce parts and to assemble equipment allowed the company to sell reasonable quality cameras and lenses in very large numbers. In 1887 they claimed 25,000 cameras sold, in 1888 sales of over 15,000 Instantograph cameras, in 1894 sales of over 120,000 cameras and 150,000 lenses in the previous ten years, and, in 1898, they claimed to be the largest makers of photographic apparatus in the world with upwards of 200,000 cameras sold. The firm's success was based on offering attractive goods at popular prices.

W. J. Lancaster was granted eighteen patents between 1885 and 1899 which were incorporated into the firm's products with the rotary and see-saw shutters being particularly successful. The firm's first cameras date from the early 1870s when they also offered ferrotype equipment and chemicals, but it was the period from the early 1880s to early 1900s that was the firm's most successful. Their Le Merveilleux, Le Meritoire, and Instantograph cameras were introduced in 1882 and remained popular into the early twentieth century undergoing numerous revisions. The Instantograph had sold over 100,000 by the end of the century. Their watch camera was patented in 1886 and two versions were produced including a compact ladies version, the Rover (1892) was a popular hand camera and a range of

professional studio cameras and multiple lens cameras was also made. Lancaster produced a range of associated accessories and darkroom equipment.

In common with its major rival, Thornton-Pickard, Lancaster failed to respond to the changing demand for smaller plate cameras and simpler amateur roll film cameras. After the First World War the firm declined rapidly with few new cameras being produced; one of it's more successful products was an enlarger. It gradually declined and ceased around 1955.

MICHAEL PRITCHARD

LANDSCAPE

The evolution of every photographic genre is highly determined by a wide range of technical developments. Some technical factors, however, were particularly relevant for the visualization of landscapes, which are characterized by infinity, capriciousness, changeability, an endless amount of tiny details, and ever-changing light conditions. As a result, more than in any other genre, the landscape photographer is obliged to select some of the available options provided by the technical apparatus. Sharpness, for instance, can determine the mood of an image. Whereas a sharp definition enables the landscape photographer to bring forward little details and texture, the use of a wider aperture can push the unfocused zones to the back, rendering a soft and mysterious atmosphere to it. Confronted with subjects in motion, such as waterfalls or sweeping foliage, the photographer has to use a speed short enough to halt the movement, or, by contrast, he can use a certain blur because it suggests movement. A longer exposure time can do justice to the complexity and variety of the image but, simultaneously, it can render the ripples on a water surface invisible. Adjusting the exposure to the terrain implies an overexposure of the sky—this resulted in the typical uniform white skies of many nineteenth-century landscape photographs. The limited sensitivity of the collodion emulsion (especially for greens) and the intense luminosity of the sky made the recording of clouds almost impossible if the exposure was correct for the tonal values of the landscape. Panchromatic films and yellow and red filters circumvented these difficulties, but wet-plate photographers often avoided glaring white skies by the combination of cloud details from another negative during contact printing in the studio.

Nineteenth-century landscape photography was also in another way highly dependent on technical limitations. Since landscapes have to be photographed on the spot, the photographer had to deal with the relative mobility of his equipment. This included first and foremost the huge size and bulk of the field camera itself since negative size determined finished print size before enlarging became easier and more practical in the 1890s.

Furthermore, the tools of a landscape photographer also comprised a tripod, a darkroom, developing gear and attachments, silver-coated metal plates or collodion plates, and a box of chemicals. Certainly after the wet-plate process appeared in the 1850s and prior to the introduction of the silver gelatin dry plate in 1871, the landscape photographer had to carry with him a whole laboratory; specially because collodion plates had to be exposed while still wet—and therefore prepared *in situ*—and developed immediately after the exposure had been made.

Landscape photography, of course, was also highly dependent on the availability and accessibility of its subject. In light of this, the genre is not only a component of the modern invention of photography but also a product of modern urban culture and its attitude *vis-à-vis* natural surroundings. The nineteenth century, after all, was an age characterized by the opening up of all kinds of territories. Within the context of the colonial enterprise, travelers and explorers discovered and charted other continents. Photography unmistakably contributed to both the physical and cultural appropriation of exotic territories and the continuous exploration and settlements of new lands. In its own way, photography was a form of mapping and it allowed the land to be controlled, visually at least. It contributed to the practical and symbolical management of the vast colonial territories which demanded the classifying, recording, census-taking, and mapping of everything in order to render it knowable, imaginable and controllable by means of European systems and on European terms.

At home, the European landscape came within reach through the railways and, at the end of the century, the bicycle. The photography of landscapes and scenery was encouraged by tourism, a modern phenomenon inherently linked with the massive production, distribution, and consumption of (mechanical) images. In the industrializing nations, railroads made formerly isolated regions accessible to new classes of travel consumers. These included middle-class families on a limited budget and schedule, who purchased photographic views as souvenirs. Later, when do-it-yourself mass consumer photography developed shortly before the turn of the century, they took their own pictures.

Furthermore, the genre of landscape photography was not only the product of new kinds of image production and new ways of approaching the lands but also of specific ways of looking at natural surroundings and the countryside. After all, throughout the nineteenth century, landscape and nature were not only important motifs in photography, they were pre-eminent themes and motifs in painting and literature as well. What's more, landscape photography was unmistakably influenced by literary and pictorial conventions. Landscape photographs confirm that the very notion of landscape

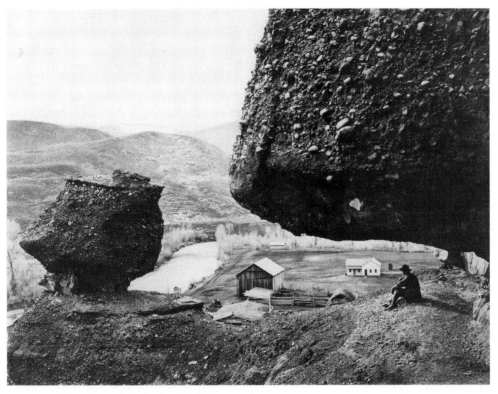

Russell, Andrew Joseph. Hanging Rock, Foot of Echo Canyon. *The Metropolitan Museum of Art, Purchase, The Horace W. Goldsmith Foundation Gift, 1986 (1986.1196) Image © The Metropolitan Museum of Art.*

was connected to picture making and aesthetic conceptualizations from the beginning. According to the *Oxford English Dictionary*, the term "landscape" occurred for the first time in 1603 and stood for "a picture representing natural inland scenery." The word was borrowed from the Dutch *landschap*, probably because of the influence and the prestige of landscape painting of the Netherlands. In most languages, the word has the double meaning of both a "piece of land, region" and an "image" representing such a piece of land. This double meaning is telling. It focuses our attention on the fact that landscape has not exclusively been a piece of the environment or nature, but has been, from the very first, dependent on its structuring by human presence and by the gaze in particular.

The importance of landscape and nature in nineteenth-century literature, painting, and photography was also endorsed by new aesthetic concepts, which originated in the late eighteenth century, on the eve of industrialization and shortly before the inception of photography. New notions, such as the sublime and the picturesque, presented the natural site not only as an ideal setting for beautiful or heroic acts, but rather as a primary source of meaning in itself. Throughout the nineteenth century, many photographers were eager to demonstrate that their new medium was perfectly suitable for visualizing these new sensibilities and to create photographic equivalents of literary and pictorial evocations of nature.

Particularly the concept of the picturesque, the development of which had been closely related to that of the English landscape garden, became a popular guideline for many landscape photographers, both professionals and amateurs. William Gilpin, the pre-eminent theorist of the picturesque, had argued in the late eighteenth century that picturesque views should be irregular, highly textured, and composed of things rugged, rustic, or antique, stripped of their utilitarian associations. Such telling details would provoke in the sensitive viewer poetic reflection on the passage of time, on the brevity of glory, and on the ephemeral nature of human achievement. Preferring the whimsicalness of nature, however, the aesthetics of the picturesque approached nature indirectly, through *pictures*. The term picturesque, consequently, refers both to a certain kind of landscape, which is suited as a subject for a painting, and to a fragment of reality that could be viewed as if it would be part of a painting. On the one hand, the English landscape gardens were designed to be viewed as a Claude Lorrain or a Nicolas Poussin might paint them. On the other, the viewer could discover and recognize picturesque scenes in nature itself. In his *Three Essays* on the picturesque (1794), Gilpin encouraged travelers, for instance, "to frame views, to graduate prospects from foreground to background, and above all to ensure variety of painted, drawn or engraved texture, which minimized similar qualities in the natural world."

A few decades later, this was right up the alley of photographers, who often used their cameras to frame similar views of the landscape. In particular British pioneers, such as John Dillwyn Llewelyn and Benjamin Brecknell Turner, and photographers of the 1850s and

1860s, such as Roger Fenton, George Washington Wilson, Francis Bedford, and William England, followed in the footsteps of the theorists and painters of the picturesque. Fenton even photographed the very same locations that Gilpin had depicted earlier in his watercolours. Other photographers referred explicitly to the concept of the picturesque in their writings. In the *British Journal of Photography* (1864), George Washington Wilson described the picturesque as "a simple viewpoint that the traveler or amateur would easily find for themselves; a convergence point toward which the eye is drawn imperceptibly by a gradation of tones and a dark foreground; a harmony of all the parts, in a closed composition which does not arouse unsatisfied curiosity." In his *Pictorial Effect in Photography* (1869), a true bestseller among photographers in England and abroad, Henry Peach Robinson quoted extensively from eighteenth-century writers on the picturesque. He also noted that the power of the art of photography was limited. "The sublime cannot be reached by it," Robinson wrote, but "picturesqueness had never had so perfect an interpreter" as photography.

In the second half of the nineteenth century, however, the picturesque was often freely interpreted as denoting any landscape endowed with scenic charm. The general and vague notion of what constitutes the picturesque became an inherent part of the Victorian imagination. It also became an imperative for every successful landscape photographer, whose task included searching and framing strategically the right sort of locations, and articulating their physical subtleties through proper exposure of the negative. Furthermore, photography democratized the picturesque, which originally entailed an exclusive capacity of the gentry, who understood both art and touring. Now, the middle classes used photography to enjoy nature. This cult of the picturesque resulted in thousands of photographs of humble landscapes and pastoral scenes that mostly ignored the brutality of urban modernization, labor, and industry. Figures and landscapes were integrated into a harmonious unity evoking a well-balanced social order. The predilection for the countryside and the peaceful village—objects already resonant with English values—transformed the notion of the picturesque into an ideological concept that contributed to the construction of a national identity.

Consequently, the frame of the picturesque turned out to be useful in the photographic survey of the colonies. Exotic landscapes were tamed and domesticated according to established terms of reference reflected in the photograph's composition and treatment of subject. Samuel Bourne's pictures, for instance, of the unwieldy and very often "un-picturesque" topography encountered on his treks in the Himalayas were unmistakably influenced by his earlier search for picturesque scenery in Wales, Scotland, and the Lake District. In many of his pictures taken in Northern India in the 1860s, spaces are contained within enclosures, encirclements, or boundaries. The world arranges itself for the viewer. The struggle with nature gave way for contemplation based on balanced proportions, carefully selected viewpoints, the use of watery reflections, and the harmonious integration of foregrounds and backgrounds—all borrowed from the tradition of the picturesque. Nonetheless, as many pictures by other European photographers working in exotic locations, Bourne's photographs are characterized by an interesting tension caused by his frustrations over trying to frame the vast spectacle of terrain within his camera's field of view and still maintain a balanced composition and containment of suitable picturesque features.

Bourne's vistas of breathtaking landscapes from the peripheries of the British empire also demonstrate that, at the time of the mid-nineteenth century proliferation of photography, the conventions of the picturesque had merged with those of the sublime. The characteristics that Edmund Burke had attributed to the sublime—obscurity, privation, vastness, magnificence, and so on—were clearly evoked in the grandeur of the exotic landscapes in Asia and the Americas that were beyond exact description. At the same time, however, painters and photographers evoked the sublime by means of a repertoire of established compositional formulae. Landscape photography, in a way, helped to domesticate the sublime and to subject it to pictorial conventions—a logic that constitutes the strategy of the picturesque.

The tension between the rough subject matter of the wilderness and the cultivated framings of the gaze was also a challenge to American photographers such as William Henry Jackson, Eadweard Muybridge, Andrew J. Russell, Carleton Watkins, and Timothy O'Sullivan, among others. Many of them worked in the context of government topographical expeditions and geological surveys, which helped to open the vast territories of the West to phenomena such as railroad construction, logging, mining, farming, urbanization, and even tourism. Whereas the 1859 stereographs of the Catskill Mountains and Niagara Falls by William England still could answer to picturesque conventions, the survey photographers working after the Civil War entered completely new kinds of lands. In contrast with the celebration of the newly found harmony between man and nature celebrated in European landscape photography, American photographers faced a frightening wilderness that, from an artistic point of view, could only be interpreted as a chaotic environment unfit for lyrical depictions. The spectacular natural scenery of the Americas lacked the picturesque balance of hills, lakes, and trees. Nonetheless, it was difficult for the painters and photographers of the American wilderness to accept nature in a naked, non-referential condition

and many of their impressive views are characterized by formulas derived from, but not coextensive with, the picturesque and sublime modes of landscape depiction. Comparable with the landscape painting by artists such as Albert Bierstadt, Frederic Edwin Church, Sanford Robinson Gifford, and Thomas Moran, the American survey photographers adopted and reformulated pictorial landscape conventions and merged them with a heretofore unmatched technical virtuosity. Joel Snyder demonstrated that critical literature of the period commended photographers for having achieved pictures faithful to nature that "coincidentally" shared specific compositional and pictorial features with landscapes wrought in other media such as painting and drawing. In other words, photographers were congratulated not for their use of landscape conventions but for their coincidental or mechanical corroboration of them.

Nonetheless, American landscape photography does not show the pastoral harmony so typical of the English interpretation of the picturesque. When pictures allude to a landscape claimed and occupied by man, not classical culture but modern industrialization enters the frame. Carleton Watkins' mining and railroad photographs in particular, for instance, attempted to portray a visual harmony between the land and the new tokens of industrial progress such as tracks of a new rail line.

In contrast with the European picturesque, however, man and civilisation are usually absent in the pictures of the American surveyors. In the spectacular large-format views of the American landscape from the 1860s and 1870s, man is often confronted with a terrifying emptiness and vastness reminiscent of the sublime in the way Edmund Burke had written about it in the eighteenth century. Moreover, compared with most examples of European landscape photography, the pictures of the American West are characterized by a more dispassionate and "placeless" look due to high vantage points, uninterrupted lines of vision, and marginal foregrounds. Miniscule figures frequently give a sense of scale and measure to the landscape but instead of mediating between the viewer and the depicted scene, they are dwarfed by the daunting natural marvels. Men are reduced to indices of the precarious and frightening relationship between man and nature. Unmistakably refering to the then popular theory of Catastrophism, a geological theory which held that the world was shaped by periodic and large-scale disasters, these landscape photographs supported a transcendentalist vision of nature. The American landscape was not only interpreted as an impressive physical reality but it also included an underlying sense of the spiritual. Nature was presented as a stage of a symbolical presence. In some pictures, *chiaroscuro* creates a natural drama. Specific viewpoints and lighting exaggerate the sudden and violent forces required to create certain geological formations. In others,

a kind of overwhelming silence results in an unusually modern, austere imagery. This is especially the case in many photographs by Timothy O'Sullivan, who preferred landscapes that seem to resist definition, such as immeasurable and inaccessible deserts. His photographs show landscapes so devoid of human reference, so lacking in the signs of history and culture, that plastic values were the only one at hand. O'Sullivan's landscapes, in consequence, can be considered the point of departure for both the modernist landscape photography of Ansel Adams and the late-twentieth-century predilection for natural and urban wastelands and non-descript areas. O'Sullivan's landscapes deny the possibility of comfortable habitation and an agreeable relation between man and the bleak and godforsaken landscape.

Strikingly, this specific evocation of the American frontier lasted only a few decades. The initial flourishing of American landscape photography passed with the closing of the frontier, to which photography contributed in contradictory ways. On the one hand, American western landscape photographs had opened the West by presenting it as potential real estate and as a site for eastern investment and development. On the other, the photographs of the natural wonders struck a romantic chord among the public and positively influenced legislation to create the first National Parks in the early 1870s. By the 1880s, photography and travel had become easier and the closing of the frontier at the end of the century was confirmed by the more impressionist approaches, which also characterized the European landscape photography of the *fin de siècle*. In the 1890s, Henry Hamilton Bennett, for instance, depicted the Wisconsin landscape as an ideal place for leisure whereas in the early landscapes of American pictorialists, every suggestion of harshness and difficulty was suppressed. The bitter cold, the cruel heat, and the infinite spaces made way for a nature that had become a part of the known habitat and the conventions of art.

Artistic conventions and cultural references also continued to play an important part in the landscape photography of many European countries. Although the picturesque quickly became a component of a kind of "Englishness," the concept was also instructive for the landscape photography practised in other regions. Many photographers with pictorial sensibilities, for instance, directed their cameras at the Italian landscape, which played such an important role in European culture in general. With its ruinous remnants of antiquity, the Italian landscape remained a reference point for artists throughout the nineteenth century. In addition, it had been a major source of inspiration for the aesthetics of the picturesque. Its enjoyment and depiction became obligatory components of the Grand Tour. Right from its inception, photography superseded the eighteenth-century *vedutismo*, the paintings of panoramic views

of places. Daguerreotypes and calotypes offered the traveler excellent "diary" potential and in the second half of the nineteenth century, other photographic processes documented, besides architecture and monuments, the countryside and mountain scenery. The Roman *campagna*, the ultimate landscape considered worthy of pictorial representation since centuries, was photographed abundantly. In the 1850s, Giacomo Caneva made a series of impressive views, some of them intended for French artists staying at the Villa Medici. During the following decades, many others, such as Ludovico Tuminello, Pietro Dovizielli, Pietro Poppi, and Federico Faruffini, made numerous studies of nature, with or without figures. At the end of the century, professional studios, such as that of the Alinari brothers in Florence, a firm specialized in pictures of artworks and architecture, also provided landscapes for the tourist market. Foreign photographers as well, such as Robert MacPherson in the 1850s, made *vedute* for tourists. With an exceptional mastery of technique, MacPherson photographed, mostly in large formats, the Latium countryside and he made many beautifully composed landscapes, such as his pictures of the ruins of Tivoli, which seem to be organically connected with the natural surroundings.

Some specific impressive locations, such as the Vesuvius, which combined classical references with a romantic fascination for the sublime, attracted many photographers such as the pioneer Calvert Richard Jones in the 1840s and Giorgio Sommer in the 1860s and 1870s. From across the bay, Sommer made spectacular photographs of the enormous plume of smoke during the eruption of the volcano in 1872. Others of his photographs, as well as pictures taken by John Buckley Greene earlier, show an exceptionally modernist sensibility for abstract shapes by focusing their attention to the volcanic concretions instead of the broad view of the Naples Gulf.

Another spectacular landscape explored by many European photographers were the Alps, which both had fascinated northern artists on their way to Italy since the renaissance and which had become a *locus classicus* of romanticism and the cult of the sublime in the late eighteenth century. Noël Marie Lerebours included an Alpine view in his famous *Excursions daguerriènnes* (1840–44), John Ruskin commissioned Frederick Crawley to make daguerreotypes of the Mont Blanc in 1854, and William England immortalized the snow-covered tops in a series of stereographs. In addition, Vittorio Sella depicted the Italian Alpine topography with an already modern dedication that evaded the often superficial curiosity of the Grand Tour. Sella even specialized in mountain pictures operating, between 1887 and 1908, in such remote and exotic areas as the Caucasus, the Himalayas, Karakorum, and Alaska. The

Italian Alps, however, were his favourite terrain. Here, in 1879, he made his first of several panoramas consisting of four or five adjacent pictures. His photographs became an important reference point for geographical and botanical societies, cartographers, geologists, and, of course, alpinists.

Some prominent French photographers explored the Alps as well. The German but Paris-based pioneer Friedrich Martens made daguerreotypes of the high mountains in 1853–54, Ferrier made a series of stereographs in 1856, and Charles Soulier made a series of views in 1869. The most spectacular examples of Alpine photography, however, were created by the Bisson Brothers and Adolphe Braun. From 1854 onwards, Louis-Auguste and Auguste-Rosalie Bisson made increasingly better shots of the high mountains. In difficult conditions, they not only managed to get the fluid collodion under control, they also produced a series of impressive large prints (as big as 70 × 100 cm) characterized by subtly balanced tonal values—no sinecure in the midst of the high contrasts of the snowy landscapes. Initially, their carefully selected viewpoints, which render a sense of depth to the landscape, were unmistakably indebted to the tradition of the picturesque. Later on, however, their snowscapes were characterized by a more austere approach showing mountaineers dwarfed by the fanciful shapes of the glaciers, and the imposing formations of the terrain and the mountain tops. Together with the seascapes of Le Gray and the architectural photographs by Baldus, the Bisson's Alpine views can be considered one of the highlights of the golden age of French photography around the middle of the century.

Sparkling Alpine scenery was also a favorite subject of Adolphe Braun, who was one of the largest producers of commercial landscape views in France during the second half of the nineteenth century. In 1866, an observer claimed that it was virtually impossible to take a step in Switzerland without stumbling upon a shop selling Braun prints and stereoviews. Based in Mulhouse, Braun turned his attention to scenic photography in 1859 with the publication of his *L'Album de l'Alsace*, a collection of large-plate views of sights, monuments, and landscapes, which were clearly indebted to previously published engravings of Alsatian views, such as Jacques Rothmuller's *Vues pittoresques*. Braun depicted the Alps, especially in Switzerland, Northern Italy, and the then recently acquired Haute-Savoie region, not only by means of large-plate views (sometimes using panoramic techniques) but also by stereographs, which were especially suited to the introduction of figures because of their palpable sensation of depth.

Braun's collection of landscapes also includes scenery in which picturesque ruins have been exchanged for tokens of modernity, such as the construction of the Gotthard Pass rail tunnel in the 1870s. This celebra-

tion of the modernity of the landscape can be found frequently in French nineteenth-century photography. In 1855, Edouard Baldus created this truly separate genre when he photographed the landscape between Boulogne and Paris changed by the construction of the railroad. In contrast with the usual picturesque approach that neglects the traces of industrial modernity, Baldus' photographs strikingly showed how all kinds of new constructions, such as railway tracks, viaducts, and bridges, fitted perfectly into the landscape. During the following decades, the photographers employed by the Ecole des Ponts et Chaussées and many others would depict the spectacle of railroad construction—an indication of the importance railroads had assumed both in the changing landscape and in the public consciousness.

This modern stance in French photography can also be found in the interest in the landscape of the everyday. As in other countries, the development of French landscape photography was unmistakably closely connected to the practise and theory of landscape painting. In France, however, other pictorial codes than those of the picturesque and the sublime were much more relevant. The work of many French landscape photographers shows similarities, for instance, with the new realist and naturalist tendencies in painting that developed in the era of photography's inception. The forest of Fontainebleau, which attracted the painters of the so-called Barbizon circle (Corot, Diaz, Millet, Rousseau) between 1825 and 1860, also became a popular photographic motif during and after the Second Empire. Painters and photographers were not only engaged in documenting a way of life they saw as rapidly slipping away under the pressures of industrialization, they also searched for humble subjects that contrasted heavily with the overworked picturesque formulas and sublime and pompous themes of academic painting.

Averse to classical *vedute* and spectacularly sublime mountain tops, photographers such as Gustave Le Gray, Alfred Briquet, Eugène Cuvelier, Constant-Alexandre Famin, Achile Quinet, Ernest Landrey, John Buckley Greene, Paul Berthier, and Henri Langerock, among others, depicted various locations in the forest that became more accessible by the railways from the 1850s onwards. Some photographers made "Studies from Nature," supplying painters with documentation, such as the *Vues artistiques diverses* by Famin. Others, such as Le Gray and Cuvelier, were painters themselves and made highly personal photographic works that often focuses on a gloomy and melancholy aspect of nature. After 1849, Le Gray made many calotypes of trees and underwood, and he later continued the series using large-size glass negatives. The perfection of his prints and their sensibility for lights and shades answer to a pre-Impressionist naturalism that owed little to traditional pictorial examples. Another photographer closely connected to

the circle of Barbizon painters, was Eugène Cuvelier, who particularly explored the rocks and sand dunes of the forest and, in doing so, created pictures reminiscent of the Rousseau's paintings in particular. He remained faithful to the calotype and fully exploited its aesthetic possibilities: the thickness of the paper negative and its grainy texture resulted in the sketchy details and schematic light effects so cherished by the Barbizon painters and the impressionists.

Many works of the Barbizon photographers show a remarkable, "impressionist" interest in the play of light, reaching its climax in Gustave Le Gray's series of large-format seascapes. Some of Le Gray's "marine" studies give an impression of an instantaneity, which can suddenly capture the impetuous movement of the waves. Constructed by means of two separate negatives (one for the sea, the other for the sky), his more tranquil seascapes skilfully capture the ways light moves over the ocean and show backlit skies heavy with clouds or the sky at sunset.

French landscape photography also included other specific motifs from contemporary impressionist painting, which, in its turn, borrowed formal features from the new medium of photography: absence of depth, abstraction through unusual viewpoints, arbitrary framings, and so forth. The impressionist fashion for the outdoors, for instance, resulted in the topographical genre of middle-class pastimes. Comparable to famous scenes by the impressionists, people at leisure were photographed in the outskirts of Paris or in the recently developed seaside resorts. Olympe Aguado, an amateur photographer close to the Emperor, was the leading exponent of this genre that gave evidence of the urbanization and domestication of the landscape. It was no accident that the places painted by the impressionists were the suburban landscapes within several hours' train commute of Paris. As in many impressionist paintings, in French landscape photography, nature is no longer the background of heroic acts (as in classical landscape painting) or of the sublime terror of natural forces (as in Romanticism), but has been translated into the environment of the *bourgeois* on a summer Sunday afternoon. As in the landscapes of the Barbizon painters and the impressionists, a great deal of French landscape photography is characterized by a dichotomy between nostalgia for a vanishing agrarian past and an interest in the emblems of industrial modernity and a specifically modern way of occupying natural surroundings.

Characteristics of Barbizon and impressionist painting would continue to play an important part in the landscape photography of many countries up until the very end of the century. Both an impressionist optics and a preference for landscape and peasant subjects also marked the late nineteenth-century vogue mode of pictorialist photography—yet another indication of the

close connection between pictorial and photographic landscape depictions throughout the nineteenth century. Corot's paintings, for instance, were a major source of inspiration for pictorialist photographers such as Peter Henry Emerson, who applauded Millet and Corot in his book *Naturalistic Photography for Students of the Art* (1893), and Léonard Misonne, who was aptly called the "Corot of photography." Many pictures by George Davidson, Alfred Horsley Hinton, Robert Demachy, James Craig Annan, Hugo Henneberg, Hans Watzek, Theodor and Oskar Hofmeister, the young Edward Steichen, and Alfred Stieglitz, among others, refer unmistakably to an impressionist aesthetics, which translated specific motifs such as people engaged in rural labor or outdoor activities into tonalist studies of transient elements. Paradoxically, pictorialism presented itself as the ultimate style of landscape depiction by both evading and stressing the inherent limitations of landscape photography. It ignored the infinite amount of details and attempted to suggest or to evoke movements and atmospheric effects, which photography cannot represent by definition. Using a selective focusing to restore actual optic sensations and capturing the general effect of landscape, definition of form was sacrificed to a diffused field of tonal landscape. All kinds of ephemeral atmospheric effects, such as smoke, haze, mist, or fog, were rendered in mediating tones. Impressionist motives such as trees, foliage, streams, and clouds became the material upon which the artist's manual influence could be exercised resulting in uniquely crafted gum prints. Furthermore, by abstracting the landscape, pictorialism stressed the idea that the landscape and nature itself possessed an essential character or emotion. No longer a depiction based on objective observation, pictorialism presented landscapes of carriers of personal expressions and feelings. Many pictorialist landscapes evoke a deep melancholy reminiscent of Symbolism. They seem to indicate the existence of a spiritual dimension of nature rather than an Impressionist depiction of the material world in terms of sensory perception. Also the medium of photography was considered capable of depicting landscapes of the mind.

STEVEN JACOBS

See also: Bisson, Louis-Auguste and Auguste-Rosalie; Bourne, Samuel; Braun, Adolphe; Cuvelier, Eugène; Expedition and Survey Photography; Fenton, Roger; Jackson, William Henry; Imperialism and Colonialism; Impressionistic Photography; LeGray, Gustave; Mountain Photography; Nature; O'Sullivan, Timothy Henry; Painters and Photography; Robinson, Henry Peach; Russell, Andrew Joseph; Sea Photography; Sky and Cloud Photography; Watkins, Carleton; Llewelyn, John Dillwyn; Fenton, Roger; Wilson, George Washington; Frith, Francis; Turner, Benjamin Brecknell; Bedford, Francis; England, William; Robinson, Henry Peach; Bourne, Samuel; Jackson, William Henry; Russell, Andrew Joseph; Watkins, Carleton Eugene, O'Sullivan, Timothy Henry, Caneva, Giacomo; Lemercier, Lerebours & Bareswill; Ruskin, John; Sommer, Giorgio; Jones, Calvert Richard; Greene, John Beasly; Alinari, Fratelli; Martens, Friedrich; Leon, Moyse & Levy, Issac, Ferrier, Claude-Marie, and Charles Soulier; Bisson, Louis-Auguste and Auguste-Rosalie; le Gray, Gustave, Baldus, Édouard; and Emerson, Peter Henry.

Further Reading

Bright, Deborah, "Souvenirs of Progress: The Second-Empire Landscapes." In *Image and Enterprise: The Photographs of Adolphe Braun,* edited by Maureen C. O'Brien & Mary Bergstein. London: Thames & Hudson, 2000.

Challe, Daniel & Bernard Marbot, *Les photographes de Barbizon: La forêt de Fontainebleau.* Paris: Bibliothèque nationale, 1991.

Chlumsky, Milan, "Une victoire des Bissons: la conquête du mont Blanc." In *Les Frères Bisson photographues: de flèche en cime 1840–1870.* Paris: Bibliothèque nationale de France, 1999.

Osborne, Peter D., *Travelling Light: Photography, Travel, and Visual Culture.* Manchester: Manchester University Press, 2000.

Sampson, Gary D., "Photographer of the Picturesque: Samuel Bourne." In *India Through the Lens: Photography 1840–1911.* Munich: Prestel, 2000.

Snyder, Joel, "Territorial Photography." In *Landscape and Power,* edited by William J.T. Mitchell. Chicago: Chicago University Press, 1994.

Szarkowski, John. *American Landscapes: Photographs from the Collection of the Museum of Modern Art.* New York: Museum of Modern Art, 1981.

Taylor, John. *Landscape, Photography and the Tourist Imagination.* Manchester: Manchester University Press, 1994.

Zanier, Italo. *Le Grand Tour in the Photographs of Travelers of the 19th Century.* Venice: Canal Editions, 1997.

LANGENHEIM, FRIEDRICH (1809–1879) AND WILHELM (1807–1874)

The Langenheim brothers, Ernst Wilhelm, and Friedrich, were born in Braunschweig in Germany, and emigrated to America, Friedrich in the early 1830s—probably around 1834—and Wilhelm probably c.1840. Sometime after arriving in America, they both anglicised their names, becoming known as Frederick and William.

William is known to have studied for a law degree in Gottingen, Germany, before emigrating to America and settling in Texas where he helped establish a settlement near San Antonio. He served in the army during the Texan War of Independence (1835–36) under General Sam Houston, and despite escaping from San Antonio just days before the fall of the Alamo, was captured and imprisoned for eleven months at Matamoras by the Mexicans. After being released, he is believed to

have worked both as a soldier and as an army clerk in Florida and New Orleans before joining his brother in Philadelphia c.1840. Friedrich worked as a journalist for the German language newspaper *Alte und Neue Welde* owned and edited by George Francis Schreiber before joining his brother in their first photographic studio. After acquiring a daguerreotype camera from Von Voigtländer, Friedrich Langenheim and Schreiber were briefly in partnership. Where William learned photography is unknown.

By 1843, the brothers were listed in a Philadelphia trade directory as operating a studio at 26–27 Exchange, Philadelphia. In their partnership, William assumed the role of senior partner.

Unusually, and perhaps reflecting their European background, by the late 1840s they offered their clientele photographs taken using both the daguerreoype and the calotype process. Calotypists were, at that time, relatively uncommon in America. So impressed was William by the calotype that he had Frederick negotiate with Talbot for the American patent rights for the paper negative process—acquired in 1849—and spent some considerable time modifying and perfecting it to suit the conditions in Philadelphia. Three significant letters from Frederick to Talbot survive in the collection of the National Museum of Photography, Film and Television, Bradford, England.

In the first of these letters, dated 10th June 1849 Frederick wrote to Talbot at length, noting

> We had the pleasure to receive a communication from our W. Langenheim, informing us of the effectual arrangement he had succeeded in making with you in regard to the purchase of your Patent. It is our interest, but it will be an especial pleasure to us to promote and perfect your invaluable invention, and in a very short time we hope to be able to send you a few specimens of Talbotypes, which will surpass in sharpness and delicacy of shading even a good Daguerreotype.
>
> The Talbotypes have created a great sensation all over the United States, and most papers of any standing contain favorable articles on the subject, among a great number of which we refer only to the Daily National Intelligencer, Washington, of May 12, which contains a long article on the subject, and which it may perhaps interest you to read.
>
> But the Talbotypes have also created a great deal of envy among our opponents and doubtless attempts will be made to infringe upon our purchased right, against which we have to guard with every possible care, and in which effort we hope you will lend us your aid.

The letters from William Langenheim to Talbot, to which Frederick refers, may yet be discovered. It is known that the Langenheims sent Talbot examples of their calotypes—including views of Philadelphia.

The exact nature of the brothers' partnership remains unclear, and although Frederick wrote to Talbot in 1854 of the failure of W. & F. Langenheim three years earlier, Frederick himself was listed as operating a daguerreotype studio in New York in 1845 and 1846—at 201 Broadway—and from 1846 until 1849 as being in partnership with Alexander Beckers. It may well be that Langenheim established the studio, trained Beckers, and then left him to manage it. As the Langenheims' sister was married to Peter Friedrich Von Voigtländer, it is perhaps not surprising that Langenheim & Beckers advertised themselves in the later 1840s as sole agents for Von Voigtländer's innovative metal-bodied daguerreotype camera and Professor Petzval's fast lens.

While in New York, Frederick travelled to, and photographed, Niagara Falls, one of his images being used as the basis for an engraving published in 1845. In the following year he took out a patent (US Patent 4370 1846) for colouring daguerreotypes, by which time both the Philadelphia and New York studios had earned much praise for the quality of their daguerreotype portraits.

As early as 1846 the brothers had become interested in the idea of projecting photographic images, and had imported episcopes from Vienna and experimented, with some success, at projecting daguerreotypes on to a screen. Recognising that the quality of the projected image from a reflected daguerreotype was not ideal, they experimented from 1848 with the creation of glass diapositives from glass and paper negatives using Niepce de St. Victor's albumen-on glass-process, the resulting process, which they patented in 1850s, becoming known as the Hyalotype. The involvement of a rival claimant to the invention, George Schreiber with whom Frederick had worked in the early 1840s, was described in an essay in *The American Journal of Photography* 13 no.137, in 1892. In that essay, Schreiber is said to have produced the first positive on ground glass c.1848.

The impact of the Hyalotype on the social history of photography was far reaching, turning the magic lantern into an important educational and information tool. Their catalogue of glass stereo diapositives would eventually become extensive.

By 1850, the brothers advertised themselves as "Daguerreotypists and Calotypists," and in that year they produced *Views in North America, Taken from Nature July 1850 by the Patent Talbotype Process* comprising just over one hundred images, but by the following year, despite continuing commercial and critical success, and being awarded medals at the Great Exhibition in London, their partnership had been dissolved. Frederick then left for a three-year sojourn in South America where, as he told Talbot in a letter upon his return in 1854, he had gone "to revive [his] spirits after the failure of the firm W. & F. Langenheim." William continued in business on his own, expanding the company's catalogue of lantern slide views

The brothers' partnership was renewed in 1854 and

by 1861, styling themselves the American Stereoscopic Company, they were producing lantern slides and stereo diapositives in huge numbers.

The brothers remained active in marketing photographs until William's death in 1874, after which Frederick retired and the company was sold.

JOHN HANNAVY

See also: von Voigtländer, Baron Peter Wilhelm Friedrich; Daguerreotype; Calotype and Talbotype; Talbot, William Henry Fox; and Petzval, Josef Maximilian.

Further Reading

Hunt, Robert, *A Manual of Photography*, London: Richard Griffin, 1857.
Johnson, William S., *Nineteenth Century Photography: An Annotated Bibliography 1839–1879*, London: Mansell, 1990.
Taft, Robert, *Photography and the American Scene* New York: Dover, 1964.
Welling, William, *Photography in America: The Formative Years 1839–1900*, New York: Thomas Crowell, 1978.
Philadelphia Photographer, Langenheim obituaries, vol. 11, p.185 (1874) and vol.16, p. 95, (1879).

LANGLOIS, JEAN-CHARLES (1789–1870)
French war photographer

The Crimean War photographs taken by Colonel Jean-Charles Langlois either on his own or with Léon-Eugene Méhédin and Friedrich Martens offer a much more chilling image of the war than Roger Fenton's more celebrated productions.

He was born in Beaumont-sur-Auge, Calvados, in 1879, the year of the French Revolution, and later joined the French army. He served in campaigns up until 1815, when he embarked on a study of painting before returning to his military career, but as an artist not as a soldier.

He developed an interest in panorama painting before 1830, later translated into an interest in panoramic photography. Posted to Algeria in 1833, he made numerous sketches which resulted in his remarkable *Panorama of Algiers* painted three years later. In 1839 another panorama painting, this time of the burning of Moscow in 1812, was opened in a specially constructed building on the Champs-Elysée in Paris.

In 1855 and 1856 Langlois made two journeys to the Crimea to record the scenes there. Working with both Méhédin and Martens, he produced a fine series of photographs, now in the Bibliotheque Nationale, sketches for a huge panorama of the siege of Sevastopol painted from inside the Malakoff Fort. The resulting painting was his first to be based on photographic sketches. It was exhibited in Paris in 1860.

JOHN HANNAVY

LANTERN SLIDES

The magic lantern, the projector which delivered thousands of Victorian slide shows, and which enjoyed renewed popularity with the introduction of the photographic lantern slide, can trace its lineage back, at least, to the middle of the seventeenth century. Some historians place the genesis of the lantern much earlier.

Before 1850, the magic lantern was used to project hand drawn and hand-painted slides as public entertainment, with narrative sequence being created by artists, and some movement being introduced by elaborate optical-mechanical features.

The introduction of the hyalotype, or photographic lantern slide, by Frederick and William Langenheim after 1850, revolutionized magic lantern shows, and creating a huge new market for photographers and photographic publishers.

The lantern slide, as introduced by the Langenheims, gave a new lease of life to the slow but very fine grain albumen-on-glass process which had been introduced a few years earlier, and not very successfully, by Felix Abel Niepce de St Victor. While its low sensitivity made it impractical as a negative medium for all but still life work, or landscape and architecture on the stillest of days, as a printing medium it proved ideal.

Using a camera obscura in reverse, large negative images could be reduced and printed on to the small glass plate for projection in the lantern. The fine grain structure of albumen-on-glass was ideal for this purpose, retaining the finest of detail—essential when the image was subsequently projected on to a large screen.

While it is clear that the Langenheims initially saw the lantern slide as an extension of the entertainment business—they charged admission to their slide shows—it proved to be of much great importance in the second half of the nineteenth century.

With series of slides covering travel, architecture, landscape, exploration, history, biblical themes, and many other subjects, the magic lantern swiftly moved from being an entertainment to being a powerful educational and instructional tool.

Lantern slides, before the advent of photography, came in a variety of sizes. "French Pattern" slides were 3.25" × 4", while "English Pattern" used a square 3.5" × 3.5" format. The European standard size was slightly smaller at 3.25" × 3.25", and it was this format which became the standard for photographic images, although the 3.5" × 4" format endured in France, America, and Japan.

Color, introduced by hand-painting over the photograph, was used for some images, but toning was more usual as, in addition to offering a variety in coloration, it also helped protect the image against premature fading under the intensity of the lantern's illumination.

While today the idea of the projected image is com-

monplace, the novelty of the large projected photographic image in pre-cinema days was considerable, and the popularity of such displays grew exponentially.

While travel themes were probably the most popular—educating an audience about the treasures of places they would never visit—the magic lantern show covered a wide range of subjects. Themes and ideas which had previously been projected using painted slides were given added realism when photographic imagery was used. Thus biblical lantern shows proliferated—the photographic "evidence" of places mentioned in the Bible being used to add authenticity to the stories thus delivered.

Many of the leading travel, architectural and landscape photographers of the second half of the nineteenth century offered their images in lantern slide format as well as traditional paper prints and stereographs. Thus the Langenheim brothers published series of views of their adopted home, Philadelphia, and, wider afield in America.

Edweard Muybridge, a consummate showman, lectured widely throughout the 1870s, 1880s, and 1890s using lantern slides of his landscape and architectural views to delight audiences. When lecturing about his ground-breaking photographic experiments in animal locomotion, in addition to using hyalograph discs in his zoopraxiscope to recreate motion, he illustrated his lectures with selections from several thousand lantern slides of single images. A vast collection of these lantern slides is preserved in Kingston Museum, England.

Aberdeen photographer George Washington Wilson's series on Windsor Castle and the River Thames could be purchased in slide format, as could his delightful 1880s series of view of life on the remote Scottish island of St. Kilda.

The photographs taken by Charles Piazzi Smyth for his *Three Cities in Russia* (1862), best known in two-volume book form, were also available as a series of warm-toned and tinted lantern slides, and lantern slide sets exist of his views of the pyramids of Giza.

The negatives for many subject photographed for the stereoscope could be reprinted as lantern slides and, trimmed down, as *cartes-de-visite* as well, considerably increasing the sales potential of a single negative.

Several manufacturers of magic lanterns offered extensive catalogues of photographic slides to their customers. Amongst these, York and Company of London, and McAllister & Brother in Philadelphia were major players. By the late 1850s, McAllisters had a large photographic department marketing slides of photographs by numerous photographers. As the majority of lanterns they sold by the 1880s were imported from Europe, especially Britain, it can be assumed that their image catalogue contained both the European and American sizes of slides.

The growth of the photographic lantern slide as an education tool has been credited with revolutionising a number of academic disciplines, most notably the sciences and the history of art. Universities throughout the world had, by the end of the century, extensive libraries of lantern slides, and continued to use them until the lantern slide was replaced by the film transparency after the Second World War.

Lantern slides as entertainment developed as a separate but equally important entity, with companies creating elaborate tableaux exploring moral and social issues such as the evils of drink, and producing narrative sets of slides to illustrate their themes—just as they had with stereocards in the 1860s and 1870s.

One such company, Bamforth & Company of Holmfirth, Yorkshire, picked up the "story-telling" idea which had been so successfully exploited in the 1860s and 1870s by the London Stereoscopic Company, and marketed series with resonant titles such as "The Curse of Drink," "The Drink Fiend," "The Road to Heaven," "Strike While the Iron is Hot," and "Deep in the Mine." It was a logical step for Bamforths to progress from the still picture sequence to the moving image, and become, for a view years, pioneers in early cinema.

JOHN HANNAVY

See also: Langenheim, Friedrich and Wilhelm; Niépce de Saint-Victor, Claude Félix Abel; Wilson, George Washington; Piazzi Smyth, Charles; and Muybridge, Eadweard James.

Further Reading

Robinson, David; Herbert, Stephen; and Crangle, Richard, *Encyclopedia of the Magic Lantern*. London: Magic Lantern Society, 2001.

Crangle, Richard; Heard, Mervyn; Dooren, Ine van, *Realms of Light*. London: Magic Lantern Society, 2005.

Humphries, Steve, and Lear, Doug, *Victorian Britain Through the Magic Lantern*. London: Sidgwick & Jackson, 1989.

LAROCHE, MARTIN (WILLIAM HENRY SILVESTER) (1814–1886)

A jeweller turned photographer, Martin Laroche is primarily remembered for the important court case *Talbot v Laroche* in 1854, in which Talbot attempted to claim that the 'new process' of collodion was covered by his 1841 British Patent No.8842.

Talbot had relinquished his patent rights over amateur photographers in 1852, the year after collodion was introduced, but had sought to retain control over the use of negative materials from which positive prints were made for professional portraiture. A situation existed whereby professionals had to pay a licence fee to Talbot to use a process given freely to them by Frederick Scott Archer.

Laroche opened a studio at 65 Oxford Street, London, before 1848—under the name 'Silvester Laroche'—initially making daguerreotypes, examples of which were shown at the Great Exhibition in 1851. He later used the wet collodion process. The studio continued to operate until at least 1862.

In the 1854 court case, Talbot was represented by, amongst others, the eminent scientist William Grove FRS, while Laroche's solicitor was Peter Wickens Fry who had worked with Archer in the development of the collodion method. The verdict confirmed Talbot's pre-eminence as the inventor of negative/positive photography, but also confirmed that collodion was not covered by his patents.

JOHN HANNAVY

LATENT IMAGE

A latent image can be most simply defined as a hidden or invisible image formed by brief exposure to light, which can be revealed to the naked eyed only by the chemical action of a developing agent.

The first steps towards the concept of a photographic latent image are often traced back to W.H.F. Talbot's work in September 1840 that led to the introduction of his Calotype process. However, there can be little doubt that L.J.M. Daguerre, albeit imperfectly, recognised the presence of some invisible pre-image state initiated by light, perhaps as early as 1837. His daguerreotype process required the use of a silvered copper plate made light sensitive by exposure to iodine vapour. Little or no visible image was produced after several minutes of exposure in the camera, but it was found that a distinct image appeared after treatment (development) with heated mercury vapour. Daguerre is reputed to have discovered his developing agent purely by accident when he left a collection of old plates in a cupboard containing an uncovered basin filled with liquid mercury. The term "latent image" was certainly used in 1839 in connection with the daguerreotype process. An account of the official report of Daguerre's technique published in *Le Constitutionnel*, 21 August 1839 states; "After 4 to 10 minutes, according to the period of the day, according to the season, and to the intensity of light, the image of immobile objects from which the lens receives the light, becomes perfectly imprinted on the plate, although this image is yet invisible and only latent ["seulement latente"].... But this image, that is yet, so to say, in a state of an unformed chrysalis, what consequently comes to reveal it out of its swaddling clothes? It is the vapour of mercury, from mercury heated to 60 Reaumur."

Talbot's concept of the latent image has been more widely recognized, perhaps because of his use of techniques closer to modern practice. The story is well documented. In his original process announced in1839,

photogenic drawing, paper coated with silver halide salts was exposed in a camera until an image appeared. The process was very slow. Many minutes, even hours, were required to produce a satisfactory picture. In the late summer of 1840 he recommenced some earlier experiments he had begun using gallic acid. His notebook of September 21 refers to "an exciting liquid" a mixture of silver nitrate, acetic acid and gallic acid. His entry of September 23 records "The same exciting liquid was diluted with an equal bulk of water, and some very remarkable effects were obtained. Half a minute suffices for the Camera the paper when removed is often blank but when kept in the dark the picture begins to appear *spontaneously,* and keeps improving for several minutes. . . ." On the same page in the context of reviving what he called old or faded pictures, he refers to a "kind of *latent* picture...." Talbot had discovered the latent image, which could be revealed using a developer, in his case, gallic acid. He later wrote in a letter to the *Literary Gazette*, 19 February, 1841, "I know few things in the range of science more surprising than the gradual appearance of the picture on a blank sheet, especially the first time the experiment is witnessed."

The mechanism of latent image formation intrigued and baffled the pioneers and continued to be the subject of speculation and dispute throughout the nineteenth century. According to the popular 1850s guide, *A Manual of Photographic Chemistry*, by T. Frederick Hardwich (third edition, 1856), "the ray of light determines a *molecular* change of some kind in the particles of Iodide of Silver forming the sensitive surface." The American authority, M.Carey Lea, offered a different explanation. In *The Photographic News*, (11 August 1865) he claimed "...the production of a developable image in the camera upon an iodo-bromised film is a purely physical phenomenon, that no decomposition of the silver salts takes place, no separation of iodine. By the end of the nineteenth century, most latent image formation theorists were sharply divided in favour of one or the other of the two approaches cited above, the chemical or the physical. The former group suggested the formation of an unknown sub halide salt while those favouring the latter argued that the action of light caused some change in the physical character of the silver salts. It was not until photography became a giant industry supported by systematic scientific research facilities in the 20th century that the mysteries of latent image formation began to be unravelled.

Modern scientific explanations are based on the *concentration speck theory* of R.S. Sheppard and colleagues working at the Kodak Research Laboratories in the 1920s and the mechanism proposed in 1938 by Professors R.W. Gurney and N.F. Mott based at Bristol University. The detailed theories are complex and the supporting experimental evidence requires an

understanding of the nature of ionic mobility, crystal structures and quantum theory. Only a much-simplified explanation is, therefore, possible.

Since the end of the 19th century, most photographic films, plates and papers have been coated with a gelatin emulsion in which are suspended crystals of light sensitive silver halides (chlorides, bromides, and iodides). A brief exposure of light is believed to act on some silver halide crystals in a way that produces an aggregate of metallic silver atoms. This aggregate is the latent image, the invisible building blocks from which the visible image is formed. The number of silver atoms involved may be very small but they render the silver halide crystals susceptible to the action of an appropriate chemical solution, (developer), which when applied causes the invisible aggregate to change and grow into a visible image of black metallic silver. Although understanding of the latent image has greatly progressed since the 19th century, its mechanism remains based on theory and subject to modification and revision. Even with the best modern technology, it remains impossible to detect a latent image by direct physical or chemical means.

JOHN WARD

See also: Talbot, William Henry Fox; Daguerre, Louis-Jacques-Mandé; Calotype and Talbotype; Daguerreotype; and Photogenic Drawing Negative.

Further Reading

Arnold, H.J.P. *William Henry Fox Talbot, Pioneer of Photography and Man of Science*, London, Hutchinson Benham, 1977.

Latent Image, *Cassell's Cyclopaedia of Photography,* edited by Bernard E. Jones. London, New York,. Cassell and Company Ltd., 1911.

Latent Image, *The Focal Encyclopedia of Photography*, vol. 1, London, Focal Press Ltd., 1965 (fully revised edition).

Mees, C.E. Kenneth, *From Dry Plate to Ektachrome Film*, New York, Eastman Kodak Company, 1961.

Schaaf, Larry J. *Records of the Dawn of Photography, Talbot's Notebooks P & Q* Cambridge University Press, 1996.

Wood, R.D. "The Daguerreotype and Development of the Latent Image: "Une Analogie Remarquable" in *The Journal of Photographic Science*. 44, no. 5 (1996): 65–167.

LAURENT, JUAN AND COMPANY (1816–before 1892)

Born Jean Laurent in Garchizy, France, in 1816, he moved to Madrid in 1843, where he reportedly registered himself as "Juan" (the Spanish style of "Jean"), and established and operated a successful company manufacturing cardboard packaging. His photographs however, where they are identified, simply bear the legend "J. Laurent" or "J. Laurent y Cia."

His earliest recorded encounter with photography dates from 1856, with the establishment of a studio at Carrera de San Jerónimo in Madrid. Although he lived in Spain for the remainder of his life, he never lost contact with his French roots and, at the height of his success, Laurent opened a gallery in Paris selling prints from his finest Spanish and Portugese architectural and landscape scenes, copies of great paintings, art and architectural treasures. Like the Englishman Charles Clifford, he photographed and sold images of Spain's rush towards the modernisation of its capital city, and the building programmes which dominated the 1860s.

Again like Charles Clifford, he went on to develop a reputation as one of the finest photographers in the city, enjoying, also like Clifford, the patronage of Queen Isabella II. Indeed, for most of the 1860s, he styled himself "Photographer of Her Majesty the Queen."

Laurent's large format camera work is technically more precise than Charles Clifford's—with great attention to details of architectural accuracy—but like Clifford, his love of the Spanish light, architecture, and scenery is apparent. In some of his architectural studies, careful choice of camera position, ideal lighting, and technical excellence combine to produce images which revel in simple geometric patterns, a direct and graphic style which others would adopt only very much later. *Puente de Zura* (Collection of the Metropolitan Museum of Art) dating from c. 1867, is a fine example of this approach.

In 1867 the studio exhibited a number of large *Álbumes de Obras Públicas* at the Exposition Universalle in París, and the production of large albums of views would remain a signature activity for the studio.

Laurent reportedly employed several photographers to create the images for these albums and catalogues, as well as a large number of support staff. One of the photographers was José Martínez-Sánchez who worked with Laurent for many years, and is believed to be responsible for a significant proportion of the studio's considerable output.

In 1866, in collaboration with Martínez-Sánchez, Laurent perfected 'Leptographic' paper ('Leptofotografía'), a collodio-chloride printing paper which was sold ready to use. The light sensitive silver chloride was held in a binding layer of cellulose nitrate, separated from the paper by a layer of barium sulphate (later known as baryta), giving a much whiter base colour to prints than had been previously possible with albumen paper. The baryta layer acted as a barrier, eliminating the spotting from rusting metal particles in the paper which sometimes happened with albumen papers, and at a stroke, the introduction of this paper removed from the photographer all the paraphernalia of having to sensitize the paper before use, as had been needed with albumen. As the manufacturers claimed, it had three times the sensitivity of albumen, and exposure times for contact printing could also be reduced significantly. In the same

year, the Leptographic Company opened a branch in Paris, reported by Marc-Antoine Gaudin in *la Lumière*, August 30, 1866, and offered samples of the new paper to members of the *Société française de photographie* for them to experiment with. For a variety of reasons, it would be a further fifteen years before commercial-scale production of collodio-chloride papers became successful—and in Germany rather than France or Spain.

It is apposite, and perhaps significant, to observe that the majority of the surviving examples of Laurent's work are printed on albumen paper rather than his own invention.

A member of the *Société française de photographie* since 1859, and a regular exhibitor in Paris where his prints and albums found a ready and wealthy clientele, Laurent exhibited only once in London, at the 1858 exhibition of the Photographic Society.

Architectural views of Granada, Toledo, Segovia, Seville, and elsewhere all attest to the quality of his output. And by the mid 1860s, as Laurent y Cia, he was the proprietor of the largest photographic publishing house in Spain, with a growing reputation—and demand for his work—wider afield.

In the 1860s alone, the company produced over twenty catalogues listing their huge archive of images.

His 1866 album of 164 photographs from the collection of the Prado Museum in Madrid, marketed through his own gallery in Paris, was distributed for the British market by Marion & Co. of London.

Laurent y Cia had the exclusive photographic franchise within the Prado from the late 1870s until his death, and produced a huge catalogue of images of the masterpieces contained within the museum. An exceptional panorama, dating from 1882–83 and showing the museum's central gallery, survives in the Prado's own collection of Laurent's work.

Another album depicted the treasures of the Madrid Armoury, and as one of the images is titled, in the negative, *Armeria de Madrid. 337. Trophée formé de diverses armes, oeuvres de Mr. E. de Zuloaga. J. Laurent Madrid*, we can recognize that the published album contained only a very small proportion of the images he had produced.

Uncertainty surrounds the exact date of Laurent's death; certainly no later than 1892, some historians have offered a date as early as 1883, with others suggesting the late 1880s or 1890. The studio was apparently owned, or at least operated, by his step-daughter Catalina and her husband Alfonso Roswag after 1883. Roswag had been employed some years earlier as one of Laurent's team of photographers, and the studio of Laurent y Cia remained in their hands until Alfredo's death in 1899.

JOHN HANNAVY

See also: Clifford, Charles; and Spain.

Further Reading

Fontanella, Lee, *La Historia de la Fotografía en España desde sus orígenes hasta 1900*. Madrid: Ediciones El Viso, 1981.

López Beriso, M., "Jean Laurent y José Martínez Sánchez: Ojos distintos para una sola mirada." In *La Andalucía del siglo XIX en las fotografías de J. Laurent y Cía*, 187–193. Seville: Junta de Andalucía, 1998.

Jacobson, Ken, and Anthony Hamber, *Etudes D´Apres Nature: 19th century Photographs in Relation to Art: Artists' Studies, Works of Art, Portraits of Artists, Mixed Media*. Peches Bridge: Ken and Jenny Jacobson, 1996.

Gaudin, Marc-Antoine, "Sur le papier leptographique," in *La Lumière*, August 30, 1866.

Garófano Sánchez, Rafael (ed.), *La Andalucía del Siglo XIX en las fotografías de J. Laurent y Cía*. (With texts by Rafael Garófano Sánchez, Ramón Montes Ruiz, Javier Piñar Samos, Carlos Teixidor Cadenas, Juan Antonio Fernández Rivero, Miguel Ángel Yáñez Polo, Marta López Beriso, and Concha Herranz Rodríguez.) Almería and Sevilla: Junta de Andalucía, Consejería de Cultura and Centro Andaluz de Fotografía, 1999.

LE BLONDEL, ALPHONSE (1814–1875)

Alphonse-Bon Le Blondel, also Leblondel, (both spellings existed until 1862)—was born in Normandy on April 19, 1814. He first trained as a painter but soon turned to photography along with two of his brothers—Alexandre and Théodore (both born in 1822). He learnt the trade in 1840–1841, most probably among a circle of daguerreotypists prevalent in Paris's Palais Royal where he used to sell photographic equipment.

As early as 1842 he made various forays as an itinerant photographer with Alexandre into the North of France (Lille, Douai, Arras), thus playing an important role in the circulation of daguerreotypes among the general public. In 1845 he founded one of the first professional studios in Lille. He rapidly caught the attention of Lille's notables by his exemplary technical expertise and an aggressive commercial strategy (cheaper prices, advertisement in the local press, and exhibitions in shops). Indeed, he managed to compel recognition for 10 years as he found no serious competitor in Lille.

From 1855, the development of the "Le Blondel Brothers" studio, of which Théodore was now a partner, expanded both on a commercial level as well as in terms of recognition among professional photographers. His success and profitability enabled him to persue his trade until 1892.

Le Blondel was one of the first professional daguerreotypists. He also experimented with paper photography as early as 1845 and marketed so-called 'advanced' calotypes at the beginning of September 1846. When studying Lille, one cannot forget to mention Louis-Désiré Blanquart-Évrard who communicated the first results of his research work on the improvement of calotypes to the Academy of Science in Paris on September 28, 1846, the very process being unveiled in

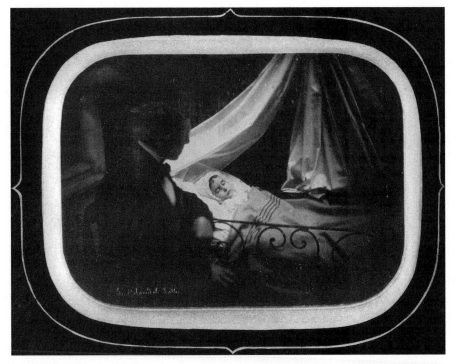

Le Blondel, Alphonse Bon.
Postmortem.
*The Metropolitan Museum of Art,
Gilman Collection, Purchase, The
Horace W. Goldsmith Foundatoin
Gift, 2005 (2005.100.31) Image © The
Metropolitan Museum of Art.*

January 1847. Despite a few allegations, no connection between the two characters can be traced as they had quite different ambitions.

Le Blondel was attentive to the technical development and ingenious improvements of the already-existing processes. Therefore, he managed to conserve his local pre-eminence by providing constantly renewed services. In 1853 he adopted the process of collodion glass-plate photography, which he used with remarkable expertise in his urban views. He also worked on ambrotypes (1854), stereoscopic photography (1859), photographic enamels (1872) and specialized in enlargements (1874). Last of all, not long before his death, the studio turned to aristotypes and snapshots, showing an interest in the new permanent printing processes—lambertypes, 'encre-grasse' printing and carbon photography. Over the course of his career, Le Blondel had tackled many photographic genres: portrait in all its forms, studies, genre scenes, topographic, and architectural views.

In the second half of nineteenth century, town planning was deeply transformed. Four cities, among the most important Paris, Lyons, Marseilles, and Lille, hired photographers to bear witness to that upheaval—Marville in Paris, Terris in Marseilles, Froissart in Lyons, and Le Blondel in Lille.

In 1870, he was commissioned by the city of Lille to capture shots of the building of Rue de la Gare. The death of their founder in 1875 did not prevent the studio from carrying on with this task and they continued to take part in professional shows. The critic Ernest Lacan admires their 'beautiful reproductions of historical monuments' at the photographic show of Le Havre in 1877. In 1878, under Théodore's management, Le Blondel's studio carried out a prestigious order from the city of Lille for Paris's World Fair: an album entitled *"Photographic Views of the Major Works Made in the Enlarged City from 1860 to 1878"* displays an outstanding survey of Lille's transformation in forty-three large-sized albumen prints: the building of thoroughfares, administrative edifices, schools, hospitals, religious buildings, industries, shops, public gardens, and stately gates. In 1882, the studio was to fulfill an important order from the city of Roubaix to take shots of the recently-built school buildings.

From 1842 onwards Le Blondel regularly displayed his works in the best-known downtown shops in order to keep his fame alive. True recognition however, came from the capital's professional photographers. In 1853 he exhibited framed portraits in Dunkirk. In 1854 he sent daguerreotypes and paper prints to Paris's newspaper *Le Propagateur,* which were then highly praised. He was awarded medals and distinctions as appreciation for his participation in Paris's World Fairs (1855, 1867, and 1878), in the shows organized by the French Society of Photography (1857, 1859, and 1861), in Le Havre's exhibition (1877), in Brussels and Courtrai's international exhibitions (1856, 1857, and 1865). Le Blondel thus gained recognition from critics (Ernest Lacan in the reviews called *La Lumière* and *Le Moniteur de la photographie,* Paul Périer in *Bulletin de la SFP*).

The technical and aesthetic quality of his work particularly asserted itself in the urban views on albumen paper. In these works, horizontal centring was favoured over wide foregrounds, which caught the subject either frontally or obliquely. Sobriety in lines,

subtlety in light and fineness in details characterize his photographs.

Le Blondel's photographs make up a rich and consistent collection of about 700 original works visible in private and public places in France and abroad. The majority can be found in Lille and the North of France with 650 "vintage" works (423 paper prints and negatives, 227 glass plates of 36cm x 26cm size). The most significant collection is that of Lille's public library, which owns 180 salt-paper and albumen prints such as portraits as well as varied views. Most importantly, the collection contains three big albums with views of Lille containing about a hundred albumen original prints—the album made for 1878's World Fair being one of these. The North's Historical Committee is in possession of the glass-plate negatives for these albums, which are now kept in the North's Record Office. The rest is divided between various institutions in Lille (Museums, Diocesan Archives) and Roubaix's public library which holds two albums dating from 1882 (64 print papers). In Paris, the Bibliothèque Nationale and Orsay Museum own a few daguerreotypes and about forty print papers.

So, as to retrace the studio's history; Lille's public Library displayed 170 photographs in Lille's Palace of Fine Arts from September 16th to December 18th 2005 in an exhibition called "Le Blondel—A Photographic View of Lille in the 19th Century," which led to the publication of a scientific catalogue.

ISABELLE DUQUENNE

Biography

Alphonse-Bon Le Blondel was born into a six-child family of clockmakers on April 19, 1814, in Bréhal, a small town in Normandy near Granville. After training as a painter, he learnt photography with Paris's daguerreotypists from 1840–1841. In 1842 he worked as an itinerant photographer in the North of France before he founded one of Lille's first professional studios at twenty-five, Rue de Paris in 1845. From 1855 he developed 'Le Blondel Brothers' company which lasted until 1892. In 1859 the studio grew larger and moved to 1, Pont de Roubaix/Rue du Cirque. With the help of his wife Angélique-Aimée Daviette (1800–1871), a fellow photographer, two branches were successively opened in Lille in 1866 and 1869. Being an excellent portraitist, Le Blondel compelled recognition as a specialist of urban views. He produced a topographical series of Lille and its great transformations in the 1870's.

He died in Lille on May 12, 1875.

Exhibitions

1853, Dunkirk, Magasin de la Marine (F)
1855, World Fair, Paris (F)
1856, Brussels (B)
1857, French Society of Photography, Paris (F)
1857, 4th Industrial Arts Exhibition, Brussels (B)
1859, French Society of Photography, Paris (F)
1861, French Society of Photography, Paris (F)
1865, Courtrai (B)
1867, World Fair, Paris (F)
1877, Le Havre (F)
1878, World Fair, Paris (F)

See also: Daguerreotype; Calotype and Talbotype; Blanquart-Évrard, Louis-Désiré; Lacan, Ernest; and Bibliothèque Nationale.

Further Reading

Le Blondel, un regard photographique sur Lille au XIXe siècle, Ghent: Snoeck Publisher, Ville de Lille, 2005.

LE GRAY, GUSTAVE (1820–1882)
French photographer, artist, inventor, and writer

Like many early photographers, Gustave Le Gray's artistic background was in painting, a fact that, as with his contemporaries, influenced his direction, his vision and the composition of his finest photographs. A student in the Paris ateliers of François-Edouard Picot and Paul Delaroche in the early 1840s, surprisingly only one example of his accomplishment in drawing or painting has so far been identified—a photographic copy dated 1854 of a drawn portrait of the painter Bénédict Masson. This absence of surviving work is despite Le Gray having set himself up as a working painter in Paris before 1847—the year in which he took up the new art of photography—and records up to 1848 which describe his contributions to various exhibitions in the city. He continued to advertise his services as a painter of miniatures well into the 1850s, by which time he was already acknowledged as an authority on photography.

Le Gray became aware of photography in the mid-1840s, and was immediately intrigued by it. By his own recollection, his first engagement with the medium was with the daguerreotype, probably under the guidance of François Arago, and by 1847–48 he was sitting for the camera of Henri le Secq, who was experimenting with a post-waxed paper negative process, probably based on Fox Talbot's calotype. Le Secq's studies of him, casually dressed and posed as the young artist, have a vitality and a confidence which were already becoming characteristics of early French photography. It is likely that Le Gray had met Le Secq and Charles Nègre while studying in Delaroche's studio.

The enthusiasm with which Le Gray embraced the art of photography, and his early grasp of its chemical intricacies, can be gauged by the fact that within a year

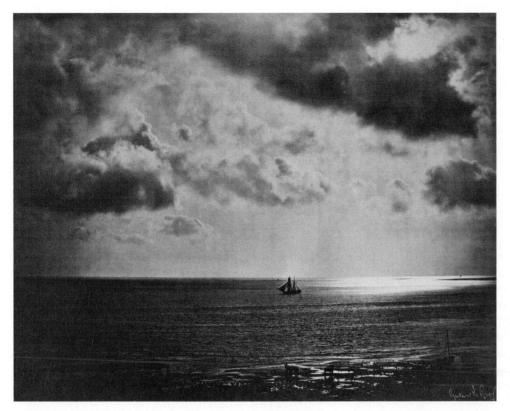

Le Gray, Gustave. Brig on the Water.
The Metropolitan Museum of Art, Gift of A. Hyatt Mayor, 1976 (1976.645.1) Image © The Metropolitan Museum of Art.

he was teaching others. A notable student—who took lessons from him in 1849—was Maxime du Camp, probably the first European photographer to travel extensively in Egypt with a camera in 1850.

Le Gray's work appeared in France's first photographic exhibition—within the *Produit de l'Industrie* exhibition in 1849—and those early images, taken in the Forest of Fontainebleu, won him a bronze medal at the exhibition. Nine images submitted to the Paris Salon in the following year were hung in the Graphic Arts section amongst the work of lithographers, but were quickly removed and returned to the artist, apparently being inadmissible.

Le Gray's confidence with the technology and chemistry of early photography manifested itself in a series of treatises, the first of which—*Traité Pratique de Photographie Sur Papier et Sur Verre,*—was published by Germer Ballière in Paris in June 1850. He was, by this time, an ardent promoter of paper negative processes and in that publication wrote

> The future and extensive application of photography will doubtless be confined to the paper process and I cannot too much engage the amateur to direct his attention and study to it. (from the English translation, "A Practical Treatise on Photography upon Paper and Glass" translated by M Cousens, London: T&R Willats, 1850)

Despite his advocacy of paper-based photography, that same treatise offers an intriguing glimpse of Le

Gray's enthusiasm for experimentation with a range of processes. In addition to his description of a range of paper processes, he noted in an appendix that "I am now making use of the following process on glass: Fluoride of Potassium or Sodium is dissolved in alcohol of 40° mixed with sulphuric ether and then saturated with collodion," a tantalising suggestion that he was using a wet collodion process before Frederick Scott Archer published his account thereof. Writing in *Plain Directions for Obtaining Photographic Pictures Upon Glass and Albumenised Paper* (Richard Willats, London 1853) Charles Heisch noted that this was undoubtedly the first published account of the method, although such a process had been predicted as early as 1847. Needless to say, Archer dismissed the Frenchman's claim because "he did not give the public the advantage of following him and that in his work of 1850 the subject is dismissed in three or four lines (Heisch quoting Archer, 1853).

Le Gray's acknowledged contribution to the emerging science of photography was not his prediction of wet collodion, however, but his widely practised *papier ciré*—the Waxed Paper Process, the first photographic negative material with a surface-coated light sensitive layer on a flexible support—announced in 1851 and arguably prefacing the materials which would dominate photography throughout the twentieth century. While Le Gray's original formulation was ideally suited to conditions in France, it had to be customised by others—including Roger Fenton, William Crookes and Dr.

Thomas Keith in Britain—to suit different qualities and intensities of light. In its various formulations it became a high-quality and user-friendly process ideally suited to travelling photographers and to amateurs. Pre-waxing the paper restricted the light sensitive chemistry to the paper surfaces, and removed the tendency for a photographic image of the paper fibres to be created in addition to the image of the subject. In its original form, with the waxed paper immersed in the silver bath, a light-sensitive coating was created on both faces of the paper. Later refinements included floating the paper on the sensitising solution, thus restricting the image-bearing layer to a single surface.

From the point of the travelling photographer, waxed paper negatives could, if required, be prepared several days before exposure, and developed several days afterwards. Thus freed from the constraints of transporting a darkroom wherever they went, photographers could concentrate solely on the image.

Le Gray demonstrated the versatility of his process in a remarkable series of landscapes taken between 1849 and 1852 in the densely wooded Forest of Fontainebleau. His understanding of the relationship between the light and the limited spectral sensitivity of his dry waxed paper negatives is manifest in these images, creating in his salt prints an intimacy which at once both draws the viewer into the composition and evokes a strong emotional relationship with the environment. By careful choice of both lighting and location, his images went far beyond simple representation, denoting a clear understanding of the potential of his process, and the unique vision of the camera.

The forest was a subject to which he returned in his later engagement with collodion, further developing his personal relationship with the place.

In parallel with his continuing exploration of Fontainebleau, Le Gray applied his talents and his process to a unique undertaking on behalf of the Commission des Monuments Historiques, an agency of the French government. Recognising the importance of photography as a tool of record, the Comte de Laborde, a curator at the Louvre working on behalf of the Commission, approached a number of founder members of the Société Héliographique in Paris in 1851 to undertake a nationwide photographic survey of historic buildings, many of which were deemed to be under threat. Laborde had long been enthusiastic in his advocacy of photography.

First to be thus commissioned was Edouard Baldus—ironically to photograph buildings around Fontainebleau, an area Le Gray knew so well. Further commissions went to Henri le Secq, and to Hippolyte Bayard, who had contributed his own unique process to the emerging development of photography.

Some months later, Gustave le Gray's name was added to the list, with commissions to photography buildings in and around the Loire valley, Orléans, and as far south as Carcassonne.

All the photographers commissioned were conversant with a range of paper negative processes, and all but Bayard used variants on the calotype or the waxed paper process to produce their images. Bayard is believed to have used albumen on glass, the process pioneered in the late 1840s by Claude Félix Abel Niépce de Saint. Victor. While about three hundred paper negatives are archived in the Musée d'Orsay in Paris, none of Bayard's glass plates is known to have survived.

Le Gray received his commission at the same time as Olivier Mestral, and the two men appear to have pooled their lists and elected to work together. The French journal *La Lumière* reported that "Accompanied by M. Mestral, M. Le Gray is working in the region of the Midi beyond the Loire towards the Mediterranean: he has not yet returned but has sent precious dispatches." While this clearly implies that negatives had been sent back to Paris, the question remains unanswered as to whether or not they were processed in the field, or sent back undeveloped.

Many of the images they created show all the hallmarks of Le Gray's mastery of light and shade. Details of buildings are revealed in bright pools of sunlight, while other areas are allowed to recede into deep shadows. They are however overshadowed by his architectural studies of Paris in the later 1850s, and of Italy and Egypt in the early 1860s.

Just what the Commission initially planned to do with these images is not clear, but in the event it did little except secure their survival. They were not published, and indeed relatively few were even printed. But as many of the buildings photographed were subsequently subjected to ill-informed "restorations" in the years that followed, these images have today acquired an historical importance far beyond any original intentions the Commission might have harboured.

Concurrent with these major undertaking with waxed paper, Le Gray had, according to N. P. Lerebours in *La Lumière* in 1852, also been working with the wet collodion process since 1850. He had also been working with albumen on glass, and Philip Delamotte exhibited two such images amongst five Le Gray titles at Great Britain's first photographic exhibition at the Royal Society of Arts, London in December 1852. Waxed paper, however, still remained his principal and preferred medium well into 1854, at which time it still featured strongly in the fourth edition of his treatise on photography.

Later in 1854, he became one of the founder members of the Société Française de Photographie, and a member of its management committee.

Whilst the dating of many of Le Gray's extant images is problematic, there is scant evidence of his continuing

employment of either waxed paper or albumen on glass into 1855. All his subsequent imagery was produced using collodion on glass.

With collodion, he returned to Fontainebleau and revisited his earlier works on the forest, exploiting the greater sensitivity of the glass plate but still exploring the pools of light which penetrated deep into the woodland. In printing some of these later images he also carried out experiments in combination printing, combining negatives of the forest walks—exposed correctly for the foliage—with separately exposed negatives of sky and cloud. This technique was also exploited in his series of seascapes from 1855, which heightened his profile considerably in the world of French photography.

Le Gray's seascapes are remarkable for a number of reasons, not least of which is the impact they had when first exhibited. They were striking and powerful, taking landscape and pictorial photography to new levels of sophistication both in design and execution. They were also phenomenally popular, selling in very large numbers—with contemporary advertisements claiming sales of over eight hundred prints.

Very little is known of the techniques used in their production, and they represent both a significant leap forward for photography and change of direction for Le Gray. Researchers have determined that they fall into two categories—those which are genuine single instantaneous exposures capturing sea and sky at the same time (but perhaps manipulated in processing and/or printing) and those which are the result of careful and controlled combination printing.

Whilst they met with significant public acclaim, their reception in the photographic press was mixed—several reviews citing the 'unnatural' relationship between cloud and sea. Dark and often overpowering skies, shot directly into the sun, give a moonlight effect to some, and a sense of an approaching storm in others. One British reviewer complained that they did not conform to contemporary expectations that photography would reflect truth in nature

> Measured by the photometer, a cloud, according to the illumination, is from a thousand to a million times more luminous than a terrestrial body. In this picture we doubt if in any part of it a greater contrast could be found than in the proportion of 1 to 30. (William Crookes, editor of The Liverpool & Manchester Photographic Journal 1:6, 15 March 1857.)

Photography's great dichotomy has always been the distance between artistic interpretation and truthful representation. While many of Le Gray's architectural studies do conform to the expectations of those who saw photography's role as being truthful to nature, the images which form his major contribution to photography's history are now rightly recognised as art.

In 1856 Le Gray moved from his studio in Chemin de Ronde de la Barrière de Clichy in Paris, to new premises in the Boulevard de Capucines, premises already partly occupied by the Bisson Frères, and later by the charismatic Nadar (Gaspard-Félix Tournachon).

Given the high profile of Le Gray's architectural, landscape and seascape photography today, it would be easy, but inappropriate, to categorise him simply as a photographer of the outdoors. His interest in portraiture predates his engagement with photography, and the photography of people was a consistent feature of much of his professional life, particularly the period between 1854–55 and his departure from Paris in the early months of 1860.

Fine studio portraits survive of the French Emperor and Empress, and of leading figures from both military and civilian life. A small number of nude studies, photographed on waxed paper, survive from the early 1850s.

In the summer of 1857, Le Gray was commissioned by the French Court to photograph an innovative military development—the creation of a special camp for the Imperial Guard at Châlon sur Marne, presided over by the Emperor and Empress themselves. The series of photographs which resulted from that commission—panoramas, military portraits and theatrically-staged tableaux, have, in their conception and execution, much in common with Roger Fenton's depiction of the war in the Crimea two years earlier. Given that the Imperial Guard had Zouave divisions—as did the British army in the Crimea, there are obvious similarities in some of the group tableaux. Despite the advances made with the wet collodion process since Fenton's commission, the large format of Le Gray's plates, and the cumbersome nature of his camera, clearly imposed limitations on any aspirations he may have had about capturing the bustle and spontaneity of the proceedings.

It is ironic, considering the importance of Le Gray's oeuvre, that by 1859 he was apparently facing financial ruin. Early in the following year, *Le Gray et Cie* ceased trading, and the photographer himself left France and his family for good. He set sail with Alexander Dumas on a Mediterranean journey which took them into the midst of Garibaldi's struggle in Italy—resulting in a remarkable series of images by Le Gray of battle-damaged buildings in Palermo and elsewhere. There is strong evidence that for part of this voyage at least, he reverted to his original preference for waxed paper—sacrificing the enhanced detail of the glass plate, for the advantages of travelling light and preparing and processing at leisure.

Le Gray parted company with Dumas in Malta, and made his way to Lebanon and Egypt, again photographing extensively wherever he went, and again using large waxed paper negatives. He remained in Egypt for the

remainder of his life, living at times in Alexandria and in Cairo.

He became a tutor in drawing and painting, and the last recorded reference to him working in photography is dated 1869. After that time, he slipped off the European photographic stage into relatively obscurity, although well respected in Cairo. He is believed to have died there in 1882.

JOHN HANNAVY

Biography

Jean Baptiste Gustave Le Gray, or Legray as he sometimes styled it, was born on August 20, 1820, the son of Jean Martin Legray and Catherine Gay, at Villiers-le-Bel, France. From about 1839 until 1843, he studied drawing and painting in Paris, before travelling to Switzerland and Italy where he met and married Palmyra Leonardi in 1844. Their first daughter, Elvira born in 1845, lived less than a year, and her name was given to their second born the following year. She died before she was three years of age, probably a victim of cholera. A further daughter and a son were born in the mid 1850s, but by 1865 only one child was apparently still alive, living with Le Gray's estranged and near-destitute wife in Marseilles. In that year, he travelled to Rome to meet with his wife, in the hope that his financial difficulties in France might permit a return, but it was not to be. Hopeful of returning to France to resume his photographic career, he had retained his membership of the Société Française de la Photographie until at least 1863.

Le Gray's death—in Egypt in 1882—was reported by Nadar, but no formal confirmation of the date has yet been discovered. Nadar reported that Le Gray suffered a broken arm after a riding accident, and that "il mourut vers 1882 dans une détresse assurément imméritée."

See also: Delaroche, Paul; Le Secq, Henri (Jean-Louis Henri Le Secq des Tournelles); Arago, François Jean Dominique; Talbot, William Henry Fox ; Calotype and Talbotype; Collodion; Waxed Paper Negative Processes; Société Héliographique; Baldus, Édouard; Bayard, Hippolyte; Niépce de Saint-Victor, Claude Félix Abel; Nadar (Gaspard-Félix Tournachon); and Bisson, Louis-Auguste and Auguste-Rosalie.

Further Reading

Cava, Paul, "Early Landscapes by Gustave le Gray" in *History of Photography* 1978, XX–XX.

Hannavy, John, *The Waxed Paper Process in Great Britain 1851–65,* unpublished PhD Thesis, London: Council for National Academic Awards, 1984.

Jacobson, Ken, *The Lovely Sea-View,* Petches Bridge: Ken & Jenny Jacobson, 2001.

Jammes, André, and Janis, Eugenia Parry, *The Art of French Calotype,* Princeton, N.J.: Princeton University Press, 1983.

Janis, Eugenia Parry, *The Photography of Gustave le Gray,* Chicago: University of Chicago Press, 1987.

Le Gray, Gustave, *Traité Pratique de Photographie Sur Papier et Sur Verre,* Paris: Germer Ballière, 1850.

Le Gray, Gustave, *A Practical Treatise on Photography upon Paper and Glass,* London: T&R Willats, 1850.

Le Gray, Gustave, "Note sur un nouveau mode de préparation du papier photographique négatif" in *Comptes Rendus,* Paris: Académie des Sciences, 1851, 23, 643–644.

Le Gray, Gustave, *Nouveau Traité Theoretique et Pratique de Photographie sur Papier et sur Verre* Paris: Lerebours et Secretan, 1852.

Le Gray, Gustave, *Plain Directions for Obtaining Photographic Pictures,* London: T&R Willats, 1852.

Le Gray, Gustave, *Plain Directions for Obtaining Photographic Pictures,* London: Richard Willats, 1853.

Ramstedt, Nils, *The Photographs of Gustave le Gray,* PhD thesis, University of California at Santa Barbara, 1977.

LE PRINCE, LOUIS AIMÉ AUGUSTIN (1841–c. 1890)

Son of a major in the French artillery, young Le Prince's interest in photography was perhaps spurred by a family friend, L.J.M. Daguerre. A surviving daguerreotype shows him as a young boy, with his parents and brother. After college at Bourges and Paris, Le Prince did post-graduate work in chemistry at Leipzig, Germany. He studied art, and specialised in the painting and firing of art pottery. Invited to Leeds, England, by old school friend John R Whitley, he stayed and joined the firm of Whitley brothers, brass founders, and in 1869 married Miss Lizzie Whitley, who had trained at the famous French pottery at Sevres. During the Franco-Pussian war he survived the Seige of Paris as an officer of volunteers, and on his return to England the Le Princes set up a school of applied art in Park Square, Leeds.

Le Prince carried out photography on metal and pottery, and his portraits of Queen Victoria and Prime Minister Gladstone were placed in the foundation stone of Cleopatra's Needle in London.

In 1888 Le Prince went to the United States on a business venture but this failed. He became manager of a group of artists who made large circular panoramas in New York, Washington, and Chicago. A 10th-scale mock-up sketch of the scene was "squared up" and each square photographed. Lantern slides of the drawings were then projected onto the huge panoramic canvases as a painting guide. These giant vistas were visually impressive but the action scenes they depicted lacked movement, which may have given Le Prince the idea for developing moving "panoramic views." Soon afterwards he started experimental work on moving picture machines in the workshops of the New York Institute for the Deaf, where his wife taught; and in 1886 he applied for an American patent for a machine using one or more

lenses (illustrating the most difficult proposition, incorporating 16 lenses). The patent was granted in January 1888, but the U.S. Patent Office deleted claims for machines with one or two lenses as having been already covered by others. His patents in Britain, France, and elsewhere, however, allowed a one-lens version.

In Paris, in 1887, to demonstrate proof of working he produced a 16-lens machine. Although this was designed to use two picture bands moving alternately, the only surviving sequence is a single set of 16 images, suggesting that the tests may have been made with a fixed plate.

Back in Leeds Le Prince rented a workshop at 160 Woodhouse Lane and engaged woodworker Frederick Mason and J.W. Longley, inventor of an automatic ticket machine, and by the summer of 1888 had constructed a "receiver" (camera), with a single lens and intermittently-moving take-up spool. The patent suggests the use of gelatine coated with bromide emulsion, or "any convenient ready-made acting paper, such as Eastman's paper film," the "stripping film" which had recently been made available in the first Kodak amateur rollfilm camera. A paper negative sequence of the family cavorting for Le Prince's camera was exposed in his father-in-law's garden, apparently as early as October 1888. Scenes of his son Adolphe playing the melodion, and of traffic on Leeds Bridge, were taken at about the same time, at between twelve and twenty pictures per second.

Projection was more of a problem, due to the unsuitability of the paper base and the registration difficulties with unperforated bands. Undeterred, Le Prince built a "deliverer" (projector), having three lenses and three picture belts and apparently using a Maltese cross intermittent movement. This machine probably used belts of glass slides, the fibre belts moving alternately to ensure that an image was always on the screen, thereby reducing flicker. A single-lens projector was also built. These machines did not succeed to Le Prince's satisfaction, and he probably experimented with celluloid which offered a more suitable image base, in 1889/1890.

Also attempting to produce motion pictures in England at about this time were William Friese-Greene, with his associates Mortimer Evans (1889 patent) and later Frederick Varley (1890 patent); and Wordsworth Donisthorpe and William Carr Crofts (1889 patent). They all had some success in shooting sequences of photographs on flexible films, but like Le Prince, had serious problems with projection and were unable to present successful motion pictures to the public. In France, Etienne-Jules Marey had also produced sequence photographs on both paper and celluloid strips, but was mostly concerned with motion analysis—examining the individual images—rather than recreating movement on the screen. (Though he would later build a projector for his unperforated filmstrips, but it was never demonstrated).

While Le Prince was experimenting in Leeds, his wife and family remained in New York, having rented and renovated a mansion in preparation for showing his apparatus and motion pictures. Apparently troubled by financial problems, in the summer of 1890 he packed up his equipment in Leeds ready for the move to New York, and in August went to France with friends. He left them at Bourges to visit his brother Albert at Dijon, where he was last seen boarding the train for Paris on 16 September, and subsequently disappeared. In 2003, an 1890 photograph of a drowned man resembling Le Prince was discovered in the Paris police archives.

STEPHEN HERBERT

Biography

Louis Aimé Augustin Le Prince, was born in Metz, France, on 28 August 1841. His father Louis Le Prince was an army major; his mother was Elizabeth Boulabert. Le Prince spent much of his life in Leeds, England, with occasional business ventures in the United States. He took sequence pictures on paper "film," but was apparently unable to achieve successful projection. According to his employee Frederick Mason, Le Prince—Gus to his family—was most generous and considerate and, although an inventor, of an extremely placid disposition which nothing seemed to ruffle. Seven years after his 1890 disappearance, Le Prince was declared legally assumed dead.

See also: Friese-Greene, William; and Donisthorpe, Wordsworth.

Further Reading

Scott, E. Kilburn, "The Pioneer Work of Le Prince in Kinematography," in *The Photographic Journal*, August 1923, 373–378.

Scott, E. Kilburn, "Career of L.A.A. LePrince" (from *SMPE Journal* July

1931) reprinted in Fielding, Raymond (ed.), *A Technological History of Motion Pictures*, Berkeley: University of California Press, 1967, 76–83.

Rawlence, Christopher, *The Missing Reel: The Untold Story of the Lost Inventor of Moving Pictures*, London: Collins, 1990.

LE SECQ, HENRI (JEAN-LOUIS HENRI LE SECQ DES TOURNELLES) (1818–1882)
French photographer and painter

Henri Le Secq was born in Paris on August 18, 1818 to Auguste-Jean-Catherine Le Secq and Anne-Louise-Françoise "Dolly" Tournaire. Le Secq's father served as the chief clerk at the Prefecture of the Seine and eventually became mayor of the ninth arrondissement (today

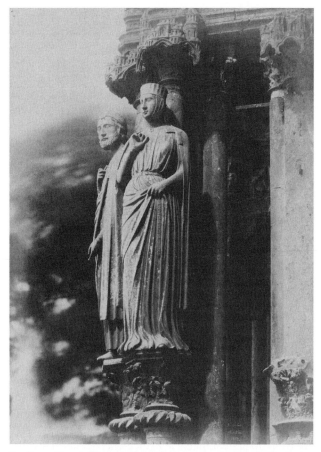

Le Secq, Henri. Grandes figures au porche nord, cathédrale de Char.
The Metropolitan Museum of Art, Purchase, The Howard Gilman Foundation and Harriette and Noel Levine Gifts, Samuel J. Wagstaff Jr. Bequest, and Rogers Fund, 1990 (1990.1130) Image © The Metropolitan Museum of Art.

the fourth). Undoubtedly influenced by his father's service to Paris, Le Secq became a connoisseur of his native city, particularly its architectural treasures, as artist, antiquarian, and most notably, as photographer.

Le Secq began his artistic studies with the sculptor James Pradier in 1835. In 1840, he entered the studio of Paul Delaroche where he began painting genre scenes, and in 1842 he exhibited his first paintings at the Salon. In 1845, Le Secq followed Delaroche to Rome and returned to Paris in 1846. At Delaroche's studio Le Secq met fellow painter Charles Nègre. In 1848, with the instruction of artist/photographer Gustave Le Gray (also a student of Delaroche), Le Secq and Nègre began to experiment with photographic processes. In this year Le Secq married Marguerite-Fanély Palais.

Le Secq was one of many French photographers making calotypes, a paper negative/positive process invented by William Henry Fox Talbot in England in the 1830s. In 1850, Le Secq and Nègre began using Le Gray's waxed paper negative process which improved the translucency of the paper negative by rubbing wax on the paper before it was sensitized and exposed in the camera. Even when his contemporaries began using glass negatives, Le Secq continued making paper negatives. Le Secq's first use of photography was to make quick preparatory sketches of posed figures in genre subjects for paintings but soon he began photographing architecture. By the time Le Secq, along with Nègre, Le Gray and others, helped to found the Société héliographique in 1851, the first photographic society to be established, he was considered one of the best architectural photographers in France.

His fame as an architectural photographer led to Le Secq's inclusion in the Mission Héliographique, the first photographic survey of historical monuments in France. The group was arranged in 1851 by the Commission des Monuments Historiques, a group of French political antiquarians, architects, and archeologists. The Commission felt it urgent to preserve France's architectural heritage by documenting medieval buildings and monuments threatened by deterioration from neglect, as well as industrialization and restoration. The Commission hired five established architectural photographers to document five provincial centers in France. Le Secq was assigned the religious edifices of Champagne, Alsace, and Lorraine. Though the mission was never fully realized (due to difficulties in obtaining permanent prints) and only 300 paper negatives survive, the Mission provided Le Secq with experience in the field and an opportunity to perfect his skills at photographing architecture. Following this first commission, Le Secq documented the sculpture of Strasbourg, Amiens, Reims, Chartres, and various other churches around Paris.

Le Secq's photographs demonstrate both his roots in Salon painting and an interest in using the camera to reach heights and vantage points previously unattainable. To make "Flying Buttresses, Reims Cathedral," 1852, Le Secq climbed to a point where he could photograph the successive arches of the flying buttresses, a vantage point that the ordinary visitor to the cathedral would not be able to reach. By 1852, Le Secq had also turned to landscape photography and photographed stone quarries and woods around Montmirail. These works show the influence of paintings by Corot, Rousseau, Dupré, and Diaz. The landscape photographs were meant to be used as studies for artists. As in the architectural photographs, Le Secq utilized the calotype process's potential for murky, moody effects to an extreme by making long exposures, thus creating dramatic compositions of deep shadow.

Between 1849 and 1853, Le Secq photographed old monuments, buildings, and churches in various states of disintegration, such as "Tour St. Jacques," 1853, as well as demolitions and various public works projects begun by Jean-Jacques Berger, Prefect of the Seine. He also photographed Notre Dame, the old Hotel-Dieu, Amiens, and Chartres. His photographs of demolitions, such as

that of the king's stables in *Place du Carrousel*, 1852, seem to foreshadow Baron Haussmann's renovations of the city in the 1860s when demolitions and construction sites would appear throughout the city. Baron Haussmann was clearing many of Paris's old streets for his renovation of Paris into wide, modern boulevards. Le Secq's intimate knowledge of and love for his native city inspired his excursions with camera and tripod. He was particularly tied to his old neighborhood, the Saint Antoine section, which was being razed for the extension of the rue de Rivoli. Le Secq also captured the old Pont Neuf, Hôtel Dieu, as well as changes taking place around Hôtel de Ville, and assembled them into albums. In 1853 six of Le Secq's negatives, including those of Chartres, Strasbourg, and Beauvais, were used by print publishers such as Lerebours and Lemercier to make lithographs.

From 1851, Le Secq's photographs were included in exhibitions, including the Universal Expositions in London in 1851 and 1855, where he was acknowledged as one of France's greatest artist-photographers, and received a silver medal for work shown in Amsterdam in 1855. In 1856, he made several photographic still lifes, composed of objects, fruit, and vegetables. By this time, Le Secq's photographic career was drawing to a close although as the paper negative went out of use and the collodion on glass negative took its place. However, Le Secq did reprint many of his waxed paper negatives. For the rest of his life, Le Secq returned to painting and regularly exhibited at the Salon and formed his own art collection of contemporary printmakers and painters such as Whistler, and Millet, as well as artists Jongkind and Daubigny and major impressionists.

After the death of his wife and only daughter in 1862, he sold a large group of his own painting and drawing collections and began collecting forged iron, particularly ancient keys, locks, and signs. In 1863 Le Secq published a pamphlet on the reform of the Salon entitled *Les Artistes, les Expositions, le Jury*, edited by A. Cadart and F. Chevalier. The following year he wrote a second pamphlet for the defense of artists entitled *Aux artistes et aux amateurs des Beaux-Arts*. In 1882, Le Secq died in Paris, leaving his art and iron collections to his sons.

KAREN REED HELLMAN

Biography

Henri Le Secq was born in Paris on 18 August 1818. He began his artistic studies with the sculptor James Pradier in 1835. In 1840, he entered the studio of Paul Delaroche where he met fellow painter Charles Nègre. In 1848, with the instruction of artist/photographer Gustave Le Gray (also a student of Delaroche), Le Secq and Nègre began to experiment with photographic processes. In 1850, Le Secq and Nègre began using Le Gray's waxed paper negative process Even when his contemporaries often used glass negatives, Le Secq kept making photographs with paper negatives. Le Secq's first use of photography was to make quick preparatory sketches of posed figures in genre subjects for paintings but soon began photographing architecture. By the time Le Secq, along with Nègre, Le Gray, and others, helped to found the Société Héliographique in 1851, the first photographic society to be established, he was considered one of the best architectural photographers in France. In 1851, Le Secq was included in the Mission Héliographique, arranged by the Commission des Monuments Historiques. Between 1849 and 1853, Le Secq photographed old monuments, buildings, and churches in various states of disintegration, which foreshadow his later photographs of demolitions and architectural documents made during Baron Haussmann's renovations of Paris in the early 1860s. By 1852, Le Secq had also turned to landscape photography and photographed stone quarries and woods around Montmirail. Le Secq published two pamphlets on the reform of the Salon. Le Secq died in Paris in 1882.

See also: Talbot, William Henry Fox; Waxed Paper Negative Processes; Mission Héliographique; Société Héliographique Française; and Lemercier, Lerebours & Bareswill.

Further Reading

Buerger, Janet, "Le Secq's 'Monuments' and the Chartres Cathedral Portfolio," *Image*, vol. 23, no. 1, June 1980, 1–5.

Jammes, Andre, and Janis, Eugenia Parry. *The Art of French Calotype*. Princeton, N.J.: Princeton University Press, 1983.

Janis, Eugenia Parry, "The Man on the Tower of Notre-Dame: New Light on Henri Le Secq," *Image*, vol. 19, no. 4 (Dec. 1976), 13–25.

——, *Henri Le Secq: photographe de 1850 à 1860: catalogue raisonné de la collection de la Bibliothèque des arts décoratifs, Paris*. Paris: Musée des arts décoratifs; Flammarion, 1986.

McCauley, Anne, "Henri Le Secq, Photographie de 1850 a 1860," *Afterimage* 15 (October 1987), 5–7.

Mondenard, A.d. "Mission heliographique, 1851: l'odyssee des images," *Connaissance des Arts*, no. 590 (January 2002), 60–67.

Rice, Shelley. *Parisian Views*. Cambridge, MA: MIT Press, 1997.

Sartre, J. "La vision de peintre du photographe Henri Le Secq," *Connaissance des Arts* no. 415 (September 1986), 94–7.

LEA, MATTHEW CAREY (1823–1897)
American photographer and author

Matthew Carey Lea, also known, as Carey Lea, son of scientist Isaac Lea and Frances Carey Lea, was born in Philadelphia on 18 August 1823. An acknowledged authority on photochemistry in the late nineteenth century and a member of the Franklin Institute, Lea

began experimenting with the chemical properties of developer in 1864. Educated through tutors and the Philadelphia chemistry laboratory of Booth, Garrett and Blair, Lea particularly studied the function of silver in the development process. His scientific advancements of photographic processes included inventing the first mordant-dye picture in 1865 and increasing the clarity of developed dry plate negatives in 1880. Lea also wrote prolifically about his experiments. In 1864–1866, he assumed the position of American correspondent to the *British Journal of Photography* and became a steady contributor to the *Philadelphia Photographer* and *Photographic Mosaics*. In 1868, he authored *A Manual of Photography*. During the 1870s and 1880s, he continued to experiment with silver halide salts and the color process, including the description of "photo haloids" (i.e., metal compounds that resemble salt) in 1885 and the discovery of "allotropic" forms of silver of various colors between 1889 and 1891. On March 15, 1897, Lea died in Philadelphia, two years after his election to the National Academy of Sciences.

ERIKA PIOLA

LEGEKIAN, G & CO
(dates unknown)

The name "G Legekian" is found on a large number of very fine images of Egypt from the late nineteenth century, but very little is known of the photographer(s) who created them.

Known to have produced dry-plate images from 10"x8" up to 'mammoth' 20" × 16" images, the Cairo-based Legekian studio—next door to the well-known Shepheard's Hotel (misspelled "Shephard's" on his cards)—was at the forefront of the tourist market from c.1880.

Legekian himself is believed to have been Armenian, but personal details are significantly difficult to find.

In 1883 or 1884 the Legekian studio was appointed Photographers to the British Army of Occupation in Sudan, and that appointment signalled a temporary change of language on their photographs—from French to English, and from *G Legekian photographie artistique, atelier special de peinture* to *G. Legekian & Co.* In 1890, some *cartes-de-visite* include both appellations. By 1891, however, their cartes and larger pictures were once again captioned exclusively in French.

Several Legekian images from the late 1890s were included in the book *Celebrities of the Army* published by Newnes in 1902, and the 1906 book *New Egypt* records that Legekian "has, besides some remarkable portraits, a unique collection of views both in large prints and in postcards."

JOHN HANNAVY

LEGGO, WILLIAM AUGUSTUS
(1830–1915)
Inventor, leggotyper, engraver, and publisher

William Augustus Leggo, was born Quebec, Quebec, 25 January 1830; died Lachute, Quebec, 21 July 1915. Trained originally as an engraver, first by his father, William Augustus Leggo Sr., and later by Cyrus A. Swett with whom he completed his apprenticeship in Boston, Leggo had by 1850 established himself as an engraver in Quebec City. From this traditional print background, Leggo, together with George Edward Desbarats (1838–1893) who became Leggo's business partner in 1864, went on in the 1860s and 1870s to pioneer important advances in the graphic arts though the application of photography to early photomechanical printing processes. Indeed in 1869, their efforts contributed towards revolutionizing global communication in terms of how newspapers were illustrated by their publication of the world's first letterpress halftone reproduction of a photograph.

Leggo's and Desbarats' early photomechanical process, named leggotyping, was first identified in 1864 as an improved photoelectrotyping process to provide an inexpensive, rapid means of producing accurate facsimilies of any type of line image via either relief or intaglio plates without assistance of engraving or other hand work. With Desbarats financial backing, Leggo continued to perfect the process and to expand its application to allow halftone images of photographs and other tonal works to be photomechanically reproduced using a type-compatible format. The goal to expand leggotyping to halftone work was achieved in September 1869 when a Canadian patent was granted for "Leggo's granulated photographs." Shortly thereafter, Leggo and Desbarats put their line and halftone photomechanical discoveries to commercial use to illustrate Desbarats' new pictorial weekly the *Canadian Illustrated News*. Launched October 30, 1869, the Montreal based paper featured a cross-lined screen halftone of William Notman's photograph of His Royal Highness Prince Arthur in its inaugural issue. Leggotyped line and halftone images were also used to illustrate *L'Opinion publique*, Desbarats' french language counterpart to the *Canadian Illustrated News*, and the process became a speciality of the two partners' firm, Leggo & Company.

Further advances in haiftone reproduction followed in September 1870 when Leggo and Desbarats applied their recently patented process which married lithography and leggotyping to the pages of the *Canadian Illustrated News*, making it the first periodical to have its illustrations printed planographically. The process was also applied to *L'Opinion publique* beginning 1871 and to the partner's illustrated newspaper, the New York *Daily Graphic*, which they launched March 4, 1873.

Within a year of starting their new American venture however, Leggo's and Desbarats close professional ties were severed when Desbarats encountered financial difficulties which left him insolvent. Leggo himself remained with the *Daily* Graphic as publisher and continued his research with photomechanical processes for some years. By 1879 however, Leggo had returned to the Montreal, where he appears to have remained in the area the rest of his life.

Beyond directing his considerable creative talents to the development of new photomechanical processes, Leggo also obtained patents for a variety of other interests, including telegraphy and photographic equipment. For example, in 1869 Leggo developed a camera to photograph architectural subjects which eliminated a problem other cameras then experienced of distorted perpendicular lines in the resulting photograph. A valuable improvement, in general, to outdoor photography, its improved picture taking capabilities were actively demonstrated to all in leggotyped half-tone within the *Canadian Illustrated News* and *L'Opinion publique*.

TERRESA MCINTOSH

LEITZ, ERNST (1843–1920)

Ernst Leitz (I) was the first in the father-son-grandson sequence of men with that name who succeeded one another as leaders of the renowned family-owned German firm of Ernst Leitz Wetzlar GmbH. He was born on the 26 April 1843 in Sulzburg (not Salzburg) in the southwestern German province of Baden. Ernst was the youngest of three children born to Christina Elizabeth Leitz (née Doebelin) and Ernst August Leitz, both of whom were teachers at the high school of Sulzburg. The parents were very religious and wanted young Ernst to study theology, but the latter had a very practical disposition and he was able to persuade his father to let him pursue a career in mechanical craftsmanship. The father arranged for Ernst to embark on an apprenticeship with the instrument maker Christian Ludwig Oechsle in Pforzheim, also in Baden, a town known for its jewelry makers and goldsmiths. Oechsle's establishment had the impressive name "Workshop for Physical and Chemical Instruments and Apparatus and Machines of the Mechanic Oechsle, Gold Controller for the Grand Duke of Baden." The shop produced a great variety of physical equipment, as shown in its 1855 catalog, which had 24 sections with a total of 553 items, including a few optical devices. Under the tutorship of the exceptionally competent Oechsle, Ernst Leitz was able to acquire a wealth of knowledge and skills that would ultimately stand him well as a solid foundation for his trade. But it appears that he realized early on that excessive versatility that did not yield a top performance in any particular

field might lead him to become a jack-of-all-trades. This portended his eventual career.

As was the custom at that time, after completing his apprenticeship, Ernst Leitz (I) began traveling as a journeyman. He visited one of his sisters in Vevey in Switzerland and after a brief time in Zurich, he found a job as an assistant to Mathäus Hipp, a prominent manufacturer of electric clocks in Neuchâtel. It is there that he first became acquainted with the process of mass production of precision parts for world-famous Swiss watches that was already routine in Swiss factories. This manufacturing process was of fundamental significance later on when he became the sole owner of a precision manufacturing enterprise. The aforementioned Oechsle also produced precision instruments, but they were made individually, which required more time, so that their prices were significantly higher.

While working for Hipp, Ernst Leitz (I) met Karl Junker from Giessen, a university town north of Frankfurt, Germany. Junker was on his way to Paris after having worked for Friedrich Belthle, who in 1855 had taken over the Optical Institute, a small microscope manufacturing enterprise founded in nearby Wetzlar in 1849 by Carl Kellner (1826–1855). Junker encouraged Ernst Leitz (I) to visit that institute because it was in serious need of competent instrument makers. Heeding that advice, Leitz joined that small firm in Wetzlar in early 1864 and only one year later, on 7 October 1865 he became Belthle's partner. Belthle was not an efficient manager, he was in poor health, and he did not cultivate adequate connections with the world of science, so that the demand for his microscopes was quite limited. When Belthle passed away in 1869, Ernst Leitz (I) became the sole owner of the company and named it "Optisches Institut von Ernst Leitz," a name that prevailed in various mutations for 119 years thereafter.

A memorable event in the career of Ernst Leitz (I) occurred on 21 September 1864 during the 39th Congress of German Natural Scientists and Physicians in Giessen, where Ernst Leitz (I) demonstrated Belthle's microscopes and where Philip Reis (1834–1874) successfully demonstrated a telephone that he had invented. Reis had demonstrated it before, but the construction was faulty until Ernst Leitz (I) became interested in it and helped Reis to build a properly functioning model, based on the knowledge of electricity, electro-magnetism and instrument making that he acquired during his journeyman years. Reis' telephone was acclaimed at that congress, but it was only promoted to institutes of physics and Reis did not possess the foresight and know-how for marketing it to business users and to the public. Only one year after Reis' death of tuberculosis on 14 January 1874, 11 years after his successful demonstration, the American Alexander Graham Bell (1847–1922)

presented an improved model and was generally credited as the inventor of the telephone.

Not yet 30 years old when he took over, Ernst Leitz (I) revitalized the lagging company by implementing the series production methods that he had learned in Switzerland, gradually overcoming the earlier lack of innovations, the growing competition and the slump caused by the outbreak of the Franco-German war in 1870. His new methods enabled him to offer faster delivery times that were quite unusual at that time. This and the participation in nature- and medical congresses with practical demonstrations brought him into closer personal contact with personalities from science and technology from well beyond the nearby universities of Giessen and Marburg. As a result, Leitz microscopes and their accessories began to gain favor in the right circles. It was in 1870 that Leitz published his first price list under the wordy title *Current prices of the achromatic microscopes of the institute founded by C. Kellner in Wetzlar, successor Ernst Leitz (formerly Belthle & Leitz) 1870.*

During these years the fields of medical histology, pathology, and bacteriology were being rapidly developed primarily by German scientists with the aid of affordable, serviceable German microscopes designed with these fields' requirements in mind. The production of Leitz microscopes began to grow vigorously, in spite of increasing but stimulating competition from Carl Zeiss, who had begun producing microscopes in 1858 and who had engaged the services of the brilliant physicist and mathematician Ernst Abbe. Additional competition was rendered by Georg Oberhäuser-Hartnack, a German citizen who had immigrated to Paris, where he produced microscopes that were cheaper and that performed better than the Belthle microscopes. Engelbert & Hensoldt also produced competing microscopes, as did the Wetzlar brothers Wilhelm and Heinrich Seibert in cooperation with a man named Gundlach. All of them had worked with Leitz's predecessors Kellner and/or Belthle at various times before setting out on their own. The statistics show that microscope production improved dramatically after Ernst Leitz (I) took over in 1869:

1849–1860	circa	400 microscopes
1861–1870	circa	600 microscopes
1871–1880	circa	2,500 microscopes
1881–1890		13,650 microscopes

The 10,000th microscope was completed in the year 1887.

Ernst Leitz's (I) older son Ludwig had developed a compact and inexpensive photomicrographic apparatus in 1882, which led to the development of three lenses for general photography marketed by Ernst Leitz (I) in 1886 called Summar, Periplan, and Duplex. The initial focal lengths were 24, 42, and 64 mm, with a maximal aperture of f/4.7. The series was later expanded and pages 608 and 609 of the 12 September 1901 issue of the London magazine "Photography" published a highly favorable report on the wide-angle performance of a Periplan No.5 lens with a focal length of approximately 8 inches (203 mm). The awareness of photography already existed during the earliest times of the firm, as evidenced in a letter in which Carl Kellner informed his friend and occasional associate Moritz Hensoldt that he had built a lens for a Daguerreotype camera. The superb quality of Leitz lenses for photography was to become one of the company's most famous attributes.

Competition triggered strong awareness of the need for improvements and innovations, and as early as 1877 Ernst Leitz (I) created a scientific department dedicated to research and development in optics. The man placed in charge was the mathematician Karl Metz, who already had experience in the computation of lenses for telescopes. The initial task was to improve the company's own achromats, building on the pioneering work already performed elsewhere by Gauss, Helmholtz, and Abbe, and later applying the possibilities provided by new types of optical glass supplied by the prominent glass laboratory of Schott & Genossen that was founded in 1886 in Jena with government support.

The growing demand for Leitz microscopes and many related instruments led to several expansions of the manufacturing space that had started in a regular house in Wetzlar that served as both a family residence and a factory, followed by several moves to larger facilities that culminated in a stately group of buildings at the foot of a hill topped by the Kalsmunt castle, where the Leica Microsystems Company buildings still stand today. At one point there were three separate substantial buildings at this location that housed the mechanical shop, the carpentry shop, and the optical shop.

Ernst Leitz (I) was a personable individual who maintained friendly relations with persons from scientific, industrial and academic circles, and this inspired him to tailor his products to their respective needs. He also had a talent for attracting and nurturing the right people for the jobs. In a significant example, he recognized the skills of Oskar Barnack and encouraged him to come to work in Wetzlar, in spite of the fact that Barnack suffered from severe asthma. Leitz offered him all the time he needed for trips to health spas and even accompanied him on some of these trips.

Barnack had worked at Carl Zeiss in Dresden and Jena from 1902 to 1910, where he had approached Director Guido Mengel of ICA, a camera-making subsidiary of Zeiss Ikon, with a prototype of a 35 mm camera that he had built, but Mengel had rejected it. At the suggestion of Emil Mechau, who had left Zeiss earlier to work on motion picture projector design at Leitz, Barnack eventually, albeit reluctantly (for health

reasons), also accepted a position at Leitz, where began working in the newly created experimental department on 2 January 1911. Ernst Leitz (I) was intrigued by Barnack's unconventionally small camera and he took it along on a trip to New York and used it to take quite a few candid pictures. That camera was the so-called "Ur-Leica," an improved version of which was placed in production by Ernst Leitz (II) [the son] in 1924 and introduced at the Leipzig Spring Fair of 1925, eventually becoming the legendary Leica camera whose subsequent models are still in production today!

Ernst Leitz (I) had a trait that was a strong characteristic of the Leitz family for the generations that followed, in that he was genuinely concerned for the welfare of his employees and he knew nearly everyone by name and would chat with them warmly during his regular rounds through the shops. He introduced the eight-hour workday and health care assistance and in 1899 a pension for invalids, widows, and orphans. His equally social-minded wife Anna Leitz visited families in need and she would discreetly slip money into their pockets to help them with their expenses. As a result, "der alte Chef" (the old boss) and his family were affectionately revered by his employees. In recognition of his achievements and his benign social engagement, on 24 December 1910 the University of Marburg bestowed an honorary degree of Doctor of Sciences upon Ernst Leitz (I).

Ernst Leitz (II) remained active until the end of his days. While on a health visit to Solothurn in Switzerland, he passed away on 12 July 1920, having survived his wife by 12 years. Because his first son Ludwig Leitz had died of a riding accident at the prime of his career in 1898, his second son Ernst Leitz (II) took over management of the company, which continued to flourish under his competent guidance.

ROLF FRICKE

LEMERCIER, LEREBOURS AND BARRESWILL

Rose-Joseph Lemercier (Paris, 1803–1887), and Aloïs Senefelder, a pupil from 1817 to 1819, worked in the Senefelder printing house directed by Knecht from 1825 to 1829. Lemercier established a lithographic printing house in 1829 in Paris, 57, rue de Seine. He came to photography in 1839, and produced his first daguerreotypes. At the beginning of the 1850s, he became interested in photomechanic process. During this period, the obstacle was in obtaining stable photographic images. The rapid fading of some silver-based prints initiated a search for a more reliable and commercially viable process. The future of photography depended on it. This issue became the central point of focus for the Société d'encouragement pour l'Industrie nationale. The Society

became one of the most important institutional forces for the development of photography. More than any other group, it foresaw the development of photography as an industry and organized competitions to encourage photographers to produce photographic prints that were of high quality, economical to produce and easy to conserve. As early as 1840, the Society concluded that if it were to progress in the industry, photography needed to abandon pre-industrial hand-made means for more modern means geared toward mass production.

From 1852 to 1854, Lemercier linked up with Lerebours, Barreswill and Davanne. Noël Lerebours (1807–1873) was optician, founding member of the Société heliographique and builder of photographic material; Barreswill was a chemistry professor at the Turgot school as was Alphonse Davanne (1824–1912).

Together they developed the lithophotographic process, which was based on the work of Niépce de Saint-Victor. This process consisted of pouring a solution of bitumen of Jude on a lithographic stone. The stone was then exposed under a negative (paper or glass). The bitumen then received the light and hardened in the areas not exposed to light. The image formed was then engraved with acid and washed from its bitumen. The hardened areas remained after the acid wash, and were then covered with printing ink. After pressing the image onto paper, the image was transferred to the paper, providing various shades and tints.

Lemercier and his associates sent sealed letters containing lithophotographic prints to photographers, the prints which were later presented by François Arago in a lecture to the Academy of Sciences on August 16, 1852. They asked for an invention patent of fifteen years on July 3, 1852, the request was accepted on August 25, 1852. Next year, Lemercier established in his lithographic studio, a photographic printing house, where he produced prints from the negatives of Henri Le Secq. Looking for a renaissance in the photographic underworld, six of those prints from Le Secq were published as prototypes of lithophotography in a treatise on the new process entitled *Lithophotographie ou impressions obtenues sur pierre à l'aide de la photographie, 1er cahier.* It was published in notebook at the Academy of Sciences in January 1854.

The prints from Le Secq represented subjects of architecture and architectural sculpture that he photographs for the Missions heliographique. They accurately reproduced old monuments and the printing on paper gave the grain conferring a certain aesthetic. Lemercier certainly tried to find an outlet (and a market) for the production of prints from the Missions heliographique. That commision, the first photographic project initiated by the French government through the Commission des monuments historique, needed printers able to produce stable images in a timely manner and as accurately as

photographic prints. Lithophotography was real progress and it easy to do. It was also less dangerous than the previous processes, and more suitable to industrial production, but because of the grainy stone, details lost their precision. By founding this photographic printing, Lemercier tried to fulfil the wish, announced in 1851, of the Société heliographique. The request was to have a photographic printer in the company itself to produce the images of photographers and commissioned project studies, which had typically been failing because of a lack of means.

In 1855, Alphonse Poitevin (1819–1882) improved the process and utilized it in his studio until 1857. Named photolithography, his process was based on the mix of albumin and bichromate of potassium propriety to retain, after exposure to light, the printing ink. The bichromate gum has been a decisive discovery of Poitevin's and a tremendous progress for photography in that it was easier to prepare and more accurate in results, and so it took the place of the bitumen of Jude in the sensitive processes of the printing plates. On October 27, 1857, for reason of poor management of business, Lemercier bought Poitevin's studio and patent, and used photolithography in his printing house. They created together a society in collective name for the utilization of the process. The profits were split down the middle. The society was later divided in February 1867. Corine Bouquin and Sylvie Aubenas showed that the use of the patent would unfortunately reveal itself barely profitable, the stress of which put the two men at odds with each other. In 1859, Poitevin began legal proceedings against Lemercier for not having put the complete title "Procédé Poitevin" on the bottom of the plates, instead putting only "P. Poitevin," and for paying less than the full cost of the patent. The judge ruled in January 1860, in favour of Poitevin.

Several photographers gave their negatives to Lemercier to print their images, like Bisson brothers, and Julien Vallou de Villeneuve, but this production stayed experimental or limited. Lemercier never really exploited his process. However, he developed the photolithography to illustrate scientific and artistic books. Two albums were published thanks to this technique: *Le Sérapéum de Memphis* by Auguste Mariette in 1857, created from Charles Marville's and Paul Berthier's negatives (30 plates); the book of Jules Labarte *Histoire des Arts Industriels* (1864–1866) about decorative arts, created from the negatives of Marville and Berthier (150 plates).

Lemercier also printed images which were not lithophotography but photographic prints. The Bisson brothers made *L'œuvre de Rembrandt reproduit par la photographie, décrit et commenté par Charles Blanc* (60 plates) and *Choix d'ornements arabes de l'Alhambra offrant dans leur ensemble une synthèse de l'ornementation mauresque en Espagne au XIIIe siècle reproduit par MM. Bisson frères* (19 plates) in 1853 in Lemercier's studio. As well as twelve images included in the *Monographie de Notre-Dame de Paris et de la nouvelle sacristie de MM. Lassus et Viollet-le-Duc* published the same year. In 1857, Lemercier also edited prints of Varroquier's and the series of stereoscopic views of Furne and Tournier's, who settled in the studio at rue de Seine two years later. The subjects were genre studies and living compositions of trade and craft, like farmers, launderess, blacksmith, hitchers, landscapes, mythology recomposed, models of nudes, scenes from operas, interiors of artist studios, taverns, and oriental interiors.

Photolithography was practice until about 1867 in Lemercier's studios, "putting his press at the service of clichés of authors at the same price conditions as ordinary lithography" write Joly-Grangedor in 1871 (BSFP 1871, 110.) The same year, Poitevin won the great duc de Luynes competition for his process of photolithography and Lemercier received a medal from the SFP for his works on his technique. But because it was not cost efficient, the process was flawed, and in December 1866, Lemercier complained to Poitevin of not making any profits off his patent. Poitevin later made an agreement with Cyprien Tessié du Mothay, associated with Charles Maréchal, who bought in March 1867 the rights of Poitevin. Lemercier, who did so much for photolithghraphy modified it into phototypy which yielded superior images. In 1873, Lemercier bought the patent of Albert of Munich's process of "Albertypy" and uses it until 1887. He also practiced photoglypty in his establishment. He presented prints in 1881 at the Ring of bookshop exhibition and in 1882 at the photographic exhibition of the Central union of decorative arts. He was awarded, at this exhibition a gold medal. Also, in 1879, Lemercier participated in the Léon Vidal lectures on industrials reproductions of works of art which took place on Wednesday at the National School of the Decorative Arts, stating, "Thanks to the obliged support of the Lemercier & Cie house, photoglyptic experiences could have been made in the presence of the pupils of the School" (*Le Moniteur de la photographie*, March 1, 1879, 33–34).

In 1887, he donated to the Société française de photographie an album of Algeria and Tunisia views. He died in Paris in January the same year.

In spite of his efforts, Lemercier stayed with the lithograph, and thus photography for him, never took a real importance in his printing house. Photolithography and the following processes born from this, remained as images printed on a plate, which represented a retreat in relation to wood engravings printed in text and,

later photoengraving. Lemercier's production however, marks an important step in the insertion of photography into books.

LAURE BOYER

Exhibitions: Amsterdam 1855, Paris 1855 (2d section), Paris SFP 1857, Bruxelles 1857, Paris SFP 1859.

Publications: *La lithophotographie ou impressions obtenues sur une pierre à l'aide de la photographie»,* 1er cahier, par MM. Lemercier, Lerebours, Barreswill et Davanne, Paris, Goupil, Gide & Baudry, London, Gambart, 1854.

Medals: London 1844, medal of honour; Paris 1848, medal of honour; London, 1862, mention honourable; Porto, International exhibition, 1866, medal of honour; Paris, SFP, 1867, medal for his work on photolithography; Chevalier of the Legion of Honour; Paris, Photographic exhibition of the Central union of the Decorative Arts, 1882, gold medal.

See also: Bisson, Louis-Auguste and Auguste-Rosalie; and Société Française de Photographie.

Further Reading

Auer, Michel and Michelle Auer, *Encyclopédie internationale des photographes de 1839 à nous jours,* Paris, Camera obscura, 1985.

Bouquin, Corinne, *Recherches sur l'imprimerie lithographique à Paris au XIXe siècle, L'imprimerie Lemercier (1803–1901),* PhD dissertation, University of Paris I, December. 1993.

Figuier, Louis, *Les applications nouvelles de la science à l'industrie et aux arts en 1855,* Paris, 1856.

Jammes, Andre, and Eugenia Parry Janis, *The Art of French Calotype,* Princeton, N.J.: Princeton University Press, 1983.

Pinsard, Jules, *L'illustration du livre moderne et la photographie,* Paris, 1897.

Slythe, Margaret, *The Art of Illustration: 1750–1900,* London, 1970; *Revue photographique,* Chronique: Ateliers de M. Lemercier, no. 18, 5 avril 1857, 1.

Rosen, H. Jeffrey, *Lemercier & Cie: Photolithography and the Industrialisation of Print Production in France, 1837–1859,* PhD dissertation, Evanston, Illinois, June 1988.

LEMERE, BEDFORD (1839–1911)

Bedford Lemere and his son Harry Bedford Lemere are the most outstanding English architectural photographers of the nineteenth century by virtue of the sheer scale and duration of their quality output. Studies of English urban life cannot take place without taking into account these key visual documents of late Victorian England.

From the early 1870s until well into the twentieth century both photographers operated from the same address, 147 Strand which was conveniently and symbolically situated on the border between the City of Westminster and the City of London. By the 1880s the company had became the standard for large format architectural work in Britain. Taking over the premises of Valentine Blanchard the firm did not vacate the same studio until after 1945. The core clientele of Lemere existed between the poles of the City of London and fashionable Westminster thus covering both the domestic and tourist areas of the West End as well as the intensive banking and commerce in the City. It thus encompassed the entire spectrum of business, bourgeois and aristocratic London. Though London generated much of the business there were extensive clients throughout the rest of England: Lemere was employed by the Rothschild family to document their county estates, their mansions in Westminster and their offices in the City—along with their sporting and collecting activities. The key art dealer Duveen used Lemere to provide the best images of his desirable stock of antiques and paintings. In the dark winter months studio commissions also came from legal firms, piano makers and fine silver manufacturers. Urban coverage is also extensive for areas in Liverpool, Manchester, Birmingham, Edinburgh, and Glasgow and other provincial cities. The only known foreign commission is significantly linked with a holiday by Queen Victoria in a grand hotel the South of France. During World War I Lemere was able to diversity by specialising in manufacturing and armaments often linked with the peacetime shipping business.

By deliberately cultivating architects and their clients from the outset Bedford Lemere built up such a sophisticated network of designers, owners and estate agents that by the 1890s prints from his standard 12x10 inch plates could be found in key families, businesses and institutions ranging from Queen Victoria and the Rothschild family to official government bodies and department stores like Harrods. Sets were purchased by architects in the United States wishing to learn about fashionable English design like the Queen Anne movement.

The professional work of Lemere first comes to attention with the important series of carved details designed to educate those studying and applying the tenets of the Gothic Revival through the collection of medieval ornament displayed at the Architectural Museum in 1872 [later the Royal Architectural Museum]. With support from the prominent architect John Pollard Seddon and with endorsements from John Ruskin, Lemere rapidly became associated with major Architects like G. E. Street, G. G. Scott, and, later, Richard Norman Shaw. In addition there are many associations with interior decorators, stained glass and furniture designers, and a range of art-manufacturing companies.

With the exception of churches, a huge range of building types were covered: best known for his total control

of elaborately decorated domestic interiors, especially country houses, Bedford Lemere never employed more than two or three assistants who maintained the objective, sober and all-inclusive style which from 1897 was emulated by photographers employed by *Country Life* magazine. This somewhat dry style without much human incident indoors exhibits a cumulative effect through carefully controlled composition and obsessive attention to detail. The images provide unparalleled records for contemporary commissioners and, today, for several national archives. Along with architecture a profitable maritime sideline was built up recording similar interiors of ocean liners and by the mid 1880s Lemere became the single most important photographer in this area being employed by Cunard, White Star, Canadian Pacific, and other transatlantic shipping companies. In 1887 with agents in New York and Paris some 8,500 images in 17 series were being advertised.

Possible rivals for the crown of architectural photography in England include Charles Latham, Horatio Nelson King, S. B. Bolas and the photographers connected with *Country Life* but though they all created superior images none were ever able to emulate the single-minded continuity of Lemere whose ability to sum up interiors using just one plate per room was evident for over 70 years. The company survived the death of H. Bedford Lemere in 1944 [when glass was still being utilized] but the decline in demand at the same time for large format plates meant that 1944 represents the zenith of large-format architectural photography in Britain.

The output and style of Bedford Lemere was seamlessly taken over and developed into a recognisable style by his son in the late 1880s as commissions diversified yet further whilst retaining the architectural core. Apart from a complete set of negative registers very little other documentary evidence has survived which is a pity since both father and son must have had considerable skills in cultivating such an extraordinarily diverse set of contacts across England linked with every aspect of architecture and property.

Perhaps one-third of the estimated total output of 100,000+ images now survive, most of them at the National Monuments Record, English Heritage. Nevertheless, even this partial survival represents one of the most detailed records ever created of Victorian and Edwardian life; it avoids the usual topographical and tourist views and systematically depicts the exteriors and interiors of everything from modest suburban houses to factories and palaces. The quality and extent show that Bedford Lemere ought to be considered a delineator of Victorian preoccupations with décor, class and industry. These unique records should be consulted by any historian concerned with design, architecture or taste in Britain. In a medium where absences are commonplace, the survival of even a fraction of this visual density means that this work archive is one of the most important in Britain.

IAN LEITH

Biography

Bedford Lemere was born in Maldon, Essex, and established his photographic career in the 1860s before he founding his own company at 147 Strand, Westminster c. 1867. In 1862 he married Anne Pennyfeather at St Pancras church, London. By the late 1880s control of Bedford Lemere & Co. passed to his son Henry [Harry] Bedford Lemere [1865–1944] who later became President of the Professional Photographers Association [1930]. The company was at the same address until the late 1940s and then relocated to South London before being absorbed in another concern. Apart from very detailed registers and a small fraction of the negatives much has been lost including all correspondence linked with commissions and all negatives taken 1929–1944. Surviving negatives, prints and proof print albums were purchased from the 1950s onwards by the Royal Commission on the Historical Monuments of England [later English Heritage]. Over 20,000 negatives and prints along with a complete set of registers survive with the National Monuments Record, English Heritage. Scottish negatives are held by the Royal Commission on Ancient and Historical Monuments of Scotland, Edinburgh. Most Shipping negatives are at the National Maritime Museum, Greenwich. Substantial print holdings exist in the Guildhall Library, City of London, and at Westminster Archives but many others are known to exist throughout English archives. Several archives in the United States and Canada hold images of the Architectural Museum as well as later material.

See also: Blanchard, Valentine; and King, Horatio Nelson.

Further Reading

Cocroft, W. D., and Leith, I., "Cunard's Shellworks, Liverpool" in *Archive: The Quarterly Journal for British Industrial and Transport History* no.11, September 1996.

Cooper, N.. *The Opulent Eye: Late Victorian and Edwardian Taste in Interior Design*, London: The Architectural Press, 1976.

Leith, I., *The Streets of London: A Photographic Record. Volume 1: Westminster Photographed by Bedford Lemere*, Liverpool: Editions, 1990.

——, "A Century of Picture Making: The Bedford Lemere Archive" in *English Heritage Collections Review vol. 4*, London: English Heritage, 2003.

——, "Amateurs, Antiquaries and Tradesmen: A Context for Photographic History in London" in *London Topographical Record vol .XXVIII*, edited by A. L. Saunders, London: London Topographical Society, 2001.

Seddon, J P. "Photographs from the Architectural Museum" in *The Architect*, vol. 8, November 30, 1872.

——, "Photographs from Selected Casts in the Architectural Museum" in *The Architect,* vol. 9, June 14, 1873.

LENSES: 1. 1830s–1850s
Technical and equipment

In 1812, William Hyde Wollaston showed that a positive meniscus lens, used with the concave side facing the object being viewed, significantly flattened curvature of field. Wollaston further flattened curvature of field by placing a stop at a distance in front of the lens, rather than directly in front, which had been the practice beforehand. This introduced a slight amount of barrel distortion.

Wollaston's lens was used by Nicéphore Niépce in his 1820s–1830s experiments with light-sensitive asphaltum. Due to the low light sensitivity of the processes, Niépce was forced to use the lens without a stop. He also found that the Wollaston lens suffered from chromatic aberration.

In 1833, Niépce's successor, Louis Jacques Mandé Daguerre, switched to an achromatic, positive meniscus lens constructed by Charles Chevalier. At first Daguerre reversed the lens, so that the stop faced the sensitized surface of the plate and convex side of the lens faced the object being photographed. Using the lens in this way, he hoped to take advantage of the condensed light at the center of the image. By 1839, and the public announcement of the daguerreotype process, he had returned to using the lens with the concave side of the lens facing the object being photographed and the stop in front. This marked an achromatic return to Wollaston's original lens arrangement.

The first camera marketed for Daguerre by Alphonse Giroux contained a similar achromatic, positive meniscus element. Because the lens needed to be stopped down to f/14 to obtain a flat field, portraits were impracticable due to the long exposure times involved; however, the lens was suitable for landscapes, architectural subjects, and still-lifes. Chevalier was soon overwhelmed by the demand for lenses, and an achromatic, plano-convex lens was substituted by his optical rival, Noël-Paymal Lerebours. Here the flat side of the lens faced the object being photographed.

By 1840, the public demand for photographic portraiture led opticians to attempt lens designs that could be used at full aperture. Returning to a duplet telescope he had designed 1834, in which two achromatic lens elements were separated by an appreciable distance, Chevalier modified it to arrive at his *Photographe à verres combinés* [Lens Made from Combined Glass]. For many years, this was the only lens capable of providing a flat field with whole-plate images when used at full aperture. It also was the first convertible lens, meaning that the lens barrel could be taken apart and the lens elements changed, depending on the subject being viewed and the format size desired.

Chevalier's lens was followed in 1840–1841 by another portrait lens, designed by Josef Max Petzval and marketed by the Voigtländer firm of Vienna. This lens could also be used at full aperture and was eventually achromatized, although the first 720 examples remained uncorrected for chromatic aberration. One difference it had with the Chevalier lens was that it condensed light at the center of the image. This provided for a shorter exposure time and centralized focus, combined with a gradual darkening of the borders of the image. More analogous to the aesthetic of portrait miniatures, it became an instant success with Daguerrian portraitists, and since Petzval had failed to secure the property rights to the lens, French and English opticians were free to copy the design and offer competing versions.

Throughout the remainder of the 1840s–1850s, photographic lenses generally divided into two classes: landscape lenses and portrait lenses.

Landscape or single lenses were at first identical to the 1830s achromatic positive meniscus advanced by Chevalier, with a stop being placed in front of the lens element at a distance equal to one-fifth of the lens focal length. These took in a narrow field of view and were composed of two types of glass, flint and crown, with the softer flint glass being located in front.

In 1854, J. H. Dallmeyer introduced a landscape lens that consisted of three meniscus elements cemented together to form an achromatic, positive meniscus lens element. This took in a much wider field of view, coupled with a significant amount of barrel distortion. The placement of a harder crown glass in front protected the lens from atmospheric pitting, to which previous landscape lenses had been subject. In 1857, Grubb modified this to form a two component landscape lens, with the crown glass in front and the flint glass behind.

Portrait or double lenses were generally variants of either the Chevalier or Petzval design. With the exception of Chevalier's lens, portrait lenses during the 1840s–1850s took in a very narrow field of view, and due to problems with curvature of field and astigmatism, were not suitable for landscapes or architecture.

In 1857, Petzval introduced an improved version of his portrait lens, based upon an unrealized 1840 design. This consisted of an achromatic, negative meniscus lens element in front and an achromatic, positive lens element in the rear, thus forming an early telephoto lens. The lens was capable of a flat field and even illumination, and was intended for architectural subjects and two-dimensional copy work. Introduced as the *Photographischer Dialyt* [Dialytic Lens], with the stop located in front, it came to be known as the Orthoscopic lens, with the stop being later relocated in between the lens elements.

Attempts to widen the angle the angle of view and correct curvilinear distortion during the 1840s–1850s usually involved symmetrical duplet arrangements, with the convex faces of opposing identical elements being oriented outwards. The first arrangement of this type was in 1841, when Thomas Davidson placed two achromatic landscape lenses face to face. This was followed in 1844 by G.S. Crundell mounting two uncorrected Wollaston meniscus lenses around a central stop. Such lenses were largely unsuccessful, due to the compounding of an already significant curvature of field problem.

In 1857, Thomas Sutton advanced a theory explaining how a symmetrical triplet lens, consisting of two opposing, achromatic plano-convex elements surrounding an uncorrected bi-concave element made of quartz, would be exempt from distortion and capable of a flat field. Stopped down, this would have been a practical wide-angle lens; however, due to the absence of surviving examples, it does not appear to have been a commercial success. It was allegedly marketed by Andrew Ross for a short period in 1859.

ALAN GREENE

See also: Chevalier, Vincent, and Charles; Lenses: 2. 1860s–1870s; Lenses: 3. 1880–1890s; Petzval, Josef Max; Ross, Andrew; Sutton, Thomas; and Wollaston, William Hyde.

Further Reading

Bolas, Thomas, and George E. Brown, *The Lens: A Practical Guide to the Choice, Use, and Testing of Photographic Objectives*, London: Dawbarn and Ward, 1902.

Eder, Josef Maria, *History of Photography*, trans. Edward Epstean, 1945, reprint, New York: Dover, 1978.

Farbre, Charles, *Traité encyclopédique de photographie* [Encyclopedic Treatise on Photography], 4 vols., Paris: Gauthier-Villars, 1889–1890.

Greenleaf, Allen R., *Photographic Optics*, New York: Macmillan, 1950.

Kingslake, Rudolf, *A History of the Photographic Lens*, Boston: Academic Press, 1989.

Monckhovan, Désiré van, *Traité d'optique photographique* [Treatise on Photographic Optics], Paris: Victor Masson, 1866.

Ray, Sidney, "The Era of the Anastigmatic Lens," in *Technology and Art: The Birth and Early Years of Photography: The Proceedings of the Royal Photographic Society Historical Group Conference, 1–3 September 1989*, edited by Michael Pritchard, Bath: R.P.S. Historical Group, 1990.

LENSES: 2. 1860s–1880s

The period 1860–1880 saw a number of developments in optical design which significantly improved the technical characteristics and speed of the photographic lens, the most important of these was the Rapid Rectilinear lens introduced in 1866.

In Britain John Henry Dallmeyer (1830–1883) and in Germany Dr. A. H. Steinheil (1832–1893) almost simultaneously announced the Rapid Rectilinear or Aplanat lens in 1866. The symmetrical design was important and came between the early period Petzval, Doublet, and meniscus-type photographic lenses, and the introduction of the Anastigmat in 1890. The design was very successful and remained one of the most popular until the 1920s and was available in wide-angle and long-focus versions. It was fitted as a general purpose lens to many field, hand and rollfilm cameras, including most standard Kodak folding cameras made between 1890 and the 1920s.

Dallmeyer's design was the subject of British patent 2502 of 27 September 1866 which described "Improvements in compound lenses suitable for photographic uses." The design as originally patented was slightly modified to become the rapid rectilinear lens which minimised optical distortion and with an aperture of up to f/6 and a field of view of around 50 degrees. Both the Dallmeyer and Steinheil lenses were composed of identical halves each half having about twice the focal length of the double objective and importantly made use of flint glass of different densities.

Steinheil introduced an almost identical design to Dallmeyer's which he called the Aplanat. It was designed by the mathematician von Seidel and was another significant example of the application of mathematical computation to lens design. Dallmeyer and Steinheil entered into a public and acrimonious debate over who had produced the lens first. Steinheil probably had priority by a few weeks but his claims of piracy of the design were not proven.

The design was extremely successful and widely copied by lens manufacturers who issued their copies under a variety of names including the well-known Euryscope, Pantoscope, Symmetrical and Universal. The Bausch and Lomb Rapid Rectilinear was particularly widespread well into the twentieth century.

While the Rapid Rectilinear lens was the most important of the 1860–1880 period there were other lenses that were useful. Steinheil began experimenting with unsymmetrical lens systems producing the Group Aplanat of 1879. The design corrected longitudinal aberrations and was further refined in his 1881 patent.

Dallmeyer, from the establishment of his firm in 1860, produced a number of other improvements to photographic optics especially producing "fast," or wide aperture, portrait lenses. In 1862 he introduced his Triple Achromatic lens which offered a lens with minimal distortion, working at around f/10. The lens was popular until it was superseded by the Rapid Rectilinear in 1866. The Dallmeyer Patent Portrait lens, also based on his 1866 patent was a variant of the Petzval lens.

The other well-known British lens manufacturer Ross introduced in 1864 a low-aperture distortionless lens which appeared in three variations all under the name

Doublet. The design was superseded by the Rapid Rectilinear. Ross also introduced the Actinic Triplet, similar to Dallmeyer's Triple Achromatic lens. In Germany Voigtländer marketed a patented portrait lens in 1878, based on the Petzval design.

While the corrected symmetrical lens designs were the most important technically and commercially there were a number of design for symmetrical lenses that were not corrected for aberrations. The resultant lenses were generally very wide-angle. The first of these was Thomas Sutton's (1819–1875) water-filled panoramic lens which was patented in 1859 and gave a field of view of around 60 degrees. More successful was the American optician C.C. Harrison's Globe lens, patented by Harrison and J. Schnitzer in 1860. The lens was made by a number of European manufacturers and remained popular throughout the century. Emil Busch's Pantoskop of 1865 was made in seven sizes. In the same year C.A. Steinheil patented the Periskop which was partly corrected although it did not become popular.

The next significant improvements in lens design were to take place from the 1880s.

MICHAEL PRITCHARD

See also: Dallmeyer, John Henry & Thomas Ross; Kodak; Bausch & Lomb; von Voigtländer, Baron Peter Wilhelm Friedrich; and Petzval, Josef Maximilian.

Further Reading

Eder, J. M . (translated by Edward Epstean), *History of Photography*, New York: Columbia University Press, 1945.

Kingslake, Rudolf, *A History of the Photographic Lens*. London: Academic Press, 1989.

——, "Pioneers of Photographic Lens Design and Manufacture" in *Pioneers of Photography. Their Achievements in Science and Technology, Springfield, SPSE, 1987*.

Ray, Sidney F., *Applied photographic optics: lenses and optical systems for photography, film, video, electronic and digital imaging*. Oxford: Focal Press, 2002

Taylor, W and H W Lee (1935), "The Development of the Photographic Lens" in *Proceedings of the Physical Society*, 47(3), 502–518.

LENSES: 3. 1890s–1900s

If the period of 1860–1880 was dominated by the rapid rectilinear lens, then the period 1880–1905 can be summed up with two designs, the anastigmats and the triplets.

The rapid rectilinear design had one major failing in that it suffered from anastigmatism. From 1884 new types of optical glass with high refractive indices which were being developed by Dr. Otto Schott of Jena. By 1886 his company, Abbe and Schott, had developed new glasses containing substances such as barium, and the new barium crown glass was incorporated into a number of lenses including Voigtländer's Euryscope lens of 1886. Barium glasses were to allow significant new lens designs to appear.

The first true anastigmat lens was designed by H.L. Schröeder and J. Stuart, and patented on 7 April 1888 (BP no. 5194). Schröeder was working for the Ross company that manufactured the lens as the Ross Concentric. It used barium crown glass and a new flint glass and it showed minimal signs of astigmatism or field curvature. The lens had an aperture of f/16 and was sold for many years.

In 1890 the German optician Dr. Paul Rudolph (1858–1935) designed a new lens for Carl Zeiss of Jena which offered a wider aperture and further corrections. It was an asymmetrical design also making use of barium glass. The lens was sold as the Anastigmat and from 1890–1893 various series of the lens were offered. With the loss of their rights on the name 'Anastigmat' the lens was renamed the Protar in 1900. The lens was made under license from Zeiss by Ross in London, Krauss in Paris, Bausch and Lomb in Rochester, and by others elsewhere. Sales of over 100,000 were claimed by 1900. A wide-angle version was still being sold in the 1930s. Zeiss's Double Protar lens, a convertible design, of 1895 offered the photographer a choice of three lenses in one.

Other companies were quick to introduce their own variant designs. In 1895 H.L. Aldis who was working for Dallmeyer designed the Stigmatic. Emil von Hoëgh's (1865–1915) patent of 1892 for a symmetrical lens was made as the Goerz Double Anastigmat and had an aperture of up to f/6.8. After 1904 this lens was known as the Dagor and remained popular well into the twentieth century. Von Hoëgh was made principal lens designer at Goerz.

The first wide-aperture anastigmat design was the Zeiss Planar of 1899 which had a maximum aperture of f/3.5.

The second significant lens design of the period was the triplet. On 25 November 1893 H.D. Taylor (1862–1943) was granted a patent for a triplet lens which consisted of three single spaced glasses. This was a significant departure from current lens designs. The lens was sold from 1893 by Taylor, Taylor and Hobson as the Cooke lens, the name in deference to Taylor's employers Thomas Cooke of York. The lens was simple and of low cost and with an aperture of f/6.3. In 1935 Taylor and Lee of Taylor, Taylor and Hobson claimed that "no fundamentally new principle of photographic lens design has been originated since Dennis Taylor invented this lens." The design was adapted by Voigtländer in 1900 for its Heliar design which was sold from 1902. The Ross Homocentric and Goerz Dogmar were similar triplet designs.

Rudolph at Zeiss further developed the Cooke design and in 1902 Zeiss introduced its most famous lens, the Tessar with an f/5.5 aperture. The Tessar was widely copied and appeared under such names as Ernon, Ektar Anticomar, Xtralux, and Lustrar from a large number of different manufacturers.

The first designs for a variable power telephoto lens—the forerunner of the modern varifocal zoom lens—also date from this period. This was developed independently by Dallmeyer in London, by Miethe in Germany and by Duboscq of France. It was patented on 15 December 1891 by Thomas Rudolf Dallmeyer (1859–1906) who had been running the Dallmeyer company since his father's death in 1883. In Germany Adolph Miethe (1862–1927) applied for a similar patent—leading inevitably to a dispute over precedence of similar magnitude to that which Dallmeyer's father had had with Steinheil in the 1860s. Dallmeyer produced a book *Telephotography* (1899) describing the use of his design.

A refinement of the lens was introduced in 1905 by K Martin and sold as the Busch Bis-Telar. This design overcame the limitations of Dallmeyer's original design and again was widely copied. Dallmeyer's own versions were sold as the Adon and Dallon and other companies sold under names such as Telestigmat, Telecentric, and Magnar.

Several other specific lens designs were developed during the period. Amongst them, a very wide-angle lens, the Hypergon, was made by Goerz and sold from 1900 and soft-focus lenses from Dallmeyer and Wollensak found favour with portrait photographers.

MICHAEL PRITCHARD

See also: Dallmeyer, John Henry & Thomas Ross; Miethe, Adolf; and and Duboscq, Louis Jules.

Further Reading

Eder, J. M., *History of Photography*, (translated by Edward Epstean), New York: Columbia University Press, 1945.

Kingslake, Rudolf, *A History of the Photographic Lens*. London: Academic Press, 1989.

Ray, Sidney F., *Applied Photographic Optics: Lenses andOoptical Ssystems for Photography, Film, Video, Electronic and Digital Imaging*. Oxford: Focal Press, 2002.

Taylor, W., and H. W. Lee (1935), "The Development of the Photographic Lens" in *Proceedings of the Physical Society*, 47(3), 502–518.

LEON, MOYSE & LÉVY, ISSAC; FERRIER, CLAUDE-MARIE; AND CHARLES SOULIER

The French photographic firm of Ferrier, Soulier, Lévy (FSL) produced a vast library of stereographic views in glass of mostly European monuments and sites during the second half of the nineteent century. In point of fact the FSL firm operated historically under eight names: (1) "Ferrier photographe," 1851–1859; (2) "Ferrier pere, fils et Soulier," 1859–1864; (3) "M. Léon et J. Lévy," 1864–1872; (4) "J. Lévy & Cie," 1872–1895; (5) "Lévy et ses Fils," or "Lévy Fils et Cie," 1895–1920; (6) "Lévy & Neurdein réunis," 1920–1932; (7) "Compagnie des Arts Photoméchaniques," 1932–1969; and (8) "Roger Viollet," 1969–present.

The phenomenon of binocular vision produced startling 3-D effects which still fascinate us today. Although FSL did from time to time produce paper stereographs, it was their superb glass stereographs which made the firm famous, and rich. Their views were universally regarded as the finest product of stereography. They produced a sense of depth that stunned first-time viewers, including Queen Victoria, at the Great Exhibition of 1851 in London. What set the glass stereograph apart from all other kinds of stereoviews—paper, tissue, daguerreotype—was the albumen-on-glass process, which offered a brilliant, very sharp, superbly contrasty and glisteningly transparent image. Viewed in direct light, it was incomparably superior to the paper stereograph, which like the stereo daguerreotype could only be viewed by reflected light.

Claude-Marie Ferrier (1811–1889) was the founder of FSL, and during the 1850s, while employed by maker of scientific instruments Jules Duboscq (1822–1894), he established the reputation of the glass stereographs. His stereographs measured 8.5 × 17 cm, the standard size for such views, whether paper, glass, or daguerreotype. These dimensions were imposed by the early stereo viewers, notably the Brewster stereoscope, which became the industry standard thanks to its enormous success at the Great Exhibition.

Claude-Marie Ferrier was born in Lyon in 1811. When he removed to Paris is unknown. The earliest mention of his work is in connection with the Great Exhibition in London of 1851, where he and Frédéric von Martens (ca. 1809–1875) produced photographic prints for Nicholas Henneman of objects figuring in the exhibition. Ferrier's photographs were printed on salted paper from albumen-on-glass negatives. The glass stereograph was "invented" at that same time, as Frederick Langenheim (1809–1879) later testified to Marcus Root: "While in Paris, in 1853, I was introduced to the celebrated optician, Dubosque-Soleil...In conversation, Mr. Dubosque told me that when he was engaged, in 1851, to arrange the display of his articles for the 'World's Fair' in London, he saw my photo magic lantern pictures, the first that he had ever seen, and thinking that such photo-positive pictures on glass might be used to supersede the daguerreotype pictures, until then manufactured for him by Mr. Ferrier, he had at once written to Mr. Ferrier, to come over to London to

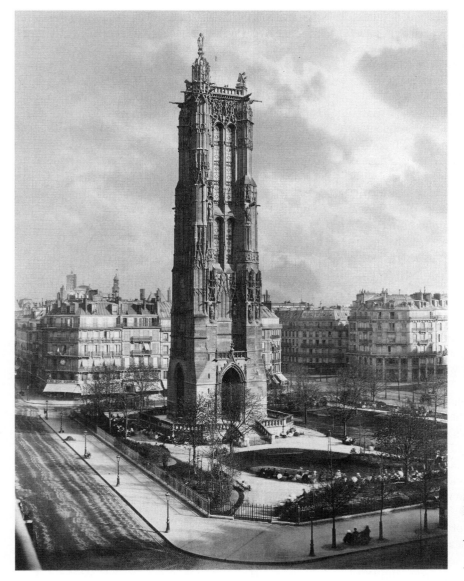

Soulier, Charles. La Tour St. Jacques la Boucherie à Paris.
The Metropolitan Museum of Art, Edward Pearce Casey Fund, 1988 (1988.1072) Image © The Metropolitan Museum of Art.

examine my transparent positive pictures taken on glass, and that since then, they had tried and made such transparent positive pictures on glass for the stereoscope" (*The Magic Lantern*, 1874).

Ferrier produced superb sets of views of Paris and the Ile-de-France (1851–1853, nos. 1–213), followed by views of England, the Loire Valley, Provence, the Coted'Azur, and Italy (1853–1854, nos. 273–599). During the period 1855–1857, additional series were produced: Switzerland (nos. 600–690), a second Italy series (nos. 700–778), Savoie (nos. 778–873), a second Swiss series (nos. 874–931). Views of Constantinople (nos. 950–1055) and Athens (nos. 1060–1095) were offered to the public as of June 13, 1857. Finally, Ferrier's early work was collected in a general catalogue published in 1859 (nos. 1–2399, with extensive numerical gaps). Various series had been offered previously in a half-dozen listings published mostly in stocklists: the Paris views in *Cosmos*, 1852; the English series in the Negretti &

Zambra equipment stocklist of 1854; a long series in the London Stereoscopic Company stocklist of 1855/1856, appended to the Brewster treatise of 1856; the Gaudin catalogue of 1856; an advertisement in the journal *La Lumiere*, June 1857; and in the Langenheim/American Stereoscopic Company sales catalogue of 1858.

Late in 1859 Claude-Marie Ferrier, known as "Ferrier *pere*," formed a partnership with his son Jacques-Alexandre (1831–1912), known as "Ferrier *fils*," and Charles Soulier (before 1840–after 1876). This firm was known as "Ferrier pere, fils et Soulier." Charles Soulier had been in partnership since 1854 with Athanase Clouzard, and produced glass stereographs of very fine quality during that period. These often carry a "CS" signature. An important collection of approximately 1200 "CS" negatives came with Soulier to the new partnership with the Ferriers: a Russian series depicting monuments and sites in Moscow and St. Petersburg (nos. 5001–5191), and an extensive series of views, mostly taken by Soulier

in Paris, Germany, Austria, Spain, England and Scotland (nos. 6001–6997). These "CS" views were incorporated into the FSL general catalogue of 1864, which was more than twice the length of that of 1859. The 1864 catalogue included most of the views first published in 1859, except for a few deletions, plus nos. 2401–6997.

The firm "Ferrier pere, fils et Soulier" was short-lived; in 1864 the Ferriers and Charles Soulier sold out to two of their employees, Moisé Léon and Isaac Georges Lévy (?–before 1895), known commercially as J. Lévy. Léon had formerly been in the silk ribbon business with Lévy at 243, rue Saint-Denis, in Paris, and was probably a silent partner in the new firm. Production of the highest quality of glass stereographs continued unabated, however. Another general catalogue was published in 1870 under the Léon and Lévy imprimatur, and included views from the first two general catalogues, plus nos. 7001-10027. The best known of the new collections of views was the series devoted to the Exhibition of 1867, issued both in glass and paper. Léon disappeared from the FSL firm in 1872, when the company assumed a new name: "J. Lévy & Cie." Lévy and later his sons ran the firm for almost a half-century, until its fusion with Neurdein in 1920.

In addition to the general catalogues of 1859, 1864 and 1870, three more general catalogues were published, in 1880, in 1886 and in 1903. The 1886 catalogue carried the numerical entries down to no. 12778; that of 1903 continued the numeration of views down to no. 27325. In between the general catalogues, thirty short stocklists of FSL glass stereoviews are known to have been published during the period 1859–1908. These latter listed the very latest additions to the stock of views available to customers. All of the FSL general catalogues after 1859 included the infilling of numerical series left empty in previous catalogues. For all practical purposes all FSL views produced after 1855 were numbered, and so their identification is simple. The effective date for each and every view is the date of the catalogue or stocklist in which the view first appears.

It would be fair to say that photographic excursions to distant sites to make negatives for full-sized glass stereographs (8 × 17 cm) had stopped by 1910, as the popularity of these larger glass views had begun to decline. Fortunately for the FSL firm their sales of magic lantern slides were substantial in Europe and the United States. The title page of the first general catalogue to mention magic lantern slides along with glass stereographs was the general catalogue of 1870. Lantern slides figure on the title pages of virtually all subsequent catalogues. The lantern slide was in effect one half of a glass stereograph. The importance of the lantern slide business explains why so many of the FSL glass stereo negatives still conserved at Roger Viollet in Paris have been cut in half; it was to simplify the printing of slides. Stereo halves were also used to produce paper prints, which are of course the mainstay of Roger-Viollet's business.

FSL enjoyed a reputation in the nineteenth century that far surpasses that of today. Their glass stereographs were universally admired as the finest produced in Europe. In Adolphe Joanne's *Le Guide Parisien* of 1863 FSL is singled out among photographic firms producing stereographs: "Let us mention especially the admirable collections of stereoscopic views in glass produced by Ferrier, pere, fils, et Soulier, at 113 boulevard de Sébastopol." The fact that the firm still exists, as Roger-Viollet, with its vast collection of FSL negatives substantially intact, makes it so much easier for us to assess the firm's substantial art-historical significance.

JOHN B. CAMERON

See also: Brewster, Sir David; Duboscq, Louis Jules; and Henneman, Nicolaas.

Further Reading

Adolphe, Joanne, *Le Guide Parisien*, Paris: Hachette, 1863, 39, where the author singles out for special praise the glass stereographs of FSL.

Brewster, Sir David, *The Stereoscope. Its History, Theory and Construction*, London: Keeler, Nancy B. "Illustrating the 'Reports by the Juries' of the Great Exhibition of 1851...,"*History of Photography,* vol. 6, 1982, 257–272.

McCauley, Elizabeth Anne, *Industrial Madness. Commercial Photography in Paris, 1848–1871*, New Haven, CT: Yale University Press, 1994.

Murray, John, 1856. Reprinted by Morgan & Morgan, 1971.

Voignier, Jean-Marie, *Les Vues Stéréoscopiques de Ferrier et Soulier*, Paris: Editions du Palmier en Zinc, 1992. This work includes an invaluable concordance of the firm's first three general catalogues of 1859, 1864, and 1870.

LEUZINGER, GEORG (1813–1892)
Swiss photographer, printer, and engraver

Born in the Swiss canton of Glaris (Glarus) in 1813, Georg Leuzinger arrived in Rio de Janeiro in 1832. He originally sent daguerreotypes from Brazil to Paris to be colored by hand and printed as lithographs. By 1861 he had opened a photographic studio, Casa Leuzinger, which was also a printing and engraving firm. Marc Ferrez apprenticed there under Leuzinger's son-in-law, photographer Franz Keller. Leuzinger originally sold other photographers' work (e.g., Stahl, Klumb, Christiano Junior). Then in 1865, he published a catalogue of 400 photographs, including his own. Leuzinger's views of Rio and the surrounding region show a keen awareness of the artistic possibilities of landscape photography. He also produced intriguingly modern scientific images of plant life for the expedition led by naturalist Louis Agassiz in 1865, published in *Journey*

in Brazil in 1868. Leuzinger won silver medals at Brazilian exhibitions (1866 and 1873) and his works were shown at the International Exhibitions in Vienna (1873) and Antwerp (1885), and the Exposition Universelle in Paris (1867 and 1887), where his panoramic view of Rio taken from Cobras Island won honorable mention in 1867. Casa Leuzinger left the photography business in 1873 and its founder died in Rio in 1892.

SABRINA GLEDHILL

LEVITSKY, SERGEY LVOVICH
(1819–1898)
Professional photographer

Sergey Lvovich Levitsky was born in Moscow in 1819 to a rich family. He was the cousin of Hertsen, the writer and outstanding public figure. He was born Lvov-Lvitsky but then changed his name to Levitsky. At his parent's request, Levitsky entered the school of law at Moscow State University, and graduated in 1839 becoming an official in the Ministry of Home affairs in St. Petersburg.

In 1843, Levitsky joined a research group commissioned to investigate the phenomenon of mineral springs in the Caucasus. During that period, he met U. Fritshe, an associate of the chemistry department at the Emperor's Academy of Sciences and the first Russian researcher dealing with the process of photography according to Talbot's technology. (Fritshe made his first photographs on the 23 May 1839). Levitsky having already bought a camera with a lens manufactured by French optician Chevalier, was interested in daguerreotype photography. On returning to St. Petersburg in 1844 Levitsky sent Chevalier his daguerreotypes with views of Pyatigorsk, Kislovodsk and other places in the Caucus. It was one of the first series of photographic landscapes taken in Russia. Later that year Levitsky retired and traveled abroad.

During Levitsky's visit to the Italian cities of Rome and Vena, he became acquainted with Senior Voigtlander and developed a friendship with him, eventually buying him a new lens for his camera. While in Rome, Levitsky took photographs of Russian painters and of the Russian writer Gogol, in Perro's studio, which is now believed to be the only portrait of this great personality.

In 1845, Levitsky took a course in chemistry and physics at the Sorbonne in Paris and met the leading daguerreotypists, including Daguerre, Charles Chevalier, Claude Félix Abel Niépce de Saint-Victor, and others. In 1849, Chevalier requested several large size daguerreotypes from Levitsky, who then when the works were finished, displayed them at an exhibition in Paris to illustrate how his lens contributed to the composition of photographs. The talent of Levitsky combined with

Levitsky, Sergey Lvovich. Alexander Hertsen, 1861.
Private Collection: Alexei Loginov" Private Collection: Alexei Loginov.

Chevalier's innovative lens won them the gold medal at the exhibition.

After the French revolution of 1848, having lost most of his estate, Levitsky moved to St. Petersburg and established himself as a professional photographer. In October of 1849, he opened a studio on the Nevsky Prospekt, opposite the Kazansky Cathedral. According to his contemporaries, his studio was one of the most fashionable studios of the city and generated great popularity among the aristocracy, writers, and musicians. This was partly because Levitsky never stopped improving the technology of photography, and during the 1850s, he developed his use of wet collodion. His works never failed to demonstrate the highest level of technique and artistry.

During the middle of the nineteenth century, Levitsky became among the first photographers to start creating psychological photo-portraits, a prominent genre of portrait in Russia at this time. The Russian artists working with these types of portraits concentrated primarily on the personality and the spiritual life of the sitter. The artists believed it was possible to penetrate into the soul of a person and this belief founded itself not only in Russian painting, but in literature, music, theatre

and photography as well. During this period, due to the likeness between the two, photography was constantly compared to painting and therefore often said to copy it. It was from this that Levitsky developed his style to use the compositional laws of painting by employing soft light thus creating soft images. While creating artistic portraits, Levitsky successfully experimented with the pose of the model, thereby re-establishing the rules of the conventional studio portrait. Instead of employing the use of tasteless painted backgrounds and accessories, he spent more attention on the personality of the model.

In February of 1856 Levitsky made several personal, as well as group portraits of famous Russian writers such as L. Tolstoi, I. Turgjenjev, N. Ostrovsky, and others. He compiled these photographs, which effectively established the most impressive and comprehensive photographic gallery of Russian literary men, to the extent that in 1857, the limited edition of these photographs quickly sold out. Years later, these portraits were often and still are used to accompany the biographies of the writers. Levitsky's contemporaries have said that he captured the reflection of each of the writer's individuality and created cognizable psychological images. He also made a portrait of the Emperor Nikolai I, which became the best canonical portraits of the tzar.

In 1858 the photographer returned to Paris where he helped an American daguerreotypist, W. Thomson, with his work and later opened a studio of his own. In spite of the severe competition with the Parisian photographers, Levitsky enjoyed great popularity and success. A couple of highly successful works placed Levitsky among the leading portrait photographers of France. His portrait of Hertsen of 1861 was bootlegged in Russia and became a classical work of the world photographic portrait. In 1864 Levitsky made several portraits of the Emperor of France Napoleon III and his family and was thus honored with the title of "the emperor's photographer,"and was subsequently admitted into the Paris photographic society. Through his constantly successful innovations with photography, Levitsky became a well-known photographer, not only in Russia but also abroad and in 1865, Levitsky made a photo portrait of the Russian empress, the wife of Alexander II, and her elder son in Nice. The empress liked the photographs so much that she suggested that Levitsky return to St. Petersburg, which he later did.

Levitsky opened a studio with his son Lev in St. Petersburg and from 1866, and quite a long time after, he was the only photographer to take pictures of the emperor and his family. His photographs served as an archetype for painted portraits, sculptures, monuments and busts. In 1890 a special photo-studio with the "Emperor's Entry" was built where advanced technologies were used to take pictures of large groups of people in various lightings.

In 1866, Levitsky became a member of Russian Emperor Technical Society (RETS) and in 1878 was one of the founders of its photography department, making it RETS' fifth department. Levitsky was in constant demand, both in Russian and abroad, and was often given presents from royalty and persons of distinction. Due to his skill and experience, he was the expert at the Russian exhibitions and three international exhibitions. In 1873 he was an exponent of the first department of photography at the Londoner international exhibition. In 1889 he took part in an anniversary exhibition in St. Petersburg hors concours, impressing the visitors at the entry to the exhibition with a large half-length of the Emperor Alexander III made by himself.

In 1847 and 1856 he conducted experiments with taking pictures in arc light and in 1879 he demonstrated 20 successful portraits made in electric light, the first of its kind in Russia. This was extremely important to Russian photography since St. Petersburg's weather was usually poor and not conducive to taking pictures without using some type of light. Levitsky displayed several portraits made in electric light at an 1883 electro-technical exhibition in Vena.

The last few years of his life Levitsky was severely ill and died in St. Petersburg in 1898. At a conversazione dedicated to the 74th anniversary of photography, the great connoisseur of photography, professor V. Sreznevsky, described Levitsky as "the farther of Russian photography, who began by creating daguerreotype works in St. Petersburg and who then raised portrait photography to the highest level of technical and artistic perfection." He was often known as the patriarch of the Russian photography. After his death the photo-studio was run by his son Lev until 1913.

ALEXEI LOGINOV

Biography

Sergey Lvovich Levitsky was born in Moscow in 1819. He graduated from the School of Law at Moscow State University in 1839 and became an official in the Ministry of Home Affairs in St. Petersburg. His first photographs were made in 1843 during his stay in the Caucasus. In 1844 he retired and left for Europe. He studied photography in Paris and in 1849 returned to St. Petersburg. From 1849 to 1858 he worked at his photo-studio and made a series of portraits of Russian writers. He worked on improving the technique of photography. In 1858 he moved to Paris and opened a studio. While in Europe, he made a photograph of the emperor Napoleon III and his family and became "the emperor's photographer." In 1865 Levitsky returned to St. Petersburg and worked there together with his son Lev. Through his ingenuity and experimentation with technique, Levitsky became one of the leading

portrait photographers of Russia. Levitsky died in St. Petersburg in 1898.

See also: Niépce de Saint-Victor, Claude Félix Abel; Daguerre, Louis-Jacques-Mandé; Chevalier, Vincent & Charles Louis; and Daguerreotype.

Further Reading

Horoshilov, P., and A. Loginov, "The Masterpieces of the Photography from Private Collections," *Russian Photography 1849–1918*, Punctum 2003, 176 pp.

Morozov, S., *Artistic Photography*, Planeta, 1986, 416 pp.

Rosenblum, N., *A world history of photography*, 3rd. ed., Abbeville Press, 1997, 45 pp.

Russian Photography, The Middle of the 19th—the Beginning of the 20th Century. Chief editor N. Rakchmanov, Planeta, 1996, 344 pp.

Russische photographie 1840–1940, Berlin, Ars Nicolai. 1993.

THE LIBRARY OF CONGRESS

Established as a legislative resource for Congressional members, the Library of Congress is America's oldest cultural and research institution. With a current budget of more than $330 million, a staff of 5,000, and collections totaling more than 100 million items, the Library has grown to become one of the leading cultural institutions in the world.

The Library of Congress was founded on April 24, 1800, when President John Adams approved legislation for the purchase of "such books as may be necessary for the use of Congress." The original collection of 740 volumes and three maps arrived from London in 1801 and were stored in the U.S. Capitol in the newly created capital city of Washington, D.C.

On January 26, 1802, Thomas Jefferson signed the first law that established regulations and a budget for a Congressional library. He believed that successful self-government depended on an informed public; his faith in democracy rose from his demand for intellectual freedom. President from 1801 to 1809, Jefferson appointed the first two Librarians of Congress and recommended books for the collection. During the Revolutionary War in 1814, the British army invaded Washington and burned the Capitol, including the Library of Congress, which had grown to 3,000 volumes. Although Jefferson called himself a man who could not live without books, he sold his personal library to Congress to replace the lost collection. At 6,487 volumes, his library contained more than twice the number of books destroyed in the fire.

Today the Library comprises three buildings in Washington, D.C., near the U.S. Capitol. The Jefferson Building opened in 1897; the Adams Building opened in 1939; and the Madison Building, the largest of the three and home to the graphics arts collections, opened in 1980. Treasures in the collections include one of only three perfect vellum copies of the Gutenberg Bible, printed around 1456; the original Declaration of Independence, drafted in 1776; and the Constitution of the United States, framed in 1787 by the Constitutional Convention.

The collections expanded rapidly after 1846, when the practice of depositing items into libraries for copyright protection was established. The copyright law of 1870 required that two copies of every creative work, including books, maps, prints, photographs, and pieces of music, to be registered for copyright must be deposited in the Library of Congress. However, the Library is not required to retain all copyright deposits, and except for the period from 1870 until 1909, it was never one of the Library's objectives. As a result, contrary to popular belief, the Library does not own a copy of every book published in the United States.

In 1866 the entire Smithsonian Institution library was transferred to the Library of Congress, firmly establishing the Library as the sole national library. Especially strong in scientific materials, the Smithsonian collection rounded out the Library's already broad scope encompassing works on the arts, literature, law, geography, history, and Americana.

Special services include a program of daily readings for the blind, initiated in 1897. In 1913 Congress directed the American Printing House for the Blind to begin depositing embossed books in the Library, and in 1931 a separate appropriation was authorized for providing books for the blind. The Library of Congress Trust Fund Board Act of 1925 allowed the Library to accept private funding, which enabled the Library to support the commissioning of new works of music and to establish chairs and consultantships for scholars. The consultantship for poetry has evolved into the position of U.S. Poet Laureate.

When Mathew Brady organized a team of photographers to compile a visual record of the Civil War in the 1860s, two copies of the photographs deposited in the Library formed the incipient photography collection. An additional 300 daguerreotype portraits of prominent Americans made by Brady were transferred to the Library from the U.S. Army War College in 1920; thousands of his negatives and plates were donated by the family of Brady's nephew in 1954. Other significant contributions to the photography archive include the 1943 acquisition of Arnold Genthe's work, which contains photographs from San Francisco's Chinatown and portraits of author Pearl S. Buck and other prominent society members; and the 1949 donation of more than 300 glass plate negatives documenting the aviation successes and failures of Orville and Wilbur Wright.

The Prints and Photographs Division has grown to be among the world's largest, with more than 100,000

engravings, lithographs, woodcuts, and other graphic arts and 13 million photographs. Unique items in the collection include a volume of daguerreotype landscapes from around the world, transferred onto copper plates and printed by letterpress. The George S. Lawrence and Thomas Houseworth Collection contains mid-nineteenth century gold-toned stereographic photographs of California and Nevada. In 1893 the Library acquired its first motion picture when W.K.L Dixon deposited *Edison Kinetoscopic Records* for copyright. In 1968 the American Film Institute formalized an agreement with the Library to develop a national motion picture collection.

Special collections within the Photographs Division include the photoprints and negatives from the Detroit Publishing Company, which was formed in 1898 (and later renamed the Detroit Photographic Company) as a partnership between printer William A. Livingstone and photographer William Henry Jackson. Livingstone owned the American rights to a lithographic process that added color to black-and-white negatives and collaborated with Jackson and other photographers to produce thousands of postcards and souvenirs, primarily of the United States.

The Farm Security Administration, headed by Roy E. Stryer, commissioned photographers Walker Evans, Dorothea Lange, Russell Lee, Arthur Rothstein, Ben Shahn, Jack Delano, Marion Post Wolcott, Gordon Parks, and others to document American life between 1935 and 1943. The project focused on Southern sharecroppers and migratory agricultural workers in the Midwest and West. Transferred to the Library in 1944, the holding includes the archives of Walker Evans and Dorothea Lange, in addition to photographs made for other government agencies, such as the Office of War Information.

Contemporary photographic holdings are diverse. In 1970 Toni Frissell donated negatives and photographs from forty years as a fashion and portrait photographer. The Library's collection includes Frissell's informal portraits of Winston Churchill, Elearnor Roosevelt, and John and Jacqueline Kennedy, as well as scenes from Washington, D.C. and Europe during World Was II. The Erwin E. Smith Collection comprises portraits of American cowboys made between 1905–1915 on ranches in Texas, New Mexico, and Arizona.

The Prints & Photographs Online Catalog provides computer access to a cross-section of the Library's visual material. Material not available online can be viewed in the Prints & Photographs Reading Room in the Library's Madison Building. Much of the material held by the Library is exhibited on site; some material is available for exhibition loan. The Library also provides reference and research services.

RENATA GOLDEN

See also: Brady, Mathew B.; and War Phtography.

Further Reading

Cole, John Y,. *A Chronological History of the Library of Congress*, Washington, D.C.: Library of Congress, 1979.

Cole, John Y., *For Congress and the Nation: A Chronological History of the Library of Congress*, Washington, D.C.: Library of Congress, 1979.

Goodrum, Charles A., *Treasure of the Library of Congress*, rev. ed., New York: H.N. Abrams, 1991.

Library of Congress web site: http://www.loc.gov/loc/legacy/loc. html.

Nelson, Josephus, and Judith Farley, *Full Circle: Ninety Years of Service in the Main Reading Room*, Washington, D.C.: Library of Congress, 1991.

LICHTWARK, ALFRED (1852–1914)
German photographer

Alfred Lichtwark was born November14, 1852, in Reitbrock near Hamburg as the eldest son of a poor miller. In 1860 the family moved to Altona where Alfred visited a school for the poor and worked subsequently as a teacher and librarian. In 1886 he was installed as managing director to the Kunsthalle (art hall) at Hamburg founded in 1846. Until his death on November13, 1914, Lichtwark presided the museum and bought a vast number of items for its collections: 1137 paintings, pastels, and watercolours, 890 sculptures, reliefs, and coins, 22,476 graphic prints and drawings, 8004 books, and 14,367 photographs.

Early in 1893, Alfred Lichtwark installed the first large show of the fine art photography movement on German ground, which was seen by more than 13,000 visitors in 51 days. This show started the career of the Viennese Trifolium (Hugo Henneberg, Heinrich Kühn, Hans Watzek), and instigated a number of similar exhibitions. Alfred Lichtwark published article after atricle on the pedagogic benefits of amateur photography, held lecture after lecture on the importance of collecting photographs, and by the end of the 19th century had managed to establish the German definition of the "engaged amateur." There has been no better mediator of the Art in Photography in German language since Alfred Lichtwark.

ROLF SACHSSE

LIÉBERT, ALPHONSE JUSTIN (1827–1913)

Born in 1827, Alphonse Justin Liébert began his career as a naval officer until he resigned to become photographer. In 1851, he opened a studio in the United States, in San Francisco, where he stayed twelve years long. Back in Paris, he promptly engaged in the French

photographic background until he joined in the Société française de photographie, 1873 in the hope of improving his technique.

He brought back from the United States the use of the melainotype process and was one of the first who used the carbon printing: he published many treatises on this subject.

Liébert also patented (1873) his own enlarger and invented a kind of color tint to put on pictures (1894); he also operated a sensitized paper factory between 1895 and 1900. Finally, he proposed the first studio equipped with the electric light (1879) and realized photographs of the Expositions universelles balloon (1889).

Moreover, Alphonse Liébert is known as one of those who recorded and photographed the events of the Paris Commune in 1870.

After his death, in February 1913, his son Georges Auguste Liébert continued his work in the studio.

MARION PERCEVAL

LIGHT-SENSITIVE CHEMICALS

Light, as a form of energy, has the power to promote chemical change. Of the many photochemical reactions, the few that are suited to making permanent photographic images employ light-sensitive salts of the metals silver, iron, uranium, and chromium, and some purely organic substances.

Silver halides were essential to the first 150 years of camera photography owing to their unique ability to capture an image "instantaneously." No other substance matches their unparalleled sensitivity, which depends on the formation of an invisible latent image, and its subsequent development, whereby the action of light is amplified enormously—a few hundredfold in the earliest development processes discovered by Henry Talbot and Louis Daguerre; but about ten million times in modern emulsions. All other photosensitive substances provide little or no amplification, and have no practical use in the camera, only for making positive prints or photograms, where intense illumination and lengthy exposures are no disadvantage.

Light of shorter wavelengths has greater intrinsic energy; the portion of the prismatic spectrum most effective photochemically is therefore the blue and ultraviolet—the "actinic" radiation discovered photographically by Johann Ritter in 1801. Photography usually entails the promotion by light of a chemical reduction of metal cations (positively-charged metal atoms) which take up, and are neutralized by the negatively-charged electrons supplied by an oxidisable substance, to form the elemental metal. Description of these photochemical reduction-oxidation reactions by traditional, balanced chemical equations tends to obscure the essence of the process, so this account will use ionic "half-reactions" explicitly involving the transfer of electrons, represented as e^-. The half-reactions are then combined proportionally to balance out the electrons in the overall equation.

Silver

Silver chloride was discovered in 1565 by Georg Fabricius in the mines of Bohemia, as the mineral "horn-silver" or *luna cornua*. By the 17th century, it was known to darken in sunlight; in 1614, Angelo Sala observed the same behaviour in silver nitrate (the *lapis lunearis* of the alchemists) when in contact with organic matter. Johann Heinrich Schulze was the first to demonstrate a primitive photographic effect in silver salts in 1725, and Carl Wilhelm Scheele showed in 1777 that the violet rays of the spectrum were most effective in decomposing silver chloride, and that the dark product was finely-divided silver. Knowledge of the light-sensitivity of the other silver halides had to await the discoveries of the parent halogens, bromine (by Antoine Balard, 1826), and iodine (by Bernard Courtois, 1811). In the following equations, X represents any of these, i.e., Cl, Br, or I:

Light + $X^- \rightarrow X + e^-$
Halide anion \rightarrow halogen atom + electron
$Ag^+ + e^- \rightarrow Ag$
Silver cation + electron \rightarrow silver metal
$X + X \rightarrow X_2$
Halogen atoms \rightarrow halogen molecule

The overall net reaction is:

Light + $AgX \rightarrow Ag + {}^1/_2X_2$
silver halide \rightarrow silver metal + halogen molecule

To prevent the reversal of this reaction and destruction of the image silver, a halogen absorber should be present: sodium citrate is used in many Printing-out papers. This process is discussed further under the entries for Photogenic drawing negative and Salted paper print. The chemistry of Development is described under Calotype or Talbotype. Pure silver halides react chiefly to blue and ultraviolet light. To render a balance of tones, negative emulsions must respond to the entire visible spectrum, which was achieved by Hermann Wilhelm Vogel's introduction of sensitizing dyes in 1873, extending the response to green light (orthochromatic plates), and eventually in 1904 to red wavelengths (panchromatic plates).

Iron

Many salts of iron(III) with organic acids are photosensitive; Johann Döbereiner first observed in 1831 that a green solution of iron(III) oxalate in sunlight

precipitates yellow insoluble iron(II) oxalate, evolving carbon dioxide gas:

UV light + $Fe_2(C_2O_4)_3 \rightarrow 2FeC_2O_4 + 2CO_2$
iron(III) oxalate \rightarrow iron(II) oxalate + carbon dioxide

This equation is the sum of two half-reactions, involving the transfer of electrons from the oxalate anion to reduce the iron(III) cation:

$C_2O_4^{2-} \rightarrow 2CO_2 + 2e^-$
$Fe^{3+} + e^- \rightarrow Fe^{2+}$

Iron(II) oxalate is too feebly coloured to constitute a satisfactory image, so a second reaction must be employed to make a permanent print, either by reducing a noble metal salt to the metal, such as silver, gold, palladium or platinum, or by forming a pigment such as Prussian blue, or ferrogallic ink.

In 1842, Sir John Herschel was the first to use iron(III) salts photographically, as the commercially-available ammonium iron(III) citrate or tartrate; the photochemistry is more complex than the oxalate, but the same principle of reduction of iron(III) to iron (II) applies. As iron(III) carboxylates are sensitive only to the ultraviolet and blue-green portions of the spectrum, they had to be exposed to daylight or sunlight in the nineteenth century.

Uranium

Light sensitivity in uranium salts was noted by Adolph Gehlen in 1804, and first used for photographic processes by Charles Burnett in 1855. Salts of uranium(VI), such as uranyl nitrate $UO_2(NO_3)_2$, (once called "uranic" salts) can be photochemically reduced on paper to uranium(IV) (once called "uranous"):

UV light + $UO_2^{2+} + 2e^- + 4H^+ \rightarrow U^{4+} + 2H_2O$
Uranyl cation + electrons + hydrogen ions \rightarrow uranium(IV) cation + water

This lower oxidation state of uranium can then reduce a noble metal salt to form the metal image of silver:

$U^{4+} + 2Ag^+ + 2H_2O \rightarrow UO_2^{2+} + 2Ag + 4H^+$
palladium:
$U^{4+} + PdCl_4^{2-} + 2H_2O \rightarrow UO_2^{2+} + Pd + 4HCl$
or gold:
$3U^{4+} + 2AuCl_4^- + 6H_2O \rightarrow 3UO_2^{2+} + 2Au + 4H^+ + 8HCl$

Alternatively, the uranium(IV) cation can be reacted with potassium ferricyanide to form the stable red pigment, uranyl ferrocyanide $(UO_2)_2[Fe(CN)_6]$, in the Uranotype process, analogous to the Cyanotype. Owing to its toxic and radiological hazards, uranium is no longer employed in photography, but it did enjoy a passing significance in the nineteenth century.

Chromium

Dichromates were discovered by Vauquelin in 1797 and used for tanning leather, before Mungo Ponton discovered in 1839 that papers coated with them changed colour on exposure to light, so launching this method of photographic imaging. The yellow-orange dichromate can oxidise many organic substances; the chromium(VI) is itself reduced to the state of blue-green chromium(III) ultimately (passing through brown intermediates of uncertain identity, possibly chromium(IV) dioxide, CrO_2). Acidic conditions are needed for the reduction half-reaction:

$Cr_2O_7^{2-} + 14H^+ + 6e^- \rightarrow 2Cr(H_2O)_6^{3+} + H_2O$
Dichromate + hydrogen ions + electrons \rightarrow hexaquachromium(III) cations + water

Light stimulates dichromate to oxidise organic matter in a number of ways, for example, oxidising a primary alcohol group (present in cellulose) to an aldehyde:

$RCH_2OH \rightarrow RCHO + 2e^- + 2H^+$
Alcohol \rightarrow aldehyde + electrons + hydrogen ions
So a typical overall reaction would be:
UV light + $Cr_2O_7^{2-} + 3RCH_2OH + 8H^+ \rightarrow 3RCHO + 2Cr(H_2O)_6^{3+} + H_2O$
Dichromate + alcohol + hydrogen ions \rightarrow aldehyde + hexaquachromium(III) + water

The product hexaquachromium(III) cation, $Cr(H_2O)_6^{3+}$, is capable of hardening (i.e. rendering insoluble) many macromolecular colloids that are normally soluble in water: either proteins such as gelatin, casein, and animal or fish glues, or carbohydrates such as starch or plant gums. This hardening is believed to result from the chromium(III) complex forming cross-links between the long organic chains to create a net-like molecular structure which is no longer soluble: carbohydrates bind to chromium(III) via their hydroxyl (–OH) groups, and proteins via their amino (–NH–) groups. The hardened colloid then acts as a vehicle to bind a pigment image in the Carbon and Gum bichromate processes, or as an etching resist in the Photomechanical processes.

Organic Substances

The "Heliographic" process of Nicéphore Niépce entails the light-induced hardening of bitumen, which becomes insoluble in lavender oil and petroleum. Bitumen has a complex and varied structure of polycyclic aromatic hydrocarbons (linked benzene rings), containing a small proportion of nitrogen and sulphur; its hardening is undoubtedly due to further cross-linking, as is the hardening of tree resins (colophony, or abietic acid) by light, first observed by Jean Sénébier in 1782. The photochemistry of these processes, which have been studied by Marignier in the 1990s, remains rather obscure.

Extracts of many plant dyes are fugitive colours and fade within hours or days of exposure to sunlight. They provided Sir John Herschel with his unfixable Anthotype process. A more permanent, positive-working organic photochemical process results from the decomposition of diazonium salts by light:

UV light + $C_6H_5N_2^+$ Cl^- + H_2O → C_6H_5OH + N_2 + HCl

phenyl diazonium chloride + water → phenol + nitrogen + hydrogen chloride

The diazonium salt that remains can couple with phenolic molecules to produce azo-dyes in a variety of colours, e.g.:

$C_6H_5N_2^+$ + $C_{10}H_7OH$ → $C_6H_5N=N$ $C_{10}H_6OH$ + H^+
Phenyl + ß-naphthol → benzene-azo-ß-naphthol + hydrogen ion
diazonium cation (a red dyestuff—Sudan I)

This reaction forms the basis of the Primuline and Diazotype processes.

MIKE WARE

See also: Salted Paper Print; Calotype and Talbotype; Photogenic Drawing Negative; Platinum Print; Positives: minor processes; and Cyanotype.

Further Reading

Bowen, Edmund John, *The Chemical Aspects of Light*, Oxford: Oxford University Press, 1946.

Eder, Josef Maria, *Ausfürliches Handbuch der Photographie* [*Comprehensive Manual of Photography*], Halle, Knapp, 1899; idem, *History of Photography*, trans. Edward Epstean, New York: Colombia University Press, 1945.

Hardwich, Thomas Frederick, *A Manual of Photographic Chemistry*, London: John Churchill, 1855.

Hunt, Robert, *A Popular Treatise on the Art of Photography*, Glasgow: Richard Griffin, 1841; idem, *Researches on Light*, London: Longman, Brown, Green, and Longmans, 1844; idem, *A Manual of Photography*, 4th ed., London: Richard Griffin, 1854.

James, TH (ed.), *The Theory of the Photographic Process*, 4th ed., New York: Macmillan, 1977.

Kosar, Jaromir, *Light Sensitive Systems: Chemistry and Application of Non Silver Halide Photographic Processes*, New York: Wiley, 1965

Marignier, Jean-Louis, "Asphalt as the World's First Photopolymer—Revisiting the Invention of Photography" in *Processes in Photoreactive Polymers*, edited by V. V. Krongantz and A. D. Trifunac, New York: Chapman and Hall, 1995.

Meldola, Raphael, *The Chemistry of Photography*, London: Macmillan, 1889.

Neblette, C. B., *Photography: its Principles and Practice*, 4th ed., London: Chapman and Hall, 1942.

Vogel, Hermann, *The Chemistry of Light and Photography*, London: Kegan, Paul, and Trench, 1888.

Ware, Mike, "On Proto-photography and the Shroud of Turin" in *History of Photography*, 21/4, Winter 1997, 26116–9.

LINDSAY, SIR COUTTS (1824–1913)
English painter and photographer

Sir Coutts Lindsay, painter and founder of the Grosvenor Gallery, was born in 1824 on the outskirts of London, the son of Colonel James Lindsay and Anne, both of whom were interested in the arts. After a stint in the army, Lindsay studied painting in the 1840s and early 1850s and exhibited paintings at the Royal Academy in the 1860s. He married Caroline Blanche Fitzroy in 1864. He took up photography at some point in the late 1840s or 1850s and made salted paper prints. His subjects mostly consisted of landscapes and architecture, particularly views of Italy. Examples of work attributed to Lindsay are in the collection of the Getty Museum and the Harry Ransom Humanities Center at the University of Texas, Austin. He was also photographed by David Wilkie Wynfield and Julia Margaret Cameron in the 1860s. Lindsay is most well-known for founding the Grosvenor Gallery in 1877, which for a number of years rivaled the Royal Academy as the most important exhibition venue for British artists. Lindsay died in 1913.

DIANE WAGGONER

LINDT, JOHN WILLIAM (1845–1926)

One of Australia's pre-eminent photographers, John Lindt produced a large volume of high quality photography, remarkable for its thematic range, aesthetic consistency and technical accomplishment. His pursuit of landscape and ethnographic subjects, coupled with a rare entrepreneurial flare, continued throughout a half century career. During his early Grafton years, from 1869–1876, Lindt produced a number of significant photographic portfolios, including *Australian Aboriginals* (c.1873–1874); *Australian Types* (c.1873–1874); and *Characteristic Australian Scenery* (1875). The latter series, commissioned by the New South Wales Government for the 1876 Philadelphia Centennial Exhibition, contains images such as *The Artist's Camp (Near Wintervale)* (1875) (Grafton Regional Gallery), and *Tower Hill Creek, N.S.W.* (1875) (National Library of Australia) which demonstrate Lindt's exceptional compositional ability and meticulous attention to exposure and printing technique, qualities apparent in much of his later work.

Strikingly, these early portfolios indicate Lindt's emblematic cast of mind to work ambitiously within defined pictorial categories. Like his contemporary and friend, Nicholas Caire (1837–1918), Lindt produced photographs with one eye firmly focused on the burgeoning national and international markets for such productions. When Lindt's *Australian Aboriginals* was marketed in late 1874, it was considered "the first

successful attempt at representing the native blacks truthfully as well as artistically" (Kerr, 1992, 475). The N.S.W. Government purchased albums for presentation to scientific institutions in England, and via an established international network of collecting agencies these photographs became the most widely distributed images of Aboriginal people in the late nineteenth century (Orchard, 1999, 163–70). The artificiality of the studio tableaux adopted by Lindt, which convey a poignancy of loss and displacement of his Gumbaynggirr and Bundjalung subjects probably not intended by the photographer, has been discussed elsewhere (Jones, 1985; Poignant, 1992; Annear, 1997; Orchard, 1999).

Lindt moved to Melbourne in 1876, established a new studio in 1877, and embarked on a series of landscape portfolios, including *Fernshaw and Watts River Scenery, Victoria* (c.1878–82), *Scenery on the Ovens and Buckland Rivers, Victoria* (c.1878–82), and *Lorne, Louttit Bay, and Cape Otway Ranges* (1883). He also made an extensive record of Melbourne public buildings and streetscapes. In June 1880 Lindt was commissioned by a Melbourne newspaper to travel to Glenrowan, Victoria to document the capture of the notorious bush-rangers, the Kelly gang. Arriving in the aftermath, Lindt produced one of his most memorable wet plate images, *Body of Joe Byrne, member of the Kelly gang, hung up for photography, Benalla*, 1880 (National Gallery of Australia). It has been acclaimed as one of Australia's first press photographs (Newton, 1988, 44). In the same year Lindt commenced his use of the recently introduced dry plate negative process—he received the first consignment to arrive in Melbourne—and from 1884 operated a second studio installed behind his newly acquired estate, "Ethelred," to service demand for his work. Sales of his Blacks' Spur scenery amounted to approximately 25,000 copies printed from the original negatives between 1882 and 1892 (Lindt, 1920, 3).

From 1869 Lindt imported quality photographic equipment and supplies direct from Germany and from about 1881 he was using recently introduced Voigtländer Euryscope lenses in the field and in the studio to produce enlargements. At this time he also became the sole agent for numerous studio supplies, including Haake & Albers' studio cameras, and Enholtz's scenic backgrounds.

In 1885 he travelled to the newly proclaimed Protectorate of British New Guinea, collecting native artifacts and producing several hundred dry plate negatives of tribal life and village scenes. A selection of fifty of these illustrated his *Picturesque New Guinea*, produced using a new autotype process. In 1888 The Argus commented on exceptional quality of Lindt's New Guinea photographs with directness: "It has often been a matter of discussion how far, or whether at all, photography may be considered a fine art. By the work of J. W. Lindt this question is decided in a way that is a triumph for his profession" (*The Argus* 27 November, 1888). In 1889 Lindt moved studio to 177 Collins Street and was commissioned by the Victorian Government to document the fledgling irrigation settlement of Mildura, in north-west Victoria. Here he produced a variety of scenes, many of which are imbued with a sense of occasion and civic optimism associated with this pioneer venture.

Under the auspices of the Royal Geographical Society (R.G.S.), Lindt made further expeditions, to the New Hebrides (1890), and to Fiji (1891), the latter trip resulting in the production of a series of outstanding autotype enlargements of a fire-walking ceremony. Some of these were first published as plates in the *Transactions of the R.G.S.* (Lindt 1894, 45–58), but plans to produce a volume along the lines of *Picturesque New Guinea* were not realized due to the severe recession of the mid 1890s. One of his last ethnographic portfolios, of named members of a touring Northern Australian Aboriginal performing troupe, was produced in an indoor studio setting in 1893.

Lindt closed his Melbourne studios and removed to "The Hermitage," at Black Spur, north-east from Melbourne in 1894. Here he continued to produce works of exceptional quality, such as *Snow at the Hermitage* (c.1905) (State Library of Victoria), and kept up with the latest international developments. He became a role model for the rising generation of pictorialist photographers. In 1924, a print of Lindt's dramatic, *The Hermitage, Blacks' Spur* (c.1912) (State Library of New South Wales), taken from one of the tree-houses in "The Hermitage" garden, was given to Harold Cazneaux (1878–1953), later recognized as one of Australia's outstanding pictorialists. In 1925 it was reported that Lindt "continues to produce remarkable and most artistic pictures of the beauties of mountain landscape. He is not a believer in the blurred effects favored by many... instead he is a master of detail" (*The Argus*, 19 March 1925). Lindt died of heart failure, on Black Friday 19 February, 1926, at the height of severe bush-fires which destroyed much of the Blacks' Spur Mountain Ash forest. "The Hermitage" and a substantial body of his work survives, most significantly in the collections of the State Library of Victoria, Melbourne. Other holdings include the State Library of New South Wales, Sydney; National Gallery of Australia, Canberra; National Library of Australia, Canberra; Clarence River Historical Society, Grafton; and Grafton Regional Gallery. Further global holdings are listed in (Orchard 1999).

KEN ORCHARD

Biography

John William Lindt was born 1 January 1845 in Frankfurt-Main, Germany, the son of Peter Joseph Lindt, a

customs officer, and Justine, née Rambach. He arrived in Melbourne, Victoria, in 1862, and settled in Grafton, New South Wales in 1863. He assisted photographer Conrad Wagner (c.1818–1910) until 1869, when Lindt took over management. Lindt married Wagner's daughter, Anna on 13 January, 1872 and opened a new studio in March 1873. He moved to Melbourne in 1876 and established studios at 7 Collins St. East, Melbourne in 1877. In 1884 he moved to "Ethelred," Hawthorn, from where he operated a second studio. Lindt made three South Pacific ethno-photographic expeditions, travelling to New Guinea (1885), the New Hebrides (1890) and Fiji (1891). Lindt was made a Fellow of the Royal Geographic Society of Australasia in 1887, and judged the 1887 General International Photographic Exhibition, Frankfurt-Main. Following the death of his wife, on 27 May, 1888, Lindt was appointed Honorary Commissioner—British New Guinea Court at the Melbourne Centennial Exhibition, 1888. He married, Catherine Cousens in July, 1889. Lindt closed his Melbourne studio in 1894, and established "The Hermitage," a mountain resort at Blacks' Spur, Victoria. He lived there until his death on 19 February, 1926.

Awards include; Brisbane, 1876; New South Wales Academy of the Arts, Sydney, 1876; Philadelphia Centennial Exhibition, 1876; Paris, 1878; Sandhurst, 1879; Christchurch, 1882; Melbourne, 1880; Amsterdam, 1883; Calcutta, 1884; Frankfurt-Main, 1885; Melbourne Centennial Exhibition, 1888; World's Columbian Exhibition, Chicago, 1893. His publications include: *A Few Results of Modern Photography* (Melbourne, 1886); *Apparatus, Chemicals and Requisites for Modern Photography* (Melbourne, 1886); *Picturesque New Guinea* (London, 1887); "Ascent of the Tanna volcano and a tour through the New Hebrides group," in *Transactions* of the Royal Geographical Society of Australasia (Victorian Branch), Vol. 8, No. 2 (Melbourne, 1891); "The Resources and Capabilites of the New Hebrides," in *Transactions,* Vol. 10, (Melbourne, 1893); "The Fire Ordeal at Beqa, Fiji Islands," in *Transactions,* Vol. 11 (Melbourne, 1894); *Companion Guide to Healesville, Blacks' Spur, Narbethong, and Marysville* (co-published with Nicholas Caire, Melbourne, 1904, reprinted 1912–13, 1916–17); and *A Tale About a Wayside Inn* (1920).

See also: Royal Geographical Society; Dry Plate Negatives: Non-Gelatine, Including Dry Collodion; and Pictorialists.

Further Reading

Croft, Brenda, "Laying ghosts to rest" in *Portraits of Oceania*, edited by Judy Annear, Sydney: Art Gallery of New South Wales, 1997.
Davies, Alan, *An Eye for Photography: The Camera in Australia*, Sydney, The Miegunyah Press in association with the State Library of New South Wales, 2004.
De Lorenzo, Catherine & Deborah van der Platt, "More Than Meets the Eye: Photographic Records of Humboldtian Imaginings," in *Mosaic* 237, Vol. 37, No. 4, edited by Dawne McCance, Manitoba: University of Manitoba, Winipeg, Canada, 2004.
Johanson, Graeme & Shar Jones, "J. W. Lindt," in *The Dictionary of Australian Artists, Painters, Sketchers, Photographers and Engravers to 1870,* edited by Joan Kerr, Melbourne: Oxford University Press, 1992.
Jones, Shar, *J. W. Lindt: Master Photographer*, Melbourne: Currey O'Neil Ross & the Library Council of Victoria, 1985.
Newton, Gael, *Shades of Light: Photography and Australia 1839–1988*, Canberra: Collins Australia & the Australian National Gallery, 1988.
Orchard, Ken, "J. W. Lindt's Australian Aboriginals (1873–74)," in *History of Photography,* Vol. 23, No. 2, edited by Michael D. Galimany, London: Taylor & Francis, 1999.
——, *The John William Lindt Collection*, Grafton: Grafton Regional Gallery, New South Wales, 2005.
Poignant, Roslyn, "Surveying the Field of View: the Making of the R.A.I. Photographic Collection," in *Anthropology and Photography 1860–1900*, edited by Elizabeth Edwards, London: Yale University Press in association with The Royal Anthropological Institute, London, 1992.
Quartermaine, Peter, "Johannes Lindt: Photographer of Australia and New Guinea," in *Representing Others: White Views of Indigenous Peoples*, edited by Mick Gidley, Exeter: Exeter Studies in American and Commonwealth Arts, No. 4, University of Exeter Press, 1992.
Willis, Anne-Marie, *Picturing Australia: A History of Photography*, Sydney: Angus & Robertson, 1988.

LION, JULES (c. 1816–1866)
American daguerreotypist

Jules Lion, also sometimes spelled as Lyons, is the earliest known African American daguerreian artist in the United States. He was also the first daguerreian artist in New Orleans.

Born in Paris around 1816, Lion was listed as a painter in New Orleans as early as 1837. News of the daguerreotype process reached New Orleans on Oct. 1, 1839, with the publication of an article in the New Orleans Bee. Within six months, in March 1840, Lion was exhibiting daguerreotypes he had made, including images of local buildings. He also demonstrated the daguerreotype process. He may have been assisted in his early experiments by his brother Achille, a dentist.

Although no documentation exists to confirm it, Lion may have influenced the renowned southern photographer George S. Cook, as Cook was a painter in New Orleans at the time and learned the daguerreotype process in the city.

Lion maintained daguerreotype studios at several locations on Royal and Charles Streets in New Orleans from 1840 to 1844. In 1843 he began offering hand-colored daguerreotypes, but a year later largely abandoned the photography business in favor of painting and

lithography. In 1848, Lion opened an art school in New Orleans and in 1865, a year before his death, he became professor of drawing at Louisiana College.

BOB ZELLER

LIPPMANN, GABRIEL JONAS (1845–1921)
French scientist and physicist

Lippmann who was born in 1845 is known for many fundamental contributions in several scientific fields: electricity, thermodynamics, optics, photography, and photochemistry. He became interested in the theory of light and, in particular, color theory. As early as 1886, he had developed a general theory of recording colors as standing waves in a light sensitive emulsion. However, most of his time was devoted to perfecting a suitable recording emulsion for his experiments. The first plates that Lippmann used were albumen emulsions containing potassium bromide. The plates were sensitized in a silver bath, washed, flowed with cyanine solution and dried. The sensitivity was extremely low. On February 2, 1891, Lippmann announced at the Academy of Sciences in Paris that he had succeeded in recording a true-color spectrum which was permanent. A little more than one year later, on April 25, 1892, Lippmann gave a second presentation at the Academy of Sciences. This time he displayed four color photographs of different objects. Later he was able to record a landscape with a grey building surrounded with green foliage and blue sky. The size of his early photographs was 4 cm by 4 cm and later 6.5 cm by 9 cm. Lippmann developed the first theory of recording monochromatic and polychromatic spectra in a panchromatic b/w emulsion. He applied Fourier mathematics to optics, which was a new approach at that time. His color photography technique is known as *Interferential Photography* or *Interference Color Photography*, however most often referred to as *Lippmann Photography*.

The principle of Lippmann photography is clear. Because of the demand for high resolving power in making Lippmann photographs, the material had to be a very fine-grain emulsion and, thus, of very low sensitivity. The coating of emulsion on Lippmann plates was brought in contact with a highly reflective surface, mercury, reflecting the light into the emulsion and then interfering with the light coming from the other side of the emulsion. The standing waves of the interfering light produced a very fine fringe pattern throughout the emulsion with a periodic spacing of $\lambda/(2n)$ that had to be recorded (λ is the wavelength of light in air and n is the refractive index of the emulsion). The color information was stored locally in this way. The larger the separation between the fringes, the longer was the wavelength of the recorded part of image information. When the developed photograph was viewed in white light, different parts of the recorded image produced different colors. This was due to the separation of the recorded fringes in the emulsion. The light was reflected from the fringes, creating different colors corresponding to the original ones that had produced them during the recording. It is obvious that there was a high demand on the resolving power in order to record the fringes separated in the order of half the wavelength of the light. It was also clear that the processing of these plates was critically important, as one was not allowed to change the separation between the fringes because that would create wrong colors. In order to observe the correct colors in a Lippmann photograph, the illumination and observation have to be at normal incidence. If the angle changes, the colors of the image will change. This change of color with angle is called iridescence and is of the same type as found in peacock feathers and mother of pearl.

Soon after Lippmann had introduced his technique several scientists and researchers began to explore and further develop this new color photography technique. Auguste and Louis Lumière produced a special ultra-fine-grain silver halide recording emulsion which had a much higher sensitivity than Lippmann's first emulsion. With the new emulsion Louis Lumière was able to recorded the first color portrait in 1893. In Germany Richard Neuhauss and Hans Lehmann contributed extensively to the development of Lippmann photography and both recorded excellent color photographs at the end of the 19th century.

Although Lippmann photography is extremely interesting from a scientific point of view, it was not very effective for color photography since the technique was complicated and the exposure times were too long for practical use. The difficulty in viewing the photographs was another contributing factor, in addition to the copying problem, which prevented Lippmann photography from becoming a practical photographic color-recording method. However, one-hundred-year-old Lippmann photographs are very beautiful and the fact that the colors are so well preserved indicates something about their archival properties. Still today, it is the only photographic technique that can record the entire color spectrum of a scene, rendering extremely realistic e.g., human skin and metallic reflections. When the Lumière brothers introduced the more practical *Autochrome* color process in 1907, the interest in Lippmann photography disappeared. However, in the late 1990s, a new interest in Lippmann's technology has been manifested by newly recorded Lippmann photographs (without the need for mercury) as well as several recent publications on interference color photography.

HANS I. BJELKHAGEN

Biography

Gabriel Jonas Lippmann was born on August 16, 1845, in Hollerich, Luxembourg, of French parents. The family moved to Paris and in 1858 he entered the Lycée Napoleon and ten years later École Normale. Lippmann studied also in Germany, with Helmholtz in Berlin and with Kirchoff in Heidelberg where he received the degree of Doctor of Philosophy in 1873. In Heidelberg he studied the relationship between electricity and capillary phenomena which led to the development of his capillary electrometer. In 1875 he moved to Paris and later became a professor of Mathematical Physics at the Sorbonne in 1883 and member of the Institute in 1886. At the Sorbonne he was teaching acoustics and optics. There he invented color photography and developed it during ten years. Lippmann became a member of the French Academy of Sciences in 1883 and its president in 1912. He was a member of the Bureau des Longitudes and a Foreign Member of the Royal Society in London. In 1908 Lippmann was awarded the Nobel Prize in Physics for his color photography technique. Lippmann died at sea on July 13, 1921, on his return from a trip to North America.

See also: Lumière, Auguste and Louis.

Further Reading

Bjelkhagen, Hans, A new optical security device based on one-hundred-year-old photographic technique. *Optical Engineering* 38 (1999): 55–61.

Bjelkhagen, Hans, Lippmann photography: reviving an early colour process. *History of Photography* 23, no. 3 (Autumn 1999): 274–280.

Connes, P., Silver salts and standing waves: the history of interference color photography. *Journal des Optics (Paris)* 18 (1987): 147–166.

Fournier, Jean-Marc, Le photographie en couleur de type Lippmann: cent ans de physique et de technologie. *Journal des Optics (Paris)* 22 (1991): 259–266.

Fournier, Jean-Marc, and Burnett, Paul, Color rendition and archival properties of Lippmann photographs. *Journal of Imaging Science and Technology* 38 (1994): 507–512.

Ives, Herbert, An experimental study of the Lippmann color photograph. *Astrophysical Journal* 27 (1908): 325–352.

Lehmann, Hans, *Beiträge zur Theorie und Praxis Direkten Farbenphotographie mittels Stehender Lichtwellen nach Lippmanns Methode* (Trömer, Freiburg i.Br. 1906).

——, Practical application of interference colour photography. *British Journal of Photography* (Col. Suppl.) (4 Nov. 1910): 83–86, Practical application of interference colour photography. *British Journal of Photography* (Col. Suppl.) (2 Dec. 1910): 92–95.

Lippmann, Gabriel, Sur la théorie de la photographie des couleurs simples et composées par la méthode interférentielle. *Journal de la Physique* 3, no. 3 (1894): 97–107.

Nareid, Helge, A review of the Lippmann color process. *Journal of Photographic Science* 36 (1988): 140–147.

Neuhauss, Richard, *Die Farbenphotographie nach Lippmann's Verfahren. Neue Untersuchungen und Ergebnisse*. Encyklopädie der Photographie, Heft 33 (W. Knapp Verlag, Halle a.S. 1898).

Senior, Edgar, Lippmann's process of interference heliochromy, in *A Handbook of Photography in Colours*, Section III, 316–343, Marion & Co., London 1900.

Valenta, Eduard, *Die Photographie in natürlichen Farben mit besonderer Berücksichtigung des Lippmannschen Verfahrens sowie jener Methoden, welche bei einmaliger Belichtung ein Bild in Farben liefern*. Zweite vermehrte und erweiterte Auflage. Encyklopädie der Photographie, Heft 2, W. Knapp Verlag, Halle a.S. 1912.

LITERARY GAZETTE
also *Journal of Belles Lettres, Arts, Sciences*

The *Literary Gazette* was a weekly review of literature, science and the fine arts that began publication on 25 January 1817. As well as being an important journal in its own right, its format provided the model for subsequent periodicals like the *Athenaeum*. The character of the *Literary Gazette* owed much to William Jerdan, who edited the journal from July 1817 to December 1850. Jerdan was a well-known figure on the literary scene and contributors to the *Literary Gazette* included Charles Lamb, Robert Southey, Edward Bulwer-Lytton, and Sir David Brewster. The *Literary Gazette* was at its most influential during the 1820s and 1830s before the commencement of the cheaper *Athenaeum*. In 1832 it was selling 4,000 copies a week, a large circulation for the time. However by 1860 sales had dropped to around 1,000 copies.

As well as its literary merits, the *Literary Gazette* reported on the meetings of the most significant scientific and learned societies. Its Parisian correspondent also provided frequent short accounts of papers read at the *Academie des Sciences*. *Mitchell's Press Directory* (1847) declared that its pages "combine the 'utile et duce' of periodical criticism, and are often the first to promulgate the novelties of science and literature." Jerdan himself was a member of the British Association for the Advancement of Science and claimed to have attended every meeting. His autobiography declared that, with some assistance, he himself "made up the [science] reports which filled hundred of columns of my publication" (*Autobiography*, vol. 4, 292). Although its articles do not carry the same authority or technical detail as the *Athenaeum*, several significant developments in early photography were announced in the *Literary Gazette*.

Henry Fox Talbot, Antoine Claudet, and Francis Bauer were among the notable figures who sent letters to the journal. Soon after Arago had made his announcement of Daguerre's process to the *Academie Des Sciences*, Francise Baur championed the cause of Niépce though a letter to the *Literary Gazette* that was printed on 2 March 1839. Similarly, immediately prior to making a patent for his calotype method, Henry Fox

Talbot published a letter announcing his discoveries on 8 February 1841. Talbot went on to send several letters recording the way that he had discovered his new process. He also used the *Literary Gazette* to communicate new developments to a wider audience. In the edition of 10 July 1841, for example, Talbot sent a letter that he had received from Dr Schafhaeutl, in Munich, detailing advances in photography "which, it is to be regretted, are little known in England."

The important role of the *Literary Gazette* in popularising photography is particularly evident in its export to America. After reading a copy of the periodical that had been transported to New York, Dr John William Draper, a friend of Samuel Morse, constructed one of first American Daguerreotype cameras in September 1839.

During the 1850s, the *Literary Gazette*'s coverage of photography was reduced to only intermittent reviews of the various photographic exhibitions. Its declining commercial fortunes meant that it finally ceased publication on 26 April 1862.

JOHN PLUNKETT

See also: Brewster, Sir David; Talbot, William Henry Fox; Claudet, Antoine-François-Jean; Bauer, Francis; Arago, François Jean Dominique; Daguerre, Louis-Jacques-Mandé; Calotype and Talbotype; Draper, John William; and Morse, Samuel Finley Breese.

Further Reading

Bourne, Henry Fox, *English Newspapers. Chapters in the History of Journalism*, London: Chatto and Windus, 1887.

Duncan Robert, "The *Literary Gazette*," *British Literary Magazines: The Romantic Age 1789–1836*, ed. Alvin Sullivan, Westport, CT: Greenwood Press, 1983: 242–247.

Gernsheim, Helmut, and Alison Gernsheim, *The History of Photography; From the camera obscura to the beginning of the modern era*, 1955; London: Thames and Hudson, 1969.

Jerdan, William. *The Autobiography of William Jerdan*, London: Arthur Hall and Virtue, 1852.

Mitchell's Newspaper Press Directory (London, 1846).

Pyle, G.J. Junior, *The Literary Gazette Under William Jerdan*, Unpublished PhD, Duke University, 1976.

"The Literary Gazette," *The Waterloo Directory of English Newspaper and Periodicals*, ed. John North, vol. 4, Waterloo: North Waterloo Academic Press, 1997: 2915–2917.

LITHOGRAPHY

Alois Senefelder (1771–1834), an Austrian actor and playwright, announced his planographic printing process of lithography in 1798. Lithography formed a major component of the revolution in print media that took place during the first half of the 19th century. By the 1840s lithography became widespread and in London, lithographic printing houses began to outnumber those of copper- and steel-plate printers.

Lithography had several advantages over relief and intaglio processes since the printmaker no longer needed to carve, scrape or dot a design onto the plate but could draw or paint it in a greasy substance on a porous printing surface, usually stone. It was a highly versatile process since a wide variety of drawing media could be used to produce the image, including chalk, crayon and pen and wash. Another feature of lithography was that it could in some respects mimic intaglio processes.

Lithography was to act as a primary building block to the photographic processes of Niépce, Daguerre, and Talbot and, in the form of a number of 'hybrid' processes, heralded photomechanical reproduction. However, while the inventors of photolithographic processes have received attention from historians, the history of photolithographic printers themselves remains largely unwritten.

A lithographic printing plate could be produced far more quickly than could those of traditional processes. This speed became even more advantageous when coupled with the acceleration in manufacture introduced in the early nineteenth century by the new mechanical printing presses. Furthermore, the lithographic stone could produce a very large number of impressions, which again brought considerable economic benefits as did the fact that, unlike steel and wood engraving, stones could be easily re-used. These were the prerequisites for mass production and for low unit costs, and they were to be central to the ultimate success of photography. As such they help explain why lithography and photography were such suitable and effective partners.

The introduction of photolithographic processes in the 1850s was the result of research initiated by Nicephore Niépce (1765–1833) and advanced by, amongst others, commercial lithographers and printers. Rose-Joseph Lemercier (1803–1887) had already been experimenting with combinations of photography and lithography since at least 1848. Together with Louis-Alphonse Davanne (1824–1912), Noël-Marie Paymal Lerebours (1807–1873), and Charles-Louis-Arthur Barreswil (1817–1870) Lemercier developed a planographic photolithographic process (*lithophotographie*) which was deposited with the Académie des sciences on 28 June 1852. In this photolithographic process a grained lithographic stone was coated with a solution of bitumen of Judea and ether, contact-printed with the original and then developed with ether. In 1854 six photographic views of French medieval churches by Henri Le Secq were published by this photolithographic process. However, in 1857 Lemercier abandoned this process, which could pull only a limited number of proofs, and purchased and comparatively successfully used the process invented by one of the most significant figures in the history of photomechanical reproduction, the French chemical engineer Alphonse Poitevin (1819–1882) whose process could provide up to 700 impressions from one stone. In 1855 had

Poitevin patented his photolithographic process in both France and England. He went on to win both prizes awarded through the competition to find a permanent photographic print process sponsored by Albert, duc de Luynes (1802–1867). Poitevin's process was improved by F. Joubert in London in 1860.

In 1857, John Pouncy's *Dorsetshire photographically illustrated* was published. Pouncy referred to the process used as photolithography but the images are heavily retouched and Pouncy may have meant that the original photography was manually copied by lithography that was in turn photolithographed. In the same year, in the Netherlands, Eduard Isaac Asser (1809–1894) invented a photolithographic process.

Around 1860 there were a number of significant advances in photolithography—largely as a result of state funding. Photozincography—invented by Colonel Henry James of Ordnance Survey Office in Southampton in the late 1850s—was based on a zinc plate rather than stone support. The process was extensively used in the reproduction of maps, though James also reproduced a series of historical and illuminated national manuscripts including the medieval Domesday Book. The reproduction of line illustrations and map printings was first made workable in commercially viable quantities in the late 1850s by John Walter Osborne (1828–1902) while working in the Department of Lands and Survey in Melbourne.

The facsimile reproduction of important historical manuscripts was another area in which photolithography was to have a significant impact. In 1866 the London publisher Day & Son exploited photolithography to publish an "exact facsimile" of William Shakespeare's famous First Folio of plays published in 1623. From 1868 William Griggs (1832–1911) of Peckham in South London, used photolithography to reproduce manuscripts, drawings and plans for a number of publications on Indian art and architecture, several of which were reports connected with the Archæological Survey of India.

Photolithography became increasingly exploited during the 1860s and this encompassed variants on the printing support and the integration of photography, lithography and other reprographic processes in 'hybrid' forms. Jules Labarte's *Histoire des Arts Industriels au Moyen Age et à l'époque de la Renaissance*, published in Paris between 1864 and 1866, is a particularly pertinent example in which photographic, photolithographic and chromolithographic processes were combined. The apogee of such a complex combination appeared in 1890 when the Art Institute Orell Fussli of Zurich invented the Photochrom—based on photolithography and used between four and fourteen asphalt coated lithographic stones to produce a "full colour" image from a black and white negative.

In Germany in the 1860s, photolithography was used to reproduce topographical views such as those printed by the firm of von Frey of Frankfurt-am-Rhein. However, it was the reproduction of architectural line drawing that saw the process's most influential role. J. Akerman of London was particularly prominent in this field. From the 1870s many of his photolithographs appeared in professional journals such as *Building News.*

Offset lithography, the commonly used photomechanical process to reproduce photographs, was introduced in England in the mid to late 1870s though the first application to print onto paper rather than metal took place in 1903 in America through the process developed by Ira Washington Rubel (died 1908)

Photolithography continues to play a prominent role in 21st century industries through its application to integrated circuits semi-conductor device fabrication.

ANTHONY J. HAMBER

See also: Niépce de Saint-Victor, Claude Félix Abel; Daguerre, Louis-Jacques-Mandé; Talbot, William Henry Fox; Lemercier, Lerebours and Bareswill; Davanne, Louis-Alphonse; Le Secq, Henri; Poitevin, Alphonse Louis; and James, Henry.

Further Reading

Senefelder, Alois, *A complete course of lithography… accompanied by illustrative specimens of drawings. To which is prefixed a History of Lithography…,* London: 1R. Ackermannm, 819.

Bryans, Dennis, *A Seed of Consequence. Indirect Image Transfer and Chemical printing. The Role Played by Lithography in the Development of Printing Technology,* 2000. PhD, Swinburne University of Technology.

Eder, Josef Maria *History of Photography*, New York: Dover Publications, 1968

Wakeman, Geoffrey *Victorian Book Illustration—The Technical Revolution*, David & Charles, Newton Abbot, 1973

Aubenas, Sylvie, "Alphonse Poitevin (1810–1882)—La naissance des procédés de reproduction photoméchanique et de la photographie inalterable," Maitre ès lettres, Paris: Ecole nationale des chartes, 1987.

Sylvie Aubenas, *D'Encre et de charbon—Le concours photographique du Duc de Luynes 1856–1867* (exh.cat.), Paris: Bibliothèque nationale, 1994.

Jeff Rosen, "Lemercier et Compagnie: Photolithography and the Industrialization of Print Production in France, 1837–1859," PhD Thesis, Northwestern University, Evanston, Ill., 1988.

Michael Twyman, *Lithography 1800–1850: the techniques of drawing on stone in England and France and their application to works of topography*, Oxford: Oxford University Press, 1970.

Michael Twyman, *Early Lithographed Books*, London: Farrand Press and Private Libraries Association, 1990.

LIVERNOIS, JULES-ISAÏE (1830–1865) AND JULES-ERNEST (1851–1933)
Canadian photographers

Jules-Isaïe Benoit *dit* Livernois was born on October 22, 1830, in Longueuil, near Montreal, Quebec. He

established his daguerreotype studio in conjunction with a sewing machine business in Quebec City in December 1854. At the height of his brief photographic career, he operated up to three studios. Married in 1849 to Elise L'Heureux (L'Hérault), she, like other husband and wife photography teams such as Darius Reynold Kinsey and his wife Tabitha, participated fully and sometimes independently in the photography business. Between 1857–1858, Elise worked under the name Madame Livernois and took daguerreotype portraits of children. After her husband died on October 11, 1865, of tuberculosis, she assumed management of his studio and established a partnership in May 1866 with her son-in-law, the photographer Louis Bienvenu; the Livernois & Bienvenu partnership dissolved in April 1873. By December 1873, her son Jules-Ernest Livernois, born on August 19, 1851, in Saint-Zéphirin-de-Courval, Quebec, assumed ownership of the Livernois studio. J.E. Livernois perpetuated his parents' vision by traveling throughout Quebec for landscape views and exterior group portraits, much as his competitor William Notman and his sons did throughout Quebec and other parts of Canada. Unlike Notman and Alexander Henderson, however, the Livernois family spent little time photographing outside Quebec. After J.E. Livernois' death on June 8, 1933 in Quebec City, the portrait studio continued to operate until 1974, first by J.E. Livernois' son Jules Livernois (1877–1952), then by an owner-operator, who left in 1969; J.E. Livernois Limitée went into bankruptcy in 1979. The largest collections of the Livernois photographs, a remarkable, detailed record of many aspects of life in Quebec, are preserved by the Library and Archives Canada and the Archives nationales du Québec. J.E. Livernois was one of four 19th-century photographers commemorated with a Canadian postage stamp in 1989. The Livernois family is also memorialized in Quebec place names.

DAVID MATTISON

LLEWELYN, JOHN DILLWYN (1810–1882)
Welsh photographer, polymath, and landowner

John Dillwyn Llewelyn was born John Dillwyn 12 January 1810 at The Willows, Swansea, the second child and eldest son of Lewis Weston Dillwyn, Fellow of the Royal Society and the Linnean Society, and Mary, *nee* Llewelyn. Upon coming of age, he assumed additionally his maternal grandfather's surname Llewelyn inheriting his estates. He usually signed himself J.D. Llewelyn.

Grandfather Llewelyn died in 1817 and the family moved to Penllergare, his former estate. In 1833 Llewelyn married Emma Thomasina Talbot, youngest daughter of Lady Mary Lucy and Thomas Mansel Talbot of Penrice and Margam, and youngest cousin of Henry Fox Talbot of Lacock Abbey. Children included the eldest, Thereza who married Nevil Story Maskelyne. At Penllergare, Llewelyn designed a supreme example of Victorian landscaping, creating two artificial lakes, a man made waterfall and growing many exotic trees and plants, some from Henry Talbot, and Sir Joseph Hooker of Kew. In his walled garden he grew tea, coffee, pineapples, and created a heated glasshouse for the propagation of orchids with a waterfall and pond.

Educated by private tutors, Llewelyn matriculated at Oriel College, Oxford in 1827. He met many of the leading scientists of the period including Sir Charles Wheatstone, Faraday, John Wheeley Gough Gutch, another early photographer, and the Groves. In 1844 he assisted Wheatstone with the first ever experiments in sub-marine telegraphy off the Mumbles, south Wales. The same year he welcomed Isambard Kingdom Brunel to Swansea for the south Wales extension of the Great Western Railway.

Llewelyn was elected a Fellow of the Royal Society, 1836, and the Linnean Society, 1837. Henry Talbot considered Llewelyn to be the first botanical photographer. In 1842 Llewelyn used the daguerreotype process to send images of rare orchids to Kew for identification. In 1848 Llewelyn demonstrated the propulsion of a small boat by an electric motor, the first time this was done in Britain, to the British Association for the Advancement of Science meeting in Swansea.

Llewelyn's public duties included being a magistrate and a member of, many local committees. He endowed schools, churches, and a large park for the people of Swansea.

News of Talbot's photographic discovery reached Penllergare in February 1839, from Talbot. Llewelyn immediately began experimenting with the new process and also the daguerreotype process. Early photogenic drawings have disappeared but the earliest daguerreotype is dated 1840. His friend, and distant relative, Calvert Richard Jones, also joined in the local excitement. Later photographic friends included Antoine Claudet, with whom Llewelyn carried out experiments on the daguerreotype process, and Philip Delamotte. Llewelyn tried all the early processes but mainly used the calotype and collodion. When Talbot challenged Laroche in 1854 for an infringement of his calotype patent, Llewelyn wrote to Peter Fry:

> I heartily grieve to hear of all his present litigation, his first step to secure himself an exclusive monopoly was a most inadvised one. It has put him in a false position and must terminate in an abundant harvest of vexation, trouble and loss. It seems however to be with him a kind of monomania—he must be a little insane on that point.

Llewelyn also tried the photoglyphic drawing process and was invited by Talbot to visit Lacock to discuss it.

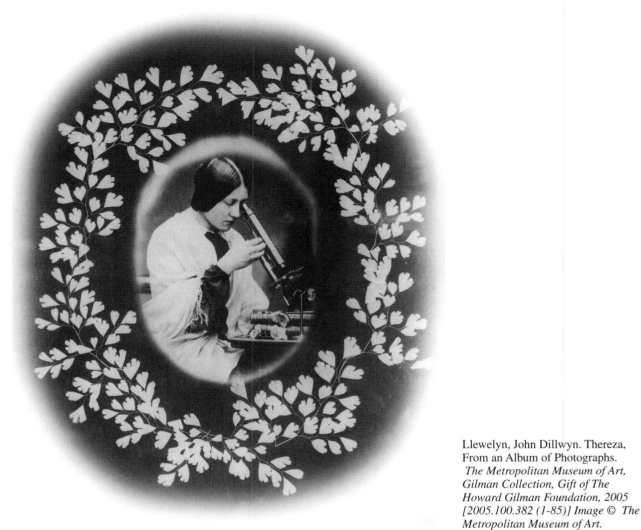

Llewelyn, John Dillwyn. Thereza, From an Album of Photographs. *The Metropolitan Museum of Art, Gilman Collection, Gift of The Howard Gilman Foundation, 2005 [2005.100.382 (1-85)] Image © The Metropolitan Museum of Art.*

Llewelyn was a founder Council member of the Photographic Society of London in 1853, and was later nominated first Country Vice-President in December 1854. He exhibited at their first exhibition in 1854 and continued until 1858. At one exhibition Queen Victoria took away a print of the November Fifth Guy Fawkes bonfire and another had to be sent from Swansea. There are a number of Llewelyn's photographs in her albums. He also exhibited at Dundee in 1854 and the Manchester Art Treasures exhibition in 1857. In 1855 Llewelyn was one of the British photographers at the Exposition Universelle in Paris, exhibiting four images under the title of *Motion* including probably the first ever photograph, by the collodion process, *Clouds over St Catherines, Tenby* taken in 1854, where the clouds are on the same negative as the main scene. Llewelyn was awarded a silver medal of honour. His first instantaneous image was taken in 1853 of *Waves Breaking in Caswell Bay*, an exposure estimated at one twenty-fifth of a second, and probably using a falling shutter of his invention. In 1859 he contributed two images to "*The Sunbeam* a book of photographic images produced by Delamotte. Announced, by Joseph Cundall in 1854, but never published, was *Pictures of Welsh Scenery.*

The major problem with the collodion process was sensitizing, exposing, and developing in a comparatively short time. In 1856 Llewelyn announced his oxymel process, peserving the collodion in a moist state for many days or weeks. *The Illustrated London News* hailed this as one of the greatest boons for photographers. He also experimented with glycerine and dry collodion plates but was not satisfied with the results.

In 1859 Llewelyn, Maskelyne, Hadow, and Hardwich, wrote a paper on *The Present State of our Knowledge regarding the Photographic Image* for the British Association for the Advancement of Science.

Photography was a family commitment and Llewelyn taught his brother Lewis Llewelyn Dillwyn, sister Mary and daughter Thereza. In 1856 he bought Thereza a single lens Murray & Heath stereo camera for her birthday. They both used it and Thereza often made a stereo image whilst her father made a mono one. Emma

appears never to have made a camera image, but did much of his printing, to an extent that Henry Talbot asked if she needed help from Nicholas Henneman.

In the 1860s, Llewelyn joined the Amateur Photographic Association, contributing to their exchange albums and becoming a member of council. He abandoned making images around the end of the 1850s possibly due to life-long asthma. In January 1854 he had been very ill, most likely due, so his mother-in-law Lady Mary wrote to Henry Talbot, to inhaling poisonous photographic chemicals.

In 1859 local militia were organised to repel a possible French invasion. Llewelyn captained the Penllergare 5th Corps. The same year he appears in a photograph, including Roger Fenton, titled *Volunteers at Hythe*.

In the late 1870s the Llewelyns moved to London and he died at Atherton Grange, Wimbledon, on 24 August 1882. He is buried next to Emma in the churchyard of his church at Penllergaer.

RICHARD MORRIS

See also: Wheatstone, Charles; Faraday, Michael; Gutch, John Wheeley Gough; Talbot, William Henry Fox; Jones, Calvert Richard; Claudet, Antoine-François-Jean; Delamotte, Philip Henry; Collodion; Calotype and Talbotype; Laroche, Martin; and Victoria, Queen and Albert, Prince Consort.

Further Reading

Gower Journal XLVIII. 1997. "John Dillwyn Llewelyn and the Electric Boat," Gower Society, ISBN 0 902767 17 8 [copy in NLW].

Arnold, H J P., *William Henry Fox Talbot—Pioneer of Photography and Man of Science*, Hutchinson Benham London 1977, ISBN 0 09 129600 5.

Barnier, John (ed.), *Coming Into Focus*, Chronicle Books, San Francisco, 2000. ISBN 0 8118 1894 2 [pbk] Calotype negatives. 17–25.

Hoskings, Eric, *Owl*, Pelham Books 1982, UK ISBN 07202 13900. Illustration of Owl at Clifton Zoo, JDL 1854.Eric Hoskings.

Morris, Richard, 'The Daguerreotype and John Dillwyn Llewelyn,' in *The Daguerrean Annual*, Pittsburgh: Daguerrean Society, 1997.

Photohistorian, RPS Historical Group, Bath. ISSN 0956 1455. No. 99 Winter 1992. The *Oxymel Process of John Dillwyn Llewelyn Part 1*.

——, ISSN 0956 1455, Part 2, No. 100, Spring 1993.

——, ISSN 0956 1455, No. 109, October 1995. *The Forgotten Negatives of John Dillwyn Llewelyn*.

Titterington, Christopher, *The V&A Album*, The Associates of the V&A 1985. ISBN 0 948107 16 2 Llewelyn and Instantaneity, 138–145,

Jeffrey, Ian, *Photography—A Concise History*. UK: Thames & Hudson. 1981. ISBN 0 500 18187 X

John Dillwyn Llewelyn, 1810–1882, *The First Photographer in Wales*, Welsh Arts Council 1980. ISBN 0 905171 60 8.

Journal of the Photographic Society of London—Volume 1, London: Taylor & Francis, 1854. Facsimile edition Royal Photographic Society 1976. Article on the Calotype process by John Dillwyn Llewelyn.

Scharf, Aaron. *Pioneers of Photography*, London: BBC Publications, 1975.

Sunpictures Catalogue 2. Llewelyn, Maskelyne, Talbot. New York: Hans Kraus Jr., Undated.

The Golden Age of Photography 1839–1900. Edited Mark Haworth-Booth. *Aperture* in association with the Victoria & Albert Museum, 1984. ISBN 0 905209 67 2.

Introduction to Photography and Time. Special issue of *Aperture*, NY, No. 158, Winter 2000, 2–11, ISBN 0 89381 898 4.

LOCKEY, FRANCIS (1796–1869)
English

Francis Lockey was born at Reading, Berkshire England, in 1796 studied at Cambridge and became a priest in 1823. He became vicar of Swainswick, a small village outside Bath in 1836, where he lived with his wife Susanna and daughter Emma.

Lockey used the daguerreotype process but is chiefly known for using calotype and waxed paper negatives well into the late 1850's. Lockey documented the Medieval, Georgian and early Victorian buildings of Bath and surrounding towns and villages. His pictures show largely deserted locations, never, or only accidentally, having figures in the composition. This was partly caused by the long exposures required with his large-format paper negatives, his negative list (private collection, UK) gives exposure times between three and fifteen minutes. Lockey also produced many large-format stereo views (most negatives were 11 × 9 inches) for use in a Wheatstone viewer.

Many of his studies were made with the help of his coachman Henry Burrough, often using the roof of his carriage as a platform to record churches and other historic buildings. Lockey was very dedicated to his craft, being well into his late fifties when making his architectural views. As well as photographing in the Bath area Lockey travelled to south and west Wales and made many studies of ruined castles, abbeys and priories in and around Swansea.

Later Lockey used the wet-collodion process to make portrait studies but unfortunately these glass negatives were destroyed. Many of his paper negatives, however, survive in museums in Bristol, Bath, and Wales.

IAN SUMNER

LOECHERER, ALOIS (1815–1862)
German photographer and studio owner

To his contemporaries, Alois Loecherer was the most well known as a distinctive portraitist of the better half of Munich's society in the 1850s. From 1845 he used Talbot's process and opened his first studio in 1848 in

the house of Franz Hanfstaengl. In 1849, he was the first to announce "photography on paper" in Munich and offered lessons in this method. In 1850, he opened the first exhibition of his genre photographs at the Munich Kunstverein. He produced large numbers of view of Munich's streets, places, backroads, and old houses. Alois Loecherer was best known for his series on the construction and erection of Ludwig Schwanthaler's statue of the Bavaria which formed one of the first series in photographic journalism.

Loecherer was the pioneer of salt printing and photography on paper in the German speaking countries. His print had comparatively large formats were overtly intended to be exhibited. Due to his early death Alois Loecherer was not able to nuture the needed impact on the development of German photography as a form of art.

Alois Loecherer was born on August 14, 1815, in Munich. From 1837 to 1839, he studied chemistry and pharmacy at Munich University under Franz von Kobell. From 1840 to 1848, he worked as a pharmacist in Munich. Married in 1849, had two daughters born in 1851 and 1852. In 1853 he settled in as a portraitist in his own house in Munich. Died on Aug. 15, 1862, of a brain attack. His studio was taken over by the photographers Albert Kristfeld and Bernhard Froehlich.

ROLF SACHSSE

LONDE, ALBERT (1858–1917)
French medical researcher, chronophotographer

Londe was born in 1858, the date and place of his birth remain unknown however. Londe was one of the pioneers of medical photography and more particularly of photography with x-rays. He was also the inventor of a form of instantaneous photography: Chronophotography, which is a Victorian application of science (the study of movement), and art (photography). The word is from the Greek chronos and photography, "pictures of time." Notable chronophotographers include Eadweard Muybridge, Etienne-Jules Marey and Ottomar Anschütz. Chronophotography and Londe are both affiliated with professor Charcot's photography which marked the beginning of medical photography's history. However, Londe's photography was characterized by chronophotography's instantaneous and motion-analyses. In 1879 Londe became a member of the Société française de photographie (S.F.P.) in Paris.

In 1878 a laboratory for medical photography had been set up at La Saltpêtrière hospital in Paris. In 1882 Londe began working there as the director of photographic service in the laboratory of the Hospice of the Salpétrière, which had a partnership with the Clinic for diseases of the nervous system run by professor Charcot. Londe broached most issues of concern regarding photography. He ordered the construction of a variable-speed, circular shutter, which was destined to replace the existing guillotine and wing shutters that proved inadequate for animated subjects or swiftly moving objects. Research conducted by Muybridge and Anschütz gave him the idea, that where speed is concerned, camera should use several lenses. Londe constructed a camera fitted with nine lenses arranged in a circle. A series of electronic magnets energized a sequence regimented by a metronome device released nine shutters in quick succession, taking nine pictures on a glass plate. He used the camera to study the movements of patients during epileptic fits. Londe's improved camera of 1891 used twelve lenses (in three rows of four) and was used for medical studies of muscle movement in subjects performing a variety of actions as diverse as those of a tightrope walker and a blacksmith. The sequence of twelve pictures could be made in anything from 1/10th of a second to several seconds. The design of Londe's laboratory at La Saltpêtrière was in many ways similar to Marey's Station Physiologique, and was similarly subsidized by the Parisian authorities. Although the apparatus was used primarily for medical research, Londe noted that it was portable, and he used it for other subjects—horses and other animals, and waves, for example. General Sobert developed, in conjunction with Londe, a chronophotographic device to help in the study of ballistics. Londe's pictures were used as illustrations in several books, notably by Paul Richer, widely read in medical and artistic circles.

During 1884, Londe lectured on photography and its scientific applications.

In 1887, he worked with Tissandier, and the Société d'Excursions des Amateurs Photographes. He was the vice-president from 1887 to 1895, president from 1895 to 1900, and president for life from 1900 on. Consequently, Londe had many photographic adventures starting with the circus, bullfights and with the theatres of the streets. The excruciating exercises of collecting images of new subjects preceded the photo-journalistic iconography. Furthermore, these subjects belonged to a universe located between reality and imaginary, and because of this limbo were curiously connected to the patients that Londe photographed in Salpetrière. These portraits reveal an attraction for the marginal beings of the industrial time.

In 1888 Londe did experiments with shots of a clown doing a perilous jump at the Hippodrome and are likely considered a study of instantaneous photography.

In 1890 he was elected a board member of the Société française de photographie, and by 1892, had been elected to the position of assistant general-secretary. During that period he compiled numerous reports on prices, inventions, and cameras.

In 1893 he constructed a camera for pictures 7 × 7 cm on plates 24 × 30 and he lectured on photography at the Arts et Métiers in Paris. In 1895 with the advent of Röntgen's X, he began creating the first radiography and radioscopy laboratory for Parisian hospitals.

The beginning of 1900 he began experimenting with several ways to photograph using artificial lighting. He experimented with neon, but the results were not successful. He showed them, however to the Club Nautique in Nice. In 1904 he resigned as active member from the Société française de photographie in Paris. Londe continued experimenting with artificial light and used magnesium, which caused a short explosion, giving off a burst of light.

Around 1908 he made a chamber based on his experiments and plan of his chrono-photographic machine, which used artificial light. He discovered also the possibilities of creating duplicate images. Because of these two contributions to photography he was made an honorary member.

Londe's interest in the Autochrome process grew in the last years of his life. The autochrome was a positive colour transparency process, patented in June 1906 by Auguste and Louis Lumiére in Lyon, France. Like other techniques at the time, it employed the additive method, recording a scene as separate black and white images representing red, green and blue, and then reconstituting color with the help of filters. To do this on a single plate, the Lumiéres dusted it with millions of microscopic (avg. size 10 to 15 microns) transparent grains of potato starch that they had dyed red (orange), green and blue (violet). This screen of grains worked as a light filter to interpret the scene when the light passed through them exposing a panchromatic black & white emulsion. The exposed plate was then reverse processed which resulted in a transparency. The first time he lectured at l'Academie des sciences his presentation was on this first industrial color method. In front of many specialists and professionals, he successfully tested with the plates, which later came onto the commercial market in 1907. He published in two years 12 texts concerning this topic. However none of its experiments was publicly shown. In 1908, his experimentation abruptly ended when his wife died, but he started again with his experiments in 1909. Finally in 1914, he showed his photographs to the Photo-Club of Nice.

He left his collection of works, equipment and documents to the Société française de photographie (S.F.P.) in Paris.

He died September 11, 1917, at the Château de Bréau at Rueil, near La Ferté-sous-Jouarre in France.

JOHAN SWINNEN

See also: France, Chronophotography, Medical Photography; X-ray Photography;

Instantaneous Photography; Société Française de Photographie; and Lumière, August, and Louis.

Further Reading

Auer, Michel, and Michèle Auer, *Encyclopédie internationale des photographes des débuts à nos jours,* CD-Rom, Neuchâtel, Éd. Ides et Calendes, diffusion Hazan, 1997.

Bernard, Denis, *La lumière pèsée. Albert Londe et la photographie de l'éclair magnésique, 1888–1915, Etudes photogaphiques,* no. 6, Mai 1999, Paris: Société française de photographie, 1999.

Boom, Mattie (ed.), *A New Art. Photography in the 19th Century,* Rijksmuseum, Amsterdam, 1996.

Boulouch, Nathalie, *Albert Londe, positions autochromistes,* Etudes photogaphiques, no. 6, Mai 1999, Paris: Société française de photographie, 1999.

Frizot, Michel (ed.), *Nouvelle Histoire de la Photographie,* Paris: Bordas, 1994.

Gautier, A., *Un Pionnier méconnu de la photographie médicale,* Albert Londe.

Gernsheim, Helmut, and Alison Gernsheim, *The origins of photography,* London: Thames and Hudson, 1982.

Heilbrun, Françoise (ed.), *L'invention d'un regard (1839–1918),* Paris: Musée d'Orsay/Bibliothèque nationale, 1989.

Lemagny Jean-Claude, *Sayag, Alain, L'invention d'un art,* Paris: Centre Georges Pompidou, 1989.

Londe, Albert, *La photographie médicale. Application aux sciences médicales et physiologiques, par,* Paris: Gauthier-Villars, 1893, x, 220 p. illus., 19 plates. 24.5 cm.

Londe, Albert, *Traité pratique de radiographie et de radioscopie: Technique et applications medicals,* Paris: Gauthier-Villars et fils, 1898, Thèse Med. Caen. 1984, no. 1248.

Witkin, Lee D. (ed.), The photograph collector's guide, London: Secker & Warburg, 1979.

LONDON STEREOSCOPIC COMPANY (c. 1854–1922)

When stereographs were demonstrated to the public at the Great Exhibition of 1851 they started a collecting craze that was to last for the next twenty years. The principle of using binocular vision to create the illusion of space had been known for some time but the introduction of photography meant its potential could finally be realised and the stereoscope, developed by Charles Wheatstone and Sir David Brewster, allowed photographs to be viewed in "solid" three dimensions. The London Stereoscopic and Photographic Company, as its name suggests, furnished the Victorian mania for stereographs and by 1854 the company had sold over half a million viewers, proclaiming in their advertising that "no home is complete without a stereoscope."

Shopkeeper George Swan Nottage (1823–1885) founded the company with his associate Howard Kennard in the early 1850s. Nottage went on to make his fortune, and was later elected Alderman and then Lord Mayor of London (1884–1885.) London Stereoscopic was soon the largest photographer and manufacturer of

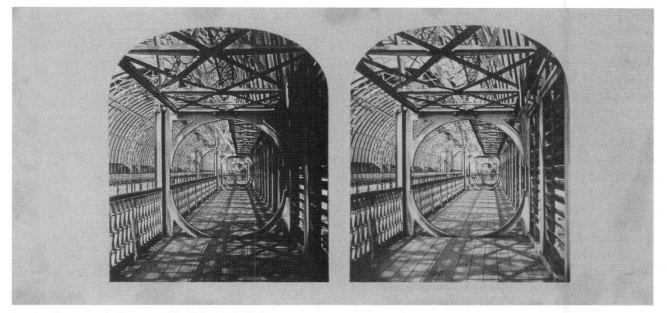

London Stereoscopic Company. The Telescopic Gallery.
The J. Paul Getty Museum, Los Angeles © The J. Paul Getty Museum.

stereographs in the Victorian era. By 1858 they were advertising 100,000 views of famous buildings and places of interest in England and abroad (although the actual figure is more likely to have been a tenth of that) and manufacturing stereoscopic cameras as well as viewers for the consumer market. Their photographers travelled as far afield as the Middle East and America. William England, who was with the firm from its inception travelled in America in 1858 and 59, documenting New York, the Hudson River, and Niagara Falls, and the new railways and bridges along the route. The important "North America Series" was immensely popular, being amongst the first photographic views of the US to arrive in Britain. England was instrumental in building the firm's reputation with travels in Ireland in 1857 and Paris in 1860 and technical advances in equipment including the invention of the focal plane shutter. He also produced the popular Comic series, which though derided at the time by intellectuals as "low art" is now an important record of Victorian domesticity and street life. His last major venture for the company was as sole photographer of the 1862 International Exhibition, for which London Stereoscopic paid the enormous sum of £1,500 for exclusive photographic rights.

London Stereoscopic also bought, distributed and published material by non-commissioned photographers, including the work of William Grundy of Sutton Coldfield (1806–1859) whose collection of 200 negatives was acquired after his death. Grundy had published a series of half stereos to illustrate *Sunshine in the Country, A Book of Rural Poetry,* (Richard Griffin & Co, 1860) comprising of idyllic rustic scenes, country folk and rural occupations. London Stereoscopic's 1860

catalogue also advertised a series of views of Switzerland by Adolphe Braun and though William England left to pursue his own career in 1863 he continued to publish views through the company's catalogues under his own name. Renowned sports and war photographer Rheinhold Theile worked as a watercolourist and photographer for the company between 1880– 894. These references to individuals are unusual, however, as London Stereoscopic rarely divulged the names of their operators.

In 1862 alone the company sold one million stereoscopic views and had offices and agents as far afield as New York. During the 1860s and 1870s, however, stereoscopy began to decline in popularity. London Stereoscopic diversified their interests adding large format travel views and portraiture to their catalogues. By 1889 they advertised a comprehensive range of cameras, lenses and general photographic goods and also offered a wide range of photomechanical printing services, including Woodburytpe, collotype, photomezzotype, photolithography, and platinogravure. Their Woodburytypes were widely used in book publication and periodicals, and next to the Woodbury Company itself London Stereoscopic were the largest manufacturers of Woodburytypes in England, often donating albums of Woodburytypes to hospitals and charities. In 1896 the commercial department of the firm at 54 Cheapside, London offered letterpress printing to the trade, as well as commercial printing of photographs in silver, bromide, carbon and platinum. They had also begun to expand into newly opened area of photoengraving and made half-tone blocks for the printing trade.

An important spin-off for the company was the

carte de visite market. Originally introduced as a novel and inexpensive idea for personalising visiting cards, Disdéri's method of taking multiple images on a single plate was the perfect medium for mass producing images of the rich and famous. The Victorians wild thirst for collecting, building up albums of politicians, clerics, actresses, and sporting heroes, was termed "cartomania" and sparked an unquenchable fascination with celebrity images that persists today. In 1861 and 1864 London Stereoscopic opened portrait studios at 110 and 108 Regent Street respectively (106 was added in 1875 while 110 closed in 1888.) They were amongst the most fashionable and chic in Europe and their catalogue of clients reads as a Who's Who of the Victorian age. Names such as Charles Dickens (including a rare portrait without beard), Sarah Bernhardt, William Booth, John Everett Millais, and William Gladstone filled the catalogues. Lord Palmerston sat for four dozen portraits in one sitting alone. They also published the famous image of the *Leviathan* engineer Isambard Kingdom Brunel by Robert Howlett in various formats and became *Photographers to Her Majesty* after obtaining the Royal Warrant in 1895. In addition to their brisk trade for the private carte-de-visite collector the London Stereoscopic commercially licensed their photographs and celebrity images for use in the press and periodicals of the day such as *The London Illustrated News* and *The Graphic,* and in theatre programs and music sheets. Their photographers covered newsworthy events such as the re-opening of Crystal Palace by Queen Victoria in 1854. In 1871, during the Franco-Prussian War London Stereoscopic Company produced micro-photographic prints, each barely larger than a postage stamp, of special pages of *The Times* devoted to messages to the inhabitants of Paris, which arrived in the besieged French capital by pigeon post.

A great deal of London Stereoscopic's success can be attributed to their versatility, keeping pace with new trends and innovations in photography. Their interests were incredibly diverse and forward-looking. The company held the patent for and manufactured a popular model of the zoetrope, having earlier revived interest in persistence of vision by demonstrating the illusion of a vase by rotating a bent piece of wire and, for a time, was the sole licensee of the phonograph. Their Regent Street offices finally closed in 1922 but they should be remembered as one of the world's first and largest producers of licensed imagery on a global basis. Their catalogue is a lasting record of and tribute to the Victorian era, documenting new worlds and great engineering projects alongside the growing obsession with celebrity and home entertainment.

SARAH MCDONALD

See also: Great Exhibition of the Works of Industry of All Nations, Crystal Palace, Hyde Park (1851); Brewster, Sir David; Wheatstone, Charles; England, William; Braun, Adolphe; War Photography; Woodburytype, Woodburygravure; Collotype; Cartes-de-Visite; and Victoria, Queen and Albert, Prince Consort.

Further Reading

Darrah, W.C., *The World of Stereographs*, USA, 1977.

Gernsheim, Helmut, *The Rise of Photography, 1850–1880*, Great Britain, 1988.

Gernsheim, Helmut, *Masterpieces of Victorian Photography*, Great Britain, 1951.

Jeffrey, Ian, *An American Journey: The Photography of William England*, Munich: Prestel, 1999.

Malcolm, John, *Thesis on Woodburytype Process*, Manchester Polytechnic, 1979.

Mathews, Oliver, *The Album of Carte-de-Visite and Cabinet Portrait Photographs 1854–1914*, London, 1974.

LOPPÉ, GABRIEL (1825–1913)
French photorapher

Born in 1825, in Montpellier, South of France, Gabriel Loppé studied in Paris and learned painting from François Diday (1820–1877), a landscape artist located in Geneva, Switzerland. A few years later, in 1848, he realized his first landscape paintings, in huge formats and panoramas appreciated by English gentlemen. Most of these patrons were members of the Alpine Club of London, as Loppé had been since 1864 who was also fascinated by exploration hikes and mountains.

Loppé's interests in photography was likely inspired by the Bisson brothers during their trip to Mont Blanc, on which he accompanied them in 1861. He never practiced as a professional photographer, and remained an amateur. As a matter of fact, he showed little interest in technique or composition, and used photography simply to create visual mementos.

Settled his studio in Geneva in 1862, Loppé opened an exhibition gallery in Chamonix in 1870. After the death of his first wife in 1874, he married Elizabeth Eccles in 1879, in London and moved to Paris in 1880, where he photographied his every day life, and of his family near the site of the Eiffel tower. Towards the end of the ninteenth century, Loppé developped a pictorialist aesthetic, particularly backlighting and smog effects under the electric light during the night.

He died in Paris in 1913.

MARION PERCEVAL

LORENT, JAKOB AUGUST (1813–1884)
Scientist and inventor

Jakob August Lorent was born on December 12, 1813, in Charleston, South Carolina. After his father died and

his mother remarried, his mother moved the family to Mannheim in 1818. In 1829, Lorent graduated from the secondary school in Mannheim and began attending the University of Heidelberg. In 1837, Lorent completed his scientific doctoral thesis, and thus graduated. Due to his family's affluence, Lorent, a private and introverted young man, was able to follow in the foot steps of his role model, Alexander von Humboldts and travelled to Egypt and Asia Minor, where he studied the natural landscape. After the death of his stepfather, Lorent received his estate which allowed him an absolute financial freedom.

During his travels to London in 1850, Lorent met W. H. Fox Talbot who introduced Lorent to photography and Talbot's own calotype process. Due to Lorent's education in science, he was able to modify Talbot's process, enabling him to become one of the most prominent photographers of his time. He understood very quickly that photographs are very easy to copy and therefore he'd only take a few photographs and focus on their quality.

His original Venice photographs measured 38 × 47 cm, but by 1856 he was using the much larger 45 × 55 cm format. These Venetian photographs increased Lorent's reputation in the European photographic community. In 1856, he exhibited these large-sized albumen prints in Brussels during a critical time of photography. Nevertheless, the editor of the photographic journal *La Lumière* based in Paris, Ernest Lacan, was absolutely enthusiastic about Lorent's work. He named Lorent the "Venetian Baldus," because Lorent's works echoed the close-up photography of Le Louvre by Edouard Denis Baldus.

Jakob August Lorent donated some of his large-format architectural photographs of Venice—worth about fourteen guilder ($160)—to help in the restoration of a church in Weimar. In the making of these large format photographs, Lorent chose to use le Gray's waxed paper process, rather than the widely popular wet collodion process on glass, greatly reducing the weight of materials he had to carry. Although the wax-paper process was favoured because it supplied sharps results, it was particularly favoured by touring photographers because of an incident that happened to Louis Auguste Bisson on his great photographic tour in 1858 through south of France when all of his glass negatives broke during a coach accident near Toulouse.

Lorent also developed the paper negative through the use of beeswax in such a way that he achieved a consistent transparency so that structure of the paper fibres, under the diffuseness of the beeswax, disappeared nearly 100 per cent. This approach influenced William Henry Fox Talbots photographs and led the French photographer Gustave Le Gray to develop a special paper negative process, which he patented 1851.

During the revolution of 1848 Lorent left Mannheim for London and married there in 1850. Lorent returned to Mannheim in 1858, from where he travelled to Granada and then to Algeria, to document old Islamic art. In 1859, Lorent took a second journey to Egypt, up the Nile, and to Nubian in pursuit of old Egyptian art that he intended to document. As was the case with his Venetian photographs, Lorent's work was also grand, the negative format being 45 × 55 cm.

Lorent reproduced the photographs of the voyages that he took between the years 1858 and 1860 in an album, that he then dedicate and personally gave to the duke of Baden, Friedrich II, entitling it, "Egypten, Alhambra, Tlemsen, Algerien" (Mannheim, 1861). Lorent noted, "As far as I know, there is no photographic work in Europe, that apprehends so completely the old manner of Egyptian art and Eastern architecture."

Lorent left for the country in November of 1860 due to political instability caused by the Bavarian King Otto I, whose reign was similar to the Osmanic Domination in Greece. Initially, he travelled to Italy and then to Corfu and Athens and in the summer 1862 he took a second trip to Greece. That same year he produced an album with "Pictures from Athens" in Mannheim.

These six years of tireless activity, both physical and artistic, are accurately represented as the apogees of his photographic career, which is evident as Lorent's large-sized photographs have no equal from 1850 to 1860. His wax paper negatives possess the outlet an hot components, that could be found, rarely through the use of wet collodium process, and mostly only through posterior tint by printing. The awards of the World Exposition in London and the Exhibition in Amsterdam in 1862 confirmed his prominent position and unrivalled talent.

In 1863 Lorent travelled to Turkey, Syria, and Egypt, then some months later in April of 1864, he went to Palestine and Egypt again. One final journey in 1865 led Lorent to Sicily. From this point on, he took photographs mainly on his "choice land," the Grand Duche of Bade, and mostly of the memorials of the Middle Ages, which he collected into three large-sized albums and produced for the Court.

Lorent donated his books and photographs to the Public Library in Mannheim. In June of 1873, Lorent moved from Mannheim to Meran, Switzerland because of health problems. Although ill, he participated in numerous international exhibitions, and occupied himself with research on platinum prints and took numerous photographs of Meran and its surroundings areas. During this time he wrote descriptive texts that accompanied his albums, giving evidence of his great intelligence and his distinct aesthetic sense. There are few documents, personal notices, and a relatively small number of photographs of this private scholar, most of

which were presumably destroyed during the shellfire of Mannheim in World War II.

On July 9, 1884, August Jakob Lorent died because of lung failure.

MILAN CHLUMSKY

Biography

In 1813, Jakob August Lorent was born in Charleston, South Carolina. He moved to Mannheim in 1818. From 1833 to 1836, he conducted his scientific studies at the University of Heidelberg. The years of 1842 and 1843 consisted of Lorent's voyages through Egypt and Asia Minor and in the autumn of 1845, Lorent revisited Egypt. During 1850 he travelled to London, and in 1851 he moved to Venice. Between 1859 and 1865, he took numerous voyages to Spain, Algiers, Egypt, Greece, Syria, Turkey, and Sicily. From 1865 to 1872 he photographed antique memorials near the Grand Duche of Baden in southern Germany. Finally, in 1873 he moved to Meran and photographed the surrounding area for the rest of his life. Jacob August Lorent died on July 9, 1884, in Meran.

Selected Works

1845 *Voyages in the Orient during the years 1842–1843*, Mannheim.

1845 *Wanderungen im Morgenlande während der Jahren 1842–1843*, Mannheim.

1861 *Egypt, Alhambra, Tlemsen, Algiers*, Mannheim (reprint: Waller F.V.,1984, *Egypten, Alhambra, Tlemsen, Algier*, Mannheim (reprint: Waller F.V.,1984).

1862 *Images from Athens*, Mannheim; *Bilder aus Athen*, Mannheim.

1865 *Jerusalem and its surroundings, Photographic album with texts from Dr. G. Roses*, Mannheim; *Jerusalem und seine Umgebung, Photographisches Album mit erläuterndem Texte von Dr. G. Rosen*, Mannheim.

1866 *Memorials of Middle Ages in the kingdoms, Württemberg: I. Department: Maulbronn; Bebenhausen, Hirschau, Alpirsbach and Herrenalb*, Mannheim

1867 *Memorials of Middle Ages in the kingdoms Württemberg: II. Department: Lorch, Murrhardt, Rieden, Oberhofen, Comburg, Faurndau and Oberstenfeld*, Mannheim. *Denkmale des Mittelalters in dem Königreiche Württemberg, II. Abteilung: Lorch, Murrhardt, Rieden, Oberhofen, Comburg, Faurndau und Oberstenfeld*, Mannheim.

1869 *Memorials of middle Ages in the kingdoms Württemberg: III. Department: Ellwangen, Blaubeuren, Denkendorf, Schwäbisch Gmünd and Brenz*, Mannheim; *Denkmale des Mittelalters in dem Köni-greiche Württemberg, III. Abteilung: Ellwangen, Blaubeuren, Denkendorf, Schwäbisch Gmünd und Brenz*, Mannheim.

1870 *Wimpfen on Neckar, history and topography to the historical documents and archaeologic studies*, Stuttgart. *Wimpfen am Neckar, geschichtlich und topographisch nach historischen Urkunden und archäologischen Studien*, Stuttgart.

See also: Baldus, Édouard; Talbot, William Henry Fox; Collodium; Louis Auguste Bisson, Louis-Auguste and Auguste-Rosalie; and Le Gray, Gustave.

Further Reading

Lorent, Jakob August, *Egypten, Alhambra, Tlemsen, Algier—Reisebilder aus den Anfängen der Photographie*, zusammengestellt von Wulf Schirmer, Werner Schnuchel und Franz Waller, mit einem biographisch—photohistorischen Anhang von Franz Waller, Verlag Philipp von Zabern, Mainz am Rhein, 1984.

Waller, Franz (ed.), *Images from Athens, Jakob August Lorent*, 1994.

LOTZE, EDUARD MORITZ (1809–1890)
German painter, artist, photographer, and studio owner

Eduard Moritz Lotze was born in 1809 in Freibergsdorf (Germany) to a family of farmers. He studied painting, drawing and lithography in Meissen and later at the Academy of Fine Arts in Dresden. In Munich began his professional career as painter and lithographer and there he learned the rudiments of photography. In 1852, he opened a photographic studio with his brother in law Hanfstaengl. Lotze moved to Verone (Italy) in 1854 where he opened a new photographic studio, which he left to his son Richard after his definitive return to Munich in 1868. He died in Munich in 1890.

While in Verone, he experienced a great professional success as a portrait photographer and photographed the Austrian military forts surrounding the city. He actively participated in the cultural life of Verone and exhibited his photographs at important expositions in the city. He was also well known in scientific circles for his *Saggio fotografico di alcuni animali e piante fossili dell'Agro Veronese* (Photographic Essay of a Few Animals and Fossils Plants of the Countryside of Verone) published together with Massalongo in 1859 and for *Monumenta graphica* as well as it is illustrated with photographic reproductions of pages from ancient codex, which was from Verone's and Padua's historical libraries.

CARLO BENINI

LUCKHARDT, FRITZ (1843–1894)
Austrian photographer, technical writer

Fritz Luckhardt was born on 17 March 1843 in Kassel (Germany, at that time seat of the government of the Kurfürstentums Hessen), the son of a soap manufacturing family. He received training as a chemist at the polytechnic institute in Kassel. During a stay in Paris he decided to become a photographer and joined the service with René Prudent Partrice Dagron. He spent a short time in England, and then in 1865 went to the establishment in Vienna where he worked first as a foreign language correspondent of the photo dealer and publisher Oskar Kramer. With the opening of his own studio in Vienna in 1867, Luckhardt's rapid ascent made him one of the most sought photographers in Viennese society at that time. In 1900 Félix Nadar called him "Le maître of the maîtres" in *Quand j'étais photographe* (Les primitifs de la photographie). For Henry Baden Pritchard in *The Photographic Studios in Europe*, 1882, Luckhardt was the epitome of a success-conscious and nonchalant gentleman. In the poses and gestures produced, in the purposeful light arrangement, Luckhardt's always more-or-less over-pointed portrait style nevertheless speaks volumes for the requirement for exclusivity of his customers and his own visual culture. In addition he also belonged to the continuous technical perfection and active lobbyism, which Luckhardt followed with the modern equipment of his studios, by various club memberships as well as by book publications and regular contributions in German-language technical periodicals.

MAREN GROENING

Biography

Fritz Luckhardt was born on 17 March 1843 in Kassel. As son of a family of soap-makers, he was to take over the enterprise of his grandfather and study chemistry at the Kasseler polytechnic institute, then go on to training at Hanover, and finally to work in a Paris perfumery. Instead he turned to photography. After a time with René Prudent Patrice Dragon in Paris and a stay in England, he settled in Vienna in 1865 and opened his own studio there in 1867 as an elegant society photographer. His business success stemmed from portraits of beautiful women (mostly actresses), which he exported in Stereoformat to the United States. He received the title of a K.K. photographer in 1870, and in 1883 was an honorary professor of the duke from Saxonia Meiningen. From 1871 to 1887 he was a secretary of the photographic society in Vienna. In addition he maintained memberships in the photographic Societies of Berlin and Frankfurt/Main as well as in Viennese agencies: Club of the amateur photographers (from 1888, 1893 renamed in Viennese Camera club), Association of Photographic Coworkers (from 1891), scientific association "Skioptikon" (from 1891). After Luckhardt's death in Vienna on 29 November 1894, his widow Franziska took over the studio. The best overview of the former private collection is probably given by Gerd Rosenberg in Vienna. In 1908 the Viennese city and federal state library bought 15 letters addressed to Luckhardt.

LUMIÈRE, AUGUSTE (1862–1954) AND LOUIS (1864–1948)

In French, *lumière* translates as "light." Auguste Lumière and Louis Lumière were born into a name that fittingly predicted their future as technological innovators in photography, cinema and, for Auguste, "medical biology, pharmodynamics, and experimental physiology" (Cartwright, 1992, 129). Auguste and Louis Lumière, two of the most famous brothers in the world, were born in Besançon, France. Their father Antoine Lumière (1840–1911) was a painter and a photographer. But their father was more than artistic; Antoine was a born businessman who was greatly motivated by the new inventions during the advent of France's *Belle Époque* (Beautiful Era). The spirit of their father and the spirit of their paternal name set the *mise en scène* for their invention of cinema. By the end of the nineteenth-century, there were many visionaries who were trying to animate the still photograph, including, most famously, Thomas Edison (1847–1931), Eadweard Muybridge (1830–1904) Charles-Èmile Reynaud (1844–1918) and, of course, the Lumière Brothers.

In 1870, fearing the Franco-Prussian war (1870–71), the Lumière family moved from Eastern France to Lyon. It was in the city center that Antoine opened his photographic studio. While running the studio, Antoine kept a watchful and excited eye on the education of Louis and Auguste. The two boys attended La Martinière, Lyon's largest technical high school. As a child, Louis was frequently troubled by headaches and had to spend much of his time at home, but, nevertheless managed to focus, very successfully, on inventions. As an adolescent, Louis designed the instant dry photographic plate christened the *Etiquette bleue* (blue label), which would amass the Lumière family fortune. With Louis's invention in hand, Antoine left the photo studio behind and acquired an extensive site on the outskirts of Lyon to manufacture and market *Etiquette bleue*.

In the summer of 1894, Antoine Lumière went to Paris and saw a demonstration of Edison's Kinetoscope. (In 1893, Edison had been granted a patent for "An Apparatus for Exhibiting Photographs of Moving Objects.") But the Kinetoscope was limited: only one person at a time could use the "peepshow" viewing

machine. The father of the Lumière brothers returned to Lyon and told them that they could do better than Edison. Antoine told his sons to get that image out of the box and they did.

In February of 1895, the Lumières received a patent for their invention of a lightweight (four kilos) motion picture camera: the Cinématographe. (Just as the etymology of photography is "light writing," cinématographe is "writing the movement"). On the sunny day of March 19, 1895, the Lumières managed to make the first film and marked the beginning of cinema. Their first film, *La Sortie des Usines* (*Workers Leaving the Factory*), was limited to seventeen meters of film and a time of no longer than fifty seconds, as was the case with all of the 1,408 little movies that the Lumières made with their Cinématographe. Shot by Louis (who was the principal filmmaker of the brothers), the famed brief movie features workers (mostly women) leaving the family's photographic glass-plate factory. Viewers witness the first characters, the first stars of cinema. *Workers Leaving the Factory* documented a simple piece of life, as did all of the Lumière films. Dramatic as their invention was, the Lumière Brothers did not see a big future with the Cinématographe. Like the Montgolfier Brothers and flight, the Lumière Brothers had "the genius for laying the intellectual foundation for a revolution" that would take place "elsewhere," in America (Gopnik, 151).

What was especially significant about the Lumière camera was that it could shoot, develop and, most importantly, project images onto a large screen. "This meant that the *opérateur* with this equipment was a complete working unit: he could be sent to a foreign capital, give showings, shoot new films by day, develop them in a hotel room, and show them the same night. In a sudden global eruption, Lumière operators were soon doing precisely that throughout the world" (Barnouw 1993, 6). Because they knew that most towns had no electricity, an ether lamp was used for projection. Viewers saw floods, crowds, men smoking opium, children running behind a rickshaw, trains coming and going, a gigantic ship, the drama and boredom of everyday life in Chicago, Mexico, Moscow, Jerusalem, China, Vietnam, Argentina, Algeria, Turkey, and Istanbul.

Not only did the Cinématographe give rise to the first newsreel, it also gave rise to the first family movie: as in the famous 1895 *Le Repas de bébé* (*Baby's Tea*) which features Auguste and his wife feeding their baby. Furthermore, given the Charlie Chaplinesque quality of many of their films, the Lumières can be credited with cinema's first comedies. Today audiences still laugh uproariously at the 1895 *Arroseur et arrosée* (*Watering the Gardener*): how funny the scene had to have been to an audience uninitiated in the world of cinema. In the 1896 *Démolition d'un mur* (*Demolition of a wall*), Louis

made humorous use of what was originally an accidental projection in reverse: a wall is knocked down only to cinematically spring back up. Certainly, the youthfulness and lightness of the Lumière films was generated by the fifty-second format, the joyful mood of the Belle Époque, but also the spirit of two young inventors in their early thirties making art.

Not to be overlooked is the magnificence and formal precision of Lumière films. Louis was a great photographer and we see this in the "art" of the films that he made with his brother. In the hands of Lumière, a pair of opium smokers, tightly framed, shot with the camera low to the ground, is a work of staggering beauty. With its compelling use of a dramatic diagonal, Louis's 1895 *L'Arivée d'un train en gare* (*The Arrival of a Train*) is the first cinematic masterpiece. "The Lumières and their cameramen, utilized with glory the deep space and receding movement available to the camera lens, which had been ground in conformity with an idea of perspective emanating continuously from the Renaissance" (Sitney, x).

While there is general agreement that the Lumière Brothers can be credited with the invention of cinema, the process of getting to that first projection on March 22, 1895, (with the first performance to a paying audience, taking place at the Grand Café, 14 boulevard des Capucines on December 28, 1895), was a sorted and complex affair. Ingenious devices that preceded the Cinématographe (the term "cinématographe" is actually owed to Léon Bouly, 1892–93) were already developed earlier. Leading up to the invention of cinema were a range of important devices that contributed to the Lumières' Cinématographe. Most obvious is the invention of the camera obscura, the photograph itself and the magic lantern, but perhaps as important are the optical apparatuses that emphasized principles of movement. Critical here are Sir David Brewster's invention of the kaleidoscope in 1815, with its multiplication of imagery with precision, and Louis J. M. Daguerre's refinement of the diorama in the early 1820s that led to the multimedia diorama, "often sitting the audience on a circular platform that was slowly moved, permitting views of different scenes and shifting light effects." (Crary 1990, 113) In the early 1830s, Joseph Antoine Ferdinand Plateau invented the "phenakistiscope," which consisted of two spinning discs, one with a figure in a sequence of movements, the other with slits to look through. Utilizing a mirror and principles of retinal persistence, the observer sees a figure in animation (a girl jumping rope, a bird flapping its wings). By 1834, the similar devices of the stroboscope (invented by Simon Ritter von Stampfer) and the zootrope, sometimes called "the wheel of life," were invented. Charles-Émile Reynaud made the first animated films, which grew out of his 1877 "praxinoscope," projecting the first animated film in 1892. By

1888, Muybridge had learned to project sequences of his photographs on an adaptation of the magic lantern. Also in 1888, Étienne-Jule Marey used sensitized paper roll film to invent a camera that could take separate, but successive pictures on a moving strip of film. With this history in mind, it is noteworthy that Peter Kubelka notes that, in fact, cinema is "not movement…Cinema is nothing but a rapid slide projection. A slide projection which goes in a steady rhythm: twenty-four slides per second" (Kubelka 1978, 149).

Along with the Cinématographe, the Lumieres are well-known in the history of photography for contributing to the process of color photography with the invention of the Autochrome. An additive process, the Autochrome plate consisted of very fine grains of potato starch used with a gelatin silver-bromide emulsion. Autochromes were expensive and were unique images, best viewed as a transparency: their true colors were impossible to catch by the limited printing possibilities at the time. The Lumières' Autochrome plates went on sale in June of 1907. The process remained confined to Europe, especially France. The photographer Jacques Henri Lartigue made some of the most successful Autochrome images between 1912 and 1927.

In 1995, in honor of the Cinématographe's centennial anniversary, forty famous filmmakers (David Lynch, Spike Lee, Wim Wenders, Zhang Yimou, John Boorman, et al.) from around the world came together to create their own fifty-second Lumière film. Using the restored original camera forty intriguing films were made by and in tribute to the well-designed, trim, hardwood box with a hand crank.

CAROL MAVOR

Biography

Auguste Lumière was born on October 19, 1862, in Besançon France and Louis Lumière was born on October 5, 1864, also in Besançon. Along with their father they ran the very successful Lumière factory, which made its fortune from the innovative glass plate for dry-plate photography, the *Etiquette bleue* (blue label), which was invented by Louis when he was a teenager. The brothers are most famous for inventing "cinema" through the Cinématographe, which was patented on February 13, 1895. They shot their famous fifty-second *Workers Leaving the Lumière Factory* on March 19, 1895. The brothers also invented an early color photographic process, the Autochrome. For much of his life, Auguste worked tirelessly on medical inventions. After 1900, much of the production of the Lumière plant in Lyons was oriented towards medical research and production. Louis died on 6 June 6, 1948, in Bandol, France and Auguste died on April 10, 1954 in Lyon, France.

See also: Brewster, Sir David; Edison, Thomas Alva; Lantern Slides; Marey, Etienne Jules; Muybridge, Eadweard James; and Plateau, Joseph Antoine Ferdinand.

Further Readings

Barnouw, Eric, *Documentary: A History of the Non-Fiction Film*, New York: Oxford University Press, 1993.

Cartwright, Lisa, "'Experiments of Destruction': Cinematic Inscriptions of Physiology," *Representations*.

Crary, Jonathan, *Techniques of the Observer: On Vision and Modernity in the Nineteenth Century*, Cambridge, MA: MIT, 1990.

Elsaesser, Thomas, editor with Adam Barker, *Early Cinema: Space, Frame, Narrative,* London: British Film Institute, 1990.

Gopnik, Adam, *Paris to the Moon*, New York: Random House, 2000.

Kubelka, Peter, "The Theory of Metrical Film," in *The Avant-Garde Film: A Reader of Theory and Criticism,* edited by P. Adams Sitney, New York: New York University Press, 1978.

Sitney, P. Adams, *Visionary Film: The American Avant-Garde*, New York: Oxford University Press, 1974.

LUMMIS, CHARLES FLETCHER (1859–1928)
American photographer, journalist, publisher

After graduation from Harvard College, Lummis took up a career as a journalist in Ohio. When offered a position in Los Angeles he walked across country and published the account of his journey, *A Tramp Across the Continent* (1892). He covered the Apache revolt led by Geronimo in 1885 for the *Los Angeles Times*, and renewed his interest in the cultures of the American Southwest. He moved to New Mexico for his health in 1887 and assisted archaeologist Adolph Bandelier for whom he photographed in the southwest and Latin America. His photographs served as the basis for the illustrations for an ethnographic study of Pueblo Indian people. In a five year period, 1888–1893, he photographed the land, people, and dwellings, the ruins and traces of past civilizations, and persistent rituals in the Southwest, Central America, and Peru. In all he made an estimated 10,000 glass plate negatives during his lifetime. Those made after his return to Los Angeles record the cultural heritage of southern California. He became the foremost proponent for the recognition and preservation of the unique cultural heritage of southern California and the American Southwest through his writing for *Century* and the illustrated magazine which he edited, *Land of Sunshine* (*Out West* after 1902) and his books, including *The Land of Poco Tiempo* (1893), and *Some Strange Corners of Our Country: The Wonderland of the Southwest* (1892). *Mesa, Canon and Pueblo* (1925), illustrated

with one hundred photographs, brought together thirty years of writing and photography on the region. The magazine *Land of Sunshine* became an important outlet both for his photography and that of others working in the Southwest. In 1907 he joined with others in Los Angeles to form the Southwest Museum which preserves important collections of Native American objects and holds a large number of his photographs.

KATHLEEN HOWE

LUTWIDGE, ROBERT WILFRED SKEFFINGTON (1802–1873)
English

Lutwidge was born in London on January 17, 1802, the second son of Charles Lutwidge and Elizabeth Anne Dodgson. His sister, Frances Jane, married a cousin, Charles Dodgson, and in 1832 gave birth to Charles Lutwidge Dodgson—the author and photographer Lewis Carroll. Skeffington Lutwidge was a favorite uncle of Carroll's and it was his influence that encouraged him to take up photography in 1856.

Lutwidge was a London-based barrister and commissioner in lunacy, he was a friend of Dr. Hugh Diamond and they were both members of the Photographic Society and the Photographic Exchange Club. His favored subject matter was architecture and in 1855 made an unusual study, in the rain, of the entrance to Knole Castle.

Lutwidge and Carroll often spent time together and on June 15, 1872, Lutwidge was photographed by his famous nephew at his Christ Church Studio in Oxford.

In May 1873 during a visit to Fisherton Lunatic Asylum at Salisbury, Wiltshire Lutwidge was attacked by patient William McKave and died six days later. Carroll's well-known poem The Hunting of the Snark, published in 1876, was inspired by his uncle's tragic death and experiences with the Lunacy Commission.

IAN SUMNER

LUYS, JULES-BERNARD (1828–1897)
French physician

Born in Paris in 1828, Jules-Bernard Luys attended medical school with the intention of becoming an intern in Paris in 1853. He obtained his doctorate in medicine four years later and became doctor in a hospital in 1862, occupying the postitions of head of department in Salpêtrière, and then later in Charity. An Anatomo-pathologist of development, his research was focused on the nervous system and the brain. Anxious to represent his findings as precisely as possible, he chose not to use traditional drawings or engravings but instead photography to display and capture his research. The first examples of these images can be found in a publication which Duchenne of Boulogne influenced him to choose as this new technique of representation was considered by many to be more accurate.

In 1873, he published photographs of the nerve centers in a text edited by Jean-Baptist Baillière. The work was composed of a book of text and an atlas comprising seventy photographs of cut and drawn brains on albumen paper. The photographs were taken in collaboration with George Luys (1870–1953), his son who was also a doctor. Encouraged by the success of this first work, Luys published two other works illustrated by photography as well.

DENIS CANGUILHEM

LYTE, FARNHAM MAXWELL (1828–1906)
French photographer

Born in 1828, Farnham Maxwell Lyte was a person of wide-ranging interests and an insatiable intellectual curiosity. He trained to be an Engineer at Cambridge University. In 1853 he traveled to Pau, France and made the acquaintance of—Jean-Jacques Heilmann and John Stewart, two photographers with whom his work is often associated. Lyte photographed both the natural and the man-made wonders of the Pyrenees.

One of the founding members of the Société francaise de photographie, Lyte had several of his photographs included in exhibitions from 1857 to 1874. He was also the inventor of what became known as "the honey process" a method of prolonging the sensitivity of coated glass plate negatives.

Most of Lyte's photographs are either salted paper or albumen prints and he worked almost exclusively with the wet-plate collodion process. His albumen prints are often easily identified by the red blind stamp on the bottom left or right hand corner of the print. He often inscribed his plates with the Latin phrase Lux Fecit (made by Lyte), a pun wittily alluding to both the act of photographing, and to his family name. He died in England in 1906.

PAULI LORI

M

MACFARLANE, SIR DONALD HORNE (1830–1904)

The son of a magistrate in Caithness, where he was born in July 1830, Macfarlane went to India in the late 1850s as a partner in the firm of Begg, Dunlop and Co., agents for tea and coal interests in the subcontinent. He appears to have taken up photography as an amateur soon after his arrival and the quality of his work attracted notice when he joined the Bengal Photographic Society in 1860. He remained an active and enthusiastic member of the society until his departure from India in 1864, winning numerous medals in its competitions and contributing several papers to its journal. The most important of these, *Landscape photography in India*, appeared in September 1862 and from 1863–64 he served as the society's president. Macfarlane's landscape work, small in quantity in terms of known examples, nevertheless reflects one of the freshest and most individual responses to the Indian landscape in the early 1860s and displays a remarkably modern compositional approach. Although Macfarlane continued with photography on his return to Europe and had his work shown at the Paris Exhibition of 1867, examples of this have not so far come to light: the scarcity of surviving prints has certainly led to an unwarranted neglect of one of the most individual photographic eyes in India in the 1860s. In his later years he served as Member of Parliament for Carlow (1880) and Argyllshire (1885, 1892), dying in London on 2 June 1904.

JOHN FALCONER

MACH, ERNST (1838–1916)
Moravian physicist

From early in the second half of the nineteenth century, photographers increasingly sought not just to decrease exposure times, but to shorten them sufficiently to be able to capture moving subjects with the crispness and full tonal range that was possible in a landscape view or a studio portrait. Gustav le Gray, Count Michael Esterhazy, Albert Lugardon, Ottomar Anschütz, and others achieved international recognition through their ability to depict movements in "instantaneous" photographs that recorded the natural motion of their subjects. The most spectacular instantaneous photographs captured movements too fast to be seen by the human eye, such as bullets or cannon shells in flight, and melded advanced photographic technology with a specialised optical apparatus developed by the professor of physics in Bonn, Dr. August Toepler, at the end of the 1850s and published in 1864. Toepler was interested in observing variations in the density of gases and fluids, and devised an apparatus where an "experimental space" containing his transparent media was framed by two plano-convex lenses on opposite sides, whose focal point was then observed by a further pair of enlarging lenses. The experimental space was lit from behind, and precisely half of the rays of its lenses were blocked by a shutter just at their focal point, in front of the observing lenses. With this specialised setup, any variation in the refraction of light passing through the experimental space caused by uneven density in the material showed up at the observation point as an unfocussed streak of light, and a Schlieren ("streak") apparatus became a standard laboratory instrument, not only for work on fluids but also for checking the imperfections of optical lenses. When a camera replaced the human eye at the observation point, and an electric spark provided appropriate illumination for a darkened experimental space, any fast-moving object that passed through the space, and the effects on the air caused by its movement, could be photographed, measured, and studied, given that a proper electrical circuit timed the release of the spark

just as the object was passing through the experimental space or Schlieren Head.

Beginning in 1884 Ernst Mach began using the Schlieren Method to photograph bullets fired by a pistol, drawn into a controversy about whether or not the French had used illegal explosive bullets, outlawed in the Treaty of St. Petersburg of 1868, during the Franco-Prussian war of 1870–71. New French rifles had caused extreme, crater-like wounds, and throughout the 1870s a number of explanations for the phenomenon had been put forward, including an idea suggested by Louis Melsens of Belgium that a spherical projectile carried compressed air with it in flight, the amount depending on its velocity. In his first experiments Mach saw no significant turbulence in the air because the bullets were travelling too slowly; he asked his colleagues Peter Salcher and S. Riegler at the Marine Academy in Fiume to continue his experiments, and they modified another Schlieren apparatus to Mach's specifications, photographing bullets fired from several types of rifles. In summer 1886 the shock waves from a bullet travelling faster than the speed of sound were photographed for the first time. Mach, assisted by his son Ludwig, then continued the experiments that autumn making more photographs of the air turbulence around a variety of projectiles, and even built a remarkable apparatus at the Krupp artillery range in Meppen where a 4 cm rapid-firing cannon was fired through a specially-built shed that provided the darkness needed to make a photograph where the plate was exposed by illumination from an electric spark. Mach began publishing his results with Salcher in 1887, and caused much excitement in both the scientific and photographic worlds. Ottomar Anschütz was inspired to make the only daylight photograph of a flying cannonshell in 1888, using specially designed weighted, pneumatically driven and electrically released focal plane shutters that operated at 76 millionths of a second at the Krupp Gruson works at Buckau-Magdeburg. Sir Charles Vernon Boys, who had made photographs of falling drops of water and other liquids by moving a photographic plate by hand through a camera while a slotted rotating disk shutter ran in front of his camera lens in the late 1880s, repeated Mach's Schlieren-method work in 1891 and 1892, producing photographs of bullets piercing a sheet of glass and other materials. Unusually, Boys used no lens in his camera, relying instead on the nearness of the bullet to the plate and his own improvements in the design of the electrical release mechanism, which much improved the briefness of his spark, to produce a defined image. Helmut Gernsheim's dismissive comment on the work of Mach and Boys, based on the fact that because the subjects were back-lit from behind the Schlieren Head the photographs produced only shadows of the passing object, seems today distinctly ungenerous. Their in-

novative technical expansion of the usefulness of photography not only led to specific scientific discoveries, but also gave new impetus to the field of electric-spark photography pioneered by Prof. Bernhard Wilhelm Feddersen in the late 1850s, and ultimately led to the striking images of Harold Edgerton at MIT in the 1930s and the development of modern stroboscopic flash units both large and small.

DEAC ROSSELL

Biography

Born at Turas, Moravia (today Czech Republic), Ernst Mach was educated at the University of Vienna, gaining his PhD in 1860. Four years later he was named professor of mathematics at Graz, and next took the chair of physics at the University of Prague in 1867, where he remained for the next 28 years. At Prague, Mach concentrated on experiments in psychology and perception, and worked on optics, mechanics and wave dynamics. He discovered the function of the semicircular canals of the ear; a phenomenon of the eye where it sees bright or dark bands near the boundaries between areas of starkly constrasting illumination, still called Mach's Bands; and first described the shock waves in the air that precede an object travelling faster than the speed of sound, leading to the colloquial expression of "Mach I" or "Mach II" for the speed of military and experimental aircraft. This last discovery was made in a series of trials using advanced photographic methods. Parallel with his experimental work in the 1880s, Mach proposed that all knowledge is derived from physical sensations, and began to argue for a rigorous interpretation of science based only on the interpretation of verifiable empirical observation. He further developed a radical concept of inertia, which he considered was exclusively a function of the interaction between one body and all the other bodies in the universe, a view which was not only controversial but which was one of the inspirations for Einstein's theory of relativity. His rejection of the existence of atoms, and his contention that matter was constructed wholly out of pure sensation was equally influential on the logical positivist philosophers, and embroiled him in vivid public disputes with Max Planck, Oswald Külpe, and even Vladimir Lenin. Mach's scientific legacy is principally as a philosopher of science although he always considered himself nothing other than a rigorous physicist. Moving to the University of Vienna in 1895, where he became professor of the history and theory of the inductive sciences, Mach began an intense battle against Einstein's theory of relativity which dominated his later work, even though he was partially paralysed by a stroke in 1901. Widely influential on European physics practitioners during his lifetime, his fight with Einstein ultimately eclipsed his reputation until recently,

when new theories about the properties and composition of sub-atomic particles have revived interest in his concepts.

See also: Le Gray, Gustave.

Further Reading

Blackmore, John T., *Ernst Mach, His Work, Life, and Influence*, Berkeley: University of California Press, 1972.

Bron, Pierre, and Philip L. Condax, *The Photographic Flash, a Concise Illustrated History*, Zürich: Bron Elektronik AG, 1998.

Mach, Ernst, "Über wissenschaftliche Anwendungen der Photographie und Stereoskopie" ["*On the Scientific Uses of Photography and Stereoscopy*"], in E. Mach, *Populär-Wissenschaftliche Vorlesungen*, Leipzig: Johann Ambrosius Barth, 1903.

Mach, E., and Salcher, P., "Photographische Fixirung der durch projectile in der Luft eingeleiteten Vorgänge" ["*The Photographic Recording of the Processes Initiated by a Projectile Travelling in the Air*"], in G. Wiedemann, ed., *Annalen der Physik und Chemie* [*Annals of Physics and Chemistry*] (Leipzig) Vol. XXXII (N. F.), 277–291.

Volkmer, Ottomar, *Die photographishe Aufnahme von Unsichtbarem* [*Photographing the Invisible*], Halle a. S.: Wilhelm Knapp, 1894.

MACKEY, FATHER PETER PAUL (1851–1935)
English-born amateur photographer

Father Mackey epitomises the private photographer: a learned scholar who knew the relevance of what he was looking *for* and *at*; precise, as befits the "age of the tripod," technically expert, poetic, he had a great love of architecture. A tireless walker, he made excursions throughout Italy, and to Sardinia and Greece, c.1884–1902, and because he travelled off the souvenir routes, he photographed many places not covered by commercial photographers. His depictions of the nuraghe in Sardinia are the earliest in existence. Equally rare is his record of the natural life of the Italian countryside, a subject not recognised by the professionals. Rarer still is the way he portrays the world for it is seen through the eyes of a Dominican priest who should not have been so interested in transitory, worldly things; self-portraits depict him deep in poetic thought in his flowing habit amidst pagan, classical ruins. Born Erdington, Birmingham, Daniel Mackey studied law (1869–1871) then the priesthood at Woodchester where, after becoming a Lector in Sacred Theology at Louvain in 1874, he taught philosophy and canon law until summoned to Rome in 1881 as editor of the Leonine edition of the works of St Thomas Aquinas which he continued for the rest of his life. He also associated with artists, such as Rodin, art dealers and collectors. He presented his photographic albums to the British and American Archeological Society of Rome

(one remains). He gave to the British School at Rome c.1913 his negatives (now lost) and nearly 2000 prints, together with a detailed catalogue, which remained forgotten until 1999. They are now of great interest.

ALISTAIR CRAWFORD

MACPHERSON, ROBERT (1814–1872)
Scottish photographer who specialised in photographs of Roman architecture and antiquities together with topographical views

For approximately fifteen years, from c.1851 to c.1866, Robert Turnbull MacPherson was one of the most sought after photographers working in Rome. From the mid 1850s, John Murray began to publish favourable notices of MacPherson in his popular guidebooks and by the time of the 1858 edition, he was named as one of the principal photographic artists working in that city. MacPherson had relocated to Rome from Scotland in c.1840. His specialised in large format albumen prints. His preferred subjects were architecture, works of art and in particular sculpture, together with topography. These subjects found a quick and ready market with the international tourists that Rome attracted. MacPherson photographed elsewhere in Italy including Venice, Perugia and Assissi but it for his photographs taken in Rome and the surrounding Campagna that he is best known.

Born in Scotland in 1814, Robert MacPherson studied medicine at Edinburgh University to qualify as a surgeon. However his medical practice was short-lived as he became increasingly interested in art. He relocated to Rome in c.1840 and established himself as a painter. In the early 1840s he also started a business as an art dealer, although to what extent this was carried out on a regular basis remains unclear. In 1849 he married Geraldine Bate, a niece of the art connoisseur Anna Jameson. From Nathaniel Hawthorne's recollections of visiting her palazzo in 1858, it is also known that Jameson collected art. MacPherson appears to have had a strained relationship with his wife's aunt, so the question of to what extent, if any, Jameson introduced him to any of the distinguished members of her circle, such as the Goethe family, remains unresolved. However it might be significant that Macpherson included a citation from Goethe on the title page of his handbook to the Vatican Sculptures in 1863. Aside from any connections that Jameson's may have provided, MacPherson had his own very mixed circle of friends and acquaintances including George Combe, a co-founder of the Edinburgh Phrenological Society in 1820 and who conversed with MacPherson about sculpture, and the Scottish novelist Margaret Oliphant who referred affectionately to both Robert and Geraldine in her autobiography.

MacPherson appears to have abandoned painting in

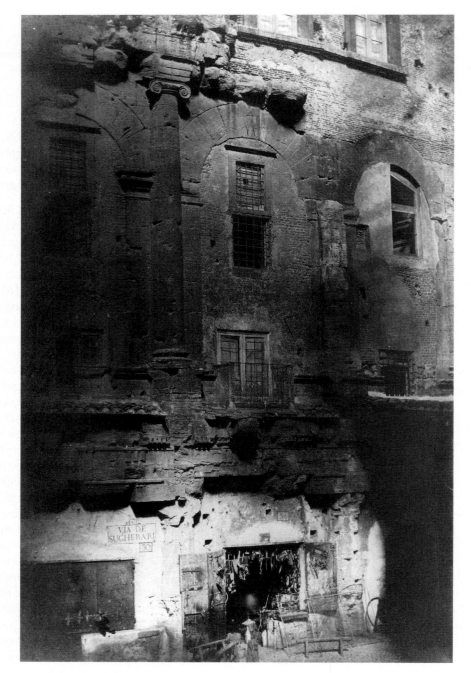

MacPherson, Robert. The Theater of Marcellus, from Piazza Montanara. *The Metropolitan Museum of Art, Gilman Collection, Purchase, Alfred Stieglitz Society Gifts, 2005 (2005.100.59) Image © The Metropolitan Musem of Art.*

favour of photography by the early 1850s, although it is very likely that he had already begun to take photographs using the calotype process as early as the late 1840s. One or more calotypes associated with the activities of the Calotype Club of Edinburgh have a tentative attribution to MacPherson but may have been taken by James Calder MacPhail. They are consistent in format and general geographic location with a number of other calotypes which appear to have been taken by Sir James Dunlop during his Grand Tour of 1847. It is also possible but as yet unconfirmed that Dunlop introduced MacPherson to photography.

MacPherson's adopted the albumen process at the start of his commercial career and then progressed to the faster collodion-albumen process. He also experimented with modifications to photolithography and in 1853 obtained a patent for improvements employing bitumen. He went on to demonstrate photolithography at the newly formed Société française de photographie and at the Photographic Society of Scotland. MacPherson exhibited two photolithographs and five albumen prints at the British Association exhibition at in the showroom of Wylie and Lochead's Warehouse in Glasgow in 1855. He contributed an even larger representation of his photographs to exhibitions at the Photographic Institution in the same year and at the Photographic Society

of Edinburgh in 1856. His residency in Rome made it desirable to employ agents or other representatives including William Ramsey, Professor of Humanity at Glasgow University. Ramsey also described MacPherson's photolithographs to an international readership in *Frank Leslie's New York Journal* in 1856. MacPherson clearly valued his links with Scotland and kept in touch with and occasionally visited photographic colleagues there. In 1862 he also exhibited over 400 photographs in London in a gallery just off Regent Street and was present at the opening.

MacPherson favoured large format photographs which necessitated the use of long exposures. In 1862 he told *The Photographic News* that he employed an exposure time of five minutes for a distant landscape in good light but that between ten and twenty minutes were necessary for near objects. For some of the sculptures permanently housed in galleries, MacPherson stated that two hours or even two days were required to produce a good negative. Typically, MacPherson's photographs were mounted and carry his oval blind-stamp. These provide attribution but also chart the course of his various studio addresses. However it was at 12 Vicolo D'Alibert that he achieved much of his success.

Some of MacPherson's negatives bear his signature. Pencil reference numbers corresponding to his catalogues frequently appear on contemporary mounts. By 1863 he listed 305 photographs including picturesque local subjects such as "The Fish-Market in the Ghetto," as well as his usual historical themes. People rarely appear as he recognised that his customers wanted photographs of classical antiquities in Rome and nearby locations such as Terracina, Tivoli and Paestum, not life in a contemporary city. Nevertheless "The Valley of St. Anatolia with the new Railway Viaduct" indicated his preparedness to occasionally include some aspects of modernity. In a different vein, "Falls of the Terni" became on of the most famous waterfall photographs of the period.

MacPherson sold his photographs separately at a uniform price of five shillings but he also stocked readyfilled albums. Other customers evidently compiled their own albums frequently mixing MacPherson's photographs with those of his contemporaries such as Carlo Ponti. His photographs possess pronounced light and shadow effects and indicate a sensitively to both the monumental and the elemental aspects of the subject matter depicted. He did not have a standardised format, preferring to trim prints to achieve strong compositional arrangements. Helmut Gernsheim perceptively observed that his prints of surpassing beauty were not dependent exclusively on the beauty of the scenery.

Vatican Sculptures, a small volume with engravings derived from MacPherson's photographs and reduced down to miniature size by Geraldine was published in 1863 with a second revised addition appearing in 1868. A companion volume to the Lateran and Capitoline collections was planned but never materialised. However MacPherson clearly photographed at the Capitoline, as a two volume album exists in at least one copy with a bound-in pricelist dated 1871. MacPherson continued to sell works of art including fourteen examples to the National Gallery of Ireland and, famously, Michaelangelo's *The Entombment* which he purchased cheaply in 1846 and sold to the National Gallery in London in 1868 for £2000. MacPherson was disappointed that what had been known in the family as 'Geraldine's fortune' realised a smaller sum than he had anticipated, particularly when his photography business was showing signs of slowing down. His health also begun to fail at this time and he died in Rome on November 17, 1872.

JANICE HART

Biography

Robert MacPherson was born in Scotland in 1814. He studied medicine at Edinburgh University (1831–1835) but his medical career was soon abandoned in favour of a very different life as a topographical painter. He moved to Rome in c.1840 and established himself as a painter in oils and also started a business as an art dealer. The most significant aspect of his activities as a dealer was the purchase of a Michaelangelo painting in 1846 and its subsequent sale in 1868. He married Geraldine Bate, a niece of Anna Jameson, the expert in Italian art. MacPherson appears to have abandoned painting shortly afterwards and turned instead to photography. It is likely that he had already begun to take photographs using the calotype process by at least the late 1840s but in the early 1850s he had moved on to the albumen process and was to subsequently adopt the collodion-albumen process. His photographic business was founded on the production of large format prints of Roman architecture and antiquities, together with views of the surrounding Campagna. He quickly achieved commercial success. His interests extended to photo-mechanical printing. His modifications to the photolithographic process was patented in 1853. He exhibited regularly in 1850s and 1860s and achieved much critical acclaim. In 1863 he brought out a small handbook, *Vatican Sculptures*, containing illustrations derived from his photographs. By c.1866 his photographic business was still very active and in 1868 he sold an hitherto "lost" Michaelangelo painting to the National Gallery in London. In the late 1860s, both his business and his health were beginning to fail. He died in 1872.

See also: Calotype and Talbotype; Edinburgh Calotype Club; and Société française de photographie.

Further Reading

Martin Bailey, "The Discovery of Michaelangelo's *Entombment*: the rescuing of a Masterpiece" in *Apollo*, October 1994, 30–33.

Pierro Bechetti, Dyveke Helsted, et al., *Rome in Early Photographs: The Age of Pius IX*. Copenhagen: Thorvaldsen Museum, 1977.

Pierro Bechetti, and Carlo Pietrangeli, *Un Inglese fotografo a Roma*. Rome: Quasar, 1987.

Alistair Crawford, "Robert MacPherson 1814–72: The Foremost Photographer in Rome" in *Papers of the British School at Rome*, vol. 67, 358–403, 1999.

Carol Richardson, and Graham Smith, *Britannia, Italia, Germaia: Tast and Travel in the Nineteenth Century*. VARIE occasional papers 1, Edinburgh, 2000.

Michael Wynne, "Fesch Paintings in the National Gallery of Ireland" in *Gazette des Beaux Arts* (January 1977): 1–8.

A microfiche of the 1863 edition of Robert MacPherson's *Vatican Sculptures* was published by Chadwyck-Healey Ltd., 1994.

MADDOX, RICHARD LEACH
(1816–1902)

Richard Leach Maddox was born on the 4th of August 1816 in Bath, England. He traveled all over the world during the 1840s as a physician and worked for a few years in Constantinople (Turkey) before returning to England. He married twice, the first time in Turkey, to Amelia Winn Ford who died in 1871, and the second time in 1875, to Agnes Sharp. He traveled with his family, which included his three children. He returned to Southampton in England and ended his photographic activities in 1886 however he continued writing for scientific newspapers.

Richard Leach Maddox was not a professional photographer, instead he was more a scientist interested in photography and the science involved in its processes. As a scientist he is especially known for his work concerning microphotography and his research to improve the photographic process. In 1853, he began working with photography, particularly microphotography, in connection with his professional work as a scientist and exhibited his work that same year in the Photographic Society Exhibition in London.

Passionate for this kind of photography, Maddox translated Dr. Félix Dujardin's manual, *Nouveau manuel complet de l'observateur au microscope*, published in France in 1842 (*The New Complete Manual for the Microscope Observer*). The translated version never was published but he did write articles on this subject for the *British Journal of Photography* between 1855 and 1883. For his research in the beginning of the 1870s on atmospheric organisms, Maddox used an apparatus of his own design, called the "aeroconiscope" described by the *British Journal of Photography* as "a kind of multiple funnel set up as a vane. The wind traversing this instrument deposited the organisms on a thin cover-glass duly prepared for the purpose" (*British Journal of Photography*, May 30, 1902, 427).

With this optical instrument connected to the camera, scientists were able to discover and study micro-organisms. During these years, they used a wet process to take photographs of their results.

Speed and picture quality were the most important topics for both scientists and photographers from the very beginning of the technique. The wet collodion process was the most sensitive technique at this time, but not practical enough because it had to be taken before it dried. At this time, the Taupenot process, also called dry collodion, was used as an alternative choice however it was a less sensitive process. A good photographic technique has to be practical and as fast as possible so researchers were always trying to improve the different processes.

One other important concern of Maddox's regarding photographic research was focused on the use of dangerous, chemical substances. His research, which required him to be at his microscope for hours up to sixteen hours a day in conjunction with him being around chemicals used for collodions vapor caused his health to deteriorate quickly. Maddox used ether to prepare his photographic plates, coating them with wet collodion and his failing health is the main reason the scientist tried to replace it in the process.

Well known from the beginning of the nineteenth century, gelatin was already being used in food and in photography (principally for photographic reproduction and impression). Maddox replaced the collodion coating with gelatin. He covered a glass with a mix of Nelson's gelatin and cadmium bromide. After drying, this plate was used as a negative, then developed with pyrogallic acid combined with silver nitrate and fixed with a sodium hyposulfite solution, which proved successful.

Maddox announced his discovery in the *British Journal of Photography*, the 8th of September of 1871, which soon was spread throughout Europe because of the various specialized newspapers and photographic associations. It's likely he realized the importance of his work, but did not follow up with improving the process. According to his notes, he did not have time to perfect it and let others scientists continue any further research.

From August 1873, the *British Journal of Photography* anticipated its future applications. Gelatin was a sensitive, fast, and dry photographic technique, which was also easy to prepare. Consequently, Richard Leach Maddox's discovery was the beginning of photographic industrialization, and one which caused a radical change concerning the picture's aesthetic due to the relatively short developing time.

Several scientists Jos. King, J. Burgess, and R. Kennett, improved the process before 1878, when Charles Bennett perfected actually perfected it by making it

more sensitive. This included warming the emulsion in a neutral medium for a few days at 32 degrees centigrade. Later, Bennett and few others like Désiré van Monkhoven, in Ghent, and George Eastman patented the process and sold readymade negatives plates.

The commercial development of the dry plate process eventually revolutionized the practice of photography, and the images produced by it. Amateur photographers did not need knowledge of chemistry or physics as this invention provided all that was needed, permitting anyone to practice photography.

Richard Leach Maddox received medals from different inventors exhibitions in Brussels, Antwerp, Belgium and the prestigious Royal Photographic Society's Progress Medal on February 12, 1901, for his research.

Maddox did not patent his various discoveries and inventions and did not make money from them as his motto was "if freely we have received, freely give" (*British Journal of Photography,* May 30, 1902, 427).

After his death on May 11, 1902, in Southampton, the *British Journal of Photography* noted that the community had lost the figure that changed photography from a long process to a more convenient one and that the part of photographic history, which had long been dominated by lengthy processes would be, for the "younger generation of photographers…ignorant of the slow and laborious manner in which gelatin photography was" (*British Journal of Photography*, May 30, 1902, 426).

MARION PERCEVAL

See also: Dry Plate Negatives; and van Monckhoven, Désiré Charles Emanuel.

Further Reading

Bulletin de la Société française de photographie, Paris: Société française de photographie, vol. 17, 1871, 271–274.

Bulletin de la Société française de photographie, Paris: Société française de photographie, vol. 19, 1873, 267–269.

Sougez Emmanuel, *La photographie, son histoire*, Paris: Les éditions de l'Illustration, 139–140.

British Journal of Photography, London: T. Benn, September 8, 1871.

British Journal of Photography, London: T. Benn, May 30, 1902.

MAES, JOSEPH (1838–1908)
Belgian photographer, collotype printer, and publisher

Melchior Florimond Joseph Maes was born in Ghent on June 10, 1838. His first experiments in collodion photography took place in 1852. His precocious talents came to the attention of Désire Van Monckhoven, who then employed him as an assistant. Together they set up a studio for the production of stereo views which was a commercial failure, and their stock of negatives was sold to Gaudin in Paris.

Maes decided to open a portrait studio, while still harbouring ambitions in the nascent area of photographic printing and publishing. His studio opened in Brussels, at Rue des Fripiers 26, on November 22, 1858. He soon began supplying photographs for book illustration, his first two commissions, for the Brussels publishing house of A. Schnée, appearing in 1860—a deluxe edition of *Histoire populaire de la Belgique* [*Popular History of Belgium*] by Louis Hymans, containing eleven albumen prints, and a study *Exposition générale des beaux-arts à Bruxelles. Le salon de 1860* [*General Fine Art Exhibition in Brussels. The 1860 Salon*] by the art critic Max Sulzberger, containing four prints.

Maes formed a partnership with a certain Michaux (possibly a romantic interest) from September 1862 to August 1863 and moved premises to Rue Fossé aux Loups 36 Place de la Monnaie. This partnership, the sole example in Maes' long career, was clearly meant to lay the ground for a publishing initiative in the area of art reproduction, but proved to be short-lived. Instead, Maes went on to run the portrait studio alone, domiciled at the address from 14 October 1863. In 1864 and 1865, he published his first major work, *Album des objets d'art religieux du Moyen Age et de la Renaissance exposés à Malines en 1864* [*Album of Religious Art Objects of the Middle Ages and Renaissance* exhibited in Malines in 1864], a series of 57 albumen prints to commemorate a landmark exhibition of sacred art organised by the British historian W.H. James Weale.

Maes married Emma Strybos on 27 October 1863, and they had two daughters, Augusta born in 1865 and Julia in 1867. The family moved to Antwerp in 1866, where Maes acquired a portrait studio from Auguste Blanche (1818–1866) at Rue des Aveugles 1 / Place du Musée on 15 April 1866. His interest in photomechanical processes, a natural outgrowth of his activities in photographic publishing, dates from around this period. The considerable economies of scale afforded by the printing press were clearly demonstrated when the Brussels firm of Simonau and Toovey published a second edition of Maes' Malines album in 1866. Using their patented photolithographic process, it sold at 60 francs a copy, compared to the 200 francs which Maes charged for the original print-run in albumen.

Maes recognised the especial potential of the collotype process, using minimally adapted lithographic presses in general use. Following the Paris universal exhibition in 1867, at which Maes exhibited, he visited the printing works run by Tessié du Motay and Arosa in France, but was dissatisfied that the number of good prints per plate rarely exceeded 75, insufficient for industrial-scale production. When Josef Albert advertised his process in 1869, announcing print-runs of several

hundred, Maes opened negotiations to acquire the rights, but was unable to reach agreement. Maes set about "reinventing" the process, and by November 1869 had produced prints in the full range of halftones. During the following year the collotype workshop went into operation, and in 1871 Maes imported a steam-powered collotype press from Germany, the first of four.

Always the shrewd businessman, and chastened by the failure of earlier ventures, Maes retained the portrait studio, a sure source of income which he operated in parallel to his printing works throughout the 1870s. He offered to supply illustrations in collotype, *photo-auto-typie* (carbon) and Woodburytype, presumably having acquired the hydraulic press for the process previously worked by Simonau and Toovey under licence up to the mid-1870s. Maes operated from Avenue de l'Industrie 24 from 1874 to 1881, and Rempart Sainte-Catherine 23 from 1875 to 1882, then sold the portrait studio at this address to his operator Georges Raynaud. From 1884 to 1895 he ran the collotype works from Rue Gramaye 10. Maes' work graced a broad range of art-historical publications, some of which he published himself. His most extensive achievement in collotype is the folio *Documents classés de l'art dans les Pays-Bas, du Xième au XVIIIième siècles* [*Schedule of Art in the Low Countries, from the Tenth to Eighteenth Centuries*], published between 1880 and 1889 and containing 720 plates with accompanying text by the architect J.J. Van Ysendyck.

As Maes secured his social standing within Antwerp society, so his public profile grew apace. He successively founded two reviews of the arts, *Revue artistique* (1878–1884) and *Chronique des Beaux-Arts* (1884–1886), supplying the illustrations from his own printworks. Joining the *Association belge de Photographie* (ABP) in 1882, he was appointed president of the Antwerp section on 6 December 1886, a post he retained as late as 1904, and held the presidency of the Association from 1889 to 1895. Chairman of the *Union Internationale de Photographie*, he hosted sessions in Amsterdam, Liège and Brussels between 1895 and 1897. He was awarded the Order of Leopold for his services.

Maes remained commercially and publicly active into old age. Although he relinquished control of the collotype works to George and René Dero from 1892 to 1894, he appears to have regained control at least for a short time around 1895. From his final address in Antwerp, Rue Rembrandt 33(3), he was registered as a person of private means, but became an agent for the Lumière company's "Cinématographe." He edited a fortnightly broadsheet *Journal de Photographie* from October 1902 to September 1905, and frequently exhibited as an amateur at the salons of the ABP.

Joseph Maes retired to the Antwerp suburb of Berchem on 7 June 1907 accompanied by his wife and unmarried daughter Augusta. He died on 4 August 1908, and was buried in Berchem cemetery. A dynamic figure in 19th-century Belgian photography, he had participated, in his various guises as photographer, printer, publisher, and increasingly successful entrepreneur, in many of the technical developments in photography for over half a century.

There are substantial holdings of Maes' work at the Bibliothèque royale Albert Ier—Département des imprimés, Brussels, Provinciaal Museum voor Fotografie, Antwerp, Stadsbibliotheek [municipal library], Antwerp, and Stadsarchief [municipal archives], Antwerp.

STEVEN F. JOSEPH

Biography

Melchior Florimond Joseph Maes was born in Ghent on 10 June 1838. Opening his first studio in 1858, he soon began supplying photographs for book illustration. Maes married Emma Strybos on 27 October 1863, and they had two daughters, Augusta born in 1865 and Julia in 1867. The family moved to Antwerp in 1866. Always the shrewd businessman, Maes recognised the potential of photomechanical processes. He set up a collotype printing works in Antwerp in 1870, which he ran for nearly twenty-five years. A key figure in 19th-century Belgian photography, Maes participated, in his various guises as photographer, printer, publisher, and increasingly successful entrepreneur, in many of the technical developments in photography for over half a century. Maes died on 4 August 1908, and was buried in Berchem cemetery.

See also: Gaudin, Marc-Antoine; Collotype; Albert, Josef; Woodburytype, Woodburygravure; and Lumière, Auguste and Louis.

Further Reading

Coppens, Jan, Laurent Roosens, and Karel Van Deuren, *"Door de enkele werking van het licht": introductie en integratie van de fotografie in België en Nederland* [*By the sole action of light": Introduction and Integration of Photography in Belgium and The Netherlands*], Antwerp: Gemeentekrediet, 1989.

De Vylder, Gustave, "Visite à l'atelier photographique de M. Maes, à Anvers" ["Visit to M. Maes' Photography Studio in Antwerp"], *Bulletin belge de la photographie*, 9 (1870): 154–157.

Joseph, Steven F., Tristan Schwilden, and Marie-Christine Claes, *Directory of Photographers in Belgium 1839–1905*, Antwerp and Rotterdam: Uitgeverij C. de Vries-Brouwers, 1997.

Puttemans, Charles, "M. Jos. Maes Président de L'Association belge de Photographie 1889–1895" ["M. Jos. Maes President of the Association belge de Photographie 1889–1895"], *Bulletin de l'Association belge de Photographie*, 22 (1895): 296–299.

Vercheval, Georges (editor), *Pour une histoire de la photographie en Belgique* [*Contributions to a History of Photography in Belgium*], Charleroi: Musée de la Photographie, 1993.

MALACRIDA, JULES
(active 1840s–1890s)
French optician and photographer

Malacrida's date and place of birth remain unknown such as the elements about his childhood, training, death or possible heirs. Optician and daguerreotypist of the first times, he was active since 1840. Between 1848 and 1860, he cooperated with the Dr. Henri Jacquart to make daguerreotypes on anthropological pieces and animals from the *Museum d'Histoire Naturelle*. In *La Lumière*, Ernest Conduché spoke in praise of these works—for the major part collected in the *Catalogue des objets renfermés dans la Galerie d'Anthropologie du Museum du Jardin des plantes* (1857)—whose specimens were shown at the Academy of Science by Geoffroy Saint-Hilaire.

In 1850, he portrayed theatrical celebrities of his period and published a book dedicated to them with Charles Gabet. Set up at rue du Coq Saint-Honoré, 7, he was arrested in 1851 for distributing Félix-Jacques-Antoine Moulin's academic nudes. More severely convicted than the author—indeed, circulation was increasingly stigmatized by law than creation—Malacrida was condemned to one year of imprisonment and to pay 500 francs. During the trial, the President of the Seine Assize Court presented the incriminated photographs such as "so obscene that giving their titles would be an outrage." Few years later, Malacrida associated with photographers and nudes diffusers addressed a petition to the Interior Minister to protest against the seizures they were subject to. However, their petition to the authorities didn't receive the desired reaction, and consequentially their situation became one where with this petition, the government had at its disposal the names of the academic nudes actors market making it easier to target, control and censor their activities.

After this episode, he produced a series of portrait and scenic genre studies (36 negatives) entitled "Etudes d'après nature" published by Lemercier and registered for copyright purposes in 1853. This same year, he moved to rue de Vivienne, 12. Like his colleague Moulin, Malacrida started a more conventional career and left Paris for Toulon (south of France) in the beginning 1860's for an unspecified duration. He went on producing portraits, scenes of genre and negatives of monuments in collaboration with his wife. In 1870, he appeared once again at rue de Vivienne in the Parisian business registries and was supposedly active until 1895.

In 1980 and 1982, several Malacrida's daguerreotypes were sold respectively at Christie's (London) and Drouot's (Paris). At the moment, informations relating to his course and work are sparse and mainly combined with Félix-Jacques-Antoine Moulin's name and their justice issues.

FRÉDÉRIQUE TAUBENHAUS

Biography

Optician and daguerreotypist active from 1840 to 1895, he is essentially mentioned today for the diffusion of Félix-Jacques-Antoine Moulin's academic nudes and for the trial which resulted in 1851. Nevertheless, a major part of Malacrida's career has been dedicated to production of anthropological and zoological negatives, theatrical celebrities portraits as well as an important number of portraits, scenes of genre and photographs of monuments whose became his specialities, particularly after his justice issues.

See also: Daguerreotypes; Félix-Jacques-Antoine Moulin; and Nudes.

Further Reading

Bajac, Quentin, Planchon-de-Font-Reaulx, Dominique, *Le Daguerreotype Français: Un Objet Photographique*: exhibition catalogue, Paris, Musée d'Orsay, May, 13–August, 17, 2003; New York, The Metropolitan Museum of Art, September, 22, 2003–January, 4, 2004.

Beaugé, Gilbert, *La photographie en Provence 1839–1895*, Editions Jeanne Laffitte, 1995.

Frizot, Michel, *Nouvelle histoire de la photographie*, Larousse, 2001.

Gabet, Charles, Malacrida, Jules, *Musée daguerrien: album des célébrités théâtrales. Portraits et biographies*, 1850.

La Gazette des Tribunaux, Juillet 1851.

La Lumière, 1858.

Nazarieff, Serge, "Félix-Jacques-Antoine Moulin," *Early Erotic Photography*, Tashen, 2002.

MALONE, THOMAS AUGUSTINE
(c. 1823–1867)

Malone was a competent chemist who worked with several early photographic processes but was usually remembered for his association with Talbot. Little is known of his early life. In 1844 he worked with Hippolyte Fizeau and Antoine Claudet etching daguerreotypes before being recruited by Nicolaas Henneman to work at Talbot's Calotype establishment at Reading. It was Malone that did much to refine and improve the Calotype process. When the establishment closed in 1847, Henneman and Malone opened a Calotype studio in London's Regent Street, which was funded by Talbot. Further support from Talbot allowed Malone to travel to Europe to meet distinguished photographic scientists. Around 1851 ill health caused Malone to leave the Regent Street business. After recovering, he became a lecturer and held posts at the Royal College

of Chemistry, the Royal Polytechnic Institution and the London Institution. He was a member of the Chemical Society and an active and often outspoken member of the Photographic Society of London.' When his post at the London Institution was abolished in 1864, Malone took a humble teaching job at a school in Clapham, South London. His health again became poor and in 1866, fearing for her safety and that of her five children, his wife committed him to Bethlem Hospital, a mental asylum. He died in Bethlem in 1867, a sad end that probably explains why his death does not seem to have been recorded in any major scientific or photographic publication.

JOHN WARD

MANN, MISS JESSIE (1805–1867)
Scottish assistant and photographer

Miss Jessie Mann was the assistant of the Scottish pioneering art photographers David Octavius Hill and Robert Adamson and one of the first woman photographers. She was born on 20 January 1805 in Perth, Scotland, the daughter of a house painter. She grew up there with her four sisters and one brother and her home was immediately opposite that of the family of D O Hill in a narrow street known as Watergate. When Jessie's father died in 1839 she moved with her two unmarried sisters, Elizabeth and Margaret, to live with their brother Alexander who had become a solicitor in Edinburgh. When Alexander married in 1842, the three sisters moved to a flat in Leopold Place, close to Rock House where Hill and Adamson set up their famous photographic studio.

Miss Mann in mentioned in two letters to D. O. Hill from his friend James Nasmyth dated 1845 and 1847. In the latter Nasmyth describes her as the "thrice worthy Miss Mann that most skilful and zealous of assistants." It is difficult to identify the photographs actually taken by Jessie Mann. It is recorded that on a tour of Britain the King of Saxony unexpectedly paid a visit to Rock House in 1844. The King of Saxony wanted to be photographed and as neither Hill nor Adamson were available "an assistant carried out the process." There are prints in the Scottish National Portrait Gallery. There are also photographs of the completion of the Balloch-myle railway viaduct in Ayrshire which could only have been taken in the spring of 1848 and Adamson had died earlier in January that year. These may also have been by Jessie Mann.

Like D.O. Hill Jessie and her two sisters in Edinburgh were supporters of the Free Church and Hill included them in his "Disruption" painting. It is said that two prints by Hill and Adasmon, one in the Scottish National Portrait Gallery and the other in Glasgow University

Library, are of Jessie Mann. In both she wears a glove on her right hand and this could be to hide the stains of silver nitrate that would have been an occupational hazard for photographic assistants at the time.

When photographic activities ceased at Rock House following the death of Adamson, Jessie became the housekeeper of Andrew Balfour who ran a private grammar school in Musselburgh a few miles from Edinburgh. There is no record of her continuing with photography although she retained an interest and kept in contact with D.O. Hill. There is a personal letter to Hill from Jessie Mann in the archives of the Royal Scottish Academy dated 1856 which is in very person terms and refers to photography.

She later moved back to Edinburgh to live with her surviving sister. She died on 21 April 1867 a few months after suffering a stroke that paralysed her down one side. She was buried in the family plot at Rosebank Cemetery, Edinburgh. She never married.

RODDY SIMPSON

MANSELL, THOMAS LUKIS (1809–1879)
British doctor and photographer

Doctor Thomas Mansell was born on Guernsey in the Channel Islands in 1809, the eldest son of Rear-Admiral Sir Thomas Mansell and Katherine Lukis.

He was educated at Trinity College, Dublin and practised as a consulting physician as well as serving as a jurat (honorary judge) to the Royal Court of Guernsey.

Mansell, along with fellow photographers including Delamotte, Lake Price and Dr. Diamond, was one of the twenty founding members of the Photographic Exchange Club in the early 1850s. In 1854 he appealed for fellow members to supply lists of data regarding negative exposure time, development, paper manufacturer, maker,focal length of lens used, etc.

Mansell was interested in technical aspects of photography and experimented with different processes. Following his move from paper negatives to glass, he used his own 'syruped-collodion' formulae, which was convenient to use, but very slow.

A river scene, taken by Mansell in Northern France in 1856, was included in an 1857 Exchange Club album, complete with comprehensive technical information. Mansell used his syruped-collodion on a 11" × 9" glass negative (developed by pyrogallic acid) and the exposure was a full 47 minutes (in bright sunshine) with a 12.5" Ross lens. He used gold-toning to produce the finished print.

Mansell showed a selection of landscapes from glass negatives, all taken in the Channel Islands or northern France, at exhibitions between 1856–58.

IAN CHARLES SUMNER

MARCONI, GAUDENZIO (1842–1885)
Photographer

Gaudenzio Marconi (who appears in many writings under the first name, Guglielmo, is likely due to a confusion with the better-known Italian inventor) was born in 1842 in Switzerland, to a family of probable Italian origin. Few traces remain of the life of this author and his family.

Before becoming a photographer, Marconi is referred to in the documentation as an "artist-painter." Most of his photographs are images of nudes (albumen prints from wet collodium plates). During the period in which Marconi worked, nude photography was a widely popular genre, with frequently interwoven and overlapping variations in style and destination. Some of these photographs were made for private collections of a more or less openly erotic character (perhaps the majority of the daguerreotype nudes), but nude images were also frequently used in scientific journals in the fields of medicine, ethnography, and anthropology.

There was also a substantial production of these works made in photographic studios that became increasingly specialized. The work circulated in the form of actual catalogues and was destined for the use of artists, including painters and illustrators as well as for art schools. The major photographic studios, like Marconi's, that supplied this market also worked intensively on the business front. They would sometimes use external distributors for selling their works so that, once the works left the studio, they would then follow an independent course that might include many different passages. Given this scenario, it is easier to understand the reasons why certain situations occurred, such as the fact that Marconi acquired and sold some images by another well-known photographer, Auguste Belloc, under his own trademark, or the fact that some photographs taken by Marconi are either unsigned or attributed to his Austrian colleague Hermann Heid (owner of the major Viennese workshop specializing in the same kind of images), in a work such as *La Beauté de la Femme*, published by the Austrian Charles-Henri Stratz in a series edited by Paul Richer.

From the mid-1850s, the use of photographs in art schools became increasingly widespread and was a substitute for live models. At the *École des beaux-arts* in Paris specific classes were held in anatomy and morphology that relied on the use of large numbers of photographs. In general, nude drawing—the study of anatomical details and particularly representations of bodies in classical poses, the so-called *académies*—constituted a highly advanced level of teaching drawing. Starting from 1871, the Marconi studio mark bore the title "Photographe de l'École des beaux-arts," indicating his collaboration with that prestigious institution as a clear mark of distinction.

In relation to the work of other contemporary photographers engaged on the same theme, Marconi's photographs bear a number of distinguishing features. Firstly, his subjects: in a market that was heavily dominated by female nudes, Marconi often used male subjects. The compositions he created show particular attention to the plastic quality of the bodies, with a clear intent of highlighting the movements of the muscle masses. The subjects are almost always photographed against neutral backgrounds or simple landscape backdrops, making very little use of decorations or props except for a few essential drapes. The Michelangelo-style representation of the vigor and volume of the bodies comes through forcefully—contrary to the works of other artists—and excludes any evocation of unreal atmospheres or the adoption of sensual poses.

During this period, photography studios like Marconi's, increasingly open to models, artists, and decorators, were alive with all the debates and the technical and theoretical developments that characterized the artistic scene of the times, inevitably leaving a deep mark on the photographic works they produced. Evolving in close touch with this artistic climate, photography was sometimes reduced to an imitation of painting, while at other times it would develop absolutely original expressions that contributed to radically changing painting itself. In the images produced by Marconi, a strong innovation was introduced through the possibility of using photography to capture images of tensed bodies in positions that would have been very difficult for models to keep throughout lengthy painting sittings.

Like other artists of his generation, Gaudenzio Marconi left France in the 1870s due to the disastrous Franco-Prussian wars, which had a dramatic impact on the artistic community. The war left its mark on his work in a series of scenes that are quite exceptional in relation to the rest of his images (at least among those that have come down to us). This series depicts events relating to the siege of Paris, the most famous of which is *Pertes de la garde mobile après le combat de Châtillon*.

Records show that after 1870 Marconi was working in Brussels. Up to 1885, Marconi appeared in the commercial registry of Brussels, though as an artist resident abroad, working as both a painter and photographer.

This was the period of his collaboration with the sculptor Rodin, for whom he produced an image, the portrait of the soldier August Neyt (it is interesting to note that in this case he did not make use of a professional model), used for the creation of the sculpture *L'Âge d'airain* (*The Bronze Age*). Rodin also asked Marconi for a photographic reproduction of the work, which was presented in preview in Brussels in January 1877 and destined subsequently for the Salon of Paris. The Rodin Museum conserves two reproductions of *L'Âge d'airain* (front and back views) that bear the

stamp "Photographe des Beaux-Arts—Marconi—Place Gd Sablon 19—Bruxelles" on the back, as well as two standing portraits of the model, together with other photographs by Marconi with extensive cuts and pencil marks, testifying to the instrumental use of these images by Rodin and the collaborators of his *atelier*.

As far back as 1870, works by Marconi belonged to the collection of images coming from the legal deposit of the *École des beaux-arts* conserved at the *Bibliothèque Nationale de France* in Paris as well as in numerous private collections. His works often appear in catalogues of the galleries that deal in artistic photographs of the 19th century.

<div style="text-align: right">Claudia Cavatorta</div>

Biography

Gaudenzio Marconi was born on March 12, 1842, in Comologne, in French-speaking Switzerland, to a family of probable Italian origin. He married Adrienne Fontaine, born in Amsterdam in 1844. As of 1862, Marconi, known as an "artist-painter" before becoming a photographer, worked in Paris, with studio at 11 rue de Buci. He specialized in photographs of nudes, which were mainly destined to art schools for teaching anatomy and morphology. As of 1869, in fact, he is registered as "photographe des beaux-arts," and from 1871 his studio trademark carried the title "Photographe de l'École des beaux-arts de Paris." In 1871, Marconi produced a number of scenes of episodes from the siege of Paris, and left France to move to Brussels. Initially he opened a studio in place du Grand-Sablon, and subsequently (as of September 22, 1876), in rue du Commerce. In 1877 he documented the sculpture *L'Âge d'airain* by Rodin. On July 23, 1879, he moved to Schaerbeck, on the outskirts of Brussels. Records show that he remained there until 1885, in rue Potter 5, working as both a painter and photographer.

Further Reading

Aubernas, Sylvie et al., *L'Art du nu au XIXe siècle. Le photographe et son modèle* [*Nude Art in the 19th century. The Photographer and His Model*], Paris: Hazan-Bibliothèque Nationale de France, 1997 (exhibition catalogue).

Billeter, Erika, *Malerei und Fotografie im Dialog* [*Painting and Photography in Dialog*], Berne: Benteli, 1979.

de Decker Heftler, Sylviane, "Le nu photographique. Art impure, art réaliste" [*"The Photographic Nude. Impure Art, Realistic Art"*], in *Photographie* 6 (1984): 51–75.

de Decker Heftler, Sylviane, "Suite Marconi 1. La piste belge" ["Marconi Suite 1. The Belgian Track"], in *Photographie* 7 (1985) 110–112.

de Decker Heftler, Sylviane, "Suite Marconi 2. Voyage en Autriche: Richer et le Dr Straz" [«Marconi Suite 2. Travels in Austria: Richer and Dr. Straz"], in *Photographie* 7 (1985): 112.

Scharf, Aaron, *Art and Photography*, London: The Penguin Press, 1968.

MAREY, ETIENNE-JULES (1830–1904)
French scientist

Etienne-Jules Marey was a scientist—what we would nowadays call a biophysicist—who used a camera in his life-long investigation of the physiological laws governing human and animal movement. His methods and images were remarkably influential in the histories of photography, art, aviation, military reform, moving pictures, physical education, and scientific labour management.

Marey was born 5 March 1830 in Beaune, capital city of wine-producing Burgundy in France. Following his father's wishes, he enrolled in Paris' Faculty of Medicine in 1849. He was drawn to the new science of physiology—the study of life processes—as a student, and after successfully passing his medical exams, he abandoned the life of a doctor for that of a physiological researcher.

Conceiving of the body as an animate machine run by a complex motor whose functions could be reduced to the newly discovered laws of thermodynamics—this was a radical concept in his day—Marey chose to study the body's most manifest form of energy: movement. He invented the graphic method, graphing instruments that traced the body's internal and external movements without interference by the practitioner. These are the mechanical ancestors of the electronic graphs and scopes universally used in medicine today.

The December 1878 publication of Eadweard Muybridge's series photographs of horses in the French journal *La Nature* showed Marey that photography could enhance the graphic method. In the winter of 1881–82 after meeting Muybridge in Paris, Marey made his first photographing instrument, a small rifle ("fusil photographique") that took twelve sequential images per second on a rotating glass disk. It was based on Jules Janssen's 1874 photographic revolver but was a notable advance, being portable, faster, and incorporating an automatic glass plate dispenser.

By summer 1882, Marey had moved his experiments to the Station Physiologique, the first large outdoor municipally-funded physiological laboratory in Europe built for him in the Bois de Boulogne. There he was aided by his talented assistant Georges Demenÿ and his mechanic Otto Lund. Marey spent each winter working on his photographic experiments at his villa in Posillipo, Naples, leaving Demenÿ in charge of the Station. This arrangement lasted until Demenÿ's 1894 departure in a disagreement over his commercialization of motion pictures.

Marey's photographic method, which he called chronophotography, was built upon his need to have what his graphing machines had provided: the visible expression of a continuous passage of time over equi-

Fremont, Charles and
Etienne-Jules Marey.
Trajectory of the
Blacksmiths' Mallet and
Hammer.
*The Metropolitan Museum of
Art, Purchase, The Horace
W. Goldsmith Foundation
Gift and Rogers Fund, 1987
(1987.1054) Image © The
Metropolitan Museum of Art.*

distant and known intervals within a single tracing. He used a single glass plate in a single camera. Behind the camera's lens which was left open, Marey fixed a rotating metal disk shutter with from one to ten slots cut into it at even intervals. His subject—in these early experiments it was one of the soldier-gymnasts from the military school of neighbouring Joinville-le-Pont—was dressed all in white and moved in bright sunlight against a black background. As the shutter was rotated (by a crank) its slots exposed the plate, capturing the subject's movement as sequence of overlapping images.

To avoid the superimposition of limbs produced by too rapid shutter rotation, Marey devised a strategy astonishing for the way it operated against our usual understanding of the ontology of the photographic image, that is, that cameras inherently replicate all detail visible to the eye. He covered first half, and then the entire body of his subject in black and marked its joints in white. The resulting photographs rendered pure movement as graphic form.

With chronophotography Marey analyzed for the first time the mechanics of how we actually walk, run and jump and how the animals with whom we share this planet move. He also photographed the movement of the inorganic: the trajectories of projectiles, the geometric forms engendered by a string or wire moving around an axis, and water where there was no bearer or guide. In 1900 he moved into the area of aerodynamic forces, constructing the first wind tunnel in which he photographed smoke filets travelling around differently shaped planes.

In 1888 when paper negative stripping film appeared on the French market, Marey replaced his glass plate with a roll film and constructed a feeding mechanism for his camera. By early 1889 Marey had made a box to contain the bobbins, feeding mechanism and the film which he backed with opaque paper—one of the first examples of daylight loading film. His camera, films and the electric zoetrope he made to synthesize his films and photographs were the centre of the photography section at the 1889 Paris Exposition Universelle. And while Marey had no interest in reconstituting the illusion of movement, his work was the fundamental catalyst to all those like Edison, the Lumière brothers, and his assistant Demenÿ, who did.

Marey's graphing, photographing and cinematographing methods changed how the working body was conceived and how it was represented in both the social and aesthetic domains. He provided a scientific basis for developing the endurance of the soldier, and for the creation of a national physical education program in France. His instruments were used to analyze worker's movements and even to rationalize a physiological basis for psychology. After his death a new European science of work emerged out of his analyses. In America his separating of the phases of locomotive acts was complicit in the work of Frederick Taylor and his time-and-motion-study associates.

After Marey's death, chronophotography also influenced how the body was represented in art. The radical transformation of the experience of time and space created by the speed and pace of life at the turn of the

century, by the experience of the newly industrialized workplace, and by new technologies—the telephone, telegraph, automobile, phonograph and cinema, made Marey's chronophotography appealing to artists who sought ways of expressing modernity. For Marcel Duchamp, Franz Kupka and the Italian Futurists, in particular, Marey's chronophotography, both scientifically accurate and lyrically graceful, supplied a language with which to depict the kinetic and emotional dimensions of the subject, materialize the forces of the invisible, and give visible form to speed and dynamism.

MARTA BRAUN

Biography

Born 5 March 1830 in Beaune, Etienne-Jules Marey was the only child of Marie-Joséphine Bernard and Claude Marey. A researcher in the physiology of movement, Marey took up photography in 1882 as a way of expanding his graphic method of recording motion. Marey's contributions to medicine—he was a pioneer of cardiology—and physiology made him an important figure in the French scientific and photographic establishment. Elected to the Chair of "Organized Bodiesli" at the Collège de France in 1869 and the Academy of Sciences in 1878, he became president of that institution and the Société française de photographie in 1895. He was the author of more than three hundred scientific articles and seven books. He collaborated with Nadar, the Lumière family, Ottomar Anschütz, Gustave Eiffel and the aviation pioneer Victor Tatin. Marey died of liver cancer in Paris 15 May 1904.

See also: Londe, Albert; Chronophotography; Muybridge, Eadweard James; France; History: 7. 1880s; and Anschütz, Ottomar.

Further Reading

Braun, Marta, *Picturing Time: the Work of Etienne-Jules Marey (1830–1904)*, Chicago: University of Chicago Press, 1992.

Dagognet, François, *Etienne-Jules Marey: A Passion for the Trace*, New York: Zone Books and Cambridge MA.: MIT Press, 1992.

Frizot, Michel, *E.-J. Marey 1830–1904, la photographie du mouvement* [*E.-J. Marey 1830–1904, the Photography of Movement*], Paris: Centre national d'art et de culture Georges Pompidou, Musée national d'art moderne, 1977 (exhibition catalogue).

Frizot, Michel, *Etienne-Jules Marey,* Paris: Photo-Poche, Centre national de la photographie, 1984.

Frizot, Michel, *La chronophotographie, temps photographie et mouvement autour de E.J. Marey* [*Chronophotography: Time, Photography and Movement around E.J. Marey*], Beaune: Association des Amis de Marey, 1984 (exhibition catalogue).

Frizot, Michel, *Etienne-Jules Marey Chronophotographe* [*Etienne-Jules Marey Chronophotographer*], Paris: Nathan, Delpire, 2001.

Leuba, Marion, *Marey, pionnier de la synthèse du mouvement* [*Marey, Pioneer of the Synthesis of Movement*], Beaune: Musée Marey, Réunion des Musées nationaux, 1995.

Mannoni, Laurent, *Etienne-Jules Marey: le memoire de l'oeil* [*Etienne-Jules Marey: The Memory of the Eye*], Paris : Cinémathèque française, 1999 (exhibition catalogue).

Snellen, H. A., *E.-J Marey and Cardiology : Physiologist and Pioneer of Technology, 1830–1904*, Rotterdam: Kooyker, n.d. (c. 1980).

Snyder, Joel, "Visualization and Visibility" in *Picturing Science Producing Art*, edited by Caroline A. Jones, and Peter Galison, New York and London: Routledge, 1998.

MARGARITIS, PHILIPPOS (1810–1892)
Greek photographer

Philippos Margaritas is generally accepted as having been the first Greek photographer. Born in Smyrna in 1810, he spent his student years in Italy practising painting. In 1842, he was appointed teacher at the School of the Arts, where he taught Basic Drawing until 1863. He was introduced to photography in 1846–47 by the French photographer Philibert Perraud who visited Athens and within the next year he experimented with the new medium using a daguerreotype camera that had been offered to the School of Arts. In 1849, he opens the first photographic studio in Greece in the garden of his house on Klafthmonos Square. His themes were initially the ancient classical monuments and portraits of members of the royal court, fighters of the Greek War of Independence, politicians and ladies dressed in regional costume. Faithful to his training as a painter, Margaritis coloured over many of his early photographs with great precision and detail. He often travelled abroad and kept abreast of the most recent developments in photography. His frequent travels made it necessary for him to find a permanent partner for his studio. In 1870, he started his collaboration with the painter Ioannis Constantinou. Ten years later, Ioannis Lambakis became the firm's third partner.

ALIKI TSIRGIALOU

MARION AND COMPANY

Marion and Company was the largest and most important supplier of photographic equipment and material in Europe during the second half of the nineteenth century. By 1896, its retail catalogue ran to 135 pages, listing products that ranged from retouching desks to trimming knives. The frontispiece proudly declared that the firm had won nine medals for the work it had exhibited. These included awards at the Exposition Des Produits De L'Industrie (Paris, 1844), the Exposition De L'Industrie Francais A Londres (London, 1849) the Great Exhibition (London, 1851), and the L'Exposition Universelle (Paris, 1878).

Marion and Company was a French stationary and

fancy goods firm with outlets in both London and Paris. The French base of the firm was connected to Auguste Marion, who published several works on photography from the late 1850s onwards, often with particular reference to the paper used in the printing process. In 1856, an advertisement in the *London Post Office Directory* described the firm as "Stationers, importers of fancy goods and photographic papers." Based at 152 Regent St and 14 Cité Bergère, Paris, *Papeterie Marion* were, at this stage, still primarily importers of French luxury goods. They sold photographic paper alongside all varieties of decorated mourning and wedding stationery (their first advert for photographic paper in *The Times* was June 30, 1854). Their subsequent growth was a product of the commercialisation of photography during the late 1850s, and is a testimony to the high-quality albumen prints required by photography.

Marion and Company is often credited with introducing the *carte-de-visite* to Britain in 1857. They were the market leaders in the supply of celebrity photographs, a position that lasted for several decades. Throughout this period, they were located at 22–23 Soho Square, and they later had their own factory at Southgate in Middlesex. Marion and Company, a wholesale house, acted as both as a central supply point and as a distribution hub for many major photographers, including John Jabez Edwin Mayall, Camille Silvy, and the Southworth Brothers. Mayall was reputed to have been paid £35,000 by Marion and Co. during the 1860s for his *carte-de-visite* of the British royal family. The firm stocked thousands of celebrity photographs of every kind, in preparation for sudden changes in demand such as the death of a well-known figure. An article in *Once a Week* by Andrew Wynter described how Marion and Company made the celebrity *carte* into a modern phenomena:

> This house is by far the largest dealer in *cartes de visites* in the country; indeed, they do as much as all the other houses put together. The wholesale department of this establishment, devoted to these portraits, is itself a sight. To this centre flow all the photographs in the country that "will run." Packed in the drawers and on the shelves are the representatives of thousands of Englishwomen and Englishmen awaiting to be shuffled out to all the leading shops in the country. (Andrew Wynter, *Subtle Brains and Lissom Fingers*, 304)

Marion and Co. were instrumental in turning the *carte-de-visite* into a general consumer artefact. In 1862, their London manager, Mr. Bishop, stated that 50,000 *carte-de-visite* passed through the firm's hands every month. In later years they published their own sets of pictures such as "Marion's Series of Eminent Political Men" (24 × 18 inches and sold for between one and three guineas).

Marion and Company sold a wide range of photographic equipment and apparatus, particularly photographic albums and paper. The success of the *carte-de-visite* went hand-in-hand with the growing popularity of photographic albums for collecting celebrity and family photographs. Similarly, *carte-de-visite* themselves had to be pasted onto cards, which were often printed with the photographer's name on the reverse, often with additional decoration. Marion and Company's expertise as stationers and sellers of fancy good made them ideally suited to supply the burgeoning trade in printed photographic product. As the century progressed though, they slowly expanded their range of good, particularly in the 1880s and 1890s when the advent of dry plates helped to make photography accessible to a large number of amateurs. In 1884, they were advertising a complete beginner's set for £2 10s. By 1896, the cheapest "Nonpareil" introductory set was only 30 shillings. It came complete with camera, a dozen plates, lens, tripod, focusing cloth, and all the necessary solutions.

In 1884, *Marion's Practical Guide to Photography* was published, specially written for the use of amateurs. It was republished in 1885, 1886, 1887, and 1898, and was one of most successful photographic handbooks. A review in the *British Journal of Photography* declared that the book dealt "in a lucid and practical manner with the various operations connected with every department of the science while the *Queen* similarly noted that "A great many ladies practise photography, and they will appreciate the instructions here given."

At the same time as it tapped into the market for amateur photography, Marion and Co. continued to supply the professional studios with equipment like scenic backgrounds (£0 50s in the 1880s) and retouching apparatus. The firm supplied the latest apparatus by most other major photographic manufacturers, such as lenses by Ross, Voigtländers and Dallmeyer. However, it also took out several patents in its own name. In the 1880s, these included Marion's own "Parcel" detective camera, which had plates 4¼ × 3¼ inches, and was disguised as a parcel through being covered with brown linen paper and tied with string.

One technique that was re-introduced to great effect by Marion and Co. was the Cyanotype. In 1881, the firm reintroduced it under the name of the "Ferro-Prussiate or blue process." The process was used to make cheap reproductions of drawings, patterns and plans, and became popularly known as the "blueprint." The firm sold prepared papers to government departments, shipbuilders, railway companies, and architects.

Unsurprisingly, the firm remained especially pre-eminent in the supply of all forms of stationery connected to photography, particularly albums, printing paper and all types of card mounts. Its photographic mounts won a gold medal at the *L'Exposition Universelle* in 1878 and a silver medal at the London Inventions exhibition

in 1885. The albums of Marion and Company even attracted the attention of *Punch* in its edition of 24 December 1881:

> In acknowledgement of having produced the handsomest, most decorative, and most original Album for Photographs, we hereby decorate Mr Marion (of *Marion & Co.*) with his own patent clasp, and create him Duke of St Albums. The public will send him their orders.

Punch's comic praise testifies to the prominence and repute and of the firm. Marion and Co. reaped the benefits of being one of the first firms to treat photography as an industry.

JOHN PLUNKETT

See also: Cartes-de-Visite; Mayall, John Jabez Edwin; Silvy, Camille; Southworth, Albert Sands, and Josiah Johnson Hawes; British Journal of Photography; and Dallmeyer, John Henry & Thomas Ross.

Further Reading

Marion, Auguste, *Pratique De La Photographie sur Papier simplifiee par l'emploi de l'appareil conservateur des papiers sensibilisés et des préservateurs-Marion*, Paris: Chez Lauteur, 1860.

——, *Procédé négatif sur papier térébenthino-ciré-albuminé-iodduré pour vues, groups, portraits*, Paris: Marion and Cie, 1858.

Marion, Auguste, *Instruction provisoire pour le tirage des épreuves positives au charbon par le procédé Marion*, Paris: A Chaix, 1868.

Marion, Auguste, *Procédés nouveaux de photographie, ou: Notes Photographiques*, Paris: A Marion, 1865.

Marion, Auguste, *Le Mariotype, ou Art des impressions par la lumière. Initiateur pour tous*, Paris, Marion, Fils and Gèry: n.d.

Marion & Co., *Catalogue of Photographic Apparatus and Materials*, London: Marion & Co., 1896.

——, *Marion's Practical Guide to Photography*, London: Marion & Co, 1884.

"Our Editorial Table. Messrs Marion and Co.'s Novelties," *British Journal of Photography,* 22 December 1882: 735.

Wynter, Andrew, *Subtle Brains and Lissom Fingers*, London: Robert Hardwick, 1863.

MARISSIAUX, GUSTAVE (1872–1929)
Belgian photographer

Born in Marles-les Mines (Pas-de-Calais, France) in 1872, Gustave Marissiaux was the youngest of three brothers and son of Gustave Léopold Marissiaux, a mining architect. In 1883, the family left France for Liège, Belgium, the region of origin of Marie Therese Micha, Marissiaux's wife. Once of age, each child of the family became a Belgian national.

In the beginning of the 1890s, Gustave Marissiaux chose to study law, but photography soon turned him away from it. In 1894, he became interested in photography, and was elected as a member of the Association Belge de Photographie [Belgian Association of Photography] (A.B.P.), the spearhead of Pictorialism in Belgium. A lecture Marissiaux gave in 1899 to the Liège section of the A.B.P., which was published the following year in the bulletin of the association, directly showed the photographer's interests. With the title "Art and photography it clearly defined the issues of artistic photography, like how to express, through the plasticity of the image, the personality of its author, or to reveal the "temperament" of the subject. To meet this criterion, Marissiaux drew on painting more than inspiration, as a method. Frequenting museums in Belgium and France led him to elect Corot, Delacroix, and Rembrandt as models. The study of their works guided Marissiaux to a deep understanding of composition and the relations between colours and work on shadows determined his approach of photography. Contemporary painters like Le Sidaner or his friends Auguste Donnay and Armand Rassenfosse, supported his look. It was therefore not surprising to find in his early works the influence of British Pictorialism, and particularly of Peter Henry Emerson. The country views that showed an isolated figure going about its duties ("Le Bûcheron" ["The Woodcutter"], 1896) recall the motives dear to the British photographer. The naturalism of the subjects evoked the open air painters and their will to find their sources of inspiration in outdoor sceneries, in opposition to academic staged imagery. But Marissiaux did not only share with Emerson this common reference to painting. His visual processing also related to the British master, through the attention given to the graduated shading, to light variations and to atmosphere rendering. One could read this in the numerous landscapes and forest interiors, with a hint of symbolism ("Coup de vent sur les hauts plateaux" ["Blowing wind on the Highland's"], 1901). By his platinum printings, Marissiaux gave these landscapes a dimension of mystery, which expressed a part of hidden, of unutterable, characteristic of the symbolist aesthetic.

Beyond these landscapes, Marissiaux also made portraits, both as a professional and as an artist. Although it might seem contradictory for a member of Pictorialism—that assumes the status of the "amateur," in the noble meaning of the term—Marissiaux opened a portrait studio in 1899. This professional activity that he apparently dissociated from his personal work, remained unrecognised, with most of the studio negatives being lost.

Nevertheless, portrait occupied a key position in Marissiaux's work. In the room of his studio, he devoted himself to "Studies," staging young girls whose attitudes denote an activity or a state of mind ("Liseuse" ["Reader"], 1899, "Mélancolie" ["Melancholy"], 1899).

A number of them allowed a purely photographic interpretation of forms and matters, and illustrate a work of lights and contrasts, as their title, "Studies," indicates.

Broadly spread in exhibitions organized by the A.B.P., but also in photographic exhibitions abroad such as Berlin (Royal Academy, 1899), Roubaix (International Exhibition of Photography, 1900), and Glasgow (International Exhibition, 1901), and printed in national and international reviews, Marissiaux's works give him access to unanimous recognition, making him a leading photographer of Belgian Pictorialism.

To these supports is added another one: the luminous projections. Organized annually by the Liège section of the A.B.P., they achieved open success by the general public. Marissiaux almost systematically took part in these projections, between 1894 and 1924. It is in that context that he set up, in 1903, a sort of "total spectacle" entitled "Venice." It proposed, in Liège Conservatory, a projection of photographic views of the lake city, accompanied with a poem recitation and music for choir, and orchestra, composed by his friend Charles Radoux. The new version of this show, presented in 1906, gave rise to no less than 26 representations, in Belgium and abroad.

Italy was for Marissiaux a genuine source of inspiration. From 1900 onwards, he travelled there every year, and visited most Italian cities of art. The photographs taken during these travels represented an important part of his work, consisting mostly of oily inks (Rawlins process). These allowed Marissiaux to dissolve details into an evanescent and coloured rendering that particularly suited the representation of Venice. He chose to regroup those Venice views in an homonymous album, published in 1907.

Surprisingly enough, the largest public success was brought by an order that orientated Marisisaux onto unexplored paths, namely social photography. Formulated by Liège Syndiciate of Coal Board, this commission consisted of illustrating the industry of coal mining in the Liège area. The photographer was invited to work with stereoscopy, to reinforce the impression of the spectator of a true immersion into the coal mining reality. Presented in 1905 at the Universal Exhibition of Liège, the result of this order was composed of 450 pictures, a third being stereoscopic views. Entitled "The Coalmine," this series also gave birth to gum-bichromate prints that became widely exhibited. Some of them also appeared in the album entitled "Artist's Visions." This portfolio reproduced in photogravure 30 pictures that retraced Marissiaux's career between 1899 and 1908.

The attractiveness of colour on the photographer manifested itself not only in his use of autochrome, in 1911–1912, but also in the experimentation with the process of a Flemish photographer, Joseph Sury. Allowing coloured paper prints, this experimental process still remains enigmatic today. Marissiaux applied it to the nudes as well as to genre scenes and landscapes, in the 1910s and 1920s.

Interrupted by World War I, Marissiaux's creative activity was bluredr in the course of the 1920s. As Pictorialism lost steam, the death of his parents and his wife pushed the photographer to become introspective, and he exiled himself to Cagnes-sur-Mer, in the south of France. He died there in 1929.

Presently, the Museum of Photography of Charleroi preserves the work of the photographer, except the negatives of the "Coalmine" series, which are deposited at the Musée de la Vie Wallonne in Liège.

DANIELLE LEENAERTS

Biography

Gustave Marissiaux was born in 1872 in Marles-les-Mines (France). He moved to Liège (Belgium) in 1883. As a law student, he took up photography in 1894, and was elected the same year to the Belgian Association of Photography (B.A.P.). His country views denote a symbolist influence. Portrait is also an important part of his work. He not only practised it as a professional, in the studio he opened in Liège in 1899, but also as an artist, in numerous "Studies." Recognized as one of the most important Belgian Pictorialist, he not only took part in the national Salons of the B.A.P., but also in several European Salons. By combining photography projection, poetry and music, he created a new form of "total spectacle," based on his images of Venice (1903). A public order was addressed to Marissiaux by the Syndicate of Coal Board. This series of stereoscopic views entitled "The Coalmine," and the album "Artist's Visions" (1908), are Marissiaux's most well-known works. He also elaborated a colour technique with the collaboration of Joseph Sury, in the course of the 1910's and 1920's. Exiled in Cagnes-sur-mer (in the south of France) in 1925, he died there in 1929.

See also: Pictorialism.

Further Reading

Arnould, Maurice, Delree, Henri, and Fraikin, Jean, *La photographie en Wallonie, des origines à 1940* [*Photography in Walloonia, from its origins to 1940*], Liège: Musée de la Vie Wallonne, 1980.

Magelhaes, Claude, and Roosens, Laurent, *L'Art de la photographie en Belgique, 1839–1940* [*The Art of Photography in Belgium, 1839–1940*], Anvers: Het Sterckshof, 1970.

Melon, Marc-Emmanuel, Marissiaux. "Le mystère de la chambre noire fermée de l'intérieur" ["Marissiaux, the mystery of the dark room locked from the inside"], in: *Clichés*, no.16, mai 1985, 40–51.

———, "La photographie à Liège au XIXème siècle" ["Photography in Liège in the 19th Century"], in: Duchesne, Jean-Patrick, *Vers la modernité. Le XIXème siècle au pays de Liège*

[*Towards Modernity. 19th Century in the Liège District*], Liège: Université de Liège/ Les Musées de Liège, 2001.
——, *Gustave Marissiaux. La possibilité de l'art* [*Gustave Marissiaux. The possibility of Art*], Charleroi: Musée de la Photographie, 1997.
Pinet, Hélène; Poivert Michel, *Le Salon de Photographie. Les écoles pictorialistes en Europe et aux Etats-Unis vers 1900* [*The Photography Salon Pictorialist Schools in Europe and in the United States around 1900*], Paris: Musée Rodin, 1993.

MARKETS, PHOTOGRAPHIC

When Louis-Jacques-Mandé Daguerre and William Henry Fox. Talbot announced their eponymous processes, neither could have envisaged the range of markets to which their inventions would be applied before the end of the century—although both men offered some early suggestions. Daguerre foresaw the primary applications of his invention being of benefit to travelers, archaeologists and naturalists—as well as the more obvious uses such as portraiture.

Also foretelling the public's enthusiasm for portraits, landscape and pictures of buildings and places, Talbot additionally predicted some novel applications of his invention. In *Pencil of Nature* (1844) he not only pioneered the photographically illustrated book as a potentially massive market for photographs, but suggested, amongst other applications, that a photographic inventory of a collection of antiques would be infinitely more useful than a written one, asking his readers, "'and would a thief afterwards purloin the treasures—if the mute testimony of the picture were to be produced against him in court—it would certainly be evidence of a novel kind?'"

Others were just as enthusiastic about the potential applications of photography. The Scottish engineer Alexander Gordon, suggested to the Institution of Civil Engineers in London as early as 1840 that photography would enable "views of buildings, works, or even of machinery when not in motion, to be taken with perfect accuracy in a very short space of time and with comparatively small expense."

Such a use of photography, he suggested, would be of great value to architects and engineers, especially when managing projects at a distance. History proved him correct. The minutes of the first meeting of the newly formed Photographic Society of London on February 3, 1853, record that the engineer Charles Blacker Vignoles, who,

> … made a few remarks in illustration of the great service which the new art would be likely to render to engineers and others having to superintend important works which they could only occasionally visit, or having to make intelligible to foreign employers speaking a different language, with whom they could interchange ideas only imperfectly in conversation, the details of blocks and ropes, and complicated constructions.

He instanced the pictures taken of the works now going on at Kieff for the suspension bridge he was erecting for the Emperor of Russia, over the Dneiper, on which photographic views had been taken weekly during the whole time of its construction, and especially of the method of raising the chains from the first tightening of the ropes to the final elevation of the whole to its proper position, which have been shown with the greatest accuracy and detail.

Here he was referring to the work of John Cooke Bourne, who reportedly chronicled every stage in the bridge's construction through to its opening later that year.

By the end of that decade, industrial photography had established itself as an essential market for photographers worldwide, with progress photography becoming an essential feature of every major construction project, from Ben Mulock's images of the construction of the Bahai Railway, 1859–1862 (another Vignoles project), through to Evelyn Carey's record of the construction of the Forth Bridge in Scotland as the century drew to a close.

The accuracy and reliability of the "evidence" offered by a photograph inspired and drove most early commercial applications. The first photographs brought back from ancient Egypt were avidly collected by academic institutions and scholars, who saw the value of the photographs as enabling studies to be undertaken without the time and expense incurred in actually visiting the locations. The subscription list for Francis Frith's *Egypt and Palestine Photographed and Described* (London, James S. Virtue, 1857), for example, includes many universities and colleges, and many leading academics, alongside the rich and influential.

Roger Fenton's contracts with the British Museum in the 1850s permitted the establishment of an independent sales point within the museum foyer, through which Fenton sold copies of many of the images of museum objects which the Trustees had commissioned him to produce, thus establishing the prototype for today's ubiquitous museum shop. This took the marketing of images of antiquity one stage further as, in addition to sales to academics and specialists, these photographs were sold to the more affluent members of the museum-visiting general public.

Just as with the Egyptian images of Frith and others, many of Fenton's commissions for the British Museum were published in bound editions. His 1856 photographic copies of the Museum's *Clementine Epistles* were produced in an edition of fifty sets, with printed introduction and bound in blue covers. Again, like Frith's Egyptian volumes, these were predominantly sold to museums, universities and wealthy historians, with at least three copies going in to the Museum's own library.

Photography was first exhibited at London's Hyde Park Great Exhibition of 1851, and by the time of the Exposition Universelle in Paris four years later,

commercially produced stereoscopic daguerreotypes, ambrotypes, and glass diapositives of the displays were available for sale, alongside paper prints from glass negatives, at special booths inside the exhibition halls.

By the time of the Centennial Exhibition in Philadelphia in 1876, the use of photography at exhibitions had been further extended by William Notman, with the creation of photographic identity cards for the exhibition staff and exhibitors, initiating the huge market for ID cards that now exists.

Today's market for photographs as advertising can trace its genesis back to the very earliest days of the medium. Daguerreotypes of industrial machinery, clocks and watches, and other commercial products, survive from the early to mid 1850s, the purpose for which can only have been promotional. By the height of the *carte-de-visite* era, the ubiquitous paper print format was also being widely used to allow travelling salesmen to demonstrate the full range of products from the companies they represented—and without the cumbersome bulk and weight of daguerreotypes.

The daguerreotype also played a limited but nonetheless significant part in the introduction of photography for the expanding tourist market mid-century—the most notable example being the concession operated at Niagara Falls by Platt D Babbitt, creating the ultimate memento of a visit, with the tourists posed against the magnificent backdrop.

Once the high cost of large paper prints began to decline in the 1860s, and the higher costs of travel declined as well, the advent of cheap rail travel—especially in Europe—and the parallel introduction of cheaper photography, created a vast market for tourist imagery. This market was dominated by, amongst others, such figures as Samuel Bourne in India, Francis Frith and George Washington Wilson in Britain, William Notman in Canada, Kusakabe Kimbei in Japan, the Adelphoi Zangaki, Pascal Sebah and others in Egypt, and Carleton E Watkins and others in America. Especially along the routes of the European and Middle Eastern Grand Tours—which grew in popularity from the 1860s—numerous photographic studios were established explicitly to cater for the growing tourist market.

The *carte-de-visite* was more crucially influential in the popularisation of the tourist image—and can be seen as the direct predecessor of the picture postcard market which emerged as the nineteenth century drew to a close and which dominated the twentieth century. The much lower price of the *carte-de-visite* and the common format with the family album ensured that the tourist image became just as much a part of family history as the portrait.

The first, and most obviously popular, market to be exploited commercially was, of course, portraiture, and the world's first professional portrait studio was opened by Alexander S Wolcott and John Johnson on March 4, 1840. The New York *Sun* carried an account of the opening:

Sun Drawn Miniatures—Mr A. S. Wolcott, No. 52 First Street, has introduced an improvement on the daguerreotype, by which he is enabled to execute miniatures, with an accuracy as perfect as nature itself, in the short space of three to five minutes. We have seen one, taken on Monday, when the state of the atmosphere was far from favourable, the fidelity of which is truly astonishing. The miniatures are taken on silver plate, and enclosed in bronze cases, for the low price of three dollars for single ones.

The first photographic studio opened in France is believed to have been that of Nicholas-Marie Paymal Lerebours, which operated from late spring 1841, but Richard Beard opened what is believed to have been Europe's first professional photographic studio at London's Royal Polytechnic Institution, on March 23, 1841, just a few weeks earlier than Lerebours.

High costs limited the market for photographic portraits in the early years largely to that stratum of society which might previously have aspired, even if it could not quite afford, to have a miniature painting made. It would be the 1860s before reducing costs, simplified techniques and processes, and the advent of the populist carte-de-visite saw the portraiture market burgeon.

By the end of the nineteenth century, most cities were heavily over-populated with photographic portrait studios—many of which would never achieve a level of financial viability. In London, for example, from Beard's original studio in 1841, the number of active photographic studios in the city had swelled to almost three hundred.

Wedding photography, today one of the mainstays of the profession, first came into popularity in the mid 1850s. Bridal portrait and full-length daguerreotypes by Southworth & Hawes of Boston survive from c.1854, with other portraits of wedding couples by unknown photographers surviving from the same period. While some of these earliest examples of the genre show the bride in a wedding dress, the majority of early wedding photographs were taken after the event, with the bride and groom, hands interlinked, presenting the bride's left hand and wedding ring to the camera. In many early daguerreotypes and ambrotypes, of course, with their lateral reversal of the image, it appears to be the bride's right hand which is offered to the lens.

Four years later, in 1858, the wedding of the Princess Royal, the eldest daughter of Queen Victoria, was photographed by Caldesi, whose pictures included the eighteen year old bride with her parents, and a group picture of her eight bridesmaids. Indeed Queen Victoria, a staunch supporter of early photography in general, also did much to popularize the wedding picture in

Britain. To mark her fourteenth wedding anniversary in early 1854, she and Albert posed before Roger Fenton's camera as if they were a wedding couple, Albert in full dress uniform—black boots replacing the white leggings of his wedding tunic—and Victoria in a simplified recreation of her 1840 wedding dress.

Within a decade, with photographs of Royal weddings widely available as cartes-de-visite prints, the popularity of the wedding photograph had started to grow exponentially. From the mid 1860s, photographers regularly advertised 'wedding groups' in the range of commissions they undertook, and by the end of the century the wedding photograph was an expected part of marriage costs. The specific album of wedding photographs, while not unknown in the nineteenth century, was largely a twentieth century innovation.

After the wedding, the photograph of the baby was an obvious market to develop, and with child mortality much higher in the nineteenth century, deathbed portraits of children also proved a significant if somewhat macabre market for the high street professional. In the event of unexpected infant death, the deathbed portrait often proved the only tangible proof that the child had ever lived.

Socially, the photograph as entertainment also provided a lucrative market for photographers—especially with the introduction of the drawing-room stereoscope in the 1850s. Companies such as the London Stereoscopic & Photographic Company in Britain, and Underwood & Underwood in America, published sets of stereo cards on a wide range of subjects including humour, religion, travel, and news. Individual stereo cards were available for sale from photographers and print-sellers, and specialist journals such as *The Stereoscopic Magazine* further popularized the medium.

In the days before the advent of the half-tone illustration in newspapers, boxed sets of stereoscopic views of important events and news stories would be marketed very quickly after the event they portrayed. Often sold in boxes resembling leather-bound books, these sets sold in large numbers despite the fact that they commanded a high price.

The market for photographically illustrated books was one of Henry Fox Talbot's early predictions, and despite the high cost of his 1844 *Pencil of Nature*, it established a market for photographers which has grown ever since. While such volumes were restricted by the need to paste in real photographic prints, costs were high and production runs small, but the demand grew consistently. With the advent of the Woodburytype in the 1870s, production became somewhat easier, the permanence of the images considerably better, and the number of illustrated books published annually considerably greater.

JOHN HANNAVY

See also: Babbitt, Platt D; Beard, Richard; Caldesi; Bourne, John Cooke; Daguerre, Louis Jacques Mandé; Expedition Photography; Exposition Universelle, Paris, 1855; Fenton, Roger; Frith, Francis; Lerebours, Nicholas-Marie Paymal; Photography as a Profession; Talbot, William Henry Fox Talbot; Travel Photography; Underwood & Underwood; Vignoles, Charles Blacker; Wilson, George Washington; and Woodburytype.

Further Reading

McCauley, Elizabeth Anne, *Industrial Madness, Commercial Photography in Paris, 1848–1871,* New Haven and London: Yale University Press, 1994.

Frizot, Michel (ed)., *A New History of Photography*, Cologne, Könemann, 1998.

Henisch, Heinz K., and Henisch, Bridget A., *The Photographic Experience 1839–1914,* University Park: Pennsylvania State University Press, 1994.

Taft, Robert, *Photography and the American Scene*, New York: Dover, 1964.

Welling, William, *Photography in America: The Formative Years*, New York: Thomas Y Crowell, 1978.

MARTENS, FRIEDRICH (1809–1875)
French inventor and photographer

Friedrich Martens (sometimes incorrectly styled as von Martens), a resident in Paris presumed to be of German origin, designed and built the world's first daguerreotype panoramic camera in the 1840s, the first camera capable of taking, with a single exposure, a view wider than the field of vision of the human eyes.

The camera had a field of view of 150° and a geared mechanism for rotating the lens which required the controlled turning of a small handle at the side of the camera. The lens, pivoting around its centre, was connected to the camera body by a flexible leather front sleeve. At the same time, a 'v' shaped aperture traversed the curved plate making the exposure, effective exposing the sky to a smaller aperture than the foreground, and overcoming the daguerreotype's tendency to solarised in the over-exposed sky. The camera manufacturer was Paris instrument-maker, N. P. Lerebours.

By 1851 he was using collodion, and was awarded a medal for his "talbotypes on glass" [sic] at the Great Exhibition which read "for richness, effect and perfection of definition, they are the finest specimens it seems possible to produce."

He joined Léon Méhédin in the Crimea photographing scenes of the conflict, subsequently published by Bisson Frères, both men later working with Jean-Charles Langlois producing panoramic images during and after the same campaign.

JOHN HANNAVY

MARTIN, JOSIAH (1843–1916)
English-born author and publisher

Josiah Martin (1843–1916) commands high respect and a special position in the history of development of new Zealand photography. A Londoner by birth he came to New Zealand in the 1870s to establish a College of Education in Auckland. For various reasons he gave this up and turned to photography. Eventually Martin became heavily involved with an area in the middle of the North Island called the Hot Lakes District. Over a short period of time, he wrote, illustrated and published several pamphlets, papers and booklets which sang the praises of the districts tourist potential. In 1889 his work in this direction was rewarded with him being elected as the president of the Auckland Institute and Museum. Another great achievement saw him appointed to the post of editor for *Sharland's New Zealand Photographer,* a journal which he edited for many years. During his tenure in this position, he advocated vociferously for the injustices that were being dealt to photographers when it came to taxes and government inaction on matters that threatened their copyright over their images. He was also one of the first photographers to make extensive and tours of some of the Pacific Islands with his camera. The results of these excursions were turned into illustrated lectures with the use of a magic lantern.

WILLIAM MAIN

MARTIN, PAUL AUGUSTUS (1864–1944)
French photographer and wood engraver, resident of Great Britain

Growing up in an era of political, technological and cultural change, Paul Augustus Martin holds a pivotal position in the evolution and growth of modern photography. Although a Frenchman by birth and by choice (he retained his natural-born citizenship throughout his life), Martin emigrated to London, England, in his youth and became a permanent resident of that city for the remainder of his life. The majority of his education, the home of his family, and the basis of his commercial and artistic life would all emanate from and resound throughout Great Britain.

Martin was born in the village of Herbeuville, France, on April 16, 1864, but at the age of five he moved with his family to Paris. The timing could not have been worse as the city endured the joint horrors of the Franco-Prussian War of 1870 and the misadventure of the Paris Commune in 1871. The family, including young Paul, faced tragedy (the loss of his younger sister) and near death on numerous occasions and immigrated to London by 1872. There the family was able to make a permanent home and Paul prospered as a student, fascinated with sports and excelling in mathematics and drawing. Fol-lowing a brief period of attending preparatory school in France, he completed his private school education in London and passed his exams in 1880.

Deciding to pursue his drawing talents, Paul apprenticed himself to a wood engraver in 1880, became a professional in 1883, and excelled in the heyday of this art throughout that decade—wood engraving enjoying a popular period of growth in the illustrated press of the day. It was also during this same decade that Martin became fascinated with amateur photography, learning the technology of dry plate processing on his own and purchasing his first camera, a quarter-plate Le Meritoire, in 1884. For the next four years he continued to work in the circles of his wood-engraver friends, employing the camera on a very limited basis for holiday outings, camping trips and vacations. Despite the limitations his amateur album of this period displays a fine technological skill and a careful professional eye, probably derived from his artistic education and experience.

By 1888, however, things began to change rapidly. Martin discovered the ever-burgeoning amateur photography movement in England with its proliferation of photographic journals and its explosion of photographic salons and camera clubs with their interesting speakers, debates and competitions. It was a dynamic period in photography's history with its established pictorialists and "old-school" photographers facing the dramatic aesthetic and cultural changes being wrought by the myriad new camera and processing technologies of the era. Not of the class or the wealth to engage in the Pictorialist traditions of the masters of the age, Martin applied himself to newer aesthetics that the dry-plate (and later the roll-film) cameras were establishing. By 1889, when he won his first amateur photographic competition, he was hooked.

The decade of the 1890s would mark the time of his greatest proliferation as well as personal change. Martin still worked as a wood engraver, but he took his cameras everywhere—and the resultant imagery reflects both his excitement and mastery of the new medium and a growing understanding about the vast potential of an era of massive photographic change. During this mature amateur period he became an active figure throughout the London camera clubs and salon exhibitions—always coming up with new original imagery and trying new techniques. His purchase in 1890 of a Facile camera (a dry-plate instrument that could be concealed in a nondescript bag and could handle up to 12 exposures) led him out into the streets of London where he captured candid photographs of "London street types" which had not been seen before. The work, while fitting somewhat into the earlier documentary traditions of photography, was clearly innovative, aesthetically mature and definitely unlike any such imagery that had come before. The street types—often manipulated with hand-drawn bases and

dubbed "living statues"—were the hits of many lantern slide evening presentations and gained Martin important notices and awards at the time. He would amplify the work to more expansive environments when he also carried the hidden camera on vacations to other British locales such as the port of Whitby, the beaches of Yarmouth, and even on Swiss vacations.

The other innovative pioneering work for which he became famous derived from his continuing fascination with the aesthetic applications of newer technological innovations. Martin experimented with a variety of nature phenomena—waves at sea, dawns and sunsets, and long exposures—before he hit upon his most resounding work: night photography. Finding new ways to handle such traditional nighttime problems as halation, exposures and incidental light, the photographer began in 1895–96 to produce elegant and complex images throughout the rain-covered, foggy streets of an urban London that was itself in the days in which gas lighting was being transformed by electricity. Martin's "London by Gaslight" won him the widest fame of all, as well as the gold medal of the 1996 R.P.S. annual exhibition and the notice of the established Pictorialists of the day. No less a figure than George Davison offered Martin a position with the rapidly growing Eastman Kodak Company in 1898.

By the century's end, however, Martin made a deliberate professional choice himself. In 1899, he sensed the end of his profession of wood-engraving in an era in which press illustrations were being transformed by photomechanical reproductions of the photographic image itself. Together with Henry Gordon Dorrett he established a professional firm—variously known as Dorrett & Martin or as Athol Studios—that featured everything from freelance press photography to commercial processing and even specialized applications for portraiture such as photo-buttons and other miniature novelties. Although the enterprise was apparently highly successful from a commercial perspective, it effectively ended all of Martin's serious photography. Although he never abandoned making his own photographs—his later work includes pictures of the street and of sporting events as well as more holiday travels—he maintained his time and focus upon running the business.

At the end of 1926 Dorrett & Martin closed their doors. In old age Martin was eventually rediscovered by the camera clubs—which engaged him to give entertaining lectures based upon his Victorian era photographs—and numerous publishers which featured his work and/or reminiscences in newspapers, magazines and books of the day. In 1939 (photography's centennial year) he was encouraged and assisted by C.H. Gibbs-Smith, Research Fellow at the Science Museum, to publish a small autobiography, *Victorian Snapshots*, which would introduce his innovative "amateur" work

to an entirely new generation of photographers. He lived in retirement with his two sons and, perhaps ironically re-haunted by the wars of his youth, passed away from natural causes during the London Blitz on the evening of July 7, 1944.

Martin's original prints are found in many important collections around the world. The main bulk of his amateur imagery—prints, negatives, lantern slides and an early album—form an important part of the Gernsheim Collection at The University of Texas at Austin. His manuscript diary and albums of wood engravings and other prints are in the possession of the Fine Arts Library, University of New Mexico General Library, Albuquerque. A large collection of imagery collected by the Royal Photographic Society, is now housed in the National Museum of Photography, Film and Television in Bradford.

ROY FLUKINGER

Biography

Paul Martin was born in rural France in 1864, and moved with his family to Paris in 1869, in time to survive the dangers of both the Franco-Prussian War and the Paris Commune in the following years. The family then moved to London, which would become Paul's adopted home for the remainder of his life. Combining a talent for drawing together with top grades in London and Parisian schools, he apprenticed himself to a Fleet Street engraving firm in 1880. His childhood fascination with the visual world eventually led him to become interested in amateur photography and to purchase his first dry-plate camera in 1884. Throughout the 1880s Martin joined photographic societies, read all he could about the technology and art of the medium, and honed his own skills on holidays and street scenes. The 1890s would mark his mature amateur period, during which he experimented with various light effects and documentary imagery—as well as doing revolutionary work in the areas of night photography and candid street images (made with a concealed plate camera called the Facile). During this same decade, he won both a certain fame and many awards from various amateur competitions throughout a number of London salons and camera clubs. Most critically of all, he came to recognize that his own profession of wood engraving was being replaced by photography and the increased use of such images in the popular photomechanical press of the day. In 1899 he made the jump, opening a firm in partnership with Henry G. Dorrett that featured everything from freelance press photography to commercial processing and specialized applications for portraiture such as photo-buttons. Although he never lost his aesthetic eye and always continued to experiment with the latest technological innovations, the management of his business cut deeply

into his own image-making and his commercial career soon undercut his active photographic endeavors. While never giving up entirely on photography, he closed down his business in 1926. He spent the remainder of his life reviving his early street photography of the late Victorian era, saw many of his pictures published in the popular press, and became a favorite lecturer in his beloved camera clubs showing his images and relating his experiences. He published his autobiography in 1939 and died in obscurity during World War II, but major holdings of his prolific imagery exist in many collections with the bulk of his archival materials surviving in the Gernsheim Collection at The University of Texas at Austin, the Fine Arts Library of the University of New Mexico, and the National Museum of Photography, Film and Television in Bradford.

See also: Eastman, George; and Kodak.

Further Reading

Flukinger, Roy, Larry Schaaf, and Standish Meacham. *Paul Martin, Victorian Photographer*, Austin & London: The University of Texas Press, 1977.

Bill Jay. *Victorian Candid Camera: Paul Martin*, Newton Abbot: David & Charles, 1973.

Martin, Paul. *A Diary of Events Personal and General, during the Life of Paul A. Martin*: Unpublished manuscript, 1944. [Owned by the Fine Arts Library, University of New Mexico General Library, Albuquerque.]

Martin, Paul. *Victorian Snapshots* [introduction by Charles Harvard (C.H. Gibbs-Smith)], London: Country Life Ltd., 1939.

MARVILLE, CHARLES (1816–c. 1879)
French photographer and illustrator

Marville was born in Paris and worked there all his life, but little is known about his biography. He had aspirations to a career as a painter, but seems to have had minimal access to academic training. By 1835 he was designing wood engravings, contributing a number of minor illustrations to Léon Curmer's illustrated edition of *Paul et Virginie*. He continued producing wood engraving designs and lithographs through the 1840s, providing illustrations for numerous publications, including Charles Nodier's *La Seine et ses bords* (1836), and Pierre Boitard's guide *Le Jardin des plantes* (1842). Marville also designed the panoramic view of Paris which graced the masthead of *L'Illustration* (1843). In July 1848 he received his only documented painting commission, a copy of Le Sueur's *La Mort de Saint Bruno*, for a provincial church. Around 1850 Marville started to make photographs.

Where and with whom Marville learned photography is unknown, but by the end of 1851 he had begun producing negatives for Louis-Desiré Blanquart-Evrard's

manufactury in Lille. Many of these fell into the genres of landscape and monument views with which Marville was familiar, and an equal number were reproductions of works of art, work he had undertaken to a lesser degree in lithography. Marville contributed more negatives to Blanquart-Evrard's publications than any other photographer—at least one hundred, spread throughout most of the firm's albums, including all the views for the 1853 travel album *Les Bords du Rhin*. Around the same time he secured a position as photographer at the Louvre, where he photographed diverse works of art and the interiors of renovated galleries, such as the "Salle des Caryatides" published by Blanquart-Evrard. A vague pattern of working methods emerges here: Marville seems to have held some sort of contractual relationship with Blanquart-Evrard, the Louvre, and perhaps others, and he retained at least some negatives to use at his discretion. The nature of his work is further hinted at in an 1851 letter to the Ministry of Public Works, wherein Marville identifies himself as *Artiste-Peintre* and member of the Société héliographique (the only evidence of his membership in the society), and seeks access to state-owned historical monuments to make exterior and interior views, as well as photographs of objects housed in the buildings, for "an important photographic publication in preparation"—presumably one of Blanquart-Evrard's albums.

As early as his engagement with Blanquart-Evrard, Marville probably intended to earn a living by his photography. Like many photographers of the moment, he contributed inventions to facilitate photographic work: a negative chassis designed for travelling in 1851, and a method for transporting collodion negatives from glass to paper in 1857. But Marville never joined the Société française de photographie, which was slanted towards the rarified world of amateurs, and he would not share the secrets of his negative transport method with that group. On the other hand, he managed to secure an assignment to photograph collections of old master drawings in Milan and Turin for the Louvre; he also forged a relationship with the painter Ingres, who commissioned Marville to make photographic records of many of his drawings. All three of those drawing collections earned the photographer money for the rest of his career.

In 1856 *La Lumière* reported Marville's use of the wet collodion process to record the arrival of the Imperial Family at Notre Dame, for the baptism of the Prince Imperial. By 1858 Marville's shift to collodion was complete, as was his turn to contemporary Paris for photographic subjects. That year he was hired by some branch of Haussmann's administration to document the newly refurbished Bois de Boulogne, a jewel of Napoleon III's modernizing plans for Paris, and an important piece of propaganda at home and abroad. The album he produced (exhibited at the 1862 International Exposition

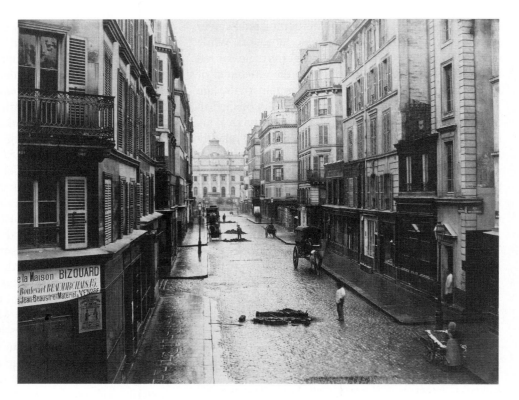

Marville, Charles. Rue de Constantine, Paris. *The Metropolitan Museum of Art, Purchase, The Horace W. Goldsmith Foundation Gift, 1986 (1986.1141) Image © The Metropolitan Museum of Art.*

in London) is a mélange of wooded landscapes similar to photographs made by Marville and others at places like Fontainebleau Forest, other views of a coiffed yet immature landscape, and records of the new built elements in the park. Marville's confrontation with this strange, modern space seems to have pushed his thinking about photography: wooded landscapes recede from his work, and urban topography becomes a central subject for the next twenty years. Moreover, his adeptness at organizing many details within the picture frame—evident in his calotypes (see for instance his series of the Ecole des Beaux-Arts and his Louvre interiors)—was broadened as he modified old landscape conventions which applied neither to photography nor to the new green spaces of Haussmann's Paris.

The change in Marville's subject matter certainly owed most to his continuing relationship with the city administration. The *Service des Promenades et Plantations* (which emerged from the Bois de Boulogne project) employed him to document the urban furniture of the new boulevards as well as the parks and squares which proliferated around the city. Around 1865 Marville received another commission, from the newly formed *Service des Travaux historiques*: a series of more than four hundred views of streets slated for demolition. In these repetitive views Marville's approach to photography, and to modern Paris, is remarkably expressed. Buildings frame and structure every view, producing stable—though not precisely symmetrical—compositions; vantage points are calculated to maximize length

of perspective and the number of elements in the frame; views are often taken at a crossroads. Time and again the result is deep perspective, a multiplicity of options for the roaming eye, and a maximum of information. In 1877, the *Service des Travaux historiques* again approached Marville, for a series of one hundred views recording the wide boulevards which replaced the earlier streets. These, along with many of his records of street furniture, were exhibited at the 1878 Exposition Universelle in Paris. Throughout these years Marville continued to take a variety of freelance assignments, most often working with architects and builders to record their projects. He also retained the negatives from all his work for the city.

Marville seems to have remained aloof from the journals and societies which comprised the Parisian photography scene, and he received little notice in his lifetime. When he is mentioned, the high quality of his work is emphasized. Notably, Nadar refers to Marville's "remarkable" collections in the city archives. Reception of Marville was also muted in the twentieth century, in part because his long professional career and low profile did not accommodate critical preoccupations with calotype photography and *amateur* aims. However, given Marville's position as a predecessor to Eugène Atget, who presumably knew the earlier photographer's work well, and perhaps modelled his own quite different project on it, Marville's continued relative obscurity in photographic literature is surprising. For instance, the many researchers who might have embraced Marville's urban records in the

1930s—including Berenice Abbott, Giséle Freund, and Walter Benjamin—apparently overlooked him.

Many of Marville's photographs still reside in the archives for which they were made. Comprehensive holdings of his urban documentation are at the Bibliothèque historique de la Ville de Paris, the Musée Carnavalet, and the Bibliothèque administrative de la Ville de Paris. The Bibliothèque historique also possess 837 of Marville's glass negatives. The Musée des Monuments français holds a number of photographs from Marville's various projects, which were acquired from the photographer by the Commission des Monuments historiques. The Bibliothéque nationale in Paris has an extensive collection of Marville's calotype work, and the Bibliothèque municipale de Lille holds a concentration of his calotypes produced for Blanquart-Evrard.

<div style="text-align: right">PETER BARBERIE</div>

Biography

Charles Marville was born in Paris in 1816. By the age of nineteen he had begun a career designing wood engravings and lithographs for books and illustrated journals. All we know of his artistic training is that at some point in the 1830s he frequented the Académie Suisse, a place where paying attendees (Courbet among them) could draw from a live model. In 1848 Marville received a commission from the state to paint of copy Le Brun's *La mort de Saint Bruno* for the Church of Saint Nicholas de Neufchâteau, in the Vosges. There is no other evidence of his career as a painter, and no known paintings by him survive. By 1851 he was practicing photography, making many images both for the Louvre and for the photographic publishing establishment begun in Lille by Louis-Desiré Blanquart-Evrard. From that point his freelance work expanded, and he seems to have enjoyed a lucrative career making art reproductions, public works records for various city agencies, and architectural photographs for architects and builders. Marville lived and worked at many Paris addresses during his photographic career: 14, rue du Dragon (1851–53); 27, rue Saint Dominique (1854–60); 6, rue de la Grande-Chaumière (1861); 86, rue Saint Jacques (1862–67); 75, rue d'Enfer (later 111 and then 75, rue d'Enfert-Rocherau) (1867–79). He exhibited at the Société française de Photographie in 1857, 1864 and 1865; his work was shown at the International expositions in London in 1862, Paris in 1867 and 1878, and Vienna in 1873. The record of Marville's death remains to be found; on September 20, 1879, one Armand Guérinet acquired his business and negatives, eventually selling the latter to the Service des Travaux historiques.

See also: Société française de photographie;

Blanquart-Evrard, Louis-Désiré; and Société héliographique.

Further Reading

Avice, Jean-Paul, *Ciels de Paris: huit photographies de Charles Marville*, Paris: Agence culturelle de Paris/Bibliothèque historique de la Ville de Paris, 1994.

Charles Marville Photographe de Paris de 1851 à 1879, Paris: Bibliothèque historique de la Ville de Paris, 1980.

Hambourg, Maria Morris, *Charles Marville Photographs of Paris 1852–1878*, New York: French Institute/Alliance Française, 1981.

Hungerford, Constance Cain, "Charles Marville, Popuar Illustrator: The Origins of a Photographic Sensibility," in *History of Photography*, vol. 9, no. 3, 1985, 227–246.

Jay, Robert, "The Late Work of Charles Marville, The Street Furniture of Paris," in *History of Photography*, vol. 19, no. 4, 1995, 328–337.

Rice, Shelley, *Parisian Views*, Cambridge, MA: The MIT Press, 1997.

——, *Marville/Paris*, Paris: Éditions Hazan, 1994.

MASURY, SAMUEL (c. 1820–1874)

Samuel Masury was a prominent American daguerreian artist who learned the process from the renowned John Plumbe Jr., with whom he was associated for many years. One of Masury's most notable images is a portrait of Edgar Allen Poe taken in November 1848, less than a year before the writer's mysterious death at age forty.

Born in Salem, Massachusetts, around 1820, Masury was educated in the public schools of Boston. He became a carriage maker, but took a deep interest daguerreotypes upon their introduction in 1839. In 1842, he became affiliated with Plumbe, and in 1843 he established his daguerreotype gallery in Salem, operating as Masury and Company.

Masury also operated a gallery in Providence, Rhode Island, and operated it from 1845 to 1852. In 1851 or 1852, Masury was seriously injured while experimenting with oxyhydrogen. A fire ignited a large bag of oxygen gas, causing an explosion while Masury was standing on the bag.

Although he never fully recovered from his injuries, Masury moved to Boston and resumed resumed making daguerreotypes, and later collodion negatives. He operated galleries on Washington Street from 1852 to 1867. He also began producing images for *Ballou's Pictorial Drawing Room Companion* journal, where his photographs were reproduced as woodcut engravings.

<div style="text-align: right">BOB ZELLER</div>

MATSUSABURO, YOKOYAMA; See YOKOYAMA MATSUSABURO

MATTHIES-MASUREN, FRITZ
(1873–1938)
German photographer, collector, and publisher

Fritz Matthies-Masuren, born in Insterburg, East Prussia on February 12, 187, was the son of the Superintendent of construction Otto Friedrich Albert Matthies and his wife Ida Johanna, and an important proponent and theorist of pictorialism in Germany. He studied painting at the Academy of Fine Arts for two years in Karlsruhe but developed a particular interest in lithography and the graphic arts. Between 1894 and 1902 he was active as a photographer (mostly of portraits and landscapes). Matthies-Masuren became an editor of and contributor to photographic journals like *Photographisches Centralblatt* [*Photographic Central Periodical*], *Photographische Rundschau* [*Photographic Review*] and *Das Atelier des Photographen* [*Photograph's Studio*], where he supported the new ideas of pictorialism. He published on the theory of pictorial photography and curated large exhibitions which travelled through Austria and Germany around 1900. Although he continued to take part in the developments of photography until the 1920s, from 1910 he became less and less active in writing. Matthies-Masuren resigned from his editorial work in 1938 and died on 10 September that year in Berlin. His collection of pictorial photographs was bequeathed to the Museum of Arts and Crafts library in Berlin, now the *Kunstbibliothek* Berlin, in 1914.

STEFANIE KLAMM

MAULL & CO. (MAULL & FOX, MAULL & POLYBLANK)

Henry Maull and his successive partnerships form one of the most outstanding examples of Victorian photographic portrait work, and their publication of the photographs of celebrities of the day, starting in 1856, was the first of its kind in the world. It was rapidly imitated allover Europe during the succeeding decades, as was the use of a brief biographical essay to accompany each portrait.

The senior partner, Henry Maull (1829–1914) began his career as an artist and printer in Bloomsbury, close to his birthplace in Clerkenwell In 1854 he went into partnership with George Henry Polyblank (1828–?) in a studio at 55 Gracechurch Street, in the City of London and two years later, in May 1856, began the issue of "Photographic portraits of living celebrities issued on a monthly basis, with biographical notes for the first four by Herbert Fry, thereafter by Edward Walford. The first number featured Richard Owen; the entire sequence ran as follows: 1) May 1856, Richard Owen; 2) June 1856, Thomas Macaulay; 3) July 1856, Robert Stephenson; 4) August 1856, John Roebuck; 5)

September 1856, Sir Benjamin Brodie; 6) October 1856, Edward Hodges Bailey; 7) November 1856, Samuel Warren; 8) December 1856, Professor Thomas Graham; 9) January 1857, Edward Matthew Ward; 10) February 1857, Lord Campbell; 11) March 1857, George Cruikshank; 12) April 1857, Rowland Hill; 13) May 1857, Sir William Fenwick Williams; 14) June 1857, William Frith; 15) July 1857, Cardinal Wiseman; 16) August 1857 Lord Brougham; 17) September 1857, Martin Farquhar Tupper; 18) October 1857, Michael Faraday; 19) November 1857, John Gibson; 20) December 1857, Earl of Rosse; 21) January 1858, Charles Kean; 22) February 1858, William Gladstone; 23) March 1858, Sir Archibald Alison; 24) April 1858, William Stemdale Bennett; 25) May 1858, David Uvingstone; 26) June 1858, Earl of Aberdeen; 27) July 1858, Daniel Maclise; 28) August 1858, Lord Stanley; 29) September 1858, Dr. Tait, Bishop of London; 30) October 1858, Austen Layard; 31) November 1858, Clarkson Stanfield; 32) December 1858, Lord Panmure; 33) January 1859, John Buckstone; 34) February 1859, Comte de Montalembert; 35) March 1859, Samuel Lover; 36) April 1859, Lord John Manners; 37) May 1858, Bishop Samuel Wilberforce; 38) June 1859, Sir John Lawrence; 39) July 1859, Lord Colchester; 40) August 1859, Archbishop of Canterbury. In October 1859, the complete set was issued in book form, distributed by William Kent & Co.

The series was an overwhelming success. *The Literary Gazette* (October 18, 1856) commented 'We acknowledge with unmixed satisfaction the excellence of the portraits. They are as successful specimens of the art as any that have yet appeared, both as to the pose of the figures, and in sharpness and delicacy of detail. They have also the advantage of being simply printed from the negatives, and entirely free from any after touches." Their success was matched by a parallel series of portraits collectively known as "Literary and Scientific Portrait Club," it was issued 1855–c 1858, without text. Among those included were the cream of the Victorian scientific world—Darwin, Playfair, Lanchester, Lyell, Murchison, Bowerbank, De La Rue, Gosse, etc. Several incomplete sets exist—one of 54 portraits, at the National Portrait Gallery, another series of 95 at the Linnean Society. The club itself "was instituted for the purpose of attaining a uniform set of portraits of the literary and scientific men of the present age at a moderate cost." The terms of admission to the club being that each member having a photograph of himself taken by the artists of the club, Messrs Maull and Polyblank, at the cost of 10s. 6d'.

The success of these series enabled Maull and Polybank to open a second studio at 187a Piccadilly, Westminster in May 1857, and a third, at 252 Fulham Road, Chelsea, in 1864, specialising in equestrian portraits. A private album of similar portraits was issued in 1856,

with eleven portraits, under the title "On the introduction and progress of the screw propeller" notably featuring Francis Pettit Smith and Charles Manley.

The partnership was dissolved March 8, 1865, and Maull continued the firm as Maull & Co., closing the City studio and opening a new one at 62 Cheapside. Polyblank filed for bankruptcy November 2, 1867, and was eventually discharged in the following January. A persistent rumor in the Polyblank family suggests that he emigrated to the United States in the late 1860s, but no further trace of him has been recorded, and the end of his career is unknown.

In 1877, Henry Maull reconstituted the firm, and took as his partner his former manager, John Fox (1832–1907). As Maull & Fox, the firm soon closed the surviving City studio, and concentrated their photographic work at 187a Piccadilly, a second-floor studio situated above the well- nown bookshop, Hatchards. The partnership was dissolved after only eight years, on May 21 1885, but Fox's son, Herbert Fox (1870–) continued the firm, assisted by Frederick Glover after Maull's retirement to Ramsgate in 1890. He died in Brighton June 26, 1914, a year after Maull & Fox became a limited company in order to acquire the Piccadilly business. In 1924 the West End studio was moved to 200 Gray's Inn Road; it was wound up October 26, 1928, and the copyright and negatives acquired by the Graphic Photo Union, eventually absorbed into Kemsley Newspapers, publishers of the *Sunday Times*, in 1952.

Like many other Victorian photographic studios, Maull found the transition to the twentieth century a leap too far. In addition, their substantial contracts with the illustrated weeklies to supply a constant stream of portraits for reproduction as wood engravings, began to decline dramatically with the introduction of photogravure and the rise of specialist firms. The firm's very static poses, with an occasional prop, had gone irretrievably out of fashion by the end of the nineteenth century .

Henry Maull's elder brother, George Maull (1820–1885) operated two photographic studios in the Lewisham area of South London in the 1860s and 1870s, but is not known to have participated in the West End studios. A good selection of work by Maull's various partnerships is held by the National Portrait Gallery, with smaller collections at the Victoria & Albert Museum & Hulton Getty.

DAVID WEBB

Further Reading

Johnson, William S., *Nineteenth Century Photography:Aan Annotated Bibliography*. New York: G. K. Hall, 1990.
Hacking, Juliet, *Photography Personified: Art and Identity in British Photography 1857–1875,* University of London thesis 1998.
Watkins, Herbert, *The Athenaeum*, May 29, 1858, 694.
Polyblank, George Henry. *Polyblank Society Newsletter* no 3 (September 1987).

MAWSON & CO. (ESTABLISHED 1828)

The company originated as Mawson and Company in 1828 when John Mawson (1815–1867) began trading in Newcastle-upon-Tyne, England, specialising in pharmaceutical products. Mawson followed the photographic discoveries of the times and once the new discipline was established, he began to produce the necessary chemicals. By 1848, he had engaged Joseph Wilson Swan (1828–1914) as his assistant, but made him a junior partner in 1865, by forming Mawson & Swan. Within two years, however, Mawson was killed in a nitro-glycerine explosion whilst officiating as Mayor of Newcastle and Swan took control. Mawson's widow was Swan's sister and Elizabeth now joined the company to supervise publishing and bookselling, and when the company eventually relinquished its interest in photographic materials, it continued to trade as Mawson, Swan and Morgan, into the middle of the twentieth century.

Swan had previously worked for six years as an apprentice to a local firm of druggists and joined with knowledge of chemistry and the evolving photographic processes. It was natural for the two men to explore aspects of emulsion making, and Mawson introduced his partner to local contacts and then constructed a small workshop for him above the pharmacy, at 39 Moseley Street, Newcastle. By 1854, Swan had perfected the production of collodion, and the company entered the growing photographic market by launching Mawson's Collodion. For forty years, the product maintained its reputation, as many testimonials confirm—"the first of its kind, the best as well, and doubtless the most largely used and widely sold of all collodions in existence."

Another success came in February 1864, when Swan patented the carbon printing process, which provided distinctive photographic prints, free from deterioration. The company marketed carbon prints, as well as the materials for making them, and offered the process under licence to third parties, such as The Autotype Company, which later purchased the rights. (In 1885, Swan also negotiated a business partnership with Thomas Annan, Glasgow.) Swan's expertise in working with electricity led to the invention of a carbon filament light bulb (1879) and variants of the invention were adapted for photographic applications, such as standardising studio lighting and controlling variable for exposing carbon prints and bromide prints.

Swan's success with the carbon process had capitalised on the company's prowess in combining a suitable gelatine for making the print, and a powerful lamp for making the exposure. With a general manager

replacing Mawson, the company continued to innovate and in 1871, addressed the growing market for silver emulsions, in liquid form, and later as dry plates. During preparation, Mawson & Swan utilised a heating stage to improve sensitivity. Production, however, was hampered by the need to coat dry plates by hand, a procedure George Eastman later dismissed as "tedious and slow."

To augment its negative materials, the company achieved a singular success in 1879, when Swan devised and patented the gelatino-bromide paper process based on silver bromide. Improved machinery was installed to ensure uniformity of coating of the paper base, which was "adapted to the production of bold and vigorous prints." Because of its sensitivity, it was "specially useful for enlargements and the matt surface made it "scarcely distinguishable from the finest Platinotypes."

At the time, Europe was considered to be the centre of photographic expertise, and English companies successfully traded in America. A young American entrepreneur, George Eastman, was impressed that the high prices were not affected by the lively competition. He had invented a machine which would replace hand-coating and once he received patent-protection in London, he intended to persuade the important manufacturers to purchase it.

He sailed to Liverpool in 1879, and received introductions to some English companies, including Mawson & Swan, but only made a few unsatisfactory sales. Eastman returned to America, and two years later, relinquished his position at Rochester Savings Bank so as to concentrate on the manufacture of dry plates at his own small factory. Soon he received complaints about product quality and he was forced to shut down production. Lacking a solution, he returned to England in March 1882 and appealed to Mawson & Swan. He was permitted to "stand in the works" for two weeks, during which time Eastman realized that his supplier of gelatine had changed its specification. He immediately struck a deal with his hosts whereby Eastman agreed to exchange manufacturing secrets for Mawson & Swan's emulsion-making knowledge.

Mawson and Swan published a catalogue covering chemicals, scientific apparatus, microscopes, electrical, magnetic and physical apparatus, and part four was "a singularly comprehensive work, enumerating everything in the way of photographic apparatus and materials, and containing prices and graphic illustrations of all articles used by the amateur or professional photographer." In addition, the company issued helpful booklets, such as, *The Wet Collodion Process, How to Make Transparencies, Photography Simplified*, and *Gelatino-Bromide Paper Process, Contact Printing and How to Make Enlargements*, to promote its papers. To encourage the use of its premium plates, the company regularly awarded silver medals for areas of specialisation, such as "instantaneous marine photography."

In 1892, the company adopted Hurter and Driffield's procedures for plate testing, and with justification claimed its "Mawson" was "the quickest plate" on the market, but recommended its Castle Plate "for all ordinary purposes." In a private note to Vero Charles Driffield, however, J. Smith Green, Mawson & Swan works manager, complained that "those who use Oxalate Iron for development are quite exceptional …." Improvements continued, and in 1896 Mawson & Swan was producing "extra rapid" plates for studio work, and special plates for the emerging "instantaneous" market (i.e., the use of hand-held cameras.) A representative's report stated: "Electric plates are taking on splendidly; the professional photographers appreciate them this dull weather, and everyone who has tried them is delighted with them."

Although much altered from the pharmaceutical company established early in the nineteenth century by John Mawson in a shop in Mosley Street, Newcastle, and which had evolved as the Head Office, Mawson & Swan had also established works in Newcastle and Gateshead, a dry plate factory at Low Fell, (on the south side of Gateshead), and offices and warehouses in Soho Square, London, to handle distribution throughout Europe and America. Despite the staff pension fund terminating in 1973, Newcastle recognised the company on October 12, 1978, by hosting an exhibition of its achievements.

RON CALLENDER

See also: Swan, Sir Joseph Wilson; Carbon Print; Emulsions; and Eastman, George.

Further Reading

Anon, (1890), Mawson & Swan, *The Tyneside: An Epitome of Results and Manual of Commerce*, London : Historical Publishing Company.

Brayer, E, (1996), *George Eastman: A biography*, Baltimore: The John Hopkins University Press.

Local Studies and Family History Centre, Newcastle City Library, Newcastle upon Tyne, England.

Tyne & Wear Archives Service, Gateshead, England, collection DT.MSM, and collection DF.SW/A/b/1 to 49.

MAXWELL, JAMES CLERK (1831–1879)
English physicist and inventor

Three photographic plates of a tartan ribbon, taken in 1861 by Thomas Sutton through red, green, and blue filters, were used by James Clerk Maxwell to demonstrate that photography in colour could be a practical proposition. Positive lantern slides made from those plates, each projected back through the taking filter,

could be reassembled on the screen to recreate the full colour of the original ribbons.

Maxwell was born in Edinburgh on June 13, 1831, and the family moved to Kirkcudbrightshire in 1834. He was educated at home for some years, but later studied at Edinburgh Academy and Edinburgh University before periods at Peterhouse and Trinity Colleges in Cambridge.

His first academic appointment was at Marischal College in Aberdeen, but four years later he was appointed Professor of Natural Philosophy at King's College, London. Already recognised as one of the eminent physicists of his day, he quickly developed a reputation as a leading authority and thinker on electro-magnetism, and was the first to offer the proposition that light was a form of electro-magnetism. He also conducted early research into colour blindness.

By 1871 he was the first Cavendish Professor of Physics in Cambridge, and a major force behind the design and establishment of the world-famous Cavendish Laboratory.

He died on November 5, 1879, at the age of only 48.

JOHN HANNAVY

MAYALL, JOHN JABEZ EDWIN (1813–1901)

John Jabez Edwin Mayall was one of the most enduringly successful professional photographers in nineteenth-century Britain. Born in Oldham in 1813, Mayall's photographic career began when he moved to Philadelphia in late 1841 or early 1842, working there at 140 Chestnut Street as a photographer until 1846. While working in Philadelphia between 1843 and 1844, Mayall made an important series of ten daguerreotypes depicting scenes from The Lord's Prayer. This illustrative use of photography was highly innovative and prefigures later work by Oscar Rejlander and Julia Margaret Cameron. In 1848, Mayall's brochure for his London studio claimed that "These are the first efforts in developing the new branch of *photographic fine art*. . .Female figures (some of the most beautiful and talented ladies of Philadelphia) have been chosen to embody the precepts of this Divine Prayer." Subsequent narrative pictures included studies of *Macbeth*, *Hamlet* and Thomas Campbell's poem "The Soldier's Dream." Many of these tableaux were shown at the Great Exhibition in 1851, where the catalogue called them "Daguerreotype pictures to illustrate poetry and sentiment."

In June 1846, Mayall returned to London. For a short while, he served as an assistant to Antoine Claudet, before setting up his own studio at 433 Strand. Mayall initially operated under the name of Professor Highschool at the "American Daguerreotype Institution." American daguerreotypes were known for their exceptional clar-

Mayall, John Jabez Edwin. The Prince of Wales (Edward VII). *The J. Paul Getty Museum, Los Angeles* © *The J. Paul Getty Museum.*

ity and Mayall was numbered among the first rank of photographers. In April 1847, the Athenaeum reviewed the work of Kilburn and Mayall and declared that the pair were "both so fertile in resource and imagination, that in their hands it will probably be proved that this art is as yet only in its infancy." One notable feature of Mayall's work at this stage was his repudiation of the practice of colouring daguerreotypes; he was worried that a reaction with the photographic chemicals would harm the permanency of the image.

According to Baden Pritchard, Mayall's great coup came in 1851 when he was asked to take pictures of the Great Exhibition. He subsequently became friends with Prince Albert and, in 1855, was invited to photograph the British royal family. In 1855, the military authorities also turned to him for advice. Two soldiers, Ensign Brandon and Ensign Dawson, were trained by Mayall for a month so they could operate as photographers in the Crimea. His improving commercial fortunes are also reflected in his opening another establishment at 224 Regent Street in 1853, which was expanded to 226 Regent Street in 1856.

Mayall was responsible for several technical developments: throughout his career he was concerned with improving the potential of the medium. On 25 January 1853, he took out a patent for the production of imitation

crayon drawings. As early as October 1850, Mayall had written to the *Athenaeum* detailing his process, and had exhibited examples at the Great Exhibition. His invention interposed a slowly revolving disc between the camera and the object being pictured. The disc, arranged on a support, had a star-shaped hole in its centre. The revolving star design made the resultant photograph similar to a vignette portrait. In 14 October 1855, Mayall also took out a patent for the making of artificial ivory to receive photographic pictures. Another area of expertise was in the enlargement of photographs. He claimed credit for being the first photographer to successfully use the collodion process to enlarge and copy daguerreotypes.

After the Photographic Society of London was founded in 1853, Mayall took an active interest in its proceedings, attending meetings and giving several papers. He was also a member of the committee set up to organise a testimonial fund for the widow of Frederick Scott Archer. His perceived debt to Archer is evident in that that, of the £747 raised, he was the largest contributor.

When photography became a commercial medium, Mayall was one of the principal beneficiaries. Unlike many of the gentlemen amateurs who dominated photography in the mid 1850s, Mayall enthusiastically embraced the rage for celebrity portrait *carte-de-visites*. In 1858, he took part in a venture with D.J. Pound, the publisher of the *Illustrated News of the World*. Together they published a series of engravings of eminent personages that were based on photographs by Mayall. Along with Maul and Polyblank's *Photographs of Living Celebrities* (1856–58), the venture represents one of the earliest attempts to exploit the value of celebrity photographs.

Mayall's commercial prosperity was secured when, in May 1860, he was again invited to Buckingham Palace to photograph the royal family. Mayall's *Royal Album* was published in August 1860 and was a phenomenal success. Consisting of fourteen *carte-de-visites* of Victoria, Albert and their children, it was the ever first set of royal photographs that were widely available. The *Athenaeum* claimed that each portrait reproduced "with a homely truth, far more precious to the historian than any effort of a flattering court painting, the lineaments of the royal race." In March 1869, the British Journal of Photography reported that Mayall had been paid £35,000 by Marion & Co. for his royal pictures. He went on to publish several sets of royal photographs, including the wedding photographs of the Prince and Princess of Wales in March 1863.

Mayall's royal patronage led to numerous commissions from distinguished personages such as Gladstone, Lord Derby, and Lord Brougham:

Imitating this high example, distinguished persons of rank and pursuit availed themselves of the photographer's services, and left him with a negative impression of themselves, from which thousands could be printed. (M.A. Root, *Camera and Pencil,* Philadelphia: J.P Linnicot, 1864: 381)

Prior to the introduction of the Copyright Bill in July 1862, one innovative feature of Mayall's celebrity *cartes-de-visite* is his attempt to counter the numerous quasi-illegal reproductions. In the early 1860s, many of his pictures are inscribed with his initials and the date of their exposure. This inscription was intended to act as the equivalent of an official trademark, which it would be illegal to copy.

Several London establishments were managed under Mayall's name from the 1860s to the 1890s, as he himself moved to the genteel environs of Brighton in 1864. His studio at 433 Strand later was complemented by others at 224 Regent Street West 1853–94; 224 and 226 Regent Street (1857–67); 15 Argyll Place, West (1859–67); 164 New Bond Street West(1881–1886); 90-91 King's Road, Brighton (1864–1904). Mayall & Co. operated at 164 New Bond Street (1887–92); 73 Piccadilly West (1893–96); 126 Piccadilly West (1897–1908). In Brighton he continued his work as a photographer through a studio in King's Road and his career is remarkable for its sheer longevity. He was a Photographic Society Council member in 1875 and, in 1880, his Bond Street studio was one of the first London establishments to use electric light. In Brighton, Mayall also became involved with local politics. He was elected as a councillor in 1871, an Alderman in 1874, and was Mayor between 1877 and 1878. Other late honours include being elected a fellow of the Royal Institution in 1864 and of the Chemical Society in May 1871.

Mayall died on 6 March 1901, bringing to an end a remarkable photographic career that spanned sixty years.

JOHN PLUNKETT

Biography

John Mayall was born in Oldham in Lancashire in 1813. His father, John Meal, was a manufacturing chemist in West Yorkshire. Mayall, who was born Jabez Meal, married Eliza Parkin in 1834, with whom he had three sons and one daughter. He left Britain for Philadelphia in late 1841 or early 1842, returning to London in 1846 and resumed his professional career. His first studio was at 433 Strand (1847–55). Many of the later studios were managed under Mayall's name as he himself moved to Brighton in 1864. Mayall was one of the foremost daguerreotypists during the late 1840s and maintained his reputation when he moved to collodion process dur-

ing the 1850s. Best known for his pictures of the Great Exhibition and the British royal family, it was the advent of the celebrity *carte-de-visite* that secured his commercial fortune. Other publications include *The Illustrated News of the World and National Portrait Gallery of Eminent Personages* (1858–63), *Royal Album* (1860), and *Mayall's Celebrities of the London Stage; A series of photographic portraits in character* (1867–68). After being widowed, Mayall married for a second time in 1871, and had two daughters and one daughter by Celia Victoria Hooper. A prominent member of the Brighton community in later life, he died on 6 March 1901.

See also: Rejlander, Oscar Gustav; Cameron, Julia Margaret; Claudet, Antoine-François-Jean; Athenaeum; Victoria, Queen and Albert, Prince Consort; Photographic Exchange Club and Photographic Society Club, London; Archer, Frederick Scott; Carte-de-Visites; British Journal of Photography; and Marion & Co.

Further Reading

Gaspey, William, *The Great Exhibition of hr World's Industry, held in London in 1851: described and illustrated by . . . engravings, from daguerreotypes by Beard, Mayall etc.,* London: 1852–1861.

Gernsheim, Helmut, and Alison Gernsheim, *The History of Photography; From the camera obscura to the beginning of the modern era*, 1955; London: Thames and Hudson, 1969.

Lee, David, "The First Royal Wedding Photographer," *British Journal of Photography* 133 (July 1986): 840–843.

Mayall, J.E., *The Illustrated News of the World and National Portrait Gallery of Eminent Personages. Chiefly from Photographs by Mayall, engraved on Steel by D.J. Pound*, London: 1858–1863.

Plunkett, John, *Queen Victoria—First Media Monarch,* Oxford: Oxford University Press, 2003.

Pritchard, H. Baden, *The Photographic Studios of Europe*, London: Piper and Castle, 1882.

Pritchard, Michael. *A Directory of London Photographers*, London: Photoresearch, 1986.

Reynolds, Leonie, and Gill Arthur, "The Mayall Story," *History of Photography* 9.2, ,1985, 89–107.

Reynolds, Leonie, and Gill Arthur, "The Mayall Story: a postscript," *History of Photography* 11.1, 1987, 77–80.

Werge, John *The Evolution of Photography*, London: Piper and Carter 1890.

MAYER AND PIERSON COMPANY

The fashionable Parisian commercial photography firm of Mayer and Pierson, consisting of Ernest Mayer, his brother Frédéric and Pierre Louis Pierson, was first established as Mayer Frères in the early 1850s as a purveyor of photographic supplies and studio portraits. Pierson, a daguerreotypist, joined the firm by 1854 and the company operated out of lavish studios on the Boulevard des Capucines serving such powerful Second Empire figures as Napoleon III and his one-time mistress the Countess de Castiglione (Virginia Oldoini), actress Rachel and composer Rossini. The firm, together with the many others that populated Paris during this period, was nurtured by the modernizing principles of Napoleon III which promoted photography as both a symbol of modern France and a desirable luxury good. Specializing in studio portraits, celebrity *cartes-de-visite* and the use of such novel processes and techniques as the ambrotype, Mayer and Pierson reached the pinnacle of its success in the late 1850s and early 1860s through a fruitful combination of artistry, technology and sound business practice; by 1862, however, Ernest Mayer had sold his share of the company to Pierson, who had taken over the business. In 1874 Mayer and Pierson was sold to Pierson's son-in-law Gaston Braun and was incorporated in 1876 under his father, the photographer Adolphe Braun. Pierson remained manager of the company until 1909. The Mayer and Pierson archive of glass plate negatives is housed by the Musée d'Unterlinden in Colmar and photographs representing the firm can be found in the collections of the Metropolitan Museum of Art, the J. Paul Getty Museum and many private collections.

The reputation of Mayer and Pierson rose above that of many other Second Empire commercial firms because of its illustrious clientele and high profile commissions, proficient use of hand-coloring to enhance its products, state of the art studios, effective use of advertising, prominent displays of photographs at World's Fairs, satellite studios in London and Brussels, publication of *La Photographie considérée comme art et industrie* in 1862, and successful lawsuit to change copyright laws during the same year. Napoleon III is believed to have first visited the Mayer Frères studio in 1853 and continued his family's relationship with the company until at least 1860. In 1856, the Emperor selected the firm to be the official photographers of the world leaders gathered for his triumph of diplomacy, the Paris Peace Congress. The following year Napoleon III whimsically appeared with the Empress Eugénie, their son and his pony for a portraiture session at the studio. The company, however, had its detractors, including their competitor Nadar, who denigrated the photographers as portraitists, claiming that "they restricted themselves, very profitably, to one style . . . of picture. . . . Without a thought for composing the picture in a manner favorable to the sitter" (*The Second Empire*, 1978, 421).

The Emperor, though, seemed not to notice this and encouraged members of his court to patronize Mayer and Pierson, among them his Italian mistress the Countess de Castiglione, with whom he had an affair between 1856 and 1857. The Countess worked with Pierson frequently between 1856 and 1867 and then only sporadically until her death in 1899. She is perhaps the company's most infamous, inventive, and intriguing patron, one who took

full advantage of the company's prestige and prowess to further her reputation as a femme fatale and developed a collaborative artistic relationship with Louis Pierson, who photographed her as herself as well as in the guise of the Queen of Hearts, the Hermit of Passy, and the Queen of Etruria among other fictional and historical characters who appealed to the Countess's sense of drama and often served a narrative purpose in her life. For example, after an argument with her estranged husband, the Countess sent him a Pierson photograph of herself masquerading as "Vengeance," carrying a dagger in her hand.

Many of Pierson's photographs of the Countess were hand painted, a specialty that the company first began to widely advertise with an exhibition at the 1855 Exposition Universelle in Paris and continued to capitalize on with a successful showing of photographs of the Countess at the 1867 Exposition Universelle, also held in Paris. In addition, the Countess took full advantage of the studio technology employed by Mayer and Pierson, including illusionistic backdrops that slid back and forth on rails, lighting controlled by mobile screens activated by springs and a plethora of architectural and decorative props.

Mayer and Pierson's success with the mass production of celebrity cartes-de-visite in the late 1850s and early 1860s, aided by the use of a special camera that allowed eight separate portraits to be taken on one negative, led to a highly publicized lawsuit against commercial photographers Thiebault, Betbéder and Schwabbé in 1862 that in the end won protection for photographs under French copyright laws by legally defining photography as an art form. In two separate instances, Mayer and Pierson cartes-de-visite had been copied and sold under the name of a different commercial company: Thiebault and Betbéder retouched a Mayer and Pierson photograph of the Italian minister Cavour and marketed it as their own and Schwabbé countertyped a carte-de-visite of Lord Palmerston and sold it as his own work. Until Mayer and Pierson filed their lawsuit, photographs were not protected under copyright law because they were not defined as a fine art like painting was. Thus when Mayer and Pierson won their lawsuit on appeal, they also claimed a victory for the definition of photography as a fine art rather than a product of science of technology.

KIMBERLY RHODES

See also: Cartes-de-Visite; Braun, Adolphe; and Nadar (Gaspard-Félix Tournachon).

Further Reading

Apraxine, Pierre, and Xavier Demange, *"La Divine Comtesse": Photographs of the Countess de Castiglione*, New Haven and London: Yale University Press, 2000.

Freund, Giselle, *Photography and Society*, Boston: David Godine, 1983.

McCauley, Elizabeth Anne, *Industrial Madness: Commercial Photography in Paris, 1848–1871*, New Haven and London: Yale University Press, 1994.

The Second Empire 1852–1870: Art in France under Napoleon III, Philadelphia: Philadelphia Museum of Art, 1978.

Solomon-Godeau, Abigail, "The Legs of the Countess," *October* 39 (Winter 1986), 65–108.

Tyl, Pierre, "Mayer et Pierson (1)," *Prestige de la photographie* 6 (1979), 5–30.

——, "Mayer et Pierson (2)," *Prestige de la photographie* 7 (1979), 36–63.

MAYLAND, WILLIAM (1821–1907)
English photographer

Born in Blackheath, Lewisham, November 21, 1821, Mayland started his photographic career in Cambridge in the 1860s. In 1869 he moved to London to join Thomas Richard Williams (1824–1871) at his studio 236 Regent Street, Westminster, and on the latter's death took sole control, although the studio name was not formally changed to Williams & Mayland until 1880.

Mayland was one of the leading lights of the pioneer photographic society, the Solar Club (1865–69), succeeding Henry Peach Robinson as Chancellor, and passing on the office to William England. In Cambridge, he photographed the construction of Sandringham House, by special commission from Queen Victoria. The scale of his *carte-de-visite* work in London enabled him to survive bankruptcy in 1878. The studio featured in H. Baden Pritchard's 1882 book *The Photographic Studies of Europe*.

Mayland was an accomplished reciter and occasional private actor, often in Shakespearian productions with his wife Mary (1832–79), a niece of Sarah Siddons. Ill health forced Mayland to close his studio in May 1882, and he retired to Tunbridge Wells, although he died in Islington on October 31, 1907. His collection of negatives was acquired by Samuel Walker.

DAVID WEBB

MAYNARD, RICHARD (1832–1907) AND HANNAH (1834–1918)
Canadian photographer

Richard Maynard was born on February 22, 1832, in Stratton, Cornwall, England, and his wife was born as Hannah (or Anna) Hatherly on January 17, 1834, in Bude, Cornwall. Married in 1852, they immigrated to Canada and lived in Bowmanville, Ontario, for a decade. They resettled in Victoria, British Columbia, where she opened a photographic studio and Richard worked as a cordwainer (shoemaker). Hannah, who likely learned photography in Bowmanville from R. & H. O'Hara, taught him the

craft. Richard's photographic work between 1873 and 1892 consisted almost entirely of single-lens and stereo landscape views, chiefly along the British Columbia and Alaska coastlines, as well as construction of the Canadian Pacific Railway between 1880 and 1886. Hannah confined herself almost exclusively to studio portraiture, starting with unsophisticated carte-de-visite poses and progressing to elaborate studio backdrops and props for group portraits by the 1890s. Recognized as an artistic genius for her multiple exposure or trick photography, she was likely aided in this work by Arthur S. Rappertie (1854?–1923), her studio assistant for over 30 years. The British Columbia Archives preserves their negatives and personal papers. Buried in Ross Bay Cemetery, Victoria, the Maynards' photographic work continues to be widely reproduced and analyzed.

DAVID MATTISON

MCCOSH, JOHN (1816–1894)
British photographer, doctor, writer, and poet

The life of military surgeon Dr. John McCosh was full of incident. Present during some of the many wars of Victorian India, he took to photography as a hobby, and perhaps as a relief from the stresses of surgery under military conditions.

He was widely travelled, and survived a terrible shipwreck when the SS *Lady Munro* was lost en route to Tasmania from India in 1836. McCosh, sent on the voyage to recuperate after a serious bout of fever, went on to write about the incident in great detail. He later published his account, and during his lifetime published several volumes of writings on subjects as diverse as travel, photography, poetry, and medicine.

The early calotypes by Dr. John McCosh embrace a number of applications of photography, and at first glance defy simple classification. Their diversity is perhaps the key to understanding them. McCosh, a British military surgeon, used the medium simply to preserve images of the people and places he came into contact with, much as the majority of camera-users do today. Attributing to him the accolade of being the first war photographer—as many writers have done over the years—is to place his work within a context the photographer himself would not have recognised.

In the introduction to a surviving album of his work, we noted

> These photographs have no pretensions to merit. The negatives were taken on paper before the present process of collodion was known. Their fidelity will, however, make amends for their sorry imperfections. Like fragile remains of lost ages, their value is enhanced because the originals are no longer forthcoming.

That single album, assembled in 1859, contains over three hundred prints, the majority from calotype negatives, and thirty-one from collodion negatives. It is now in the collection of the National Army Museum, London. Contained within its pages are many portraits of friends and fellow officers, portraits of Burmese men and women, a number of views of the architecture, landscape and military installations of the places in which he served as an army doctor—Burma, Bengal, and elsewhere in India, and a single calotype image by Calvert Jones. Included are a number of images unquestionably taken while on active service in war zones, but these are far removed in subject and treatment from the photography at war—or of war—created by Roger Fenton, James Robertson, Alexander Gardner, and others.

Writing in 1856 in *Advice to Officers in India*, after he had retired from the army, McCosh wrote

> I would strongly recommend every assistant-surgeon to make himself a master of photography in all its branches, on paper, on plate glass, and on metallic plates. I have practised it for many years, and know of no extra professional pursuit that will more repay him for all the expense and trouble (and both are very considerable) than this fascinating study—especially the new process by Collodion for the stereoscope. During the course of his service in India, he may make such a faithful collection of representations of man and animals, or architecture and landscape, that would be a welcome contribution to any museum.

These remarks confirm that he had used collodion, and certainly thirty-one of the prints in the album are from collodion negatives, but the architectural views are all on paper.

While two of his early calotype self-portraits are captioned "the Artist"—two others taken on collodion are untitled—his advice to other aspiring photographers makes reference only to representation and not to any aesthetic sensibilities or intentions.

McCosh was introduced to photography some time in the 1840s. The earliest image for which a date can be conjectured is 1848, and the naivety of the images from this date suggests that these may be early examples of his photography. His interest in the medium may have been triggered some time between 1844 and 1847, when he was stationed near the Nepal border at Almra. Much of his work is small format, with images measuring no more than 10cm x 8cm, and typically limited to simply posed studies of colleagues and friends. The format of his portraits varied little whether on paper or glass, suggesting the same camera might have been used for both.

Amongst his subjects were Vans Agnew, photographed in 1848. Shortly after posing for McCosh's camera, Agnew was murdered by the local Hindu Governor, Mulráj during the 2nd Sikh War. The combination of a small camera with which to make his calotype

negatives, a large lens, and the bright light of the Indian sub-continent combined to reduce exposure times considerably. The combination of these features enabled McCosh to pose and photograph his subjects with little need to contrive positions that could be sustained for extended periods of time. Even in his early works the figures seem relaxed and natural. Several of his Burmese images show growing confidence in posing his subjects and in controlling the medium. McCosh worked outdoors often posing his subjects posed against white backgrounds. Relaxed squatting or crouching poses have been used, giving a modernity and an immediacy to the faces and figures he presents. This very direct approach belies the age of these images and the insensitivity of the process he was using.

By the time of the 2nd Burma War 1852–1853, lightweight bellows cameras—such as those designed by William [Marcus] Sparling, Major Halkett and others—were available, and by the mid 1850s when McCosh wrote his *Advice to Officers in India* they had become commonplace for military personnel and other amateurs working overseas. To McCosh, they offered no attraction whatsoever and he commented

> The camera should be made of good substantial mahogany, clamped with brass, made to stand extremes of heat. The flimsy, folding portable cameras, made light for Indian use, soon become useless.

From that it can be assumed that he remained loyal to the sliding box design, despite its weight.

Several of the images produced in 1852 and 1853 are of a larger format than those from earlier in his career, pointing to a larger—and heavier—camera. The prints from these later negatives measure up to 20cm × 22cm, suggesting a camera approaching whole plate in size, compared to the probable quarter plate size of earlier images.

Although there are no specific dates attributable to his collodion images, it is clear McCosh continued to take photographs well into the 1850s. Indeed, he appears in an 1856 photograph taken at Hampton Court by Roger Fenton to commemorate the summer outing of the three year old Photographic Society, posing in front of a horse-drawn photographic carriage similar to that used by Fenton for much of his collodion photography.

JOHN HANNAVY

Biography

John McCosh was born into a medical family in the Scottish village of Kirkmichael in Ayrshire on the 5th of March 1805. Several brothers also became doctors, and John joined the Bengal Medical Service as an assistant surgeon at the age of twenty-six. He enrolled at Edinburgh University in 1840 to take a degree in military surgery, surgery, and medical jurisprudence. His medical career was spent almost entirely in and around India, and saw service in the 2nd Sikh War (1848–1849) and the 2nd Burma War (1852–1853). It is from the period spanned by these two conflicts that his surviving photography dates. He retired from the army in 1856. In addition to his interests in medicine and photography, McCosh enjoyed writing poetry, and published several works of verse after retiring from military service. He died in London on 16th March 1885. The generally accepted spelling of his name is "McCosh although "MacCosh" and the abbreviated "M'Cosh" have also been identified. The images in the surviving album are identified as "Photographs by Jethro M'Cosh, Surgeon, Bengal Army."

See also: Calotypes and Talbotypes; War Photography; and Wet Collodion Negative.

Further Reading

Hannavy, John, *A Moment in Time: Scottish Contributions to Photography 1840–1920*, Glasgow: Third Eye Centre, 1983.

Hershkowitz, Robert, *The British Photographer Abroad*, London: Robert Hershkowitz, 1980.

McCosh, John, *Advice to Officers in India*, London: Allan and Company, 1856.

McKenzie, Ray, "'The Labour of Mankind'" John McCosh and the Beginnings of Photography in British India" in *History of Photography*, 109–118, London: Taylor & Francis, 1987.

Russell-Jones, Peter, "John McCosh's Photographs" in *The Photographic Journal*, 25–27, London: The Royal Photographic Society, 1968.

Worswick, Clark, *The Last Empire*, London: Gordon Fraser, 1976.

MCGARRIGLE, JOHN (active 1870s)

Little is known about this photographer other than the fact that he claimed to have been employed by the Mexican government prior to his arrival in Auckland, New Zealand.. During his short stay in Queen Street, he secured a wonderful series of Maori studies in the form of carte-de-visite portrait sittings. When he left New Zealand in the early 1870s, he managed to leave these in the custody of someone who later negotiated their sale to the Dunedin firm of Burton Bros. Burton's were expanding their collection of New Zealand views at the time and this collection of Maoris portraits, which they never acknowledged, served them greatly for many decades to come. With no written records to fall back upon, it is difficult to identify or assess the true wealth of McGarrigle's work or how these engaging portraits came into being. Tribes coming to Auckland from their ancestral lands may have been enticed into his studio for their portrait by inducements like a free set of prints if they gave permission for them to be

used as sales to colonists who wanted to send studies of Maori heads to friends overseas. The mix and match of European costuming with traditional clothing and artifacts certainly suggests a very impromptu series of studio encounters.

<div style="text-align: right">WILLIAM MAIN</div>

MCKELLEN, SAMUEL DUNSEITH (1836–1906)

S.D. McKellen was born in Ireland in 1836 and a year later the family emigrated to Manchester where Samuel was to spend most of his working life. McKellen trained as a watchmaker and jeweller and had opened his own business by 1861.

It was around this time that McKellen developed an interest in photography making his own camera from a cigar box and lens. By 1881 he had began to design the camera that would lead one obituary to describe him as 'the father of the modern camera.' The design was made up for him by the Manchester camera maker Joshua Billcliff which McKellen then field tested and extensively demonstrated. It was shown at the annual exhibition of the Photographic Society in October 1884 where it was awarded a gold medal—the first the Society had given for a camera. McKellen was elected to the Society the following month, although he let his membership lapse.

McKellen began commercial manufacture of his camera which was sold under the Treble Patent name and incorporated at least three of his four patents from the same year. By 1887 the camera incorporated eight McKellen patents. The design was based on McKellen's own experiences as a photographer and was intended to be: light in weight, rigid, easily erected and folded into a compact shape, to accept lenses of different focal lengths, simple in construction and with a swing back and front. The design allowed mass-production and McKellen's factory was was soon employing thirty-five workers and mechanised to allow this. The design was a significant development of the Kinnear camera of 1857 but incorporating the McKellens own principles. It camera was copied by volume manufacturers such as Thornton-Pickard against whom McKellen took legal action and the design, from different manufacturers, remained popular until the early 1900s.

McKellen produced a range of other photographic equipment including a Detective hand camera which he patented in 1888 and licensed to Marion and Company. This camera was significant for incorporating an internal mirror for reflecting the image on to a ground glass screen and a roller blind shutter for which he gave acknowledgment to Thomas Sutton and his design of 1861.

McKellen received twenty-eight photographic pat-

ents between 1884 and 1904 but he was not a good businessman and failed to secure his designs losing sales to competitors. He was also under capitalised. A move to establish a public company in 1899 and new products failed to provide financial security and by the time of his death he was penniless and estranged from his wife.

S.D. McKellen died on 26 December 1906 in a Manchester hospital.

<div style="text-align: right">MICHAEL PRITCHARD</div>

See also: Patents: Europe and the United Kingdom; and Lenses: 2. 1860s–1880s.

Further Reading

McKellen, John, "S D McKellen. Father of the Modern Camera," in *Photographica World*, 93 no. 3 (2001): 9–19.
Davies, David A., "The Manchester Camera Makers 1853–1940," special issue *The Photographist*, Winter/Spring 1986.

MCLAUGHLIN, SAMUEL (1826–1914)
Irish photographer, inventor

Samuel McLaughlin was a watchmaker, publisher, and photographer; born Rathlin Island, County Antrim, Ireland, January 28, 1826; died Los Angeles, California, August 26, 1914. Born in Ireland of Scottish parentage, Samuel McLaughlin was living in Quebec City by the age of fifteen. He began work as a watch and chronometer maker, and then, after a brief period working with a firm of silversmiths in New York, became a book and periodical agent and publisher of city directories, 1854–57. He took up photography as an amateur, later turning professional, for a time, in partnership with Samuel McKenney and William Lockwood. McLaughlin produced Canada's first photographically illustrated serial publication *The Photographic Portfolio: A Monthly View of Canadian Scenes and Scenery* (1858–59), a series of twelve views in and around Quebec City, with accompanying letterpress text. In September 1861, he was appointed the first official "photographist" for the Canadian government and moved to Ottawa where he remained a civil servant for the next thirty years. Best known for his architectural views of the construction of the Parliament Buildings in Ottawa, McLaughlin worked as Chief Photographer for the Department of Public Works and later the Department of Railways and Canals, producing impressive documentation of many Canadian public works projects, most notably wharves, timber slides and booms, dams, and fish breeding works along the Saguenay River. He was succeeded by his son Daniel after he retired to Los Angeles, where he died.

<div style="text-align: right">JOAN M. SCHWARTZ</div>

MEADE, CHARLES RICHARD (1826–1858) AND HENRY W. M. (c. 1823–1865)

Subscribers to *Gleason's Pictorial Drawing-Room Companion*, found its cover for July 24, 1852, dominated by a spectacular, full-length, engraved portrait of newly-deceased statesman Henry Clay. His obituary credited this "excellent likeness" to an original daguerreotype by Meade Brothers, New York. Charles Richard and Henry William Mathew Meade were already familiar figures to readers. Their own, very handsome likenesses had graced "The Brothers Meade," an article in the June 12th issue. These talented daguerreotypists, dealers, manufacturers, and instructors, became celebrities in their own right. Their fame was obscured and much of their legacy lost due to the early demise of both brothers. For this reason and because inadequate labeling may result in surviving pictures being credited incorrectly or to "photographer unknown," critical analysis is very difficult. Nevertheless, from their firm's establishment in Albany, New York in 1842, through the period following its 1850 relocation to a magnificent gallery in New York City, at 233 Broadway, the achievements of Henry and Charles Meade rank them among the most important of professional daguerreotypists and early photographers. The largest collection of their work is at the National Portrait Gallery, Washington, D.C.

In *Esquisses Photographiques*, Ernst Lacan took note of the superiority of Meade Brothers' pictures and the great interest of French daguerreotypists in their technical excellence. Charles R. Meade published an account of how this was achieved in the prestigious journal edited by Lacan, *La Lumiere*. He revealed that Meade Brothers used Voigtlander and French lenses, an American camera by Fisch with a lens 6 inches in diameter, and either French star or Christofle (scale) plates. He described the Meade method of preparation and development in detail and noted that the extra work of electroplating star plates (with the aid of a battery by Farmer) could be avoided by using the Christofle brand. Charles also discussed lighting and backgrounds used by the Meades and said exposure time for a half plate on a beautiful day was about twenty seconds and a little more if the weather was gloomy.

Ballou's, the successor to *Gleason's,* boasted that its engraved likenesses of the Misses Fox, the Rochester spirit rappers, were from a daguerreotype by Meade Brothers "and are therefore reliable." Lola Montez inscribed a copy of a Meade picture as follows: "I consider this lithograph the best likeness I have yet had taken of myself." A review of three portraits displayed at Ernst Lacan's Paris home indicated that their appearance could only be compared to Antoine Claudet's work and that "By a very special arrangement of the light, by the care brought to the polishing, by the artistic choice of the pose, Messrs. Meade give to their portraits a relief which recalls the illusion of the stereoscope. When one has seen these beautiful plates, one understands the reputation that these artists have made for themselves in America and the value that is attached to their works" (Gaudin, Charles. "Réunion Photographique," in *La Lumiere*, February 24, vol. 1, 1855, 29–30, [Paris], J. Lafitte, 1995). The brothers also composed allegorical and genre works such as a group of scenes illustrating Europe, Asia, Africa, and America and the "Seven Ages of Man," after Shakespeare, a series of tableaux taken by Charles.

Henry toured England, France, and Germany on business in 1847–48. On Charles's subsequent trip, later in 1848, he visited Bry-sur-Marne, France, and charmed Daguerre's niece, Georgina Arrowsmith, into persuading the inventor to pose for some very rare and important daguerreotypes. One day, Charles arrived to find Daguerre working in his garden and announced that he had come to take his portrait. Daguerre immediately complied, changing into a white shirt and tie, dark vest, and formal coat with the Legion of Honor on one lapel. Charles took eight or possibly nine portraits on this occasion. During his visit, Daguerre showed Charles the first daguerreotype, a view of Bry, and told him how it was made. Charles left two originals in Europe, gratefully giving one each to Daguerre and his niece, and brought the rest home. One was displayed at the Meade gallery, whose collection would eventually include John Quincy Adams, Franklin Pierce, James Buchanan, Millard Fillmore, Napoleon III, Louis Kossuth, Commodore Perry, Sam Houston, Jenny Lind, Catherine Hayes, Edwin Forrest, Charlotte Cushman, Billy Bowlegs, and many others. From views of Niagara Falls, Broadway, and a moving train shown as if still, to H. K. Brown's equestrian statue of Washington in Union Square, and panoramas of regiments in City Hall Park, the Meades also took many fine outdoor pictures. "Meade Brothers, American Daguerreotype Galleries" reflected their patriotic theme as did the carpet with the eagle and stars chosen for their Williamsburgh branch. At the Washington Monument may be seen the block they donated; it is inscribed simply, "To Washington, An Humble Tribute, From Two Disciples of Daguerre."

On another European trip in 1853, Henry received sets of new medals from America with profiles of Henry Clay and Daniel Webster as they appeared on Meade daguerreotypes. He was to present them to Queen Victoria and Emperor Napoleon III. In London, he met the most important daguerreotypists and at a Lacan soirée in Paris, Henry displayed a Meade daguerreotype of Levi Hill. *La Lumière* reported that it was "one of the most beautiful plates we have seen" and that distinguished attendees such as Nièpce de St. Victor, another color experimenter, studied Hill's appearance with great interest. Meade Brothers had demanded Hill

show his "hillotypes" to fellow daguerreotypists; one of those who would see them was Charles R. Meade. Both brothers were honorary members of the Societe Libre des Beaux Arts and Henry brought funds they had collected for its proposed monument to Daguerre and Nicephore Niepce. He visited Daguerre's widow and niece at Bry, took pictures of Daguerre's chateau and grave monument, and operated in his laboratory.

When last in Europe in 1854–55, Charles visited London and studied new photographic processes in Paris. On June 8, 1855, he took his own daguerreotype of Rachel, star of the Comedie Francaise, as Phedre, when she came to have her portrait taken by the studio of Mayer and Pierson. Similar arrangements allowed him to take tragédienne Adelaide Ristori, also rumored to be coming to America, the King of Portugal, and Rossini. He took outdoor photographs of Notre Dame, the *Palais de l'Industrie,* and the *Cirque de l'Impératrice,* all published in the *Photographic and Fine Art Journal,* and stayed long enough to arrange the Meade exhibit at the Exposition Universelle. The following year, Charles invented a process for taking photographs on silk.

RITA BOTT

Biography

The Meade family arrived from England at the port of New York on November 7, 1834, on the ship *Philadelphia.* They lived in Troy, New York, and later moved to Albany. In their daguerreotype business, Henry W. M., b. London, c.1823, and Charles R. Meade, b. London, April 11, 1826, were assisted by their father, Henry Richard, and their sister, Mary Ann Meade, both daguerreotypists and photographers. Henry R. claimed to have helped start the firm in 1841 in a petition for financial support made to the National American Photographic Association in 1872. Mary Ann, who ran the business in its last years, died January 17, 1903, and was described as "the first woman to have practiced the art of Daguerre" in her *Brooklyn Eagle* obituary. Both she and her father were pictured on Meades' "Frontispiece for Albums" with Daguerre, Niepce de St. Victor, Charles R., and Henry W. M. Meade. The whole family, including their mother, Mary Ann, lived at 233 Broadway, New York, after relocating from Albany in 1850 and until each brother married. Charles married Marietta F. Roff on June 17, 1851, and they had two children, Kate F. and Henry A. Meade. Henry W. M. Meade married Sarah Meserole on September 7, 1853; their two children were Sarah and Jessie Meade.

Meade Brothers began in 1842 at a Douw's Building in Albany, New York, and moved to the Exchange in 1843. In addition to taking pictures, offering instructions, and producing cases and other items in their "manufactory" for sale and their own use, they became major importers and dealers of equipment and supplies. They operated branches in Buffalo, Saratoga Springs, and possibly Canada for a time but relocated completely to 233 Broadway in 1850. In July, 1853, they opened a branch in Williamsburgh, L. I., (later Brooklyn) at 1st and South 7th Streets. The 1855 New York State Census reported that the Meade firm's annual product of daguerreotypes was valued at $15,000, its tools and machinery at $1,500, and its stock at $10,000 [$1: 1855 = $22.46: 2006]. It experienced financial difficulties as early as January, 1857 due to Charles being ill with tuberculosis. After spending the next winter in Havana, Cuba, he died at St. Augustine, Florida, on March 2, 1858. Business remained difficult and a branch at 805 Broadway was unsuccessful. The main gallery was refitted and operated through the war years. After Henry died in New York on January 25, 1865, Mary Ann continued the business for another four years.

The firm won one gold, five silver (one for calotypes in 1848), and one bronze medal from the American Institute and a diploma from the New York State Agricultural Society. Complimentary letters were received from Daguerre; Lola Montez; Fletcher Webster; Louis-Philippe, King of the French; Emperor Nicholas I of Russia; Queen Victoria; and Napoleon III for receipt of either Meade pictures or medals based upon them. They exhibited twenty-four daguerreotypes at the Great Exhibition of the Works of Industry of All Nations, Crystal Palace, Hyde Park (1851) and won "Honorable Mention" for their exhibits at the Great Exhibition, New York (1853–54), and the Exposition Universelle, Paris (1855).

See also: Daguerre, Louis-Jacques-Mandé; Hill, Levi L.; and Lacan, Ernst.

Further Reading

Bott, Rita Ellen, "Charles R. Meade and His Daguerre Pictures," in *History of Photography,* 8, no. 1, Jan.-Mar. 1984, pp. 33–40.

"The Brothers Meade," in *Gleason's Pictorial Drawing-Room Companion,* 2, no. 24, June 12, 1852, 377; "The Brothers Meade and the Daguerreian Art," *Photographic Art Journal,* 3, no. 5, May 1852, 293–295. [Same article as in *Gleason's,* with addition of a poem]

Canfield, C.W. "Portraits of Daguerre," and "More Portraits of Daguerre," in *American Annual of Photography,* 1891, 26–36; 1893, 77–81.

"Daguerreotype Galleries of Meade Brothers," in *Gleason's Pictorial Drawing-Room Companion,* 4, no. 6, Feb. 5, 1853, 96; "Our Daguerreian Galleries—No.1, The Meade Gallery, New York," in *Photographic Art Journal,* 5, no. 2, Feb. 1853, frontispiece, 99–100.

"Daguerreotype of Daguerre," in *New York Tribune,* Oct. 19, 1850.

"Henry William Mathew Meade," *New York Illustrated News,* 3, no. 67, Feb. 2, 1861, 236.

Johnson, William. "Meade Brothers, New York, NY: Meade, Charles Richard;

Meade, Henry William Mathew," in *Nineteenth Century Photography: An Annotated Bibliography, 1839–1879,* Boston, MA: G. K. Hall, 1990.

Lyons, Volina Valentine. "The Brothers Meade," in *History of Photography,* 14, no. 2, Apr.–June 1990, 113–134.

Meade, Charles R., "Procede de M.M. Freres de New-York Pour Obtenir des Epreuves" ["Process of Messrs. Meade Brothers of New York for Obtaining Proofs"], in *La Lumiere: Journal Non Politique: Beaux-Arts, Heliographie, Science,* Feb. 24, 1855, 34, Paris: J. Lafitte, 1995.

Rinhart, Floyd, and Marion Rinhart, *The American Daguerreotype,* Athens: University of Georgia Press, 1981.

MEDICAL PHOTOGRAPHY

Medical photography is a broad term that encompasses photographs of patients, ward and operating theatre scenes, photomicrography, portraits of doctors, etc. The term 'medical' is synonymous with the word 'clinical.' Medical photography is however, the term most commonly used to refer to photographs of patients, diseased body parts, organs, and specimens. Medical photographs, i.e., those with a clinical content, are images of somatic diseases of the body and are distinct from images of clinical psychiatric diseases. Although the apparent visual signs of disease were often the main reason that led to the photograph being taken, in the final image, the pathology may only appear as an incidental element, disguised in conventions of nineteenth century portraiture. Many of the clinical conventions that we associate with medical photography such as the before and after shot, plain backgrounds, or the black box placed over the patient's eyes did not develop until the late nineteenth century. Improvements in photographic technology also helped the medical-clinical photograph to become part of a clinicians teaching collection and or clinical records.

Writing in 1931, Josef Maria Eder published an account of the history of photography in Europe, which was later translated by Edward Epstean in 1945 (Eder 1931). In the chapter on scientific photography, Eder describes what he believes to be one of the first applications of photography to medicine. This was in the field of photomicrography. He outlined the pioneering work by the French physician Alfred Donné (1801–1878) demonstrated in his cytology atlas, *Cours de Microscopie* (1845), made with Jean Bernard Léon Foucault (1819–1869).

One of the earliest clinical portraits identified by many was a calotype taken by the eminent Scottish photographers, David Octavius Hill (1802–1870) and Robert Adamson (1821–1848), sometime between 1843 and 1847 (Wilson 1973). The image is taken directly face on to the sitter, and cropped above her waist, perhaps in order to draw the attention of the viewer to the upper half of the body. Wilson suggests that:

[T]he clothing around her neck has been drawn back to show the goitre. This photograph contrasts strongly with their other works, in which artistic arrangement of the sitter is a main consideration. This must be one of the earliest clinical photographs, if not indeed the first. (Wilson 1973, 104)

Wilson attempts to contextualise the image by suggesting tentative links between Hill and Adamson and Dr James Inglis (1813–1851), who had an interest in goitre. However, if one looks at this photograph within the broader context of Hill and Adamson's work it becomes apparent that the sitter's dress and bonnet are strikingly similar to those worn by fisherwomen in Hill and Adamson 'Newhaven' photographs, taken during the early-to-mid 1840s.

In general histories of photography, little reference is made to medical-clinical photography. Those who do, on the whole, tend to cite Dr Hugh Welch Diamond's (1809–1886) psychiatric portraits taken at the Surrey County Asylum in Twickenham. Using Frederick Scott Archer's (1813–1857) wet-collodion process, Diamond used photographs for diagnostic purposes and case notes. He also showed the patients their photographic portraits following treatment for therapeutic purposes.

Heimann Wolff Berend (1809–1873) was another doctor who used photography as part of his clinical practice from the 1850s. Berend founded an orthopaedic clinic in Berlin and employed a professional, L. Haase to photograph his patients before and after surgery. Berend's collection contains hundreds of photographs which combine both portrait and clinical conventions.

Many medical men began to publish their photographic endeavours in books and medical journals. Theodor Billroth (1829–1894) the Viennese surgeon and pioneer in abdominal surgery began to use photography while working at the Chirurgische Klinik in Zürich. During the 1860s he employed J. Ganz to take stereoscopic photographs to accompany cases notes published in 1867 (Gernsheim 1961). Similarly the French neurologist, Dr Guillaume Amand Benjamin Duchenne (1806–1875) was a pioneer in the use of photography as a medium for observation, representation and knowledge in medicine. Duchenne photographed patients undergoing electric stimulation of their facial muscles and published the results in his book *Mécanisme de la Physionomie Humaine* [The Mechanisms of Human Facial Expression] in 1862. In the same year he published a book containing images of pathological cases including ataxia. Duchenne de Boulogne was one of the first to use clinical photographs in his book on neurological disorders published in 1863.

In the field of dermatology Alexander Balmano Squire (1836–1908) published *Photographs (Coloured from Life) of the Diseases of the Skin* in 1865. Inspired by Squire's work A. Hardy (1811–1893), a doctor at the

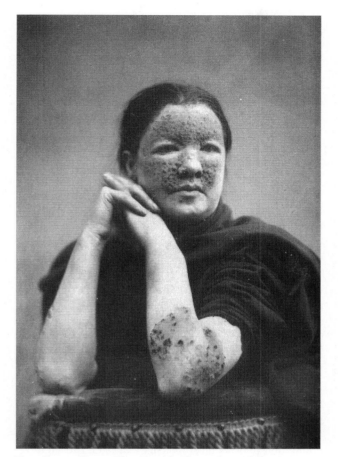

Fox, George Henry. Photographic Illustrations of Cutaneous Syphilis (1 of 48).
The J. Paul Getty Museum, Los Angeles © The J. Paul Getty Museum.

St. Louis Hospital in Paris employed his former pupil, A. de Monteméja, to run a photographic studio within the hospital during the 1860s. They built up a large teaching collection of dermatogical photographs and stereoscopic images.

> In America during this period Surgeon-General Hammond had decreed that photographs should be taken of the casualties of the American Civil War (1861–1865). One of the world's largest collection of medical photographs, many of which are *carte-de-visite* [visiting cards] are now preserved at the Army Medical Museum in Washington, D.C.

Richard Leach Maddox's (1816–902) improved dryplate available from the early 1870s encouraged and advanced the progress of photography in hospitals and other institutions. The neurologist Jean Martin Charcot (1825–1893) established a photographic Service Laboratory at La Saltpêtrière, Paris in 1878. Charcot installed Albert Londe (1858–1917) as the director of the Laboratory. In 1893 Londe published one of the first texts dedicated to medical photography entitled *La Photographie Médicale* [Medical Photography].

The in-house photography of the hospital also aided the move from commercial photographic portrait to clinical photographic conventions. Teachers, clinicians, researchers, and students used photographs of patients' bodies and their abstracted parts to visually enrich medical teaching. In Alison Gernsheim's 1961 account of the history of medical photography she states that 'I am unable to say when photography was first officially recognized by an English Hospital. St Bartholomew's Hospital at any rate had by 1893 a large number of photographs' (Gernsheim 1961, 2, 149). In Scotland, the eminent surgeon William MacEwan (1848–1924) had began taking photographs for use in his Private Journals and a collection of clinical photographs from the late 1880s which he added to throughout his teaching career at the Glasgow Royal Infirmary and later at the Glasgow Western Infirmary. MacEwan built up a collection of over seven hundred photographs covering a variety of subjects including rickets, carcinoma and hernia. The photographs were mounted on boards with case notes written on the verso. On his death his collection continued to be used and added to by his son Dr John A.C. MacEwan (1874–1944) and his colleagues at the Glasgow Royal Infirmary.

Not all medical men however, were willing to take photographs and in some instances portrait photographers would be brought into the hospital to photograph the patients or the patient would be sent to the local portrait studio.

Towards the end of the nineteenth century photography had found its way into medical journals, hospital wards journals, pathological reports and so on. Some began to devise technology that would allow them to take specialist photographic images of the body for example the human retina was photographed in 1885 by W.T. Jackman and J.D. Webster used a camera attached to a patient's head with an opthalmoscopic mirror in front of the lens; a long exposure of over two minutes was required. In 1887 Eadweard Muybridge (1830–1904) using a chronophotographic technique produced a series of images capturing the movement of subjects walking with a pathological gait.

As a subject the history of medical-clinical photography has been discussed in several fields including the history of medicine, the history of photography and medical photography, and theoretical debates from the history of art and visual culture.

Historians of medicine have been preoccupied with discussing the role of images as sources, focusing on problems of interpretation, and have, for instance, been keen to adopt theories derived from the history of art and visual culture. Discussions by historians of art and visual culture are often concerned with the 'status' of the photograph, and whether it can be understood as an 'objective document' or simply as an aesthetic object.

Conversely, historians of photography and medical photography debate technical issues, as well as locating and describing the 'first' clinical photographs and or presenting them as a seamless chronological narrative. Creating such a linear account involves leaping from one medical speciality to another, ignoring the possibility that each discipline such as orthopaedics, dermatology, etc., may have its own particular ancestry, influences and development.

It was not until 1961 that the first survey dedicated to the history of medical photography was written by Alison Gernsheim, and published in two parts (Gernsheim 1961). Since then the analysis of medical and clinical photography has thrown up dedicated historians of medical photography, resulting in attempts to go beyond identifying the first medical and clinical photographs, creating a wider debate on how they can be interpreted and used within historical research. One of the most prolific writers on this subject is Dr Stanley B. Burns. In 1988 Burns, together with Joel-Peter Witkin, an artist and photographer, published *A Morning's Work*, a selection of nineteenth-century medical photographs from the Burns Archive (Burns 1998).

The work of historians of art and visual culture relating to photography has arguably had the most impact on the way historians of medicine have considered clinical photographs. Many theories derived from the history of art and visual culture have debated the artistic-scientific-mechanical nature of photography. There is a vast body of literature, which aims to encourage us to 'look' in particular ways.

John Tagg argues that medical-clinical photography was a representational act rather than a creative undertaking (Tagg 1988). Tagg applies Michel Foucault's theories concerning observation, realism and objectivity in his exploration of the clinical gaze in nineteenth-century photography. He argues that technical advances, which occurred during the mid-to-late nineteenth century, facilitated the expansion of photography into medicine (Tagg 1984). It was within new institutions of knowledge, such as the hospital, that photography was to become perceived and accepted as a form of truth and evidence. Tagg's argument implies that the medical profession as a whole accepted photography as a medium of truth. However, in reality there was no consensus. Arguments for and against the use of photography were regularly reported in nineteenth-century medical periodicals such as the *British Medical Journal* (*BMJ*) and *The Lancet*.

The historian of art, Martin Kemp, encourages us to look at the details in medical photographs with a more discerning eye. Kemp's work has done much to stimulate debate concerning the history of photography (Kemp, 1988). He argues that individuals were faced with a series of photographic choices, which included staging, exposure and printing. By analysing each of these criteria one can gain insight into 'accessory and contextual information' (Kemp 1988, 123). Kemp suggests that the inclusion of details, such as the patient's clothes, are medically, but not socially, redundant. The border information in an image contributes to an understanding of the practice of medical photography. Kemp describes such details as 'accessory images.' It is the posing of the patient, clothes, and setting which reflect both 'conscious and unconscious choices' of the photographer. He is keen to point out that 'it was not so much that any doctor could simply become a photographer from the first, special skills and knowledge were involved in the production of photographs of the desired technical quality but rather that a layer of artistic mediation was eliminated' (Kemp 1988, 123).

Integrating images into historical research poses many problems for historians of medicine. As previously mentioned, Daniel Fox and Christopher Lawrence alerted us to potential pitfalls, such as presenting images in the form of 'coffee table books' or simply reaffirming what has already been said in the accompanying text (Fox & Lawrence 1988, 6).

Many previous studies have been content with presenting a visual and seamless chronological narrative of medical-clinical photography, irrespective of its local contexts of production, use and circulation. The contextual approach, emphasizes the need to analyze and relate images to their local contexts of production and circulation. This approach can be taken further by expressing visually the narratives that exist between photographs, images, text and artifacts. This not only encourages image-based research, but presents the results in a convincing, discursive and creative way.

PAULA SUMMERLY

See also: Duchenne, Guillaume-Benjamin-Amand; Gernsheim, Alison; Hill, David Octavius, and Adamson, Robert; Muybridge, Eadweard James; Calotype and Talbotype; Dry Plate Negatives: Non-Gelatine, Including Dry Collodion; Dry Plate Negatives: Gelatine; Cartes-de-Visite; Chronophotography; and Photomicrography.

Further Reading

Bengston, B.P., and Kuz, J.E., *Photographic Atlas of Civil War Injuries, Photographs of Surgical Cases and Specimens: Otis Historical Archives*. Georgia: Kennesaw Mountain Press, 1996.

Burns, S.B. *A Morning's Work: Medical Photographs from the Burns Archive and Collection, 1843–1939*, Sante Fe, NM: Twin Palms Publishers, 1998.

Duchenne G.B. *Album de Photographies Pathologiques Complémentaire du livre intitulé De l'électrisation localisée*. New York: Baillière Brothers, 1862.

——, *Mécanisme de la Physionomie Humain: ou analyse électro-*

physiologique de l'expression des passions, etc., Paris: J.-B. Baillière et fils, 1862.

Eder, J.M., *History of Photography,* New York: Columbia University Press, 1945.

Fox, D.M., and Lawrence, C. *Photographing Medicine: Images and Power in Britain and America Since 1840.* New York: Greenwood Press, 1988.

——, "Medical Photography in the Nineteenth Century, Part 1,"*Medical and Biological Illustration* 2, 1961, 85–92.

Gernsheim, A. "Medical Photography in the Nineteenth Century, Part 2," *Medical and Biological Illustration* 2, 1961, 147–156.

Kemp, M.. "A Perfect and Faithful Record: Mind and Body in Medical Photography before 1900," in *Beauty of Another Order: Photography in Science,* edited by A. Thomas and M. Braun, London: Yale University Press, 1988.

Londe, Albert, *La Photographie Médicale. Application aux Sciences Médicales et Physiologiques,* Paris: Gauthier-Villars, 1893.

Rosen, G., "Early Medical Photography," *Ciba Symposia* 4, 1942, 1344–1355.

Witkin J.-P., and Burns S.B (eds.), *Masterpieces of Medical Photography: Selections from the Burns Archive,* Pasadena, CA: Twelvetrees Press, 1987.

Squire, Alexander John Balmanno, *Photographs (Colored from Life) of the Diseases of the Skin*, London: J. Churchill and Sons, 1865.

Summerly, P.. "The MacEwan Collection of Clinical Photographs (circa 1880–1918)," *Journal of Audiovisual Media in Medicine* 24 (2001): 145–148.

Tagg, J., "The Burden of Representation," *Ten-8* 14 (1984): 10–12.

Wilson, G.M., "Early Photography, Goitre and James Inglis," *British Medical Journal,* II (1973): 104–105.

MÉHÉDIN, LÉON-EUGENE (UNKNOWN)
French photographer

Léon Méhédin remains somewhat of an enigma. He was a French national but the place and date of neither his birth nor death are known.

His name first appears at the time of the Crimean War, linked with that of Colonel Charles Langlois, who hired him to assist with the taking of reference views which would later serve as the basis for Langlois' panorama painting of the *Taking of Sevastopol*, a successor to his already celebrated painting of the siege. The painting commission came from Napoleon. Some of their work is jointly credited, while other images are credited to Méhédin alone.

Méhédin's wide panoramic vistas of the destruction in the city are powerful reminders of what has been described as the first modern war. Amidst the desolation and the abandoned gun carriages, the exposure has just been short enough to preserve the image of the French flag.

Becoming interested in the potential of the panorama, he continued to produce fine studies including the aftermath of the Battle of Tchernaya.

While in the Crimea, Mehedin also collaborated with Friedrich Martens on several photographic excursions in the areas surrounding the ruined Malakoff Fort and the Redan. These may also have served as reference for Langlois.

JOHN HANNAVY

MEISENBACH, GEORG (1841–1912)
German etcher

Georg Meisenbach was born on May 27, 1841, in Nuremberg, as the son of a copper etcher and pub owner. A talented draftsman from early youth, he learned etching in copper and steel in Nuremberg and, working for several renowned companies, making himself a good name. In 1874, he moved to Munich where he started working on experiments with Gillot's zinkenite lithography. Cooperating with a number of printers and financial advisers, Meisenbach managed to develop his form of grid lithography after photographic images in 1881 and gained worldwide patents for it in 1883, parallel to the patent by Angerer & Goeschl from Vienna. The process consisted in preparing the printing plate by an exposure through two plates of very finely lined glass which converted any greyscale into small squares of different diameter. Meisenbach's business partner Josef Ritter von Schmaedel called grid lithography the "autotype process". The first publication of the autotype process was the catalogue to the exhibition of electricity in Munich in 1882, combining two of the most important media of modernity. Schmaedel helped Meisenbach to construct a machine for lining glass in 1883. Restlessly experimenting Meisenbach spent the rest of his life in devotion to the autotype process and its adaptation to any technical progress imaginable. Georg Meisenbach died in 1912 in Munich.

ROLF SACHSSE

MELHUISH, ARTHUR JAMES (1829–1895)

Arthur James Melhuish was born in London in 1829, he married in 1853, and had three sons and four daughters. Melhuish was a photographer, publisher, a portrait painter, picture dealer, and a designer of photographic apparatus. He joined the Photographic Society in 1856.

His photographic studio was his principal activity and he opened his first in Blackheath, Greenwich, in 1857, later moving to 12 York Place, Portman Square in 1863, and then Old Bond Street, and Pall Mall, all in London. This latter studio was renamed Melhuish and [James] Gale in February 1894 and lasted until Melhuish's death. Melhuish was secretary of the Amateur Photographic

Association from 1861 to 1889 the formal role giving him, a professional photographer, access to Royalty and to London fashionable society and scientific community. In 1873 he was created Photographer Royal to the Shah of Persia following his visit to London.

In addition to his main business as a photographer Melhuish formed partnerships with Thomas Miller McLean and Robert Peters Napper trading as McLean, Melhuish, Napper and Co at 26 Haymarket from 1859 until September 1861 when Napper left the firm; as McLean, Melhuish & Co.; as McLean, Melhuish & Haes, when Frank Haes joined in September 1861 until March 1863 when Melhuish left. These firms seem to have been both photographic studios, with coloured photographs a speciality, and extensive publishers of photographs.

Melhuish contributed photographs to various publications such as *The Stereoscopic Magazine* (1858–1865) published by Lovell Reeve, the Howett's *Ruined Abbeys and Castles of Great Britain* (1862) and he also printed the stereographs tipped-in to Piazzi Smyth's *Teneriffe* (1858) also published by Lovell Reeve. He exhibited widely in a personal capacity and through his businesses and was patronised by the Albert, Prince of Wales in the later 1850s on several occasions.

Melhuish patented three significant pieces photographic equipment. In 1854 (patent number 1139) he designed, with Joseph Spencer, a photographic roll holder using sensitised paper. This was described to the Photographic Society in 1856, demonstrated to the Prince of Wales and was used by Frank Haes when he photographed at London zoo. In 1859 two patents (numbers 2557 and 2965) related to the construction of cameras in metal. This was the first all-metal camera and one extant example resides in the collection of the National Museum of Photography, Film and Television in Bradford. The *Photographic News* reported on the camera in 1859.

Away from photography Melhuish started the *Church of England Pulpit and Ecclesiastical Review* in 1873 and published articles on a diverse range of subjects such as mental analysis, ghosts and the geology of the bible. He was an Honorary Fellow of the Meteorological Society and elected a Fellow of the Astronomical Society in 1863.

He died in Brondesbury, London, on 1 November 1895 leaving an estate valued at £794.

MICHAEL PRITCHARD

See also: *Photographic News (1858–1908).*

Further Reading

Henisch, B.A., and H.K., "A J Melhuish and the Shah,'" in *History of Photography* V(4) October 1980, 309–311.

MERLIN, HENRY BEAUFOY (c. 1830–1873)
Australian

Henry Merlin is thought to have arrived in Sydney in December 1848 but may have been a newspaper reporter in Norfolk in 1851 who arrived in Australia in 1853. Speculation exists as to his prior and subsequent activities. In 1863 Merlin married in London and possibly learnt photography for in 1864 he was established as a travelling photographer in South Victoria and Victoria and by 1866 was trading as the American and Australasian Photographic Company (A.&A.Co). Such American references in brand names were popular in the gold rush era. Merlin employed an assistant, Charles Bayliss (1850–97) and together they set out to photograph house to house throughout Victoria and New South Wales. The pair worked their way north inland to Sydney where the studio was located from 1870.

In March 1872, the Merlin followed the gold rush to Hill End west of Sydney where he met the enriched German-born immigrant miner Bernard Otto Holtermann. The latter appointed Merlin official photographer for the Holtermann International Travelling Exposition, a massive photographic documentation of the colony, later shown at the 1876 Philadelphia Centennial exhibition. Merlin's involvement however, was cut short by his premature death in Sydney in September 1873. The main work fell to Bayliss. Merlin also excelled in journalism with many articles appearing in the *Town & Country Journal*.

A large collection of A&A Co negatives is held in the State Library of New South Wales but surviving prints are mostly cartes de visites, often faded.

GAEL NEWTON

MESTRAL, AUGUSTE (1812–1884)
French photographer

Until very recently, practically no biographical information was available on this photographer, who was active in France in the late 1840s and early 1850s. Even his first name was veiled in mystery. The initial O, which has frequently been mentioned since the 1970s, seemed not to appear in a single nineteenth-century document. Research carried out in the context of two major 2002 exhibitions—on the *Mission héliographique* and on Gustave Le Gray, with whom Mestral was befriended and collaborated—resulted in a rudimentary insight into his life. It seems that he was born in 1812 in the Jura region, that he adopted the family name of his mother's former husband and that he became a clerk after having studied law. He established himself in Paris in 1844 and from 1848 onwards he was reputed

to be a successful maker of daguerreotypes. In spite of the long-time mystery of his name and life, Mestral's contribution to the history of photography should not be underestimated. In 1851, he was one of the forty founding members of the Société héliographique and, three years later, one of the ninety-three founding members of the Société française de la photographie. His name appeared frequently in the pages of the journal of these associations, *La Lumière*, especially during the years 1851–1853. The journal reports, for instance, that Mestral announced some technical improvements at several occasions. It was also written that he was part of a commission responsible for the compilation of the *Album de la Société héliographique*, in which all members were directed to submit their pieces so that progress could be observed from day to day. In addition, it was stated that he occupied himself with reproductions on paper of vast amounts of daguerreotypes.

By that time, Mestral had gained a reputation with the quality of his portraits, first on daguerreotype, later on paper. In *La Lumière*, the critic Francis Wey spoke of a collection of about 1,200 portraits—none of which survived or could be identified—and mentioned their "intimate, familiar and true aspects, which unmistakably betray[ed] the spiritual kind-heartedness of their author." Wey also mentioned some landscapes and he favourably described a view representing the canal sluice in Thoraise, on the borders of the Doubs, Mestral's native region. A similar photograph that survived, taken around 1853, illustrated Mestral's talents as a landscape photographer: he succeeded in evoking the play of light on the foliage and the water surface while structuring the composition by means of a stable foreground.

Mestral's name, however, was first and foremost connected with what later has been labelled the *Mission héliographique*. This famous assignment, issued by the *Commission des Monuments Historiques* in 1851, consisted of photographing an impressive series of medieval churches and monuments from classical antiquity. This impressive task to record the highlights of French architectural heritage by means of the new medium of photography, was assigned to five members of the Société héliographique, who all became key figures in nineteenth century photography: Edouard Baldus, Hippolyte Bayard, Henri Le Secq, Gustave Le Gray, and Mestral. It is not clear how Mestral became involved in the project since he was known for his portraits and no references are made to pictures of historical monuments prior to the 1851 mission. Initially, there was probably some hesitation among the Commission as well. At a certain stage in the preparation, his name disappeared from all documents but, eventually, Mestral was assigned with the fifth mission, which included photographing monuments in the regions of the

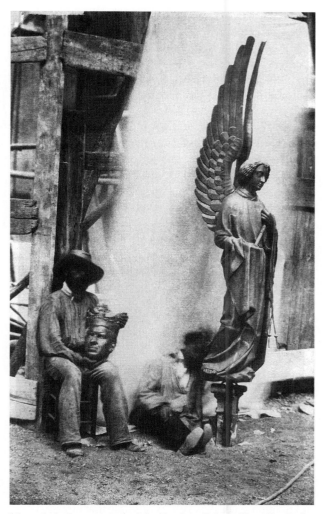

Mestral, Auguste. Angel of the Passion, Sainte-Chapelle, Paris. *The Metropolitan Museum of Art, Gilman Paper Company Collection, Purchase, The Howard Gilman Foundation Gift, 2002 (2002.9) Image © The Metropolitan Museum of Art.*

Charente, Dordogne, Gironde, Garonne, Tarn, Aude, Eastern Pyrenees, Lot, Chorèze, Haute-Loire, Puy-de-Dôme, Nièvre, and Cher. Mestral, however, decided to join forces with Le Gray, who was assigned with the fourth mission, which followed a more western itinerary. Mestral had close connections with Le Gray, certainly since 1848 and maybe even since the early 1840s. In his 1854 treatise on photography, Le Gray mentions Mestral as one of his pupils and he also made a portrait of Mestral, which survived. One can only guess about the specific nature of their collaboration for the Mission but it is probably wrong to assume that Mestral, who had acquired a reputation at that time, was only an assistant to Le Gray. Precisely because they joined forces, they succeeded in taking multiple views of a single building. Making full use of the new technique of dry wax paper, which was developed by Le Gray a few months before, they took about thirty views on a

single day, which was really exceptional in those years. Sometimes, there were only minor differences among several shots, but as the journey progressed, more different views and fragments of a building were taken. Their collaboration resulted in some true masterpieces of nineteenth century architectural photography, such as their view of the Grand staircase of the castle in Blois, which was exhibited in London in 1854, their pictures of the Cloister of Moissac, or their photographs of the fortifications of Carcasonne.

After his participation to the Mission, Mestral continued photographing monuments. Without receiving an official commission, he explored Normandy and Brittany—both regions ignored by the Mission—in 1852. Henri de Lacretelle wrote lyrically about these pictures in *La Lumière* in 1853 and he praised in particular Mestral's talent to render both details and a general view. In addition, Mestral directed his gaze at the restoration of the Notre Dame of Paris, where he photographed the sculptures of Victor Geoffroy-Dechaume in 1854.

STEVEN JACOBS

Biography

After a long period of obscurity about essential biographical data, it recently turned out that he was born in Rans (Jura) on March 20, 1812, as Thérèse Jean-Baptiste Augustin, aka Auguste Mestral. He is the son of Pierre and Jeanne Françoise Poux, the latter was a widow of a certain Claude Etienne Mestral. After finishing law studies in Dijon in 1833, he becomes a clerk in Paris and Ecouen successively. It is possible that already here, around 1840, he meets Le Gray, who was an assistant of Mestral's predecessor. In 1844 he establishes himself in Paris, where he gains reputation as a portraitist. A founding member of the Société héliographique, he contributes to the Mission Héliographique in 1851, photographing monuments together with Le Gray. All that time, he has his studio in the Rue Vivienne in Paris. In 1856 he leaves the capital and, probably, photography as well. Many of his negatives are left to his friend Ernest Moutrille, a Besançon banker and amateur photographer. He turns up in Rans, where he marries in 1858 and lives from his fortune. He dies the first of March 1884.

See also: Mission Héliographique; Le Gray, Gustave; Société héliographique; Société française de photographie; Wey, Francis; Baldus, Édouard; Bayard, Hippolyte; and Le Secq, Henri.

Further Reading

De Mondenard, Anne, *La mission héliographique: Cinq photographes parcourent la France en 1851*, Paris: Editions du patrimoine, 2002.

Voignier, Jean-Marie, "Mestral," *Etudes Photographiques*, 14, January 2004, 144–46.

MEXICO

The first photographs taken in Mexico were made by Jean François Prélier, a French engraver living in Mexico City, who returned from a trip to France with two cameras in December of 1839. He demonstrated the new daguerreotype process when he debarked in Veracruz, and shortly after his return to the capitol he took the first photograph of Mexico City—a view of the cathedral—on January 26, 1840. Thus, the first photographs made in Mexico were taken barely six months after the invention of the daguerreotype had been announced in the Mexican press (June 1839). The fact that they were made by a foreigner foreshadowed the development of photography in Mexico in the nineteenth century that resulted in a history as we now know it dominated by foreign names, particularly those of French, German, and American photographers. The reasons for this were twofold: first, from an economic perspective cameras were costly and bore high import taxes, and Mexican society lacked the well-educated middle class from which photography initially drew its ranks in England, Europe, and America. Second, for most of the nineteenth century Mexicans used photographs primarily as a private celebration of family and community, whereas foreigners were keenly interested in photographing Mexico's monuments, landscape, indigenous peoples, and political events. In fact, in the nineteenth century, only Egypt attracted as many photographers as did Mexico. Because these images by foreigners tended to be made for public consumption—they appeared in a wide range of publications and were often readily available for purchase—they gained a worldwide currency that photographs made by and for Mexicans did not.

Within two years after Prélier's first photographs, photography had become a business in Mexico. Although itinerate photographers, who traveled the traditional commercial routes were plentiful, professional studios were beginning to open in the larger cities. In 1842 Randall W. Hoit was the first photographer to establish a studio in Mexico City. He was followed shortly thereafter by fellow New Yorkers Francisco Doistua, Andrew J. Halsey, and Richard Carr. Joaquín María Díaz González, the first native Mexican daguerreotypist, opened a studio on the Calle de Santo Domingo in 1844. In 1856 there were seven photographic studios operating in Mexico City, in 1860 there were over twenty studios, and by 1870 seventy-four studios were in existence.

The years of the French Intervention (1864–1867) saw the burgeoning of photography in Mexico. Tied to

the protocol of the court of Maximilian and the official documentation of political events, photographs were a way of legitimizing the emperor. The court brought the European carte-de-viste craze to Mexico, and portraits of Emperor Maximilian, Empress Carlotta, General Bazaine, members of the court, and its Mexican supporters circulated widely in Mexico and abroad. François Aubert, the official court photographer, made images of the court at play, during ceremonial occasions, and during war, following Maximilian up to his last moments. His images of Maximilian's execution and post-mortem portraits were banned in Europe, but nevertheless circulated widely.

Other French photographers active during this period included Jules (Julio) Amiel, Auguste Mérille, Jean Baptiste Prévost, and Auguste Péraire. Photographers Julio de Maria y Campo, José Pedebiella, and J. B. Parés came from Spain. Mexican-born photographers, many of whom had studied at the Academia de San Carlos in Mexico City, included Francisco Montes de Oca, Lauro Límon, Andrés Martínez, Luis Campa, Antíoco Cruces, Agustín Velasco, Joaquín and Maximino Polo, Luis Veraza, Manuel Rizo, and Julio Valetta. Although many of these men were initially trained as painters, photography became part of the annual salon at the academy in 1870, and shortly thereafter photographs were included in the exhibitions of the Arts and Trades School.

A major trend in Mexican photography during the nineteenth century focused on travel and exploration. Foreign photographers were variously interested in documenting the ethnographic, archaeological, and natural sights of Mexico. Their interest came out of a "rediscovery" of the Americas, initially a romanticized return to pre-Conquest lands, wild and untamed in comparison to archaeological sites in Europe and the Middle East. The Viennese Baron Emanuel von Friedrichstahl was the first of the archaeologist-explorers, making daguerreotypes of sites in the Yucatan in 1840. He was followed by John Lloyd Stephens and Frederick Catherwood, Désiré Charnay, Lord Alfred Percival Maudslay, Augustus and Alice Dixon Le Plongeon, and Teobert Maler. Charnay, who began his archaeological explorations in 1858, was the first to break with the romanticized conception of ancient Mexico and use photography as a tool for scientific research.

Charnay and anthropologist-explorers such as Léon Diguet, Carl Lumholz, and Frederick Starr made ethnographic portraits of indigenous peoples and recorded daily life. While these photographers purported to have a scientific mission, the resulting images are closely aligned to the genre of "tipos" or Mexican popular types that depict people according to social category, regional costume, or profession, and that had been produced by earlier photographers such as Aubert, who made a series of studio portraits of street vendors. The genre was popular among both native and foreign practitioners. Americans William Henry Jackson and Charles B. Waite and Frenchman Abel Briquet made numerous tipos and images of "Mexican scenes." The Mexico City firm of Cruces y Campa made a carte-de-visite series of staged Mexican scenes for the 1876 Philadelphia Centennial Exposition. Lorenzo Beceril, a native-born studio photographer in Puebla was well-known for his portraits of Tehuanas, the distinctively costumed women from the Isthmus of Tehuantepec.

Promotion of Mexico was another activity of those traveler-photographers who were patronized by the Mexican government and private entrepreneurs. Focusing their lenses on the future rather than the past, photographers such as William Henry Jackson, Charles B. Waite, Abel Briquet, and Guillermo Kahlo (father of Frida Kahlo), photographed progress. Their images of landscapes in transition showed a Mexico being changed by engineering projects such as telephone lines, tunnels, railroads, bridges, and dams. The work of these chroniclers of the modernization of Mexico often appeared in the guise of tourist views, since tourists were seen as potential investors. Their work also memorialized the achievements of the ambitious Porfirian government (1884–1910), and highlighted the natural resources that could attract foreign investors. These photographers were frequently commissioned to produce albums recording the development of railways, mines, and factories.

Photography as a means for documenting historical moments and disseminating news had existed in Mexico since daguerreotypes were taken of American troops and wounded soldiers in Saltillo during the Mexican-American War (1846–1848). Aubert's images from the French Intervention were of a certain documentary nature, and were used in Europe to report the news from afar. However, it was the Porfiriato that made extensive use of photography to record its accomplishments. A cadre of photographers such as Agustín Victor Casasola and Guillermo Kahlo were always on hand to document ceremonial occasions such as the dedication of buildings and public works. In 1896 Rafael Reyes Spíndola, owner of several newspapers, began to print photographs in his papers. As Mexico moved determinedly into the twentieth century, photojournalism rapidly developed as a means for both recording change and keeping the public abreast of events. By the end of the first decade of the twentieth century the tool that the Porfirian government had recognized and used so successfully had been used to document both its apogee and its demise.

BETH GUYNN

See also: Cruces, Antioco and Luis Campa; Daguerreotye; and Landscape.

Further Reading

Debroise, Olivier, *Fuga Mexicana: Un recorrido por la Fotografía en México*, México, D.F.: Consejo Nacional para la Cultura y las Artes, 1994.

Imagen Historica de la Fotografia en México/Museo Nacional de Historia, Museo Nacional de Antropología, Mayo-Agosto de 1978. México: Instituto Nacional de Antropología e Historica, Fondo Nacional para Actividades Sociales, 1978.

Jesús Hernández García, Manuel de, *Los Incios de la fotografía en México: 1839–1885* México: Editorial Hersa, 1985.

Memoria del Tiempo: 150 Años de Fotografía en México/Consejo Nacional para la Cultura y las artes, Instituto Nacional de Bellas Artes. [México City]: Museo de Arte Moderno, 1989.

Nagar, Carole Naggar, and Fred Ritchin, eds., *México through Foreign Eyes, 1850–1990/Visto por Ojos Extranjeros, 1850–1990*. New York: W.W. Norton, 1993.

Ojos franceses en México: [el catálogo de la exposición]. México: IFAL: Centro de la Iagen, 1996.

Tovar, Guillermo, *La Ciudad de los Palacios: Crónica de un Patrimonio Perdido*. Mexico City: Vuelta, 1990.

MEYDENBAUER, ALBRECHT
(1834–1921)
German photographer

Albrecht Meydenbauer was born in Tholey, Saarland, on 30 April 1834, to the physician Albrecht Meydenbauer senior and his wife Friederike. In 1856–58 he studied architecture at the Bauakademie [School of Architecture] in Berlin and became a construction surveyor for the Prussian government. After an accident at the Wetzlar cathedral in 1858, Meydenbauer developed the idea that the direct measurement of sites could be replaced by indirect measurements using photographic images. In a memorandum, written in the fall of 1859, he laied out a project to photograph all Prussian monuments with the greatest detail and accuracy with the intention of gathering and protecting the images in an archive of cultural heritage. In the course of his work he designed a photogrammetric camera that combined a photographic camera with a measuring instrument and began testing it in 1867 with other scientists, on architecture and topographical views. 1885 Meydenbauer was called to the Prussian Ministry of Culture and founded the Königlich preußische Meßbildanstalt [Royal Prussian Photogrammetric Institute] in Berlin, the first institution worldwide for the photogrammatic documentation of architectural heritage. Between 1885 and 1920 the institute produced records of about 2,600 objects in nearly 20,000 photogrammetric images on glass plates, in and around Berlin and the Prussian territories until 1900, and then operating abroad (Athens, Baalbeck-Lebanon, Istanbul). Meydenbauer resigned in 1909 and moved to Bad Godesberg, near Bonn, where he died on 15 November 1921. The photogrammetric archive now resides in the Brandenburg Landesamt für Denkmalpflege [Landmark Preservation Office of the Federal State of Brandenburg] in Wünsdorf near Berlin.

STEFANIE KLAMM

MICHETTI, FRANCESCO PAOLO
(b. 1851)

Francesco Paolo Michetti was born in Tocco di Casàuria (Italia) in 1851, and soon after his birth, his family moved to Chieti, where he later attended a technical school.

He was awarded a scholarship to attend the Accademia di Belle Arti (Academy of Art) in Naples, where he studied with the painter Morelli. After his studies he moved to Francavilla where he bought an ex-nunnery.

Francesco participated in the Biennale in Venice with the portrait *La figlia di Iorio*, in the Exposition Universelle in 1878, and in other expositions in Germany and in London where he displayed some of his paintings and statues. His style was similar to that of the current Verismo, but it wasn't until 1871 when he went to Paris that he devoted himself fully for the first time to photography.

He immediately understood the peculiarity of the two expressive means, and always emphasized the differences between the two techniques and their autonomy without submitting one to the other.

In the 1870s his subjects were static but after photographs become more like snapshots he devoted himself to reportage of life in Abruzzo from 1890 to 1895. He used photography not only as a way to make his paintings more realistic, but, together with painting, developed an instrument to describe natural life by giving his personal, subjective views.

After 1900 he stopped painting and devoted himself to photography.

CARLO BENINI

MICHIELS, JOHANN FRANZ
(1823–1887)
Photographer

Michiels was born in Bruges (Belgium) on 4 October 1823 and he died on 21 January 1887 in Cologne (Germany). From around 1850 to 1859, Michiels worked in Bruges as a wood-carver and sculptor. He created the pulpit in the church of Saint-Jacques in Ypres and the pulpit in the church in Roesbrugge, both of which were destroyed during the First World War. He worked as wood-carver till 1843. During this period he had also become interested in photography after seeing daguerreotypes in Brussels.

Michiels became a photographer and publisher and

became famous for his photographs of city views, architecture and reproductions of art works. As an artist he used photography as a unique technique to make reproductions as a way to distribute this art.

Very well known are his photographs of the Flemish Primitives as is his view of the Quai Vert in Bruges (made in 1848), which is one of the oldest known photographs of Bruges, published by Blanquart—Evrard in the "Album de l'artiste et de l'amateur," 1851. During the years 1853–1854 he published the album "Variétés Photographiques." Some months later he left for Cologne (Prussia), but his main residence remained in Bruges however he later moved his domicile to Cologne in 1855 and became a Prussian citizen by naturalization the same year.

Museum art and the collection, classification and conservation of sculptures and other mediums became a new role for and subject of photography long before museums began to see photography themselves as objects of art. The photographer captured images of the building and its furnishings, but above all of the objects exhibited there. Michiels gained, in Cologne during the period 1852–1857, a fine reputation as an architectural photographer, thanks to his close collaboration with the publisher Franz Carl Eisen (1812–1861). He recorded the construction of Cologne Cathedral and published albums of the new stained-glass windows "Die neuen Glasgemälde im Dome zu Köln," five prints, 1853; "Album von Köln," fourteen prints, 1854; "Album von Berlin, Potsdam und Sans-Souci," sixty prints, 1857. These photographs were financially successful thanks to the commercial spirit and merchandising of Eisen who already had a flourishing business that sold graphic prints. An album of his reproductions of the shrine of Saint Ursula, 'Der Reliquienschrein der heiligen Ursula zu Brügge" with eight 22 × 31 cm albumen prints, appeared under the Eisen imprint in 1854 and in 1857, Michiels returned to Bruges.

Michiels' diplomatic skills won him a wide circle of upper class admirers. He was invited to teach photography to the crowned prince of Prussia, who later became de Emperor Friedrich III. He also had an exhibition as member of the Prussian delegation in Paris. During this period Michiels traveled to Russia to take photographs of works of art in the Hermitage Museum in Sint-Petersburg.

In 1858 he began with A. Laureyns an établissement photographique in Bruges, which found success for one year only.

During 1859–1860 he lived in Brussels working for several museums and had his photographs of works of art in the collections at European Museums published by Gestewitz in Düsseldorf.

The recognition of the history of art as a discipline

was responsible for a renewed interest for Old Art and photography made a significant contribution to the rediscovery of Old Art. National heritage was transferred to a glass plate or a sheet of paper and subsequently disseminated to those interested. The search to find the best methods of reproduction of works of art stimulated the technical skills and even inventions in this field. Photography came in a position concurrent with gravure and lithography. But soon the photographic medium created its own place in artistic and contemporary debates; slowly but surely, photography became intertwined with the professional activities of lithographers and printers, while photographs became increasingly employed for illustrating of books and other publications.

From 1861 to around 1864 Michiels set up a studio in Brussels, Rue Neuve, 88. After the death of his son Bruno in 1863, he finally moved back to Germany and opened a shop selling art objects with two of his daughters.

His photographs of museums bear witness to the significance that was attached to these relatively modern institutions. In topographical surveys of cities and regions, pictures of museums were included alongside churches, palaces and old town halls. Museums had a symbolic function as guardians of material culture; they gave the nation its cultural identity, while serving as a major attraction for tourists in search of souvenirs.

He died in Cologne on 21 January 1887 and his funeral was held in the Dom in Köln.

JOHAN SWINNEN

See also: Photography and Reproduction; Blanquart-Evrard, Louis-Désiré; Photography of Paintings; Photography of sculputure, Architecture.

Further Reading

Andries Pool (ed.), Camera Gothica: Gothische kerkelijke architectuur in de 19de-eeuwse Europese fotografie, Antwerpen, O.-L. Vrouwekathedraal, Provinciebestuur, Antwerpen, 1993.

Joseph, Steven; Schwilden, Tristan; Claes, Marie-Christine, Directory of photographers in Belgium 1839–1905, Volume I, text, Uitgeverij C. de Vries-Brouwers, Antwerpen, 1997.

Michiels, Guillaume, De fotografie en het leven te Brugge 1839–1918, Brugge, 1978.

Ruys, Christoph (ed.), Belgische fotografen 1840–2005, Foto-Museum Provincie Antwerpen/Ludion, 2005.

Swinnen, Johan. De paradox van de fotografie, Uitgeverij Hadewijch/Cantecleer, Antwerpen, 1992.

MICROPHOTOGRAPHY

The term "microphotography" has been used to describe two very different processes. According to its etymology, the term microphotography should describe

leisure occupation for those seeking self-education and improvement. The microscope slides produced for this audience, offering such sights as crystallized urine, blood cells, or an uncanny encounter with a housefly, offered access to a new visual domain and the opportunity to gain first hand experience of nature's inner truths. Studying nature in the nineteenth century was, above all, a visual process, involving extracting greater truths through visual observation and comparison.

The meaning of the microphotograph must be situated in this broader context of spectacle and optical entertainments. But where does the balance between scientific intent and specular indulgence fall with respect to microphotography's various forms? In one respect, the microphotograph was unlike its closest relatives, the microscope slide or photomicrograph in that it drew on a separate visual tradition. Whereas histology imagery would seem to invoke the scientific logic of precision and accuracy, the microphotograph offered pleasant illusions more akin to a magic lantern show. Dancer's roots as a producer of magic lanterns, and the easy fit between microphotographs and souvenirs support this idea. And yet observations taken through the microscope, recorded by whatever means, were considered to be of questionable ontological value by many contemporary scientists. Due to a lack of standardized documentation procedures, images of microscopic specimens were regarded at best as a highly suspect form of visual evidence. Photography did little to change this situation. The "objective" image recorded by the camera did not meet contemporary criteria for scientific accuracy and precision. Advocates from the domain of popular science, on the other hand, tended towards the grandiose in their estimation of the value of microscope images. They promote the edifying effects of gazing through the microscope objective both on aesthetic and scientific grounds. Moreover, in popular texts, microscope slides and illustrations were rarely organized and viewed in a way that could be called systematic or methodical. The average bourgeois viewer's experience with a microscope probably proceeded in much the same way. Microscopy and photomicrography both catered to a public whose appetite for new visual experiences outpaced its desire for education. In result, within the popular context the kind of attention directed to a microscope slide and a microphotograph seems closer than expected.

Contemporary discourse on microscopy offers reasons to further discriminate between the magical allure of optical trinkets like the Stanhopes and the practice of studying miniaturized photographs under the microscope. Microscopy between 1850–1870 was embedded in a cogent, power-laden political discourse on Nature that was used to recruit mass audiences for domesticated life science. In public discourse microscopic study was touted as an optimal means for training the public in a faculty it was sorely lacking—the ability to see independently and objectively, and thus develop vision into a tool of rational thought. Dancer's microphotograph slides often appeal to quantitative analysis, saying, for example, that 112 eminent men could be identified, or that a slide contains 1687 letters. The point was probably not to actually count but to suggestively appeal to this logic whereby microscopic study would develop the viewer's ability to synthesize discrete analysis and meta-observation.

The monuments, heroes, and landmarks featured in both souvenirs and slides likewise offer edifying content, yet seem to reveal a slightly different set of desires at play. The scopic pleasure offered must have been one of discovering what is human and familiar in the otherwise alien spaces of microscopic observation. It has even been suggested that these subjects reflect the colonial impulse of the age. Amateur literature on microscopy of the period is filled with reveries to the hidden worlds and exotic adventures the expanded vision microscopy made possible. If, therefore, amateur microscopy domesticated nature by bringing it into the space of the parlor, the projection of human artifacts and accomplishments into otherwise alien territories reads as a metaphoric attempt at domination.

Whatever the content of the image, the primary allure of the microphotograph was the possibility of experiencing a technical marvel. As tiny, perfect copies, microphotographs evince a pleasure akin to that offered by other kinds of miniatures including toys, dioramas, and staged panoramas. Souvenirs and religious effects appropriated this pleasure as a purely magical indulgence, whereas microphotography's other forms invite the viewer to play at being a scientist. Utilizing the microscope, focusing the objective, waiting for something to come into view, and scrutinizing the results, the viewer enacted the scopic logic of the natural sciences without actually submitting themselves to the intellectual rigors of scientific study.

STACY HAND

See also: Photomicrography; Nature; Science; Photographic Jewelry; Tourist Photography; Brewster, Sir David; Dancer, John Benjamin; Shadbolt, George; Sidebotham, Joseph; Lenses: 1. 1830s–1850s; Lenses: 2. 1860s–1880s; and Markets, Photographic.

Further Reading

Benjamin, Marina, "Sliding Scales: Microphotography and the Victorian Obsession with the Miniscule." In *Cultural Babbage: Technology, Time and Invention*, edited by F. Spufford, and J. S. Uglow. London: Faber and Faber, 1996.

Bracegirdle, Brian, *A History of Microtechnique*, Ithaca, N.Y.: Cornell University Press, 1978.

Breidbach, Olaf, Representation of the Microcosm—The Claim

became famous for his photographs of city views, architecture and reproductions of art works. As an artist he used photography as a unique technique to make reproductions as a way to distribute this art.

Very well known are his photographs of the Flemish Primitives as is his view of the Quai Vert in Bruges (made in 1848), which is one of the oldest known photographs of Bruges, published by Blanquart—Evrard in the "Album de l'artiste et de l'amateur," 1851. During the years 1853–1854 he published the album "Variétés Photographiques." Some months later he left for Cologne (Prussia), but his main residence remained in Bruges however he later moved his domicile to Cologne in 1855 and became a Prussian citizen by naturalization the same year.

Museum art and the collection, classification and conservation of sculptures and other mediums became a new role for and subject of photography long before museums began to see photography themselves as objects of art. The photographer captured images of the building and its furnishings, but above all of the objects exhibited there. Michiels gained, in Cologne during the period 1852–1857, a fine reputation as an architectural photographer, thanks to his close collaboration with the publisher Franz Carl Eisen (1812–1861). He recorded the construction of Cologne Cathedral and published albums of the new stained-glass windows "Die neuen Glasgemälde im Dome zu Köln," five prints, 1853; "Album von Köln," fourteen prints, 1854; "Album von Berlin, Potsdam und Sans-Souci," sixty prints, 1857. These photographs were financially successful thanks to the commercial spirit and merchandising of Eisen who already had a flourishing business that sold graphic prints. An album of his reproductions of the shrine of Saint Ursula, 'Der Reliquienschrein der heiligen Ursula zu Brügge" with eight 22 × 31 cm albumen prints, appeared under the Eisen imprint in 1854 and in 1857, Michiels returned to Bruges.

Michiels' diplomatic skills won him a wide circle of upper class admirers. He was invited to teach photography to the crowned prince of Prussia, who later became de Emperor Friedrich III. He also had an exhibition as member of the Prussian delegation in Paris. During this period Michiels traveled to Russia to take photographs of works of art in the Hermitage Museum in Sint-Petersburg.

In 1858 he began with A. Laureyns an établissement photographique in Bruges, which found success for one year only.

During 1859–1860 he lived in Brussels working for several museums and had his photographs of works of art in the collections at European Museums published by Gestewitz in Düsseldorf.

The recognition of the history of art as a discipline was responsible for a renewed interest for Old Art and photography made a significant contribution to the rediscovery of Old Art. National heritage was transferred to a glass plate or a sheet of paper and subsequently disseminated to those interested. The search to find the best methods of reproduction of works of art stimulated the technical skills and even inventions in this field. Photography came in a position concurrent with gravure and lithography. But soon the photographic medium created its own place in artistic and contemporary debates; slowly but surely, photography became intertwined with the professional activities of lithographers and printers, while photographs became increasingly employed for illustrating of books and other publications.

From 1861 to around 1864 Michiels set up a studio in Brussels, Rue Neuve, 88. After the death of his son Bruno in 1863, he finally moved back to Germany and opened a shop selling art objects with two of his daughters.

His photographs of museums bear witness to the significance that was attached to these relatively modern institutions. In topographical surveys of cities and regions, pictures of museums were included alongside churches, palaces and old town halls. Museums had a symbolic function as guardians of material culture; they gave the nation its cultural identity, while serving as a major attraction for tourists in search of souvenirs.

He died in Cologne on 21 January 1887 and his funeral was held in the Dom in Köln.

JOHAN SWINNEN

See also: Photography and Reproduction; Blanquart-Evrard, Louis-Désiré; Photography of Paintings; Photography of sculputure, Architecture.

Further Reading

Andries Pool (ed.), Camera Gothica: Gothische kerkelijke architectuur in de 19de-eeuwse Europese fotografie, Antwerpen, O.-L. Vrouwekathedraal, Provinciebestuur, Antwerpen, 1993.

Joseph, Steven; Schwilden, Tristan; Claes, Marie-Christine, Directory of photographers in Belgium 1839–1905, Volume I, text, Uitgeverij C. de Vries-Brouwers, Antwerpen, 1997.

Michiels, Guillaume, De fotografie en het leven te Brugge 1839–1918, Brugge, 1978.

Ruys, Christoph (ed.), Belgische fotografen 1840–2005, Foto-Museum Provincie Antwerpen/Ludion, 2005.

Swinnen, Johan. De paradox van de fotografie, Uitgeverij Hadewijch/Cantecleer, Antwerpen, 1992.

MICROPHOTOGRAPHY

The term "microphotography" has been used to describe two very different processes. According to its etymology, the term microphotography should describe

extremely small photographs that are viewed through a microscope or magnifying lens. Throughout its history, however, the term has been routinely applied to photographs of microscopic subject matter large enough that they may be viewed unassisted. The later are more precisely termed photomicrographs and are dealt with in a separate entry.

History

In many ways the idea of combining the camera and the microscope was an obvious extension of the camera's innate potentials. Not only was the knowledge of lenses and light required by photography also required by the successful microscopist, but the projected image visualized through the microscope was analogous to that recorded in the camera. No less a pioneer than William Henry Fox Talbot (1800–1877) took photographs through the microscope as early as1835.

Logically, the process could just as easily be reversed, using the microscope lens to reduce rather than enlarge the image recorded by the camera. The resolution required to print an image so small, however, made the accomplishment more technically difficult. The earliest microphotographs were probably delicate, irreproducible daguerreotypes that have not survived. After these initial experiments the historical development of microphotography diverged from that of photomicrography because of the different use-value assigned to each. The value of preserving and sharing what was seen through the microscope as photomicrographs was clear. The microphotograph, on the other hand, seemed to many contemporaries to have no practical applications. George Shadbolt (1819–1901), who coined the name microphotography, was of the opinion that "microphotographs can never be more than amusing curiosities." Most microphotographs were indeed produced as novelties, and it is as a novelty product that microphotographs became a significant feature of nineteenth-century visual culture. The idea to use microphotography to reduce and store information as microfilms arose independently, and was not put into practical application until the 1930s.

Like many milestones in the history of photography, microphotography was most likely pioneered by several people working around the same time. John Benjamin Dancer (1812–1887), is generally credited with successfully producing the first microphotograph. Dancer was an optician, inventor and entrepreneur who specialized in producing optical equipment like microscopes and magic lanterns. Dancer's first successful microphotograph, a daguerreotype of a 20 inches long document reduced to 3mm in length, was printed in 1839. According to a later account, his technique involved using the eye of a freshly killed ox as a lens. The wet collodion process invented in 1851, with its excellent resolution

and easy reproducibility, galvanized a new wave of experimentation. Dancer produced his first collodion microfilms early the following year. Although he lost a priority dispute with Dancer as to who could claim to be the inventor, Shadbolt was working in a microphotography around this time as well. He became the first to publish a workable microphotographic process in 1857. Others surely printed microphotographs as well, either out of curiosity or as demonstrations of technical acumen. Alfred Rosling, for example, exhibited pages of the *Illustrated London News* at the Photographic Society of London in 1853 to demonstrate the resolution of his lenses. Although they were not produced for that purpose, Rosling's microphotographs must be considered the first newspaper microfilms.

According to biographers, it was by accident that Dancer happened upon the idea to market microphotographs. When Edward William Binney asked Dancer to produce a photographic record of a memorial tablet, Dancer printed a microphotograph instead. Distributed to friends in early 1853, the image generated so much interest as to convince of microphotography's salability. Dancer's slide-mounted microphotographs quickly became a popular addition to the natural history slides and microscope equipment his company offered the bourgeois consumer. He offered microphotographs featuring local monuments, famous persons, and miniaturized texts like the Lord's Prayer. The subject choices reflect the microphotograph's status as an entertaining novelty destined for the bourgeois parlor, and simultaneously appeal to an implicit educational benefit to be derived from exercising one's faculties of visual observation.

Production of novelty microphotographs spread abroad when Sir David Brewster (1781–1868) toured Europe with examples of Dancer's work, which were displayed at the Académie des sciences in Paris and later presented to the Pope. The most prolific manufacturer was René Dagron (1819–1900) in Paris, who launched lucrative businesses selling images that were inset, along with a tiny, jewel-like magnifying lens in curios such as a signet rings, penknives, and religious charms. These trinkets, called Stanhopes, were immensely popular as souvenirs featuring a "hidden" vista that magically unveils itself to the knowing eye. Although popularity waned after the 1870's, Stanhopes remained in production through the 1970s.

The idea applying microphotography in preserving public records and library catalogs received rare mentions in periodicals as early as 1853. It was espionage, however, that provided the biggest impetus to the use of microphotography for information storage in the nineteenth century. In a 1857 article on the micrometer for the 1857 *Encyclopedia Britannica*, Brewster took up the theme in a way that echo in popular fiction for decades to come, writing that "microscopic copies of dispatches

Foucault, Jean-Bernard-Leon and O. G. Mason. Plate VI Cours de Microscope Complementaire des Etudes Medicales...Atlas execute d'apres nature au Microscope-Daguerreotype. *The J. Paul Getty Museum, Los Angeles* © *The J. Paul Getty Museum.*

and valuable papers might be transmitted by post, and secrets might be placed in spaces not larger than a full stop or a blot of ink." Microphotography was successfully employed to hide information from enemies for the first time in the Franco-Prussian War. In October 1870 Charles de Lafollye, of the Service de correspondences extraordinaires, assisted by Gabriel Blaise, produced the first microphotographic military dispatches. Messages were hand written in large script on cards and then photographed. The resulting prints were inserted in hollowed out quills and attached to a feather on a pigeon's tale. Later that year a letterpress was adopted for printing the messages, allowing copies to be kept which can be viewed in the Musée Postal, Brussles. Before escaping Paris in balloon named Niépce in 1870, Dagron was contracted to set up a similar pigeon post that would carry military and private communications back into occupied France. His prints represented a three-fold improvement over those of Blaise, recording the same amount of information on a sheet about 11 × 6 mm. Microphotography received more limited use in the American Civil War, where one regiment reportedly sent microphotograph dispatches across confederate lines pasted inside coat buttons. Noses, ears and fingernails

became the hiding place for microscopic secrets in the Russo-Japanese war of 1904–1905. Brewster's prophecy was finally fulfilled during World War I, when messages were sent to spies hidden on top of printed periods and commas in magazines.

Microphotography in Nineteenth-Century Visual Culture

The instant demand Dancer and Dagron discovered for microphotographs may seem surprising if it were not for the immense desire to explore all modes of visuality that characterizes the latter half of the nineteenth century. This passion for new ways of seeing and being seen inspired the invention of myriad optical trinkets and devices that could exist anywhere on a continuum that ran between, but always blended, spectacular entertainment and educational intent. After the invention of the achromatic microscope in 1823, microscopy became an important element in this visual culture. Produced cheaply in the 1830s, microscopes became a common addition to the bourgeois parlor, where they offered a recreational activity that fit into a public campaign promoting the natural sciences as an appropriate

leisure occupation for those seeking self-education and improvement. The microscope slides produced for this audience, offering such sights as crystallized urine, blood cells, or an uncanny encounter with a housefly, offered access to a new visual domain and the opportunity to gain first hand experience of nature's inner truths. Studying nature in the nineteenth century was, above all, a visual process, involving extracting greater truths through visual observation and comparison.

The meaning of the microphotograph must be situated in this broader context of spectacle and optical entertainments. But where does the balance between scientific intent and specular indulgence fall with respect to microphotography's various forms? In one respect, the microphotograph was unlike its closest relatives, the microscope slide or photomicrograph in that it drew on a separate visual tradition. Whereas histology imagery would seem to invoke the scientific logic of precision and accuracy, the microphotograph offered pleasant illusions more akin to a magic lantern show. Dancer's roots as a producer of magic lanterns, and the easy fit between microphotographs and souvenirs support this idea. And yet observations taken through the microscope, recorded by whatever means, were considered to be of questionable ontological value by many contemporary scientists. Due to a lack of standardized documentation procedures, images of microscopic specimens were regarded at best as a highly suspect form of visual evidence. Photography did little to change this situation. The "objective" image recorded by the camera did not meet contemporary criteria for scientific accuracy and precision. Advocates from the domain of popular science, on the other hand, tended towards the grandiose in their estimation of the value of microscope images. They promote the edifying effects of gazing through the microscope objective both on aesthetic and scientific grounds. Moreover, in popular texts, microscope slides and illustrations were rarely organized and viewed in a way that could be called systematic or methodical. The average bourgeois viewer's experience with a microscope probably proceeded in much the same way. Microscopy and photomicrography both catered to a public whose appetite for new visual experiences outpaced its desire for education. In result, within the popular context the kind of attention directed to a microscope slide and a microphotograph seems closer than expected.

Contemporary discourse on microscopy offers reasons to further discriminate between the magical allure of optical trinkets like the Stanhopes and the practice of studying miniaturized photographs under the microscope. Microscopy between 1850–1870 was embedded in a cogent, power-laden political discourse on Nature that was used to recruit mass audiences for domesticated life science. In public discourse microscopic study was touted as an optimal means for training the public in a

faculty it was sorely lacking—the ability to see independently and objectively, and thus develop vision into a tool of rational thought. Dancer's microphotograph slides often appeal to quantitative analysis, saying, for example, that 112 eminent men could be identified, or that a slide contains 1687 letters. The point was probably not to actually count but to suggestively appeal to this logic whereby microscopic study would develop the viewer's ability to synthesize discrete analysis and meta-observation.

The monuments, heroes, and landmarks featured in both souvenirs and slides likewise offer edifying content, yet seem to reveal a slightly different set of desires at play. The scopic pleasure offered must have been one of discovering what is human and familiar in the otherwise alien spaces of microscopic observation. It has even been suggested that these subjects reflect the colonial impulse of the age. Amateur literature on microscopy of the period is filled with reveries to the hidden worlds and exotic adventures the expanded vision microscopy made possible. If, therefore, amateur microscopy domesticated nature by bringing it into the space of the parlor, the projection of human artifacts and accomplishments into otherwise alien territories reads as a metaphoric attempt at domination.

Whatever the content of the image, the primary allure of the microphotograph was the possibility of experiencing a technical marvel. As tiny, perfect copies, microphotographs evince a pleasure akin to that offered by other kinds of miniatures including toys, dioramas, and staged panoramas. Souvenirs and religious effects appropriated this pleasure as a purely magical indulgence, whereas microphotography's other forms invite the viewer to play at being a scientist. Utilizing the microscope, focusing the objective, waiting for something to come into view, and scrutinizing the results, the viewer enacted the scopic logic of the natural sciences without actually submitting themselves to the intellectual rigors of scientific study.

STACY HAND

See also: Photomicrography; Nature; Science; Photographic Jewelry; Tourist Photography; Brewster, Sir David; Dancer, John Benjamin; Shadbolt, George; Sidebotham, Joseph; Lenses: 1. 1830s–1850s; Lenses: 2. 1860s–1880s; and Markets, Photographic.

Further Reading

Benjamin, Marina, "Sliding Scales: Microphotography and the Victorian Obsession with the Miniscule." In *Cultural Babbage: Technology, Time and Invention*, edited by F. Spufford, and J. S. Uglow. London: Faber and Faber, 1996.

Bracegirdle, Brian, *A History of Microtechnique*, Ithaca, N.Y.: Cornell University Press, 1978.

Breidbach, Olaf, Representation of the Microcosm—The Claim

for Objectivity in 19th Century Scientific Microphotography. *Journal of the History of Biology* 35 (2):221–250, 2002.

Carruthers, Ralph Herbert, *Microphotography; an Annotated Bibliography*: New York, 1936.

Gooday, Graeme, "'Nature' in the Laboratory: Domestication and Discipline with the Microscope in Victorian Life Science." *British Journal for the History of Science* 24 (1991):307–341.

Hayhurst, J. D., *The Pigeon Post into Paris, 1870–1871*. Ashford: J. D. Hayhurst, 1970.

Luther, Frederic, "The Earliest Experiments in Microphotography." *Isis* 41 (3/4) (1954) :227–281.

——, *Microfilm: A History, 1839–1900*, Annapolis: National Microfilm Association, 1959.

Marien, Mary Warner, *Photography: A Cultural History*, New York: Harry N. Abrams, 2002.

Markle, Donald E., *Spies and Spymasters of the Civil War*, New York: Hippocrene Books, 1994.

Scott, Jean, *Stanhopes: A Closer View*, Essex: Greenlight Publishing, 2002.

Sidebotham, Joseph, "On Micro-photography." *Photographic Journal* VI, 92 (1859): 91.

Stevens, G.W.W., 1*Microphotography—Photography and Photofabrication at Extreme Resolutions*, London: Chapman and Hall, 1968.

MIETHE, ADOLF (1862–1927)

German photo-physicist and photographic writer

Adolf Miethe, born Adolf Christian Heinrich Emil Miethe in Potsdam on 25 April 1862 to city councillor and chocolate factory owner Albert Miethe and his wife Karoline, studied physics, astronomy and chemistry in Berlin and Göttingen. He had worked as an assistant at Potsdam's astro-physical observatory and in 1887, with the help of Johannes Gaedicke, invented the first widely used magnesium flash powder. After gaining his doctorate in astro-photography, Miethe was employed as a scientific collaborator by several optical firms in Potsdam, Rathenow, and Brunswick, in the latter as a director of the company Voigtländer & sons. In 1899 he was appointed successor to Hermann Wilhelm Vogel in the chair of photo-chemistry, photography and spectral analysis at the Technische Hochschule [Institute for Technology] Charlottenburg, Berlin where he expanded the photo-chemical laboratory and founded an observatory. During his lifetime Miethe undertook several expeditions, amongst others to Egypt and Norway, before he died in Berlin on 5 May 1927. He edited and contributed to several photographic journals, like Das Atelier des Photographen [Photographer's Studio] and Photographische Chronik [Photographic Chronicle] and wrote several treatises for amateur and professional photographers alike. Miethe designed several new microscope and camera lenses, including a telephoto lens, and he was much occupied with enhancements of astronomical

photography, color photography and emulsion sensivity to spectral light.

STEFANIE KLAMM

MIGURSKI, KAROL JOSEF (active 1850s–1870s)

Professional photographer

Josef Migurski, a native of Poland, became interested in photography in 1850s. He owned a photographic studio in Odessa. He was also the author of the first photographic instruction manual in the Russian language, entitled *The Practical Guidance on Photography* where the descriptions of the equipment and formulas of chemical solutions were given. It also included advice on various types of photography, for example studio portraits, architectural, and landscape photography. Migurski popularized photography through this. In 1863 he lectured on the technology of the photographic processes in the Richelieu lyceum in Odessa. In the "Novorossiysk calendar of 1864" Migurski placed an announcement devoted to the photographic institute which he established. There, one could study the theory and practice of photography.

Migurski was the author of the albums *The views of the town Akkerman* (1869) and *The album of the Odessa's port works* (1869). Migurski also extensively photographed Odessa. Apart from creating city views, he also made genre scenes, for example photographs showing building works and diving works in Odessa's port.

Also notable, Migurski won the Great Silver Medal in 1872, at the Polytechnic Exhibition in Moscow. Additionally, he was a military photographer of the Russian troops' General Staff during the Russian-Turkish war of 1877–1878.

ALEXEI LOGINOV

MILITARY PHOTOGRAPHY

Apart from the portrayal of the aftermath of war and limited use on the battlefield, photography was adopted by the military in the nineteenth century to serve the causes of advancing nations of Europe and the United States. The early history of the military's use of the camera is inextricably bound to survey work in domestic and foreign exploits, including various engineering projects such as the construction of bridges and railroads, and the exploration of politically sensitive regions. This essay is not about the photography of war, but the deployment of the medium by army personnel and civilians acting on behalf of political authority or nationalist concerns who understood how photography could function outside the portrayal of conflict. In 1860, Captain Henry

Schaw, Chief Instructor of the Telegraph and Photograph School, offered a ten-point list for photography, including the recognition of borders and landmarks in remote areas, the reproduction and distribution of plans and maps, the documentation of military maneuvers and the apparatus of warfare, the depiction of "remarkable persons and costumes of foreigners, and the general picturing of building, bridges, and other structures" (Howe 2003, 231). Although these endeavors were not always directly connected with warfare, they could scarcely be called neutral in terms of ideological meaning. Even an army's contribution to public works was politically motivated by government authorities concerned with the administration and control of their domains.

Already by the mid-1850s, a close alliance existed between military trained and civilian operators in their mutual concern for applying the medium to documentary enterprises of potentially strategic significance. Roger Fenton's pictures of encampments and ships in harbor in the Crimea of 1855 and Gustave Le Gray's depictions of military exercises at Camps de Châlons of 1857 provide early indications that independent practitioners known for landscape and other genres might work in support of nationalist causes. John McCosh, surgeon in the employ of East India Company's infantry produced landscape and architectural views while engaged in at least two tours of duty, the Second Sikh War (1848–49), and the Second Burmese War (1852). His realization of the significance of the camera for multiple subjects led him to include a section on photography in his Advice to Officers in India, published in 1856. McCosh's conviction of the medium's importance coincided with the flourishing of other efforts on the subcontinent and elsewhere. In addition to McCosh's fellow doctor John Murray, British army officers Captain Thomas Biggs, Captain Linnaeus Tripe, Major Robert Tytler, and his wife Harriet Christina, were enchanted with India's splendid architectural past, and thus contributed to a growing archive that increased throughout the second half of the century. The photographic societies of the three Presidencies of Bengal, Bombay, and Madras in the late 1850s counted in their membership military personnel together with civilian amateurs and commercial practitioners who were also concerned with the preservation of antiquities and peoples of the subcontinent. Photographers like Felice Beato and Lala Deen Dayal attached themselves to military operations, Beato first in the aftermath of the Indian Rebellion of 1857, and Deen Dayal in the 1870s with the British military elite. As a native Indian, Deen Dayal was unique in his ability to straddle "princely India" and Anglo-India by working under the patronage of the wealthy sixth nizam of Hyderabad and of the British Raj, recording palaces and royalty, as well as landscape views, military maneuvers, and artillery.

The example of India underscores the considerable alignment of European military and civil authority in world affairs. Photography has frequently been characterized as an emblem of conquest and territorial appropriation; witness Eugène Durieu's report to the French Photographic Society, "that photography would conquer unknown territories as the victorious armies of France conquered land" (Marien 2002, 86). Major Charles Callwell used the term "small wars" to characterize conflicts which "dog the footsteps of the pioneer of civilization in regions far off" (Ryan 1997, 73). Callwell's observations are not exclusive to war per se, but engage an ideology of "extended empire," which can be perceived as symbolically reinforced by the production of photographs as apparently benign as a landscape or an architectural view. Early photographs of the Himalayas by Deputy Commissioner Philip Henry Edgerton function as illustrations of a remote area that could well figure into the development of a trade route into Central Asia. Though Egerton's one-time journey through Spiti was in no way clandestine, his explorations represent a gathering of intelligence fostered by competition with Russia, as evident in his published photo-illustrated account (1863). The commercial photographer John Burke extensively covered Britain's penetration into Afghanistan from the North-West Province of India during the Second Afghan War (1878–80). Like Egerton's, Burke's pictures more than suggest associations with the "Great Game," the contest of territory between Britain and Russia often covertly fought in the mountainous regions of Afghanistan, India, Tibet, China, and Russia, and made popular by the operations of Rudyard Kipling's fictional character Kim.

The Royal Engineers' school at Chatham began to teach photography in 1856. The Engineers were involved in numerous surveys of strategic military importance around the world. The mission of the Abyssinia Campaign of 1867–68 was to rescue several Europeans held captive by Theodore (Tewodros II), Emperor of Abyssinia. The expedition's leader, General Sir Robert Napier of the Royal Engineers, made sure to document the scene of the army's exploits; the powerful Sir Roderick Murchison of the Royal Geographical Society had sanctioned the entire project in the cause of empire. The Sinai Peninsula, a politically sensitive region that loomed large in the cultural imagination for its biblical associations, gained the attentions of both the British and the French in the latter half of the century. The great rivalry between these two powers, trailing back to Napoleonic France, is seen in the controversy over Egypt and the Sinai region. The Ordnance Survey of the Peninsula of Sinai was launched collaboratively in 1868 by private agency and the War Department, which administered the Royal Engineers. The expedition's objective was to map the area for both scientific and scholarly reasons. The

Engineers' Sergeant James MacDonald took at least 300 pictures of geographical and ethnographic interest. The construction of the Suez Canal was underway during the survey, and it is hard not to imagine MacDonald's record and the survey report of value in Britain's political designs to dominant the seas and global transport (Howe 2003, 237). Activity in the Middle East was not limited to Europeans: Egyptian Colonel Muhammad Sadiq (or Sadic Bey), skilled in photography, explored Arabia around 1880 with the intent to map the vast terrain. Sadiq did not use the camera an official capacity, but photographed places that would not ordinarily welcome western investigation, most notably the holy city of Medina (Madinah).

The Great Surveys of the American West following the Civil War reflect a similar correspondence—even tension—between military and civil patronage and the meaning of photographs. The case of Timothy O'Sullivan's work for three different expeditions following his employment with Mathew Brady and Alexander Gardner during the Civil War is particularly instructive. The War Department in association with the army's Chief of Engineers was a major sponsor of Clarence King's U.S. Geological Exploration of the Fortieth Parallel, for which he hired the experienced O'Sullivan. This was a matter of expediency on King's part in order to gain the support of Washington. His work was an essentially civilian enterprise, albeit with the Union's strategic interests at stake; the government would see the value of King's reports from the vantage point of economic prosperity and potential settlement in along the transcontinental railway. The U.S. Army tended to see itself traditionally in the leadership role of explorations of the western territories. Thus Brigadier General Andrew A Humphreys, the Chief of Engineers who backed George Montague Wheeler's U.S. Geographic Surveys West of the One Hundredth Meridian, looked at the civilian surveys of Powell and Hayden, as "bureaucratic rivals." How this actually plays out in the photography and reports of the Great Surveys reveals a fascination with the desert and arid mountainous regions of the Great Basin, from geological features to artifacts of the vanishing tribes. The displacement of Native Americans must be considered in any consideration of western expansion and enterprises like King's or Wheeler's. Documentation of the current hostilities between the US and the Indian nations was relatively limited in contrast to the preoccupation with their heritage and remains, as seen in O'Sullivan's picturing of the cliff dwellings in the Cañon de Chelle, New Mexico, for the Wheeler survey in 1873. O'Sullivan worked as well for the 1870 season in the Isthmus of Darién (Panama) under Lieutenant-Commander Thomas O'Selfridge of the U.S. Navy. From a military standpoint, mapping and identifying areas through photographic reconnoiter-ing, as in the instance of Panama in preparation for the proposed canal, proved useful for the future security of U.S. interests.

Photographs related to military reconnaissance and exploration or civil operations with military associations contributed to an archive that would assist in ordering a world which, in the previous century, remained only partially comprehended. Set within the context of institutional reports, collections, exhibitions, and popular printed formats such as the stereograph and the wood engraving, photographs were instrumental in serving to engender a geographical identity for regions under industrial development or surveillance. The process of identification and recognition of subjects, repeated through the dissemination of photographic reproductions, played to imaginative conceits of the observer. Documentary photographs could not function outside of the symbolic and the utilitarian basis of their production, for which there were ideological assumptions underlying the original objectives of expeditionary and military enterprises. Such ventures yielding a photographic record circulated in the public domain had a galvanizing role in the "civilizing mission" of the west by reinforcing the power and presence of modern industrial nations throughout the world.

GARY D SAMPSON

See also: Biggs, Colonel Thomas; Burke, John; Durieu, Jean-Louis-Marie-Eugène; Egerton, Philp H.; Fenton, Roger; Le Gray, Gustave; McCosh, John; O'Sullivan, Timothy Henry; Tripe, Linnaeus; Tytler, Harriet and Robert C.; Documentary; Expedition Photography; Landscape; Mountain Photography; Panoramic Photography; Science; Survey Photography; and War Photography.

Further Readings

Egerton, Philip Henry, *Journal of a Photographic Trip through Spiti, to the Frontier of Chinese Thibet, with Photographic Illustrations*, London: Cundall, Downes and Co., 1864.

Frizot, Michel, ed., *A New History of Photography*, Köln: Könemann, 1998.

Howe, Katherine, "Mapping a Sacred Geography: Photographic Surveys by the Royal Engineers in the Holy Land, 1864–68." In *Picturing Place: Photography and the Geographical Imagination*, edited by Schwartz, Joan M., and James R. Ryan, London and New York: I.B. Tauris, 2003.

Kelsey, Robert, "Viewing the Archive: Timothy O'Sullivan's Photographs for the Wheeler Survey, 1871–74." In *Art Bulletin*, v. 85 no. 4 (December 2003): 702–23.

Marien, Mary Warner, *Photography: A Cultural History*, New York: Harry N. Abrams, 2002.

Khan, Omar, *From Kashmir to Kabul: The Photographs of John Burke and William Baker 1860–1900*, Munich: Prestel, and Ahmedabad: Mapin Publishing, 2002.

Pinney, Christopher, and Nicolas Peterson, eds., *Photography's Other Histories*, Durham: Duke University Press, 2003.

Ryan, James R., *Picturing Empire: Photography and the*

Visualization of the British Empire, Chicago: University of Chicago Press, 1997.

Sampson, Gary D. and Lala Deen Dayal, "Between Two Worlds." In Vidya Dehejia, *India Through the Lens: Photography 1840–1911*, 258–291, Washington, D.C.: Smithsonian Institution.

Sandweiss, Martha, *Print the Legend: Photography and the American West*, New Haven and London: Yale University Press, 2002.

Trachtenberg, Alan, *Reading American Photographs: Images as History, Mathew Brady to Walker Evans*, New York: Hill and Wang, 1989.

MIOT, PAUL-EMILE (1827–1900)
French photographer and hydrographer

The French photographer and naval officer Paul-Emile Miot produced some of the earliest known photographs of the east coast of Canada and Newfoundland. His photographs present a remarkable early picture of this coastline and its peoples, particularly because a career naval officer took them during official missions, and without compromising his successful naval career. But more importantly, his use of photography as an aid to the work of the mapmaker is an important application of the medium, and one which is still used extensively today.

Miot was born in Trinidad to a French father and a West Indian mother, and the family returned to Paris while he was still quite young. Intent on a career at sea, he entered the Naval Academy in Paris in 1843, and emerged in 1849 with the rank of sub-Lieutenant.

He first served on the *Sibylle*, being given the command of the merchant ship *Ceres* in 1849, and survived an epidemic of yellow fever which killed two thirds of his crew. From the autumn of 1855, until hostilities ceased in the spring of the following year, he served as an officer with the French naval fleet based at Kamiesch during the Crimean War

There exists in the archives of the Bibliotheque nationale a remarkable series of photographs of the French fleet taken at Kamiesch by Jean-Baptiste-Henri Durand-Brager and Pierre Lassimonne, dating for the period of Miot's service there, and some researchers have suggested, as yet without corroboration, that Miot's interest in photography may date from that time and a possible encounter with those two photographers. He started to experiment with the camera early the following year while on leave from the navy.

It is also suggested by several sources, that during that same commission, Miot, still a sub lieutenant, met Lieutenant (and later Admiral) Georges-Charles Cloué, who would play a pivotal role in the development of his naval career thereafter.

By the following year, 1857, Miot was demonstrating his photographic accomplishments, sailing with Cloué for the first time, and now promoted to full lieutenant.

That voyage, to Newfoundland on board the *Ardent* resulted in his earliest known photographs, which were met with some acclaim back in Paris, and used as the basis for line illustrations in *le Monde Illustré*.

In a letter preserved in Archives nationals in Paris, dated September 27, 1857, Cloué describes the importance of Miot's photography in assisting with their hydrographic and mapping mission.

> One of the officers of the *Ardent*, Lieutenant Miot, took up photography during his last period of leave. He is remarkably successful, Commodore, as you have been able to see for yourself. I have given some thought to utilizing this new science, which, until now, might have appeared to have no more than an artistic value, for our precision work, and I believe that, thanks to the ability and the intelligence of Mr. Miot, I have achieved results that give extremely high hopes for the future.
>
> Theodolite readings taken from the main points of triangulation require a certain experience of drawing to produce the views, which, with the aid of the angles that are included in them, are invaluable in later recreating the contours of the coast and the main features of the terrain.
>
> Henceforth, a few angles taken with the theodolite will suffice, and the readings will be complemented by a photographic view on which the angles need not be calculated until the moment when the map is drawn. I have had Mr. Miot take several of these views, taking care that the focal point of the instrument's lens is in the same position for each of the views, so that the horizontal distances on the print always represent the same number of degrees in the angle.
>
> When taking measurements from the photographic views, with a graduated metal ruler, of the distances that separate the verticals drawn from various readings, I have frequently obtained accuracy to within one minute compared to the angles provided by theodolite readings.

Miot had taken his own camera and equipment on the voyage, although Cloué did arrange for a 'small, suitably-equipped photographic laboratory' to be established for him onboard the *Ardent*. It is clear that Cloué saw this work as a partnership between Miot and himself—photographer and chart maker—admitting to have no photographic knowledge himself, and to be entirely dependant upon Miot's expertise.

Further voyages to Newfoundland saw Miot's photographic productions as more and more closely integrated with the survey itself—but not exclusively so—and by 1860 he and his work had achieved official recognition, with photographic facilities established at the Dépot des cartes et plans. When the *Ardent* got trapped in ice, Miot carried his camera on to the ice-flow, and produced some magnificent studies that rival the best Arctic pictures of the nineteenth century. During stopovers in the French islands of Saint-Pierre-et-Michelon (today

the last remaining fragment of the French Empire) off the coast of Newfoundland, he also became the first person to take photographs of the islands inhabitants and their villages.

Photographs from the Newfoundland expedition were printed for Miot by Furne et Tournier of Paris, and the decision to hand the negatives over to a commercial printing house suggests that they were produced in quite large numbers. Others were used as the basis of engravings for *Le Tour du Monde* over a period of months in 1863, a part-work published intermittently until the mid 1870s.

By 1863 he had his first naval command, and almost four years later completed a tour of duty which had taken him to Mexico and Martinique. The period from 1868 to 1871, now promoted as Admiral Cloué's Chief of Staff, saw him circumnavigate South America, along the way visiting the Marquesas Islands, where he produced accomplished group portraits of the Royal Family of Vahitou.

The deands of a blossoming naval career seem to have limited Miot's time for photography, the majority of surviving images covering the period 1858-1875. By 1881 he had reached the rank of Rear-Admiral, and Vice-Admiral by 1888. By then he was deskbound in Paris, retiring from the navy at the age of sixty-five.

A substantial number of his glass plate negatives survive in the archives of the Ministére de la marine in Vincennes, France.

JOHN HANNAVY

Further Reading

Castelain, Jean-Pierre, and Yves Leroy, *Images de Saint-Pierre-et-Miquelon,* Le Havre: le Volcan, 1990.

O'Reilly, P., *Les Photographes à Tahiti et leurs oeuvres 1842–1962,* Paris: Société des Océanistes, 1969.

MISONNE, LÉONARD (1870–1943)

Known as one of the most important Belgium photographers of his time, Léonard Misonne was born in 1870 in Gilly, Belgium. After being introduced to photography in 1891 during his engineering studies in Louvain, he joined the Photo-Club of the city and decided to give time to arts—painting, music, and photography.

As he became a member of the Association belge de photographie, he took part of his first exhibition in 1896 with pictures of the country and the peasant life in a style he developed until his death in the pictorialist aesthetic. From this time he never gave up exhibitions especially in Paris, New York, London, Germany, and Austria, which gave him international acknowledgement.

He obtained the visual effects and atmosphere thanks to the different processes he used. In a first period, he printed his photographs on carbon however between 1900 and 1910 he used Fresson paper and then oil print he learned from Constant Puyo.

MARION PERCEVAL

MISSION HÉLIOGRAPHIQUE

In 1851 the *Commission des Monuments historiques*, part of the French Ministry of the Interior, sent photographers on five missions to different regions of France to make records of historic monuments which were being restored or were slated for restoration. The buildings in question were primarily examples of medieval ecclesiastical architecture, but Renaissance palaces, Gallo-Roman structures, and some pre-historic stone groupings were included. The Mission héliographique, as the project has come to be called, is one of the first instances of photography conceived and commissioned by a government agency for archival purposes. In 1851 it also constituted one of the largest photographic projects ever undertaken. The photographers involved include several great figures in the history of photography: Henri Le Secq, Edouard Baldus, Hippolyte Bayard, Gustave Le Gray and Auguste Mestral. Le Secq was sent north-east to Champagne, Lorraine and Alsace. Baldus was dispatched to Provence by way of Fontainebleau, Burgundy, and the Dauphiné. Bayard was assigned Normandy. Le Gray and Mestral were directed to the center and south-west, and undertook their missions together: they began in the Loire Valley, circled down into Languedoc, and returned through Auvergne. Each photographer was provided with a list of monuments to record; parts of buildings and even works of art were often specified on the lists.

Le Secq used Le Gray's waxed paper negative process and produced between 150 and 200 negatives, although the commission acquired a set of only 96 negatives and prints. Baldus worked with albumenized paper negatives and made 46 negatives and prints (some of his finished negatives combine multiple spliced views). Le Gray and Mestral used waxed paper negatives and contributed 120 negatives and prints. Bayard employed glass negatives with Niépce de Saint Victor's albumen process. Although Bayard's photographs were discussed in the press, it is unclear whether he ever turned them over to the Commission: only a handful of prints identified as part of his mission now exist. The other photographers' negatives (which number close to 300 with duplicates and panoramas) are housed at the Musée d'Orsay. 165 of the prints survive from the original set, and most of these are divided between the Musée des Monuments français and the Photothèque du Patrimoine in Paris.

There is some evidence that the photographers were selected out of a competition (such a contest is indicated in an 1853 letter written by a student of Baldus).

However all five photographers were members of the newly-founded Société héliographique, and several other members of that Society were government functionaries with some connection to the Commission des Monuments historiques, notably Léon de Laborde, who was a member of both bodies. Thus it appears that the Société héliographique was somehow involved in developing or at least encouraging the photographic missions. But the Society and the Commission had different objectives. The Commission devised the survey to document structures that were slated for government-sponsored restoration, so the buildings chosen were not necessarily the chief monuments of their respective cities. Moreover a number of the photographs, such as "Dolmen de Bagneux près Saumur" by Le Gray and Mestral, seem to reflect the particular enthusiasms of Prosper Mérimée, director of the Commission, more than any institutional imperative. Most of the regions of France are included in the survey, indicating some interest in a representative collection of views. But the Commission acquired only certain views made by the photographers: Le Secq, Le Gray and Mestral all made many more photographs than requested on their trips, but the extra work did not interest the Commission. Much of Le Secq's work has survived; it is comprised almost entirely of building views, and yet the Commission acquired only a portion, for instance, of the 43 photographs he made of Strasbourg Cathedral (his work not purchased by the commission is now housed at the Bibliothèque des Arts décoratifs in Paris). A photographic record for its own sake was outside the Commission's purview. The negatives and prints it acquired were filed in dossiers on the respective buildings they represented. The Commission never published or exhibited the photographs.

Such a photographic archive did not match the interests of the Société héliographique. The group's objectives were indicated as early as March 1851, when *La Lumière* reported that the photographic missions had given impetus to the Society's desire to found a photographic publishing establishment. Evidently the members envisioned printing views from the project for public dispersal. The scope of the Society's hopes for the missions is indicated by Francis Wey's 1853 reference to the projcet in his essay "Comment le soleil est devenu peintre:"

> ...The public is deprived of these prints that everyone would examine and discuss; the photographers are denied the publicity they had hoped for, and our country cannot honor the most beautiful body of work that has been produced to date. We had asked for as much and we had hoped for more.

The photographs were in fact widely discussed in the photographic press, where the distinctive approaches of the photographers were noted. Baldus combined negatives with amazing skill in several views, such as "Palais des Papes et Notre-Dame-des-Doms" taken in Avignon. In this and other images he typically depicted his subject from a distance, with the entire structure placed centrally in the frame, giving it an air of monumentality. Le Secq's heroics were not on the order of combined negatives or monumental views, but in climbing all over and around a building to capture perspectives of rarely-seen details. In views such as "Cathédrale, flèche, angle nord-est" taken at Strasbourg, he combined his rooftop escapades with dynamic off-center compositions that often vivify the sculpted figures. Le Gray and Mestral frequently emphasized the graphic patterning of darks and lights in the picture frame, making imaginative use of the calotype's blank skies. Their compositions give the subjects a sense of grand scale and architectural harmony, as seen in the view "Eglise, ensemble est" taken at the church of Saint-Julien-de-Brioude. Despite these creative prerogatives, the various processes the photographers used all point to a desire for smooth negative surfaces and optimal clarity, an obvious requirement for architectural records. The fact that only Bayard employed glass is not surprising: transport of the negatives was precarious, and Niépce's process was very slow with uneven results. Along with the Mission photographs themselves, Baldus' subsequent production of finely detailed calotype views points to the desire of these photographers to make good architectural documents with the calotype process.

However hidden from view the Mission photographs remained, they were part of a wide impulse to document France's architectural heritage. Baron Taylor's *Voyages Pittoresques* is frequently cited as a lithographic model for the Mission héliographique, but the specific archival requirements fulfilled by the Mission mark its difference from Taylor's Romantic atlas. The use of photography for such a project was untested in 1851, but it was not without precedent. The *Commission des Monuments historiques* had itself ordered six "daguerreotype views" of unspecified subjects from Bayard in 1849. As early as 1843 the architect Felix Duban had hired Bayard to make between 20 and 50 daguerreotypes of the château at Blois for a restoration ordered by the Commission (a handful of these are preserved at the Société française de photographie). Closer to the sentiments of the *Voyages Pittoresques*, Le Secq had privately undertaken a photographic record of Amiens Cathedral in 1850. These endeavors and the Mission itself demonstrated that photography could serve both the public's imaginative relationship to the past and the instrumental needs of architects and committees. Throughout the 1850s photographers continued to record monuments all over France. In 1852 Charles Nègre embarked on a photographic tour of his native Provence, photographing

many of the same monuments Baldus had recorded, with publication of a de luxe album in view. That same year Le Secq began returning to the great Cathedral towns of Chartres, Amiens, Reims, and Strasbourg. His motivations seem personal, but some of his views found their way into the albums of Louis-Desiré Blanquart-Evrard, which were marketed to a broad art-world milieu. Baldus' mission launched his commercial career: he went on to photograph old and new monuments for the government, the railroad companies, and for his own trade in views. His work, and that of Charles Marville a bit later, continued to fill the archives of city and state. But both photographers retained their negatives, a lesson they had perhaps learned from the fate of this first photographic mission.

PETER BARBERIE

See also: Marville, Charles; Blanquart-Evrard, Louis-Désiré; Nègre, Charles; Société française de photographie; Wey, Francis; Niépce de Saint-Victor, Claude Félix Abel; Mestral, Auguste; Le Gray, Gustave; Bayard, Hippolyte; Baldus, Édouard; Société héliographique; and Le Secq, Henri.

Further Reading

Daniel, Malcolm, *The Photography of Edouard Baldus*, New York: The Metropolitan Museum of Art, 1994.
Gautrand, Jean-Claude, *Hippolyte Bayard: naissance de l'image photographique*, Paris: Trois Cailloux, 1986.
Jammes, André and Eugenia Parry Janis, *The Art of French Calotype, with a Critical Dictionary of Photographers, 1845–1870*, Princeton, NJ: Princeton University Press, 1983.
Janis, Eugenia Parry, and Josianne Sartre, *Henri Le Secq, Photographe de 1850 à 1860, Catalogue raisonné de la Collection de la Bibliothèque des Arts Décoratifs, Paris*, Paris: Musée des Arts Décoratifs, 1986.
Janis, Eugenia Parry, *The Photography of Gustave Le Gray*, Chicago: The Art Institute of Chicago and The University of Chicago Press, 1987.
La Mission héliographique, photographies de 1851, Paris: Inspection générale des Musées classés et contrôlés, 1980.
Mondenard, Anne de, *La Mission héliographique: cinq photographes parcourent la France en 1851*, Paris: Éditions du Patrimoine, 2002.
——, "La Mission héliographique: mythe et histoire." In *Études photographiques*, 2, (May 1997) : 60–81.
Un Voyage héliographique à faire, The Mission of 1851: The First Photographic Survey of Historical Monuments in France, Flushing, New York: Godwin-Ternbach Museum at Queens College, 1981.

MOFFAT, JOHN (1819–1894)

One of the most widely reproduced portraits of William Henry Fox Talbot was taken in 1864 by the Edinburgh photographer John Moffat. That same year he gave the first public demonstration in Scotland of photography by the light of burning magnesium wire.

Born in Aberdeen on 26 August 1819, the son of a successful bookbinder, John Moffat moved to Edinburgh with his parents in 1827. Trained as an artist and engraver, he owned his own engraving business in Edinburgh by 1848. As an amateur photographer, examples of his work were shown at the 1851 Great Exhibition in London, and opened his first portrait studio in Edinburgh's Nicholson Square in 1853. In 1857 he opened the first of five studios on Princes Street. The studio occupied premises at 125/126 Princes Street until 1962. Throughout his professional career, Moffat combined his interests in art and photography, operating an art gallery on the first floor of his Princes Street premises, selling oils and watercolours by the leading artists of the day.

He was a leading figure in the Photographic Society of Scotland from its inception in 1856 until it ceased to function in 1873, and in the Edinburgh Photographic Society from 1863 until his death, serving as its President for many years.

Moffat's obituary was carried by the British Journal of Photography.

JOHN HANNAVY

MOIGNO, ABBÉ FRANÇOIS (1804–1884)
French religious teacher, author, nicknamed "the Apostle of Projection"

Born in 1804, Moigno entered the Society of Jesus in 1822, leaving in 1844 to become a high school chaplain. In 1850 he introduced David Brewster to Duboscq, who then constructed Brewster-pattern stereoscopes. Moigno established 'Le Cosmos,' a popular science magazine, in 1852. His visit to the Royal Polytechnic in London in 1854 fueled a lifelong enthusiasm for image projection. Moigno's initial attempts to present lectures illustrated by slide projection were forbidden by the authorities, but he persevered. In 1864 he gave presentations of photographic slides in temporary venues, and after a difficult start, his more permanent Salle de Progrès, set up in Paris in 1872, was a success. Moigno's 1872 book 'L'Art des Projections' was the first French magic lantern manual. His 1882 catalogue of photographic slides—many by professional photographer Armand Billon—comprised over 4,000 items featuring Geography, History, Biology, and other topics. Photography itself was one subject, with microscopic photographs, portraits of Niépce and Daguerre, and photographs of equipment. Moigno's later claim to have originated educational teaching by slide projection was overstated, but he was certainly a major proponent of the method for decades. He died in 1884.

STEPHEN HERBERT

MONPILLARD, FERNAND 1865–1937
French photomicrographer

Fernand Monpillard quickly acquired a reputation as an exceptional photomicrographer. His "Laboratory of Microphotography" was located at 22, Saint-Marcel boulevard in Paris, not far from the national Museum of natural history. He collaborated with many naturalists, biologists, and mineralogists whose articles were often illustrated with his work. At the end of 1870, photography acheived a scientific quality that Monpillard never failed meet. Becoming a member of Société française de photographie (SFP) in 1892, he frequently shared his research on plates with orthochromatic emulsion, which caused the indirect reproduction of colors or trichromatic synthesis. With the development of the histology and microbiology, the microscopic observations required color and Monpillard worked to obtain images that would further the succes of scientific investigations.

If he worked to integrate photomicrography into the experimental protocol, he also contributed to the history of color photography. Auguste and Louis Lumière profited from his research on coloured screens as they used them for their autochrome plates. From 1908 to 1932, during the evening he gave projection shows of his autochrome plates there that were used for scientific and geographical applications at the SFP. Monpillard published his first treatise of photomicrography in 1899 (*Microphotography*, Paris, Gauthier-Villars) according to his technical courses given t the SFP, and then another in 1926 (*Macrophotography and microphotography*, Paris, Gaston Doin and Co). He was also the director of the luxurious review *La Photographie Française* from 1901 to 1905.

CAROLE TROUFLÉAU

MONTFORT, BENITO DE
(active 1850s)
French aristocrat and benefactor

Writing in the journal *The Chemist* in February 1852, in an article entitled 'Photography in France', Roger Fenton described his visit to the Paris home, at 15 Rue de l'Arcade, of Colonel Benito de Montfort, son of Baron de Montfort, and the founder of the Société heliographique, the world's first photographic society. The society's rooms were in de Montfort's house in one of Paris's most desirable and elegant neighborhoods near the Bourse.

> An entire suite of apartments, consisting of four or five rooms, at the top of the house, of course, and opening on to an extensive terrace, with an excellent light, is devoted to the purposes of the society. One room is entirely occupied, walls, drawers and cupboards, with choice specimens of the art, mostly in metal; another is fitted up with a laboratory, one corner of which is an enclosure surrounded with yellow curtains, to exclude the light. In fact there is every requisite facility, both for receiving the amateurs in a suitable locale, and for their trying experimentally, any new development of the science.

Such facilities attested to Montfort's enthusiasm for the new society which had been set up in 1851 as a meeting point for a number of eminent scholars and men of science, who were interested in the new art of photography. Despite Fenton's comment that most of the images he saw were daguerreotypes, the forty founding members included many who were producing work of the highest quality with the several negative/positive processes of the time—including Baron Gros, Baldus, le Secq, Mestral, le Gray, Lerebours and Vicomte Vigier.

Fenton would later use his knowledge of the French organization as one of the triggers for the foundation of the Photographic Society of London in 1853. So, indeed, would Antoine Claudet, now accepted as the probable author of a handwritten proposal for the formation of the London Society, now in the collection of the national media Museum, Bradford. In that document, the proposal that the new society should have its own rooms (in Claudet's premises) describes a layout remarkably similar to the suite of rooms Montfort had made available to the Société heliographique.

Many of Benito de Montfort's ideas for the Société heliographique were far-sighted and inspirational. The organisation would collect exemplary works, would publish an *Album* of the finest paper photography, and would publish a journal—*la Lumière* initially edited by F A Renard, then by the Jesuit Abbé François Moigno and later by Ernest Lacan—in which all the latest advances and ideas were circulated to members, and which was available on subscription to non-members. The editorial offices of *la Lumière* were also in Montfort's house. Interestingly, Abbé Moigno went on to edit *Cosmos*, also founded by Montfort in 1852, initially as a scientific journal, but later with considerable interests in photography as well.

The first *Album* was produced in spring of 1851, the cost of binding it being met by Montfort—described by le Gray as Comte de Montfort—out of his own pocket. While *la Lumière* prospered and continued in regular publication until 1867, the Société heliographique ceased to function after only two years, to be replaced in 1854 by the Société française de photographie, which published its own journal, the *Bulletin*.

Two further albums were produced in 1852 and 1853, and despite the society's rules stating that in the event of it being wound up, the albums were to be given to the Bibliothèque nationale (then the Bibliothèque royale)

and the library being advised of the imminent gift in March 1853, there remains no trace of them.

Montfort served for a time as the Societé heliographique's first President, before being replaced by Baron Gros, and for its entire existence, the society continued to enjoy premises within Montfort's house. Remarkably, little is known of Benito de Montfort private or public life, and of his practical involvement with photography, nothing. However, in his day, as one of French photography's earliest benefactors, he was renowned for his generosity. His importance in the propagation of the understanding of photography was acknowledged by le Gray in the concluding paragraphs of his introduction to his booklet *Plain Directions for Obtaining Photographic Pictures* in 1852 (English language edition Philadelphia: A. Hart, 1853).

JOHN HANNAVY

See also: Baldus, Edouard; Fenton, Roger; le Gray, Gustave; le Secq, Henri; Lacan, Ernest; la Lumière; Mestral, Auguste; Moigno, Abbé François; and Société heliographique.

Further Reading

Jammes, André and Eugenia Parry Janis, *The Art of French Calotype*, Princeton and Guildford: Princeton University Press, 1983.

Kamlish, Marion, "Claudet, Fenton and the Photographic Society", in *History of Photography* Vol. 26, No. 4, 2002, 296–306.

McCauley, Elizabeth Anne, *Industrial Madness, Commercial Photography in Paris 1848–1871*, New Haven, CT and London: Yale University Press, 1994.

MOODIE, GERALDINE (1854–1945)
Canadian photographer

Geraldine Fitzgibbons Moodie was born in Toronto, Canada, on October 31, 1854, to Agnes Dunbar Moodie, an illustrator, and Charles Thomas Fitzgibbon, a lawyer and registrar. In 1870, the family relocated to Ottawa where Geraldine completed her education. She traveled to England in 1877, where she met and married her husband, John Douglas Moodie, who joined the North-West Mounted Police in 1884. The Moodies relocated frequently and lived at every major Mounted Police post in Western Canada, as well as in the Hudson's Bay district of the Eastern Arctic. Geraldine Moodie began to practice photography in the 1890s and she opened her first photographic studio in Battleford in 1895. While much of her photographic activity consisted of customary portrait work, she also photographed the activities of both the Mounted Police and the Native communities that surrounded her. Of particular interest are her photographs of the Inuit people that she encountered in the

Arctic. Her interest in botany also led her to photograph plant life. John Moodie retired from the Mounted Police in 1917 and they settled in Maple Creek, later moving to British Columbia and then to Alberta, where Geraldine Moodie died on October 4, 1945.

ANDREA KORDA

MORAITES, PETROS (c. 1835–1905)

Petros Moraites was born on the island of Tinos in the Aegean Sea. He studied painting in Athens but very soon, fascinated by the new medium, he became involved in photography. In 1859, in collaboration with the Greek photographer Athanasios Kalfas, he opened his first studio located at Ermou Street in Athens. The very same year, the two partners presented photographs at the 1st Olympiad (held in Athens) winning a silver medal for their photographic reproductions of landscapes. In September 1860, the partnership ended and Moraites moved his studio to Aiolou Street. Many important personalities of the Greek society: politicians, intellectuals, ambassadors, actors including members of the royal family, as well as ordinary people, posed before his camera. It is assumed that around 1868, he was appointed photographer to H.M. the King, a title bestowed for the first time on a Greek photographer.

Moraites's depictions have been distinguished for their "precision in execution, purity of line, harmony and perfection, without corrections, of photographic work." He earned many distinctions in various photographic exhibitions in Greece [2nd (1870), 3rd (1875) and 4th (1888) Olympiad held in Athens] and abroad [Weltausstellung 1873 held in Vienna and Exposition Universelle (1878) held in Paris]. After his death, his studio was taken over by his son, Georgios P. Moraites, who was soon afterwards obliged to sell it to Nikolaos Pantzopoulos.

ALIKI TSIRGIALOU

MORAN, JOHN (1831–1903)
American photographer and painter

John Moran, a Philadelphia landscape and cityscape photographer, was born in 1831 in Bolton, England to weavers, Thomas Moran Sr. and Mary Higson Moran. A brother to landscape painters Edward, Peter, and Thomas, an active member of the Photographic Society of Philadelphia, and an early proponent of photography as a fine art, Moran began his career in photography in Philadelphia in 1860. For the next decade, Moran focused on landscape photographs of the region, including notable views of the Wissahickon Valley and Delaware Water Gap in addition to stereographic views of Philadelphia landmarks and estates. In 1865, Moran

delivered his "The Relation of Photography to the Fine Arts" paper to the Photographic Society of Philadelphia for which he later served as the vice-president from 1870 to 1873. In 1870, he sold an album of views of early Philadelphia architecture to the Library Company of Philadelphia. Soon thereafter, Moran acted as official photographer for both T.O. Selfridge's expedition to the Darien Isthmus in Panama (1870–1871) and the United States' observation of the Transit of Venus in Tasmania and South Africa (1874). By the late 1870s, following his display of landscape views at the Centennial Exhibition of 1876, Moran abandoned photography for landscape painting. On February 19, 1903, Moran died of Bright's Disease at the New York City home of his son, Thomas.

ERIKA PIOLA

MORAVIA, CHARLES BARCLAY WOODHAM (c. 1821–1859)

Employed as an executive engineer with the Public Works Department in India in the 1850s, Moravia was given responsibility for the demolition of buildings in Delhi after the Mutiny. All his known photographic work appears to date from around this period, during which he produced an outstanding range of views of Indian architecture around Delhi, which survive in the form of albumen prints from his paper negatives, generally signed 'Ch. Moravia' and dated in the negative. In 1859 Moravia was appointed Principal of the Engineering School at Lahore, but his career was cut short by his death from smallpox at Sialkot, where he was buried on 30 April 1859.

JOHN FALCONER

MORSE, SAMUEL FINLEY BREESE (1791–1871)
American daguerreotypist, artist, and inventor

Morse, the eldest son of Calvinist Congregationalist minister and geographer Jedidah Morse and Elizabeth Anne Breese, was born 27 April 1791 in Charlestown, Massachusetts. Best remembered as the father of the telegraph, Morse was also known by his contemporaries as the father of American photography, an association often overshadowed by his revolutionary invention. A man blessed with a mechanical mind and cursed with financial instability, Morse pursued photography in the 1840s following a thirty-year career as an artist, inventor, author, and publisher. A recipient of a privileged education at the Phillips Academy (Andover, Massachusetts) and Yale College (Class of 1810), Morse trained for a career as an artist at the Royal Academy in London between 1811 and 1815. Through his foreign

study, he developed a nativist ideology that influenced his professional decisions for the rest of his life. Morse would return to America and attempt to create a unified national culture through art and technology.

After Morse returned to the United States, he pursued his artistic career, first through a failed Boston studio and then through itinerant portrait painting. Despite a few prominent commissions in the 1820s, Morse never achieved financial stability. His two colossal paintings, *House of Representatives* (1823) and the *Gallery of the Louvre* (1833), created and exhibited as part of his nativist mission, failed as well. Consequently, Morse sought other outlets to fulfill his intellectual, financial, and professional goals. In 1826, Morse helped to establish and was elected the president of the National Academy of Design in New York. In 1827 he established the periodicals *Journal of Commerce* and *Academics of Art*. In 1832 and 1835, respectively, he was appointed professor of Painting and Sculpture and professor of Literature of the Arts and Design at the University of the City of New York, later New York University. Between 1832 and 1838, with financial and intellectual partners Alfred Vail and Leonard Gail, Morse invented and perfected the telegraph for which he received a patent in 1840. In May 1838, as a Congressional bill to appropriate funds for his invention sat in a political quagmire, Morse traveled to Europe to seek foreign investment.

Following its inception in early 1839, the daguerreotype became the one invention that rivaled the telegraph in prestige. On 5 March 1839, during his time in Paris, Morse met with Louis Daguerre and witnessed "one of the most beautiful discoveries of the age." As a trained artist and inventor who had experimented unsuccessfully with photography in the early 1800s, Morse immediately envisioned the cultural impact of this new type of "drawing." In April 1839, Morse authored one of the first American eyewitness accounts of the daguerreotype. Soon thereafter, he became synonymous with the burgeoning field of American photography when his narrative, first published in his brothers' periodical the *New York Observer*, was republished across the country. A month later, he had Daguerre elected as an honorary member of the National Academy of Design and within days of the arrival of the description of the process to the United States in September 1839, Morse became one of the first Americans to announce success in the creation of a daguerreotype.

His daguerreotype view of the new Unitarian Church in New York City was disclosed in the 28 September 1839 edition of the *Journal of Commerce* and in the ensuing months he continued to experiment with the new process aiming to decrease the exposure time of daguerreotypes by several minutes in order to produce portraits. After engaging Daguerre agent Francois Gouraud as an instructor, Morse began keeping detailed

notebooks from January-February 1840, which are preserved in the collections of the Library of Congress, of his lessons and continued experiments with the medium in a glass enclosure on the roof of his university. Through weekly entries, sketches, and charts of carefully inventoried plates, he described his trial and error methods to properly acidize, clean, and iodize the plates, as well as, most importantly, to master the correct exposure time given available light to produce a clear image. By mid-January, Morse had discharged Gourard, whom he felt provided inadequate, outdated instruction and began to more actively collaborate with university colleague, chemist, and daguerreian, John Draper, who had calculated the proper chemical focal measurement needed for successful exposures. Within weeks, through continual trials of variant exposure times using Draper's focal calculation and with equipment designed by George Prosch, Morse overcame his "imperfect" results and produced a superb plate of City Hall in early February. By the fall, his quest to quickly expose focused portraits was finally fulfilled when he perfected a five-lens system developed by Draper. The system of corrected and concave lens allowed Morse to decrease the focal length and exposure time and still produce a distinct image using indirect sunlight. As a result, Morse reported to Draper in November 1840 that he was able to photograph an indoor portrait within five seconds.

During the same period ,Morse and Gouraud started a long public debate about each other's technical abilities and professional qualifications. Morse emerged from the feud perceived as the competent daguerreotypist while Gouraud was seen as the fraud seeking personal fame and fortune. In 1840 and 1841, his reputation unscathed, Morse made one of the earliest group portraits, a view of the Yale reunion class of 1810, and with Draper opened a commercial portrait studio, advertised as the "Palace of the Sun on Broadway," on the roof of the university. By spring 1841, Draper left the studio and Morse opened a second facility on the roof of his brothers' newspaper building.

As he had with portrait painting, Morse pursued portrait daguerreotypes as a means to support his career as an artist. Unlike many of his colleagues, Morse perceived daguerreotypes as "portions of nature herself" that were to be used in place of artists' sketches. As an ally of the medium, he concluded to the National Academy of Design on 24 April 1840 that the daguerreotype was a catalyst for a "revolution of art" that would elevate the artist and the society that viewed his work. Morse believed that daguerreotypes would lead to his long desired national American culture. Given this reputation, Morse quickly became sought after as a mentor for daguerreotypy and from 1840 to 1841 taught such prominent future photographers as Mathew Brady,

Morse, Samuel F. B. Portrait of a Young Man.
The Metropolitan Museum of Art, Gilman Collection, Purchase, W. Bruce and Delaney H. Lundberg Gift, 2005 (2005.100.8) Image © The Metropolitan Museum of Art.

Anthony Southworth, and Samuel Broadbent. By May 1844, following the successful completion of a telegraph line between Baltimore and Washington, D.C., Morse retired as a professional daguerreotypist.

This prophetic artist, however, maintained an association with the field until the end of his life. Daguerreotype portraits of his second wife and daughter from the late 1840s in the collections of the New York Historical Society suggest that he continued to make daguerreotypes as a pastime. From 1851 to1852, he professionally endorsed photographer Levi H. Hill in his quest to be accredited as the inventor of a color photographic process and he judged photography competitions such as the Anthony Prize in 1853. The mid-1850s saw celebrated photographers Mathew Brady and Marcus A. Root requesting Morse's views about his pioneer role in photography. In 1871, he deposited his first camera with Abraham Bogardus, president of the National Photographic Association, which was later acquired by the Smithsonian Institution. According to a July 1871 *Photographic Times* article, he also donated the "first daguerreotypes produced in this country" to Vassar College, of which he was made a trustee in 1865.

After the U.S. Supreme Court upheld Morse's telegraph patent in 1854, Morse's monetary woes ended. Financially secure from the licensing fees of his cel-

ebrated communication device, Morse spent his later years on his estate, Locust Grove, on the Hudson River. On 2 April 1872, the father of American photography, passed away at his home in New York City.

ERIKA PIOLA

Biography

Samuel Finley Breese Morse was born 27 April 1791 in Charleston, Massachusetts. Educated at Phillips Academy in Andover, Yale College, and the Royal Academy, Morse was an artist, inventor, and daguerreotypist who pursued his various professions with a desire to create a national American culture. He opened a Boston art studio in 1815 and a New York art studio in 1823. In 1818, he married his first wife, Lucretia Walker, with whom he had three children, and in 1848, married his second wife and cousin, Sarah Elizabeth Griswold, with whom he had four children. From 1826 to 1832 he organized and was elected president of the National Academy of Design and became an art professor at the University of the City of New York. In 1840, he opened a daguerreotype studio and was granted a patent for the invention of the telegraph. Between 1836 and 1854, he ran unsuccessfully for the offices of New York Mayor and Congressman. In 1854 the Supreme Court upheld his telegraph patent for which he received several national and international honors. Morse spent his later years in Europe and at his estate Locust Grove. He died 2 April 1872 in New York City.

See also: Bogardus, Abraham; Brady, Mathew, Daguerreotype; Draper, John; Daguerre, Louis-Jacques-Mandé; Hill, Levi H., and Southworth, Albert Sands, and Josiah Johnson Hawes.

Further Reading

Kloss, William, *Samuel F.B. Morse*, New York: H.N. Abrams in association with the National Museum of American Art, 1988.

Larkin, Oliver W. *Samuel F. B. Morse and American Democratic Art*, Boston: Little, Brown and Company, 1954.

Mabee, Carleton, *The American Leonardo: A Life of Samuel F.B. Morse*, Fleischmanns, N.Y.: Purple Mountain Press, 2000.

Morse, Samuel Finley Breese, *Samuel F.B. Morse: His Letters and Journals*, edited and supplemented by his Son Edward Lind Morse, New York: Houghton Mifflin, 1914.

Prime, Samuel Irenaeus, *The Life of Samuel F.B. Morse, LL.D., Inventor of the Electro-Magnetic Telegraph*, New York: D. Appleton and Company, 1875.

Rinhart, Floyd and Marion Rinhart, *The American Daguerreotype*, Athens: The University of Georgia Press, 1981.

Root, Marcus, *The Camera and the Pencil, or the Heliographic Art*, Philadelphia: Lippincott, 1864.

Silverman, Kenneth, *Lightning Man: The Accursed Life of Samuel F.B. Morse*, New York: Alfred A. Knopf, 2003.

Staiti, Paul J., *Samuel F.B. Morse*, Cambridge: Cambridge University Press, 1989.

MOSCIONI, ROMUALDO (1849–1925)
Italian photographer

From Viterbo, south of Rome, Moscioni had a successful photography business during the albumen period at various addresses in Rome from 1868 onwards. He specialised in topographical views, excavations, early Christian archaeology along with art works, including Etruscan, which will continue to provide historical information for generations to come. In 1889 his business moved to the fashionable Via Condotti which demonstrated his success on becoming the "purveyor to the Imperial museums of Berlin, Petersburg and the Art Museum of Copenhagen." He was in competition with similar material from the larger companies, such as Alinari, Anderson, Brogi. His fourth catalogue, published in 1921, listed 24,900 images (26,000 by the time of his death). Between 1868 and 1895 he had amassed 8,600 negatives. At the turn of the century he was still making, 300+ negatives on average per year but between 1903 and 1921 it rose to 700. Fortunately around 26,000 glass plate negatives, much of his life's work, were divided between the archives of the Vatican Museum, the American Academy in Rome, the Ministry of Education, and the Archivo Forografico Comunale in Rome. Thus Moscioni is one of the few photographers of the period whose large output is so fortunately preserved.

ALISTAIR CRAWFORD

MOTION PHOTOGRAPHY: PRECHRONOPHOTOGRAPHY TO CINEMATOGRAPHY

With the application of photography, the free-flowing images of the artist's *camera obscura* were frozen, and it would be several decades before motion could be recorded and reproduced by the new medium. However, moving images produced from a series of pictures preceded the commercial introduction of photography. In 1832 Belgian scientist Joseph Plateau, investigating the phenomena of Faraday's Wheel, devised the phenakistiscope, a cardboard disc with a sequence of drawings that appeared to move when the images, reflected by a mirror, were viewed through slots in the disc. Viennese Professor Simon Stampfer simultaneously developed his similar Stroboscope. These "philosophical toys" were soon being sold as conversation pieces, and led to the daedelum drum-form version, suggested by English mathematician William George Horner, and marketed from the 1860s as the zoetrope.

The application of photography to moving images was inevitable, but slow exposure times before the 1860s/70s meant that photographing sequences of subjects moving in "real time" was an impossibility. Experimenters compiled sequences from series of static

poses, the subject assuming the key positions of the action being represented.

Since stereoscopic photography was the latest advance, experimenters naturally supposed that moving photographs would be stereoscopic. London-based daguerreotypist Antoine Claudet was intrigued by the idea of stereoscopic phenakistiscopes, but limited his experiments to a two-phase stereogram. Essentially a standard stereoview portrait, each image represented the extremes of a simple staged movement; for example a man putting a cigarette to his lips and removing it. In the viewer a revolving shutter obscured and revealed each picture in turn, one to each eye, resulting in a stereo portrait with a limited motion effect. Similar stereograms were later sold in France.

Other inventors actually constructed photo-phenakistiscopes. French optician Louis Jules Duboscq's was called the Bioscope; one version used twelve sets of stereo halves, left/right images placed one above the other. Subjects—the sole surviving example shows a beam engine—were posed in incremental positions representing a sequence of motion, and brought dimensionally to life in the special viewer.

Englishman William Thomas Shaw patented his Stereotrope in 1860. A series of stereocards was mounted in an octagonal case, incorporating an ingenious drum shutter. In the United States in 1861, Coleman Sellers patented several ideas for stereo-motion viewers including his Kinematoscope, a drum-form tabletop stereoviewer holding six sequential stereograms.

The inventor of the stereoscope, Charles Wheatstone, attempted various stereo motion viewing devices between 1849 and 1870. An existing machine has a strip of images showing a soldier presenting arms.

One rather advanced result was successfully achieved in 1864 by Scottish mechanic James Laing. A conventional stereoscopic plate camera was used to photograph a wooden model village, with cotton-wool smoke rising from a cottage chimney, and a revolving windmill. Frustrated by the zoetrope's limited capacity—"this fixity of number ... does not suit the motoroscopic effect"—the pictures for his successful Motoroscope viewer were arranged on a long continuous belt, one of several ideas suggested by experimenter Peter Desvignes some years earlier. Sadly, no images have survived. This stop-motion animation preceded trick filming by thirty years.

Duboscq produced a projecting phenakistiscope c.1853, while Austrian lanternist Ludwig Leopold Döbler toured with a similar device, built by inventor Franz Freiher von Uchatius. In the 1860s lanternists developed the 'wheel of life' slide—a projection phenakistiscope, with silhouette images arranged on small glass discs—for use with an ordinary optical lantern. Another lantern device, Beale's choreutoscope (1866), comprised a sequence of images on a strip of glass, moved intermittently by a pin-and-cam movement similar to the maltese cross later used in motion picture film machines. None of these projection devices made use of photographs, but static photographic images on glass had been projected by magic lantern from around 1850.

Projection of photographic images shown sufficiently fast to give an appearance of life in motion was achieved by Henry Renno Heyl in Philadelphia in 1870. The photographs, including a repeating sequence of a waltzing couple, were posed individually. Not yet a motion picture of a subject in real-time motion, neverthless successful public Phasmatrope performances were given.

As exposure times decreased and 'instantaneous' photography became possible, attempts were made to photograph sequences taken in 'real time,' with the subject actually in movement—with or without the complications of stereoscopy.

In 1876 English political activist Wordsworth Donisthorpe patented the Kinesigraph camera for multiple glass plates. With the announcement of Edison's newly-invented phonograph Donisthorpe suggested using results from the two instruments together, to screen images of a politician speaking, for instance, but the technology was not sufficiently advanced.

In contrast to those who had a vision of reproducing moving scenes by photography, whom we could call proto-cinematographers, there were also experimenters whose main aim was to obtain a series of images showing phases of motion for purposes of analysis. Initially these chronophotographers had little interest in synthesizing such sequences into a moving picture, but later most would attempt some form of motion synthesis.

Eadweard James Muybridge, an accomplished and well-known photographer, was commissioned to photograph a trotting horse to determine whether it had all four feet off the ground at one time. His single photographs were sufficiently clear to confirm that the horse was indeed 'unsupported' during it's trot and gallop. Muybridge extended his experiments in 1878 to include sequences of animals and humans taken with 12 or more cameras, some of which were stereoscopic. Despite using low-sensitivity wet plates, his results were successful and engravings of his horse sequences widely published, proving of great interest to French physiologist Etienne Jules Marey.

Marey had been analysing human, animal and bird movement using mechanical devices attached to the subjects, connected to an instrument that drew traces on a revolving drum. Muybridge's photo sequences were important in confirming results obtained by Marey's traces, and the physiologist asked the photographer to try sequences of birds. Muybridge's success was limited, so Marey devised a photographic gun for shooting twelve photographs on a glass disc. Though small and lacking detail, the images were useful for Marey's research

on flight. Marey continued with chronophotography, devising large single-lens cameras using wheels or discs with images set around the periphery. Individual images often overlapped, enabling a larger number to be recorded. Overlapping was not of consequence for analytical purposes, and Marey was not concerned with producing motion pictures.

The interest in Muybridge's work continued. To 1870s eyes the frozen positions of the horses' limbs had seemed ludicrous. Muybridge placed the sequences in a zoetrope to synthesise the movement, which appeared perfectly natural, confirming the veracity of each component photograph. The zoetrope being limited to a small audience, he devised a projecting phenakistiscope or Zoogyroscope (later Zoopraxiscope), to present sequences in motion on a large screen. The large glass discs featured painted silhouettes based closely on his sequence photographs. The Zoopraxiscope horizontally compressed the shape of each image on projection, so the painted images were elongated to compensate. Some discs featured a composite scene based on several sequences, such as a bull chasing a man, and a few included elements that were pure imagination. Muybridge now bridged both camps: those content to simply analyze a strip of sequential images, and others trying to invent a motion picture process. In the 1880s he lectured in Europe and the USA, projecting slides of his individual photographs alternately with animated silhouette sequences, generating widespread interest in moving pictures. In 1884 Muybridge was contracted to continue his work, at the University of Pennsylvania. His sequences included zoo animals, nude studies of women, and male athletes. Taken on dry plates, they included more detail than his earlier attempts.

Meanwhile in Germany in 1884, Ottomar Anschütz—who had designed shutters for instantaneous photography—started chronophotographic experiments, with 12 and then 24 cameras. His images, taken on fast dry plates, were of high quality. Like Muybridge, Anschütz became interested in animating sequences of athletes and animals. His zoetrope introduced an ingenious arrangement of three rows of slots of different numbers, for viewing strips with differing numbers of images, essential when photographing animals moving at different speeds. Anschütz's other viewing devices included a large wheel with images rear-illuminated by a synchronised electrical flash lamp.

By 1888 Marey was using sensitized paper strips for his photographic analysis. Other inventors, with a vision of cinema, recognised the need for such a flexible medium. Their cameras mosly used some form of intermittent movement, the film being stationary as each frame was exposed. In 1888 Louis Aimée Augustin Le Prince, a Frenchman working in England, was perhaps the first of these visionaries to successfully photograph

sequences on paper 'film': traffic on Leeds bridge, his son playing the melodion, and the family in their garden. The images were transferred to belts of glass slides for projection. Several projector designs failed to produce an exploitable result, and Le Prince got into debt. On a visit to France he disappeared, an apparent suicide.

With the availability of rollfilm, Donisthorpe restarted his motion picture experiments, involving draughtsman William Carr Crofts. Their 1889 camera, designed for paper rolls but later using celluloid, featured a unique optical compensation mechanism. Although taken at a slow rate, a camera test of London's Trafalgar Square seemed promising, but unperforated film made projection difficult and success eluded them.

Portrait photographer William Friese-Greene became interested in motion photography through his friend James Arthur Roebuck Rudge, whose magic lantern shows had included simple devices for animated movement. Friese-Greene demonstrated one of Rudge's lanterns, and then developed with engineer Mortimer Evans a camera for taking sequences on a flexible support—initially paper, later celluloid. At around five pictures per second the results were limited, and there was no successful method of motion projection. Their 1889 patent included pins on the drive roller to improve traction. A film of King's Road Chelsea (c. 5 fps) can today be manipulated into a proto-motion picture. In 1893 Friese-Greene patented a stereoscopic sequence camera devised by Frederick Varley, but again the framerate was slow.

These film pioneers found successful projection elusive, but the earlier chronophotographers had by the early '90s developed techniques for commercial exploitation in peepshow machines, using very short photo sequences in motion. An arcade version of Anschütz's "Electrical Wonder" machine, with images set around the periphery of a disc, was produced in quantity, and appeared at the Columbian Exposition, Chicago, in 1893.

Marey's assistant, gymnastics specialist Georges Demenÿ, supervised the production of chrono sequences featuring soldiers and athletes. Demenÿ designed the 'beater' camera movement, later adopted by many other film pioneers. Exposed on strips of unperforated celluloid negative, the individual positives were mounted around a Phonoscope disc, for direct viewing or small-scale projection. One intended use was (mute) talking portraits, to help the deaf to lip-read. Demenÿ's interest in the commercialisation of motion pictures eventually caused a split with his scientist mentor. (Marey had briefly attempted film projection, but his 1892 projector was not successful.) Initially a commercial failure, with the advent of perforated film Demenÿ's beater mechanism would be successfully exploited in early cinematograph equipment by the Gaumont Company.

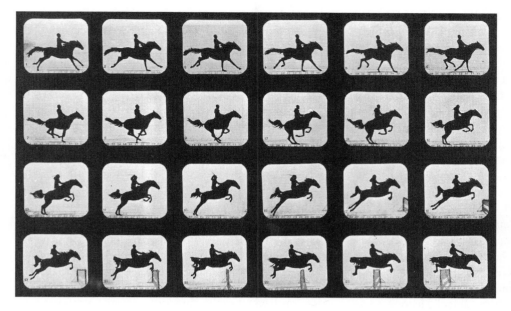

Muybridge, Eadweard. Horse Jumping.
The Metropolitan Museum of Art, Harris Brisbane Dick Fund, 1946 (46.160.51) Image © The Metropolitan Museum of Art.

Edison's latest wonder was also to have appeared at the Chicago World's Fair, but wasn't ready in time. From 1888 his assistant William Kennedy-Laurie Dickson had been in charge of developing what became the kinetoscope, the first commercial motion picture film machine. Initial experiments used tiny images set in a spiral on a sheet of celluloid wrapped around a glass cylinder, and viewed through a microscope. Soon Dickson adapted the medium recently adopted by Marey; long strips of celluloid—but Dickson added perforations to register the pictures on strips measuring 1¾ inches (approximately 35mm) in width—the industry standard still used today. The unwieldy electric Kinetograph camera was fixed in a tarpaper-covered studio with opening roof, the building movable to follow the sun. Film production started at the Orange, New Jersey, Black Maria studio in 1893.

Projected moving images of some duration were shown by artist-inventor Emile Reynaud in Paris from October 1892. In 1877 Reynaud had invented the praxinoscope—a spinning-drum toy incorporating a ring of mirrors to reflect the sequential color drawings—followed by a toy-theatre version, and a domestic projection arrangement. His large-screen development of the praxinosope projector became known as the Théâtre Optique. His *Pantomimes Lumineuses* initially used drawings painted on transparent squares mounted on a perforated horizontal belt, and manipulated to-and-fro to produce presentations of 15 minutes with typically 500 pictures. These animated cartoon figures, including Pierrot and Columbine, were superimposed onto a lantern-slide background. The show continued for years.

In 1892 Muybridge, recognising the limitations of his outdated, painted silhouette discs, decided to produce a new series with photographically-reproduced outline drawings coloured-in by hand, to show at the World's Fair. The result was even further removed from his chronophotographs.

Photographic motion picture films as a commercial reality arrived in April 1894, when Edison's kinetoscope was finally launched in a New York "kinetoscope parlour" (penny arcade). Subjects included strongman Eugen Sandow, skirt dancer Annabelle, and boxing enactments. The kinetoscope peepshow was technically simple. A long loop of film, rear-illuminated by an electric bulb, travelled continuously (not intermittently), each frame viewed for a brief fraction of a second through a slot in a revolving shutter; a glimpse short enough to avoid blurring of the image. Kinetoscopes were shipped around the world, and many inventors were inspired to develop screen projection of photographic motion picture films. Soon, many would succeed where Le Prince, Friese-Greene, and Donisthorpe had failed.

By the time Muybridge had completed his final Zoopraxiscope colored discs the Edison kinetoscope had been launched, and in Germany Anschütz had devised a twin-disc Electrotachyscope machine for projecting, with an intermittent mechanism, true photographic sequences. Anschütz arranged public showings from November 1894 featuring similar subjects to the kinetoscope, including a barbershop scene and card players; but of very limited duration. Photographic moving pictures had reached the big screen, and Muybridge abandoned his Zoopraxiscope.

Other chronophotographers also attempted to project their picture sequences. German teacher Ernst Kohlrausch worked independently on the analysis of gymnastic movement. Turning to chronophotography in 1889, he arranged 24 cameras on a wheel. A more sophisticated camera arrangement followed in 1892. Kohlrausch also studied the gait of mentally ill patients. Keen to develop a machine to show the results in movement

while lecturing, his 1892 multi-slide projector featured revolving lenses, but was not successful. A later projector used a rotating light source, but the introduction of cinematography precluded further development.

During 1895 news spread that in France the Lumière brothers, active workers in their father's photographic plate factory, had succeeded in producing the Cinématographe—for taking, printing, and projecting 35mm perforated film by means of a pin-shuttle movement. From February they demonstrated the result, including the one-minute subject *Workers Leaving the Factory*, to photographic and scientific societies.

English engineer Robert Paul was making Kinetoscope copies, but needed a cinematographer to produce the films. Birt Acres, manager of a photographic materials company, had long been interested in the idea of motion pictures, producing glass-plate chronophotographs of cloud formations, and was experimenting with a 35mm motion picture film camera. He took a new mechanism design to Paul, who built it. A successful test in February 1895 led to the production of England's first films, including the *Oxford and Cambridge Boat Race*. Acres departed to Germany in June to film the opening of the Kiel Canal under the sponsorship of the Stollwerk chocolate and vending machine company, and the Pau/Acres partnership dissolved in acrimony.

With his 1894 picture play *Miss Jerry* and others, American lecturer Alexander Black gave many performances of photographic dissolving-scene slide narratives, the "slow movie," just before the public's first view of projected films.

The first film screenings to a paying audience were those of the Eidoloscope, in New York City. Kinetoscope licensees Otway and Gray Latham produced a camera for 2-inch film, and shot an extended boxing match. The projector worked on the kinetoscope principle, with continuously moving film. To prevent a blurred image the shutter aperture was extremely narrow, limiting the size of the projected image. Nevertheless, public performances were given from May, 1895.

In September-October, at the Cotton States Exposition in Atlanta, Georgia, inventors Thomas Armat and Charles Francis Jenkins used their 35mm Phantascope projector to give screenings of kinetoscope films.

By summer 1895 German lanternist Max Skladanowsky had developed a projector using two loops of 54mm film, with double optical and lighting systems, projecting frames alternately from each band. (His first films were taken on an 1892 chronophotographic roll film camera, designed with his brother Emile). With a picture always on the screen there was no blackout period, significantly reducing flicker. The machine was used to project six-second, repeating sequences—subjects included *The Boxing Kangaroo*—at the Berlin Wintergarten theatre from 1st November, and in Hamburg

on 21 December. A week later the Lumières opened public shows at the Grand Café in Paris, with such films as *Baby's Breakfast*.

Back in England, Acres demonstrated screen projection in January 1896, and Paul likewise the following month. In the USA, Jenkins and Armat argued and split up, and Armat sold the projector design to the Edison camp. When high-profile shows commenced in New York in April 1896, the machine appeared as the Edison Vitascope.

Dickson had left Edison in 1895, and after briefly assisting the Lathams joined Elias Koopman, Herman Casler and Harry Marvin in an association soon to become American Mutoscope and Biograph (with associated overseas companies). Intending to produce a peepshow to rival the Edison kinetoscope, they soon realised that their hand-cranked mutoscope had a limited future, and devised a projector. The 68mm film negative was perforated in the camera to provide a reference to register the images on the positive. The projector used a gripper-roller to pull down the unperforated print. The huge electric camera was cumbersome but the image was of high resolution, and the large-format Biograph would be used in a limited number of prestigious venues for some years before the company adopted 35mm. Their flip-photo mutoscope appeared in amusement arcades from 1896, persisting as a nostalgic novelty for decades.

As the first film pioneers struggled to project photographic motion pictures onto screens, others continued to use sequence photography for chronophotographic analysis: C.V. Boys with rifle bullets and bubbles, A.M. Worthington the shape of liquid splashes. The introduction of cinematography around the world from 1896 had little effect on chronophotography for analytical purposes, which continued apace, in turn making use of the technical developments of the commercial medium, especially the use of 35mm perforated celluloid; in 1900 Marey constructed a 35mm film version of his chonophotographic gun.

In Paris, from 1896 Reynaud adapted photographic motion pictures for his Théâtre Optique, but in 1900 his show was closed.

In the twentieth century, the high-speed motion picture insect and balistics photography of Marey's successor Lucien Bull and colleagues would provide the transition from chronophotography to scientific cinematography; and from the flickering images of Edison's peepshow would grow a worldwide motion picture industry, communication-entertainment medium, and art form.

STEPHEN HERBERT

See also: Acres, Brit; Anschütz, Ottomar; Brewster, Sir David; Bull, Lucien George; Casler, Herman;

Chronophotography; Dickson, William Kennedy-Laurie, Donisthorpe, Wordsworth, Duboscq, Louis Jules, Friese-Greene, William; Edison, Thomas Alva; , Instantaneous Photography; Kodak; Le Prince, Augustin; Lumière, Auguste and Louis; Marey, Etienne Jules; Muybridge, Eadweard James; Philosophical Instruments; and Rudge, John Arthur Roebuck.

Further Reading

Braun, Marta, *Picturing Time. The Work of Etienne-Jules Marey (1830–1904)*, Chicago: University of Chicago Press, 1992.

Coe, Brian, *The History of Movie Photography*, Westfield, NJ: Eastview Editions, 1981.

Fusslin, Georg, *Optisches Spielzeug oder wie die Bilder laufen lernen* [*Optical toys or how Pictures learnt to move*], Stuttgart: Verlag Fusslin, 1993.

Hecht, Hermann, *Pre-Cinema History, An Encyclopaedia and Annotated Bibliography of the Moving Image Before 1896*, London: Bowker-Saur / British Film Institute, 1993.

Herbert, Stephen (Editor), *Eadweard Muybridge. The Kingston Museum Bequest*, Hastings: The Projection Box/Kingston Museum and Art Gallery, 2004.

Herbert, Stephen (ed.), *A History of Pre-Cinema* (3 vols.), London: Routledge, 2000.

Herbert, Stephen, and McKernan, Luke (eds.), *Who's Who of Victorian Cinema, a worldwide survey*, London: British Film Institute, 1996.

Hendricks, Gordon, *Eadweard Muybridge. The Father of the Motion Picture*, Mineola, NY: Dover, 2001

James Laing, "On the Motoroscope," *Proceedings of the Royal Scottish Society of Arts*, 1864.

Mannoni, Laurent, "Archaeology of cinema/pre-cinema."I In *Encyclopedia of Early Cinema*, edited by Richard Abel, London and New York: Routledge, 2005.

Mannoni, Laurent (trans. Crangle, Richard), *The Great Art of Light and Shadow. Archaeology of the Cinema*, Exeter: Exeter University Press, 2000.

Musser, Charles, *The Emergence of Cinema: The American Screen to 1907*, Berkeley, Los Angeles, London: University of California Press, 1990.

Rossell, Deac, *Living Pictures. The Origins of the Movies*, Albany, NY: State University of New York Press, 1994.

MOULIN, FÉLIX-JACQUES-ANTOINE (1802–c. 1875)
French photographer

One of the most prominent Parisian photographers of the 1850s, Félix-Jacques-Antoine Moulin worked in many genres, utilizing a great variety of techniques. Sometimes controversial, Moulin aroused a wide range of critical opinion during his years of greatest activity. Today he is best known for his production in certain categories of subject matter, notably the female nude and orientalist figure studies; other aspects of his oeuvre that were admired in his day, particularly his staged genre scenes, are now less familiar.

Born in 1802, Moulin may have come from an artisan background and lacked the art-academy training of some other important early photographers. The circumstances of his training as a photographer are unknown. By the end of the 1840s he was active as a daguerreotypist with a studio at 31 bis, faubourg Montmartre in Paris. Moulin's first documented photographs are academy or nude studies of female models, nominally for use by artists. The fine Two Standing Nudes in the Metropolitan Museum of Art, New York belongs to a series of daguerreotypes depicting carefully lighted models in natural, relaxed poses before plain backdrops. Several of the models are adolescents, their ages carefully noted in inscriptions of the back of the cases. Several closely related daguerreotypes now in Vienna (Höhere Graphische Bundes-Lehr- und Versuchanstalt) bear the inscribed dates 1849 or 1850.

Moulin apparently also essayed less innocent studies that led him into legal difficulties. On July 23, 1851 he was tried by the Cour d'assises de la Seine, together with an optician/dealer, Jules Malacrida, and Mme. veuve René, a maker of daguerreotypes. According to a contemporary acount, the police "...seized at their homes a great number of subjects so obscene that to state even the titles given to them in the judgment would be a violation of public morality; and the reading of this document had to take place behind closed doors, along with the rest of the proceedings" (Annalesde l'imprimerie, no. 6, 1851). Moulin was sentenced to a month in prison and a fine of 100 francs, penalties considerably milder than those meted out to his co-defendants. Since the offending images have disappeared, it is not possible to determine why they were found so objectionable. Serge Nazarieff has attempted to identify a large number of anonymous erotic or pornographic daguerreotypes and salt prints, mainly stereoscopic, as works by Moulin. Of these, the most plausible attribution is an image of a clothed youth embracing a nearly nude girl against the artificial backdrop of a hayfield, a setting also used in a number of female nudes attributed to Moulin; this tableau vivant has some similarities to Moulin's later stagings of more conventional genre subjects.

After this setback Moulin was able to reinvent himself as a more respectable practitioner, opening a new entrance to the same studio through 23, rue Richer. He continued to produce "academies" or female nudes, but from 1853 onward took the precaution of placing prints of these images on legal deposit at the Bibliothèque Impérial, Paris. The young women, often well-known models, in these images adopt seductive poses and are accompanied by such boudoir props as mirrors, jewelry, and draperies, as they are in contemporary photographs by Auguste Belloc, Ambroise Richebourg and others. Usually executed as salt prints, the images are somewhat larger and more atmospheric than Moulin's

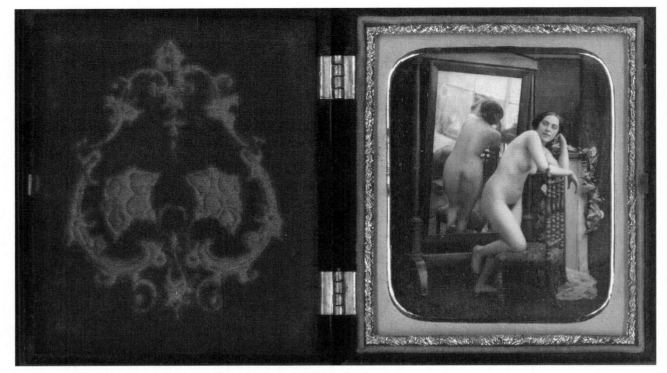

Moulin, Felix Jacques. Female Nude standing with back to full-length mirror.
The J. Paul Getty Museum, Los Angeles © The J. Paul Getty Museum.

daguerreotypes. In addition, Moulin offered for sale portraits, genre subjects, and pictures of scenic views and monuments. Technically innovative, he worked with Louis-Amédée Mante to produce prints on artificial ivory and marketed steroscopes and English collodion. With the help of his wife and daughter he also printed negatives by other photographers, acquiring the rights to Roger Fenton's images of the Crimean War.

During the early 1850s Moulin began to show his work in photographic exhibitions, not only in Paris but internationally in London, Amsterdam and Brussels. His work was discussed in such journals as the *Revue photographique, Bulletin de la Société française de photographie, Le Propagateur,* and *La Lumière,* in which he was mentioned some thirty times between 1852 and 1866. Critics like Ernest Lacan praised Moulin's industry and in particular the artistry of his genre subjects. With titles such as The Spinner, The Fisherwoman, The Drinkers, or Painters at Work, these vignettes of everyday life were actually staged in the studio or outdoors before moveable sets. Moulin also stubbornly continued to exhibit his female nudes, including many among 56 works he showed during the Exposition Universelle in Paris in 1855. The critic Paul Perier, however, claimed to find them vulgar and repetitive, while Moulin's first biographer, the Abbé Moigno, though praising Moulin's hard work and technical competence, suspected the photographer of not being truly contrite about his earlier indiscretions.

In 1856 Moulin traveled to Algeria, armed with a letter of introduction from the Minister of War and accompanied by 1,100 kilograms of baggage. He spent eighteen months traveling and photographing local officials, genre scenes (again often staged on sets), views, and monuments. *La Lumière* published extensive excerpts from his letters from Algeria, written in a colorful, assured style. Moulin's Algerian work again shows his strength in genre subjects, though the views are less effective. Some of these works were engraved and published in 1858 in L'Illustration. Around 1859 Moulin published more than three hundred as albumen prints in albums in several formats, variously entitled *L'Algérie photographiée* or *Souvenirs de l'Algérie.*

Moulin recorded government-sponsored festivities in Cherbourg in 1858 and continued to show his photographs in major exhibitions, but he gradually ceased making original work. In 1862 Moulin advertised the availability of his studio on the occasion of his retirement, though as late as 1866 he submitted work for inclusion in the Exposition Universelle of 1867. Still living in 1875, Moulin does not seem to have remained active as a photographer. To date the diversity of his work in subject matter and technique has perhaps discouraged monographic study or exhibition; most recent research on Moulin has appeared in the catalogues of thematic exhibitions. In recent years, however, Moulin's Algerian work has been shown in one-artist exhibitions in Arles and Algiers.

DONALD ROSENTHAL

See also: Africa, North; Genre; Nudes; Orientalism; and Stereoscopy.

Further Reading

Aubénas, Sylvie, *L'Art du nu au XIXe siècle: le photographe et son modèle*, Paris: Hazan/Bibliothèque nationale de France, 1997.

Bajac, Quentin, and Dominique Planchon-de Font-Réaulx, *Le daguerreotype français. Un objet photographique*, Paris: Musée d'Orsay, 2003.

Bibliothèque Nationale de France, *Galerie de photographie, Des photographes pour l'empereur: Les albums de Napoléon III*, Paris, 2004.

Lacan, Ernest, *Esquisses photographiques*, Paris: Grassert, 1856.

Marbot, Bernard, *After Daguerre: Masterworks of French Photography (1848–1900) from the Bibliothèque Nationale*, New York: Metropolitan Museum of Art, 1980.

Moigno, François, "Biographie: M. Moulin," *Revue photographique*, December 5, 1855.

Moulin, Félix-Jacques-Antoine, *L'Algérie photographiée*, Publication Nationale, Paris: Moulin, c. 1859.

Nazarieff, Serge, "Félix-Jacques-Antoine Moulin." In *Early Erotic Photography*, edited by Nazarieff, Cologne: Benedict Taschen, 1993.

Rouillé, André, "Le document photographique en question," *L'Ethnographie*, spring 1991

Rouillé, André, and Bernard Marbot, *Le Corps et son image: Photographies du dix-neuvième siècle*, Paris: Contrejour, 1986

Van Monckhoven, D., "La photographie en Algérie," *La Lumière*, March 22, June 21, and June 28, 1856.

MOUNTAIN PHOTOGRAPHY

Mountain photography encompasses both mountain systems as landscape forms and the mountain summit as a photographic platform for recreational and scientific purposes. Both types of photography embodied similar technical obstacles. For the purpose of this article, the definition of a mountain will be that offered by the National Geographic Society: any landform with an elevation of more than 1,000 feet (300 metres) above the surrounding land and a pointed summit; the former distinguishes a hill from a mountain while the latter separates a mountain from a plateau. Most of the significant challenges to photography as a science occurred in mountain ranges at altitudes where photographic chemistry and optics become near to impossible due to climatic conditions (freezing temperatures or zero visibility factors). Because of the Euro-American dominance in the field of world exploration, examples of mountain photography are mainly drawn from European and North American sources.

The European Romantic arts movement of the late 18th and early 19th centuries helped set the stage for mountain photography as an art form. Artists themselves, once photographic technology improved enough by the 1880s, also used photographs as an *aide-mémoire* in two ways: in place of and as a complement to field sketches, or more directly as the visual source for their art. Prior to the widespread introduction of halftone printing at the start of the 20th century, photographs were reproduced through a variety of photomechanical processes, not all of which were equally successful at accurately rendering the tonal and other visual qualities of a photograph.

Apart from purchasing original photo prints, including stereograph views and glass lantern slides, of mountain scenes, those interested in acquiring such images could buy view albums or books in which were photomechanical reproductions of mountain photographs. The three most accurate methods of reproduction prior to the adoption of halftone printing were the photogravure, the collotype and the Woodburytype. European and British publishers dominated this market in the 19th century. Among the more prominent of these firms were the Alinari brothers (Fratelli Alinari), Adolfe Braun, George Washington Wilson, and James Valentine.

The three mountain systems which resulted in the earliest notable achievements in mountain photography and large numbers of photographs are the European Alps, the Asian Himalayas and the North American Rocky Mountains. To a lesser extent other mountain ranges in North America, South America, Russia, Asia, Africa, Australia, and New Zealand also attracted photographers.

The daguerreotype process was first used to photograph both the Rocky Mountains and the Alps. The United States Army Corps of Topographical Engineers surveyor and explorer John C. Frémont was the first to bring a daguerreotype kit into the Rocky Mountains between June and October 1842 on his initial foray into the Western United States. He was completely unsuccessful at his efforts to photograph mountain scenery in Wyoming that August. A second expedition in 1843–1844 by Frémont to the Rocky Mountains also included a daguerreotype kit, but no written record survives of its use. Frémont's third expedition in 1845 included an artist, Edward M. Kern, but no daguerreotype equipment. Due to his political activities in California between 1846 and 1848, Frémont ended up resigning from the U.S. Army. He led two further, privately financed expeditions through the Western U.S. with a goal of surveying a route for a transcontinental railroad. On the last of these, in 1853–1854, he hired New York City artist and daguerreotypist Solomon N. Carvalho (1815–1897). A second photographer who used the calotype process, Mr. Bomar, was also hired, but his services were later dispensed with. Despite having no outdoors photographic experience, Carvalho appears not to have hindered the expedition with his photography. According to Palmquist and Kailbourn (2000), it took him up to two hours to produce each view, with most of that time required for removing and repacking his equipment.

In a letter to the editor of the *Photographic and Fine-Art Journal* (v. 8, 1855, 124), Carvalho provided some details of his experiences:

> I succeeded beyond my utmost expectation in producing good results and effects by the Daguerreotype process, on the summits of the highest peaks of the Rocky Mountains with the thermometer at times from 20 degrees to 30 degrees below zero, often standing to my waist in snow, buffing, coating, and mercurializing plates in the open air. In nearly every instance Barometrical, and Thermometrical observations were obtained at the same moment, with the picture. … I had considerable trouble with iodine, which under ordinary circumstances requires 80 degrees Fht. before it will part with its fumes. I had to use artificial heat in every instance; I found it necessary to make up in quantity for the loss of temperature. I generally employed Anthony's anhydrous sensitive [iodine], and my boxes during a continuous use of five months only required replenishing four times, notwithstanding they were opened every time I made a picture, to arrange it smoothly at the bottom. The coating boxes were made expressly for my use on the Expedition by E. Anthony, Esq., and I cheerfully recommend the use of similar ones for like purposes. (Quoted from Taft, 1964, 264–65)

Carvalho's autobiography also summarized the difficulties he faced in the Rocky Mountains. At one point Frémont himself accompanied Carvalho on a three-hour climb to a mountain peak and took meteorological observations while Carvalho produced a panorama of the landscape below (Carvalho 1859, 82). Other primary problems facing mountain photographers of any era were atmospheric haze or hazardous weather conditions. During the dry season forest fires caused by lightning strikes also reduced or destroyed visibility. Although some of Carvalho's daguerreotypes were sent back East and copied by Matthew B. Brady's studio and Carvalho himself ended up an invalid for a while in Salt Lake City, the original daguerreotype plates and apparently Brady's copy prints and negatives were lost.

A similar fate to Carvalho's work also befell that of John Mix Stanley (1814–1872), a well known painter of Indian portraits, an artist on a U.S. Army exploring expedition, and a commercial daguerreotypist. He accompanied a railroad survey led by Isaac I. Stevens through the northern Rocky Mountains to Olympia, Washington, from the spring to the fall of 1853. He appears to have concentrated, given his past interest in documenting the Native American population, in taking portraits rather than attempting landscape views. Stanley's daguerreotypes from this trip are believed to have been destroyed, along with his more valuable Indian Gallery collection of his art, in a 1865 fire at the Smithsonian Institution.

The first large-scale private attempt to commercially photograph an overland route from the East to California in order to lure settlers west was undertaken by the California daguerreotypist John W. Jones in 1851. He travelled from California to Independence, Missouri. Jones also solicited daguerreotypes from other photographers in the surrounding territories. He is reported to have produced 1,500 daguerreotypes on his journey, but no trace of these photographs is known to exist (Palmquist and Kailbourn 2000, 333). Some of these photographs are supposed to have depicted the Sierra Nevada Mountains. A painted panorama based on these daguerreotypes, *Great Pantoscope of California, the Rocky Mountains, Salt Lake City, Nebraska & Kansas*, was opened in 1852 in Boston and circulated for two years in the eastern United States.

Beginning in the early 1850s, wet-collodion negative photographers produced much more dramatic results of mountain scenes than could be achieved with the daguerreotype process. In the western United States, numerous exploring expeditions and adventurous photographers acting alone in the 1860s and 1870s generated substantial numbers of Rocky Mountain views. The California side of the Sierra Nevada Mountains in which Yosemite National Park is situated also saw significant photographic activity, including mammoth-plate views. The most prominent mountain photographers in the United States of this period were Carleton E. Watkins, Timothy H. O'Sullivan, Eadweard J. Muybridge, Andrew J. Russell, and William H. Jackson. Jackson's photograph "Mountain of the Holy Cross" taken in August 1873 while a member of F.V. Hayden's geological survey party, is considered the most important mountain photograph in 19th century America. The construction and completion of the transcontinental railroad in the United States offered some photographers such as Frank J. Haynes unprecedented opportunities for national exposure, not only for his railroad photography, but also as the official photographer of Yellowstone National Park in Wyoming.

Lesser known photographs of the Canadian Rocky Mountains were taken by anonymous Royal Engineers photographers accompanying the North American Boundary Commission surveys of 1858–1862 and 1872–1875. As happened in the United States during route planning for the transcontinental railroads, survey parties looking for suitable routes through the Rocky Mountains and other mountain ranges of British Columbia included photographers. The two most notable photographers who accompanied these geological and geographical surveys were Benjamin Baltzly (1871), an employee of the William Notman & Sons firm of Montreal, Quebec, and Charles G. Horetzky (1871–1879). The construction of the Canadian Pacific Railway through the Rocky Mountains was documented by several photographers, including Richard Maynard and William McFarlane Notman and land surveyors employed by the Canadian government. The Surveyor

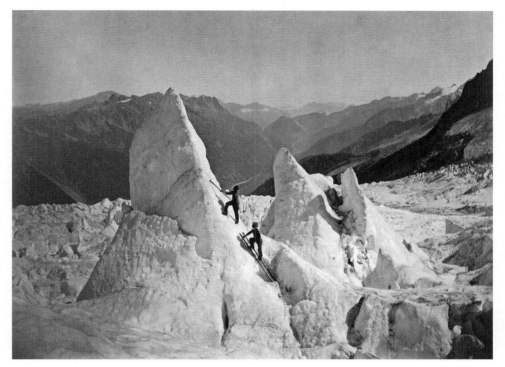

Charnaux, Florentin.
Pyramide de Glace sous les
Grands Mulets.
*The J. Paul Getty Museum,
Los Angeles © The J. Paul
Getty Museum.*

General of Canada, Edouard Deville (1849–1924), is recognized as being the first to use photogrammetry (photographic surveying) on a large scale with dry-plate cameras within the Rocky Mountains beginning in 1887. As a result of the success of his method, Canadian members of the International Boundary Commission of 1892 surveying the mountainous boundary between Alaska and Canada quickly produced visual data from mountaintops which their American counterparts were unable to equal. As happened with the U.S. railroads, the Canadian Pacific Railway encouraged commercial photographers with free passes and sometimes even a special railway car equipped with a darkroom. The company also established its own photographic public-ity department whose first photographer was Alexander Henderson. The CPR also imported Swiss mountain guides to the Rocky Mountains. Mountaineering and amateur photographer families such as the Vaux fam-ily of Philadelphia sometimes hired these or Canadian guides on their annual expeditions to the Canadian Rockies.

Because recreational mountain climbing developed within the European Alps, the first mountaineering pho-tographs were taken there shortly after the daguerreo-type process was announced, but possibly not before the American explorer Frémont's abortive attempts in 1842. A German photographer Friederich von Martens who lived in Paris was appointed to take photographs on a French government expedition to the Alps in 1844. The British art critic John Ruskin claimed to have da-guerreotyped the Matterhorn in 1849. Frederick Crawley is credited with the 1854 daguerreotype "Mont-Blanc,

Chamonix" (Frizot, 1998, 55). In the early 1860s the French Bisson Brothers produced spectacular mountain-eering photographs on Mount Blanc. Some other signifi-cant Alpine photographers who were also mountaineers were William F. Donkin (Great Britain), Vittorio Sella (Italy), and Joseph Tairraz (and descendants, France). The French photographer and publisher Adolphe Braun also produced beautiful Alpine photographs during the 1860s. The first detailed photographic survey of the Alps was started in 1859 by Aimé Civiale and published in France in 1882 (*Les Alpes au point de vue de la géog-raphie physique et de la géologie*).

Photographic documentation of recreational moun-taineering was encouraged by the formation of climbing clubs beginning in the mid-1850s. Photography was used as an educational aid to assist aspiring mountain climb-ers in understanding the hazards and physical rigours. English Lake District mountaineers and photographer brothers George and Ashley Abraham documented their rock and mountain climbing activities beginning in the 1890s and encouraged others in this emerging sport. Due to the cumbersome nature of early photographic equip-ment, however, amateur photography by mountaineers did not produce significant numbers of photographs until after the late 1880s and the introduction of the Kodak roll film camera system.

The Himalayas in Asia, being the highest mountains in the world, attracted many European photographers. None were as initially successful, however, as Samuel Bourne, the first photographer to attempt photography at altitudes thought to be impossible to photograph in. Based in India, he made three trips to document the

Himalayas between 1863 and 1866. Bourne published accounts of his adventures in the *British Journal of Photography*. Like Carvalho before him in the Rocky Mountains, but at much higher altitudes, Bourne described the effects of the cold and the weather on his efforts to photograph at over 15,000 feet elevation in the Taree Pass:

> … while at this elevation I was anxious, if possible, to try a picture; but to attempt it required all the courage and resolution I was possessed of. In the first place, having no water I had to make a fire on the glacier and melt some snow. In the next place, the hands of my assistants were so benumbed with cold that they could render me no service in erecting the tent, and my own were nearly as bad. These obstacles having at length been overcome, on going to fix the camera I was greatly disappointed after much trouble to find that the sky had become obscured, and that a snow storm was fast approaching. Shivering through my whole frame and almost frozen to the ice, I stood waiting to see if it would blow over. It did so in about fifteen minutes, but not in the direction I wanted to take a view; but as there was no probability that waiting longer would better my condition, I placed the camera and proceeded to coat a plate. I thought the collodion would never set. I kept the plate at least five minutes before immersing in the bath, and even that was hardly long enough. Exposed fifteen seconds (size 12 × 10), and found it was somewhat overdone; but my hands were so devoid of feeling that I could not attempt another. I managed to get through all the operations, and the finished negative—though rather weak, and not so good a picture as it would have been if the snow storm had not prevented my taking the view as intended—is still presentable, and I keep it as a memento of the circumstances under which it was taken, and as being, so far as I am aware, a photograph taken at the greatest altitude ever yet attempted. (Bourne, "Ten Weeks with the Camera in the Himalaya," *British Journal of Photography*, February 15, 1864, quoted in Ollman, 1983, 10)

According to Scharf (1976, 91), the highest altitude at which Bourne photographed was 18,600 feet at Manirung Pass. Fabian and Adam (1981, 180) report that until 1880 this was the highest point at which a photograph was taken. The 1880 high-altitude photography was accomplished with the dry-plate process by British climber Edward Whymper during one of his ascents of the inactive volcano Chimborazo (20,703 feet) in Ecuador. Similar problems as faced Bourne in the Himalayas also challenged the Scottish Astronomer Royal and scientific photographer Charles Piazzi Smyth during 1856 expedition to Tenerife, Canary Islands, where he set up a telescope on the volanic peak of Mount Guajara at the 10,700 feet elevation and photographed his activities with a wet-collodion stereo camera. He wrote in his book, *Teneriffe, an Astronomer's Experiment* (1858), which included 20 mounted stereographs,

"In taking pictures of the several volcanic phenomena, our camera and photographic tent had been blow over more than once. … [but] other unlooked-for accidents would often occur, amongst the most frequent of which, was the opening of cracks in camera-box, or plate-boards, in consequence of the desert-like dryness of the air" (Smyth, *Teneriffe*, 152, in Schaaf, "Piazzi Smyth at Teneriffe: Part 1, 296–97) Other vexatious problems that hindered Smyth's photography included heat from the sun and sulphur fumes.

The last great mountain photographs of the 19th century were taken during the Klondike Gold Rush by dedicated photographers such as E.A. Hegg, Frank La Roche, and Asahel Curtis (Edward S. Curtis' younger brother). They endured the same hardships as the gold seekers with whom they travelled. Hegg's classic "Packers Ascending Summit of Chilkoot Pass" (1898) captures the chill air as an endless line of mostly men makes their way to top of the 3,739 feet high pass dividing Alaska from British Columbia. Another nearby trail through the White Pass (2,885 feet) formed the route for a railway built between 1898 and 1900 and still operating as a tourist attraction. Harry C. Barley was the official photographer for the railway. Edward S. Curtis was himself also recognized for his 1890s mountaineering photographs in Washington State, which led to his appointment as the official photographers for the 1899 Harriman Alaska Expedition.

DAVID MATTISON

See also: Alinari, Fratelli; Braun, Adolphe; Bridges, George Wilson; Valentine, James and Sons; Daguerreotype; Brady, Matthew B.; Wet Collodion Negative; Watkins, Carleton Eugene; O'Sullivan, Timothy Henry; Jackson, William Henry; Russell, Andrew Joseph; Muybridge, Eadweard James; Haynes, Frank Jay; Royal Engineers; Notman, William & Sons; Maynard, Richard and Hannah; Henderson, Alexander; Friederich Martens; Ruskin, John; Bisson, Louis-Auguste and Auguste-Rosalie; Sella, Vittorio; Civiale, Aimé; Bourne, Samuel; Kodak; Roll Film; and Curtis, Edward Sheriff.

Further Reading

American Memory, Library of Congress, "Taking the Long View: Panoramic Photographs, 1851–1991," http://memory.loc.gov/ammem/pnhtml/pnhome.html.

Bensen, Jon, *Souvenirs from High Places*, Seattle: The Mountaineers, 1998.

Birrell, Andrew, *Benjamin Baltzly: Photographs & Journal of an Expedition Through British Columbia, 1871*, Toronto: Coach House Press, 1978.

Birrell, Andrew, "Survey Photography in British Columbia, 1858–1900," in *BC Studies*, no. 52 (1981–82), 39–60.

Buckland, Gail, *Reality Recorded: Early Documentary Photography*, Greenwich: New York Graphic Society, 1974.

Carvalho, S.N., *Incidents of Travel and Adventure in the Far West*,

New York: Derby & Jackson, 1857. Digital facsimile of the 1859 edition available at "Making of America" (http://moa.umdl.umich.edu).

Cavell, Edward, *Legacy in Ice: The Vaux Family and the Canadian Alps*, Banff: Whyte Foundation, 1983.

"Central Pacific Railroad Photographic History Museum," http://www.stereographs.com/Museum/index.html.

Eder, Josef Maria, *History of Photography*, translated by Edward Epstean, New York: Dover Publications, 1978, originally published: New York: Columbia University Press, 1945.

Fabian, Rainer, and Adam, Hans-Christian, *Masters of Early Travel Photography*, New York: Vendome Press, 1983. Translation of: *Frühe Reihen mit der Kamera*, 1981.

Frizot, Michel, *A New History of Photography*, English language ed., Köln: Könemann Verlagsgesellschaft, 1998.

George Eastman House, "Still Photograph Archive, Charles Piazzi Smyth—Teneriffe," (http://www.geh.org/fm/stm/htmlsrc4/teneriffe_sum00001.html.

Gernsheim, Helmut, *The Rise of Photography, 1850–1880: The Age of Collodion*, London: Thames and Hudson, 1988.

Gidley, Mick, "Edward S. Curtis Goes to the Mountain" in *Pacific Northwest Quarterly*, 75, no. 4 (October 1984): 164–170.

Goetzmann, William H., *Exploration and Empire: The Explorer and the Scientist in the Winning of the American West*, New York: W.W. Norton & Co., 1978.

Hales, Peter B., *William Henry Jackson and the Transformation of the American Landscape*, Philadelphia: Temple University Press, 1988.

Haworth-Booth, Mark, ed., *The Golden Age of British Photography, 1839–1900*, Millerton: Aperture, 1984.

Horetzky, Charles, *Canada on the Pacific: Being an Account of a Journey from Edmonton to the Pacific...*, Montreal: Dawson Bros., 1874. Digital facsimile available at "Early Canadiana Online," http://www.canadiana.org.

Horetzky, Charles, *Views in the Cascade Mountains, British Columbia: On Coast Exploration of 1874*, S.l.: s.n., 1874. Digital facsimile available at "Early Canadiana Online," http://www.canadiana.org.

Jackson, Christopher E., *With Lens and Brush: Images of the Western Canadian Landscape, 1845–1890*, Calgary: Glenbow Museum, 1989.

Jackson, William Henry, *Time Exposure: The Autobiography of William Henry Jackson*, Albuquerque: University of New Mexico Press, 1986, originally published: New York: Van Rees Press, 1940.

Naef, Weston J., and Wood, James N., *Era of Exploration: The Rise of Lanscape Photography in the American West, 1860–1885*, Buffalo: Albright-Knox Art Gallery; New York: Metropolitan Museum of Art, 1975.

Ollman, Arthur, *Samuel Bourne: Images of India*, Carmel: The Friends of Photography, 1983.

Palmquist, Peter E., and Kailbourn, Thomas R., *Pioneer Photographers of the Far West: A Biographical Dictionary, 1840–1865*, Stanford: Stanford University Press, 2000.

Rinhart, Floyd, and Rinhart, Marion, *The American Daguerreotype*, Athens: University of Georgia Press, 1981.

Rosenblum, Naomi, *A World History of Photography*, New York: Abbeville Press, 1984.

Salkeld, Audrey (ed.), *World Mountaineering*, Vancouver: Raincoast Books, 1998.

Sandweiss, Martha A., *Print the Legend: Photography and the American West*, New Haven: Yale University Press, 2002.

Schaaf, Larry, "Piazzi Smyth at Tenerife: Part 1, The Expedition and the Resulting Book," in *History of Photography* 4, no. 4 (October 1980): 289–307.

Schaaf, Larry, "Piazzi Smyth at Tenerife: Part 2, Photography and the Disciples of Constable and Harding," in *History of Photography* 5, no. 1 (January 1981): 27–50.

Scharf, Aaron, *Pioneers of Photography: An Album of Pictures and Words*, New York: Harry N. Abrams, Inc., 1976.

Silversides, Brock V., *Waiting for the Light: Early Mountain Photography in British Columbia and Alberta, 1865–1939*. Saskatoon: Fifth House Publishers, 1995.

Taft, Robert, *Photography and the American Scene: A Social History, 1839–1889*, New York: Dover Publications, 1964, originally published: New York: Macmillan Co., 1938.

"Time Exposure: The On-Line Bibliography Of Web-Based Information About William Henry Jackson," http://www.fit.edu/InfoTechSys/resources/cogsei/whjte.html.

University of Washington Libraries, "Guide to the Souvenir of the Harriman Alaska Expedition Photograph Album Collection May-August 1899," http://www.lib.washington.edu/specialcoll/findaids/docs/photosgraphics/HarrimanAlaskaPHColl333.xml.

University of Washington Libraries, Digital Collections, "Harriman Alaska Expedition of 1899," http://content.lib.washington.edu//harrimanweb.

MOUNTING, MATTING, FRAMING, PASSE-PARTOUT, PRESENTATION

Photographs in their mounted and decorative formats often reveal how the photographs fit into a given culture. For the researcher however, the type of frame and style of its decoration define with relative accuracy the date of its making, the social and historical reference of the photo itself, the wealth of the owners of the photographs and their personal, emotional relationship to the person photographed.

The framing of photographs, daguerreotypes, and talbotypes basically served a two-fold purpose in the 19th century. Frames mainly existed to protect the picture from environmental damage, and to decorate the picture it contained. Both simple and ornate decorations established additional roles and possible implications of the frame, such as ornamental details like a larger border and various colours. These details produced the illusion of an extended space beyond the photograph and thus enhanced the effect of the picture. The aesthetic purpose of the frame was successfully fulfilled when harmony was achieved between the picture and its frame. The frame, passe-partout, and installation of the photograph changed throughout time and this was characteristic of and often determined by social groups as well as the technique, materials used, and implementation of the photograph itself.

Out of the pictures that were "written by light" or created using image producing chemicals through the use of various techniques, direct-positive and positive pictures, not the negatives, were only available for mounting or framing. The purpose of photographing played a part in whether the photo was framed or not, and if so, what kind of frame was chosen. More often

than not, artistic and family pictures, and those for private use were framed, while applied photographs for illustrated reports, and scientific purposes mostly remained without a frame unless they were later used for the formerly stated reason.

The expertise of the photographer be it professional, hobbyist or private, was not as significant as the reason or the genre of photographs in determining what would be framed. Amateur, dilettante works, landscape or event photographs were usually rarely placed in ornamental and expensive frames, and on the contrary, that was typical of portraits in the 19th century.

Photographs were thought to be similar to drawings and paintings, and in general, thought to be the more artistic product of the genre of representation, of everyday life. It was especially true if the appearance of photographs were similar to that of a drawing or painting because then the same functions were fulfilled. Early products of positive procedures, like the talbotype positives, Calotype Prints, Talbotype Prints, Salted Paper Prints or the Salted Paper Prints were produced until the 1860s, and so were Plain Paper Prints, which were used to make photographs look like large-sized coloured landscapes. Portrait photographs were meant to look as if they were painted over canvasses to strongly resemble aquarelles or temperas, and to appear passe-partouted or in traditional frames in elegant homes or at exhibitions.

Daguerreotypes were put into expertly crafted, glazed picture-frames varying in thickness mainly in order to protect them and prevent them from being damaged (Karlovits 1973, 33). Another method of protection was to place them into wooden, or from 1854 on, plastic cases called the Union case, which were lined with pressed pigskin, or more seldom with cowhide, or with paper and could be locked with embellished silver snaps. Such cases were manufactured by craftsmen and bookbinders or specialists, according to the Commercial Directory of Birmingham. For instance it is said that John Smith made thermoplastic cases in England from 1859.

The carefully designed cases were decorated with embossed motives. Manufacturers produced millions of cases; therefore the possibilities of different decorations are very vast. The lids of the wooden cases bore the popular decorative motives of plant ornaments. These traditional motives were usually replicated from the cases of miniature paintings and silhouette pictures. Many times the same cases were used for containing daguerreotypes and William Shew, for instance, made such cases in Boston.

Other types of decoration could also be seen on plastic cases to the degree that about 800 patterns can be found today. Between the prefigured earlier forms used for similar functions, replications of prayer book covers or church windows, as well as adaptations of classic paintings can also be found. The themes of the motives vary from religious scenes from the life of the Saint Family to historic Columbus stepping on the land of America to even other popular figures like Cupid, musicians, children, chess players, and fire fighters. Additionally, the art or style in which these cases were made helps historians date the making of the cases; for example, patriotic motives only appeared following the American Civil War.

The inside of the case-lids were protected by embossed velvet, while daguerreotypes themselves were protected by decoratively tailored distance pieces like passe-partout made of copper or other material, cover glasses, airtight adhesive tape at the seal, and by carbon from behind. It was not until 1850 that the thin, flexible, gilded brass framing appeared, which held the picture, the passe-partout and the glass together.

The extension of the passe-partout placed above the daguerreotypes was extremely diverse. The shape of the passé-partout served as an indicator in identifying the time period in which they were manufactured as square forms with cut off corners and oval or arched forms were typical of the 1840s, while four-, eight-, nine- or multi-angled arched forms were used until the 1850s. In the decade that followed, the whole surface, primarily the line of the extension, was decorated. The decoration consisted of thinner or thicker lines and circles that closely fit together, thus creating the visual effect of gems or strings of pearls. The surface of the passe-partout could be plain, with no decoration in order to emphasise the picture as much as possible, or it could be richly decorated and consequently the "frame" would give the "picture" the optical illusion of spatiality.

In the 1850s daguerreotypes were relatively costly to make, therefore, they were seldom produced and mainly owned by the wealthy. Their exterior was made to suit the taste of the customers. Portraits functioned as a status symbol through the act of self-representation, and as such, these images depicted mostly people of the higher classes who were usually "framed" in most decadent ways.

Ambrotypes or Collodion Positives on Glass (1851–1885) were placed in cases similar to daguerreotypes. They were used so frequently because photograph dealers and photographers wanted to make use of their leftover stocks after daguerreotypes went out of fashion. Interestingly enough, owners of daguerreotypes often replaced the pictures with new ones in instances where they became damaged or if another person became more important to them, which indicated that installations were valuable articles and why they were inherited throughout generations.

In the decades that followed, multiple photographs became common as more inexpensive media was used. The wealthy favoured the unique, masterly elaborate,

Harrison and Hill. Group Portrait of an Unidentified Family.
The J. Paul Getty Museum, Los Angeles © The J. Paul Getty Museum.

and expensive photographs. These specific forms of installation were miniature Colloido-Chloride, Print-ing-Out Process, Ivorytype. Photographs on Ivory, and Eburneum Print photographs were concealed and embedded into jewellery or pendants, rings, bracelets, brooches, pins, and badges. Crystoleum, Crystalotype, Chromo-Crystal portraits were fitted into brooches, lids of pocket-watches, and other ornamental pieces of jewellery as well. In such cases, the photograph was not "intended for the public" as much as it was intended for "personal" use, which is apparent not only by the size of the photograph, but also by its location and the occasions for which it was worn. The material on which the pho-tograph lay was usually some precious metal or ivory, but the photograph held the real and symbolic value, which also expressed the personal emotional attachment between the person depicted and the person wearing the picture. One too could include Stamp Portraits (1855) in this group. Although their medium was paper and not noble metal or other valuable material, letter-paper, visit cards, brochures, keepsake albums often had value for the owners of these objects.

As more painters and dexterous craftsmen became involved in photography, unique, high-quality artworks were created with a combination of photographic and painting techniques, for example, collages by Victor Hugo like the Collage de Hauteville House, Guernesey, 1855 or Souvenir de Marine Terrace, 1855. The former picture—having the inscription "Jersey is composed of mysterious colours and details, and is reminiscent of the form of a monstrance. In the focal point of the artwork, a larger photograph taken of the cliff of the exile, can be seen surrounded by other photographs. Decorative, painted architectonic "frames" of the photographs were placed around the original image and though it were a "settings of precious stones." The colours in the picture of ultramarine, gold, and black, and the themes, which were void of the elements of everyday life, impressed upon the viewer a spiritual meaning. As a new mem-ber of the Künstler Sänger Verein, an amazing tableau created in 1858, served a similar function. The central element of this composition was an artfully planned text, decorated with graphical elements like illuminated initials. The text was surrounded by 12 ambrotypes, which appeared as ornaments of the frame as if they were "precious stones." This effect was enhanced by the frame and its gilded surface.

Family trees and tableaux of boards, which were made in the last decades of the 19th century, were made for exact purposes in predetermined forms by specialists. The genealogy of the Habsburg family, for instance, was completed in 1864. It basically used graphic elements

like heraldic symbols and traditional place-filling motives in a style typical of the era and applied illustrative elements of printed materials. However, unlike the formerly common family trees, photographs of half-length, three-quarter and full portraits of the family members appeared above the inscriptions of their names.

The second half of the 19th century photography aimed at conquering other spheres of everyday life. In 1854 photographers became interested in placing photographs on china and marble. Ceramic Photographs and Porcelain Photographs were placed on the sides and bottoms of coffee and tea sets, flowerpots, jugs, plates, fruit-dishes, bonbonnières, ashtrays, jewel-cases, vases, cups, decanters, pendants, brooches, pipe-heads, desk-sets, and. The spatial form itself and its presentation coupled with the photographs, and subsequently painted ornamental motives, created the specially shaped artistic mounting and the essence of custom work.

Additionally, mourning family members placed photographs on gravestones for quite some time. The primary function and purpose of photographs was realised here. The medium, which bore the photograph, was itself the installation and at the same time the material and place of use, being the last resting-place of the ancestor, all coalesced to capture the exact and most basic reason for photography. It was in this way that the photograph retained the image of the deceased person "to the end of times" and displayed it for all to see.

In the 1860's and 1870's visit cards, portraits of cabinet pictures, and also newspaper clips and other pictures were made with Albumen Print, Alboidin—Protalbin Paper, Matt Albumin—Albumat Paper, Solio Printing-out Paper, Ferroprussiate, Sepia Paper processes, and other different technologies and were placed in expensive and decorative photo albums of all sizes. These albums had wooden covers bound in elegant cordovan-leather, calfskin, or velvet decorated with embossment, intaglio printing with gilded metal inlays, or hand-painted or -embroidered flowers. These objects were important pieces of furnishing for drawing rooms. Their compilation and exhibition was a fashionable occupation of aristocratic women and studying them was a popular social activity.

At the end of the 1870's, photographs became parts of the interior decoration in decorative frames. They were placed on pianos or chests of drawers. The frames were still works of art, and their material, and elaborate design generally matched the culture, like that of Victorian England. These frames were made of ivory, solid glass with gilded or engraved edges, they were carved and/or engraved, painted wood, gilded or had silvered metals or nickel, and had plush velvet stamped with embroidered flower decorations, and complicated or even simple ornaments. Also "quasi" forms of frames were produced, like easels, doghouses, horseshoes,

hearts pierced by an arrow, etc., but by this time, the Oxford-form already had a simple design.

Besides the prevailing modern style frames, picture mountings of former eras, generations, and periods of history remained in use not only because of their own values, but mainly because of the sentiments relating to the images, as was the case of portraits, which served as a visual historical image of a person that a particluar family wanted to respect. If a member of the family passed on, often his/her's image played an organic part in the furnishings of the home.

In the last decades of the 19th century, a procedure was developed which used a new solution, technology, and materials. The golden age of Opalotype was developed in the 1890's. Mainly landscape photographs were made for tourists in important places they wanted to remember. These photographs were applied into souvenirs, desk sets, porcelain trinkets, and into objects later worn as jewellery.

Due to the invention of quick photographs, more inexpensive materials, technological processes, more and more middle to lower class people could afford to buy photographs. Consequently, the usage of photographs in terms of materials, technologies, and decoration changed as did the formerly established norms of what photographs looked like in terms of tastes and style.

Less spectacular but more durable, were cheap pannotypes which were seldom installed, but in the case that they were, it contained a modest passe-partout, glass and a wooden frame. Penny photographs, ferrotypes were seldom placed under glass and were mainly not installed. Their more respected variations were accompanied by paper passe-partout, which were framed with gilded prints and edge ornaments, similarly to religious lithographs.

A special camera with more lenses, was developed for this purpose and very small Ferrotypes (1.5×2.2 cm in size), otherwise know as "gems" were made in America. They were applied into different types of jewellery like brooches, pins, pendants, or onto simple white cards, and into special, small-sized albums. One or two of these gems could be placed onto one page of an album ("Cambridge" Album, 1867), and later, even more appeared a page where one could see 3, 4, 5, or 6 at a time (Remick and Rice, Massachusetts). In the oval cut out around the picture an embossed ornament could be arranged, like a simple geometric or flower pattern with colouring. Albums with rich miniature decorations were also made for American aristocracy, while the family albums of the middle class had no decoration at all. The fashion of decorative, coloured cards and albums reached Europe and Australia from America as well. Europeans were familiar with many English, American and Australian photograph albums on which tintypes were built into visit cards. Similarly, in Europe, the edges of

the Ferrotype plates made in photograph booths of the slot automate named "Bosco automat" (Conrad Bernitt, Hamburg, 1895; Budapest, 1896) were folded up around the picture, and the inscriptions came on them such as "Millennial souvenir 1896 Budapest."

Demanding customers could enrich their collections with artworks made with more and more modern technologies, and the qualities of the pictures demanded spectacular installations. Matte Collodion Printing-Out Paper, Platinotype, Platinum print, Palladiotype, Palladium Print, Palladio Paper, Starkepapier were photographs rich in shades of tones with artful effects. The products of noble procedures—like Pigment Print, Carbon Print, Gum Print, Papyrographie, Oil, or Oil Transfer—were painting-like artistic photographs, therefore they were put in passe-partout much larger than the original picture, which was of course in accordance with the fashion of the era, and they received specially formed secessionist wooden frames.

In the last third of the 19th century the majority of photographic products were made by studios. At the same time, however, the cover or back of the photographs served as an excellent advertising surface for the photographer to list his name, site of operation, awards and prices of the studio's products. The typography on the back and at the edges followed the characteristic styles of other applied graphical products which entailed richly decorated firm logos, and medals awarded at exhibitions set into heraldic patterns and were displayed as such. Printed documents serving official and social purposes like letter headings, menu cards, invitations, ball-programmes, memorial certificates, advertisements, programmes, and boxes of photographic raw materials were all made in a manner following the similar eclectic tastes. Graphics and illustrated papers, multiplied by the ease of printing, flooded the main stream by the end of the century, and photographs were no exception.

Sometimes for personal use, pressed flowers were placed around the photograph in the corners of the passe-partout and it was thus framed. Print-clips, mostly of coloured flowers, were purchased in shops and often replaced real flowers, but some photographers copied or enlarged the photographs on designed cartons for unique designs.

The passe-partouts of enlarged photographs were mainly decorated by traditional ornaments, usually with one or more thin or thick line on the edge, while other printed materials like devotional pictures often had decorations in the corners. Embossed edges—gilded or not—were also common.

Three tendencies prevailed in the history of framing and installation of photographs. Formerly used and applied forms of high art and popular culture were inherited, which directly inspired methods of framing pictures through the use of various technologies throughout various eras, including the placement of picture so that it appeared in a mirror. Unique forms were developed particularly for the products of photography and were contigent upon the norms of the different time periods, which adapted to changing technologies. Specialists in serial production and standard forms often produced these forms. A great number of individual variations were also characteristic of framing and installing photographs however, and were conceived as the unique image creating process. These objects were not, or were only partial works of specialists. They were common in the second half of the 19th century, and were characteristic of the increasing number of photographs which were made to order, and for private use. Even if the photographs were placed in purchased prefabricated frames or ones ordered from specialists, often the one giving the present or the user added their own modifications to the frame, passe-partout, or even to the photograph itself.

The wooden frame was often modified with skin, velvet or other textile covering which was typically embroidered or covered with other various decorations. The passe-partout usually had real pressed flowers or later, flowers cut from prints or drawn flowers or leaves placed on it. The photograph itself often had a dedication or message on it. The most archaic variation is the rhyming portrait welcoming letter, which was well known by villagers of eastern towns and villages of the Carpathian Basin. The sender of photographs like these commonly wrote quasi-folklore poems on the photograph or its back, with the idea that the photograph acted on behalf of the person which served to welcome new members of the family, cite complaints, or to ask for accommodations. Photographs were created for individual use, and were most often portraits, group photographs, and sometimes photographs of a landscape or a building. These photographs adapted to the functions of decoration and to the idea of the object. In one or more places, and in different ways and forms, the photograph expressed personal contact. Different means of installation and framing of the photograph primarily fulfilled this function. The individual's tastes, skills, education, and the social status of the photographer automatically reflected this.

KLÁRA FOGARASI

See also: Calotype and Talbotype; Daguerreotypes; Wet Collodion Positive Processes; Collodion; Printing-Out Processes; Tableaux; Carte-de-Visite; Cabinet Cards; and Tintype (Ferrotype, Melainotype).

Further Reading

Ehlich, Werner, *Bild und Rahmen im Altertum*—Die Geschichte des Bilderrahmes, 1954.

En collaboration avec le soleil Victor Hugo photographies de l'exil, Heilbrun, Francoise, Molinari, Danielle, Paris 1998.

Falke, Jacob, *Rahmen*, Wien, 1892.

Kincses Károly, *Hogyan (ne) bánjunk (el) régi fényképeinkkel?* Magyar Fotográfiai Múzeum, 2000.

Marcel Safier, "The Gem & Carte de Visite Tintype," http://members.ozemail.com.au/~msafier/photographs/tintypes.htm.

"Photographs George Eastman House Rochester," in *Photography's Public and Private Lives*, 312–313, Ny, Taschen Köln, London, 1999.

Pieske, Christa, *Bilder für jedermann: Wandbilddrucke 1840–1940.* Berlin: Staatliche Museen Preussischer Kulturbesitz; München: Keyser 1988.

Recht, Camille, *Die Alte Photographie*, Paris und Leipzig, 1931. (Sammlung P. Nadar, Paris: Lazerges (H.) und Dallemagne—Portrat, 1864.)

Roeper, Adalbert, *Bilder-und Spiegel-rahmen,* Leipzig: Baumgartner's Buchhandlung, 1897.

Schiffer, Herbert F., *The Mirror Book—English, American & European*, Exton: Schiffer Publishing L., 1983.

Solodkoff, Alexander, *Masterpieces from the House of Faberge,* New York: Harry N. Abrams, 1984.

Spiegel, Rahmen,*Tafeln zur Geschichte der Möberformen—1904–1911.*

The Victorian pattern glass and china book: The classic Victorian illustrated pattern catalog of English and foreign ornamental tableware, glassware, and decorative household goods, New York: Arch Cape Press, 1990.

MUCHA, ALPHONSE MARIE (1860–1939)
Professional photographer

The arrival of the young Moravian painter, Alphonse Mucha, in Paris in 1887 heralded the beginning of a career which would elevate him to the highest echelons of the Art Nouveau movement. Mucha's paintings, posters and typographic designs epitomise the extravagance of the period.

Mucha's interest in photography dates from about the time of his arrival in Paris, initially commissioning photographs as part of the preparations for his works, but his interest soon became a passion which would endure for the remainder of his life.

By the end of the 1880s he had started to take his own photographs but, according to his son Jiri Mucha, 'he remained the world's worst photographer'—an inaccurate remark as many of his photographs show remarkable visual perception (see Ovenden, *Alphonse Mucha Photographs*, Academy Editions, 1974).

Like many painters of the period, Mucha made extensive use of photographs of models posed in his studio, and many examples of these survive, several squared and ruled up ready to be used as sources for major works.

Mucha became interested in the psychic investigations of Albert de Rochas, the librarian at the Ecole polytechnique in Paris, and in conducting photographic experiments in his studio at rue de Val de Grace, he continued work which de Rochas had started with Nadar decades earlier.

JOHN HANNAVY

MUDD, JAMES (1821–1906)
English photographer

From his photographs it is possible to show that James Mudd was working as an amateur from around 1850. In the *Manchester Trades Directory* of 1852, James Mudd and his brother, Richard are referred to as calico printers' designers at 54 George Street. By 1854 they appear as calico printers' designers and photographers at 94 Cross Street, while the George Street address remains. In 1861, James Mudd appears as a photographer at 10 St. Ann's Square while Richard is still at George Street. In 1871 the firm is recorded as J. Mudd & Son. The son, James Willis Mudd, seems to be connected with the studio from about 1865 although no particular work can be attributed to him. George Grundy worked as an assistant from about 1880 and eventually bought the business in 1895. In the *Directory* of 1900 the firm still appears under the name of J. Mudd & Son although the ownership had passed to Grundy some years previous though the address was now recorded as 10 Police Street. James Mudd and James Willis Mudd continued to work in photography from Bowdon, Cheshire until 1905, after which date all activity ceased. It was only following the death of James Mudd in 1906 that the business was known as G. Grundy & Sons.

The landscape was Mudd's initial interest in photography. Early Mudd calotypes correspond very closely in location with calotypes taken by Joseph Sidebotham in Wales in 1851 or 1852. Both Mudd and Sidebotham were involved in calico printing in the Manchester area thus providing the link for their collaboration. Two landscapes on waxed paper, "Cottages at Trefriw" and "a Watermill" were hung in the *Exhibition of Art Treasures of the United Kingdom* held in Manchester in 1857. Also that year he gave a paper, "Artistic arrangement of photographic landscapes" to the Manchester Photographic Society. It would appear from reviews of various exhibitions in London, Dublin and Edinburgh in the period from 1857 to 1865 that Mudd was considered an equal with Francis Bedford, O. G. Rejlander, Henry Peach Robinson, and Camille Silvy.

In 1857, Mudd produced a series of photographs illustrating the effects on local flora allegedly caused by emissions from a chemical works at Irlam near Manchester. These images, which catalogued the effect of pollution from the works on trees downwind of the site, were taken in support of a celebrated court case, *Regina v. Spence*, which was heard in court in 1857. The court found against the owner of the alum works in question, but while the environmental pollution was proved, the court ruled that the noxious fumes had not had any detrimental effect on the local residents! While not apparently presented in court, these photographs stand

as one of the earliest uses of photography in support of such a legal action. They are preserved in an album in the collection of Salford Library.

Interaction between individuals interested in the emergence of photography played a major factor in its early development in the Manchester area. James Mudd was a member of the Manchester Literary and Philosophical Society being elected to membership in 1852. As a member he would have come in contact with J. B. Dancer; while primarily a scientific and optical instrument maker was a key figure in the early development of photography. Other members included Joseph Sidebotham; James Nasmyth, an engineer; James Mercer, a dye-stuffs chemist; Charles Beyer, the founder of the Beyer-Peacock Locomotive Works at Gorton, near Manchester; and J. P. Joule, the chemist. In August 1855, the Manchester Photographic Society was formed and the first Council included Joule, Sidebotham, Dancer and Nasmyth. James Mudd and Alfred Brothers, who was also a professional photographer, were members of the society and on the Council by the second year of its existence.

Mudd started photographing locomotives and other machinery for Charles Beyer of the Beyer-Peacock Locomotive Works in early 1856. Beyer would have considered his choice of photographer with care. He was meticulous in his control of the designs and production of his locomotives. The photographs by Mudd show his designs to be simple and effective both in aesthetic and functional terms. Initially using the wet collodion process without much success, Mudd reverted to the waxed paper process. By 1857 he was using the dry collodio-albumen process for this work with considerable success. The majority of the photographs were taken at the Gorton Works where he used a 12×15 inch camera for pictures of locomotives and whole plate for many of the machines. During the period 1870–75, and in addition to his work for Beyer-Peacock, Mudd was also photographing locomotives made by Nasmyth Wilsons and the Sharpe Brothers.

By 1861, Mudd was in business as a portrait photographer in Manchester's fashionable St. Ann's Square where he used collodion for his carte-de-visites and his cabinet portraits. Later, with the popularity of the CDV reaching its peak there were many "photographic artists" within a small radius of St Ann's Square. Mudd was in direct competition with Alfred Brothers, Silas Eastham and Lachlan McLachlan who all had businesses in the Square itself. Like many of his contemporaries, Mudd would have used the portrait business to form the basis of his income to offset against his speculative activities and also to keep his darkroom assistants in work when other parts of the business were slack.

Mudd's architectural photography shows a remarkable sensitivity for the subject. His early work for Francis Frith, of which "Deakins Entire" was a reject, shows an exceptional range of tonal values as well as a remarkable lens definition over the whole area of the image that is superior to that of his contemporaries. Again he used dry collodio-albumen negatives. For his 11×8 inch plates, he uses 4 inch "Lerebour" lens "well stopped down," and for 7×5 inch plates, a Dallmeyer Triplet.

Mudd also used the photographic process as a sketchbook for his paintings. Most known paintings date from the period 1875 and 1895. They include "River Liffey, Dublin," "Alderley Church in Snow," "Dunham Park," "Seascape," and "Nant Francon Pass." His ability as a painter can be gauged from the catalogues of the period where they are listed from £50 to £100. In 1977 a painting by Mudd of the opening of the Manchester Ship Canal in 1894 was discovered in Manchester. The painting is described as having "meticulous detail of the Barton Swing Bridge and patterns of the flags which could only be done with (resource) to photographs…. The painting shows all Mudd's misty background effect."

Many of Mudd's photographs and paintings survive as do his papers and writings on aspects of photography. It is evident that he was a fine professional and versatile photographer, a craftsman and painter who achieved considerable stature in the eyes of his contemporaries.

MICHAEL HALLETT

Biography

James Mudd was born in 1821 in Halifax, the son of Robert Mudd, whose occupation was described as a cheese and bacon factor. James Mudd died in Bowdon, Cheshire in 1906. In the *Manchester Trades Directory* of 1852, James Mudd and his brother, Richard, are referred to as calico printers' designers at 54 George Street. By 1854 they appear as calico printers' designers and photographers at 94 Cross Street, while the George Street address remains. In 1861, James Mudd appears as a photographer at 10 St. Ann's Square while Richard is still at George Street. In 1871 the firm is recorded as J. Mudd & Son. The son is James Willis Mudd who seems to be connected with the studio from about 1865 although no particular work can be attributed to him. George Grundy worked as an assistant from about 1880 and eventually bought the business in 1895. By 1900 the firm still appears under the name of J. Mudd & Son although the ownership had passed to Grundy some years previous though the address was now recorded as 10 Police Street. James Mudd and James Willis Mudd continued to work in photography from Bowdon, Cheshire until 1905, after which date all activity ceased.

See also: Art Treasures Exhibition (Manchester, 1857); Bedford, Francis; Rejlander, Oscar Gustav; Robinson, Henry Peach; Silvy, Camille; and Dancer, John Benjamin.

Further Reading

Chapman J.T., *Manchester and Photography*, Palatine Press, Manchester, 1934.

Gray, Priscilla M., *James Mudd: Early Manchester Photographer*, unpublished MA thesis for the University of California, 1982.

Hallett, Michael, *Significant years in the history of photography in the Manchester area*, unpublished MPhil thesis for the Council for National Academic Awards (CNAA), 1976.

Hallett, Michael, "James Mudd Photographer, 10 St. Ann's Square, Manchester," *British Journal of Photography*, 9 July 1982, 730–736.

Mudd, J., "Artistic Arrangement of Photographic Landscapes," *Liverpool and Manchester Photographic Journal*, 1857, 156.

Mudd, J., "The Collodio-Albumen Process," *The Collodio-Albumen Process: Hints on Composition, and other papers*, Thomas Piper, Photographic News Office, London, 1866.

Mudd, J., "On the Development of Under and Over-Exposed Collodio-Albumen Plates," *British Journal of Photography*, 17 July 1868, 343.

MULOCK, BENJAMIN ROBERT (1829–1863)
British photographer and civil engineer

Ben Mulock grew up in a Newcastle and London. When he was sixteen, his mother died and his father, the Reverend Thomas S. Mulock, deserted his three children. Because their mother's legacy was held in trust until they came of age, Ben's sister Dinah began writing for a living, and brother Tom, a promising artist, went to sea. He was killed by falling from the mast when his ship was in dry-dock in 1847. In 1848 Ben enrolled at University College London, where he studied Latin, Mathematics and Natural Philosophy with a view to becoming a civil engineer. However, when he turned 21 in 1850 he received £400 from his mother's trust and emigrated to Australia, where he became a farmer and later joined in the gold rush. Four years later, he returned to Europe due to persistent eye troubles, and underwent treatment in Germany and Switzerland in 1854 and 1855. By June 1855 he had joined the Army Works Corps. He spent the first half of 1856 in the Crimea, working on railway provision during the war. Shortly after returning to England in July 1856, he joined the Liverpool Public Offices Engineers Department. During most of 1858 he worked in the office of James Newlands, the City Engineer, and is said to have expressed a desire for "more congenial work." It was while staying at Linacre Grange, a farmhouse north of Liverpool, that he became a self-taught photographer. Some of the pictures he took there have been published in *The Mellards and their Descendants*. He also produced stereographic photographs and panoramas. By December 1858 he was in London, working as a photographer for JJ Mayall, but he was already in contact with John Watson, the contractor for the Bahia and São Francisco Railway (BSFR), who hired him to photograph the first stage of the works in northeastern Brazil. Charles Blacker Vignoles, who designed and supervised the BSFR, was a strong advocate and pioneer of recording the construction progress of engineering works using drawings or photographs.

Mulock arrived in Bahia on November 1, 1859. He described his first impression of the city with an artist's eye: "I never saw a place that pleased me more at first-sight. It stretches round the Bay in the form of a crescent—the shore is high and the houses rise one height above another, intermixed except right in the centre of the town with Banana and Cocoa-nut trees all looking so green." He immediately set about photographing the railway works, beginning with the terminus under construction in Calçada, and continued sending batches of "views" back to the head office in England, often twice monthly via the English and French mails. Mulock worked in the field with a portable darkroom of his own design (a letter he wrote about a similar invention was published in the *Photographic Journal* in 1859). This would also have held his plates and the necessary chemicals for the day's work. Glass plates were coated with chemicals (collodion) immediately prior to use. After processing they were varnished to retain the image. Printing was done on albumen-coated paper, which was sensitized the night before printing. On one particular upcountry expedition, he took 150 photographic plates and the associated chemicals with him, transported on a pack-mule. Only one glass plate broke. Towards the end of the period, he experimented with the new dry process, which enabled him to coat the negative prior to leaving base, and obviated the need to take chemicals with him. It was his practice to take additional plates of his views while in the field, and to transfer or duplicate the resulting negatives when back at base. While Ben was in Bahia, two engravings based on his photographs of the BSFR were published in the *Illustrated London News* (1860).

Mulock returned home six months before his contract expired because he felt there was nothing more for him to do. He took hundreds of photographs during his two and a half years in Brazil, including stunning portraits of the "City of Bahia." The panoramic view of the city as he first saw it, taken from a fort surrounded by water, could be considered his masterpiece. Ferrez writes that its clarity and perfection are unrivalled (1989, 33). The BSFR presented an album of Mulock's photographs to Emperor Pedro II of Brazil, himself an amateur photo-

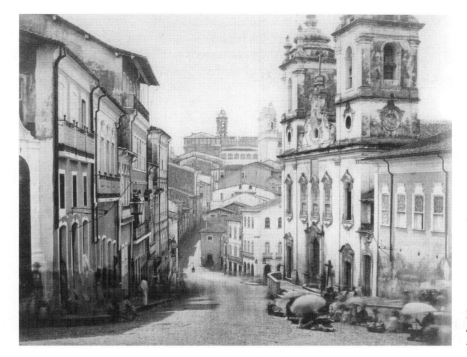

Mulock, Benjamin. *Rosario Church.*
*Acervo da Fundação Biblioteca
Nacional, Brasil.*

grapher, in July 1861. Ironically, it would bring Mulock the recognition he longed for, but only in Brazil. The pictures in the Emperor's album are now housed in the National Library at Rio de Janeiro (an undisclosed number were stolen in 2005) and the Moreira Salles Institute, and have been published by Gilberto Ferrez (1989). The photographs reflect a combination of a civil engineer's eye and artistic sensibility. While Mulock records the facts honestly and dispassionately, he always provides plenty of detail to be gleaned by the interested observer. His style has been compared with that of the "straight photography" movement of the 20th century.

While in Bahia, Mulock had spent more time up-country than in the city, where he had come down with a serious bout of "intermittent fever" (probably malaria). When he returned to England in the spring of 1862, he was ill, complaining of liver problems. However, by October he was in Swansea, Wales, working as an engineer and surveyor for John Watson. While there, a few months before his death, he wrote to Dinah asking her to send him the photographs of the City of Bahia, which she did. The whereabouts of these pictures are unknown. The same is true of John Watson's collection of Mulock's complete photographs of Bahia. The Vignoles family—direct descendants of C.B. Vignoles and his son Hutton Vignoles, the resident engineer of the BSFR—have donated 137 progress photos to the Institution of Civil Engineers. The Bosch Foundation in Stuttgart, Germany owns a number of Mulock's photographs. There are also four prints at the Harry Ransom Research Center, The University of Texas at Austin.

JOHN VIGNOLES AND SABRINA GLEDHILL

Biography

Benjamin Robert Mulock was born in Newcastle-under-Lyme, England, on June 18, 1829, the youngest child of Thomas Samuel Mulock, a Dublin-born nonconformist preacher descended from minor Irish gentry, and Dinah Mellard, the daughter of a prosperous Newcastle tanner. Ben had two siblings: Thomas Mellard Mulock, and Dinah Maria Mulock, who attained international fame in her time as a novelist under her married name, Mrs. Craik. In 1840, the family moved to London. That year, Ben began learning music (he played the concertina and the piano) and by 1843 he was showing an interest in civil engineering. He was educated in London. After he came of age and received his inheritance, he traveled extensively. His most important work as a photographer was done in Bahia, Brazil, between November 1859 and April 1862. In early 1863, about a year after returning from Brazil, he began showing signs of "melancholia" and was "placed in Doctor Tuke's asylum in Hammersmith" on June 7, 1863. He managed to escape but was "knocked down and run over by a heavy van" (Reade 1915, 84–85). He died of his injuries five days later.

See also: Mayall, John Jabez Edwin; Vignoles, Charles Blacker; Dry Plate Negatives: Non-Gelatine, Including Dry Collodion; Albumen Print; and Wet Collodion Positive Processes.

Further Reading

Collins, Michael, *Record Pictures: Photographs from the Archives of the Institution of Civil Engineers,* Göttingen, Germany: steidlMACK, 2004.

Ferrez, Gilberto. *Bahia, Velhas Fotografias 1858/1900*, Rio de Janeiro: Kosmos Editora, 1989.

Koppel, Susanne, Loschner, Renate, and Kirschstein-Gamber, Brigit (eds), *Brasilien-Bibliothek der Robert Bosch GmbH*, Stuttgart, Germany: Deutsche Verlags-Anstalt, 1986–1991.

Martins, Ana Cecília, Miller, Marcela, and Sochaczewski, Monique (organizers), *Iconografia Baiana do Século XIX na Biblioteca Nacional*, Rio de Janeiro: Fundação Biblioteca Nacional, 2005. Mitchell, Sally, *Dinah Mulock Craik*, Boston: Twayne Publishers, 1983.

Mulock, Ben R., "A New Photographic Barrow," in *The Photographic Journal*, vol. 6 (October 1859): 60–61.

Mulock, Benjamin, and Mulock, Dinah, Unpublished correspondence, UCLA Library, Dept. of Special Collections

Reade, Aleyn Lyell, *The Mellards and their Descendants Including the Bibbys of Liverpool with Memoirs of Dinah Maria Mulock and Thomas Mellard Reade*, London: privately printed at the Arden Press, 1915.

"The Bahia Railway," in *The Illustrated London News* (October 20, 1860): 380, 382.

MULTIPLE PRINTING, COMBINATION PRINTING, AND MULTIPLE EXPOSURE

The groundwork of photographic multiple printing, the combining of two or more images to form a new representation, can be found in Johann Carl Enslen's *Face of Christ Superimposed Over Leaf*, 1839. This composite photogenic drawing was made from two photogenic negatives using William Henry Fox Talbot's negative/positive paper process. Between 1841 and 1842 Talbot experimented with soft edge, out of focus masking and pin registered overlay positives to control contrast in his prints of white busts and statues against darker backgrounds to retain highlight detail. This multiple printing method is now called highlight and shadow masking and was also practiced by the Countess of Ross in the early and mid-1850s, Gustave Le Gray, Camille Silvy, and others to print in clouds and skies.

Combination printing was the practice of combining two or more negatives to make a harmoniously, seamless photograph. The practice evolved in order to overcome a major technical obstacle that was blocking photography's recognition as art. This was the collodion wet-plate's insensitivity to all parts of the spectrum except blue and ultraviolet radiation, which gave colors an inaccurate translation into black-and-white tones. Red or green subjects were not properly recorded and appeared in prints as black. Exposures, calculated to record detail in the land, overexposed the sky. The amount of overexposure was not even and produced areas of low density in the negative. When the negative was printed these sections appeared gray and mottled, an effect not suitable for picturesque landscapes. Typically the sky was masked out so that it printed as white. When clouds were needed they were created using chemicals, India ink, and other coloring methods.

The artistic solution proposed by Hippolyte Bayard in 1852 involved making two separate negatives, one for the ground and a second for the sky. This response could have been derived from the earlier daguerreotype cloud studies by Albert Southworth and Josiah Hawes and calotypes by others. After processing the two negatives were masked, with the land's features printed in from the first negative and the sky's from the second. Landscape photographers often made a stock collection of sky negatives, which were used in printing future views. George Barnard used combination printing in his *Photographic Views of Sherman's Campaign* (1866) for clouds and a group portrait of Union general William Tecumseh Sherman and his generals—one general who missed the group photograph was put in later.

William Lake Price was one of the first photographers to exhibit work utilizing this dual-negative technique in 1855. However, it was Gustave Le Gray's spectacular seascapes of 1856–1858, achieved from separately-made cloud negatives, that attracted public attention for both stopping the action of waves and their dramatic cloud formations. Le Gray was not the first to make instantaneous seascapes, but his photographs challenged the notion that photography was an automatic process by clearly demonstrating that photographers could control the medium and translate their feelings into images.

The method caught fire with Oscar G. Rejlander's allegorical tableaux, *The Two Ways of Life, 1857* that plainly verified the artistic potential of combination printing and paved its way to becoming an accepted practice. Rejlander set out to create a photograph that was morally uplifting and instructive and required "the same operations of mind, the same artistic treatment and careful manipulation" as works done in crayon or paint. Rejlander produced an elaborate allegorical piece contrasting Philosophy and Science during a six-week period in which he made sketches, hired models, and produced thirty separate negatives which he masked, printed on two pieces of paper, and connected. This work was rephotographed, and editions were reproduced. The photograph's unusually large size, 16 x 31 inches, made people stop and notice, enabling it to hold its own on a gallery wall. *The Two Ways represents* "a venerable sage introducing two young men into life—the one, calm and placid, turns towards Religion, Charity and Industry, and the other virtues, while the other rushes madly from his guide into the pleasures of the world, typified by various figures, representing Gambling, Wine, Licentiousness, and other vices; ending in Suicide, Insanity and Death. The center of the picture, in front, between two parties, is a figure symbolizing Repentance, with the emblem of Hope." Queen Victoria gave Rejlander's vision a big boost by purchasing it for Prince Albert.

Two Ways did not sell well and provoked debate on the ethics of combining negatives to manufacture an image that never existed, marking an early instance

of critical thinking about the medium. The picture's detractors claimed it was a violation of the "true nature" of photography; works of "high art" could not be accomplished by "mechanical contrivances." In the Victorian age, when piano "legs" were dressed with pantaloons, the photographic nudity of *Two Ways* was shocking. The process of combination printing led to the first photographic montages designed for a public audience, providing an intriguing set of representational possibilities that allowed for the inclusion of subjective experiences and values. As the process questioned established viewing rules, many felt threatened and rejected the new way of picturemaking. The concept that art was a matter of ideas and not limited to specific practices was given voice by the French naturalist Louis Figuier, who believed photography could improve artistic eloquence and public taste, and that "what makes an artist is not the process but the feeling."

The rise of photography as an art form would transform art's function of portraying reality. Photography encouraged artists to explore new directions that eventually included abstraction, in which the concept of art as imitation of nature was abandoned. Rejlander's efforts have been criticized as being "imitations," but were an important and necessary step to expand the boundaries of photographic practice and inspire others to enlarge photography's dialogue within society. The artistic criticism and financial hardships took their toll on Rejlander, however, who only made a few more combination prints; none of them approached the polemic nature and scale of *The Two Ways*.

Rejlander's *The Two Ways of Life* inspired Henry Peach Robinson to undertake combination printing. In 1858, Robinson exhibited *Fading Away*, made from five negatives, showing a young girl on her deathbed with her grieving mother, sister, and fiancée. By Victorian standards this sorrowful scene was scandalously morbid, as it did not conform to accepted ideas about what a photograph should picture. More distressful scenes were painted, but because *Fading Away* was a photograph the public considered it inappropriately realistic and an indecent invasion of personal privacy. After Robinson revealed that his principal model "was a fine healthy girl of about fourteen, and the picture was done to see how near death she could be made to look," the work was criticized for being manufactured.

The combination prints of Rejlander and Robinson challenged the belief that painters alone had the right to "create" scenes while photographers were workmen operating mechanical equipment. For photography to succeed in the art world it had to debunk such confining ideas. Combination printing was given the Royal seal of approval when Prince Albert bought it and gave Robinson a standing order for every pictorial image he created. Once audiences overcame the shock of the combination print, they accepted it, realizing that Robinson's fundamental ideology embraced their notions of art. This made Robinson the most popular, emulated, and well-to-do photographer of the second half of the nineteenth century. Robinson's books and articles actively articulated his position and influenced the development of future photographers. His *Pictorial Effect in Photography* (1869), which advocated the basic canons of painting, "composition and chiaroscuro," as the "guiding laws" of an art photograph, was the most widely read photography textbook of the nineteenth century.

Robinson sought methods for uniting the rational with the subjective, to allow photographers to achieve the picturesque. He believed that combination printing gave "much greater liberty to the photographer and much greater facilities for representing the nature of nature." Critics were outraged by Robinson's constructed images for violating their sense of photographic veracity. Combination printing was acceptable in landscapes as the public was conditioned by painting to expect idealized renditions, but when it came to portraying human beings viewers associated photography with unarranged truth. Robinson was able to expand photography's reach and get the public to embrace his combinations as expressing the accepted allegorical ideals and standards of the day. Robinson's work possesses a duality common to educated practitioners born before the invention of photography who thought like painters. Although Robinson broke no new representational ground, he showed that photography could achieve the same artistic goals as painting, thus allowing the next generation to explore photography's own morphology.

In the short term Robinson's work had the opposite effect. His allegorical ideas, magical theatrical techniques, and moralizing sentiment were so successful that they dominated photographic discourse and stifled other ways of thinking photographically until the 1880s. Robinson's striving for a literary image, reminiscent of nineteenth-century painting, has been in critical eclipse for most of the twentieth century. Yet today Robinson's practices look like progenitors of the postmodern photographers who stage tableaux before the camera and digitally manipulate their materials.

The camera's ability to make multiple exposures was used to create the most common form of multiple imaging in the nineteenth-century that of ghost or spirit stereographs. Ghosts were created when a veiled figure entered the scene for a portion of the exposure, producing a transparent phantom. To maintain believability, less scrupulous operators concealed their methods from the public and used ploys such as: a plate with a previously recorded ghost image, a transparency of a ghost image placed in front of the lens, a miniature ghost transparency placed behind the lens, or a ghost image

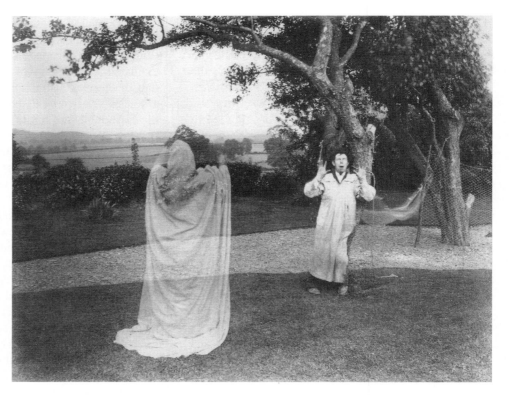

Hobson, W.S. Amateurs playing ghost scene. *The J. Paul Getty Museum, Los Angeles © The J. Paul Getty Museum,*

reflected into the lens during exposure. These representation were the result of *spiritualism*, a dubious spin-off movement of Transcendentalism that was founded in Rochester, New York, in 1848 by the medium Margaret Fox and her sisters, who later admitted their activities were fraudulent. Spiritualists believed that the human personality survived death and could communicate with the living through a medium that was sensitive to the spirit's vibrations. This gave rise to so-called spirit photography, which purported to make visual records of ectoplasmic manifestations of persons in a state beyond death. William Mumler, who ran the best-known spirit photograph studio in New York in the early 1860s, was eventually arrested as a swindler, though the charges were eventually dismissed because trickery was not proved. Nevertheless, spirit photographs attracted a large audience of predisposed believers who paid no attention when it was demonstrated that spirit photographs were produced by double exposure or multiple printing. Other photographers used these techniques and got into this commercially viable escapade without making any supernatural claims. To help sell his stereoscope, Sir David Brewster suggested making "ghost" stereo cards for fun; they quickly became a fad. Although Americans did not get involved with allegorical combination printing, spirit pictures encouraged experimentation with multiple exposure and acceptance of this style of depiction. Even though ghost cards were known to be fabricated, the fact that they were done photographically gave the appearance of truth. Spirit photography spread to Europe during the mid 1870s and again in the 1890s.

These were times of recession for portrait studios, and ghosts were good for business.

For the intellectually inclined, John Thomson was the first to incorporate the multiple print concept in order to fashion two three-part panoramas in his limited edition book *The Antiquities of Cambodia; a series of photographs taken on the spot, with letterpress description*, 1867.

ROBERT HIRSCH

See also: Talbot, William Henry Fox; Le Gray, Gustave; Silvy, Camille; Wet Collodion Positive Processes; Wet Collodion Negative; Bayard, Hippolyte; Southworth, Albert Sands, and Josiah Johnson Hawes; Barnard, George N.; Price, William Lake; Rejlander, Oscar Gustav; Victoria, Queen and Albert, Prince Consort; Robinson, Henry Peach; Mumler, William H.; and Brewster, Sir David.

Further Reading

Newhall, Beaumont, *Photography: Essays & Images* The Museum of Modern Art, New York,1980, 90.

Rejlander, O. G., "On Photographic Composition with a Description of Two Ways of Life," *The Photographic Journal* IV, no. 65 (April 21, 1858): 191–196.

——, *Humphrey's Journal of Photography*. 9, no. 6 (July 15, 1857), 92–93.

"Fifth Annual Photographic Exhibition," *Art Journal* (April 1, 1858): 120–21.

Figuier, Louis, *La Photographie au Salon de 1859*, Paris, 1860, 14.

Robinson, Henry Peach, *The Elements of Pictorial Photography*, Percy Lund & Co., Ltd., Bradford, 1896, 102.

——, *Pictorial Effect in Photography*, Preface, unp. Reprinted by Helios, Pawlet, VT, 1971, second impression 1972.

——, *Pictorial Effect in Photography,* Piper & Carter, London, 1869.

MUMLER, WILLIAM (1832–1884)
The first spirit photographer

Originally an engraver in Boston, Mumler was learning the trade of portrait photography in 1861 when, by his own account, a spirit 'extra' suddenly appeared on one of his plates. His newly discovered powers as a photographic medium were eagerly reported in the local Spiritualist press and he soon had many clients coming to his studio who were grieving for lost loved ones. Grateful sitters included Moses Dow, who was photographed with the spirit of his adopted daughter seeming to offer him a white rose, and the widow of Abraham Lincoln, who was photographed with Lincoln appearing to rest his hands on her shoulders. Many cartes-de-visite such as these were produced and sold as proof of spirit survival throughout the world-wide Spirititualist movement. After moving his business to New York he was arrested for fraud in May 1869. At the sensational trial prominent Spiritualists testified to their belief in his powers, whereas witnesses from the photographic industry enumerated the various ways identical effects could be obtained through double exposure. The judge reluctantly dismissed the charges because Mumler hadn't been caught in the act. He returned to Boston where he continued his business for several more years. In 1875 he published his memoirs, which were full of the testimony of grateful clients.

MARTYN JOLLY

MUNDY, DANIEL LOUISE (c. 1826–1881)
English photographer

Daniel Louise Mundy (1826/7–1881) was born in Wiltshire, England, and arrived with sufficient capital (from the Australian goldfields perhaps) to buy into a well-established photographic business in Dunedin in 1864. At this time, the province of Otago, was experiencing a gold rush. So any previous experience he may have had in Victoria would have served him well in these turbulent times. Following on from this, Mundy staged a well timed move north to Christchurch in the mid to late 1860s. This was during the height of great public expectations about finding a route through New Zealand's Southern Alps to the West Coast Goldfields. Mundy seized upon this sense of high commercial expectation with a splendid set of scenic photographs showing the road as it existed between the two provinces. After Canterbury, Mundy moved to Wellington and then onto Auckland. Before he'd realised it, he'd practically photographed all of New Zealand's major settlements. As well he spent a lot of time in the Hot Lakes District photographing the Pink and White Terraces which were being billed as one of the Seven Wonders of the World. He returned to England in the mid 1870s and lectured on his photographic exploits, publishing two books, *Rotomahana and the Boiling Springs of New Zealand* (1875), and *The Wonderland of the Antipodes* (1873) that were illustrated with his photographs using the autotype process.

WILLIAM MAIN

MURRAY, JOHN (1809–1898)
British surgeon and photographer in India

John Murray came to India in 1833 as a civil surgeon in the employ of the East India Company. Having settled into his post at Agra by the mid 1850s, Murray had already taken up photography, the value of which for documentary purposes was recognized in the military and civil establishment on the subcontinent. In 1856, Murray's fellow surgeon John McCosh had written in his *Advice to Officers in India*, "I would strongly recommend to every assistant-surgeon to make himself a master of photography in all its branches" (45–46). Murray focused his attentions particularly on architectural views of Mughal India and environs, which comprise some of the most intriguing imagery of the decade in a large corpus of plain and waxed paper negatives and corresponding salted paper and albumen prints.

Murray participated in the photographic culture of his day both in British India and in London. Twenty seven of his large salt prints were displayed at the first exhibition of the Bengal Photographic Society in March 1857; these were listed by title in the show's catalogue, and included landscapes of the hill station of Nynee Tal and the Mughal architecture of Agra. Like other photographic societies of the period, Bengal had formed to provide support for serious amateurs and commercial operators who shared a common passion for the medium—the best of photographs judged by their topicality or associative interest as well as artistry and technical execution. Murray continued to show his photographs at least until 1867, though they had been deemed earlier in the decade somewhat wanting in resolution compared with the results of the wet collodion on glass process. He remained a member of the Bengal Photographic Society until his departure from India at his retirement in 1871.

In November 1857 John Hogarth exhibited Murray's paper prints in London, reinforcing the political and cultural ties between the metropolitan center of the homeland and Britain's occupation of the subcontinent.

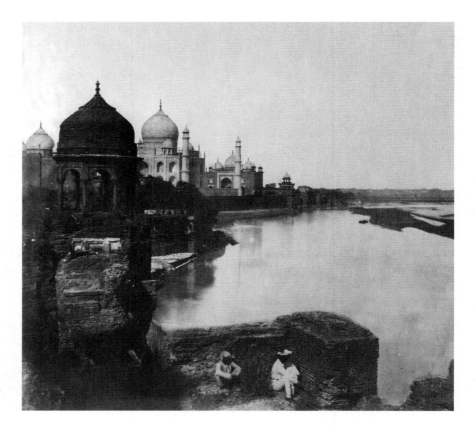

Murray, John. The Taj Mahal from the Bank of the River, Agra.
The Metropolitan Museum of Art, Gilman Collection, Purchase, Joseph M. Cohen Gift, 2005 (2005.100.71) Image © The Metropolitan Museum of Art.

Murray was in the city during this time, having taken leave of absence from his post in Agra from April 27, 1857 to February 5, 1858. As a seller of fine prints at Haymarket, Hogarth had understood the importance of photographs not only as aesthetic objects but as agents of pronounced sentiment associated with British colonialism. The pictures offered viewers a graphic opportunity for imaginative reflection on India's past and carried potent meaning with respect to the bloodshed that was presently occurring between native India and the British. This was the rebellion of sepoys—Indians pressed into the service of the British army—which had broken out in May 1857, and was soon to become a populist uprising. Known variously as the Indian Mutiny and Rebellion of 1857, the fighting, brutal and devastating to both factions, ultimately hardened British resolve to impose imperial authority over India under Queen Victoria. Hogarth exhibited thirty of Murray's 15 × 18 inch prints from calotype negatives. The December 1 issue of *Art Journal* posted a review of Murray's work, which the writer observed to be "a series of beautiful photographs, presenting localities that must hereafter be regarded with an interest far beyond that which ordinary historic events communicate." Murray's artistry notwithstanding, the reviewer was clearly making reference to the insurgency. In 1858 Hogarth published a volume of the doctor's views, *Photographic Views in Agra, and Its Vicinity*, with descriptions by J. Middleton, Principal of the Company's College at Agra. This was followed the

next year by *Picturesque Views in the North-Western Provinces of India*, also a Hogarth production, with text by Major-General J.T. Boileau. Boileau appreciated the subtlety of craft and picturesque appeal of Murray's pictures, while drawing special attention to evidence of politically symbolic import within individual views—a Union jack, for instance, atop the famous Delhi Gate of Agra Fort, "the emblem of British supremacy in India." Among other noteworthy practitioners on the scene in the aftermath of 1857 were Felice Beato, Charles Shepherd, and the photographer couple Major Robert and Harriet Christina Tytler, who were assisted in their art by Beato and Murray himself.

As a doctor Murray found correlations between the land and diseases endemic to monsoon climates. He kept a valuable medical library (moved for protection during the peak of the rebellion), published studies on cholera, and on the topography of localities in north central India. Thus, while many of his photographs emphasize the architectural legacy of the Mughal empire, they include features that bear testimony to an intimate knowledge of the terrain beyond an eye looking for the picturesque. A series of pictures from Agra Fort overlooking the Jumna River, for instance, reveal seasonal changes, where the water level varies, sand bars shift, and foliage flourishes or diminishes. They suggest an awareness of how visual evidence might serve to demonstrate existing conditions of place that would complement any written report. These and many other prints whose

main subjects appear ostensibly as the grand edifices of Mughal palace precincts and fortifications yield to the persistent observer the contrast of vernacular habitations of indigenous peoples.

Murray's documentation of such places coincided with European scholarship toward the systematic grasp of India's place in world culture. Historians under the new Raj especially venerated the achievements of the great Mughal dynasties, sometimes at the expense of India's Hindu past. Murray himself was acknowledged in the English press of the period as contributing to efforts to preserve the Taj Mahal ("Mofussil letters, Agra Dec 31, 1863," *The Englishman*, Jan 7, 1864), and the evidence of restoration is visible in certain of his pictures of Akbar's Palace and Agra Fort. Hence, however compelling subsequent photographers found the red sandstone and marble forts, palaces, and mosques, and other edifices of Britain's powerful predecessors, Murray's pictorial interests were well informed by his commitment to service and abiding concern for securing the cultural heritage of his adopted home.

GARY D SAMPSON

Biography

John Murray was born in November 1809, to Alexander Murray, a farmer in Blackhouse, Aberdeen County, Scotland. He received his M.D. at Edinburgh in 1831, successfully passed his examination to become Assistant Surgeon with the United East India Company in 1832, arriving in India the following year. By 1848 he was full Surgeon at Agra, made Deputy Inspector General in 1858, following nearly a year's leave in London during the Indian Rebellion, rising to Inspector General in 1865. His peak period of photography began in the mid 1850s and lasted until the early 1860s, which resulted in hundreds of views of Delhi, Agra, Fatehpur Sikri, Cawnpore, Benares, and elsewhere, many associated with the 1857 hostilities and Mughal India, and at least in part made at the request of Lord Canning, Governor General of India at the time. His method of choice was an variation of LeGray's waxed process, where the negative was waxed twice for greater detail—once before sensitization and once after exposure. His pictures appeared in a number of exhibitions and publications through his associations with the Bengal Photographic Society and with John Hogarth in London (see bibliography), and some were translated to wood engraving as witnessed in the *Illustrated London News*. He retired in 1871, leaving India, and died at Sherringham, Norfolk, July, 1898.

GARY D. SAMPSON

See also Felice Beato; John McCosh; Societies, groups, institutions, and exhibitions in India; India and Afghanistan; Waxed paper negative processes;

Architecture; History; Topographical photography; Harriet and Robert C. Tytler.

Further Reading

Bayly, C.A., ed., The Raj: India and the British 1600–1947, London: National Portrait Gallery, 1990.
Catalogue of Pictures in the Exhibition of the Photographic Society of Bengal, 4th March 1857, Calcutta: Cranenburgh, Bengal Military Orphan Press, 1857: 10–11.
Dehejia, Vidya, *India Through the Lens: Photography 1840–1911*, Washington, D.C.: Smithsonian Institution, 2000.
Metcalf, Thomas R., *Ideologies of the Raj*. III.4, *The New Cambridge History of India*, Cambridge: Cambridge University Press, 1994.
Murray, John, *Photographic Views in Agra, and Its Vicinity*, London: J. Hogarth, 1858.
———, *Picturesque Views in the North Western Province of India*, London: J. Hogarth, 1859.
Pelizzari, Maria Antonella (ed.), *Traces of India: Photography, Architecture, and the Politics of Representation, 1850–1900*, Montréal: Canadian Centre for Architecture, and New Haven: Yale Center for British Art and Yale University Press, 2003
Roll of the Indian Medical Service 1615–1930, compiled by Lieut. Col. D.G. Crawford. London: W Thacker and Co, 1930: 1220.

MURRAY, RICHARD (UNKNOWN) AND HEATH, VERNON (1819–1895)

The career of Murray and Heath can be divided into two phases. In late 1855 or early 1856, Richard Murray and Vernon Heath began a firm of opticians, specialising in scientific and philosophical equipment. During the following five years, they built a reputation as one of the premier firms supplying photographic apparatus and material. As well as a their own design of stereoscope and carte-de-visite cameras, Murray and Heath's stock included a variety of accompanying lenses, camera stands and special field boxes for outside work. Other scientific equipment sold by the firm ranged from opera glasses and microscopes to galvanic batteries.

Little is known about Richard Murray aside from the fact that he worked for a period at Newman's opticians in Regent St, which supplied stereoscopic lenses to Sir Charles Wheatstone in 1832. Vernon Heath (1819–1895) was the nephew of Lord Vernon, the art philanthropist who bequeathed his extensive collection of paintings to the National Gallery. Heath's reminiscences were published in 1892. They detail his career and constitute one of the first book-length memoirs by a photographer.

Many notable photographers and institutions used Murray and Heath's optical equipment. The firm supplied apparatus to Queen Victoria and Prince Albert in 1857, a privileged position that they advertised through their catalogues, all of which carry the royal arms. Other customers included the Board of Trade, the Foreign Office, Admiralty, and the East India Company. The

reliability of their cameras under difficult climactic conditions is reflected in the fact that it was used during Lord Elgin's visit to China and on Livingstone's journey to the Zambesi in 1858.

The repute of Murray and Heath was such that their equipment was reviewed in the *Art Journal* in 1859. Their cameras were praised for both their durability and the numerous minor technical innovations they had introduced. The review concluded that Murray and Heath could have "but small necessity for our praise, yet it affords us real pleasure to add to our testimony upon their photographic apparatus to that of the most distinguished photographers."

At the beginning of 1862, Murray and Heath sold their business to Charles Heisch, Professor of Chemistry at Middlesex Hospital. Heisch was also a keen photographer and a regular contributor to the pages of the *Photographic News.* A new catalogue issued by Heisch promised to "maintain the high character already established by this house, more especially for Apparatus suited to the tropical climates." The firm continued to operate under the name of Murray and Heath at 43 Piccadilly. However, the following year, Vernon Heath started as a full time photographic studio from the same address.

Heath operated at 43 Piccadilly between 1863 and 1876, and as Vernon Heath & Co. between 1877 and 1885. He was made bankrupt in early 1886, but was working at the same studio again between 1887 and 1888. Heath's interest in photography began in January 1839 when he heard Faraday announce Daguerre and Fox Talbot's discoveries at the Royal Institution. Sometime after the death of Lord Vernon in 1849, Heath started work a professional photographer. His early pupils included Dr. Livingstone and the young Prince Alfred, the future Duke of Edinburgh. Royal commissions feature prominently in Heath's career. In 1862, he was involved in a court case with a publisher, Robert Mason of Paternoster Row, over a disputed negative of Prince Albert. The case, which Heath won, centred around the number of negatives Heath had agreed to take for Mason, who wanted to use them for *carte-de-visite.*

At the wedding of the Prince of Wales in March 1863, Heath enjoyed the honour of being invited by Queen Victoria to photograph the marriage ceremony in the Chapel Royal at Windsor. Heath subsequently became a friend of the Prince and Princess of Wales. He was invited to Sandringham on several occasions, and made £1,000 from a photograph of two of the Prince's Indian mastiffs. His work for the royal family continued as late as 1887, when he was asked by Queen Victoria to photograph her Golden Jubilee garden party at Buckingham Palace.

One important technical innovation introduced by Heath was a means of reproducing and enlarging negatives. The process came about through his attempts to ensure that he could produce enough pictures of Prince Albert from the single negative involved in the court case. Heath's process involved printing a positive transparency of the negative on glass instead of paper, and then using this transparency to make more negatives. The process, with some modifications, became the principal means of enlarging negatives. Heath gave a paper describing his technique at the Photographic Society of London in March 1862, which was also published in the *British Journal of Photography.*

Heath's pictures included both portrait photographs and landscapes, although he was more renowned for the latter. His work often stemmed from high profile social connections. These included a request from Lady Burdett Coutts in 1867 to picture a garden party; photographing the Landseer's lions at the base of Nelson's column; and being commissioned by the Admiralty in 1865 to record details of the French fleet visiting Portsmouth. Much of his best photography stemmed from picturing Scottish landscape, often through long visits to the estates of Scottish noblemen. After one typical visit to the Duke of Argyll's estate in Inverary, Heath took a photograph of Glen Shira, which he then enlarged to 43 × 53 inches. For this and other pictures he sent to the Paris Exhibition in 1878, he was awarded the only gold medal for landscape photography given to British photographers. In his latter years, Heath was a strong advocate of the autotype process and gave a paper at Royal Institution on the subject in February 1874.

One unexpected admirer of Heath's landscape work was John Ruskin. In 1882, Ruskin wrote in reply to an approach from Heath to view his work:

> If you could know how often I have paused, in my greatest hurries, at that recessed window in Piccadilly, and how often I have retired from it in a state of humiliation and wretchedness of mind, and accused first the sun, and then you, and then the nature of things, of making all one's past labours hopeless, you would understand the interest I shall have in really seeing you. (Quoted in *Vernon's Heath's Recollections,* 294)

Vernon Heath died on 25 October 1895, and an obituary in *The Times* singled out his pictures of Burnham Beeches for particular praise.

JOHN PLUNKETT

See also: Cartes-de-Visite; Stereoscopy; Victoria, Queen and Albert, Prince Consort; Faraday, Michael; Daguerre, Louis-Jacques-Mandé; Talbot, William Henry Fox; and Photographic Exchange Club and Photographic Society Club, London.

Further Reading

A Catalogue of Photographic Apparatus, Chemicals, & C, Manufactured and Sold by Murray and Heath, London: George Nichols, 1862.

Catalogue of Photographic Apparatus, Processes & C., London: Murray and Heath, 1859.

Heath, Vernon, "Mason v Heath. To the Editor," *British Journal of Photography,* 15 March 1862: 112–113.

Heath, Vernon, *Vernon Heath's Recollections,* London, Cassell and Co., 1892.

"Mr Vernon Heath's Studio" *Photographic News,* 30 May 1863: 264.

"New Books. *Catalogue of Photographic Apparatus, Processes & c.* (London: Murray and Heath, 1859)," *Journal of Photography,* 15 July 1859: 180.

"Obituary. Vernon Heath," *The Times,* 29 October 1895: 8.

"Photographic Apparatus" *Art Journal,* n.s. 5 (1859) 24.

MUYBRIDGE, EADWEARD JAMES (1830–1904)

Born Edward James Muggeridge, also known as Muggridge, Maygridge, Muygridge, Eduardo Santiago Muybridge. He was a photographer, inventor, and lecturer. One of the most influential and colourful photographers of the nineteenth century, Muybridge's achievements span three distinct categories: landscape photography, motion photography, and early cinema. The motion photographs, in particular, are among the most easily recognized photographs of the nineteenth century, comprised of grids of instantaneous photographs of humans and animals performing various behaviours and taken in rapid succession.

Although he was born in, and retired to, the London suburb of Kingston, his entire photographic career was spent in the United States. Muybridge was one of four sons born to Susannah and John Muggeridge, Kingston merchants recorded as selling coal and later grain. After attending Queen Elizabeth's Free Grammar School, Eadweard moved to London, apparently to receive vocational training. He may have been apprenticed in the city, but records from this period are scant, and his tendency to exaggerate biographical details renders information about his early training suspect. Around 1851–52 he settled in New York City, where he was an agent of the London Printing and Publishing Company, arranging the importation of unbound books from London for their binding and sale in the United States. He also worked for Johnson, Fry and Company, an American publishing company with offices in Boston, New York and Philadelphia. His work seems to have involved a considerable amount of travel. In his personal scrapbook, now in the collections of the Kingston Museum and Heritage Service, visits to numerous American cities are mentioned, including New Orleans and other shipping ports in the United States. Around 1855 Muybridge set out on his own, establishing a booksellers at 113 Montgomery Street in San Francisco. He also remained an agent for London Printing and Publishing. His interest in books persisted throughout his career, and many of Muybridge's photographic projects were conceived as bound volumes.

Around 1858 Muybridge's brother George joined him in the San Francisco book business, followed by his youngest brother Thomas. George is thought to have died of tuberculosis shortly thereafter. In 1860, Eadweard decided to return to New York and London, presumably on business. His decision to take a stagecoach rather than an ocean liner proved fateful. On July 2, 1860, his Overland Stage coach crashed in Northeast Texas, and Muybridge suffered a severe head injury. He was knocked unconscious and was said to have lost his senses of taste, smell, and hearing for several months. After two months convalescing in New York, he continued to London where he was under the care of Sir William Gull, Queen Victoria's private physician. In total he spent about a year recovering from the accident. Several scholars have attributed changes in Muybridge's personality to this injury, theorizing that he suffered brain damage. The veracity of this claim may never be proved, but his unorthodox and mercurial personality in his adult working life is undisputed.

Like much of his early life, Muybridge's whereabouts from 1861 to 1867 are mysterious. His return to the United States was almost certainly interrupted by the Civil War. However, by 1867 Muybridge was back in San Francisco where he quickly established himself as a successful landscape photographer. It is unclear whether he learned to photograph in England or the United States. An amateur photographer named Arthur Brown has been nominated as a possible teacher in England. In the United States, Muybridge befriended the Daguerreotypist Silas T. Selleck (active 1850s–70s), who is thought to have worked for Mathew Brady before moving to San Francisco. If Selleck provided photographic training, there is little evidence of this. Claims that Samuel Morse taught Muybridge appear to be spurious.

In late 1867 or early 1868, Muybridge and Selleck opened a studio in San Francisco specializing in photographs of California and the Pacific Coast. Landscape dominated his practice for about six years. He began with views of San Francisco, and then photographed the Yosemite Valley. By 1868 he had moved to Vancouver and Alaska; later he would photograph Pacific coast lighthouses, the Farallon Islands, geysers and railroad lines. He developed an astonishing virtuosity with the camera, producing mammoth plate albumen prints scarcely rivalled in their beauty. Soon his works challenged his principal rival in California landscape, Carleton Watkins (1829–1916). Many of Muybridge's images were published under the name "Helios," a reference to the sunlight used to expose them. He also dubbed his operation "the Flying Studio."

By 1872 Muybridge had become affiliated with the studio of Bradley and Rulofson in San Francisco, where he was recognized as the outdoor photography

specialist. When Leland Stanford, former Governor of California, United States Senator, and President of the Central Pacific Railroad, approached the studio with a commission to photograph galloping horses, Muybridge was assigned the case. Whether Stanford already knew Muybridge, possibly as a result of his railroad photographs or other contacts, is unknown. As a horse breeder and avid reader of equine literature, Stanford wished to obtain photographs of a horse's gait in order to ascertain whether it has all four hooves from the ground at any point in its stride. This necessitated an unprecedented degree of instantaneity as it required exposures faster than the naked eye could see. Initially, Muybridge set about the project using wet-plate collodion materials, which are inherently slow and awkward to use. The motivation for Stanford's commission has been the subject of much speculation, but was almost certainly prompted by a friendly disagreement with a rival. The oft-repeated claim that Muybridge was retained to settle a substantial wager does not appear to be true.

There are conflicting accounts about the date and location of Muybridge's first horse in motion experiments. The subject of the photographs is said to have been Stanford's fast horse Occident. Some reports place the first attempts to photograph him in May of 1872 at the Union Park Race Course in Sacramento, but if such experiments occurred they do not appear to have been successful. Subsequent attempts may have occurred in Sacramento the following year, but a young assistant, Sherman Blake, recalled them being conducted at the Old Bay District Track in San Francisco, which Stanford helped construct. Most probably they were begun unsuccessfully in Sacramento during one of Muybridge's trips to Yosemite (Muybridge photographed there in 1867 and 1872), and moved to San Francisco to be nearer to his base of operations. In any case, photographs from this period have not been preserved. Both Muybridge and Stanford said they were too fuzzy and indistinct to merit publication, but were adequate to judge the position of the horse's hooves. The only visual record of these earliest experiments exists in the form of drawings, possibly copied from lantern slide projections, currently in the collections of the Iris and B. Gerald Cantor Center for Visual Arts at Stanford University, and a Currier & Ives lithograph of Occident trotting published in 1873.

In 1873 Muybridge created a series of photographs documenting the Modoc Indian War. Muybridge was sympathetic to the Native American fighters, who were resisting violent forced resettlement and took refuge in the rocky chasms outside the Lava Beds, near the Oregon border. He produced some thirty-one stereo views of the campaign, which were published by Bradley & Rulofson. Muybridge claimed to have photographed both sides of the conflict, but scholars have identified his photograph of 'A Modoc Brave' as a member of a rival tribe, and his other photographs of Modocs seem to have been made exclusively from prisoners.

In 1874 Muybridge's career was interrupted by an infamous series of events culminating in the murder of his wife's lover. In 1872, at age forty-three, Muybridge had married a twenty-one year old divorcé named Flora Stone. The next year Flora began an affair with a dandyish socialite named Major Harry Larkyns. Muybridge warned them apart, and when Flora became pregnant in 1873, he had no reason to suspect the child was not his own. The truth was revealed when Muybridge found a photograph of the child, whom he and his wife had named Floredo, with an annotation on the back reading "Little Harry." Muybridge had never seen the picture before, which had evidently been sent to Flora by Larkyns. With the parentage of the child deeply in doubt, Muybridge flew into a rage and determined to avenge himself. He travelled roughly eighty miles to the city of Calistoga in northern Napa County, where Larkyns was staying. He traced him to a house on the grounds of the Yellow Jacket Mine, and called him to the door. Witnesses record him as saying, "Good evening, Major. My name is Muybridge. Here is the answer to the message you sent my wife." He then shot Larkyns once near the heart. Larkyns died instantly. Muybridge was arrested and tried, but acquitted on grounds that the killing was a justified defense of his family.

Released from jail Muybridge travelled to Central America, where he spent the next year photographing the landscapes of Guatemala and Panama, and particularly the workings of coffee plantations. The brooding, atmospheric quality of these photographs gives some indication of his turbulent mental state at the time. After his return, in January of 1877 Muybridge produced two dramatic panoramas of San Francisco from the hill at California Street: a "small" panorama of twenty-two panels each approximately 7 × 8 inches, and a "large" panorama of thirteen panels, each approximately 21 × 16 inches. When fully extended the large panorama is 17'4" long. The panoramas represent Muybridge's last concerted effort at landscape photography before fully immersing himself in the motion photography for which he became world famous.

After a hiatus of some four years, Muybridge resumed his project photographing horses for Stanford in 1877. This time, the photographs were made at Stanford's farm in Palo Alto, which would later become the campus of Stanford University. An ambitious scheme was devised not just to photograph a single moment in a horse's stride, but also to make a succession of photographs at regular intervals, each isolating a particular moment in an animal's stride. State-of-the-art lenses were ordered from Dallmeyer in London, and cameras were commissioned from Scoville in New York. Muybridge also claimed to have developed a speedier chemistry, which

enabled more rapid exposures. To maximize available light and further shorten exposure, Muybridge built a track with an angled whitewashed wall on one side to reflect light, and scattered the ground with lime. Working with Stanford's engineers (who included telegraph designers), Muybridge and his team rigged the cameras with automatic shutters—at first these were purely mechanical but later they were electrically fired. Two basic systems were employed. For free-running horses, thin threads were drawn across the track which the horses would break as they ran, each successive thread activating a shutter. For horses pulling sulkies, the threads were buried underneath the track and pressure activated by the weight of the carriage's wheels.

The new system was fully operational in 1878. Its sophistication outstripped anything attempted previously, and is hardly foreshadowed in his earlier motion experiments. Not only did it enable Muybridge to photograph animals moving at speeds never before photographed, it also resulted in distinctive sequences of imagery delineating the transitions from one posture to another. Muybridge published them in grids, initially of twelve frames. To launch the new venture Muybridge held a press conference on June 15, 1878, in Palo Alto. Newspaper and magazine representatives in attendance, and photographs were made using the new system. Two horses were photographed, Abe Edgington (trotting) and Sallie Gardner (running). The Abe Edgington photographs were published as the first in a set of six cabinet cards titled *The Horse in Motion;* the Abe Edgington image became known as *Abe Edgington trotting at a 2:24 Gait.* Abe Edgington was the subject of three sequences in the set. The others depicted Mahomet, Sallie Gardner, and Occident.

Reproduced and disseminated throughout the world, Muybridge's *Horse in Motion* grids were the most sensational photographs of their day. Contemporaneous accounts describe crowds gathering outside shop windows in which they were displayed, and Muybridge received correspondence from admirers internationally. On his mounts, Muybridge changed his title to "Landscape and Animal Photographer." The rapturous attention given the photographs prompted Muybridge to continue his experiments through 1879. However, the publicity garnered by the photographs created tensions between Muybridge and Stanford over who should receive credit for them which led to the dissolution of their partnership.

Muybridge and Stanford published competing compendiums of Muybridge's photographs. Muybridge widened the scope of his project to include other animals, including deer, dogs, cats, oxen and even humans performing various tasks. He assembled 203 of these in a handmade album he called *The Attitudes of Animals in Motion. A Series Illustrating the Consecutive Positions*

Assumed by Animals in Performing Various Movements Executed at Palo Alto , California, in 1878 and 1879; it was published in 1881. The plates in this album exist in both albumen and printing-out paper versions. Stanford asked his friend the physician J.D.B. Stillman to write about the pictures, which resulted in the book *The Horse in Motion as Shown by Instantaneous Photography with a Study on Animal Mechanics* in 1882. In Stanford's book the original photographs were copied as lithographs, and Muybridge was not listed on the title page. He was mentioned merely as a skillful photographer. The publication of the book prompted Muybridge to sue Stanford, ending any hopes of continuing the project in Palo Alto. Stanford prevailed in court, mainly on the grounds that Muybridge could not lay claim to authorship as his work depended heavily on an electrical trigger mechanism designed by Stanford's engineer, John D. Isaacs.

Starting in the 1880s Muybridge spread his reputation by lecturing about his photographs in the United States and Europe. His presentations involved lantern slides made from his motion photographs, alternated with slides of historical representations (paintings, sculptures etc.) of animal motion. Muybridge pointed out inaccuracies in historical representations and the superiority of his technique. An important innovation he employed in his presentations was the zoopraxiscope, a projection device he invented in 1879 to show short animated loops of motion photographs. Because his photographs had been made in sequence, Muybridge reasoned that when shown in rapid succession they could easily be animated. This was a well-established principle of optical toys such as the phenakistiscope, but had not been perfected using photography. The zoopraxiscope combined a projecting lantern, rotating glass discs on which reproductions of Muybridge photographs were painted, and a counter-rotating slotted metal disk which spun at the same speed, acting as a kind of shutter. Contrary to popular belief, actual photographs were not used in the zoopraxiscope. Because it relied on a spinning disk with a counter-rotating aperture, the zoopraxiscope projected images that looked unnaturally short and squat. To compensate for this, skilled copyists were employed to paint the images on the disks in an elongated, stretched form so that when they were projected they returned to normal proportions. Nevertheless the illusion of animated photographs was convincing and inspired numerous other attempts to animate photography using a projector. For this reason Muybridge is often credited as one of the inventors of the motion picture.

Having severed all ties with Stanford, Muybridge approached numerous potential patrons to sponsor his continued investigations. The University of Pennsylvania finally agreed, giving him equipment and laboratory space on campus. From 1884 to 1886

Muybridge produced 781 motion studies under the partial supervision of Thomas Eakins, which he published in 1887 under the title *Animal Locomotion*. It became Muybridge's best-known work. The plates in *Animal Locomotion* were printed using the collotype photomechanical technique, although a nearly complete set of cyanotype proofs for the project is currently held at the Smithsonian Institution, National Museum of American History. Whereas in California Muybridge used trip wires to activate his shutters, in Pennsylvania he used a timer mechanism. This permitted him to photograph behaviours in which the subject does not proceed straight ahead at a constant rate. His equipment was markedly better than it had been in California. Equipped with thirty cameras which could be directed simultaneously at different angles, he was also able to take advantage of gelatine dry-plate chemistry, which was both faster and more convenient than the wet-plate materials used earlier. Although *Animal Locomotion* contains further photographs of horses and other animals borrowed from the Philadelphia Zoo, the primary focus was on humans. Men and women, nude or partially clad, are shown engaged in activities ranging from the banal to the highly esoteric: walking, running, and jumping are interspersed with dancing, smoking, and women pouring water over each others' heads. Of special interest are images made of people with physiological disorders, including an amputee, a pathologically obese woman, and a girl with multiple sclerosis. These photographs presage the diagnostic role photography would assume in scientific investigations, particularly under the influence of Etienne-Jules Marey and his colleagues in France. The volume was also highly influential among artists: subscribers to *Animal Locomotion* included the painters Lawrence Alma-Tadema, Ernest Meissonier, John Everett Millais, William Bouguereau, August Rodin, and James Abbott McNeill Whistler.

After *Animal Locomotion* Muybridge retired from photography and focused instead on lecturing and writing about his work. In 1893 he staged a zoopraxiscope theatre show at the World's Columbian Exposition in Chicago. It closed early due to tepid interest.

PHILLIP PRODGER

See also: Instantaneous Photography; Brady, Mathew B.; Morse, Samuel Finley Breese; Watkins, Carleton Eugene; Wet Collodion Negative; Dallmeyer, John Henry & Thomas Ross; Eakins, Thomas; Collotype; Cyanotype; and Marey, Etienne Jules.

Further Reading

Coe, Brian, *Muybridge & the Chronophotographers*, London: Museum of the Moving Image, 1992.

Gordon, Sarah, "Prestige, Professionalism, and the Paradox of Eadweard Muybridge's Animal Locomotion Nudes," *Pennsylvania Magazine of History and Biography*, vol. XXXX, no. 1, January 2006, 79–104.

Haas, Robert Bartlett, *Muybridge: Man in Motion*, Berkeley and London: University of California Press, 1976.

Harris, D. (ed.), *Eadweard Muybridge and the Photographic Panorama of San Francisco, 1850–1880,* Montreal: Canadian Center for Architecture, MTI Press, 1993.

Hendricks, Gordon, *Eadweard Muybridge the Father of the Motion Picture*, London: Secker and Warburg, 1975.

Mozley, Anita Ventura (ed.), *Eadweard Muybridge: the Stanford Years*, Stanford: Stanford University Museum of Art, 1972.

Palmquist, Peter, "Imagemakers of the Modoc War: Louis Heller and Eadweard Muybridge," *Journal of the Shaw Historical Library* 8 (1994).

Prodger, Phillip, Prodger, Phillip, "How Did Muybridge Do It?," *Aperture*, no. 158; 'Time,' Spring 2000: 12–16.

——, "The Romance and Reality of the Horse in Motion." In *Marey/Muybridge, pionniers du cinéma*, edited by Joyce Delimate, 44–71, Beaune/Stanford, Beaune: Conseil régional de Bourgogne, 1996.

——, *Time Stands Still: Muybridge and the Instantaneous Photography Movement,* New York: Oxford University Press, 2003.

Solnit, Rebecca, *River of Shadows: Eadweard Muybridge and the Technological Wild West,* New York: Viking, 2003.

MYERS, EVELEEN (1856–1937)
English photographer

Eveleen Myers, née Tennant, was born in 1856 to Charles Tennant, an M.P. of Cadoxton, Glamorganshire, Wales, and his wife Gertrude, née Collier. In London, the Tennants were part of prominent artistic and literary circles. In 1880, Myers married F.W.H. Myers (1843–1901), psychical researcher and co-founding member of the Society for Psychical Research as well as writer and inspector of schools in Cambridge. The couple lived in Cambridge and had three children. Myers first began photographing to take portraits of her children in 1888, and she practiced photography, working in platinum, in the late 1880s through the early twentieth century. Her work consists of portraiture, artistic studies, and allegorical works. She photographed notable men and women, including Robert Browning and William Ewart Gladstone. These two portraits, along with *Rebekah at the Well* and *The Summer Garden*, are probably her best-known works and were reproduced in *Sun Artists*, Number 7, April 1891. Myers's photographs are in the collections of, among others, the National Portrait Gallery, London, and the Getty Museum. She died in 1937.

DIANE WAGGONER

N

NADAR (GASPARD-FÉLIX TOURNACHON) (1820–1910)
French photographer, writer, and caricaturist

To the question—"Who do you think is the world's greatest photographer?"—French essayist Roland Barthes provided a simple, one-word answer: "Nadar." And in the history of French photography in the nineteenth century, there are few who rival the artistry and output of this man who lived for eighty years of the nineteenth century and ten of the twentieth century.

Nadar's notoriety in photography came after successful careers first in writing and publishing and then in caricature. Based in Paris, Nadar met and communed with a large circle of late-Romantic artists and writers, as well as the radical social thinkers of the time. This circle considered itself bohemian and in opposition to anything bourgeois; it was politically and socially liberal and believed in the importance of art, personal integrity, and freedom of self-expression.

Photographic Beginnings

In 1854, although working at the time on his lithographic pantheon of contemporary "poets, novelists, historians, publicists, and journalists," Nadar offered to assist his younger brother Adrien in developing a new career. Nadar not only paid for his brother's lessons with Gustave le Gray, but he also managed to establish Adrien in his own portrait studio in Paris. It appears that it was always Nadar's intention to join Adrien in taking up photography; later that year Nadar commenced photography lessons with the firm of Adolphe Bertsch and Camille d'Arnoud. By September of 1854, however, Adrien's studio was failing to the point that Nadar felt compelled to step in and take control. Together the brothers made a small series of portraits, some of which were used to complete the portraits used in the *Panthéon Nadar*.

Nadar also arranged for the studio's work to be exhibited at the Exposition Universelle of 1855.

By January of 1855 Adrien requested that the brothers separate, leaving Nadar to set up shop in his own residence at 113, rue Saint-Lazure. Adrien also adopted the name "Nadar jeune." Nadar had created his own name in 1838—a pen name (with a few variations) by which he was known his entire professional life. Beginning in 1855 (with appeals ending only in June 1859), a lawsuit was filed by Nadar to make Adrien cease and desist his use of the appellation "Nadar jeune." During those years Adrien did have some success as a photographer, while Nadar also established himself as a portrait photographer, becoming a member of the Société française de photographie in 1856 and winning a gold medal at the Exposition Photographie in Brussels in the same year.

Photographic Technique

In line with what he would have learned from Adolphe-Auguste Bertsch (who invented a faster and aesthetically finer collodion process for negative plates), Nadar's first prints were made from wet-collodion negatives on high-quality salted paper. By 1855 Nadar produced signed, mounted, salted paper prints: they measured 11 × 8¼ inches. Although disparaging of Disdéri's *carte de visite* format (Nadar considered it unaesthetic), by 1860 he had "submitted" to the raging fashion and was producing both full-size and *carte* prints (both salted paper and albumen, although the low-cost, commercially produced albumen papers would eventually prevail). From his earliest days as a photographer, it appears that Nadar manipulated his negatives in the darkroom; by the 1860s it is clear that he was retouching his negatives, making the retouching of prints rare. Nadar also experimented with artificial lighting not only for his portraits but also for his work photographing the Paris catacombs and sewers. He had always been a master at manipulating

natural light to aesthetic effect in his studio and soon abandoned electric light for his portraits.

Portrait Photographer

Nadar's turn to portrait photography appears to be a natural progression from his work in caricature. Already focused on capturing the essence of individuals' physiognomy through drawing and then mass producing the caricatures through lithography, Nadar possessed the aesthetic and interpersonal skills to use the medium of photography to its best advantage. Not only did he study with a photographer producing the finest-quality prints in Paris in 1854, but he also had a ready-made clientele, as well as name recognition. His circle of acquaintances was very broad, and many up-and-coming and established artists, writers, and social activists had already sat for Nadar. One of two extant albums that Nadar used for guests to sign when sitting for their portraits comprises over 400 names (with accompanying commentaries or samples of drawing, music, or poetry) of the most famous individuals working in music, art, poetry, fiction, politics, and the military in a twenty-year period between the mid-1850s and the early 1870s.

In 1876 Ernest Lacan—editor-in-chief of France's first photography magazine, *La Lumière*—evaluated Nadar's eminence in portrait photography: "His prints, their formats large for that period, had an entirely new look about them. Nadar generally worked in broad sunshine or at least lit his sitter in such a way that one side of the face was very bright and the other very dark. The pictures generally resembled what are today called 'portraits à la Rembrandt.' They were very artistic and enjoyed a great success" (quoted in Françoise Heilburn, "Nadar and the Art of Portrait Photography," *Nadar*, New York: Metropolitan Museum of Art, 1995, 36). Many scholars consider a mere six-year period from 1855 to 1860 to be Nadar's era of greatness in portrait photography. In 1860 Nadar undertook the construction of a new, large photographic studio at 35 boulevard des Capucines. Completed in 1861, it cost 230,000 francs, all of which Nadar borrowed. Financial considerations, therefore, and the popularity and economy of the *carte de visite* format forced Nadar to alter his original method of photographic portraiture. The results included smaller, less detailed prints as well as the miniaturization of his existing archive of prints (he re-shot original prints to create smaller negatives that would accommodate the *carte* format).

Typical of a Nadar photographic portrait is the lack of props or elaborate backgrounds. He also patented a technique in which the edges of the prints are faded. All attention centers on the subject, and most prints comprise only one individual. Nadar's subjects are never harshly cast, but they are not idealized either. In general, he de-emphasizes clothing, requesting that his subjects choose dark garments for their sitting. Nadar also de-emphasizes the subject's hands—frequently eliminating them from the shot or hiding them inside clothes or the folds of cloth. There is no one pose that Nadar adopts for his sitters. Some look left, some right—with eyes looking forward or with eyes looking down; some sit or stand and look directly at the camera, although most are posed standing or sitting at an angle from the camera. But as one scholar comments: "As Nadar is forced into rapid, high-volume production in the early 1860s [. . .] a bland, stereotyped portrait emerges [. . .] which relies on conventional dress and body language, flat lighting, and traditional studio props" (Ulrich Keller, "Sorting Out Nadar," *Nadar*, New York: Metropolitan Museum of Art, 1995, 86).

Among those photographed by Nadar are: Mikhail Bakunin, Théodore de Banville, Charles Baudelaire, Hector Berlioz, Sarah Bernhardt, Jules Champfleury, Gustave Courbet, Honoré Daumier, Eugène Delacroix, Gustave Doré, Alexandre Dumas (père and fils), Théophile Gautier, Edmond and Jules de Goncourt, Constantin Guys, Victor Hugo, Edouard Manet, Jules Michelet, Jean François Millet, Henri Mürger, Gérard de Nerval, Jacques Offenbach, Pierre Joseph Proudhon, Gioacchino Rossini Rossini, George Sand, Giuseppe Verdi, and Alfred de Vigny.

Aerial Photography

In 1858 Nadar took his first aerial photographs from a balloon tethered near the Arc de Triomphe. He had actually attempted this endeavor the year before but was unsuccessful in making photographs, because the gases used in the balloon chemically interacted with his negatives. Nadar was a firm believer that the path to human flight lay with machines heavier than air, so he had his own balloon, called *le Géant* [Giant], built in 1863 in anticipation that the profits from its rides would generate enough income to build a helicopter. Between 1863 and 1867 he made five ascents in *le Géant* and remarkably increased his notoriety, but this adventure ultimately proved to be a financial disaster.

Subterranean Photography

In his quest for technological innovation and new pursuits, Nadar negotiated the right to photograph underground in Paris—first the catacombs in 1861–62, then the sewers in 1864–65. Victor Hugo had made the sewers famous in *Les Misérables*, and the catacombs fascinated such compatriots as Gustave Flaubert and the Goncourt brothers, all of whom toured the burial sites in 1862. Of course, the idea of going underground after having soared above ground seems only fitting. Although less

Nadar. Eugène Pelletan.
*The Metropolitan Museum of Art,
Purchase, The Howard Gilman
Foundation Gift and Rogers Fund,
1991 (1991.1198) Image © The
Metropolitan Museum of Art.*

than pleased with the results of using artificial light in his portrait sittings, Nadar understood that electric light was absolutely necessary for underground photography; he represents the first photographer ever to attempt such a task. Using magnesium flares for light in the catacombs, Nadar needed to expose the negatives for upwards of 18 minutes. As a result, he decided to use mannequins rather than living humans to simulate workers (although at least one image exists in which Nadar himself appears). These staged images with their harsh lighting, nevertheless, represent a progressive experiment to push the boundaries of the medium and increase Nadar's fame as well. His work in the sewers a few years later was more problematic technically and yielded approximately two dozen images. They failed to capture the full extent of recent renovations, nor did they depict the ancient sewers described by Hugo. His power source entailed long wires attached to batteries that remained above ground.

Retirement

In 1873 Nadar purchased a home in the countryside outside of Paris where he and his wife Ernestine then spent most of their time. Political upheavals that included the fall of Napoléon III, the siege of Paris, and the subsequent Commune (itself overturned by the second siege of Paris) left Nadar physically, emotionally, and financially spent. He vacated his large studio on the boulevard des Capucines and relocated to small quarters in the rue d'Anjou. Interesting to note, however, is that Nadar allowed the Impressionist artists to mount their first exhibition in his old establishment on the boulevard for which he still held the lease. His son Paul now managed the business, although it was not until 1895 that Nadar formally turned over all rights to the name and all remaining partnership in the business. In his retirement Nadar began yet another career as a memoirist, which included the 1900 publication, *Quand j'étais un photographe* [*When I Was a Photographer*].

Nadar's final work as a photographer occurred in 1897 after his son failed to pay him his annuity: he opened a portrait studio in Marseilles but sold it in 1899. In 1900 Nadar was honored with a retrospective exposition of his work at the Exposition Universelle. The last decade of his life found him in failing health, although he survived both his younger brother Adrien and his wife Ernestine. Upon Paul Nadar's death in 1939, the Nadar studio ceased to exist.

NANCY M. SHAWCROSS

Biography

Born Gaspard-Félix Tournachon on 6 April 1820 in Paris, Nadar was the first child of printer/publisher Victor Tournachon and Thérèse Maillet. Originally educated in and around Paris, Nadar began but never completed the study of medicine in Lyons, where his father had relocated the family. In 1838 Nadar returned to Paris on his own and adopted "Nadar" (sometimes "Nadard") as his pen name. In Paris in the 1840s, Nadar allied himself with a band of vagabond artists that Henri Mürger immortalized in *Scènes de la vie Bohème* [Scenes from the Life of Bohemia]; among them was Charles Baudelaire. Nadar's first career was as a writer, but by 1846 he had embarked on a second career as a caricaturist, culminating in his 1854 tour de force, *Panthéon Nadar* (a revised version appeared in 1858), a set of two enormous lithographs comprising caricatures of noted Parisians. In 1854 Nadar also married Ernestine-Constance Lefèvre and assisted his brother Adrien by financing photography lessons for him with Gustave Le Gray and setting up a photographic studio, first for Adrien and then for himself. Though he continued to do caricatures throughout the 1850s, by the 1860s Nadar was an established portrait photographer in Paris, becoming a member of the Société française de photographie in 1856, exhibiting in its Salon in 1859, and pioneering a number of photographic techniques and locations, such as the first aerial photography and artificial lighting in 1858, equestrian photography in 1861, and photographing the catacombs and sewers of Paris in 1861–62 and 1864–65, respectively. In addition to these careers Nadar was also an aeronaut and financed a hot-air balloon called *le Géant* [*Giant*]. Nadar retired from photography in 1873, leaving his studio to his son Paul (1856–1939) to run. During his retirement Nadar continued to write and publish memoirs; he briefly re-emerged as a photographer in 1897 in Marseilles. Nadar died in Paris on 20 March 1910, fourteen months after the death of his wife.

See also: Le Gray, Gustave; Bertsch, Auguste-Adolphe; Wet Collodion Negative; Lacan, Ernst; *Cartes-de-Visite;* and Aerial Photography.

Further Reading

Baldwin, Gordon, and Judith Keller, *Nadar—Warhol, Paris—New York: Photography and Fame*, Los Angeles: J. Paul Getty Museum, 1999 (exhibition catalog).

Chevallier, Alix, and Jean Adhémar, *Nadar*, Paris: Bibliothèque nationale, 1965 (exhibition catalog).

Gosling, Nigel, *Nadar*, New York: Knopf, 1976.

Hambourg, Maria Morris et al., *Nadar*, New York: Metropolitan Museum of Art, 1995 (exhibition catalog).

McCauley, Elizabeth Anne, *Industrial Madness: Commercial Photography in Paris, 1848–1871*, New Haven: Yale University Press, 1994.

Nadar, *Quand j'étais photographe* [*When I Was a Photographer*], Paris: Seuil, 1994.

Nadar, *Correspondance* [*Correspondence*], edited by André Rouillé, Nîmes: J. Chambon, 1998.

Nadar: les années créatrices: 1854–1860 [Nadar: The Creative Years, 1854–1860], Paris: Réunion des Musées Nationaux, 1994 (exhibition catalog).

Néagu, Philippe, and Jean-Jacques Poullet-Allamagny, *Le Parisian souterrain de Félix Nadar, 1861*, Paris: Caisse nationale des monuments historiques et des sites, 1982 (exhibition catalog).

Prinet, Jean, and Antoinette Dilasser, *Nadar*, Paris: A. Colin, 1966.

NADAR, PAUL (1856–1939)
French photographer, entrepreneur, and son of Nadar

Paul Nadar was born February 8, 1856, in Paris, the only son of Ernestine and Félix Tournachon, better known as Nadar. Considered one of the premier portraitists of his time, Félix Nadar was celebrated for his *Panthéon Nadar,* caricatures of mid-to late 19th century Parisian cultural players, and his informal photographic portraits of these artists, writers, and performers.

Nadar's collodion-on-glass portraits were renown for their intimacy and details. As opposed to the work of contemporaries such as Disdéri, Nadar used minimal props. In lieu of elaborate backdrops and costumes, his subjects were shown in everyday clothing, either in frontal or three-quarter angle views. Mirrors, combined with natural and artificial lights, created dramatic shadows and framed his subjects in light, an effect intended to mirror their personal aura. Amongst the most intimate of Nadar's works were his photographs of Paul. In a celebrated work of 1856, the infant Paul is shown being fed by his wet nurse. Two years later, Paul is shown resting against the body of Madame Lefranc in a work that recalls late Italian Renaissance and Baroque images of the Madonna and Child.

By 1862, Nadar lost interest in studio photography, yet was forced to accept commissions from politicians and prosperous bourgeoisie. As a result, his celebrated aesthetic was often compromised as he, like most studio photographers, focused on lucrative *carte-de-visites.*

Nadar increasingly relied on studio assistants, who sometimes worked without him, to create his photographs. Despite the commissions, Nadar closed his studio on the fashionable boulevard des Capucines in 1871. That same year, he established a smaller practice at 51 rue d'Anjou. Run by his wife, Ernestine, this studio catered to a more affluent clientele and prospered. Paul, who had been trained by his father, acted as the artistic director, while Nadar pursued other interests. Paul became manager in 1874 and led the Nadar Studio in a different direction. While Nadar photographed wealthy clients in order to fund other projects, Paul actively sought such commissions, even photographing theater troupes and producing the occasional nude postcard to make the studio profitable.

Paul changed the celebrated Nadar aesthetic in order to accommodate this new clientele. Paul and Ernestine embraced conventional studio photographic props that Nadar despised, such as artificial backdrops, contrived poses, and elaborate furniture to create a more decorative style. Although the photographs show more generic expressions and less personality than in his father's portraits of his friends, this fashionable aesthetic catered to the new style and allowed the studio to financially prosper.

Between 1880 and 1885, Paul ran the Nadar studio. Because of his aesthetic and production methods, critics have portrayed Paul as less concerned with craftmanship than his father. Paul worked with gelatin instead of collodion negatives to increase the number of negatives and did not use salted paper or albumen for printing as Nadar had done. Therefore, when he reworked his father's glass negatives, his prints lacked the delicacy and degrees of tonality of the originals. In addition, he often altered Nadar's negatives, minimizing the rich backgrounds to make more pictorialist, and hence more fashionable, images. Although not actively involved in the studio, Nadar disapproved of these changes and, after years of fighting, father and son were estranged around 1885.

This estrangement proved to be brief as in 1886 the Nadars worked together on the celebrated *Entretien de M. Nadar avec M. Chevreul, le jour de son centenaire (M. Nadar Interviews M. Chevreul on his Hundredth Birthday)*. Intended to illustrate scientific and technological progress, the photographs anticipated the photographic series and photojournalism. Originally made for the newspaper *L'Illustration*, eight of the twenty-seven photographs had a delayed debut on September 5, 1886, in *Le Journal Illustré*. Termed the first photo-interview, it was to be a conversation between the noted chemist and color theorist Eugène Chevreul and Félix Nadar on the former's birthday recorded by Nadar on a photophone and photographed by Paul using a camera with a roll-film attachment, which due to technical problems had to later be rewritten by Nadar.

In 1886, Paul Nadar took control of the Nadar Studio and began photographing from a hot-air balloon as his father had earlier, even photographing the infamous fire at the at l'Opéra Comique in 1887. He exhibited these works at the Société française de la photographie and was caricatured in the press as "The Fearless Paul Nadar" for his courage and his photographic experimentation. In 1890, Paul embarked on a trip across Europe and Asia to Turkestan following the ancient silk route. Paul acted as an early photojournalist, documenting his travels and photographing sites as diverse as bazaars, mosques, and desert landscapes. During his voyage, he worked with experimental new equipment from Eastman Kodak that used flexible films, which proved more portable and instantaneous than the standard glass plates. In 1893, he became the French agent for George Eastman and Eastman Dry Plate & Film Company, known as Eastman Kodak, and opened the first Parisian Office of Photography, which sold photographic equipment, including hand cameras, designed for amateur photographers.

Paul presented his work to prominent photography associations, including la Société Française de la Photographie and la Société des Hautes Etudes Commerciales. In 1891, he founded the journal *Paris-Photographe*, which, despite publishing prominent pictorials, was in financial trouble by 1894. The same year, he married Marie Degrandi, an actress at the Opéra Comique. In 1895, Félix Nadar officially transferred legal ownership of the Nadar Studio to his son, which he ran until his death on September 1, 1939. The Nadar studio, run by Paul's daughter, Marthe closed a few years after Paul's death. In 1950, Paul's second wife, Anne Nadar, sold the photographic collection, archives, and documents from the Nadar studio to the French government. The Caisse Nationale des Monuments Historiques et des Sites acquired about 60,000 negatives while the Bibliothèque Nationale acquired all prints, archives, and documents made by and concerning Félix and Paul Nadar. Discovered amongst the 400,000 glass negatives acquired by the Ministry of Education were Paul's photographs of Marcel Proust and his circle of friends and family members. In 2001, Anne-Marie Bernard edited a critically acclaimed book, *The World of Proust, as seen by Paul Nadar,* which featured a selection of these images.

JENNIFER FARRELL

Biography

Paul Nadar was born on February 8, 1856, in Paris. He was the only son of Ernestine and Félix Tournachon, better known as Nadar. Paul Nadar was trained in photography by his father, the celebrated portraitist. First as artistic director and later as manager, he ran his father's

third and final studio at 51 rue d'Anjou. Under Paul, the new studio catered to a more affluent clientele and prospered. As a photographer, Paul made fashionable images of the bourgeois and aristocratic clientele. In 1890, he began shooting from a hot-air balloon as his father had earlier. After these works were exhibited, he was caricatured in the press as "The Fearless Paul Nadar" for his courage and his experimentation with photography. In 1890, Paul photographed sites in Europe and Asia along the ancient silk route. He worked with new equipment from Eastman Kodak and, in 1893, he became an agent for George Eastman in France. He inherited the Nadar Studio after his father's death in 1910. The studio survived only a few years after Paul's death on September 1, 1939.

See also: Cartes-de-Visite; Collodion; Pictorialism; and Société française de photographie.

Further Reading

Bernard, Anne-Marie ed., *The World of Proust as Seen by Paul Nadar*, Cambridge, MA: The MIT Press, 2002.
Hambourg, Maria Morris ed., *Nadar,* New York: The Metropolitan Museum of Art, 1995 (exhibition catalogue).
McCauley, Elizabeth Anne. *Industrial Madness, Commerical Photography in Paris, 1848–1871*, New Haven, CT: Yale University Press, 1994.

NARCISO DA SILVA, JOAQUIM POSSIDÓNIO (1806–1896)

Joaquim Possidónio Narciso da Silva was one of the main 19th century Portuguese photographers. Particularly during the 1860s, he produced beautiful salt paper prints of Portuguese monuments, however he is best known as an architect and archeologist. His photography was, as a matter of fact instrumental to his research in architecture and archeology. Very young he went with the Portuguese Royal Family escaping from the Napoleonic invasions to Brazil. Latter, between 1821 and 1834, he studied and worked in France and Italy. He was a founding member of the Real Associação dos Arquitectos Civis e Arqueólogos Portugueses in 1863 and latter of the Museu Nacional de Arquelogia. Before that, in 1862–63 he published the illustrated magazine *Revista Pitoresca e Descritiva,* which, in several issues, presented 26 photographs as salted paper prints of some of the most important Portuguese monuments. As a photographer, as well as an architect and archeologist he promoted nationalism by means of knowledge of monuments and history. In 1875 he was a member of the commission charged of the reform of fine arts where he proposed the inclusion of photography in museums.

NUNO PINHEIRO

NASMYTH, JAMES HALL (1809–1890) AND CARPENTER, JAMES (1840–1899)

James Nasmyth's place in the history of photography lies in the area of scientific illustration. He was a successful inventor who was able to retire in 1856 to pursue his interests as an amateur astronomer. Nasmyth had built his first telescope in 1827 and began to study the surface of the moon in 1846. He made a series of drawings recording his observations as photography was not yet able to record images under these conditions. These drawings received a medal when they were exhibited at the Great Exhibition in London in 1851. Nasmyth then constructed three dimensional models of the surface of the moon based on these drawings. These models were then photographed under conditions of bright sunlight to emphasis the contours of the terrain.

These photographs were of the special type used in the Woodburytype process. In the process of developing these special photographs, the lighter areas were rinsed away, leaving intaglio matrices. Lead was pressed into these matrices to form a relief and this relief was used to print the illustration in the book. The result was an image that more faithfully reproduced the continuous value gradations within the emulsion of a photographic print than the hatching technique of engravings. These Woodburytypes were published in a book titled *The Moon as a Planet, a World, and a Satellite* in 1874 in collaboration with James Carpenter, Nasmyth's friend and a professional astronomer associated with the Royal Observatory at Greenwich.

The creation of Woodburytypes was a cumbersome and time-consuming procedure. At the time, however, it was a practical medium for printing a photograph with a text. Tipping actual photographs into a text strained the limits of producing large amounts of positive prints from a single negative. The economic alternative of an engraving made from an original photograph allowed the intervention of the hand to subvert the objective value of photography as a mechanical imaging process which had been one of photography's most valued attributes from its earliest development.

The Woodburytypes maintained the integrity associated with mechanical imaging technology as objectivity was a central concern for science and scientific illustration. Thus the Woodburytype would have seemed to be the perfect medium for scientific illustration despite being cumbersome and expensive. It is ironic that Nasmyth's use of drawings and the construction of models, accepted practice in scientific research and publication, may be seen as subverting the very truth value of the photograph that made photography a valued tool for science. Nasmyth's models of the moon's surface reflected his desire to present "a rational explanation of the surface details of the moon which should be in accordance with the generally received theory of planetary

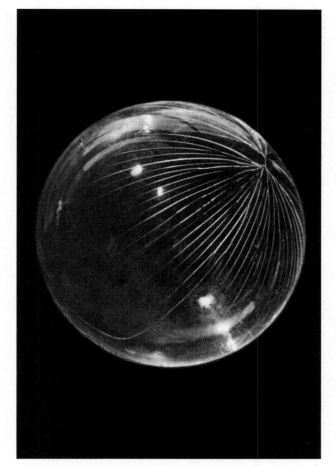

Nasmyth, James and James Hill Carpenter. Glass Globe. Cracked by internal pressure illustrating the cause of bright streaks radiating from Tyoho.
The J. Paul Getty Museum, Los Angeles © The J. Paul Getty Museum.

formation." Some of the models were even designed to simulate volcanic activity, including eruptions. Theories of planetary formation were based on contemporary knowledge of the earth's geology and Nasmyth himself had observed volcanic activity during his travels. Yet the models involved the use of the hand in their construction, defying the advantages believed to be an inherent quality of mechanical reproduction.

The value of scientific illustration is based on an implicit faith in the processes of observation, reason, and representation. Theories of planetary formation were dependent on the reliability of the knowledge of the geology of the earth. This reasoning by analogy was based on the belief that similar effects had similar causes. Nasmyth applied this conceptual algorithm to a comparison of a dried apple and the back of a human hand. His reasoning was simple: similarities between the skin of the apple and the skin on the back of a human hand could be the product of similar subcutaneous phenomena. The evidence was supplied by the juxtaposition of photographic reproductions.

Naysmyth's faith in the objectivity of his drawings and his models was consistent with the scientific practice of the time. It was also consistent with his use of drawings and models when developing a new idea for a machine. Naysmyth was a very successful inventor. He was constructing miniature steam engines at the age of 17 and was commissioned by the Scottish Society of the Arts to create a steam powered vehicle capable of carrying up to six people in 1827. Nasmyth started his own business in 1834 at the age of 26 in which he successfully built steam engines and machine tools and, in 1839, drew sketches for the design of a steam hammer which he eventually patented in 1842.

Nasmyth's sketches and drawings represent the first stage in the concrete realization of an idea. The working models he constructed represent the second stage and demonstrate that his ideas do indeed work. The third stage is the manufacturing of the full-scale machine. In a move that was prescient for the time, he recorded these sketches in photographs as early as 1839 as record of and as proof that he had worked out the idea. There are no records of photographs having been made of the models or full-scale machines as if they themselves were the concrete documentation for the idea. In the case of the photographs of Nasmyth's models of the moon's surfaces, complete with simulated volcanic activity, one might conclude that the models themselves were the demonstration and proof of his ideas. The photographs and resulting Woodburytype illustrations were a means of making his ideas available to a wider public.

Nasmyth credited his ability to develop his ideas through drawings to the art instruction he had received from his father, Alexander Nasmyth. We can also trace his interest in mechanical reproduction, illustration and model making to the same source. Alexander Nasmyth used a *camera obscura* in his art instruction and created models when redesigning estates. The owners of the estates he painted often asked him to redesign their estates to more closely resemble the imaginative landscape paintings. Alexander Nasmyth was also considered the founder of the Scottish school of landscape painting and was also known as an artist.

KARL F. VOLKMAR

See also: Woodburytype, Woodburygravure.

Further Reading

Armstrong, Carol, *Scenes in a Library: Reading the Photograph in a Book*, Cambridge, Massachusetts, MIT Press, 1998.

Cantrell, John A., James Nasmyth and the Bridgewater Foundry, *A Study of Entrepreneurship in the Early Engineering Industry*, Manchester: Manchester University Press, 1985.

Nasmyth, James, *James Nasmyth, Engineer: An Autobiography*, Ed. Samuel Smiles, (1883; Lindsay Publications, 1990).

NASTYUKOV, MIKCHAIL PETROVICH
(active 1860s–1880s)
Professional photographer

Mikchail Petrovich Nastyukov had his own studio in Moscow since 1862, and from 1869, he worked in the Nizshni Novgorod fair. His studio photo-portraits were always performed on a high technical and artistic level. Sometimes they were *cartes-de-visite*, and sometimes when rather large they were framed and served as a decoration. His studio was quite popular among the people of various social statuses and wealth. Nastyukov photographed painters, writers, actors, and others, and is proved by the considerable number of photographic portraits in existence. Unfortunately we know nothing about his private life, his friends or his environment. It is only known that in the 1860s he was under the patronage of His Highness Crown Prince Alexander (the future czar Alexander III). In 1869 Nastyukov created a group portrait depicting Prince Alexander with his wife and his retinue

The most outstanding of his works was the series of photographs of Volga towns. The series was in 1866–67 and then comprised an album under the title "Views of Volga from Tver' to Kazan'." The photographs glued upon passe-partouts were made by contact method from negatives sized 30–40 cm. It was one of the first important photographic series showing Volga's area.

Nastyukov was one of the first photographers to work outdoors on a large scale. This outdoor work was naturally hindered by considerable technical problems due to the fact that photographers of the time had only wet-collodion method at their disposal. The cumbersome camera, low sensitivity of photo-plate—all these limited the choice of scenes for photography. But the primary objective of any photographer was to break away from the concepts of painting forced upon the artistic value of photographs. For quite a long time photography had been viewed only as an auxiliary means for painting with the main function of recording reality.

Nastyukov made photographs of the monuments of architecture paying special attention to orthodox cathedrals—and they looked grand in his photographs. He was one of the first to start taking photographic chronicles of the Russian architectural monuments. This theme later attracted the attention of the Russian photographers. Nastyukov was in constant search of new images and objects, which is how he started making photographs of peasants from the neighbouring villages.

In the second half of the 19th century, the lives of peasants (with serfdom abolished only in 1861) was a burning issue, which found its reflection in the democratic art. The photographer combined architectural images with images of common people and their life. However technical problems prevented him from rendering life the way he wanted. So that his photographs would remain descriptive he built their composition through the use of the laws of painting.

In 1867, Nastyukov worked in Simbirsk, the town that attracted another outstanding photographer working in Russia, the Scots-born William Carrick, known in Russia as Vasiliy Andreevich Carrick.

In 1869, having accumulated enough experience in outdoor photography, Nastyukov accompanied the Great Prince Alexander Alexandrovich and his wife in their trip throughout Russia. This trip included a visit to the fair in Nizshni Novgorod and Nastyukov accompanied them as their photographer. For these photographs Nastyukov was awarded a bronze medal at All-Russia Polytechnic exhibition in Moscow in 1872.

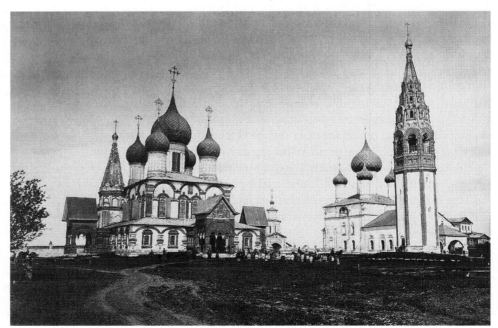

Nastyukov, Mikchail Petrovich. The Church in Yaroslavl 1867.
Private Collection: Alexei Loginov.

Nastyukov also received the title of the photographer of His Highness Crown Prince Alexander (the future czar Alexander III).

In the 1870s, Nastyukov photographed the views of Moscow and its suburbs. In the village of Borodino, where in 1812 the great battle of the Russian troops against the army of Napoleon took place, the photographer captured images of the peasant life. In 1879, Nastyukov photographed the flood which took place in Moscow in April. The album of these photographs was given to the Moscow general-governor V. Dolgorukov. At the moment the album is in the collection of the State Russian Library.

In 1883, he made a series of photographs under the following title "Groups of foremen from all over Russia taking part in the celebration of crowning of the Royal Highness in May of 1883." This album is comprised of 512 portraits. It was purchased into the collection of the Emperor's Public library. Photographic ideas introduced by Nastyukov were taken up and developed by some other prominent Russian photographers, such as Andrey Karelin and Maksim Dmitriev.

Since 1865, Karelin worked in Nastyukov's studio. By that time Karelin was already fond of photography and had retouching experience. In Nastyukov's studio he learned the technology of the photographic processes during the time when Nastyukov was busy making photographs of Volga views. Karelin's works on Volga comprised his famous "Nizshni Novgorod" album. This experience would provide Karelin the knowledge to open his own studio in future.

In 1873 Maksim Dmitriev, who was then fifteen years old, became Nastyukov's apprentice. In Russia the adolescents were often taken to various workshops to study crafts. There they usually did hard work. In Nastyukov's studio, Dmitriev became exceptional familiar with the technology of the photographic processes. Once he became a well-known photographer, he developed his teacher's ideas in the album called "Volga series."

Nastyukov was a prominent figure in Russian photography at its start, but there are unfortunately very few reference sources on his life and work, most of them nowadays are lost. In the photographic circles of his time Nastyukow was considered an important photographer. Thus his failures were always noticed. In the beginning of the 1880s there came a new generation of Russian photographers. It was probably difficult for Nastyukov to compete with them. The last mentioning of his studio work to be found in literature is dated from the year 1883.

He was one of the pioneers of the full-scale outdoor photography. It is also worth mentioning that in his work he used and developed purely photographic expressive means.

ALEXEI LOGINOV

Biography

Mikchail Petrovich Nastyukov had a studio in Moscow since 1862. He worked at the Nizshni Novgorod fair since 1869. In 1866—67s he made an album of photographs called "Views of Volga from Tver' to Kazan'." Nastyukov worked in Simbirsk and Nizshni Novgorod, and acted as an accompanying photographer to the Great Prince Alexander Alexandrovich and his wife during their trip throughout Russia. Nastyukov received the title of the photographer of His Highness Crown Prince Alexander (the future czar Alexander III). Nastyukov was one of the first in Russia to successfully complete a full-scale outdoor photo-session employing purely photographic expressive means.

Further Reading

Russian Photography. Edited by N. Rakchmanov, M., Planeta, 1996.
Russische Photographie 1840–1940. Ars Nicolai GmbH., Berlin, 1993.
Horoshilov, P. ,and A.Loginov, *The Masterpieces of the Photography from Private Collections. Russian Photography 1849–1918,* Punctum 20036.

NATTERER, JOSEPH (1819–1862) AND JOHANN (1821–1900)

The Natterer brothers belonged to a dynasty of Museums curators, which fostered their scientific activity, particularly in the Dienst der Naturalien-Kabinette des kaiserlichen Hofes, now the Naturhistorisches Museum in Vienna. Their grandfather had worked there, and their father Josef Natterer as well as his brother Johann Natterer (1787–1843), who traveled to Brazil.

Joseph and Johann Natterer began their career at the Institut as Assistenzkuratoren. Joseph and Johan were involved with photography for a short time, but during that time, they created a new photochemical sensitization process for the daguerreotype (iodine bromine chlorine mixture) around 1841. Their accelerated process, and a camera using the fast lens computed by Josef Petzval in 1840, resulted some of the earliest known "instantaneous" pictures (street scene with figures) with exposures of possibly less than one second. This innovation took place in the Fürstenhofrunde in Vienna, a club established by scientists, technicians, the medical profession, artists, and pioneers of photography. This club enabled the progressive orientation of photographic culture in Austria during the nineteenth century, which was extraordinarily important.

MAREN GRÖNING

Biography

Joseph Natterer was born on 23 May 1819 in Vienna.

He did not receive special academic training. He began as Kustos Adjunkt" (Assistenz curator) at the Dienst der Naturalien-Kabinette des kaiserlichen Hofes (today the museum of Natural History in Vienna). From 1855 to 1858, he traveled Nubien (today the majority area of the Sudan) and Central Africa, where he acquired, among other things, animals for the imperial Menagerie in the park of Schoenbrunn, Vienna. He returned to Africa as an Austrian consulate representative to Khartum. He died on December 17, 1862 of malaria. Johann Natterer was born on October 13, 1821, in Vienna. He received his medical degree, but worked like his brother Joseph as an assistent curator) at the Dienst der Naturalien-Kabinette des kaiserlichen Hofes. Apart from his main profession as a physician (until 1874) and politician in the Viennese local council (1861 to 1879), he also worked as an inventor. In addition to the advancement of the Daguerreotype to instananeous photography, with the help of his brother, he created the construction of a compressor pump involving the liquefaction of carbonic acid, which set a new standard for the industry. He died on December 25, 1900, in Vienna.

See also: Austro Hungarian Empire, excluding Hungary; Societies, groups, institution, and exhibitions in Austria; Daguerreotypie; Moment photography

MAREN GROENING

Further Reading

Bauer, Alexander, "Johann Natterer 1821–1900," in *Österreichische Chemiker-Zeitung*, 4. Jahrgang, 1901, 1–8.

Starl, Timm, *Biobibliografie zur Fotografie in Österreich 1839 bis 1945*, 1998ff. (wird regelmäßig aktualisiert), http://alt.albertina.at/d/fotobibl/einstieg.html.

Starl, Timm, *Lexikon zur Fotografie in Österreich 1839 bis 1945*, Wien: Album, Verlag für Photographie, 2005.

NATURALISTIC PHOTOGRAPHY

Naturalistic Photography was the term introduced by Peter Henry Emerson to describe both the aspiration for and practice of photography as a distinct form of art. Initially articulated in "Photography as a Pictorial Art," first in a lecture offered at the Camera Club of London on March 11, 1886, and later printed in *The Amateur Photographer* (March 19, 1886), it received full treatment in the manual, *Naturalistic Photography for Students of Art* (1889). Emerson offered a theory of art grounded in the principle that the finest art was that which was true to nature, and, more specifically, true to nature as perceived by the human eye. "Wherever the artist has been true to nature, art has been good. Whenever the artist has neglected nature and followed his imagination, there has resulted bad art" (Emerson, 1886). Further,

the element that distinguished photography from other visual systems was its inherent truthfulness. From this core principle, he advised that for photography to be an art form it must be independent, not imitative, of other artistic forms, such as painting. "Truth to Nature" was achieved under his system of "Naturalistic Photography" when the photographer turned to nature for his subjects, rather than created tableaux that mimicked the subjects and compositional strategies of painting But more than the stipulation to photograph the subjects found in nature, Emerson decreed that in order for a photograph to be "truthful" it must faithfully incorporate the way in which the human eye apprehended the scene. In a long prologue, Emerson had argued for the congruence of art and science; one did not contradict the other and art must incorporate the knowledge derived from science. This had special relevance for photography and a theory of human vision. As a medical student, Emerson had followed the developments in achieving a scientific model of human vision and he was particularly persuaded by the physiologic mechanism of vision proposed by German physicist Hermann von Helmholtz in *Handbook of Physiologic Optics* (1867). Helmholtz described a visual mechanism in which the human eye registers in sharp detail only the limited portion of the visual field that it is directly focused on and attentive to, and that elements that are not within the area of focal interest are unsharp to a greater or lesser degree depending on their position relatively to the central area of focus. For Emerson, Helmholtz's theory of selective vision explained the lack of artistry he found in photographs that were disconcertingly sharply focused across the entire image. They did not represent truthfully the world as seen by the human visual apparatus.

Emerson translated Helmholtz's model into the practice he described as "differential focus," the intervention by the photographer, through choice of lens, to limit sharpness to a single point in the image while suppressing details in surrounding areas. The resultant photograph more closely accorded with the way that nature directly perceived would register in the eye.

> Nothing in nature has a hard outline, but everything is seen against something else, and its outlines fade gently into that something else, often so subtly that you cannot quite distinguish where one ends and the other begins. In this mingled decision and indecision, this lost and found, lies all the charm and mystery of nature. (Emerson 1889, 150)

Emerson defined the equipment and procedures for achieving naturalistic photographs: a whole plate size view camera, a tripod, and most importantly, longer focal length lenses with the correct "drawing power" to render the scene in "natural" perspective with detail correctly distributed throughout the scene in accord with

natural human vision. He declared hand cameras a tool for amateurs and condemned enlarging, retouching, and, most vehemently, combination printing. He recommended printing in platinum—the Platinotype Company had introduced commercially prepared platinum papers in 1880—or in photogravure—an ink-based printing process. Both had the potential to produce a very long scale of contrast and soft tones with a delicacy of effect that was particularly suited to natural vision and differential focus.

Emerson positioned his theory of a photographic art based in science and true to the inherent qualities of both the photographic process and nature in opposition to the practice of art photography proposed by Henry Peach Robinson in *Pictorial Effect in Photography* (1869). Robinson stated that photography in order to attain the status of an art must combine both the real and the ideal, and that in the pursuit of this standard the photographer must compose as did painters. In practice, this meant planning and organizing the picture through sketches and studies, and translating the pictorial ideas into photographs through the use of subjects posed and lighted to emulate paintings. Frequently the results were large, complex prints built up from a number of negatives. Robinson's vision of photographic art was highly constructed and artificial. Emerson articulated his theory—in lectures, articles, and his book, and in a series of combative letters to photographic journals—as diametrically opposed to a bankrupt and ill-considered practice that had no artistic merit. Although Emerson's position on photographic art is generally presented as oppositional to Robinson's, it should be recognized as a continuation of contemporary discourse on naturalism in art. Ideas of naturalism in painting had been articulated by Francis Bates, "The Naturalistic School of Painting," in 1886 and by Thomas Goodall with whom Emerson collaborated on *Life and Landscape on the Norfolk Broads.*

Illustrating his theory of naturalistic photography, Emerson produced a number of photographically illustrated books and folios in platinum and photogravure: *Life and Landscape on the Norfolk Broads* (1886); *Pictures from Life in Field and Fen* (1887); *Idyls of the Norfolk Broads* (1888); *Pictures of East Anglian Life* (1888); *Wild Life on a Tidal Water* (1890); *On English Lagoons* (1893); and *Marsh Leaves* (1895). In his work, he returned again and again to the watery fens of eastern England, recording scenes of ancient rural rhythms. Emerson's use of differential focus in photographs printed in soft Platinotype or as photogravures captured a very personal visual experience of a natural order uniting land and people. In point of fact the fens were changing under the pressures of drainage and land recovery schemes and the onslaught of modern tourism. The self-professed proponent of an equivalently scientific and artistic view of nature in photography created a romantic and nostalgic record of a vanishing way of life.

In 1891 Emerson reversed himself and acknowledged that one could not attain in photography the degree of expressive control necessary for it to be defined as an art. In 1895 he published a pamphlet the title of which, set on a black bordered page, proclaimed *The Death of Naturalistic Photography: A Renunciation*. His reading of recent scientific studies on the chemical processes in photographic development had convinced Emerson that the photographer could not control the tonal values of a print through the development process to the extent that he had assumed. He concluded that the degree of chemical determinism meant that photography could not be an art.

> The limitations of photography are so great that, though the results may and sometimes do give a certain aesthetic pleasure, the medium must always rank the lowest of all arts....Control of the picture is possible to a *slight* degree, by varied focusing, by varying the exposure (but this is working in the dark), by development, I doubt (I agree with Hurter and Driffield, after three-and-a-half months careful study of the subject), and lastly by a certain choice in printing methods. But the all vital powers of selection and rejection are *fatally* limited, bound in and fixed by narrow barriers. (Emerson 1895, n.p)

Despite his rejection of the scientific basis of photography as an art, he continued to make and publish photographs. *On English Lagoons* and *Marsh Leaves* were both released after his repudiation of photography as an art. In 1898 he published a third and revised edition of *Naturalistic Photography* which was substantially the same as earlier editions—the same description of the technique for and justification of differential focus, the same stipulations regarding equipment, the same prohibition on enlarging and darkroom manipulation, the same guidelines for photographic printing. The most significant change was in the final chapter now titled, "Photography—Not an Art."

Despite Emerson's rejection of his position, Naturalistic Photography had a lasting effect. He had articulated a position for photography as an art form based on the inherent attributes of photography and its intimate connection with the natural world. If he had disavowed his insistence on the scientific basis of his theory of photographic practice, he had not disavowed his pugnacious criticism of previous practitioners of art photography. His stipulation to adhere to photographic principles and to use the camera in the natural world influenced succeeding generations. His luminous prints stood as exemplars of what could be achieved with the direct depiction of visual experience.

KATHLEEN STEWART HOWE

See also: Robinson, Henry Peach; and Hurter, Ferdinand, and Driffield, Vero Charles.

Further Reading

Emerson, P. H., *Naturalistic Photography for Students of Art*, London: Sampson, Low, Marston, Searle and Rivington, 1889; rpt. New York: Arno, 1973.

——, *The Death of Naturalistic Photography: A Renunciation*, London: privately published, 1895.

Handy, Ellen, "Art and Science in P. H. Emerson's Naturalistic Vision." In Mike Weaver, ed., *British Photography in the Nineteenth Century: The Fine Art Tradition*, edited by Mike Weaver, 181–196, New York: Cambridge University Press, 1989.

Handy, Ellen (ed.), *Pictorial Effect Naturalistic Vision: The Photographs and Theories of Henry Peach Robinson and Peter Henry Emerson*, Norfolk, VA: Chrysler Museum, 1994.

McWilliams, Neil, and Veronica Sekules (eds.), *Life and Landscape: P.H. Emerson, Art & Photography in East Anglia, 1885–1900*, Norwich, England: Sainsbury Centre for Visual Arts, 1986.

NAYA, CARLO (1816–1882)
Italian photographer and studio owner

Carlo Naya was born at Tronzano di Vercelli in 1816. He studied law at the University of Pisa. Thanks to an inheritance, he travelled extensively, visiting the most important cities in Europe, Asia and Northern Africa. In 1857 he settled in Venice where he opened a studio as a photographer. He became very well—known for his views of the city's monuments and works of art. His photographs were sold by Carlo Ponti, a photographer and seller of engravings and optical instruments. Naya collaborated with other Venetian photographers to produce an album of views of Venice in 1866, when the Venetian Republic was annexed to Italy. He then opened a studio at Procuratie Nuove which was visited by artists, scholars and tourists. He took photographs of Giotto's frescoes in the Scrovegni Chapel in Padua, in 1864—1865 and in 1867, to document the restoration works. He won many awards: the Great Medal at the Universal Exhibition of London (1862); gold medals at the Exhibitions of Groningen (1869), Trieste and Dublin (1872). He died in Venice in 1882. His wife, Ida Lessiak, was left in charge of the studio. She died in 1893 and her second husband, Antonio Dal Zotto, took over the atelier. On his death, in 1918, the studio was closed and the main part of the photographic archive was bought by the publisher Osvaldo Böhm.

SILVIA PAOLI

NÈGRE, CHARLES (1820–1880)
French photographer and painter

A successful academic painter, Charles Nègre turned to photography in the 1840s and elaborated an aesthetic of intimate, highly subjective compositions that suggested moments seized from everyday life. He produced some of the first photographic genre studies and street scenes and sought to imbue the photograph with an emotional immediacy that contradicted its reputation as a dispassionate product of science. "Photography is not a remote and barren art," he explained. "[It] does not destroy the personal feelings of the artist" (Rouillé, 133).

Nègre was born in Grasse, France on 9 May 1820, the first of four children to the owners of a confectionery business. Rather than join the family enterprise, Nègre embarked on an artistic career, taking drawing lessons

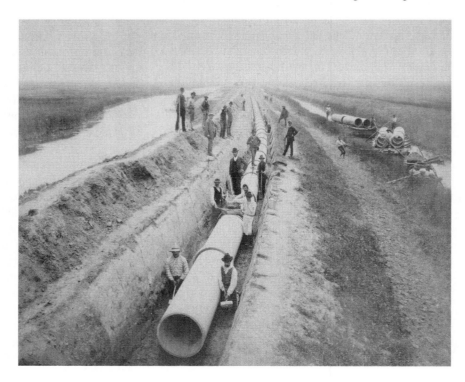

Naya, Carlo. Acquedetto di Venezia (nuova condotta). Cantiere dell' Argine. Arrangement of the aqueduct of Venezia.
The J. Paul Getty Museum, Los Angeles © The J. Paul Getty Museum.

from Sébastien Pezetti of Aix-en-Provence while in high school. His father encouraged Nègre's ambitions, helping send him to Paris in 1839 to apprentice in the studio of Paul Delaroche. Delaroche was one of France's most distinguished painters and an early advocate of photography, counting among his apprentices the the budding photographers Gustave Le Gray, Roger Fenton, and Henri Le Secq.

In 1841 Nègre entered the Ecole de Beaux-Arts and in 1843 he briefly worked in the studio of Michel-Martin Drolling before moving to the studio of Jean-Auguste-Dominique Ingres, where he remained for several years. Beginning in 1843, he exhibited historical and mythological paintings at the annual Salon in Paris, and continued to exhibit there on and off until 1864, well after he had become better known as a photographer.

Nègre first attempted photography by making daguerreotypes in 1844 as an aid to his painting, but by 1848 he had moved to the calotype process for the greater aesthetic flexibility offered by its paper negative. Nègre would modify the negative with ink or pencil as well as adjust printing methods to meet his artistic intentions. While his first photographs were primarily model studies and studio portraits, he soon broadened his scope to produce action scenes of working people taken from the streets of Paris. From chimney sweeps to itinerant musicians or vendors at the market, Nègre sought formally challenging but unified images of harmonious effect, reminiscent of the Flemish and Dutch Masters he much admired.

These genre scenes had an immediate impact on the emerging photographic community. "The Little Rag-Picker" (1851), an image of an exhausted boy resting beside his heavy basket, was deemed "no longer a photograph" but rather "a thoughtful and intentional composition" by contemporary critic Francis Wey. Although those terms do not seem mutually exclusive, the comment underscores the early perception of the photograph as merely a mechanical exercise inconducive to producing pictorial harmony.

Nègre devised a series of lenses to allow for the very short exposure times required to capture these scenes, and while the bustling participants in his market scenes blurred slightly, each is readily distinguishable at his or her task. It was his "Chimney-Sweeps Walking" (1852), however, that attracted the most praise for delivering a sense of arrested movement. As Nègre carefully posed his three subjects in simulated stride it was not an image of motion as such, but of an effect that testified to the artist's technical and compositional capabilities. While he occasionally incorporated elements from these photographs in his Salon paintings, he also mounted and signed the prints as finished works in their own right.

By the early 1850s, Nègre was searching for ways to live as a professional at his photography without resorting to the common, stultifying choice of studio portraiture. Encouraged by the government's 1851 Mission Héliographique [Heliographic Mission], which had employed his friend Le Secq and others to photograph historic monuments, Nègre spent the summer of 1852 documenting the landmarks of his native Midi region. Although he had hoped to publish a comprehensive album of these photographs, he managed only two installments in 1854 before the project ran aground. A project to photograph all of Paris' landmarks, which occupied him for three to four years in the mid-1850s, met a similar fate. However, one image from that series, popularly known as "Le Stryge" [The Vampire] (c.1853), was a success upon exhibition and has become an icon of 19th-century photography. A striking hybrid of Romanticism and modernity, it depicts Le Secq haughtily posed in his top hat among the grotesque sculptures decorating the parapet of the cathedral of Notre Dame, from which he surveys the urban sprawl like a cosmopolitan demigod.

Nègre's two excursions to Chartres—in 1851 and around 1854—illustrate the evolution of his landscape and architectural work. During his first visit with Le Secq, Nègre produced idyllic, pastoral village scenes embodying the picturesque style he had learned while an art student. The photographs from his second visit, however, are much larger and concentrate on the city's famous cathedral, emphasizing symmetry and monumentality. Influenced by the photography of Le Secq and Edouard Baldus, Nègre approached the building like a sculptural text to be read in parts, privileging clear information over sentiment and mood. Despite his stylistic adjustments, Nègre struggled to win government commissions and, perhaps out of desperation, wildly proposed making a photographic catalog of the history of man, a suggestion that earned him only a modest contract photographing selected works in the Louvre.

It was in 1858, on one of his final projects, that Nègre reconciled his talent for capturing small genre scenes with the more grandiose demands of public photography projects. Asked to document a new imperial asylum erected in Vincennes to house disabled workers, Nègre favored large plates to depict the complex's exterior, but reverted to smaller plates (requiring shorter exposure times) to capture the interior scenes of employees at their tasks. These contemplative compositions of cooks, pharmacists and nurses present labor as simple yet ennobling and reflect Nègre's belief that a combination of "observation, sentiment and reason reproduces effects that make us dream, and simple motifs that move us." In "Vincennes Imperial Asylum: The Linen Room" (c.1858), sunlight falling gracefully on a nun folding sheets turns her endeavor into a gesture of quiet splendor worthy of Vermeer.

A founding member of the Société héliographique

Nègre, Charles. A Street in Grasse, Montée de Fontlaugière.
The Metropolitan Museum of Art, Purchase, Jennifer and Joseph Duke Gift and Chairman's Council Acquisitions Fund, 2000 (2000.286) Image © The Metropolitan Museum of Art.

[Heliographic Society] and the Société française de la photographie [French Photography Society], from his first daguerreotype experiments Nègre was deeply involved in promoting photography and contributing to its technical improvement. From 1854 to 1867, in an attempt to capture the generous De Luynes prize for the advancement of photogravure, he perfected a process that used gilding via galvinoplasty to increase tonal ranges in prints. Though he lost the competition, he was invited to present his results—first patented in 1856—at industrial exhibitions throughout Europe.

His health failing, Nègre returned to his native Midi in 1863, finding work as a high school drawing instructor and opening a commercial studio in Nice. He continued to promote his photogravure process through writings, lectures and exhibitions, but was never able to parlay his efforts into commercial success beyond a small series of photogravures of Chartres cathedral assembled for the government in 1858 and a contract to produce the plates for the Duc de Luynes' book, *Voyage à la Mer Morte* [Voyage to the Dead Sea] in 1871.

Nègre's photographs from his Nice years were limited to standard carte-de-visite portraits and Riviera views intended for the tourist trade. When he died in Grasse on 16 January 1880, his career had fallen into obscurity, his photogravure process having long been forgotten and the emerging dry-plate process making motion photography a banal affair available to all with a camera. It was only with the exhibition of selections from his personal archives in the 1960s and 1970s that his reputation was reestablished.

STEPHEN MONTIERO

Biography

Charles Nègre was born on 9 May 1820 in Grasse, France. He studied at the Ecole des Beaux-Arts in Paris, apprenticing in the studios of Delaroche, Drolling and Ingres. He exhibited paintings at the annual Salon in Paris on several occasions between 1843 and 1864 and was appointed drawing instructor at the Ecole Supérieure du Commerce [Higher School of Business] in Paris in 1852. He took up photography in 1844 as an aid to his painting. Particularly known for his genre studies, he also made extensive photographic surveys of the Midi region in 1852 and of Paris landmarks during the mid-1850s. In 1858 he undertook a government commission to photograph selections from the Louvre collection, followed by a commission to photograph the Imperial Asylum in Vincennes in 1859. He exhibited his photographic work in over two dozen exhibitions throughout Europe, including the exhibition of the International Society of Industry in Amsterdam in 1855, the Universal Exhibition in Paris in 1855, 1863, 1867, 1868 and 1878, the French Photography Society exhibition in 1855, 1859, 1861 and 1864, the International Exhibition of Industrial Arts in Brussels in 1857 and 1861 and the Universal Exhibition in London in 1862. He patented an improved photogravure process in 1856. In 1863 he moved to Nice, where he opened a commercial studio and taught drawing at the Lycée Imperial [Imperial High School] until 1878. He died in Grasse, France, on 16 January 1880.

See also: Delaroche, Paul; Le Gray, Gustave; Fenton, Roger; Le Secq, Henri; Daguerreotype; Calotype and Talbotype; Mission héliographique; Baldus, Édouard; Société héliographique Française; Société française de photographie; and Photogravure.

Further Reading

Borcoman, James, *Charles Nègre 1820–1880,* Ottawa: National Gallery of Canada, 1976.

Heilbrun, Françoise (ed.), *Charles Nègre: Photographe 1820–*, Paris: Musées Nationaux, 1980.

Jammes, André, *Charles Nègre Photographe 1820–1880*, Paris: André Jammes, 1963.

Nègre, Charles, *De la Gravure Héliographique, Son Uitilité, Son Origine, Son Application à l'Etude de l'Histoire, des Arts et des Sciences Naturelles* [*On Heliographic Engraving, Its Usefulness, Its Origin, Its Application to the Study of History, the Arts and the Natural Sciences*], Nice: V.-E. Gauthier, 1866.

Nègre, Joseph. *The Riviera of Charles Nègre: First Photographs of the Côte d'Azur (1852–1865),* Aix-en-Provence: Edisud-TAC-Motifs, 1991.

Rouillé, André, *La Photographie en France, Textes & Controverses: une anthologie 1816–1871* [Photography in France, Texts and Controversies: an anthology, 1816–1871], Paris , Macula, 1989.

Sotheby's, *La Photographie III, Collection Marie-Thérèse et André Jammes: L'Œuvre de Charles Nègre [Photography III,* the Marie-Thérèse and André Jammes Collection: The Work of Charles Nègre*], Paris: Sotheby's, 2002.

NEGRETTI AND ZAMBRA (1850–1899)
Optical instrument firm

Negretti & Zambra was established in 1850. Of the two partners, Henry Negretti and Joseph Warren Zambra, the former is by far the better documented and became known as "one of the pioneers" of British photography through his improvements to apparatuses and through his marketing of high-quality stereoscopic views.

Enrico Angelo Negretti was born on 13 November 1818 in Como, Italy. Leaving home at an early age, he had arrived in England by the time he was twelve years old and became apprenticed to Francis Augustus Pizzala at nineteen. By 1839 he set up his own establishment as a glass blower; after a brief partnership with the widow of another glass blower and barometer maker, by 1845 he was again in business for himself, soon expanding to include a range of philosophical instruments and running two branches, at 19 Leather Lane and 9 Hatton Garden. On 1 July 1845 he married Mary Peet, who subsequently worked in the firm; the couple had five children, of whom three survived their infancy.

On 24 April 1850, Negretti entered into partnership with Joseph Warren Zambra, born at Saffron Waldon in 1822 to an English father and an Italian mother. Negretti & Zambra seized the opportunity to promote their wares at the Great Exhibition of 1851, where they won a prize medal for glass instruments shown in Class 10, "Philosophical instruments and their dependent processes," the same category that featured several photographic apparatuses, such as an early stereoscope constructed by Louis Jules Duboscq. Following their success at the Crystal Palace, Negretti & Zambra were named meteorological instrument makers to the Queen, but they soon became better known for their stock of equipment relating to the daguerreotype, calotype, and collodion processes—cameras, glass plates, head rests, tripods, dark tents, frames, and chemicals. When the Crystal Palace re-opened in Sydenham in 1854, Negretti & Zambra were appointed official photographers and a year later sent a team of operators, including Philip Henry Delamotte, to produce a number of instantly popular images of Queen Victoria's reception of Napoleon III and the Empress Eugénie.

As business grew, the company moved to larger and more numerous facilities: 59 Cornhill (1860–72), 1 Hatton Gardens (1860–69), 107 Holborn Hill (1860–61), 122 Regent Street (1862–76), 153 Fleet Street (1865–73), Holborn Circus (1870–76), Charterhouse Street (1870–76), 45 Cornhill (1873–76), Crystal Palace, Sydenham (1883–99). The last-named establishment

was among London's first portrait studios to feature electric lighting.

Negretti & Zambra became best known as publishers of stereoscopic views. By the 1860s their catalogue included interiors of the Crystal Palace; genre scenes; views of Europe, America, and India; and Claude-Marie Ferrier's instantaneous transparencies on glass. The landmark series depicting the Near and Far East were eagerly anticipated and exceptionally well reviewed. The first of these, *Stereoscopic Views in the Holy Land, Egypt, Nubia, &c.*, with negatives by Francis Frith, appeared in 1858; followed by *Stereoscopic Views in China* in 1859 and *Scenes and Scenery in Java* in 1861, photographed by P. Rossier and Walter Bentley Woodbury, respectively. Contrary to contemporary reports, Negretti & Zambra did not typically commission and finance a photographer to undertake an expedition, but would purchase the negatives and assume all costs of production and distribution. These could be considerable, as in the case of the views of Japan, which featured high-quality mounting and packaging in a Japanese style, as well as special stereoscopes made to the firm's order in Japan and bearing Japanese-style decorations. Sales were very brisk, although undercut by poor-quality pirated versions.

Negretti & Zambra were responsible for innovations in several other areas of photography. In 1855 they sold packets of albumen glass plates guaranteed for one month in the attempt to popularize this process (though ultimately albumen-on-glass did not compete with collodion wet plates); in 1858 they marketed an advanced oxy-hydrogen (or limelight) magic lantern capable of magnifying a projected image to 40 feet in diameter; and in 1868 they sold an early bellows-style pocket camera designed by C.D. Smith. The firm were also pioneers in the field of photographically illustrated books and the reproduction of works of art: they produced the prints, reduced from 3-foot-square negatives, were tipped into Richard Henry Smith's *Expositions of the Cartoons of Raphael* (London: J. Nisbet, 1860) and *Expositions of Great Pictures* (London: J. Nisbet, 1863). Negretti & Zambra won a prize at the International Exhibition of 1862 for the series of 100 stereographs Frith made during a second trip to the Holy Land, published as *Egypt, Nubia, and Ethiopia* (1862), with a text by Joseph Bonomi and Samuel Sharpe, and sold with a folding stereoscope for 3 guineas. A photographic venture of Negretti's that seems not to have a commercial motivation was his flight in a balloon to take aerial photographs, accomplished on 28 May 1863, five years after Nadar's famous flight ascent in France.

A charismatic and energetic man, Negretti enjoyed a public profile, especially among the Italian community. He hosted Garibaldi when he visited London in 1854 and ten years later served as chief of the reception committee that greeted the now-famous Italian patriot. In 1864 Negretti intervened in a high-profile murder investigation, saving the innocent Serafino Pelissoni from the gallows by proving that Pelissoni's cousin Gregorio Mogni was in fact guilty of the crime. For this he received a knighthood from King Victor Emmanuel. In his last years Negretti spent time in Como, but he died at his Cricklewood home on 29 September 1879. Zambra survived him by eighteen years, dying at his home in Hampstead on 23 December 1897.

Negretti & Zambra's success was such that in 1861 the *Art Journal* credited them with completing "what we might entitle a stereographic *cordon* in and about London." But because the firm did not specialize in subsequent decades, by 1879 it as not, as the *British Journal of Photography* noted, quite as well known as it had been. The last commercial branch closed in 1899.

BRITT SALVESEN

See also: Books illustrated with photographs: 1850s and 1860s; Great Exhibition of the Works of Industry of All Nations, Crystal Palace, Hyde Park (1851); Delamotte, Philip Henry; Frith, Francis; Rossier, Pierre; and Woodbury, Walter Bentley.

Further Reading

Bonomi, Joseph, and Samuel Sharpe, *Egypt, Nubia, and Ethiopia*, illustrated with photographs by Francis Frith, London: Smith, Elder and Co., 1862.

Haaften, Julia Van, "Francis Frith and Negretti & Zambra," *History of Photography* 4, 1 (January 1980): 35–37.

Negretti & Zambra, *Egypt and Nubia: Descriptive Catalogue of One Hundred Stereoscopic Views of Pyramids, the Nile, Karnack, Thebes, Aboo-Simbel and All the Most Interesting Objects of Egypt and Nubia*, London: Negretti & Zambra, 1858.

Negretti & Zambra, *An Illustrated Descriptive Catalogue of Optical, Mathematical, Philosophical, Photographic and Standard Meteorological Instruments, Manufactured and Sold by Negretti & Zambra*, London, Negretti & Zambra, 1859.

Negretti, P. A., "Henry Negretti—Gentleman and Photographic Pioneer," *Photographic Collector* 5/1 (1984), 96–105.

"The Late Mr. Henry Negretti," *British Journal of Photography* 26, 1013 (3 October 1879): .472.

NEKHOROSHEV, N. (active 1870S)

N. Nekhoroshev worked in Tashkent. He was the author of *The Turkistan Album* published in 1871–72 in six copies and divided into three parts: *The Ethnographic Album*, *The Crafts Album*, and *The Historical Album*. One of these copies made its way to the Emperor Alexander II.

The Ethnographic Album consisted of two volumes and included the following types of photographs: national types of the Turkistan Territory, views of towns and villages, images of clothing, utensils, and musical instruments.

The Crafts Album included photographs of local industries.

The Historical Album included portraits of the Russian military men photographed in action during the military expedition to Middle Asia and also included landscapes and views of the Turkistan Territory from the numerous fortresses.

The Turkistan Album was a main and monumental photographic work in Russia during those times. No other Russian territory was so systematically and completely photographed as the Turkistan Territory was because of Nekhoroshev's photographs. The greatest value of the album was the fact that the life of the territory's nations was photographed from nature. The leading Russian art critic V. Stasov expressed his high praise and opinion of the album. He found the photographs therein valuable, and not just to the sphere of documentation and ethnography, but to Russian culture as well. Stasov mentioned that "each photograph is a really folk image…truly and picturesquely showing the Turkistan customs and life."

ALEXEI LOGINOV

NETHERLANDS

The invention of photography was announced in The Netherlands as soon as in other countries; newspapers and magazines reported on it in 1839, especially after the first public demonstrations of the process in Paris. The first Dutchman to take up a camera was the Amsterdam painter and dealer in artists' materials Christiaan Julius Lodewijk Portman (1799–1868), who exhibited three daguerreotypes (maybe a few more) at an art exhibition held in October 1839 in The Hague. Some of these were made in Paris—where he is supposed to have acquired equipment for making daguerreotypes —some in Amsterdam and The Hague. Portman's daguerreotypes are unknown nowadays and it is uncertain whether he took up photography as a way of earning money or as an interesting experiment. It was probably he who translated into Dutch one of Daguerre's manuals; it was published in a magazine, not separately. After the first few practitioners had come and gone and many an article had been published in newspapers and magazines in 1839, photography seemed to slip out of public notice for about two years. In 1842 a number of itinerant photographers took up the medium. Well into the 1850s most photographers travelled from one city to the other, often staying only a few days. Setting up a temporary studio in a hotel, an inn or at a private house, they sometimes showed specimens of their work in the shopwindows of local art dealers. Judging by their names, most of these itinerant photographers seem to have been French (or Belgian). However, it was recently discovered that the best known of these, Edouard

François, who in his newspaper advertisements implied that he was Parisian, was actually a young Dutchman, Eduard de Prouw. He took on a French name to make a better impression onto his clientele: all things French had a good reputation in those days. Moreover, the pseudonym suggested he had been trained in one of the main centres of photography. Instead of returning each winter to Paris, as his newspaper announcements suggest, he lived in the Dutch capital all his life. Due to the fact that only in the other seasons was there sufficient light to make photographs, he was only active as a photographer part of the year, practising another (unidentified) job in winter. Those who really came from abroad sometimes visited The Netherlands as part of a larger journey from France and/or Belgium to the north west of Germany. For instance, Louis Lumière, who was the second person known to have been working as a daguerreotypist in The Netherlands—he demonstrated the process in the Hague in November 1839—was also active in Ghent and Antwerp (October–November 1839) and in Bremen (January 1840). He is believed to have been a Parisian merchant, but his name is not to be found in the literature of early French photography. The same applies to the others who visited The Netherlands: A. Derville (1842), F. la Moile (1848–1850, 1852–1853), and Louis Schweig (1846, 1853). Besides foreigners, Dutch photographers also travelled the country. Most of these earliest photographers are known to us mainly through advertisements and articles in the press, rather than through their works, which have either not survived or are unidentified today.

The earliest photographer from whom a significant body has survived is the Amsterdam amateur Eduard Isaac Asser (1809–1894), a lawyer by profession. Some fifteen daguerreotypes and four albums with about 200 prints were kept in the family until recently, when the whole collection was transferred to the Rijksmuseum in Amsterdam. Asser often directed his camera towards his family and friends and also photographed quite a few still-lifes and cityscapes. Only a few of Asser's photographs are dated, but he seems to have made most of them in the first half of the 1850s. The photographs in the four albums especially introduce us into the world of a well-to-do Amsterdam family. Unfortunately, Asser did not caption the prints, nor did he leave any written account of his working methods or aesthetic considerations. Some of his portraits have a charm and liveliness that is lacking in most portraits made by professional photographers. As far as we know, Louis Wegner (1816–1864) was the only professional photographer who did portraits in a "grand manner" in the 1850s. A series of four rather large portraits he made of the painter Nicolaas Pieneman is noteworthy.

From the late 1850s onwards, most professional photographers set up a permanent studio instead of

travelling around. This must be due to a growing number of clients, especially after the introduction of the carte-de-visite around 1860. One of the very first to realise the commercial viability of the carte-de-visite was Maurits Verveer (1817–1903), who established himself in The Hague in 1857. From 1861 he launched a rather large series of portraits of "Tijdgenooten in Kunsten en Wetenschappen" (contemporaries in the arts and sciences). Amongst them were writers, painters, university professors, and clergymen. A contemporary comment on Verveer's portraits suggests that—in general—clergymen and low-necked danseuses sold best. The habit and fashion to exchange carte-de-visite portraits is demonstrated by the diary of the Danish writer Hans Christian Andersen, who, during a stay in The Netherlands in 1866, gave away many copies of his portrait and received a similar number in return from people he met. As in other countries, it was a hobby to collect such portraits and to put them in an album specially designed for that purpose. Very often, such an album would begin with royal persons, followed first by other famous people and then by acquaintances of the one who compiled the album.

Professional photographers depended almost completely on the making and selling of portraits, both of well-known persons and of individuals who wanted a (half) dozen of their portraits to circulate among their friends and relatives. All other subjects—topographical views, art reproductions, the construction or demolition of buildings—were comparatively marginal. Pieter Oosterhuis (1816–1885) was one of the very few who closed down his portrait studio—he did so in 1869—to concentrate upon photographing the construction of railways, canals, breakwaters, bridges, sluices and other public works. In the second half of the 1850s he had already started making a great many stereoscopic views in Amsterdam and other towns. The latter survive in rather large quantities, so they must have sold well. Commissions for photographs of public works probably paid handsomely, otherwise Oosterhuis would probably not have taken the decision to close down his studio. He seems to have been the only photographer whose commissions were located throughout the country, whereas in most cases a commission was awarded to a local photographer.

Most of his colleagues, however, stuck to portraiture. In Amsterdam their number rose from six in 1851 to about sixty by 1899. The Hague and Rotterdam followed: in these cities about fifty and about fourty photographers respectively were active in 1899. Judging by the occupational censuses that were held three times in the 19th century, most studios, especially in the smaller towns, were rather small: in 1889 and 1899 the average photographer had only one assistant. The actual number of people working in a photographic studio may have been a little higher, as it is likely that in many cases the photographer's wife and/or children worked there, too, without being counted in the census. Contrary to what is regularly asserted in the literature of Dutch photography, the carte-de-visite was not within everyone's reach: many people did not earn enough to be able to afford the relative luxury of having themselves photographed or collecting pictures of famous people. A set of twelve cartes-de-visite usually cost about four or five Dutch guilders in 1865—c. 30 to 35 Euro in today's money. That was simply too much for the lower classes.

In the first two decades, photographers often took on other jobs, in order to earn a living. Like in any profession, some became quite prosperous, while others never escaped poverty. Research into assessment-lists that have survived suggests that since the 1860s most photographers managed to be independant from other jobs and earned a decent living. A popular assumption is that many photographers originally were second-rate painters who changed their profession to earn more money. In fact, only approximately one-third of the professional photographers had a background in the arts (painting and engraving, especially), while a similar number came from commerce and handicraft. Those who had started as artists did not always completely give up their original profession, but sometimes practised the two at the same time. (It is the same with printing firms, which continued to produce engraving or lithography, but took up photographic printing as an extension of their activities.) Although some photographers reached prosperity, only some of them formed part of the cultural or social elite. Societies or clubs counted few photographers among their members, with the exception of artists' societies, of which many photographers were still members even if they did give up their former artistic occupation. Photographers are seldom mentioned in letters, autobiographies and other material that might otherwise have given some information on what kind of people they were and how they were looked upon. The social standing of photography was not very high, and, assuming that in the 19th century most people still married within their own class, the professions of their fathers-in-law may serve as an indication as to which kind of occupations photography was mostly associated with. Most brides were the daughters of working men, craftsmen, and tradesmen; they nearly all had a lower or middle class background. Apparently these were the classes in which photographers belonged.

Throughout the 19th century there was no other way to learn photography than to be trained by an accomplished photographer. Until 1942 photography was a profession that could be practised without a license, i.e. the obligation of having finished some official education. Although there were occupations easier to enter

or to master (requiring less financial investments and technical-chemical skills), there may have been some charlatans in photography, many of whom were active at fairs or still wandering from one small town or village to another. Several photographers complained about these less appreciated "colleagues." (Sometimes a photographer would accuse a rival of being a quack, evidently one of the worst insults one could think of.) It is not unlikely, however, that these complaints were mainly prompted by the wish of established photographers to be accepted as full-fledged citizens or even artists. As it has already been pointed out, the photographer's social status still left much to be desired.

On the one hand, feeling superior to people who made their money on fairs or by roaming around, photographers must have felt much less secure about their relationship with the arts. They so often presented themselves as artists—especially by calling themselves "peintres-photographes" and by surrounding their names by images of putti, palettes, and other symbols of the arts on the back of their photographs—and that strongly suggests a wish to be equalled with traditional artists. The latter will not always have appreciated these efforts to claim or reach the status artists held. Photography was not considered an art. On the contrary, it was judged a technical invention that required certain skills but no artistic mastery. The camera did most of the work, not the photographer. Painters or engravers hardly ever expressed themselves upon this subject, but art critics were more outspoken. Photography might be useful as a documentary means—it was especially appreciated as a way to reproduce works of art—but it lacked artistic qualities. The ways of reasoning will have been about the same as in any other country.

To be sure, most portrait photographs *did* lack artistic merit. Carte-de-visite portraits are done in the same way to an astonishing degree. Variation was a word not in the photographer's vocabulary. The same props were used over and over again: tables, seats, carpets, columns, balustrades, in later decades also painted backgronds. The setting and postures were regardless of the persons depicted. It is striking that the wealthy, amateur photographer Alexandrine Tinne (1835–1869) used exactly the same props when she made some portraits of her relatives in the garden of her house in The Hague in 1860–1861. The same applies to a series of domestic scenes the amateur photographer Jordaan Everhard van Rheden made in the 1860s and 1870s. One would have expected an amateur to feel free to deviate from the stereotype settings professionals took to.

Regarding the invention or development of new techniques or apparatus, Dutch photographers were not in the front row. They merely followed what was being done abroad. At first France was the country that was looked upon as a source of things new, later Germany took over this role. There have been a few exhibitions—especially those in Amsterdam in 1855 and 1860—where foreign photographers like Gustave Le Gray, Edouard Baldus, and the Bisson brothers showed their works, but this seems not to have stimulated Dutch photography very much. There is no sign that it changed much after these exhibitions took place. Photographers still clung to making portraits; cityscapes, art reproductions and the like were produced on a much smaller scale. Landscapes are quite rare in Dutch photography and until the advent of Pictorialism (*picturalisme* in Dutch) in the 1890s "free photography" hardly existed. Amateurs were an exception to this, but their number was relatively modest. However, they hold an important place among the photographers who have left a considerable oeuvre that is still appreciated nowadays for its artistic qualities. Besides Asser and Tinne three men should be mentioned who were active in the last decade of the 19th century: the painter Georg Hendrik Breitner (1857–1923), his friend and colleague Willem Witsen (1860–1923), and the architect and headmaster of a technical school Jacob Olie (1834–1905). Breitner and Olie photographed extensively on the streets in Amsterdam and did portraits—Breitner also photographed many nudes—while Witsen mainly took portraits of his fellow artists and of young contemporary writers. All three made pictures that lack the stiffness and coldness of professional work. As they did not take part in exhibitions and their work was not known outside their own circles, they did not have any influence on the course of Dutch photography. Other amateurs united in societies that were founded in many a Dutch town from 1887 onwards. This was due to the introduction of smaller, easier to handle cameras and readymade negative plates. Some amateurs were quite serious about their hobby, others were just making snapshots without giving much attention to composition and other aspects of photographic aesthetics.

Snapshot photographers were fiercely attacked for lowering the average level—especially by the Pictorialists who wanted photography to be accepted as an art form rather than considered just a pleasant pastime. Pictorialism rose in the 1890s and was to dominate the scene after the turn of the century. It recruited its followers from both professionals and amateurs. They not only turned against the snapshot photographers who were criticised for being too unpretentious, but they also scorned the way most professional portrait photographers conceived their occupation. The Pictorialists took offence at the props used over an over again and at the large amount of retouching which made people look like "billiard balls" or "wax statues.." Instead, Pictorialists like P. Clausing, C.M. Dewald, and C.E. Mögle wanted to do justice to their sitters by treating them as individuals. No portrait should be the same, as

no person is identical. They also paid more attention to better printing techniques like the platinum print and the gum bichromate print. Apart from portraits, they did landscapes, genre scenes, and city views; in this, they were much inspired by the painters of The Hague School. There is, perhaps, a certain nostalgia in Pictorialist pictures; scenes of quiet life on the land constitute a substantial number of them. They usually display a quiet atmosphere, largely due to the diffused incidence of light. The concern felt for farmers, workmen, tramps, and gypsies was rather superficial, however, as they mainly served as picturesque motifs. The 1890s saw a new élan, with the founding of photographic magazines and the organisation of some international exhibitions. In 1902, the Nederlandsche Fotografen Kunstkring (NFK, Dutch Art Photographers' Circle) was founded to give some more direction to the Pictorialist school. Some belonging to the first generation of Pictorialists could also be dubbed naturalist photographers, but as their number was modest, like the amount of their pictures that have survived, it is not always easy to make a clear division between the two tendencies.

In the 19th century, Dutch photography followed a course that did not differ much from what was happening abroad. Despite international exhibitions that were held from time to time, some photographer's membership of foreign photographic societies, and the constant influx of foreign—especially German—photographers who settled in The Netherlands, 19th-century Dutch photography did not develop to the same heights as in some other countries.

HANS ROOSEBOOM

See also: Bisson, Louis-Auguste and Auguste-Rosalie; Pictorialism; Baldus, Édouard; Le Gray, Gustave; Cartes-de-Visite; Asser, Eduard Isaac; and Lumière, Auguste and Louis.

Further Reading

Coppens, Jan, and A. Alberts, *Een camera vol stilte: Nederland in het begin van de fotografie, 1839–1875,* Amsterdam, Meulenhoff, 1976.

Coppens, Jan, Laurent Roosens, and Karel van Deuren, *"... door de enkele werking van het licht ...": introductie en integratie van de fotografie in België en Nederland, 1839–1869,* Antwerp, Gemeentekrediet, 1989.

Leijerzapf, Ingeborg Th. (ed.), *Fotografie in Nederland 1839–1920,* The Hague, Staatsuitgeverij, 1978.

Leijerzapf, Ingeborg Th. (ed.), *Geschiedenis van de Nederlandse fotografie in monografieën en thema-artikelen,* Alphen aan den Rijn/Amsterdam, Samson/Voetnoot, 1984–. [a series still being published]

Rooseboom, Hans, *De schaduw van de fotograaf. Status en positie van Nederlandse beroepsfotografen, 1839–1889,* Leiden, Primavera, 2006 or 2007.

Venetië, Robbert van, and Annet Zondervan, *Geschiedenis van de Nederlandse architectuurfotografie,* Rotterdam, 1989.

NETTLETON, CHARLES (1826–1902)
English studio owner and photographer

Charles Nettleton was born in 1826 in London, the son of George Nettleton and Susannah Feathers. Charles worked as a manufacturing chemist in London and in 1854 immigrated to Melbourne, Australia where he was employed as a photographer in the studio of Duryea and McDonald. Nettleton performed the outdoor work. Nettleton set up his own studio in 1858 and plied a trade in portraiture but he remained a prolific view photographer, working for the Victorian Government and City of Melbourne Corporation, capturing all aspects of Melbourne and the Victorian countryside, including buildings, public works, transportation and sporting teams. For a brief period in 1861 Nettleton was in partnership with Charles Hewitt, during 1862 he managed the Melbourne Stereoscopic Company and then he formed another brief partnership with John Calder. Finally in 1864 he established premises in Madeline St., North Melbourne although various branch facilities were opened over the years. Nettleton produced the first commercial album in Australia, *Melbourne Illustrated by Photographs* in 1868 and he prolifically produced views in carte de visite, full plate and mammoth plate sizes for many years, being a master of the wet plate process. Nettleton exhibited widely at Australian and International Exhibitions. He finally retired from his profession in 1893 and he died on 4 January 1902.

MARCEL SAFIER

NEUHAUSS, RICHARD (1855–1915)

Richard Neuhauss was a doctor of tropical medicine who resided in Berlin but traveled widely. He published on many medical subjects but also was a superb experimentalist in photography with a special affinity for the Lippmann Process. Following German colonization he traveled to Papua New Guinea and published on his medical and photographic studies of the indigenous people there. He made a number of photographs of Otto Lilienthal's early flight experiments, and worked on early cinematography.

His Lippmann shooting records and about a half dozen plates are held by the Preus Fotomuseum in Vestfold, Norway, near Oslo. The lists describe more than 2,500 test exposures, a record for the process. Of these, only a tiny fraction, perhaps two dozen are known to survive. Most may have been failures. According to the lists, their subjects were relatively few and shot repeatedly, including self portraits, stuffed parrots, dead butterflies, still-lifes of flowers and foods, and a few outdoor images. He published a number of papers and a book on the process. He used his technical skills to publish images of microscopic thin-sections of

Lippmann images, which display their internal layered structure. Based on his surviving Lippmann images, he was a master of the process.

A primary source of interest for him in his photographic pursuits was the search for a color photographic process that would render high fidelity color images of microscopic subjects. In this goal he appears to have succeeded, as there is a superb Lippmann-type image of a microscope slide of a thin section of a human liver, showing the presence of a parasite, held at the National Technical Museum in Prague. Due to the super high resolution of Lippmann-type images, it would be capable of extreme further enlargement. As it is it is simply beautiful.

WILLIAM R. ALSCHULER

NEURDEIN FRÈRES
French company

One of the leading commercial photographic firms of the late nineteenth century, Neurdein Frères offered a diverse production including portraits, architectural and picturesque views of France and neighboring countries, and studies of provincial or North African women in traditional costume. Also heavily involved in photography of works of art shown in the Paris Salon and of the temporary architecture of several World Fairs, Neurdein Frères eventually acquired semiofficial status, managing and supplementing the French government's archives of photographs of historical monuments. These added administrative duties led to the withdrawal of Neurdein Frères from other photographic activities and to its eventual merger with a rival firm. Though its work was extensively published by Neurdein Frères itself and by other firms, it is not widely known today. Recent controversies over "Orientalist" photographs of women, however, have again brought attention to works by Neurdein Frères.

Little is known about the background of the Neurdein family. Etienne (1832–after 1915) and Louis-Antonin Neurdein (1846–after 1915) were the sons of the photographer Jean César Neurdein, who worked under the pseudonym of Charlet. In 1863, one of the Neurdeins operated a studio on the Rue des Filles-du-Calvaire in Paris. Subsequent Parisian locations of the Neurdein firm were the Rue des Filles-Saint-Thomas, Boulevard de Sébastopol, and Avenue de Breteuil. By 1868 the firm, now under the name E. Neurdein, advertised portraits of historical personalities and contemporary celebrities and already offered views of France, Belgium, and Algeria. The views were sold initially as albumin prints, later sometimes as gelatin silver prints, and were also reproduced in postcard format under the names ND Phot. or X Phot. The firm also became involved in extensive book publication based on its own photographs.

The brothers maintained a division of labor: Etienne managed the studio in Paris and made portraits, while Louis-Antonin traveled extensively, making architectural and landscape views.

The portraits, whether of prominent or little-known individuals, were usually in carte-de-visite format and differed little from comparable work produced by other photographic firms of the period. One Neurdein portrait, however, a Woodburytype of the chemist and political revolutionary François-Vincent Raspail, was included in 1878 in the prestigious *Galerie Contemporaine*, a lavish biographical publication dominated by works by the well-known portraitists Nadar and Etienne Carjat. The undated portrait of Raspail, who died in that year, depicts a still-forceful older man.

Views of castles, cathedrals, and architectural decorations, particularly in the French provinces, made up a large part of the firm's production; in this the Neurdeins emulated the role of other prominent European firms, such as Fratelli Alinari of Florence, in documenting architectural and artistic monuments. The selection of views offered was vast: a catalogue published by the firm in 1900, covering only works available in postcard format, ran more than five hundred pages. Louis-Antonin was by no means, however, the only photographer recording historic French architecture, and it is difficult to define a *style Neurdein* that might separate his work from views made by rival firms. Neurdein's photographs of medieval buildings, such as the Abbaye-aux-Hommes, Caen, are often taken from rooftop level to give views clearly separating the subject from the surrounding townscape. Other images provide valuable documentation of much vernacular architecture that has since disappeared due to war damage or modernization. This interest in bird's-eye views eventually may have led to Louis-Antonin's experiments with panoramic photography, especially of Paris, one of the most distinctive areas of his work.

Around 1900 Neurdein Frères branched into a new endeavor, depicting Algerian and Tunisian women in native costume in images disseminated both as albumin prints and postcards. This popular genre belongs more to erotica than to ethnology: the models often are overdressed and seminude at the same time. Such images have been condemned in recent years as manifestations of colonialist domination. It is true that these photographs are quite different from Neurdein's earlier, more sedate images of Alsatian or Breton women in folkloric costume, and the intervention of a local photographer working for the firm is a possibility. The North African figure studies are nevertheless more discreet than comparable images produced by rival firms such as Lehnert & Landrock, Geiser, or Lévy.

Louis-Antonin became a member of the Société française de photographie in 1884 and joined the Chambre syndicale de la photographie in 1886, followed by Etienne in 1902. The brothers were awarded prizes in several exhibitions, including the Expositions Universelle, Paris of 1889 and that of 1900, for views, often of considerable technical achievement, that were produced using a Moëssard panoramic camera. Their negatives of paintings exhibited in the annual Paris Salon were published in phototypogravure, creating lithograph-like images that were probably seen as more faithful to the original works.

In view of these accomplishments, the French government in 1898 awarded Neurdein Frères a concession to manage the photographic archives of the Service des Monuments historiques. This responsibility, which continued until World War I, involved maintaining the collection and printing and selling photographs from existing negatives by many artists. The firm also recorded additional historic monuments, particularly in Corsica, adding a thousand glass plate negatives that still exist in the archives. These activities left less time for the firm's other work, and early in the new century it merged with the Lévy firm as "Lévy et Neurdein réunis, 44, rue Letellier, Paris," operating under that designation into the 1920s.

Albumin prints, frequently large, by Neurdein Frères are found in many souvenir albums put together by British and American tourists to record their travels on the Continent. Such works preserve an architectural heritage that often has been altered or lost. The firm's popular views of Paris and of the Exposition Universelle of 1900 were issued in albums of mounted albumin prints and published in photogravure, often following a fixed order of subjects. Through these images, as well as their panoramic cityscapes and their controversial figure studies from the North African colonies, Neurdein Frères made a significant contribution to the photographic record of their time.

DONALD ROSENTHAL

See also: Architecture; Orientalism; Woodburytype, Woodburygravure; *Galerie Contemporaine (1876–1884)*; Nadar (Gaspard-Félix Tournachon); Marey, Etienne Jules; Alinari, Fratelli; Société française de photographie; and Expositions Universelle, Paris (1854, 1855, 1867, etc.).

Further Reading

Alloula, Malek, *The Colonial Harem*, Minneapolis: University of Minnesota Press, 1986.
Auer, Michèle, and Michel Auer, "Neurdein." In *Encyclopédie internationale des photographes de 1839 à nos jours*, Hermance, Switzerland: Camera Obscura, 1985.
Khemir, Mounira, "ND Photographe." In *L'Orientalisme: L'Orient des photographes au XIXe siècle,* Paris: Centre National de la Photographie, 1994.
Mathews, Oliver, *Early Photographs and Early Photographers*, London: Reedminster Publications, 1973.
Neurdein Frères, *Extrait des collections photographiques de Neurdein Frères: peintures et sculptures des musées nationaux: peintures et sculptures diverses*, Paris: Neurdein Frères, 1895.
Neurdein Frères, *Le panorama salon d'après les clichés photographiques de Neurdein frères,* Paris: Ludovic Baschet, 1895.
Neurdein Frères, *Catalogue des collections de sujets édités dans le format carte postale par Neurdein frères*, Paris: Neurdein, 1900.
Neurdein Frères, and Maurice Baschet, *Le panorama: exposition universelle,1900...avec les photographies de Neurdein frères et Maurice Baschet*, Paris: Ludovic Baschet, 1900.
Sebbar, Leïla, and Jean-Michel Belorgey, *Femmes d'Afrique du Nord: Cartes postales (1885–1930)*, Saint-Pourçain-sur-Sioule [Auvergne]: Bleu autour, 2002.

NEVILL, LADY CAROLINE EMILY (1829–1887); AUGUSTA, LADY HENRIETTA (1830–1912); AND FRANCES, LADY ISABEL MARY (1831–1915)

The 1852 exhibition at the Society of Arts in London included *A Portrait* by Lady Augusta Nevill, together with *Portrait of a Lady* by her sister Lady Isabel. With their sister Lady Caroline, they were the daughters of William Nevill, 4th Earl of Abergavenny.

'The Ladies Nevill' contributed two collections of work entitled *Portraits and Groups* and *Portrait Groups* to the 1854 exhibition of the Photographic Society of London, of which they were all members. All their images exhibited in 1852 and 1854 were described as by the collodion process.

These appear to be the only two occasions the ladies exhibited their work in major exhibitions, preferring instead to circulate images through the Photographic Exchange Club.

The Photographic Exchange Club album for 1855 contains two images by Lady Augusta, of the family home, Allington Castle in Kent, one by Lady Caroline, of Malling Abbey, and one titled *Allington, Kent* by L.F.C.Nevill whose identity cannot be confirmed. All are by le Gray's Waxed Paper process.

Two years later, the 1857 album included *Birling, Kent* by Lady Caroline, and two views of Eridge, East Sussex by Lady Augusta Mostyn. Lady Augusta married the Hon. Thomas Lloyd-Mostyn in 1855.

There are no records of their involvement with photography after 1857.

JOHN HANNAVY

NEW SOUTH WALES GOVERNMENT PRINTER

The New South Wales Government Printer (NSWGP), a public works department in Sydney, was established in 1859 as an extension of the postage stamp department. The first Government Printer, Mr. Thomas Richards, established the "Photolithographic and Lithographic" department in 1868 and the "Photomechanical" department in 1877. Richards' intention for the photographs was the depiction of natural features and the material progress of the colony; the distribution of the photographs was promotional. Photographs were sent to international exhibitions, including the Centennial International Exhibition, Melbourne, 1888, when the department sent 178 photographs. The main form of presentation, however, was in album format, produced internally by the Printer's binding department. The quality, style, and size of the albums were remarkable and produced as gifts for official visitors. The "Album of Views of New South Wales" presented to Lord Knutsford, the Colonial Secretary, in 1891 at the first Federal Convention includes civil works, public buildings, bridges, the Sydney Botanic Gardens and outlying districts. The photographers within the department remain unknown, but the "Narrative of the Expedition of the Australian Squadron to the South East Coast of New Guinea, October to December, 1884" (1885) has been attributed to Augustine Dyer (1873–1923). Photographs were purchased and commissioned from commercial operators including Henry King, Charles Bayliss, and Charles Kerry. Mr. Charles Potter succeeded Mr. Richards as the Government Printer in 1886.

JULIA PECK

NEW ZEALAND AND THE PACIFIC

Although the chronology of events regarding the announcement of the Daguerreotype process in late 1839 could have seen a camera and chemicals loaded on board one of the New Zealand Company's immigrant ships as it set sail from London to establish a settlement in Port Nicholson, in the lower half of the North Island, New Zealand, this was not to be. Thus the opportunity to document the founding of a British Colony from day one was passed over as other more important necessities of life found room in chests and trunks of those who braved the long voyage and the uncertainties of life in a new country. When a camera finally entered the coastal waters of New Zealand, it probably wasn't even taken out of its case before it left the northern port of the Bay of Islands in March 1841, on board a barque bound for Sydney, Australia. There its owner, a Captain Lucas of the French vessel Justine made a daguerreotype on April 13, 1841 which received publicity and is still heralded as the first photograph to be made in Australia.

The first written account of a daguerreotype being made in New Zealand appears in the journals of Lieutenant-Governor Edward John Eyre 1815–1901, who recorded that he failed in an attempt to get a likeness of Eliza Grey, wife of the Governor George Grey, who sat for him on the verandah of Government House, Wellington on September 17, 1848. Besides the amateur attempts of Eyre, trader entrepreneurs like J. Polack and J. Newman advertised their services in the art of daguerreotype portraiture in Auckland in May 1848. Promising as these announcements may seem, no New Zealand daguerreotype earlier than November 1952 can be positively attributed to any particular photographer. In this instance, it was Lawson Insley who visited several settlements in New Zealand between 1851–1853. His clients were Civil Servants, Ministers of the Church and successful trades people. When he finally left for Australia in 1853, he was one of the last itinerant photographers who came to New Zealand before crossing the Tasman Sea for more lucrative prospects in Australia.

After Insley, there was a gap of a year or so until 1855, when John Nichol Crombie 1827–1878 a Glaswegian who visited, provided portraits for whoever could pay his fees. His contribution to New Zealand photography is important for a number of reasons. First he experienced the transition from daguerreotype to collodion positives (ambrotypes) and then finally to the wet plate negatives which allowed paper prints to be made from a collodion negative. Secondly, his achievements in photography are easy to document because of numerous comments made about him in newspapers of the day. From all accounts, he was very outgoing and attracted attention wherever he went in New Zealand and overseas. During a brief visit to where he was born in 1862, he lectured the Glasgow Photographic Association on his New Zealand experiences. This event was duly reported in the British Journal of Photography which included some interesting statistics concerning how many portraits he made as a daguerreotypist in New Zealand. Thus we have a very good picture of his life and times as a pioneer photographer who spent nearly all of his professional years in New Zealand. While portraiture naturally remained his main source of livelihood, he periodically covered topical events, from a Royal Tour to Civil Engineering Projects in Auckland.

The constant flow of photographers between Australia to New Zealand continued in the 1850s and into the next decade following gold discoveries in both the North and South Islands.

Daniel Louis Mundy 1816/7–1881 was born in Wiltshire, England, and arrived in Dunedin in 1864 with sufficient capital to take over William Meluish's photographic business. Two years later he moved to

Christchurch where he made the acquaintance of geologist Julius von Haast, a person who was to play an important role in Mundy's photographic career. Leaving the portrait side of his business to a partner, Mundy commenced a series of New Zealand landscapes, starting with a journey from Canterbury to the gold fields of the West Coast through a newly discovered pass in New Zealand's Southern Alps. In doing so he depicted a route along which supplies could be transported to the diggings safely without recourse to using coastal shipping and the treacherous river ports of the West Coast. Gradually as he moved further afield from Christchurch he acquired a range of views which made him the first to go about the task of accumulating a fairly representative selection of New Zealand views.

Forever mindful of the circumstances that made New Zealand unique from the rest of the world, Mundy photographed the country's major rivers, lakes and mountains, supplementing these when he could with mining operations, flora and fauna. In 1869 with history in mind, he journeyed to the East Coast of the North Island to photograph the spot where Captain Cook had landed a hundred years ago. An exponent of the collodion process he developed many tricks of the trade to combat the stress and strain of taking photographs in a country where there were very few roads. His trials and tribulations along with other interesting anecdotes are recorded in the British Journal of Photography December 25, 1874. Altogether he made 250 photographs which he considered to be the pick of his collection. He exhibited these in London while supervising the production of his book, Rotomahana—the Boiling Springs of New Zealand, 1875. With descriptive notes by the distinguished Austrian explorer and academic Ferdinand von Hochstetter, his plates were printed using the newly discovered Autotype Process. The quality and presentation of his work at the 1873 Vienna International Exhibition and Rotomahana earned him a decoration from the Austrian Court.

In later years he moved to Australia where amongst other things he gave magic lantern lectures about his adventures in New Zealand and how he had to ford snow fed rivers in the Southern Alps and journeyed through territory in where the hostile Maori chief Hone Heke and his raiding parties were known to reside.

While Mundy and other photographers were coming to grips with landscape photography in New Zealand, Dr. Alfred Charles Barker 1819–1873 was documenting his family and friends in Christchurch. Barker came to New Zealand from England in 1850 on one of the first four ships that founded the Canterbury settlement. When a riding accident curtailed his activities as a medical practitioner, he gave up his practice and concentrated on Civil Administration, Land Deals and Photography. His earliest adventures into photography are dated 1858 and include the way Christchurch was founded on swamplands which had to be drained before the town could be laid out to a grid pattern bounded by four avenues a mile apart. Using equipment that he improvised for his needs, his work is noted for his outdoor portraits which were made in his Œstudio—the front garden of his house. Despite a somewhat cavalier attitude towards certain technical disciplines like using odd bits of glass which he crudely shaped to fit his camera, his portraits reveal personal characteristics of many of his sitters. A distinguishing feature of his work is a series of self portraits which he made from 1858 to shortly before he died in 1873. These tell of the hardships colonial life held for him.

John Kinder 1819–1903 who was born in London came to New Zealand in 1855 and took up a position as headmaster at the Church of England Grammar School in Auckland. A brilliant draughtsman and watercolourist, he took up photography around 1860 and quickly mastered the collodion process. Because a considerable number of his photographs replicate some of his watercolour studies, an observer might be drawn to conclude that he acquired his photographic skills purely as an aide memoir for his painting. Contradicting this are his more informal photographs which disclose a sensitive eye for studies which range from a Maori youth selling fruit on an Auckland Street, to friends and neighbors posed outside their houses. Possibly the most entrancing are a series of photographs of his wife Celia who posed for him on a number of occasions. In comparison to Barker, Kinder's studies are extremely formal and correct in every detail. They reveal a meticulous person whose approach to the visual arts were based strictly on the conventions of 19th century art.

Women photographers for the most part in New Zealand during the 19th century, were confined to assisting their husbands. Elizabeth Pulman 1836–1900 who was born in Cheshire, went beyond these limitations upon the death of her husband in 1871 and took over the control of their studio in Auckland. With her son Frederick, she carried on a very successful business which was noted for its fine selection of Maori portraits.

Another notable contributor to the photographic documentation of New Zealand was James Bragge 1833-1908 who was born in South Shields and traveled with his wife and family to Wellington in 1864. His photographs show how Wellington changed in stature from a sleepy Provincial Town to a Capital City with the transfer of Central Government from Auckland in 1865. This episode in the development of the capital was made all the more dramatic with injections of capital from overseas which had been negotiated by the then Prime Minister Julius Vogel in the 1870s. Bragge's commitment to large format photography with 16 × 14 inch glass plate negatives, leaves nothing in doubt over the

appearance of the Capital City and its hinterland—the Wairarapa. His views of this region, which were made with the aid of a horse driven van that served as a portable darkroom, encouraged investors to develop this region. His work on this project earned him medals at the Sydney and Melbourne International Exhibitions of 1879 and 1880–1881.

As admirable as the professional activities of Crombie, Mundy and Bragge might be, the colossus of New Zealand 19th century landscape photography was undoubtedly Alfred Henry Burton 1834–1914 who was born in Leicester. As one of four sons who helped their father John Burton operate a photographic business which had branches in Birmingham, Nottingham and Derby, he was no newcomer to photography when he joined his younger brother Walter in 1868, who had immigrated to Dunedin, New Zealand, two years previous to this amalgamation. This was not the first time Alfred had been in New Zealand, in 1856 he'd journeyed to there to spend three years in Auckland as a printer, following this up with a similar stay in Sydney, Australia.

The firm the brothers founded became known as Burton Brothers. It prospered with Walter responsible for the portrait trade, allowing Alfred to travel beyond Dunedin to build up a collection of scenic views in a specially constructed van which acted as a portable darkroom. The first series of negatives he made was devoted to settlements in the province which had yielded rich deposits of alluvial gold. Then by the Government steamer Luna in 1874, he accompanied an exploratory expedition to a territory on the South West corner of the South Island known as Fiordland.

After Walter's death by suicide in 1880, Alfred admitted Thomas Mintaro Muir to the partnership, an arrangement which allowed Alfred to continue documenting nearly every town and settlement in both North and South Islands. In 1884 he took his camera on a winter cruise of the South Pacific and added another valuable series of views which were known as "A Camera in the Coral Islands." The following year, he chanced upon an expedition that was being formed to explore the upper reaches of the Whanganui River. The expedition was mounted to investigate a possible route for the North Island Main Trunk Railway between Wellington and Auckland. This trek passed through an area called the King Country which was populated by Maori tribes. Over a period of 37 days in April-May 1885, Alfred managed to make 230 whole dry-plate views featuring the various villages through which he and the expedition passed. Today these photographs are considered the most important authentic visual records of the Maori in their natural habitat. Their sale under the title "Maori at Home," won him many awards including a Fellowship of the Royal Geographic Society of Great Britain.

In 1898, Alfred sold his interests in the business to George Moodie 1865–1945 who was born in Dunedin and had taken over the role of the firms scenic photography. Moodie went on to expand the business under the title of Muir and Moodie. A major part of his energies were directed towards the tourist trade with albums of scenic views and postcards. He was the first photographer, born and raised in New Zealand, to make a distinguished career for himself.

Nineteenth century photography in New Zealand was dominated by the documentation of the land. The impact that this focus had on our forefathers at the time is reflected upon by one art authority, Edward Lucie-Smith. Drawn to comment on a particular New Zealand photograph by James Bragge of bush covered hills he said. "To the eye of someone nurtured on European landscape painting, this still seems an impossible almost outrageous kind of image—a land altogether alien, hostile, and sufficient unto itself." As the land was cleared and farmed, the emphasis changed from studies of virgin bush and natural features to what had been won by clearing the land with a destructive policy called "Slash and Burn." After these pioneering years which established a sound economic footing through farming, photographers became preoccupied with providing attractive views of the natural environment for the burgeoning tourist trade. Hence when George Dobson Valentine 1852–1890 from the Scottish firm of Valentine and Sons died in Auckland after a six year residency in New Zealand, the parent firm dispatched another operator from the other side of the world to carry on his unfinished work. Valentine had come to New Zealand in an attempt to recover from tuberculosis with no thoughts of contributing anything to the firms catalogue of world views.

After a short while it appeared that he could not resist the temptation to make a number of images featuring the principal tourist attractions in the North Island. While the fascination he held for his new environment was probably no different from those who had experienced a similar commitment 30 years earlier, there was now a larger and more visually literate clientele who were as rapacious as those who looked with wonderment upon their daguerreotype likeness.

19th Century Photography in the South Pacific

Nineteenth century photography in the South Pacific falls into several phases. First, there were photographers who were based in Australia and New Zealand who visited the Islands to secure a representative selection of the natives and their environment. New Zealand firms like Burton Bros. of Dunedin and Josiah Martin of Auckland, were matched by their Australian counterparts, namely Kerry and Co. of Sydney, John William Lindt of Melbourne and John Beattie of Hobart. Gradually some of

the larger Islands boasted a resident photographer who not only supplied local needs but were well placed to cash in on the fascination which the developed world held for the people of the South Pacific. With the advent of hand held cameras, missionaries were encouraged by their Religious Orders to record their work of converting the natives to Christianity. This rather patchy coverage during the 19th century, gradually gave way to a more detailed and scientific methodology by virtue of ethnographic expeditions that were mounted by various Governments and Scientific Institutions.

The first substantial body of work to be compiled by a photographer in Samoa, was made by John Davis ?–1893 who as early as the 1870s was producing carte de visite studies while holding the job of postmaster in Apia. Following Davis's death, Alfred John Tatterstall acquired his negatives and continued to sell them for years afterwards. While the pioneering work of Davis must be acknowledged, especially the studies he made of various Samoan customs, the title of who represented the people of the South Pacific to their best advantage, must surely fall upon the shoulders of Thomas Andrew 1855–1939.

Andrew was born in Auckland, New Zealand and operated photographic businesses in both Napier and Auckland. In 1886–1887 he made a tour of the South Pacific on board the schooner *Southerly Buster* to promote trade between New Zealand and the Islands. When his Auckland photography business burnt down in 1891, he decided to move to Apia where he at first began work as an assistant to the incumbent Davis. Andrew went on to extend his range of views to take in a number of staged re-enactments relating to the way victims were dealt with in intertribal warfare in the Fiji Islands. His Samoan nude studies are keenly sought by collectors.

Alfred Henry Burton q.v. in 1884 made what some describe as the first organized expedition to consciously gather together photographs of Samoa and other Islands such as Fiji and Tonga in the Pacific. While his views of villages and plantations are notable for their fine attention to detail, a large proportion of the studio studies which Burton had listed in his catalogue under the title The "Camera in the Coral Islands," were probably the work of either Davis or Andrew.

Another New Zealand based photographer who made a solid contribution to the documentation of the people of the South Pacific was Josiah Martin 1843–1916 who wrote extensively of his experiences when he returned from a tour of The Friendly Islands—Tonga in 1896 in Sharland's *New Zealand Photographer*, a journal which he edited for a number of years.

From Australia John William Lindt 1845–1926 journeyed to the New Hebrides—Vanuatu in 1889 and backed it up with a superb series of Fijian fire walker studies the following year. While Charles Kerry 1858

–1928 was more an entrepreneur and publisher of photographs, he was also a first class cameraman. Another Australian photographer operating for Kerry & Co. called George Bell, made a splendid postcard series titled By Reef and Palm. Finally, Tasmanian John Beattie 1857–1930 spent five months on board the mission steamer Southern Cross touring the Melanesian archipelago where he amassed 1,300 plates at the turn of the century.

While the South Pacific was admittedly a very idyllic if not exotic hunting ground for photographers, their motivations for venturing forth were undoubtedly driven by European concerns. Several nations like Great Britain, France, the United States and Germany vied for control of Samoa and other dependencies when Empire Building was fashionable. No matter the motifs and its spread out nature, Oceania was surprisingly well documented in the 19th century.

WILLIAM MAIN

See also: Daguerreotype; Wet collodion Positive Processes; Itinerant Photographers; Valentine, James and Sons; Cartesde-Visite; and Kerry, Charles.

Further Reading

Blanton, Casey et al., *Picturing Paradise,* Florida: 1995 (exhibition catalogue).

Cato, Jack, *The Story of the Camera in Australia,* Melbourne: Georgian house, 1955.

Knight, Hardwicke, *Burton Brothers Photographers,* Dunedin: McIndoe, 1980.

Main, William, *Auckland Through a Victorian Lens,* Wellington: Millwood, 1977.

——. *Bragge's Wellington and the Wairarapa,* Wellington: Millwood, 1974 .

——. *George Dobson Valentine: History of Photography,* October 1982.

——. *Maori in Focus,* Wellington: Millwood, 1976.

Main, William and Turner, John B., *New Zealand Photography From the 1840s to the Present,* Auckland: PhotoForum, 1993.

Maitland, Gordon, *The Two Sides of the Camera Lens 19th century photography and the indigenous people of the South Pacific: Photofile—Sydney* (double issue), Spring, 1988.

New Zealand Dictionary of Bibliography, vols. 1–3 London: Department of Internal affairs, 1990–1995.

Willis, Anne-Marie, *Picturing Australia A history of photography,* Angus and Robertson, 1988.

Wood, R. Derek, The Voyage of Captain Lucas and the Daguerreotype to Sydney, *NZ Journal of Photography* August 1994, (reprinted) *Daguerrean Journal,* New York: 1995.

NEWHALL, BEAUMONT (1908–1993) AND NANCY (1908–1974)

Beaumont was the pre-eminent photographic historian of the twentieth century. A pioneering author, curator, teacher, and photographer, Newhall is universally ac-

knowledged for his vitally important role in establishing the history of photography as a unique and serious field of study. Through his critical appreciation and rigorous scholarly inquiry Newhall championed the medium of photography as an art form in its own right. His overriding contribution to its study was to interpret photography from an historical, critical, and aesthetic perspective, rather than in a strictly technological approach.

Beaumont Newhall's mother was a semi-professional photographer. One of his earliest recollections was of "standing beside my mother in her darkroom while she developed glass plates by the red glow of the safelight. I was fascinated to watch the image appear, as if by magic in the glass tray" (*Focus*, 10). When he was fifteen Newhall taught himself photographic processing, and making photographs became a lifelong passion.

The summer prior to entering Harvard Newhall fell under the spell of the movie *Variety* (1925), directed by Ewald André Dupont, and photographed by Karl Freund. Erich Mendelsohn's *Amerika: Bilderbuch eines Architekten*, 1926, depicting skyscrapers, grain elevators and other industrial buildings was also an early influence, teaching him a new way of looking at photography. At Harvard he hoped to study film and photography, but as there were no courses offered in these subjects, he studied art history. His professors included Adolph Goldschmidt and Paul Sachs. In 1934 he presented his first paper, "Photography and Painting," on the history of photography, at the College Art Association.

In 1936 while working as the librarian at Museum of Modern Art (MOMA) in New York, Newhall, curated the museum's first exhibition of photographs at the request of Director Alfred Barr. Conceived of as an overview of the history of the art form, *Photography 1839–1937* contained a combination of historical and contemporary photographs. Its real impact however, lay in the display of the little-known nineteenth century works. Furthermore, in eschewing the then popular "pictorial" school of photography in favor of exhibiting only "pure" or "straight" [straightforward] photography, Newhall propounded a new photographic aesthetic. In the exhibition catalog Newhall also introduced formal criteria for judging photography as a fine art. The catalog was revised as *Photography: A Short Critical History* (1938), which in turn formed the basis for his *History of Photography from 1839 to the Present Day* (1949). Revised five times and translated into several languages, *History of Photography*, has been recognized as a seminal work in the history of photography and continues to be a widely read textbook.

After this first exhibition, Newhall's passion for photography became his vocation. In 1940 MOMA formed its Department of Photography with Newhall as its curator.

He remained at MOMA until 1947, although his wife Nancy Newhall (1908–1974, see summary below) served as Acting Curator from 1942–1945, while he was stationed overseas, during which time she curated fifteen exhibitions for the museum. Other seminal exhibitions curated by Newhall include the photography section of "Art of Our Time" (1939); "Photographs of the Civil War and the American Frontier" (1942); and the Edward Weston Retrospective (1946).

In 1948 Newhall became the first curator of photography at the George Eastman House and began developing his second major photography collection for an institution. Nancy Newhall arranged the Eastman House's permanent photography exhibition. In the late 1960s Beaumont and Nancy assembled a collection of photographs for the Exchange National Bank of Chicago, an early example of corporate collecting.

When Newhall arrived at Eastman House he had already spent a summer teaching at Black Mountain College. Throughout his tenure at Eastman House he continued to teach at a variety of institutions. He and James Card developed the first courses given for academic credit in the histories of motion pictures and photography at the Rochester Institute of Technology and the University of Rochester. Newhall was known for the quality of his teaching—stressing original thought and research, and the exploration of new subjects in order to expand the history of photography. Many of Newhall's students became curators or professors at major institutions.

Nancy and Beaumont Newhall counted many contemporary photographers among their close friends, most notably Edward Weston, Alfred Stieglitz, Minor White, Paul Strand, and Ansel Adams with whom Nancy collaborated on numerous projects. Nancy Newhall's concentration on working with practicing photographers was no doubt due to her own training as a painter and artist. In addition to her more than two decades of work with Ansel Adams, Nancy Newhall wrote and worked with Paul Strand and Edward Weston, whose day books she edited (1961–66). Whereas posthumous evaluations of an artist's life and work had been the norm for art history monographs, Nancy Newhall's scholarly work on living photographers set a precedent for serious publications about contemporary artists. The books that she collaborated on with Ansel Adams helped formulate another new genre of pictorial essay—scholarly nature photography books, as epitomized by *This is the American Earth* (1960).

Although Newhall revised and updated his extremely influential core study *History of Photography* five times, the book has not been without its detractors, especially in the late twentieth century when the methodology of art history and the discipline's assumptions came under close scrutiny. Newhall's methodology has sometimes been seen as old-school formalism. Yet, as Carl

Chiarenza has pointed out, "no one has yet produced a less biased, more idea-oriented, or more interesting general history of photographic picture reproduction" (*Colleagues and Friends*, 14).

John Szarkowski has aptly contextualized Newhall's long and productive career and his influence on the study of photography:

> When Beaumont Newhall was beginning his essential work, the great photographer Brassai did not know the name of the great photographer Peter Henry Emerson, and Alfred Stieglitz had not heard of Timothy O'Sullivan. No coherent sketch of photography's first century existed...A half-century later virtually every photographer of ambition has a reasonably catholic knowledge of the tradition that he or she is part of, and almost every art historian understands, at least in theory, that photography is part of their problem. Such a change was not wrought by one person, but it is clear that no one person contributed so much to that change as Beaumont Newhall. (*Colleagues and Friends*, p. 41)

BETH ANN GUYNN

Biography

Beaumont Newhall was born in Lynn, Massachusetts, on June 22, 1908. His parents were Dr. Herbert William Newhall (1858–1933), and Alice Lillia Davis Newhall (1865–1940). He received A.B. and A.M. degrees in art history from Harvard University, and did further graduate work at Harvard, the Courtauld Institute of Art, the University of London, and the Institut d'Art et d'Archéologie, University of Paris.

Newhall was a lecturer at the Philadelphia Museum of Art, an assistant in the Department of Decorative Arts of the Metropolitan Museum of Art, and the founding librarian at the Museum of Modern Art, New York, before becoming that museum's first Curator of Photography in 1940. In 1948, Beaumont Newhall became the first Curator of Photography at the George Eastman House and its Director in 1958, building a significant photography collection. In 1971 Newhall became Visiting Professor of Art at the University of New Mexico, where he helped to establish the first doctoral program in the history of photography at an American university. Over the years he also taught at Black Mountain College, University of Rochester, Rochester Institute of Technology, State University of New York at Buffalo, and the Salzburg Seminar in American Studies.

His honors include two Guggenheim fellowships; Honorary Fellow, Royal Photographic Society of Great; Corresponding Member, Deutsche Gesellschaft für Photographie; Fellow of the Photographic Society of America and recipient of its 1968 Progress Medal; and the 1970 Culture Prize of the German Photographic Society.

Newhall wrote over 650 articles and essays. His books include: *History of Photograph from 1839 to the Present Day*, (1949), *Masters of Photography* (with Nancy Newhall, 1958), *The Daguerreotype in America* (1961), *Frederick Evans* (1964), *Latent Image: The Discovery of Photography* (1967); *Airborn Camera: The World from the Air and Outer Space* (1969); and *Photography: Essays and Images. Illustrated Readings in the History of Photography* (1980).

Newhall married Nancy Wynne Parker in 1936. After Nancy's death he married Christi Yates in 1975. Beaumont Newhall died in 1993.

Nancy Wynne Parker Newhall was born in Lynn, Massachusetts, on December 15, 1908. She graduated from Smith College in 1930 and studied painting at the Art Students League, New York, and married Beaumont Newhall in 1936. She served as Acting Curator of Photography at the Museum of Modern Art from 1942–1945, replacing Beaumont who was overseas with the Army Air Force reconnaissance units.

Nancy Newhall curated photography exhibitions, wrote articles about photographers, edited and introduced photography books by Ansel Adams, Paul Strand, Edward Weston, and others, collaborated with Adams on several books about the American West, including *Death Valley* (1954), *Yosemite Valley* (1959), *The Tetons and Yellowstone* (1970), and *This is the American Earth* (1960), the first title in the Sierra Club's exhibit format series; and *P. H. Emerson: the fight for photography as a fine art* (1975). *Eloquent Light* (1963), her biography of Ansel Adams, covered his career from 1902 to 1938; *The Enduring Moment*, the second volume of Adams' biography was unfinished at the time of her death. With Minor White, Nancy Newhall founded the photography magazine *Aperture*. She died in 1974, struck by a falling tree while rafting down the Snake River with Beaumont.

The papers of Beaumont and Nancy Newhall are held at the Getty Research Library; the Center for Creative Photography, University of Tucson; Houghton Library, Harvard University; and the Marion Center for Photographic Arts Library, College of Santa Fe, which also holds the bulk of their personal library.

See also: Eastman, George; and Stieglitz, Alfred.

Further Reading

Beaumont Newhall. [Rochester, N.Y., George Eastman House, 1971] Compiled by R. Sobieszek, and P.A. Slahucka.

——, *Colleagues and Friends*. Santa Fe: Museum of Fine Arts, Museum of New Mexico, 1993. Published in conjunction with an exhibition at the Museum from Apr. 24–Aug. 31, 1993.

Coke, Van Darren (ed.). *One Hundred Years of Photographic History: Essays in Honor of Beaumont Newhall*, Albuquerque: University of New Mexico Press, 1975.

Newhall, Beaumont, *Focus: Memoirs of a Life in Photography*, Boston: Little, Brown, 1993.

——, *The History of Photography: From 1839 to the Present*, New York: Museum of Modern Art; Boston: Distributed by New York Graphic Society Books, c. 1982. Text first published in the exhibition catalog *Photography, 1839–1937* by the Museum of Modern Art in 1937. In 1938 the text and illustrations were reprinted as *Photography: A Short Critical History*.

——, *In Plain Sight: The Photographs of Beaumont Newhall*. Foreword by Ansel Adams. Salt Lake City, UT: G.M. Smith, 1983.

——, *Latent Image: The Discovery of Photography*, Garden City, NY: Anchor Books: Doubleday, 1967.

——, *Masters of Photography*, New York: Bonanza Books, 1958.

Walch, Peter, and Thomas F. Barrow (eds.), *Perspectives on Photography: Essays in Honor of Beaumont Newhall*, Albuquerque: University of New Mexico Press, 1986.

NEWLAND, JAMES WILLIAM (?–1857)

Newland hailed from Redgrave in Suffolk, England. He was a travelling daguerreian photographer who spanned the continents. He is first noted as J. W. Neuland at 124 Royal St., New Orleans in 1845. He travelled via Panama and Jamaica until in December 1846 he was in Lima, Peru then in early 1847 in Callao. In July he was in Valparaiso then he traveled on to Fiji and Auckland, New Zealand, before arriving in Australia where he set up a studio on the corner of King and George Streets, Sydney from March 1848 for three months. Newland presented lavish lantern shows and a diorama in Sydney that he travelled with to Newcastle and Maitland, where he also operated temporary studios. From October 1848 Newland worked from a studio in Murray St., Hobart Town where he took the earliest known Australian landscape photograph and claimed to have upward of two hundred daguerreotypes in his gallery including portraits of natives from Fiji, New Zealand, Peru, Chile, and Granada and a panorama of Arequipa, Peru. The studio closed in December and it appears Newland then left for Calcutta, where he opened the first professional daguerreian studio in Loudon's Buildings, taking in F. W. Baker as his assistant. By 1857 Newland had expanded into positives on paper and glass and he offered stereoviews of Calcutta and its vicinity. He took in his half-brother Frederick Welling as an assistant, and, following Newland's tragic murder at the outset of the Indian Mutiny in May 1857, Welling continued to operate the studio until its closure in 1860.

MARCEL SAFIER

Holdings: Macleay Museum, University of Sydney; State Library of NSW, Sydney; Tasmanian Museum & Art Gallery, Hobart; British Library, London.

NEWMAN, ARTHUR SAMUEL (1861–1943)
English inventor and manufacturer

Arthur Newman was born in 1861. After school he worked for H. and E. J. Dale of London, where he progressed to designing and making photographic changing boxes. He later joined Simpsons of Clerkenwell and became a partner where he was to meet Julio Guardia.

In 1886 Newman was granted his first patent for a photographic shutter (British patent number 7156) which was sold by the London Stereoscopic Company. The shutter was attached to the lens barrel and the shutter blade inserted into an aperture in the barrel.

The partnership of Newman and Guardia seems to have started in late 1891 with the Spanish-born Julio Guardia providing business experience and capital and Newman providing the engineering skill. The firm gained a reputation for producing high-quality cameras starting with a hand camera range (1892), the Nydia (1899), single lens reflexes from 1903 and, from 1908, the Sibyl range which had been originally patented by Newman and the company in 1905. Guardia died in 1906 and shortly afterwards in 1908 Newman left the company relinquishing his shares in return for retaining the rights to the film equipment he had designed. Newman and Guardia Ltd continued making cameras into the post-1946 period.

After his departure Newman established a long-lasting partnership with the photographic retailer and manufacturer James A Sinclair as Newman & Sinclair Ltd, principally producing 35mm motion picture cameras and equipment. NS cameras accompanied Herbert Ponting on Scott's 1910 Antarctic journey, Shackleton's expedition and the 1924 Everest expedition. NS cameras were used extensively for location and studio filming well into the late twentieth century.

Newman's reputation was such that he acted as a retained consultant for the Eastman Kodak Company in Rochester and he designed Pathé's very successful Baby Pathé 9.5mm amateur camera. Newman was actively involved with the Royal Photographic Society and he was instrumental in setting up the British Kinematograph Society in 1931.

He died aged eighty-three in London on 12 August 1943.

MICHAEL PRITCHARD

NEYT, ADOLPHE L. (1830–1892)
Belgian amateur photographer

Born in Gent 13 April 1830, Neyt developed a reputation as an enthusiastic amateur of scientific photography,

concentrating on astronomical and microscopical subjects. His ability to enlarge these images while retaining the clarity of the original was much admired. Most of Neyt's extant photographs were made in the 1860s, when he also joined both the Société française de photographie (1864–1885) and the Association belge de photographie. In 1869, a dozen of his photographs of the moon were presented to the Belgian Royal Academy of Sciences. Neyt perfected a method of making images through a telescope attached to a clockwork, enlarging them to a size of 25 centimeters in diameter with a camera obscura. Some, or perhaps all, of these lunar images were exhibited at the 1873 International Exhibition in Vienna. Although his photographic activity appears to have slowed after 1870, he remained involved, collaborating in 1887 with Édouard van Beneden on the book, *Nouvelles recherches sur la fécondation et la division mitosique chez l'Ascaride mégalocéphale* (Leipzig, W. Engelmann), to supply four accompanying photographs for this work on cellular biology. Neyt died in Oostende 21 September 1892.

KELLEY WILDER

NICHOLLS, HORACE WALTER (1867–1941)

Horace Walter Nicholls was born on February 17, 1867, in Cambridge, England, the eldest son of Arthur Nicholls and Charlotte Johnson, both of Norfolk. His grandfather was John Nicholls, an architect, builder and restorer of cathedrals, churches and castles. The family home was Newnham Grove, Grantchester, Cambridge.

Horace learned photography from his father and uncle, both of whom were listed as professional photographers by the late 1860s. Arthur not only taught his son the technical aspects of wet-plate photography, he maintained that a photographer, even a commercial photographer, was an artist. Horace learned from his father that the camera gives one limitless creative potential and that what some call "tricks" in photography can, with a clear aesthetic vision, purpose, or wit, produce images of originality and value. By the age of fourteen, Horace was listed in directories as a photographer working at his father's studio in Sandown, Isle of Wight.

Nicholls daughters spoke of their father's *wanderlust*. When he was about twenty years old, Nicholls saw an advertisement in a newspaper for a young man to work for a photographer in Chile. He applied and was offered the job and went on an exotic adventure. Nicholls returned to England around 1889 and began working at the Cartland Studio in Windsor. George Cartland held a Royal Warrant. It was here that Nicholls met his future wife, Florence Holderness.

After about three years in Berkshire, Nicholls again became restless and decided South Africa was the next frontier. It was, in the 1890s, an attractive location for an ambitious, talented young man; and after Chile, it may even have seemed a modest choice for someone of British origin soon to be married. Johannesburg, however, in 1889 was little more than a settlement, with acres of empty land between makeshift buildings.

Horace Nicholls arrived in Johannesburg in September 1892 and joined the photographic studio of James F. Goch. He returned to England the following year to marry, and then sailed with his new wife back to South Africa in October 1893. Nicholls now dubbed himself "the Johannesburg Photographer" having renamed his former employer's studio "Horace W. Nicholls, The Goch Studio." In 1896 he left the studio to record a year of tumultuous events: a political crisis, a railway disaster, a dynamite explosion and a huge fire (opposite his studio), a railroad accident, infestation of locusts and a drought. He became the official photographer for the London-based publication *South Africa*. And it was in South Africa, during the Boer War (1899–1902) that he first established an international reputation, making sometimes dramatic, sometimes somber photographs of the conflict. He documented the bombardment of Ladysmith, the movement of troops to frontlines, officers relaxing, the burying the dead and much more. He became one of the world's earliest photojournalists.

Nicholls helped establish the "profession," licensing his pictures for "one-time use and suing publications for infringement of copyright." He was determined, at the onset of photojournalism that photographers should be able to make a living in their new profession and be treated respectfully. It was in the early 1890s the halftone process for reproducing photographs became a commercial viability. When Nicholl's Boer War photographs appeared in the press, half the visual reportage was still drawings.

Nicholls was a quirky photojournalist. After his success documenting the Boer War, he turned aside from major events and concentrated on what today might be called "human interest" stories. He liked to stay away from the pack of early photojournalists and create his own subjects. He stated, "The chief aim of my work in photography is pictorial effect in preference to photographing anything and everything." He always tried to make strong, compelling pictures.

The one subject he could never resist, even if the field was filled with cameramen, was "the Season." Ascot, Derby, Henley, Goodwood, Cowes were annual events he photographed with wit and imagination. Even though he prided himself on being a journalist, he was always ready to montage crowd scenes, multiplying the numbers of people watching the horse race and altering juxtapositions. He liked multiplying the number of umbrellas, too, held overhead. A viewer would be mis-

guided to "believe" all Nicholls press pictures, many of which appeared in *Black and White, The Daily Sketch, The Daily Mirror, Illustrated London News, Penny Pictorial, South Africa, The Bystander, The Illustrated Sporting News, The Graphic, The Referee, The Sphere, The Sunday Companion, The Tatler, The Times and The Guardian.*

When the Great War broke out in 1914, George Nicholls, Horace's eldest son, enlisted (he died in combat in 1917). Horace envisioned himself as a war correspondent, but at 47, he was too old to be with the combat troops. He wrote frequently to the Department of Information to receive an official appointment and asked to be sent abroad. He did receive an appointment, but he would stay in England recording the home front and providing the propaganda-type images that were being requested of the agency. He was recorded events such as the review of troops by the King and also munitions factories, shipbuilding, prisoners of war, men back from the Front and everything else that was required.

The photographs taken between 1917 and 1918 constitute some of Nicholls' finest work. He will especially be remembered as capturing the moment in history when women walked out of their homes and into men's jobs. The combination of a seemingly thorough investigation, a straightforward approach, and great sensitivity make his "women at war" photographs one of his most important contributions to the history of photography. "A Woman Coke Heaver," "A Woman Grave Digger," "The Electric Trolley Driver," are among his classics.

Immediately after the end of the war, the Ministry of Information's responsibility of commissioning and collecting photographs was transferred to the Imperial War Museum where Horace Nicholls was asked to be on staff. He role was to head the darkroom and be responsible for the care, preservation and re-photographing of deteriorating negatives from all the war fronts. He, himself, had made 2,300 negatives during these years. He stayed at the Museum from 1918 until his retirement in 1932.

Even during his years of civil service, he worked freelance for newspapers and journals. In the twenties and thirties, along with scores of family photographs, he produced professional quality images on holidays at home and abroad. Horace Walter Nicholls retired to Worthing and died of diabetes on 28 July 1941. The major collections of his glass and film negatives and prints are in the Royal Photographic Society Collection at the National Media Museum in Bradford, the Imperial War Museum, London and with the Nicholls family.

GAIL BUCKLAND

See also: Africa (sub-Saharan); and War Photography.

Further Reading

Buckland, Gail, *The Golden Summer: The Edwardian Photographs of Horace W. Nicholls*, London: Pavillion, 1989.

NIÉPCE DE SAINT-VICTOR, CLAUDE FÉLIX ABEL (1805–1870)
French army officer and chemist

Abel Niépce de Saint-Victor was born on 26 July 1805 in Saint-Cyr, France. He was the second cousin of Nicéphore Niépce, to whom he always referred as an uncle. A career officer in the military, in 1827, he graduated from the École de cavalerie de Saumer [Cavalry School of Saumer]. In 1842, he obtained the rank of lieutenant and was stationed with the first regiment of dragoons at Montauban.

Niépce de Saint-Victor's first encounters with chemistry are legendary. One day, he accidentally stained the red pants of his military uniform with vinegar or lemon juice. Wanting to remove the stain, he tried a number of chemical solutions and finally succeeded with a few drops of ammonia. Following this, the French Minister of War decided that all the lapels, collars, and ornamental details of the uniforms of all the regiments of cavalry—which had previously been variously colored pink, saffron yellow, and crimson—should be orange. Niépce de Saint-Victor was put in charge of chemically altering the original colors of the uniforms so as to arrive at the same color. He succeeded in this, saving the army a great deal of money, and his vocation to the study of chemistry was determined.

In 1845, Niépce de Saint-Victor was stationed at the Military Police station of Paris, located in the faubourg of Saint-Martin. There he set up a laboratory in the basement and began research on photochemical operations, largely financed from his own salary.

On 25 October 1847, he published a report of his investigations to the French Academie des Sciences [Academy of Sciences]. There he described a method he called atmography, which reproduced engravings on paper, porcelain, glass, and metal surfaces, using iodine vapors and starch. In the same report, he described a method for obtaining negatives on glass, using starch.

As a consequence of the French Revolution of 1848, on 24 February 1848 his laboratory was burned down and all his equipment destroyed. He was then placed on non-active duty, whereupon he returned to the study of negatives on glass. This led to his publishing a follow-up report to the Academy des Sciences on 12 June 1848, in which he described a method for making negatives on glass using albumen. The procedure was similar to the calotype process then being used, but was capable of finer detail. One drawback was that it was difficult obtain an even coating of albumen on glass. Another

drawback was that the light-sensitivity was low, so as to make portraiture an impossibility. Nevertheless, albumen on glass may be considered significant as the prototype for the later wet-collodion process.

In July 1848, he was stationed with the 10th regiment of dragoons, outside Paris.

In April 1849, he was promoted to Captain of the Republican Guard of Paris and established a laboratory at the military barracks located on the rue Mouffetard. Also in 1849, he received a medal and 2000 francs from the Société d'Encouragement [Encouragement Society] and was awarded the Legion d'honneur [Legion of Honor].

In 1850, he indicated the use of albumen as a binding agent for paper negatives and positives. He also introduced improvements to his albumen on glass process using honey as an accelerator in the iodizing stage and the application of heat in the sensitizing stage, which made portraits possible. He also remarked on the effect of halation, noting how the rear surface of the glass plate reflected light back upon the light-sensitive surface.

Inspired by the work of Edmund Becquerel, in 1849–1852, Niépce de Saint-Victor attempted to make color photographs using a process he called *héliochromie* [heliochromy]. This involved the direct exposure in the camera of a silver plate coated with silver chloride, which had been dipped in a weak solution of sodium hypochlorite, followed by lead chloride in dextrine. Using this process in 1851–1852, he obtained colored reproductions of variously colored subjects like a bouquet of flowers, a stained glass window, and dolls with different types of clothing; however, the images were never adequately fixed and the colors soon faded.

By a miracle of preservation, three of Niépce de Saint-Victor's heliochromes dating to 1851 survive today in a close to original state, thanks to their having been stored in a light-tight box in the collection of the Parisian Musée National des Techniques [National Museum of Technology]. Using low-light level illumination, these were reproduced as color transparencies by the museum, and published in 1984 by Bernard Levebrve. Apart from having turned reddish and faded slightly, the plates show a successful rendition of original colors, the subjects being a detail of a stained glass window and two studies of dolls.

From 1853–1855, Niépce de Saint-Victor returned to Nicephore Niépce's 1820s heliographic process, using copper plates coated with light-sensitive asphaltum. Here he was assisted by the engraver François-Augustin Lemaître, who had also assisted Nicéphore Niépce. By thinning the asphaltum with benzene, he was able to obtain much thinner coatings of asphaltum and radically shorten exposure times in contact printing; however,

the process rendered images which were flat and dull, and unable to render delicacy of detail. Similarly, in copying an original photograph or engraving with a camera, the resulting image was diffuse and needed to be re-engraved by hand in order to obtain details.

In 1854, he was appointed Commandant of the *Palais du Louvre* by Napoléon III. This also coincided with a decision to put him on non-active duty, effectively reducing his salary to one-third of what it had been formerly. He lived at the Louvre until his death.

From 1857–1859, Niépce de Saint-Victor experimented with reproducing images in different monochromatic colors, which he again called *héliochromie* [heliochromy]. Using paper sensitized with uranium nitrate, in combination with either potassium ferricyanide, cobalt nitrate, or gold chloride, he arrived at red, green, and violet toned prints. Blue prints were made with paper feebly sensitized with potassium ferricyanide, followed by a bath of mercuric chloride and development with oxalic acid.

In the last years of Niépce de Saint-Victor's life, he wrote a series of articles on the action of light upon light-sensitive surfaces. In 1862, he joined the Société française de photographie [French Society of Photography] and donated a number of original negatives and prints to their collection. In 1861, 1862, and 1863 he received the *Prix Trémont* [Tremont Prize]. He died on 6 April 1870 and was buried at the *cimitaire Montparnasse* [Montparnasse Cemetery].

ALAN GREENE

Biography

Abel Niépce de Saint-Victor was born on 26 July 1805 in Saint-Cyr, France. A career officer in the army, he devoted his life to the study of photo-chemistry. In 1848, he introduced the albumen on glass process, a precursor of the wet-collodion process. In 1851, he made color photographs on silver plates, which reproduced the different colors of the original subjects, but he never successfully fixed the images. In the mid-1850s, he furthered the earlier research of his second cousin, Nicéphore Niépce, increasing the light-sensitivity of Niépce's 1820s heliographic printing process. In the late 1850s, he discovered ways to make photographic prints with different monochromatic hues, using uranium nitrate. He wrote numerous articles concerning his research, in different scientific and photographic journals, throughout the 1840s–1860s. A recipient of the French Legion d'honneur, as well as many other medals and prizes, he was commander of the Palais du Louvre from 1854 until his death on 6 April 1870.

See also: Becquerel, Edmond Alexandre; and Niépce, Joseph Nicéphore.

Further Reading

Auer, Michèle, and Michel Auer, *Encyclopédie internationale des photographes de 1839 à nos jours* [*International Encyclopedia of Photographers from 1839 to the Present*], 2 vols., Hermance, Switzerland: Editions Camera Obscura, c. 1985.

Colson, R., *Mémoires originaux des créateurs de la photographie* [*Original Reports on the Creators of Photography*], Paris: Georges Carré and C. Naud, 1898, 115–142.

Larousse, Pierre, *Grand dictionnaire universel du XIXe siècle* [*Large Universal Dictionary of the 19th Century*], 17 vols., Paris: Administration du Grand dictionnaire universel, 1866–1890, vol. 11, pp. 999–1000 [under the entry heading, "Niépce de Saint-Victor (Claude-Félix-Abel)"].

Lefebvre, Bernard, *A. Niépce de Saint-Victor et la table servie* [*A. Niépce de Saint-Victor and the Set Table*], Rouen, France: Association Recherche et Documentation Photographiques et Bernard Lefebrve, 1984.

Marignier, Jean-Louis, *Nicéphore Niépce: 1765–1833: l'invention de la photographie* [*Nicéphore Niépce: 1765–1833: The Invention of Photography*], Paris: Belin, 1999.

Niépce de Saint-Victor, Claude Marie François, *Recherches photographiques* [*Photographic Research*], Paris: Alexis Gaudin, 1855.

Niépce de Saint-Victor, Claude Marie François, Traité pratique de gravure héliographique sur acier et sur verre [*Pratical Treatise on the Heliographic Gravure on Copper and Glass*], Paris: V. Masson, 1856.

"*Notice sur les travaux de M. Niépce de Saint-Victor* [Note on the Work of M. Niépce de Saint-Victor]," *La Lumière* [Light], no. 17, 1 June 1851, pp. 65–67.

NIÉPCE, JOSEPH NICÉPHORE (1765–1833)
French inventor

A decade of intense experimentation with light-sensitive chemicals and the camera obscura led the Frenchman Joseph Nicéphore Niépce to produce the first permanent images made by the action of light in a camera sometime between 1826 and 1827. The ultimate inability of Niépce to capitalize upon his discovery, which he called Heliography, during his lifetime, left his work in relative obscurity for more than a century. At the time of his death in 1833, Niépce was in a business partnership with Louis-Jacques-Mandé Daguerre, and the extent of Niépce's contribution to the wildly successful Daguerreotype process, made public in 1839, has been the subject of considerable debate. Although Niépce did not himself succeed in perfecting a marketable photographic process, he did resolve perhaps the greatest problem facing early experimenters, how to fix the action of light so as to preserve images formed in light-sensitive materials. Moreover, Daguerre's eponymous process can be seen to emerge directly out of his partnership with Niépce, in the specific chemicals and materials that Daguerre used. More broadly, the details of Niépce's career as an inventor illustrate many of the social and economic forces that fueled the rise of photography in the mid nineteenth century. Niépce sought to bring together advances in optics, chemistry, and mechanics to create a fully automatic means of image production, and thereby to make his fortune.

Niépce's father Claude and his father before him had been King's Counselors, and held land in and around Chalon-sur-Saône in Burgundy, where Niépce was born the third of four children. Following school in Chalon he enrolled in 1786 at the Oratoire in Angers with the intention of entering religious service but withdrew after two years, prior to taking his vows. In the course of his studies he had developed a strong interest in chemical and physical science. After 1788, six years of Niépce's life were devoted to military service, both domestic and foreign. During the early years of the Revolution Niépce was in the National Guard in Chalon, and in 1792 he joined the Revolutionary Army, serving in Sardinia and Italy. He left the army in 1794 with an ocular disorder and settled in Nice, where his older brother Claude joined him. Niépce married Agnès Roméro in 1794, and their first child (the only of three to survive childhood), a son Isidore, was born in 1795. While in Nice, Nicéphore and Claude began investigations into the idea of an internal-combustion engine, work that eventually led to their invention of a boat motor called the Pyréolophore, patented in 1807.

Nicéphore and family, with Claude, returned to Chalon in 1801. In addition to overseeing the family lands and vineyards, the two brothers began to pursue a host of engineering and manufacturing projects. In this respect they were early examples of the new occupation offered to middle-class Frenchmen in the post-Revolutionary years: inventor. The Pyréolophore, which they tested successfully on the River Saône, was the first internal combustion boat motor. Also in 1807, in response to a public competition, the brothers conceived a new hydraulic pump system for the town of Marly to deliver water to Versailles. In 1811, Nicéphore answered a government call for a new process of extracting indigo dye from the woad plant, undertaking nearly two years of intense experimentation. When the new printing process of lithography, invented by Alois Senefelder in 1798, was introduced to France in 1813, Niépce endeavored to practice the technique in Chalon, largely self-taught and at a distance from the material and technical resources found in Paris (in a similar spirit, when the first bicycle, the Draisienne, invented in Germany by Baron Karl von Drais, appeared in 1817, Niépce responded by building his own working model). According to Isidore Niépce, his father's approach to lithography was far from conventional, as he would experiment with different varnishes and acids, on a variety of supports. He also began to attempt to impress designs onto lithographic plates through the action of light, perhaps out of a lack of drawing facility (Gernsheim, 29).

In 1816, with the ten-year patent on the Pyréolophore due to expire the following year, work on the boat engine was taken up again in earnest. The brothers experimented with liquid instead of powdered fuel, including an asphalt known as Bitumen of Judea, and developed what stands as the first fuel-injection system (Hardenberg, 78). At the same time, Claude moved to Paris, in search of supporting partners for the enterprise. When patent renewal in France was rejected, despite several improvements to the device, Claude moved to London, submitting a letter of patent in 1817. With Claude permanently away from Chalon in 1816, Nicéphore began his first experiments with the camera obscura and light-sensitive materials. From this point forward, Claude would largely take responsibility for the boat engine, while Nicéphore turned increasingly to experiments in what he would come to call Heliography, or sun-writing, which he undertook in a workroom at the Niépce family estate, Le Gras, in the village of Saint-Loup-de-Varennes, near Chalon.

Niépce's first experiments with light-sensitive materials placed in a homemade camera obscura were conducted in 1816. He succeeded in taking impressions of views out of his workroom window using paper coated with muriate (or chloride) of silver, but the images were not permanent. Moreover, they were negative images, and attempts to print them in the positive were not successful. At the same time, he experimented with the use of light-sensitive resins on stones or plates, with the intention of etching the images thereby made, and then using the etched plates for ink printing. He foresaw his greatest success lying in this direction: etching would render the fleeting image permanent, and printing would allow its endless reproduction.

It was at this point that he began to experiment with bitumen of Judea (previously used as a fuel for the brothers' engine) as a light-sensitive coating. The bitumen, he had discovered, hardened when exposed to the sun's rays, whereas parts that had not been exposed could be dissolved and washed away by oil of lavender. The result was a fine image formed where light had fallen. His first success with this technique, in 1822, was made by placing an oiled engraving of Pope Pius VII directly on a glass plate coated with a thin layer of bitumen. The image, which was later accidentally destroyed, would have been a negative impression of the engraving. Niépce then turned to applying this process to pewter plates, which he etched in acid, the plate being receptive to the acid in precisely those parts where the lines occurred in the original engraving, and resistant where the exposed bitumen formed a barrier. The etched plate could then be printed in the traditional manner. In 1826, Niépce used this technique to copy an engraving of Cardinal d'Ambroise by Isaac Briot onto pewter plates. He enlisted a Paris engraver, Augustin

François Lemaître, to etch the plates and pull prints for him, with considerable success. This technique would come to be called heliogravure.

Niépce envisioned adapting this process to the camera, so that images made from nature could be etched and printed. While never realizing this goal, he was able to capture a faint reverse image of a camera view onto polished stone as early as 1824, though attempts to etch the stone and bring out the nearly invisible image may well have destroyed it altogether. In 1826 he turned increasingly to pewter plates, the reflective surface of which rendered the image more clearly visible, and he acquired more sophisticated equipment from renowned opticians Charles and Vincent Chevalier in Paris, purchasing a camera and several lenses. He began to refer to his efforts to take directly the image of nature as "heliographic," i.e., drawn by the sun. The *View from the Window at Le Gras*, in the Gernsheim Collection of the Harry Ransom Humanities Research Center of the University of Texas at Austin, is an especially durable example of this technique and seems to have been viewed as a significant accomplishment by Niépce himself. The view out his workroom window, onto the chicken house and fields, was one that Niépce's letters describe repeatedly as a subject for his attempts with a camera, starting in 1816 with his silver-chloride images on paper. The large heliographic plate (measuring 20.3 × 16.5 centimeters) carries a faint coating of bitumen where light struck the plate within the camera; by viewing the plate at an appropriate angle one sees the shadow areas, reflected in the bare pewter, appearing dark in contrast to the relatively light film of bitumen, the result being a legible, if elusive, positive picture of the estate's buildings and the landscape beyond. The exposure time for this image is not known; estimates range from eight hours, proposed by Helmut Gernsheim, who recovered the specimen in 1952, to three or more days, the latter assertion being consistent with attempts to recreate the technique as well as in line with evidence from Niépce's letters (Marignier, "Heliography," 58).

Whether produced in 1826 or, as seems more likely given his increasingly excited letters, 1827, the *View from the Window at Le Gras* was in any case executed prior to September, 1827, when Niépce brought it to London, via Paris, with an assortment of examples of his technique, now christened *Héliographie*. On the way to London with Agnès, to visit Claude who had fallen ill, Niépce met with Daguerre, who had written to him in early 1826 after hearing of his experiments. Daguerre was eager to learn the technique devised by Niépce, who for his part was reluctant to share his findings. Niépce had eventually relented and sent Daguerre an example of an etched heliographic plate. Daguerre had responded with criticisms and suggestions but with overall enthusiasm. Visiting Daguerre in Paris, Niépce

was thoroughly awe-struck by Daguerre's renowned Diorama, yet he remained skeptical about sharing his secrets, given Daguerre's lack of proven experience in fixing the action of light (Daguerre's efforts in this regard had consisted of transitory images made in phosphorescent materials). At the same time he was clearly impressed by the ambition and energy of the worldly Daguerre, whose forward thinking and business acumen might bring about the long sought-after success.

Niépce's efforts to find interest in his Heliography in London were largely disappointed, owing both to his own reticence about the details of his process, and to the lack of visibly dramatic results to his process. At Kew, where Claude was living, Niépce met the King's Head Gardener, William Townsend Aiton, who arranged for the examples of Niépce's heliography and engravings pulled from heliographic plates to be sent to Windsor Castle and displayed alongside other items of contemporary scientific interest. The King's reaction, if any, is unknown, and the items were returned without comment. Aiton then introduced Niépce to Francis Bauer, painter in residence at the Royal Botanical Gardens and member of the Royal Society. Attempts to find support from the Royal Society were met with tentative interest but no great result, nor did Niépce succeed in efforts to arouse interest among members of the Society of Arts. Bauer, however, remained supportive, and on departing for France, Niépce presented him with several examples of his work, including the *View from the Window at Le Gras*, framed like a presentation piece. This was inscribed on the back, by Bauer, "Monsieur Niépce's first successful experiment in fixing permanently the image from nature."

On his return to France in early 1828 (Claude had died shortly after the Niépces departed), Niépce immediately sought to remedy the faintness of the heliographic image, acquiring new lenses from Chevalier, including William Wollaston's periscopic lens. To strengthen the image he proposed using a silver-coated copper plate rather than pewter as the base for the bitumen layer. Following exposure the plate would be held in contact with iodine fumes, which reacted with the bare metal, turning it dark. The bitumen could then be dissolved, leaving the plate reflective in the light areas, and blackened in the dark areas. This allowed for greater contrast and tonal range, as well as for a clearly positive image. He further sought to find a way to lighten those areas exposed to light.

On 14 December 1829, Niépce and Daguerre formally entered into business together. Their provisional agreement was for a ten-year partnership, the goal of which was for Daguerre to assist in perfecting Niépce's invention, both men sharing information freely with the other. As a result of the agreement Niépce drew up a "Note on Heliography," laying out the process for his partner. Daguerre procured new achromatic lenses for Niépce. While Daguerre traveled to Saint-Loup-de-Varennes on three recorded occasions, the bulk of the exchange between the two partners took the form of written correspondence, in which Niépce and Daguerre employed a numerical code to disguise the specific formulas and procedures under consideration, lest they be stolen before officially unveiled.

In 1832 the partners devised an essentially new process that they called the Physautotype (a neologism meaning, roughly, nature's self-image). Instead of bitumen this process used a whitish resin extracted from oil of lavender, which left a light coating affixed to the plate where it had been exposed to light, once it was developed in the vapors of white petroleum (Marignier, "Physautotype," 357–358). As with the improved Heliograph, no examples of the Physautotype appear to have survived, although both processes have been successfully recreated based on Niépce's notes (see Marignier, *Niépce*). Another possible improvement, a heliographic picture on glass depicting a table prepared for a meal, no longer survives but was reproduced in 1891, in a form that suggests that it possessed considerable tonal gradation.

Niépce died suddenly in 1833, without having realized public success with his techniques. In1835, the partnership was renegotiated between Daguerre and Isidore, to the benefit of Daguerre, who assumed a dominant role in the enterprise, and again renegotiated in 1837 to give the name Daguerreotype to the now much advanced process (Batchen, 25). When the Daguerreotype was announced in 1839, although still within the original ten-year partnership term, emphasis was placed on the single-handed advancements made by Daguerre to salvage the ultimately impractical technique of Niépce. Defenders of Niépce, beginning with Isidore in 1840, have sought to solidify his position as the inventor of photography. In a historical irony, Daguerre's implicit claim to have invented the process that bore his name led to Niépce's first posthumous fame. Hearing of the Daguerreotype in 1839, Francis Bauer wrote a lengthy letter to the *Literary Gazette of London* declaring that Niépce had invented substantially the same technique some ten years previously. In response, a display was arranged at the Royal Society by Sir Charles Wheatstone (Smith, 49). Both William Henry Fox Talbot and Sir John Herschel saw Niépce's work in 1839, the latter declaring Niépce to be the obvious originator of Daguerre's technique, while crediting Daguerre with shortening the exposure time from several hours to as many minutes.

The dreams of both Nicéphore and his brother Claude to realize their fortunes through invention were never realized, and in the wake of Nicéphore's death in 1833 the family estate was sold to cover the many debts accrued

by the brothers. Isidore subsequently reaped the benefit of the partnership with Daguerre in the form of a share of the pension awarded by the French government. As for the reputation of Niépce, the efforts of Victor Fouque in the 1860s, Helmut Gernsheim in the 1950s, and Jean-Louis Marignier in the 1990s, have sought to account for Niépce's role in the history of photography and credit him for his innovations. Apart from debates concerning chronology, priority, and influence, the larger continuity of Niépce's heliographic work with cultural issues surrounding the early history of photography began to be explored by scholars in the 1990s.

STEPHEN PETERSEN

Biography

Joseph Nicéphore Niépce was born 7 March 1765, in Chalon-sur-Saône, in Burgundy, to a landowning family with ties to the Royal Court. The third of four children, he was educated for religious service but, at the time of the Revolution, conceived a career as a scientific inventor. He served in the National Guard from 1788–1792, and as a second lieutenant in the Revolutionary Army from 1792 to 1794. Recovering from health problems in Nice, he met and married Agnès Roméro in 1794. A son, Isidore, was born in 1795. The family returned to Chalon in 1801, where Nicéphore and his older brother Claude shared management of the family estate and worked together on a series of mechanical inventions, until Claude left in 1816. In relation to his work with lithography after 1813, Niépce began to investigate the use of light-sensitive materials for the production of images, including images formed in the camera obscura. Over the next decade he developed his process, called Heliography, but was unable to achieve public recognition. He joined in a business partnership with Louis-Jacques-Mandé Daguerre in 1829. Niépce died on 3 July 1833 in Saint-Loup de Varennes. In addition to the holdings at the University of Texas at Austin, important collections of heliographic studies are at the National Media Museum, Bath, and, with Niépce's pioneering camera equipment, at the Musée Nicéphore Niépce, Chalon-sur-Saône.

See also: Daguerre, Louis-Jacques-Mandé; Daguerreotype; Heliogravure; History: 2. 1826–1839; and Lithography.

Further Reading

Batchen, Geoffrey, "The Naming of Photography: 'A Mass of Metaphor'." *History of Photography*, vol. 17, no. 1 (Spring 1993): 22–32.

Fouque, Victor, *The Truth Concerning the Invention of Photography: Nicéphore Niépce, His Life, Letters and Works*, reprint edition of 1935 original, translated by Edward Epstean, New York: Arno Press, 1973.

Gernsheim, Helmut, *The Origins of Photography*, New York: Thames and Hudson, 1982.

Hardenberg, Horst O., *The Niépce Brothers' Boat Engines*, Warrendale, PA: Society of Automotive Engineers, 1993.

Jay, Paul. *Niépce: Genèse d'un Invention*, Chalon-sur-Saône: Musée Nicéphore Niépce, 1988.

Marignier, Jean-Louis. "Heliography: The Photographic Process Invented By Nicéphore Niépce Before His Association with Daguerre, New Light on the invention of Photography." *The Daguerreian Annual* (1996): 53–63.

Marignier, Jean-Louis, *Niépce: L'Invention de la Photographie*, Paris, Belin, 1999.

Marignier, Jean-Louis,. "The Physautotype: The World's Second Photographic Process, Invented by Niépce and Daguerre in 1832." *The Daguerreian Annual* (2002–2003): 350–362.

Nicéphore Niépce: Une Nouvelle Image / Nicéphore Niépce: A New Image, Chalon-sur-Saône: Société des Amis du Musée Nicéphore Niépce, 1998 (conference proceedings).

Smith, R.C. "Nicéphore Niépce in England." *History of Photography*, vol. 7, no. 1 (January 1983): 43–50.

NIGHT PHOTOGRAPHY

The night, according to the French Academy's dictionary of 1858, is 'the length of time during which the sun is below our horizon.' Night is perceived as the opposite to day and daylight. It occupies a mythical space in many cultures and has been imaged through the centuries both negatively and positively. It can be unfathomable, threatening, sorrowful, sexual, modern, dreamlike or poetic. Rembrandt van Rijn's night prints and Francisco de Goya's twilight scene 'Los Caprichos' were precursors to the increasing interest in this subject to a nineteenth-century audience. Night scenes became very fashionable from the 1850s, documenting the social impact of the first gas and electric lights and immortalising the developing modernity of the city. Night and night-life captured the public imagination, spurred on by contemporary painters such as Edgar Degas, Toulouse Lautrec, Claude Monet and James McNeill Whistler.

Technically, photographing night was extremely difficult. It required a very long exposure time and therefore stillness, as well as light from the moon or an artificial source. An added complication was the urgency associated with making daguerreotypes (used from the 1840s to mid-1950s) and wet collodion negatives (used from the 1850s until the 1880s). These need to be developed straight after the image is made, and the complications for the nineteenth-century photographer being in the dark or depending on dangerous and volatile artificial light sources hindered the process.

As photography evolved, so did strategies and techniques for photographing at night. Wet collodion plate negatives must be kept moist from the time they were coated with collodion until they are developed. Exposure time was typically twenty seconds to five minutes and the plate usually dried out in ten minutes. To keep the collodion wet for longer and thus permit a longer

exposure, people experimented with adding substances such as water-absorbing zinc salts or honey. From the 1870s the invention of the highly sensitive dry plate or gelatino-bromide process reduced exposure times to 1/25 second, and soon after cameras became more portable. These advances made photographing at night much easier.

Since it was hard to take photographs in the dark, particularly with the early techniques, night effects could be achieved with photographs taken in daylight: daguerreotypes and calotype negatives produce a reversed background that could be interpreted as a night sky, black against the detailed foreground. Scenes apparently depicting the night were often taken in daylight, *The Illustrated Times* (10, 252, 1860) critiquing, for example, that 'Messrs Bissou's no.35 contains a most successful moonlight effect, though no doubt taken in sunlight.' Gustave le Gray photographed directly into the sun hidden behind clouds to obtain an artistic image that could be mistaken as night ('Brick au clair de lune,' 1856, Musée d'Orsay, Paris).

Night subjects suited many of the viewing devices that were developed. The Italian optician and photographer Carlo Ponti produced night scenes with his invention, the 'Megalethoscope,' a photographic viewer that allowed photographs, slid into the back of the device, to be viewed firstly by reflective light, and then by light from behind. 'Place St Marc avec l'eglise' (1875, George Eastman House) shows crowds in St Mark's square surrounded by illuminations. Areas on the back of the print have been embellished, and this colouring could only be seen when light shone through from the back of the print, echoing the effect of time as the image revolved from (black and white) day to—when back-lit—colorful night.

Extra kudos could be earned by taking pictures at night rather than mocking darkness. One of the earliest known images of night (strictly twilight), possibly by Louis Daguerre, is captioned 'Le ponts en la galerie du Louvre, à 5.15. Soleil coucheant' (1839, National Media Museum, UK). It shows bridges along the Seine in Paris and is faint but detailed, suggesting that documentary images of night were possible, and sought after, from the beginnings of photography.

Providing documentary evidence with photographs was a significant advance in journalism, and relied on the problematic assumption that photographs always represent reality. One of the earliest reportage images was a daguerreotype of mills burning at night, taken by George N. Barnard in Oswego, New York, on 5 July 1853 (George Eastman House). The night sky is lit by huge flames, recording a dramatic moment with startling effect.

The night sky was also documented in a scientific way. Daguerre recorded an image of the moon around 1838, with others following suit. Lunar daguerreotypes of George Philips Bond and John Adams Whipple were shown at the 1851 Great Exhibition at Crystal Palace, London and were so popular that they went on tour in Europe. The subsequent wet-plate collodion prints by Warren De La Rue, along with Lewis Morris Rutherford's albumen print *The Moon, New York* (1865) continued to spark the interest in lunar photography. In 1889, Director of the Meudon Observatory, Jules Janssen, recommended that a photographic atlas of the moon be undertaken, insisting that photographs would give the most authentic results. Photographs were also used to document the movements of comets and stars in the sky, contributing to scientific evidence at the time.

Yet the subject of the moon was also used to evoke emotion or atmosphere. Ferrier and Soulier's stereoscopic photograph 'Pont Louis Philippe. Paris. Effet de lune' (1860) shows the night sky being investigated in the same way as John Constable's painterly explorations of the moody daytime sky. The aim could have been to capture a specific time and place, as well as to illuminate and fix the mysterious moon. Moonlight was a romantic symbol, favoured by schools of artists and movements such as Luminism, an American movement in the 1840s and 1850s. As industrialisation advanced in many cities and nature was revered, night landscapes either heightened the atmosphere of the modern city at night, or accentuated its dreamlike qualities.

Whilst artists were exploiting the night imagery in nature, darkness and photography was used to advance the spiritualism movement, popular from mid-century. Various techniques such as double exposures or composite printing were used to produce images of spirits in darkness. Spirit photography fuelled the fascination with the supernatural during this period.

In contrast to the darkness used to effect in spirit photography, many photographers took advantage of modern artificial light sources, such as electricity or magnesium-based inflammable powders. In the 1857 Birmingham photographic Society exhibition, an unknown photographer exhibited a photograph with the caption 'Portrait taken by Gaslight at Midnight. This is a great curiosity, being one of the few attempts made to obtain Portraits by artificial light. The observer will notice the singular effects of light and shade.' Dutch photographer Henry van der Weyde used artificial light and different lenses to take photographs at night. Much later, in Paris in the 1890s, Belliéni took artificial light out onto the night street. In the last two decades of the nineteenth century, artificial light became a key subject in photographs as well as an aid to photographers at night.

Artificial light played an important role in socio-documentary photographs. Jacob Riis used primitive flash photography techniques to document the New York

streets at night, publishing his photographs as books such as *How the Other Half Lives* (1890). At the turn of the century, Lewis W. Hine's photographs accentuated bad working conditions by concentrating on dark or artificially lit spaces. For him, natural light equalled good health and vice versa.

Lit up at night, the modern city became a fin-de-siècle fascination. The French photographer Louis-Gabriel Loppé was one of the first photographers to document cities at night, taking advantage of the dry plate process. He photographed London, Liverpool and Paris producing works such as 'Illuminations de la tour Eiffel la nuit' (c.1889, Musée d'Orsay). His work was influential: Brassaï later reproached Andre Kertez for stealing Loppé's idea of photographing at night.

Paul Martin was also influential. Imaging the city in an artistic manner, his 'Piccadilly Circus at Night, London' (1896), for example, was part of the lantern-slide series 'London by Gaslight,' which won a Royal Photographic Society gold medal in 1896. The exposure time was around fifteen minutes and the camera lens was partly shielded from the lights of passing cars. Martin accentuated the gas lamps by tinting the prints in this series blue and yellow. Due in part to the interest in his work, a society of Night Photographers was founded in Britain. Photographers including Alfred Steiglitz, inspired by Martin, made works such as 'Night, New York' (1897), and continued working on night photography into the twentieth century.

A complex but popular subject, night photography in the nineteenth century broaches the gap between pictorialism and realism, scientific and imaginary scenes and, due to the technical difficulty in producing images of night, stood at the forefront of photographic advances of the nineteenth century.

SOPHIE LEIGHTON

See also: Daguerre, Louis-Jacques-Mandé; Le Gray, Gustave; Lunar Photography; Martin, Paul Augustus; and Spirit, Ghost, and Psychic Photography.

Further Reading

Ferris, Alison, *The Disembodied Spirit*, Brunswick, ME: Bowdoin College Museum of Art, 2003.

Hallenberg, Heather, *Night Lights: 19th and 20th Century American Nocturn Paintings,* Cincinatti,OH: Taft Museum, 1985.

Heilbrun, Françoise, and Bajac, Quentin. *Orsay: La Photographie*,Paris, Editions Scala, 2003.

Lenman, Robert (ed.). *The Oxford Companion to the Photograph*,London, Oxford University Press, 2005.

Lunn Gallery, *Lewis Hine: Child Labor Photographs*, Washington, Lunn Gallery/ Graphics International Ltd., 1980.

Mulligan, Therese, and Wooters, David (eds.), *Photography from 1839 to today: George Eastman House, Rochester, NY,* New York: Taschen, 2000.

Schivelbusch, Wolfgang, *Disenchanted Night: The Industrialisation of light in the Nineteenth Century*, London, University of California Press, 1988.

Taylor, Roger, *Photographs Exhibited in Britain 1839–1865*, Ottawa, National Gallery of Canada, 2002, http://www.peib.org.uk.

Email links:
http://www.edinphoto.org.uk/
http://photography.about.com/library/weekly/aa111802a.htm

NOACK, ALFRED (1833–1895)
German photographer

Augustus Alfred Noack was born in Dresden on 25th May 1833. The son of a doctor, he studied xylography, illustration and engraving at the Dresden Academy of Fine Arts with Hugo Burkner. In November 1856 he went to Rome where he was a member of the Deutschen Künstverein until April 1860. In the same year he moved to Genoa where he founded one of the most important Italian photographic factories in Vico del Filo. He devoted his activity to views of various tourist resorts in northern Italy but mainly views of Genoa and the Ligurian landscape. He also took photographs of works of art in the museums and churches of Genoa, but he became a very well-known photographer mainly through his landscapes, which were widely circulated by reviews and tourist guides and contributed to creating a typical image of the Ligurian region in accordance with the 19th century vision of pictorial tradition. In the 1880s,

Noack, Alfredo. Statue of a Little Girl.
The J. Paul Getty Museum, Los Angeles © The J. Paul Getty Museum" "The J. Paul Getty Museum, Los Angeles © The J. Paul Getty Museum.

using the instantaneous photographic process, Noack took important pictures of street life in Genoa, giving an idea of ancient crafts and social habits. He died in 1895 and his archive was taken over by Carlo Paganini. In 1926 his heir, Maria, sold the entire archive, with more than 4,000 negatives, to the City of Genoa, where it is now kept.

SILVIA PAOLI

NORMAND, ALFRED-NICOLAS (1822–1909)
French architect and photographer

Alfred-Nicolas Normand, architect, Prix de Rome scholar at the French Academy, arrived Rome 1846 and took up the calotype, usually signed 'A Normand' and dating from 1850–52. This small collection depicts views of Rome and Pompei, along with Palermo, Athens and Constantinople. His expert images, evocative and sensitive, redolent with the pathos of classical antiquity, surpassed the topographical and architectural study which became common in the commercial albumen period which mostly extinguished such private calotype photographers. The French artists on their Grand Tour to Rome were to form one of the first significant groups of calotypists in Italy, subsequently described as *La Scuola Romana di Fotografia* although there is no evidence of a group as such. Along with the other artists from Northern Europe and America they frequented the social life in Rome centred around the Caffè Greco. The French 'group' included Jean-François-Charles André (1813–83), known as Count Frédéric Flachéron, sculptor, lived Rome 1839–67; Eugène Constant, painter, lived Rome 1848–55, probable the first in Rome to use the new albumen on glass; and Prince Giron des Anglonnes, a contemporary of Normand, also working 1850–52. Normand also became known for his architectural drawings and studies which continue to be sold today in the poster market. He remained a member of the Academy des Beaux-Arts in Paris until 1890, although little would appear to be known of his life.

ALISTAIR CRAWFORD

NORWAY

Through the year of 1839 the publisher Hans Thøger Winther (1786–1851) kept the Norwegian public informed about what was happening in France. In October of 1840 the first daguerreotype was exhibited in Bergen and at the beginning of 1841 another was shown at an exhibition arranged by the Art Society in the capital Christiania (now Oslo). Winther was himself experimenting with fixing images and in 1842 he published his first photographs as lithograph reproductions "from life." Three years later he published an extensive handbook explaining the direct positive process, the negative/positive process and a method for conversion of positives into negatives and vice versa. People could also buy cameras made of wood or cardboard, built after his instructions; his work inspired a growing group of photographers in Norway.

Norway was a rural society with a small population mainly living from agriculture and fishing. There were no really big cities and only a few industrial settlements in the beginning of the 19th century. At the same time, a growing national awareness based on new political circumstances, was making room for new activity, such as building universities, industrialization, railroads, a growing media and political parties. The artistic community formed an important part of this project. So did the growing population of photographers: from 80 active photographers in 1855–60 to about 700 in the national census of 1900 (Erlandsen 2000, 175). It is an interesting fact that the new technique developed side by side with the growing society. We can very much read what was considered important by what was photographed and how the images were used. First and foremost, the community of photographers catered to the demands of the growing middle class for portraits. But they also both documented society as it developed, contributed to new fields and helped give Norwegians images to understand and develop a culture and an identity.

One of the most important early participants in the field of photography in Norway was the Danish pharmacist Marcus Selmer (1818–1900). He came to Bergen in 1852 and established a portrait-studio were he made daguerreotypes and photographs in other techniques. He soon started on a big project: photographing people in local costumes and landscapes from different parts of the country. The images were offered to the popular illustrated press and tourists—both growing industries. The probably first news photography can also be attributed to Selmer: a photograph of the remains of a house burnt down in January 1863 and advertised for sale two weeks later.

Knud Knudsen (1832–1915) probably learnt to photograph from Selmer whom he worked for for many years before he started his own studio in Bergen in 1864. He was the first to systematically photograph the whole of Norway: from Kristiansand to the North Cape. He also documented a rapidly vanishing rural culture. Knudsen made all together 9,000 images before 1898, when he retired and left his business to a relative. No doubt earlier painters and their choice of places to go influenced him, but he expanded the repertoire and that way also peoples knowledge of the country.

The Swedish photographer Axel Lindahl (1832–1906) was engaged by the publisher Richard Andvord in 1882 to photograph Norway. He travelled all through

the country and completed an archive of about 3,000 images, very much the same way Knudsen did. His perhaps most important and innovative images are those of glaciers and winter landscapes from Svalbard. Two series of pictures were published in 1892 and 1897, apart from an extensive use of the archive for illustrations and sale of mass-produced images for tourist-albums. Many more produced landscapes and cityscapes towards the end of the century: Per Adolf Thorén (1830–1909), Ole Tobias Olsen (1830–1924) and the brothers Thorvald Aron (1871–1896) and August Brunskow (1862–1906) worked as a team.

It is an interesting fact that quite a lot of women worked as photographers in Norway from the end of the 1880s and onward. There are several explanations for this. First, the improved technique at this time was easier and fast to learn, it was not very expensive to establish a photographic business, and a law was passed in 1866 that allowed women to have a trade. The large surplus of unmarried women made it necessary to find acceptable occupations. Not all could be teachers or servants, look after their old parents or be looked after by relatives. There was also the belief that women were more suited because of a special artistic understanding. They produced mostly portraiture, but also landscape postcards. It seems, though, that they did not usually travel as extensively as their male counterparts mentioned above, and if their landscapes are different, it is because children often are found playing in the streets or on the beaches. The images have no romantic meaning as defined earlier in the century. They are merely a realistic documentation of small villages and peaceful scenery in places that were popular to visit in the summer. Marie Høeg (1865–1949) and Bolette Berg (1871–1944) in Horten; Louise Abel (1841–1907) in Christiania; Augusta Charlotte Solberg (1856–1922) in Lillehammer; Louise Wold (1869–) in Holmestrand; Hulda Marie Bentzen (1858–1930) and Agnes Nyblin (1869–1945) both in Bergen, are only a few worthy of notice. Nyblin developed the firm, when her husband died in 1893, into one of the most influential in Bergen. From 1897 she also worked as a police photographer.

Towards the end of the century the photographic community started organizing to protect their trade. In 1877 the first copyright-law was passed, and in 1882 the first attempt to organize Norwegian photographers was made: Det fotografiske Selskab i Christiania (The Photographic Society in Christiania). The inspiration came from Denmark and it was started for the purpose of promoting interest and knowledge about photography through meetings, discussions and research. Both professional and amateur photographers were welcome. There was also a plan to buy photographs from well-known foreign photographers and arrange exhibitions that could inspire local photographers. One of the leading portrait-photographers, Ludwig Szacinski (1844–94) was chosen chairman, but the association did not last for long.

In 1894 there was a new attempt made and the initiator, portrait photographer Christian Gihbson (1857–1902) was chosen chairman this time. It is clear that at this time Amateurs were seen as a threat. Everyone who "… used photography as a main source of income" could join (Erlandsen 2000, 189). The most important issue at the end of the century was weather photography was art or handicraft. This was important in terms of group identification and education. In 1899 a committee was appointed to elucidate the problem and two years later they concluded that photography should be part of the Union for industry and handicraft.

HANNE HOLM-JOHNSEN

See also: France; and Daguerreotype.

Further Reading

Bonge, Susanne, *Eldre fotografer i Norge [Old photographers in Norway]*, Bergen 1980.

Digranes, Å., Greve, S., Reiakvam, O., *Det norske bildet. Knud Knudsens fotografier 1864–1900 [The Norwegian Image. Knud Knudsen's photographs]*, Oslo 1988.

Erlandsen, Roger, *Pas nu paa! Nu tar jeg fra Hullet! Om fotografiens første hundre år i Norge 1839–1940 [Watch out! Now I am taking the picture! About the first hundred years of photography in Norway 1839–1940]*, Våle, Forlaget Inter-View A/S, 2000.

Halaas, Kristin, *I fotografens regi. Norsk portrettfotografi 1860–1910 [Directed by the Photographer. Norwegian Portrait photography 1860–1910]*, Oslo, Norsk Fotohistroisk Forenings skriftserie 9, 2004/5.

Meyer, Robert, *Den glemte tradisjon. Robert Meyers Fotohistoriske Samlinger [The forgotten tradition. Robert Meyer's Photo historical Collection]*, Oslo kunstforenings Skrifter 1, 1989.

NOTES AND QUERIES

Notes and Queries commenced as a weekly publication in November 1849, selling at 4d and 5d stamped. It was edited by William John Thoms, a Fellow of the Society of Antiquaries and former contributor to the *Athenaeum*. The purpose of the journal was to provide a cheap and frequent means for the interchange of information in the form of notes between "the artist, the man of science, the historian, the herald, and the genealogist." Aimed at a learned general audience, the principal concern of *Notes and Queries* was the solution of questions concerning genealogy, literary quotations, proverbs, folklore and archaeology. The scope of the periodical was also perfectly suited to appeal to the educated and eclectic gentlemen amateurs who dominated early British photography.

Thoms was a keen amateur photographer with a particular interest in architectural photography. A member of the Photographic Exchange Club, his photographs included pictures of Herne's Oak and of Pevesney Castle. Consequently, for the first five years of its existence, *Notes and Queries* was an important forum for discussions upon the refinement of the various photographic processes. Before the Photographic Society of London and the numerous local photographic societies established themselves, it provided a means for enthusiasts to exchange and disseminate new technical advances. Almost two hundred entries on photography are listed in the index to the first twelve volumes. In its edition of November 4, 1854, the *Athenaeum* noted that "Our contemporary, *Notes and Queries*, seems to be making itself the special organ of photographic discussion and intelligence." Similarly, Thoms himself described the success of the journal in furthering the cause of photography:

> The shadow of a doubt that we once felt as to the propriety of introducing the subject of Photography into our columns, has been entirely removed by the many expressions of satisfaction at our having done so which have reached us. . . (9 October 1852, 347)

The photographic coverage of *Notes and Queries* began in September 1852. Thoms asked his friend and fellow antiquary Hugh Welch Diamond to contribute a series of letters on the archaeological benefits of using photography to record old monuments and buildings. Diamond would later be a founder member of the Photographic Society of London and a future editor of the *Photographic Journal*. Many other notable amateur practitioners contributed to the journal during the early 1850s. These included Philip Henry Delamotte, Frederick Scott Archer, Edmund Kater, Sir William Newton, and George Shadbolt, founding member of the Photographic Society of London and future editor of the *Liverpool and Manchester Photographic Journal*.

The issues raised in *Notes and Queries* were primarily of a scientific nature. Diamond and Delamotte both published details of the different experiments they used for taking collodion photographs. The pages of *Notes and Queries* are thus a valuable guide to the difficulties experienced by early photographers, and their ingenious attempts to solve the problems they faced. However, the advent of specialist photographic journals, along with the establishment of the collodion process, meant that the number of entries on photography declined substantially after 1855.

JOHN PLUNKETT

See also: Archer, Frederick Scott; Photographic Exchange Club and Photographic Society Club, London; Delamotte, Philip Henry; Wet Collodion Positive Processes; and Wet Collodion Negative.

Further Reading

Algar, F., and Wilfred H. Holden, "W.J. Thoms: Our First Editor." *Notes and Queries* 198 (1853): 125, 223.

Notes and Queries. The Waterloo Directory of English Newspaper and Periodicals, vol. 5, edited by John North, 3567–3570, Waterloo: North Waterloo Academic Press, 1997.

Seiberling, Grace, and Carolyn Bloore, *Amateurs, photography and the mid-Victorian imagination*, Chicago: Chicago UP & International Museum of Photography, 1986.

Spurgeon, Dickie A., "*Notes and Queries*," *British Literary Magazines*: The Victorian and Edwardian Age 1837–1913, edited by Alvin Sullivan, 281–285. Westport, CT: Greenwood Press.

Thoms, William J., "The Story of 'Notes and Queries'." *Notes and Queries* 5th series, vol. 6 (1876): 1, 41, 111, 221, and vol. 7 (1877): 1, 222, 303.

NOTMAN, WILLIAM & SONS (1856–1935)
Canadian photographers

In December 1856, William Notman, fleeing arrest in Scotland, opened a photography studio in Montreal. Daguerreotypist Thomas Coffin Doane, in business from 1848, had offered to sell his operation but Notman established a new firm producing ambrotypes, tintypes, and albumen prints. By his death in 1891, Notman had built the most successful nineteenth-century photography enterprise in North America. At its peak in 1874, the Montreal studio alone, with a staff of thirty-seven men and eighteen women, produced fourteen thousand photographs. Notman's specialty was portraiture. Montreal citizens and distinguished visitors, from Sitting Bull to the Prince of Wales, were portrayed in Notman's elegant house style. Notman's was also popular for complex composite photographs, studio tableaux of hunting and sporting scenes, especially in winter, and Canadian landscape views.

An accomplished photographer and skilled businessman, Notman sought out opportunities to position his work prominently in Canada and the United States. His first major commission in 1858 was to document an engineering feat: the construction of the Victoria Bridge at Montreal, a two-mile long tubular steel railway span, the longest in the world. In honour of a visit by the Prince of Wales to inaugurate the Victoria Bridge in 1860, Notman produced the Maple Box Portfolio, a presentation album featuring five hundred photographs and stereographs of Canadian views and bridge construction. Two editions were made: one for Windsor Castle, one for the studio. After the royal family accepted the gift, Notman claimed the title Photographer to the Queen, although there is no documentation that the honour was officially bestowed.

In 1868, Notman opened his first branch studios, in Ottawa and Toronto followed by branches in Halifax and St. John, New Brunswick. While Montreal remained

the base of operations, Notman also pursued opportunities in the United States starting in 1869 with college photographs for Vassar, Harvard, Yale, Princeton, and others. These were printed and compiled into albums in Montreal. In 1875, new postal regulations governing exports to the United States jeopardized the college trade and so in 1877, Notman began opening American branches under the name of the Notman Photographic Company. Permanent studios in Boston, Albany, Newport, and Cambridge were complemented by seasonal studios operated in small college and resort towns for a total of twenty-four branches in North America. In 1876, Notman established the Centennial Photographic Company in Philadelphia to secure exclusive photography rights for the United States Centennial World Fair. Notman's Montreal studio also entered the photographic competition at the fair. One of the judges, German photographer Hermann Vogel, commending the quality of North American photography practices, wrote that "ahead of all stands Notman."

Notman shared his expertise in letters, articles, and photographs with the *Philadelphia Photographer* edited by Edward Wilson. In 1867, for example, he introduced the cabinet portrait format to North America with an article and a sample tipped into the January edition. Another Notman innovation was the first photo-identity card, called a photographic ticket, produced at the Centennial Photographic Company to regulate entry for exhibitors, press, and employees of the 1876 World Fair. Notman studio photographs were also distinguished in the United States as the first to be used in advertising. Travelers Insurance, pioneering the illustrated hanging calendar, commissioned Notman to make composites of the Union and Confederate Commanders for their 1883 calendar, followed by composites of Famous American Authors, Eminent Women, and Famous Editors.

Notman relied on his brothers, John Sloan (1830–1879) and James (1849–1932), other young men he had trained as photographers, and his sons William McFarlane (1857–1913), George (1861–1921), and Charles (1870–1955) to manage studios as he expanded operations. Although women held a variety of positions at Notman's and numbered up to thirty percent of employees, none were photographers. William McFarlane began in 1873 as an apprentice and by 1882 became a partner in the firm. He specialized in view photography and is best known for work done for the Canadian Pacific Railway between 1884 and 1909, photographing landscape along the transcontinental line between Montreal and Calgary and into the Rocky Mountains, and First Nations people in the western provinces and territories. He also photographed extensively in Nova Scotia, Newfoundland, and Quebec.

George apprenticed in Montreal in 1884 and represented Notman's in London at the 1887 Golden Jubilee.

In 1890, he moved to Boston and in 1893 left the family firm to establish his own studio in New York followed by one in Boston. In 1900, he returned to Montreal but left the photography industry.

Charles apprenticed in Boston in 1888. He returned to the Montreal studio following his father's death in 1891 and established a reputation for portraiture. In 1894, Charles joined William McFarlane as a partner in William Notman and Sons. On William McFarlane's death in 1913, Charles became sole proprietor. Upon his retirement in 1935, the studio's artifacts were sold to Associated Screen News. These included four hundred thousand prints compiled in two hundred day books from 1860 to 1935, two hundred thousand negatives, employee wages books documenting names, salaries, and employment dates of four hindred employees from 1864 to 1917, and an alphabetical index to the day books. In 1955, benefactors donated these materials to the McCord Museum of Canadian History at McGill University in Montreal where the Notman Photographic Archives, housing the most extensive collection of a single nineteenth-century photography studio in the world, now resides.

COLLEEN SKIDMORE

Biography

William Notman was born in Paisley, Scotland on 8 March 1826. He was the eldest of seven children of Janet Sloan and William Notman Sr. a manufacturer of women's shawls who in 1840 established a dry goods business in Glasgow. Notman received a classical education that included drawing and painting. As a young adult he entered the family business and learned photography although the details of his training are unknown. In 1853, Notman married Alice Woodwark of Gloucestershire, England. Three sons and five daughters were born between 1856 and 1870. In May 1856, Notman fled to Montreal to avoid arrest for illegal business practices undertaken to avert bankruptcy of the Notman firm. His wife and infant daughter joined him three months later. His parents, three brothers, and one of his three sisters followed in 1859. William Notman died of pneumonia in Montreal on 25 November 1891.

See also: Daguerreotye; Wet Collodion Positive Processes; Tintype (Ferrotype, Melainotype); and Albumen Print.

Further Reading

Hall, Roger, Gordon Dodds, and Stanley G. Triggs, *The World of William Notman,* Toronto: McClelland and Stewart, 1993.

Harper, J. Russell, and Stanley Triggs, *Portrait of a Period: A Collection of Notman Photographs 1856 to 1915,* Montreal: McGill University Press, 1967.

Skidmore, Colleen, "'All That Is Interesting in the Canadas': William Notman's Maple Box Portfolio of Stereographic Views, 1860." *Journal of Canadian Studies* 32 (1997–1998): 69–90.

——, "Concordia Salus: Triumphal Arches at Montreal, 1860." *Journal of Canadian Art History* XIX (1998): 86–112.

——, "Women Workers at Notman's Studio: Young Ladies of the Printing Room." *History of Photography* 20 (1996): 122–28.

Triggs, Stanley, *The Composite Photographs of William Notman*, Montreal: McCord Museum of Canadian History, 1993 (exhibition catalogue).

——, *William Notman's Studio: The Canadian Picture*, Montreal: McCord Museum/McGill-Queen's University Press, 1992 (exhibition catalogue).

——, *William Notman: The Stamp of a Studio,* Toronto: Art Gallery of Ontario/Coach House Press, 1985 (exhibition catalogue).

——, Brian Young, Conrad Graham, and Gilles Lauzon, *Victoria Bridge: The Vital Link*, Montreal: McCord Museum of Canadian History, 1992 (exhibition catalogue).

NUDES

In E. M. Forster's novel, *A Room with a View* (1908), Lucy Honeychurch expressed her rebelliousness by buying a photograph of Botticelli's *Birth of Venus*—this in defiance of her chaperone's warning that "Venus, being a pity, spoiled the picture, otherwise so charming." Almost contemporaneously, in 1910, seven-year-old Kenneth Clark was "expounding" his favourite pictures to his Victorian grandmother. "Unfortunately," he recalled in his autobiography, "I began with Giorgione's *Concert Champêtre*. We were sitting on a sofa near the window and I turned to the page in triumph. 'Oh dear, it's very nude' said my grandmother, and rose from the sofa in confusion."

These episodes show that the nude was an uncomfortable subject in the Victorian and Edwardian periods. In addition, they draw attention to the tension that existed between the aesthetic and erotic aspects of such subjects. In the case of photography, this tension was exacerbated by the realism of the medium, a realism that made it difficult for the viewer to be "diverted ('sublimated') in the direction of art"—as Freud put it in his *Three Essays on the Theory of Sexuality* (1901). Susan Waller (2003) highlighted the problematic nature of photography when she observed that during the Third Republic of France photographic reproductions of paintings of nudes that had been publicly displayed in the Louvre or in the Salon could not be displayed in shop windows, even when the government censorship authority had approved their sale.

Freud's assertion that sexual curiosity might be "sublimated" to become, at least in part, an aesthetic appreciation of the body has proved contentious. "If the nude is so treated that it raises in the spectator ideas or desires appropriate to the material subject, it is false art, and bad

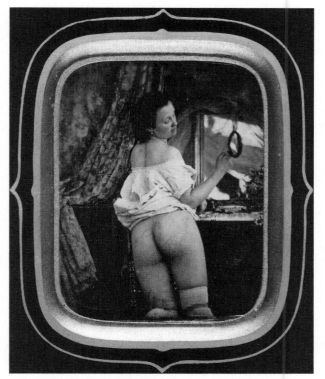

Unknown. Nude with Mirror.
The Metropolitan Museum of Art, The Rubel Collection, Purchase, Lila Acheson Wallace Gift, 1997 (1997.382.45) Image © The Metropolitan Museum of Art.

morals," wrote philosopher Samuel Alexander in *Beauty and Other Forms of Value* (1933). Kenneth Clark, on the other hand, maintained in *The Nude* (1956): "No nude, however abstract, should fail to arouse in the spectator some vestige of erotic feeling … and if it does not do so, it is bad art and false morals. The desire to grasp and be united with another human body is so fundamental a part of our nature, that our judgment of what is known as 'pure form' is inevitably influenced by it; and one of the difficulties of the nude as a subject for art is that these instincts cannot lie hidden." More recently, Camille Paglia in her highly influential book *Sexual Personae* (1990) insisted on the fundamentally sexual nature of the nude in art; at the other end of the spectrum is Maxim Du Camp's 1863 observation that "art should have no more sex than mathematics." In fact, photographs of the nude may be situated at all points in a spectrum ranging from the chaste to the obscene. Moreover, the character of the photograph may change, depending on the nature of the consumer and whether he was an artist, medical student, scopophiliac or voyeur.

Drawing from the nude model was central to the training and practice of artists in the early modern period and remained so in academic art curricula in Europe and North America throughout the nineteenth century. This being the case, it is not surprising that photographers worked from the nude and produced studies from the

nude to be used by artists. In France Eugène Durieu produced nude studies in the 1850s working in collaboration with Eugène Delacroix. During the Second Empire, photographers made large numbers of academic studies of nude models (*académies*) for the instruction of artists. By contrast, Edgar Degas, and Pierre Bonnard, at the end of the century, took intimate nude studies of their own companions and models.

In Edinburgh in the 1840s, David Octavius Hill and Robert Adamson produced a remarkable half-length nude study of Dr George Bell holding a studio pose. In England Oscar Gustav Rejlander's combination print *The Two Ways of Life* (1857) contained several nude women, some of whom are shown in flagrantly erotic poses. Although Queen Victoria and Prince Albert purchased a copy of this photographic allegory, it generated considerable controversy at the time. When it was exhibited in Edinburgh, for instance, the nude figures were hidden behind a curtain. In the Victorian period artists' models were presumed to be loose women, and in this instance the suspicion was heightened by the fact that Rejlander had used vaudeville artists as his models. Viewers were also offended by the mistaken assumption that male and female models had been posed together in Rejlander's studio. Rejlaender also made numerous photographs of individual nudes for the use of artists. Almost thirty of these glass negatives are preserved in the National Museum of Photography, Film and Television in Bradford; a portfolio containing nine of these studies was published when the plates were still in collection of the Royal Photographic Society.

Among nineteenth-century American painters, Thomas Eakins made extensive use of photographic nude studies, often posing his students to echo ancient sculpture. Photographs of his male students bathing, used for the painting *Swimming* (1885), are in the tradition of Michelangelo's figure studies for his unrealised mural *The Battle of Cascina*. The homoerotic nature of Michelangelo's male figures was also continued by Eakins's photographs, as was the case with photographs of nude young men taken contemporaneously by Fred Holland Day in Boston and by Wilhelm Von Gloeden at Taormina in Sicily. Von Gloeden combined Mediterranean subjects and subject matter with suggestions of Hellenic love, whereas Day invested his Christian subjects with melancholic eroticism.

Apart the production of artists' studies, there was a huge industry in France devoted to the production of commercial images of erotic, sexually explicit, and obscene photographs of nude models (McCauley 1994). The line between the artistic and the explicit or indecent was often blurred, and could depend to some extent upon the nature of the viewer. Freud provided useful retrospective guidance in this respect when he characterised the "normal" viewer as someone whose interest [could] be shifted away from the genitals on to the shape of the body as a whole." Photographs that focused exclusively upon the primary or secondary sexual characteristics of the nude were often produced as microphotographs and as stereo images; the latter had the particular attraction for the voyeur of enhancing the realistic and tactile qualities of the models. File BB3, preserved in archives of the Préfecture de Police in Paris, contains numerous obscene photographs of nudes and of individuals engaged in sexual acts; this file was compiled during the Second Empire to assist in the identification, classification and punishment of individuals involved in the illegal production of erotic images (Pellerin 2000).

Photographs of naked men and women were also taken for scientific or pseudo-scientific purposes to assist in the recording and classification of information. The accuracy and taxonomic value of photography was exploited in fields ranging from medicine to anthropology and ethnology and even to criminology. In the United States Joseph T. Zealy produced in 1850 a series of fifteen daguerreotypes of first- and second-generation African slaves on a plantation near Columbia, South Carolina. These plates, preserved in the Peabody Museum, were made for the Harvard professor Louis Agassiz to support his research into comparative anatomy and body typing (Phillips 1997). It is significant that the subjects were stripped of their clothing in order to have their bodies recorded for study and classification. This troubling aspect of the plates distinguishes them from photographs of ethnographic subjects, for whom nudity was their natural state. The non-consensual nature of the Peabody plates is a common feature of scientific studies of the nude body. It is noteworthy that Freud linked the concealment of the body to civilization, observing that "The progressive concealment of the body which goes along with civilization keeps sexual curiosity awake." In short, photographing a subject nude was itself a code indicating that the individual belonged to a "lower" or "other" form, one that was separate from normal society by illness, race or behaviour; nudity objectified the "other," whether the figure was an indigenous African, a hysteric, or a criminal convicted of indecent acts.

An especially troubling category of nude photography in the nineteenth century is that concerning child subjects. Middle-class Victorians idealised children, especially female children, as creatures untainted by society, but this romantic view coexisted with the realities of incest and child prostitution, evils that affected the middle classes as well as the poor. Charles Lutwidge Dodgson commented specifically on the naturalness and beauty of the nude female child. Moreover, he famously photographed some of his little girl friends nude. Very few of these photographs survive, and those that do have been coloured (clothed in watercolour, so to speak). Julia

Margaret Cameron also photographed nude children, often "clothing" them as allegories or presenting them as Christian subjects. Had Cameron not been female, her photographs would have caused as much concern among historians as Carroll's. Oscar Rejlander also photographed nude children, employing them to personify Painting and Photography, for instance, and having them echo *putti* in Renaissance paintings such as Raphael's renowned *Sistine Madonna*. It is exceedingly difficult for us in the twenty-first century to view such images without being affected by contemporary concerns regarding paedophilia and child pornography, and it must also have been difficult to do so in the Victorian period. Regardless of whether children are asexual or have sexuality instincts latent in them from an early age (as Freud believed), in a post-Freudian society photographs of nude children exude a disturbing eroticism.

Finally, it is useful to distinguish between the completely and the partially nude figure and to consider what effect the presence of some clothing has on the erotic nature of the image. Freud's emphasis upon the erotic nature of the partly veiled body was echoed not long ago by the French theoretician Roland Barthes. "Is not the most erotic portion of a body *where the garment gapes*?" he asked in *The Pleasure of the Text* (1975). "It is intermittence … which is erotic," he continued, "the intermittence of skin flashing between two articles of clothing." Conversely, the philosopher and legal scholar Thomas Nagel (2002) has argued that concealment and decorum are inseparable and that the exercise of restraint, especially with regard to clothing, is essential to civilized interaction among men and women.

GRAHAM SMITH

See also: Durieu, Jean-Louis-Marie-Eugène; Delacroix, Ferdinand Victor Eugène; Degas, Edgar; Bonnard, Pierre; Hill, David Octavius and Robert Adamson; Rejlander, Oscar Gustav; Eakins, Thomas; Day, Fred Holland; Gloeden, Baron Wilhelm von; Dodgson, Charles Lutwidge (Carroll, Lewis); and Cameron, Julia Margaret.

Further Reading

Clark, Kenneth, *The Nude: A Study in Ideal Form,* New York: Pantheon, 1956.

Edwards, Susan, "Pretty Babies: Art, Erotica or Kiddie Porn," *History of Photography* 18:1 (Spring 1994), 38–46.

Ellenzweig, Allen, *The Homoerotic Photograph: Male Images from Durieu/Delacroix to Mapplethorpe,* New York: Columbia University Press, 1992.

McCauley, Elizabeth Anne, "Braquehais and the Photographic Nude," in *Industrial Madness: Commercial Photography in Paris 1848–1871,* New Haven & London: Yale University Press, 1994, 149–194.

Nagel, Thomas, "Concealment and Exposure," in *Concealment and Exposure and Other Essays,* Oxford & New York: Oxford University Press, 2002.

Pellerin, Denis, "File BB3 and the erotic image in the Second Empire," In *Paris in 3D: From stereoscopy to virtual reality 1850–2000,* in association with the Musée Carnavalet, Museum of the History of Paris, ed. Françoise Reynaud, Catherine Tambrun, Kim Timby, London: Booth-Clibborn Editions, 2000, 90–99.

Phillips, Sandra S., "Identifying the Criminal." In *Police Pictures: The Photograph as Evidence,* San Francisco: San Francisco Museum of Art/Chronicle Books, 1997.

Smith, Alison, *The Victorian Nude: Sexuality, Morality and Art,* Manchester: Manchester University Press, 1996.

Smith, Alison, ed., with contributions by Robert Upstone et al., *Exposed: The Victorian Nude,* London: Tate Publishing, 2001.

Waller, Susan, "Censors and Photographers in the Third French Republic," *History of Photography* 27:3 (Autumn 2003), 222–235.

NUTTING, WALLACE (1861–1941)

Nutting was born in Rockbottom, Maine, and raised on his uncle's farm by his widowed mother. After quitting school his mother encouraged him to become a minister. Nutting married a widow called Mariet Griswold Caswell during his theological training and was a Congregational Minister until the age of forty-three, when he retired due to Neurasthenia. Not content to just write and travel, he produced antique reproductions of American furniture and took up photography. In his lifetime he produced over a million hand-tinted platinum prints of an idealised country life and its buildings' interiors. Nutting was so successful at one point, that he was employing over a hundred people to assist him in his work. His three volume *Furniture Treasury* was a guide to American antiques, which firmly established the business of antiques within America. The guide was illustrated with more than five thousand photographs of early American furniture, mostly taken by Nutting himself. He produced a series of guide books dedicated to his extensive travels. These books depicted scenes of beauty from both Great Britain and America; for example, *England Beautiful*. He also published, in 1924, a book called *Photographic Secrets*. Aside from his books, Nutting established five profit making museums in which to house his photographs and examples of American furniture. Nutting's photographic influence upon America was displayed in magazines such as Country Life, whereby in 1902 a collection of Nutting and Stieglitz's photographs were published together.

JO HALLINGTON

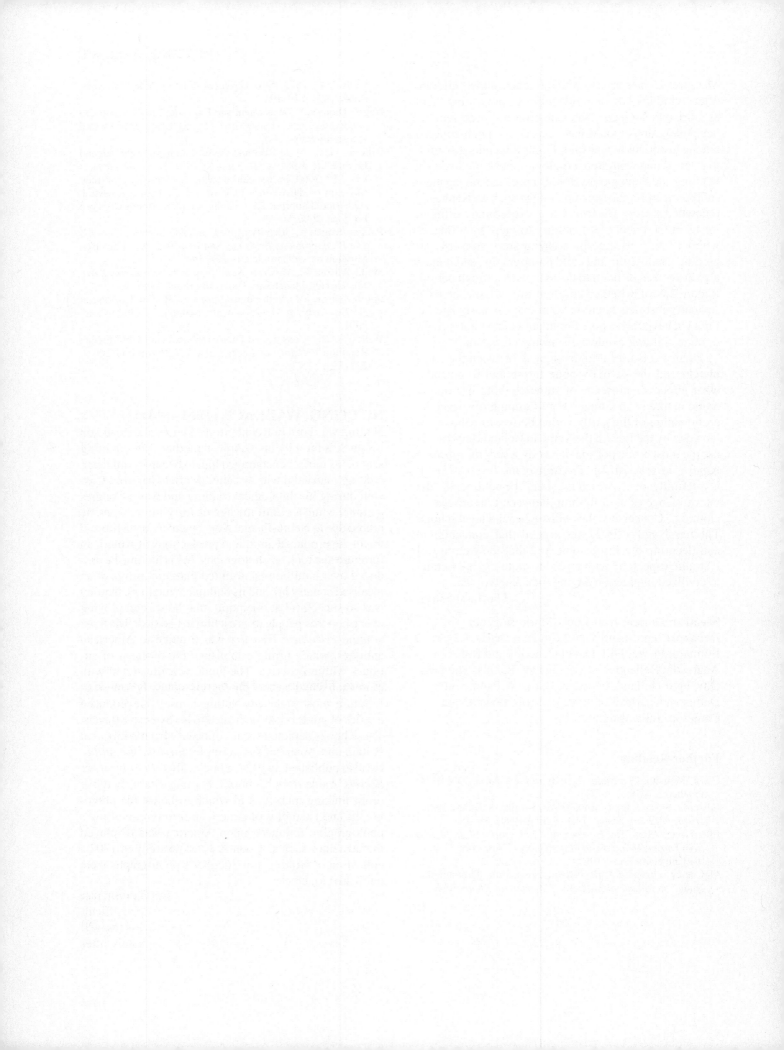

O

O'SULLIVAN, TIMOTHY HENRY (1840–1882)

American photographer, probably born Ireland

While little evidence survives regarding the personal life of photographer Timothy H. O'Sullivan, his photographic legacy is extensive. O'Sullivan was a major figure in two areas of early American photography: the documentation of the Civil War and the survey photography of the American West.

From the outset, O'Sullivan's personal life presents more questions than answers. He was born in 1840, probably in Ireland, to parents Jeremiah and Ann O'Sullivan. His family moved to the United States in 1842, as part of the massive wave of immigrants who fled the severe potato famine in Ireland. His birthplace has been mistakenly reported as New York City, because O'Sullivan himself made this claim on a questionnaire when applying for work at the U.S. Treasury Department, but O'Sullivan biographers have determined this to be incorrect.

By the age of 18, O'Sullivan had begun working in Mathew Brady's photographic studio in Washington D.C., which was being managed by Alexander Gardner. The studio, like most in photography's early years, was dedicated to making portraits, but with the onset of the Civil War, Brady turned his attention to the pursuit of field photography. By 1861, Gardner and O'Sullivan both belonged to Brady's "Photographic Corps" which became known for its war views. Late in 1862 Gardner had had a falling out with Brady and left to begin a photographic business of his own. O'Sullivan continued with Brady for a short time longer, but it is thought that when Gardner opened his own studio in Washington in May of 1863, O'Sullivan joined Gardner. O'Sullivan's work for Gardner included copying maps for the Union Army's strategic use, as well as making a variety of views of the war including individual and group portraits of military members and civilians engaged in the war, views of camps, forts, bridges, railroads, buildings, earthworks, towns, fields and plantations, and of changes wrought by the war.

These photographs were published in *Catalogue of Photographic Incidents of the War from the Gallery of Alexander Gardner, Photographer to the Army of the Potomac,* 1863 and *Gardner's Photographic Sketch Book of the War,* 1865/1866. Some of O'Sullivan's most memorable photographs were of the battlefield dead. Perhaps his most famous, *A Harvest of Death,* made at Gettysburg in 1863 and published in *Gardner's Photographic Sketch Book of the War,* shows a field littered with bloated Union corpses. A mounted soldier and the distant hills blur out of focus in the background. Instead of using a standard eye-level viewpoint, O'Sullivan has placed his camera close to the ground, bringing the viewer nearer to the dead men. This low vantage point also causes the battlefield to appear to rake steeply upward, filling more of the picture plane. Rather than aggrandize the heroics of war, O'Sullivan forces the viewer to confront the reality of the war's casualties. Including this powerful image, O'Sullivan made a total of forty-four negatives of the 100 published in *Gardner's Photographic Sketch Book of the War*, most of them landscape views of architecture including forts, bridges, railroad stations, churches, homes and tents employed by the army during the war.

Beginning with his field photography during the civil war, and continuing into his survey photography, Timothy O'Sullivan made glass plate collodion negatives. This method, also known as wet-plate because of the process of coating the glass with wet collodion just prior to exposure in the camera, was particularly difficult when employed in the field. The coating process (as well as the need to develop the negative immediately after

exposure) required field photographers to travel with portable darkrooms, or dark tents. In order to make large photographic prints, large glass negatives were needed, and traveling across the countryside by wagon with chemicals, large wooden cameras, and many sheets of glass made the process of photography quite burdensome by today's standards.

Throughout his career, in addition to single views, O'Sullivan made stereographic views of his war and survey subjects. These stereographs, which were collected widely in Victorian America, display two nearly identical images side-by-side, mounted on a small card.

Designed to imitate human binocular vision, they are best seen in a special viewer, called a stereoscope, which blocks out peripheral vision and creates the illusion of a three-dimensional image. Since these images are created with a special camera featuring two lenses separated by the same distance as human eyes, O'Sullivan had to travel with even more photographic equipment in order to make stereographic views.

In 1867, O'Sullivan was appointed to the Geological Explorations of the Fortieth Parallel by Clarence King, the United States Geologist in Charge. The survey had two explicit concerns: to study the natural resources along the Union and Central Pacific Railroads, and to document the geology of a section of the West one hundred miles wide from the Sierra Nevada Mountains to the Rocky Mountains. Unstated, but implicit in the goals of the survey, was that this research would help to promote the future development of the region by white settlers. This meant identifying possibilities for economic development, recording the local flora and fauna, evaluating the opportunities for mining, and assessing Indian hostilities. For King, as a geologist, this survey was also an important opportunity to produce not just a geological section, but a geological history, which would support his fervent belief in the concept of Catastrophism. This theory asserted that geological features of the earth's surface were created by a series of catastrophic and violent events, such as floods and earthquakes, rather than by slow evolution. King intended for O'Sullivan's geological photographs to illustrate his survey report, and therefore to visually demonstrate Catastrophism.

O'Sullivan had his photographic supplies shipped ahead, and then traveled to San Francisco by way of the Isthmus of Panama. Once there the party gathered in Sacramento, California, and set out on July 3, 1867. The going was arduous—King's men endured steep, snowy mountain passes, hot desert basins, and rough rivers. Most of the men caught malaria, O'Sullivan being one of the few to avoid it. While little has come down to us in O'Sullivan's own words, one of the rare written records of a survey expedition is a story that was published in *Harper's New Monthly Magazine* in September 1869.

The article, entitled "Photographs From the High Rockies," does not mention O'Sullivan by name, but scholars believe the story relates his exploits on King's survey. In one colorful episode the article recounts how the photographer's boat became lodged against some rocks while descending the Truckee River, which flows from Lake Tahoe in California to Pyramid Lake in Nevada. Concerned that the boat would be dashed to pieces by debris crashing along in the rough water, O'Sullivan stripped off his clothes and dove into the raging river. From the shore, he maneuvered ropes to free the boat and brought it to safety. This story suggests the danger and adventure that were an inherent part of exploring and photographing the rugged Western country for members of the nineteenth-century survey expeditions like King's.

The first season, in 1867, O'Sullivan photographed in Western Nevada and made his now-famous and otherworldly image of the tufa domes in Pyramid Lake. The King party spent that winter in Virginia City and Carson City, Nevada, and in the former O'Sullivan made photographs of the gold and silver mines, several hundred feet under ground. Not only were conditions unbearably hot, with temperatures reaching more than 130 degrees Fahrenheit, but the darkness of the mine shafts required O'Sullivan to use a magnesium flare to make his exposures. Despite these difficult circumstances, he produced many photographs of miners and the interior of the mines. In 1868, O'Sullivan continued to work in Western Nevada, and also photographed Mono Lake, California, and the Snake River and Shoshone Falls in southern Idaho. O'Sullivan returned to Washington D.C. in the winter of 1868-9 to print his first survey photographs, which were used internally but not published. In fact, throughout his career as an expedition photographer, O'Sullivan never printed in the field. He made negatives as he traveled, and only saw his results later, when he printed back in the East. Also upon his return to Washington D.C. in 1868, O'Sullivan began his courtship of Laura Virginia Pywell, whom he would later marry. By May of 1869 he was back in the West, on his third survey season with Clarence King, photographing the mountains near Salt Lake City, as well as northern Utah, and southern Wyoming.

In January of 1870, during a lull in the surveying while King waited to see if future appropriations would be forthcoming, O'Sullivan photographed on the Atlantic side of the present-day Isthmus of Panama (then the Isthmus of Darien, in the State of Panama in Colombia). This position with a Navy Department survey, whose mandate was to identify a canal route, yielded photographs of the ship and crew, along with some views of native Indian villages, coastline and architecture. The region's dense foliage and the high humidity, however, prevented the topographical views that were the survey's goal. After

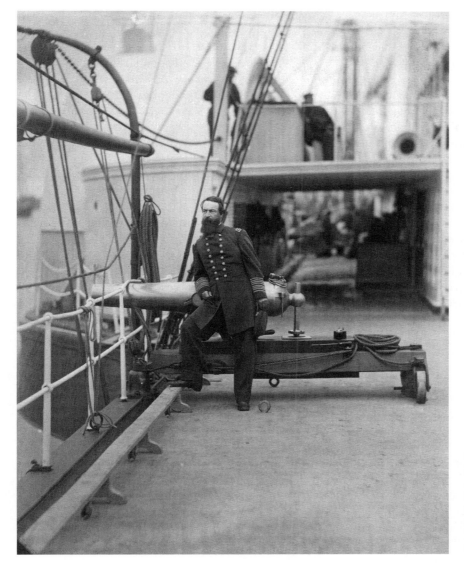

O'Sullivan, Timothy H., Print
Attributed to Alexander Gardner.
Admiral David Dixon Porter on the
deck of his flagship the "Malver"
after the victory at Ft. Fisher, North
Carolina.
The J. Paul Getty Museum, Los Angeles
© The J. Paul Getty Museum.

seven months, O'Sullivan returned to the United States and was replaced by the Navy with photographer John Moran. The change in personnel has caused confusion in attributing the Panama photographs, resulting in many Moran photographs being credited to O'Sullivan.

Lieutenant George Montague Wheeler hired O'Sullivan in September of 1870 to join his survey of the American Southwest, with permission from King, who maintained O'Sullivan on his payroll. Wheeler's expeditions were different from King's in several ways: Wheeler's survey was the only military expedition of the four major expeditions to be conducted in the West, and unlike King, Wheeler appreciated the value of photographs in the promotion of the survey itself. The survey's goals were similar to King's: to prepare accurate maps, document the physical features of the land, find sites for roads and military operations, assess the population and disposition of the resident Indian peoples, and evaluate the geology and vegetation as to their usefulness to settlers.

In May of 1871, O'Sullivan set out from Halleck Station, Nevada with Wheeler's crew, but because he had more seniority in Western surveys than the other explorers, O'Sullivan was often entrusted to head up side trips apart from Wheeler. Lieut. Wheeler led even more arduous expeditions than O'Sullivan had experienced with King. In their first season the survey team endured tremendous heat crossing Death Valley, and Wheeler often forced extended marches that lasted more than a day. The most challenging part of the trip involved traveling more than 200 miles up the Colorado River to the Grand Canyon. The party was divided into three boats: one headed by Wheeler, another by O'Sullivan and a third by Grove Karl Gilbert, the geologist on the expedition. The difficult journey took more than 30 days in all, and in the process Wheeler's boat was destroyed, along with many of his survey notes. Despite the physical challenge of the ascent, O'Sullivan was able to make photographs of the river canyon and of the crew, including the Mohave Indians who accompanied the survey

team. This first season with Wheeler also included an exploration of the mining districts in Nevada, and a period photographing in Northern Arizona. At the end of the survey season, O'Sullivan returned to Washington D.C. to print the season's work.

During the 1872 season, O'Sullivan returned to work with Clarence King photographing in Nevada, Utah, Wyoming and Colorado, but by 1873 was back with Wheeler. The intervening winter allowed O'Sullivan to print two sets of King survey photographs which were sent to the 1873 World's Fair in Vienna, along with other printing for both the King and Wheeler expeditions. On 11 February 1873, while in Washington D.C., O'Sullivan married his longtime sweetheart Laura Virginia Pywell. That year he spent the season in Arizona and New Mexico, making images of the Grand Canyon, and taking perhaps his most famous survey photograph, an image of the White House Ruins in Canyon de Chelly. The Indians settled near Santa Fe and in Arizona also became a primary subject that season. The winter of 1873–4 was again spent in Washington D.C. printing for both King and Wheeler, and in May O'Sullivan began producing official sets of images from Wheeler's survey, which were comprised of both large format and stereographic views. In July of 1874 O'Sullivan embarked on what would be his last season of photography in the West. He began in New Mexico and Colorado photographing Indians and the countryside for Wheeler, and then took a solo trip to a site he had photographed many years before: Shoshone Falls in Idaho. These would be O'Sullivan's last photographs in the West.

Once again the winter found O'Sullivan printing in Washington D.C. but this time that work continued through the middle of 1876. After that little is known about O'Sullivan's work; in 1878 he appears in the Washington D.C. directory as the partner of another photographer, William J. Armstrong, but it seems that venture did not last long. He was on the payroll at the United States Geological Service under King temporarily in 1880, and was the photographer to the U.S. Department of the Treasury from November 1880 to March of 1881, but retired with tuberculosis of the lungs. In September of 1881, O'Sullivan returned to his parents' home in Staten Island, too ill to take care of himself. On 18 October 1881, O'Sullivan's wife died of tuberculosis in Washington, D.C. and he traveled to attend her funeral there, returning to Staten Island. On 14 January 1882, Timothy H. O'Sullivan died on Staten Island, also from tuberculosis, at the age of 42.

REBECCA A. SENF

Biography

Timothy H. O'Sullivan was born in 1840, probably in Ireland, to Jeremiah and Ann O'Sullivan. His family emigrated to the United States in 1842. In 1861 and 1862 O'Sullivan photographed the Civil War for Mathew Brady, but spent the rest of the war working for Alexander Gardner. His war photographs were published in *Photographic Incidents of the War from the Gallery of Alexander Gardner, Photographer to the Army of the Potomac* and Gardner's *Photographic Sketch Book of the War,* 1865/1866. In 1867 he was appointed to Clarence King's Geological Explorations of the Fortieth Parallel and photographed for King in 1867-1869 and again in 1872 in California, Nevada, Utah, Wyoming, Colorado, and Idaho. O'Sullivan spent six months of 1870 with the Darien Expedition, photographing in present-day Panama, but the wet weather and heavy foliage hampered much successful work. That same year he was hired by Lieutenant George Wheeler to participate in his explorations, eventually known as the United States Geographical Surveys West of the One Hundredth Meridian. Between 1871 and 1874, O'Sullivan spent three seasons photographing for Wheeler in California, Nevada, Arizona, Colorado, Utah, and New Mexico. During his time with the western surveys, most winters were spent printing negatives made during the exploration season. 1874 marked his last year photographing in the West, after which he returned to Washington D.C., where he continued to work, including a brief job with the United States Treasury Department in 1880–1881. He left the government position just five months after beginning, due to tuberculosis, from which he died on 14 January 1882, at age 42.

See also: Brady, Mathew; Gardner, Alexander; Survey Photography; War Photography; Camera Design: Stereo Cameras; Stereoscopy; and Wet Collodion Negative.

Further Reading

Dingus, Rick, *The Photographic Artifacts of Timothy O'Sullivan.* Albuquerque: University of New Mexico Press, 1982.

Horan, James D., *Timothy O'Sullivan: America's Forgotten Photographer.* Garden City, NY: Bonanza Books, 1966.

Katz, D. Mark, *Witness to an Era: The Life and Photographs of Alexander Gardner.* New York: Viking, 1991.

Krauss, Rosalind, "Photography's Discursive Spaces: Landscape/View." *Art Journal* 42, 4 (Winter 1982): 311–19.

Naef, Weston J., *Era Of Exploration: The Rise Of Landscape Photography In The American West, 1860–1885.* Buffalo: Albright-Knox Art Gallery; Boston: distributed by New York Graphic Society, 1975.

Newhall, Beaumont and Nancy, *T. H. O'Sullivan, Photographer.* Rochester, NY: George Eastman House, in collaboration with the Amon Carter Museum, 1966.

Novak, Barbara, "Landscape Permuted: From Painting to Photography," *Artforum* 14 (Oct 1975): 40–59.

Sandweiss, Martha, "Undecisive Moments: The Narrative Tradition in Western Photography." *Photography in Nineteenth-Century America.* Fort Worth, TX: Amon Carter Museum, 1991, 98–129.

Snyder, Joel, "Aesthetics and Documentation: Remarks Concerning Critical Approaches to the Photographs of Timothy O'Sullivan." *Perspectives on Photography*. Ed. P. Walch and T. F. Barrow. Albuquerque: University of New Mexico Press, 1986, 125–50.

Snyder, Joel, *American Frontiers: The Photographs of Timothy O'Sullivan, 1867–1874*. Millerton, NY: Aperture, Inc., 1981.

Trachtenberg, Alan, "Naming the View." *Reading American Photographs: Images as History, Mathew Brady to Walker Evans*. New York: Hill and Wang, 1989, 119–63.

OEHME, CARL GUSTAV (1817–1881)
German instrument maker and photographer

Carl Gustav Oehme was born in Berlin in 1817, and trained as a mechanic or mechanical instrument maker. He is reported as having visited Paris in 1840 where he met Daguerre, and learned the rudiments of the daguerreotype process from him, returning to Berlin in 1841 where he was one of the first artists to exhibit daguerreotypes in Germany.

While in France, he met fellow German L. Philipp Graff (1814–1851), an optical instrument maker and later professional photographer, and Graff also contributed daguerreotypes to the 1841 exhibition. Oehme and Graff went on to become two of the most important early photographers in Berlin.

Oehme opened a studio in Berlin in 1843 at No. 20 Jagerstrasse, from where, trading as Gustav Oehme, he produced daguerreotype portraits for many years. He was still using the process into the later 1850s.

Some sources suggest that he also operated a portrait studio in Hamburg 1854/5, but this has yet to be confirmed.

Oehme's surviving daguerreotypes, predominantly 1/6th plate size, evidence masterful control of soft yet directional lighting, and a sensitivity towards posing which gave his group portraits a natural appearance which belies the long exposures necessary.

JOHN HANNAVY

OGAWA KAZUMASA (1860–1929)
Japanese photographer

Ogawa Kazumasa (the characters used in his given name are also read Kazuma or Isshin) was born August 15, 1860, in present-day Saitama prefecture, near Tokyo. He was the second son of Harada Shôzaemon, a samurai and retainer of the Matsudaira clan, and his wife Miyoko. At the age of three Ogawa became the adopted son of Ogawa Ishitarô, a common practice in nineteenth-century Japan.

Ogawa had a strong interest in English, and was first introduced to photography around age 13 through his English tutor, a British missionary. Around the same time he also had a chance to visit the studio of Uchida Kuichi, then the premier photographer in Tokyo, which further piqued his interest. Ogawa became familiar with the wet collodion negative process while serving as an apprentice to the photographer Yoshiwara Hideo for six months during the mid-1870s. In 1877, just seventeen years old, he opened his first photography studio in Gunma Prefecture with a second-hand quarter-plate camera that he used to take carte-de-visite portraits. Despite the limited availability of quality photographic chemicals and supplies, it appears that this studio was quite successful. However, Ogawa closed it in 1880 and resolved to go abroad to further his photographic knowledge.

Ogawa made his way to the United States as a sailor on an American frigate, spending eighteen months in Boston and Philadelphia in 1883–1884. He studied portraiture, carbon printing and plate making, and collotype in Boston. In Philadelphia he studied dry plate techniques and manufacturing with John Carbutt, who developed the first commercial dry plate negative. Ogawa sent news of the latest advances in American photography back to Japan, where they were published in *Shashin shimpô* (*Photographic News*), Japan's first photography periodical. He also shipped dry plates, which were just starting to be used in Japan around this time. The information he conveyed to other Japanese photographers experimenting with dry-plate technology was instrumental in helping them successfully master the technique.

After returning to Japan, Ogawa established a studio in Tokyo in 1885 called the *Gyokujunkan*, and thereafter rapidly became involved with a number of innovative photography-related businesses and projects. Ogawa had several appointments and commissions that gave him access to an unusually wide range of subjects. In 1886 he was appointed photography instructor for the army, in a division that was then part of the Land Survey Department. In 1888 he participated in a survey of Japanese cultural assets under the auspices of the government. His affiliations with the military and the government enabled him to photograph such varied subjects as the Sino-Japanese War, the Russo-Japanese war, the aftermath of the Boxer Rebellion, the palace buildings of the Forbidden City, Beijing, and antique sculpture, paintings, and architecture of ancient temples in Kyoto and Nara. His style was also varied, ranging from straightforward documentary photographs to beautifully composed artistic images that prefigured a modernist aesthetic.

Perhaps even more noteworthy than the diversity of his subject matter, however, was his influential role in developing photographic printing techniques within Japan and in promoting a domestic photographic

industry. In 1888 Ogawa, Kajima Seibei, and William K. Burton, an amateur photographer and a professor of engineering at Tokyo Imperial University, formed the *Tsukiji Kampan Seizô Kaisha* (Tsukiji Dry-Plate Manufacturing Company), one of Japan's earliest commercial dry-plate manufacturers. Although it folded several years later, Ogawa continued to support other domestic dry-plate companies. He then established Japan's first photoengraving company, *Ogawa Shashin Seihanjo* (Ogawa Plate-Making Shop) in 1889. Through the Ogawa Shashin Seihanjo, he became a prominent publisher and produced numerous books featuring high quality collotype images. Ogawa himself took many of the photographs. Among the earliest items published by the Ogawa Shashin Seihanjo was Japan's first art magazine, *Kokka* (National Essence), still in production today. *Kokka* focused on traditional Japanese art and early issues reproduced Ogawa's classic images of Japanese Buddhist sculpture taken as part of the 1888 survey of cultural assets.

Significantly, Ogawa's books were largely directed towards a Western audience, and consequently he played an enormously important role in exposing Japan to the West as it emerged from two and a half centuries of isolationism. Most of his publications included English language captions and information, sometimes combined with Japanese text; many were so popular that they were printed in multiple editions. Typical topics were scenic or general themes that appealed to Westerners' curiosity about Japan. Some sample titles are: *Illustrations of Japanese Life*, with collotypes of people engaged in various daily activities, issued in multiple editions between 1892–1918; *The Charming Views in the 'Land of the Rising Sun* (1904), with 174 black and white photographs covering all areas of Japan including Formosa (Taiwan) and Korea; and *Photographs of Japanese Customs and Manners*, with several editions published around 1900. Flowers were another common subject and Ogawa released titles such as *Lilies of Japan* and *Chrysanthemums of Japan*. The full-page color collotypes of flowers he contributed to the multi-volume work *Japan, Described and Illustrated by the Japanese*, published by J. B. Millet Company in the late 1890s, are among his best-known work. And of course there was the perennially favorite theme of geisha. In 1891, Ogawa was commissioned to photograph 100 local geisha to celebrate the opening of the *Ryôunkaku* or "Asakusa Twelve Stories," an amusement center in the tallest building in Tokyo. These images as well as other portraits of geisha were incorporated into various editions released over the next decade, including *Types of Japan, Celebrated Geysha of Tokyo* (1892); *Celebrated Geishas of Tokio* (1895); and *Geisha of Tokyo* (multiple versions, 1898–1902).

Ogawa's other activities included being a founding member of Japan's first amateur photography association, *Nihon Shashinkai* (the Japan Photographic Society) in 1889. The same year he established a second version of *Shashin shimpô* (the first version, mentioned above, had ceased publication in 1884) and served as editor until 1896. He became the first Japanese photographer to be nominated as a fellow of the Royal Photographic Society of England in 1895, and was the first photographer appointed as a member of the Japanese Imperial Art Academy in 1910.

Ogawa was well regarded during his lifetime, widely recognized for his innovation in establishing new photographic technologies in Japan. Based on his influence on the Japanese photography industry, the many activities in which he was involved, and his reputation as a superb photographer, Burton described him as "the greatest authority on photographic matters in his country" (Burton, 1894, 185). In 2004 he continues to be regarded as a pivotal figure and a pioneering entrepreneur in Japanese photographic history. His work is in the collections of Nagasaki University and the Tokyo Metropolitan Museum of Photography.

KAREN FRASER

See also: Uchida Kuichi; Wet Collodion Negative; Carte-de-Visite; Collotype; Carbutt, John; Dry Plate Negatives: Gelatine; Dry Plate Negatives: Non-Gelatine, Including Dry Collodion ; Burton, William Kinninmond; Photographic Exchange Club and Photographic Society Club, London.

Further Reading

Bennett, Terry, *Early Japanese Images.* Rutland VT: Charles E. Tuttle, 1996.

Bethel, Denise, "The J.B. Millet Company's *Japan: Described and Illustrated by the Japanese*—an initial investigation," in *Image*, Spring-Summer 1991, 2–21.

Burton, William K., "A Japanese Photographer," in *Anthony's Photographic Bulletin*, March 22 1890, 181–185.

Ozawa Kiyoshi, *Shashinkai no senkaku—Ogawa Kazuma no shôgai* (A Pioneer of Photography—The Life of Ogawa Kazuma). Tokyo: Nihon Kokusho Kankôkai, 1994.

Tucker, Anne Wilkes et al., *The History of Japanese Photography.* New Haven: Yale University Press in association with the Museum of Fine Arts, Houston, 2003.

Worswick, Clark, ed., *Japan: Photographs 1854–1905.* New York: Pennwick/Alfred A. Knopf, 1979.

OLIE, JACOB (1834–1905)
An animated nineteenth-century amateur photographer in Amsterdam

To Jacob Olie photography was a pursuit which he practised intensively in his youth and again in later life after an interlude of 25 years. Olie was originally trained as a carpenter and took lessons in drawing and in theoretical

subjects at a private technical school. At the age of 16 he joined the Maatschappij tot Bevordering der Bouwkunst (Society for the Advancement of Architecture) and in 1855, he and a small group of kindred spirits founded the society Architectura et Amicitia, a debating club where the international magazine portfolio brought news of developments in the arts, the natural sciences and technology. It was in these circles that Olie received further theoretical training and his wider cultural interests were shaped. He translated sections of E.E. Viollet-le-Duc's *Entretiens sur l'architecture* and lectured on *Grammaire des arts du dessin* by Charles Blanc, former director of the Paris École des Beaux Arts. During the years he also participated succesfully in many competitions for artistic architectural designs.

The first time the word 'photography' was mentioned at one of the society's meetings was by Olie in 1857. He cited a report from a Dutch periodical about the Architectural Photographic Society that had been set up in London with the aim to provide its members with reasonably priced photographic illustrations of 'noteworthy' buildings from all countries. The matter came up once again, but Olie received little response among his fellow members for his proposal to collaborate with the English and exchange photographs for measured drawings.

For architects the photograph and the drawing were not comparable media. For someone like Viollet-le-Duc, drawing was a higher form of seeing, despite the importance he attached to photography as an aid in restoration. However, at the weekly art reviews more and more photographs were shown. In 1859 Olie brought along a series of stereoscopic views of Amsterdam by Pieter Oosterhuis. Shortly thereafter, he began himself experimenting with the art of photography.

Olie probably took his first photographs in the summer of 1861, only a few months after he had started his career as a teacher of architectural drawing at the technical school. At that time there were enough publications available with technical instructions for would-be photographers. In his notebooks Olie copied recipes for collodion, which he had taken from E. Robiquet (*Manuel théorique et pratique de photographie sur collodion et sur albumine*, 1859) and A.A.E. Disdéri (*L'Art et la Photographie*, 1862), among others. Olie built his own camera, a simple model, similar to the earliest daguerreotype cameras, which could take glass plates of 10.5×12.8 cm which he cut himself from window glass.

That first summer Olie explored the utterly familiar world of the busy dockland and industrial area where he was born and where he still lived among his extended family of craftsmen, ship-builders and timber merchants. Here he took scenes not normally recorded by commercial photographers: a ship under construc-

tion, a mast-makers yard, or views taken from the deck of a ship.

In 1862 Olie equipped his camera with a new lens of sharper definition and took up portraiture, a genre which he had never attempted as a draughtsmen. He made more than 150 portraits of his family, friends and acquaintances, sometimes capturing them in their own environment, and on other occasions against an artificial backdrop of cloths, rugs and props, like those used in the professional portrait studio. Sometimes Olie moved his darkroom equipment to friends and relatives who lived in the city centre and photographed from their attic windows. In some cases the views he made from these high vantage points can be fitted together to breath-taking panoramas. They provide a unique and highly personal portrait of Amsterdam's city centre. Unlike his drawings, Olie never submitted his photographs to exhibitions, but in 1864 and 1865 he presented his albumen and salted-paper prints to his colleagues at an Architectura et Amicitia meeting. Soon after, he abandoned his photographic experiments for many years.

Olie would only return to photography after his retirement as headmaster of the technical school in 1890. By then, he was a 56-year-old widower with four young children ranging from four to eleven years of age. He still used the same camera but fitted with a new lens. Olie built a number of ingenious cassettes which he could load at home with ready-made dry-gelatin plates of 9x12 and 13×18 cm. In the intervening years, his interest in photography had not waned. Olie gave slide shows for his pupils and others audiences with the magic lantern. The teacher in him recognized the educational potential of the picture machine and it may well have inspired him to produce his photographs specially for it.

Between 1890 and 1904 Olie took over 3600 photographs, most of them portraying the city of Amsterdam, including street scenes and residents and workers in their own surroundings. Amsterdam was in the process of rapid transformation and Olie recorded construction works at different stages of completion, moving about the building sites freely as he knew the architect, the client or the building contractor. Often his views are not topographical in the strictest sense, but the city serves as a backdrop for public events—military parades and balloon lift-offs, visits by dignitaries and ship launchings. He continued to display a predilection for high viewpoints in this period, even when it was no longer strictly necessary.

What fascinated Olie was the new architecture within its urban context. Unlike some artists of his day, he was not charmed by decay. Although the painter-photographer G.H. Breitner and Olie were both admirers of Amsterdam's beauty, they produced quite distinct bodies of work. While Breitner reinforced the shabbiness of the old districts and evoked the dank atmosphere of decay,

Olie composed views in which old and new fused into an organic whole. Olie's photography is also very different from that of the younger generation of pictorial photographers who sought to render the 'soul' of the city in atmospheric photographs. Employing refined photographic processes, they would often blur the city's contours in their hand-crafted prints. In contrast, Olie's photographs are lucid images of a tangible world.

After the turn of the century, Olie began to use a modern, hand-held camera which could take several 9 × 12 cm glass plates. It gave him a new mobility and allowed him to work in a more casual manner. Olie and his family were zealous hoarders. Besides the thousands of photographs, negatives and drawings he left behind, a veritable mountain of personal material has been preserved. The Amsterdam city archives purchased this rich legacy from his heirs in two portions, in 1959 and 1990.

ANNEKE VAN VEEN

Biography

Jacob Olie was born on 17 October 1834 in Amsterdam, from a long line of raftsmen and whalers. Trained as a carpenter and an architectural draughtsman, he taught drawing at the first technical school in Amsterdam from 1861 on, and in 1868 became its headmaster. As a member of the leading architectural societies in the Netherlands, he studied zealously architectural and art history and played an active role in the debates on architectural theory and the concepts of form. He practised and demonstrated his skills in drawing and design in many competitions. In 1861 Olie started to photograph with a daguerreotype-model camera which he had built himself, using wet-collodion plates. The next four years he portrayed the dockland and industrial area where he was born and still lived, choosing unusual subject matter. He also made many portraits of his family, friends and acquaintances, and used their homes in the city center to set up his darkroom equipment and photograph the views from their windows which in some cases can be fitted together to large panoramas. Pressure of work forced him to abandon his pursuit. After his retirement in 1890 Olie took up photograpy again, this time on industrial dry-gelatine plates. Until the age of 70, Olie worked at fever pitch, producing some 3600 photographs of Amsterdam, outlying areas, and the wide surroundings. He was particularly interested in the transformation of the capital into a modern city, focussing on new architecture as an organic part of the urban context. He never exhibited his photographs, but projected them as lantern slides to a wide audience. Jacob Olie died in Amsterdam on 25 April 1905. His rich legacy is kept at the Amsterdam city archives.

See also: Architecture; Domestic and Family

Photography; History: 5. 1860s; History: 8. 1890s; Lantern Slides; Netherlands; and Topographical Photography.

Further Reading

Aarsman, Hans (introduction), *Jacob Olie. Amsterdam gefotografeerd aan het eind van de 19de eeuw door Jacob Olie* [Amsterdam Photographed at the End of the 19th Century by Jacob Olie], Amsterdam: De Verbeelding, 1999

Baar, Peter-Paul de, *Jacob Olie, fotograaf van Amsterdam. Drie wandelingen door de stad rond 1900* [Jacob Olie, Photographer of Amsterdam. Three Walks through the City around 1900], Bussum/ Amsterdam: Thoth, 1999

Boorsma, Anne Marie and Ingeborg Leijerzapf, "Jacob Olie" in *Geschiedenis van de Nederlandse fotografie in monografieën en thema-artikelen* [History of Dutch Photography in Monographs and Subject-Essays], edited by Ingeborg Leijerzapf, Alphen aan den Rijn/Amsterdam: Samsom, Vol. 5, 1986

Coppens, Jan, Guido Hoogewoud and Deborah Meijers, "Jacob Olie (1834-1905)" in *Jaarboek Amstelodamum* [Yearbook Amstelodamum], 68, 1976, 122-142

Eeghen, I.H. van, *Amsterdam in de tweede helft der XIXe eeuw, gezien door Jacob Olie Jacobsz* [Amsterdam in the 2nd Half of the 19th Century seen by Jacob Olie Jacobsz], Amsterdam: Amstelodamum 1960

Nieuwenhuijzen, Kees (composer), *Jacob Olie, Amsterdam gefotografeerd 1860-1905* [Jacob Olie, Amsterdam Photographed 1860-1905], Amsterdam: Van Gennep, 1973[1], 1974[2], 1974[3], 1981[4]

Schmidt, Fred (composer), *Jacob Olie. Amsterdam en omstreken. Foto's 1890-1903* [Jacob Olie. Amsterdam and Surroundings. Photographs 1890-1903], Amsterdam: De Verbeelding 2002

Veen, Anneke van, "Jacob Olie sees the Museumplein" in *Jong Holland* [Young Holland], 15, 1999, 2, 52-57

Veen, Anneke van, *Jacob Olie Jbz (1834-1905). Monografieën van Nederlandse fotografen 10* [Jacob Olie Jbz (1834-1905), Monographs on Dutch Photographers 10], Amsterdam: Focus 2000

OOSTERHUIS, PIETER (1816–1885)
Topographical and industrial photographer of the Netherlands

When the artist Pieter Oosterhuis took up photography he had passed the age of 35, newly married moreover, and determined to maintain his family from the earnings of his Atelier Photographique et Daguerréotypique. At last, he had come out of the shadows of his father, the successful painter and illustrator Haatje Pieters Oosterhuis. At the time of the opening of his first studio over 240,000 people were registered in Amsterdam, while the number of studios was only six, which was very few compared with cities like Hamburg and Berlin. This reveals a sense of adventure and a talent for entrepreneurship in Oosterhuis, which impression is intensified by the fact that he was probably one of the very first to apply the stereo technique in the Netherlands.

Stereo photography had been presented to the Dutch public for the first time in 1855, at the International

Exhibition of Photography in Amsterdam. The overwhelming success must have inspired Oosterhuis to introduce the novelty in his portrait studio and to apply it also to topography. This brought out the best in him. The Dutch cityscape would become one of Oosterhuis's major genres for the next 25 years. The genre of the topographically precise cityscape is rooted in a long-standing north-Netherlandish tradition in drawing and printmaking. Oosterhuis photographed the views which topographical artists had depicted before him. Restricted to a picture plane of barely seven by seven centimetres, he succeeded in composing remarkably powerful images by adapting skilfully the proven compositional schemes.

There was a growing public for Oosterhuis's stereographs. Increased tourism and a greater urge to travel made the publication of stereoscopic views a profitable undertaking. In the early years Oosterhuis did not experience much competition from his own countrymen who catered for the local market. The Parish publisher Alexis Gaudin & Frères issued the series *Hollande* in 1858 with 71 views of Amsterdam, Rotterdam, The Hague, Haarlem and Dordrecht. These cities were linked by rail from 1847 and every tourist took them in on his tour of the Netherlands, in pursuit of the landscapes portrayed by famous Dutch 17th-century masters. In the following years, Oosterhuis had the tourist trail in the provinces of Holland and Utrecht entirely to himself, uncontested even by the French company of Adolphe Braun, whose son Gaston did not visit the Low Countries until 1864.

After a short-lived collaboration in 1858 or 1859 with an Amsterdam bookseller and publisher, Oosterhuis published the bulk of his stereographs himself. No publisher is given on his large collection of almost four-hundred views, sold as *Vues de Hollande* in the early 1860s. Following the introduction of the larger cabinet size for portraits in 1867, Oosterhuis brought out new series of cityscapes. He continued to make them until the end of his career and after his death his son Gustaaf carried on. From the 1870s on virtually all professional photographers made tourist views. To withstand this fierce competition Oosterhuis felt compelled to produce extensive photographic coverage of Amsterdam and other places in order to diversify his supply.

By that time Oosterhuis's career as a portraitist had come to an end. In 1869 he sold the establisment and devoted himself entirely to his topographical series as well as to a new branch of the profession. December 1858 saw the appearance of the first Dutch publication to be illustrated with "a photograph from nature": inside the *Praktische Volks-Almanak* an albumen stereograph by Oosterhuis was pasted, showing Dam Square in Amsterdam. Following the *Revue Photographique* of 5 March 1858 the author of the accompanying article quotes the example of a New-York engineer who contracted a photographer to record the daily progress of building projects spread throughout the United States. The photographs furnished the engineer with all that he needed "to direct construction from a distance." And, the author asked rhetorically: "Would a Dutch photographer be capable of an achievement like this?"

October 1861 Oosterhuis began photographing the excavation work for a new lock near Amsterdam. It was the first assignment of its kind in the Netherlands, soon followed by a second in the remote province of Zeeland. A bill of 1860 established a nationwide railway network at public expense. To the newly emancipated group of civil engineers it brought a whole new field of activity and a chance to distinguish themselves in prestigious projects. These developments contributed to the decision to systematically document the construction of public works with the aid of photography, culminating in 1869 in a ministerial decree to make this practice compulsory.

Between 1861 and 1884 Oosterhuis undertook twelve large assignments commissioned by central government departments. He found himself gazing down on immense construction sites, where he had to familiarize himself with a new landscape photography. The *Tijdschrift voor Photographie* devoted ample space to Oosterhuis's Zeeland photographs in 1864 and 1865 and praised Oosterhuis's "artistic sense." The nature of the industrial assignments demanded a larger format than was customary for tourist photography. Oosterhuis worked with a variety of cameras, ranging from a camera for plates measuring roughly 18 × 26 cm on his first assignments, to the largest which produced images of over 32 × 42 cm. His fellow photographers admired the outstanding sharpness and the "wide field of vision" of these landscapes, which were taken with an orthoscopic lens on dry collodion plates. Oosterhuis was well-known for his immense precision, never exposing more than one single plate for each commissioned view point.

Like all photographers of his generation Oosterhuis was forced to diversify. He worked also on assignments from the industry, private societies, and the Amsterdam local authorities. At the International Photographic Exhibition of 1877 in Amsterdam, where he was awarded the Gold Municipal Medal, he submitted engineering photographs, landscapes and cityscapes, "views and cloud studies," and dry plate negatives, in addition to art reproductions in carbon print and silver print. Two years later, no less than 64 photographs by Oosterhuis were incorporated in the *Patriotic Album*, a "welcome greeting" from the nation to Princess Emma, King Willem III's young bride. After this milestone in his career, the latter years of his life were less prosperous. Oosterhuis suffered from tuberculosis and his youngest son Gustaaf became more active. After his father's

death, Gustaaf continued the firm under the name "P. Oosterhuis" until 1936.

ANNEKE VAN VEEN

Biography

Pieter Oosterhuis was born on 20 January 1816 in Groningen, the son of an artist. Trained as a painter by his own father, he took up photography in the early 1850's. In 1852 he opened the sixth daguerreotype studio in Amsterdam. Four years later he marketed his first stereoscopic views on glass and on paper. Until his death Oosterhuis published his cityscapes "in their thousands," initially as stereographs, later as cabinet cards, establishing himself as the *homo topographicus* of the Netherlands *par excellence*. In addition to these tourist photographs, Oosterhuis worked on engineering assignments from the central government. During more than twenty years he photographed nationwide the modern landscape and geometric forms of railways, railway bridges, station buildings, canals, locks, and docks under construction. He developed a vocabulary for these landscapes which bears a striking resemblance to French, British, or even Russian engineering photographs of the period. By his contemporaries he was esteemed the first among the Dutch landscape artists. As a painter he was a member of the artist association Maatschappij Arti & Amicitiae, but later he joined the Amsterdam Photographic Society. In the 1870's Oosterhuis regularly published articles on technical issues in the photographer's magazine *Tijdschrift voor Photographie*. At the 1877 Exhibition of Photography in Amsterdam Oosterhuis was awarded the Gold Municipal Medal. After his death on 8 June 1885, his youngest son Gustaaf (1858-1938) continued the firm.

See also: History: 4. 1850s; History: 5. 1860s; History: 6. 1870s; Industrial Photography; Netherlands; Societies, groups, institutions, and exhibitions in the Netherlands; Topographical Photography; and Tourist Photography.

OPPENHEIM, AUGUST F.
(active 1850s)
German photographer

It is conjectured that the German photographer August Oppenheim was born in Dresden. Around 1852 he was instructed in the art of photography and, more specifically, in the calotype method, by Gustave Le Gray. A year later, during the course of a photographic tour, he visited Greece and recorded the antiquities, with the aim, as he wrote, "to give to those who had not been fortunate enough to see these monuments with their own eyes a clear idea of them, and to others pleasant memories."

Details of this journey, as well as of the difficulties he encountered, he published in the periodical *Lumière* (issue 6, April 1853). His intention was to publish, on his return to Dresden, a three-volume work. In the end, this was limited to two volumes under the titles respectively of *Die erhaltenen griechischen Tempel auf der Akropolis* and *Details der Akropolis*. These photographs of his were finally included in *Atheniensiche Alterthümer*, published in 1854. An important honourable mention was awarded to him for the photographs he exhibited at the Industrial Fair in Munich.

ALIKI TSIGRILAOU

OPTICS: PRINCIPLES

The ability to manipulate light dates back to ancient times. The understanding of the nature of light, which involved debates over whether it is composed of waves or particles, began in the 1500s and 1600s. The discovery of and the elaboration of principles needed to design optics with confidence began in the early 1800s.

It seems quite likely that reflections in calm lakes and ponds were seen and wondered at since the dawn of human existence, perhaps millions of years ago, but no trace remains. The earliest optical devices we have found are stone and obsidian mirrors from the Bronze Age in Europe and the Middle East. It is likely that at about the same time people noticed their reflections in the blades of metal swords, axes and armor if they were highly polished. Flat mirrors reflect light at the same angle as it is incident at, and the formation of an image takes place in the eye of the beholder. A mirror can concentrate light if its surface is made concave. There are Greek accounts of Archimedes' "burning mirrors" being used to ignite the sails of Roman ships in battle, using concentrated solar energy. These mirrors were made of polished metal. A helmet or breastplate, being convex on its outside, spreads light and, if of high enough quality, forms a reduced-scale, wide angle image, rather than a concentration of light or a magnified image.

Transparent materials transmit light and can also manipulate it. We find glass jewelry which spreads light into colors, a property called dispersion, from the Bronze Age on, and this was undoubtedly long predated by the discovery that natural crystals such as quartz, calcite, amethyst, and emeralds, created colorful dispersal and multiple reflections of light. And again going back to early human times our ancestors saw and must have wondered at the colors of mother-of-pearl, rainbows, sun-dogs, lunar halos and other natural phenomena.

Small apertures in opaque surfaces when illuminated from one side will form images on a surface placed on the opposite side. This phenomenon was remarked in classical Greek times, dating back to 250 BC. It allows

one to safely view a partial solar eclipse in shadows and images cast on the ground by a leafy tree.

All these phenomena can be explained based on the nature of light and its behavior in different materials and at material boundaries. If a material is internally uniform in density and transparency, then light travels through it in straight lines and only changes direction, or refracts, at the boundary to another medium. At each boundary the path direction changes, and the angle of change (with respect to a perpendicular to the surface at the penetration point) is called the angle of refraction. If the surface is flat, the light entering it at a given angle is refracted the same amount everywhere on the surface. If the surface is curved, then the angle of refraction varies over the surface. If the shape is part of a sphere, the piece is said to be a lens and it can focus or defocus light, depending on whether the surfaces are convex or concave. (It should also be noted that at each boundary between different materials a fraction of the light is reflected: for glass and air it amounts to about 4%, and can give rise to multiple internal reflections inside lenses or rear-surface mirrors.)

The angular amount of refraction of a material is measured by a number unique to each material, called the index of refraction, the ratio of bending in a material to that of empty space, which is set equal to one. Air and other low-density gases have indices of refraction just a bit larger than one. Water at sea level has an index of refraction of 1.33, natural crystals, glass and plastics generally fall in the range 1.25 to 1.8. Some relatively exotic composition glasses have indices of refraction well over 2.5, which means lenses made out of them can be of thinner material and still bend light as much as thicker lenses made of lower index glass. (An aside: Einstein's relativity shows that, in the presence of matter, space itself curves and thus light's path in space is curved proportionate to the distance and density of that matter. It shows up in astronomy in curved arc images of distant galaxies seen around massive foreground galaxies. This effect is ignored in classical optics and so far has found no application in conventional photography!)

Lens making became a profession in the late renaissance in Europe. The Dutch optician, Snell (1580-1626), discovered and published a short mathematical relation for the bending of light in 1626, by sending light beams through glass surfaces of varying shapes and indices of refraction and carefully measuring the angle of incidence of the light as it struck the glass, and then the angle it was deviated to inside. He also measured the angles at the light ray's emergence on the far surface, into the air.

Snell's law is: $n_1 \sin \theta_1 = n_2 \sin \theta_2$.

In words that is: the index of refraction of light in the first medium times the sine of the angle of incidence at the boundary is equal to the index of the light in the second medium times the sine of the angle of refraction in the second material. The unprimed numbers are the numbers in the first medium, the primed numbers refer to the second medium. The Greek letter theta (θ) refers to the angle in degrees. Recall that the sine of an angle is a trigonometric property and can be found in mathematical reference tables or calculated by hand or computer. Since by its definition, the sine of any angle between zero degrees and 90 degrees is somewhere between 0 and 1, and since the index of any ordinary transparent material is greater than one, a light ray entering glass from air will be bent to a smaller angle than the angle of incidence it had at entry. When a ray leaves the denser material, passing from glass to air, the ray will bend back to a larger angle.

Snell's law was empirically derived. It can be derived theoretically using the electromagnetic wave theory of light founded by James Clerk Maxwell in the 1860s, and also by Fermat's principle of least time of travel. The latter idea relies on the fact that the index of refraction is not only a measure of bending strength but also the ratio of the *speed* of light in a material to that in empty space.

Snell's law and a little further work led to a useful formula, still applicable with certain restrictions, for describing practical optical systems. It is called the lens maker's formula:

$$1/fl = (1/OD) + (1/ID).$$

The OD is the distance from the object in question to the center of the lens, the ID is the distance from the lens center to the focused image, and fl is the focal length, the distance from the lens center to the focused image when the object is at infinity. The focal length is also, by definition, one half the radius of curvature of the lens surface. It should be noted that this formula can be repeatedly applied to follow light through a series of lenses. With proper observation of positive and negative sign conventions it can also be used to study mirrors. The restrictions are that the lens have a shallow curvature, or equivalently that it has a very long focal length compared to its diameter. And light rays are assumed to travel in straight lines except when they cross material boundaries. This is called the Thin Lens Approximation. The lens maker's formula is a shortcut of use in deciding where an image will focus for an object at a given distance using a lens of known focal length, or for a quick design of a simple optical system. This formula also can be used to get the image magnification, which is the ratio: $M = ID/OD$.

Aside: Fresnel (1788–1827) in the early 1800s garnered a large prize fund from the French Academy of Science by designing a very thin lens, for use in lighthouse lights. These were used successfully for that purpose but now find much larger use as lenses for

theatrical spotlights, in camera viewfinder focusers, and also as novelty wide-angle lenses for automobile rear windows. Think of taking a set of nested concentric circular cookie-cutters and slicing a lens into a series of rings. Then shave off the bulk of the glass in the rear, leaving only the front curvature. Cement the resulting rings to a thin flat sheet, and the result is like a Fresnel lens (which is actually molded). This is a really thin lens!

Using the Thin Lens Approximation and simple geometrical rules, it is possible to quickly draw the principle light paths in a lens system. For each lens, a light ray down the system axis (a perpendicular through the lens center) travels straight on. A ray parallel to the axis, emerging from an off-axis point of the object as if it came from infinity, is bent by the lens to pass through the rear focal point, and a ray passing from the same object point through the front focal point (at an angle) emerges from the lens parallel to the axis (note the symmetry!). Where the latter two rays cross is the point where the original point of the object is imaged. In cases where the image rays converge to a focus, the image is termed real.

If, in leaving the lens, the rays only diverge, then an image can only be seen by the use of an additional lens, say that in your eye, and the image is called virtual. Convex lenses and concave mirrors can give real or virtual images, depending on whether the object is closer or farther than one focal length away from the optic. Concave lenses and convex mirrors yield only virtual images.

Snell's Law, which describes the refraction of light, along with the law of reflection (the angle of incidence equals the angle of reflection), can be applied at each point of a boundary surface to predict the path of light rays as they pass through. By doing this step by step at all points (or a sample) of a surface of known shape, one can follow a ray of light through a system of any complexity, and in reasonable detail. This process is called ray tracing, and until the advent of computers was carried out by hand. There some complications to this process, however.

First, the index of refraction of any real transparent material varies with the color (wavelength or frequency) of light. This effect is called dispersion, and explains why prisms are able to spread white light out into the visible spectrum. In general the index is greatest in the blue and diminishes continuously into the red and infrared. Mirrors do not suffer from this problem. This effect causes any lens to send blue rays to a different focus point than green or red ones. The result is called chromatic aberration, and results in color fringes surrounding images of objects with sharp edges, such as the Moon. It was discovered in the middle 1700s that this problem could be removed by sandwiching together two lenses of different indices of refraction, one convex and the other concave, carefully choosing their focal lengths, to make the dispersion of the second approximately cancel that of the first. These pairs are called achromatic lenses. All modern lenses for cameras and telescopes are achromats.

Second, every lens or mirror has a natural limit to resolution caused by the wave nature of light, called the diffraction limit. Waves bend around any edge, straight, curved or jagged. This is termed diffraction. Light does this and this results in fuzzy shadow edges (visible under careful examination) and also fuzziness in the whole image. The larger the opening of the lens or mirror, the less important this is and the sharper the image. The longer the wavelength of light (the redder it is) the worse the effect. This diffraction limit can not be evaded in conventional optics.

The diffraction effect can actually be put to use, however. A simple round pinhole carefully made in an opaque sheet will give a real image on almost any size surface behind, at almost any distance. What you gain in areal coverage and depth of focus you sacrifice in speed and exposure time. In conventional optics (lenses or mirrors)the aperture is wide and concentrates a lot of light. In pinhole cameras, just a tiny amount of light passes through. A conventional "fast" lens might have a focal length to diameter ratio ("f/stop" or "speed") of f/1.2 or f/1.8. The speed of a pinhole is usually f/150 or more.

Aside: A more efficient way than a pinhole to use diffraction to manipulate light and form an image is a second invention of Fresnel: the zone plate. Fresnel found an exact formula to compute the widths of transparent gaps between and widths of concentric opaque rings to form a lens based on diffraction. A zone plate looks just like a bullseye, but it is a mathematical construct.

There are also distortions of image shape due to lens or mirror shape. If the surfaces are spherical then off-axis rays do not focus at the same distance as on-axis ones. Spherical aberration, along with comatic aberration (images at the edge of the field of view spread out into fan "tails" like comets), barrel distortion and pincushion distortion (rectangular objects have "swollen" or "collapsed" images, respectively) along with chromatic aberration all have to be reduced to make an optical system produce high quality images. With the use of ray tracing in modern computers all of these problems can be solved.

Compound lenses have been designed for many different purposes. Perhaps the two greatest challenges are to find excellent wide angle lenses, and to find zoom lenses which maintain focus and image quality, along with maximum speed at every magnification. Again computers have allowed many different solutions to these problems.

If one surface of a compound optical system can be made to change shape microscopically and the image sharpness can be sensed instant by instant, you can use computer control to integrate this information and "sculpt" the flexible surface to make ultra sharp images in real time. Such star "de-twinkling" systems ("rubber" mirrors) are now available for astronomers and can make earth-based telescopic images almost as sharp as those made from Earth orbit. But they are not yet available for ordinary commercial cameras. However, overall motion compensation ("de-jiggle") is here in binoculars and some digital cameras. It may not be long before it appears in film cameras too.

Holography, the making of 3-dimensional images using laser light, can use or dispense with lenses and mirrors to achieve focused images. The images are formed by preserving the distance, brightness and color information carried by light waves, in the form of microscopic interference patterns, which are recorded on super-high resolution emulsions. Only laser light has the color purity and wave orderliness to form stable interference patterns, and all motion must stop for the duration of the exposure, down to a millionth of an inch, to avoid blurring out the interference pattern.

Holograms can, however, be made of small moving objects if the laser can emit a very intense short flash. Holographic large-scene snapshots are not yet on the horizon.

WILLIAM R. ALSCHULER

See also: Lenses: 1. 1830s–1850s.

Further Reading

Eder, Josef M., *History of Photography,* transl. E. Epstein, New York: Dover, 1978

Jenkins, F.E. and White, H.E. *Fundamentals of Optics*, New York, McGraw Hill, 4th ed., 1976

Mortimer, F.J., and Sowerby, A.L.M. *Wall's Dictionary of Photography*, London: Fountain Press, 16th ed., 1940.

ORIENTALISM

The term Orientalism was particularly used in the 19th century often as a facet of Romanticism to refer to the depiction of the Near and Middle East, primarily by western artists. Images of history, everyday life, monuments, landscapes, portraits, etc. depicting the life and culture of the geographic region that included modern day Turkey, Syria, Iraq, Iran, the Arabian peninsula, Jordan, Israel, Lebanon, Egypt, Libya, Tunisia, Algeria, Morocco, and sometimes modern Greece, Albania, and Sudan, constituted the realm of Orientalism.

In the 19th century the lure of the exotic, the mystique of the lands of the "Arabian Nights," the "Other" of unseen landscapes and unexperienced cultures, and the adventures of travel to new frontiers, all contributed to the growing popularity of Orientalism in painting, sculpture, and photography. Eugène Fromentin wrote in 1859, "The Orient is exceptional…it escapes general laws…This is an order of beauty which, having no precedents in either literature or art, immediately strikes us as appearing bizarre. All its features appear at once: the novelty of its aspects, the singularity of its costumes, the originality of its types, the toughness of its effects, the particular rhythm of its lines, the unaccustomed scale of its colors…It is the land of…inflamed landscapes under a blue sky, that is to say brighter than the sky, which constantly leads…" (Eugène Fromentin, *Une Année dans le Sahel*, ed. Elisabeth Cardonne, Flammarion, Paris, 1991 (1859) pp. 184–85.)

Orientalism frequently implies travel, in actuality, or simply from one's armchair, evoking deep seated colorful and/or steamy reveries, that inspired artists as they attempted to trace the trails that led to new geographic vistas, and to new realms of the imagination. The Orient was to become "unveiled" in images that were both accurate and inauthentic as artists and photographers worked "in situ" and in studio settings, often conflating dream and reality, truth and fiction.

In more recent years writers such as Edward Said in his 1978 *Orientalism* or Linda Nochlin in her 1989 essay, "The Imaginary Orient" (in *The Politics of Vision: Essays on Nineteenth Century Art and Society*, New York, 1989, 33–59) have argued that the Orient was a "creation of the West" and that many images represented aspects of Western domination and imperialism. Thus, in viewing "Orientalist" photographs, it is important to consider issues such as: why and how various photographs were taken; the role of individual and national power; the role of large format images, albums, and postcards; Colonialism and Post-Colonialism; documentary, propaganda, and artistic elements.

One of the most important publications in the early development of Orientalism was the French government's *Déscription de l'Egypte* (Paris 1809–22), 24 volumes illustrating the monuments, people, flora, and geography of Egypt following Napoleon's campaign in Egypt. Writers such as Flaubert, Chateaubriand, Théophile Gautier, and Pierre Loti all visited the Near and Middle East and incorporated "Oriental" themes and elements in their writings. With the advent of photography in 1839, the latter part of the 19th century saw increased demands for albums and images of the "alluring" Orient.

Improved means of transport and organized tourism also caused an increase in the market for photographic images of the Orient. The advent of steamships made it possible for the middle classes to travel to distant shores. In 1841 Thomas Cook began his organized tours. A full Mediterranean tour took passengers to the

Egyptian pyramids, the Biblical sights of the Holy Land, the classical antiquities of the Aegean and to Istanbul. The Hamburg-American Packet (Hapag) Company merged with North German Lloyd in 1857 to become Hapag Lloyd, launching its own grand tours to the East. The Orient Express began in 1883 and by 1889 had extended its retail service to Istanbul. New travel guidebooks were produced for the increased tourism, and international trade exhibitions of the 19th century also focused attention on the Orient. The opening of the Suez Canal in 1869 brought further improved conditions for travel and allowed photographers easy access to Oriental lands.

Among the first to travel to North Africa, shortly after the invention of the Daguerreotype in 1839, the painter Horace Vernet went to Egypt and the Holy Land to photograph, accompanied by the daguerreotypist Fréderic Goupil-Fesquet. Daguerre had predicted that the intensity of Egyptian light would help produce an image more quickly. The first daguerreotype taken in Egypt by Fosquet in October 1839, was titled "The Harem of Mohammed-Ali in Alexandria." (It actually only showed a half-open door and two guards.) The subjects of "Woman" and "Other" were to become a popular, as elements of the exotic, sexual, and decadent, were incorporated into many photographs.

Photography became a significant travel aid for artistic, archeological and geographic expeditions. In 1849–51, Maxime Du Camp accompanied Flaubert on his trip to Egypt and published some of his images in 1852 in an important album, *Egypte, Nubia, Palestine, et Syrie*. Several of the painter Jean-Léon Gérome's expeditions to the East included a photographer—his brother-in-law Albert Goupil in 1868, and Auguste Bartholdi in 1855. Bartholdi, perhaps better known as a sculptor, recorded both monuments, such as his "Colossi of Memnon" 1855, as well as aspects of their day to day travels.

The largest group of travelling photographers came from France, the second largest from England. Other European countries such as Italy, Germany and Austria and the United States had relatively few photographers travelling to the area in the early days of photography. There were few "local" photographers, in part due to religious restrictions, forbidding the making of "graven images." The first local photographers thus to open up shops were primarily Christians.

The relative prosperity in France and England during the middle of the 19th century allowed for more frequent travel to the Orient. The French government, in particular, encouraged Orientalist studies and often financed exploration trips. Maxime Du Camp and Auguste Salzmann were among the first to receive such support, followed by Louis de Clerq, Louis Vignes, and Théodule Déveria. Government survey missions from England were fewer than from France but the British tended to spend years rather than months surveying and photographing. Significant were the military expeditions of the Royal Engineers, in particular, the Ordnance Survey of Jerusalem (1864–65) and the Ordnance Survey of Sinai (1868–69) with James MacDonald as official photographer. The Palestine Exploration fund was established in 1865 and an American Palestine Exploration Society was founded in 1870. The first American expedition under Dr. Selah Merrill arrived in Lebanon in 1875. Tancrede Dumas of Beirut was the official photographer for that mission.

Religious mission groups also often had photographers. As example, James Graham, lay secretary of the London Jews Society, came to Palestine for four years and was an active photographer there. In general, according to Nissan Perez, in *Focus East*, British photographs tended to be more objective while the French images tended to contain more mystery and emotion. "If the British in their truthful images denuded the Orient from its silken veil of Arabian Nights fantasy, the French wrapped it even more and made it more mysterious, more sensual—a project of pure Western fantasy and imagination. With an eye for detail and daring composition, French photographers [such as Teynard] reflected in their images the spirit of the places rather than the stark reality..." (Nissan Perez, *Focus East: Early Photography in the Near East (1839–1885)*, New York, Harry Abrams, 1988, p. 83)

Technical advancements in photography also had an effect on the type of photographic images produced. Initially the French daguerreotype and the British process, the calotype or talbotype, were employed. The latter system often produced quite atmospheric prints. These processes were overtaken by the wet collodion process that enabled Francis Frith to produce his beautiful large 16 × 20 inch negatives beginning with his first trip to Egypt in 1856. This process allowed for much faster exposures, often four to five seconds versus the calotype exposures which could be two minutes or the daguerreotype which could take as long as twenty minutes. The wet process gave way to the dry collodion process by 1875. Plates could then be prepared in advance and developed when appropriate. The development of gelatino-bromide emulsions in 1871, that were factory produced and exported from factories in Britain, France, and Germany to places such as Port Said in Egypt in the 1870s, was also significant. Innovations in lens design such as the 1886 Rapid Rectilinear lens further reduced exposure times and distortion in the image. These technical advancements made it possible for commercial photographers to better market their images and for photographers to set up photographic studios. In Port Said, the commercial market was initially dominated by Hippolyte Arnoux who had a floating darkroom on

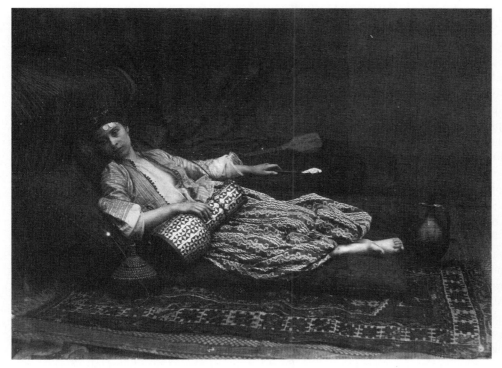

Fenton, Roger. Reclining Odalisque.
The Metropolitan Museum of Art, The Rubel Collection, Purchase, Lila Acheson Wallace, Anonymous, Joyce and Robert Menschel, Jennifer and Joseph Duke, and Ann Tenenbaum and Thomas H. Lee Gifts, 1997 (1997.382.34) Image.

the Suez Canal, and the Zangaki Brothers who had a horse drawn mobile darkroom that actually appeared in a number of their images. Arnoux photographed the building site of the Suez Canal, and was known for his various studio portraits. Images such as his albumen prints "Odalisque, Egypt" c. 1880, and "Portrait of a Women," c. 1880, both using the same model against an alluring painted backdrop, are archetypal images of the exotic, seductive woman, that some studios fostered through the staging of such images.

The British Francis Frith was probably the first "entrepreneur" photographer to establish himself as the producer and promoter of large scale scenic and architectural photographs of the distant Eastern lands. Frith traveled to the Middle East three times between 1857 and 1860 and became the owner of the successful photographic-view company, F. Frith and Co., the largest such company in England. Frith's exquisitely detailed photographs record a world, often far off the beaten tourist track—that was in subsequent years to become vastly changed by the effects of archaeology, tourism and the politics of conflicting nations. One sees, for example, "Frith's Boat on the Nile," as its triangular sails pierce the quiet Nile and its silent sculptural, rocky shores; or "Cairo: The Mosque of the Caliph El-Hakim" where Frith shows the viewer the ancient mosque (990–1003), in ruins by the 1450s. Frith's framing of the majestic tower in a central arch form brings majesty and dignity to the monumental structure. In the foreground Frith has kept several people to show scale and local color. During much of his travelling, Frith dressed in "native dress"; a well-known self-portrait shows him in Turkish

costume. Back home in England, the Victorians were enamored with foreign "costumes" that were picturesque and belonged to the middle and upper classes of any given country. Frith's book production in 8¾ × 6½ inch formats, contained beautiful albumen prints. From 1858–1862 his titles included, *Egypt and Palestine Photographed and Described by Francis Frith*; *Cairo, Sinai, Jerusalem*, and the *Pyramids of Egypt: A Series of Sixty Photographic Views by Francis Frith*; *Egypt, Nubia, and Ethiopia: Illustrated by One Hundred Stereoscopic Photographs;* and *Egypt, Sinai and Palestine, Supplementary Volume* (4 volume series).

While Frith's photographs were usually based on actuality, the Oriental photographs of Roger Fenton, comprising a suite of approximately 50 works, were studio based, from his London Albert Terrace studio. Fenton had traveled to the Crimea in 1855 on commission from the publisher, Thomas Agnew, and support from Queen Victoria to photograph the Crimean War effort. In so doing, Fenton provided one of the first extensive photo documentations of any war, and so collected many objects and fabrics that he was to use in his Oriental studio studies in the late 1850's. These images were not authentic, but were widely accepted by a public that sought the exotic and sensual, that was "safe" to view through the distance provided by the photographic image. In his 1858 "Pasha and Bayadère" one finds the elaborate details of patterned draperies, rugs, tables, and vases, and dress in a well articulated triangular composition of the three main characters on Fenton's stage set. Upon careful viewing, one can see there are actually strings holding the young woman's

hands, rhythmically placed above her head for the long exposure.

Other significant studios, established in the Middle East, included the Maison Bonfils, Abdullah Freres, Sébah and Joaillier, and Lehnert and Landrock. Félix Bonfils studied photography initially with Nièpce de Saint Victor. With his wife Lydia, who took studio portraits while he photographed throughout the Middle East, Bonfils established a successful business in Beirut, beginning in 1867, the first French photographer to relocate to the region. In 1871 he submitted prints of Egypt, Palestine, Syria, and Greece to the French Photographic Society and received its medal. His son, Adrian, who had mastered Arabic, took over the Maison Bonfils in 1885 when his father died. While many of the studio's images are posed, the photographs nonetheless are both documentary and artistic representations of 19th century Oriental cultures and monuments, that are important to consider in studying this era and region.

The Abdullah Freres were three brothers of Armenian origin who were particularly noted for their photographic work in Istanbul, often photographing royal guests in Istanbul. They also served as official photographers to Sultan Abdul Aziz in 1863, and later to Sultan Abdul Hamid II. For a brief period from 1886–1888, Kevork and Housep Abdullah established themselves in Cairo. The brothers sold their studio to Sébah and Joaillier in 1899.

Pascal Sébah initially worked in collaboration with Henri Béchard. Sébah received medals at International Exhibitions in Paris, Vienna and Philadelphia. With such success he opened a second studio in Cairo in 1873. In 1884 Policarp Joaillier became his partner in Istanbul. Noteworthy in Sébah's career was his collaboration with the Turkish painter Osman Hamdi Bey, whom he met in 1873. Sébah took photographs of models according to Bey's specifications for Bey's paintings and also experimented with light and shade. In his paintings, Bey often reacted to the cliché of the Oriental woman as sex object. Sébah also photographed models in traditional Turkish dress for an important album and Ottoman exhibition in Vienna in 1873.

Rudolph Lehnert, born in Bohemia (part of the Austrian-Hungarian Empire) in 1878, made his first trip to Tunis in 1903 and fell in love with the country. In 1904 he opened a studio with his friend, Ernst Landrock from Saxony. The two were captivated not only by the exotic beauty of people and places of North Africa, but also wished to capture a purity they felt was rapidly disappearing. From 1904–1930 the two worked closely. Their photographs of the Ouled Nail tribe in and around the Bou Saada oasis are particularly striking. During World War I their studio was confiscated by the British. In 1920 they founded a new company, Orient Kunst Verlag, and in 1924 they restarted their commercial enterprise in Cairo. By 1930, Lehnert returned to Tunisia where he died in 1948. The business they founded still continues in Cairo today, selling postcards and reproductions at 44 rue sherif Pasha.

In response to some Orientalist representations of Middle Eastern life by Western photographers that were perceived to be more fiction than fact, the Ottoman Sultan Abdul Hamid II, at the occasion of the 1893 World's Colombian Exposition, presented fifty-one photography albums to the National Library of the United States (now in the Library of Congress). The ornate albums containing 1,819 photographs by various Istanbul photographers emphasized reform and modernization. One sees for example, images of the elaborate Dolmabahçe Palace, constructed in 1856 that contains Eastern and Western architectural elements, or photographs of factories, docks, libraries, or a group of girls in a girls school, in simple uniforms, their heads uncovered.

By the 1890s the larger prints of some of the above photographers or photographers such as Francis Bedford, Robert Murray or Antonio Beato, had begun to become less popular. Such was in part due to the development of the PZ print, produced by Photoglob, Zurich. The process referred to as photochromy produced delicate, fairly accurate colored images. Not color photography, the process involved the use of collotype photolithography with a solution of asphaltum of ether, and involved as many as sixteen printings of different colors. This color process was applied to postcards, which became most popular when new postal regulations in 1894 allowed pictures to be mailed on postcards. And by 1900 the invention of the box camera brought competition to the staged Orientalist image, both large and small, as the family snapshot gained increase popularity.

Yet the impact of Orientalist photography still continues as the complexities of fact and fiction, dream and reality, continue to be studied. As Amelia Edwards wrote in 1892, "It may be said of some very old places as of some old books, that they are destined to be forever new…Time augments rather than diminishes their everlasting novelty…" (Amelia Edwards, *Pharaohs, Fellahs and Explorers*, New York, Harper and Brothers, 1892, 3).

KATHERINE HOFFMAN

See also: France; Daguerreotype; and Calotype and Talbotype.

Further Reading

Baldwin, Gordon; Daniel, Malcolm; and Greenough, Sarah. *All the Mighty World: The Photographs of Roger Fenton, 1852–1860*, New Haven: Yale University Press, 2004.

Beaulieu, Jill and Roberts, Mary, eds. *Orientalism's Interlocations: Painting, Architecture, Photography*, Durham and London: Duke University Press 2002.

Benjamin, Roger. *Orientalism, Delacroix to Klee*, London: Thames and Hudson, 2003.

Edwards, Amelia. *Pharaohs, Fellahs, and Explorers*, New York: Harper and Brothers, 1892.

Fromentin, Eugène. *One Année dans le Sahel*, ed. Elisabeth Cardonne, Paris: Flammarion, 1991. (original 1859)

Haller, Douglas. *In Arab Lands: The Bonfils Collection at the University of Pennsylvania Museum*, Cairo: The American University in Cairo Press, 2000.

Howe, Katherine Stewart and Wilson, Michael. *Excursions Along the Nile*, Santa Barbara: Santa Barbara Museum of Art, 1993.

Naef, Weston. *Early Photographers in Egypt and the Holy Land*, New York: Metropolitan Museum of Art, 1973.

Nochlin, Linda. *The Imaginary Orient* in *The Politics of Vision: Essays on Nineteenth Century Art and Society*, New York: 1989, 33–59.

Osman, Colin. *Egypt: Caught in Time*, Cairo: The American University in Cairo Press, 1999.

Özendes, Engin. *From Sebah and Joaillier to Foto Sabah-Orientalism in Photography*, Istanbul: Yap Kredi Publication, 2004.

Peltre, Christine. *Orientalism in Art*, New York: Abbeville Press Publisher, 1998.

Perez, Nissan. *Focus East: Early Photography in the Near East, 1839–1885*, New York: Harry Abrams, 1988.

Said, Edward. *Orientalism*, London: Routledge & Regan Paul, 1978.

Van Haaften, Julie. *Egypt and the Holy Land in Historic Photographs*, New York: Dover Publications, 1980.

OTTEWILL, THOMAS & CO.

The Ottewill company has long been recognised as one of the best quality manufacturers of cameras and photographic equipment of the 1850s and 1860s. The Ottewill double folding camera is reputed to have been the inspiration for Lewis Carroll's poem *Hiawatha's Photographing* (1857). Carroll's camera was made by Ottewill and supplied to Carroll by the London firm of R. W. Thomas of Pall Mall.

The business of Thomas Ottewill was established in 1851 and as such can be considered as one of the earliest British specialist photographic manufacturers. The business was listed first at 24 Charlotte Terrace, Copenhagen Street in Barnsbury, London, subsequently expanding to numbers 23 and 24 for the remainder of the firm's existence. The *London Post Office Directory* first records the firm from 1854 as Daguerreotype Apparatus Manufacturers, a listing which was expanded to Photographic Apparatus Manufacturers from 1856, until the firm's disappearance circa 1866.

The firm was listed as Ottewill & Morgan in 1855 before adopting the title Thomas Ottewill & Co from 1856–63. The following year it became Ottewill, Collis & Co until it was last recorded in the directories in 1866, although from other sources the firm seems to have remained active until 1868. The firm claimed in 1856 (*Photographic Notes*, 1 November 1856, np) to 'have erected extensive workshops adjoining their for-

mer shops, and having now the largest manufactory in England for the make of Cameras, they are enabled to execute with dispatch any orders they may be favoured with.' The firm exhibited 'a Monster camera made by Mr Ottewill upon Capt. Fowkes' plan' at the Photographic Society's 1858 exhibition.

An 1865 advertisement (*Yearbook of Photography* 1865, adv) stated that the firm was photographic apparatus manufacturer to the governments of 'England, India, Italy, Switzerland, the Colonies, etc' and that a fresh infusion of capital, together with a general knowledge of the photographic art would allow it to supply every article connected therewith of first quality'.

The firm advertised regularly throughout its existence in the *British Journal Photographic Almanac* and *Yearbook of Photography,* the *Journal of the Photographic Society and Photographic Notes*. The firm's reputation was exhanced by the double folding sliding camera that it started making from the early 1850s. The design was registered formally on 25 May 1853 and attracted much favourable comment in the photographic press. The *Journal of the Photographic Society* (December 21 1853, 149) stated of the design that 'there is none which more fully combines the requisite strength and firmness with a high degree of portability and efficiency.' The design remained available into the 1860s. Other cameras advertised by the firm were equally innovative. Ottewill produced Captain Francis Fowkes's camera (British provisional patent number 1295 of 31 May 1856) in teak for the British government and an Improved Kinnear-pattern camera in 1859 that he claimed was the first to introduce a swing back. They also produced Frederick Scott Archer's folding camera which has been registered in 1854. As with other manufacturers Ottewill produced boxform cameras in single lens and stereoscopic versions as well as studio and portrait cameras from the early 1860s. The firm claimed to have been the first to introduce the swing back in 1859. In 1860 the firm produced a miniature camera clearly inspired by Thomas Skaife's Pistolgraph of 1859 made from mahogany which was mounted on a box that contain all the parts.

Lewis Carroll recorded in his diary for 18 March 1856 that 'we [Reginald Southey who taught him to take photographs] went to a maker of the name of Ottewill… the camera with lens etc will come to just about £15.' The camera was delivered on 1st May. Carroll's £15 did not include the chemicals and associated processing equipment which probably came separately from R W Thomas of London.

The Ottewill firm supplied and advertised cameras and photographic equipment under it's own account. It also supplied several well-known London firms with cameras to be re-badged under their own name, including the firm of Ross who were primarily lens

manufacturers. In an 1867 advertisement Ottewill & Collis state '15 years manufacturers to Ross the Optician. Mr Collis having had upwards of 13 years experience in Mr Ross's establishment.' Ottewill also employed Patrick Meagher who went on to successfully establish his own firm in 1860.

Most of Ottewill's cameras can be criticised for their lack of innovation, but there is no faulting the very high quality of craftsmanship with which their cameras were made and a contribution to British camera making which, in the words of the *British Journal Photographic Almanac* of 1898 (p 640) 'may be regarded as the source to which the best school of English camera-making traces its origin'.

MICHAEL PRITCHARD

See also: Archer, Frederick Scott; Fowke, Francis; Dodgson, Charles Lutwidge (Carroll, Lewis); and *British Journal Photographic Almanac (1859-)*.

Further Reading

Channing, Norman and Dunn, Mike, *British Camera Makers. An A-Z Guide to Companies and Products*, Claygate, Parkland Designs, 1996.

OTTOMAN EMPIRE: ASIA AND PERSIA (TURKEY, THE LEVANT, ARABIA, IRAQ, IRAN)

The discovery of photography was publicly announced in the Ottoman Empire on 28 October 1839, the news appearing in the government newspaper *Takvim-i Vekayi*, published in Istanbul in Turkish, Arabic, French, Greek and Armenian.

The spread of photography in the lands of the empire was pioneered by numerous travelers, writers, archaeologists, artists and architects (Özendes, 1995, 26).

On 21 October 1839 the French painter Horace Vernet (1789–1863) and the daguerreotypist Goupil Fesquet (1817–1878) sailed from Marseille to photograph the sights of the East. They arrived in Syria on 30 October and in Alexandria in November. In Egypt they found that Pierre Gustave Joly de Lotbiniere (1798–1865) had preceded them and was photographing on the banks of the Nile. From Egypt they traveled by caravan via Sinai to Syria, visiting Palestine, Tyre, Saida, Deir El Kamar, Damascus, Jerusalem, Nazareth, Beirut and Baalbeck, before travelling to İzmir on the Aegean Sea, arriving on 8 February (Özendes, 1995, 85).

Joseph Philbert Girault de Prangey (1804–1892), a student of Islamic architecture, visited the Middle East between 1842–1845 taking Daguerreotypes of Islamic buildings and monuments. These pictures were published in *Monuments Arabes d 'Egypte de Syrie, et d*

'Asie—Mineure dessinés et mesurés de 1842 à 1845 in Paris in 1846 (Özendes, 1995, 96).

Excursions daguérriennes: Vues et monuments les plus remarquebles du globe 1840–1844 published in Paris by Nicolas Paymal Lerebours contains 114 photographs taken by Fesquet, Lotbiniere and Prangey (Özendes, 1995, 96).

The French writer Maxime du Camp (1822–1894) arrived in İzmir in May 1843, and after visiting Ephesus and other sites in the region traveled to Istanbul, and from there to Greece, Italy and Algeria. Du Camp's illustrated account of this journey entitled *Souvenirs et Paysages d 'Orient: Smyrne, Ephése, Magnésie, Constantinople, Scio* was published in Paris in 1848 (Özendes, 1995, 98).

Ernest Edouard de Caranza, a French physics and chemical engineer who worked in Imperial Gunpowder Factory (Baruthane-i Amire) since 1839, took many Calotypes in Istanbul between 1852–1854 and presented an album to the Ottoman palace. During this period he was given the title of royal photographer (Özendes, 1995, 107).

Alfred Nicolas Normand (1822–1909), who visited Istanbul in 1852, took Calotypes in which composition took precedence over technique (Özendes, 1995, 108).

A photograph of Péra taken by the Irish aristocrat John Shaw Smith (1811–1873) in 1852 is the earliest known combination of two negatives (Özendes, 1995, 108).

Jacob August Lorent (1813–1884) traveled to North Africa in 1858 and documented Arab culture, publishing his photographs in *Egypten, Alhambra, Tlemsen, Algier: Photographische Skizzen* in Mannheim in 1861 (Özendes, 1995, 148).

Francis Frith (1822–1898) arrived in Egypt in September 1856, and the photographs he took were exhibited in England in 1857. The same year he traveled to the Middle East and traveled through Palestine and Syria until May 1858. His photographs of both journeys were published in *Egypt and Palestine Photographed and Described*. In late summer 1859 Frith returned to Egypt and from there traveled to Sina, Petra, Palestine, Syria, Damascus, Jerusalem, Beirut and Jaffa, photographing İzmir in 1860. The same year he established Frith and Co., which became Europe's largest producer of photographs. His own portrait in Turkish costume is on the first page of his album entitled *Egypt, Sinai and Palestine*, which is illustrated by 37 photographs (Özendes, 1995, 149).

The British landscape photographer Francis Bedford (1816–1894) accompanied Edward Prince of Wales on his journey to Turkey and the Middle East in 1862, and in 1863 his photographs appeared in *Tour in the East; Photographic Pictures of Egypt, The Holy Land and*

Pesce, Luigi. In the Mosque of the Damegan/The Eunuchs. *The Metropolitan Museum of Art, Gift of Charles Wilkinson, 1997 (1997.683.21) Image © The Metropolitan Museum of Art.*

Syria, Constantinople, The Mediterranean, Athens, etc published in London by Day & Son (Özendes, 1995, 154).

In 1862 A. de Moustier traveled through Anatolia taking photographs, which were used to illustrate the 15 volume *Le Tour du Monde* published in 1864 (Özendes, 1995, 156).

Tancrede R. Dumas, who founded a studio in Beirut in 1860, took photographs in Istanbul in 1866 (Özendes, 1995, 162).

L. Fiorillo of Alexandria and G. Lekegian of Jerusalem are noted particularly for photographs of their own localities (Özendes, 1995, 82).

Travelers to this region mainly took photographs of eastern cities, so different from their western counterparts, ancient ruins, the pyramids of Egypt and Muslim cemeteries (Özendes, 1995, 44)

James Robertson (1813–1888), who worked as an engraver at the mint in London between 1833–1840, was employed in Istanbul from 1841, after the Ottoman government decided to modernize the Imperial Mint. He and Felice Beato (1825–1903) photographed Malta in 1850, and Greece, the Balkans and Anatolia in 1851. In 1853 Robertson's photographs were published as *Photographic Views of Constantinople* by Joseph Cundall in London, followed the next year by *Photographic Views of Antiques of Athens, Corinth, Aegina etc*, again by the same publisher.

After the Crimean War broke out between the Ottomans and Russians in 1853, first France and then, in March 1854, Britain, joined the war as allies of Ottoman Turkey. Roger Fenton was commissioned to photograph

the war, and with his horse-drawn cart inscribed with the words "Photographic Van" he took over 360 photographs in 1855. When Fenton became ill and returned to England, Robertson and Felice Beato went to the Crimea in August 1855, and took over sixty photographs of Sivastopol, Malakoff and Balaklava during the last months of the war.

Beato traveled to India in 1857, China in 1860 and Japan in 1862. Robertson closed his studio in Istanbul in 1867, but evidently remained there fore another decade, since the last medallion that he designed for the Ottoman Mint is dated 1876. In 1881 he went to Japan, where he died in 1888 (Özendes, 1995, 89).

Carlo Naya (1816–1882) opened a studio in Péra, Istanbul, in 1845. Upon the death of his brother Giovanni in 1857, he returned to Italy and settled in Venice (Özendes, 1995, 100).

As western travelers became more familiar with the Islamic countries, they began to photograph local people as well as monuments, streets and markets, and this led to the emergence of local studios in the major cities of the Ottoman Empire (Özendes, 1995, 44).

In Istanbul studios began to be established from the 1850s, mainly along Grand' Rue de Péra, in the district where westerners working in the city congregated (Özendes, 1995, 35).

The first Ottoman studios were established by Armenians and Greeks, since although there was a portrait tradition in court circles, Islamic orthodoxy frowned on representation of the human figure and Muslims were reluctant to be photographed. Armenians were skilled artists and artisans, famed particularly as pharmacists,

chemists and goldsmiths. So Armenians with the knowledge of chemistry required for the Daguerrotype process, and who moreover studied this subject at the Murad-Raphaelyan School in Venice were among the first Ottoman photographers (Özendes, 1995, 21).

The Ottoman Greek photographer Basile (Vasili) Kargopoulo (1826–1886), who opened his studio on Grand' Rue de Péra in 1850, created a valuable documentary record of the time with his photographs of Istanbul and daily life in the city. He was awarded the title of royal photographer by Sultan Abdulmecid (r. 1839–1861), a position he held for many years, and was also private photographer to Sultan Murad V (1840–1904 r. 1876) (Öztuncay, 2000).

Fascination with the Orient began with the Turqueries fashion in the 16th century, when diplomats and travelers had their portraits painted wearing Turkish costume. In the 18th century the Istanbul embassies of principal European countries employed artists to do paintings and drawings of Turkey, Middle East and Egypt to satisfy the curiosity of friends and colleagues back home. In the 19th century the floodgates of Orientalism opened.

Although photography was supposedly the opportunity to see the 'real' Orient rather than artists' interpretations, photographers created scenes that perpetuated the preconceived European image of the Orient.

Westerners were fascinated above all by eastern women, and in response to this demand photographers generated a new category of photographs with titles like 'A Turkish Woman' or 'Young Turkish Girl' In fact it was out of the question that any Muslim woman would have sat for such photographs, and the women portrayed were generally foreigners or local prostitutes. When photographers had trouble finding models they even resorted to dressing up men in women's clothing. Although their faces are veiled, close scrutiny of eyes, hands and thick ankles reveals the deception (Özendes, 1999, 9, 160).

Pascal Sébah, (1823–1886), who opened his photographic studio, *El Chark,* on Postacılar Street in Péra in 1857. In 1873, he opened a branch studio in Cairo, and exchanged some negatives with H. Bechard, who had been working in Cairo since 1870. Each set their own signatures to the other's negatives.

After Pascal Sébah's death his studio remained in business, and in 1888 when Policarpe Joaillier became a partner, the name El Chark was changed to Sébah & Joaillier. This firm became the foremost representative of Orientalism in photography.

When Kaiser Wilhelm II (1859–1941) visited Istanbul in 1889, he was photographed by Sébah & Joaillier, and the firm was awarded the title of photographers by appointment to the Prussian court (Özendes, 1999).

Vichen Abdullah (1820–1902) began his photographic career touching up photographs for Rabach, who

had opened his Istanbul studio in 1856. In 1858, when his younger brother Kevork (1839–1918) returned from studying at the Murad-Raphaelyan School in Venice, they and another brother Hovsep (1830–1908) took over Rabach's studio. The new firm became known as Abdullah Fréres.

In 1863 a portrait of Sultan Abdulaziz (r. 1839–1876) taken by Abdullah Frères earned them the title of royal photographer.

In 1886 at the request of Khedive of Egypt Tevfik Pasha, the Abdullah brothers opened a branch in Cairo.

They closed down the branch in Cairo in 1895, and at the end of 1900 sold their studio to Sébah & Joaillier (Özendes, 1998)

Nikolai Andreomenos (1850–1929) took a job touching up photographs at the Abdullah brothers' first studio in 1861 and took this over in 1867. He then opened a branch in Péra and became one of the photographers who won entry to the palace, giving lessons in photography to crown prince Vahdettin, later Sultan Vahdettin (1861–1926 r. 1918–1921) (Özendes, 1995, 164).

In the early 1870s Guillaume Berggren (1835–1920) opened a studio on Grand' Rue de Péra and took what are considered to be the loveliest contemporary images of Istanbul. He was decorated by the Swedish king Gustaf V (1858–1950) during his visit to Istanbul in 1885. When Berggren died his niece had all his photographic equipment buried with him in the Swedish cemetery in Istanbul (Wigh, 1984).

Felix Bonfils (1831–1885) opened a studio in Beirut in 1867. His son Adrien (1861–1929) joined the studio in 1878, and continued to work as a photographer for a decade after his father's death in 1885 (Özendes, 1995, 174).

Bogos Tarkulyan (?–1940) acquired his photographic training as assistant to the Abdullah brothers. In 1890 he opened his own studio, which he named Phébus, and became known as 'Phébus Efendi' (Mr. Phébus). Tarkulyan was also a skilled artist, and became the first Ottoman photographer to color photographs (Özendes, 1995, 175).

Ottoman studio owners prepared graphic designs incorporating the decorations they had received from the Ottoman sultans and European rulers, and medals they had won, and these were sent to the Bernhard Wachtl firm in Vienna to be printed on the back of mounts for Carte-de Visite and Cabinet sized photographs (Özendes, 1995, 65).

Photography came to be very widely used during the reign of Sultan Abdulhamid II, who used it as a way of keeping up with events around the empire without leaving his palace. By appointing photographers to record events and institutions all over the country, Sultan Abdulhamid became the principal patron of photography in Ottoman Turkey. When it was decided to pardon a

large number of prisoners to commemorate the 25th anniversary of his accession to the throne, he had photographs taken of the inmates in prisons throughout the country.

In 1893 the sultan sent photograph albums to the president of the United States and the monarchs of Britain and France to promote the country's image (Özendes, 1995, 28).

In the nineteenth century photography was added to the curriculum of the Imperial School of Military Engineering. Graduates in art from this school who had become photographers were employed to teach the new subject. Among them were Ali Rıza Bey (?–1907), Ali Sami Aközer (1866–1936), Captain Hüsnü Bey (1844–1896) and Ahmed Emin (1845–1892).

Ali Sami Bey, one of the military photographers appointed by Sultan Abdulhamid II, took photographs documenting the 1898 state visit of Kaiser Wilhelm II, who from Istanbul traveled to Jerusalem. Ali Sami Bey presented an album of these photographs to the sultan. Garabet Krikorian of Jerusalem also took photographs of the kaiser's journey (Özendes, 1989).

Adjutant Major Mehmet Hüsnü (1861–?), Bahriyeli Ali Sami and Fahrettin Türkkan Pasha (1868–1948) were among the photographers graduated from other military schools who were employed by the palace (Özendes, 1989).

Baghdad's most eminent photographer Z. G. Donatossian took photographs of every official inauguration, while Sadık Bey's photographs of Mecca were the first of the holy city ever to be taken (Özendes, 1995).

In Persia the first Daguerreotype was a portrait of 13 year old Prince Nasar-od-din Mirza taken during the reign of Muhammed Shah Qajar (r. 1834–1848) by the Russian diplomat Nikolaj Pavlov in 1842.

A photographic laboratory established in the royal palace by Muhammed Shah reflects the growing interest in photography, which had been introduced by western visitors to Persia. This laboratory could be described as the first official studio (Tahmasbpoor, 2004).

ENGIN ÖZENDES

See also: Kargopoulo, Basile (Vasili); Berggren, Guillaume (Wilhelm); and Abdullah Frères (Abdullahian Brothers), Whichen, Kevork and Hovsep.

Further Reading

Özendes, Engin. *Photography in the Ottoman Empire 1839–1919,* 1st edn. Istanbul: Haşet, 1987 2nd edn. Istanbul: İletişim, 1995.

——. *Photographer Ali Sami 1866–1936* İstanbul: Haşet Publications, 1989

——. *Abdullah Frères: Ottoman Court Photographers,* Istanbul: Yapı Kredi Publications, 1998

——. *From Sébah & Joaillier to Foto Sabah: Orientalism in Photography* Istanbul: Yapı Kredi, 1999

Öztuncay, Bahattin. *James Robertson,* Istanbul: Eren, 1992

Öztuncay, Bahaattin. *Vasilaki Kargopoulo,* Istanbul: BOS A.Ş. 2000)

Tahmasbpoor, Mohammad Reza, Tehran: 2004

Wigh, Leif. *Photographic Views of the Bosphorus and Constantinople* Stockholm: Fotografiska Museet, 1984

OTTOMAN EMPIRE: EUROPEAN (BULGARIA, SERBIA, MACEDONIA, ALBANIA, AND BOSNIA)

Albania

Three generations of photographers from the Marubbi family represent the core of the history of photography in Albania. The first, Pjetër Marubbi (1834–1903) or Pietro Marubbi, an architect, painter, sculptor and photographer, was born in Piacenza, Italy, and as a member of Garibaldi's movement, came to Albania where he in 1864 founded the first studio for photography in the town Shkodra. The Studio Marubbi, as it was printed on the reverses of his cartes-de-visite, which worked until 1890, was specialized both for portrait-making and for photographic documentation of the famous marketplace (bazaar) in Shkodra. With remarkable success and greatest attention he documented city-scenes, as well as the scenes of fishermen's lives. When shooting landscapes, he chose the panoramic aspect, whilst in documenting the scenes of old urban settlements he sometimes boldly shortened the perspective. Some carte-de-visite portraits by Pietro Marubbi look like salt prints, but they are made on albumen paper. Many are hand-colored and varnished. Marubbi published some of his photographs on life and customs in Albania in the magazine "Illustracione Italiana." Later on, in the 20th century, his photographs were often used as illustrations in many books about Albania. They were motives on the first postcards and many other reproductions.

The second generation of Marubbi photographers is represented by brothers Mati and Kel Kodheli, Pjetër Marubbi's adopted sons. It was Kel who took over the Studio, because Mati died young (1862–1881). Kel Marubbi (1870–1940) documented, as a good reporter, all the important events and persons involved in the movement for liberation of Albania from the Ottoman Empire. Especially important are his reports about the mountainous regions where he took photographs of anonymous peasants and shepherds as well as interesting folklore types. Around 1900, the Studio Marubbi was, according to the print reverses on the photographs, the official photographer for the Montenegrin royal family Petrović in Cetinje.

Kel's son, Gegë Marubbi (1907) who had continued his father's work, gave the entire collection of negatives from the Studio Marubbi, with a span of almost hundred years (1864–1952), to the Albanian Country. In 2005, UNESCO and its Italian-founded PASARP program started the process of digitizing about 240,000 negatives, glasses and films of this collection.

Kolë Idromeno (1860–1939), one of the leading painters of realism, had also a studio for photography in Shkodra. He printed numerous postcards, notably in Austria and Germany at the turn of the century.

Bosnia and Herzegovina

According to the latest research, the oldest existing photograph was taken in Sarajevo in 1855, and its author was Georg Knežević. It is a photograph of a bride and bridegroom (Jaša and Gavrilo Jelić), who were both from families of tradesmen, and were thus members of the middle class in a society that was still feudal. Georg Knežević was a traveling photographer, who worked first in Budapest, then Novi Sad, Segedin, Belgrade, Sarajevo and finally in Zadar. He combined the form of carte-de-visite with paper negatives printed on salted paper when making portraits in his improvised atelier, but in his senior works he used wet plates and albumen paper. He regularly visited Sarajevo for longer periods of time, of which a number of private collections of photographs give evidence. Although he was a traveling photographer, Knežević wrote his name, surname, profession and location both on the back and on the front of his photographs in Cyrillic letters.

During the insurrections in Herzegovina in 1875–1878, came a traveling photographer named Silvio S. Maskarić from Dubrovnik. He made many portraits of the insurgents, as well as of the refugees who found shelter in Dubrovnik's surroundings. Beside wet plates, he also used the ambrotype technique.

With the arrival of the Austro-Hungarian army in 1878, many traveling and official photographers came to the area. Traveling with the army, their photographs were often of executions and other military subjects but they usually lack the signature of their authors.

The first permanent studio for photography was opened in Sarajevo by Anton Shadler who came from Vienna in 1878. Another photographer, František Franjo Topič came to Sarajevo as a representative of the Viennese Court Art Institute C. Angerer and Goshl. He was very active as an outdoor photographer until 1905 and he published many photographs in the official annual of Provincial Government "Bosnian" (Bošnjak).

The National Museum (Zemaljski muzej Bosne i Hercegovine) was founded in 1885 and from 1891 it published its illustrated "Annual" (Glasnik) with photographs of Ćiro Truhelka, the director of the Mu-

seum and of A. Weinwurm, photographer. In the book "Durch Bosnien und die Herzegowina kreuz und quer" (Through Bosnia and Herzegovina along and across), Berlin 1897, an eminent number of Weinwurm's photos was included.

At the end of the 19th century, there were many photographers in Bosnia and Herzegovina from all the countries within the Austro-Hungarian Monarchy: G. E. Abinum, Emanuel Buchwald, Ignaz Lederer, A. Viditz, Stefan Ossko and A. Hoiger working in Sarajevo, Ottmar Rebaglio and Johan Patzelt in Banja Luka, Anton Kuzcento in Livno, Julius Zenter in Brčko, Vladimir Merćep in Bileća and Cisar Leopold in Bosanska Krupa.

The first amateur photographer and mountaineering reporter was doctor Radivoje Simonović from Sombor, who climbed Herzegovina's mountains in 1888, and some of his photographs were published in the magazine "Nova Iskra" (New Spark) from Belgrade.

Bulgaria

The first photographers in Bulgaria were foreign traveling photographers that came in the middle of the 19th century. They were mostly French, Austrian, Hungarian and German. The oldest existing photograph was made by a traveling photographer in 1851 in the town Šumen, and it represents an orchestra founded by Mihail Šafran, an immigrant from Hungary and participant of the revolution of 1851.

Before he founded the most prominent studio for photography in Sofia in 1878, Anastas Karastojanov (1822–1880) was the court photographer of the Crown-Prince Mihailo Obrenović in Belgrade under the name of Anastas N. Stojanović, as it was printed on the reverses of his cartes-de-visite from 1863. Being a participant of the Bulgarian national revival (Vazrazdane), he made dozens of portraits of the prominent insurgents. He also used the wet plates technique when he documented the spectacle organized in the streets of Belgrade on the occasion of the 50th anniversary of the Obrenović dynasty and of the uprisings for the liberation from Turkey. His sons Ivan and Dimitar had continued the work at the studio "Braća Karastojanovi" in Sofija, and it had been prosperous from 1878 until the middle of the 20th century.

Ivan Stojanov Papazov-Zografov, learned to paint icons at the Holy Mountain, first, and around the year 1860, he began making photographic portraits as well as icons in Panaguriste. Because of the fact that he participated in the April's insurrection, he and his wife received the capital punishment, and his studio for photography was destroyed. We can judge his work only by a remaining family album with photographs. Stojan Karaleev was also both a painter of icons and a

photographer. He learned to paint icons in Kiev where he also bought a photo-camera around 1870.

Nikifor Nenčev Minkov (1838–1928) gained his first knowledge of photography in Rumania, and around 1860, he founded a photographic studio in Istanbul under the name of "Nikifor Konstantinopol." During the Russian-Turkish war of 1876, he took panoramic overviews with military troops and scenes of life behind battlefield.

Toma Hitrov (1840–1906), together with Josif Buresh opened a photographic studio "Slavjanskata Svelopisnica" in Sofia around 1890. He made portraits, of which the best ones are those of the cabinet format, but he also photographed everyday life in the streets of Sofia. His portraits of contemporaries (insurgents, prominent writers, scientists and intellectuals) are very direct and sincere, and they show the author's keen sense for analyzing characters. He remained faithful to the wet plates technique until the end of the 19th century. He was one of the first photographers who systematically documented the landscapes and locations where the key events of the Bulgarian insurrection took place. At the beginning of the 20th century, his daughters Ivanka and Bojka took over the studio. They learned photography in Dresden and Berlin.

Many foreign photographers had their permanent studios in bigger Bulgarian towns, only after the liberation, that is to say, at the end of the 19th century. Some of which are the following: M. Wolf, Fr. Bauer, O. Markolesko, M. Rekhnitch, J. Buresh, V. Velebni, F. Grabner, M. Kurtz, etc.

The Collection "Portraits and Photos" kept in the National Library St. Cyril and Methodius in Sofia, consists of over 80.000 photo documents.

Macedonia

In the second half of the 19th century, came a number of traveling photographers from Serbia, Bulgaria, Turkey, Greece and Austria to the regions of today's Macedonia. Authors that are truly essential for the development of photography as well as for cinematography are beyond doubt brothers Yanaki and Milton Manaki.

The Manaki Brothers were born in a small village Avdela, Kostur area, Greece. They started to work together in 1898. During this time Yanaki (1878–1960) was a drawing professor in the high school in Yoanina, where he opened his photo studio with his younger brother Milton (1882–1964). In 1905 they moved their studio to Bitola and opened their well-known "Studio for art photography." In that period, Bitola was an important political, economic and cultural center for the Balkans. At the invitation of King Karol the First, they took part in the Big World Exhibition in Sinaia-Romania in 1906. They won a Gold medal for their photo collection and received the title of court photographers of His Majesty Karol the First.

Their unique skills and artistry attracted many outstanding Balkan personalities, including Prince Mehmed, later to become the sultan of Turkey, King Karol I of Rumania, as already mentioned, and many of the legendary insurgents of the Macedonian revolutionary units of the uprising against Ottoman's empire.

The photo-legacy of the Manaki Brothers with 18.513 negatives, of which 7.715 are glass plates, is kept at the Macedonian State Archive, Regional Dept, Bitola.

Serbia

The work of Anastas Jovanović (1817–1899) belongs to the pioneer age of the calotype process in the Balkans, with more than 800 paper negative and 500 paper positive pieces, kept in the City's Museum in Belgrade. In his *Autobiography*, he described in detail his first encounter with daguerreotype and calotype in Vienna where he was from 1838 as student at the Academy of St. Ana and later, as photographer and lithographer, until 1859. According to J. M. Eder, an Austrian historian of photography, Anastas Jovanović practiced calotype as a member of the group around Anton Martin, the author of the book *Repertorium der Photographie* (1846/8). As many of Jovanović's portrate calotypes are dated 1850, it can be asserted that they were part of the preparations for the publication of *Spomenici Serbski* (Serbian Memorials), a series of lithographs of intellectuals, writers and prominent personalities from the young Serbian state. The portrait genre stands out in Jovanović's photographic opus not only because it greatly outnumbers all other motifs, but also because of its exceptionally high artistic merit. His decision to use close-ups helped him span the distance between his Voigtlander camera and the model.

The legacy of Anastas Jovanović includes paper negatives of the streets and squares of old Vienna as well as the fortress of Petrovaradin on the Danube and the Library of Belgrade photographed by Petzval's portrait lens in 1850, so that parts at the corners of the paper remained unexposed. He photographs outdoor scenes as panoramic overview, but searching for dynamic light-and-dark relations. The body of Jovanović's calotype works contains some still-lifes, interiors and reportages about historic events, such as the withdrawal of the Turkish army from the Belgrade fortress in 1867. Photographs of the exteriors that Jovanović made later on indicate that he, with the process of wet plates, adopted the conventional style of photographic approach.

The public in Serbia could read about the invention of daguerreotypes in *Magazin za hudožestvo, književstvo i modu* (The Magazine for Art, Literature and Fashion) already in 1839. Another magazine, "Srbske narodne

novine" (Serbian Popular Newspaper) states that Dimitrije Novaković made the first daguerreotype of the city of Belgrade. Serbian press reports about another domestic author—Milija Marković, a clergyman, who learned the technique from a German traveling photographer Adolf Deitsch in 1850. Josif Kappilleri, traveling daguerreotyper, came to Belgrade in 1844, and Florian Gantenbein came from Switzerland to open a permanent studio in Belgrade in 1860.

The appearance and publishing of collections of photographs in the format and outfit of cartes-de-visite coincided with the incline of the first Serbian dynasty: Obrenović's. Early studios of cartes-de-visite portraits, as Richard Musil and Mirić, Panta Hristić, Anastas Stojanović, Đoka Kraljevački, Aleksa Mijović, Milan Jovanović and others, introduced the international language of Disderi's portrait into Serbian photography. Their work is no different from the work of foreign photographers such as Nicolaus Stockmann, Moric Klempfner and Lazar Lezter.

The value of documentary approach becomes particularly apparent during Serian-Turkish war 1876–1878. Ivan Gromann, a Russian photographer, made a series of photographs in the wet plates technique about the scenes of war as well as fragments of everyday life in the south of Serbia. His intention was to perceive and document reality in its totality.

MILANKA TODIĆ

See also: Cartes-de-Visite; and Wet Collodion Positive Processes.

Further Reading

Antić, Radmila, *Anastas Jovanović, talbotipije i fotografije*, Beograd: Muzej grada Beograda, 1986.

Boev, Petar, *Fotografsko izkustvo v Bulgaria (1856–1944)*, Sofija: Državno izdatelstvo Septemvri, 1983.

Debeljković, Branibor, *Stara srpska fotografija, Old Serbian Photography*, Beograd: Narodna biblioteka Srbije, National Library of Serbia, 2005.

Eder, Josef Maria, History of Photography, New York: Columbia University Press 1945, 379.

Faber, Monika, The First Decade of the New Medium 1839–1950, *The Eye and the Camera*, Paris: Seul, 2003, 69.

Girard, Gérard, "Notes on Early Photography in Albania" in *History of Photography*, Volume 6, Number 3, 1982, 241–256.

Jankulovski, Robert, *Exhibition at Fotofakt*, Skopje: Gallery Skopje, 2001.

Kadaré, Ismail, *Albanie, visage des Balkans. Ecrits de lumière* (photographies de Pjetër, Kel et Gegë Marubi), Paris: Arthaud, 1995.

Malić, Goran, *Milan Jovanović, fotograf, Milan Jovanović, The Photographer*, Beograd, Srpska akademija nauka i umetnosti, Serbian Academy Science and Arts, 1997.

Marušić, Nikola, *Istorija fotografije u Bosni i Hercegovini do 1918, Photography in Bosnia and Herzegovina to 1918*, Tuzla: Foto-savez Bosne i Hercegovine, Photographic Association of Bosnia and Herzegovina, 2002.

Nixon, Nicola, "Albania at the turn of the 19th Century: The Photos of the Marubi Family" in *Tirana Times*, September 12, Tirana 2005, 8.

Stardelov, Igor, *Manaki*, Skopje: Kinoteka na Makedonija, 2003.

Todić, Milanka, *Fotografija u Srbiji u 19 veku, Photography in Serbia in 19th Century*, Beograd: Muzej primenjene umetnosti, Museum of Applied Arts, 1989.

Todić, Milanka, *Istorija srpske fotografije (1839–1940), The History of Serbian Photography (1839–1940)*, Beograd: Prosveta, Muzej primenjene umetnosti, 1993.

Todić, Milanka, "Anastas Jovanović: Calotype Portraits and Cityscapes, *Photography and Research in Austria—Vienna, the Door to the European East*, Passau: Dietmar Klinger Verlag, 2002, 13–21.

Todorova, Maria, *Imagining the Balkans*. New York: Oxford University Press, 1997.

http://home.drenik.net/foto/anastas/index.htm

http://www.shkoder.net/foto/foto_mf.htm

http://www.mymacedonia.net/links/manaki.htm

OVERSTONE, LORD (1796–1883)
English patron

Samuel Jones-Loyd, first, and only, Baron Overstone, was an influential banker, a collector of Italian, Dutch, and French old-master paintings, and a munificent patron of the arts. He was one of the organizers of and lenders to the Manchester Art Treasures exhibition of 1857. His place in nineteenth-century photographic history is due to his connection with Julia Margaret Cameron and her family, to whom he provided substantial long-term financial support, in large part because of the friendship he had formed at Eton College with her husband, Charles Hay Cameron.

It was Mrs. Cameron's habit to give albums of her work to members of her family and to famous men whom she admired, like Sir John Herschel and George Frederick Watts, both of whom sat to her. As a likely acknowledgement of the largesse that had underwritten her photographic endeavors, on August 5, 1865, Mrs. Cameron gave Lord Overstone an album containing 111 photographs that she had made in the previous eighteen months, beginning with some of her earliest images. She indexed them in three categories: "Portraits," "Madonna Groups," and "Fancy Subjects for Pictorial Effect." Inevitably, Overstone became one of her sitters, but not until 1870.

GORDON BALDWIN

OWEN, HUGH (1808–1897)

As a photographer, Hugh Owen is now chiefly remembered for his photographs of the objects exhibited at the Great Exhibition of 1851 (otherwise known as Exhibition of Works of Industry of All Nations) and for being the first photographer to photograph a cornfield (an achievement since early emulsion usually rendered

yellow as black). Little is known of Owen's early life except that he was born in 1808. He was an accountant and the Chief Cashier for the Great Western Railway, employed by Isambard Kingdom Brunel. Owen even lived for a while, in and apartment in the Temple Meads building, above the railway's offices. He was married twice—the first time at St. Mary's Redcliffe Church to the daughter of Thomas King a Master of the Society of Merchant Venturers—and it is known that he had at least one child (a daughter).

It is not clear how or when Owen first became interested in photography, but most accounts have him making photographs by 1847. In a letter to W.H.F. Talbot written in March of 1845, Owen requests a sample of Talbot's calotype process and says that he as "for some time practiced the process on Silver." This statement implies that he was familiar with the dagurreotype process before learning the rudiments of photography on paper. It has also been suggested that Owen once worked with another Bristolian photographer by the name of John Bevan Hazard in the 1850s, though further research needs to be done to determine the exact nature of their collaboration.

In 1851 Owen, along with the French photographer C.M. Ferrier, was "elected by his peers" to make 155 photographs for the Executive Committee of the Great Exhibition. The photographs were intended to illustrate the Reports by the Juries and the prints were to be made by Nicholas Henneman using Talbot's salted paper process. Concern over the quality of Henneman's printing though led the majority of the prints to be produced in France under the supervision of Robert Jefferson Bingham who had also taken several of the pictures. It was an ambitious project and the first known attempt to photograph the contents of an exhibition and thus represents an important watershed in the history of catalogue publishing. Surviving prints from this body of work show that in some instances Owen chose to photograph the object in isolation, as we can see for example in *Camel Gun*, where the gun and its elaborately decorated saddle are set against a dark background. There are no clues about how the gun was displayed, what other objects surrounded it, or how it would have appeared to the viewers who paraded through the Crystal Palace in 1851. The photographs seem to have been meant more as a kind of inventory rather than a souvenir of the exhibition itself. Approximately one hundred and forty bound sets of the reports were made and were distributed to Queen Victoria, the Exhibition Commissioners, the British Museum and "a few other institutions."

The city of Bristol was also commonly featured in Owen's photographs. One of his earliest photographs was of the shops of the Corn Exchange on Narrow Quay. Dating from the 17th century, the building was demolished in 1849 and was one of several examples of historic architecture in Bristol that Owen sought to record and preserve through photography. A number of these photographs were exhibited in London at the Society of Arts exhibition in 1852 and the Photographic Institution in 1853. These images reflect the almost documentary style with which he approached his subjects. Heavily influence by the Picturesque tradition, he also photographed scenes from the countryside around Bristol including waterfalls, quarries and "ruins" as we can see in a work titled *The Bishop's Palace*. Probably photographed in the late 1840s or early 1850s only two decades after the Bristol riots of 1831 that had been the cause of the building's destruction. Given his position as an employee of the Great Western Railway, it is no surprise to find that Owen also photographed trains—and in particular one that had gone of the rails—as can be seen in the photograph titled *Bristol and Exeter Railway No. 20*. Several of his photographers were later copied and made into lantern slides and then were eventually turned into postcards featuring the city of Bristol and its environs.

Owen was also one of the founding members of the Calotype Club in 1847. The majority of his photographs are salted paper prints made from paper negatives (except for a few prints he made while trying out the wet-collodion process). Although he experimented with the wet- collodion process, his distaste for the medium (apparently he was irritated by the staining of his fingers by the collodion mixture) led him to abandon photography around 1855.

Photography was not Owen's only hobby. He was obviously very interested in the historic sites of Bristol and was made a Fellow of the Society of Antiquarians. In 1873 he published a book titled *Two Centuries of Ceramic Art in Bristol* and was considered an expert in the field.

Although somewhat a forgotten figure within the history of photography, Owen is considered to be the master of early photography in Bristol. His contributions to the history of early photography in England are only beginning to be re-discovered. His photographs were often left unsigned but occasionally bear the letters HO. Owen's work can be found in public collections around the world but the largest collection appears to be in the Bristol Records office. He died in 1897.

LORI PAULI

Exhibitions

1851 *Great Exhibition of the Works of Industry of All Nations*, Royal Commission, Crystal Palace, London
1852 *An Exhibition of Recent Specimens of Photography*, Society of Arts, London

1853 *Photographic Exhibition*, Aberdeen Mechanics Institute, Aberdeen, Scotland.

1853 *Exhibition of Photographic Pictures*, Photographic Institution, London.

1853–54 *Society of Arts*, 1st Tour, London.

1854 *Exhibition of Photographic Pictures in Dundee* Royal Infirmary Fund, Dundee, Scotland.

1854 *Exhibition of Photographs and Daguerretoypes*, Photographic Society, London.

1855 *Exhibition of Photographs and Daguerreotypes* (Second Year), Photographic Society, London.

1888 *Exhibition of the Royal Photographic Society of Great Britain*, London.

Collections

Bristol Records Office, Bristol.
Swansea Museum Library, Swansea.
Victorian and Albert Museum, London.
J.Paul Getty Museum, Los Angeles, California.
Harry Ransom Humanities Research Center, University of Texas, Austin, Texas.
Canadian Center of Architecture, Montreal, Quebec.
National Gallery of Canada, Ottawa, Ontario.

See also: Calotype and Talbotype; Dagurreotype; Edinburgh Calotype Club; and Wet Collodion Positive Processes.

Further Reading

Belsey, James. *A Small Light in the Far West: Victorian Photographers in Bristol*. Bristol. Cartwrights Solicitors in conjunction with Bristol Museums and Art Gallery, 1996.

Winstone, Reece. *Bristol's Earliest Photographs*. Chichester, R.J. Acford Ltd. 1974.

P

PACHECO, JOAQUIM INSLEY
(c. 1830–1912)
Portuguese painter and photographer

Born in Cabeceiras de Basto, Portugal, in about 1830, landscape painter, watercolor artist and photographer Joaquim Insley Pacheco learned the daguerreotype method from Frederick Walter in Ceará, Brazil, before studying under Mathew B. Brady and Jeremiah Gurney in New York. He also used the ambrotype and platinotype methods and was "an apologist of photopainting." Pacheco in 1854 founded a photographic studio in Brazil originally called Pacheco & Son (later Insley Pacheco) and returned to the US to photograph the Civil War (1861–1865). Renowned for his portraits, he was a favorite of Emperor Pedro II. Appointed Imperial Photographer on December 22, 1855, and dubbed a Knight of the Royal Order of Christ, Pacheco won over 16 medals for works shown at the Imperial Academy and national and international exhibitions. He took part in the 1862 London Exhibition, the Expositions Universelles of 1867 and 1889 in Paris, the Vienna Universal Exhibition (1873), the Philadelphia Universal Exhibition (1876), the Buenos Aires Continental Exhibition (1882), and the Chicago Exhibition (1893) among others. His photographs won honorable mention in Vienna, first prize at the Oporto International Exhibition in Portugal (1865) and a gold medal at the Louisiana Purchase Exposition (1904). He died in Rio de Janeiro in 1912.

SABRINA GLEDHILL

PAINTERS AND PHOTOGRAPHY

Artists from the time of the Renaissance relied on optical devises such as the camera obscura as an aid to create landscapes, interior views, still-lifes and portraits. The way that a camera records a view differs from how our eyes see the same scene. The camera image perspective is perceived differently, and the images are in sharper focus. Painters using the camera obscura knew this, and used this forerunner of the camera to meticulously render objects, and to represent depth and dimension on the flat surface of canvas.

With the invention of the daguerreotype, the image captured by the camera was no longer fleeting. It now had the same permanence as a painting and could be framed, stored in a case and shared with others. Some artists and critics feared that photographs would eventually replace painted portraits and landscapes. Samuel F. B. Morse (1791–1872), who brought Daguerre's process to the United States in 1839, believed that "Art is to be wonderfully enriched by this discovery. How narrow and foolish the idea which some express that it will be the ruin of art." Morse was obviously correct, and during the second half of the nineteenth century, photography influenced artists both self taught and academically trained, in styles as diverse as Folk Art, Realism, and Impressionism.

Portrait Painting

The public began to look at paintings in new ways as a result of the photographic images that were available to them after 1839. Daguerreotypes provided likenesses that made the work of itinerant artists appear less true to life, and they were less expensive than painted portraits. The growing interest in daguerreotype portraits resulted in a reduced interest in miniature portraits in the 1840s and 1850s, and some painters of miniatures began to earn a living hand coloring daguerreotypes. Not every artist abandoned miniature painting. John Henry Brown (1818–1891) of Lancaster, Pennsylvania, did not even take up the art of miniature painting until the 1840s. He relied heavily on daguerreotypes as an aid in creating

his miniatures which he sold for between $100–$250 to wealthy patrons in Philadelphia. This was significantly more that the three to six dollars charged for painted daguerreotypes.

While some artists stopped painting portraits as a result of the competition of daguerreotypes, most artists painting life-sized portraits quickly found ways to use the new technology as a tool to assist them in the creation of their work. Photography was recognized as an aid to the making of portraits by both Itinerant portrait painters in New England capturing the likeness of local inhabitants, and the Academically trained artists in Europe painting portraits of world leaders. Painters such as Horace Bundy (1814–1883), who found their clientele by traveling from town to town in New England, frequently advertised portraits painted from both photographs and daguerreotypes (*Horace Bundy Broadside*, March 1851, Dodge & Noyes Printers, New Hampshire Historical Society, Concord). Advertisements show that portrait artists made use of photographs in a numerous ways. They used daguerreotypes to paint portraits of deceased family members, or as a visual aid that eliminated long sittings for the subjects of the painting. Some artists, such as the Itinerant artist Erastus Salisbury Field (1805–1900) created group portraits of large families from several photographic images of both living and deceased family members (*Ruben Gilbert Puffer Family*, c. 1857–650, courtesy Stephen P. Putter Family on loan to Historic Deerfield, Inc.). This type of photo-montage, painted in oil by Field or watercolors by other anonymous painters, often had the sitters appear much too small for the room they inhabited (Unidentified Photographer, *Campbell Family*, ca. 1870 albumen print photomontage with watercolor, George Eastman House, museum purchase).

Photographers and academic and self taught artists began to paint over enlarged photographs in the 1850s. In 1856 Mathew Brady was advertising "large portrait photographs printed on canvas and colored with oil paint." David Acheson Woodward (1823–1909), a portrait painter and art instructor, patented a solar camera in 1857 that used light from the sun and copying lenses to enlarge a small negative onto large photographically sensitized paper or canvas. Many artists did not simply paint the photograph, but would use the photograph as a starting point, changing the background of the room, the pattern of fabric, style of the clothing, or expression of the face of the sitter. Erastus Salisbury Field who was experimenting with a variety of ways to use photographs in his work must have been familiar with D. A. Woodward's solar camera. Field, in his portrait of an *Unknown Woman* c. 1855, (formerly titled *Clarrisa Field*, oil on paper adhered to canvas, Museum of Fine Arts, Springfield, Massachusetts) took an enlarged photographic image on paper (photograph on file at the Museum of Fine Arts Springfield) and pasted it onto his canvas and then painted directly over the paper. Woodward brought his technique to Europe in 1859 where he influenced many painters including the French artist Leon Cogniet (1794–1880) who he met in England. Cogniet used Woodward's invention to paint the full length portrait of *M. Magne* over a photograph by Andre-Aldolphe–Eugene Disderi. *Phot-pientre* was the term used by Disderi to describe his process of printing enlarged images on canvas. Cogniet also created several preliminary sketches of the subject—so the photographic image was only one step used to complete the portrait. Almost a decade after Woodward's trip to Europe, Isaac Rehn's method of creating solar photographs was described in the *Philadelphia Photographer*, June 1868. The article reports that he prepared the canvas by brushing on a mixture of zinc white, egg albumen, ammonium chloride and silver nitrate. Most painters did not own a solar camera, but could obtain canvases with photographic images by sending negatives through the mail to photographers such as Albert Moore of Philadelphia who would enlarge the negative onto paper or canvas.

Political portrait paintings were more widely available as a result of photography. Portraits of American leaders such as Abraham Lincoln, Henry Clay, General Grant, John C. Calhoun, and Daniel Webster were in great demand for display in public buildings and in private parlors. Mathew Brady's Studio was a source for many of these photographs. Artists such Chester Harding (1792–1866), George P. A. Healy (1813–1894), George Henry Story (1835—1923), and Thomas Sully (1783–1872) all used photographs to paint political portraits. George Healy's *The Peacemakers* (White House Collection) painted in 1868 shows a meeting that took place three years earlier. Healy used life sketches he made of Lincoln in 1862 and Brady's studio photographs of Lincoln, General Grant (1864, Library of Congress), General Sherman and Admiral Porter to paint this scene.

Landscape Painting

By the late 1840s, landscape artists began to alter the way they painted as a direct result of their exposure to landscape photographs. The ways that landscape painters were influenced by photography is wide-ranging. Calotypes and Collodion prints that blurred leaves on trees and placed areas of light and shadow into flat plans influenced Jean Baptiste Camille Corot's (1796–1875) paintings. Corot was part of a group of painters and photographers working in the forest near Arras, France. This group tended to prefer romantic naturalism which presented the spirit of nature in vague forms and soft focus. The photographer Adalbert Cuvelier and the

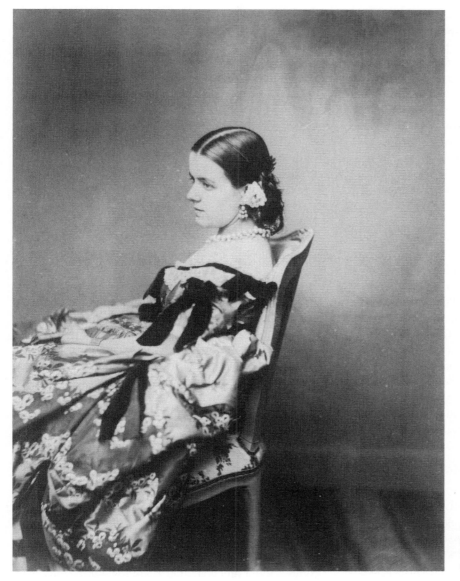

de Gaillard, Paul. Portrait of a Woman Seated in Profile.
The J. Paul Getty Museum, Los Angeles
© *The J. Paul Getty Museum.*

painter/photographer Constant Dutilleux were among this group.

Later in the nineteenth century, the United States Geographical and Geological expositions often included both painters and photographers, and they influenced each others work. The painter Thomas Moran (1837–1926) and photographer William H. Jackson were on the same exposition to survey the Yellowstone region in 1871, and Moran at times used photographs taken by Jackson in his paintings During the 1880s, photographers Timothy H. O'Sullivan, William H. Jackson, A. J. Russell, Jack Hillers and Edward Muybridge frequently relied on the framing devices of trees and mountains used by Hudson River School artists like Thomas Cole and Frederick Church. Hillar and Muybridge often sought out high vantage points in which to set up their cameras so they could offer an above ground view like those often found in Hudson River School paintings (John Hillar *Mouth of Zion Park*, c. 1872–73, albumen

print, Denver Public Library.) Muybridge also manipulated his prints in the darkroom in order to express the aesthetic of landscape paintings.

Albert Beirstadt (1830–1902) was among the first American landscape artists to be influenced by photography. He was familiar with the large western photographs of Carleton Watkins (exhibited December 1862 at Goupil's gallery in New York) and Watkins' work encouraged him to go to Yosemite Valley. The work of Watkins and other landscape photographers most likely caused Albert Bierstadt to paint his landscapes from new vantage points with altered perspectives. Previously, Beirstadt had followed a tradition of landscape painting that placed the viewer's eye level well above ground. Imitating the new photographic views, Beirstadt began to paint landscapes from the ground level looking off to the base of mountains that soar above the viewer as in *Looking up the Yosemite Valley* (Haggin Museum, California). The other type of landscape view that

1045

Bierstadt adopted from photography can be seen in *Thunderstorm in the Rocky Mountains*, 1859 (Museum of Fine Arts, Boston, gift of Mrs. Edward Hall and Mrs. John Carroll Perkins). In this work he placed the foreground, middle ground and distance all below eye level at the lower portion of his canvas. The way that Bierstadt painted the large rocks in *Thunderstorm in the Rocky Mountains* may also have been influenced by stereoscopes that brought dimension to objects in the foreground. Beirstadt's accurate rendering of geological and botanical forms leads viewers to believe that real scenes are represented in his paintings. His landscapes, were however idealized views that relied on truthful details.

The art critic John Ruskin (1819–1900) was interested in how photography could bring truthfulness to fine art. He studied daguerreotypes of architecture and landscape views in an attempt to capture their detail and tonal qualities within his own drawings. The Pre-Raphealite Artists, whose work he championed, used photographs as an aid in creating their paintings. Ruskin's writings, however, encouraged artists to paint from nature and only use photographs for drawing or studies. As time past, he grew even less enthusiastic about photography's role in painting, and wrote in 1868 that "I knew everything that the photography could and could not do;—I have ceased to take the slightest interest in it."

Impressionist Painters and Photography

Impressionist artists had a close association with photographers. In 1874, the conservative judging at the French Academy exhibitions prompted Claude Monet (1840–1926) and other Impressionists to exhibit their works independently in the studio of the photographer Nadar. French and American Impressionist artists, noted for painting out of doors (*en plein air*) using loose brush work, relied on photographs to understand the placement of forms, to capture particular times of day, and the changes of light and shadow on figures and the landscape.

The American artist Theodore Robinson (1852–1896) noted that "Painting directly from nature is difficult as things do not remain the same; the camera helps to retain the picture in your mind." Robinson first used photographs to create crayon portraits in the 1870s. He continued to use photographs as an aid in painting portraits and landscapes during his years in Giverny with Claude Monet. Robinson often used a grid on his cyanotypes or albumen prints as a guide to transfer the composition onto canvas. He stated that "I must beware of the photo, get what I can of it and then go." While transferring the photographic image on to canvas, he freely made alterations such as removing or repositioning objects and figures. Robinson's paintings

At the Fountain, also entitled *Josephine in the Garden,* c. 1890, (Canajoharie Library and Art Gallery) was one of a series of paintings created after photographs of this subject (c. 1890, cyanotype, Terra Foundation for the Arts, Gift of Mr. Ira Spanierman, C1985.13). His oil on canvas of *Two in a Boat,* 1891 corresponds to his albumen print of the subject (Terra Foundation for the Arts, Gift of Mr. Ira Spanierman, C1985.1.1). Robinson used a grid on the photograph as an aid to transfer the forms of the boat and figures onto canvas, but omitted one of the boats that did not suit his sense of composition when he was painting the subject.

Nineteenth century painters were working from photographs that provided tonal variations, but no information about color. Impressionist artists used photographs in the same way they used pencil sketches. Impressionists usually remained faithful to the colors they recalled from direct observation. They had to rely on nature, their imagination and their talent as painters, to transform the photographs they used into paintings.

Portrait and landscape photographers often framed their subjects following traditions found in painting. Impressionist painters however, noticed that many photographs taken by amateurs did not follow these traditions and showed major figures, not framing devices, at the edge of the picture. This is demonstrated in many of Edward Degas' (1834–1917) paintings including *Carriage at the Races,* c. 1873 and *Bouderie,* 1873–1875. At times photographs captured awkward poses and cut off figures at the edge of the picture. Edward Degas noticed these images and began to purposely paint figures at the edge, rather than center of the canvas.

Degas' accurate copying of photographs also resulted in a new somewhat distorted perspective in some of his works. His paintings, at times, show large foreground figures and a much smaller scale for figures only a bit further away. This exaggerated perspective could be found in all styles of painting copied from photographs. It was often a point of criticism, and was even the subject of a Nadar cartoon in 1859 that ridiculed the exaggerated foreshortening and impossibly large shoes of a seated figure with his legs outstretched towards the viewer.

Nude Studies Used by Painters

Nude photographs were used by artists as studies for painted figures. Eugene Delacroix and (1798–1863) Gustave Courbet (1819–1877) were both drawing and painting nudes from photographs by the mid 1850s. Eugene Durieu, and Julien Vallou de Villeneuve were among the many photographers in France providing nude studies to painters. Paul Cézanne used a photograph of a nude male for his painting *The Bather,* c. 1885 (Museum of Modern Art). In this painting, Cézanne transformed a photographic image of a nude male in a

static pose standing on a rug (Unknown photographer, Museum of Modern Art) into a walking figure in a landscape.

The American realist painter Thomas Eakins took photographs of nude models for his paintings, and provided his students with nude studies of himself and others. The nude figures in his paintings *Arcadia,* 1883 (Metropolitan Museum of Art) and *Swimming*, 1885, (Amon Carter Museum, Fort Worth, Texas) were created by copying figures from photographs. Sometimes Eakin's combined individual nude studies such as his photograph of Susan Macdowell Eakins, c. 1883 (Pennsylvania Academy of Fine Arts) into larger figure groups within a landscape setting.

Motion in Photographs and Paintings

Impressionist artists copied the blurred images caused by the movement of figures and slow exposure times in order to express motion in their paintings. This can be seen in Robinson's painting *Gathering Plums*, 1891 (Georgia Museum of Art, University of Georgia, Eva Underhill Holbrook Memorial Collection of American Art) where the artist faithfully copied the blur caused by the movement of the plum pickers hands.

Exposure times of 1/50th of a second were possible as early as the late 1850s. The reduced exposure time allowed for instantaneous photographs of city life. By 1861 the London Stereoscopic Company was boasting that their photographs showed horses legs and walking figures "without a blur." Stereoscopic photographs often showed these snapshots of city life with walking figures in poses not traditionally found in art.

Edward Muybridge's instantaneous photographs influenced a number of painters in the 1880s. Muybridge's 1872 commission to photograph race horses in motion resulted in photographs that contradicted what had been depicted in paintings, and lead to his open criticism on the way that Realist artists such as Rosa Bonheur (1822–1899) painted horses. The actual motion of a running horse's legs was recorded by Muybridge placing a bank of cameras along the race track and taking a series of stop action photographs. The photographs revealed that all four hoofs actually left the ground, but not in a way actually depicted by painters. By the 1880s Muybridge was lecturing and using lantern slides to compare his photographs of horses in motion to famous paintings he felt did not accurately represent the horse's movement.

Edward Degas (1834–1917) and Thomas Eakins (1844–1916) responded in different ways to this new visual information. Eakins took a scientific interest in animal locomotion and his painting *May Morning in the Park* shows horses trotting in front of a carriage in a manner demonstrating the influence of Muybridge's photographs *The Horse in Motion Abe Edgington trotting* (photographic print on card, The Library of Congress) and *Lizzie M trotting, harnessed to sulky, Animal Locomotion pl 609.* (1884–86). Muybridge's book *Animal Locomotion* included human motion which also intrigued Eakins. The American Realist artist was particularly interested in how muscles in the human body worked and used sequential photographs of figures walking to gain insight into how to paint a figure in motion.

Both Degas and Eakins, not only studied Muybridge's photographs, but also took their own photographs of figures in motion. Degas was particularly interested in painting ballet dancers and photographed them to better understand how they moved. Paintings such as *Carriage at the Races*, c. 1873 (Boston Museum of Fine Arts), and Eakin's *May Morning in the Park*, convey motion through the accurate rendering of the horses' legs and also by positioning the subjects at the edge of the canvas to show that they are traveling across a landscape that continues beyond the picture's edge.

More to Discover about Individual Artists and Their Use of Photographs

Painters found many ways to use photographs in combination with preliminary sketches or to replace pencil studies for paintings. Both Impressionist and Realist artists drew penciled grids on their canvas to aid copying photograph images onto canvas. The French artist Jules-Meuenier projected glass lantern slides on to his preliminary drawings which he then transferred to canvas. Eakin's also traced projected images onto his canvas. Other artists, including Eakins, used a pantograph that allowed lines traced on the photograph to be transferred in a different scale onto canvas.

While most painters in the second half of the nineteenth century found some use for photographs as an aid in creating their work, they did not always openly admit to their reliance on photographs to their public and art critics. During the 1880s, artists including Eakins and the French Realist Pascal Aldolphe-Jean Dagan-Bouveret (Photograph of the artist working at Ormoy from a model on *The Pardon in Brittany*, 1886, Metropolitan Museum of Art, Archives dela Haute-Salone, Vesoul, France) went so far as to pose for photographs depicting them painting from a live model, when they in fact had relied heavily on photographic studies to create the painting. Conservators and art historians looking closely at nineteenth century paintings, artists' letters and journals will continue to uncover information about how photographs were used by individual artists.

DIANE E. FORSBERG

See also: Morse, Samuel Finley Breese; Daguerre, Louis-Jacques-Mandé; Daguerreotype; Calotype and Talbotype; Muybridge, Eadweard James; Ruskin, John; Delacroix, Ferdinand Victor Eugène; Courbet, Gustave; Eakins, Thomas; and Nudes.

Further Reading

Biagell, Matthew, *Albert Bierstadt,* Watson-Guptill Publication.

Coke, Van Daren, *The Painter and the Photograph: from Delacroix to Warhol*, Albuerquerque: University of New Mexico Press, 1964.

Forsberg, Diane, "Erastus Salisbury Field: Mezzographs and Other Experiments with Photography in Portrait Painting." In *Painting and Portrait Making in the American Northeast*, 235–246. Boston.

Henisch, Heinz, and Bridget, Heniscxh, *The Photographic Experience 1839–1914: Images and Attitudes,* Pennsylvania State University Press, 1993.

Johnson, Sona, *In Monet's Light: Theodore Robinson at Giverny* Baltimore Museum (exhibition catalog) 2005.

Ogden, Kate Nearpass, "Mussing on Medium: Photography, Painting, and the Plein Air Sketch," *Prospects* 18 (1993).

Pascall, Douglas, "The Camera Artist," in Sewell, Darrel, *Thomas Eakins* Philadelphia Museum of Art 2002 (exhibition catalog) pp 239–255.

Ruggles, Mervyn, "Photographs on a Photographic Base," *Journal for American Institute for Conservation*, vol. 24, no. 2, article 4 (1985): 92–103.

Tucker, Mark, and Mica Gutman, "Photographs and the Making of Paintings" in

Sewell, Darrel, *Thomas Eakins* Philadelphia Museum of Art 2002 (exhibition catalog), 229–238.

Sharf, Aaron, *Art and Photography*, Pelican Books, 1974.

Verplanck, Anne, "The Art of John Henry Brown." *The Magazine Antiques*, November 2004.

Weisberg, Gabriel, "P.A.J. Dagnan-Bouvert and the Illusion of Photographic Naturalism." *Arts Magazine*, April 1982.

Wilgus, Jack, *Professor Woodward: Pioneer Photographic Inventor and Educator*, Forays, Spring, 1996.

PANORAMIC PHOTOGRAPHY

Since its birth, photography sought to compete with human vision by the reproduction of reality; with the panorama, it succeeded in exceeding it. The panorama indicates, in photography, an image of the broadest possible angle of vision (up to 360°); it thus exceeds the extent covered by an ordinary lens (50°) and that covered by the human binocular vision (approx. 160°). It follows in the fashion of the painted panoramas presented in specially built rotundas, whose prototype was patented by the Scot Robert Barker in 1787 and who knew a great vogue in the first half of the nineteenth century. The painters also had the idea to use photography to save time in the realization of their painted scenes. One of the most famous examples is the The Siege of the Malakoff by Colonel Charles Langlois, made of 14 plates, created in 1855 and inaugurated in 1860 on the Champs-Elysées. To help in the project, he was assisted in the photography by Leon Méhédin and in the printing by Frederic Martens.

A photographic panorama can measure a few centimeters or several meters, and consist of only one or several assembled prints. It is obtained by means of a «wide angle» lens or from an ordinary lens assembled on a special apparatus. The nineteenth century distinguished four categories of panoramic images: panoramas of views, consisting of a lengthened image, carried out with only one lens and in only one take; panoramas formed of the juxtaposition of several views; panoramas realized by a mobile lens allowing the coverage of an angle of 150° (since 1845); and panopticons, views embracing a complete horizon or more (since 1890). Initially, the juxtaposition of several prints proved to be an effective means to widen the field of vision; but the photographers were not satisfied with this type of properly pictorial representation. The photographic panorama acquired its autonomy thanks to the invention of special apparatuses known as panoramic.

On June 23, 1845, Frederic Martens, who in the 1830s created engraved panoramas of the large towns of Europe then towards 1840 created engravings according to daguerreotypes for the Lerebours' *Excursions daguerriennes*, presented at the Academy of Science the first panoramic room for daguerreotype; this room, known as also Mégascope, was marketed by Lerebours. The principle is as follows: an ordinary lens laid down on a pivot traverses all the points of the horizon according to a horizontal movement produced by a crank; this objective makes it possible to take photographs of 12 × 38 cm, very clear on the surface, embracing an angle of 150°. The daguerreotype marries the cylindrical curve of a drum; thanks to this curve, the points most unequally distant are brought to the surface of the plate, which is rectified after the shot is taken. The clearness of the image is due to a vertical narrow slit at the bottom of the box which follows the objective in its movement; this slit lets only the central rays act on the sensitive layer. An expensive and cumbersome device, being able to produce only daguerreotypes, this apparatus was dedicated to a restricted use.

In 1848, Napoleon Garella, a mining engineer in Algiers, eager to apply panoramic photography to his work, obtained two tests rectified with its "planopanoramic," "rectilinear" apparatus, which did not require bending the plates of daguerreotypes: the sensitive plate turned with the lens, which allowed the use of plain negatives. In 1850, Peuvion adapted this device to negative glass. The field of vision covered by this type of apparatus is of 180°, that is to say half of a view. In 1856, Martens Schuller, nephew of Martens, reached a similar result starting from the invention of his relative, by applying the principle of the revolving unit of Garella to the ap-

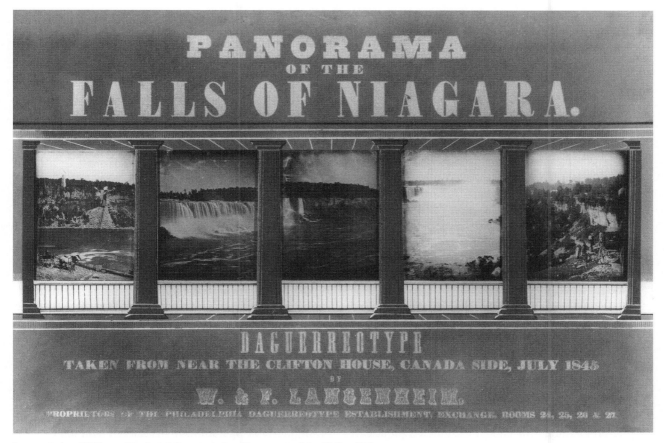

Langenheim, William; Frederick Langenheim. Panorama of the Falls of Niagara.
The Metropolitan Museum of Art, Gilman Collection, Gift of The Howard Gilman Foundation, 2005 (2005.100.495) Image © The Metropolitan Museum of Art.

paratus of his uncle. This apparatus includes a lens of 15 cm focus, turning on itself. The sensitive glass plate must follow the lens in its movement while being maintained constantly in relation to him and equal distance. Instead of the lens alone, all the camera turns around the pivot fixed under the axis of the objective thanks to a mechanism of casters. The frame carries the glass plate in a carriage to casters and turns too. The plate presents thus successively all the parts of its surface at the narrow slit. The rotating movement can be regulated by means of a mechanism or be directed by hand, which makes it possible to prolong or decrease the installation according to the light. The apparatus can thus carry out a whole review; very clear iamges are obtained. The disadvantages of this apparatus are the slowness of the preparation of the glass plates, their weight and their brittleness.

In 1858, Garella improved his first apparatus, resulting in a type close to that of Martens Schuller. The same year, Ross manufactured in London an apparatus designed by Sutton, for curved plates and provided with an angular large objective of 120°. In the 1860s, the inventions multiplied. In 1862 the patent of the pantoscope of Johnson and Harrison in London was registered, for

plates with collodion; to the exposition of the Société française de photographie of 1865, Brandon exhibited a panorama taken on top of the Saint-Jacob Tower in Paris, with this apparatus. In 1865, Martens, who continued to improve his invention, obtained a view on only one negative, of a great clarity. In 1867, the Abbé Rolin presented at the SFP a panoramic apparatus allowing the creation of several partial shots forming a panorama, on the same plate.

In these first three categories of images the principal photographers of the years 1850–1870 illustrated themselves, who saw in the panorama a technical challenge; one could see many examples of them in the exposures (panoramas of cities, of mountains) signed Baldus, Bisson, Braun, Gray (scene of Châlons), Marville for France, Hill and Adamson for the United Kingdom. In addition to insistence on the effect of the illusion produced, criticisms generally commented on the homogeneity of the tone and the connection between the prints. The World Fairs, which emphasized the wonders of nature and the richness of the colonial empires, and which resorted to the new medium, exhibited many panoramas. In 1851, Martens was distinguished at the Great Exhibition in London for his panoramic images on

albuminous glass. In 1855, he showed at the Exposition Universalle, Paris views of the Alps (on this occasion, the critic Ernest Lacan called him the "photographer of the mountains") in particular a panorama of Mont Blanc composed of fourteen prints and one of the Geneva Lake, "one of those scenes in front of which one stops seized by surprise and admiration" (Louis Figuier). In spite the many panels repainted, the sight of Mont Blanc was appreciated for its smoothness: "Nothing is more admirable nor more imposing than this panorama. One recognizes there the feeling and the key of a consumed artist, and, as for the exactitude of the details, it is enough to have an idea of it, to compare the photographic tests, placed around, with the parts of the drawing which reproduce them. Not a stone was forgotten, not a piece of ice has escaped the scrupulous hand of the artist "(Ernest Lacan). In 1855 also, the Bisson brothers exhibited a 150 cm-long image of Paris. Baldus, using the apparatus of Garella, showed a picture of Mount-Gilds with the lake Chambon, 130 cm long, and a picture of the interior of the arenas of Arles, both discussed by critics. At the 1867 Exposition Universalle, the Abdullah brothers showed a panorama of Constantinople that was 220 cm long.

One could also see panoramas at the exhibitions of the Société française de photographie. In 1859, Sinigaglia, photographer of Padua, exhibited a picture of Venice in ten prints, almost four meters long. In 1861, Jeanrenaud, who used the apparatus of Sutton, exhibited a panorama of Thoune, which Lacan considered to be full of charm and harmony. In 1861, Baldus showed a Panorama of Tuilleries and the Louvre, which offered a view of two hundred degrees, about which a critic said that it " is beyond imagination, almost inducing dizziness" (Ladimir). In 1865, Gueuvin exhibited two panoramas of Paris taken from the Tower Jacques Saint, each forming an angle of 180°, taken with the apparatus of Koch and Wilz; Gaudin noted that they seemed to have been taken from a single viewpoint after the juxtaposition of different negatives, so that the junction was successful. In 1869, Koch and Wilz presented panoramic pictures obtained with their apparatus: a panorama of Paris capturing seven bridges, a great panorama of Meudon, Bellevue, Sevres.

The panorama had various scientific applications, like the technique of the photogrammetry of Colonel Laussedat around 1850–1853 (land surveys and soldiers). Paul Perier, who had percieved the views of the Alps de Martens not through photography, "but a kind of geological plan, a work of geographer or engineer" (1855), seemed to foresee the work of Aime Civiale, who provided panoramas of mountains to the best scientists, and more particularly geological, without artistic claim. He showed some at the SFP; in 1863, he showed a circular panorama close to Monte Moro and a

panorama of l' Oberland; one of them measured eighty centimeters high and four meters long.

It was necessary to await the manufacture of flexible film in gelatino-bromide in the 1880s to see panoptiques appear (complete view). In 1883, Moessard invented the cylindrographe, patented in 1889 (same principle as Martens): two prints were necessary to obtain a whole panorama. In 1889, the apparatus of the Benoist brothers made it possible to obtain a complete view on glass.

The most important invention was, in 1890, the Cyclograph of Damoizeau. A camera is assembled on a swivel slide on a circular plate. A frame with rollers containing two reels of films allows a compact device and a reduced format of the apparatus as a whole. A clockwork motor rotates a cylinder containing the film, and the same clockwork motor rotates the camera. The same mechanism thus activates the rotation of the apparatus and the unfolding of the film in opposite direction, which makes it possible to produce images of great clarity. The clockwork is at variable speed, involving a more or less long rotation. A meter indicates the quantity of film available. An lens of 50 cm focus requires a 30 cm length plate and can produce a panorama of 3,14 m. It allows the use of lenses of different focuses and thus the creation from views of considerable length. This apparatus is characterized by its perfection and its simplicity of operation. It was shown with the Colombian Exhibition of Chicago in 1893 and taken again by Sheldon to the United States.

In 1895, Ducos du Hauron discovered the principle of the Microcosm (a silver plated ball reflects the image on to a flat plate or film). In 1899, Louis Lumière invented Photorama which made it possible to see the views of panoramic images and take pictures at the same time (systems of drums). Photography then exceeded the limits of the field of ordinary vision by showing on only one image what the human glance can see only while moving. The image becomes the ground of infinite investigations, out of the reference mark of the traditional prospect. From a faithful search for reproducing reality, this photographic technique leads to going beyond this reality.

HELENE BOCARD

Further Reading

G. Bapst, *Essai sur l'histoire des panoramas et des dioramas, extrait des rapports du jury international de l'Exposition universelle de 1889*, Paris, Imprimerie nationale, 1889.

Gabriel Cromer, "Quelques épreuves et documents relatifs à l'histoire de la photographie panoramique," *Bulletin de la Société française de photographie*, juin 1930.

G. Glanfield, "A Short History of Panoramic Cameras," *The Photographic Collector*, vol. 3, no. 2, Autumn 1982.

Panoramas. Collection Bonnemaison. Photographies 1850–1950, Arles, Espace Van Gogh, juillet–septembre 1989, Actes-Sud, 1989.

Sandra Petrillo, "La photographie panoramique au XIXe siècle : le regard qui balaie l'espace," *Coré*, no. 2, mars 1997.

PANUNZI, BENITO (1819–1894)

Nothing is known of his whereabouts before he arrived in Argentina.

He was a painter and architectural draughtsman, and is known to have taught drawing. The first national census (1869) records him as an Italian, 50 years old, single, a photographer with a studio at 55th Cuyo Street, Buenos Aires. The studio was named "Fotografía Artística."

He published country views, mostly from Buenos Aires and surroundings, accompanying them with a nice paper folder (583 mm by 430 mm), titled: *Fotografía Artística—Album de Vistas y Costumbres de Buenos Aires*. The images then were bound in albums.

The earliest known dated photograph is from 1868 (the seventh one), so, usually it is supposed that he started keping records not too before 1866. Usually he received, wrongly, the authorship of a small and crude album *Vedute di Buenos Aires*.

Excellent copies of his works are kept in Archivo Audiovisual de Venezuela—Biblioteca Nacional and private Argentine collections.

Roberto Ferrari

PAPER AND PHOTOGRAPHIC PAPER

Paper has played an essential part in photography initially in the late 1830s and 1840s as a support medium for both the negative and positive, and increasingly from the 1850s, as the principal means of producing a positive, on commercially produced photographic papers. During the initial period the quality of the paper was crucial to the end result while later on it was mainly a support to new photographic emulsions and printing processes being developed.

During the period up to the early 1850s, paper for photographic use was usually selected and coated by the photographer, although some retailer's such as London's Horne, Thornthwaite and Wood offered pre-iodised, waxed and albumenised papers. All the manuals of the period and instructions to amateurs gave clear advice on selecting paper for photographic use.

W.H. Thornthwaite writing in 1853 stated: 'There are various kinds of paper I have found well suited for the purpose, but that manufactured expressly by Turner, the blue wove of Whatman, and the positive paper of Carson Frères, of Paris, appear to produce the best results.' He continued: 'those sheets only are to be employed which are of an even texture and free from specks and water-marks; these specks should be carefully avoided, as they are generally small particles of iron left in the substance of the paper during the process

of manufacture, and which, brought in contact with any salt of silver, speedily produce a brown stain on the paper of considerable size. The suitableness and quality of the paper is best ascertained by holding each sheet opposite a strong light, either of a window or lamp, and when approved a pencil mark should be made on one side of each sheet for the purpose of distinguishing it when required.' Thomas Sutton in his *Calotype Process* (1855) recommended Hollingsworth paper for negatives which he had specially made for the purpose of negatives. He described it: 'It is truly excellent, giving intense blacks, fine definition and beautiful half-tones. It improves by age; and, in fact, it is not in first-rate condition until it has been made for a year or two'.

These statements make a number of wider points about papers. There was general agreement that English papers were preferable to those of foreign manufacture. W.H.F. Talbot and his employees used J. Whatman Turkey Mill papers made at Hollingsworth's Mill at Maidstone, Kent, and R. Turner's Chafford Mill was also recommended. English papers were generally sized with gelatine while foreign papers were sized with starch leading to a better quality and improved light sensitivity through the organic compounds present in gelatine, a fact which was realised later and made use of.

The quality of the weave of the paper and effect on wet strength and finer 'grain' of the paper was crucial in producing more detailed negatives and chemical cleanliness all had a bearing on the quality of the final image. J.B. Hockin in his *Practical Hints on Photography* (1860) recommended English papers for Calotype photography and French paper, notably that made by Canson Frères, which was sized with starch, as being best for the waxed paper process.

There were other requirements for printing papers and other preferences amongst contemporary writers. Sutton stated that 'the paper commonly employed for positives is that manufactured in France by Messrs Canson frères' and he preferred the heavier weight although it was, he said, more inclined to chemical spotting than the lighter weight. He expanded on this by saying that the papers manufactured by Turner and Whatman although more sensitive than the Canson frères had a courser grain leading to poorer definition in the final Calotype print.

Hockin describing the printing of collodion negatives detailed what was required from the paper: 'that it be fine and close grained, with a very smooth surface, and sufficiently permeable to the liquids employed, without being rendered by them prone to be readily torn during the long series of washings and manipulations to which it is to be subjected. It should also be free from any "water-mark," and most especially free from metallic or other particles which induce ineradicable defects in the pictures.' Different qualities were required from the

paper depending on whether it was to be used simply as salted paper or as albumised and salted. For the former Hockin recommended English paper (Towgoods) and for the latter foreign papers only were suitable, the result of their being sized with starch which 'confers upon them a certain permeability by the very glutinous liquid, without detracting much from their strength or rendering them bibulous.'

Gustave le Gray writing in 1853 on the waxed-paper process stated that very thin paper from Lacroix or Canson Frères was required for making waxed-paper negatives. This was expanded on by Roger Fenton, an acknowledged practitioner of the process, who stated that the 'beauty of the results depends much upon a judicious selection of [paper].' Fenton noted that Whatmans and Turners paper were recommended for their firmness and evenness of texture but that their gelatine sizing limited their suitability for photography. Paper from the Whatman mills from 1832–1838 was preferred as it was thinner and less highly sized and was 'much used by the French, who say that it gives better half-tones, and supports the action of the gallic acid for a longer time.' Fenton recommended thin Chanson paper despite it being prone to iron spots which was sensitive, being sized with starch, one side was smooth and made from courser rags than the Whatman paper which gave it greater strength. Lacroix paper was similar in quality but with less spotting although slightly coarser.

In summary the three main paper processes, the Calotype and waxed-paper for negatives and printing paper each required different qualities from paper with the former more suited to English papers and the latter two to European papers.

The appearance of the collodion negative on glass from the early 1850s saw a rapid decline in the use of paper negatives and from the 1860s the major use of paper in photography was for the production of photographic postives. Increased commercialisation of photographic printing, the preparation of sensitised papers on a large scale and new processes affected the paper requirements through the rest of the nineteenth century. With the ready availability of pre-prepared printing papers the early range of papers tested and prepared by photographers was reduced to those available commercially which by the end of the century had expanded to large range of types, surfaces and weights.

The printing out process with paper made light sensitive through silver nitrate and salt goes back to pre-1839 experimenters and was used by Talbot and Herschel in 1839. These silver chloride papers remained the dominant type over silver bromide papers throughout the century because of their stronger blacks. The coating of paper with albumen to produce finer prints by overcoming the grain and porosity of paper was described by Blanquart-

Evrard in 1850. Once and twice albumenised papers superseded starch and gelatine-filled silver chloride papers which had been introduced in the 1850s. Albumunised papers remained popular until the 1890s.

Experimentation and the development of permanent emulsion printing papers was advanced by the work of G. Wharton Simpson who developed collodio-chloride silver emulsion printing process, later called the celloidin process. This work was complimented by the work of J.B. Obernetter (1840–1887) of Munich who was the first to manufacture collodio-chloride papers on a commercial scale. The paper was claimed to have greater definition and permanency over the albumen papers that it gradually displaced. Colonel Abney in a paper read before the Photographic Society described gelatine chloro-citrate papers which led to their subsequent commercial manufacture.

The rise of the amateur photographer using dry plates and later rollfilm encouraged a demand for permanent and easily workable printing papers. By 1890 gelatino-chloride silver emulsion papers (aristo papers) and collodio-chloride silver papers (celloidin papers) had almost completely displaced the earlier albumen and starch papers.

The other principal photographic paper is use during the later nineteenth century was gelatine silver bromide paper. In 1874 Peter Mawdsley of the Liverpool Dry Plate Company described the possibility of using gelatine silver bromide papers for photographic printing which he believed was 'destined to play a most important part in the future of dry plate photography.' (*Yearbook of Photography* 1874) He manufactured such papers commercially emphasising their sensitivity and matt surface which was suited to over-painting. Mawdsley met with limited commercial success and it was Sir Joseph Swan (1823–1914) who in 1879 was granted British patent number 2968 for photographic printing paper coated with bromide of silver. The patent noted that the paper could be employed in a long band and prints made as the band advanced allow for large runs of prints to be made. Swan emphasised the short exposure in weak artificial light that would ensure successful results for the amateur.

Factories manufacturing silver bromide papers opened in France by E Lamy at Courbevoie and in Britain by Mawson and Swan, Morgan and Kidd and Marion & Co amongst others. Silver bromide papers, being more sensitive than the better quality silver chloride papers, as a medium for rapid printing with artificial light and for enlargements was rapidly adopted from 1880. To meet this demand emulsion coating machines for paper and plates were developed in Germany, Britain and the United States. Matt surfaced silver bromide papers were introduced from 1879 using starch paste instead of

gelatine and the Eastman Kodak Company introduced it's own matt papers which it called 'platino' from 1894. Matt papers displaced the more usual glossy papers for commercial and artistic photography although glossy papers were used in certain areas because of its greater resolution of detail.

Automatic printing machines were also developed the first of which was patented in 1883 by Schlotterhoss in Vienna. By the mid-1890s mass-production of photographic postcards using silver bromide papers was commonplace. Between 1895 and 1913 Arthur Schwartz's Neue Photographische Gesellschaft in Berlin had produced 40 million metres of photographic paper.

Silver chloride and silver bromide papers were not the only photographic paper in use. Other photographic printing papers using variants on the basic silver chloride and bromide formulae and new papers extended a demand for papers and commercial manufacture.

Gelatine silver chloride positive paper was first described by Eder and Pizzighelli in 1881 and large scale manufacture started from late 1882 by Dr. Just in Vienna. Leon Warnerke in London started the production of gelatine silver chloride paper in 1889 appreciating the warm tones compared to the cold tones achieved with silver bromide paper. Increased appreciation of gelatine silver papers and the marketing of such papers by the Eastman Kodak Company under the Velox tradename led to the dominance of this type of paper in the twentieth century.

Gelatine silver bromo-chloride emulsions for prints were described in 1883 and a range of papers was marketed in Britain under the Alpha tradename from the later 1880s and by Ilford Ltd under the clorona name and by other European manufacturers.

Self-toning papers which incorporated gold chloride or platinum were manufactured from the 1890s to improve the final colour of the print from the typical reddish colour to a more acceptable sepia to brown prints. Two new processes in the 1870s led to the development of a new range of papers. William Willis's (1841–1923) platinotype process patented in 1873, 1878 and 1880 led to the commercial introduction of a range of platinum papers manufactured for the trade and amateur use through his Platinotype Company. He also developed the palladium process requiring palladiotype paper and a silver-platinum paper, satista. These also saw commercial success.

The other area that saw the commercial development of new papers was the introduction of pigment processes. Swan's transfer process of 1864 was developed commercially by the Autotype Company which manufactured and sold pigment papers exclusively. The gum bichromate pigment process, popular from the mid-1890s also allowed companies to produce special papers and other transfer processes such as bromoil moved paper away from a purely sensitised base.

The 1870s and 1880s saw a short-lived return to paper being used as negative support in an effort to develop smaller and more portable cameras suitable for amateur use. Leon Warnerke in 1875 produced dry collodion silver bromide films on chalk coated paper which could be stripped. This was not successful but the idea was resurrected by George Eastman in 1884 who developed a paper film using a specially developed coating machine which he patented in 1885. The sensitised paper roll was used in an Eastman-Walker roll holder and attached to the back of a camera. The grain of the paper was intrusive and was replaced by a stripping film where the paper served as a temporary carrier for the emulsion layer which was transferred to a glass plate after development. The introduction of celluloid from 1888 as a carrier for photographic emulsion in 1888 quickly superseded paper roll film, although glass remained the main support for professional photographic emulsions until the 1960s.

The use of paper throughout the nineteenth century saw a move away from the paper being critical to the effectiveness of the process to one where the paper was primarily a carrier for a silver halide photographic emulsion and, later, non-silver emulsions and pigments, leading manufacturers to develop increasingly specialist surfaces and weights of photographic paper for increasingly specialist or aesthetic ends.

MICHAEL PRITCHARD

See also: Sutton, Thomas; Whatman, J. & Co.; Talbot, William Henry Fox; Calotype and Talbotype; Dry Plate Negatives: Non-Gelatine, Including Dry Collodion; Le Gray, Gustave; Cameron, Henry Herschel Hay; and Blanquart-Evrard, Louis-Désiré.

Further Reading

Eder, J.M., *The History of Photography*, New York, Columbia University Press, 1945.

Hercock, R.J., and Jones, G.A., *Silver By the Ton. A History of Ilford Lmited 1879–1979*.

PARKER, JOHN HENRY (1806–1884)
English publisher and photographer

John Henry Parker, publisher and bookseller from Oxford became Director of the Ashmolean Museum, Oxford, in 1870, published *The Manual of Archeological Terminology* (1836), and *The Manual of Gothic Architecture* (1849). After he came to Rome in 1863, he founded the British and American Archaeological Society of Rome in 1865 and carried out several excavations on behalf of the Pope. He became convinced that photography was a more accurate method of recording

than drawing and was the first to demonstrate the use of photography in archaeology and to use magnesium lighting for photography by artificial light. From 1866 onwards he commissioned the Italian photographers, Giovan Battista Colamedici, Carlo Baldassarre Simelli, Francesco Sidoli, Filippo Lias, De Bonis and Filippo Spina as well as the Canadian, Charles Smeaton, to document the 'Antiquities of Rome from the Classical Age to 1600.' In 1869 his catalogue had 1500 images and by 1879 boasted 3391 which he published in reproductions, issued in 12 parts from 1874–1878 as *The Archaeology of Rome*. A set of actual photographs was offered in 1879 as *A Catalogue of Three Thousand Three Hundred Photographs of Antiquities in Rome and Italy*. The majority of the plates however were lost in a fire in 1893 and there are only three nearly complete sets of the photographic prints known, one is at the British School at Rome.

ALISTAIR CRAWFORD

PARKES, ALEXANDER (1813–1890)
English inventor

Alexander Parkes, the originator of over eighty patents during his career, covering a range of inventions in metallurgy, rubber, vulcanisation, and plastics, was born in Birmingham, the fourth of eight children, and would eventually have twenty children of his own—eight by his first wife, twelve by his second.

Parkesine, the invention for which bears his name, was the first plastic material based on cellulose nitrate, and was introduced during the 1862 International Exhibition in London. As such, it predated and predicted the massive plastic industry which has emerged subsequently. Indeed, Parkes anticipated many of the uses to which cellulose-based plastics might eventually be applied.

Four years later, in 1866, he established The Parkesine Company to market the material, and an alternative to rubber, or the gutta-percha and shellac-based thermoplastics which were then in vogue. The company was based in Hackney Wick in London.

Despite the great expectations Parkes had for his new material, The Parkesine Company ceased manufacture after only two years, and closed with significant debts. Parkes had anticipated being able to market the material at a price of less than a shilling per pound, a target which proved unachievable.

His work, however, laid the foundation for the modern plastics industry. The American John Wesley Hyatt introduced the most significant product based on cellulose nitrate, with the development in 1863 of *celluloid* on which photography for so long depended.

JOHN HANNAVY

PATENTS: BRITAIN AND EUROPE
Britain's first patent relating to photography was granted to the patent agent Miles Berry on behalf of Louis Jacques Maude [*sic*] Daguerre and Joseph Isidore Niepce, junior, on 14 August 1839 for the daguerreotype process. Richard Beard, who had licensed Daguerre's process, was granted the next in June 1840 for an improved camera with internal mirror and improvement to operating the process. The third was granted to William Henry Fox Talbot for his calotype process. The 1840s saw only eleven photographic patents being granted.

The Great Exhibition of 1851 acted as a catalyst for reformed patent law as manufacturers and patentees sought greater protection and attempted to meet increasing competition from the United States, although the resulting Act only partially met their demands. In comparison with the American system Britain's patent process left much to be desired for patentees. The Patent Law Amendment Act of 1852 reduced the cost of a single patent for the United Kingdom to £25 (plus renewal fees) from a previous minimum of £310 and the application process was simplified. The number of photography patents increased. The 1850s saw 185 classified by the Patent Office as photography, the 1860s 273 and the 1870s 213. The 1883 Patents, Designs and Trade Marks Act further reduced the cost of a patent and simplified the application procedure and during the 1880s 750 photography patents were recorded with the next decade, the 1890s showing 1778. The Patent Office photography classification included some subjects that were not strictly photographic such as emulsions and stands and some patents that might be seen as photography were included in other classifications such as advertising and printing.

Unlike the American system, under the British patent system there was no requirement for the applicant to show novelty and many patents were simply variants on existing designs rather than novel designs of apparatus, chemical processes or applications of photography. The two Patent Acts of the nineteenth century each coincided with significant changes to photographic technology which led to significant increases in the number of patents being applied for and in the areas in which patentees were applying for patents. The 1860s, for example, saw a significant number of patents relating to photographic printing and photo-mechanical printing processes and the latter remained strongly represented until the 1890s. In the 1880s and 1890s patents for roll holders were widespread, as were those for shutters and studio and flash illumination. In the 1890s as new technology began to coalesce into practical applications kinematography patents started to appear regularly and from 1896 Röntgen, or X-ray photography, was represented for the first time.

In Europe there were different patent systems operating which offered varying degrees of protection to the patentee. In France the modern patent system was established by 1844 and consisted of a simple registration system with the state remaining an active participant in managing both the patents and their exploitation. An inventor could choose between a patent or offering an invention to the government in returned for an award from a special fund. Until 1902 patent specifications were not published although the original application was available for inspection. In Germany unified national patent legislation was passed in 1877 which established a central office for granting patents. Government policy was intended to encourage economic development and in some areas, such as chemical products patents, were prohibited. The government encouraged the diffusion of patent information by publishing claims and specifications before they were granted. From 1891 a *gebrauchsmuster* offered a parallel but weaker system of protection through a registration system.

Elsewhere in Europe two countries took a view that patents were not morally acceptable. The Netherlands reinstated a patent system in 1912 and Switzerland in 1888 mainly as a response to international pressure.

Japan, as part of its modernization policy during the mid and late nineteenth century, sent an envoy in 1886 to examine the European and American patent systems. As a result the first national patent law was passed in 1888 copying many features of the American system which were considered superior to the various European systems, although it placed many restrictions on patentees. A new law was passed in 1899 after Japan signed the Paris Convention which brought it into line with the convention and extended patent protection to foreigners.

Despite some serious deficiencies in its patent process the British patent specifications record some of the key developments in photography. Some notable patents include the Woodburytype process (number 2338 of 1864 and others), the platinotype process (number 2011 of 1873) and the Kodak camera (number 6950 of 1888). Many other British patents are unlikely to have ever been produced commercially. Several innovations that one might have expected to be patented were not, the most significant being Frederick Scott Archer's wet-collodion process which he published and made freely available in 1851 ensuring a wide-spread and rapid adoption compared to the patented daguerreotype and calotype processes. Both of those were robustly defended through the law courts.

MICHAEL PRITCHARD

See also: Daguerre, Louis-Jacques-Mandé; Talbot, William Henry Fox; Daguerreotype; Calotype

and Talbotype; Woodburytype, Woodburygravure; Platinotype Co. (Willis & Clements); and Kodak.

Further Reading

Davenport, Neil, *The United Kingdom Patent System. A Brief History with Bibliography*. Homewell: Kenneth Mason, 1979.

Hewish, John, *Rooms Near Chancery Lane. The Patent Office under the Commissioners 1852–1883*, London: British Library, 2000.

Khan, B. Zorina, 'An Economic History of Patent Institutions,' http://eh.net/encyclopedia/article/khan.patents

Patents for Inventions, Abridgments of Specifications Class 98, Photography, Periods 1839–1900, two volumes, reprint, New York: Arno Press, 1979.

van Dulken, Stephen, *British Patents of Invention 1617–1977. A Guide for Researchers*, London: British Library, 1999.

PATENTS: UNITED STATES

In order to encourage improvements in the applied arts, the United States government in 1790 gave inventors (citizens and non-citizens) temporary, exclusive rights to profit from their inventions. The purpose was to promote public good through individual ingenuity; the incentive was the guarantee of ownership and attendant profits. Patent rights, however, were limited. The original Patent Act of 10 April 1790 fixed the term of U.S. letters-patent for inventions at no more than fourteen years; in 1861 it was expanded to seventeen years.

In spite of the protest mounted by some in the photographic community who believed that photography could only be advanced by the free exchange of ideas, most involved in the business understood that the costs associated with patent rights were an inevitable part of doing business. However, exclusive patent rights were frequently challenged, especially if the patentee defined his invention so broadly that others could easily be accused of infringement. And patent holders who insisted upon substantial fees sometimes found themselves outfoxed by others who circumvented their patent rights by inventing slight modifications, for which they too could apply for and receive a patent.

Particularly contentious was the fourteen-year controversy surrounding three patents issued in 1854 to James A. Cutting. In one of these patents, *Improvement in Compositions for Making Photographic Pictures* (11 July 1854, No. 11,266), known as the bromide patent, Cutting had modified Frederick Scott Archer's collodion process to include bromide, which made film more light-sensitive and thus speeded up the process. Since the patent included all wet-plate photography, it would be hotly contested by the full photographic establishment who saw it as a threat to the progress of photography, collodion being a new and important medium for making both positives and negatives.

Some of the most important photographic patents of the hundreds that were granted in the nineteenth century are the following. The first U.S. Patent in photography was issued in 1840 to Alexander S. Wolcott for his *Method of Taking Likenesses by Means of a Concave Reflector and Plates So Prepared as that Luminous or Other Rays Will Act Thereon* (8 May 1840, No. 1,582). His reflector shortened the time of exposure in the camera when taking a daguerreotype. Ann F. Stiles was the first woman to be issued a photographic patent. Her invention, a *Case for Daguerreotype-Pictures* (22 January 1850, No. 7,041), consisted of a tube-like case in which one could view a small daguerreotype through a magnifying lens. Albert S. Southworth was issued a patent for a *Plate-Holder for Cameras* (10 April 1855, No. 12,700), which allowed the photographer to prepare one plate then slide it into place for multiple views in rapid succession, or for stereoscopic views on one plate. Edward J. Muybridge received two patents for an *Improvement in the Method and Apparatus for Photographing Objects in Motion* (4 March 1879, Nos. 212,864 & 212,865) for instantaneous photography, where the subject is in rapid motion. George Eastman's patent for a *Method and Apparatus for Coating Plates for Use in Photography* (13 April 1880, No. 226,503), transformed photography from wet plate to dry plate by making commercial gelatine dry plate affordable. His machine could spread gelatine emulsion easily and uniformly over glass, and eliminated the early problems with the process.

Patents were not only issued for photographic methods, but also for albums, cases, stereoscopes, cameras, stands, head rests, burnishing tools, printing frames, plate holders, photographic backgrounds and baths, etc. Whereas many patents saw their way to manufacture or use, others were quickly abandoned or never realized.

JANICE G. SCHIMMELMAN

See Also: Cutting, James Ambrose; Eastman, George; Muybridge, Eadweard James; and Southworth, Albert Sands, and Josiah Johnson Hawes.

Further Readings

Harmant, Pierre G., Qui est l'inventeur. Liste des brevets d'invention des origines jusqu'a 1889 (50 ans de decouvertes) [Who is the Inventor? List of Patents from the Beginning to 1889 (50 Years of Discoveries)], in *Schweizerische Photorundschau*, 1963–1966.

Jensen, James S., Cutting's Edge, in *Collodion Journal*, vol. 5 no. 19, Summer 1999, 1–2, 4–9.

Jordan, Doug, Some Patents of Note: Early Coloring Patents, *The Daguerreian Annual 1994*, n.p.: The Daguerreian Society, 1994, 73–78.

Marillier Claude-Alice and R. Derek Wood, "Pierre G. Harmant

(1921–1995): A Bibliography," in *History of Photography*, vol. 21 no. 3, Autumn 1997, 248–52.

Schimmelman, Janice G., *American Photographic Patents 1840–1880: The Daguerreotype & Wet Plate Era*, Nevada City, CA: Carl Mautz, 2002.

Taft, Robert, *Photography and the American Scene*, New York: Macmillan Company, 1938.

Welling, William, *Photography in America: The Formative Years 1839–1900*, New York: Thomas Y. Crowell, 1978.

PAUL, ROBERT WILLIAM (1869–1943)
English inventor and electrical engineer

Born October 3, 1869, at 3 Albion Place, Highbury, North London, and active in Britain's early motion picture industry, Paul had following a technical education and employment with the electrical instrument makers Elliott Bros, Strand, started his own business in 1891, at 44 Hatton Garden. Asked by two Greek entrepeneurs to make copies of the Edison Kinetoscope motion picture peepshow machine, he realised that the design had not been patented in England and started making examples on his own account. Introduced to photographer Birt Acres, their resulting camera for 35mm film provided motion pictures for Paul's kinetoscopes. Subjects taken by Acres in 1895 included The Derby (the oldest surviving English film), Rough Sea at Dover (screened in New York in April 1896), and several comic scenes. After an acrimonious split with Acres, Paul made a successful film projector, the Theatrograph, and a new camera. Films included A Soldier's Courtship, shot on the roof of London's Alhambra Theatre. Paul built a studio and continued producing motion picture machines and films until leaving the changing industry in 1910, to concentrate once again on electrical engineering. He died March 28, 1943, at Twickenham, England.

STEPHEN HERBERT

PEASE, BENJAMIN FRANKLIN (1822–1888)
American engraver, studio owner, and photographer

One of eight children, Benjamin Franklin Pease was born November 17, 1822, in Poughkeepsie, New York, to Dudley Pease, and Sara Rilley. According to the family genealogy, Benjamin was considered an artist as a young adult and by 1846 he was engaged as a wood engraver.

Pease arrived in Lima, Peru, ca. 1852, and a published advertisement states that he purchased a daguerreotype studio at 14 Plateros. Sometime around 1855 he married Peruvian Mercedes Ramírez and together they had eighteen children, though not all the children survived.

He operated successfully for several years at the

Plateros location in Lima during a time the city was experiencing extensive population growth and economic change. This period also brought about more photographic competition. Pease moved his studio sometime around 1859 to a street level location, 182 Plateros, the same building in which Emilio Garreaud had his studio. Historian Keith McElroy, who has complied extensive biographical information on Pease, characterized Pease's daguerreotypes as "straightforward studio portraits... [that] meet high standards, and he served a distinguished clientele, including presidents, intellectuals, and socialites."

In order to compete in the burgeoning photographic community, in addition to his daguerreotypes, Pease began to offer the public ambrotypes, various kinds of hand painted images, and photographs on paper. By all accounts he remained successful. But this success was eventually overshadowed by yet another technological advancement, the carte-de-visite. In the summer of 1856 Benjamin Pease and his family left for Europe. The control of his studio was left to D. David Vargas and D. Fuljencio M. de Urgarte.

Benjamin Franklin Pease returned to Peru ten years later and operated an establishment that made and sold shoes, sewing machines, and other items. He died in Pisco, Peru, in 1888.

MICHELE M. PENHALL

PECK, SAMUEL (active 1840s–1850s)
American inventor and photographer

Samuel Peck was instrumental in the introduction and initial development of the thermoplastic union case in the early 1850s, and thus responsible for the first application of molded plastic to photography.

After spending his early years as a grocer, Peck is listed as an early daguerreotypist operating a studio in New Haven, Connecticut, from the mid 1840s until early 1852, by which time he was also making leather daguerreotype cases, probably in partnership with the Scovill Manufacturing Company. His first patent, issued in April 1850, was for an improved holder for daguerreotype plates during buffing.

Peck's first patent for a thermoplastic composition case (US Patent 11,758) was issued on October 3, 1854, and by the following year, the partnership with Scovill had been formalised into a new company known as Samuel Peck & Co.

Over the following six years, Peck's company, along with rivals A P Critchlow, and Littlefield, Parsons & Co., was highly influential in the popularisation of the thermoplastic case. Peck, however, is believed to have left the company in 1857.

His engagement with photography and case-making was relatively short-lived, and he developed further careers, first as a music-hall proprietor, and then as an undertaker.

He is believed to have died c.1879.

JOHN HANNAVY

PENCIL OF NATURE, THE

Despite its limited initial audience, *The Pencil of Nature* was an epoch-making publication, both technically and aesthetically. Published in six instalments between 1844 and 1846 by William Henry Fox Talbot, it was a luxurious work that constituted the first true photographic book, incorporating in quarto format a total of twenty-four pasted-in original calotype prints (whereas earlier, daguerreotype-based publications had used engraved reproductions), and setting a model for later similar productions by Talbot and others. The subjects ranged from artwork to houseware, scenes in Talbot's Lacock Abbey estate, and English monuments. The prints, of various sizes, were produced at Talbot's Reading Establishment by Nicolaas Henneman and assistants, and pasted in along with a frontispiece, prefatory notes including a "brief historical sketch of the invention of the art," picture titles and lengthy captions in ornate type. The *Pencil of Nature* was sold by subscription, the price of instalments varying with the number of prints (from twenty-one shillings for Part II with seven prints, to seven shillings six pence for three prints in the last parts). Although nearly three hundred copies were produced of the first instalment, interest later dropped and fewer than one hundred were made of the last one. This small printing—a paradox for a book considered to be an ancestor of mass illustration—accounts for the rarity of extant full sets, fortunately supplemented by facsimile editions. Despite its limited circulation, however, the *Pencil of Nature* achieved Talbot's goal of illustrating his invention of a "new art"—an art indeed so novel that Talbot had to warn readers that the plates were produced "by the mere action of Light." It was not only a technical feat, but an ambitious attempt at giving artistic and aesthetic status to the calotype and, more generally, photography. Many of the pictures reflected a heritage of fine arts, and the caption for Plate VI, "The Open Door," explicitly linked its "common" subject—a barn door with tools on either side—to "the Dutch school of art." Thus, the *Pencil of Nature* almost single-handedly created the pictorial tradition in photography. This artistic bend, however, went beyond a generic affiliation with the fine arts, and the caption for Plate VI, as others in the book, should not be read as mere prophecy. More fundamentally, the *Pencil of Nature* enacted an aesthetics and practice of photography that

were strongly rooted in the subjectivity of its author. A number of the pictures illustrated a private (and even aristocratic) realm, which Talbot's texts construed as the antithesis to the universalist, Republican discourse that surrounded photography in France. In the *Pencil of Nature*, photography triggered fancy, as exercised especially in the activities of reading, writing, and more generally playing with signs; it engaged the reader's curiosity as a novel kind of sign itself. Thus fulfilling the concerns voiced in the preface, the *Pencil of Nature* succeeded in establishing—in contrast to the utilitarianism of the daguerreotype—an alternative definition of photography as "pencil of nature," i.e. the playful art of applying the "mere action of Light" to a singular, human creation.

FRANÇOIS BRUNET

See also: Talbot, William Henry Fox; Calotype and Talbotype; Henneman, Nicolaas; and Daguerreotype.

Further Reading

Buckland, Gail, *Fox Talbot and the Invention of Photography*, Boston: Godine, 1980.

Gernsheim, Helmut, *Incunabula of British Photographic Literature, A Bibliography*, London and Berkeley: Scolar Press, 1984.

Newhall, Beaumont, ed., [W.H. Fox Talbot,] *The Pencil of Nature*, New York: Da Capo, 1969.

Schaaf, Larry, *The Anniversary Facsimile of H. Fox Talbot's The Pencil of Nature*, New York: Krauss, 1989.

——, *The Photographic Art of William Henry Fox Talbot*, Princeton, N.J.: Princeton University Press, 2000.

von Amelunxen, Hubertus, *Die Aufgehobene Zeit, Die Erfindung der Photographie durch William Henry Fox Talbot* [Time Suspended, the Discovery of Photography by W.H.F. Talbot], Berlin: Nishen, 1989.

PENN, ALBERT THOMAS WATSON (1849–1924)

The son of a family of shoemakers originating in Northamptonshire, Penn was born in Street, Somersetshire on 30 March 1849. Leaving home before the age of twelve, by 1865 he had arrived in Ootacamund, the South Indian hill station in the Nilgiri range west of Madras. During his first decade as a photographer in India, Penn appears to have worked closely with the firm of Nicholas Brothers (later Nicholas and Curths), before establishing his own studio in Ootacamund in 1875. From 1871 Ootacamund had served as the seat of Government for Madras during the hot season and the influx of European visitors to the hills, swelling the resident population, assured the photographer a steady market: for the last quarter of the 19th century, the Penn studio was the most successful photographic business in the Nilgiris, producing a comprehensive record of

the town and surrounding hills in work that is often reminiscent of the picturesque style of Samuel Bourne. Penn also made an important documentation of the 1877 famine in South India and an extensive record of the hill tribes of the Nilgiris, in addition to supplying illustrations for a number of published works. He came back to England with his wife in 1911, but returned to South India after the First World War and died at Coonoor in the Nilgiris on 19 October 1924, where he is buried in the Tiger Hill Cemetery.

JOHN FALCONER

PENROSE PICTORIAL ANNUAL

From its first issue in 1895 as *The Process Work Year Book* Penrose's Annual, as it was more generally known for nearly a century, provided a review of progress in photo-mechanical and printing work and in its early years offered a unique source of examples of different photo-mechanical printing processes.

It was initially published by A W Penrose & Co which had opened a Photo-Process Stores at Upper Baker Street, London, and was edited by William Gamble (1864–1933) the partner in the firm responsible for the process engraving side of the business. He also edited Penrose's *Process Work*. From 1897 the annual was printed and bound by Lund Humphries of Bradford who in 1909 acquired an interest in the publication when they took over as publishers. Gamble emphasised in 1898 that Penrose saw the annual as more than simply a commercial venture, it was designed to promote photo-mechanical printing more generally.

Gamble had felt the need for an annual review which would give engraving firms the opportunity of showing specimens of their work. In the annual these were pages that were supplied directly by those firms as printing blocks or as printed sheets which enabled the annual to be produced and sold at a price that was significantly lower than its actual costs of production. No payments were made to photographers as the annual considered that an appearance in its pages constituted an introduction to editors and publishers. The specimen pages were supplemented by an editorial surveying progress over the previous year and articles on techniques and materials. In the early years these included many authors from photography such as Bolas, Brothers, Waterhouse, Sanger Shepherd, Chapman Jones and Horsley Hinton. Advertising pages at the rear of the book included catalogues from Penrose and firms from the printing, process and photographic trades. Gamble aimed the annual at 'the editor, publisher, author, artist, photographer, printer, engraver, paper maker, ink maker, binder…'

In 1896 the annual became *The Process Year Book. An Illustrated Review of Photo-Mechanical Processes.*

Penrose's Annual. The next year Gamble in his editorial emphasised that the annual's primary object was the exposition of British work. In 1898 it was subtitled 'a review of the graphic arts' which it retained until its demise and *Penrose's Pictorial Annual* was included on the masthead for the first time. The annual found a ready market and the early volumes quickly sold out. During the early 1900s it further expanded its pagination with more illustrations and articles.

By the 1920s as photo-engraving techniques became static the scope of the annual was expanded to include articles on printing and after Gamble's death in 1933 the new editor Richard B Fishenden further widened the scope to include modern art and experiments in creative colour photography. The annual failed to appear in 1914, 1917–19, 1941–48 and 1963. During its final years, publication was irregular and the last volume, number 74, appeared in 1982.

MICHAEL PRITCHARD

Further Reading

Taylor, John, 'A checklist of Penrose Articles 1895–1968.' In *The Penrose Annual 1969. The International Review of the Graphic Arts*, edited byr Herbert Spencer, 253–292, London: Lund Humphries, 1969..

Moran, James, *Printing in the 20th Century: a Penrose Anthology*, London: Northwood Publications, 1974.

PERCY, JOHN (1817–1889)
English physician, photographer, and inventor

John Percy was born on March 23, 1817, and studied medicine in Paris and Edinburgh where he qualified as a doctor in 1838. An early enthusiast for photography, he is believed to have first experimented with the medium in 1844, using Talbot's calotype process.

He later studied mineral sciences, was elected a Fellow of the Royal Society in 1847, and took up a teaching post (later Professor of Metallurgy) at the newly opened Government School of Mines and Science Applied to the Arts (now Imperial College) in London's Jermyn Street in 1851. There he was assisted by John Spiller with whom he would subsequently take and exhibit photographs using Archer's collodion process. Their joint work appeared, in the 1857 Photographic Exchange Club album, and the 1857 exhibition of the Photographic Society.

Amongst Professor Percy's many scientific innovations was a means of extracting silver from photographic paper waste.

Surviving images point to him showing an early interest in stereoscopy and the Wheatstone Reflecting Stereoscope, producing images for this instrument contemporaneously with Roger Fenton and others.

In the year of his death, 1889, he was awarded the prestigious Albert Medal for, as the citation read 'his achievements in promoting the Arts, Manufactures and Commerce, though the world wide influence which his researches and writings have had upon the progress of the science and practice of metallurgy.'

JOHN HANNAVY

PERIER, CHARLES-FORTUNAT-PAUL CASIMIR (1812–1897)
French amateur photographer

Charles-Fortunat-Paul Casimir Perier was one of the quintessential "gentleman amateurs" of early photography. The son of Casimir Perier, Prime Minister of France (1831–32), Perier helped manage the family's vast industrial and financial interests, although his avocation was in art collecting and connoisseurship. He acquired important collections of Dutch and Barbizon painting, and his taste for realism extended to the new art of photography. While evidently not a member of the earlier Société héliographique, Perier was a founding member of the Société française de photographie, which he served as vice-president. He photographed with paper and collodion negatives, and participated in the international exhibitions of the 1850s, in which he showed virtually all genre of subject matter, very little of which is known today. His work is rarely discussed in the early literature, perhaps in part because he was himself one of the era's few photography critics, writing lengthy and sensitive reviews in the *Bulletin de la Société française de photographie*. These articles also promoted Perier's own, sometimes polemical views, such as his argument that photography must be accepted as a fine art, albeit of secondary rank. Perier's photographic activity declined in the 1860s, as he turned more interest to writing on the French Salon and art in general.

LAURIE DAHLBERG

PERINI, ANTONIO (1830–1879)
Italian photographer

Fortunato Antonio Perini was born at Treviso in 1830. From the early 1850s he devoted himself to photography and in 1853 he was given official permission to practise as a photographer by the Venetian government. In 1854 he started to collaborate with Carlo Ponti, who collected and sold views of Venice by various photographers. In 1855 Perini showed an album of Venetian views at the Exposition Universelle, Paris and in 1856 he presented a similar album at the Universal Exhibition of Brussels. He took photographs of the solar eclipse on 15th March 1858. On 10th February 1859 he opened a shop

in Venice, next to the San Marco tower. He became very well-known for his professional skill, mainly for his photographs of works of art. In 1862 he won a prize at the International Exhibition in London with an album of 110 albumen prints representing the miniatures of the Grimani Breviary, a famous religious book kept in the Marciana Library in Venice. In 1878 he published his last work, an album of 24 albumen prints of the miniatures of Attavante Fiorentino. In his last days he wrote a letter to his friend Carlo Naya in favour of the proposal by Carlo Brogi of Florence, for a law defending the intellectual and artistic rights of photographers. He died in Treviso on 21st August 1879. His 1872 Vesuvius pictures still survive in the private Italian collection, P. Becchetti collection, Rome, and they are also published.

SILVIA PAOLI

PERMANENCY AND IMPERMANENCY

Photographs need not, of necessity, fade" wrote Robert Hunt (1857), and "where they do fade, blame rests with the photographer, who has not bestowed the required care in giving them permanence... and if the pictures are toned with gold instead of sulphur, photographs are as permanent as water colour drawings.

That statement was made at a time when the fading of photographs had threatened to undermine the whole future of photography. Far from being the permanent record of nature drawing herself, photographs were becoming seen as being as transient and temporary as the light which originally created them.

The issue of fading was of such widespread significance in the early 1850s, and its causes so little understood, that a letter on the subject appeared in the first issue of the *Journal of the Photographic Society*. The writer, identified only as J.G.M., asked if

there is any known method by which a positive photograph, prepared only with an ammonio-nitrate of silver solution, may be prevented from fading, or by which it may be revived, having faded; I have one in this latter condition taken about a year ago, and of which the details are certainly becoming obscured, the dark parts being much lighter.

It was done in winter, during rain, and in a much warmer latitude than this.

The assumption that the weather conditions during the taking of the negative might have had some impact on the resulting permanence or impermanence of the print, demonstrates how limited was the average photographer's understanding of the chemistry involved in photographic production.

The editor's recommendation, that a solution of hy-drosulphuric acid might restore the image, would have produced only a temporary improvement. Sulphur in the image would, in time, be identified as one of the many factors that contributed to impermanence.

Within two years of this letter appearing in print, the Photographic Society of London, increasingly aware of the mounting scale of the problem, established a committee of photographers and chemists to explore the problem. Their remit was "to take into consideration the Question of the Fading of Positive Photographic Pictures upon paper." The so-called "Fading Committee" chaired by Roger Fenton, was made up of many of the eminent figures of the day, its work funded by a donation from Prince Albert.

While Fenton may have held the chair, the project was led by the eminent chemist T. F. Hardwich. The brief for Hardwich's team had, in effect, been established while the salt print was pre-eminent, but the introduction of the albumen print in the early 1850s had exacerbated the problem. The greater concentration of chemistry within the more impermeable structure of the albumenised surface layer of the print had increased rather than reduced the problems caused by continuing chemical reactions after the processing cycle had been completed. Albumen prints were much harder to wash than salted paper prints, and the chemistry contained within the emulsion more complex. The methodology used by Hardwich to determine the causes and effects—in what was the first scientific study of its kind—established the principles upon which the effects of aging on photographs would be determined for many years. His experimental methodology is still held up as an exemplar.

Almost since the dawn of photography, fading had been recognised as an issue, but not one which appeared to afflict all photographers equally. While Talbot and Henneman had experienced significant fading problems with many of the production runs of prints made by Henneman at the Reading printing establishment in the mid 1840s, prints made by Hill and Adamson in Scotland had not exhibited such difficulties.

There were a number of differences in the manner in which the prints had been made. Henneman had observed that the print colour was 'improved' as the fixing bath aged—due in fact to increased levels of sulphur in the fixer—and thus elected to fix his prints in increasingly old hypo baths. Hill and Adamson, preferring the use of a more dilute, but always fresh, fixer, did not encounter the problem. While Henneman gave limited washing to the completed prints—thus inefficiently removing the complex thiosulphates from the paper thickness—Hill and Adamson washed for up to twenty four hours. While Henneman's shorter wash might have proved reasonably effective in warm weather with warmer water, in winter with cold water it would have

failed to significantly reduce the level of contaminants which would, in time, cause fading. The impact of cold water washing on albumen paper was even greater, with the cold water reducing the permeability of the albumen even further.

The practice of using aged fixers continued until the mid 1850s, recommended by many writers as a means of producing a print colour which was consider more 'pleasing.' It is remarkable that such a deleterious effect was directly as a result of *a positive decision* by photographers.

It was not until 1855 that the importance of fresh fixer and effective washing were widely publicised and understood. The understanding came, in part at least, from the scientific investigations of Alphonse Davanne and Jules Girard, published at about the same time as the 'Fading Committee' in London was undertaking its own exploration.

The most effective solution to the longer term fading of prints came from the combination of efficient fixing and washing, with gold toning, which greatly reduced the effect of sulphur on the image structure. The 'gold bath' became an almost universal stage in print production, but in spite of it, the effects of sulphur in the atmosphere over the past century and a half has bleached the edges of a significant proportion of Victorian prints, both on salt paper and albumen.

While gold toning may have arrested the lightening of the developed tones in an albumen print, no counter was ever discovered for the yellowing of the highlights, caused by the combined effects of light and pollution on complex silver/albumen salts which remained within the paper's image-carrying layer. While intensifiers were produced to 'redevelop' faded images, they could not be used on prints which exhibited this yellowing, as they effectively developed the highlights as well, introducing a buff 'fog' into the highlights.

Questions over image permanency led, in part, to the evolution of printing processes which were not exclusively dependent upon the conversion of silver salts to metallic silver. Carbon, platinum, and pigment processes all resulted in prints which were impervious to the effects of air-borne pollution, and which at the same time expanded the repertoire of the creative printer.

Other permanent printing processes grew out of the quest for methods which would facilitate print production on a truly commercial scale—such as Woodburytype, Autotype, and others—and the introduction of ink-based lithographic and gravure processes.

JOHN HANNAVY

See also: Salted Paper Print; Albumen Print; Printing and Contact Printing and Printing Frames; Carbon Print; Platinum Print; and Woodburytype, Woodburygravure.

Further reading

Hunt, Robert, *A Manual of Photography*, London: Richard Griffin and Company, 1857.

Tissandier, Gaston (trans, John Thomson), *History and Handbook of Photography*, London: Sampson, Low, Marston, Searle & Rivington, 1878, reprinted New York: Arno Press, 1973.

Sparling, W., *The Theory and Practice of the Photographic Art*, London: Houlston and Stoneman; Wm S. Orr and Co, 1856.

Wall, E.J., *Dictionary of Photography*, London: Hazel, Watson & Viney, 1897.

Crawford, William. *The Keepers of Light*, New York: Morgan & Morgan, 1979.

Hardwich, T. Frederick. *A Manual of Photographic Chemistry*, London: John Churchill, 1855.

Wilde, F., "The Permanency of Photographs—Silver, Carbon, and Platinum." *American Journal of Photography*, vol. 12, no. 134, Feb. 1891.

Blanquart-Évrard, Louis-Désiré, *Traité de photographie sur papier*. Paris: Librairie encyclopédique Roret, 1851.

Reilly, James M., *The Albumen and Salted Paper Book: The History and Practice of Photographic Printing, 1840–1895*, Rochester, New York: Light Impressions, 1980.

PERSPECTIVE

In photography, as in art, there are generally accepted to be two forms of perspective worthy of consideration–linear perspective and aerial perspective. The importance of both was clearly and distinctly understood from the earliest days of the medium.

Linear perspective—sometimes referred to as *isometrical perspective* by nineteenth century practitioners—is the phenomenon by which the spatial aspects of the three dimensional world in which we live are recognized by issues of apparent visible scale. The distance that we perceive in three dimensions is conveyed and visibly recreated in two dimensions by our recognition and understanding of those changes in scale. Thus, an object that appears smaller in a photographic print or a painting is read as being further away from the eye or the camera lens from a similarly sized object that is reproduced larger.

Aerial perspective—the term was coined by Leonardo da Vinci—has, on the other hand, long been understood as the enhancement, or otherwise, of the sense of distance conveyed in a picture by the effect of haze, smoke or water vapor in the air.

While the former implies distance by the convergence of lines towards a notional vanishing point, the latter uses the reduced distinctiveness of objects farther from the lens to imply their distance from the viewer.

The conditions which produced marked aerial perspective were not always seen as being advantageous to the photographer. Especially in the 1850s, when the pursuit of technical excellence was seen to be of greater importance than effect, aerial pollution was seen as a distinct problem, especially in cities where the smoke

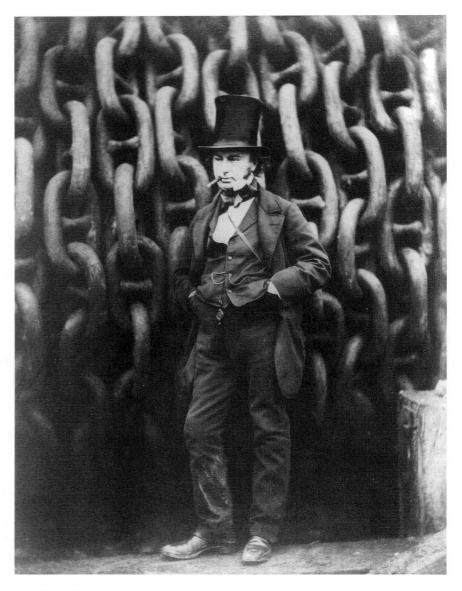

Howlett, Robert. Isambard Kingdom
Brunel Standing Before the Launch.
*The Metropolitan Museum of Art,
Gilman Collection, Purchase,
Harriette and Noel Levine Gift,
2005 (2005.100.11) Image © The
Metropolitan Museum of Art.*

from coal fires combined with moist air to limit the occasions on which the atmosphere was quite clear.

Edinburgh, Scotland, was known as 'Auld Reekie'—literally 'old smokie'—because of the combination of damp air and smoke from fires. Thus, in a lecture to the Photographic Society of Scotland in 1856, the amateur photographer and advocate of le Gray's waxed paper process, Dr Thomas Keith, lamented the persistent effect of aerial perspective on his pictures:

> I am quite satisfied that the commonest cause of failure arises from the paper being exposed in bad or indifferent light, especially in town, where the atmosphere is much adulterated with smoke. I never got a good picture where there was the slightest trace of that blue haze which smoke produces between the camera and the object.

Yet, it is the spatial effect of that aerial perspective which gives many of Keith's pictures their character. The same is true of Roger Fenton's beautiful study *The Terrace and Park, Harewood House*, where, thanks to

the haze of a Yorkshire summer, the picture reads as a series of planes, like the layers of a stage set, each lighter and less distinct than the one before it, receding into the distance.

It is, arguably, the impact of moisture in the air that enhanced the effect of aerial perspective in European photographs, and gave the work of European pioneers a quality distinctively different from the work produced in drier climates. In order to assess the likely final appearance of a photograph, photographers were encouraged to consider the scene without color, and thus to assess the tonal impact of aerial perspective. In *The Practice of Photography—A Manual for Students and Amateurs*, 1855, Philip Henry Delamotte suggested:

A black mirror, such as is used by artists, will be found useful in making choice of a view, as, by neutralizing the colours of objects, it more nearly exhibits the resulting photographic effect.

That was, of course, only partly true, due to the

limited color sensitivity of the materials then in use. The black mirror more truthfully exhibited the sort of tonal relationships which would be created on a panchromatic material—something that was still decades in the future. The blue sensitivity of calotype, waxed paper and wet collodion actually exaggerated the impact of aerial perspective, lightening the middle distance and distance more than was apparent to the naked eye, due to the increased blueness of the light which reached the camera from those distances.

In photography, linear perspective is a function of the relationship between the focal length of the lens, and the lens to subject distance. If the lens to subject distance remains constant, then so does perspective even if the focal length of the lens is changed. If, however, a wide-angle lens is used, and the camera is moved closer to the foreground subject, then the relationship changes and a distortion is introduced. That distortion appears to change perspective, and has been an issue which has had to be confronted and addressed ever since lenses were first used as an aid to drawing.

Early illustrators using the camera lucida as an aid to drawing quickly recognized the change in spatial reading, which a short focal length lens gave to them. Such effects are visible in the railway illustrations of John Cooke Bourne in the 1840s, who, for example, would later take up the camera himself as the photographer on the construction of Charles Vignoles' bridge over the Dneiper in Kiev. Users of both the camera lucida and the camera obscura had long understood that unless their instruments were level, a distortion caused by changes in vertical perspective would ensue. Talbot and his circle recognized this problem early on in the history of photography—where the tendency to tilt the camera upwards to include the topes of buildings introduced a horizontal perspective effect which we know today as 'converging verticals.'

In a letter to Talbot in June 1839, quoted in Schaaf (2000), his uncle, William Fox Strangways, offered a criticism of his early photogenic drawings, with the observation:

> I wish you could contrive to mend nature's perspective—we draw objects standing up & she draws them lying down which requires a correction of the eye or mind in looking at the drawings.

Cameras would later be fitted with rising lens panels to correct this distortion, enabling the tops of buildings to be included while keeping the instrument perfectly level. Others asserted that the creation of a true or natural perspective was beyond the capability of the camera. Writing in the *Journal of the Photographic Society* in June 1853, John Leighton believed that the single photograph would always suffer from the fact that "linear perspective [appears] comparatively flat when contrasted with binocular perspective as exemplified in the stereoscope." That comparative flatness was in fact a realistic representation of perspective, not a distortion.

Many artists saw the perspective created by the camera lens as being as being a distortion, an unnatural reading of the subject. Yet, as would later be proved, the camera's perspective was entirely natural—it was the expansion of perspective which was commonplace in paintings which was false. The painter George Frederick Watts (1817–1904) believed that photography "has unfortunately introduced into art a misconception of perspective which is as ugly as it is false," and the American artist Joseph Pennell (1857–1926) was so disillusioned by the perspective created by the camera that he abandoned using photographs as reference.

For much of the second half of the nineteenth century, the lenses used in architectural and landscape photography were of relatively long focal length, requiring quite a substantial camera to subject distance in the case of churches and cathedrals. Such lenses—with a field of view of between 10° and 30°—were essential if large format images were to be created which exhibited the degree of sharpness demanded by early photographers. Until optical manufacturing techniques advanced sufficiently to eliminate spherical aberration, long focal length lenses were the surest way of achieving a perfectly flat image field across the entire plate area. The effect of that was to create a slight compression of perspective—the flatness about which Leighton, Watts, Pennell and others complained. By the end of the century, with wide-angle lenses offering fields of view of between 50° and 80°, photography was able to create the same sort of enhanced perspective so beloved of painters.

KUEI-YING HUANG

See also: Delamotte, Philip Henry; Keith, Thomas; and Talbot, William Henry Fox.

Further Reading

Delamotte, Philip Henry, *The Practice of Photography – A Manual for Students and Amateurs*, London: Photographic Institution, 1855 (reprint New York: Arno Press, 1973)

Schaaf, Larry, *The Photographic Art of William Henry Fox Talbot*, Princeton and Oxford: Princeton University Press, 2000

Scharf, Aaron, *Art & Photography*, Harmondsworth: Pelican Books, 1974

PERU

In September of 1839, a major Lima newspaper (*El Comercio*), offered its readers news of the new Daguerrean process. Peruvian engagement with photography was not far behind that of more affluent countries (an in some cases it was ahead). In July of 1842, Maximiliano Danti

opened the first photography studio in Peru while Berlin's first studio opened in August of 1842 (McElroy 1977). Photohistorian Keith McElroy notes that photographers active in Peru during the Daguerreotype era (1839–1859) were generally from France or the United States. While the former emphasized "art, current European style and good taste," the latter based their marketing on "speed, prices and technical proficiency" (McElroy 1979a).

Philogone Daviette was the second known daguerreotypist in Lima (1844) and possibly the first in Perú to offer postmortems. Jacinto Pedeville (Pedevilla) arrived in 1846 and is credited (along with Felix Salazar) with introducing albumen prints in Peru in 1853. Early North American daguerreotypists include J. M. Newland (also known as Juan Newman), active in Lima and Callao (1846) and Arequipa (1847), and Arthur Terry who managed a Lima studio between 1848 and 1852. After moving to Chile, Terry was in partnership with Cipriano Clavijo who was later active in Arequipa and Trujillo between 1860 and 1892.

The first known native-born Peruvian photographer Juan Fuentes was active in Lima beginning in 1856. His idea to photograph convicted criminals as an innovative record keeping device was eventually funded by the government. Other Peruvian-born photographers from that era include Felix Salazar who worked in Lima between 1854 and 1887. Salazar was in a succession of partnerships with other photographers (Richardson, Bouvier, Remorino, and P. E. Garreaud). Salazar also produced views of the Arequipa Revolution of 1867 and the great Arequipa Earthquake of 1868.

North American Benjamin Pease arrived in Peru in 1852 and bought the studio of compatriot Arthur Terry. According to McElroy, Pease "produced the most significant body of daguerrean plates and built the first of the grand [photography] salons in Lima" (1979b). Later, Pease successfully transitioned into the cdv era. In 1870 Pease took a series of photographs of the Mollendo to Arequipa railroad line whose construction was supervised by the noted engineer Henry Meiggs. Other arrivals from the United States included Henry de Witt Moulton (who had worked at the famed Gurney and Fredricks studio in New York) and Villroy L. Richardson. Both men had been contracted to work at the Pease studio. Later, they were both affiliated for a time with the studio of Pedro Emilio Garreaud.

Villroy Richardson opened his own studio in Lima in 1862. Richardson's well executed cdvs were much in demand as were his images of the Lima to La Oroya railroad line. In the 1860s he produced photomontages, placing political personalities on the bodies of animals and later produced a series of popular political caricatures on cdvs. When he did not heed government warnings to cease, Richardson was arrested and released only after his political favorite became President. Henry Moulton's negatives of Lima and most significantly, the Chincha islands (where fortunes in guano were harvested), were made into prints by U.S. photographer Alexander Gardner. The images appeared in *Rays of Sunlight in South America* (c.1865).

Ricardo Castillo first worked for the Richardson studio. In the late 1890s, Castillo operated the latter's studio in association with Ignacio Lecca, and later managed his own studio. Castillo produced carbon prints, photographed the mining area of Cerro de Pasco and documented portions of the destruction resulting from the War of the Pacific between Peru/Bolivia and Chile (1879–1884). Eugenio Maunoury opened his elegant studio in 1861 and is credited with popularizing the *carte-de-visite* in Peru. Manoury along with José Negretti and the major Lima studios had great success marketing cdvs of *tapadas* (women posing in *mantos* (shawls) and *sayas* (skirts) once worn by Limeñas during the colonial period and which signified flirtation). Maunoury's affiliation with Nadar in Paris was noted on his cdvs and the logo was later used by the famed Courret studio when it acquired Manoury's three studios in 1865.

The Courret brothers studio established in 1863, merits special attention due to "The quantity, quality and duration of its production" (McElroy, 1977). Eugenio operated the camera while Aquiles took care of the business details. In the 1870s, the latter left Peru and Eugenio managed the studio until around 1892 when he returned to France. The elegant Courret studio produced thousands of cdvs and cabinet cards, outdoor scenes of various cities (Lima, Callao) events (earthquake of Arica and Arequipa, Industrial exposition of 1869); and of the Oroya railroad line. According to McElroy, "It would be impossible to illustrate a history of Peru in the second half of the 19th century without including Courret portraits" (McElroy 1977). The Courret studio was transferred to Adolfo Dubreuil and a series of successors. Portions of the Courret Archive have been preserved.

Photographers in the provinces were able to maintain successful studios in various cities, especially in Arequipa which for a time prospered due to a large demand for alpaca wool. Ricardo Villalba (also spelled Villaalba) owned a studio in Arequipa during the 1870s. He produced cdvs, remarkable photographs of the Mollendo to Puno railroad line and views of Lake Titicaca. Felix Renaut, active in Arequipa between 1868 and 1874, produced cdvs and stereoviews. Miguel and Luis Alviña whose familial relationship if any, is not known, both worked in Arequipa in the 1860s. Luis also worked in Cusco in the 1870s and participated in an expedition to Paucartambo in 1873. Some of his albumen prints of that region's people have survived.

Carlos Heldt worked in Trujillo, Lambayeque and Arequipa between 1870 and 1890. Juan Manuel Anda was active in Tacna and other southern Peruvian locations between 1878 and 1910, where he specialized in studio photography. Toward the end of the 19th century, Charles Kroehle produced notable photographs of the Amazon region and its people, some of which were published in Miles Moss's book *A Trip into the Interior of Perú (1909)*. Kroehle's photos of Lima and its environs were published in A*lbum de Lima y sus Alrededores* (1900).

Frenchman Emilio Colpaert photographed various areas of Peru between 1859 and 1862 focusing primarily on ethnographic and archeological subjects. He also owned one of the first studios in Cusco (1862). His compatriot Pablo Emilio Garreaud opened a studio in Lima in 1856 with T. Amic Gazan. In 1862 Garreaud traveled to various locations in Peru, photographing views of and people in Cusco, Arequipa and the Altiplano. These were used to illustrate a major work, *El Atlas Geográfico del Perú* (1865). Pablo Emilio was the father of Fernando Garreaud who between 1898 and 1899 traveled throughout Perú documenting various regions for a national documentation project published as *Peru 1900*.

Late 19th century studio owners who enjoyed success into the 20th century include Rafael Colmenares active in Ayacucho, Lima, and Callao; Miguel Chani in Cusco; and Emilio Díaz and Max T. Vargas in Arequipa. Manuel Moral was active in Lima between 1884–1896, after which he sold his studio and went on to publish some of Peru's most important illustrated periodicals including *Prisma, Variedades* and *Ilustración Peruana*.

Climate, indifference and lack of resources have contributed to the loss of portions of the Peruvian photographic patrimony. Private collectors and some institutions can be credited with preserving important portions of this heritage. The history of Peruvian photography received its first major attention in the work of Keith McElroy who in 1977 conducted an in-depth study of 19th century Peruvian photography. In his study McElroy identified over 140 photographers. Since that time the number of articles, exhibitions and books on the subject has grown significantly. The latest and most comprehensive project was the exhibition held at the Museo de Arte in Lima and the Fundación Telefónica in Lima (2001–2002). The two volume catalog of the exhibition includes a detailed essay on the history of Peruvian photography, photographs showing the range and quality of Peruvian photography since its beginnings, and a directory of over 500 photographers active in Peru between 1842 and 1942.

YOLANDA RETTER

See also: Carte-de-Visite; Negretti and Zambra; and Villalba, Ricardo.

Further Reading

Herrera Cornejo, *La Lima de Eugenio Courret, 1863–1934*, Lima, Gráfica Novecientos Seis, 2001.

Majluf, Natalia and Eduardo Wuffarden, *La Recuperación de la Memoria: Perú, 1842–1942*, Fundación Telefónica y Museo de Arte de Lima, Lima, Perú, 2001.

McElroy, Keith, *The History of Photography in Perú in the Nineteenth Century, 1839–1876*, PhD Dissertation. University of New Mexico, 1977.

——, "The Daguerrean Era in Perú 1839–1859." *History of Photography*, 3 (1979a): 111–123.

——, "Benjamin Franklin Pease: An American Photographer in Lima, Perú." *History of Photography*, 3 (1979b): 195–209.

PERUTZ, OTTO (1847–1922)

Otto Perutz was born on July 27, 1847, in Teplitz-Schoenau (Teplice, Czechia) to a family of industrial manufacturers, mostly in the textile industry. Little is known about his formal training, the first record being his installation as managing director at the Bayerische Aktiengesellschaft fuer chemische und landwirtschaftlich-chemische Fabrikate (BAG) at Heufeld near Munich which had been founded in 1857 under the supervision of the German chemist Justus von Liebig. The BAG worked on agrochemical substances and had no relation to photography. On April 13, 1880, Perutz bought the Chemische und pharmaceutische Produktenhandlung Dr. F. Schnitter & Co. in Munich, a merchant in photochemical substances necessary for wet plate processes. In 1882, Perutz came into contact to Johann Baptist Obernetter who had worked as a chemical assistant to Joseph Albert and his printing house and was licensed by Hermann Wilhelm Vogel to produce dry plates after his method of sensitisation with Eosin (orthochromatic plates). Introduced in August 1887, the Perutz plates were an instant success due to their rapidity and extended spectral sensitivity. The company grew quickly and concentrated on a number of different products: From 1893 it produced large format glass plates for the use in stained windows as in church houses, villas, or official buildings; these large format positives were developed and monochromically tinted in the company. From 1896, Perutz was the first company to produce glass plates for the Roentgen process of X-ray photography.

On July 1, 1897, Otto Perutz sold his enterprise to the Engelhorn family, then owners of large chemical companies like Boehringer (Ingelheim) and BASF (Ludwigshafen). He returned to the BAG where he became member of the board of trustees in 1902, a position he held until his death on January 18, 1922. The managing director of the new Perutz company was Franz Mayerhofer, a modernist in many aspects. For the time of his direction, until 1922, Perutz had the most modern advertising, marketing, and product range of all German film and plate companies. In 1900 and 1902, two plates

which extended spectral sensitivity were launched which had been created in collaboration with Adolf Miethe, the successor of H.W.Vogel in Berlin, and Arthur Traube, then assistant to Miethe. From 1904 to 1910, Traube constantly worked with Perutz and developped a number of colour sensitive plates, preparing his own colour photography inventions which he was to market in his own company Uvachrome from 1910 onwards. Under the direction of Curt Engelhorn, from 1924 to 1938, Perutz managed to stay away from being swallowed by the I.G.Farben concentration, and survived as an independent film producing company until its integration to the Agfa-Gevaert holding in 1964.

ROLF SACHSSE

PETIT, PIERRE (1832–1909)
French photographer and studio owner

Pierre Petit practiced daguerreotype beginning in 1849 and was trained as photographer in Disdéri's studio. In 1858, he left to join Trinquart, with whom he opened the "Photographie des Deux mondes" the following year at 31, Cadet place, not far from the boulevard. In 1860, they opened a branch in and then, in 1861, they opened another in Marseilles. In 1859, Petit started to work with the immense project *Galerie des hommes du jour, portraits photographiés* (*Gallery of portraits of men of the moment*), headed by the critic Theodore Pelloquet, which had appeared in installments since 1861. These portraits were taken on whole plates and printed, which was then placed on Bristol-board paperboard. Accompanying each portrait was a biographical note about the person in the image. The professional singer Pauline Viardot, the journalist Alphonse Karr, the painter Eugene Delacroix, and many others appeared in this gallery. At the same time, Petit undertook a series of portraits of bishops, for which he received, in 1862, the title of "photographe de l'épiscopat français" (photographer of the French episcopate). He created a total of 25,000 portraits of ecclesiastics. He was also interested in the techniques of mechanical reproduction so much so that Poitevin granted the right to him to use his process, which guaranteed the better conservation of portraits.

Similar to his activity as a portraitist, Petit documented the Expositions Universalle. In 1855, he was part of the "Société du Palais de l'industrie" (Company of the Palace of Industry), which was set up by Disdéri, and was responsible for reproducing the various sections of the exposition. In 1867, he received along with the young assistant Bisson, an imperial commission for the exclusive control of reproduction of the overall pictures. Leon and Lévy were responsible for the stereoscopic views and Michelez for the reproductions of works of art. Petit worked in a private house built on the exhibi-tion site. In 1875, he reproduced the collections of the Musée Dupuytren, totaling 85 plates. In 1878, he again photographed the Exposition(s) Universelle. He also made a report to the head office of Paris in 1870–1871 during the Franco-Prussian war and another on the construction of the Statue of Liberty in New York, between 1871 and 1886.

Petit worked with the Société française de photographie in 1875, but only took part in three of its exhibitions, 1859, 1861 (with Trinquart), and 1863, each time from various framed images. He presented portraits primarily, but also group portraits, studies of animals, an image of the Champs-Elysées, and reproductions of Roman frescos. His portraits were noted by critics, who regarded them as the best of their kind, even by the prestigious Francis Wey. The *Galerie des hommes du jour* was qualified on several occasions as "monumental."

Pierre Petit was appreciated by the critics and by the public for the direct aspect of his portraits which were simple on neutral background, and without decoration. Critics also praised his images for their natural poses, the frankness of the images, his skill to seize the character of the model while playing with the various shades of light, and for his irreproachable execution. Ernest Lacan was one of most laudatory in this respect, evoking the striking resemblance of his portraits: "He did not only reproduce the features of his models, he reproduced their true facial appearance" (*La Lumière*, August 13, 1859). Familiar with the parallels with painting, the critic compared the strength of the tone and the boldness of the parties captured in Petit's portraits to the works of the great Spanish painters. Ernest Lacan also compared him with Nadar, his principal competitor as portraitist on the Parisian scene. Francis Wey greeted the way in which he managed to release all the energy and the grandeur of the model and the critic Ladimir greeted his artistic feeling, his manual dexterity, and his capacity to represent intimate thoughts (*Le Pays*, June 24, 1861). More than the portraits of celebrities are his figures of children.

In 1862, Petit published the *Simples conseils ; manuel indispensable aux gens du monde* (*Simple councils; essential handbook with the society peoples*), a small work with a misleading title that moved away from the technical handbooks that were published then. This contained texts written on him by various critics as well as caricatures made of him which testify to his notoriety as a great part of his portraits were drawn from the calling card format which allowed a broad diffusion of them. To attract customers, Petit used the advertising space affixed to the buildings of his district, that announced his establishment to the passersby. One can see one of them on the street Laffitte by Charles Marville. A sign of his success was the expansion of his establishment on the rue Cadet in 1876. On this occa-

sion, Ernest Lacan described it like "a true museum," with a gallery lit by transparent photographs on glass, like stained glass (*Moniteur de la photographie*, November 16, 1876).

Even if he illustrated in other genres, Pierre Petit remains particularly well-known as a portraitist. His career, like those of Disdéri or Nadar, is a perfect illustration of the popularity of the photographic portrait and of the prosperity that of some large professional workshops knew, as true "temples of photography."

HELENE BOCARD

Further Reading

Michèle Auer, and Michel Auer, *Encyclopédie internationale des photographes de 1839 à nos jours*, Hermance, Camera Obscura, 1985; *Pierre Petit photographer*, Rochester, International museum of photography at George Eastman House, 1980.

PETZVAL, JOSEF MAXIMILIAN (1807–1891)

Josef Petzval is widely recognized as the father of photographic optics, being the first person to apply mathematical computation to the design of a photographic lens.

Born in Spisská Belá—then in the Austro-Hungarian Empire but today in Slovakia—he studied physics and later mathematics in the Institutum Geometricum in Budapest, now part of Budapest University.

After graduation, with a doctorate in physics, he lectured part time at the Institutum, while also working as an engineer in Prague. In 1838, he moved to Vienna and took up the position of Professor of Mathematics at the University of Vienna, where he spent the next forty years. In the following year, he designed the rapid portrait lens which bore his name and which revolutionized photography.

His interest in photographic lenses is believed to have been triggered by a discussion with his friend and colleague Andreas von Ettinghausen, after the latter had returned from Paris where he had seen the daguerreotype demonstrated. Ettinghausen lamented the fact that exposures with the new process were too long to make portraiture a practical proposition, and Petzval embarked on research to see if the design of lenses could be improved to reduce exposures.

The result, computed before the end of 1839, and produced in prototype by early 1840, was an innovative design using two pairs of achromatic lenses that reduced exposure times by more than 95%. Daguerre's original camera used a lens with an effective aperture of f/16, while Petzval's alternative offered a fixed aperture of f/3.6.

Descriptions of the portrait lens, in early manuals,

attest to its reliability and popularity. In the 1860s, William Lake Price described it as:

> A front crown lens of unequal convex curves, to which are cemented a double flint lens of unequal concave curves; the back combination is a crown lens of unequal convex curves and a concavo–convex flint lens at a little distance from it. For more than a quarter of a century this lens, without further changes in its construction than modification of its curves, has been ised not only for the class of pictures its name denotes but for a variety of others.

Petzval's design used two pairs of color-corrected lens glasses, their negative elements facing towards the centre, on either side of a large central space. It was the creation of the space between the pairs that achieved the desired result. That result was a combination which offered significant correction of chromatic aberration and coma, but like all such designs, suffered significantly from spherical aberration.

The design did not create a flat image field, and while this was not a major issue when used to make small daguerreotype portraits, it had severe limitations when it came to larger plate sizes, as definition and sharpness fell off significantly towards the edges of the plate. Given the small sizes of daguerreotype plates popularly used at the time, and the fact that enlargement of the photographic image was still decades in the future, the loss of edge definition was not immediately seen as a problem. A variation on the design later partially eliminated the problem, and allowed the lens to be used for architecture and landscape. It was, however, the portrait lens which achieved greatest significance in the evolution of photography and, accompanied by the considerably increased sensitivity of the daguerreotype plate which resulted from the chemical innovations of John Frederick Goddard, made portrait photography a practical proposition. Between them, these two men and their ingenuity effectively reduced exposure times from many minutes to just a few seconds.

Being of limited means, Petzval could only afford to patent his design within the Austro-Hungarian Empire, and agreed, for a single payment, to license the manufacture to Peter Wilhelm von Voigtländer, who produced the first commercially available lenses in 1840. One of the first cameras to be sold with the Petzval lens attached was Voigtländer's unique metal-bodied daguerreotype camera of 1841. About six hundred examples of this camera are believed to have been manufactured, but very few are known to have survived.

Petzval's relationship with Voigtländer deteriorated from 1845 when Petzval saw the success of the lens and realized that, apart from his original payment, he would not benefit from it. When Voigtländer subsequently moved his manufacturing facility from Austria to Germany, and outside the scope of Petzval's patent,

their dispute continued for many years. Voigtländer, however, went on to refine and develop the design, and his 'Orthoskop' lens—a direct derivative of the original design—achieved widespread success as a landscape lens.

Recognizing the shortcomings of the original lens, Petzval applied his mathematical skills to resolving the problems of spherical aberration, and in so doing, evolved a mathematical calculation to measure and predict the flatness of the resulting image field. The 'Petzval Condition' or 'Petzval Sum,' derived in 1843, became the standard method for quantifying this problem and resolving its effect. It is still in use today.

Petzval is also credited with the design of opera glasses, and therefore with contributions to the evolution of binoculars. He also proposed mirror reflectors for light bulbs, to gather and reflect a higher proportion of the available illumination, and made significant contributions to the worlds of mathematics, acoustics and physics.

However, a break-in at his house in Vienna in 1859 resulted in the loss of many of his manuscripts—several of them unpublished—and resulted in him abandoning his plans to publish definitive books on the subject of optics.

He retired from scientific pursuits in 1877, and died in Vienna in 1891.

CARYN NEUMANN

Biography

Born in Spisská Belá–then in the Austro-Hungarian Empire but today in Slovakia—Josef Petzval was one of six children. His father was a teacher and musician. Josef studied physics and later mathematics in the Institutum Geometricum in Budapest, now part of Budapest University, and after graduation, with a doctorate in physics, lectured part time at the Institutum, while also working as an engineer in Prague. In 1838, he took up the position of Professor of Mathematics in Vienna, where he spent the rest of his professional career, retiring in 1877.

An intensely private man, relatively little is known of his private life, and even his biographer Ludwig Ermenyi could offer little information. He is known to have married late in life—in 1869 at the age of 62—but was divorced four years later. In 1877 he moved to Kahlenberg of the outskirts of Vienna where he became a virtual recluse and died in 1891, largely forgotten and almost penniless. History, however, has not forgotten him.

Further Reading

Kingslake, Rudolf. *Lens Design Fundamentals.* New York: Academic Press, 1978.

Smith, Warren J. *Modern Lens Design: A Resource Manual.* New York: McGraw-Hill, 1992.

PHILADELPHIA PHOTOGRAPHER

Under the editorship of Edward L. Wilson, *The Philadelphia Photographer* was established in 1864 with the sponsorship of the Philadelphia Photographic Society. Wilson had left business a year previous to work with the Philadelphia photographer Frederick Gutekunst. The journal was published twice-monthly, and distinguished itself from the New York journals by including a tipped-in photograph, varying from views, portraits and copies of engravings, in each issue. The journal included one of Edward Muybridge's views of Yosemite in 1869. In contrast to the more scientific concerns of *The American Journal of Photography* and *Humphrey's*, Wilson saw the *Philadelphia Photographer* as serving a more general readership, including the "novice, experienced artist or amateur." "No centre table is without its album, and no parlor wall entirely bare of photographs. Yet how few know how they are made; how to get the best or where; which are the best kinds; or how to sit and what to wear," Wilson wrote in the first issue. After 1869, *The Philadelphia Photographer* was the remaining independent photography journal and the most influential journal in the field in the last decades of the 19th century.

Writers for the journal included Matthew Carey Lea, chemist and scion of the Philadelphia publishing family, who reported on and evaluated photographic chemistry and wrote summaries of his reading of the British and European photographic journals. In 1864 and 1865, Coleman Sellers wrote a series "Letters to an Engineer, On Photography as Applied to His Profession" that traced the connection between industry and photography; he also profiled Dr. Thomas Kirkbride's use of the Lagenheim brothers' magic lantern slides displays at the Philadelphia Hospital for the Insane. Hermann Vogel regularly wrote a "German Correspondence" column for the journal and reported on photographic events in Europe beginning in 1865; during the 1870s, John Towler, former editor of *Humphrey's*, wrote a regular column as well.

Technological and chemical reporting in the journal ranges from wet and dry plates to discussions of magic lantern slides, stereographs in the 1860s and 1870s. In the 1860s, the journal published articles titled "Photography as a Moral Agent" and "Photography and Truth." Wilson and his writers weighed in on discussions of artistic view photograph in the 1870s, promoting the artistic visions of photographers and their medium, recommending in 1871 that Henry Peach Robinson's *Pictorial Effect in Photography* was the standard-bearer in photographic literature. In the 1880s the journal gave

regular coverage to the burgeoning amateur movement and camera club outings as well as discussed half-tone printing, highlighting the tensions that remained at the end of the decade between artistic and scientific interests in photography.

Wilson also published *The Magic Lantern* (1874–1885) and the annual digest *Photographic Mosaics*. He also wrote and published a number of books, *The Philadelphia Photographer* absorbed *Photographic World* in January 1873 and *Photographer's Friend* in 1875. The journal was continued as *Wilson's Photographic Magazine* and published monthly in New York from 1889–1914.

Alongside the technological information profiled in its pages, social and cultural historians have looked to the journal to trace attitudes toward and responses to 19th-century photography, among them Sara Greenough, Peter Bacon Hales, Mary Panzer, Barbara McCandless, and Alan Trachtenberg.

ANDREA L. VOLPE

See also: Wilson, Edward Livingston; Lea, Matthew Carey; and Robinson, Henry Peach.

Further Reading

Greenough, Sara, "'Of Charming Glens, Graceful Glades and Frowning Cliffs': The Economic Incentives, Social Inducements and Aesthetic Issues of American Pictorial Photography, 1880–1902." In *Photography in 19th-century America,* edited by Martha A. Sandweiss, Fort Worth, Texas and New York: The Amon Carter Museum and Harry N. Abrams, 1991.

Johnson, William S., *Nineteenth-century Photography: an Annotated Bibliography, 1839–1879,* Boston: G.K. Hall and Co., 1990.

McCandless, Barbara, "The Portrait Studio and the Celebrity." In *Photography in 19th-century America, edited by Martha A. Sandweiss*, Fort Worth, Texas and New York: The Amon Carter Museum and Harry N. Abrams, 1991.

Panzer, Mary. "Romantic Origins of American Realism: Photography, Arts, Letters in Philadelphia, 1850–1875," PhD dissertation, Boston University, 1990.

Taft, Robert, *Photography and the American Scene*, 1938 reprint, 1964, New York: Dover.

Trachtenberg, Alan. "Photography: the Emergence of a Key Word. In *Photography in 19th-century America, edited by Martha A. Sandweiss*. Fort Worth, Texas and New York: The Amon Carter Museum and Harry N. Abrams, 1991.

PHILOSOPHICAL INSTRUMENTS

The term "philosophical instrument," despite being in popular use, was never clearly defined but was in general use during the eighteenth century through to the mid-nineteenth century. From the 1850s the term gradually fell out of favour and was not replaced. Philosophical instruments were generally used to explore and demonstrate in either an academic or popular way the basic principles of natural philosophy, or science.

Scientific instruments played an increasing role in scholarly study and working life from the middle ages. Accurate measurement and calculation was essential for navigation, manufacturing and construction, and trade and commerce and through the sixteenth and seventeenth centuries this need lead to the development and refinement of instruments such as back-staff, octant and sextant for navigation; compasses, levels and theodolites for surveying; and scales, weights and rules for commerce. These were developed out of practical need and represented the everyday trade of instrument makers.

From the mid-seventeenth century experimentalism had superseded theories about the natural world based on Greek thought and grand hypotheses. Francis Bacon had shown that experimentation, observation and careful records could be used to make scientific deductions and this new methodology was taken up by the Royal Society in London. The major centres of scientific learning in Europe began teaching experimental philosophy using practical apparatus. Popular demonstrations and lectures rapidly spread across Europe and America. Their effect was to stimulate the demand for the commercial manufacture of philosophical instruments for demonstration and teaching purposes. The basic design of most instruments varied little into the twentieth century.

Although many of the instruments were used for demonstration and teaching purposes many, such as telescope and other optical devices also had a practical aspect to them and were sold by instrument makers to a wider public and for practical commercial and business use. During the later eighteenth and early nineteenth century, many makers described themselves as 'optical and philosophical instrument makers' rather than mathematical instrument makers, chemical manufacturers or specialised makers of, for example, spectacles or scales. A number of firms associated with early photography used this description of their business. Philosophical instruments were produced in a range of qualities as, for example, simple brass 'student' microscopes through to elaborately-decorated gilt and silver finished microscopes for use by royalty, confirming their dual use as instruments for scholarly use and as home entertainment.

Although the definition varied slightly philosophical instruments were originally understood to demonstrate mechanics, magnetism, pneumatics, hydrostatics and hydraulics, electricity, heat, sound and light. Meteorological instruments were also included.

Mechanical models were used to demonstrate various mechanical effects including gravity, forces, inertia, momentum, inertia and levers and pulleys. Steam models were produced from the early nineteenth century of different types of engine and engineering tools such as cranes and mills.

Magnetism and the compass were essential for safe

navigation and natural magnets or lodestones were used to demonstrate the power of magnetism.

Pneumatics, the study of air and gases, and especially the creation of a vacuum led to the development of air pumps from the late seventeenth century.

Hydrostatics. This was the name given to apparatus used for demonstrating all effects involving water. This ranged from model diving bells that made use of pressure to move a model up and down a water-filled cylinder, to the Tantalus cup demonstrating the siphon, to elaborate fountains and the use of water under pressure. Instruments such as the hydrometer were developed to measure specific gravity.

Electricity was studied extensively during the eighteenth and nineteenth centuries and machines were developed to produce electricity and then to store it. Static electricity was studied and machines produced in the later eighteenth century culminating the Winshurst machine that used two counter-rotating glass disks to generate static electricity to produce an electric spark. Many electric devices were used as forms of popular entertainment. Geissler tubes were glass tubes containing a high vacuum which contained gases that glowed when electricity was passed through them. The discovery of electric current lead to the development of measuring instruments such as the electrometer and galvanometer and storage methods such as the Leyden jar.

Heat—apparatus was developed to show that some materials expand and contract under heat, that mirrors could be used to focus heat and the nature of heat as an energy form which lead to the development of Crooke's radiometer.

Sound demonstrations in the eighteenth century were limited with the principal experiment showing that a noise disappeared in a vacuum. In the nineteenth century work into tuning forks and resonance lead to the development of the telephone and phonograph.

Meteorological instruments. The refinement of the principal meteorological instruments occurred during the eighteenth century with the thermometer to measure temperature; the hygrometer to demonstrate humidity in the air; and barometer to measure air pressure.

Light—which had most relevance to photography—was studied through apparatus designed to demonstrate and make use of scientific discoveries. Early studies traced light through different media such as water, the use of mirrors and light through lenses and prisms. Microscopes and telescopes made use of the development of advances in lens design and the understanding of refraction and reflection of light. Mirrors appeared as Claude Lorraine glasses for drawing, and in different forms to view anamorphic drawings. The camera obscura made use of lenses, mirrors and the camera lucida used a prism, to aid drawing. The zograscope,

stereoscope, magic lantern and kaleidoscope all derive from optical study.

Allied to this was the study of the eye and how it worked with the brain. The demonstration of persistence of vision was shown through the thaumatrope, phenakistiscope, zoetrope and praxinoscope.

Other areas of optical study also developed instruments such as the polariscope and polarimeter which made use of the discovery of polarisation. The spectroscope allowed chemical composition to be determined through the study of emitted light. According to Turner the spectroscope 'contributed more to modern science than any other instrument'.

The development of instruments to study and demonstrate scientific principals lead to a rapid increase in scientific knowledge during the nineteenth century and a growth of scientific instrument makers who produced the standard demonstration instruments as well as their own variants and entertainments based on scientific principles. In 1701 there were 151 instrument maker's working in the British Isles which had increased to 837 by 1851. It was from the group of 'optical and philosophical instrument makers' that the first photographic retailers and specialised photographic manufacturers emerged in the early 1840s and 1850s.

MICHAEL PRITCHARD

Further Reading

Clifton, Gloria, *Directory of British Scientific Instrument Makers 1550–1851,* London: Zwemmer, 1995.

Hackmann, W.D., "The Nineteenth Century Trade in Natural Philosophy Instruments in Britain." In *Nineteenth Century Scientific Instruments and their Makers,* edited by P.R. de Clerq, Amsterdam: Editions Rodopi, 1985.

Holbrook, Mary, *Science Preserved. A Directory of Scientific InstrumentsCcollections in the United Kingdom and Eire,* London: HMSO, 1992.

Turner, Gerard L'E, *Nineteenth Century Scientific Instruments,* London, 1983.

——, *Scientific Instruments 1500–1900. An Introduction,* London: University of Berkeley, 1998.

PHILOSOPHICAL MAGAZINE

Using the relatively new printing technology of stereotyping, the *Philosophical Magazine* was launched in 1798 by Alexander Tilloch (1759–1825):

> the grand Object of it is to diffuse Philosophical Knowledge among every Class of Society, and to give the Public as early an Account as possible of every thing new or curious in the scientific World, both at Home and on the Continent. ('Preface,' *Philosophical Magazine,* 1, 1798)

Initially, the journal was in competition with another recently-founded periodical, William Nicholson's *Journal of Natural Philosophy, Chemistry and the*

Arts, but the *Philosophical Magazine* absorbed this in 1813. In 1822, Tilloch took the printer Richard Taylor (1781–1858) into partnership as both editor and co-proprietor in the face of increasing commercial competition. This move proved successful, and after Tilloch's death in 1825, leaving Taylor sole owner and editor, the *Philosophical Magazine* (known throughout its many permutations affectionately as '*Phil. Mag.*') managed to absorb Thomas Thomson's *Annals of Philosophy* in 1826 (when its editor Richard Phillips became co-editor) and David Brewster's *Edinburgh Journal of Science* in 1832, when Brewster became the third editor of the amalgamated *London and Edinburgh Philosophical Magazine and Journal*. A Dublin editorship was created when the eminent chemist Robert Kane (1809–90) was invited onto the editorial board in October 1840.

As W.H. Brock and A.J. Meadows have written:

> one estimate suggests that 64 per cent of all nineteenth-century scientific periodicals were commercially published rather than issued as the official journals of learned societies. Such journals served an important number of functions. They speeded up publications at times when the proceedings of scientific societies appeared intermittently or only once or twice a year ... Such journals also provided intelligence of science in foreign journals for those who read no foreign languages or who had no access to large libraries. They also aired controversies or allowed space to issues involved in new research programmes; they accepted for publication the minor and even trivial research with which learned societies could not be bothered, thereby continuing to cater for the popular and cultural (and often provincial) images of science during a time when it was undergoing the rigor of specialisation. On the other hand, such journals often accepted for publication original findings or theoretical speculations that were considered unorthodox by the societies. In this respect they kept the scientific societies on their toes, broke their monopolies, and made them less authoritarian and cliquish than they might have been. (Brock and Meadows 1984, 93)

Before the specialist photographic journals became established, the *Philosophical Magazine* provided a ready forum for early papers discussing the emergence of the new science. For instance, one of those of the pioneer photographer, W.H.F. Talbot, read before the Royal Society but then not submitted to its prestigious journal, the *Philosophical Transactions*, appeared in the *Philosophical Magazine* in early 1839. Other important papers relating to photography in 1839 included ones by Sir John Herschel and John Towson; subsequently in 1840, John William Draper discussed daguerreotype portraits, and Antoine Claudet published his method of speeded-up daguerreotype development there in August 1841, having discovered it in May. Herschel published a variation of a paper published earlier in the *Philosophical Transactions* in February 1843, while

George S. Cundell wrote about the calotype in May 1844, and in December that year, George Shaw and Dr Percy published 'On some photographic phaenomena' (Gernsheim 1984, 137–9). However, as the nineteenth century progressed, the *Philosophical Magazine* became increasingly specialized, and by the last quarter of the century it had become almost entirely a journal composed of physics articles.

A.D. Morrison-Low

See also: Brewster, Sir David; Claudet, Antoine-François-Jean; Herschel, Sir John Frederick William; Talbot, William Henry Fox; Royal Society, London; Philosophical Transactions; Calotype and Talbotype; Daguerreotype; Science; Cundell, George Smith and Brothers; Draper, John William; Shaw, George.

Further Reading

Arnold, H.J. P., *William Henry Fox Talbot: Pioneer of Photography and Man of Science*, London: Hutchinson Benham, 1977.

Brock, W.H., ' Brewster as a Scientific Journalist.' In *Martyr of Science: Sir David Brewster 1781–1868*, edited by A.D. Morrison-Low and J.R.R. Christie, 37–42, Edinburgh: Royal Scottish Museum, 1984.

Brock, W. H., and Meadows, A.J., *The Lamp of Learning: Taylor & Francis and the Development of Science Publishing*, London and Philadelphia: Taylor & Francis, 1984.

Dawson, G., Noakes, R., and Topham, J.P., 'Introduction.' In *Science in the Nineteenth-century Periodical: Reading the Magazine of Nature*, edited by Geoffrey Cantor, Gowan Dawson, Graeme Gooday, Richard Noakes, Sally Shuttleworth, and Jonathan R. Topham, 1–34, Cambridge: Cambridge University Press, 2004.

Gernsheim, Helmut, *Incunabula of British Photographic Literature 1839–1875*, London and Berkeley: Scolar Press, 1984.

PHILOSOPHICAL TRANSACTIONS

The Royal Society of London is deemed to have been founded at an informal meeting at Gresham College in the City of London on 28 November 1660, shortly after the restoration of the Stuart monarchy in the person of the king, Charles II. 'On 15 July 1662', wrote Marie Boas Hall:

> a formal Charter of Incorporation was enacted for 'the Royal Society', while in April 1663 a second charter denominated it 'Regalis Societas Londini pro Scientia naturali promovenda', the Royal Society of London 'for improving naturall Knowledge'. It is thus the oldest continuous scientific society in the world still operating under its original charter, and its principal publication, the *Philosophical Transactions*, is the oldest continuous scientific journal. (Hall, 1984, ix.)

The *Philosophical Transactions of the Royal Society of London* first appeared in 1665, with beginnings that upon closer scrutiny were turbulent but ground-

breaking; however, by the early nineteenth century, the Society was beginning to reform itself. Under the forty-two year presidency of Sir Joseph Banks it had epitomised the gentlemen's club leisurely investigating a wide range of curiosities; after his death in 1822, it began to transform itself into a rigorous and disciplined body pursuing the increasingly professionalized sciences, across social boundaries. The twice-annually published *Philosophical Transactions* followed this self-reforming trend, and as the main publication of what was effectively the nation's independent academy of science, was treated with considerable respect.

Only a handful of important scientific papers relating to the emergence of photography were published in the *Philosophical Transactions*, all within the first decade of photography's genesis. This apparent paucity can be explained by the comparative rapidity with which other commercially-produced periodicals, such as the *Philosophical Magazine*, could produce a publication. Also, the emergence of journals dedicated exclusively to photography in the early 1850s meant that the writers, assured of an interested audience, in due course went elsewhere. But amongst the important papers which appeared in the *Philosophical Transactions*, the pre-eminent scientific journal of the English-speaking world, were several by Sir John Herschel (FRS from 1813), one of which was awarded the Royal Society's Royal Medal; this was published in 1840 and in it he divided photography into positive and negative images for the first time, mentioned his experiments with photography on glass, the use of hyposulphite for fixing, and the necessity for achromatic lenses for correct delineation. An earlier paper, read before the Society in March 1839, was mislaid until recently. Other significant photographic papers were published in the *Philosophical Transactions* by Robert Hunt and Antoine Claudet; two papers about the application of photography to recording instruments were placed there by Sir Charles Brooke and Sir Francis Ronalds.

A.D. MORRISON-LOW

See also: Claudet, Antoine-François-Jean; Herschel, Sir John Frederick William; Hunt, Robert; Talbot, William Henry Fox; Royal Society, London; and Philosophical Magazine.

References and Further Reading

Gernsheim, Helmut, *Incunabula of British Photographic Literature 1839–1875*, London and Berkeley: Scolar Press, 1984.

Hall, Marie Boas, *All Scientists Now: the Royal Society in the Nineteenth Century*, Cambridge: Cambridge University Press, 1984.

Johns, Adrian, "Miscellaneous Methods: Authors, Societies and Journals in Early Modern England," *British Journal for the History of Science*, 33, part 2 (2000), 159–186.

Schaaf, Larry J., "Sir John Herschel's 1839 Royal Society Paper on Photography," *History of Photography*, 3, part 1 (1979), .47–60.

Schaaf, Larry J., "Herschel, Talbot and Photography: Spring 1831 and Spring 1839," *History of Photography*, 4, part 3 (1980), 181–204.

PHILPOT, JOHN BRAMPTON (1812–1878)
English photographer

Born in England, John Brampton Philpot resided in Florence from about 1850 until his death in 1878. In 1856 Philpot made thirty calotypes which record the sculpted figures of the Tuscan "pantheon" in the exterior niches of the Uffizi. A series of 28 calotypes of Florence date from the same period, for four of these were exhibited in 1856 at the Photographic Society of Scotland in Edinburgh. Also in the 1850s Philpot produced facsimiles of drawings in the Uffizi in connection with a proposal to compile an inventory of the collection. Baedeker mentioned this aspect of Philpot's production in his 1877 Handbook for Northern Italy, listing Philpot's business as one of the principal photographic establishments in Florence: "Philpot & Co., Borgo Ognissanti 17 (reproductions of Uffizi drawings)."

GRAHAM SMITH

PHOTO-CLUB DE PARIS

In the 1880s, photographic technique and practice evolved, it became easier to take pictures, thanks to the introduction of the Gelatino-bromide process. This invention permitted an industrialization of photography. Lots of people bought a camera and photographed—for most of all—their family life and their entertainments.

Likewise, the institution had to follow this fundamental change. Scientific members of photographic societies and long time users tried to make recognize photography not only as a leisure but as a new subject of research.

Following the techniques simplification, a new type of amateurs emerged. Born for almost all of them during the 1850s, they were not particularly involved in chemistry. Along with it, a new kind of gathering, the Photo-Club de Paris created in 1888 after an article in the newspaper "L'Amateur photographe," was entirely dedicated to the amateurs, and not only to the scientific community, which was the main audience of the Société française de photographie. The Photo-Club had a real program : it was struggling to make photography recognized as an art and to give a real status to the creators. It corresponded to a new expectation that the established institutions could not satisfy.

However, one of its most important initiators, Maurice Bucquet, searched for acknowledgement of the

institution with distinguished members of the other photographic societies like Doctor Etienne-Jules Marey (the famous physiologist), Doctor Dujardin-Beaumetz and Albert Londe (already member of the French photographic society and the Société d'Excursions des Amateurs photographes: Excursions Society of the photographic Amateurs).

As the other guilds, the Photo-Club de Paris gave to its members the possibility to use a new modeling and development workshop, a chemistry laboratory dedicated to the tests, a library next to a reading room and other places to meet every month and to participate to the projections sessions.

In order to "show to the other photographic societies that the Photo-Club de Paris take an important part in the general toil" ("montrer aux autres sociétés qui s'occupent de photographie la part que le Photo-Club de Paris prend dans le labeur général," in *Bulletin du Photo-Club de Paris*, 1891, 9), the amateurs' association published between 1891 and 1902, the *Bulletin du Photo-Club de Paris* in which members could find a transcription of the photo-club's life: communications about techniques as well as artistic considerations, descriptions of novelties like new cameras or chemistry methods for development or pictures treatments and summaries of foreign researches. This publication had to sustain the debate and to claim the position of the Photo-Club. In 1903, the *Bulletin* became independent and turned its name into "La revue de photographie."

Thereby, the association took a central role in the diffusion of a new trend considered as the first artistic photographic movement. Beginning with the book of Peter Henry Emerson, *Naturalistic Photography for Students of the Art*, published in 1889, Pictorialism opened a new avenue for photographers. The Pictorialists saw the excursionist's and the family practices only as entertainment, whereas they treated their pictures with particular processes. Using printed techniques such as gum bichromate or oil transfer, they searched to give to their photographs drawing effects considered as the best way to make recognize photography as an art. But soon, two esthetics appeared, the vaporous one and the detailed one. A dispute to choose the best one followed.

To distinguish them from the excursionists, members of the Photo-Club de Paris took part to the international exhibition of 1892, the "first international exhibition of photography and related arts" ("Première exposition internationale de photographie et des arts qui s'y rattachent"), and soon organized the "First exhibition of photographic art" ("Première exposition internationale d'art photographique du Photo-Club de Paris) in 1894, from the 10th of January to the 30th of January, closely modeled on the French artistic Salon. The academic painter Léon Gérôme even presided the jury from 1895 to his death in 1904.

The creation of the Photo-Club de Paris was part of a worldwide movement, along with the Wiener Camera Club in Vienna, the Linked Ring based in London and the Camera Club of New York. These associations accelerated the internalization of the photographic institution, promoted the International Union of Photography, creating links between societies. The pictorial movement used their luxurious publications to diffuse their esthetics, works and researches.

In France, members of the Photo-Club de Paris and the most representative members of Pictorialism were Léon Robert Demachy (1859–1936) and Emile Constant Puyo (1857–1933). These charismatic leaders theorized the esthetic and wrote many articles published in different newspapers. They met each other at the Photo-Club in 1895. Less prominent figures included René Le Bègue and Henri Fourtier.

Very involved in printed technique, Demachy was one of the first to employ the gum bichromate already used by Alphonse Poitevin (in France) and John Pouncy (in Great Britain) in their own research during the 1850s.

He spread his method thanks to several articles and illustrated lectures in Paris, Brussels, and London. He was also a specialist of the bromoil process. These printed techniques made photographs look like drawings, gave them an artistic touch and permitted the interpretation of reality.

With the public recognition, first during the Exposition Universelle of 1900 in Paris, came the time of the suspicion about pictorialism. Some photographers and critics underlined its lack of creativity and innovation: the vogue of etheral and vaporous photography vanished with the birth of the "straight photography."

However, the Photo-Club de Paris' position about the artistic photography remained the same, always represented by amateurs. With the First World War, the association became less and less powerful but was still headed by one man, Constant Puyo (Demachy stopped his practice during the war) who still approved the same esthetic. In 1924, it became the responsibility of the French photographic Society to continue to organize photographic exhibitions.

The life of the Photo-Club de Paris had always been bound with the first artistic photographic movement. Its influence disappeared with the death of the pictorialist approach and the death of Puyo in 1933 marked its last activities.

MARION PERCEVAL

See also: Demachy, (Léon) Robert; Puyo, Émile Joachim Constant; Gum Print; Société française de photographie; Pictorialism; Emerson, Peter Henry; Brotherhood of the Linked Ring; and Amateur Photographers, Camera Clubs, and Societies.

Further Reading

Bulletin du Photo-Club de Paris, 1891–1902.
La photographie pictorialiste en Europe, 1888–1918, Point du Jour Editeur, 2005.
Poivert Michel, *Le pictorialisme en France*, Paris: Höébeke/Bibliothèque Nationale, Collection Le siècle d'or, 1992.

PHOTOCHROM PROCESS
The Swiss process

This beautiful photomechanical process was worked out by one of the oldest printing and publishing firms in the world, Orell Füssly, of Zurich, Switzerland, funded in 1504 by Hans Rüegger. The firm still exists, along with Photoglob AG, founded by the former "Art Institute Orell Füssly" in 1889 for the worldwide distribution of photochrom pictures. Using up-to-date technology, they are currently the leading postcard publisher in Switzerland and their range of printed products include city maps and coffee-table books.

The descendants of Orell Füssly did not keep details of the trade secrets associated with the 19th century Photochrom process but a modern investigation by Dr Bruno Weber confirmed what many had been saying all along. The process was lithographic in nature and made use of a light-sensitive material first used by Nicéphore Niépce in 1814: asphalt, also known as bitumen, which can be dissolved in benzene and thinly coated onto a grained litho stone. When the coating is dry it can be exposed under a continuous-tone negative and after an exposure of 10 to 30 minutes under the summer sun (several hours in winter) the parts of the image that were protected from the light by the dark areas of the negative will remain soluble when subjected to a solvent such as turpentine. The rest of the image will remain on the stone and can be made ready to receive a greasy ink that will create a visible image that can then be transferred to paper.

While the above photographic system sounds simple, adapting it to the production of full color reproductions would be a different matter. The man who made this happen was Hans Jakob Schmid (1856–1924), a lithographer from the Swiss town of Nürensdorf. One can only imagine the difficulties involved in printing six to fifteen colors from a single black and white negative. One stone was required for each color. A registration system had to be designed that was so efficient that even today one needs a magnifying glass to discover minute imperfections in the printing process.

Very large editions of town views were made by this process, which can be classified as a form of screenless lithography. The Zurich Central Library currently houses about 10,000 Photochrom landscapes and city views given by the "Art Institute Orell Füssly" between the years 1891 and 1914.

The first photolithographic polychrome prints were made in 1886. At that time this new printing technology was referred to as "photo-chromo printing process." After 1888 it became known as "photochrom." It was also known under the name of Aäc.

Photochroms have almost the appearance of natural color photographs, although under a magnifying glass they will show a delicate grain pattern. Single illustrations printed in Switzerland, Germany and the US often have a characteristic caption in gold lettering along the base of the print, with a serial number and "P.Z." for Photochrom, Zurich.

In the UK the process was exploited by the Photochrom Company Ltd, which also used a different spelling for its name and its products: Photochrome (sic). Their large illustrations did not carry the P.Z. initials but did show a serial number. We do not know how active the English firm was but of the many Photochrom(e) Company illustrations that appeared in the *Penrose Annual*, all but one, in Vol. 9 (1903), were in fact conventional half-tone relief engravings.

There were other successful photolithographic operations including the Frey process invented by Frey & Söhne, of Zurich. This was acquired by Hudson & Kearns in Britain but never successfully exploited by them. There were also variants by Photostone, Wetzel & Naumann, Müller & Trüb, Schulz, etc.

In 1897 the Photochrom Co. of Detroit, USA, was created after William A. Livingstone (of The Detroit Photographic Company) went to Zurich to obtain exclusive U.S. rights to the Photochrom process which they used to print color postcards, beginning in 1898. In 1905 the company name was changed to the Detroit Publishing Company. From 1907 they also used Phostint as a trade name. The firm was active in the production of color printing until 1931. Much of the company's archive is now housed at the Library of Congress, in Washington, D.C. The collection includes over 25,000 glass negatives and transparencies as well as about 300 color photolithographic prints, mostly of the eastern United States. The collection includes the work of a number of photographers, one of whom was the well known photographer William Henry Jackson (1843–1942). Other parts of the collection are housed at the Colorado Historical Society (Denver, Colorado) which has approximately 13,000 images, primarily glass plate negatives of views west of the Mississippi. Their collection also includes vintage photographs, Photochrom prints, postcards, and the Detroit Publishing Company's negative record log. The Historical Society also has one of Jackson's diaries from the 1870s.

The Henry Ford Museum & Greenfield Village (Dearborn, Michigan) has approximately 18,000 vintage photographs, 9,500 postcards, and 2,500 Photochrom prints from the Detroit Publishing Company.

Photochrom was later adapted to offset lithography and produced excellent screenless color lithographs in various art books published between WW I and WW II (e.g., Gottfried Wälchli: Martin Disteli Romantische Tierbilder, Zürich/Leipzig, Verlag Amstutz & Herdeg, 1940). The last Photochrom operator, Frédéric Wälti, retired at the age 81 as recently as 1970.

The French Process

The Swiss photochrom process should not be confused with the similarly named multi-color process introduced by Léon Vidal in France in 1872. The "photochrome," often anglicized "photochromy," was first seen in the photographic exhibition at the Palais de l'Industrie in Paris in 1874. The prints were much like chromolithographs, except that the base illustration (key plate) was a photograph usually printed by the woodburytype process.

In other cases, the colors were applied in sections (selected manually) made by the carbon transfer process. These photochromes, never achieved the realistic effect of the Swiss process but they were suitable for printing reproductions of crowns, diamonds, and other precious objects from the Louvre and other French institutions. Fine examples can be seen in Paul Dalloz' *Trésor Artistique de la France, 1ère série,* (Paris, Moniteur Universel, 1883).

LUIS NADEAU

See also: Vidal, Léon; Poitevin, Alphonse; Photoglob Zurich/Orell Fussli & Co.; Postcard; and Photography and Reproduction.

Further Reading

Burdick, Jefferson R., *The Handbook of Detroit Publishing Co. Postcards,* Essington, PA: Hobby Publications, 1954.

Fritz, Georg (E.J. Wall, trans.), *Photo-Lithography,* London: Dawbarn and Warn, 1896, 20, 75

Hesse. *La chromolithographie et la photochromie-lithographie,* Paris: French ed., by A. Mouillot & C. Lequatre, 1902.

Hughes, Jim, *The Birth of a Century: Early Color Photographs of America.* London; New York: Tauris Parke Books, 1994.

Lowe, James L., and Ben Papell, *Detroit Publishing Company Collector's Guide.* Newton Square, PA: Deltiologists of America, 1975.

Ogonowski, E., *La photochromie. Tirage d'épreuves photographiques en couleurs,* Paris: Gauthier-Villars, 1891.

Read-Miller, Cynthia (ed.), *Main Street U.S.A., in Early Photographs: 113 Detroit Publishing Co. Views,* New York: Published for Henry Ford Museum & Greenfield Village, Dearborn, Mich. by Dover Publications, 1988.

Stechschulte, Nancy Stickels, *The Detroit Publishing Company Postcards: A Handbook for Collectors of the Detroit Publishing Company Postcards including checklists of the regular numbers, contracts, Harveys, miscellaneous art cards, the 50,000 series, sets, Little Photostint Journeys, mechanical postcards, the panoramas, and many others*, Big Rapids: Michigan, N.S. Stechschulte, 1994.

Vidal, Léon, *La photographie des couleurs par impressions pigmentaires superposée,* Paris, 1893.

——, *Traité pratique de photochromie,* Paris, 1903.

Weber, Dr Bruno, "Rund um die Welt in Photochrom." In *Deutschland um die Jahrhundertwende,* edited by Helga Königsdorf and Bruno Weber, 145–150. Zurich, 1990.

——, "With the Photochrom on Five Continents." *The PhotoHistorian,* no. 133 (2001), supplement, 10 pp. Translated from the German by Steven F. Joseph.

PHOTOGALVANOGRAPHY

The name of this photomechanical process came from Duncan C. Dallas, at one time manager of the Patent Photo-Galvanographic Company, a short-lived printing and publishing firm set up for the exploitation of an English patent granted to Paul Pretsch (1808–1873), an Austrian photographer and inventor.

Paul Pretsch arrived in London in 1854 and took out an English Patent, No. 2373, dated Nov. 9, 1854, for "Improvements in producing Copper and other Plates for Printing" In the following year he formed the Patent Photo-Galvanographic Company with a number of partners, including Roger Fenton (1819–1869), as the chief photographer.

Commencing in December 1856, they published a serial portfolio, *Photographic Art Treasures, or Nature and Art Illustrated by Art and Nature.* This was the first photographically engraved reproductions of works of art. There were five issues published, each containing four plates, the last publication appearing in early 1857. Their *intaglio* process, which was the first to utilize the reticulation of gelatin, was based in part on W.H.F. Talbot's 1852 photoglyphic engraving patent and produced plates often heavily retouched by hand engravers—a common practice in the printing industry at the time. Nevertheless, many of the plates were exceedingly good, considering the state of the printing technology at the time.

At a meeting of the Photographic Society of London in June 1856, Pretsch exhibited specimens of his work in various stages and read an interesting paper on "Photogalvanography, or Engraving by Light and Electricity," in which he explained the principles and applications of his process, founded on the peculiar properties of animal glue (gelatin) mixed with chemical ingredients so that it can be made to swell or shrink to produce images that could be turned into intaglio plates. In the course of discussion Pretsch stated that the granular appearance of the matrices was due more to the formation of silver chromate rather than to the iodide (*Phot. Journal,* vol. 3, 58). This chemically induced granularity is interesting and indeed questionable as more recent methods of photogalvanography and collotype printing used the effect of elevated temperature during the drying stage of the matrix.

In the same journal (vol. 5, 1859, 109 and 132), there is a reprint of another paper by Pretsch on "Photography subject to the Press," in which he gives his reasons for abandoning the etching methods of photo-engraving used by Talbot in favor of the photo-galvanographic and gave a short sketch of his method, stating that the granulation was a distinctive feature of it, and was indispensable for the reproduction of any tint by a printing plate. There is another paper on "Photo-galvanography, or Nature's Engraving" (vol. 6, 1959, 1) illustrating with a plate from a negative by O.G. Rejlander, "I pays," which is interesting not only as a good specimen of the process, but also because it is an early example of the process of *aciérage*, by which the electrotyped plate was coated with iron and so was made capable of yielding the large number of copies required (3,000) instead of having to prepare a number of duplicate plates or make a transfer to stone for inferior photolithographic results. A description of the aciérage process is given by F. Joubert, the inventor, in the same number of the journal.

Notwithstanding Pretsch's remarkable skills and inventions, much of his career, and the progress of photography and photomechanical printing in general, were harmed by W.H.F. Talbot's intransigence when it came to negotiating the licensing of his patents. A study of Talbot's correspondence, now made possible thanks to Larry J Schaaff's *The Correspondence of William Henry Fox Talbot* project, reveals a dark side to this otherwise well regarded inventor as we see him displaying an incredible level of greed and lack of respect for Pretsch's efforts. In early 1857 Pretsch was forced to abandon his publishing activities with the photogalvanic process following a lawsuit by Talbot. Despite this he kept improving his processes, notably for relief (block) printing, and maintained contact with Talbot, sending him specimens of his new methods and begging him for permission to exploit his new inventions. The following, from a letter Pretsch sent to Talbot, June 1, 1861, shows the level of desperation facing the Austrian inventor.

Sir,

I have been informed by Mr. Hogarth that you intend to postpone the conclusion and settlement of our affairs till your return from the Continent. I must confess that this would be too much for my means which are now utterly exhausted;—the transactions with yourself and Mr. Hogarth have been carried out since February (four months), and before that time since several years I have been living on my own resources, but which are now perfectly exhausted, and at an end without any hopes of being renewed. I do not suppose that it is your intention, to torture me;—I think I have not deserved such degrading pains for my hard labour and unceasing skillfull work.

I have therefore to request most urgently the favour of you, that you may make your decision <u>at once</u>, whatever it may be.—Last Friday night has been forwarded to you the draft draught of the indenture with suggestions for

your approval. I beg therefore to send your reply to this as soon as possible, and I rely at least in this instance on your reasonableness and impartial kindness.

I enclose the impressions of two blocks which I have latterly finished. Both of them are *absolutely untouched by the graver.*

Expecting very soon your kind reply, permit me to remain_Sir_Your very obedt. Servt

Paul Pretsch

Despite many such efforts, his plea was not met favorably.

At the Exhibition of 1862, in London, he exhibited half-tone photogalvanographic plates in intaglio and in relief, and obtained the only medal awarded for that class of work. He did a good deal of work in illustrating the *Journal of the British Museum*, but found it, however, difficult to get on in London, and after a serious illness he returned to Vienna in 1863. He was taken on again in the Imperial State Printing Office, but his health had broken down and he made no further progress in perfecting his methods. In 1873 he died of cholera.

Others improved photogalvanography under the names of *helioplasty, leimtype photo-electrotype, swelled gelatin* and *wash-out processes*. It was employed in England almost exclusively by A. & C. Dawson, who styled themselves otherwise the Typographic Etching Company. It was in all essentials identical with the original Pretsch process. It had considerable merit, but was hopelessly expensive and slow compared with the other methods.

LUIS NADEAU

See also: Pretsch, Paul.

Further Reading

Eder, Joseph Maria, *History of Photography*, 581–590, Dover: New York: Columbia University Press, 1978, originally published 1945.

Fritz, G., *Festschrift zur Enthüllungsfeier der Gedenktafel für Paul Pretsch*, Vienna, 1888.

Leopold, Joseph, *Phot. Korr.*, 1874, 180. [The most detailed account of Pretsch's process of *intaglio* photo-galvanography.]

Pretsch, Paul: "Photo-galvanography, or Engraving by Light and Electricity." *Phot. J.* 3 (1854): 58.

——, "Photo-galvanography, or Nature's Engraving." *Phot. J.* 6 (1859): 1.

Volkmer, Ottomar, *Die Photo-Galvanographie zur Hertsellung von Kupferdruck-ud Buchdruckplatten nebst den dazu nöthigen Vor-und Nebenarbeiten,*. Halle: Knapp 1894.

Waterhouse, J., "Paul Pretsch and Photo-galvanography," *Penrose Annual* 16 (1910–1911): 137–142.

PHOTOGENIC DRAWING NEGATIVE

In 1834, William Henry Fox Talbot invented a light-sensitive paper that he named "photogenic drawing

paper." For the next ten years he used it to make his "photogenic drawings," by exposure to sunlight in contact with flat, semi-opaque objects, such as leaves, lace, clichés-verres, or printed pages—a type of image now called a photogram. In August 1835, using the same sensitized paper, Talbot succeeded in making the first camera photographs in silver, which he referred to as "Views taken with the camera obscura. The pictures … represent the scene reversed with respect to right and left, and also with respect to light and shade." It was not until 1840 that Sir John Herschel proposed the noun "negative" for such a photograph having a reversed tonal scale, but neither he nor Talbot ever used the expression "photogenic drawing negative," which has been coined in recent times to distinguish a camera negative recorded on photogenic drawing paper.

Talbot choose the finest rag paper available—customarily, the gelatin-sized writing-paper from John Whatman's Turkey Mill in Maidstone, Kent. He immersed each sheet for a few minutes in a dilute (ca. one per cent) solution of sodium chloride (common table salt), then, after blotting the sheet dry, he brushed one side of it with a strong (ca. 18 per cent) solution of silver nitrate. The result was to precipitate silver chloride within the fibres of the paper, according to the chemical reaction:

ILLUSTRATION
$$AgNO_3 + NaCl \longrightarrow AgCl + NaNO_3$$
silver + sodium —> silver + sodium
nitrate chloride chloride nitrate

The high concentration of silver nitrate ensured that an excess of this substance was retained within the paper—a condition that Talbot had found essential for light-sensitivity. The paper was usually dried in front of a fire. Upon exposure to sunlight for a few minutes, it turned a rich purplish-black, due to the formation of metallic silver in a finely-divided state, according to the photochemical reaction:

ILLUSTRATION
$$light + AgCl \longrightarrow Ag + \tfrac{1}{2}Cl_2$$
UV + silver —> silver + chlorine
light chloride metal gas

The chlorine evolved was rapidly absorbed by other constituents of the sensitized paper, otherwise it would have reversed the reaction. This is the silver chloride printing-out process, in which the silver image is formed entirely by the action of light; consequently, it has very low sensitivity compared with development processes. In contrast to the ease of making photograms with "photogenic drawing paper," it proved barely sensitive enough to yield negatives in a camera obscura, which had to be small, with a lens of large aperture to maxi-

mise the brightness of the image. Even so, exposures of about one hour were required, and the subjects had to be brightly sun-lit. Talbot's earliest known photogenic drawing negative—of the sky seen through a latticed window at Lacock Abbey—is dated August 1835. This, and other photogenic drawings, were first exhibited to the public at the Royal Institution on 25 January 1839, when Michael Faraday announced Talbot's invention.

After exposure, photogenic drawing paper remains sensitive to light owing to the unchanged silver chloride. In February 1835, Talbot discovered that the obliteration of his images could be prevented by treatment with a saturated (32 per cent) solution of sodium chloride, or a solution of potassium iodide; the former rendered the silver chloride much less light-sensitive, and the latter converted it to inert silver iodide, so that his photographs could conveniently be viewed in daylight. These were the first fixing processes: chloride-fixed specimens were often reddish-brown in the shadows and tended rapidly to acquire a characteristic pale lilac "veil" over their highlights, which Talbot found quite attractive; iodide-fixed images showed primrose-yellow highlights due to the colour of silver iodide. Both types of photograph remain somewhat light-sensitive, however, and cannot be exhibited without risk of perceptible damage. It has been estimated that a light exposure of only 3–4 hours under the most stringent gallery illumination of 50 lux, may cause a just-noticeable change in a halide-fixed photogenic drawing.

In January 1839, Sir John Herschel discovered the more effective "hypo" method of fixing—or "washing out" as he more accurately described it—using sodium thiosulphate (then known as "hyposulphite of soda") to dissolve out the residual silver chloride entirely. Photogenic drawings fixed by this means are stable to light, but if the sodium thiosulphate itself has not been fully washed out of the paper, they may fade severely owing to the slow conversion of image silver into yellowish silver sulphide:

ILLUSTRATION
$$2Ag + Na_2S_2O_3 \longrightarrow Ag_2S + Na_2SO_3$$
silver + sodium —> silver + sodium
metal thiosulphate sulphide sulphite

In March 1839, Talbot made the first use of silver bromide in photography—an important innovation for which he does not receive full credit. His "common photogenic paper" was treated with a ten per cent solution of potassium bromide to convert the silver chloride into silver bromide, and then coated with excess silver nitrate, to yield a more sensitive paper. Talbot privately called this his "Waterloo paper," and employed it with some success in his cameras until the use of photogenic drawing paper for negative-making was totally eclipsed,

in September 1840, by his pivotal discovery of the much faster calotype development process. Nonetheless, Talbot's recipe for "common photogenic drawing paper," which was not restricted by patent, continued to be universally used until ca. 1855 to make positive contact prints from camera negatives; such positives, then called "re-transfers" or "copies," are today referred to as salted paper prints. Thiosulphate-fixation rapidly became the preferred method, although Talbot himself persisted in the use of halide (i.e., chloride, bromide, or iodide) print-fixation for some years, possibly due to an aesthetic preference for the interesting colours that the process generated, compared with the uniformly dull brown of the thiosulphate-fixed images.

The camera exposures for making photogenic drawing negatives were lengthy—typically, one hour—during which interval the sun moved relatively through an angle of 15 degrees of arc; consequently, in any sunlit scene, the areas of shadow were diminished and their hard edges diffused, while the reflections from highlights were multiplied. Photographs printed from photogenic drawing negatives often display a softness of modelling that is quite different from the chiaroscuro qualities seen in the much faster calotype process. Talbot's photogenic drawing negatives made in 1839–40 recorded the luminosity of his scenes with a delicacy that is quite inaccessible to the instantaneous vision of the human eye, and the modern camera.

MIKE WARE

See also: Talbot, William Henry Fox; Herschel, Sir John Frederick William; and Faraday, Michael.

Further Reading

Proceedings of the 1992 Conference, *The Imperfect Image: Photographs, their Past, Present and Future*, edited by Ian and Angela Moor, London: Centre for Photographic Conservation, 1993.

Proceedings of the Photographic Materials Group Meeting, 1993, *Topics in Photographic Preservation*, 5, 1993. Austin, Texas: American Institute of Conservation.

Schaaf, Larry J., *Out of the Shadows: Herschel, Talbot and the Invention of Photography,* New Haven: Yale University Press, 1992.

——, *Records of the Dawn of Photography: Talbot's Notebooks P and Q,* Cambridge: Cambridge University Press, 1996

——, *The Photographic Art of William Henry Fox Talbot*, Princeton, NJ and Oxford: Princeton University Press, 2000

Ware, Mike, *Mechanisms of Image Deterioration in Early Photographs: the sensitivity to light of WHF Talbot's halide-fixed images 1834–1844*, London: Science Museum and National Museum of Photography, Film & Television, 1994.

——, "Quantifying the Vulnerability of Photogenic Drawings," in *Research Techniques in Photographic Conservation*, edited by Mogens Koch, Tim Padfield, Jesper Stub Johnsen, and Ulla Bogvad Kejser, Copenhagen: Royal Danish Academy of Fine Arts, 1995.

——, "Invention *in Camera*: the Technical Achievements of WHF Talbot" in *Huellas de Luz. El Arte y los Experimentos de William Henry Fox Talbot*, edited by Russell Roberts, Madrid: Museo Nacional Centro de Arte Reina Sofia, 2001.

——, "Luminescence and the Invention of Photography: 'A Vibration in the Phosphorus'," *History of Photography*, 26/1, 2002, 1–12.

PHOTOGLOB ZURICH/ORELL FÜSSLI & CO.

Photochromy is a lithographic printing process for disseminating photographs via colour printing off several stones, a combination of collotype and chromolithography for the production of "photolithographic polychrome half-tone images." The process consists of the direct photographic transfer of an original negative onto litho and chromographic printing plates and is most commonly known by its commercial name of "photochrom."

Whilst Lemercier had experimented with an analogue process in the 1860s, and Vidal's process enjoyed limited dissemination in the 1870s, neither enjoyed commercial success Breakthrough occurred in the mid-1880s when a lithographer in Zürich, Switzerland experimented with the process successfully enough for Orell Füssli & Co., then a leading firm of banknote and map printers, to decide to incorporate it into its development and manufacturing plans. The first photolithographic polychrome half-tone prints produced by the firm in 1886 were always subsequently described as the firm's own invention, while the identity of the actual inventor was never mentioned in the firm's catalogues or other publications. The unheralded inventor was in fact Hans Jakob Schmid (1856–1924), a lithographer from Nürensdorf. He worked at Orell Füssli and Co. from November 1876 onwards, initially as a lithographer, then as a machine minder. After an experimental phase, a patent application was filed for the new process in Austria-Hungary on 4 January 1888.

Due to the business acumen of Heinrich Wild-Wirth (1840–1896), partner in the firm since 1873 with his brother Paul Felix, and, from 1890, chairman of the board, the photochrom process was widely disseminated and achieved unparalleled success in the market for colour photographs. The trading company Photochrom Zürich, founded in 1888 to exploit the process, incorporated the collotype printers and publishers Schröder & Co. in 1895. The company thereafter traded as Photoglob Co. (since 1974 Photoglob AG) and is still active, especially in the postcard business, as a subsidiary of Orell Füssli Graphische Betriebe AG. The Photochrom Co. Limited was established in London in 1896 as successor to the London office of Photochrom Zürich, set up in 1893. An identically named subsidiary in Detroit produced and marketed photochrom prints in America,

with the collaboration of William Henry Jackson. The photochrom market transformed the firm into an international concern.

The photochrom production process required the participation of four different specialists: photographer, chromolithographer, stone-polisher and planographic printer. The grained litho stone was coated with a thin layer of bitumen purified in ether and dissolved in benzene. On this light-sensitive surface, a reversed photographic half-tone negative was firmly applied, with the sensitized side face down. By means of exposure to daylight, lasting 10 to 30 minutes in summer, up to several hours in winter, the bitumen would harden in proportion to the action of the light, rendering it insoluble to normal solvents. Then the lithographer or photochrom operator washed the bitumen matrix in various acid-free turpentine solutions, soaking off the soft bitumen in proportion to the amount of exposure the plate had received. The matrix was then retouched painstakingly with cotton wool tabs or a badger's hair brush, in the tonal scale of the particular colour, strengthening or softening the tones as required. The gradation of the positive bitumen image could be strongly influenced by this manual procedure.

Following the chemically worked transformation of the photographic half-tones into the grain structure of the stone surface, the polisher treated the developed image with finely powdered pumice stone, for grinding the surface grain smooth. Readying the layer for subsequent etching remained a long guarded commercial secret. The prepared stone, with its highly resistant etching surface, was, according to this method, degreased with a solution of 1° to 3° nitric acid, as for normal litho stones, the image area repulsing the acid, then washed clean, dried, coated with moisture-bearing gum arabic, and dampened. After the fatty lithographic colours had been applied by roller, the stone was then ready for printing off. Each tint required a separate stone bearing the corresponding retouched image, and each print was usually the product of at least six, and as a rule between 10 and 15 tint stones, and thus an equal number of pulls through the press. An initial print run of "upwards of 150 to 200 impeccable prints" (*Photographische Correspondenz* 1888, 498) soon increased; individual print-runs are unknown, but probably amounted to several thousand prints by the early 1890s.

Photochrom prints subsequently became the object of an extraordinary collecting cult, rivalling stereo views as the favoured proxy souvenir of the armchair traveller. The photochrom operators' standard output consisted of landscapes and cityscapes, the colour range of which sometimes proved to be either too muted or too harsh in the early years, but then settled down to present all corners of the globe in a uniform photochrom style of characteristically slightly hazy watercolour tints. Pho-

tochrom Zürich was early on offering more than Swiss views—by 1891 it was supplying views of the Riviera, the Rhine valley, Italy, France, and Britain. The company was soon sending its own photographers out throughout the continent to take views of sites and monuments. In January 1896, the company's stock included 3,000 European subjects. A standing exhibition was opened in central Zürich "to give everyone the opportunity to view our whole picture collection and, on that basis, put together a travel itinerary."

Around this time the scope of the collection was broadened to include views from North Africa, Turkey, Syria and Palestine, India, Russia, and the United States, later Central and South America, adding Persia in 1911, alongside China, New South Wales, and New Zealand. The "P.Z." logo in gilt lettering on each print, standing for Photochrom and Photoglob Zürich, together with a caption and inventory number, served as an instantly recognisable trademark.

Prints were available in seven sizes, the majority in sizes II (16 × 12 cm.) and III (21 × 27 cm.). The mounts were available in six different designs: black with bevelled gilt edges, olive with broad gilt ruling, plain light grey with the print recessed, grey matt frame, washable enamel mount on laminate base, and on glass. An ideal photochrom library for the systematic collector in 1899 included a solid oak cabinet, with compartments designed to house 34 albums of 200 prints each—a total of 6800 prints.

Photochroms may be considered to constitute a significant achievement in printing technology wedded to dynamic marketing in the field of popular landscape imagery. After the First World War, which brought an end to the cult of this type of collecting, Orell Füssli's main output consisted of poster printing and high value art reproductions in the photochrom process. The last photochrom operator retired as recently as 1970. Orell Füssli Verlag AG is now a leading multi-media publishing house headquartered in Zürich. The trading arm Photoglob AG specializes in the distribution of maps, albums, illustrated works and guide books of Swiss interest.

About 10,000 unmounted photochrom prints are housed in the print collections of the Zurich Central Library, an annual donation by the Art Institute Orell Füssli and its subsidiary Photoglob Co., from 1891 to 1914, of that year's complete output.

STEVEN F. JOSEPH

See also: Collotype; Lemercier, Lerebours & Bareswill; Vidal, Léon; and Jackson, William Henry.

Further Reading

Southall, Thomas W., *"In the Colors of Nature: Detroit Publishing Company Photochroms."* In *Intersections: Lithography, Photography, and the Traditions of Printmaking,* edited by

Kathleen Stewart Howe, 67–75, Albuquerque: University of New Mexico Press, 1998.

Weber, Bruno, "Mit Photochrom in fünf Kontinenten," *Turicum* 10 (1979): 33–41 ["With the Photochrom on Five Continents"] *The PhotoHistorian*, 133 (2001), supplement: 1–8.

——, "Rund um die Welt in Photochrom [Round the World in Photochrom]." In *Deutschland um die Jahrhundertwende*, 145–150, Zürich: Orell Füssli, 1990.

PHOTOGLYPHIC ENGRAVING

Photoglyphic Engraving is an early process of photogravure invented by William Henry Fox Talbot (1800–1877), but one that was rapidly superseded by the Talbot-Klic process of 1879. Talbot's first photomechanical invention, "Improvements in the art of engraving, in which photographic processes are used" (English. Pat. No. 565), was recorded in 1852. Talbot had discovered the light-sensitivity of a mixture of potassium dichromate and gelatin. He was the first researcher to publish the fact that chromated gelatin becomes insoluble after exposure to light and loses its capacity of swelling in cold water.

He applied this principle to a printing process that made use of dichromated gelatin coated on a steel plate prepared for engraving. When dry, the gelatin coating was exposed to sunlight under a positive image. After exposure, the parts of the gelatin coating that were not exposed to light were dissolved in hot water, leaving a relief image. The plate was then ready for etching with bichloride of platinum, which was poured over the plate. This solution would first attack the thinner parts of the gelatin relief and would leave a depression in areas that were protected from light by the positive image. This depression could be filled with ink like any intaglio plate (etchings, line engravings, etc.) and the resulting image could be transferred onto paper with a printing press.

One can easily imagine that Talbot's first results were suitable for line reproductions. For the production of prints that produced the shades of a real photograph he invented a primitive form of half-tone screen: *photographic veils*. To quote from the patent abridgement, "To produce the effect of engraved lines or of uniform shading, the image of a piece of folded gauze, or other suitable material, is impressed upon the gelatin prior to the image of the object required being formed. Plates of zinc or lithographic stones are also readily engraved by this process." Nevertheless, Talbot himself admitted that his first photomechanical invention did not succeed in reproducing photographs with a full range of tones.

In his follow-up patent of 1858 (No. 875), he introduces new modes of etching. With the first method the picture is no longer washed, but as soon as it is removed from the copying frame it is covered with pulverized copal or other resin. This fine powder is then heated over a lamp, which makes it melt and stick to the plate.

When the plate has cooled it is etched by means of a nearly saturated solution of perchloride of iron in water; the etching being accomplished in consequence of the perchloride solution penetrating the gelatin wherever the light has acted upon it, but refusing to penetrate those parts upon which the light has sufficiently acted.

Once again, we see an idea borrowed from traditional printmaking. In this case, it is the old aquatint etching process invented in the 1760s by J.B. Le Prince (1734–1784). With this intaglio process a full scale of tone is obtained by etching a multitude of extremely small pockmarks in a random manner on the printing plate. Niepce de Saint-Victor had documented the use of the aquatint grain in his *Traité Pratique de Gravure Héliographique* (Paris, 1856, 44).

In another variant of the etching process, the exposed picture is washed in warm water before receiving the resin powder. Another method made use of an electrotype etching. Specimens of Talbot's new processes appeared in *Photographic News* in 1858 as reproductions of photographs of Spain, France and elsewhere by Soulier and Clouzard. William Crookes, the publisher of *Photographic News*, was quite impressed by Talbot's new invention:

> We have recently been favoured with the inspection of some new photographic prints, or to speak more correctly, PHOTOGLYPHIC ENGRAVINGS, executed by a new process, the result of experiments made by Mr. H. Fox Talbot. By means of his invention common paper photographs can be transferred to plates of steel, copper, or zinc, and impressions printed off afterwards with the usual printer's ink. The plates engraved by this mode are indeed beautiful in themselves as photographs, and will bear strong microscopic inspection, the most minute detail being given with astonishing fidelity. They are free from many of the imperfections which were so evident in former attempts, and the manner in which the half-tones are given is really wonderful; the specimens are of various subjects, showing the perfection which can be obtained in any branch of pictures. Even in these copies the detail is so fine that when a powerful microscopic power is brought to bear on them, we are enabled to trace the names in the shops in the distance, and easily read the play-bills in the foreground, and this in a picture only a few inches square, while the minuteness in architectural subjects is most remarkable. In a view of Paris there is all that can be desired in half-tones, and the perspective is almost as good as in a photograph.

The new invention was named "Photoglyphic Engraving" by Talbot and led to a considerable amount of activity among experimenters. It eventually evolved in what became known as the Talbot-Klic process, which was introduced in 1879, two years after Talbot's death.

This process is also referred to as heliographic etching with chromated gelatin process, photographic

etching, photoetching; photoglyphy and photoglyptic engraving.

LUIS NADEAU

See also: Heliogravure; Photogravure; and Talbot, William Henry Fox.

Further Reading

Bull, A.J., "The pioneer work of Fox Talbot," *Penrose Annual*, vol. 37 (1935):. 63–64.

Denison, Herbert, *A Treatise on Photogravure in Intaglio by the Talbot-Klic Process*, London, Iliffe & Son, 1895, reprinted by The Visual Studies Workshop, Rochester, 1974.

Morrish, David, and MacCallum, Marlene, *Copper Plate Photogravure: Demystifying the Process*, Boston, Focal Press, 2003.

Schaaf, Larry J. (project dir.), "The Correspondence of William Henry Fox Talbot," the University of Glasgow web site.

Stannard, William John, *The Art-Exemplar. A Guide to Distinguish One Species of Print From Another with Pictorial Examples and Written Descriptions of Every Known Style of Illustration...*, 77–82, 1859..

Talbot, C.H., "Some account of Fox Talbot's process of photographic engraving," *Penrose Annual*, vol. 8 (1902–1903):. 9–16.

Talbot, H.F., "Photographic engraving," *Journal of the Photographic Society*, . vol. 1 (1853):. 42–44.

PHOTOGRAMMETRY

Photogrammetry, the art of making measurements from images, synthesizes the science of mathematics and the technology of photography. The development of photography in the 19th century, which is the embodiment of projective geometry, led to widespread development of photogrammetry for topographic and architectural measurement by the end of the century.

The mathematical basis of photogrammetry is projective geometry; initial work in this area was done by Lambert (1728–1777), with Poncelet's 1822 treatise providing a broad basis for later development. Projective geometry is a generalization of standard Euclidean geometry, with the basic axiom being that parallel lines meet in a point. This describes the properties of central perspective, in that parallel lines imaged by a lens appear to meet at the vanishing point.

Given this mathematical basis, mapping was first attempted using freehand perspective drawings from multiple viewpoints. In 1846, Aimé Laussedat (1819–1904), a captain in the French Army, experimented with freehand perspective drawings for mapping of the Pyrenees. Discovering the limited accuracy and detail from using freehand drawings, he experimented with the *camera lucida*. The camera lucida used a four-sided prism to project a view of the scene onto the drawing paper, where it could be traced by the operator. After several improvements to the device and the development of graphical techniques to produce the final map,

Laussedat produced drawings of the façade of l'Hotel des Invalides in 1849 and a topographic map of the fort du Vincennes in 1850. He named this technique *iconometrie*.

The development of photography at this time provided another method of generating perspective views, although Laussedat realized that existing cameras would not be suitable for mapping purposes due to their narrow fields of view and lack of calibrated orientation. He therefore commissioned the Paris instrument maker Brunner to construct a camera to his specifications in 1859. The camera had a 50cm focal length lens and used glass plates with a 27 × 33 cm format. The internal camera geometry was established by *fiducial marks* exposed on the plates, which allowed the reconstruction of the position of the plate relative to the principal point (intersection of the optical axis with the image plane). The first topographic map was produced in 1861 depicting the village of Buc and covering approximately 200 hectares. This and other successful mapping demonstrations led to the establishment of a French military mapping unit using Laussedat's equipment and techniques.

Albrecht Meydenbaur, a German architect, realized the potential of photography for documenting and measuring buildings. Understanding the limitations of the cameras of the time, he designed his own camera which combined stable imaging geometry with a measuring circle from a surveying instrument. His *phototheodolite* was tripod-mounted and had a wide angle lens with a 105° field of view and a 25cm focal length, imaging onto a 30 × 30 cm and later 40 × 40 cm format glass plate. Leveling screws maintained the image plane in a vertical position, thereby simplifying the graphical reduction of the data. Later versions were designed to be collapsible, to ease transportation, and with a lens which could be vertically shifted to better record buildings.

Meydenbaur's initial experiments were performed in 1867 in Freyburg-on-Unstrut, where he photogrammetrically documented the town church and topography. In a paper describing this work he introduced the term "photogrammetrie." While military applications were unsuccessful, the detailed metric information derived from his photographs proved valuable for architectural documentation. His work led to the formation of the Royal Prussian Photogrammetric Institute, whose goal was the photogrammetric documentation of German cultural monuments and which still holds a large archive of Meydenbaur's photographs.

Ignazio Porro (1801–1875), an Italian surveyor and instrument maker, developed a panoramic camera for mapping in 1858. By mechanically scanning a narrow field-of-view lens he obtained a wide field of view without the accompanying lens distortion. However, data reduction from the panoramic imagery could not

be done using the standard graphical methods; Porro therefore invented the *photogoniometer*, a telescope placed at the optical center which measured the angles at the camera position between objects in the scene. The telescope used the same type of lens as the camera, thereby canceling out the effects of lens distortion in the measurement. Later rediscovered by Koppe, this Porro-Koppe design principle has been widely used in photogrammetric equipment.

The latter part of the 19th century saw widespread adoption of photogrammetry for topographic mapping in many different countries. The first textbook on photogrammetry was published by Carl Koppe in 1889.

Data reduction was initially accomplished using graphical methods similar to those used in standard surveying. Instruments were designed to automate the operations involved in drafting, using mechanical joints to reproduce the projection through the lens. However, these approaches had the shortcoming of requiring identifiable points in each image, a difficulty for topographic mapping.

The introduction of stereoscopy and the invention of lens and mirror stereoscopes pointed to a different approach to the problem, although the first instrument to use stereoscopic viewing was not introduced until 1896 by Deville in Canada. Based on a Wheatstone mirror stereoscope, the instrument was not geometrically rigorous and was difficult to use since it required that the operator simultaneously view the stereo model through half-silvered mirrors and a physical point in the stereo space.

One of the biggest issues in applying photogrammetry to topographic mapping was the lack of a suitable viewpoint, especially in flat or wooded terrain. Laussedat conducted experiments with Tournachon (Nadar) in 1858 on using photographs from balloons, although the wet collodion process used was difficult to accomplish in a balloon. With the introduction of dry plates balloon photography became more practical and military reconnaissance operations became widespread. However, mapping presented further problems, including covering wide areas and determining the position and orientation of the photograph. Wide area coverage was achieved by using panoramic cameras or by using multiple synchronized cameras at different viewing angles. Camera position was determined using known photo-identifiable points or geometric figures on the ground, while mechanical devices were used to maintain the camera axis in a vertical orientation.

Aerial photography from kites also became common, using trains of kites carrying stabilized cameras. Cameras could be lowered to change plates without lowering the kite.

J. Chris McGlone

See also: Camera Design: Panoramic Cameras; Camera Design: Stereo Cameras; Meydenbauer, Albrecht; Military Photography; Nadar (Gaspard-Félix Tournachon); Panoramic Photography; Perspective; Aerial Photography; and Stereoscopy.

Further Readings

Albertz, J., "Albrecht Meydenbauer—Pioneer of Photogrammetric Documentation of the Cultural Heritage," *Proceedings of the 18th International Symposium CIPA (International Committee for Architectural Photogrammetry)*, Potsdam, 2001.

Blachut, T.J., and Burkhardt, R., *Historical Development of Photogrammetric Methods and Instruments*, Bethesda: American Society for Photogrammetry and Remote Sensing, 1989.

Doyle, F.J., The historical development of analytical photogrammetry, *Photogrammetric Engineering*, 30(2):259–265, 1964.

Koppe, C., *Die Photogrammetrie oder Bildmesskunst*, Weimar: Verlag der Deutschen Photographen-Zeitung, 1889.

Meyer, R., 100 Years of Architectural Photogrammetry, *Kompendium Photogrammetrie*, Vol. XIX, Leipzig: Akademische Verlagsgesellschaft, pp. 183–200.

McGlone, J.C. (ed.), *Manual of Photogrammetry*, Fifth Edition, Bethesda: American Society for Photogrammetry and Remote Sensing, 2004.

PHOTOGRAMS OF THE YEAR (1888–1961)

Photograms of the Year began as the November 1894 issue of the British journal *Photogram*. In the inaugural issue, the editors wrote of their hopes for a separate, more fully realized volume the following year. Devoted to photography "as a means of artistic expression fully up-to-date," the stated aim of the publication was to review exhibitions in England and the United States and reproduce a representative selection for critique. Henry Snowden Ward and Catharine Weed Barnes Ward, editors of the *Photogram*, started the annual. Both had extensive experience as photographers, writers, and editors of other photograph magazines, and their names were well-known in photographic circles in the United States and England. They knew many influential photographers and writers, and were able to engage people like A. Horsley Hinton, editor of the British journal *Amateur Photographer* and author of several books on photography; writer and master of the gum-bichromate process, Robert Demachy and Alfred Stieglitz, leader of the American Photo-Secession, to write articles.

The annual emerged out of the photography movement known as pictorialism and art photography that began in the last decade of the 19th century. Until World War I, the title positioned itself in the center of that movement in Europe and the United States and played a secondary role in the dialogue about the nature of artistic photography stirring the photographic world at

the time. The audience for the journal was the serious amateur photographer who wanted to perfect his craft, and aspired to make a photograph situated within an artistic tradition. The reviews made a point of aesthetic analysis, and in the first issue, the Linked Ring exhibition was lauded for showcasing expressive photographs that eschewed technique over purer artistic aspirations. In these early years, the annual reported on the latest artistic developments, and followed the careers of the major international figures—with news and reproductions of works by important British photographer H.P. Robinson, pioneering American Alvin Langdon Coburn, venerable Baron Adolf de Mayer and newcomer Edward Steichen. Exhibitions large and small were covered, along with the groundbreaking salons at the turn of the century, including the Photographic Society of Philadelphia Salons and the Photo-Club de Paris. This focus on exhibitions would remain throughout the life of the title. As the annual was published in Great Britain, the yearly Royal Photographic Society exhibition and other British displays were covered, along with reports and analysis of the year's exhibits in Europe, the United States, Canada, Australia, South Africa, and Japan. With the exception of a few lead articles on more general topics, the body of the journal was given over to geographically centered assessments of the state of artistic photography and critiques of the numerous reproductions published in every volume. The editors also opened the pages to works from readers for review.

The annual remained devoted to pictorial photography and the salon movement for close to 70 years. As the international art world changed, and pictorial photography was no longer considered the most progressive form, the emphasis of the periodical shifted to the myriad small photographic societies that cropped up in every major metropolitan area as well as smaller cities and towns. These groups kept the pictorial photography movement alive in the 20th century. In 1961, the title changed to *New Photograms*, and contained the expected reviews of exhibitions worldwide and analysis of individual works. But the editor gently criticized pictorial photography for being somewhat conformist and lacking in vitality. He announced an expansion of content to embrace less conventional aspects of the genre, including photojournalism and more experimental works. Curiously, this was be to the last volume.

BECKY SIMMONS

See also: Ward, Henry Snowden; Ward, Catherine Weed Barnes; Hinton, Alfred Horsley; Amateur Photographer (1884–); Demachy, (Léon) Robert; Stieglitz, Alfred; Art Photography; Pictorialism; Brotherhood of the Linked Ring; Robinson, Henry Peach; Coburn, Alvin Langdon; Steichen, Edward

J.; Photo-Club de Paris; and Royal Photographic Society.

Further Reading

Harker, Margaret, *The Linked Ring: The Secession Movement in Photography in Britain, 1892–1910,* London: Heinemann; A Royal Photographic Society Publication, 1979.
Keller, Ulrich F., "The Myth of Art Photography: A Sociological Analysis," *History of Photography*, vol. 8, no. 4 (Oct.–Dec.1984): 249–272.
Le Pictorialisme en France, Paris: Editions Hoëbeke/Bibliothèque nationale, 1992.
Le Salon de photographie: Les écoles pictorialistes en Europe et aux Etats-Unis vers 1900, Paris: Musée Rodin, 1993.
Sternberger, Paul Spencer, *Between Amateur and Aesthete: The Legitimization of Photography as Art in America, 1880–1900.* Albuquerque: University of New Mexico Press, 2001.

PHOTOGRAPHIC AND FINE ARTS JOURNAL, THE

The Photographic Art Journal was published between 1851 and 1860 in New York City by Henry Hunt Snelling; the journal was retitled *The Photographic and Fine Arts Journal* in 1854. The publication was the second photographic trade journal produced in the United States (following behind the *Daguerrean Journal*, later *Humphrey's Journal*), and offers insights into the development of the daguerreotype to the age of collodion in the United States, with particular focus on New York City in the age of Mathew Brady.

The journal's view of photography aligned it more with the fine arts than the scientific approach to photography advanced in the pages of *The American Journal of Photography* and *Humphrey's*. "Photography," Snelling wrote, was viewed "too much as a mechanical occupation...In too many instances men enter into it because they can get nothing else to do; without the least appreciation of its merits as an art of refinement, without the taste to guide them and without the love and ambition to study more than its practical applications." Such a narrow interest neglected both the sciences "drawing, painting and sculpture, sister arts, a knowledge of which [would] elevate taste and direct the operator into the more classical walks of his profession," Snelling wrote in the first issue of 1851. He wrote of his concern with the moral elements of the daguerrean art but the journal also serialized technical manuals like Philip Delamotte's *The Practice of Photography* and Désiré van Monkhoven *Photography on Collodion*.

Like its contemporaries, the journal relied on reprints to fill its pages, drawing widely from publications as diverse *as Hunt's Merchant's Magazine*, the *London Art Journal* and *La Lumiere* on such topics ranging from forgery to photographic chemistry. A series of unsigned

articles, "Photographic Galleries of America," which profiled commercial studios in Philadelphia, Washington, New York, Baltimore, Cincinnati, and Richmond in the mid and late 1850s is particularly useful for the photographic historian. Writers for the journal included Marcus Aurelius Root, the Philadelphia daguerreotypist, who published early excerpts of *The Camera and the Pencil* in its pages, and New York daguerreotypist and photographer Nathan G. Burgess.

While publishing the journal, Snelling met Edward and Henry Anthony and later became the general manager for their photographic supply business, E. and H. T. Anthony and Company. Snelling was also a photographic publisher, reprinting Delamotte's manual and T.F. Hardwich's *Manual of Photographic Chemistry*, originally published in London. Snelling himself authored *The History and Practice of the Art of Photography* (1849), *A Dictionary of the Photographic Art* (1854) and *A Guide to the Whole Art of Photography*, a gallery start-up manual (1858). Snelling sold the journal to Charles A. Seely, editor of the *American Journal of Photography* in 1860, and was subsequently less of a presence in the photographic press, although he continued to write for *The Philadelphia Photographer* and *Anthony's Photographic Bulletin* in the 1870s and the 1880s.

The journal is a frequent source of information for Robert Taft's *Photography and the American Scene* (1938, reprint 1964). Alan Trachtenberg cites the journal in his cultural history of the daguerrean era in *Reading American Photographs: Images as History, Mathew Brady to Walker Evans* (1989) and Mary Panzer, in *Mathew Brady and the Image of History* (1997), draws on Snelling's view of daguerreotypes in her cultural and photographic history of Brady's New York.

ANDREA L. VOLPE

See also: Snelling, Henry Hunt; and Brady, Mathew B.

Further Reading

Johnson, William S., *Nineteenth-century Photography: an Annotated Bibliography, 1839–1879,* Boston: G.K. Hall and Co., 1990.

Panzer Mary, *Mathew Brady and the Image of History.* Washington, D.C.: Smithsonian Institution Press, 1997.

Snelling, Henry Hunt, *A Dictionary of the Photographic Arts.* 1854, reprint, New York: Arno Press, 1979.

——, *The History and Practice of the Art of Photography.* 1849. Reprint, with an introduction by Beaumont Newhall, Hastings-on-Hudson, New York: Morgan and Morgan, 1970.

Taft, Robert. *Photography and the American Scene.* 1938, reprint, New York: Dover, 1964.

Trachtenberg, Alan, *Reading American Photographs: Images as History Mathew Brady to Walker Evans,* New York: Noonday Press, 1989.

Welling, William, *Photography in America: the Formative Years 1839–1900,* New York: T.Y. Crowell, 1978.

PHOTOGRAPHIC EXCHANGE CLUB AND PHOTOGRAPHIC SOCIETY CLUB, LONDON

During the 1850s, the exchange of photographs between some early practitioners became formalised. Two clubs are referred to as the Photographic Exchange Club and both were instigated in 1853: the Photographic Exchange Club (1853) and the Photographic Society Club (1853). Among other organisations, which advertised photographic exchanges, were the Liverpool and National Photographic Exchange Club (1856), the Architectural Photographic Association (1857) and the Amateur Photographic Association (1859).

The aim of the earliest clubs was to enlarge the portfolios of amateurs throughout Great Britain who had limited leisure to devote to photography. Clubs for the exchange of prints, such as etchings, already existed and distribution was made possible by the postal service.

Photographic exchanges achieved rapid popularity because of the large number of positives that could readily be obtained from a negative.

The Photographic Exchange Club was advertised first through the pages of *Notes and Queries*, a fortnightly, antiquarian periodical edited by one of the club members, William John Thoms. The Photographic Society Club was established from within the newly formed Photographic Society of London (later RPS) and publicised in the *Journal of the Photographic Society*. In both clubs, the first issues of photographs did not take place until 1855. Some photographers participated in both exchanges.

The Photographic Exchange Club appears to have begun as an antiquarian exchange. A printed leaflet (RPS Collection, NmeN) contains a list of members and the rules of the exchange. Initially, there were twenty-one members, but ultimately twenty eight members took part in one or more exchanges. The members were Francis Bedford, W. G. Cambell, A. B. Cotton, Francis Edmond Currey, Philip Henry Delamotte, Hugh Welch Diamond, Thomas Damant Eaton, Joseph James Forrester, George Glossop, Robert Howlett, Edward Kater, John Dilwyn Llewelyn, Robert Wilfred Skeffington Lutwidge, Thomas George Mackinlay, John Richardson Major, Thomas Lukis Mansell, Sir William Newton, Lady Caroline Nevill, Lady Augusta Mostyn (nee Nevill), John Percy, Henry Pollock, Arthur Julius Pollock, William Lake Price, Henry Peach Robinson, Alfred Rosling, George Shadbolt, William John Thoms, Peter Wickens Fry was listed as a member but did not take part in the exchange.

The cost of membership was 10 shillings per annum to cover expenses. John Richard Major was secretary and treasurer. Every member sent him the requested number of copies of the same un-mounted image and he compiled and posted out a complete set of different prints to each of them. In some cases the recipient incorporated these prints into their own albums (Pollock album, Arnold Crane Collection, Getty), others mounted them on individually in a portfolio (Eaton Collection, Norfolk Record Office). Only two sets of bound exchange clubs prints are known to exist. They are the 1855 and 1857 Exchange Club albums of Lady Augusta Mostyn, which have printed title and content pages (IMP/GEH), and of Henry Peach Robinson (RPS/NmeN).

The photographic exchange operated by the Photographic Society Club produced a typographically printed album with pasted-in photographs in a limited edition of about 50. The Chiswick Press imprint and typographic design suggests that Joseph Cundall, publisher and club member was actively involved. As well as a printed title and photographer's name, each print was accompanied by technical details, such as lens aperture and exposure time, and a page of poetry or prose. Benjamin Brecknell Turner was the first secretary of the Photographic Society Club exchange, nominally, he was succeeded by Philip Henry Delamotte. Forty-four photographers contributed to the 1855 album and thirty-nine to the 1857 album.

The contributors to one or both albums were J. Anthony, A. Batson, F. Bedford, Sir J. Coghill Bart., C. Conway Jr., J. Cundall, F.E. Currey, H. W. Diamond, P.H. Delamotte, R. Fenton, J.J. Forester, G.B. Gething J. J. Heilman, T.H. Hennah, F. Horne, R. Howlett, A Kerr, Rev. J. Knight, J.D. Llewlyn, R.W.S. Lutwidge, Mary E. Lynn, Rev F S Marshall, Count de Montizion, T.G. Mackinlay, J.R.Major, J.R. Major D.D., J.L. Mansell, W.W. Nichol, Lord O'Fitzgerald, Dr Percy, Lieut Petley, W.C. Plunkett, A.J. Pollock, H. Pollock, L. Price, O.G. Rejlander, G. Shadbolt, J.Stewart, G Stokes, W.J. Thoms, H. Taylor, A. Rosling, B.B. Turner, W.E.Vivian, H. White. Operational details and costs are yet to emerge, but remaining copies of the album were available at 10 Gns (£10 10s).

The two early photographic exchange clubs set national standards for the production of photographs and they established image types for the rest of the nineteenth century. Both these exchange clubs ceased to operate after 1858. With the commercialisation of photography, many of the first generation of practitioners stopped photographing. One group, including Delamotte, Fenton and Lake Price proposed a commercial exchange, the Photographic Association (Ltd), with shareholders and management salaries. Some became members of other exchanges, Shadbolt become Vice-President of the North London Photographic Association, and, in particular, several joined the Amateur Photographic Association, which was to become the main mechanism for the exchange of photographs during the 1860s.

CAROLYN BLOORE

See also: Fenton, Roger; Fry, Peter Wickens; and Diamond, Hugh.

Further Reading

Bloore, C. and Seiberling G., *A Vision Exchanged*, London, V&A, 1985.

Photographic Album for 1855 and *Photographic Album for 1857*, IMP/GEH, RPS/NmeN. Among other collections holding copies of these albums are: Gernsheim Collection, Humanities Research Centre, University of Texas at Austin; Ottawa, National Gallery of Canada; Santa Monica, J. Paul Getty Museum.

Photographic Exchange Club albums,1855 and 1857, International Museum of Photography at George Eastman House; Royal Photographic Society Collection at the National Museum for Photography, Film and Television.

Seiberling, G., with Bloore, C., *Amateurs, Photography and the Mid-Victorain Imagination*, Chicago 1986.

PHOTOGRAPHIC JEWELRY

Jewelry that contains an image rather than a stone combines decoration (jewelry) with function (an image of a loved one). Photographs began replacing cameos and miniatures beginning with daguerreotypes. The photographic method dictated the style of the jewelry. Daguerreotypes required a glass covering and appeared in traditional jewelry such as rings, pendants, lockets, and bracelets. Tintypes took a decorative form as suspender clasps and belt buckles. The history of photographic jewelry spans from the daguerreotype to the present.

Worn by men, women, and children photographic jewelry lent itself to a variety of settings depending on sex and age. Women generally selected pins, lockets, rings, bracelets, and even coat buttons including matched sets of bracelets, earrings, and necklaces. Men favored keywinds (used to wind watches), watch fobs, rings, cuff links, stick pins, and coat buttons.

Before the late nineteenth century, all of these pieces were custom-made for specific clients with unique images. Individuals interested in owning one could purchase it directly from a photographic studio or have a jeweler insert the picture into a setting. It took skill to create the item so that the image was not damaged when set into the piece. Jewelers created specially made pieces, using precious metals and marketed them to affluent clients. Costume jewelry settings made of brass also existed. With the advent of mail order catalogs in the late nineteenth century customers could choose photo garter buckles, belt buckles, charms and buttons to show off paper prints or tintypes usually covered with a piece

of protective glass. Abraham Lincoln used a tintype portrait button for political campaigning.

J.B Dancer's development of microphotography in the 1850s created a new trend—stanhopes. A microscopic image could be included in any item including jewelry. When held to the light, the magnifying glass peephole allowed for viewing. Most stanhopes feature multiple scenes of tourist locations.

Queen Victoria popularized photographic jewelry as a symbol of mourning when she wore pieces adorned with Prince Albert's image after his death in 1861. Most mourning pieces of photographic jewelry contain a reminder of the deceased. In the period 1861–1880 photographs appeared in lockets and brooches with a swiveling compartment to hold swatches of hair or clothing. Photographer William Bambridge of Windsor created some of the first pieces worn by Queen Victoria. She also ordered a set of nine gold lockets from Garrard & Company, possibly for her children. Dancer designed a mourning ring for Queen Victoria that contained a photograph of Prince Albert attributed to John Jabez Edwin Mayall. The Queen wore jewelry with Albert's image for the rest of her life, choosing a photographic bracelet for the Diamond Jubilee.

Most of the images included in jewelry are portraits. Usually these individuals had a familial relationship with the owner of the piece. Today, most of these images are nameless and separated from the original family. Identification of the image is possible based on several factors: the type of photographic image; clothing worn for the portrait; and jewelry setting. The photographic method establishes a creation date for the piece, but not necessarily a timeframe for the image. Since different settings faded into and out of fashion, the style and type of jewelry determines when the piece was fashionable. Costume assigns a narrower span of dates based on clothing details. Any locks of hair, handwriting samples, fabric swatches, or other types of insertions behind the picture can help identify the subject of the piece. It is important to be careful when establishing a date for a piece of photographic jewelry. Later images could be set into older pieces of jewelry or vice versa. Examine the jewelry and the image thoroughly before deciding on a time frame.

Since photographic jewelry is collected both as jewelry and as photography—the two linked by their setting, it is not unusual to find the jewelry without the image. Early collectors often discarded the unidentified image. The value of a piece of photographic jewelry depends on the type of image, the metal used, whether it includes hair or other evidence, and the rarity of the setting. Lockets and pins are common with rings and keywinds the most unusual. Today, photographic jewelry is very collectible and difficult to locate.

MAUREEN TAYLOR

See also: Daguerreotype; Tintype (Ferrotype, Melainotype); Mayall, John Jabez Edwin; and Victoria, Queen and Albert, Prince Consort.

Further Reading

Bury, Shirley, *Jewelry 1789–1910: The International Era (1789–1861)* Wappingers Falls, N.Y.: Antique Collector's Club, 1991.

Dimond, Frances, and Roger Taylor, *Crown and America: The Royal Family and Photography, 1842–1910,* London, Penquin Books, 1987.

Fales, Martha, *Jewelry in America: 1600–1900.* Wappingers Falls, N.Y.: Antique Collectors Club, 1995.

Gilbert, George, with Larry West and Patricia Abbott. "Photographs to Adorn And Be Worn (The Era of Tintypes in Jewelry)." In *Photographica*, vol. 20 no. 2 (April 1991): 16–19.

Quentin, H. *Les photo-bijou : matériel et procédés employés pour l'exécution des bijoux photographiques médaillons, broches, boutons, épingles, etc.* [Photo-jewels: hardware and processes employed for the execution of the photographic jewels medallions, pins, buttons, pins, etc.] Paris: C. Mendel, 189–?.

West, Larry and Patricia Abbott, "Daguerreian Jewelry: Popular in Its Day." In *Daguerreian Annual* (1990): 136–140.

West, Larry J, and Abbott, Patricia A (with contributions by Grant Romer, Joan Severa, and Joyce Jonas), *Antique Photographic Jewelry: Tokens Of Affection and Regard*, New York, West Companies, 2005.

PHOTOGRAPHIC NEWS (1858–1908)

The *Photographic News* was an important agent in the popular dissemination of photographic knowledge. It commenced publication as a weekly journal on September 10, 1858, selling for 3*d.* unstamped or 4. stamped. The first issue consisted of twelve pages of text and six pages of adverts. Unlike the pre-existing photographic journals, the *Photographic News* was not the organ of any of the London or regional photographic societies.

The success of the *Photographic News* was a product of the growing number of professional practitioners in the late 1850s. As the introductory address of the second volume claimed, "the *News* has done what other journals of similar character failed to do; made photography a subject of interest to the public generally" ("Preface" iv). The range of subjects covered by the journal made it more lively and readable than its principal competitor, the *British Journal of Photography*. It quickly established a successful format that was to last until the mid 1880s. In these years it also produced an accompanying publication, *The Yearbook of Photography and Photographic News Almanac*. The main areas covered by the journal were technical improvements and instruction; notes and queries; critical reviews of literature and exhibitions; trade gossip; and reports from the photographic societies of Britain and Europe.

The first editor of the *Photographic News* was William Crokes, a distinguished chemist who was also

secretary of the Royal Institution. After January 1860, the journal was edited jointly by Thomas Piper and George Wharton-Simpson. Simpson remained as editor until his sudden death in 1880, having also become sole proprietor of the journal in 1860. It was under Simpson's imprimatur that the *Photographic News* was the leading photographic journal. Simpson provided excellent reports of international developments in photography and introduced many contributors who subsequently became well-known photographic figures. These included Henry Peach Robinson, A.W. Vogel and Colonel Stuart Wortley. After Simpson's death, the journal was taken over by H. Baden Pritchard, the head of the photographic department at the Royal Arsenal, Woolwich. Pritchard introduced the illustration of photographs and the *Photographic News* is a significant historical record of early forms of photomechanical reproduction.

The *Photographic News* was at its most influential from the late 1850s to the mid 1880s. During this period, its readership was predominantly made up of professional photographers. It was the increasing ease with which photography could be carried out, combined with the corresponding increase in the number of amateurs, which meant the alteration and subsequent slow decline of the *Photographic News*. In 1884, Pritchard died and Thomas Bolas became editor. In 1891, Pritchard's widow sold the journal to T.C. Hepworth, who attempted to make the journal much more attractive to amateur photographers. In 1892, it changed proprietors for the final time and reformatted itself as primarily a paper for amateurs. Trade gossip gave way to a weekly competitions and pictorial analysis. Subsequent editors were E.J. Wall (1897–1902), Richard Penlake (1902–1906) and F.J. Mortimer (1906–1908). The journal finally ceased publication in 1908 when it was amalgamated with the *Amateur Photographer*.

JOHN PLUNKETT

See also: British Journal of Photography; Robinson, Henry Peach; Vogel, Hermann Wilhelm; and Pritchard, Henry Baden.

Further Reading

Seiberling, Grace, and Carolyn Bloore, *Amateurs, photography and the mid-Victorian imagination*, Chicago: Chicago UP & International Museum of Photography, 1986.
"Fifty Years of the Photographic News," *Photographic News* 8 May 1908: 446–447.
"Introductory Address," *Photographic News* 10 September 1858: 1.
"Preface," *Photographic News* 2 September 1859: 4.

PHOTOGRAPHIC NOTES (1956–1867)

Edited by Thomas Sutton (1819–1875) the 'indefatigable experimenter and journalist' (*British Journal Photographic Almanac* 1876, 22) *Photographic Notes* appeared on 1 January 1856 and ceased publication in 1867 when it merged in February into *The Illustrated Photographer* which started publication that same month. During the early part of its life it was associated with Blanquart-Evrard who wrote occasionally for it, and with whom Sutton worked, and it became the house journal for the Manchester Photographic Society, Photographic Society of Scotland and Birmingham Photographic Society. The editorial content of *Photographic Notes* reflected the preferences and prejudices of its editor and Sutton was not afraid to voice opinions that other contemporary publications would not—notably against the Photographic Society of London.

The first numbers of *Photographic Notes* appeared in January and February 1856, published in Jersey by Sutton and Blanquart-Evrard from St Brelade's Bay, Jersey where Sutton was resident and ran his own photographic printing works. The publication was more successful than Sutton had anticipated, for a second edition of these numbers was published on 1 May 1856 in a 'remodelled' form 'suppressing two or three articles of minor importance.' A third edition was also published of numbers 1 to 4. Throughout the earlier period of the journal, revised or combined editions of particular numbers were issued.

Sutton described the journal as being ready to report the proceedings of photographic societies in the United Kingdom; to include notices of matters relating either to the theory or practice of photography; at the service of the professional and amateur photographer; to include extracts from foreign journals; and leaders that will contain a resume of the photographic views and a discussion of the photographic topics of the day. He concluded 'in offering our own opinions, we wish it to be understood that we invite discussion'.

In issue 5 of 25 April 1856 Sutton reported that *Photographic Notes* had 'obtained a circulation more than half that of the Journal of the Parent [the Photographic of London] Society.' The May issue reported that it had been adopted as the journal of the Photographic Society of Scotland and in June that the Manchester Photographic Society had adopted it. The Birmingham Photographic Society adopted the journal from early 1857. Monthly publication was stopped in favour of fortnightly publication on the 1st and 15th of the month from 1 September 1856. With issue 13 of 15 October Sutton reported that circulation had 'received a sudden increase' and that numbers 3 and 11 were out of print and that 4 and 12 nearly so. He would be reprinting back numbers and increasing the print run.

Sutton did not include material already published in other British photographic journals, principally the *Liverpool Photographic Journal* (later the *British Journal of Photography*) and the *Journal of the Photographic*

Society and in October 1857 attributed the success of *Photographic Notes* to the fact that it did not copy articles and the demise of the *Photographic Record* and *Liverpool Photographic Journal* to copying. He claimed to address the 'whole class' of British photographers and not certain sections. He did include material that he consider useful from French and American journals on occasion and by early 1858 was making arrangements to distribute *Photographic Notes* to America.

The contemporary view of the *Photographic Notes* is best summed by J Trail Taylor writing in the manuscript journal *The Photographer* and reproduced in *Photographic Notes* (15 June 1857) 'Photographic Notes, from the beginning, has occupied a high place' and reflects the individuality of the editor 'who is everywhere present from the title page to the closing advertisement. He writes as he thinks, and his honesty may be relied on, for the he seems ever ready to retract what he finds erroneous.' For this reason *Photographic Notes* provides a useful alternative to contemporary debates and issues and in it's early years it's frequency gave it a topicality not enjoyed by its rivals.

MICHAEL PRITCHARD

See also: Blanquart-Evrard, Louis-Désiré; and Sutton, Thomas.

Further Reading

Gernsheim, Helmut, *Incunabula of British Photographic Literature*, London, Scolar Press, 1884.
Koelzer, Walter, *Photographic and Cinematographic Periodicals*, Dusseldorf, Der Foto Brell, 1992.
Photographic Notes, Thomas Sutton, 1856–1867.

PHOTOGRAPHIC PRACTICES

Photography in the 19th century was very much a practice, from the studio or the photographic van to the card album and photolithographic publication. The following presentation will concentrate on practices involving the use of photographs, a vast topic in view of the formidable spread of photography in the 19th century.

The 19th century viewed, appreciated and used photographs not just as images but as objects. Because of the amount of investment, technique, and effort that was required to produce a satisfactory and durable photograph, and because the overwhelming majority of photographs produced were portraits, photographs were treated not just as valuable images but as precious objects, especially in the early days. This was particularly true in non-reproducible processes such as the daguerreotype and its later imitation the ferrotype, or tintype. The daguerreotype, nicknamed "silver plate," sometimes hand-colored and often gilded, was inherently a precious object, and visitors to some of the more ambitious daguerreotype "galleries," such as Mathew Brady's in New York, regularly described them as fairy-like, glittering palaces. More commonly, daguerreotypes and tintypes, because they were single images with hard metal bases, usually small, and generally portraits, invited procedures of preservation and exhibition that tended to define them as both relics and ornaments. Thus the finished daguerreotype or tintype would be framed and inserted in a wallet or case, often decorated on the outside and lined with red or purple velvet inside. This made it possible to mail the picture or to carry it along, as soldiers often did, but also to display it and treasure it, in the same fashion as miniature paintings had been earlier. In the era of the daguerreotype, when obtaining a portrait of oneself or of one's family or friends was a rare and a costly occurrence, and since such portraits had a very strong sentimental value, likenesses of loved ones were prized objects that expressed a combination of feeling, novelty, and prestige, as indicated by early daguerreotypes with sitters holding another daguerreotype portrait. Daguerreotypes were shown in the sitting-room, sometimes carried to formal occasions, but also sent as gifts to far-away friends and relatives, even across oceans, and the action of opening the case added solemnity to the experience of seeing a face that might not have been known beforehand. From 1840 on, the business of daguerreotype frames and cases was one of the most successful and creative activities deriving from photography. Although the demand for cases faded with the decline of the daguerreotypes in the 1850s, it picked up again with the popularization of the tintype. Historian Robert Taft reported a case of an American manufacturer receiving an order in 1862 from a single operator for 3000 gross of these cases. A cheaper form of presentation for tintypes was to mount them in envelopes with a window for viewing the picture. A related practice, although rarer and more status-conscious, was to insert miniature daguerreotype portraits of beloved ones or spouses in various kinds of jewels, such as pocketwatch cases and brooches. All of these practices amounted to a kind of framing, by which the emotional appeal of the picture was at the same time highlighted and confined. Similarly, and in keeping with the constant 19th-century association of photography with the memorializing of the deceased, portraits of loved ones in daguerreotype, and then in tintype as well as in photographs transferred onto ceramic bases, were often placed on graves, and patents for the fastening of such effigies on tombstones were taken out starting in the 1850s. These ritualistic, almost religious, uses were also common with paper photographs later in the century, as is evident from mentions of them in novels such as Thomas Hardy's *Jude the Obscure* and especially Marcel Proust's *Remembrance of Things Past*, where the ordinary seductions of photographs are

Pécarrère, Pierre Emile Joseph.
Chartres.
The Metropolitan Museum of Art,
Gilman Collection, Purchase,
Anonymous Gift, 2005 (2005.100.37)
Image © The Metropolitan Museum of
Art.

a recurring motif. As a whole, however, the private cult of photographs was only the most visible aspect of a very general tendency of 19th-century culture to treat photographs as objects.

The case of paper prints obtained by the various negative-positive processes deserves special attention, because they were the most common kind of photographs after 1855, and because they would naturally seem to function more as images and less as objects. They too were nonetheless subject to the logic of objectification, partly because, like daguerreotypes, they remained rare and precious possessions, but partly also because they seemed almost too immaterial to function culturally without some sort of "hard" environment. First of all, finished prints of any quality were rarely left unmounted. As if a paper photograph had been too thin or too fragile an object to exist on its own, it was systematically mounted, usually on cardboard, but sometimes on wood or glass. The typical professional mount was not just a material base, but also functioned as a marker, serving to integrate the pictures in social and cultural networks. Very often mounts included the name and location of the studio or of the organization the photographer belonged to, as well as some decorative lining or frieze along the edges of the picture, while the back might present more information about the studio, quippings from the press, or advertisements for other businesses; in the case of commercial or archival views, captions and information about places would also be included. Large, deluxe, or specially significant prints would be framed and displayed, like daguerreotypes, while the more common photographs were kept in boxes and, of course, albums, which were sold by many specialized businesses. After 1855, the mass production of carte-de-visite portraits and stereographic views induced specific procedures of storage and display, and encouraged collecting and exchanging practices that spread quickly through the upper classes of society; the relative uniformity of formats and mounts was something like a standard, facilitating filing and circulation. The

very concept of the carte-de-visite as a kind of visual identity card engendered the related concept of the card album with slots of uniform size for sliding in cards, and by 1880 socially prominent families would often have collected enough cards to fill several of these 100- or 200-card albums. Similarly, the standardized format of stereoviews was intended to fit in popular stereoscopes and special boxes, which might typically hold fifty stereoviews, a number that is probably indicative of the extent of an ordinary stereo collection in a well-to-do urban household around 1875. Amateur photographic clubs developed in some cases as arenas for exchanging, comparing, and discussing stereoviews and other pictures; the same would be true, around 1900, for illustrated postcards, which in many ways continued the tradition of 19th-century photographic collections, while introducing photography into the realm of private correspondence. Finally, one of the more significant types of photographic object produced in the 19th-century was the photographically illustrated book, a category that actually covered a wide array of techniques and practices, from hand-made and hand-captioned single-copy photographic albums to full-fledged publications including photographic prints or, more commonly, photolithographs. Although photographic books are not the subject of this entry, it is worth mentioning here that the whole association of photography and paper, from William Henry Fox Talbot's research on, was geared precisely at making photographs that would be compatible with the space and economy of books and more generally printed matter, thus emphasizing their iconic, iconographic, and informational dimensions, as opposed to their materiality and their exhibition value as separate objects. At the same time, the urgency and difficulty of this association of photography with the book also hinted back at the resilient materiality of photographs, a factor one needs to take into account in order to understand more generally why so much of 19th-century photographic practice tended to treat photographs as objects.

One of the typical features of 19th-century photography is that it nourished the desire of producing a total illusion of reality—of replacing real things with images that were as life-like as possible—with a still primitive state of technology, which could only produce this illusion by resorting to and often paradoxically foregrounding its own infrastructure of objects, materials, and tools. Some of the more obvious examples of this paradox are panoramic photography, magnesium lighting, and especially photosculpture, a pre-holographic technique that was devised as early as the 1850s and that consisted of sculpting, with the help of a pantograph, from several photographs of a given subject taken at different angles. The three-dimensional illusion was more ordinarily realized after 1860 by stereophotography, and in this case

also all the paraphernalia that surrounded the production as well as the contemplation of stereoviews functioned as a framework for the rapturous experience of seeing "solid pictures" or "sun sculptures." According to Oliver Wendell Holmes's famous dictum, with stereography "form is henceforth divorced from matter," and "matter as a visible object is of no great use any longer, except as the mould on which form is shaped" ("The Stereoscope and the Stereograph," 1859). The "mould," in this case, included the mounted cards and every aspect of their production, as well as the stereoscope itself, and the various implements used to store and transport the cards. Another striking illustration of photography's materiality is the fact that glass remained for much of the century, and into the 20th, the dominant base in negative-positive processes. The glass processes perpetuated preciousness, weight, and fragility as inherent characteristics of photography. Meanwhile, the unfeasibility of enlargements called for a scale of equipment, production space, and transportation that, with the increasingly large formats practiced by landscape photographers especially, could only emphasize the "hardware" aspect of the medium, and therefore its visibility as a technology, as opposed to its semantic and artistic dimensions. The materiality of photographs, however, was not just the result of technological constraints; rather, it should be seen as a cultural framework that governed much of the technological evolution itself, as is shown by countless 19th-century experiments on adapting photographs to virtually every type of base or surface, a spectacular example being the cyanotypes on cloth used by American home quilt-makers after 1880. Although "blueprint" quilts served memorial functions, it often seems that the production of photographic objects—i.e., the actual transformation of images into objects—was a goal in itself, beyond whatever social uses may have been intended. As a result, although photography as an abstract entity was called upon as a tool of truthful illustration, decoration, or commemoration, the very diverse objects it was produced with and applied to consistently advertised the parallel or parasite message of its own technicality and materiality.

After the realm of private practices, comparable observations may be made about many 19th-century institutional practices wherein the acquisition, accumulation, and conservation of photographic archives seem to have obeyed a self-justifying logic, whether or not actual utilitarian or documentary benefits can be ascribed to these archives. Strictly commercial interests, such as those of railroad companies and early tourist businesses, would justify investments in photography as a tool of illustrating landscape and thus promoting a firm's service. In the United States, the major railroad companies sometimes outfitted a special photographic car that served as an exhibition and sales room for views

of scenes along the way. Similar justifications can be adduced for the photo-sessions and group picture opportunities that started to appear after 1860 in organizations of every kind, from army regiments to school faculties, for which photography provided collective or corporate visual identities. At the same time, however, vast quantities of photographs were produced and accumulated with little ascribable justification under the aegis of armies, government agencies and other educational, scientific or medical organizations. Collections such as those of French and British expeditionary photography to the Middle East and the Far East, or those of U.S. surveys in the American West, are often loosely labeled "documentary." Yet beyond the general notion that they reflected colonial or strategic motivations, it is often hard to account precisely for their purpose, except by suggesting that the constitution of a photographic archive was a self-justifying practice, or a sign of modernity and technicality, which was as such suitable to illustrate the efficiency of the organization that produced it. Such archives were routinely described to budgeting authorities in terms of numbers of items secured, as opposed to informational content. Most of these photographic collections never reached the general public, or were only briefly and partially shown at exhibitions. In some cases, however, as with some of the U.S. federal surveys of the American West after 1865, photographs and especially stereographs were distributed or sold to the public, and special services were created to that effect, in response to an explicit public demand. Whether or not they were distributed, however, these large photographic collections induced procedures of archiving, cataloguing, serializing, captioning, describing, and in some cases publishing, which are historically significant as such, for they amounted to early systems of photographic documentation. Such documentary ventures contributed to making photography a customary adjunct to almost every undertaking of description, identification and analysis of visible phenomena, to the extent that around 1880 the photographic representation of many subjects had become an integral part of their cultural perception. This perception was often framed by and limited to one particular image which tended to function as an icon, as in the case of portraits of great historic figures (Queen Victoria, Napoleon III, Abraham Lincoln, Victor Hugo, etc.) that were also carried in engraved form by illustrated magazines and even reproduced as postage stamps. But it was no less common for photographic representation to emphasize accumulation, multiplicity, and seriality. Thus, the abstract concept of photography as an apparatus of truthfulness was enacted either through the treasuring of memorable icons or through the accumulation of many different views, but both practices reflected an aspiration to obtain total depiction of the visible world.

Yet for a variety of reasons, one of them being that no single photograph or collection of photographs could produce the total view that the idea of photography seemed to promise, many 19th-century photographic practices embodied the opposite assumption that photographs as such were incomplete messages, semantically deficient, particularly because lacking in context. The photographically illustrated book was only one major example of practical and discursive apparatuses that served to endow photographs with meaning, and which consistently surrounded the apparition of photographs in social life. Mounts with imprinted serial numbers, captions, and decorative motifs, and the ideal picture collections that they referred to, were more common manifestations of a general practice (which in fact predated photography) of anchoring visual messages in textual and more generally cultural contexts. Thus, the scope of large-scale institutional ventures such as the expeditionary photography campaigns already mentioned could only be legitimized by ascribing the thousands of photographs gathered to didactic, memorial or scientific purposes, even though as noted above the mere achievement of these large collections appears to have served as de facto justification in many cases. In these large-scale documentary ventures, pictures were often made or presented in serial form (for instance in albums, sets of stereoviews, or descriptive catalogues that were used for marketing prints), emphasizing a requirement for descriptive exhaustiveness that nonetheless remained a utopia. Many procedures of photographic description, such as multi-plate panoramas and grouped views of the same subject from different angles, answered the same concern for a totalizing depiction, while at the same time acknowledging failure to achieve it and denying the sense of self-containment that would, in the 20th century, be associated with a great photograph. In more specialized uses such as police and medical records, the specific methodologies of picture-taking, filing, and comparison that were devised in the late 19th century aimed at bringing out clues or signs that photographs of a more lay kind, or considered in isolation, would not convey. Meanwhile, in many ethnophotographic collections the actual documentary content was largely if not exclusively a function of captioning and commentary. Exhibitions of photographs, especially in the context of world fairs, often grouped them by process and then by topic or geographical area, rather than by author or style, and thus they interpreted pictures not on formal or even strictly technical grounds but in relation to what they represented, and to what in 20th century art-historical terms would be considered external categories. It should also be remembered that for most of the 19th century photographs were structurally incomplete with respect to the printed media, which could not incorporate them

without transferring them into some printable form. 19th-century photographs had little or no public life in their original photographic appearance (except on stereocards), and instead they were reproduced in engraved or lithographed versions that more often than not, and even with semi-automated processes, transformed the visual message and impregnated it with specific intentions. Conversely, this technical incompleteness also meant that photographs were like raw materials, usable for any purpose, and transferable onto any base, from chromolithographs to magazine engravings to postage stamps. Finally, it is known that an artistic echo to these technical procedures was found in the practice of many painters, sculptors and even writers, who (whether or not they welcomed photography amid the sphere of art) used photographs as studies or preliminary sketches, i.e., as documents that were at the same time deficient as works of art and useful (sometimes even essential) to the creation of works of art.

In sum, the diversity, ingenuity and intensity of 19th-century photographic practices may reflect, in part, the primitive state of a technology that did not yet lend itself quite so easily to the universal uses that it seemed destined to fill. More fundamentally, however, these practices registered the oscillation of 19th-century culture between a fascination that led people to magnify and sometimes to multiply the brilliant realism of photographic images, and a reticence, or perhaps a mere lack of familiarity with the workings of photography, which caused attitudes of restraint and an urge to control or frame its power.

FRANÇOIS BRUNET

See also: Daguerreotype; Tintype (Ferrotype, Melainotype); Brady, Mathew B.; Cartes-de-Visite; Amateur Photographers, Camera Clubs, and Societies; Books Illustrated with Photographs; Talbot, William Henry Fox; Victoria, Queen and Albert, Prince Consort; and Hugo, Charles and François-Victor.

Further Reading

Frizot, Michel, (ed.), *Nouvelle histoire de la photographie* [A New History of Photography], Paris: Bordas, 1994.
Gernsheim, Helmut, and Alison Gernsheim, *The History of Photography from the Camera Obscura to the Beginning of the Modern Era*, New York: McGraw-Hill, 1969.
Newhall, Beaumont, *The Daguerreotype in America,* New York: Duell, Sloan & Pearce, 1961.
Rinhart, Floyd, and Marion Rinhart, *The American Daguerreotype*, Athens (Ga.): University of Georgia Press, 1981.
Rosenblum Naomi, *A World History of Photography,* 3rd ed., London: Abbeville Press, 1997.
Scharf Aaron, *Art and Photography,* New York: Penguin Books, 1986.
Taft, Robert, *Photography and the American Scene: A Social History 1839–1889* (1938), repr. New York: Dover, 1964.

PHOTOGRAPHIC RETAILING

From the outset, the emerging profession of photography had two distinct but associated requirements—a market place for pictures and a source of equipment and materials. Thus a photographic retail marketplace emerged catering for both requirements—outlets for the supply of the latest in equipment and chemistry, and a shop window for the photographs themselves.

Many early retailers of photographic equipment were optical instrument makers—the Parisians Charles and Vincent Chevalier made Daguerre's first experimental cameras, while Alphonse Giroux et Cie manufactured and marketed the first commercially produced daguerreotype outfits in 1839. The absence of any patent control over the design of daguerreotype cameras, however, meant that within a very few years other French manufacturers—including Chevalier and Nöel Marie Paymal Lerebours—were producing and marketing almost identical instruments at prices much lower than Giroux's original 600 franc outfit. Giroux reportedly sold all his original production run of outfits within the first few days after Daguerre's announcement of the process. That the inventor and a manufacturer/retailer should work so closely together at the dawn of a new medium may seem surprising, but Daguerre was always convinced of the success of his invention, and Giroux was related to Daguerre's wife.

Giroux had pre-sold a number of camera outfits to Berlin art-dealer Louis Sachse who had intended to become Germany's first recorded photographic retailer. He retained one of the outfits for his own use. Gernsheim (1982) recounts that, in the event, there was a delay before Sachse could sell the cameras, and was beaten to the market place by a few days by nearby optician Theodor Dörffel who had manufactured his own apparatus, and significantly undercut the Giroux/Sachse price. Dörffel's outfit—but without a lens as these were in very short supply—went on sale on 15th September 1839.

The Giroux camera was the first to be marketed and used in many European countries—at least two thousand are believed to have been sold—but was very quickly copied locally, the replicas and later improvements driving prices down by the dawn of the 1840s. The names of many of these early entrepreneurial retailers have not been preserved.

In Great Britain, J.T. Cooper, a London chemist with premises at the Royal Institution became the first person to retail papers for William Henry Fox Talbot's photogenic drawing process—with a month of Talbot's announcement of his discovery on January 31, 1839—while Ackermann & Co, a print-seller with premises at 96 Strand, London, became the first supplier in Britain to retail a complete outfit for making photogenic drawings, at a cost of one guinea. Additional supplies of paper could be purchased separately for two shillings.

In London, the business of Horne & Thornthwaite first emerged about 1841, becoming Horne, Thornthwaite & Wood from 1844, developing into a major force in photographic retailing in England, both through their premises in London, and, from the mid 1850s, through extensive advertising in the emerging photographic press.

By the mid 1840s, Richard Willats, a chemist and optician, was importing Lerebours' cameras from France into Great Britain, and even working with the French manufacturer—suggesting modifications and improvements to the design. Within a few years, the firm of T & R Willats became one of London's leading retailers of photographic materials and equipment, and the publisher of both original, and English translations of, several pivotally important early photographic manuals.

In London, one of Willats' major rivals in the photographic market place, George Knight & Sons, also published instruction manuals as well as supplying materials.

The back pages of instruction manuals often carried advertisements for the leading retailers of the day—offering the photographer a ready directory for everything photographic. Thus, for example, at the back of the 1855 edition of Philip Delamotte's *Manual of Photography*, Andrew Ross offered a wide range of cameras and lenses from his Holborn premises, as well as papers and chemicals; Horne & Thornthwaite invited readers to send for their catalogue; Dinneford & Co listed all the necessary chemicals for the preparation of wet collodion, and waxed paper; Halifax and Co. of Oxford Street, and Howard George Wood of Cheapside both offered a range of British and French papers; and Knight & Sons advertised Voigtländer's lenses.

In Manchester, England, John Joseph Pyne, originally a chemist, opened his first 'Photographic Depot' in the mid 1850s, retailing equipment and 'photographic materials from France, Germany, and America.

It is an interesting feature of early British photographic advertising that foreign goods were sold as if they had a certain advantage over locally produced equipment and materials—in London, photographer J.J.E. Mayall originally advertised his studio as the American Daguerreotype Gallery, while in Liverpool, John Atkinson advertised heavily the imported equipment and materials available from Atkinson's American Photographic Stores. Atkinson imported Scovill products—for which he was the sole English agent in the 1850s, Peck's union cases. Skelling's American Ambrotype Varnish, and 'American cases, matts and preservers in a hundred varieties' as well as a range of French products including Jamin-Darlot camera lenses.

American retailers were similarly heavy in their promotion of British and especially French products.

In America, the most notable pioneers in photographic retailing included the Scovill Manufacturing Company which had started retailing daguerreotype plates in the closing weeks of 1839, and Edward Anthony, who opened his first studio in New York in 1841 selling daguerreian apparatus and supplies as well as taking portraits. By 1846 Scovill had established a large retail outlet in New York and reportedly had become the largest manufacturer and retailer of daguerreotype plates in America. In 1847 Anthony moved exclusively into manufacture and retailing and, in 1854, published the most comprehensive catalogue of photographic equipment and materials yet produced.

Anthony's *Comprehensive and Systematic Catalogue of Photographic Apparatus and Materials, Manufactured, Imported and Sold* was prefaced with the promise that "Those who purchase of him do so from the original manufacturer, and not at second hand, or from a jobber." Not strictly true, of course, as Anthony sold a wide range of imported goods for which he was not the manufacturer—including cameras by Chevalier and by Voigtländer, blue skylight glasses, and leather daguerreotype cases from France and Great Britain.

By the early 1860s, the expanding retail market for photographic equipment and materials in New York City was dominated by four companies—Scovill, Anthony, Holmes Booth & Hayden, and J. W. Willard & Co. But there were many more retailers—the advertising at the back of the John Towler's 1864 manual *The Silver Sunbeam* occupied almost thirty pages, and demonstrated just how competitive the market place had become.

With the advent of dry plates, and of manufacturers producing plates and papers commercially, a separation gradually occurred between manufacturers and retailers, and by the late 1870s, the idea of the photography shop—destined to become a familiar sight in every town as a one-stop source of everything needed to practice either as an amateur or professional—had been established.

Early retailers of photographic images included George Lovejoy's bookshop and library in Reading, England, where images by Henry Fox Talbot and Nikolaas Henneman were sold in the 1840s.

For many years, the print shop, the bookshop and the stationers was the most usual outlet for photographs. As people travelled throughout Europe and the Americas, specialist shops, often set up by the photographers themselves, were opened to cater for the demand for photographs fuelled by a growth in tourism. The route of the Grand Tours of Europe included many locations where large format images could be purchased, and when touring in the Middle East became popular, retail premises appeared along the banks of the Nile, amongst them outlets for the works of the Félix and Adrien Bonfils, the Zangaki Brothers, Antonio Beato, Pascal Sebah and others.

Bookshops along both European and Middle Eastern tourist routes increasingly catered for the well-off visitor, with expensively produced albums of photographs. Photographically illustrated albums, as well as single unmounted prints, of such locations as Florence, Pompei, and Rome in Italy, the architectural treasures of Ancient Greece, and the treasures of the Nile were all available by the late 1850s. Italian photographers such as Alinari, and Brogi, both in Florence, catered for the art lover, selling both large format prints and cartes-de-visite of the treasures of Italy's most famous cities and galleries.

In America, as the country was opened up to tourists, the same pattern emerged, with souvenir photo booths opening at all the major attractions. One of the first was at Niagara Falls, where in the early 1850s, Platt D. Babbitt established an outdoor facility, photographing visitors against the dramatic backdrop of the Falls, but also selling 'off the shelf' scenic views as well.

When the Crystal Palace building was removed from the Hyde Park site in London and rebuilt at Sydenham, photographers Negretti & Zambra opened a retail outlet within the building for photographic souvenirs of a visit to the exhibition complex. By 1855, and the opening of the Exposition Universelle in Paris, the idea of selling photographic souvenirs at exhibition sites was well established, and Parisian photographer André Adolphe Eugène Disdéri formed a company specifically and exclusively to make and retail souvenir photographs—daguerreotypes, stereo daguerreotypes and paper prints.

Subsequent exhibitions and world fairs all had a photographic franchise, selling souvenirs of the visit, a pattern which continue past the end of the century to this day.

By the mid 1850s, the distribution of the finest images from several of the leading photographers of the day was already being handled by well-established art dealers. In London, P & D Colnaghi had established themselves as early promoters of photography, and with Thomas Agnew of Manchester co-marketed Roger Fenton's Crimean War photographs in Great Britain. Those same images were distributed and marketed in New York by Williams & Co., and in France by Parisian photographer and print-seller, Félix-Jacques-Antoine Moulin, from his premises at 23 Rue Richer.

Colnaghi's entry into the photographic retail market was belatedly reported in *The Art Journal* in 1857, which reported:

> In addition to the other departments of their extensive and very complete establishment, Messrs P. and D. Colnaghi have just completed the requisite arrangements for the productions of photographs of the highest class and of the largest size and also in every possible vartiety. We have been able to examine many of these photographs and their excellence justifies our pronouncing their appearance as a new era in art.

Colnaghi also handled the distribution and marketing of some of Fenton's photographs of the treasures of the British Museum, but in his business dealings with the museum authorities in the 1850s, Fenton introduced a number of innovative marketing approaches, including an agreement to produce negatives without charge in return for the right to sell prints himself, made after the museum's orders had been fulfilled. This culminated in the establishment of a sale kiosk in the museum foyer, where images were sold to the visiting public by Fenton's staff. The success of this venture, in addition to substantial print orders from the museum trustees themselves, kept a number of staff at Fenton's printing establishment occupied.

They later also marketed many of the works of Julia Margaret Cameron, both in large format prints, and in the increasingly popular carte-de-visite size.

The popularity of the carte-de-visite and the stereoscope turned even relatively small photographic portrait studios into retail establishments, with the rise of the album fuelling demand for images from the catalogues of leading producers such as Mayall, the London Stereoscopic Company, Nadar, and others. E.H.&T.Anthony also became distributors of cartes, with their catalogues being retailed from studio outlets throughout America and Europe.

Many studios stocked and retailed portraits of European royalty, American presidents, stars of stage and music hall, and other celebrities.

With poor copyright protection for photographs, however, many of the sales thus achieved did not benefit the original photographers, with copies rather than originals being offered for sale. One of the first to establish what is now recognised as 'image rights' and thus benefit financially from the sale of his 'likeness,' was Tom Thumb, who controlled the marketing of pictures of himself and his family.

For much of the 19th century, the photographic exhibition served as a successful retail outlet for images, with exhibition catalogues from the early 1850s giving a price for each image on display.

By the early 20th century, however, the retail market for photographic images had largely been transferred to the picture postcard.

JOHN HANNAVY

See also: Agnew, Thomas, and Sons; Alinari, Fratelli; Anthony, Edward, and Henry Tiebout; Babbitt, Platt D.; Beato, Antonio; Bonfils, Fèlix, Marie-Lydie Cabanis, and Adrien; Brogi, Giacomo, Carlo and Alfredo; Cameron, Julia Margaret; Colnaghi; Daguerre, Louis-Jacques-Mandé; Disdéri, André-Adolphe-Eugène; Fenton, Roger; Giroux, André; Henneman, Nicolaas; Horne and Thornthwaite; Lemercier, Lerebours & Bareswill; Mayall, John

Jabez Edwin; Moulin, Félix-Jacques-Antoine; Scovill and Adams; Sebah, J. Pascal and Joaillier; Talbot, William Henry Fox; and Zangaki Brothers.

Further Reading

Arnold, H.J.P., *William Henry Fox Talbot Pioneer of photography and man of science*, London: Hutchinson Benham, 1977.

Delamotte, Philip H., *The Practice of Photography* London: Photographic Institution, 1855, reprint New York: Arno Press 1973.

Gernsheim, Helmut, *The Origins of Photography,* London: Thames & Hudson, 1982.

McCauley, Elizabeth Anne, *A.A.E.Disdéri and the Carte de Visite Portrait Photograph*, New Haven and London: Yale University Press, 1985.

Towler, J., *The Silver Sunbeam: A Practical and Theoretical Text-Book*, New York: Joseph H. Ladd 1864, reprint New York: Morgan & Morgan, 1969.

Zanier, Italo, *Le Grand Tour*, Venice & Paris: Canal & Stamperia Editrice, 1997.

PHOTOGRAPHISCHE CORRESPONDENZ

Between 1888 and 1938, the *Photographische Correspondenz* undoubtedly was the most renowned magazine in photographic sciences. Any invention or scientific photographic progress mentioned in this magazine meant that it was a validated device or process. This was due in part because of its behind the scenes editor Joseph Maria Eder, then the foremost source and teacher in photographic sciences to the degree that the quality of this paper's articles had a canonic character. Before publication, any method offered, process introduced, or industrial operation presented was tested by Eder in his laboratories at the Viennese Hoehere Graphische Lehr- und Versuchsanstalt [Higher Institute of Graphic Arts and Reproduction Technology] which he founded in 1888. The shift of the magazine into photographic science was not only due to his influence but to the competition of a number of other magazines, too, which also concentrated on the publication of Fine Art imagery.

Photographische Correspondenz started in 1864 as a periodical from practitioners to practitioners. The first editor, Ludwig Schrank organized exhibitions and wrote papers for an equally sound practice in economy and arts. Fixed to ideals of craftmenship, the magazine focused on composition, lighting, posing, and the different genres of photography. Fine Art was discussed in its practical aspects, from the discussion of printing processes to questions of the copyright for photographs. From 1888 on, not only the contents of the papers changed but the illustrations and photographers as well. Any important scientist in the German speaking world who something to contribute about photography did it in *Photographische Correspondenz*, from the archeologist Heinrich Schliemann to the physicist Ernst Mach, and

a number of other unnamed astronomists. The quality of these articles culminated in the first decade of the 20th century when Theodor Scheimpflug and others published their researches for the first time in Photographische Correspondenz.

Portrait photography in the studio was the main interest of the editors and authors in the first decades of *Photographische Correspondenz*. Printing technology seemed to be the main concern in the years to follow mirroring itself in the prints accompanying the periodical itself: After 1888, most of the images were produced in Eder's school, and often new technologies of both lithographic and autotype processes were used for one issue or another. The experimental characteristic of the print preparation allowed for artistic experiments o, and therefore a number of important Fine Art photographers published their works in *Photographische Correspondenz* like Hugo Henneberg, Wilhelm von Gloeden, Heinrich Bachmann, Robert Demachy, Hugo Erfurth, Hermann Clemens Kosel, and Fred Boissonas. The contrast of the scientific approach in the articles, a bourgeois habitus in the news, and a slow approval of aesthetic developments mark the overall appearance of this magazine.

Undoubtedly too, *Photographische Correspondenz* had a number of strong competitors in the world, and in German language as well: The *Photographische Rundschau*, under direction of Richard Neuhauss, mostly managed to publish international articles in German translation earlier than *Photographische Correspondenz*, and from 1900 onwards there were a number of good periodicals exclusively devoted to Fine Art Photography, which surpassed *Photographische Correspondenz* in aesthetic quality by far. But there was no other magazine in German language that had the earliest news of scientific developments, than *Photographische Correspondenz*.

ROLF SACHSSE

See also: Eder, Joseph Maria; Schrank, Ludwig; Mach, Ernst; von Gloeden, Baron Wilhelm; Demachy, (Léon) Robert; Photographische Rundschau; and Neuhauss, Richard.

Further Reading

Photographische Correspondenz. Technische, artistische und commerzielle Mittheilungen aus dem Gebiete der Photographie, redigiert und herausgegeben von Ludwig Schrank, Wien Vol. 1, 1864 (July)—Vol. 107, 1971.

Photographische Correspondenz, from vol. 7, 1870; Organ der photographischen Gesellschaft in Wien; from vol.8, 1871, edited by E. Hornig; from vol. 11, 1873, in *Verlag der Photographischen Correspondenz;* from vol. 25, 1888 in special cooperation with Josef Maria Eder edited by Ludwig Schrank; from vol. 40, 1903, as *Photographische Korrespondenz*, editing committee: Josef Maria Eder, Artur Freiherr von Hübl etc.,

dir. Wilhelm J. Burger; no number in 1923; from vol. 62, 1926, subtitled as *Zeitschrift für wissenschaftliche und angewandte Photographie und die gesamte Reproduktionstechnik*, edited by Adolf Schirtlich; from vol. 77, 1941 edited by Othmar Helwich; vol. 81, 1945, vol. 107, 1971, dir. Othmar Helwich.

Richard Zahlbrecht, and Joseph Maria Eder, Wien 1955.

Otto Hochreiter, Timm Starl (ed.), *Exh.cat. Der zweite Eindruck, Bildbeigaben der Photographischen Correspondenz 1864–1971*, Österreichisches Fotoarchiv im Museum Moderner Kunst, Wien 1984.

PHOTOGRAPHISCHE RUNDSCHAU

The magazine *Photographische Rundschau* was launched in Vienna in 1887. Its subtitle read 'Centralblatt fuer Amateurphotographie. Organ des Club der "Amateur-Photographen" in Wien' and displayed clearly the aims of this new addition to the world of photographic periodicals. The *Photographische Rundschau* was among the earliest magazines specifically produced for amateurs, for non-specialists in both art and science. The first editors of the periodical were Carl Srna and Carl Schiendl, who was replaced from issue No. 5 by Charles Scolik, then a well-known author on photography.

With the second year the *Photographische Rundschau* moved from Vienna to Halle on Saale, to the publishing house of Wilhelm Knapp, one of the first specialists in photography. With volume 8, 1894, the magazine not only changed the title—*Photographie Rundschau. Zeitschrift fuer Freunde der Photographie*—and its editorship but shifted towards a broader understanding of photography at all. Richard Neuhauss, the new editor, was a renowned scientist in photo chemistry but had firm roots in the fine art photography movement as well. The publication now was lavishly illustrated with at least four pages of perfect prints in different techniques, mostly phototypes or heliotypes, often enough even three-colour prints.

With volume 19, 1905, the magazine was united with *Photographisches Centralblatt* from Vienna but kept its subtitle and hosted a trifolium of editors: Richard Neuhauss, Fritz Matthies-Masuren and Hermann Schnauss. Fritz Matthies-Masuren was a painter and fine-art photographer, and as an art critic he gained enourmous influence on the German scene short before World War I. In 1907, Neuhauss vanished from editorship in favour of Robert Luther, and Schnauss was replaced by Otto Mente; both were lecturers in photo-chemistry and gave the magazine a more scientific note. By 1912, volume 26 of the *Photographische Rundschau* was united with volume 49 of the *Photographische Mitteilungen* to become *Photographische Rundschau und Mitteilungen* as which it was published for the next 32 years (and counted as the older one). If one credits the later magazine *Fotografie*—the official GDR publication in amateur photography—as the subsequent follower of the earlier periodical, the *Photographische Rundschau* has existed for exactly 103 years, up to 1990.

The long history and the number of changing editors set light to the social role the *Photographische Rundschau* played. It was the earliest amateur periodical in German language but it contained larger parts of scientific news as well as messages from clubs and congregations. The main reason to subscribe this magazine, at least after 1894, was its perfect illustration with photographs from masters of the art. Later, there were more luxuriously illustrated periodicals like the *Sonne* or the *Kunst in der Photographie*, but it was the *Photographische Rundschau* where young followers of the art could see images by important professionals. Accompanied by lengthy debates on the pros and cons of printing processes, by long critical essays on exhibitions and contests, the magazine secured its reader with the information necessary to take part in most of the photographic affairs in Germany.

And the *Photographische Rundschau* even set sails for one phrase, maybe by incident: In August 1905, the Belgium fine art photographer Alexandre published an image in this magazine, showing a number of soldiers on horses in a hollow valley, under the title 'Avantgarde im Hohlweg' (Avantgarde in the defile). Six years before Guilleaume Apollinaire's first use of the word avantgarde in the context of fine art, the *Photographische Rundschau* seems to have contributed to the critic's vocabulary.

ROLF SACHSSE

PHOTOGRAPHS OF THE GEMS OF THE ART TREASURES EXHIBITION (MANCHESTER, 1857)

A major concern of mid-Victorian Britain was the relationship between art and industry. One of the key movements in this debate was The Exhibition of the Art Treasures of the United Kingdom held in Manchester in 1857. The site of the exhibition was the Manchester Cricket Club's ground at Old Trafford. It was opened by Prince Albert on the 5th May 1857 in the presence of Queen Victoria, remaining open for 142 days and closing on the 17th October that year. In retrospect, this exhibition was one of the most spectacular art exhibitions of the nineteenth century.

At the time, Manchester was at the centre of Britain's industrial heartland. A French social commentator of the period on visiting the great mill town of Manchester in 1835 was appalled by what he found: 'A sort of black smoke covers the city.... Under this half-daylight 500,000 human beings are ceaselessly at work.... From the foul drain, the greatest stream of human industry flows out to fertilise the world.' (*Journeys to England and Ireland*, 1835).

The main exhibition hall was a vast iron and glass

structure not unlike a railway shed with a decorative brick façade designed by local architect Edward Salomons. Inside, the walls and ribs of the galleries were decorated by the firm of Crace of London and each column bore the gilt monogram of the show: 'ATE.' The main hall was flanked by two picture galleries while the whole layout resembled a cathedral with a transept and a massive organ at the far end. Watercolours and photographs were displayed on a balcony, and the Indian collections were tucked into a gallery on one side of the organ.

The exhibition brought together some sixteen thousand works of art, including paintings by Duccio, Michelangelo and Rembrandt, Renaissance maiolica and glass, medieval metalwork, treasures from the English East India Company, as well as modern sculpture, paintings, watercolours and photographs. The organisers used three compelling arguments to persuade lenders: the idea of educating the masses, the promotion of British wealth, and the ultimate incentive, royal patronage.

Photography was represented by 597 examples of which 247 were portraits. It included the work of such names as Francis Bedford, Roger Fenton, Gustave Le Gray, John Dillwyn Llewelyn, John Mayall and William Lake Price. Oscar Rejlander's *Two Ways of Life* was hung at the exhibition and a print purchased by Queen Victoria for Prince Albert. Contributing photographers from the Manchester area included James & Robert Mudd and Alfred Brothers.

In 1853 Philip H. Delamotte recorded the various stages in the reconstruction of the Crystal Palace at Sydenham and photographed the Royal Family there in 1854 and 1855. Delamotte was later awarded the photographic rights for The Exhibition of Art Treasures. Alfred Brothers was asked by the Manchester print dealer Thomas Agnew to take photographs of the opening of the exhibition that was attended by Queen Victoria and other members of the Royal Family.

More than one million visitors came by road or rail to the Old Trafford site. On a single day the show was seen by the Duke of Wellington, the Bishop of Oxford, Florence Nightingale and the painter David Roberts. The exhibition gave hundreds of thousands of working-class Victorians a glimpse of a world beyond the factory and the pub. For many, 1857 marked the start of 'a noble era in which Art took Industry by the hand, and gave her all she needed to command the world' (*The Art-Treasures Examiner*, 2).

MICHAEL HALLETT

See also: Albert, Josef; Bedford, Francis; Fenton, Roger; Le Gray, Gustave; Llewelyn, John Dillwyn; Mayall, John Jabez Edwin; Price, William Lake; Rejlander, Oscar Gustav; Delamotte, Philip Henry; and Great Exhibition of the Works of Industry of All Nations, Crystal Palace, Hyde Park (1851).

Further Reading

The Art-Treasures Examiner: A Pictorial, Critical and Historical Record of the Art-Treasures Exhibition, at Manchester, in 1857, Manchester, 1857.

Hallett, Michael, *Significant years in the history of photography in the Manchester area*, unpublished MPhil thesis for the Council for National Academic Awards (CNAA), 1976.

Manchester Guardian, 5th May 1957.

A walk through the Art-Treasures Exhibition at Manchester under the Guidance of Dr. Waagen. A Companion of the Official Catalogue, London, 1857.

PHOTOGRAPHY AND REPRODUCTION

While photography can be defined as a reprographic process, and thus all images created are reproductions, one of the great applications of the medium during the second half of the 19th century was in the reproduction of manufactured objects and aspects of the natural world and its phenomena.

Photography redefined the concept of facsimile and objectivity throughout the second half of the 19th century and the medium was exploited across a wide range of applications where accurate reproduction was required. In order to achieve this, photography needed to overcome a number of technical barriers. The first was the ability to reproduce fine linear detail and replicate tonal ranges in order for a monochromatic photographic image to 'look like' an original subject. The other challenge was to act as an intermediary to capture and then reproduce colour in printed form. Both of these were achieved in a number of stages during the 19th century though it was the 20th century that saw their eventual full flowering.

The 19th century saw photography become fully integrated and inextricably linked to 'ink on paper' printing. Photographic illustration accompanying printed text had started as early as 1840 with the five photomechanical heliogravures in Berres' *Phototyp nach der Erfindung des Prof. Berres in Wien*. By the end of the century photography—largely through industrialized photomechanical processes—was illustrating publications distributed across the entirety of human activity. Thus photography distributed the reproduced world through a number of channels; as loose photographic prints in a wide variety of formats; as photomechanical prints and as illustration to printed texts.

Photographic formats included the stereoscopic view, and the lantern slide, both modifications to existing technology. Sir David Brewster (1781–1868) invented the first practical stereoscopic camera in 1849 and this '3-D' format quickly became popular, being used to reproduce subjects including topographical views, sculpture, architecture and sets of genre scenes representing stories depicted through pictorial narratives. Current events such as wars, and natural disasters including floods, fires, train-wrecks, and earthquakes were enormously

popular subjects and distributed through international networks. The format was commercially exploited well into the 20th century.

William and Frederick Langenheim of Philadelphia patented their photographic lantern slide process in 1850 and called it the 'Hyalotype.' This photographic format had enormous impact both as a form of entertainment and for learning. The dual projection of 'slides' was exploited by 19th century art historians to form a cornerstone of the discipline's 'comparative' methodology. Both this and the stereoscopic format were pivotal moments in the development of visual perception.

The reproduction of two-dimensional graphic art encapsulated a number of the dimensions of 19th century photography. This ranged from engineering, architectural and technical drawings and maps through fine art engravings and old printed texts, to oil paintings. Photography was also used to reproduce itself, as in the case of photographic copies of unique Daguerreotypes. Another dimension here was the rise form the 1860s of photographic 'piracy.'

Photography was applied to technical drawings in fields such as architecture and civil engineering. By 1847 the engineer Isambard Kingdom Brunel (1806–1859) was using the Daguerreotype for professional purposes. He sent Daguerrotypes of his engineering drawings to prospective railway builders across Europe. By the 1850s Brunel was using photography as a contractual tool during the construction of his vast ship the *Great Eastern,* built at the yard of John Scott Russell (1808–1882) at Millwall on the River Thames. From the 1860s most major civil engineering projects were being documented photographically. By the 1870s there was wide spread use of photolithography to reproduce architect's and engineer's drawings.

Photolithography was also used to reproduce important historical texts ranging from Shakespeare's original folios to William Griggs's 1871 reproduction of the Mahabhasya (an authority on Sanskrit grammar), consisting of some 4674 pages. This was carried out for £6000 less than the estimate for a manual tracing of the original manuscript. Between 1899 and 1903 Griggs produced the sixty plates for one of the landmarks of 19th century colour photolithography, George F. Warner's *Illuminated manuscripts in the British Museum.* Such applications underline aspects of photography's role in 19th century scholarship.

The use of photography to reproduce maps became well established by the 1860s. In the late 1850s Colonel Sir Henry James, (1803–1877) director of the Ordnance Survey Office in Southampton, introduced his photoplanographic process called Photozincography. The function of the Ordnance Survey and the politics involved in its funding dictated that the primary application of this process lay in its reproduction of maps. James regularly

pointed out that Photozincography reduced the cost of map making by several thousand pounds a year. However, James also used Photozincography to reproduce historical and illuminated manuscripts in the British national collections, the chief example of which was the 11th century Domesday Book published by the Ordnance Survey Office between 1861 and 1863.

Both Daguerre and Talbot considered the reproduction of the fine and decorative arts and architecture a key application for their respective photographic processes. Talbot's experiments in particular covered a wide range of the fine and decorative arts. From engravings, printed texts and paintings, through porcelain, glass to sculpture. These subject matter were used within his landmark publication *The Pencil of Nature* (1844–1846).

Technical innovation in 19th century photography was also connected with a number of reproductive applications of the medium. For instance, the limited spectral sensitivity of photographic emulsions caused problems for the reproduction of polychrome objects such as oil paintings. In the late 1870s Gaston Braun (1845–1923), the son of the great photographic publisher Adolphe Braun (1812–1877) of Dornach, exploited developments in photochemistry to create orthochromatic collodion-bath plates to reproduce paintings in the Prado Museum, Madrid and the Hermitage, St Petersburg. These photographs caused considerable astonishment in the photographic and art world but since Braun kept completely silent about his system, it could not be adopted by other companies, thus permitting Braun et Cie to achieve pre-eminence in this specialised field However, orthochromatic (also known as isochromatic) film was not sensitive to the entire visible spectrum and it was not until 1902 that Professor Adolph Miethe and Dr Arthur Traube, of the technical college in Berlin-Charlottenburg, discovered that by using a red-violet dye, subsequently called 'ethyl-red,' it was possible to produce truly panchromatic plates and thus to correctly register in monochrome the colours of the visible spectrum in their proper tonal relationships.

The principles of colour photography had been largely established by James Clerk Maxwell (1831–1879) in the 1860s. Charles Cros (1842–82), another pivotal figure in the history of colour photography, produced colour photographs of paintings by the entrepreneurial and controversial avant-garde artist Edouard Manet (1832–83). One of these photographs was used by the collector of Impressionist art Ernest Hoschedé (1837–1891) for the cover of his review *Impressions de mon voyage au Salon de 1882* (A. Tolmer, Paris, 1882). However, during the 19th century the use of photographic colour reproductions were frequently the result of a combination of photographic and manual processes. One of the more complex of these 'hybrid' processes was the *photochromie* of Léon Vidal (1834–1906), which combined chromolithography

and the Woodburytype photomechanical process. Since Vidal primarily reproduced works of fine and decorative art —rather than scenes from nature—it was difficult for the observer to determine the resulting accuracy.

Throughout the 19th century, the manual transcription of photographic originals to form a variety of graphic illustrations to place. This to a degree masks the medium's impact. While the *Illustrated London News* prominently credited those illustrations that were after photographs, other publications did not. One of the primary reasons for manual transcription was one of speed and cost. Publications working within strict timescales exploited cheap labour to create graphic illustrations based on photographs. The rise of photomechanical processes—particularly during the 1870s—greatly increased photographic reproduction during the last two decades of the 19th century. However, it is not always easy to identify such productions. Simple line drawing illustrations were frequently not credited as being produced by photomechanical processes. At the other extreme, from the early 1870s the French engraver Amand Durand (1831–1905) produced a series of 'facsimile' heliogravures of drawings, etchings and engravings by the Old Masters which were so accurate that it was reported that a 'distinguishing mark' had been placed next to his 'deceptive copies.'

Photographic reproduction was applied to a number of areas of 19th century science. Light and colour theory and astronomy were greatly aided by the introduction of photometry and the work of William de Wiveleslie Abney (1844–1920).

Medical photography provided the capability to document and reproduce diseases, abnormalities and clinical conditions. These ranged from such as diseases of the skin, through surgical procedures to Dr Hugh Welch Diamond's photographs of the insane—taken from the late 1840s- that were also used to develop diagnostic techniques. Photographs frequently were transcribed into engraved medical illustrations. Thousands of photographs of pathological specimens and soldiers wounded in the American Civil War were used to provide illustrations for monumental six volume *The Medical and Surgical History of the War of the Rebellion* published in Washington, D.C., between 1870 and 1888.

The second half of the 19th century saw an explosion in scholarship in every conceivable academic discipline. Numerous societies and institutions were formed to represent these interests, whether in a professional and amateur capacity. Many of these not only formed photographic collections but also encouraged the photographic reproduction of pertinent objects and artefacts. In some instances 19th century local history and architectural societies joined with photographic societies to achieve their aims. The publications of these societies and illustrations were another channel by which photographic reproduction had a major influence on the dissemination of knowledge and the promotion of scholarship.

In the autumn of 1839 John Benjamin Dancer (1812–1887) made the first microphotograph on a Daguerrotype plate at 160X reduction. Photomicrography became increasingly used in the second half of the 19th century in fields such as botany and entomology. During the Franco-Prussian War of 1870, the microphotographs of the Frenchman Prudent René-Patrice Dagron (1819–1900) were exploited to provide a mail service to and from Paris while the city was under siege. Some 115,000 messages were allegedly transmitted in this way. Such uses also formed the early use of microphotography for purposes of spying and transmitting illicit messages, an application suggested by Dancer in the mid 1850s. In the 1880s Robert Koch (1843–1910) made microphotography a central tool of bacteriology. During the 20th century the microfilm became a key technology to distribute information and knowledge.

By the end of the 19th century, photography and photomechanical processes had largely eliminated the requirement for labour intensive manual printmaking methods for the production of utilitarian botanical illustrations. Related to this is the matter of the change in contexts. In the 1880s, the Harvard botanist Asa Gray (1810–1888) purchased large photographic prints taken by Carleton Watkins (1829–1916) on a California State Geological Survey, to augment the Gray Herbarium. Gray formerly acquired these images as botanical illustration, though today Watkins' images are primarily viewed within the context of their aesthetic value.

Photography was used to document manufactures and produce in-house records or advertising materials and illustrated catalogue for a wide range of industries. By the early 1860s photos replaced drawings in the china manufacturer Minton company pattern books. From the 1870s the Baldwin Locomotive Works of Philadelphia began publishing photographically illustrated catalogues.

During the last third of the 19th century photography began to have a significant commercial impact on the various components of the industry. The construction industry the works of architects, architectural masons, manufacturers of decorative fixtures and fittings, etc. were all photographically reproduced. In 1872, a critic writing on the industrial results of photography pointed to the savings being made through the efficient use of photography. "Does a builder require a number of metal brackets from Birmingham? Instead of having to incur the delay and expense of attending the transmission of a specimen from the manufacturer, he receives by return of post a photograph of the article wanted, and gives his order accordingly."

ANTHONY HAMBER

Further Reading

Armstrong, Carol, *Scenes in a Library: Reading the Photograph in the Book, 1843–75*. MIT Press. Boston, MA:. 1998.
Parr, Martin, and Gerry Badger. *The Photobook: A History*, vol. 1, London: Phaidon Press, 2004.

PHOTOGRAPHY AS A PROFESSION

The professional exploitation of photography came about surprisingly quickly after the daguerreotype became a practical proposition. The era of the professional began in the early 1840s with a few operators producing high price images for an elite few. The nineteenth century ended with photography as a major employer catering for a mass market, and with professional photographers establishing collectives and associations to protect their interests.

Those first sixty years of professional photography were punctuated with major 'firsts' and with the profession generating and nurturing most of the applications of the new medium which are taken for granted today. During that time, many thousands of photographic studios opened their doors. Very few of them survived for any length of time as a result of fierce competition, falling prices and a lack of business acumen.

The first photographers were, predominantly, artists and scientists who explored the potential of the medium out of curiosity and fascination. It was not until exposure times were reduced sufficiently to make portraiture a practical proposition that the photographic studio evolved. That the daguerreotypist could do in a few minutes what had taken the miniature painter hours or even days to complete immediately caught the imagination of those able to pay the not inconsiderable cost of having their likenesses made.

The dawn of professional photography in the United States was marked as 1840, and the New York *Sun* carried an account of the opening by Alexander S Wolcott and John Johnson of the world's first professional photographic studio on March 4:

> Sun Drawn Miniatures.– Mr A. S. Wolcott, No.52 First Street, has introduced an improvement on the daguerreotype, by which he is enabled to execute miniatures, with an accuracy as perfect as nature itself, in the short space of three to five minutes. We have seen one, taken on Monday, when the state of the atmosphere was far from favourable, the fidelity of which is truly astonishing. The miniatures are taken on silver plate, and enclosed in bronze cases, for the low price of three dollars for single ones.

This is believed to be the earliest publication of the cost of having a daguerreotype portrait taken professionally. Three dollars represented a week's earnings for the majority of Americans, clearly placing the daguerreotype in the same social stratum as the miniature painting.

The first photographic studio to be opened in France is believed to have been that of Nicholas-Marie Paymal Lerebours, which opened in late spring 1841. He had sold daguerreian equipment from his optical instrument shop at 13 place du pont-neuf in Paris, since taking over the business from his father in 1839. During his first year as a professional photographer he is reported as having taken around 1500 portraits. Other claimants for France's first studio include E. T. Montmirel, and Louis-August Bisson. Montmirel reportedly charged a minimum of ten francs per portrait in 1842, again the equivalent of a week's wages for the average worker.

Also in 1841 Lerebours wrote and published his *Derniers perfectionnements apportés au daguerreotype* and in the following year published his *Treatise on photography*, which sold eighteen hundred copies. A fourth edition appeared in 1843.

Richard Beard opened what is believed to have been Europe's first professional photographic studio at London's Royal Polytechnic Institution, on March 23, 1841, just a few weeks earlier than Lerebours.

Beard, who had initially paid £150 to purchase a licence to use the daguerreotype from Daguerre's English agent Miles Berry, later bought out all Berry's rights and effectively therefore gained control of professional photography in England. His patent control and resulting licensing policy, granting exclusive rights to practice the process professionally within defined geographical areas, arguably constrained the development and growth of professional photography in England for several years.

The Frenchman Antoine François Jean Claudet opened his first studio in London in June 1841, having acquired a licence direct from Daguerre. That set him uniquely outside Beard's patent control. Claudet's Adelaide Gallery prospered for many years, and in the early years especially, was the setting for some of the most significant improvements to the daguerreotype as far as the professional exploitation of photography was concerned. Claudet's chemical improvements considerably reduced exposures, and his other innovations included the painted studio backgrounds which became popular worldwide.

The media was keen to publicise the new medium, and many local newspaper stories were devoted to the opening of professional portrait studios. One of Claudet's former operatives, a 'Mr Edwards,' keen to escape the cost of Beard's English licences when he sought to establish his own professional studio, moved to Glasgow, and opened his own business in the city. *The Glasgow Herald* newspaper in March 1843 noted that

> Mr Edwards, a cadet of the Adelaide Gallery in London—which has turned out some of the very finest specimens of the art—has established his painting rooms (to speak in the old phrase) in a handsome saloon 43 Buchanan

Street, erected for the purpose, so that the light of day, which acts to him the part of a pencil, may have free and uninterrupted access.

Initially there was insufficient demand for a full-time professional photographic studio, even in some large cities. Photographers had to have another source of income. That might be a bookseller, or even a print-seller.

Itinerant photographers opened temporary studios for a few days or weeks, then moved on to a new location. Their advertisements were remarkably similar on both sides of the Atlantic, separated only by time. In Washington, D.C., the *National Intelligencer* noted on June 30, 1840 that, "Mr Stevenson would inform the citizens of Washington and the District that he has taken rooms at Mrs. Cummings on Penn. Ave. a few doors from the Capitol where he is prepared to take likenesses by the daguerreotype every fair day from 10am till 4pm." Three years later, in the small Scottish town of Dumfries, *The Dumfries & Galloway Courier* announced on March 27, 1843 that Mr Edwards 'of the Adelaide Gallery in London':

> respectfully intimates his arrival in Dumfries, where he purposes remaining a few days, in the exercise of a profession which is altogether new in the South of Scotland. He has engaged apartments at Mrs Williamson's, Irish Street, where his specimens may be seen every lawful day from 10 to 4 o'clock. NB As Mr Edwards has pressing engagements in Russia, Prussia, &c., this may be the only opportunity of his being in Dumfries again, if ever, for a lengthened period of years.

While early professional interest was predominantly directed towards the daguerreotype, it was not exclusively so. Robert Adamson became Edinburgh's first professional photographer to use Talbot's calotype in early 1843. The *Edinburgh Review* noted in January of that year that, "Mr. Robert Adamson, whose skill and experience in photography is very great, is about to practice the art professionally in our northern metropolis." He opened his 'studio' in May of that year at Rock House on the Calton Hill, although the exposure times necessary required the photographs to be taken outdoors in the garden. Despite several daguerreotypists having operated in the city since before the end of 1841, Adamson remained, until 1846, the only professional photographer listed as such in the city's trade and street directories.

Nicholas Henneman, Talbot's assistant, also became a professional calotypist when he was appointed manager of the Reading printing establishment in December 1843, and took some of the images published in *The Pencil of Nature*. By 1848, with the Reading establishment closed, he was operating the 'Sun Picture Rooms,' the calotype studio Talbot had established the previous year in London's Regent Street.

The expansion of professional portrait photography was, understandably, driven by price. While the high price daguerreotype was the sole option, markets remained small and exclusive. The ambrotype widened those markets by providing a lower cost option to those who aspired to a cased portrait, but it was the advent of the carte-de-visite, introduced by André-Adolphe-Eugène Disdéri in 1854 which really established photography as a universal medium. With the carte-de-visite, photography no longer sought to emulate and imitate the painted miniature but, instead, evolved a new and uniquely photographic alternative, which itself created a market for albums, frames and the paraphernalia of portrait collecting.

Interestingly, while no specifically professional manuals were published, the 1850s saw the emergence of handbooks directed specifically towards the non-professional—recognition of the fact that the amateur needed to know less about the manipulation of the medium than his professional counterpart.

Not all so-called 'professionals' had any great understanding of the medium. Henry Mayhew, in his 1861 *London Labour and the London Poor* included as one of his case studies, a 'Photographic Man' who had been a fairground performer before turning to photography, a subject he knew nothing about. Relying on public ignorance of the workings of the photographic process, Mayhew's case study was just one of many con men, who sold poor quality 'sixpenny portraits' to their unsuspecting customers, often moving on to new locations before their disappointed customers could demand their money back. Relying on the fact that the poor seldom possessed good quality mirrors—and thus really did not know what they looked like—Mayhew's 'photographic man' even managed to sell customers portraits of someone else.

Such practices were in sharp contrast to the standards maintained by the great portrait studios of Southworth & Hawes, Whipple, Brady and others in the United States or Mayall, Claudet or Kilburn in the UK, and the great commercial photographers like Nadar or Hippolyte Collard in France, Roger Fenton, P. H. Delamotte, and others in Britain, or John Carbutt, Alexander Gardner *et al* in America. Indeed, the rapidly falling prices, brought about by the carte-de-visite, are often cited as a likely reason for Fenton's sudden abandonment of photography in 1862.

By the 1870s, the majority of the professional specialisms with which we are familiar today were in place. Portrait studios in their thousands produced cartes and cabinet photographs, while the expanding tourist market was met by output from professional photographer/publishers such as G. W. Wilson, Francis Frith, and James Valentine in the UK, Antonio Beato, the Zangakis, Bonfils and the Sebahs in Egypt, Adolphe Braun and others

in Europe, Bourne and Shepherd in India, the Bierstadts, Notman in Canada, and Carleton Watkins, William H Jackson and others in the United States.

Specialist industrial and architectural photographers emerged to photograph the many great construction projects of the Victorian era, aided by more sophisticated equipment, faster emulsions and greater consistency and reliability.

Photographic associations had, from the 1850s, been open to all who were interested in the medium, their meetings populated by amateurs and professionals alike. As the century progressed, however, the requirements of amateur and professional began to diverge. While the amateur was still concerned with experiment, with exhibition and with the interchange of ideas, the professional faced a widening range of challenges, not least of which were to do with copyright and the duplication and dissemination of images. The introduction of cheap methods of photomechanical reproduction of photographs made the resolution of these issues even more pressing.

Until the mid 1870s, the use of photographs as book illustration was easy to control, but with the advent of the Woodburytype, Autotype, and other pigment printing processes, it became easier and cheaper. Walter Bentley Woodbury's *Treasure Spots of the World* published in 1875—and often described as the world's first 'coffee-table book'—heralded the dawn of a potentially large new market for professional photographers.

Copyright laws throughout the first three decades of photography did not include the image, giving the photographer little protection against the commercial exploitation of his/her work by others.

In most countries of the world, by the end of the century, the concept of automatic copyright in a photograph was still decades in the future. In the UK, as copyright in an individual image had to be registered at Stationers' hall, and a small fee paid per image, few photographers exercised a right which they had enjoyed since the 1870s.

Once newspapers and magazines could reproduce photographs, the professional became open to frequent exploitation. Individually the photographer was powerless. Collectively, the profession could bring about change. Thus the century ended, and the 20th century began, with the formation of first professional associations in Britain and the United States.

JOHN HANNAVY

See also: Wolcott, Alexander Simon and John Johnson; Lemercier, Lerebours & Bareswill; Beard, Richard; Talbot, William Henry Fox; Henneman, Nicolaas; Disdéri, André-Adolphe-Eugène; Southworth, Albert Sands, and Josiah Johnson Hawes; Whipple, John Adams; Brady, Mathew

B.; Mayall, John Jabez Edwin; Nadar (Gaspard-Félix Tournachon); Fenton, Roger; Delamotte, Philip Henry; Gardner, Alexander; Wilson, George Washington; Frith, Francis; Valentine, James and Sons; Beato, Antonio; Bonfils, Fèlix, Marie-Lydie Cabanis, and Adrien; Braun, Adolphe; Notman, William & Sons; Canada; Societies, groups, institutions, and exhibitions in Canada; Watkins, Alfred; Jackson, William Henry; and Woodbury, Walter Bentley.

Further Reading

McCauley, Elizabeth Anne, *Industrial Madness, Commercial Photography in Paris, 1848–1871* New Haven and London: Yale University Press, 1994.

Henisch, Heinz K., and Henisch, Bridget A., *The Photographic Experience 1839–1914*, University Park: Pennsylvania State University Press, 1994.

Taft, Robert, *Photography and the American Scene*, New York: Dover, 1964.

Welling, William, *Photography in America: The Formative Years*, New York: Thomas Y Crowell, 1978.

PHOTOGRAPHY IN ART CONSERVATION

Over the centuries the restoration of works of art has been both a business, and a source of additional earnings for artists: Paintings, sculptures and buildings were often part of ritual, or other functional contexts, and often the preservation of such use value was considered to be of more importance than either the artistic value or the historical authenticity of a work of art. Thus, if artists could not preserve the piece by completing or repairing it, they were qualified to replace or remake the lost piece.

Along with the general status of works of art in society, the position of restoration changed during the 19th century: The authenticity of the pieces themselves started to rank higher, although it remained disputed how restoration as a profession should present itself: Theoreticians such as Violett Le Duc took the position that in cases of doubt, the reconstruction of historical monuments and works of art was necessary, while John Ruskin advanced the view that restoration was the most brutal form of destruction. This juxtaposition remained fundamental for debates on conservation well into the 20th century, for example in the disputes surrounding the preservation of monuments in which Georg Dehio and Alois Riegl took part. These controversies affected the work of the restorers.

Until well into the 19th century it had been the task of the artists' appointed gallery directors to restore the paintings within collections. Since the 1850s, restoration increasingly became a profession in its own right, one

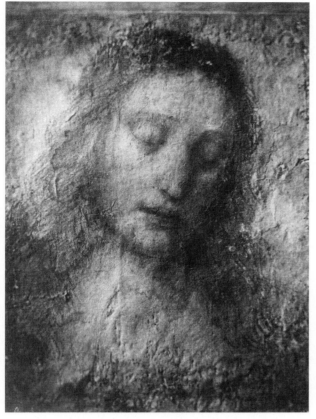

Gérard, Léon. Leonardo da Vinci, Drawing Christ in "The Last Supper."
The Metropolitan Museum of Art, Gilman Collection, Purchase, Mr. and Mrs. Andrew W. Saul Gift, 2005 (2005.100.51) Image © The Metropolitan Museum of Art.

which often collaborated with the developing academic discipline of history of art, appropriating and developing a scientific foundation for its practise.

Among the first to work in this field was Humphry Davy who around the same time conducted studies on substances sensible to light and inquired into pigments and papyri excavated in Pompeji, publishing his findings on the latter in 1819. The first laboratory for the scientific investigation and treatment of museum collections was founded in 1888 in the Royal Museum in Berlin, run by Friedrich Rathgen until 1927. Photography, now as then, is being used in restoration mainly for two purposes: on the hand it is used for documenting the inventory, and on the other it is applied to the study of works of art by scientific means and methods.

Arago was already aware of the importance photography could have for the examination of works of art when, in his speech in the Chamber of Deputies on July 6 1839, he drew the attention of the audience to the fact "that if photography had been known in 1798, we should now have correct images of a somewhat considerable number of emblematical pictures, of which the cupidity of the Arabs, or the fatal mania of certain travellers for destruction has for ever deprived the scientific world."

Even though for the moment, scientific documentation receded into the background, initial evidence of it can be found in the volume Egypte, Nubie, Palestine et Syrie published by Louis Desire Blanquart-Evrard in 1852: The work was primarily a commercial enterprise, but the photographs by Maxime Du Camp, illustrating the subject as prints on paper was pathbreaking for the further development of the architectural photography. Du Camp, for instance, had fellow travellers pose in front of the buildings in order to visualize the architectural dimensions. A year earlier, the French Commission des Monuments Historiques appointed photographers such as Edouard Baldus, Hippolyte Bayard und Henri Le Seq to document architectural ensembles in French cities before they were pulled down in the course of modernization. As a consequence of the 'Mission Heliographique,' photographers during the next years were more and more involved in similar enterprises: in 1855, the architect Jean Baptiste Lassous appoints Charles Nègre to document the restoration of the cathedral in Chartres, and Désiré Charnay is sent to Mexico in 1857 to photograph the ruins of the ancient indian cultures. At about the same time, similar initiatives were begun in several German cities: In Cologne, the building authorities ordered pictures to be taken of buildings due for demolition, and in Hamburg, Georg Koppmann was paid to document buildings of historical significance. In other places, such initiatives were triggered by private commercial or antiquarian interest: While Eugene Atget's photographs of the vanishing Paris, for a long time remained in obscurity, Fratelli Alinari in Florence produced and sold photographs with urban motifs. However, of more commercial interest and as well significant for restoration, were the reproductions of sculptures, paintings and graphic arts marketed by Alinari. Similar enterprises were undertaken by Adolphe Braun (Paris/Dornach), Josef Albert and Franz Hanfstaengl (Munich).

These firms systematically reproduced private and museum collections; the catalogue of the company of Adolphe Braun in 1887 offered tens of thousands of different works of art. With these commercial campaigns, a vast number of works were reproduced for the first time and thus were available for the stylistic comparisons necessary for tests of authenticity, the separation of 'hands' and for the purpose of establishing dates. Occasionally however, the commercial photographers caused work for the restorers than aiding them: Well into the 20th century, reproductive photographers exchanged recipies about how to treat paintings in order to obtain stronger contrasts and brighter colours. In particular, cooking oil and mixtures of albumen, sugar and glycerine enjoyed great popularity. To avoid such incidents and, moreover, to participate in the profitable business of reproducing works of art, some museums appointed

their own photographers: Already in 1855, the Louvre had pictures of its collection of antique sculptures taken by an internal photographer, and the prints were used not only for reference in the deeds, but sold to scientists and the interested public. In London the newly founded South Kensington Museum assumed the function of reproducing exhibits for the British Museum and the National Gallery since 1859; the Reproduction Room committed to selling the prints, but closed four years later because the museum's atelier was not able to cope with the demand.

At around the same time, photography was first used to document the work of restoration of artworks: The Munich chemist Max von Pettenkofer had developed a process for regenerating torn varnish, instead of the common practice of removing it from the paintings. To demonstrate the advantages of his process, he had a painting by Domenico Quaglio photographed by Josef Albers, first in 1859 and then again in 1864. The photographs showed a significant increase of fissures and dull spots in the varnish vanishing after the regeneration. Pettenkofer recommended exhibiting such photographs together with the paintings, a suggestion that had rarely been taken into consideration until recently. This kind of photography borders on its application as an analytic tool for restoration.

In the 1890s, Arthus Pillans Laurie used a stereo microscope to investigate the surface of paintings in order to find out which pigments were used by the old masters and to detect forgeries by analyzing the brush strokes; however he published most of the results only after the turn of the century. As well, Theodor von Frimmel used microscopes and photographs to understand the regularities of the formation of crackles in the paint; he published one of his photographsin his Handbuch der Gemäldekunde (1894). Raking light was systematically used for the investigation of paintings since the 1890s: with its help, traces of pentimenti and earlier versions could be detected. In the course of restoration of two portraits by Christoph Amberger in Braunschweig in 1892/93, subsequent alterations were discovered, changing the donors into saints; the findings were confirmed by later radioscopies. X-ray examinations of works of art were executed within months after Röntgen published his discovery in January 1896, indicating that lead paint absorbs the radiation.

Already in March 1896 the Frankfurt physicist Walter König had investigated paintings using X-rays. In the following years, a number of smaller publications referred to the new method of examination, which proved to be particularly useful for the verification of works of art. Around 1913, the Weimar roentgenologist Alexander Faber systematically researched the absorptions of different pigments used for paintings, and even though the general procedure was known at that time,

in 1914 he was issued a patent for a 'Procedure for the determination of overpaintings in oil paintings and similar objects.'

Other photographic methods for the investigation of works of art in use today were not applicable yet in the 19th century. Since Hermann Wilhelm Vogel had developed the appropriate emulsions in 1873, infra-red photography was technically possible; for paintings, however, it has only been in use since the 1930s. On the other hand, while the sensitivity of photographic emulsions to ultra-violet rays has been known since the beginnings of photography; it became of practical value only after the invention of the mercury vapour lamp by Küch in 1906. Its first application for purposes of restoration was by P.R. Kögel who, with the help of this method, could decipher illegible palimpsests.

A curiosity in this context is the heliography of a painting by Vernet now preserved in the Harrach collection in Rohrau/Lower Austria: The canvas of the painting was penetrated by a bomb splinter during the revolutionary fights in Vienna in 1848. The hole, however, was not mended: instead, a small piece of cardbord with a note about the damage was mounted to the back of the painting, such that it was readable through the hole. In this state the painting was reproduced. The hole was mended only in the course of another restoration executed in 1961.

FRIEDRICH TIETJEN

See also: Davy, Sir Humphry; Blanquart-Evrard, Louis-Désiré; Du Camp, Maxime; Baldus, Édouard; Bayard, Hippolyte; Mission Héliographique; Nègre, Charles; Alinari, Fratelli; Braun, Adolphe; South Kensington Museums; X-Ray Photography; and Vogel, Hermann Wilhelm.

Further Reading

Althoefer, Heinz (ed.), *Das 19. Jahrhundert und die Restaurierung*, München: Callwey, 1987.
Bridgman, Charles F., "The Amazing Patent on the Radiography of Paintings." *Studies in Conservation* 9 (1964): 135–139.
Gemälde im Licht der Naturwissenschaft, Herzog Anton Ulrich Museum, Braunschweig, 1978, exhibition catalogue.
Nicolaus, Knut (ed.), *Heinrich L. Nickel: Fotografie im Dienste der Kunst*, Halle: Fotokino Verlag, 1959.

PHOTOGRAPHY OF PAINTINGS

The graphic reproduction of works of art has an extended and diverse history and photography followed the tradition in which the depiction of the fine and decorative arts bestows some kudos on the reprographic processes being used. Photography was invented at a time when a large and vibrant market in the reproduction of paintings was rapidly evolving. This market encompassed a wide range of sectors from highly expensive *de luxe*

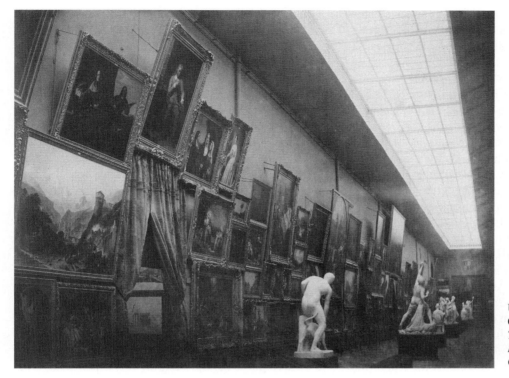

Unknown (Photographer).
Galerie Anglaise.
*The J. Paul Getty Museum,
Los Angeles © The J. Paul
Getty Museum.*

engravings to cheap wood cuts used a loose prints or to illustrate cheap such as the *Penny Magazine*, first published in 1831, that produced 'a revolution in popular Art throughout the World.

Both Louis Jacques Mandé Daguerre (1787–1851) and William Henry Fox Talbot (1800–1877) appreciated the importance of reproducing works of art (including paintings, drawings, engravings, sculpture and decorative art) not only for proof of their respective photographic processes but also for their commercial application. Subsequently, during the 19th century art reproduction was to form a key and commercially very significant part of the photographic market. Until the 1870s, the photography of works of art (including paintings) was considered a standard advertised service offered by commercial photographers.

At the time of photography's invention a plethora of reprographic processes were available and by 1859 William John Stannard listed no less than 156 in his privately published *Art Exemplar*. These relief planographic processes were being exploited to meet the rising demand for loose graphic reproductions and the business opportunities offered by rapidly expanding and diversifying commercial markets. Throughout the 19th century, photography was to compete and interact with manual reprographic processes in the reproduction of paintings. Indeed this forms a significant part of the history of photography during the 19th centuy.

During the 1840s a variety of amateurs used the Daguerreotype to document paintings in their collections though the scale and scope may never be known.

In parallel, commercial photography was being used to document public collections—or collections open to the public. In February 1848, Richard Beard, a leading London photographer, had been given permission to Daguerreotype paintings in the National Gallery in London and a month later a certain John Woolley asked 'permission to make copies of two or three pictures in this gallery by means of the Calotype Camera.' Such small but significant activities were being undertaken in many countries.

It is also known that during the 1840s leading artists had their paintings photographed. Jean-Auguste-Dominque Ingres (1780–67) was one of the earliest acclaimed contemporary painters to apply photography to document his work. In 1842 he had a Daguerreotype taken of his painting of Saint Peter destined for Santa Trinita dei Monti in Rome. This may have been to enable Ingres to have Daguerreotypes with which to teach his students. In 1848 Gustave Le Gray (1820–1884) Daguerreotyped the painting *Anacréon, Bacchus et l'Amour* by Jean-Léon Gérôme (1824–1904) exhibited at that year's Salon. In the 1860s Gérôme developed extremely close professional relationships with the photographer Robert Bingham (1825–70), regularly having his paintings photographed before being sold. Gustave Courbet (1819–1877) exploited photography to reproduce his paintings and had commercially available photographs produced of those paintings that were refused by the 1855 Salon. Photographers including E. Baldus, P.A. Richebourg, E. Carjat and C. Michelez all registered photographs of paintings by Courbet at the Dépôt legal in Paris.

The photography of painting was identified as significant by a wide range of influential photographers during the 1840s and was strategically used to further the cause of the revolutionary process. An album of Calotypes by David Octavius Hill (1802–70) and Robert Adamson (1821–48), presented to the Royal Academy of Arts in London in c.1848 included a reproduction of a painting entitled *The Dance* by William Etty (1787–1849).

However, the photography of paintings, like most applications of photography, was to scale up very significantly from the early 1850s. While most 19th century commercial photographers marketed themselves as generalists covering the general requirements of their customers across Europe and beyond, some created significant reputations for art reproduction. These included Fratelli Alinari of Florence, Adolph Braun (1812–1877) of Dornach, Robert Macpherson (1814–1872) and James Anderson (1813–1877) in Rome, Leonida Caldesi (1823–1891) an Italian working in London, Robert Bingham (1825–1870) the Parisian-domiciled Englishman, and Juan Laurent (1816–c.1890) and Charles Clifford (1819–1863) in Madrid; Hanfstaengl and F. Bruckmann in Munich; At the end of the century Frederick Hollyer (1837–1933) was renowned for his reproduction of paintings, particularly using the Platinum print process.

By the 1850s all aspects of the commercial art world including painters, sculptors, architects, engravers, art dealers and auction houses had adopted photography. The public sector in the form of museums also adopted the medium and in some instances appointed photographers. Charles Thurston Thompson (1816–1868) was one of the earliest of these and his career at the South Kensington Museum (now the Victoria & Albert Museum) during the 1850s and 1860s set an benchmark as he recorded the permanent collections, temporary loan exhibitions and ventured abroad to photograph in France, Spain and Portugal. It is significant that as early as the 1860s commercial photographers were complaining that museum 'in-house' photographers –such as Thurston Thompson—were given preferential treatment and were being heavily subsidised by Government departments that enabled them to undercut the prices at which they sold photographs. In Thompson's case this was largely due to the sappers from the Royal Engineers that were being used at South Kensington as part of the unofficial yet permanent photographic facilities.

By 1880 the South Kensington Museum held a collection of some 50,000 photographs acquired from a variety of sources and channels all over the world. Many of these were reproductions of paintings. Thompson also undertook commercial work photographing paintings on behalf of leading art dealers. In 1863 he was employed by the art dealer Ernest Gambart (1814–1902) on several occasions to photograph paintings

that he was selling. These included *Shetland Ponies* and the *Ferry Boat crossing the Lake in the Highlands* by Rosa Bonheur (1822–1899), and *Derby Day by* William Powell Frith (1819–1909).

The photography of paintings was hindered by a number of technical problems during much of the 19th century. Levels of illumination were particularly critical. In the early 1840s Talbot had taken paintings outdoors into the cloister at Lacock in order to enable high enough levels of illumination for adequate camera exposures to take place and this practice continued for several decades. In 1858 the Raphael Cartoons were taken outdoors from Hampton Court Palace to be photographed twice in parallel, once by Charles Thurston Thompson and once by Leonida Caldesi. To the modern observer the general views photographed of this work being undertaken by Thompson and Caldesi are curious since the paintings have been placed upside down. This was to enable easier framing on the ground glass screen of the camera—the image on a plate camera always being vertically inverted from the actual view as seen by the human eye.

Many paintings are hung in ways that make their photography difficult or impossible. Paintings can be hung high off the ground. They can be hung in corners and thus have restricted illumination. In 1860 paintings from the Royal Collection at Buckingham Palace were removed to the London photographic studio of Caldesi, Blanford, & Co for photography to take place. From the 1850s some public museums and galleries built photographic studios to enable photography of paintings to take place.

To counter the challenges of instances where paintings could not be moved—such as wall frescoes—some photographers built scaffolds to position the camera at the paintings mid-point and thus remove any distortion. The most significant example of this was the use by Adolphe Braun et Cie. Of a movable scaffold to photograph Michelangelo's frescoes in the Sistine Chapel in Rome. These photographs, published in 1869 using Swann's Carbon print process and almost exclusively of details the fresco scenes, had a major impact on the study of these paintings and were greeted with universal acclaim.

While the use of mirrors to reflect light was known, artificial light sources were very rarely exploited in the photography of painting during most of the 19th century. Artificial light sources were very rarely used in the photography of painting during most of the 19th century the preference was for natural 'North' lighting in studios. One particularly significant early example of the use of artificial lighting to photograph paintings took place in the subterranean Early Christian Catacombs in Rome during the late 1860s and 1870s where magnesium light was used to illuminate the Early Christian fresco decora-

tion. These images appeared in the publications of John Henry Parker (1806–1884) dealing with the Roman and Early Christian archaeology of Rome.

One of the most prominent challenges to the photography of painting was the limited spectral sensitivity of black and white photographic materials that could not reproduce the full colour spectrum. This was of particularly apparent in the reproduction of paintings and frequently evidenced in religious paintings where the traditional blue colour of the Virgin Mary's cloak would be reproduced as a very light tone due to the photographic emulsions being oversensitive to blue thus making a very dark area on the negative—which in turn printed as a light tone in the photographic print. Some photographers 'retouched' their negatives of paintings to counteract the tonal imbalances introduced by the spectral sensitivity of the photographic emulsions they used. Others retouched the photographic print and then rephotographed the retouched photograph in order to create a second negative from which they might print more tonally accurate photographic prints. That photographers were willing to go to such lengths indicates the commercial value of the market for photographs of paintings during the 19th century and it is significant that it was the specialist photographic art reproduction company of Adolph Braun that developed and then introduced improved orthochromatic (or isochromatic) emulsions in 1878, fully panchromatic film being introduced in 1905.

Related to this technical limitation of 19th century photographic processes is the fact that during much of the 19th century photography was exploited to copy reproductions after paintings, such as engravings, lithographs and the like. Undoubtedly, the copying of achromatic engravings was a simple and thus extremely cheap form of copy photography. In some instances there were practical and economic reasons for photographers or publishers not being able to photograph directly from paintings. However, throughout the 19th century the engraving remained highly esteemed and thus photographs of important engravings after paintings were frequently seen as valuable in their own right.

Producing 'colour' photographs of paintings was addressed in a number ways. Firstly, was the hand colouring of monochrome photographs of paintings. An example of a hand coloured Calotype from the studio of Nicolaas Henneman dated to the late 1840s survives and the colouring of Daguerreotypes was also well developed by this time as photographers exploited the professional talents of miniature painters in new commercial fields. A significant market for coloured photographs developed and Vincent van Gogh (1853–1890), while working in the London office of the printseller Goupil, mentioned this in a letter to his brother in November 1873.

The development of hybrid reprographic processes was also an avenue that was explored to reproduce paintings in colour. Between 1864 and 1866 Jules Labarte's *Histoire des Arts Industriels au Moyen Age et à l'époque de la Renaissance* was published and was illustrated with two 'albums' containing 150 plates created by the Parisian printer Lemercier through a synthesis of photographic, lithographic, photomechanical and chromolithographic processes. However, few of the plates are of 'paintings.' Similarly, the Photochromie process of Léon Vidal (1834–1906) introduced in 1875 and which combined chromolithography and the Woodburytype photomechanical process was little used to reproduce paintings.

Colour photographic processes were developed as early as the late 1860s and paintings by Edouard Manet (1832–1883) reproduced at this time. Charles Cros (1842–1882), the inventor of one of the earliest colour photographic processes copied *Jeanne—Le Printemps*, Manet's portrait of Jeanne Demarsy, dated 1881–82. This photograph was used by Ernest Hoschedé (died 1892) for the cover of his review *Impressions de mon voyage au Salon de 1882* (A. Tolmer, Paris, 1882). Cros and Manet shared an interest in the problems of colour-printing technology and the reproduction of this painting was part of their experiments in colour photogravure.

Photographs of paintings were disseminated through a number of channels. Print dealers dealers formed a primary channel. In Florence, Fratelli Alinari formed an association with the print seller Bardi in the early 1850s. In the same decade the London firms of Paul and Dominic Colnaghi and Thomas Agnew & Sons commissioned and published photographs of paintings. Together these two dealers copublished one of the landmarks in the photographic reproduction of paintings *Photographs of the "Gems of the Art Treasures Exhibition," Manchester, 1857*. This title consisted of some 200 photographs—100 "Ancient" masters and 100 'Modern' masters—taken directly from the paintings. These photographs formed a milestone in 19th century art historiography in that it helped in the reattribution of a number of works by the Old Masters, often to the detriment of the owners who had perhaps sent a work of an 'Old Master' to Manchester only to have it returned as a copy or work of another, lesser artist. A contemporary review of these photographs also pointed to the democratisation of art; "These things bring Art nearer the reach of the poor man—to whom it will some day become, not mere furniture and wearying luxury, but hope and comfort, and prophecy and exhortation."

Colnaghi set up a photographic studio specialising in art reproduction and formed a professional relationship with Leonida Caldesi that prospered during the late 1850s and 1860s.

Throughout the 19th century stationers and book shops also provided a wide range of photographs for

purchase. Little research has been undertaken in the role of such outlets. However, they played a significant role in the distribution of photographs of works of art at a regional and particularly a local level. In parallel, purchasing photographs of paintings from printed catalogues remained common throughout the 19th century.

Some remarkable works were created using photographs of paintings. At the 1862 International Exhibition held in London, the Belgian photographer Edmond Fierlants (1819–1869), was reported to have exhibited two works, copies of orginals by Hans Memlinc (ca.1440–1494); a life-size replica of the *Shrine of St. Ursula*, with photographic reproductions of the painted panels (at £45), and the *Mystic Marriage of S. Catherine* (at £12. 4s).

A wide variety of photographic print formats were exploited for art reproduction during the 19th century. These ranged from thumbnail-sized prints, used as border decoration in photo albums, to the large Elephant format images of paintings in major European galleries published in portfolios by Adolphe Braun et Cie. In some instances a variety of different loose print sizes were available of the same image. The carte de visite from the 1850s and Cabinet from the 1860s were both used to document a wide variety of works of art including paintings. Paradoxically, examples of photographic stereoscopic views of paintings are also known, though given the two-dimensional nature of most paintings this format seems particularly inappropriate.

The photographic lantern slide, one of the cornerstones of the teaching of art history, was invented in the late 1840s and was beginning to have a significant impact in the teaching of art in Germany by the end of the 1870s. It was not until the 1960s that this format was abandoned in favour of the 35mm slide. It is also significant that black-and-white photographic slides remained predominant—particularly in German-speaking countries, since there were widely held beliefs that the "inaccuracy" of colour photography could distort the reproduction of the original painting.

The use of photography for the illustration of art books began in the 1840s and has proved to be one of the most significant applications of photographs of works of art. Talbot's Reading establishment printed the photographic illustrations to William Stirling's *Annals of the Artists of Spain* published in 1848. Although as few as 50 copies—25 each in quarto and octavo format—may have been produced, the publication was doubly important; firstly as the first photographically illustrated art history book and secondly that some of the illustrations were photographs taken directly from the paintings they represented, rather than manual intermediaries such as engravings or lithographs. British publishers such as Samson Low, Bell & Daldy, A.W. Bennett, Day & Son, Seeley, Jackson & Halliday and Bickers & Son were prominent as publishers of photographically illustrated

art books during the 19th century and several thousand titles were published during this period. While many of these photographically illustrated books contained pasted in Albumen prints of paintings (or reproductions after them), by the end of the century photomechanical processes were almost exclusively used.

Though comparatively little appreciated in the 21st century, the 19th century photography of paintings formed a central position in the history of the medium during that century. This was from an aesthetic, technical and market development perspective. The impact on the history and study of painting is difficult to over estimate.

ANTHONY J. HAMBER

See also: South Kensington Museums; Photography and Reproduction; and Daguerreotype.

Further Reading

Hamber, A.J., *'A Higher Branch of the Art' Photographing the Fine Arts in England 1839–1880*, 1996.

Laura Boyer, *La photographie de reproduction d'œuvres d'art au XIXᵉ siècle en France, 1839–1919*, Thèse de doctorat en Histoire de l'Art, Institut d'Histoire de l'Art, Universite Marc Bloch, Strasbourg, 2004.

Stephen Bann, *Parallel Lines: Printmakers, Painters and Photographers in Nineteenth-Century France*, New Haven and London, 2001.

PHOTOGRAPHY OF SCULPTURE

The practice of drawing from sculpture—particularly from ancient sculpture—was a central element in the education of artists in Italy during the fifteenth and sixteenth centuries. Antiquities such as the *Apollo Belvedere*, the *Belvedere Torso*, and the *Laocoön*—after its rediscovery in January 1506—were fundamental to the figurative vocabulary of every Renaissance artist. Indeed, the study of sculpture complemented direct study of the human figure, and, in the case of the female figure, an antique *Venus* might serve as a surrogate for a live model. Life drawing and the study of plaster casts of sculpture remained at the core of every academic art curriculum in Europe and in North America throughout the early modern period.

Photography was presented as a new form of drawing, and so it is not surprising that sculpture became one of the primary categories of subject matter among the English and French pioneers of the new art. Nor is it surprising that plaster replicas of many of the works that had been important to the formation of Renaissance artists should also have had a formative influence on the early history of photography. In the 1840s the *Apollo Belvedere* and the *Medici Venus* were still considered to represent the Greek ideal of male and female beauty. Small-scale portable versions of these and other ancient

Lampue. Still Life of Sculpture and
Architectural Fragments.
The J. Paul Getty Museum, Los Angeles
© The J. Paul Getty Museum.

sculptures were popular souvenirs among visitors to
Italy and were therefore natural and readily available
models for early photographers. Life-size casts of the
same works became essential elements in academic
training in the fine arts. Photography was assimilated
into this practice through the production of 'academies'
for study by posing nude models.

In the first sentences of his commentary on the *Bust
of Patroclus* in the first fascicle of *The Pencil of Nature*,
William Henry Fox Talbot defined what was to become
an important and continuing relationship between pho-
tography and sculpture:

Statues, busts, and other specimens of sculpture, are
generally well represented by the Photographic Art; and
also very rapidly, in consequence of their whiteness.
These delineations are susceptible of an almost unlimited
variety: since in the first place, a statue may be placed
in any position with regard to the sun, either directly op-
posite to it, or at any angle: the directness or obliquity of
the illumination causing of course an immense difference
in the effect. And when a choice has been made of the
direction in which the sun's rays shall fall, the statue may
then be turned round on its pedestal, which produces a
second set of variations no less considerable than the first.
And when to this is added the change of size which is

produced in the image of bringing the Camera Obscura nearer to the statue or removing it further off, it becomes evident how very great a number of different effects may be obtained from a single specimen of sculpture.

In fact, sculpture featured prominently in Talbot's own repertoire almost from the inception of photography. In a memorandum of March 1840 he placed sculpture first among ten divisions by which he classified photogenic drawings, and notes of photographs he took in 1840 establish that many of those depicted sculpture. The *Patroclus* appears several times, and an *Apollo*, a *Venus*, an *Eve*, and four *Sabines* are also listed. In fact, more than a dozen negatives depicting a miniature version of Giovanni da Bologna's *Rape of the Sabine Woman* are known. Although Talbot photographed the *Patroclus* in the south gallery of Lacock Abbey, it was often the case that the sculptural subjects would be carried outside to be photographed in the grounds of the abbey, and in some instances it is apparent that the object is standing on grass. It is noteworthy, therefore, that *Diogenes*, a sculpture in the entrance hall of the Abbey, was one of the first subjects Talbot photographed after discovering the latent image. It is also significant that a small-scale replica of Antonio Canova's *The Three Graces* is the subject of a photograph that is being made in the well known panorama of Talbot's Printing Works at Reading.

Photographs of sculpture likewise appear in all Talbot's photographically illustrated books. The first of these, the *Record of the Death Bed of C. M. W.*, has as its frontispiece a plate depicting a marble bust of the deceased. The *Patroclus* is illustrated twice in *The Pencil of Nature*, first as plate V and again as plate XVII. Plate six in *Sun Pictures in Scotland* is a photograph of a sculpted effigy of Maida, Sir Walter Scott's favourite dog. The volume of *Talbotype Illustrations* that was published to accompany copies of Sir William Stirling's *Annals of the Artists of Spain* contains several photographs depicting works of sculpture.

Sculpture was also among the first subjects treated in the earliest history of photography in France. In 1838 and 1839 Louis-Jacques-Mandé Daguerre photographed still-life compositions that included statuettes and reliefs. One well-known daguerreotype representing a collection of shells and fossils is effectively a miscellany of sculptural objects. Sculpture was the principal category of subject matter in the body of work made by Hippolyte Bayard in 1839 and 1840. Photographs mounted in an album preserved in the Société française de photographie in Paris, for instance, show that he photographed some forty different plaster casts in this formative period. Bayard continued to photograph arrangements of sculpture during the 1840s and 1850s. Among these pictures is one beautiful composition in which five different casts form a figurative garland around a replica of the renowned *Venus de Milo*.

Bayard, Daguerre, and Talbot evidently recognised and exploited the fact that plaster casts, because of their whiteness and stability, provided ideal practical models for photography. However, Talbot's interest in the *Patroclus,* the *Sabines,* and the *Three Graces* may also have been stimulated by a wish to explore the possibility of depicting expression and movement. The *Patroclus* is an exceptionally animated sculpture, one that appears physically and spiritually alive. Giambologna's sculptural group, described in John Murray's *Handbook* of 1847 as "wonderful for its expression and its energy of action," neverthelesss stands patiently still for Talbot, enabling him to capture its violent torsion and turbulent energy. Similar points might be made with respect to Charles Nègre's renowned photograph of 1859 depicting the sculptural group *Boreas and Orythia* in the Tuileries Gardens in Paris.

David Octavius Hill and Robert Adamson occasionally introduced works of sculpture into their portraits and subject pictures. In these portraits the sculpture alludes to the nature of the sitter, much as books do in Hill and Adamson's portraits of churchmen, and in this respect the sculpture serves as do the coins medallions, and statuettes that appear in Renaissance portraits by Bronzino, Titian, and others. A calotype of Elizabeth Rigby, for instance, portrays her with a plaster cast of a bronze by Pierre Philippe Thomire depicting two cupids fighting over a heart. This group is clearly appropriate to a portrait in which the sitter is depicted in a mood of romantic reverie. A colossal head entitled *The Last of the Romans* serves straightforwardly as an 'occupational' attribute in Hill and Adamson's portrait of John Stevens, the sculptor responsible for this work. This head functions more allusively in *The Morning After 'He Greatly Daring Dined,'* a composition that is perhaps a lightly moralising sermon on the effects of intemperance. Transporting the sculpture to Rock House must in itself have been a considerable challenge. In a more serious vein, the sculptural tombs in Greyfriars Churchyard provide settings for compositions by Hill and Adamson that are in effect meditations on mortality.

In the spring of 1846 the Reverend Calvert Richard Jones made two negatives in Florence from Giovanni da Bologna's *Rape of the Sabine Woman*. These studies recall Talbot's earlier efforts to record his miniature *Sabines* and serve also a form of homage to Talbot. However, Calvert Jones's pictures of Giambologna's sculpture and a precisely contemporaneous photograph of Baccio Bandinelli's *Hercules and Cacus* are also instances of the employment of photography to document works of art for touristic purposes. Such images enabled the traveller—like Napoleon—to carry off 'trophies' of travel. Indeed, the first catalogue produced by the Fratelli Alinari consists entirely of architectural views and photographs of sculpture. Such photographs

also enabled the armchair traveller to experience these attractions without having to leave home.

The ritual of purchasing photographic 'spolia' became an integral part of the 'work' of tourism, and photographs of sculpture formed a significant portion of any representative collection of views of Florence, Rome, and Venice, for example. Among the innumerable photographers that supplied such portable records were—in addition to the Alinari—James Anderson, Adolphe and Henri Braun, Giacomo Caneva, Robert Macpherson, Carlo Naya, and Carlo Ponti. Photographs of ancient sculptures excavated in Rome during the pontificate of Pius IX contributed to the myth of the Papacy, as did the lavish photographic albums documenting the Vatican sculptures that Macpherson and the Brauns published in the 1860s. Working farther afield in the sphere of travel photography, including the photography of sculpture, were, for instance, Felix Bonfils in Athens and Constantinople; **M**axime Du Camp, Francis Frith, John B. Greene, Félix Teynard in Egypt; Lous De Clercq in Syria; Auguste Salzmann in the Holy Land.

Travel photography and photography that was intended to document the history of art and architecture were closely related. In France in the early 1850s, Charles Nègre, Em. Pec, and Henri Le Secq recorded the sculpture at Chartres, for instance, in addition to photographing the cathedral itself. In England, Roger Fenton was employed in 1854 to document the ancient sculpture in the British Museum. After constructing a studio on the roof of the museum, Fenton set about photographing dozens of Assyrian tablets and other works of sculpture. In order to ensure that there was sufficient light, it was often necessary to have the objects carried out on to the roof itself, a practice that in turn required Fenton to devise ingenious ways of controlling and modulating the natural light; occasionally he would even dust the sculpture with powder to make the surfaces more conducive to photography. Between February 1854 and May 1856, Fenton and his assistants produced over eight thousand salt prints of sculpture. From these beginnings, the scholarly study of sculpture became inseparable from the history of the photography of sculpture, and understanding of particular works of sculpture was shaped in significant part by the character of the photographs that were available. Conversely, the interests and needs of art historians might affect the nature—general views and details—and particular viewpoints of the photographs that were made.

Sir David Brewster**'s** invention in 1849 of the stereoscope made it possible to produce photographs of sculpture that more closely approximated the sensation of relief and volume provided by the subject itself. Sir David himself affirmed that such views would enable the student of sculpture to "avail himself of the labours of all his predecessors." He would "virtually carry in his portfolio . . . the gigantic sphinxes of Egypt, the Apollo, and Venuses of Grecian art, and all the statuary and sculpture which adorns the galleries and museums of civilized nations." Indeed, such images came to be perceived as accurate and true substitutes for the models themselves. As a result of the publication of millions of inexpensive stereoscopic prints and slides of ancient and modern statuary, sculpture was literally "photographed into . . . popularity."

Talbot's observations concerning the "almost unlimited variety" that is possible when photographing sculpture raises important questions concerning the nature of the relationship between the two media. In relation to the graphic arts and printing, for instance, photography is a reproductive process in which the correspondence between the matrix and the image appears relatively straightforward. For a start, the subject and the photograph are both two-dimensional. A photogenic drawing of an engraving or a leaf is a direct impression of the object made by the action of light. With sculpture, however, the relationship between the object and the image is exceedingly complex and is, as Talbot indicates, "susceptible of an almost unlimited variety."

Elements contributing to this variety are the three-dimensional character of the matrix, the changing nature of the sculpture's ambience, and the character of the photographer's intervention. Rather than being an impartial and objective impression of the subject, a photograph of a sculpture is a discrete image, one that is a visible record of dialogue between photographer and object, a dialogue that took place at a particular place and time. This dialogue may be affected significantly by the conditions under which the photographer is working and by the limitations of contemporary technology. In order to produce a satisfactory plate of Alessandro Vittoria's *St Jerome*, for instance, the Venetian photographer Carlo Naya left his camera standing in the Frari for several days.

That a photographer may take possession of a sculpture is illustrated by the famous series of photographs of Auguste Rodin's *Balzac* created by Edward Steichen in 1908. The ambivalent relationship between sculpture and photography was also recognised by Constantin Brancusi when he asked Man Ray to teach him how to make his own photographs. Underlying this request was Brancusi's experience of seeing a photograph of his work by Alfred Stieglitz. "It was a beautiful photograph, [Brancusi] said, but it did not represent his work. Only he himself would know how to photograph it." Even when the photographer is self-effacing, as the American art historian and photographer Clarence Kennedy intended to be, the image is inevitably a record of a dialogue between the photographer and the object.

GRAHAM SMITH

See also: Talbot, William Henry Fox; Daguerre, Louis-Jacques-Mandé; Bayard, Hippolyte; Nègre, Charles; Hill, David Octavius, and Robert Adamson; Jones, Calvert Richard; Fratelli Alinari; Anderson, James; Braun, Adolphe; Caneva, Giacomo; MacPherson, Robert; Naya, Carlo; Ponti, Carlo; Travel Photography; Du Camp, Maxime; Frith, Francis; Greene, John Beasly; Teynard, Félix; De Clercq, Louis; Salzmann, Auguste; Nègre, Charles; Le Secq, Henri; Fenton, Roger; Brewster, Sir David; Steichen, Edward J.; and Stieglitz, Alfred.

Further Reading

Baldwin, Gordon, Malcolm Daniel and Sara Greenough, with contributions by Richard Pare, Pam Robertson and Roger Taylor, *All the Mighty World: The Photographs of Roger Fenton 1852–1860*, New Haven and London: Yale University Press, 2004.

Bergstein, Mary, "Lonely Aphrodites: On the Documentary Photography of Sculpture," *Art Bulletin*, 1992, 475–498.

Bergstein, Mary, "The Mystification of Antiquity under Pius IX: The Photography of Sculpture in Rome, 1846–1878." I n *Sculpture andPhotography: Envisioning the Third Dimension,* edited by Geraldine A. Johnson, 35–50, Cambridge: Cambridge University Press, 1998.

Fraenkel, Jeffrey (ed.), with an essay by Eugenia Parry Janis, *The Kiss of Apollo: Photography & Sculpture 1845 to the Present*, Fraenkel Gallery in association with Bedford Arts, Publishers: San Francisco, 1991.

Hamber, Anthony J., *"A Higher Branch of Art": Photographing the Fine Arts in England, 1839–1880,* Amsterdam: Gordon and Breach Publishers, 1996.

Haskell, Francis, and Nicholas Penny, *Taste and the Antique: The Lure of Classical Sculpture 1500–1900,* New Haven and London: Yale University Press 1981.

Johnson, Geraldine A., "Sculpture and Photography: Envisioning the Third Dimension." In *Sculpture andPphotography: Envisioning the Third Dimension,* edited by Geraldine A. Johnson, 1–15, Cambridge: Cambridge University Press, 1998.

Joel Snyder, "Nineteenth-Century Photography of Sculpture and the Rhetoric of Substitution," In *Sculpture andPphotography: Envisioning the Third Dimension,* edited by Geraldine A. Johnson, 21–34, Cambridge: Cambridge University Press, 1998.

PHOTOGRAVURE

An intaglio photomechanical printing process invented by Karl Klic (1841–1926) of Vienna in 1879. It was based on F.H. Talbot's photoglyphic engraving process of 1852. Intaglio refers to methods of printing in which the lines, dots, grain or other elements of the printing plate, are sunk in the plate so that the depressions are filled with ink for printing. Photogravure, aka. gravure, aquatint photogravure, dust grain photogravure or Talbot-Klic process, is the best known intaglio process. In capable hands, it can produce high quality images with a rich matt surface, on a wide variety of papers.

Common etchings, mezzotints and line engravings are also intaglio processes.

Photogravure is the ultimate facsimile process for the reproduction of etchings because the lines it reproduces are actually etched in the printing plate just like the original etching plate. Rembrandt's work has been the subject of more facsimile reproductions than any other artist's. Philip Gilbert Hamerton (1834–1894), in his book, *The Graphic Arts* (1882) provides an insight into the techniques used in France. On Goupil, "... [it] is a secret, and all I know about it is that the marvelously intelligent inventor discovered some means of making a photograph in which all the darks stood in proportionate relief, and from which a cast in electrotype could be taken which would afterwards serve as a plate to print from." On Dujardin "... he covers a plate made of a peculiar kind of bronze with a sensitive ground, and after photographing the subject on that simply etches it and has it retouched with the burin if required." And on Amand Durand, "He bites his plates like ordinary etchings; and when they are intended to represent etchings he rebites them in the usual way and works upon them with dry point, &c., just as an etcher does, but when they represent engravings he finishes them with the burin." He concludes, "The reader now perceives the essential difference between the Goupil process, in which there is no etching, and the processes employed by the héliograveurs, which are entirely founded upon etching."

Photogravure was popular with pictorial photographers at the end of the 19th century and in the early part of the 20th century. The most impressive use of this process was the production of Edward S. Curtis' 20 volume work, *The North American Indian*, each containing 75 hand-pulled photogravures and 300 pages of text, produced between 1907 and 1930. Alfred Stieglitz's Camera Work, which had 53 issues between 1903 and 1917, included 544 illustrations, 416 of which were photogravures. Alvin Langdon Coburn (1882–1966) produced the photogravure illustrations for his books —83 plates and over 40,000 prints.

Peter Henry Emerson (1856–1936) used platinum printing for his first book but learned photogravure, which he referred to as "photo-etching," a term a found more suitable to a medium of original expression rather than as a method of reproduction. His best known works include *The Compleat Angler, or the Contemplative Man's Recreation,* a two-volume work (1888, 54 photogravures) and *Wilde Life on a Tidal Water. The Adventure of a Houseboat and Her Crew* (1890, 30 photo-etchings).

Around the 1880s, Thomas Annan (1829–1887) entered into a partnership with Sir Joseph Wilson Swan and purchased the rights to use the photogravure process from the Imperial Printing Works in Vienna. His most impres-

Annan, James Craig. A Wayside Shrine, Ronda.
The Metropolitan Museum of Art, Alfred Stieglitz Collection, 1949 (49.55.271) Image © The Metropolitan Museum of Art.

sive work was published in photogravure by his second son, James Craig Annan (1864–1946), *Old Closes and Street—Glasgow, A Series of Photogravure, 1868–1899* (Glasgow, T&R Annan & Sons, 1900, 50 plates).

More recent efforts include portfolios of the photographs of Robert Mapplethorpe (1946–1989) and Eduard Steichen (1879–1973).

Aquatint photogravure is practiced today by a small group of artist photographers and printmakers. The early process did not meet the requirements of popular publications which required large print runs rapidly executed. The improvements have been too numerous to be discussed at length in the context of this article but we will mention the main inventions. It was the same Karl Klic mentioned above, who founded the Rembrandt Intaglio Printing Co., at Lancaster, England, in 1895, where the first rotary gravure (aka. rotogravure) process that made use of a doctor blade (to wipe the excess ink off the surface of the plate) and a cross-line screen was secretly exploited for many years. Printing from cylinders on paper fed from large spools reduced the cost of high-quality photogravures to a point where they began appearing in popular publication.

Although the square pattern of photogravure screens is normally associated with mass produced rotogravures, Austrian born Theodor Reich worked out a way to use a cross-line screen with a flat-plate gravure ca. 1897 and sold his invention to F. Bruckmann of Munich in 1903. The process was exploited under the name mezzo-tinto-gravure and was advertised in the Penrose Annual until at least 1927.

In 1904 the first rotogravure plant in America, the American Photogravure Co., started operation in Philadelphia. In 1910 the first example of the Rembrandt Intaglio color process appeared in a book, Colour Printing and Colour Printers, by R.M. Burch and C.W. Gamble. In the same year, Mertens introduced his Monochrome Intaglio Process, i.e., intaglio pictures combined with letterpress text. This method was popular until the 1950s. In 1913, Alfred Stieglitz' Camera Work published five duogravures in the April/July issue. These two- color gravures should not be confused with the duotone photoengravings advertised as "duogravures" which appeared in many books published by the Boston firm L.C. Page & Company during the years 1901 and 1925. In was not uncommon in those days for publishers to claim that the cheaper processes they used, including collotype, were photogravure.

Until fairly recently, the modern commercial process was called screen photogravure or rotogravure. In this process, the continuous tone positive and gravure screen were exposed in succession onto carbon tissue which was then mounted on the copper-plated gravure cylinder. A later form, where the plate is made flat and afterwards curved around a cylinder, was known as "plategravure" (ca. 1930s).

In an effort to remove one of the main difficulties of the original photogravure process, researchers have tried to replace the chemical etching step with other methods that involved "spark erosion" and laser engraving, the latter developed by Crosfield but abandoned in early 1990. The most popular method currently employed is based on the electromechanical engraving process invented by Hell in Germany in 1952. The Helioklischograph uses up to a dozen vibrating styli with diamond tips that peck out tiny pits in the copper surface.

LUIS NADEAU

See also: Baldus, Edouard; Curtis, Edward Sheriff; Goupil & Cie; and Niépce, Joseph Nicéphore.

Further Reading

Bonnet, *Manuel d'héliogravure*, Paris: Gauthier-Villars, 1890.

Braun, Alexander, *Der Tiefdruck, seine Verfahren und Maschinen*, Frankfurt: Polygraph Verlag, 1952.

Cartwright, H.W., and MacKay, Robert, *Rotogravure, A Survey of European and American Methods*, Lyndon, KY: MacKay Pub. Co., 1956.

Denison, Herbert, *A Treatise on Photogravure in Intaglio by the Talbot-Klic Process*, London: Iliffe & Sons, 1895. Reprinted in 1974 by the Visual Studies Workshop, Rochester.

Gasch, Bernard, *Rakeltiefdruck, Halle*, Wilhelm Knapp, 1950

Geymet, *Traité pratique de gravure héliographique*, Paris: Gauthier-Villars, 1885

Hamerton, Philip Gilbert, "The Graphic Arts. A Treatise on the Varieties of Drawing, Painting and Engraving." In *Comparison with Each Other and with Nature*, London, Seeley, Jackson and Halliday, 1882.

Huson, Thos., *Photo-Aquatint and Photogravure*, London, Dawbarn & Ward, 1897.

Jammes, André, et al., *De Niépce à Stieglitz: La Photographie en Taille-douce*, Lausanne, 1982.

Lilien, Otto M., *History of Industrial Gravure Printing up to 1920*, London: Lund Humphries, 1972 (155 pp.).

Morris, David, and MacCallym, Marlene, *Copper Plate Photogravure: Demystifying the Process*, Boston: Focal Press, 2003.

de Zoete, Johan, *A Manual of Photogravure*, Haarlem, Netherlands, Joh. Enschedé en Zonen, 1989.

PHOTOHISTORIANS

For several decades after the publication of the first photographic processes in 1839, and indeed for most of the nineteenth century, photography was primarily regarded as an invention. Its history, therefore, was predominantly written as the history of an invention, comparable as such to histories of the steam engine or the electric telegraph, and more often than not filled with the petty personal quarrels, as well as broad generalizations on the invention's utility, that attended such enterprises at the time. Accordingly, most of the first historians of photography were its scientific patrons, inventors, or early practitioners, and the histories they wrote were predominantly "technical," as they have often been called, or rather professional and promotional. After 1914, and more so after 1930, new brands of photohistorians emerged, some of them early collectors of photography's incunabula, but others from outside the ranks of the profession and even the realm of amateurs. Between 1930 and 1970 they gradually changed the perception of nineteenth-century photography, which came to be regarded more as a socio-cultural artefact, and also appreciated in artistic as well as financial terms. Starting in the 1960s and especially after 1970, the influence of art historians, museums, the art market, and art-historical models on photographic history became more marked, without extinguishing other approaches, especially those of collectors, by then more specialized, and cultural historians and critics, who challenged traditional art-historical assumptions while broadening even more the scope of photographic history.

The very first attempts at writing a history of photography were embedded in the very procedures of publication of the various processes that competed for recognition and influence, starting in 1839: thus François Arago's and, to a lesser extent, William H.F. Talbot's presentations to the French and British learned bodies contained some historical research on the origins of the invention. These accounts aimed, among other goals, at establishing the usefulness and even the cultural legitimacy of the invention. They were decidedly less technical than broadly scientific, and placed photography—envisioned as a discovery, even more than an invention—within a relatively long-term history of science. Thus Arago, while endorsing the claims of the French inventors Niépce and Daguerre, was the first to link their research to those of alchemists, as well as earlier (French) physicists, be it in order to better stress the magnitude of the inventors' achievement. Incidentally, it must be noted that Arago's choice to designate Daguerre and the daguerreotype—over Talbot, but also over Niepce—as the true beginners of photography caused, in France, a long string of priority claims and vindications (Isidore Niépce's in 1841, Victor Fouque's in 1867, Adolphe Mentienne's in 1891, etc.) that led to sometimes significant historical disclosures. In 1949, the publication by Russian historian Torinan Kravets of a large body of Niepce-Daguerre correspondence preserved (since 1840) in the Russian Academy of Sciences still echoed that ancient feud, which has, repeatedly since then and

even as recently as 2004, been rekindled by various publications of such documents.

More generally, the keen interest that scientists initially took in the invention and its scientific applications explains the leading role that chemists and physicists played among early photo-historians. Beyond Arago, who authored, in addition to his famous 1839 speech to the French Parliament, several memoirs on the subsequent development of photography, a number of the leading academic scientists of the time contributed historical remarks and some essays on photography, its origins, and its significance, especially for the theory of light. These include the Englishmen John F. W. Herschel, David Brewster, and, more specifically for photographic methodology, Robert Hunt (whose *Treatise on Photography* (1841) and *Researches on Light* (1844) are, arguably, the most significant early publications on the subject), the Frenchmen Joseph-Louis Gay-Lussac, Jean-Baptiste Biot, the Germans Johann Madler, Alexander von Humboldt (and, later, Hermann Vogel, perhaps the single most influential scientific writer on photography in the nineteenth century), and the American expert on photochemistry John W. Draper.

These early accounts, more scientific than technical, paved the way for at least two subsequent kinds of "scientific" histories of photography. One was embedded in the larger genre of popular science, represented by encyclopaedias, magazines such as *The Scientific American* (founded in 1845), and illustrated surveys of the "wonders of modern science" of the kind that the French polymath Louis Figuier became famous for; these perpetuated a number of legends about the beginnings of photography but maintained its link to popular and general culture. The other was the later, far more specialized, and ever-widening investigation of what would come to be known as the "prehistory" of photography, which would often be associated with more strictly technical, or methodological, surveys of its development. In the last years of the nineteenth century, this trend, which may perhaps more properly be called technical, was represented by the British expert John Werge (*The Evolution of Photography*, 1891) and, above all, by the Viennese chemist Josef-Maria Eder, arguably the first major historian of photographic and imaging technologies, with his monumental *Ausführliches Handbuch der Fotografie* in four volumes (1891–96), followed by his groundbreaking *Geschichte der Fotografie* (four editions were published between 1895 and 1932). In the twentieth century, this brand of technological history was primarily pursued by German-language historians, from Erich Stenger to Helmut Gernsheim, though it had echoes in France (with Georges Potonniée) or in the United States (with Edward Epstean, originally a photo-engraver, who was also Eder's English translator); but its influence can be

felt, until the end of the twentieth century, over much photo-history.

Although practitioners or advanced amateurs often had a hand in this scientific-technical brand of photohistory, as shown by the examples of Vogel, Werge, or Eder, another, more specifically professional, brand of photohistorians emerged very early on with the appearance of the first specialized treatises, or handbooks. Daguerre himself had entitled his 1839 manual *Historique et description des procédés du daguerréotype et du Diorama.* While most of the handbooks published in the 1840s contained few historical remarks, the formation after 1850 of more self-conscious professional organizations and the appearance of the first specialized magazines (in France, the U.K., and the U.S.) was accompanied by the publication of more ambitious treatises that more and more often included several historical chapters. One of the very first such compendia was the American Henry Hunt Snelling's *The History and Practice of the Art of Photography*, published in 1849, but it was soon followed by a host of competitors (such as, in the U.S., John F. Towler's *The Silver Sunbeam* and Marcus A. Root's *The Camera and the Pencil*, both published in 1864). The Société héliographique (founded in 1851, replaced in 1854 by the Société française de photographie), the Royal Photographic Society, formed in 1853, or the American "daguerrean" associations, each of which started publishing a magazine between 1850 and 1855, all busied themselves, and increasingly with time, with historical investigations. Writers such as Ernest Lacan in France or H.H. Snelling in the United States came to be regarded as authorities on the subject by their peers. Indeed, this burgeoning historical, technical and critical curiosity cannot be separated from the campaigns waged by leading professionals (and some devoted amateurs) to establish their art, or their commerce, on a firmer cultural basis—in short, to legitimize photography, and to rally, towards this goal, the support of unified and coherent professional constituencies. Lacan, Snelling, and their likes were neither great scientists nor careful historians; their writings were eclectic, often second-hand, sometimes full of errors; they were prone to nationalist claims and parochial arguments on the universal usefulness of their activity; but in the second half of the nineteenth century, they probably best embodied the emerging self-consciousness of a "photographic field" that sought both recognition by the academies and a certain measure of autonomy and self-reliance. Moreover, this trend is important in that it set a model for later campaigns for the recognition and institutionalization of photography, photographic art, or photographic education, which, as in the example of Alfred Stieglitz's Photo-secession, most often included a strong interest in the history of photography and an equally strong doctrine about how it should be written. Even the typical eclecticism of much

20th-century writing on photo-history may, arguably, be ascribed to this professional model.

To complete this survey of nineteenth -century photo-historians, it must be noted that aside from the scientific and professional writers, there were a few attempts —though not many— at more cultural, or philosophical, interpretations of the invention of photography. Some important accounts of photography's beginnings were thus penned by a few artists and art critics —such as the Frenchman Francis Wey—, or essayists and writers such as the Frenchman Charles Baudelaire, the Englishwoman Elizabeth Eastlake, or the American Oliver Wendell Holmes. It is surprising to see how much these early, often bold, commentators foreshadowed the later, more celebrated theses of twentieth-century critics such as Walter Benjamin or Roland Barthes. Until the end of the century, however, photo-history, like photography itself, remained very much the province of aficionados and professionals, while the general public had to be content with brief overviews placing it among the wonders of the century.

Though this entry cannot concern itself with the many succeeding generations of photo-historians after 1900, some remarks are in order as to how these later writers participated in the changing perceptions of nineteenth-century photography. To be sure, the major shift was from the perception of photography as invention to its recognition as art, and that paradigm change was deeply influenced by the crusades of virtually every avant-garde from Modernism to Conceptual art, as well as the strategies of influential collectors and then museums. Photo historians participated, often actively, in this shift, a major example being Beaumont Newhall, art historian turned curator of photography at New York's Museum of Modern Art (MOMA) and then the single most influential photo-historian of the twentieth century, who increasingly regarded the history of nineteenth-century photography as a history of pictorial expression, rather than one of technology. At the end of the twentieth century, the training of art historians routinely encompassed photography, and especially its "primitives," by now firmly established on the art market and in the artistic canon; ever-more expansive exhibitions and monographs were devoted, largely by historians with a training in art history, to a growing number of early masters. But this inclusion of photo-history into art history, the subject of much passionate debate after 1980, must not be overestimated, and neither should the work of twentieth -century photo-historians be reduced to it. At least three other separate trends must be noted here. First, many collectors of early photographs were also experts on "photographica" (materials, objects, practices, etc.), and, from Gabriel Cromer to Helmut and Alison Gernsheim, Floyd and Marion Rinhart, or Michel Auer, they have not only kept alive an interest in the history of

photographic technology but expanded it in many ways. Second, it must be stressed that, exactly at the same time as Modernist-inspired exhibitions of the photographic art pioneered its recognition in the 1930s, in Germany, France, and the United States, other perspectives on the early history of photography emerged, in the very same countries, from the inspiration of folklore studies, social history, and sociology. Examples include, in the United States, Robert Taft's *Photography and the American Scene* (1938), but, more decisively, the important German works of Helmut Bossert and Heinrich Guttman, Heinrich Schwarz, Siegfried Kracauer, and even Gisèle Freund, all of which left their imprint on the shorter and better-known essays by Walter Benjamin. This sociological trend, which, among other things, paid close attention to the reception, spread, and social uses of photography in the nineteenth century, has arguably exerted, if indirectly, just as strong an influence as the art-historical model did on later more cultural histories of photography, of the kind exemplified, in the 1980s and 1990s, by Naomi Rosenblum and especially Michel Frizot. Lastly, one cannot but observe, since 1990, that photography and photo-history have been increasingly understood as the matrix of a broader cultural history of images or visual culture, and that their appeal largely outreaches the realm of any specialized branch of cultural history.

FRANÇOIS BRUNET

See also: Talbot, William Henry Fox; Daguerre, Louis-Jacques-Mandé; Herschel, Sir John Frederick William; Brewster, Sir David; Eder, Joseph Maria; Werge, John; Vogel, Hermann Wilhelm; Société française de photographie; Société héliographique; Lacan, Ernst; Stieglitz, Alfred; and Wey, Francis.

Further Reading

Baier, Wolfgang, *Quellendarstellungen zur Geschichte der Fotografie* [*Sources Towards the History of Photography*], Munich: Schirmer/Mosel, 1977.

Bolton, Richard (ed.), *The Contest of Meaning: Critical Histories of Photography*, Cambridge: MIT Press, 1989.

Brunet, François, *La naissance de l'idée de photographie* [*The Birth of Photography as an Idea*], Paris: Presses Universitaires de France, 2000.

Eder, Josef Maria, *History of Photography*, New York: Dover, 1978 [1945 translation from *Geschichte der Photographie*, 4th ed., Halle: Knapp, 1932].

Etudes photographiques, # 16, May 2005, "Les nouveaux enjeux de l'histoire."

Freund, Gisèle, *La Photographie en France au dix-neuvième siècle, Etude de sociologie et d'esthétique* [*Photography in Nineteenth-Century France, A study in Sociology and Esthetics*], Paris: A. Monnier, 1936.

Frizot, Michel (ed.), *A New History of Photography*, Cologne: Könemann, 1998. (transl. from *Nouvelle histoire de la photographie*, Paris: Bordas, 1994).

Gernsheim, Helmut, *The Origins of Photography*, London: Thames and Hudson, 1982.

Gernsheim, Helmut, and Alison Gernsheim, *The History of Photography from the Camera Obscura to the Beginning of the Modern Era*, New York: McGraw-Hill, 1969.

Goldberg, Vicki (ed.), *Photography in Print, Writings from 1816 to the Present*, New York: Simon and Schuster, 1981.

History of Photography, 1997, t. 21, no. 2, "Why Historiography?"

Marien, Mary Warner, *Photography and its Critics : A Cultural History, 1839–1900*, Cambridge: Cambridge University Press, 1997.

Newhall, Beaumont (ed.), *Photography : Essays and Images*, New York: The Museum of Modern Art, 1980.

——, Beaumont, *The History of Photography*, 5th ed., New York: The Museum of Modern Art, 1982.

Rosenblum, Naomi, *A World History of Photography* , 3r ed.,New York: Abbeville Press, 1997.

Taft, Robert, *Photography and the American Scene: A Social History 1839–1889* (1938), repr. New York: Dover, 1964.

Wells, Liz, ed., *Photography: a Critical Introduction*, 3rd ed., London: Routledge, 2004.

PHOTOLITHOGRAPHY

Photolithography is a photomechanical printing process that combines lithography with photography. Throughout its history, photolithography has included a variety of forms and printed image effects. Today, it is used in the printing of everything from magazines to soup can labels.

Lithography Lithography was invented in 1798 by a German author, Aloys Senefelder, who was looking for a practical way to publish his plays. Lithography is based on the principle that water and grease do not mix. The traditional lithographic process is as follows: On a flat printing surface marks are made in a greasy medium. The surface is dampened with water, which settles only on the unmarked areas, as it is repelled by the greasy drawing medium. Next, a roller covered with greasy printing ink is rolled over the surface. The ink adheres only to the drawn marks, the water repelling it from the rest of the surface. Finally, the ink is transferred to a sheet of paper by running the paper and the printing surface together through a special press.

From the beginning artists were intrigued with lithography, as they could draw and paint directly onto the printing plate. Many famous artists, including Pablo Picasso, Marc Chagall and Andy Warhol, have used this process. In the early 19th century lithography was usually monotone and not favored for commercial purposes. Stones were used as the printing surface, which was a cumbersome and expensive method. By the 1850s stones were replaced with metal plates— first zinc, then copper in the 1890s. After the American Civil War mass production of lithographs was possible. However, it wasn't until after the 1876 Centennial Exhibition in Philadelphia, where it received great exposure, that lithography flourished.

The first photolithographs As early as the 1850s, attempts were made to create lithographic printing surfaces by means of photography. While the ultimate goal was to create photographically realistic images, the first photolithographs could only create lines. These prints are often called *line photolithographs*. In this process, a document, such as a pen and ink sketch or hand written document, was photographed. The negative that was produced was used to expose a photographically sensitive sheet. The lines of the image would harden and the image was transferred to the printing stone or metal plate for printing. Transferring the image this way from a paper sheet, as opposed to drawing the image directly onto printing stone or plate, is called *transfer lithography*. From the 1860s, line photolithography was used to reproduce engravings, maps, architectural drawings and similar documents. In many early examples, it is difficult to near impossible to determine if such a lithograph was a photolithograph or a manual (by hand) lithograph.

While line photolithography was useful, there was strong desire to add tone and similar detail to the print. The earliest commercially viable technique that could create tone was the *ink-photo*, developed by a London firm, Sprague and Co., in the early 1880s. This was a transfer lithograph using the reticulation of gelatin to break up the photographic image into dots and squiggles. Once the image was photographically transferred on the gelatin surface, it was transferred to the printing stone or zinc plate and printed. This process is closely related to the collotype. The ink-photo was easier and cheaper to mass produce than the collotype, but the image was inferior. "Inc-Photo" and the company name is often printed is often printed on these prints. The ink-photo processes was used to illustrated many books.

Halftone photolithography With the introduction of the half-tone process, commercial printers could first make photolithographic prints with near photographic detail. Halftone is a photomechanical process that is applied to numerous printing processes, including relief (the common method of printing for 19th century publications), intaglio and lithography. It is often referred to as the *screen process* or *dot process*. With the use of special screens or glass with cross-hatched lines that break up the image, the halftone process translates the tones and detail of a photographic image into a printed pattern of tiny dots. Under magnification these dots are obvious, but from normal view they meld into what appears to be photographic tone. Typically, in the darker areas of the print, the dots are larger and closer together. In the lighter areas, the dots will be smaller and further apart. Examination of the photographically realistic image in a modern newspaper or magazine will reveal the halftone dots.

The halftone process was quickly applied to commercial relief printing, with half-tone prints commonly

appearing in newspaper and similar publications in the 1880s–1890s. The practical commercial application of halftone to photolithography was not so swift. Today, halftone photolithography is a dominant form of commercial printing.

DAVID RUDD CYCLEBACK

Further Reading

Curwen, Harold, *The Process of Graphic Reproduction in Printing*, London, 1966.
Gascoigne, Bamber, *How to Identify Prints*, New York, New York: Thames and Hudson, 1986.
Griffiths, Antony, *Prints and Printmaking: An introduction to the history and techniques, Berkely, California*, University of California Press, 1996.
Newton, Charles, *Photography in Printmaking*, London, Victoria and Albert Museum, 1979.

PHOTOMECHANICAL: MINOR PROCESSES

The nineteenth century produced a great many photomechanical inventions that never became very successful. There were many reasons for this. The processes had to be practicable and they had to offer advantages over competing technologies, such as speed of operation and reduced cost. New processes could takes years of development at great expense and working conditions did not allow any significant control on important variables such as air temperature, humidity and levels of sunlight. The period literature is filled with comments to the effect that certain processes that made use of gelatin coatings "worked better on the Continent than in England," on account of the dryer weather. Technical manuals often described changes in chemical formulas based on the season, e.g., "during the winter months, a five percent solution of bichromate is recommended while two percent will suffice in the summer months."

There were also human factors such as a tendency for employees to resist changes that would have threatened their job security.

Etched Daguerreotype

Within weeks of Daguerre's announcement (1839) experimenters were trying to convert the daguerreotype image into a printing plate suitable for intaglio printing. The daguerreotype picture is produced by the deposit of mercurial vapor which combines with the silver and the polished surface of the silver surface itself. As the electro-chemical relations of these two metals are dissimilar, it was thought that the daguerreotype plate could be etched by the agency of the voltaic battery. Dr. Berres of Vienna, Fizeau in France, and Grove in England, succeeded either by direct chemical action, or by electro-chemical processes in engraving these plates,

and in many examples the details were preserved "in a very charming manner." Claudet was very successful in engraving the daguerreotype picture by a modification of the process by Fizeau. The latter gilded the daguerreotype image, and then etched the parts not covered by the gold, which acted as a resist. The difficulty of biting the daguerreotype plate image to a sufficient depth to obtain the requisite ink-holding grain soon led to abandonment of the method.

Nevertheless, a number of publications were produced by this form of *etched daguerreotype*. The first one was by Joseph Berres of Vienna, *Phototyp nach der Erfindung des Prof. Berres in Wien*, (Vienna, 1840), illustrated with 5 plates from daguerreotypes, etched with nitric acid. Also of note are the *Excursions Daguerriennes, représentant les vues et les monuments anciens et modernes les plus remarquables du Globe*, (Paris, 1840–1843) in which three of the 111 plates were printed directly from daguerreotype plates by the Fizeau process.

Dallastype

This was a process for making relief blocks for typographic printing. It was probably the most successful invention of Duncan Campbell Dallas, who made half-tone blocks, and used a ruled screen instead of, or sometimes in combination with, his dallastint reticulated grain. The blocks were made of type metal, evidently cast in plaster molds taken from the gelatin relief. Dallas presented an example of his work to the *Photographic News* in 1864, calling it "dallastype." Dallas, however, appears to have changed the names of his processes as time went on.

Dallas advertised dallastype, dallastint and chromo-dallastint in W.T. Wilkinson's *Photoengraving* (ca. 1888–1890), but the only one that seems to have been used in books to any extent was dallastype. Some of the illustrations in Robert *Dickson's Introduction of Printing into Scotland*, 1885, were dallastypes. They were also used in Dickson & Edmond's *Annals of Scottish Printing*, published by Macmillan & Bowes in 1890. Pulls from some of the blocks in the latter book were given to William Blades by Dallas and are now in a scrapbook in St. Bride's printing library, London.

Expresstypie

A process for making grained half-tone blocks, invented by Cronenberg, ca. 1895. It used a grained screen, placed in contact with a gelatin dry plate, to make a grained negative. This was printed onto zinc or copper in the usual way. The grain had a reticulated character resembling that of collotype.

Goupil Gravure

Invented by Rousselon in France (ca. 1874) who de-

scribed his process as follow: "The value of our process of photogravure consists in the possibility of obtaining, by means of light, an etched copper-plate exactly like the ordinary copper-plate, and giving all the gradations of tone and half-tone, as drawn by nature in the ordinary photograph. Our process is founded on the discovery of a chemical substance which crystallizes under the influence of light, the crystals becoming larger the longer they are exposed to it. After exposure it only remains to make a deposit of copper, by means of the electric battery, on the crystalline surface, and thus a plate is obtained yielding proofs in which every detail and gradation of tone is faithfully reproduced."

Walter B. Woodbury, the inventor of the woodbury-type, asserted that the Goupil process was based on a suggestion made by him to Goupil around 1870. According to Donald Cameron Swan, the process was based on his father's (Swan's) photo-mezzotint process.

Goupil and its successor, Boussod, Valadon, & Cie, used the process extensively for art reproduction, less frequently for printing original photographs. The overall excellence of a Goupil gravure –the density of black, the separation of tones, and the clear, crisp quality of the image– was not surpassed until the introduction of the Rembrandt photogravure process in 1894. Goupil gravures appeared in Seeley and Co.'s monthly art periodical *The Portfolio*.

Luxotype

A half-tone process patented in 1883 by Brown, Barnes and Bell, a Liverpool firm of photographers. A photographic print was pressed against a metal plate engraved with a stipple in relief, and thus became embossed with a stipple. It was then strongly lighted from one side so that the stipple could be photographed, and a negative suitable for making a half-tone block was thus obtained. A modification of the process was to rub a pigment into the depressed parts of the embossed surface of the print, so that it could be copied by direct lighting. Specimens can be seen in *Photographic News*, vol. 27, 1883.

Photoxylography

Name given to early photoengraving processes (from the early1850s on) that used the production of a photographic image on boxwood blocks as a guide for the engraver's knife, instead of using an image drawn by hand on the wood block. According to Stannard (*Art Exemplar*, 1859) the number of the *Microscopic Journal* for June, 1853, was the first and a thoroughly successful operation on an extended scale of this beautiful invention. Photoxylography was used by the *Illustrated London News* from 29 Dec. 1860. Pannemaker and his students are mentioned as the best practitioners of this art.

These techniques, in capable hands, gave beautiful results, but were inferior to true continuous-tone processes like collotype and aquatint photogravure, and the introduction of the half-tone process of the early 1880s made their practice largely obsolete.

Photozincography

A photolithographic process worked out by Col. Sir Henry James at the Ordnance Survey Office in Southampton, England, and at first, starting in 1859, simply a method of preparing a photo-lithographic transfer and applying it to a zinc plate, afterwards printed from. Direct prints from negatives were then made on the zinc plates. Photozincography may refer to a line or half-tone process.

Sir H. James read a paper to the British Association "On photozincography," in Sept. 1861. His first successful photozincograph was a reproduction of an etching, in 1859. A facsimile of the *Domesday* book, or ancient record of the Survey of English lands, ordered in 1086 by William the Conqueror, followed later in 1859.

LUIS NADEAU

See also: Collotype; Half-tone Printing; Heliogravure; and Woodburytype, Woodburygravure.

Further Reading

Devincenzi, Giuseppe: *Procédé de gravure électrochimique*, Paris: Imprimerie de Mallet-Bachelier, 1855.

Baroux, Eugène: *Application de la photographie à la gravure sur bois*, Paris: chez l'auteur, 1863.

Fleck, Kaspar: *Die Photo-Xylographie; Herstellung von Bildern auf Buchsbaumholz für die Zwecke der Holzschneidekunst, mit 5 Abbildungen*. Vienna and Leipzig: A. Hartleben, 1911.

Gervais, Thierry: *D'après photographie. Premiers usages de la photographie dans le journal L'Illustration. (1848–1859)*. Paris, graduate thesis (EHESS), 2003.

Grupe, E.Y.: *Instruction in the Art of Photographing on wood: Complete Formulas and Process for Block Printing for Engravers' Use*. Leominster, Mass., F.N. Boutwell, printer [ca. 1882].

Lainer, Alexander: *Anleitung zur Ausübung der Photoxylographie*. Halle, Knapp, 1894

Nadeau, Luis, *Encyclopedia of Printing, Photographic and Photomechanical Processes*, , Vol. 1 & 2, Fredericton (Canada): Atelier Luis Nadeau, 1989–1990.

Scott, Captain A. de C., *On Photozincography and Other Photographic Processes Employed at the Ordnance Survey Office, Southampton*. London: Longman & Co., 1862.

Smillie, Thomas W., *Photographing on wood for engraving*. (In Smithsonian Institution. Smithsonian miscellaneous collections. Washington, 1905. Vol. XLVII (Quarterly Issue, Vol. II) pp. 497–499) Publication 1568.

Stannard, William John: *The Art-Exemplar. A Guide to Distinguish One Species of Print From Another with Pictorial Examples and Written Descriptions of Every Known Style of Illustration...* Written and Compiled by S[Stannard]. N.d., 1859.

PHOTOMICROGRAPHY

Photomicrography is a hybrid innovation that grew out of the convergence of the novel nineteenth-century technologies of photography and microscopy. Although Victorians occasionally used the terms photomicrography and microphotography interchangeably, the photographic process was different for each. Microphotography involved taking a photograph of a large object (a portrait, page of text, or anything easily observed with the unaided eye) and reducing it to microscopic dimensions for viewing with the aid of a microscope. Photomicrography used the microscope to photograph a magnified image of microscopic-sized specimens (e.g., algae and other minute organisms, insects or their parts, animal and plant tissues); from these photographs enlarged prints and magic lantern slides could be prepared for both the advancement of knowledge and entertainment. Owing to its usefulness as a scientific laboratory tool, photomicrography endured through the Victorian era and after.

In England in 1802, Thomas Wedgwood and Humphry Davy first captured images of objects using a microscope with sunlight as the light source and pieces of white leather sensitized with silver nitrate. By the mid- to late-1830s, William Henry Fox Talbot had experimented with photomicrography using his "photogenic drawing" salt print process (Talobotypes/calotypes) producing images depicting the microscopic structure of plant sections; other English workers also used this technique, but Talbot's process did not adequately convey the fine detail of the original microscopic image. This technique did permit relatively easy duplication of images, however. Also in England around 1840, London surgeon and microscopist Jabez Hogg produced photomicrographs of biological specimens as did Manchester optician and inventor John B. Dancer, although the latter is better known for his microphotographs of famous people and scenes.

Continental Europeans were more prominent in the pursuit of photomicrography as a laboratory tool than their English contemporaries owing to their adoption of the daguerreotype. In 1840, the Viennese physical scientist Andreas Ritter von Ettingshausen produced wonderfully sharp daguerreotype images of microscopic cross-sections of botanical specimens, as did his contemporary the Viennese anatomist Josef Berres.

The Paris physician Alfred Donné and colleague, Léon Foucault, produced in 1844–45 the first biomedical textbooks to be illustrated with engravings made from his daguerreotype photomicrographs (*Cours de Microscopie Complémentaire des études Médicale, Anatomie Microscopique et Physiologie des fluids de l'économie* and *Atlas du cours de microscopie exécuté d'après nature au microscope daguerreotype avec M. Léon Foucault*). Included were images of salamander blood, pollen grains, and starch granules.

Daguerreotypes had the advantage of showing fine detail, unlike calotypes, but they were not readily reproducible in large numbers. The development of the wet collodion process overcame this obstacle, for it allowed prints of photomicrographic subjects to be produced in quantity permitting mass distribution in scientific publications, such as the pioneering illustrations contained in the English *Quarterly Journal of Microscopical Science* during the early 1850s. The dry-plate, or gelatino-bromide process, formulated by Dr. Robert L. Maddox, one of the Victorian era's great English photomicrographers, did much to popularize photomicrography and to make it more convenient. Other scientists advanced photomicrography through their publications and research. Most notable among them were Joseph von Gerlach of Erlangen, who wrote a treatise on *Photography as an Aid to Microscopic Research* (Leipzig, 1863), and Berlin bacteriologist and physician, Robert Koch. In 1877, Koch took the first photographs of bacteria; four years later, at the International Medical Congress in London, he displayed a series of photomicrographs of bacterial cells and tissue sections that aided in the dissemination of his sophisticated ideas on the germ theory of disease and helped silence skeptical colleagues. At the close of the century, almost all that was known about medical photography and photomicrography in Europe was contained in Albert Londe's *La photographie médicale. Application aux sciences médicales et physiologiques* (1893).

In America proponents of scientific photomicrography were supported not by universities or research institutes, as their counterparts in Europe, but by museums, which were then the intellectual equivalent. The Smithsonian Institution in Washington, D.C., published Dr. John Dean's research concerning the gray substance of the medulla oblongata and trapezium; this 1864 work was illustrated with photomicrographs of neuroanatomical sections. The recognized doyen of American biomedical photomicrography, however, was Dr. Joseph J. Woodward of the Army Medical Museum (AMM) also in Washington. Woodward, a Philadelphia-trained physician who became a military surgeon at the beginning of the Civil War, assumed museum duties under the auspices of the Office of the Surgeon General in 1862 and remained in the museum for the next 20 years. The AMM would develop a reputation for its extensive use of medical photography along with applied art techniques to create permanent visual records of soldiers' injuries, ailments, and pathological specimens. Military personnel prepared microscopic slides and undertook all photographic work within the museum. He and the AMM fast became recognized internationally as the center for photomicrography in America at this time. These medical photomicrographs were in demand and exchanged for images produced by other photomicrographers such as Maddox in England and Gerlach in Germany.

Woodward's pursuit of photomicrography was grounded in two intellectual traditions. One was the published work of Donné, Hogg, Dean, and other European and American photomicrographic pioneers. The other arose from his unwavering commitment to the usefulness of the microscope as an aid to understanding the causes of disease. Woodward's knowledge and position aided the efforts of two assistant army surgeons, William Thomson and William Norris, who, using the wet collodion process, first took photomicrographs of pathological preparations in spring 1864. The specimens were prepared by Woodward and photographed through a Zentmayer microscope (the official U.S. Army instrument stipulated by Woodward). During the next two decades, Woodward himself produced thousands of photomicrographs depicting a dazzling array of pathological conditions and other biological specimens.

For Woodward, photomicrography was first and foremost a scientific tool. Although like many amateur microscopists and photographers he did capture in his photomicrographs the beauty of diatoms (phytoplankton that exhibited many beautiful shapes, appearances and arrangements) better than any one else, this aim did not fully interest him. Rather, he used these microscopic creatures as test subjects to determine the resolving power of his lenses; owing to his skills both as a microscopist and photographer, he was able to work at the absolute technical limits of the best equipment available. Woodward's Toner Lecture series presented in 1873 at the Smithsonian Institution is also exemplary of his scientific approach. Concerned by the structure of cancerous tumors and how adjacent tissue was affected, Woodward prepared a series of 70 lantern slides from the museum's collection of photomicrographs for his lectures. Not only did he wish to educate his medical audience through these novel visual media, but he also desired to show how his illustrations corresponded with the latest scientific findings of European histologists. In so doing, Woodward ably demonstrated how photomicrography was becoming a necessity in the laboratory setting.

Woodward's legacy to scientific photomicrography went beyond his own contributions, for the AMM spawned successors through the nineteenth century and beyond: Dr. George M. Sternberg used this technique in bacteriological studies of the blood of yellow fever sufferers in Cuba; army surgeon William M. Gray, museum microscopist and photographer, became known for his series of histological photomicrographs. By the close of the nineteenth century, photomicrography had advanced enough to record such intricate processes as the reproduction of cells and their nuclei by division (mitosis and meiosis), with chromosomes clearly visible.

Overlapping the activities of laboratory-based investigative scientists who used the microscope-camera combination as a powerful scientific tool were the activities of other Victorians who pursued photomicrography as an uplifting recreation or who, as avocational scientists, studied natural history (i.e., descriptive and inventory-based science). Microscopy, then, like photography, became a feature of polite Victorian culture, especially in England. The study of the microscopic world became genteel recreation for both men and women, as they peered at the teeming life in samples of pond water or at the beauty of a butterfly's scales. The natural revelations of the microscope bolstered religious viewpoints of God's infinite creativity and wisdom. Photomicrography fit nicely with this worldview as it could make tangible to many what only amateur microscopists previously could see. Numerous books existed which included plates of photomicrographs of minutely detailed examples of the plant and animal kingdoms, while extolling the virtues of photomicrography. In *Nature through Microscope & Camera,* for example, published by the Religious Tract Society of London, Richard Kerr bemoaned the fact that amusement had become the order of the day in later Victorian England at the expense of education. However, the evils of trashy novels, bridge parties, and football and cricket talk could be counteracted somewhat, he maintained, through the entertaining and civilizing power of the microscope, especially when it was equipped with a camera. Photomicrography was instructive, useful and an intellectual pastime that would be good for the nation. Commercial vendors also sold slide sets of preserved biological specimens for "amateurs" to photograph through their microscopes. Especially enchanting for photographers were diatoms owing to the distinct markings of these microorganisms, consisting of striations and concentric rings of dots. Equally intriguing was photographing snowflakes. In 1885, the American amateur photomicrographer, Wilson A. "Snowflake" Bentley, first photographed an ice crystal through a microscope; he would continue this work in sub- freezing weather for the next 40 years, producing about 4,500 photomicrographs, and helping to prove that no two snowflakes were the same.

The apparatus available for photomicrography ranged from the relatively simple and cheap to the most complex and expensive. Regardless of sophistication or cost, the hobbyist, serious amateur, and scientist alike used a similar combination of equipment for photographing through the microscope. Critical was the light source, which had to be intense and constant to compensate for the lack of sensitivity of photographic plates. Bright sunlight was effective. At the AMM Woodward was able to take full advantage of natural daylight because of Washington, D.C.'s, southern latitude and his use of a heliostat, which constantly tracked the sun. But those

who worked at night, or who did not live in sunny climes, could not avail themselves of this form of light. In such circumstances, electric light, kerosene and oil lamps, or the combustion of magnesium ribbon were used. The preferred artificial illumination was a combination of oxygen and coal gas or hydrogen ignited under pressure to heat a block of lime white-hot to produce limelight. Of course, a major disadvantage of this method was the likelihood of setting wooden photographic equipment and furnishings on fire.

As important was the work area, which would probably incorporate a darkroom, where photomicrography was undertaken. The location had to be free from vibration to avoid obtaining blurred images (exposures could take upwards of several minutes); precautions were observed such as suspending equipment from beams, or equipping table legs with rubber shock absorbers. Similarly, it was recommended not to undertake photomicrography at times of the day when heavy traffic was moving in nearby streets. Initially, the choice of compound microscope was not itself crucial, although later in the century the better the fine focusing mechanism and lenses on the instrument, the sharper the image to be photographed. Instruments manufactured in England were often bulky, with body tubes up to nine inches long, compared with more compact continental European microscopes that typically had shorter body tubes of approximately six inches. Perhaps because of this difference in construction, English photomicrographers usually aligned the microscope, bellows, and camera/plate assembly horizontally; the convention of most Europeans was to align their equipment vertically. The later Victorian period saw the adoption of European techniques owing to the domination of German laboratory science and the attendant rise of optical manufacturing companies such as Carl Zeiss and E. Leitz, which produced superior quality, standardized photomicrographic apparatus.

Following the Victorian era, improved optics for both cameras and microscopes, newer photographic techniques and equipment such as faster speed black and white roll film, 35 mm color slide processes, motion picture and digital technologies, led to higher quality, more detailed and more revealing photomicrographs. Yet these later improvements should not overshadow the revelations and achievements of this original nineteenth-century convergent technology. Just as important was the lasting philosophical impact that photomicrography had on the scientific mind. While art (sketching and painting) as applied to medicine and science would endure, laboratory scientists believed that photography through the microscope was more accurate than artistic drawings of specimens done laboriously by hand and from memory. In brief, photomicrography (and biomedical photography in general), like science itself, was perceived to be objective, free of human bias, and more truthful; such rhetoric did much to propel all three pursuits during the nineteenth century and later.

J.T.H. CONNOR

See also: Wet Collodion Positive Processes.

Further Reading

Barger, M. Susan, and William B. White, *The Daguerreotype: Nineteenth-Century Technology and Modern Science*, Baltimore: The Johns Hopkins University Press, 1991.

Beale, Lionel S., *How to Work with the Microscope*, London: Harrison, 1865.

Bentley, W.A., and W.J. Humphreys, *Snow Crystals*, New York: Dover Publications, 1962.

Bracegirdle, Brian, *A History of Microtechnique*, Lincolnwood, IL: Science Heritage, 1986.

Bousefield, Edward C., *Guide to the Science of Photo-Micrography*, London: J. & A. Churchill, 1892.

Connor, J.T.H., and Michel Rhode, "Shooting Soldiers: Civil War Medical Images, Memory, and Identity in America." In *Invisible Culture: An Electronic Journal for Visual Culture* 5 (2003); www.rochester.edu/in_visible_culture/Issue%205/ConnorRhode/ConnorRhode.html.

Eder, Josef Marie., *History of Photography*, New York: Dover Publications, 1972.

Frey, Heinrich, *The Microscope and Microscopical Technology* (translated by George R. Cutter), New York: William Wood & Company, 1880.

Gage, Simon Henry, *The Microscope*, Ithaca, NY: Comstock Publishing Company, 1904; 1932.

Gernsheim, Alison, "Medical Photography in the Nineteenth Century." In *Medical and Biological Illustration* 11 (1961): 85–92.

Henry, Robert Henry, *The Armed Forces Institute of Pathology: Its First Century, 1862–1962*, Washington, DC: Office of the Surgeon General, Department of the Army, 1964.

Hogg, Jabez, *The Microscope: Its History, Construction, and Application*, London: George Routledge and Sons, 1898.

Kerr, Richard, *Nature—Through Microscope & Camera*, London: The Religious Tract Society, 1905.

Knapp, W.H., "Mitosis Illustrated by Photo-Micrographs." In *Journal of Applied Microscopy* 1 (1898): 47–51

Marien, Mary Warner, *Photography: A Cultural History*, London: Lawrence King, 2002.

O'Connor, Erin, "Camera Medica: Towards a Morbid History of Photography." In *History of Photography* 23 (1999): 232–234.

Pringle, Andrew, *Practical Photo-Micrography*, London: Iliffe & Sons, 1902.

Schaaf, Larry J., *Out of the Shadows: Herschel, Talbot, and the Invention of Photography*, New Haven, CT: Yale University Press, 1992.

Spitta, Edmund J., *Photo-Micrography*, London: Scientific Press, 1899.

Woodward, Joseph J., *On the Structure of Cancerous Tumors and the Mode in which Adjacent Parts are Invaded,* Smithsonian Miscellaneous Collections 266, Washington, DC: Smithsonian Institution, 1873.

Zimmerman, Lorenz E., Daniel M. Lambert, and Joe M. Blumberg, "William Thomson (1833–1907): Military Surgeon, Pioneer Photomicrographer, Clinical Ophthalmologist." In *American Journal of Ophthalmology* 69 (1970): 487–497.

PHOTOMONTAGE AND COLLAGE

Photomontage is created when an original composite image is photographed to produce a seamless unified effect in order to turn out duplicate photographic copies. Montage is from the French "monter," meaning to mount. It is a hand process used to alter camera-derived images and introduce subjectiveness into a photograph. Generally, existing photographs are cut apart and selected portions are glued onto a flat surface and rephotographed. The widespread use of photocollage had its start in early photo albums before the days of mass production. In these personal albums, photographs and flowers were pasted onto pages and later hand painted or sketched on by the album's creator. Photomontage on the other hand, was a thing people in mourning created to ease their grieving. The photomontages usually consisted of cartes-de-visite and montaged portraits on to elaborate photographic backgrounds and typically included a photograph of a picture frame on cabinet. From these creations came the development of montaged multi-view panels which were then re-photographed and sold as cartes-de-visite, thus creating the market.

In 1863 André Disdéri applied for a French patent for his "carte mosaïque" (mosaic carte). The precedent was the composite images of celebrities and eminent personalities that were commonly circulated by means of the printing press. Disdéri's mosaic cartes, featuring thematic portrait composites of actors, dancers, generals, the French royal family, and social groups received enthusiastic public support. Each mosaic carte could be comprised of twenty to one thousand faces. They served as advertising (studio address appearing on either the front or back of the carte) and people could come to his "Palace of Photography" and also buy a carte of their favorite personality or have one of their own made by the man who photographed everyone from Napoleon III to the Pope. The introduction of the cabinet style photograph starting in the 1860s offered the mass-market a larger image area that the carte-de-visite and encouraged more photographers to experiment with combining images.

As in combination printing, montage was devised to overcome aesthetic and technical limitations. The concept of removing a photograph from its original context and placing it into a new one has had profound effects on the viewer's willingness to accept as "real" visual information supplied by the photograph. The mosaic broke the rules about representing perspective, point of view, space, and time, and yet the public willingly accepted these radical changes as long as they remained photographically anchored. The term, photomontage, was not introduced until after World War I by the German Dadaists.

Collage (from the French *coller*, to glue or paste) is the practice of cutting and pasting together of two- and/or three-dimensional materials, including lace and dried flowers and plants, to form a new visual composition. In creating a collage no effort is made to conceal that the result has been assembled and is not a seamless image. Collage can be seem in Victorian family albums that incorporated the hobbies of appliqué print and water-color that allowed people, almost exclusively women, to privately alter and interpret photographic images.

Another form of collage involves bringing together disparate images to form a new meaning. During the American Civil War, the United States Post Office Dead Letter Office assembled groups of photographs in a grid fashion and displayed them in hopes that someone would recognize a face and claim the photograph. This practical strategy of disseminating would eventually be adopted into artistic and scientific photographic practice.

Lady Filmer (1840–1903) was an aristocratic amateur who made early collages that combined carte-de-visite portraits with watercolor designs of butterflies and floral arrangements. These pieces, with their occasional sexual allusions, disclose a pre-Freudian spirit of unconscious association, a component of mental life not subject to recall at will, which required a new form of expression because the language for such a discussion had yet to be invented. Since such work was done for personal reasons and was not publicly exhibited or written about, it appears that there was no nomenclature to discuss what was being done. This sort of individual interaction with photographs did allow people with some artistic skill to reorient images in time, space, and meaning. Collage positioned photography to investigate free association, to use cut and paste methods to examine dreams and enable the unconscious, repressed residue of socially unacceptable desires and experiences to be consciously presented. The technique is the forerunner of surrealistic practices and images developed in the twentieth century.

Hand-coloring was widely practiced from photography's earliest days of to overcome its initial inability to record color. For an extra fee, the operator made notes about the color of the sitter's clothes, eyes, and hair. Color was hand-applied, based on these notations, directly on the finished image, which covered every process including daguerreotypes, paper prints, and tintypes. By 1843 John Plumb, Jr. was offering "color" portraits in his chain of studios by electroplating portions of the finished daguerreotype.

Alfred H. Wall promoted the practice in his *Manual of Artistic Colouring as Applied to Photographs* (1861). Wall, a former miniature and portrait painter, said that painting over a photograph was no more unacceptable than painters such as Leonardo and Titian painting over the *abbozzo*. Wall complained that artists repudiated hand-colored photographs because they were not paintings and that photographers rejected them because

they altered the camera's image. Wall saw no reason for censuring work that combined "the truth of the one with the loveliness of the other."

Composite and hand-colored images required time and deft handwork. This addition of time was seen as a way to make photography less mechanical and more artistic. This in turn increased a photograph's value and encouraged photographers to portray subjects previously reserved for painters. As photographs were not precious objects, some people took the liberty to interact with this supposedly fixed form of representation and interjected their own personal feeling about the subject. This began an ongoing exploration of fabricating illusion that expanded the photographic syntax to include subjective reality and how the tension between the two could produce new meaning. Hand-coloring and mixed media methods began to extend and transform the photograph into areas that conventional photography could not go. Conceptually, it acknowledges a photograph is not a fixed entity, but one that is open to continuos process that can accommodate change, expansion, and innovation.

ROBERT HIRSCH

Further Reading

Henisch, Heinz K., and Bridget A., *The Photographic Experience 1839–1914: Images and Attitudes.* University Park: The Pennsylvania State University Press, 1994.

PIAZZI SMYTH, CHARLES (1819–1900)
British astronomer

Piazzi Smyth (who used his middle name together with his surname) was born in 1819 in Naples, Italy. He seemed destined for fame in the field of astronomy. Named after the Italian theologian and astronomer Giuseppe Piazzi (1746–1826), he was the second son of Rear-Admiral William Henry Smyth, F.R.S., who had once been president of the Royal Astronomical Society, and Annarella Warington. Piazzi Smyth received his scientific education early, first in his father's observatory at Bedford and then at the Royal Observatory at the Cape of Good Hope, South Africa, where he assisted Sir Thomas Maclear from 1835 to 1845. His first calotypes date from around 1843; it is likely that he learned the technique from Sir John Herschel, a close family friend who was also in Cape Town at this time. His interest in photography would also have been nurtured in the circle around his father's close friend Dr. John Lee, which included William Henry Fox Talbot, James Glaisher, and Sir David Brewster; and at the salons of astronomer and amateur photographer Lord Rosse.

In 1845 Piazzi Smyth was named Astronomer Royal for Scotland, and the following year became Regius Professor of Practical Astronomy at the University of Edinburgh. Though hampered throughout much of his career by the chronic underfunding of the Calton Hill Observatory (recently placed under treasury control), Piazzi Smyth devised brilliant projects relating to the observation, measurement, and documentation of astronomical phenomena. One of the earliest of these initiatives was an expedition to Tenerife, the largest of the Canary Islands. In June 1856—accompanied by his new bride, Jessica Duncan—Piazzi Smyth went to the volcanic island to test his theory that the stars would be better observed from high points above ground-level pollution, to observe the solar spectrum, and to measure the thermal radiation of the moon, thus establishing the modern practice of high-altitude observation and pioneering spectroscopy and infrared astronomy. He also undertook a significant photographic documentation project, resulting in the first stereoscopically illustrated book: *Teneriffe, an Astronomer's Experiment; or, Specialities of a Residence above the Clouds* (1858), which contains 20 plates (from wet-collodion negatives on albumen paper) and sold for 21 shillings. Piazzi Smyth chose the stereoscopic format because the equipment was comparatively portable and because he felt it provided maximum accuracy and objectivity while minimizing the risk of accidental flaws and tampering. Far more effectively than the drawings and paintings he also executed on site, Piazzi Smyth's photographs demonstrated the clarity of the atmosphere at high altitude. Upon his return from Tenerife, he turned over the printing to Glaisher, a fellow astronomer and accomplished photographer, and A. J. Melhuish, photographer and optician. Publisher Lovell Augustus Reeve then supervised the production of an edition of 2,000, which entailed the mounting of 40,000 stereo pairs onto pre-printed pages. Jessica Piazzi Smyth printed additional photographs for subsequent official reports of the expedition (1859), and Piazzi Smyth employed another method of photographic reproduction—a photoglyphic engraving etched by Talbot—in an account published the *Edinburgh Astronomical Observations* (1863).

Piazzi Smyth's work in Tenerife earned him a Fellowship in the Royal Society, but his next major project—an excursion to Egypt to measure the Great Pyramid of Gizeh—was not as well received, largely owing to his expressed intent to prove the divine basis of the pyramids' construction. Piazzi Smyth had first encountered this theory in the writings of one of its most vocal proponents, John Taylor, whom he met through either Herschel or Lee. Piazzi Smyth was intrigued, and eventually obsessed, with the idea that the seeming coincidence of its measurements (the "sacred cubit") with the earth's polar axis reflected God's intervention—and that he could demonstrate this with modern instruments of quantification.

Photography was one of these tools, and despite severe financial limitations Piazzi Smyth made several extremely important advances in Egypt, where he applied new techniques that had not yet been tested in the field. The gear that he and his wife packed for their journey in November 1864 included a dry-plate apparatus, a pair of small-format cameras wet plates, magnesium wire, chemicals, a dark tent, a microscope, and various measuring implements. Piazzi Smyth specially designed the small cameras to produce miniature (1 inch square) negatives on 1 x 3-inch glass microscope slides, and to keep out the dust that caused problems for wet collodion. (He had experimented with the miniature format in Russia in 1859, achieving instantaneous effects in urban scenes and englarging them later.) To document his measurements of the pyramid's exterior, he took photographs that include rods and figures for scale. But to photograph the dark interior chambers, he generated bright light by employing magnesium wire, which had been discussed in the photographic journals and presented by Brewster at the March 1864 meeting of the Photographic Society of Scotland in Edinburgh.

Returning to the U.K. with 166 images (about half on dry plates and half on miniature wet collodion plates), he set about making enlargements, breaking with current precedent by cropping selectively. Prints were exhibited at the September 1865 meeting of the British Association for the Advancement of Science, held in Birmingham, and the images reached a much wider audience through lantern-slide lectures. Piazzi Smyth's ideas about the pyramids attracted a following of religious fanatics but were viewed with suspicion in scientific circles. The Royal Society's dismissive attitude prompted Piazzi Smyth to resign his fellowship in 1874, but he continued to make valuable contributions in various fields, spectroscopy in particular. In 1876 he designed another special small-plate camera, this time to produce systematic photographs of cloud formations—the first application of photography as a serious tool for meteorological research. Piazzi Smyth retired from his professorship and his post of Royal Astronomer on 18 August 1888, and he and his wife settled near Ripon, in Yorkshire. There Piazzi Smyth adapted his solar spectrograph for photographic work and recorded the entire range of the solar spectrum. He also resumed cloud photography, making 500 photographs in three years and presenting examples to the Royal Society and to the Royal Society of Edinburgh. He died on 21 February 1900.

BRITT SALVESEN

Biography

Charles Piazzi Smyth was born in 1819 in Naples, Italy, the son of amateur astronomer Vice-Admiral William Henry Smyth. He received his scientific education in his father's observatory at Bedford and then at the Royal Observatory at the Cape of Good Hope, South Africa (1835–45). In 1845 Piazzi Smyth was named Astronomer Royal for Scotland, and in 1846 became Professor of Practical Astronomy at the University of Edinburgh. He published the first stereoscopically illustrated book, *Teneriffe, an Astronomer's Experiment*, in 1858, and in subsequent trips to Russia (1859) and to Egypt (1864) continued to employ photography for documentary purposes, putting into practice theoretical improvements such as dry plates, miniature negatives, and magnesium flares. In his final decades, Piazzi Smyth was somewhat alienated from the British scientific community, largely owing to his eccentric views on pyramidology. He resigned from the Royal Society in 1874, retired from his professorship in 1888, and settled in the Lake District, where he designed cameras suitable for spectroscopy and cloud photography. He died at Clova, his Yorkshire home, on 21 February 1900.

See also: Archaeology; Artificial Lighting; Astronomy; Books Illustrated with Photographs: 1850s; Books Illustrated with Photographs: 1860s; Camera Design: 3. 1860–1870s; Camera Design: 7. Specialist and novelty cameras; Meteorological Photography; Mountain Photography; Royal Society, London; Science; Sky and Cloud Photography; Spectrography and Spectroscopy; Travel Photography; and Wet Collodion Negative.

Further Reading

Brück, Hermann Alexander, *The Peripatetic Astronomer: The Life of Charles Piazzi Smyth*, Bristol/Philadelphia: A. Hilger, 1988.

Gill, Arthur, "Photography at the Great Pyramid in 1865," *Photographic Journal* 105/4 (April 1965):.109–18.

Nicol, John, "Photography in and about the Pyramids: How it was accomplished by Professor C. Piazzi Smyth," *British Journal of Photography* 13/318 (8 June 1866): .268–70.

Piazzi Smyth, Charles, Journals, albums of paintings, and photographs, Royal Society of Edinburgh.

Piazzi Smyth, Charles, Laboratory notebooks, log books, and correspondence, Royal Observatory, Edinburgh.

Piazzi Smyth, Charles, *Teneriffe, an Astronomer's Experiment; or, Specialities of a Residence above the Clouds*, London: Lovell Reeve, 1858.

Piazzi Smyth, Charles, *Life and Work at the Great Pyramid during the months of January, February, March, and April, A.D. 1865; with a discussion of the facts ascertained*, Edinburgh: Edmonston and Douglas, 1867.

Piazzi Smyth, Charles, *A Poor Man's Photography at the Great Pyramid in the Year 1865*, London: Henry Greenwood, 1870.

Schaaf, Larry, "Charles Piazzi Smyth's 1865 Conquest of the Great Pyramid," *History of Photography* 3/4 (October 1979):331–354

Warner, Brian, *Charles Piazzi Smyth Astronomer-Artist, His Cape Years*, Cape Town, 1983.

PICTORIALISM

Pictorialism was the vanguard movement in art photography from about 1891 to 1910. It was especially strong among photographers in the United States and Europe who established their reputations in an organized international movement. They banded together to establish photographic processes as art. The work of camera, composition and printing served related artistic ideals: the ascendancy of the individual over the mass, the emergence of the artist from the crowd and the value of scarcity.

Apart from the broad aim to make pictures by photography, almost nothing else about pictorialism is straightforward, certainly not its beginning or its end. The years 1891–1910 may signal the start and finish of the art movement, but not the limits of the everyday word "pictorial." This is partly a problem of terms: pictorialism was an end-of-century organized movement, whereas the word "pictorial" had been in general use in the 1860s and simply meant looking like a picture. In the 1890s art photographers who wanted to demonstrate their modernity turned "pictorial" into a contemporary artistic "ism." However, the arguments that tore the art movement apart stemmed from the general meaning of the word "pictorial"—looking like a picture. Increasingly, no one could agree what a picture should look like. The nature of pictures suddenly became uncertain, and so did pictorialism.

Henry Peach Robinson described the nature of the pictorial in photography in the 1860s. He wrote eleven books on art photography and the most popular, *Pictorial Effect in Photography*, was printed four times from 1869–1893. Pictorial effect was achieved by making photographs look picturesque, overlaid with the early 19th century individualism of Romanticism and combined with the mid-century fashion for storytelling pictures. Pictorial effect depended on adapting the forms and styles of academic painting, including the architecture or structure of the image. Robinson used combination printing to build his pictures in the darkroom, but his interest in Pre-Raphaelite painting and its patchwork of parts meant that the space in his finished photographs often looks strange and unrealistic, though produced by purely photographic means.

In the 1880s Robinson's piecemeal style was condemned by Peter Henry Emerson. Both men believed that photographic techniques could be used to make art, though they emphasized different procedures. Emerson believed that a photograph must be made in the camera rather than in the darkroom. Ideally, this meant creating the picture in a single composed shot with no faking and dodging. Emerson replaced the word "pictorialism" with "naturalism" which claims to represent the actual world as it appears before the camera. But Emerson was just as obsessed as Robinson with art and personal expression, though the ways of achieving both were changing. During the 1880s, there was a shift away from anecdotal pictures, and this is evident in Emerson's work. Some of the earliest images published in *Life and Landscape on the Norfolk Broads* (1887), such as "The Dame School," tell stories, but most of them do not. Emerson gradually dispensed with content. The late images, published in *Marsh Leaves* (1895), are dominated not by subject matter but how photographs represent light and shade.

By the late 1880s, art photographs were not tied to storytelling paintings. They could be meaningful on their own, especially if they were atmospheric, impressionistic or symbolic. Moreover, what caused so much experimentation and excitement in the 1890s was the sheer number of techniques available to turn photographs into art.

Although the pictorialists needed mass-produced photographic materials, they pretended to stand apart from automation, and celebrated hand-work or other skills. Pictorialists used the best materials available in the High Street, but disdained the ordinary commercial or industrial nature of photography. They intended their photographs to be completely different from the objectivity sought by scientists and social recorders. The emphasis was not on utility but on expression. As artists, they also set out to be utterly different from snapshooters.

Antony Guest, in his book *Art and the Camera* (1907), claimed that the highest aim of every amateur was to glimpse the "Dream City of Art." This was the distant, magic home of the artist, that "gifted being for whom there is more richness in life than for ordinary mortals." To signal that they placed feeling and imagination over the authority of fact, the pictorialists embraced soft focus and the evocation of mood. Though engaged in dreaming, they also knew they had to express this in new photographic techniques. They became experts in combining different graphic devices. When art photographers pictured themselves at work on a print, which was rarely, it was to demonstrate their skill in precise and difficult processes. Alvin Langdon Coburn photographed himself working at an etching press, and John Cimon Warburg pictured himself working on the oil pigment of a gum print.

The pictorialists' program was romantic-expressive. It was concerned with identifying and staying close to the supposedly eternal standards of nature, beauty and truth. It was optimistic about the world it surveyed and wished to conserve. However, by 1908 the pictorialists were in open conflict about the nature of their art. The movement began to break up, signalled by the collapse of the Brotherhood of the Linked Ring in London in 1910. That year, more divisions surfaced in the United States. Alfred Stieglitz organized The International Exhibition of Pictorial Photography in Buffalo, New

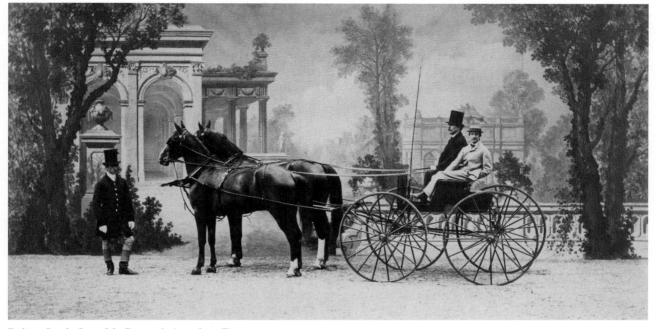

Delton, Louis-Jean. Mr. Brower's American Trotters.
The J. Paul Getty Museum, Los Angeles © The J. Paul Getty Museum,

York, to display work from 1894–1910. However, he included only the work of his own circle known as the Photo-Secessionists. The offense taken by the counter-Secessionist organization, called the Photo-Pictorialists of America, was so great that Stieglitz decided to take no further part in advancing pictorialism. The rows among other pictorialists carried on, with further splits evident in exhibitions designed to keep pictorialism alive to the present day. Despite its popularity, or because of it, pictorialism's contribution to art photography was largely ignored until the late 1970s. Recognizing its historical importance also meant acknowledging its ignominious end. In 1978 historian Weston Naef described pictorialism's late phases as "the most despised art movement of the twentieth century."

Since the late 1970s, there has been an increasing interest in pictorialism, with more books, exhibitions and auction-house sales of the work. Stieglitz and other Photo-Secessionists remain the best-known art photographers of the period. The orthodox history centers on Stieglitz and his circle and has altered little other than to recover a few neglected artists—significantly men whose careers were discernibly thwarted by Stieglitz, such as Fred Holland Day and Rudolf Eickemeyer Jr. That history repeats the aims of pictorialism laid down by its first advocates. It tends to repeat the self-assessments and earliest reviews of the movement as based in personal vision, with emphasis on the spiritual superiority of the artist in a materialistic world.

Of course, this history continues to separate photography as art from its increasing ease, cheapness and popularity. From the early 1890s, some photographers saw the mass production of easy-to-use cameras as a threat to art. Whereas once it had been possible to make art photographs only with whole- or half-plate cameras on a tripod, now people tried to achieve similar effects with hand-held cameras and negatives no bigger than a quarter-plate. In theory, if these newcomers had the correct disposition they also had the potential to make art. In theory and in practice, as George Davison showed with "The Onion Field" (1889), an art photograph could be produced with a pinhole camera, with no lens or plate at all. Davison demonstrated that technology was irrelevant, since the basis for art was the romantic-expressive temperament.

Yet, despite the importance of character, technology was still a crucial factor in differentiating the artistic amateur from the snapshooter. Art photographers bought their own expensive equipment, furnished their own darkrooms (or used those of exclusive clubs), and produced individual and exquisite prints. In the 1890s, an enthusiast for hand cameras warned buyers against trying to "take" a landscape with a cheap camera without a shutter. The ownership of the landscape, even at the level of ideas, remained with those who were not only cultivated but also rich enough to afford elaborate plate cameras. It was important to stay up-market with equipment, or (like Davison) temper low-level technology with a superior understanding of composition and darkroom skill.

The mass production of photographic goods led inevitably to the popularity of photography as a pastime among the lower middle classes, and an increasing number of clubs and societies. The *British Journal*

Photographic Almanac for 1881 listed 20 societies, all in large cities in England. By 1891, this number had risen to 172 and, by 1901, had risen again to 229. Societies were also founded in towns and suburbs. The spread of clubs and societies throughout Europe and the United States meant a proliferation of art interest among amateurs, so the serious art photographers had to become much more exclusive.

Exclusivity could be achieved by being knowledgeable about art. Many ideas in art, such as aestheticism and naturalism, already had long histories in the 19th century, but the pictorialists tried to see their relevance to contemporary art. They studied recent versions of the arts of "ism": aestheticism, naturalism, impressionism, Japonisme, and symbolism. Pictorialists rummaged in these varied art styles for prescriptions and justifications to create for themselves an art movement that was primarily aesthetic.

Though satirized in the 1820s, aestheticism survived into the 1890s as the affected and extravagant cult of the beautiful that characterized the "Aesthetic Movement." In his conclusion to *The Renaissance* (1873), Walter Pater claimed that those with "sensibility" would find the most precious moments of life in "the desire of beauty, the love of art for art's sake." In Britain, aestheticism in art was first ridiculed because of its dandyism and then tainted by its association with the perceived decadence of Aubrey Beardsley and Oscar Wilde. Nonetheless, an enthusiasm for "art for art's sake" was important in dislodging Victorian moralizing and anecdote from art and photography.

Naturalism was chiefly concerned with representing an idealized country life, as if it actually existed and could be shown directly, seemingly without mediation or manipulation. The countryside and country folk appeared to be both natural and heroic. The art movement developed in Europe and the United States from the 1820s. Towards the end of the century naturalism was continued in Britain in the paintings of George Clausen, who was a friend of Peter Henry Emerson. During the same period in the United States naturalism flourished in the paintings of Albert Bierstadt, and in the photographs of Rudolf Eickemeyer Jr., and in Arthur Scott's photographs for John Coleman Adams's *Nature Studies in Berkshire* (1899).

Even as it developed, Impressionism was the most famous of all French art movements. Although controversial in the 1870s, "impression" was quickly (and loosely) adopted as a way of viewing the world. The term was not confined to one style of depiction, but described an attitude to art that had already been made famous by Emile Zola in 1866, when he remarked that a work of art was "a corner of creation seen through a temperament." Photographers latched onto that idea even more than the methods of Claude Monet or Edgar Degas. The word "impression," as long as it was associated with artistic temperament, became the most widely used term—sometimes of abuse—in *fin de siècle* art photography. Part of the problem in Britain, at least, was that the word was linked with James Abbot McNeill Whistler, whose impressionistic "Nocturnes" had been so controversial in the 1870s, but who was feted by the time he died in 1903. A particularly rich example of his influence can be seen in Edward J. Steichen's "Flatiron" (1907). Steichen achieved his effect by making a print from a complex mix of blue pigment gum bichromate and platinum salts, which required considerable technical mastery.

Pictorialists liked the decorative pattern and order of Japonisme. It is characterized by a pronounced flatness of the picture, high skyline, or the abstract nature of the overall image. It was made popular in the United States (among others) Arthur W. Dow's *Composition* (1899). Japanese woodcut design is common in pictorial photography, as in James Craig Annan's "The White House" (1905) and Alvin Langdon Coburn's "Wapping" (plate 10 from *London*, 1909).

Symbolism was a highly charged, eroticized art form in Europe. The pictorialists translated it into something gentler. It had a pronounced mystical air, as in George H. Seeley's "Glowworm" (1903/08), Clarence Hudson White's "The Bubble" (1898/1905), and Anne W. Brigman's "Spirit of the Glacier" (1906). In Britain, Alvin Langdon Coburn was captivated by the mystery religion of Rosicrucianism and illustrated the mystical poet and playwright Maurice Maeterlinck's *The Intelligence of Flowers* (1907).

Though fraught with ambiguity and conflict in their practice, art photographers nevertheless modeled themselves on the art establishment. They held annual "salons," put their prints up for sale, judged each others' work, and awarded medals. They kept up a continuous flow of critical opinion and confirmatory acts. They took portraits of each other, wrote reviews, and formed alliances. An accumulation of opinion and reputation flowed within and across continents. Their activities created a "hothouse" atmosphere, designed to keep out what they felt to be the enemies of art. The density of material flowing in the system appealed to the Romantic standards of truth and beauty, which was opposed to the banal and manufactured.

This clamour for prestige among art photography has been harshly judged by historian Ulrich Keller. However, what is important about his work, and perhaps suggests why it has been somewhat overlooked in the standard books on the pictorialists, is that he moves away from taking them entirely on their own terms as artists. He insists not only on examining their contradictions, but also on placing them in the contexts of art production and consumption and business.

Attacking their aesthetics, Keller writes that the pictorialists were "charmed" by the high status "reserved for the artist/genius in Victorian times" and set their sights "on producing high-art works à la Titian and Rembrandt." However, the claims for art were not always based on the "old masters." Other favored models included popular contemporary (or still fashionable) artists such as Jean Baptiste Camille Corot, George Frederic Watts, and, above all, Whistler. Further, the pictorialists could not have accepted that their place was to stay with what Keller calls the "merely decorative" arts of the Aesthetic Movement, since they were contending for a new space for art photographs as *pictures*.

Keller also argues that in constructing their own fame, the pictorialists built "a prestige-oriented pseudo art world" on a medium with no stable position or history as an art form, and with negligible support from curators and collectors. The pictorialists' self-promotion was indeed similar to that of the art world, no doubt because of prestige. It could not have been for financial reward, since none of the practitioners was making serious money from art photography, and yet they continued to pursue it in their spare time.

The position of the pictorialists is complex, because most were middle-class professionals. Pictorialism was only a hobby and full-time camera work was extremely rare. Yet the attraction of mimicking high art becomes clearer if it is considered in terms of social class. Artistic production and promotion had no direct business significance and was largely concerned with membership of the correct social set. In London, the elite art photographers formed the Brotherhood of the Linked Ring in 1892, breaking away from the already elite (but inartistic) Royal Photographic Society. But despite their secession, art photographers were not bohemians seeking a place outside the market. On the contrary, they were themselves a niche market. The big photographic firms recognized the special cachet of art, and financed the amateur magazines to encourage art aspirations. They continued the same appeal in organized amateur exhibitions with special sections for the elite art photographers. For instance, Kodak's large exhibition in London in 1897 featured well-known British pictorialists such as Henry Peach Robinson, James Craig Annan, George Davison and Alfred Horsley Hinton. Furthermore, many of these photographers were employed in the trade. Hinton was a dealer in photographic goods and editor of *The Amateur Photographer* from 1893–1908; Annan was employed in his father's firm of portrait, commercial and industrial photography; Davison was directly connected with Kodak from 1889–1913, and was Managing Director of the company in England from 1900–07. Robinson was a professional portrait photographer and successful author. Other exhibitors included such famous members of the Brotherhood of the Linked Ring as Malcolm Arbuthnot, who married a Kodak heiress and managed the company's Liverpool branch, and James Booker Blakemore Wellington, who founded the company of Wellington and Ward, manufacturers of photographic plates.

The tendency to retreat into metropolitan and otherwise exclusive societies was matched in Europe in the Cercle l'Effort (Brussels) and the Trifolium (Vienna), and in the USA by the Elect (Chicago) and the Photo-Secessionists (New York). Such elite clubs were directly comparable to the exclusive gentlemen's clubs of high society. In addition, many of the leading members of these societies were unusually wealthy and highly educated. The Wiener Camera Club enjoyed the patronage of the Royal Family and aristocrats, as well as photographers of international standing and high status, including lawyers (Joseph T. Keiley), bankers (Robert Demachy), merchants (Theodor and Oskar Hofmeister), and heirs (Heinrich Kühn). Not surprisingly in such company, the emphasis was on stylish clothes, on gatherings in fine restaurants, and luxurious club accommodation.

The pictorialists agreed on their exclusivity. However, they scarcely agreed on anything else. They constantly wrangled among themselves about methods and styles. The movement began promisingly in 1891 with an art photography exhibition organized by the Trifolium group in Vienna, but personal rivalries meant it ended badly in London in 1909–10 with the self-destruction of the Brotherhood of the Linked Ring. Pictorialism then rapidly disintegrated as a forceful movement.

The seeds of discord were already present from 1889. Despite the importance of the final pictorial effect, this was nevertheless related to technical choices, and art photographers engaged in bitter disputes over processes. The controversy over printing began in 1889, when Emerson caused a scandal by advocating differential focusing, and thereby broke with sharp imagery. The arguments were complicated by those who advocated print manipulation in the darkroom and those who believed the photograph should be printed "straight," insisting on the purity and integrity of the chemical process. The opposing factions never resolved the matter in arguments stretching over twenty years, and from this distance the differences between them are less striking than their similar aim—to make rare and unique prints that were remote from everyday snapshots, or illustrations printed in magazines and papers by off-set lithography.

Divided by technique, the two main camps held some ideas in common. For example, both camps declared that truth to nature was the most important ideal, and neither believed this should be mistaken for realism, or too much detail. However, one camp declared that it was the duty of the photographer to improve on reality by any means possible in order to approach the ideal of nature. These means included staging scenes, altering

actuality, and combining or altering negatives in the darkroom. The leader of this group was Henry Peach Robinson, but he died in 1901, and then the chief exponents of such practices included such different stylists as Lydall Sawyer, Alfred Horsley Hinton, and Francis James Mortimer. Nature could also be improved by using one of a number of oil pigment processes, such as the gum print, which were invented and improved upon in the first years of the 20th century. These enabled such different photographers as Robert Demachy, Dudley Johnston, Leonard Misonne, and Edward Steichen to use a brush to coat the paper with oil pigment. They applied as much pigment as they liked to make images that were varied in draughtmanship and rich in color, often looking like lithographs. Opponents of those "handwork" methods referred to such images disparagingly as "fuzzygraphs."

The opponents of "handwork" also believed that art resided in nature but thought that true artists should be able to see the composition before them in the ground-glass screen of their camera. They advocated "straight" or "pure" photography, with the minimum of darkroom interference. Since the 1880s, the leading proponent of "pure" photography was Emerson, who never joined any of the secessionist art societies but was extremely influential. He claimed that the mass market was spoiling photography, declaring the order of rank for pictorial representation to be oil paintings first, followed by photogravures and finally "a good photograph, one which is a picture, and which is printed in platinotype." Emerson's ideas were carried forward by Stieglitz and many other pictorialists, including Frederick H. Evans, George Davison, and Alvin Langdon Coburn. These photographers liked to make platinum prints, which had a metallic sheen, or photogravures, which could look like engravings or etchings.

Arguments between the "pure" and "handwork" camps helped to destroy late pictorialism, but other factors were involved. In addition to the squabbles among its advocates, pictorialism was already in a weak position. With some justification, the death of pictorialism as a form of modern art stems from its politeness. Consistently, pictorialism is consigned to the margins because of its attachment to the drawing-room values seen in the art of the late Victorians and Edwardians. Its advocates wrote dull appreciations according to increasingly old-fashioned formula. However, pictorialism continued to flourish in camera clubs and international exhibitions because it was pleasant and not too modern. Its popularity increased in the clubs because it helped produce an idealized or improved view of a utilitarian or mechanized world. Of course, once pictorialism became popular, its appeal to the famous *fin de siècle* art photographers ended.

Pictorialism suffered even more when one of its methods, combination printing, was put to new use—but not in art. When it was dangerous or forbidden to use a camera outdoors during wartime, combination printing was widely used to fake war scenes that were useful propaganda; no doubt that contributed to pictorialism's sudden demise in depicting truth to nature after 1918.

The more pressing problem by 1910, however, was that pictorial aesthetics seemed outdated. The Victorian ideals, the comfortable drawing-room life, which is so evident in Edwardian pictorial photography, were no longer the appropriate style for art as modernism gained ground in Europe. *Fin de siècle* art movements were brushed aside by modernism; optimism based on eternal values was destroyed as mechanization took command. The conserving arts gave way to the explosive forward movement of the avant-garde. Pictorialism could not stand the blast of modernism in the guise of Cubism, Futurism, abstraction, Neo-classicism, New Realism, and Surrealism.

Despite its elitist claims as an art form, the pictorialists' grasp of contemporary art trends was always tenuous, even before 1910. Pictorialism was never avant-garde when compared with current movements in Fine Art. It was always behind the times. When it seemed to be getting abreast of the times, as in Alvin Langdon Coburn's Futurist-inspired "Vortographs," exhibited in London in 1917, or in Paul Strand's Cubist-inspired work published in the last issue of Stieglitz's *Camera Work* in 1917, it was vilified by most pictorialists. Coburn retired from photography and *Camera Work* folded—though Stieglitz and Strand went on to make enormous contributions to art photography *outside* pictorialism. The reputations of these men have remained high not so much for their contribution to pictorialism, considerable as that was (especially from Stieglitz and Coburn), but because of their dedication to the elitist, exclusive nature of art photography. As soon as pictorialism became common fare, a way of making pictures that any enthusiast could enjoy, it was of no interest to the elitists. Once it had failed to keep its distance from the mass of amateurs, pictorialism could no longer fulfill its ambition to be art, because art by definition was made by and for the few, and not by or for the multitude.

JOHN TAYLOR

See also: Stieglitz, Alfred; Demachy, (Léon) Robert; and Brotherhood of the Linked Ring.

Further Reading

Anderson, A.J., *Artistic Side of Photography in Theory and Practice*, London: Stanley Paul and Co., 1910.

Bunnell, Peter C. (ed.), *A Photographic Vision: Pictorial Photography, 1889–1923*, Salt Lake City, UT: Peregrine Smith, 1980.

Caffin, Charles H., *Photography as a Fine Art*, New York: Morgan and Morgan, 1971 (facsimile of 1901 publication).

Davidov, Judith Fryer, *Women's Camera Work: Self/Body/Other in American Visual Culture*, Durham and London: Duke University Press, 1998.

Doty, Robert, *Photo-Secession: Photography as a Fine Art*, Rochester: George Eastman House, 1960.

Green, Jonathan (ed.), *Camera Work: A Critical Anthology*, New York: Aperture, 1973

Guest, Antony, *Art and the Camera*, London: G. Bell and Sons 1907.

Handy, Ellen, *Pictorial Effect, Naturalistic Vision: The Photographs and Theories of Henry Peach Robinson and Peter Henry Emerson*, Norfolk, VA: The Chrysler Museum, 1994 (exhibition catalogue).

Harker, Margaret, *The Linked Ring: The Secession Movement in Photography in Britain, 1892–1910*, London: Heinemann, 1979.

Harker, Margaret, *Henry Peach Robinson: Master of Photographic Art 1830–1901*, Oxford: Blackwell, 1988.

Holme, Charles (ed.), *Art in Photography: With Selected Examples of European and American Work*, London: The Studio, 1905.

Holme, Charles (ed.), *Colour Photography and Other Recent Developments of the Art of the Camera*, London: The Studio, 1908.

Homer, William Innes, *Alfred Stieglitz and the Photo-Secession*, Boston: New York Graphic Society, 1983.

Keller, Ulrich F., "The Myth of Art Photography: A Sociological Analysis." *History of Photography*, 8/4 (October–December 1984): 249–275.

Keller, Ulrich F., "The Myth of Art Photography: An Iconographic Analysis." *History of Photography*, 9/1 (January–March 1985): 1–38.

Kunstphotographie um 1900: Die Sammlung Ernst Juhl, Hamburg: Museum für Kunst und Gewerbe, 1989 (exhibition catalogue).

Naef, Weston, *The Collection of Alfred Stieglitz: Fifty Pioneers of Modern Photography*, New York: Metropolitan Museum of Art, 1978.

Roberts, Pam (ed.), *Alfred Stieglitz, Camera Work: The Complete Illustrations*, London: Taschen, 1997.

Robinson, Henry Peach, *Pictorial Effect in Photography*, London: Piper and Carter, 1869.

Robinson, Henry Peach, *Picture-Making by Photography*, London: Hazell, Watson and Viney Ltd, 1889.

Taylor, John, *Pictorial Photography in Britain 1900–1920*, London: Arts Council of Great Britain, 1978 (exhibition catalogue).

Taylor, John, "Henry Peach Robinson and Victorian Theory." *History of Photography*, 3/4 (April 1979): 295–303.

Taylor, John, "Pictorial Photography in the First World War." *History of Photography*, 6/2 (April 1982): 119–41.

Tilney, F.C., *The Principles of Photographic Pictorialism*, Boston: American Photographic Publishing Co., 1930.

Weaver, Mike, *Alvin Langdon Coburn: Symbolist Photographer*, New York, Aperture, 1986.

Weaver, Mike (ed.), *British Photography in the Nineteenth Century: The Fine Art Tradition*, Cambridge: Cambridge University Press, 1989.

Yochelson, Bonnie, and Kathleen A. Erwin, *Pictorialism into Modernism: The Clarence White School of Photography*, New York: Rizzoli, 1996.

PIGOU, WILLIAM HENRY (1817–1858)
English photographer

Dr. William Henry Pigou took over the task of recording the ancient monuments of the Bombay Presidency from Colonel Thomas Biggs in early 1856 and spent over a year as Government Photographer on the project. Before taking on this assignment, Pigou had been a member of the Bombay Photographic Society (since 1854) and, according to Biggs, had several years experience of photography in India. Some fine landscape images by Pigou also survive.

Using large format paper negatives (up top 16" × 12"), post-waxed, Pigou's work was, with a few publicly criticised exceptions, precise, architecturally accurate, and usually photographed under oblique lighting conditions selected to reveal the intricate sculptured facades which decorated many of these monuments.

His work, together with that of his predecessor and his successor, was eventually published in India in 1866, subsidised by the Committee of Architectural Antiquities in Western India, in Taylor and Henderson's *Architecture in Dharwar and Mysore. Photographed by the late Dr. Pigou, Bombay Medical Service, A. C. B. Neill, Esq. and Colonel Biggs, Late of the Royal Artillery.* These large format portfolios—containing tipped-in albumen prints—were published in London by John Murray. Some of the photographs were later used as the basis for the engravings which illustrated James Fergusson's History of Indian and Eastern Architecture, also published by John Murray, in 1876.

JOHN HANNAVY

PIOT, EUGÈNE (1812–1890)
French photographer and publisher, collector, and art historian

A wealthy amateur, Eugène Piot started practicing daguerreotype in 1840, when he traveled to Spain with his friend Théophile Gautier (both were part of the Romantic community which colonized the Rue du Doyenné, in Paris in 1835). The poet mentioned this photographic venture in his travelogue, *Tras los Montes*, but none of Piot's plates survived. A remarkable art connoisseur and collector (he bequeathed his collections to the Institut de France, the Bibliothèque Nationale, and the Louvre), Piot traveled and photographed in Italy, Greece, and the Near East.

His subjects are chiefly architectural views related to his artistic and archeological interest. He is mostly known for publishing photographic albums a few months before Blanquart-Évrard, to the surprise of the photographic milieu. Familiar with publishing, Piot created, in 1842, an art journal, *Le Cabinet de l'amateur et de l'antiquaire*. In June 1851, he released

the first (and probably unique) installment of *L'Italie monumentale*. Emphasizing on the competition between photography and printmaking, Francis Wey considered that "thus begins the series of art travels books illustrated by photography: Mr. Piot created a new commercial field" (*La Lumière*, August 17, 1851, p. 111). His other publications—none of which he completed—include *L'Acropole d'Athènes* (1852), *Temples grecs* (1854), *Rome et ses environs*, and *L'élite des monuments français*.

Piot exhibited at the Royal Society of Arts in London (1852), at the 1855 Exposition universelle in Paris (First Class Medal), and at the Société française de photographie (1857, 1859).

PIERRE-LIN RENIÉ

See also: Blanquart-Evrard, Louis-Désiré; Wey, Francis; and Société française de photographie.

Further Reading

Courajod, L., "Eugène Piot et les objets d'art légués au Louvre," *Gazette des Beaux-Arts*, May 1890.
Dalarun-Mitrovitsa, Catherine, "Eugène Piot," *Éclats d'histoire. Les collections photographiques de l'Institut de France 1839–1918*, 42–44. Arles: Actes Sud, Paris: Institut de France, 2004, Jammes, Isabelle, *Blanquart-Évrard et les origines de l'édition photographique française. Catalogue raisonné des albums photographiques édités, 1851–1855*. Genève, Paris: Droz, 1981.
Piot, Charlotte, "Eugène Piot (1812–1890), publiciste et éditeur." *Histoire de l'art*, no. 47 (November 2000): 3–17.
Sainte-Marthe, Bertrand, *Les publications photographiques d'Eugène Piot*. Master Thesis, University Paris 4, 1992.

PIZZIGHELLI, GIUSEPPE (1849–1912)

Giuseppe Pizzighelli (according to his friend and co-researcher Josef Maria Eder) was the son of an Austrian army surgeon of Italian origin, and was educated at the military academy in Vienna.

He is first recorded as a keen amateur photographer in the late 1860s, while a serving lieutenant in the Austrian army, working with his friend and fellow officer Victor Tóth, and wet collodion plates and 'Busch combination lenses for portraits and landscapes' (Eder 1945).

Despite training as a military engineer, in 1878 Pizzighelli was appointed as head of the photographic department of the Austrian army's Technical Military Committee in Vienna, with the rank of captain, and his important published contributions to the development of photography all date from after this appointment.

It was during this posting that Pizzighelli joined with Baron von Hübl in the preparation of platinum prints—following William Willis's instructions. Von Hübl was a fellow captain—later to achieve the rank of Field Marshall—and their work led to the introduction of a significant improvement to the process that Willis had patented in 1873. It was Pizzighelli and von Hübl's work in the later 1870s and early 1880s which improved the reliability and manufacturing consistency of the paper itself, and led to much more widespread use of platinum as the ideal 'permanent' printing medium.

He and von Hübl published their experimental results in early 1882, and their work was awarded a medal by the Vienna Photographic Society—an organization with which he would have a continuing relationship. An abridged version of their account was translated into English and published in the *Journal of the Photographic Society* in the same year.

Their much more comprehensive book *Die Platintype* was also published in 1882. It was also translated into French and published by Gauthier-Villars of Paris in 1883 and, translated into English by J. F. Iselin and edited by William de Wivileslie Abney, it was published in London by Harrison & Sounds in 1886.

The platinotype enjoyed considerable popularity within the expanding community of art photographers in the closing years of the ninententh and early years of the twentieth centuries—notable inclusions being Frederick H Evans, Paul Martin, Alfred Steiglitz, Paul Strand, and Clarence White.

While several published sources make much of the claim that Pizzighelli and von Hübl gave their process 'freely to the world,' an 1887 patent exists in Pizzighelli's name which suggests the contrary. By that time he had been posted to Bosnia as an engineering officer, and was working alone. That 1887 patent refers to a modified version of the platinotype—a printing-out paper using sodium ferric oxalate and potassium chloroplatinate which did not require further development. It was briefly marketed as the Pizzitype, but ironically—bearing in mind that he and von Hübl had improved the consistency of the developed platinum print—it was, allegedly, inconsistency in manufacture which led to the material being withdrawn from sale.

Pizzighelli and Eder are credited with the production of the first chemically developed gelatin silver chloride emulsions in 1881—both prints and glass diapositives—twelve years before Leo Hendrik Baekeland's introduction of Velox 'gaslight' paper. They had started their collaboration in 1880 and reported their work to the Vienna Academy of Sciences in January 1881, publishing their results in a lengthy-titled pamphlet in the same year—*Die Photographie mit Chlorsilbergelatine und chemischer Entwicklung nebst einer praktischen Anleitung zur raschen Herstellung von Diapositiven, Stereoskopbildern, Fensterbildern, Duplikat-Negativen, Vergrösserungen; Kopien auf Papier* ... Eder went on to produce the first gelatin silver chloro-bromide emulsions himself. When later writers asserted that others had prior claim for the production of the first developed silver chloride emulsions, the 75-year old Eder asserted his

and Pizzighelli's claims to their invention in the *Journal of the Photographic Society* in 1930.

To demonstrate the fineness of the grain structure of their silver chloride plates, Eder and Pizzighelli made reduced size positives from existing collodion negatives by their friend Victor Angerer, the well-known Viennese portrait photographer. These were exhibited at the twentieth anniversary exhibition of the Vienna Photographic Society in 1881. What caused especial interest amongst those seeing these images for the first time was the hitherto unavailable range of print colours which the two pioneers had produced by using a range of different developers. In Edward Epstean's translation of Eder (1945) the colours are described:

> The warmest bright red shades were developed with hydroquinone and ammonium carbonate, the brownish tones with ammonium ferro-citrate, the greenish brown tones with alkaline gallic acid solution, and so forth… This diapositive exhibit was awarded the gold-enamel medal by the Vienna Photographic Society.

Pizzighellis and Eder's work was further developed by Dr. Ernst Just in 1882, and by Leon Warnerke in 1889.

In his role as head of the army photographic department, Pizzighelli was clearly an influential figure. It was to him that Adolphe Steinheil brought his newly computed aplanatic lens set for testing in 1881. The aplanat design had been something with which Steinheil had been working since the late 1860s, producing lenses which were virtually free of both chromatic and spherical aberrations, and which offered a very flat field—characteristics which were essential for much of the work in which Pizzighelli's unit was engaged.

Amongst many texts, Pizzighelli wrote two manuals on photography—*Anleitung zur Photographie für Anfänger* published in 1890, and *Handbuch der Photographie. Für Amateure und Touristen,* published in 1892.

After a lengthy military career—achieving the rank of colonel—he retired to Florence in 1895, where he began an enduring relationship with the Società Fotografica Italiana, eventually become a director and later president. He died in Florence in 1912, at the age of 63.

JOHN HANNAVY

See also: Huebl, Baron Arthur Freiherr von; Evans, Frederick H.; Willis, William; and Eder, Joseph Maria.

Further Reading

Eder, Josef Maria, *History of Photography*, translated by Edward Epstean, New York: Dover Publications, 1945.

Pizzighelle, Giuseppe, *Anleitung zur Photographie für Anfänger*, Berlin: Knapp, 1890.

———, *Handbuch der Photographie. Für Amateure und Touristen*, Berlin: Knapp, 1892.

PLATEAU, JOSEPH ANTOINE FERDINAND (1801–1883)
Belgian physicist, inventor of the phenakistiscope

Joseph Plateau was born in Brussels, Belgium, in 1801. He became an orphan at fourteen. A pupil at the Atheneum, Brussels 1817–22, he was much influenced by his teacher Adolphe Quetelet. Quetelet would later found the periodical 'Correspondence mathematique et physique,' in which Plateau's technical papers were published. Plateau enroled in the Philosophy Faculty of the University of Liège in 1822. In 1823–24 he obtained diplomas in art and law. Fascinated by chemistry, Plateau carried out his own experiments and in 1824 obtained the Diploma in Physical and Mathematical Sciences. He became a mathematics teacher in 1827, and had soon published a paper on optical perception, and designed instruments for perception experiments. His 1829 doctoral thesis, 'Dissertation on Several Properties of Impressions Produced by Light on the Organ of Sight,' includes observations on colour theory, and also anorthoscopic (distorted) drawings which appear normal when viewed through a spinning, slotted disc. The anorthoscope was marketed in 1836.

In 1830 Plateau moved to Brussels, teaching physics 1833–34. By late 1832 he had invented the phenakistiscope, or phénakisticope [original spelling]—from *phenax* -"deceptive" and *skopeo*, "I look at." An almost identical device, the stroboscope, was invented simultaneously by Austrian physicist Prof. Simon Stampfer. Plateau's instrument comprised a disc with a small central hole, mounted on a handle so that it could spin freely. Each disc had small equidistant radial apertures around the circumference and pictures on one side. The disc was spun with the pictures facing a mirror, and the moving images viewed through the slots, by reflection. Other versions of the device comprised two discs on the same shaft, one with slots and the other containing a sequence of images. When the two discs rotated, an animated picture was seen by viewing the picture disc through the slots in the shutter disc. Most of the animation sequences were drawn in a cycle, a continuous flow with no beginning or end. Plateau's first subject was a line drawing of a pirouetting dancer, in sixteen positions.

Versions with a variety of names, including Phantasmascope and Fantascope, were sold commercially as a philosophical toy by various publishers in France and England, with discs featuring a wide range of imaginative animated drawings, including abstract designs of coloured balls. Plateau himself received no financial reward for his invention.

Within a few years Plateau had produced an improved version, with backlit pictures on translucent varnished paper, designed and geared in such a way that the optical

distortions apparent in the original model were reduced. The subjects were fantastic characters designed by the Belgian artist Jean-Baptiste Madou, extrapolated into motion sequences by Plateau himself. The result could now be viewed more comfortably with both eyes, and by more than one spectator.

Plateau moved to Ghent in 1835, and became a professor at the University. Plateau's experiments relating to visual perception were wide-ranging, and included the persistence of luminous impressions on the retina, accidental colours, the contrast of colours, and coloured shadows. He observed and commented on many aspects, including 'irradiation'—the phenomenon of a bright object seen against a dark background appearing larger than it actually is, related to the recurrent mystery of the apparent size of the moon being larger on the horizon than when it is high in the sky. He devised an instrument to study the effect, which is measurable, and his results were published in 1839. When he was around forty-two years old, Plateau gradually went blind as a result of an inflammation of the eyes. (This was probably not, as is often suggested, caused by experiments involving direct viewing of the sun). Undaunted, he continued to experiment assisted by his colleagues, friends and family, including his elder son Félix. For decades Plateau continued his studies of visual persistence, especially the varying persistence of different colours. He believed that this effect was a property of the retina, but it is now known to be linked to the brain.

As well as undertaking optical research, Plateau also studied the phenomena of capillarity and surface tension of liquids, and his important work in that field is still well known. Many experiments describe the structure of soap films, illustrating the mathematical problem of the existence of a minimal surface with a given boundary—now named Plateau's Rules. Stereoscopic photographs of Plateau-type laminar soap films formed on wire shapes, taken about 1880, are in the J. Plateau collection, Ghent.

Plateau's phenakistiscope viewer evolved into the zoetrope drum-form moving picture device, and was the spur for many later experiments. In 1843 the obscure English experimenter T.W. Naylor suggested a machine for projecting phenakistiscope-disc drawings, and a plan of the device was published.

Several of Plateau's correspondents and contemporaries soon suggested viewing devices for a more ambitious idea; the presentation of moving photographs. Inventor of the stereoscope Charles Wheatstone, daguerreotypist Antoine Claudet and others struggled with the problem over many years. In 1852 the French optician Jules Duboscq combined Plateau's phenakistiscope with Wheatstone's stereoscope to produce the Bioscope, a direct viewing instrument for producing a stereosopic photographic moving image. (The name would later be

used for motion picture film machines). In 1879 Eadweard Muybridge devised his successful Zoogyroscope or Zoopraxiscope projector developed from Plateau's phenakistiscope principle, with glass discs bearing painted figures based on his famous American sequence photographs. Joseph Plateau died in 1883. His colour vision research was an important contribution to the subject, and his principle of producing moving images by rapid succession of a number of progressive poses would later be a key feature of the invention of motion pictures on film.

STEPHEN HERBERT

Biography

Born in Brussels on October 14, 1801. His father was Antoine Plateau (1759–1815), his mother Catherine Thirion (1771–1814). After his father's early death, an uncle supported and encouraged Plateau's early studies. Plateau married Fanny Clavareau, August 27, 1840. He was a member of the Royal Academy of Belgium, a correspondent of the Institute of France, and a member of many European academies and learned societies. Joseph Plateau died in Ghent on September 15, 1883, forty years after he lost his sight. No photographic portrait was known until the 1990s when an evocative daguerreotype, taken by photographer Pilizzaro in 1843 just before Plateau went blind, was discovered in France. It was acquired by the Museum of the History of Science, University of Ghent, and is now in their permanent collection.

See also: Duboscq, Louis Jules; Wheatstone, Charles; and Claudet, Antoine-François-Jean.

Further Reading

Dorikens, *Maurice, Joseph Plateau 1801–1883. Living between Art and Science*. Belgium: Provincie Oost-Vlaanderen 2001.

Hecht, Hermann, Ann Hecht (ed)., *Pre-Cinema History. An Encyclopaedia and Annotated Bibliography of the Moving Image Before 1896*. London: British Film Institute / Bowker Saur 1993.

PLATINOTYPE COMPANY

In 1879, William Willis junior founded the Platinotype Company in order chiefly to manufacture and market his platinum printing papers. Five years of research in his private laboratory at Bromley, Kent, had followed his initial patent of 1873—Improvements in Photochemical Printing—before Willis advanced sufficiently to offer his invention, described in his patent of 1878, to the public. A factory was established at 66 Beckenham Road, Penge, and the Company's sales office at 29 Southampton Row, High Holborn, London, which later

transferred to 22 Bloomsbury Street.

By 1880 the first commercial platinotype papers were on sale, with a choice of rough or smooth surface, on medium or thick paper, at a price of 1/- (one shilling = 12 'old' pence = 5 'decimal' pence) for a sheet 17.75 x 22.75 inches; other sizes could be supplied pro rata at a unit cost of ca. 4 d/sq.ft ('old' pence per square foot). By 1892, the Company was selling platinotype papers in nine sizes, pre-cut to match the negative formats then current, at a unit cost of ca. 8 d/sq.ft, which remained constant over the next 15 years, and may be compared with the cost of ca. 3 d/sq.ft for printing-out papers, and 6 d/sq.ft for the new bromide enlarging papers. For storage, perfect dryness was of paramount importance, otherwise the sensitizer became fogged by the action of moisture; accordingly, the Company supplied the paper sealed in soldered tins, and recommended storing it in special tubes containing a desiccant of anhydrous calcium chloride. Sensitized textiles could also be supplied for 1/- to 1/6 per square foot: nainsook—a very fine muslin; sateen—for d'oyleys, mats, and lampshades; and rough oatmeal cloth—for screens, antimacassars, cosies, and mantle-cloths.

Because the process was protected by Willis's later patents of 1878 and 1880, prospective users, both amateur and professional, were initially obliged to pay the Company 5/- for a licence to practise platinum printing. This requirement was suspended in 1888 when Willis launched his new cold bath process, described in two more patents, of 1887, in which the development bath contained all the platinum salt. It proved short-lived, however, owing to an uneconomic defect: platinum metal tended to precipitate from the stored developer. Willis withdrew this platinum in the bath process in 1892, upon introducing his final, most successful modification, cold development paper, which he protected by secrecy rather than patent.

In 1885 the Platinotype Company was awarded the gold medal of the International Inventions Exhibition. By the 1890s, Willis's range of papers offered every combination of texture, weight, more or less contrast, and black or sepia image—numbering about 20 varieties. These sensitized papers were of two main types: one could only be developed hot, the other was also suited to development at room temperature. The image colour varied slightly, from bluish-black in cold development (ca. 20 °C), especially using the Company's proprietary D Salts as developer, to brownish-black at high temperature (ca. 75 °C). Most workers preferred cold development to avoid scalding their fingers. Willis also devised Sepia platinotype papers, which incorporated a mercury(II) salt in the sensitizer. These called for hot development; but to obtain a sepia colour with the ordinary papers, some workers added mercuric chloride to their cold development baths.

The company's platinotype papers were coded by a single letter to designate hot bath papers, a doubled letter for cold development papers, and 'S' to indicate sepia papers. Willis later added a parchmentized paper having a semi-glossy surface—Japine paper. The surfaces, weights, and image colours available were as follows:

A, AA Smooth surface, medium weight
B, BB Smooth surface, heavy weight
C, CC Rough surface, very heavy weight,
K, KK, KS Smooth surface, heavy weight, higher contrast
S Smooth surface, medium weight, sepia colour, hot bath process
RS Rough surface, very heavy weight, sepia colour, hot bath process
T, TT, TS Rough surface, heavy weight, higher contrast
Y, YY, YS Smooth surface, very heavy weight
Z, ZZ, ZS Slightly rough surface, very heavy weight

Willis purchased the platinum salt, potassium chloroplatinite, from the leading precious-metal refiners, Johnson Matthey, whose company records for the sales of this salt make possible a rough calculation that the production of platinotype paper was usually in excess of one million square feet per year.

Other goods marketed by the Platinotype Company included chemicals, porcelain dishes, printing frames, and calcium chloride tubes. A director of the company, Herbert Bowyer Berkeley (1851–1891), was responsible for one of the most significant improvements to photographic processing by discovering that developers for silver emulsions could be stabilized by the inclusion of sulphite, which enabled the development of negatives to greater density ranges without fogging. The company marketed this important innovation in 1882 as the very first proprietary developer, "Sulpho-pyrogallol." The works manager of the company's factory in Penge, WH Smith, also collaborated with Willis to produce a hand-portable 'Key camera,' patented on 28 March 1889, which incorporated a novel method of changing the glass plates.

The chief competitor to Willis's platinotype was Pizzighelli's printing-out platinum paper, invented in 1887, which was manufactured by Hezekiel and Jacoby in Berlin, Dr Just in Vienna, and Unger and Hoffmann in Dresden. Such paper was also made in England by Berger and Company, and by Hardcastle; but the major photographic companies, Ilford and Kodak, did not enter the platinum paper market until the early 20th century. To retail the Platinotype Company's products in the United States, the sister-company of Willis and Clements was founded ca. 1885, with offices at 25 North Seventh Street, Philadelphia, later moving to 1624 Chestnut Street. Rival suppliers in the United

States included JC Millen of Denver, Colorado, E and HT Anthony of New York, and the American Aristotype Company of Jamestown.

As a consequence of the "platinum famine" brought on by the Russian Revolution and the Great War, the Platinotype Company had to diversify its products, introducing as substitutes "Satista" paper in 1913, and "Palladiotype" paper in 1917. On the death of William Willis in 1923, the Company passed to his younger brother, John, and was subsequently headed by a cousin, Alfred Willis Clemens, until 1937, when the Company was voluntarily dissolved.

MIKE WARE

See also: Platinum Print; Willis, William; and Bromide Print.

Further Reading

Abney, William de Wiveleslie, and Clark, Lyonel, *Platinotype, its Preparation and Manipulation*, London: Sampson Low, Marston, 1895.

Child Bayley, R, *The Complete Photographer*, London: Methuen, 1932.

Cottington, Ian, "Platinum and Early Photography." *Platinum Metals Review*, 28/4, 1984, 178–188; and in *History of Photography*, 10/2, 1986, 131–139.

Hinton, Alfred Horsley, *Platinotype Printing*, London: Hazell, Watson, and Viney, 1897

Levenson, Gerald, "Herbert B. Berkeley and the Sulphited Developer." *The Journal of Photographic Science*, 34/1, 1986, 34–40.

Nadeau, Luis, *History and Practice of Platinum Printing*, Fredericton, New Brunswick: Atelier Luis Nadeau, 3rd edn. 1994

Tennant, John (ed.), *The Photo-miniature*, "Platinotype Processes," 1/7, October 1899, 318[–]355; "Platinotype Modifications," 4/40, July 1902, 153–193; "Platinum Printing," 10/115, May 1911, 305–342.

Ware, Mike, "The Eighth Metal: the Rise of the Platinotype Process."In *Photography 1900: The Edinburgh Symposium*, edited by Julie Lawson, Ray McKenzie, and Alison Morrison-Low, Edinburgh: National Museums of Scotland and National Galleries of Scotland, 1993.

Willis, William, *British Patents,* nos. 2011, 5 June 1873; 2800, 12 July 1878; 1117, 15 March 1880; 1681, 2 February 1887; 16003, 21 November 1887.

——, et al., in *The British Journal of Photography*, 24, 1877, 172–173; 25, 1878, 25, 400, 605; 26, 1879, 73–74, 340; 27, 1880, 232–233, 399–400; 28, 1881, 43, 64, 474; 34, 1887, 101; 35, 1888, 778

——, "Recent Improvements in Platinotype." *The Journal of the Camera Club*, 2, 1888, 47–]0, 99, 103; 4, 1890, 121; 6, 1892, 53–55; 7, 1893, 170–173.

PLATINUM PRINT

From the earliest days of photography, the noble metal platinum was recognised as a potential image substance. Both Sir John Herschel in 1839, and Robert Hunt in the 1840s, sought to employ platinic salts photochemically, but found no real success. Printing in platinum

did not show any promise until 1873 when, in search of a greater permanence than silver afforded, William Willis junior, of Bromley, Kent, turned to experimenting with the little-known platinous—as opposed to platinic—salts. Progress did not prove easy, however: to achieve satisfactory quality, Willis had to include salts of silver, lead, and even gold in his sensitizers. Such uncertain mixtures won little attention for his processes at first. In the struggle to fulfil his original concept, Willis's endeavours spanned twenty years of research, producing five British patents. By 1878 he had succeeded in eliminating the silver from his sensitizer, which emboldened him to found the Platinotype Company to market his platinotype paper, but its processing called for a scaldingly-hot, poisonous, developing bath, which had little appeal.

By the mid-1880s Willis was facing competition from Giuseppe Pizzighelli and Baron Arthur von Hübl in Austria, who devised a printing-out platinum paper in 1887. The photographic press praised Willis's paper in 1888, but it was not until 1892 that he finally perfected the process with his "cold development" paper, which was instantly acclaimed, ensuring that his product enjoyed much wider use. By the close of the century, more platinotypes could be seen on the salon walls than any other print medium: the process had achieved pre-eminence.

Platinotype is a later addition to the group of iron-based photographic printing processes, whose principles were discovered by Sir John Herschel in 1842, using ammonium ferric citrate. Platinotype differs in requiring ferric oxalate, which is decomposed by light to insoluble ferrous oxalate, as first noted by Johann Wolfgang Döbereiner in 1831. At this stage, the image is faintly visible, partially printed-out in pale buff on a yellow ground. It further requires development in a bath of hot (80 °C), strong (30 per cent) potassium oxalate solution to solubilise the ferrous oxalate, which can then reduce the platinous salt, included as potassium chloroplatinite, to platinum metal in a finely-divided state known as "platinum black." These two reactions may be represented by the following chemical equations:

ILLUSTRATION

$$UV\ light + Fe_2(C_2O_4)_3 \longrightarrow 2FeC_2O_4 + 2CO_2$$

UV light + ferric oxalate —> ferrous oxalate + carbon dioxide

$$2FeC_2O_4 + 4K_2C_2O_4 + K_2PtCl_4 \longrightarrow 2K_3Fe(C_2O_4)_3 + 4KCl + Pt$$

ferrous + potassium + potassium —> potassium + potassium + platinum

oxalate oxalate chloroplatinite ferrioxalate chloride metal

To clear the print, all the residual chemicals are removed by three successive baths of very dilute hydrochloric

acid, followed by washing in water, to leave an image of pure platinum black embedded in the surface fibres of the paper sheet.

The problem with this elegant process is that the reduction of the platinous salt is slow, and may be further inhibited by additives in the paper, such as gelatin size. Unless the reaction is speeded up by using hot developer, the chemicals tend to wash out of the paper before the image is fully developed. How Willis's "cold development" paper overcame this problem was never disclosed, but it appears to employ an alum-rosin paper size in preference to gelatin. The maintenance of a dry storage environment for unexposed paper was vital to avoid degradation by moisture. In contrast, the presence of some moisture was essential to facilitate the chemistry of the printing-out platinotype process of Pizzighelli and Hübl; but this was hard to control, so attempts to market commercial papers of this type foundered rather quickly.

Platinotype claimed a threefold advantage over all other photographic printing processes: it was said to be "permanent, artistic, and simple." Acknowledged as the easiest process, it was three times faster than silver printing-out paper. Of its permanence there could be no doubt, because platinum is the most inert of metals, impervious to attack by any common substance. What was not recognised in the 19th century, is that platinum black is also a very efficient chemical catalyst and, when exposed to the—usually polluted—Victorian atmosphere, it promoted the formation of strong acids within the paper fibres. Thus the paper of a platinum print may be embrittled by acidic degradation over the years, albeit the image remains pristine: historic platinotypes should therefore be handled carefully, to avoid damage.

Concerning the aesthetics of the process there was at first some equivocation: the dominant photographic print medium from 1855–1895, was the albumen print, providing the familiar brown silver image in a glossy layer of hardened egg white. For photographers habituated to this medium, the neutral grey-black platinum print with its luminous tonal gradation and totally matte surface came as a shock. Some connoisseurs greatly preferred it, however, dismissing albumen as "sharp and slimy." To accommodate all tastes, Willis introduced both "Sepia" and "Japine" platinotype papers into his commercial range. Platinum printing was much used for portraiture, landscape, and important documentary work. Like albumen, it could only be contact-printed. Platinotype paper cost about twice as much as silver printing-out paper, but it was comparable in price with the new (1890s) bromide enlarging papers.

Platinotype was the favoured medium of the Brotherhood of the Linked Ring; notable users included Frederick H. Evans, whose great series of cathedral interior studies was begun in 1890, Henry Peach Robinson,

whose most important exhibition work was printed entirely in platinum, as was the portraiture of Frederick Hollyer, the atmospheric landscapes of Alfred Horsley Hinton, and George Davison, the genre studies of Frank Meadow Sutcliffe, and, from outside the fraternity, Peter Henry Emerson with his handsome volume of 40 platinotypes, *Life and Landscape on the Norfolk Broads*, printed in limited edition by James Valentine of Dundee.

By 1900, the platinum print had reached its zenith, widely acknowledged as the finest printing medium in the photographic repertoire; but its glory would prove short-lived: the First World War would transmute platinum into a strategic material, requisitioned for making explosives, rather than pictures. Photography's most beautiful and permanent of all processes enjoyed a commercial lifespan of only 30 years, but happily the tradition of the hand-crafted platinum print continues even today.

MIKE WARE

See also: Platinotype Co. (Willis & Clements); Evans, Frederick H.; Robinson, Henry Peach; and Brotherhood of the Linked Ring.

Further Reading

Abney, William de Wiveleslie, and Clark, Lyonel, *Platinotype, its Preparation and Manipulation*, London: Sampson Low, Marston, 1895.

Cottington, Ian, "Platinum and Early Photography." *Platinum Metals Review*, 28/4, 1984, 178–188; and in *History of Photography*, 10/2, 1986, 131–139.

Crawford, William, *The Keepers of Light*, Dobbs Ferry, New York: Morgan and Morgan, 1979.

Hinton, Alfred Horsley, *Platinotype Printing*, London: Hazell, Watson, and Viney, 1897.

Nadeau, Luis, *History and Practice of Platinum Printing*, 3rd revised ed., Fredericton, New Brunswick: Atelier Luis Nadeau, 1994.

Pizzighelli, Giuseppe, and Hübl, Baron Arthur von, *Platinotype*, translated by J.F. Iselin, London: Harrison and Sons, 1886; reprinted in *Nonsilver Printing Processes*, edited by Peter C Bunnell, New York: Arno Press, 1973.

Ware, Michael J., "An Investigation of Platinum and Palladium Printing." *The Journal of Photographic Science*, 34 /13, 1986, 165–177.

Ware, Mike, "The Eighth Metal: the Rise of the Platinotype Process." In *Photography 1900: The Edinburgh Symposium*, edited by Julie Lawson, Ray McKenzie, and Alison Morrison-Low, Edinburgh: National Museums of Scotland and National Galleries of Scotland, 1993.

PLUMBE JR., JOHN (1809–1857)

"After having devoted nearly all our time, for upwards of three years, upon the U.S. transcontinental railroad—exhausting all our pecuniary means—we at last, after being laughed at as a madman, were obliged to resort to taking

daguerreotype likenesses, in order to keep up the soul of our undertaking, by supporting our body." John Plumbe, Jr., *The Plumbeian*, January 6, 1847.

John Plumbe Jr., a man of extraordinary ability and vision, was the pre-eminent promoter of photography in America during the 19th century and the first effective advocate for a United States transcontinental railroad. Plumbe was born at Castle Caereinion, Welshpool, North Wales, on July 13, 1809. His family was English and when John was twelve they immigrated to the United States. Trained as a civil engineer, he was quick to comprehend the importance of railroads to national development and passionately presented his idea for a Pacific railroad to Congress in 1838, a decade before others seriously considered the matter.

Plumbe first became aware of the wondrous daguerreotype process while in Boston during the Spring of 1840 where he probably received instruction from Daguerre's agent, François Gouraud. Turning to photography to finance his railroad ambitions, Plumbe helped to shape a developing industry. With unbounded optimism and tireless vigor Plumbe immersed himself in the new art and science to become America's first nationally known photographer. He attained this distinction by winning the highest honors in photographic competitions at scientific and industrial fairs. Plumbe was the first to introduce a franchised photographic business, establishing within six years a chain of twenty-six galleries in the United States with outlets in Paris and Liverpool, most of which were accessible by railroads. He advertised his business extensively in the leading American newspapers and furthered his reputation through brand name recognition, requiring all photographs from his numerous galleries to prominently bear the Plumbe name.

Beginning in Boston in 1840, Plumbe established the United States Photographic Institute and opened branch galleries or "photographic depots" as the railroad advocate called them. In addition to taking photographic portraits, Plumbe manufactured and imported cameras and offered complete daguerreotype outfits. He taught the first generation of American photographers including Gabriel Harrison, William Shew, and Samuel Masury. Plumbe's 1841 daguerreotype manual is the earliest published American photographic work. Pursuing an interest in color photography, Plumbe purchased from Daniel Davis Jr. in 1842 the rights to a patented process to apply color to daguerreotypes by selective electroplating and he promoted this feature extensively.

By 1843 Plumbe relocated the center of his photographic operations to New York City where many noted celebrities of the day frequented his fashionable Broadway establishment. Plumbe's New York gallery was filled with the likenesses of famous authors, artists, musicians, and entertainers, among them Washington Irving, Edgar Allan Poe, John James Audubon, and Tom Thumb. Many of these fine daguerreotype portraits were reproduced as lithographs by print maker Nathaniel Currier.

Plumbe opened a daguerreian gallery in Washington, D.C., late in 1844 where he photographed the leading statesmen of the day. On several occasions Plumbe received invitations to the White House from President James K. Polk and secured the first photographs showing the interior of the Executive Mansion, including the earliest portrait of a United States President with his Cabinet. In the Spring of 1846, Plumbe produced a series of architectural daguerreotypes of Washington, D.C., depicting the United States Capitol, the White House, the Patent Office and Post Office. These images, the earliest photographic records of Washington, D.C., are now preserved at the Library of Congress.

Toward the end of 1846 Plumbe established the National Publishing Company in Philadelphia and issued a series of decorative sheet music, "The Plumbe Popular Magazine," and a portfolio of thirty-four lithographs entitled "The National Plumbeotype Gallery." All of these works were illustrated with "Plumbeotypes," namely lithographs made from zinc plates transferred from Plumbe daguerreotypes. "The National Plumbeotype Gallery" is of particular importance as it represents the first collective collaboration of photography and print making for portraiture. However, the public did not favor Plumbe's ambitious publishing efforts and by mid-1847 he was forced to suspend all production and refocus his attention to the photographic business and his transcontinental railroad advocacy. John Plumbe suffered severe financial reverses during 1847–1848 due in part to the mismanagement of his vast enterprise and the significant increase of competition in the photographic field. By 1849 all of his fine establishments had either been sold to meet the obligations to his creditors, or had been transferred into the hands of his operators.

During the Gold Rush of 1849, Plumbe journeyed to California to determine first hand the feasibility of a Pacific railroad. Encouraged by his survey Plumbe continued to write, lecture and memorialize Congress for the construction of the transcontinental railroad. He returned to his family's home in Dubuque, Iowa, in 1854 where he opened a U.S. patent agency and a steam milling operation.

Suffering from physical and mental illness John Plumbe Jr. ended his eventful life on May 28, 1857. In 1976 a group of historians erected a monument at Plumbe's grave site extolling his contributions to photography; his genius for promoting photography in America was second only to that of George Eastman.

CLIFFORD KRAINIK

Biography

Born in Welshpool, Wales, July 13, 1809, he immigrated to America age twelve and studied civil engineering. He advocated construction of U.S. transcontinental railroad in 1838. Plumbe turned to photography in 1840 to finance railroad advocacy and established twenty-six galleries in major U.S. cities between 1840 and1846. He manufactured and imported daguerreotype supplies in Boston and New York City. Plumbe was awarded medals at institute competitions in Boston, Philadelphia, and New York. He purchased patent rights for color daguerreotypes in 1842. Plumbe promoted brand name recognition and advertised extensively. He secialized in celebrity portraits in Washington, D.C., and New York galleries and established the National Publishing Company in Philadelphia in 1846.

Inventor of the plumbeotype process (lithographs from daguerreotypes), he took the earliest photographs of the U.S. Capitol and the White House in 1846. He suspended his photographic business, 1847–1849, and moved to California (1849–1853) where he continued to advocate for the transcontinental railroad. Plumbe committed suicide at Dubuque, Iowa, May 28, 1857. A monument was erected to Plumbe at the Linwood Cemetery in Dubuque in May of 1976. The first retrospective exhibition of his work was held at the Historical Society of Washington, D.C., 1997.

See also: Daguerreotype; and Eastman, George.

Further Reading

Fern, Alan, and Milton Kaplan, "John Plumbe, Jr. and the First Architectural Photographs of the Nation's Capitol," *Quarterly Journal of the Library of Congress*, January 1974.

King, John, "John Plumbe, Originator of the Pacific Railroad," *Annals of Iowa*, 3d ser. 6, no. 4, January 1904.

Krainik, Clifford, "John Plumbe: America's First Nationally Known Photographer by Robert Taft with notes by Cliff Krainik," *The Daguerreian Annual*, The Daguerreian Society, 1994.

——, "A 'Dark Horse' in Sunlight and Shadow: Daguerreotypes of President James K. Polk," *White House History*, White House Historical Association, vol. 2, no. 1, 1997

——, "National Vision, Local Enterprise: John Plumbe, Jr., and The Advent of Photography In Washington, D.C.," *Washington History*, The Historical Society of Washington, D.C., vol. 9, no. 2, 1997.

Miller, Jim, "Dubuque Settler Plumbe 'Screams To Be Recognized'," *Dubuque Telegraph Herald*, 29 September 1974.

Newhall, Beaumont, *The Daguerreotype in America*, New York: Dover Publications, 1976.

Rinhart, Floyd and Marion, *The American Daguerreotype,* Athens, Georgia: The University of Georgia Press, 1981.

Tolman, Ruel Pardee, "Plumbeotype," *Antiques*, July 1925.

PLÜSCHOW, PETER WEIERMAIR WILHELM (1852–1930)
Italian photographer

Born Mecklenburg, Germany 1852. By the 1870s Wilhelm Plüschow had a photographic studio in Naples trading in studio portraits and occasional journalism. First cousin to Baron Wilhelm von Gloeden whom he assisted in turning his interest in photography into a business in Taormina, Sicily in 1888. By now both were photographing the male nude. Influenced by Gloeden's style, by the time Plüschow moved to Rome as 'Guglielmo Plüschow,' he was producing male and female nudes which gained a reputation throughout Europe and America for overt homoerotica. Much praised by the author John Addington Symonds who lived in Rome, Plüschow, along with his Sicilian assistant, Vicenzo Galdi (1856–1931), often avoided the more romantic trappings of Gloeden's classical props, in favour of realism, with an emphasis on the sexual promise of male peasant youth. Forerunners of Pier Paolo Pasolini (1922–1975) and his love of *ragazzi*, Plüschow and Galdi's overt depictions of potent male sexuality, many said pornography, landed both of them in trouble and Plüschow was forced to return to Berlin and obscurity in 1910. Even now, while Gloeden can still be read as the poetic homeric dream. Plüschow, with his once only photographed models in highly suggestive poses, still challenges and he rarely enters the directories. However he can be regarded as a pioneer of contemporary gay culture, perhaps in time more relevant than Gloeden.

ALISTAIR CRAWFORD

POITEVIN, ALPHONSE LOUIS (1819–1882)
French chemist and printmaker

Poitevin was born in 1819 in France. He contributed to several fields of photography. He took up the study of photography while still a student in the Ecole Centrale, almost immediately after Daguerre's process was published in 1839. He recognized the one great defect of this method is that it gives but a single photograph. He tried to solve that problem by trying to make molds by electrically depositing copper upon the silver plate carrying the daguerrean image. During this work he discovered a method of photo-chemical engraving upon plates coated with silver or gold. This discovery turned out, however, to be of no practical importance. In 1847 when working at the Eastern Salt Works he continued his work on trying to make copies of daguerreotypes on silvered copper. The details of these methods were published in two papers in *Comptes Rendus Hebdomadaires*

des Séances de l'Académie des Sciences (vols. 25 and 27, 1848), as well as in his book. In this case copper was deposited on the lights, fixed and covered with a solution of gelatin, which was allowed to set and dry slowly. Then it was stripped, carrying the copper deposit with it. In this way he was able to transform daguerreotype images into negatives from which prints could be made on silvered papers. Experience from this early work led him to his most important discovery, the photographic engraving technique, which happened in 1854.

Poitevin is recognized for establishing the basic principles of *photo-lithography*, *carbon printing* and *collotype printing*. In August 1855 he patented a helioplastic process, by which films of dichromated gelatin were exposed to light under a negative and then soaked in water, which resulted in a relief image from which a mold could be made. Mungo Ponton in Scotland had discovered in 1839 the effect of light on dichromates and William Henry Fox Talbot had in 1853 discovered that dichromated gelatin which had been exposed to light would allow greasy ink to adhere to it, although it repelled water. Based upon these facts Poitevin invented his new photo-lithographic processes: carbon printing and collotype printing. A negative was printed onto a tissue of pigmented gelatin and potassium dichromate that, when washed and transferred to a second sheet, produced a durable, rich shiny print. Carbon prints are noted for their permanence and their rich and glossy dark tones. The carbon print process reached the height of its popularity between 1870 and 1910.

His work in heliochromy started in 1865 with some experiments on the possibility of recording colors on paper coated with silver chloride, similar to the earlier work by Herschel and Becquerel. First it was necessary to obtain violet sub-chloride of silver before recording the images. To sensitize the paper for exposure he dipped the paper in a solution of potassium dichromate and copper sulfate and let it dry. When such a paper was exposed to light beneath a transparent colored picture, such as a painting on glass, the colors of the picture reproduced on the paper. The main problem with heliochromy of this type was how to fix the images. As a fixing solution, Poitevin used water with sulfuric acid and after that glazed the pictures with albumen, but permanent images proved impossible to retain. Specimens of the process were exhibited at the 1867 Paris exhibition.

In 1879 he described an iron printing process which was his last publication in the field of printing processes based on photographic techniques.

HANS I. BJELKHAGEN

Biography

Alphonse Louis Poitevin was born at Conflans, Sarthe, France, in 1819, and educated at St. Calais. In 1839 he went to Paris and entered Ecole Centrale des Arts and Métiers, leaving it in 1843 with a Civil Engineer Diploma. After the publication of the daguerreotype process in 1839, Poitevin took up the study of photography while still a student at Ecole Centrale. After his Diploma he was appointed engineer at Eastern Salt Works which he resigned from in 1855 to move to Paris to work on his printing process and to start a printing company. However, he was not that successful in business and he sold his patent rights to Lemercier, a well-know French lithographer. At this time Poitevin became a manager at Pereire's Chemical Factory in Lyon. From Pereire's factory he went to the glassworks at Ahun-les-Mines and then to those of Falembray. Later he spent some time in Africa at the mines Kefun Thebul. In 1869 he returned to France where he started to work at an alum factory in St. Germain Lambron.

Poitevin was awarded several medals and prizes, e.g., a silver medal by the Société d'Encouragement des Arts for his photo-chemical engraving method. For the discovery of the permanent photographic printing process he was awarded the Duc de Luyne's Prize of 20,000 francs and the Marquis of Argentil's Prize of 12,000 francs as well as the order of Chevalier of the Légion d'Honneur. Poitevin died at Conflans on March 4, 1882.

See also: Talbot, William Henry Fox Talbot; Herschel, Sir John Frederick William; and Becquerel, Edmond Alexandre.

Further Reading

Poitevin, A. L., *Traité de l'impression photographique sans sels d'argant*, Paris 1862.

Davanne, M. A., *Notice sur la vie et les travaux de A. Poitevin*, Paris 1882.

Liesegang, R.E., *Die Heliochromie. Das Problem des Photographirens in natürlichen Farben. Eine Zusammanstellung der hierauf bezüglichen Arbeiten von Bequerel, Niepce und Poitevin,* , Düsseldorf, Liesegang's Verlag, 1884.

POLAND

Poland of the 19th century was divided up amongst three neighbouring countries: Russia had the Kingdom of Poland and Warsaw (i.e., the central area), the Austrian-Hungarian Empire had Galicia, Lwów and Cracow (i.e., the southern and eastern area) and the Prussian Kingdom had the Poznan part (the western area). After 1945 up to the present time, the Schlesien, Pommern and Ost-Preussen territories became part of Poland, however they were an integral part of Prussia during the 19th century. As in western Europe, the development of photography there depended on the demands of a society that was not as affluent as that of western Europe. It also depended on new technological methods being used in France and Germany. Initially, photographers used to travel to

Paris, London or Berlin to learn the trade, nevertheless after 1851 they travelled in order to study the collodion process. Unfortunately, most towns do not have any documentary archives, nor information on the number of photographic concerns nor how long they lasted.

Warsaw. From January 1839, frequent articles appeared on the subject of daguerrotype photographs; by October of the same year daguerrotype photographs sent over from Paris and Berlin as well as the work of the physicist, A. Radwański, were being exhibited. In November, a French revue was sold that included an article by M. Strasz discussing the daguerrotype process and A. Giroux's camera that had been brought over from Paris was sold for 1000 roubles. The bibliophile, S. Mielżyński, translated the revue in Paris and then sent it on to Posen, where it appeared in the press prior to November 13. In January 1840, a new translation was sold in Warsaw. The following people used daguerrotype photographs to enhance their work: the artists: M. Zaleski (1839–42) and A. Wysocki (1841–42); the astronomer: A. Prażmowski (1839) and the lithographer: M. Scholtz (1840–41), who from 1842 earned money on his daguerrotype photographs From 1842, itinerant daguerrotypists from Berlin and Vienna came to Warsaw. The most famous establishments were as follows: K. Beyer (1845–77) who produced scenes of Polish towns, catalogues exhibiting ancient and historical monuments and thousands of portraits; K. Brandl (1857–98) the creator of nature photographs; J. Mieczkowski (1850–1915) who took part in 9 exhibitions and who was awarded a prize for his portraits.The first photographic firms that were set up in larger towns were in: Częstochowa (1864, M. Arbus); Kalisz (1857, S. Fingeruth); Kielce (approx. 1858, W. Krajewski); Lublin (1857, T.Boretti); Łódź (1862, D. Zoner), E. Stummann from 1874 and B. Wilkoszewski from 1888 took photographs of towns; Piotrków (1865, K. Suplik); Płock (1864, P. Pawłowski); Radom (1860, L. Makarski).

Lwów, the capital of Galicia, discovered daguerrotype photography due to the work of Professor J.Gloisner. People could pay to have their portraits taken at H. Chołoniewski's and J. Pohlman's establishment (1843) as well as at Szarmacki and J.Dobrowolski's photographic firm (1844). E.Trzemeski (1869–post 1914) left the greatest heritage. In 1883 he took 20 photos related to Jan III Sobieski and scenes of Galicia (a gift for the Photographic Society in Paris in 1886) and produced albums of the following towns: Podhorce and Zloczów. In 1890 together with J. Eder he published a zincography. T. Szajnok, active from 1863 until his death in 1894, produced phototype samples which he sent to Paris in 1870, he published albums of the towns of Krasiczyn and Żólkiew in 1868–69 and in March 1891 helped to set up the first association of amateur photographers—the Amateurs Club. After 1861, J. Eder,

published a series of photographs of Cracow, Przemyśl, Rzeszów, Rabka and railway train stations. Those that most frequently exhibited their works in western Europe, were: T. E.Bahrynowicz, J. Eder, Z. Goldhammer, N. Lissa and D. Mazur.

Cracow, the ancient capital of Poland, that was just a small provincial town in the 19th century, discovered daguerrotype photography in 1840 via the work of the physicist S.L.Kuczyński, in 1844 via the work of A.Wysocki, and approximately in 1850 the work of J.Schindler. Itinerant photographers were as follows: H. Wilczek (1843), J.W. Weniger (1851) and A. Weidl from Vienna (1854), K. Szczepkowski (1844–47), D. Zoner (1844,1847), I. Marek (1849,1856/57), Birnstein (1856), F. Gantenbein (1858). Most probably, the first permanent establishment was that of S. Żabieński (1845–52), then W. Maliszewski (1848–80), S. Balicer (approx. 1848), I. Mażek (1860–63) and Ignacy Krieger with his son Natan (1860–1926), who after 1870 produced 113 photographs of historical monuments, peasant types and Stachowicz's drawings and sold them in four sizes. The most famous firm was that of W. Rzewuski (1859–96) who focused on wealthy people, town scenes and works of art. A. Szubert from 1867 took photos of the surrounding countryside of Cracow and also concentrated on various works of art; he was awarded many prizes at a number of exhibitions. Manuals began being published in Cracow: A. Karoli (1893), W. Kleinberg (1894) and A. Larisch (approx. 1902).

The Tatra mountains and its inhabitants, a 110 kilometers south of Cracow, were photographed by: A. Szubert (from 1871), W. E.Radzikowski (1891–99) and M. Karłowicz (after 1902). In the spring of 1871, the members of the Association in Berlin organized an excursion to the Tatra mountains, and in 1872 their chairman, H.W. Vogel, took a number of photos there. Photographers tended to limit themselves to portraits in the other towns of Galicia. After 1870 some firms opened up but there were very few of them. There were two famous photographers from Kamieniec Podolski namely J.Kordysz (approx. 1860–71) a member of the French Society of Photographers who exhibited town scenes and peasant types at their exhibition of 1863 and M.Greim, who subsequently bought his firm and continued with his activities. Polish people were a majority in the area where Poznan was the capital. From 1842 various photographers worked there namely: J.T. Willnow from Berlin and Tuch from Hamburg. The first permanent establishment was that of B. Filehne (1844–approx.1880). The family of A. Zeuscher produced the greatest number of photographs of Poznań inhabitants (1857–1915). After the revolution of 1863/64 many emigrant Poles earned a living from photography: C. Mietkiewicz and N. Straszak in Brussels, W.Ostroróg "Walery" in Paris, J. Kordysz in Kiev, J. Migurski in

Odessa, J. Berkowski in the Kingdom, W. Malinowski in Riga. Amateurs: L. Barszczewski in Central Asia, J. Kozłowski in Suez, J. Potocki in Africa, J. Stróżecki, R. Szwoynicki, L. Kraszewski and others in Siberia. There were about 35 in France and approximately 60 photographers in Berlin who had Polish surnames. A large percentage of photographers were of Jewish origin.

Schlesien. This was a very industrialized region with numerous wealthy towns and bourgeoisie that made the most of their photographers. I have a list of approximately 210 daguerrotypists and itinerant photographers prior to 1860 in Schlesien. 19 originated from Berlin and 38 were from Breslau (Wrocław), its capital. Here, amateur photographers, K. Langhans and T. Goldamer, exhibited daguerrotype photographs at the art exhibition of 1840. In 1844, the mechanic, Karl Staritz, took daguerrotype photographs, and from 1846, E.Wehnert earned his living from them. H. Krone was born here and taught the daguerrotype process, he was known for his activities in Dresden. The most prolific, with thousands of architectural photographs were made in the establishment of E.v. Delden (1877–97), a Berlin man. A.Leisner from 1876 covered the surfaces of porcelain dishes with photos from the surroundings of Waldenburg (Wałbrzych).

Pommeren. The area including the Baltic coast line, with two ancient and wealthy ports. Danzig, where monuments were first photographed by C. Damme (1850). In 1858, E. Flottwell sold a series of 8 photographs of the town and 23 photographs in connection with the 300th anniversary of the grammar-school. The following photographers printed their own photographs of monuments: R.Fischer (approx. 1870), A. Gottheil (approx. 1860), R.T. Kuhn (approx. 1894) and H. Ruckwardt (1889). The most famous ones in Stettin were the following: E. Kiewning, L. Klett, A. Pauly.

JACEK STRZAŁKOWSKI

Further Reading

Krystyna, Lejko, and Jolanta Niklewska, *Warszawa na starej fotografii*, Warszawa 1978.

Mossakowska, Wanda, *Początki fotografii w Warszawie (1839–1863)*, Warszawa 1994.

POLICE PHOTOGRAPHY

The emergence of photography in the nineteenth century coincided with the introduction and professionalization of the police. In 1800 the world's first professional police service was established by Act of Parliament in Glasgow, in response to the failure of the city's old system of employing unpaid constables and hired watchmen to keep law and order over the expanding population. Other industrialised British towns experiencing similar rises in criminality quickly followed suite. In 1829, just a decade before the public announcement of the daguerreotype, the Metropolitan Police Force (The Met) was founded in London. The Met, the first civil police force organized on modern lines, provided the model for other early municipal police forces around the world, including in Gibraltar (1830), Toronto (1834), Boston (1839), and New York City (1845).

Nascent law enforcement agencies soon recognised the value of photography for identifying criminals. From as early as 1841 in France, and over the next decade in other Western Europe countries and the United States, police forces paid professional daguerreotypists operating in the vicinity of their stations, to take portraits of suspects. Ambrotypes mounted in ornamental frames, dating from the late 1850s and 1860s in the collection of Birmingham's West Midlands Police Museum show how closely early police photographs resembled regular commercial studio portraiture. By the 1870s their format and conventions were gradually adapted to police requirements. Offenders were photographed against plain backgrounds, posed frontally—sometimes with a mirror to simultaneously show their profile—and often holding a board on which was written their name and detention number. Attention was directed towards their hands—placed on their chest—which were considered useful for identification purposes. The photograph illustrated a paper record documenting further details including name and aliases, date and place of birth; marital status, occupation and address; vital statistics and distinguishing features; reason for conviction and sentence.

From the mid-1850s, with the technical advances in the positive-negative system of photography and the diffusion of the carte de visite, the practice of creating and disseminating portraits of criminals became more widely used. Photographically-illustrated criminal records were sorted and classified according to offence committed in albums and card indexes. In America these 'rogues' galleries' were often displayed in a grid—on purpose-made boards or racks—in police stations. As the number of records grew, sorting, classifying and, particularly, retrieving an individual's details became increasingly impractical.

In 1856 the journalist and critic Ernest Lacan (1829–79) advocated the wider use of portrait photography by the French police for checking recidivists and escapees. However, his suggestion for the systematic use of the medium to apprehend criminals was not adopted until the 1870s. Following the violent repression of the Paris Commune of 1871, the Parisian police used photographs taken by the Communards of themselves posing proudly and defiantly on their barricades or triumphantly beside the destroyed Vendôme Column, to track down and punish the insurgents. In addition, Eugène Appert (active

1870s) took individual photographs of those incarcerated in Versailles for the police, prefiguring the format and practices adopted by the studio established in the Paris Police Department in 1872—the first official photographic service to be set up in a police station.

In 1888 Alphonse Bertillon (1853–1914), who had begun his career as a record clerk in the Paris Police Department, became Director of its Identification Bureau due to his invention of anthropometry—the first scientific system of criminal identification. The system, named *bertillonage* in his honor, consisted of recording eleven measurements of set parts of the head and body on a card which, accompanied by two photographs and additional physical details such as eye and hair color, established a unique, classifiable and, most importantly, retrievable criminal record. Replacing the unreliable system of eyewitness accounts, in 1882 *bertillonage* had led to a marked increase in the number of arrests of multiple offenders and was subsequently adopted by police departments outside of France, such as New York City (1888), Argentina (1891) and Chicago (1894). Since bertillonage used photographs in the process of identification, in 1888 Bertillon annexed the préfecture's photography studio to his own department and introduced a strictly uniform photographic technique to complement the system's precision. Bertillon stipulated the standardization of lighting conditions, exposure time, distance from the subject, pose and scale of reduction, ensuring that a clear full face and profile portrait—a mug shot—appeared on each identification card. He also created the *portrait parlé*, an identification chart of sectional photographs of facial features, such as ears and noses, mounted side by side to enable comparison and contrast.

Photography also played an important role in the solving of crimes, by identifying and documenting clues as well as people. Although not widely accepted as evidence in a court of law until the end of the nineteenth, forensic photography was used from the late 1850s to discredit forged documents (*Luco et al. v. USA*, 1859), record crime scenes (Lausanne, France, 1867), including traffic accidents (*Blair v. Inhabitants of Pelham, USA*, 1875) and provide evidence of injuries (*Redden v. Gates, USA*, 1879). Bertillon contributed greatly to this field by devising metric photography—the inclusion of a measuring scale in photographs to provide a permanent record of the scale and relationship between objects at a crime scene. He also developed contact methods of photography which he used for reproduction and enlargement of admitted or questioned documents, most famously *le bordereau* in the case of the Dreyfus Affair for which he submitted evidence for the prosecution in 1894. Soon after the turn of the century bertillonage was supplanted by the more reliable system of dactyloscopy or identification by fingerprints. Ironically, this change of method caused a growth in the number of specialized police photographers as it increased the need for records to be made of impressions of finger and handprints found at crime scenes. This practice, of which examples can be found in the Archives Historiques et Musée de la Préfecture de Police, Paris, was initiated by Alphonse Bertillon in the 1880s.

Photographs of criminals were also adopted outside the judicial system. In the 1860s *cartes de visite* of notorious villains were sold to the public, satiating popular fascination with deviancy and abnormality and prefiguring the celebrity status accorded to gangsters in 1930s America. In the 1870s police photographs were subjected to statistical analysis in order to identify a criminal 'type.' These investigations were underpinned by the pseudo-sciences of physiognomy and phrenology, a belief in the correlation between an individual's internal character traits and their facial features or shape of head. Italian criminologist Cesare Lombroso (1835–1909) assembled a collection of photographic portraits of murderers in the hope of discovering clinical signs of disposition to criminality. Meanwhile in Britain, influenced by the evolutionary theories of his cousin Charles Darwin, British biostatistician and eugenicist, Francis Galton (1822–1911) devised a new system of physiognomic record to show the features common to violent criminals, felons and sexual offenders. Galton created 'composite portraits' by re-photographing pictures of prisoners on the same plate by successive multiple exposures to create a photographic 'mean.' Although the notion of the 'born criminal,' who can be recognized by certain physical traits, such as a low forehead, 'jug ears' and large jaw, is now considered incorrect, it continues to influence representations of criminals in popular culture.

ANNE-MARIE EZE

See also: Anthropology; Appert, Eugène; Bertillon, Alphonse; Brady, Mathew B.; Crime, Forensic, and Police Photography; Duchenne, Guillaume-Benjamin-Amant de Boulogne; Ethnography; Lacan, Ernest; and Zola, Emile.

Further Reading

Bertillon, Alphonse, *La photographie judiciaire: avec un appendice sur la classification et l'identification anthopométriques*, Paris: Gauthier-Villars, 1890.

Bertillon, Alphonse, and Spearman, E.R. The identification of the criminal classes by the anthropometrical method. An address...And Speech by M. L. Herbette [on the same subject] ... Translated from the French by E. R. Spearman, London: Spottiswoode & Co., 1889.

Frizot, Michel, "Body of Evidence: The Ethnophotography of Difference." In *A new history of photography*, edited by Michel Frizot, Köln: Könemann, 1998.

Hamilton, Peter, and Hargreaves, Roger, *The Beautiful and the Damned: The Creation of Identity in Nineteenth CenturyP-*

photography, London: Lund Humphries in association with the National Portrait Gallery, 2001.

Jaeger, Jens, "Police and Crime Photography." In *The Oxford Companion to the Photograph,* Oxford: OUP, 2005.

Lacan, Ernst. *Esquisses photographiques à propos de l'Exposition universel et de la guerre d'Orient. Historique de la photographie, etc.* Paris, Grassart, 1856.

Lombroso, Cesare. *L'uomo delinquente.* Torino: Bocca, 1889.

Phillips, Sandra S., Haworth-Booth, Mark, and Squiers, Carol. *Police Pictures: The Photograph as Evidence.* San Francisco: San Francisco Museum of Modern Art, 1997.

Rhodes, Henry Taylor Fowkes, *Alphonse Bertillon: father of scientific detection,* London: George G. Harrap & Co, 1956.

Rouillé, André, "The rise of photography." In *A history of photography,* edited by Jean-Claude Lemagny and André Rouillé; translated by Janet Lloyd, Cambridge: Cambridge University Press, 1987.

Sansone, Sam J. *Police Photography,* Cincinnati, OH: Anderson Pub. Co., c1987 (1988).

Tagg, John, *The Burden of Representation: Essays on Photographies and Histories,* Basingstoke: Macmillan Education, 1988.

POLLOCK, ARTHUR JULIUS (1835–1890), HENRY ALEXANDER RADCLYFFE (1826–1889), AND SIR JONATHAN FREDERICK (1783–1870)
English

Baron Pollock was Lord Chief Baron of the Exchequer and succeeded Sir Charles Eastlake as second president of the Photographic Society from 1855 to 1869. Sir Frederick insisted that photography should be called a practical science rather than an art and we have him to thank for suggesting that the society should form a permanent collection. He married twice and had a very large family. Henry was the eleventh child from his first marriage, Julius was the thirteenth and the first son of his second marriage. Like their father, both sons were members of the Photographic Society of London.

Henry was educated at Trinity College, Cambridge and became Master of the Supreme Court of Judicature. He published 'Directions for Obtaining Positive Photographs upon Albuminized Paper' in the Society's Journal in 1853 and a glycerine process for dry-collodion plates in 1856. As well as conventional half-plate prints he produced stereo images and there are thirteen examples in the Getty Collection.

Both brothers photographed at the family home Hatton, west of London and in North Devon. The half-brothers were obviously close and in 1860 Henry married Amelia Bailey from Lynton in North Devon and Julius married her sister Ellen a year later.

Julius was educated at Kings College, London, and trained as a physician. He made photographic studies of people with deformities and an album of his work is in the collection of the Royal College of Medicine.

IAN SUMNER

PONTI, CARLO (c. 1822–1893)
Optician and photographer

Carlo Ponti, optician and photographer, was born in Sagno in the Canton Ticino around 1822–1824. As an adult he moved to Paris, where he worked in the Cauchoix studio for about five years. He then moved to Venice for good in 1852 and opened a little optician's shop in piazza San Marco 52. His high quality products soon made him famous throughout the Veneto province, and for many years he had sole rights on some of them. He began to expand in many directions, working as an optician, or creating and built instruments for astronomy and physics and photographic lenses (especially for panoramic shots). He sold his own creations, as well as those of other companies; and was a photographer, editor and distributor of photographic prints, both his own and others. Thus he was a versatile personality, informed and attentive to scientific innovations, the demands of the market and progress in know-how in the field of photography. He enlarged his store, and his clientele and sales grew. He became famous, and obtained various forms of recognition: on 30 May 1854 he was awarded a silver medal for photographic equipment, lenses in particular, at the Esposizione Industriale Veneta (industrial exhibit for the Veneto province). In the same year he started to photograph Venice with a systematic thoroughness, and in 1855 he already had a catalogue of 160 photographic views of Venetian architecture (*Guida fotografica illustrata della città di Venezia*), each with a historical and aesthetical caption. An introductory text goes through the evolution of Venetian architecture. Ponti presented the work at the Universal Exhibition in Paris in 1855 as a photographic history of the various architectural styles typical of the city, and he won a prize for it. His multifarious career made it necessary for him to collaborate with different people, like Francesco Maria Zinelli and Giuseppe Beniamino Coen. He also worked with the most important photographers in Venice, like Carlo Naya (1816–1882), Domenico Bresolin (1813–1899), and Antonio Fortunato Perini (1830–1879). Domenico Bresolin, painter and photographer, studied at the Accademia di Belle Arti in Venice. Ever since the 1850s, he had concentrated his efforts in the calotype process, doing important views of the monuments of Venice. His photographic prints, which he also did as albumen prints, are among the best in the period in terms of their definition and the quality of the printing. In 1864 he obtained the chair in landscape at the Accademia (the position had formerly been held by Francesco Bagnara), and stopped taking photographs. In that year, Bresolin handed over his studio and archive to Carlo Ponti, who then distributed the other photographer's images with the "Ponti" stamp, thus creating quite a few attribution

problems. Ponti then handed Bresolin's studio over to Giovanni Brusa. Antonio Fortunato Perini collaborated with Carlo Ponti after 1854, and he probably did some of the photographs in the catalogue Ponti presented at the *Exposition Universelle* in Paris in 1855. Perini was among the first to open a photographic studio in Venice and to spread the albumen print technique. He was especially concerned with the photographic reproduction of the manuscripts and miniatures in the Biblioteca Marciana.

Carlo Naya opened his photographic establishment in Venice in 1857. He worked with Ponti from that time onwards, furnishing Ponti's shop with photographic prints which were often pubished by Ponti with his own trade mark, and, as in the case of Bresolin, considerable confusion occurred in this case, too. Together with Ponti, he also published several albums of views, among which were the *Vedute di Venezia*, which came out the day after the Veneto was annexed to Italy in 1866.

Ponti did his photographs between 1854 and 1875. He took shots not only of Venice, but also of other places in northern Italy, and, between 1860 and 1865, Rome. He published other catalogues of his works, the *Catalogo di fotografie delle principali vedute* in 1864 and, in 1872, the *Catalogo generale delle fotografie*.

In 1860, he created a special viewer for large format photographs, the *Aletoscopio* (from the Greek: "precise view"). In 1861 he presented it to the Société française de photographie and, on 14 April of the same year, to the Istituto di Scienze, Lettere ed Arti in Venice, where he earned honourable mention in May. On 11 January 1862 Carlo Ponti obtained sole rights for his invention and began to sell it. Later, he created different variants, like the Megaletoscopi*o*, a bigger version of the Aletoscopio, which he had finished in 1862. For the new invention, he was awarded the Grand Prix at the Great International Exhibition in London that year. He registered the trade mark on 10 July of the same year, entrusted the manufacture of the apparatus to the cabinet maker Demetrio Puppolin and then promoted sales. He also made a special version of the Megaletoscopio, the Megaletoscopio privilegiato, to see slightly curved photographs. Both the Aletoscopio and the Megaletoscopio—and their variants—made it possible to see the same images enlarged by lenses, and with two different effects: the "day effect," with reflected light, and the "night effect," in transparency. In this last case, the photograph was reinforced on the back by other sheets of paper painted in different colours and pierced with little holes. The whole, illuminated from the back, changed the colours and light of the positive image, creating a "night effect."

In 1866 Carlo Ponti became the official photographer of His Majesty Vittorio Emanuele II, when the Veneto became part of the Italian nation. His growing business enabled him to open branches in other cities: Paris, London, Liverpool, Berlin, Stuttgart, Lyons, New York, Chicago, Philadelphia, Boston, Montreal, and San Francisco. At this time Ponti lost sole rights on the sales of the Aletoscopio and its variants because of the administrative uncertainty in which the Veneto found itself in the years following the annexation. In fact, an apparatus now housed in the Musée Suisse de l'Appareil Photographique in Vevey bears the trademark of Carlo Naya, who, copying Ponti's models, had begun to manufacture and sell the Aletoscopio. This initiative got him involved in a long legal battle in 1868, and Ponti used every means he could to get Naya sentenced. From 1868 onwards, then, the collaboration between the two photographers stopped. Until 1876 Ponti tried to get back sole rights on his creation, but without any success. He made, however, countless variations on his first apparatus, and gave them highly original names: Amfoteroscopio, Dioramoscopio, Pontioscopio, Cosmorama Fotografico are only a few examples.

The invention of the Aletoscopio must be placed together with those inventions that, slowly and well before the 19th century, led from the static image to the image as something with movement, and, to cinema. Ponti played an active part in this story, from the moment that stereoscopic photography began to be widespread and the subsequent experiments that increasingly expanded the potential range of expression of photographic images.

Carlo Ponti died in Venice on 16 November 1893; he was blind by that time, but had spent many long years of his life in a profession he had taken up out of passion and honesty.

The Museé Suisse de l'Appareil Photographique in Vevey houses an exemplar of the Megaletoscopio, accompanied by twenty albumen prints attributed partly to him and partly to Carlo Naya. More of his photographs are in public and private collections (Fototeca della Soprintendenza per il Patrimonio Storico, Artistico e Demoetnoantropologico, Brera, Milan; Museo di Storia della Fotografia Fratelli Alinari, Florence; Dietmar Siegert Collection, Münich; Wilfried Wiegand Collection, Frankfurt am Main; Department of Photography, J. Paul Getty Museum, Malibu).

SILVIA PAOLI

Biography

Carlo Ponti was born in Sagno (Canton Ticino) sometime between 1822 and 1824, and died in Venice on 16 November 1893, by which time he was already totally blind. At present, research has not turned up very much about his life or training. We only know that he went to the Cauchoix studio in Paris for five years, studying as an optician and photographer. He set up residence in

Venice, where he worked as an optician, photographer and publisher of photographic prints, but he never gave up his Swiss citizenship. He soon became rich and famous, and this led him to open branches of his firm in Paris, London, Liverpool, Berlin, Stockard, Lyons, New York, Chicago, Philadelphia, Boston, Montreal, and San Francisco. He showed his photographs and the lenses and apparatuses he invented at the main exhibits of the time: Venice 1854, Paris 1855, London 1862. He became famous through his invention of a special instrument for viewing enlarged photographic images, the *Aletoscopio,* and he created various versions of it. He published several catalogues of his images in 1855, 1864, 1866, and 1872. Ponti was a well-read, multifaceted personality, and was always interested in the latest scientific and cultural developments of his time.

See also: Bresolin, Domenico; and Perini, Antonio.

Further Reading

Becchetti, Piero, *Fotografi e fotografia in Italia 1839–1880,* Rome, Quasar, 1978, 124–125.

Jauslin, Jean—Frédéric et al., *Carlo Ponti. Un magicien de l'image*, Vevey, Musée suisse de l'appareil photographique, 1996 (exhibition catalogue).

Lawson, Julie, *The Stones of Venice*, Scottish National Portrait Gallery, Edinburgh 1992 (exhibition catalogue).

Miraglia, Marina, "Note per una storia della fotografia italiana (1839–1911.," In *Storia dell'arte italiana*, 473–474, Turin, Einaudi, 1981..

Prandi, Alberto, "Carlo Ponti." In *Fotografia italiana dell'Ottocento*, edited by Marina Miraglia et al., 172–174. Venice, Electa/ Alinari, 1979.

Verwiebe, Birgit, "L'illusione nel tempo e nello spazio. Il megaletoscopio di Carlo Ponti, un apparecchio fotografico degli anni 1860." *Fotologia,* 16/17 (Autumn/Winter 1995): 53–61.

von Dewitz, Bodo, Siegert, Dietmar, and Karin Schuller-Procopovici (eds.), *Italien sehen und sterben. Photographien der zeit des Risorgimento (1845–1870)*, 282–283, Heidelberg, Braus, 1994, (exhibition catalogue).

PONTON, MUNGO (1801–1880)
Inventor and polymath

The Scottish lawyer Mungo Ponton was the inventor of a photographic process that was to lead to developments that would have a huge impact on the visual culture of the nineteenth century and beyond through the mechanical reproduction of photographic images.

The announcements in January 1839 by Louis Jacques Mandé Daguerre and William Henry Fox Talbot of the discovery of photography created a ferment of interest in Edinburgh, Ponton's home-town. Edinburgh had just gone through a period of intellectual prominence, known as the Scottish Enlightenment, which had seen a flourishing in the arts and sciences and many gifted and able scientists were keen to experiment with the new discovery. The meetings of the Society of Arts for Scotland, which had been founded by Sir David Brewster in 1821, was the forum for discussion of the invention of photography in the months following the announcements of Daguerre and Talbot.

Ponton had began experimenting with Talbot's process and this was when he made his remarkable discovery, which he presented to a meeting of the Society of Arts for Scotland on 29 May 1839. His paper was titled "Notice of a cheap and simple method of preparing paper for Photographic Drawing, in which the use of any salt of silver is dispensed with." What Ponton had discovered was the light sensitive qualities of potassium dichromate. This was to be the basis of many mechanical means of the reproduction of photographs and of producing permanent images.

Ponton had found that a piece of paper soaked in potassium dichromate was sensitive to light and an object place on the surface would leave an outline with gradations of tone "according to the greater or less degree of transparency in the different parts of the object." Fixing was simply a matter of washing in water when those portions which had been acted on by the light readily dissolved and those exposed were completely fixed. Ponton did acknowledge that the process was not sensitive enough to be used in a camera.

It is not known if Ponton realised that the potassium dichromate solution he was using was combining with the gelatine used to size the paper to create the chemical reaction. However, of particular importance for the development of Ponton's process, and its use in future printing techniques, was that he did not try to patent his discovery but on the contrary made it available and it was published in the *Edinburgh New Philosophical Journal* in July 1839 and widely reproduced.

Those who experimented with Ponton's discovery included Talbot, Edmond Becquerel, Alphonse Louis Poitevin and John Pouncy, who all took out patents for the processes they developed. Talbot in particular appreciated the important part played by gelatine. Joseph Swan also patented his carbon process and later recalled that his first attempt at photography was after reading about Ponton's process in a weekly journal and that he was not slow to grasp the underlying principle. In 1840, at the age of seventeen, M Carey Lea, who was to become one of the leading American photographic scientist in the nineteenth century, used Ponton's process to produce a series of photogenic drawings. The album of these is in the Franklin Institute, Philadelphia.

Ponton deserves the accolade of a pioneer of photography although he left it to others to exploit the use of potassium dichromate and the processes that were a

direct consequence of Ponton's discovery include; gum bichromate, carbon printing, photogravure, Woodbury-type, Autotype and collotype. The mechanical production of photographs made them widely available and easily accessible with a huge impact on visual culture up to the present time.

The potassium dichromate process was not Ponton's only involvement in photography. In March 1840 he reported to a meeting of the Society of Arts for Scotland that he achieved a daguerreotype image on lithographic stone. In 1845 he won the Society's silver medal for his process on how to register the hourly variation in temperature on photographic paper. (He had already received a silver medal in 1838 for his improvements to the electric telegraph.) Also in 1845 he described a variation of the calotype process for portraiture allowing shorter exposures.

No known photographic images by Ponton are known to exist although these must have been produced in the various processes he used. Various items belonging to him, comprising drawings and publications as well as a photograph of him, aptly a carbon print, and a portrait oil painting by Samuel Mackenzie, are in the Scottish National Photographic Collection at the Scottish National Portrait Gallery, Edinburgh.

The combination of a busy business life and his amateur scientific experimenting took a heavy toll and Ponton's health and he suffered a major breakdown in about 1845. He had to retire from his legal work and by 1846 had moved to the milder climate of Clifton, Bristol, England, where he was to remain until his death. He was more-or-less an invalid for the rest of his life and much of the time he was house-bound, describing himself in correspondence as a "close prisoner." However, his physical limitations did not effect the activity of his brain. He had become a Fellow of the Royal Society for Edinburgh on 20 June 1834 and presented papers on polarisation and micrometry. He subsequently devised a photometer and presented a paper about this to the Society in 1856. In 1859 and 1860 Ponton presented papers to the British Association for the Advancement of Science on the laws of chromatic dispersion and the wave-lengths of the solar spectrum. He contributed articles to various journals and was responsible for a number of publication on scientific and religious themes including a mingling of the two. The titles were: *The Sanctuary—Its Lessons and Worship* (1849), *The Material Universe: Its Vastness and Durability* (1863), *The Great Architect; as Manifested in the Material Universe* (1866), *Earthquakes and Volcanoes* (1868), *The Beginning: Its When and Its How* (1871), *Glimpses of Future Life* (1873), *Songs of the Soul: Philosophical, Moral and Devotional* (1875) and *The Freedom of the Truth* (1878). In *Songs of the Soul* there is hymn "Praise God who roused the quivering light" which is a celebration of photography.

RODDY SIMPSON

Biography

Mongo Ponton was born at Balgreen, Edinburgh, on 20 November 1801, the son of a farmer. After his schooling, most likely at the Royal High School of Edinburgh, he became a legal apprentice and on 8 December 1825 he was admitted to the Society of Writers to the Signet, an ancient legal fraternity dating back to the fifteen century. Ponton showed commercial acumen as well as scientific innovation and was a founder of the National Bank of Scotland and became its secretary. On 24 June 1830 Ponton married Helen Scott Campbell, the daughter of the brewer, Archibald Campbell. The couple had seven children: Elizabeth born on 8 April 1831, John on 20 March 1832, Archibald Campbell on 9 June 1833, Alexander Campbell on 30 September 1834, Mungo Stewart on 31 August 1836, Bethia Katherine on 28 July 1838 and Matthew Moncreiff on 19 March 1841. Ponton's first wife died on 7 August 1842 and on 7 November 1843 he married Margaret Ponton, to whom he may have been related, the daughter of Alexander Ponton who was a solicitor. A son, Thomas Graham, was born on 28 August 1844. Ponton married for a third time on 1 August 1871 when his bride was Jane McLean the daughter of an Edinburgh merchant.

Ponton died at his home 4 Paragon, Clifton, Bristol on 3 August 1880. Of his children, John became a newspaper editor in the United States while Archibald became a prominent architect in Bristol and inherited at least some of his father's interest in photographic experimentation. In 1908 Archibald won the silver medal at the Tunbridge Wells Arts and Crafts Technical Photographic Section for the discovery of Autochromatic Shadow-Graphs.

See also: Poitevin, Alphonse Louis; Pouncy, John; Talbot, William Henry Fox; Carbon Print; Collotype; Gum Print; Photogravure; and Woodburytype, Woodburygravure.

Further Reading

Morrison-Low, A D, "Photography in Edinburgh in 1839." *Scottish Photography Bulletin,* no. 2 (1990).

Proceedings of the Royal Society of Edinburgh, no. 11 (1880–82).

The Edinburgh New Philosophical Journal, vol XXVII, no. LIII, July 1839.

Wight, G W, "Early Photographic History of Edinburgh." *Edinburgh Journal of Science, Technology and Photographic Art,* no 14, (1939–40).

Transactions of the Royal Scottish Society of Arts, vol. I, Edinburgh, 1841.

——, vol III, Edinburgh, 1851.

PORNOGRAPHY
Origin, production, and market

Pornography is the presentation of the nude body, or of sexual behaviour designed to arouse the viewer's excitement. The tradition of pornographic images can be traced back to the first-century fresco found in a Pompeii brothel. In the nineteenth century, the invention of photography provided an unprecedented realistic quality, and it was not long before this invention was adopted to represent nude figures, for the purpose of academic study or of erotic pleasure. Pornography as a genre shares many common features with two other categories, viz. erotic photography and photographs of the nude, and the attempt to clearly differentiate them has proved extremely difficult, for the realism and indexical quality of photography have broken down the division between the transcendental and the transparent, undermining the legitimate status of the naked body in visual presentation. In the endeavour to define these genres, the aesthetic quality presented in the pictures and the purposes behind their production can serve as important criteria: while nude photography displays the ideal beauty of the human body (whether successfully or not) and closely allies itself to academic art, erotic photography is intended to elicit sexual responses from the viewer, while avoiding an explicit presentation of the sexual act. In the genre of pornography, sexual scenes and the explicit display of bodily private parts become indispensable themes, and the aim is the gratification of the viewer's psychological and physical pleasures. Such pictures have proved to be disturbing to many viewers and, as Martin Myrone suggests, while erotic art is regarded as realistic, concerned with love, and of supreme technical excellence, pornography is considered to be crude (in its means of expression), unreal, brutal, and ugly (Myrone 2001, 31).

Even if pornography is assigned to a different category from nude and erotic photography, the three genres were initially difficult to separate, and they may actually come from the one original source—nude photography. In 1841 Lerebours opened a studio in Paris, advertising the first photographic nude under the name of 'academies' thus is considered as the first nude photographer. The period following 1845 witnessed the blossoming of nude photography produced by professional studios. Owing to the controversial nature of this art-form, many nude pictures remain anonymous, and they are difficult to date precisely. Furthermore, only a small number of photographers are known for their erotic or pornographic production: Auguste Belloc, Bruno Braquehais, Felix Jacques-Antoine Moulin, Giacomo Caneva, Jean-Louis-Marie-Eugene Durieu, Julien Vallou de Villeneuve, and Louis Jules Duboscq, have produced commercially-oriented erotic and pornographic photography.

Continental countries such as France, Italy, and Holland, being more tolerant of obscene images than Victorian Britain, have been the major suppliers of these images, and Paris became the unchallenged centre of the erotic photography industry, exporting its product throughout Europe. For wealthy tourists, Paris provided easy access to browsing obscene, bawdy, and pornographic works. Certain studios in Paris would accept commission from customers to make nude photographs according to their special requirements. Daguerreotype nudes could be bought in opticians or from street vendors around a certain area (e.g., the Palais Royale in Paris). As for the more explicit, pornographic images, the luxury brothels in both Paris and London were the venues where these could be acquired. The prosperous pornography industry was, however, by no means given the seal of official approval. Distributors of pornography had to perform their activity discretely to avoid police interference. Regulations against, and censorship of, pornography were suggested and implemented from time to time. In Britain, Lord Campbell, recognising that pornography was a cause of social disorder, proposed the Obscene Publication Act in 1857, in the hope that the production and distribution of pictorial and literary pornography would be brought under control. In France, the authorities tried to draw a line between academic study of the nude and pornography. Nude photography could be sold, under the title of academic study, but only within the walls of the Ecole des Beaux Arts. The so-called soft-core erotica could be openly sold, but its legality was based on ambiguous guidelines, and the vagaries of the government censors decided whether it was pornography or not (Godeau 1986, 94).

It is difficult to say exactly how many erotic and pornographic pictures were made during the nineteenth century, since this production was underground and not officially recorded. Nonetheless, the mass production and wide market can be gauged from reports of several police raids of 'dirty photos.' One of the most famous cases is the raid made on Henry Hayler at his Pimlico studio in London. As the *Times* court report of April 20, 1874, pronounced, the police seized

> no less than 130,248 obscene photographs. Mr. Collette said the defendant had been for years engaged in this traffic. Hayler and his wife and family were themselves represented in the photographs. The man went round to dealers with miniatures photographs numbered, and they were ordered of him in large and small quantities.

Across the Atlantic, around 194,000 obscene photographs, together with 5,500 indecent playing cards, were seized by Anthony Comstock, a special agent of the US Post Office, in 1873–74 alone.

Although the market of pornographic pictures proved to be large, in the early years the audience was limited to the upper-middle class, owing to its rather high price.

For example, a tinted erotic stereograph plate cost some 20 francs, and explicit scenes would cost more, while the average daily wage of a worker in the 1850s was around 3 francs (Richter 1989, 88). Daguerreotype pornography was often exquisitely hand-coloured, exhibiting careful arrangement of lighting and the model's pose. Together with the singularity of each plate, such a daguerreotype was designed as a personal deluxe item to be enjoyed by the privileged.

In order to meet the growing demand and to expand the market further, the photographers of the period were inspired to produce less expensive stereoscopic cards on salted paper, which is more commercially attractive than daguerreotype nudes. Notwithstanding, it was not until the 1880s and the appearance of a new, cheaper format of pornography—the postcard—that the working class generally gained access to pornography. Unlike stereoscopes, postcards require no special viewing apparatus. They are financially affordable, even to the poor, and have the ability to communicate through their images and the written messages they carry simultaneously. For the first time, the working class became consumers rather than merely objects of pornography (Sigel 2000, 860).

Style and Model

Nineteenth-century pornographic pictures share great similarities in terms of their composition and style. This may be due in part to the rather narrow subject-matter, which is mostly of a secret, sexually allusive nature. A female model is often placed in the setting of a private bedroom or toilet, photographed as if she were caught in the process of undressing or, in some more explicit pictures, displaying her private parts and caressing herself in a sexually arousing way. A large dressing mirror is commonly used in the setting; not only is it a necessary furnishing in such a room, it also performs the function of reflecting more of the model's body to the viewer. Feminine items such as jewellery, flowers, drapery, and lace also serve as indispensable decorations on the model, enriching the picture with details and also providing a vivid contrast of texture from the naked flesh.

Pornography that shows explicit sexual activities largely follows the mode already present in graphic art. Images of coitus, oral sex, and masturbation appearing in pornographic photography could all be found in earlier and contemporary prints. Nevertheless, the technique of photography does influence the mode of representing sexual scenes and requires certain necessary modifications, therefore resulting in a repertory of pose, which becomes in a sense more limited (Godeau 1986, 96). For example, while the traditional pornographic print had displayed sexual activity, photographic pornography would show a fragmental part of the woman's body or the detailed, focused presentation of intercourse of man and woman. Such depiction of a fragmental body rather than of full-scaled sex in action is the result of the long exposure-time required by early photography. In some cases, photographers adopted a serial format to present sexual activity in progress and provide it with a story-line: for example, a French pornographic 'Wedding Series,' presently held in the Kinsey Institute's archive, shows the newly-wed couple undressing, caressing each other, and having sex, in three continual pictures. The viewer would therefore observe these pictures with the anticipation of watching a drama. As Linda Williams argues, such continuum pornography attempts to render the "truth" of sex not as an exhibitionistic pose but as an act (Williams 1995, 27). Later in the century, with the development of more instantaneous forms of photography and shorter exposure lengths, the models would appear to be literally 'caught in the act' (Williams 1995, 31), and such sexual acts gradually became a staple of photographic pornography.

Beside the sexual act between man and woman, gay or lesbian sex constitutes a smaller, but undeniably significant aspect of the pornographic repertoire. To the heterosexual viewer, such gay porn not only provides a deviant sexual spectacle, but also violates the patriarchal order by blurring the boundary between the active/passive, male/female divide which is often presented in heterosexual porn. To modern researchers, gay pornography of the nineteenth-century suggests a new way to understand contemporary sexuality, as will be discussed below.

Pornography and Its Spectatorship

Although the proliferation of mass-produced pornography in the nineteenth century has been acknowledged, it was not until the 1960s, when there emerged some alternative views about Victorian values, many of them of feminist origin, that these 'dirty photos' begin to receive serious attention. To researchers, pornography seemed to open a new path to understanding nineteenth century histories, especially those of society, gender, sexuality, class, and even colonialism. Among these, the long-held impression of prudent Victorians in sexual denial was questioned from time to time, through the study of pornography and other unearthed literature. It is suggested by Steven Marcus in his *The Other Victorians* that these materials evince the dark Freudian underside of Victorian values, or as Michel Foucault proposes in his *History of Sexuality*, paradoxically constitutes a part of the vast apparatus of production of sexuality.

On the other hand, when the history of pornography itself is concerned, the indexical, excessively realistic quality of photography has made these pornographic pictures quite distinct from pornography in traditional formats such as print or painting. In Abigail Solomon-

Godeau's view, such images do not represent an extension of an existing tradition of erotic and pornographic images, but rather constitute a whole new genre, one made possible only with the invention of photography and the new status of the photograph as trace of the real (Godeau 1991, 229). As such, previous ways of reading images are no longer sufficient, and the demand arises for novel approaches to supply interpretation for this new genre. Some have tried to study these images in the light of feminist film theory, focusing on the key role of the spectator in the whole operation and production of pornography. This is not only because much of pornography's arousing effect is achieved in the eyes of the viewer—which explains in part why the separation of erotic pictures from dirty ones is often a controversial issue—but also because the spectator is regarded as directly exercising his active power over the female object as the result of photographic technology, which seemingly provides the real presence of the woman's flesh. When it comes to stereoscopic porn, the secretive voyeurism and the sensational tactile illusion offered by the apparatus enhance the visual pleasure even further, and the objectification of the woman's body becomes inevitable.

There are yet other ways of viewing nineteenth-century pornography where the spectatorship is concerned. Some theorists are not satisfied with the fact that the viewer is homogenised as an active and masculine master in male-gaze theory, recognising that there are impasses in the theory which would handicap the study of other important audiences of pornography, such as the female viewer. Although women were unlikely to be the targeted audience of pornography, wide dissemination made it impossible for them to avoid the sight of pornographic images. Upper-middle-class women seem to have had ready access to pornography, and with the emergence of pornographic postcards from the 1880s, even working-class women could afford a sexual spectacle if they so wished. Such an 'unnatural,' outrageous scene of woman looking at pornography, and even sharing the male attraction to pornography, has proved especially disturbing. According to Walter Kendrick, this historically new phenomenon of woman as porn observer may well have been the real cause of the alarm felt by moral defenders, which triggered a series of trials and regulations on obscene materials, both in France and Britain. In the contemporary study of nineteenth-century pornography, however, the significance of the female spectator and her relationship to these images is surprisingly ignored. Williams suggests that the omission may be ascribable to the dominance of the "male gaze" model, which fails to consider "a plurality of differently disciplined spectator-observers seduced in different ways by a range of erotic-pornographic images" (Williams 1995, 22). Such an omission is observed to have also happened in the case of gay porn and gay viewers. The male gaze model of interpreting pornography, however, does provide a way of seeing how these marginalised images might have helped to consolidate the social order, be it of gender or class, by showing the stereotypical relationship between man and woman. On the other hand, the challenge to such an approach not only proposes to interpret these images from multiple viewpoints, but also suggests how pornography might actually be the focus of a subversive spectatorship. No matter what kind of approaches are taken to understand these images, nineteenth-century pornography has claimed an important role in the study of contemporary history, reminding researchers, through its controversial nature, of the possibility of a more fluctuating social relationship.

KUEI-YING HUANG

See also: Erotic Photography; Nudes; Moulin, Félix-Jacques-Antoine; Caneva, Giacomo; Durieu, Jean-Louis-Marie-Eugène; Vallou de Villeneuve, Julien; and Duboscq, Louis Jules.

Further Reading

Crary, Jonathan, *Techniques of the Observer: On Vision and Modernity in the Nineteenth Century*, Cambridge: MIT Press, 1990.

Foucault, Michel, *The History of Sexuality, Vol I: An Introduction*, trans. Robert Hurley, New York: Pantheon, 1978.

Hyde, H. Montgomer, *A History of Pornography*, London: Heinemann, 1964.

Kendrick, Walter, *The Secret Museum: Pornography in Modern Culture*, New York: Viking, 1987.

Marcus, Stephen, *The Other Victorians*, New York: Basic, 1966.

McCauley, Elizabeth Anne, *Industrial Madness: Commercial Photography in Paris 1848–1871*, New Haven and London: Yale University Press, 1994,

Mulvey, Laura, "Visual Pleasure and Narrative Cinema." *Screen* 16.3 (1975): 6–18.

Myrone, Martin, "Prudery, Pornography and the Victorian Nude (Or, What do We Think the Butler Saw?)." In *Exposed: the Victorian Nude*, edited by Alison Smith, London: Tate, 2001.

Peckham, Morse, *Art and Pornography: An Experiment in Explanation*, New York, Harper & Row, 1971.

Richter, Stefan, *The Art of the Daguerreotype*, London: Viking, 1989, 23–35.

Sigel, Lisa Z, "Filth in the Wrong People's Hands: Postcards and the Expansion of Pornography in Britain and the Atlantic World, 1880–1914." *Journal of Social History* 33.4, (Summer 2000): 859–885.

——, *Governing Pleasures: Pornography and Social Change in England, 1815–1914*, London: Rutgers University Press, 2002.

Soloman-Godeau, Abigail. "The Legs of the Countess," *October*, 39 Winter, 1986, pp.65–108.

——, "Reconsidering Erotic Photography: Notes from a Project of Historical Salvage." In *Photography at the Dock: Essays on Photographic History, Institute and Practices*, Minneapolis: University of Minnesota Press, 1991, 220–237.

Williams, Linda, "Corporealized Observers: Visual Pornographies and the 'Carnal Density of Vision.'" In *Fugitive Images: From Photography to Video*, edited by Patrice Petro, Bloomington: Indiana University Press, 1995, 3–41.

PORTER, WILLIAM SOUTHGATE (1822–1889)
American photographer

At the Great Exhibition of 1851 at London's Crystal Palace, a panorama of the Cincinnati waterfront was exhibited. Comprising eight separate whole plate daguerreotypes, the panorama measured over five and a half feet in length, and was of a quality so high that historians have been able to identify every vessel moored along the banks. The panorama was photographed across the river from the rooftop of a building in Newport, Kentucky, by Charles H Fontayne and William Southgate Porter in September 1848.

Porter had first worked with Fontayne in his Baltimore studio in 1844, and after Fontayne moved to Cincinnati in 1846, appears to have operated the studio alone until, in the spring of 1847, he opened another studio—Porter's City Daguerreian Gallery—in Pittsburgh. By late 1847 he had employed S. Hoge as an assistant, but by the spring of 1848, he had sold the Baltimore studio to Hoge and worked in Pittsburgh, where on May 22 he produced another remarkable panorama— comprising seven whole plate daguerreotypes—of Fair Mount Waterworks. This time the images were vertical and presented in a mount measuring 367mm x 998mm.

He rejoined Fontayne in Cincinnati later that year, and their partnership lasted until 1852, when Fontayne once again left the business. After a succession of other partners, he operated alone after 1863 from several addresses.

JOHN HANNAVY

PORTUGAL

The first news of the discovery of the technique of fixing images obtained with a camera obscura arrived in Portugal in 1839 through periodicals imported from France and the United Kingdom. In the same year Portuguese periodicals published notices presenting the calotype (*Revista Literária*, Porto, March 1839) and the daguerreotype (*O Panorama*, Lisbon, May 1839) processes The earliest recorded photograph taken in Portugal dates from 1841, a daguerreotype portrait taken by the English painter, William Barclay. In the early years, all equipment was imported, and experiments with the daguerreotype process were conducted in several institutions from ca.1842, including the physics department of the University of Coimbra.

During the 1840s and 1850s some European da-

guerreotipists, mainly French, travelled through Spain and Portugal, to make a business in portrait photography. Amongst the first in itinerant photography of the two first decades were Blackwood (Porto, 1843–44), the French Giles (Lisbon, 1843–44), Madame Fritz (Lisbon, ca.1843–45), E. Thiesson (Lisbon, 1844–45), who did a lot of commercial portrait photography in Lisbon and took some photographs of Africans with an anthropological approach, Adolpho and Anatole (Lisbon and Porto, 1845), Chambard & Poirier (1846), Dubois & C.ª (Lisbon; Porto, 1849; Coimbra, 1855, 1856), Juliette de Humnichi (1851), P. K. Corentin (Porto, 1851, 1853, 1856; Lisbon, 1851–52; Coimbra, 1852; Minho province, 1853), who taught photography and wrote the *Resumo historico da photographia desde a sua origem até hoje* (1852), the first photographic book published in Portugal. Some found here conditions for a more permanent business like the French Pedro Cochat (1849–57), J. Rodrigues Marten (ca.1849–53) or Martin (1857–63), Louis Monnet (Porto, 1856–62; Braga 1856–57, 1861; Coimbra, 1859), probably the first to do stereoscopic work and instantaneous photography in these towns, Alfred Fillon, established in Porto (1857–59), and then in Lisbon (1859–ca.69, ca.71–81). Wenceslau Cifka was probably the first to open a permanent photographic studio in Lisbon (1848–ca.80). To improve their incomes, some of these early foreign photographers made digressions to take portraits in the province where there weren't any established photographers. Many gave photographic lessons and sold photographic apparatuses, performing a major role in the formation and establishment of the first Portuguese photographers. These also established their businesses in the main cities: Francisco Augusto Metrass (Lisbon, 1847–ca.1848), Lucas de Almeida Marrão (Lisbon, 1851–97), Miguel Novaes (Porto, 1854–68), also painters, Francisco Augusto Gomes (Lisbon, 1852–71), Vicente Gomes da Silva (Funchal, Madeira island, ca.1848–1906), and António da Conceição Matos (Coimbra, 1856–69), also a painter. While most of these photographers offered only daguerreotypes, some also offered prints from paper and glass negatives—albumen on glass and wet collodion—and ambrotype positives In this early period there were already a few amateurs like the Count of Farrobo (1849), the painter João Baptista Ribeiro (1852–54) and Carlos Alexandre Munró (1857–66). Calotype practicionners were rare in Portugal. We should mention the British amateurs Frederick William Flower (ca.1853–58), and Joseph James Forrester (ca.1854–59), both in Porto. Forrester was also the author and editor of the earlier known Portuguese publication illustrated with a tipped-in photographic print (1855).

In the 1860s, with the popularity of the carte de visite format, a reduction in costs, and the popularity of the

family album, there was an exponential increase in the number of photographic studios in the main cities. Some former portrait-painters became part or full time photographers. Between the most significant photographers of this decade, for their quality and production, were Lisbon's studios of the Club Photographico Lisbonense (1860–62), Santa Bárbara (ca.1865–70s), Joaquim Coelho da Rocha (1865–91), José dos Santos Loureiro (1863–80), Francesco Rocchini (1865–93), a former cabinetmaker who also built photographic cameras and other apparatuses on demand, the Swedish M. J. Schenk (1850s–80), also a painter, who introduced here the diamond cameo portraits in 1867, and José Nunes da Silveira (ca.1860–67), who introduced the wothlytype process in Portugal and Spain in 1864, António da Fonseca (1862–92), Photographia Universal (ca.1866–1900), and Augusto S. Fonseca (1868), Porto's studios of the German Martin Fritz (1859–ca.1874), Henrique Nunes (1861–66), José da Rocha Figueiredo (1863–69), Photographia Nacional (1865–74), Photographia Talbot (1865–79), Sala & Irmão (1863–ca.94), Pinto & Ferreira (1863–67), Manuel José de Sousa Ferreira (1868–1906), and José Joaquim da Silva Pereira (1870–81), Coimbra's studios of Arsène Hayes (1863–74), and José Maria dos Santos (1869–1900), Braga's studio of Matias António de Magalhães (1864–69), Guimarães's studio of António Augusto S. Cardozo (ca.1860–78), also a painter. Madeira island's João Francisco Camacho (1863–92), Luanda (Angola)'s Abílio Moraes (ca.1863–ca.72), followed after his death by his widow and their sons. As in other countries Portuguese photographic studios were essentially supported by the studio portraits.

Eduardo Knopfli and Jacques Wunderli kept doing itinerant work throughout the country since the early 60s and throughout the 70s, although in the 80s we find the second established in Viseu and Braga. Secondary towns register the passage of occasional itinerant photographrs from early dates, but only had their first permanent studios in the sixties. We should also mention the amateur photographers Carlos Relvas (ca.1862–ca.93), Filipe Mesquita who made a large series of stereoscopic views of Lisbon (Lisbon, early 1860s), Russell Gordon (1861) and Amélia de Azevedo (ca.1863), both in Madeira Island. Worth of remark was also José António Bentes, a military officer who wrote a manual (1864) and a treatise of photography (1866). This decade foreign photographers made significant views work in Portuguese territory like the stereoscopic series taken by R. A. Miller/Miller & Brown in Açores archipelago, or J. Laurent, large format views and stereoviews (ca.1868–69).

In the late 1850s, and throughout the 1860s, several important series of architectural and topographical photographs were produced. Eugène Lefèvre took views of the main cities and monuments and made an *Album de Portugal* (1857). Some individuals belonging to the cultural elites of the time, inspired in foreign photographic inventories of patrimonial works, were personnally commited in the register and inventory of Portuguese monuments, like Antero de Seabra, an amateur photographer, who took photographs of monuments, urban landscapes, as part of a personal project (ca.1858–64), and public works for the Ministério das Obras Públicas (ca.1861–64). He printed a series of photographs under the title *Portugal*. Joaquim Possidónio Narciso da Silva, architect of the royal house and archeologist, also photographed Portuguese monuments, archeological sites and objects and edited them in the *Revista Pittoresca e Descriptiva de Portugal* (1861–63). The British Charles Thurston Thompson photographed monuments in Porto, Coimbra, Batalha Alcobaça, Tomar and Lisbon, for the South Kensington Museum of London (1866). In 1866–67, 1877 and 1879 Carlos Relvas photographed Portuguese monuments and landscapes by his own iniciative. Both published some of this work in the photographically illustrated periodical *Panorama Photographico de Portugal* (1869–74). Diogo (or Jacques) Francem photographed monuments for the Portuguese section of the Paris 1867 international exhibition (1865–67). Henrique Nunes photographed monuments and archeological pieces published in the book *Monumentos Nacionaes* (1868) and latter in the *Boletim da Real Associação dos Architectos Civis e Archeologos Portuguezes* (1874–82), Francisco Martins Sarmento documented his pioneer archeological works (1868–76), and Augusto Xavier Moreira took a series of views of the monuments of Lisbon (1865–68), sold both individually and in albums. The Lisbon photographers Augusto César Pardal and his son published reproductions of art objects and engravings reproducing famous paintings (1869–79).

The early 1860s saw the first publications illustrated with tipped-in photographs, predominantly carte-de-visite size albumen prints, depicting authors and other celebrities—continuing a publishing tradition which had previously depended on engravings. The publication of such editions reached its peak in late 1870s and early 1880s, the tipped-in photographs being replaced by collotype illustrations in the 1880s, and eventually photogravure.

Amongst the most significant photographers who opened their studios in the 1870s were Lisbon's studios of Photographia Popular (ca.1870–99) who worked in several processes, including carbon and photo-mechanical prints, Alfred Fillon (2nd studio, ca.1871–81), Ricardo Pereira de Melo Bastos (1872–85), António Maria Serra (1872–1900), Photographia Central (1872–1900), Damião da Graça (ca.1872–1900), Martin Fritz (ca.1874–ca.1888), Henrique Nunes (ca.1869–83), João Francisco Camacho (1879–98), Porto's Photographia Universal

(1870–1900), Photographia da Casa Real of Emílio Biel (ca.1874–1900), União (1872–1900), and Célestin Bénard (1869–90), Coimbra's studios of J. Sartoris (1876–1900-) and Adriano da Silva e Sousa (1876–1900), Braga's António Pereira da Silva Braga (1870–79), Viana do Castelo's José Joaquim Ferreira (1870s–80s), Póvoa de Varzim's António José de Barros (1874–94), Tomar's António da Silva Magalhães (ca.1871–97), Ponta Delgada (Açores)'s António José Raposo (ca.1870s–91), Luanda (Angola)'s José Nunes da Silveira (ca. 1869–78), and José Augusto da Cunha Moraes (ca.1877–97), José R. Gambôa in Moçambique and S. Tomé (1875–95), and Maria Eugénia Reya Campos, self-entitled the first Portuguese woman photographer, who's activity goes back at least 1872, established in Évora (1881–82), and in Lisbon (1885–1900-). In this decade the French photographers and editors J. Lévy & C.ª published extensive series of images of Portugal in several formats, including glass and paper stereoviews and magic lantern slides (ca.1875). Lachenal & Favre (1871– ca.82) and Adolphe Block also edited stereoviews of Portugal. Amongst the relatively small number of amateurs we should mention José Gil (ca.1876–1905) and Maria Collecta d'Assumpção Pacheco, (Elvas, ca.1876, 1892).

With the consolidation of photographic business in the main cities, from the seventies to the end of the century, we assist to the progressive establishment of photographic studios in small towns, seaside resorts, and spas. Some of them formerly had studios in the main cities and many worked as collaborators of the main photographers. Seasonal activity became common among some city photographers who every year opened temporary photographic studios in these places, accompanying the public affluence in the respective seasons. The regional spreading of photographic studios continued progressively towards the end of the century, and some small province towns only had their first permanent studios in the following century.

In the 1870s José Júlio Rodrigues, professor of chemistry at the Polytechnical Academy and responsible for the photographic section of the *Direcção Geral dos Trabalhos, Geodésicos, Topographicos, Higrographicos e Geológicos do Reino*, had a major role in the experimentation and introduction of several photomechanical processes. He organized the first national photographic exhibition in these installations (1875), published the book *Procédés photographiques et méthodes diverses d'impressions aux encres grasses* (Paris, 1879) and started making experiments with the collotype process in 1874. Carlos Relvas introduced in Portugal the Carl Heinrich Jacoby's collotype variant in 1875. Emílio Biel & C.ª Porto's important photographic studio learned the technique and used it to illustrate many books and several albums (1880s–1900s). Biel's house investment in this technique has attainned unrivaled mastering in Portugal.

Amongst the most significant photographers of the 1880s were Lisbon's studios of Augusto Bobone (1885–1910), also a painter, Muñiz & Martinez (1888–1900s) and Joaquim Fritz (ca.1888–91), Porto's studios of the Photographia Moderna of Leopoldo Cyrne & C.ª and latter of Ildefonso Correia & C.ª (1884–1900s), who edited the internationally upraised photographic magazine *A Arte Photographica* (1884–85), Peixoto & Irmão (1881–1900s) who practised a lot of processes, including carbon and photo-mechanical printing, introducing the woodburytype technique, Fulgêncio da Costa Guimarães (ca. 1883–94), Henrique António Guedes de Oliveira (1886–1900s), Coimbra's Adriano Gomes Tinoco (ca.1884–1910), Braga's Photographia Universal of A. Solas (1883–88), Viseu's Francisco Paino Perez (1884–87), a Spanish formerly established in Coimbra (1787–80) who also did itinerant work in the Beira and Alentejo provinces, Funchal's (Madeira island) Augusto Maria Camacho (1882–1900s), Manoel d'Olim Perestrello (1879 or 1888–1910s), Goa's (India) Souza & Paul (ca.1890s–1910). The amateur Adolpho Moniz photographed in Portuguese India (ca.1890). Qualified amateurs like Paulo Plantier (Lisbon, 1887), Joaquim Augusto de Sousa (Funchal, 1870–1905), Eduardo Alves (Porto, ca.1884–86), Antero Araújo (Porto, 1885–86), Margarida Relvas (1884–85), and Camilo dos Santos (1886–87, 1898–99) revealed technical maturity and aesthetical formation. Many of these, along with professionals and foreign photographers participated in the *Exposição Internacional de Photographia*, organized by Photographia Moderna and realized in 1886 in Porto's Crystal palace. Two years before, Álvaro Joaquim de Meirelles claimed the invention of a movement stereoscope, adapting two praxinoscopes to a stereoscope viewer. During this decade Emílio Biel & C.ª documented the newly built railroad lines of Beira Alta (1882), Douro (1883–84), Minho, and the construction of Porto's bridges of D. Maria Pia and D. Luís.

Between the most significant photographers in the 1890s were Lisbon's studios of Arnaldo da Fonseca (1891–ca.96) who published a photography treatise (1891), Vidal & Fonseca (1895–1914), and the reporters António Novaes (1896–1900-) and Joshua Benoliel (1898–1900-), Porto's José de Carvalho (1890–96), Braga's Francisco G. Marques (1893–1925), Póvoa de Varzim's Avelino Barros (1895–1900-), Viseu's Perez & Filhos (1880s–90s), Santarém's Manoel A. Silva Nogueira also established in Faro worked in Caldas da Rainha during thermal season and Nazaré during bath season, Évora's Ricardo dos Santos (1887–1900), Lourenço Marques (Moçambique)'s Louis Hily (ca.1894–1905) and the brothers J. and M. Lazarus (1899–1908). Manuel Goulart, originary from the Açores archipelago and established in New Bedford (U.S.A.), took a large stereoviews series entitled Azores, Madeira and Portugal (1897).

Some amateurs also emerged in this decade, like Aurélio da Paz dos Reis, who introduced cinema in Portugal (Porto, 1896), and did extensive stereoscopic work.

In the last decade of the century, and the early years of the 20th century, there was a significant growth in the number of photographic studios away from the major population centres, driven by population movement, and by a reduction in prices which brought photographic portraiture within the reach of all levels of society. At the same time, many more people became involved in amateur photography in Portugal, as was happening in other countries.

The first photoengravings made and published in Portugal appear for the first time in 1890s periodicals, made by Lisbon's studios of José Pires Marinho (1894), Castello Branco & Alabern (1895), and Porto's Marques de Abreu (1898).

From the 1840s until the end of the century, French and British photographic publications were available in bookshops in Lisbon, Porto, and Coimbra. 'The majority of photographic plates, cases, cards, albums, cameras, and other apparatus was imported and sold by specialist dealers in the major cities. Only two short-lived attempts to develop a Portugese manufacturing industry met with any success—in Lisbon, the factory of *A Portugueza* (1899) and the Porto factory of Pinheiro d'Aragäo & C.a.

NUNO BORGES DE ARAUJO

See also: Wet Collodion Negative; Calotype and Talbotype; Forrester, Baron Joseph James de; Itinerant Photographers; Relvas, Carlos; South Kensington Museums; Cartes-de-Visite; Albumen Print; Collotype; and Photogravure.

Further Reading

Araújo, Helena, et. al.,"Fotografia e fotógrafos insulares. Açores, Canarias e Madeira," [S.l.]: Centro de Estudos de História do Atlântico / Museu de Fotografia Vicentes, 1990.

Ramires, Alexandre, "Revelar Coimbra. Os Inícios da imagem fotográfica em Coimbra, 1842–1900," Lisboa: Museu Nacional Machado de Castro, 2001.

Sena, António, "História da imagem fotográfica em Portugal, 1839–1997," Porto: Porto Editora, 1998.

Serén, Maria do Carmo; Siza, Maria Tereza, "O Porto e os seus fotógrafos," Porto: Porto Editora, 2001.

Teixidor Cadenas, Carlos, "La Fotografía en Canarias y Madeira. La época del daguerreotipo, el colódión y la albumina, 1839–1900," 2.ª ed. Madrid: Carlos Teixidor Cadenas, 1999.

POSITIVES: MINOR PROCESSES

During the first sixty years of photographic experimentation, a host of processes were devised for printing positives from camera negatives. Their proud inventors tended to confer idiosyncratic names on these innovations, adding to a bewildering list that obscures the commonalities of these nineteenth-century processes: many are just minor variations on well-established photochemical themes. To confer some structure on what would otherwise be a miscellany, the processes for making positive photographs are gathered here into five basic categories, according to the nature of the light-sensitive chemical: whether it is a salt of silver, iron, uranium, or chromium, or an entirely organic compound. The accompanying Table is intended as an alphabetical finding-aid by name, giving the inventor, date, category, and essential nature of each process.

Silver Halide Processes

The transformation of a silver halide (chloride, bromide, or iodide) into silver metal by the action of light has always provided the mainstream of photographic practice. The major 19th-century processes for making silver positives are described under the entries for Albumen, Bromide print, Daguerreotype, Gelatin silver print, Photogenic Drawing, Salted paper print, Tintype and Wet Collodion positives. This section outlines the other named silver processes, which found less widespread recognition. It may be assumed that the light-sensitive component was silver chloride and the image consisted of silver, except when stated otherwise, and that all the processes (with one exception) were therefore "negative-working," i.e., they inverted the tonal scale, making a positive from a negative, and vice versa. Many of these processes differ only in the organic binding agent which acted as the vehicle for the silver halide, or in the substrate upon which it was coated. Included here as photographic "positives" are those silver processes that actually furnished a negative image, which was then treated or mounted so that it appeared positive when viewed under reflected light, i.e., minor variations of the Ambrotype, Daguerreotype and Tintype processes. In the Table, this category of process is designated as "silver negative."

Aristotype was just an elegant proprietary name for a silver chloride printing-out paper, using either collodion (Johann Obernetter 1868), or gelatin (Paul Liesegang 1884) as the binder, rather than albumen. *Aristo-Platino* was a silver halide paper marketed by the American Aristotype Company (1894), which required toning–with gold, platinum, or both. *Platino-Matt* and *Platino-Bromide* papers also belied their names, being silver halide papers, with starched matt surfaces to mimic platinotype. The *Alabastrine* process was a variant of the Ambrotype invented by Frederick Scott Archer in 1851: an underexposed wet collodion negative on glass, presented as a cased object, was backed in the mount with black paper so that a positive image was seen by reflected light. Alabastrine had the added

feature that the silver image was bleached by mercuric chloride, converting it to silver chloride and mercurous chloride, so whitening the deposit in the highlights. The *Pannotype* of Wulff and Company (1853) is another variation on Ambrotype, backed by black waxed linen, or leather, rather than paper.

The *Hillotype* enjoys a notorious history: it was claimed in 1850 to be a natural colour version of the Daguerreotype, and the life of its inventor, Levi Hill, reads no less colourfully. Although denounced as fakes by jealous daguerreotypists of the day, there are specimens of original Hillotypes in the Smithsonian Institution. Hill's chemically bizarre procedure is complicated and dangerous, but was carefully replicated in 1985 by Joseph Boudreau, who succeeded in obtaining Hillotypes showing some vestiges of "natural colour."

The first *Direct positive* silver photographs were created in 1839 by Hippolyte Bayard, who used his unnamed positive-working process directly in the camera with considerable success. In 1840, Henry Talbot devised a similar "positive photogenic drawing paper" which he called *Leucotype*: an ordinary salted silver paper was heavily exposed and fixed, to provide a uniform, black ground of silver; treatment with strong potassium iodide solution rendered this layer susceptible to bleaching by light, which formed pale yellow silver iodide. Such photographs tend to fade in the light, and are very rare.

With their *Hyalotype* of 1849 the brothers Friedrich and Wilhelm Langenheim provided the earliest lantern slides as silver-albumen positive transparencies (diapositives) on glass, using the Niépceotype process of 1847 due to Claude Felix Abel Niépce de Saint Victor. Other variations bearing names suggestive of a glass substrate were: John Whipple's *Crystalotype* of 1854, and the *Opalotype* publicised by P.C. Duchochois in 1865 using translucent opal glass. The *Crystoleum* process of 1880 involved glueing an albumen positive face down onto a concave glass surface, removing much of the backing, and colouring by hand in oils. Such manual embellishment featured in other named processes: Wilson's *Sennotype* of 1864 was a hand-coloured albumen positive on glass; Urie's *Relievotype* of 1854 was a collodion positive on glass with the background scraped away, and re-backed with a painted card; it was introduced by Thomas Lawrence in 1857.

A wider range of substrates was made possible in 1888 by the Kodak Company's *Transferotype*, which was a "stripping emulsion" whereby the silver-gelatin image could be transferred onto glass or canvas, for example. Prints on genuine ivory are rare; *Ivorytype* (John Mayall 1855) and *Eburneum* prints (John Burgess 1865) were imitations on specially-whitened substrates. To make satisfactory photographic images on enamels and ceramics which had to be fired at high temperatures under a glaze, the *Photoceramic process* due to Pierre Michel Lafon de Camarsac in 1855 used chemical toning to replace the silver by a more refractory noble metal, such as gold, platinum, or iridium. Other photoceramic techniques employed refractory pigments applied by the carbon process (see below).

Some silver sensitizers incorporated novel chemical constituents. Robert Hunt added succinic acid in his *Energiatype* process of 1844: a paper that could either be printed-out, or developed (with ferrous sulphate, causing Hunt to re-name this process "*Ferrotype*"—not to be confused with the alternative name for Tintype.) Jacob Wothly included uranium salts in a silver emulsion in his eponymous *Wothlytype* of 1864. Extravagant claims for this print-out process (sometimes misleadingly called Uranotype) attracted attention initially, but its virtues were soon discounted; it did however represent the first use of collodion as a binding agent.

Iron Carboxylate Processes

The "ferric" processes—collectively called 'siderotypes' by Sir John Herschel—are based upon light-sensitive salts of iron(III) with "vegetable acids" such as citric, tartaric and oxalic, which are polycarboxylic acids. The photochemistry is described under light-sensitive chemicals, and under Cyanotype and Platinum Print—the two major nineteenth-century iron-based printing processes. Besides these two, there were more than a dozen minor siderotype processes, both positive- and negative-working, which furnished images in a variety of substances.

Henri *Pellet's process* of 1877, called *Cyanofer* in France, produced Prussian blue prints, but differed from the simple cyanotype in being positive-working. A version of the sensitizer due to Giuseppe Pizzighelli and Ludwig von Itterheim contained a mixture of iron(III) chloride, tartaric acid, and gum Arabic: the gum was hardened by the iron(III) salt, but where light fell this was reduced to iron(II), allowing the gum to re-soften. A developer of potassium ferrocyanide formed Prussian blue in the insoluble, unexposed regions and, to fix the image, the Prussian white formed in the soluble, exposed regions was washed away. The Pellet process was reputed to be difficult to work satisfactorily—highlights were often blued—but it found some application for copying purposes, for instance reproducing maps for the Survey of India Office. Alphonse *Poitevin's process* of 1860 had a commonality with Pellet's: it was also positive-working, and relied on the ability of iron(III) chloride to harden a colloid, in this case gelatin carrying a pigment. In regions where the light caused reduction of iron(III) to iron(II), the gelatin re-softened, and was washed away in the development bath with its attendant pigment. Also based on cyanotype were John Mercer's

Chromatic photographs on textiles of the 1850s, but the Prussian blue images were alkali-bleached to iron(III) hydroxide, which then served as a mordant to bind vegetable dyestuffs.

The *Palladium print* is a close analogue of the platinum printing process, and came to be much-used from 1916, when its invention was credited to William Willis, whose Platinotype Company marketed a commercial *Palladiotype* paper. There is, however, evidence that prints in palladium were made and exhibited as early as 1856 by Charles Burnett of Edinburgh, as described below under uranium processes.

Several siderotype processes yielded an image of silver, by the iron(II) photoproduct reducing silver nitrate. This theme originated in 1842 with Sir John Herschel's *Argentotype*. His sensitized paper was coated with ammonium iron(III) citrate, and the development bath contained silver nitrate. In 1843 Herschel also devised his curious *Breath print* process, using a mixture of ferrotartaric acid and silver nitrate. No image was visible after exposure, but it sprang into existence as soon as the paper was breathed upon, because exhaled moisture promoted the development reaction. Towards the close of the nineteenth century, several derivatives of Herschel's argentotype appeared: variously dubbed *Brownprint* (patented by H. Shawcross in 1889), *Sepiatype* (Sharp and Hitchmough Company 1891), and *Vandyke* (Arndt and Troost 1895), they mixed ammonium iron(III) citrate with silver nitrate, adding tartaric acid to inhibit precipitation of silver citrate; images printed-out in shades of brown, were washed in water, and fixed in dilute sodium thiosulphate. A closely-related process, but employing iron(III) oxalate, was the *Kallitype*, so-named and patented by W.W.J. Nicol in 1889, 1890, and 1891, although this well-explored formulation had been anticipated as early as 1844 by Robert Hunt in an unnamed process. Kallitype needs an alkaline-buffered developer to avoid re-dissolving the silver image. Owing to difficulties in fixing and clearing, iron-based silver prints were generally prone to deterioration, and acquired a poor reputation for permanence. Despite wide publicity of these processes in the nineteenth-century photographic literature, surprisingly few historic specimens have been positively identified in present-day collections.

The most striking of Herschel's 1842 discoveries was *Chrysotype*, which provided deep purple images in nanoparticle gold (a pigment known to ceramicists as the Purple of Cassius). For chemical reasons, Herschel's procedure required the gold salt to be in a developing bath or wash; such profligacy inhibited his pursuit of the process, but a number (ca. 20) of his specimens have survived perfectly to the present. Later attempts to re-invent the gold process (Robert Hunt 1844, Alfred Jarman 1897) re-named it *Aurotype*. By the end of the nineteenth

century, the employment of gold as a printing medium had been completely discounted, although it continued to be much used for toning silver images.

Between 1842 an 1844, Herschel was also striving to perfect an iron-based process providing an image in metallic mercury; he found indications that both negative- and positive-working versions might be possible. This may account for Talbot's suggestion of the name *Amphitype* for this process (not to be confused with the 1849 silver *Amphitype* of Blanquart-Evrard), replacing Herschel's original name of *Celanotype* (also spelt *Kelaenotype*). According to Herschel, his mercury photographs were the most exquisite imaginable. The process was doomed to failure, however, because mercury metal is volatile, and in the space of a few days or weeks such images simply evaporate. Specimens authenticated by Herschel's own annotations exist today as stained scraps of paper, without any discernable images.

It has long been known that iron(III) salts react with gallic or tannic acid to produce intense black pigments; iron-gall ink has been the chief writing medium since medieval times. Procedures for making photographic images in this substance devised by *Colas* (1883), Alphonse Poitevin (*Ferrogallic process* 1859), and *R. Nakahara* (1894), were all positive-working and chiefly used for copying line drawings and text, rather than continuous-tone pictorial purposes.

The *Dusting-on* or *Powder* process of Henri Garnier and Alphonse Salmon (1858) made use of the hygroscopic property of iron(III) citrate to remain tacky, especially in sensitizers containing sugar or honey; it only dries and hardens where exposed to light. A positive-working image could therefore be obtained by dusting over the exposed paper with a powdered pigment, which adhered selectively to the shadow areas.

Johann *Obernetter's ferrocupric* process of 1864 involved a roundabout chemical procedure to yield an image in the stable pigment, Hatchett's brown, copper(II) ferrocyanide. In Thomas *Phipson's* little-known process of 1861, ammonium iron(III) oxalate was the sensitizer; it was reduced by light to an iron(II) salt, which reduced potassium permanganate solution to the insoluble, brownish-black manganese dioxide.

Uranium processes

In this minor category, the oxidation-reduction chemistry is analogous to the previous iron case. Invented by Charles Burnett over 1855 to 1857, the uranium printing processes were capable of yielding images in stable substances, just like the siderotype processes. Under the action of light, and in the presence of organic matter, a uranium(VI) salt was reduced to uranium(IV), which in turn reduced a noble metal salt to the metal. By this means, Burnett made the first *palladium prints* in

1856, and obtained fine images in gold and silver. The uranium salts were washed out in the wet processing, so the finished *Uranium prints*, as they were inaccurately called, should contain no uranium, only the precious metal, and are therefore not radioactive. However, this is not true of Burnett's other uranium printing process of 1855, sometimes called *Uranotype*, as a close analogue of the Cyanotype: the uranium(IV) photoproduct reacted with potassium ferricyanide to yield uranyl ferrocyanide, a Bartolozzi-red pigment (also formed in the "uranium toning" of silver or platinum prints). Such photographs will be radioactive. In 1858, Niépce de Saint Victor also published, and sought patent rights for uranium printing processes essentially identical to those published by Burnett a year earlier. Unsurprisingly, this gave rise to some highly acrimonious exchanges in the photographic periodicals of the day.

Dichromate Processes

The orange-coloured, water-soluble dichromates of sodium, potassium, and ammonium were called "bichromates" in the nineteenth century—a nomenclature now disapproved as chemically misleading, but which persists in photohistorical usages. Under the action of light, dichromates are reduced by organic matter to chromium(III) salts, which have the ability to harden organic colloids, such as gum or gelatin, as explained under light-sensitive chemicals. If a pigment is incorporated in the sensitized layer, it will be retained where light has fallen and rendered the colloid layer insoluble, but may be washed off the paper where the colloid remains soluble—in the unexposed regions—thus providing a negative-working photographic process.

The major nineteenth century dichromate processes may be distinguished by the colloid: Carbon printing uses gelatin, Gum Bichromate employs gum Arabic (gum Acacia), but in the Fresson process the identity of the colloid still remains a proprietary secret. Dichromate processes are also of great importance in the preparation of plates for photomechanical printing processes.

Mungo Ponton was the discoverer of light-sensitivity in dichromated paper in 1839; he noted that exposure caused a colour change from yellow to brown, and the former could be washed out, leaving a negative-working image in white on greenish-brown. Henry Talbot experimented with dichromated gelatin in 1852 with a view to using it for photomechanical printing, but Alphonse Poitevin is generally acknowledged as the major promoter of the photographic pigment printing processes in 1855. *John Pouncy* obtained a patent for the gum process in 1858. Some named minor variations on the major dichromate processes will now be outlined.

The direct carbon process of 1878 due to Frédéric *Artigue*, also known as *Charbon-Velours*, was improved by his son, Victor in 1893, and was the forerunner of the Fresson process; the image was developed by a mildly abrasive suspension of sawdust in water. *Autotype* was the name adopted by the Autotype Fine Art Company, set up in the 1870s, for its carbon transfer tissues, marketed in a variety of pigment colours. *Lambert-type* (1875) was a carbon transfer from the surface of collodionised glass, so produced a print surface of notable brilliance. The *Photo-aquatint* was a re-naming of the gum bichromate process in 1894, when it was popularised by the skilled exponents, Alfred Maskell, Robert Demachy, and Alain Rouillé-Ladevèse.

Dusting-on or *Powder processes* are also possible with dichromated colloids. In preference to iron salts, Garnier and Salmon turned to dichromated gum and sugar in 1859, relying on this hygroscopic colloid to remain 'tacky' in the absence of light. Pigment was dusted onto the exposed surface, as described before, to yield a positive-working image. It is alleged that the funerary ashes of cremated loved-ones could thus be used to constitute their own portraits! Alessandro Sobacchi's *Anthracotype* of 1879 was also a dust-on process, using graphite powder as the pigment. There is also an *Ink* processes in hardened dichromated colloids due to G.W. Perry in 1856 or V.J. *Sella's process* of 1857. Thomas Manly's *Ozotype* of 1898 included manganese(II) salts in the dichromate sensitizer, and essentially produced hardening of a separate gelatin layer by diffusion transfer. Manly's *Gum ozotype* of 1899 was the analogue using gum Arabic.

A few dichromate processes differ from those above in not entailing colloid-hardening. The *Aniline process* of William Willis senior (1864) relied on the residual dichromate, after exposure, to exert a powerful oxidising action on aniline vapour, producing in the unexposed areas intensely coloured "aniline dyes" of the mauveine type. It enjoyed some importance as an early positive-working reprographic process for plans.

The *Chromatype* process of Robert Hunt (1843) had several manifestations: he added copper(II) sulphate to the potassium dichromate to improve its sensitivity; the image substance formed by development was an insoluble chromate of a heavy metal such as silver, mercury or lead, which are all highly coloured—orange and red. This process is positive-working, commonly producing a yellow image on an intense red ground of silver chromate, and, because dichromate solutions tend to penetrate paper, the image is usually clearly visible on the verso. Hunt also employed gold chloride to develop a *Gold chromatype* in which the final image was deep violet nanoparticle gold. Burnett's little-known dichromate-based *Cuprotype* of 1857 resembles Hunt's chromatype in its sensitizer, but the image substance formed was Hatchett's brown, copper(II) ferrocyanide, as in *Obernetter's process*.

Alphabetical List of 19th Century Photographic Processes for Making Positives

Process	Inventor	Year	Category	Image	Binder & substrate
Alabastrine	Scott-Archer	1851	Silver negative	Silver chloride	Collodion on glass with black backing
Albumen	Blanquart-Evrard	1850	Silver	Silver	Albumen on paper
Ambrotype	Scott-Archer and Fry	1851	Silver negative	Silver	Collodion on glass with black backing
Amphitype also Celanotype	Herschel	1844	Iron	Mercury	Paper
Amphitype	Blanquart-Evrard	1849	Silver negative	Silver	Albumen on glass with black backing
Aniline	Willis senior	1864	Chromium	Aniline dyes	Copying on paper
Anthotype also Phytotype	Herschel	1839	Organic	Flower colouring	Paper
Anthracotype see **Carbon**	Sobacchi	1879	Chromium	Carbon and pigments	Dusted on moist gelatin
Argentotype	Herschel	1842	Iron	Silver	Paper
Aristo-Platino	Aristotype Co.	1894	Silver	Silver + gold + platinum	Paper. Toned
Aristotype see **Collodion**	Obernetter	1868	Silver	Silver	Collodion print-out
	Liesegang	1884	Silver	Silver	Gelatin print-out
Artigue	Artigue	1878	Chromium	Pigment	Colloid on paper
Asphalt also Heliographic, Bitumen and Niépceotype	Niépce	1822	Organic	Bitumen of Judaea	Silver, tin, or pewter plate
Aurotype see Chrysotype	Hunt	1844	Silver	Gold, silver	Paper
	Jarman	1897	Iron	Gold	
Autotype also **Carbon**	Autotype Company	1870	Chromium	Pigment	Gelatin double transfer on paper
Bayard process see Direct Positive	Bayard	1839	Silver	Silver	Paper
Bitumen also Heliographic	Niépce	1822	Organic	Bitumen of Judaea	Silver, tin, or pewter plate
Blueprint also **Cyanotype**	Herschel	1842	Iron	Prussian blue	Paper or textiles
Breath print	Herschel	1843	Iron	Silver	Paper
Bromide print see Gelatin silver bromide	Mawdsley Swan	1874 1879	Silver	Silver	Gelatin on paper
Brownprint see Vandyke	Shawcross	1889	Iron	Silver	Paper
Carbon	Poitevin	1855	Chromium	Pigment	Gelatin on paper
Carbon transfer	Fargier Swan	1860 1864	Chromium	Pigment	Gelatin transfer onto paper Double transfer
Celanotype also Kelaenotype	Herschel	1842	Iron	Mercury	Paper
Celloidin process see Collodion	Kurtz	1889	Silver	Silver	Collodion on paper
Charbon Velours	Artigue	1892	Chromium	Pigment	Colloid on paper
Chlorobromide print	Eder	1883	Silver	Silver	Gelatin on paper
Chromatic photograph	Mercer	1858	Iron	Vegetable dyestuffs	Textiles or paper
Chromatype	Hunt	1843	Chromium	Silver chromate	Paper
Chrysotype	Herschel	1842	Iron	Gold	Paper
Colas see Ferrogallic	Colas	1859	Iron	Iron gallate ink	Copying on paper

Process	Inventor	Year	Category	Image	Binder & substrate
Collodion	Simpson	1865	Silver	Silver	Collodion on paper
Crystalotype see Hyalotype	Whipple	1854	Silver	Silver	Albumen on glass Lantern slides
Crystoleum		1880	Silver	Silver and oil pigments	Albumen on glass Hand-painted in oil
Cuprotype	Burnett	1857	Chromium	Cupric ferrocyanide	Paper
Cyanofer also Pellet process	Pellet	1877	Iron	Prussian blue	Paper
Cyanotype	Herschel	1842	Iron	Prussian blue	Paper or textiles
Daguerreotype	Daguerre	1837	Silver negative	Silver Amalgam	Silvered copper plate
Diazotype see Feertype	Feer	1889	Organic	Azo-dyes	Paper or textiles
(Direct positive) see Leucotype	Bayard	1839	Silver	Silver	Paper
Dust-on see Powder process	Garnier and Salmon	1858 1859	Iron Chromium	Pigment	Sugar, honey, and gum on ceramics
Eburneum see Ivorytype	Burgess	1865	Silver or Chromium	Silver or Pigment	Collodion transfer on white backing
Energiatype	Hunt	1844	Silver	Silver	Gum on paper
Feertype	Feer	1889	Organic	Azo dyes	Paper or textiles
Ferrogallic see Colas	Poitevin	1859	Iron	Iron gallate ink	Gum or gelatin Copying on paper
Ferro-prussiate see **Cyanotype**	Marion and Company	1872	Iron	Prussian blue	Paper
Ferrotype see **Tintype**	Smith	1856	Silver negative	Silver	Collodion on black lacquered tinplate
Fresson process	Fresson	1899	Chromium	Pigment	Colloid on paper
Gelatin silver bromide see Bromide print	Mawdsley	1874	Silver	Silver	Gelatin on paper Development
Gelatin silver chloride see Printing-out paper (P.O.P.)	Abney	1882	Silver	Silver	Gelatin on paper Print-out
Gold Chromatype	Hunt	1843	Chromium	Gold	Paper
Gum Bichromate	Poitevin Pouncy	1855 1858	Chromium	Pigment	Gum arabic on paper
Gum Ozotype	Manly	1899	Chromium	Pigment	Gum on paper
Heliographic also Asphalt	Niépce	1822	Organic	Bitumen of Judaea	Silver, tin, or pewter plate
Hillotype	Hill	1850	Silver	Silver and other metals	Silver plated copper sheet
Hyalotype	Langenheim Brothers	1850	Silver	Silver	Albumen on glass Lantern slides
Ink Process see Sella's Ink	Perry	1856	Chromium	Iron gallate ink	Gelatin on paper
Ivorytype see Eburneum	Mayal	1855	Silver	Silver	Hand-coloured, waxed and backed
(Iron Oxalate) Kallitype	Hunt Nicol	1844 1889	Iron	Silver	Paper
Kelaenotype also Celanotype	Herschel	1842	Iron	Mercury	Paper
Lambert-type see **Carbon**	Lambert	1875	Chromium	Pigment	Stripped from collodionized glass

(*Continued*)

Alphabetical List of 19th Century Photographic Processes for Making Positives (Continued)

Process	Inventor	Year	Category	Image	Binder & substrate
Leucotype see Direct positive	Talbot	1840	Silver	Silver	Paper
Melainotype also **Tintype**	Martin	1853	Silver negative	Silver	Collodion on black lacquered tinplate
Nakahara see Colas	Nakahara	1894	Iron	Iron tannate ink	Copying on paper
Obernetter's ferrocupric	Obernetter	1864	Iron	Cupric ferrocya-nide	Paper
Opalotype	Duchochois	1865	Silver Chro-mium	Silver Pigment	Opal glass plate
Ozotype see **Carbon**	Manly	1898	Chromium manganese	Pigment	Diffusion transfer hardening gelatin
Palladium print Palladiotype	Burnett Willis junior	1856 1916	Uranium Iron	Palladium Palladium	Paper Paper
Pannotype	Wulff and Company	1853	Silver negative	Silver	Collodion on black waxed linen
Pellet print	Pellet	1877	Iron	Prussian blue	Gum on paper
Phipson's process	Phipson	1861	Iron	Manganese dioxide	Paper
Photo-aquatint see *Gum bichromate*	Rouillé-Ladevèse, Maskell and Demachy	1894	Chromium	Pigment	Gum Arabic on paper
Photoceramic	Camarsac	1855	Silver	Platinum- or Gold-toned	Vitrified on enamel and porcelain
Photogenic drawing	Talbot	1834	Silver	Silver	Paper
Physautotype	Niépce and Daguerre	1830	Organic	Colophony resin	Glass or silvered copper plate
Phytotype also Anthotype	Herschel	1840	Organic	Flower colouring	Paper
Pizzighelli's see Platinum print	Pizzighelli	1887	Iron	Platinum	Print-out on paper
Platino-Matt & Platino-bromide	Imperial Co. Barnet Co.	1900	Silver	Silver	Paper matt surface
Platinotype or **Platinum print**	Willis	1873	Iron	Platinum	Paper
Poitevin's process	Poitevin	1860	Iron	Pigment	Gelatin on paper or ceramics
Ponton's process	Ponton	1839	Chromium	Chromium oxides	Paper
Powder process see Dust-on	Garnier and Salmon	1858 1859	Iron Chromium	Pigment Pigment	Sugar, honey, and gum on ceramics
Primuline process see Diazotype	Green, Cross, and Bevan	1890	Organic	Azo dyes	Paper and textiles
Printing-out Paper see **Gelatin Silver Chloride**	Ilford Company	1891	Silver	Silver	Print-out on paper
Relievotype	Urie	1854	Silver	Silver	Collodion on glass painted background
Salted paper print	Talbot	1839	Silver	Silver	Paper
Sella's ink process see Ink process	Sella	1857	Chromium	Iron-gall ink	Paper
Sennotype	Wilson	1864	Silver	Silver	Albumen on glass hand-coloured
Sepia platinotype see **Platinotype**	Willis jnr	1878	Iron	Platinum and Mercury	Paper
Sepiatype see Vandyke	Sharp and Hitchmough	1891	Iron	Silver	Copying on paper

Process	Inventor	Year	Category	Image	Binder & substrate
Tintype also Ferrotype	Martin	1853	Silver negative	Silver	Collodion on black lacquered tinplate
Transferotype	Kodak Company	1888	Silver	Silver	Gelatin transfer to glass or canvas
Uranium print	Burnett Niépce de Saint Victor	1857 1858	Uranium	Gold or Silver	Paper
Uranotype	Burnett	1855	Uranium	Uranyl ferrocyanide	Paper
Vanadium print	Endeman	1866	Vanadium	Aniline dye	Paper
Vandyke see Argentotype	Shawcross Arndt and Troost	1889 1894	Iron	Silver	Paper
Wothlytype	Wothly	1864	Silver and Uranium	Silver	Collodion on paper

Organic Processes

This category is rather diverse in the materials it embraces, but all are purely organic, some macromolecular or colloidal, and do not involve inorganic salts. The photochemistry is not well-understood in all cases, but entails colloid-hardening and dye-bleaching processes.

The oldest organic process was also the first to provide a camera image that has survived to the present day: the *Heliographic* process invented by Joseph Nicéphore Niépce around 1822, also known as the *Asphalt* or *Bitumen* process. Bitumen of Judaea dissolved in oil of lavender was thinly coated onto a metal plate or stone; the layer hardened selectively in the light, and was developed by the same solvent. Niépce employed it mostly as a photoresist to make lithographic plates for the photomechanical copying of engravings. But upon a shiny metal plate (tin, pewter, or silver-plated copper) a degree of tonal reversal gave an apparently positive image, which could be enhanced by iodination. Such a camera photograph by Niépce, dating from 1827, is in the Gernsheim Collection of the University of Texas. A point of terminology deserves clarifying here: although the very first photographic process was named "héliographie" by Niépce, later in the 19th century the word "heliography" came to be widely used for all "sun-printing," moreover "heliographic processes" included those intended specifically for reprographic copying purposes, that is for line, rather than continuous tone, images.

The *Physautotype* process due to Nicéphore Niépce and Louis Daguerre (ca. 1830) was rediscovered only recently (ca. 1995) by Jean-Louis Marignier: exposure to light of colophony resin (abietic acid) can cause its insolubilization, even without the presence of metallic salts. The image on glass or shiny metal is developed by washing, and has a subtle character when viewed by transmitted light: its visibility depends on selective optical scattering, rather than absorption, of the light.

The *Anthotype* or *Phytotype* process, first devised by Herschel in 1839, simply entailed the bleaching by sunlight of fugitive flower colorants (now known to chemistry as anthocyanins). Herschel found most success with yellow japonica, red poppy, common heartsease, double ten week stock, harlequin flowers, and purple groundsel; he crushed the flower petals to pulp, extracted the expressed juices with alcohol, and filtered the solutions for dyeing the paper. To bleach the dye under an engraving, giving a positive image, required exposures to bright sun ranging from an hour or two for the most sensitive dyes, to several weeks for the least. By dispersing sunlight with a prism, Herschel performed spectrographic analyses of the responses, which showed that a given dye was most effectively destroyed by light of its complementary colour. Herschel believed this positive-working process had potential for a system of direct full-colour photography, but could find no method of fixation, as the pictures inevitably faded in the light.

Monochrome images were later obtained by the more sensitive *Diazotype* or *Feertype* (Adolf Feer 1889), and *Primuline* (A.G. Green, C.F. Cross, and E.J. Bevan 1890) processes, which depended on the decomposition of diazonium salts by light. The remaining unchanged salt—which is highly reactive—was then allowed to couple with an organic compound included in the developer to yield an azo dye, so providing a positive-working reprographic process in a variety of colours, determined by the choice of the coupling agent.

MIKE WARE

See also: Light-Sensitive Chemicals; Albumen Print; Bromide Print; Daguerreotype; Gelatin Silver Print; Photogenic Drawing Negative; Salted Paper Print; Tintype (Ferrotype, Melainotype); Wet Collodion Positive Processes; Liesegang, Paul Eduard; Archer, Frederick Scott; Cased Objects; Hill, Reverend Levi L.; Smithsonian Institution; Bayard, Hippolyte; Talbot, William Henry Fox; Langenheim, Friedrich and Wilhelm; Lantern Slides; Niépce de Saint-Victor, Claude Félix Abel; Whipple, John Adams; Coloring by Hand; Kodak; Hunt, Robert; Wothly, Jacob;

Cyanotype; Platinum Print; Platinotype Co. (Willis & Clements); Burnett, Charles John; Herschel, Sir John Frederick William; Toning; Poitevin, Alphonse Louis; Carbon Print; Fresson Process; Autotype Fine Art Company; Demachy, (Léon) Robert; and Niépce, Joseph Nicéphore.

Further reading

Brothers, Alfred, *Photography: Its History, Processes, Apparatus, and Materials*, 2nd ed. London: Charles Griffin, 1899.

Brown, George E,. *Ferric and Heliographic Processes*, London: Dawbarn and Ward, 1902.

Burton, W.K., *Practical Guide to Photographic and Photo-Mechanical Printing*, London: Marion and Co., 1892.

Clerc, L.P, *Photography Theory and Practice*, 2nd English edn. London: Isaac Pitman 1937..

Crawford, William, *The Keepers of Light*, Dobbs Ferry, New York: Morgan and Morgan, 1979.

Eder, Josef Maria, *History of Photography*, trans. Edward Epstean, New York: Colombia University Press, 1945.

Farber, Richard, *Historic Photographic Processes*, New York: Allworth Press, 1998.

Glafkides, Pierre, *Photographic Chemistry*, trans. K.M. Hornsby, London: Fountain Press, 1958.

James, Christopher, *The Book of Alternative Photographic Processes*, Albany, New York: Delmar, 2002.

Jones, Bernard E. (ed.), *Cassell's Cyclopaedia of Photography*, London: Cassell, 1911.

Lietze, Ernst, *Modern Heliographic Processes*, New York: Van Nostrand 1888; reprinted Rochester, New York: Visual Studies Workshop, 1974.

Nadeau, Luis, *Modern Carbon Printing*, Fredericton, New Brunswick: Atelier Luis Nadeau, 1986.

Nadeau, Luis, *Encyclopedia of Printing, Photographic, and Photomechanical Processes*, Fredericton, New Brunswick: Atelier Luis Nadeau, 1989.

Neblette, C.B., *Photography: its Principles and Practice*, 4th ed. London: Chapman and Hall, 1942.

Reilly, James M, *The Albumen and Salted Paper Book*, Rochester NY: Light Impressions, 1980.

Scopick, David, *The Gum Bichromate Book*, 2nd ed. Boston: Focal Press, 1991.

Stevens, Dick, *Making Kallitypes*, Boston: Focal Press, 1993.

Wall, E. J., *A Dictionary of Photography,* London: Hazell, Watson, and Viney, 1895.

POSTCARD

A postcard is a 3½ × 5½" stiff card with a printed image on its face (recto) and room for an address, message, and postage on its back (verso).

The postcard, however ubiquitous in the twenty-first century, is a quintessential product of the nineteenth century, embodying many of the characteristics of the age in which it was born and developed. On one hand, the postcard was a means of rapid, brief communications in an increasing busy age. Gladstone, for example, wrote much of his voluminous daily correspondence on plain halfpenny postcards. On the other hand, the craze for sending and collecting picture postcards epitomized the Victorian mania for acquiring, classifying, and arranging specimens.

The postcard's visual antecedents include eighteenth-century pictorial visiting cards and trade cards, nineteenth-century pictorial writing paper and envelopes, and cartes-de-viste, the collecting craze of the 1860s. The development of the postcard's physical format is directly linked to nineteenth-century postal regulations imposed by both individual countries and the International Postal Union. In the early nineteenth century, mail rates were based on the number of sheets in a letter (including the envelope), and the distance it was to travel. In 1840 the British Post Office instituted the penny post, establishing a flat rate of one penny per half ounce. Letter writing became affordable for a greater part of the population. As people became dependent on corresponding by post for both personal and commercial use, they sought ways to exchange messages more rapidly and economically.

In 1865 Dr. Heinrich von Stephan, a German post office official, proposed an "offenes Postblatt" or open post sheet, at the Austro-German postal Conference. He described a printed, postage-paid card with one side for the address and the other for the message, which could provide the user with a certain ease and convenience not associated with paper-and-envelope letters. Although von Stephan's idea was not adopted by the Germanic postal service, the idea of open-sheet letters, sent at printed material or penny post rates was adopted by some people throughout Britain, Europe, and North America, especially for business matters. In fact, the earliest postcard is generally acknowledged to be Lipman's Postal Card, a plain card published in Philadelphia in 1861 (patent applied for by John P. Charlton).

The idea of a postcard continued to gain currency throughout the 1860s, culminating with a suggestion by Dr. Emanuel Herrmann, an Austrian professor of economics, for a "Correspondenz-Karte" to be printed by the post office on a "thin buff-colored slice of cardboard." Similar to von Stephan's idea, Herrmann saw his card as a solution for sending a brief message by post. Later that year the Austrian post office produced what is considered to be the first official postcard. On its face of was printed the Austrian emblem with "Correspondenz-Karte" above it, a two kreuzer stamp in the top right-hand corner, and three ruled lines in the center for the address. It was immediately popular—2, 936,102 cards were sold in first three months.

The first official German, English, and Swiss postcards debuted the following year, and the first U.S. postcards were printed in 1873. The standard postcard size was 4 ¾ × 3 1/3 or 4 ¾ ×3 inches (4 ½ × 3 ½" for the British size). In the first year of their use 75 million halfpenny cards were posted in Britain alone. By 1903

the number of postcards sent in Britain was almost ten times that amount.

Although entrepreneurs quickly recognized the possibility of producing cards embellished with borders, advertisements, and pictures, governments continued to regulate and monopolize postcards. Privately printed postcards could be sent through the post, but at the standard, rather than reduced, rate. In general, there were fewer postal regulations on the continent than in Britain and the United States, so countries such as Germany, Switzerland, and Austria led the way in the evolution from the plain postcard to the picture postcard. Various people are claimed to have produced the first picture postcards. The two most often agreed upon are Leon Bésnardeau and A. Schwartz, both of whose cards appeared in 1870, inspired by the Franco-Prussian war. An Austrian postcard printed by A. Schwartz of Oldenburg, showing a soldier and cannon in upper left-hand corner, is considered to be the earliest government-issued pictorial postcard. In France Leon Bésnardeau, a stationer in Sillé-le-Guillaume, printed a card for the Breton troops showing stacked weapons and an empty battlefield surrounding the address area.

In 1870 English firms began to print pictorial advertisements on post office halfpenny cards, but these were not considered to be official cards, nor were they picture cards in the purest sense. In 1872 private printers in many countries won the right to print cards provided they had official postage printed on them. German, Swiss, and Italian publishers all printed early view cards; in Nuremberg J.H. Locher of Zurich printed a series of views of his city which may have been the earliest view cards issued. Although the printers had won a victory for cards with pictures, the use of such cards was still strongly tied to commerce. Single-color small views of cities and attractions such as spas and restaurants were printed on cards more to attract business to these venues than for the sake of producing an attractive card that would be purchased and sent for its intrinsic value.

In 1875 the First Congress and International Postal Treaty established a fixed rate for letters sent to all member countries of the union. Postcards could now be sent abroad between member countries at half the letter rate. However, at this time the address and postage were still placed on the front of the cards, which constrained the size of the image. It gradually it became the practice to reserve one side for the address, with no other writing allowed on it, and the other side for the picture and stamp. The choice was between having a front with smaller pictures and space for writing, or a picture covering the entire face, so that if the sender wished to include a message it could only be written over the image. The divided-back postcard, which solved the problem of providing space for the message, address, and postage all on one side of the card, leaving the other side completely free for the image, did not come into being until 1902, when it was adopted by Great Britian, with other countries quick to follow suit.

Although instantaneous photography was readily available by the time the first postcards appeared, real photographs were not used as postcards until almost the turn of the twentieth century. Instead, photographs formed the basis from which the image was reproduced. By the 1890s single-color picture postcards had given way to full-color cards reproduced from photographs by means of collotype, chromolithography, photogravure, or half-tone photo engraving. The photograph was seen only as the basis for the card. Even when it recorded an event, the photograph was thought of solely as the intermediary from which half-tone blocks could be made and printed. Thematic cards such as those made popular by Bamforth and others were carefully posed and arranged and views were carefully framed. Such cards were advertised as being based on "real life photos."

The potential of the real-photo postcard was realized late in the century when established photographers began to capitalize on their existing stock of images and expertise. While some well-known photographers scoffed at the picture postcard medium, others such as William Jackson in the United States, and Francis Frith and Valentine and Sons in England, recognized the potential for both making and publishing photographic postcards. Soon other photographers began selling negatives to picture postcard companies.

The real–photo postcard was given a boost just before the turn of the century when George Eastman introduced lightweight, hand-held cameras pre-loaded with 100-exposure rolls of film. Advertised by the slogan "You press the button, we do the rest," the entire camera was returned to Kodak for developing. One could receive either small prints or sepia-colored real photo postcards.

Starting in 1902 Kodak offered a pre-printed card back for printing negatives as postcards. Many itinerate photographers used postcard stock, and they and other professional photographers could have their name or logo printed on it. Glass plates and sheet film were also available in postcard size. The following year the #3A Folding Pocket Kodak was introduced which took postcard-sized photographs on roll film. It included a waist-level viewfinder that could be rotated 90 degrees, allowing the user to take horizontal as well as vertical pictures. Postcard format cameras were soon produced by other manufacturers. Made by amateurs and "professionals" alike, the age of the gelatin silver snapshot photograph had begun, lasting well into the first half of the twentieth century.

BETH ANN GUYNN

See also: Collotype; Frith, Francis; Valentine, James and Sons; Eastman, George; and Kodak.

Further Reading

Burdick, J.R. (ed.), *Pioneer Postcards*, Syracuse, N.Y.: Voss Litho, 1957.

Carline, Richard, Pictures in the Post: The Story of the Picture Postcard. Bedford, England: Gordon Fraser, 1959.

McCulloch, Thomas R., *Card Photographs: A Guide to their History and Value*. Exton, Pa.: Schiffer Pub., 1981.

Miller, George, and Dorothy Miller, *Picture Postcards in the United States, 1893–1918*. New York: C.N. Potter: Distributed by Crown, 1976.

Morgan, Hal, and Andreas Brown (foreword by John Baskin), *Prairie Fires and Paper Moons: The American Photographic Postcard, 1900–1920*, Boston: D.R. Godine, 1981.

Phillips, Tom, *The Postcard Century: 2000 Cards and Their Messages*, London: Thames & Hudson, 2000.

Postcard Collector, Iola, WI: Krause Publications. Nov. 1983 (Continues: *American Postcard Journal, and Post Card Collector's Bulletin*).

Staff, Frank, *The Picture Postcard and its Origins*. New York: Fredrick A. Praeger, 1979.

Walter, Karin, *Postkarte und Fotografie: Studien zur Massenbild-Produktion*, Würzburg: Bayerische Blätter für Volkskunde; München: Bayerisches Nationalmuseum, 1995.

POSTMORTEM PHOTOGRAPHY

Postmortem photography has its roots in a long tradition of posthumous memorial and funerary portraiture. These costly portraits were mainly of wealthy persons or well-known figures who were usually depicted as if still living. Visual clues within the painting signaled that it was a post mortem portrait. These portraits were intended to create the illusion of life in death. Although usually for the private consumption of the family of the deceased, they sometimes had a more public, commemorative purpose.

The first postmortem daguerreotypes were made in 1841, only two years after the daguerreotype was introduced. For the first time, photography made postmortem portraits relatively accessible for all who wanted them. At the apex of the Victorian obsession with death, postmortem photographs became a popular accoutrement of the rituals of death and mourning. The realm of posthumous portraiture shifted from a strictly upper class practice to a middle and lower class one. By 1850 almost any family that desired an image of their dearly departed could afford the cost of approximately 25 cents for a daguerreotype.

This phenomenon is another instance of how early photography was quickly put into the service of an existing or perceived daily need. By the mid-nineteenth century the preoccupation with death had taken a firm hold on both sides of the Atlantic. Death was seen as the ultimate act of nature, in both romantic and realistic terms. Due to the high mortality rates of the nineteenth century, especially among infants and children, death was perceived as God's will, beyond all human control. Ever-present and inevitable, death was an accepted familiar. Because death usually occurred at home, the experience of death was shared by all family members, as a event to be recorded and remembered. The death of a loved one signaled the completion of relationships, the closing of the circles of family and life. In some sense, the visual manifestations of mourning, and perhaps postmortem photographs most of all, were the links that served as both the aperture and closure of the circle.

Postmortem photography served several purposes. It was a way to console the bereaved, to share the image and details of the death of a loved one with those who had not been there, and to memorialize the deceased. A photograph created a tangible object that represented the deceased. This became especially important when the posthumous image was the only existing likeness of the individual. Postmortem photographs were kept on parlor tables and mantels and in family albums. They were also sent to far away relatives along with written accounts of the death. In all aspects postmortem photographs were literally "memento mori." Elizabeth Barrett wrote of a postmortem daguerreotype in her possession, "It is not merely the likeness which is precious—but the association and the sense of nearness involved in the thing…the fact of the very shadow of the person lying there forever!…I would rather have such a memorial of one I dearly loved, than the noblest artist's work ever produced" (Gernsheim and Gernshiem, *History of Photography*, 64).

Early on some miniaturists and other artists turned to photography, recognizing it as both a faster way to record the deceased and as a way to increase their business. Conventions from the posthumous painting tradition such as the inclusion of watches and clocks or bottles of medicine are often found in early photographs. Photographers did not hesitate to advertise their services. "Secure the shadow 'ere the substance fade" was a popular early advertising slogan for daguerreotypists. In an era when photographic portraiture was still not considered a matter of course and many of the living had never had a photographic portrait taken, it called out to the increased importance being placed on portraiture, whether living or posthumous, as a method of remembrance. Nathan Burgess concluded his 1855 article "Taking portraits after death" with these words: "How true it is, that it is too late to catch the living form and face of our dear friends and will illustrate the necessity of procuring those more than life-like remembrances of our friends, ere it is too late—ere the hand of death has snatched away those we prize so dearly on earth" (*The Photographic and Fine Art Journal*, 8:80). This practicality of this statement lies in the fact that before

Aubert, Francois. Corpse of Emperor Maximillian.
The J. Paul Getty Museum, Los Angeles © The J. Paul Getty Museum.

embalming became prevalent photographs had to be taken quickly while the body was on ice. The deceased were often buried on the same day they died. Thus the deceased was often rushed to the photographer's studio or the photographer often came to the home on short notice.

The intimacy of early postmortem images is striking. They often show in death that which would not have been shown in life. Images that we would consider very private—a wife mourning a husband at his death bed; women and girls in white burial gowns, meant to represent confirmation or wedding dresses, yet bearing a close resemblance to nightgowns; the overt portrayal of grief rather than stoic acceptance; even the canonized poses of grief which seem so staged and histrionic to contemporary viewers—were readily viewed and widely. The admittance of the photographer to a very private space shows the status of the photographer, along with the doctor and clergyman, as an important character in the final act of death. It bears repeating that throughout the 19th century grief was an acceptable public emotion, widowhood was seen as a lifelong female role, and the discussion of death and the deceased was considered a polite topic of conversation.

Unlike conventional portrait photography, in postmortem photography long exposure times were possible without discomfiting the sitter. The problems often encountered with blurring were not an issue, resulting in images that were crisper and of an often higher quality, than those of live subjects. The need to remain still during long exposures often created a lack of facial expression in images of the living, grieving relatives. Their grief was most often expressed through the conventional symbolism of their poses. This creates the dichotomy wherein portraits of the deceased seem to have a more expressive, relaxed demeanor than those of the living. Articles in photographic trade journals described techniques for photographing the dead including lighting and positioning the body, practical advise such as having relatives leave the room "should they witness some little mishap likely to befall the occasion" and how to open the eyes of the deceased with a spoon.

The earliest postmortem photographs were the simplest. In the daguerreotypes, ambrotypes, and other plate images of the 1840s and 50s the deceased was portrayed close-up and alone, with few, if any, accoutrements. Little attempt was made to soften the effects of death. With the exception of the "sleeping" child, the fact of death was quite obvious. Many images were taken exactly where the deceased had expired, without arranging the body. Often parents are shown holding a child in their laps, as if it is still alive, or holding it up for. Frequently the subject, usually a child, is placed across a studio chair or couch in a pose representing "the last sleep." Some images of this type depict the child in its bed, often in a christening outfit. "The last sleep" was the dominant theme of postmortem photography from 1840–1880. The close-up, "sleeping" image conveyed the ancient symbolism of death as sleep or a rest from one's labors. This convention can also be seen as the denial of death. It is often difficult to tell, especially in images of the very young, if the subject is living or deceased.

Sometimes the subject is seated upright on a chair or couch with its hands crossed in its lap and the eyes closed. The seated pose seems also to be an attempt to portray the subject as alive, although death is more evident than in the 'last sleep" convention. This pose was especially favored when no living portrait had been taken or when the family was considering having a posthumous portrait.

The inclusion of favorite items of the deceased in the image is concept taken from the posthumous portraiture tradition. Children were often depicted holding a small doll or favorite toy. Scattered toys (often studio props), abandoned in the moment of play symbolized the deceased's departure. Another subject favored for infants was the "from carriage to coffin" convention depicting the infant laid in a baby carriage with its small coffin present in the background shadows.

Sometimes multiple images were taken of the deceased: alone, with a parent or spouse, at the gravesite, and so on. Since daguerreotypes were unique images, this was one way of creating more than one image. Such images also recorded the different aspects death and mourning and the specific events and feelings associated with them.

Special black mourning cases embossed with funerary designs were made for postmortem daguerreotypes. If no postmortem photograph had been taken a photograph of the person while alive was sometimes put in a mourning case. Funeral notices, poems, letters, and other small remembrances were often kept in the case. As the century progressed photographs were included in mourning lockets and rings and all sorts of other memorial photographic paraphernalia was invented. In 1851 a U.S. patent for a special case to imbed daguerreotypes in tombstones was granted.

In the 1860s with the advent of albumen prints and the invention of the popular carte-de-visite, multiple prints of the postmortem photograph became possible. This facilitated the dissemination of images to relatives in distant locations, often accompanied by a letter describing the death, funeral, and mourning practices being observed. At this time images start to depict simple surroundings and tend to show the subject "at peace" with the hands crossed over the body.

In the mid-19th century the illustrated press such as the Illustrated London News and Harper's Weekly routinely published images of death, particularly images from war or gruesome accidents. In 1863 Matthew Brady began to produce images of the civil war dead that were sold to a popular audience in the form of stereographic cards. Images of death became a type of collectible news item. While this topic deserves further exploration elsewhere, for the purposes of this article it is worth noting that such wide acceptance of death as news image probably would not have been as easily accepted by the public were it not for the already widespread production of postmortem photographs for private use.

By the 1870s stereographs become a popular format for postmortem images. The stereograph's popularity was soon eclipsed by the larger format cabinet card, which afforded greater freedom in the posing, lighting and background of the postmortem portrait. The cabinet card remained popular through the turn of the century. In the larger format images of the dead became more staged and an interest in the beautification of the deceased surfaced for the first time. Rather than recording the raw facts of death, or denying death, flattering poses and the increased inclusion of symbolic accoutrements pointed out the transience of life. A stopped clock signaled the moment a life had ended; a rose held downward held indicated that the child depicted was indeed dead; the head and body resting on pillows stood for eternal sleep and a closed book symbolized a closed life. Flowers were also placed around the body. Flower arrangements in symbolic shapes such as crosses became popular. Personal effects, especially for children, were increasingly included and elements of the photograph were often hand-tinted.

In the 1880s the practice of embalming the deceased became more common, allowing more time to beautify the corpse and to set up elaborate poses and scenes. Casket photographs become more popular as the more luxurious and comfortable looking cloth-lined casket replaced the narrow wooden coffin heretofore in common use. Sometimes the image of the deceased was superimposed into the center of a stock background of flowers and wreathes, creating a lush, abundant setting foretelling the deceased's final destination in paradise. From 1885–1910 this increased emphasis on placing the deceased in the coffin within a larger funeral "scene" became more popular, especially for adults.

Beginning in the early 1880s black mourning cards were frequently distributed to mourners. The simplest contained only the name of the deceased. The most elaborate contained a poem from the vast stock of funeral literature that had been written over the course of the century, as well as a photograph of the deceased. This sideline to the practice of postmortem photography continued through the early decades of the 20th century. It is but one example of the numerous businesses that grew up around the high Victorian preoccupation with death and contributed to the outcry by numerous late Victorian social critics against the commercialization of death.

In the late 19th century death and the responsibilities associated with it increasingly moved from the home and family to institutions. The death of the sick occurred more often at the hospital, the body was prepared by professionals at the funeral parlor rather than by the family, and the wake was held there instead of at the home. The formal room in the family home known as the parlor where important visitors were received and viewings and wakes were held began its transformation into the modern living room as the funeral parlor replaced many of its previous functions. Postmortem photography taken at the funeral home emphasized the social aspect of the funeral, both as a family gathering and as the last record of the deceased as a tangible member of the family circle. The funeral director often took on the role of postmortem photographer, a service that he could discreetly offer the family.

As funeral rites and practices changed, some aspects of death became more private and many of the visible trappings of mourning began to disappear. The practice of photographing the deceased became more private, as evidenced by the fact that photographers no longer openly advertised their postmortem services.

The postmortem image seems have been made more for the private consumption of the family or even the individual within the family who requested it. By the turn of the century, the popularity of amateur photography brought about by the Kodak brownie camera had already made the need for a professional postmortem photographer even less necessary, particularly for those who wanted their desire to record the deceased to be more private. The photographic postcard format was popular among amateur postmortem photographers, but unlike other subjects, it was rarely sent through the mail as a postcard. When postcard images were sent, they were enclosed in a letter. Since the format was inexpensive and supplies were widely available it was often simply the format of choice for private consumption. By the end of the century, postmortem images in general were more frequently kept and put away rather than openly displayed or sent to relatives.

The practice of postmortem photography continued throughout the 20th century and is still alive in the 21st century. However, by the 1930s and 40s new funerary rites and customs had supplanted the high Victorian funerary practices. Death was no longer a socially acceptable topic of conversation; grief and mourning became very private, with view visible manifestations. In a manner of speaking, postmortem photography, once openly discussed and displayed, went underground.

Note: This article of necessity focuses on the 19th century Anglo-American practices of postmortem photography. A survey of practices around the world, focusing on places like Mexico, which have a rich and distinct tradition of postmortem photography, requires a separate series of articles.

BETH ANN GUYNN

See also: Daguerreotype; and Wet Collodion Positive Processes.

Further Reading

Burns, Stanley B., *Sleeping Beauty: Memorial photography in America*, Altadena, Ca.: Twelvetrees Press, 1990.

Norfleet, Barbara P., *Looking at Death*, Boston: David R. Godine, Publisher, 1993.

Meinwald, Dan, "Memento Mori: Death and Photography in Nineteenth Century America." *California Museum of Photography Bulletin*, vol. 9, no. 4, (1990).

Morley, John, *Death, Heaven and the Victorians*, Pittsburgh: University of Pittsburgh Press, 1971.

Pike, Martha, and Janice Gray Armstrong, eds., *A Time to Mourn: Expressions of Grief in Nineteenth Century America*, Stony Brook: Museums of Stony Brook, 1980.

Ruby, Jay, *Secure the shadow: Death and Photography in America*, Cambridge, Mass.: MIT Press, 1995.

Sobieszek, Robert A., *The Spirit of Fact, the Daguerreotypes of Southworth and Hawes, 1843–1862*. Boston: Godine, 1976.

Van der Zee, James, *Harlem Book of the Dead*. New York: Morgan and Morgan, 1978.

El arte ritual de la muerte niña, Artes de México; n.s. no.15, México, D.F. : Artes de México, 1992. (The Ritual Art of Child Death)

POTTEAU, JACQUES-PHILIPPE (1807–1876)

J.-P. Potteau first practiced photography in 1861 when he was an assistant in the laboratory of malacology, at the Natural History Museum in Paris. His photographic work, at its beginning, is difficult to distinguish from that of Louis Rousseau, whose activity he takes over as the official photographer, in a field as vast as the museum's collections. Today he is better remembered as a portraitist, an important work undertaken as early as 1862 in his studio next to the botanical garden—Jardin des Plantes. Many foreigners visiting Paris where taken there and Potteau was able to portrait tens of people, members of Oriental embassies—China, Cochinchina, Japan, or Siam. He also started taking anthropological portraits of Algerians, Annameses, Bohemians, Indians, Italians, Kabyles and French. His photos are highly restrained: the models are posed either full face or side view, frontal, from a fixed distance, somewhat gravely. This approach to portraiture will be more frequently used, in the nineteenth century and later, for ethnography or even anthropometry. J.-P. Potteau's works, rich of more than a thousand photos, are yet to be fully explored. Most of his works is preserved at the Quai Branly museum in Paris.

JÉRÔME GHESQUIÈRE

POU Y CAMPS, JUAN MARIA (1801–1852)
Spanish photographer

One of the first daguerreian manuals to appear in Spain—*Exposicion Historica y Descripcion de los Procedimientos del Daguerreotipo y del Diorama* was translated from the inventor's original text by Joaquin Hysern y Molleras. It contained extensive notes on experiments carried out by Dr. Juan Maria Pou y Camps—one of the first to make daguerreotypes in Madrid—who also published the volume.

He had attended public demonstrations of the process in Paris, and recognised that the process could be improved significantly. By the end of October 1839 Pou and colleagues in Madrid had produced their first images, and before the end of 1839, their improvements and observations on the process had been incorporated into the manual.

One suggestion was the adaptation of the camera to act as a photometer. Thus he was probably the first

person to recognise that photographers needed some means of accurate exposure determination.

His interest in photography, however, seems to have been relatively short-lived, and there is scant evidence of further engagement with the medium after 1840.

Dr. Juan Maria Pou y Camps was born in Girona in northern Spain and studied pharmacy in Barcelona, becoming Professor of Pharmacy in Pamploma by the age of 28. By 1849 he was listed as Professor of Pharmacy at the University of Madrid. He died in Madrid in 1852.

JOHN HANNAVY

POUNCY, JOHN (C. 1808–1894)

Active from the daguerreotype period John Pouncy remained firmly a Dorset photographer based for his whole life in the county town of Dorchester—yet his reputation was international. His long career, his patents in 1858 (No.780), 1863 (No.267) and 1868 (No. 3849) for his carbon process and his venture into colour fine art reproduction should all be seen in the context of his obituary: he "displayed a strong will and firm determination, and when one he had convinced himself that he was right it was difficult to move him" (*Dorchester Chronicle*, 29 March 1894). This determination provides the context for the fraught reception of his claims since his reluctance to reveal the exact details of his discoveries clearly fostered popular disbelief and pedantic professional jealousies.

Pouncy was copying prints and drawings as early as 1855 but the un-gentlemanly grilling which this provincial entrepreneur received from the Photographic Society came to a head 1858 (with Roger Fenton in the chair) and was first unravelled by Arthur T. Gill in a series of two articles in 1965. The complex story of how a pioneer determined not be overwhelmed if not bullied by the combined scientific might of London prompted Gill to ask whether this surprisingly dramatic meeting "did not nearly come to blows" (*Photographic Journal*, February 1965, 57). To several authoritative audiences Pouncy demonstrated his ability to produce prints but he would not divulge the exact process—individual prints were, and still are, very convincing, but they did not lend themselves to mass production so Pouncy's discovery was soon superseded by more robust processes which could be applied on a commercial and industrial scale. The Victoria and Albert Museum holds at least one print which proves just how tonally rich Pouncy's images could be in comparison with the rather less satisfactory views reproduced in his famous publication *Dorsetshire Photographically Illustrated* (1857) which can claim to be the first to transfer photographic images into published illustrations—though these look much more like lithographs than photographs.

Pouncy, whose own confidence can hardly have been aided by the consistent misspelling of his name (Pouncey) over three consecutive meetings by the otherwise punctilious Photographic Society, was not going to be forced to reveal every detail of his revolutionary carbon process which promised to make permanent images often still infamous for their evanescence: he was well aware that he would "have the credit of one of the greatest discoveries photography has ever known" (*Photographic Journal*, 11 December 1858, 91). Despite this lack of commercial success it would still be true to say about him that "there need be no more lamentation over fading photographs" (*The Builder*, 31 October 1868, 800). It is clear that on many occasions that he could show examples of his process so it is with some justification that he claims "I can produce in printing ink of any colour direct from the negative photographic positives, negatives, transparencies, transfers for lithographic or press printing, and photographs in ceramic colours, which can be transferred to and burnt on china, earthenware, &c" (*British Journal of Photography*, January 13 1865, 18).

His process turned out in the end to be far less successful than that of Pretsch and Poitevin and their successors like Swan. Poitevin won the prestigious Duc de Luynes competition in France: Pouncy was awarded the silver medal and complained of French perfidy. Pouncy never conceded his claims and for a period of at least ten years in several countries continued such a concerted campaign that it has successfully baffled photographic bibliographers ever since. He certainly applied his skills in an apparently successful colour reproduction process for paintings in conjunction with his son Walter (the 1868 patent) which is still in need of a modern study by historians of art and printing quite apart from photography. The quite conventional Pouncy studios in Dorchester are the locus of several photographic puzzles needing further scrutiny. Even before taking up photography John Pouncy was a painter, glazier, carver, gilder and dealer in oil paintings so it is clear that he continued mix and apply these skills using photographic techniques to the point where the *Art Journal* gave a favourable endorsement in an undated article (presumably of the late 1860s) in relation to the colour copying of paintings by John Faed. This later manifestation of a permanent colour process was read to Photographic Society of Scotland in 1864 (described in *The British journal of Photography*, 1865). The extent of colour printing or application to ceramics associated with Pouncy remains uncertain.

Though Pouncy was championed by Thomas Sutton and was much feted, by the 1870s he would have known about the more viable variants of his process being brought to industrial success by photographers like Adolphe Braun and companies like the London Stereoscopic

Company but he continued to operate for another thirty years keeping secrets which are still only partially understood. He remained an independent pioneer: a sign outside his shop in Dorchester reinforces the proprietary nature of his claims "John Pouncy Inventor of Photographs in Carbon and Oil Colours on Canvas Panels. Inspection invited. To be only obtained from John Pouncy"

IAN LEITH

Biography

Pouncy lived his entire life in the market town of Dorchester maintaining his business in decorative materials as well as photography. Born in 1808 or 1809 he owned a succession of shops and studios in the town at least one of which proudly advertised his quite justifiable claims to photographic fame. His son Walter (1844–1918) collaborated with him and later operated in Swanage, Dorset. Elsewhere, he exhibited in Edinburgh)[1858, 1863, 1864) and London ([1862) receiving medals in Berlin (1865), Edinburgh (1863), and Paris. He died in Dorchester in March 1894.

See also: Fenton, Roger; Swan, Sir Joseph Wilson; Poitevin, Alphonse Louis; Pretsch, Paul; Sutton, Thomas; Braun, Adolphe; and London Stereoscopic Company.

Further Reading

The Builder, June 24 1865, 447 "Photography in Printing Ink" [noting demonstration at King's College London].

The Builder, 22 February 1868, "Photography in Printers' Ink and Colours" [reproduces part of an address to the British public made by Pouncy on the treatment he received in France].

The Builder, 31 October 1868,p.800, "Photographs in Printers' Ink."

Dorset County Chronicle, 29 March 1894 [Obituary].

Gill, A T., "One Hundred years Ago *Photographic Journal*, (Feb/March, 1965).

Heathcote, B. and P. *A Faithful Likeness: The First Photographic PortraitSstudios in the British Isles 1841 to 1855*, Lowdham, Nottinghamshire: Bernard & Pauline Heathcote, 2002.

Johnson, J R., "On a greatly simplified process of printing in carbon or other permanent pigment." *Photographic Journal* (15 May 1869): 31–33.

Photographic Journal (11 December 1858): 89–94.

Pouncy, J., *Dorsetshire Photographically Illustrated...the detail and touch of nature faithfully reproduced by a new process on stone, by which views are rendered truthful, artistic and durable*, London: Bland & Long; Dorchester: John Pouncy, 1857.

——, "On Carbon Printing," in *British Journal of Photography* (January 13 1865) [read at the Photographic Society of Scotland, December 13, 1864] .

Robinson, J. B., *Joseph Barlow Robinson: A Record of the Great International Exhibition...United Kingdom Class 14 Photographic Apparatus & Photography*, Victoria & Albert Museum X.754, 1862. [A compilation of original 1862 Exhibition photographs which contains a carbon print by Pouncy so far unidentified but almost certainly showing Melrose Abbey, Scotland].

Sutton, T., *Photography in Printing Ink, being a description of the process recently patented by John Pouncy, of Dorchester*, London: Sampson & Low, Son & Co., 1863.

PRESTWICH, WILLIAM HENRY (1831–1912)
English photographer

William Prestwich was the head of a talented family most of whose members were engaged in some form of the photographic business. From 1870– 892, Prestwich ran a string of photographic studios in the London area, and at the same time took out a series of patents for improvements in lenses, emulsions, stereoscopes and lantern slides. This in turn led to the formation of the Prestwich Manufacturing Co., in T ottenham in 1895 with his son John, destined to become one of the pioneer firms in the field of cinematograph equipment.

The firm started as the Moto Photo Supply Co., in the City of London, and sold their products through the established firm of W C Hughes. Prestwich illustrated his first camera in the *Magic Lantern Journal Annual* (1897– 1898), following this with a demonstration at the Hackney Photographic Society. Several early motion pictures used it, notably by Prestwich's son Edward, including Queen Victoria's Diamond Jubilee, and W.G. Grace at Lord's. A fiction film, *The Artist's Model*, was made in 1898.

Prestwich retired at the end of the century, and the firm, later known as J A Prestwich Industries Ltd continued under John Prestwich's direction until his death in 1952. The firm was taken over by Villiers Engineering in 1964. William Prestwich died in Laughton, Essex November 1, 1912.

DAVID WEBB

PRETSCH, PAUL (1808–1873)
Austrian photographer

The publication in 1856 and 1857 by Paul Pretsch's Patent Photo-galvanographic Company of the first part of *Photographic Art Treasures or Nature and Art Illustrated by Art and Nature* was heralded as a new era of photo-mechanical reproduction, and as a practical means of bringing lower costs to the publication of photographically illustrated works.

However, the limitations of the process, the need for extensive retouching, and the lack of subtlety in the important mid-tones of the image, brought criticism and acclaim in equal measure from the photographic press. Five parts were published, each containing four images. Photographers included Roger Fenton, appointed

photographic manager of the company in 1856, William Lake Price, Lebbeus Colls, and William Howlett. Contributions by Oscar Rejlander and others were planned but never published.

Before the company went into production, Pretsch received a letter from Talbot requiring him to purchase a licence, as he asserted that Pretsch's process infringed his 1852 patent. There were fundamental similarities.

Paul Pretsch was born in Vienna and trained as an engraver. He moved to London in 1854 for the express purpose of exploiting his new process. Two British patents were granted in 1854 and 1855, and premises established in London's Holloway Road.

By 1858 the company had ceased trading, and Pretsch later worked for de la Rue as an engraver.

JOHN HANNAVY

PREVOST, CHARLES HENRY VICTOR (1820–1881)
French and American photographer

Victor Prevost was born in 1820 in La Rochelle, France. As a young man, he studied art in Paris with Paul Delaroche. He went on to work as a lithographer, and exhibited several lithographs at the Paris Salons of 1845 and 1846.

Soon after this, however, Prevost decided to go to New York City, where he began earning his living as a lithographer. In 1848 and 1849, Prevost worked for the lithographic forms of Goupil, Vibert & Co. and Sarony & Major.

From 1850 until 1852, Prevost worked in a studio with five other artists. One of the other tenants was a daguerrotypist, which may have piqued Prevost's interest in photography. Prevost's workplace was also only a few blocks from the Broadway studios and galleries of the major daguerrian portraitists of the city.

During the early 1850s, the daguerreotype was the primary photograph format in the United States. Although in 1840 William Henry Fox Talbot had introduced the calotype, a paper-based photographic process, he took out a patent on the process and required anyone interested in using it to license the technique. Only a few American photographers cared to do so, none of them in New York.

Meanwhile, the paper negative process was further developed by several Frenchmen. Gustave Le Gray, a French artist, developed a method of waxing the paper negatives before they were placed into the sensitizing bath, which allowed the negatives to be kept for two weeks before exposure, and then to be kept for up to a week before developing and printing. Le Gray published his findings in France in July 1851; they were translated and printed in America in 1852. One of the few Ameri-

can photographers interested in the new paper process was Victor Prevost.

In 1853, Prevost traveled to France to learn this new method of photography from Le Gray. While there, Prevost made a series of photographs of the French countryside, which were subsequently published in an illustrated edition of *Twenty Years After*, a historical novel by Alexandre Dumas. In these early examples of his photographic work, Prevost manages an exquisite feel for composition, and shows a mastery of the new technique.

Upon returning to New York in the latter part of 1853, Prevost set up a photographic studio at 43 John Street. Later that year, he entered into a partnership with Peter Comfort (P.C.) Duchochois, whom he had met in France. Duchochois became known for his prolific contribution to the photographic scientific literature.

In a New York City business directory for 1853, Prevost listed himself as a photographer. Other major photographers in the city continued to list themselves as daguerrians. The next four years were Prevost's most productive as a photographer, and resulted in the first paper-based photographs of New York City.

While some of Prevost's images echo standard scenes that were being engraved and lithographed for public consumption at the time, his photos display a more artistic sensibility, in keeping with his training. In New York City, Prevost mainly photographed outdoor scenes—commercial buildings, churches, backyards of urban residences, larger country estates and residences, and ships in dock on the Hudson. Similarly, the rural estates and scenes he photographed in upper Manhattan, West Point, New York, and several towns in New Jersey display a sense of scale more in line with the Hudson River School artists than with daguerrian portraiture.

Prevost entered some of his photographs in the photographic competition at the New York Exhibition of the Industry of All Nations at the Crystal Palace in 1853–1854. He was awarded several honorable mentions but his photograph made from a waxed paper negative lost the prize to one taken with the wet-collodion, glass-plate negative process. Nevertheless, Prevost was intrigued by the exhibition and took many photographs of the interior of the building, including several views of neo-classical statues, as well as the large machines exhibited.

In 1854, Prevost traveled to West Point to photograph the solar eclipse on May 26. Many daguerrotypists photographed this astrological event, but Prevost appears to have been the most prolific photographer, making nineteen exposures onto waxed paper negatives in quick succession. A subsequent album was made, showing the consecutive prints, as well as a smaller composite image printed from all the negatives.

That same year, photographs by Prevost and Ducho-

chois were published in the *Photographic and Fine Art Journal,* along with a note celebrating their work. Despite this praise, it was difficult for the two to compete with the successful daguerrian studios that dominated New York's photographic market. Prevost's partnership with Duchochois only lasted until 1855, after which he went to work for Charles Fredericks, another photographer who was expanding from daguereotypes to include paper photographs made from wet collodion glass plate negatives. While working for Fredericks, Prevost listed himself in city directories as a chemist, suggesting that he mixed chemicals or printed photographs for Fredericks.

In 1857, Prevost gave up on earning his living through photography. His wife Louise had been assisting her aunt at her school near Madison Square, Madame Chegaray's Institute for Young Ladies. Victor Prevost joined the faculty as a teacher of drawing, painting, and physics. He continued to work as an educator until his death.

Despite having abandoned photography as a career, Prevost continued to photograph the continually changing face of New York City. In the fall of 1862, he photographed and compiled an album of 35 views in Central Park, which was still undergoing construction. These albumen prints were made from glass negatives. In the late 1870s, he completed an album of eighteen photographs of the American Museum of Natural History. The photographs show the exterior of the building, completed in 1877, and several of its collections.

Prevost died in New York in April 1881. He was buried in Calvary Cemetery in Brooklyn. He was largely forgotten after his death, until a cache of his negatives was discovered in 1901, and he was thereafter celebrated as the creator of the first paper photographs of New York City.

Collections of Prevost's waxed paper negatives and/ or surviving salt and albumen prints are held by the following institutions in the United States: George Eastman House, Metropolitan Museum of Art, Museum of the City of New York, New-York Historical Society, New York Public Library, and Smithsonian Institution.

JENNY GOTWALS

Biography

Charles Henry Victor Prevost was born in 1820 in La Rochelle, France. As a young man he studied art in Paris under Paul Delaroche. Prevost worked as a lithographer, and exhibited his work in the Paris Salons of 1845 and 1846. In 1849, Prevost was living in New York and was married to Louise Berault. Their son Emmanuel Emile was born in 1850. In 1853, Prevost went to France, where he learned Gustave Le Gray's new method for creating calotypes. From 1853–1855 Prevost had a partnership with P.C. Duchochois, and began taking paper photographs of New York City urban sights, and rural areas in upper Manhattan and New Jersey. Prevost exhibited his calotypes at the New York Exhibition of the Industry of All Nations at the Crystal Palace in 1854. From 1855–1856, Prevost worked for photographer Charles D. Fredericks. In 1857 Prevost began working as a teacher, and continued to work as an educator and principal until his death. Prevost died in New York in April 1881.

See also: Calotype and Talbotype, Fredericks, Charles Deforest; Great Exhibition, New York (1853–54); Le Gray, Gustave; and Waxed Paper Negative Processes.

Further Reading

Duncan, R. Bruce, "I, Victor Prevost –" in *Graphic Antiquarian,* vol. 4, no. 1, 1976, 5–11.

Jammes, Andre, and Eugenia Parry Janis, *The Art of French Calotype,* Princeton, NJ: Princeton University Press, 1983.

Newhall, Beaumont, "Victor Prevost, Early New York Photographer." *Image,* vol. 3, no. 1 (1954): 3–5.

Rosenheim, Jeff L. " 'A Palace for the Sun': Early Photography in New York City." In *Art and the Empire City, New York, 1825–1861,* edited by Catherine Hoover Voorsanger, and John K. Howat, New York: Metropolitan Museum of Art, 2000 (exhibition catalog).

Scandlin, W.I., *Victor Prevost, Photographer, Artist, Chemist: A New Chapter in the Early History of Photography in this Country,* New York: Evening Post Job Print, 1901.

Van Gulick, Ellouise, *Victor Prevost, Photographer of New York,* Thesis (M.A.), Albuquerque, New Mexico: University of New Mexico, 1982.

PRICE, WILLIAM LAKE (1810–1896)
English photographer

Like many early photographers, William Lake Price originally trained as a painter, turning to photography c. 1854. Before that date, his landscape and architectural watercolours had been exhibited widely, including several exhibitions at the Royal Academy in London, and the Old Water Colour Society.

He joined the Photographic Society of London shortly after its formation, and exhibited his work at the Society's Annual Exhibitions from 1855 until 1860. His work was predominantly both genre and portraiture, and his study 'Don Quixote in his Study' was widely exhibited, and also chosen as one of the photogalvanographic plates for the first series of Paul Pretsch's *Photographic Art Treasures* published in 1857. His portraiture subjects included Prince Albert, Owen Jones, and many of the leading Royal Academicians of his day, including William Powell Frith, Clarkson Stanfield and David Roberts.

Lake Price was a popular lecturer on many subjects relating to photography, and his lectures were widely published in photographic journals in both Britain and

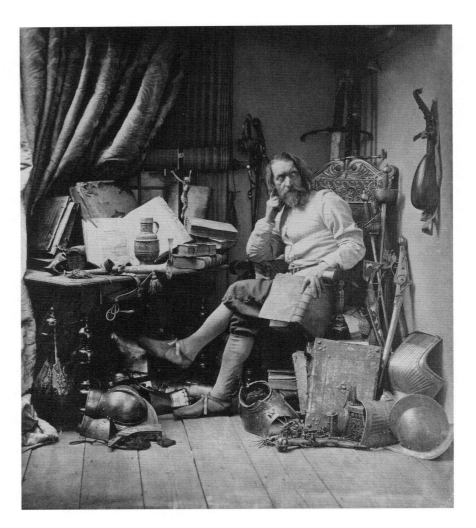

Price, William Lake. Don Quixote in His Study.
The Metropolitan Museum of Art, Gift of A. Hyatt Mayor, 1969 (69.635.1) Image © The Metropolitan Museum of Art.

the United States. His book, *A Manual of Photographic Manipulation* was first published in 1858 by John Churchill in London, with a second edition published a decade later. He announced his retirement from photography in 1862, but returned to both practice and write about photography six years later, continuing to lecture and write intermittently until 1889.

JOHN HANNAVY

PRINGLE, ANDREW (b. 1850)
English photographer

To his contemporaries, Andrew Pringle was "a gentleman" and "usually polite and obliging." One of three brothers, Pringle was educated at Harrow School, then Trinity College, Cambridge, before serving in the 8th Hussars.

Pringle took up photography in 1874 and travelled in France, Germany, Switzerland, Italy, Spain, and Africa. He investigated all processes and, with Professor W K Burton, published *Processes of Pure Photography*. By 1886, he specialised in photomicrography and at a dermatological congress, Pringle created a sensation by illustrating a rare bacillus. He wrote textbooks on the optical lantern, and on photomicrography, and contributed illustrations to *Kleine's Histology*.

When he was President of West Kent Amateur Society, *The Photographic News* of 1889 asserted that Pringle never took offence "until his good nature was rudely strained by the incautious." His procedures were methodical and by noting every factor affecting development, as well as "anything else that occurred to me," he identified "the secure exposures, the doubtfuls and the 'instantaneously'-exposed plates, which were sure to require more or less care."

Pringle was a Fellow of the Royal Meteorological Society and a former president of the Photographic Convention.

RON CALLENDER

PRINTING AND CONTACT PRINTING

Shortly after William Henry Fox Talbot produced his first successful images with his Photogenic Drawing process in 1834, the concept of printing was introduced into the practice and language of photography. This

marked the most radical difference between the daguerreotype and the paper negative. The unique direct positive of the daguerreotype may, initially, have offered finer detail and higher quality, but the ease of duplication via the negative marked the real birth of photography as we know it today.

It was inspired thinking on Talbot's part to recognise that the lights and shades, reversed in his photogenic drawing, could be restored by exposing another sheet of salted paper in contact with the negative. Just as the original photogenic drawing paper was exposed in the camera until a visible negative image of the required strength was achieved by the action of light alone, so the first positive prints were exposed in contact until the positive achieved the required density. No development was originally involved, with the exposed and printed-out image then simply fixed and washed.

As Robert Hunt wrote, in 1857, in his *Manual of Photography*,

> The copying frame is an indispensable requisite to the photographer: it is used for copying all objects by transmission, and for multiplying the original pictures, obtained by means of the camera obscura from nature: it is, indeed, the printing-press of the artist.

The 'copying frame' remained the essential tool of the photographic printer for several decades, with racks of frames arranged outdoors and directed towards the sun—as seen in the celebrated panorama of Talbot and Henneman's printing establishment at Reading. Because of the low sensitivity of the material, and the inherent density of the negative, printing on a commercial scale only became viable once the negative was waxed or oiled to increase its translucency—and thus reduce exposure times. Only then could multiple copies be made within an acceptable time frame—the approach adopted by Talbot for *The Pencil of Nature* (1844) and *Sun Pictures in Scotland* (1845).

Commercially available printing frames used two sprung bars across the back to hold the negative in close contact with the positive paper. A hinged back allowed for one spring to be released, and the printing paper gently folded back to assess progress.

The 'salt print' as it became known, remained, essentially, the same material which had been used in the camera, the only difference, as it evolved, being the introduction of a 'developer' to reduce exposure times. That 'developer' was not dissimilar to the sensitizing bath used to activate the light sensitive chemistry before exposure—namely silver nitrate, acetic acid and gallic acid.

The idea of developing prints was originally proposed as an expedient for printing on dull winter days—where light levels might double or even treble exposure times. Sparling's *Theory and Practice of the Photographic Art*

(1856) advised that 'positive printing by the negative method,' as the production of developed prints was known, should only be undertaken by the most skilful. Quoting another eminent teacher on photography, he reported that

> Mr Hardwich advises the amateur to master the manipulation of the ordinary positive process before trying that by development... ... The exposure to light is conducted in the ordinary printing frame: it extends from a few seconds upwards. On removing the negative a very faint image is seen, which develops rapidly when the gallic acid is applied. The development being completed, the prints are well washed and fixed in hyposulphite of soda, one part to four of water. The tint is improved by adding a little nitrate of silver (a few drops of the exciting bath) to the gallic acid towards the end of the process, but a better plan is to tone the prints in the gold bath

The quality of the salt print, correctly exposed and processed, was high, and despite the introduction of the albumen print in 1850, salt prints remained popular with many users well into that decade. Thus, many of the prints published in 1856 after Roger Fenton's trip to the Crimea were developed salted paper prints—and despite problems of fading experienced by many users, many of Fenton's Crimean images retain their original richness.

Albumen printing paper, introduced in 1850 by Blanquart-Evrard of Lille, offered a higher concentration of silver halide, contained within a thin layer of egg-white on the surface of the paper, significantly enhancing the sharpness of the print, and extending the tonal range. Like salt prints, albumen paper could be used either as a printing-out paper or as a developed paper with a significantly shorter exposure. As Blanquart-Evrard's intention in introducing the paper was to introduce commercial production methods, the developed print was the norm, and with it, he claimed to be able to produce in excess of two hundred prints per day from a single negative. That represented a remarkable progression from the original printed-out salt print, where the daily output from a single negative was counted in single figures.

Guidance on the progress of the printed-out image, assessed by inspection, was offered in many manuals. Sparling (1856) advised that

> if the general aspect of the print is a rich chocolate-brown in the case of albumen, a dark slate-blue with gelatine or ammonio-nitrate paper, or a reddish-purple with paper prepared on serum of milk, probably the subsequent colouration will proceed well.

Again, the printing frame was the only piece of equipment necessary—that is until the introduction of the Solar Enlarger in 1857. David Acheson Woodward designed and patented the idea of the solar enlarging camera, able to make enlarged life size prints from

quarter plate and half plate negatives with an exposure of about forty-five minutes. The camera used a mirror and condenser lens to focus sunlight on to the negative, the image being projected on to the paper via a copy lens. Patented improvements to the solar enlarger, in the 1860s and 1870s saw it equipped with a heliostat—a clockwork motor to rotate the mirror—thus ensuring that the light beam remained concentrated on the condenser lens throughout the exposure.

A modification of Woodward's design, introduced in 1864 by Desiré Charles Emanuel van Monckhoven, was the first instrument to really look like an enlarger. Fitted into the wall of the darkroom, it gathered light in the same way as Woodward's apparatus, but used a more complex lens assembly to correct for spherical aberration and thus produce a sharper more evenly illuminated print.

The enlarger, faster printing emulsions, improved processing chemistry and brighter light sources revolutionised the production of prints by the 1890s.

By that time, though, the higher and higher quality and sharpness of the print had prompted some image-makers to revisit the impressionistic quality of the paper negative and salt print, and also to invent, explore and develop alternative readings of the positive image through ink, gum, platinum, carbon and other printing processes. Together, they offered photographers a huge diversity of means of expression by the century's end.

JOHN HANNAVY

See also: Salted Paper Print; Albumen Print; Developing; Enlarging and Reducing; and Permanency and Impermanency.

Further Reading

Hunt, Robert, *A Manual of Photography*, London: Richard Griffin and Company, 1857.

Tissandier, Gaston (translated by John Thomson), *History and Handbook of Photography*, London: Sampson, Low, Marston, Searle & Rivington, 1878, reprinted New York: Arno Press, 1973.

Sparling, W. *The Theory and Practice of the Photographic Art*, London: Houlston and Stoneman; Wm S. Orr and Co, 1856.

Van Monckhoven, Desiré, *Photographic Optics*, London: Robert Hardwicke, 1867, reprinted New York, Arno Press, 1979.

Wall, E.J., *Dictionary of Photography*, London: Hazel, Watson & Viney, 1897.

Blanquart-Évrard, Louis-Désiré, *Procédés employés pour obtenir les épreuves de photographie sur papier, présentés à l'Académie des sciences*. Paris: C. Chevalier, 1847.

Crawford, William. *The Keepers of Light*, New York: Morgan & Morgan, 1979.

Hardwich, T. Frederick. *A Manual of Photographic Chemistry*, London: John Churchill, 1855.

Jones, Bernard E, *Encyclopedia of Photography*, London: Cassell, 1911. Reprinted New York: Arno Press, 1974.

Blanquart-Évrard, Louis-Désiré, *Traité de photographie sur papier*. Paris: Librairie encyclopédique Roret, 1851.

Reilly, James M., *The Albumen and Salted Paper Book: The History and Practice of Photographic Printing, 1840–1895*, Rochester, NY: Light Impressions, 1980.

PRINTING-OUT PAPER

While the idea of printing-out paper is as old as photography itself, such products remain available today, meeting the needs of a small specialist market where the unique characteristics of such papers are still sought after. Today's papers, based on gelatine-silver chloride technology, can trace their lineage back to the 1880s, but the first printing-out papers were used by Fox Talbot in the 1830s.

The term, 'Printing-Out Paper,' and its abbreviated form P.O.P. date only from the early 1890s, when Ilford Ltd in England coined the phrase and introduced it as a trade name for their silver chloride paper, but it has since been applied retrospectively to a large group of printing materials.

The essential and defining characteristic of a printing-out paper is that the image is produced by the action of light alone. There is no chemical amplification of that image by development, the printing going through the simple stages of exposure, fixing and washing, or exposure, toning, fixing and washing, the latter sequence resulting in a richer print colour and greater permanence.

Generally speaking, the earliest printing papers were of very limited sensitivity, requiring long exposures in contact with a paper or glass negative. They could be toned, fixed and washed in relative well-lit spaces, and certainly by candlelight. Thus, such prints were not dependent upon a safe-lit darkroom. Their modern counterparts, however, require to be treated with a greater deference if optimum print quality is to be maintained.

Printing-out papers fall into three categories, two of which are based on silver halide chemistry. The third group comprises processes such as cyanotype (qv), using non-silver-based light sensitive chemistry, where the exposed print is washed to remove soluble salts after exposure.

The two major silver-based groups are salted papers and those papers where the light sensitive chemistry is held in an emulsion or carrier coated on to the surface of the paper itself.

Fox Talbot's salted paper—effectively the same material used to make a negative in the photogenic drawing process—was the first printing process, achieving widespread popularity and almost-universal dominance for more than a dozen years. Although it could be used as a developed paper—with exposure times reduced from hours to seconds—many amateurs and professionals alike continued to use it without development. There

were advantages—the developed image rarely exhibited the extended tonal range of the printed-out version.

The same was true of albumen paper, the first paper to carry the image on the paper surface, and introduced in 1850s by Blanqart-Evrard. Although conceived as a developed printing material—to facilitate printing on an industrial scale—albumen was used by a large percentage of photographers, again amateur and professional, as a printing-out material. It was easier to manipulate, more predictable, and less susceptible to the vagaries of changing chemical strengths and conditions.

Granted, developed papers were faster to use, but only when large production runs of prints from single negatives were being made, were such considerations important. In the home darkroom, or small professional studio, printing was a lengthy process in any case. Salted paper had to be made by hand by the photographer, and while albumen paper could be bought already coated with the albumen layer and some of the chemistry, it had to be sensitised and dried before it could be used.

In 1866, the Frenchman Juan Laurent in collaboration with Spaniard José Martínez-Sánchez perfected 'Leptographic' paper ('Leptofotografía'), a collodio-silver chloride printing paper which was sold ready to use. The light-sensitive silver chloride was held in a binding layer of cellulose nitrate, separated from the paper by a layer of barium sulphate (later known as baryta), giving a much whiter base colour to prints than had been previously possible with albumen paper. The baryta layer acted as a barrier, eliminating the spotting from rusting metal particles in the paper which sometimes happened with albumen papers, and at a stroke, the introduction of this paper removed from the photographer all the paraphernalia of having to sensitize the paper before use, as had been needed with albumen. As the manufacturers claimed it had three times the sensitivity of albumen, exposure times for contact printing could also be reduced significantly. Despite such promise, the paper was not a commercial success, and it would be the 1880s before ready-made silver chloride papers achieved significant popularity.

In 1882, William de Wiveleslie Abney published the procedure for making a gelatine-silver chloride paper, but it did not immediately go into production.

One of the first collodio-chloride papers to achieve success—and very similar in chemistry to Laurent's—was introduced in 1884 by Paul Eduard Liesegang of Dusseldorf, who called his paper 'Aristotype.' In the following year, fellow Germans Ashmann and Offord added gold to their emulsion, and in so doing created a paper which self-toned in the fixing bath, eliminating one of the processing stages.

It has been argued that, after the introduction of commercially manufactured gelatine dry plates, the commercial manufacture of ready-to-use printing papers was driven not by an increase in printing efficiency, but the continuation of the subtle print quality which had been possible with albumen. Collodion and gelatine-based printing papers, when developed, produced a neutral image, whereas when used as printing-out papers, the rich warm brown tones of the gold-toned albumen paper could be imitated.

The year after Liesegang's success, in 1885, the Britannia Works Company in England—forerunner of Ilford Ltd—introduced the first of their gelatine-based silver chloride papers, a product which was replicated throughout the world by several companies. It is the successor of that gelatine-based silver chloride emulsion which persist as a specialist product today.

JOHN HANNAVY

See also: Cyanotype; Salted Paper Print; and Albumen Print.

Further Reading

Hunt, Robert, *A Manual of Photography*, London: Richard Griffin and Company, 1857

Tissandier, Gaston (translated by John Thomson), *History and Handbook of Photography*, London: Sampson, Low, Marston, Searle & Rivington, 1878, reprinted New York: Arno Press, 1973.

Wall, E.J., *Dictionary of Photography*, London: Hazel, Watson & Viney, 1897.

Blanquart-Évrard, Louis-Désiré, *Procédés employés pour obtenir les épreuves de photographie sur papier, présentés à l'Académie des sciences*. Paris: C. Chevalier, 1847

Hardwich, T. Frederick. *A Manual of Photographic Chemistry*, London: John Churchill, 1855.

Jones, Bernard E, *Encyclopedia of Photography*, London: Cassell, 1911. Reprinted New York: Arno Press, 1974.

Blanquart-Évrard, Louis-Désiré, *Traité de photographie sur papier*. Paris: Librairie encyclopédique Roret, 1851.

Reilly, James M., *The Albumen and Salted Paper Book: The History and Practice of Photographic Printing, 1840–1895*, Rochester, NY: Light Impressions, 1980.

PRITCHARD, HENRY BADEN (1841–1884)

Henry Baden Pritchard was born on 30 November 1841 the son of Andrew Pritchard the well-known optician, spectacle and optical instrument maker. He was educated in Eisenach and Lausanne and entered the War Department at Woolwich Arsenal in 1861 at the age of twenty and remained there until his death, superintending the photographic branch. He married Mary Evans in 1873 after meeting her at the house of his friend H.Pp Robinson in Tunbridge Wells.

Pritchard joined the Photographic Society in 1868 and was elected to Council in 1870, he became Honorary Secretary in 1872, returned to Council in 1874 and

was Vice President at the time of his death. Between 1868 and 1877 he published twelve communications in the Society's journal. He was treasurer of the Photographers' Benevolent Association.

In 1880 Pritchard took over as editor of the *Photographic News* after the death of G. Wharton Simpson and extended the journal's reporting of news and scientific coverage. His *The Photographic Studios of Europe* (1882, second edition 1883) was based on his original reports carried in the *Photographic News* between 1880 and 1883. He also edited the *Year Book of Photography* from 1881–1884. Pritchard wrote or edited other photographic technical books and contributed numerous papers to photographic, scientific and other journals. He was elected a Fellow of the Chemical Society in March 1872.

Although his photographic activities were prolific Pritchard also published several novels and a play. He died suddenly of pneumonia at Blackheath, Greenwich, on 11 May 1884 at age forty-three.

MICHAEL PRITCHARD

PROCESS PHOTOGRAM

The precursor to *The Process Photogram* was an ad hoc series of articles and reports in *The Photogram* from its launch in January 1894. Subsequently *The Process Photogram* would claim its launch date as January 1894. *The Photogram* was edited by Henry Snowden Ward who had a particular interest in photo-mechanical processes and he justified its inclusion in what was primarily a photography journal by stating: 'we believe that photo-processes are on the eve of great advancement.' That statement was not misplaced as the 1890s saw a significant increase in interest in all methods of transferring photographic images on to the printed page through a mechanical press using inks. Three-colour work and the reproduction of photographs in periodicals and catalogues were particular concerns of the magazine.

In January 1895 *The Process Photogram* was launched as a separate supplement. Snowden Ward stated: 'The Process Photogram is the outcome of a double wish. Photographic readers wished for less process matter while photo-mechanical readers expressed a wish for more. To meet both we start a new edition at first, with only eight extra pages, devoted to purely process matter.' The initial print run of 1000 was increased to approximately 2000 after A W Penrose & Co offered to send it free of charge to their customers. *The Process Photogram* was strongly practical in its articles and focused on trade news and apparatus, descriptive visits to companies, theoretical articles on, for example, printing screens and reviews of patents, new techniques, processes and equipment. In 1896 the supplement added

'*and Illustrator*' to its masthead which it retained until volume XII number 144 of December 1905. Number 145 of January 1906 number 145 saw the journal being renamed *The Process Engraver's Monthly. The Process Photogram.*

From January 1907 it appeared as a totally separate publication from *The Photographic Monthly* (the successor to *The Photogram*). Its stated aim was to be the representative organ of all who used photo-mechanical and photo-chemical methods of illustration: workers in zincography (line and half-tone), collotype, photolithography, photogravure, Woodburytype and other photo-reproduction processes and to provide an epitome of technical progress and discovery and a means for the discussion of commercial subjects. It's size and pagination was increased and it promised new pictorial, confidential (trade) and special supplements.

The Process Engraver's Monthly, with the subtitle *Process Photogram* until 1947, continued until volume 56 (1956) when it became *Process: the photomechanics of printed illustration,* and from 1961 *Graphic Technology.*

MICHAEL PRITCHARD

See also: Ward, Henry Snowden; and Woodburytype, Woodburygravure.

Further Reading

Walter Koelzer, *Photographic and Cinematographic Periodicals 1840–1940* (in three languages), Köln: Der Foto Brell GmbH, 1992.

PROJECTORS

The projection of glass-based images was already commonplace when photography was introduced. The slide projector, or magic lantern, had been invented in the seventeenth century, perhaps by the Dutch scientist Christiaan Huygens, and was in widespread use in Europe by the end of the century. The popular Phantasmagoria was a ghost-show using lantern projections. Few projectors dating from before 1800 have survived. A typical magic lantern of that date comprised a rectangular or cylindrical metal body containing the illuminant (an oil lamp) capped with a chimney or cowl, hooded to reduce lightspill. The arrangement of the internal components was: concave metal reflector, lamp, then a large glass condenser lens to concentrate the light. The slide stage, an external construction of grooved supports into which long glass painted slides could be moved along, was fixed in alignment with the condenser. In front of the slide stage was the objective, or focusing, lens; a sliding tube containing one or more glass elements.

Soon after the introduction of photography, photographic images were being made on glass. To show

photographic slides at their best, magic lantern lenses needed improvement. Spherical aberration, which blurred the edges of the projected image—more evident with the fine detail of a photograph than with earlier painted scenes—could be reduced when the Petzval lens, designed for cameras in 1841, was adopted for slide projection. Chromatic aberration, causing color fringing—which became more apparent with monochrome photographic images—was corrected with the introduction of achromatic lenses.

In Britain in particular, from the 1850s, many magic lanterns had wooden bodies, usually with a sheet metal lining to protect the wood from the internal flame, with a metal dome top and cowl. These wood-bodied projectors, being cooler externally, were safer to operate. The external metal parts were usually made from brass and lacquered, the device taking on a prestigious appearance, conferring status to the user.

From mid-century, professional users of the lantern—lecturers and showmen—started to employ limelight as an illuminant. Hydrogen and oxygen gases from leather bags (later, metal cylinders), were mixed in the limelight burner to produce a strong flame. This flame played on a small cylinder of quicklime, which glowed white hot. Much brighter than an oil lamp, limelight could produce very large screen images.

Other illuminants introduced included, from the 1850s, the electric arc lamp—though providing the necessary current was difficult and limited its use—and from the 1890s, acetylene.

One important magic lantern, the Sciopticon, developed in the United States in 1869, had a larger condenser than usual to avoid cropping the corners of a projected image and an improved lamphouse for cooler running.

From the 1830s, it became the practise for advanced presentations to use two magic lanterns mounted side-by-side, with a manually-operated rocking double-shutter arrangement in front of the lenses. Each shutter had a serrated edge, and as the shutter unit was operated the image from one projector gradually faded out as the image from its twin projector faded in, producing a dissolve effect. These pairs were difficult for one operator to manage, and in the late 1850s the vertical double or biunial lantern was introduced and eventually became popular. With one lantern above the other, manipulation of the slides was easier. From the 1870s the triple lantern (some versions known as triunials) started to appear from English, German, and later American manufacturers. Some biunial and triunial lanterns had slots in which glass filters could be placed, useful for giving instant color tints to photographic slides.

A different method of construction became popular in the United States. The base of the lantern comprised two parallel metal rods, on which the components—reflector, illuminant, condenser unit, slide stage and focusing lens—were mounted. Each component could slide to and fro, enabling very easy adjustment of their relative positions. Vertically stacked double and triple versions were also manufactured. In America slide projectors—especially biunials—became known as stereopticons, even though the image was not stereoscopic. (Today, the term can lead to confusion as it is also used to mean a hand-held or cabinet 3-D viewing device).

Most early slides were set in wooden frames, but from the 1870s mechanical slide holders made the changing of unframed glass slides easier.

Special lanterns for the projection of opaque pictures and objects, including (from the 1840s) photographic images, were known as episcopes, megascopes, or wunderkameras. Epidiascopes could also show transparent slides.

The first color photographs, made using the additive process by James Clerk Maxwell in Britain in 1861, were projected by means of superimposed slides from three magic lanterns, each with a color filter: red, green, and blue.

From the late eighteenth century, lanterns for domestic use were made in Germany, which continued to be a major producer throughout the nineteenth century, during which production became widespread in England, France, and the United States. Most lanterns for use in the home had simple pressed steel bodies, and used paraffin (kerosene) lamps. The finish was sometimes bare metal in the early days, and later a black 'lacquer' (paint), or a chemically-produced blue metallic effect. From the 1840s to the 1920s, the miniature magic lantern was a popular children's toy. Slides were mostly painted or lithographed, but some later German and English toy lanterns showed photographic slides made in small sizes.

Photographic societies frequently projected slide images made by their members, and this use of the lantern for amateur photography extended its sphere of operation. A specialist use was the projection of microphotographs, by means of a high-power magnifying attachment. Some lantern users, especially those with church and scientific connections, were uncomfortable with the term 'magic,' referring instead to the 'optical lantern.'

Photographic motion pictures came to the lantern screen from 1895–96, and would eventually become a special branch of optical projection. Many early film machines could also show conventional lantern slides, usually by the operator simply pushing the lamphouse from the cinematograph mechanism to the slide stage.

During the twentieth century, the magic lantern evolved into the 35mm slide projector.

STEPHEN HERBERT

See also: Lantern Slides.

Further Reading

Crangle, Richard, Stephen Herbert, David Robinson (eds.), *Encyclopaedia of the Magic Lantern*, Ripon: The Magic Lantern Society 2001.

Crompton, Denis, Richard Franklin, and Stephen Herbert, *Servants of Light: The Book of the Lantern*, Ripon: The Magic Lantern Society 1997

Guerin, Patrice, *Du Soleil au Xenon: Les techniques d'éclairage à travers deux siècles de projection*, Paris: Prodiex 1995

Hecht, Hermann (ed. Ann Hecht), *Pre-Cinema History: An Encyclopaedia and Annotated Bibliography of theMoving Image Before 1896*, London: Bowker Saur / British Film Institute 1993.

Herbert, Stephen (ed.), *A History of Pre-Cinema* (3 vols), London: Routledge 2000.

Hrabalek, Ernst, *Laterna Magica: Zauberwelt und Faszination des Optrischen Spielzeugs*, Munich: Keyser 1985.

Mannoni, Laurent, *Le mouvement continué: Catalogue illustré de la collection des appareils de la Cinémathèque française*, Milan: Mazzotta 1996.

Mannoni, Laurent (trans. by Richard Crangle), *The Great Art of Light and Shadow: Archaeology of the Cinema*, Exeter: University of Exeter Press 2000.

New Magic Lantern Journal. London/Ripon: April 1978 (ongoing).

Optical Magic Lantern Journal and Photographic, London: 1889–1903

PROUT, VICTOR ALBERT (active 1850s–1860s)
English photographer

Prout was an early professional photographer largely recognised today for his three distinct early 1860s publications: *The Interior of the Abbey of Westminster: The Thames, from London to Oxford, in Forty Photographs,* and *Mar Lodge, August 1863. A series of photographs illustrating the visit of their Royal Highnesses the Prince and Princess of Wales to Mar Lodge, the seat of the Rigfht Hon.the Earl and Countess of Fife, during the Braemar Gathering of 1863.* The Westminster Abbey folio, published by P.&D. Colnaghi & Co.Ltd. in 1860, contained 23 albumen prints showing the abbey's ancient monuments. Prout made good use of the dramatic natural light for these early interior views. Later, photographs from this series were published as stereos by the publisher James Elliott. The most distinctive of his works is undoubtably the unique series of 40 panoramic views of the Thames, England's greatest river. The publication is not dated but was produced around 1862 in two parts and published by Virtue & Co. The tranquil wide-angle views were made with a special panoramic camera built for Prout by London opticians Ross & Co.When first published the Thames river photographs were not credited to Prout but have been attributed to him since. The Mar Lodge publication contained 70 studies, ranging in size from carte-de-visite to whole-plate, were published by Prout in 1864. The tableaux-style photographs were staged for the camera by the actor and artist the Hon. Lewis Wingfield (1842–1891). All of Prout's known images are well-executed, exhibiting good technique and careful use of daylight to produce his collodion negatives. He exhibited his architectural studies along with copies of paintings at London photographic exhibitions between 1856 and 1862 and operated a portrait studio at 15 Baker Street, Portman Square, London from 1862–1865. Prout was able to produce a wide range of high-quality work, all of it artistic in style and content. However, he seems to have had little commercial success and in the mid 1860's moved to Australia and worked as a studio photographer with Freeman Brothers in Sydney from around 1866. He is known to have made the only photographic portrait of the colonial artist Conrad Martens.

IAN SUMNER

PULITI, TITO (1809–1870)
Italian

Tito Puliti (1809–1870) trained as a pharmacologist before becoming an assistant in the Royal Museum of Physics and Natural History in Florence. There, on 2 September 1839, in the presence of Giovanni Battista Amici, he made the first daguerreotypes in Tuscany—and probably the first in Italy—by following instructions received the day before. On 7 October, in the third session of the first meeting of the Society of Italian Scientists, which was held at Pisa under the patronage of Archduke Leopoldo II, Puliti exhibited his daguerreotypes to the delegates, having already shown them at the Accademia delle Belle Arti in Florence. At the end of the session he was invited to demonstrate the process on 10 October by taking a daguerreotype of the Cathedral buildings from the hospital of Santa Chiara.

GRAHAM SMITH

PULMAN, GEORGE (d. 1871)
English-born photographer

George Pulman was originally from Manchester, UK, and travelled to New Zealand after the Land Wars of the 1860s. In 1867 he commenced business with his wife, Elizabeth Pulman, as the proprietor of a photographic studio in Shortland Street, Auckland, specialising in topological and portrait photography. Upon George's death on 17th April 1871, Elizabeth took over the photographic business, which went on to become one of New Zealand's most influential studios. In later years Elizabeth was aided by her son Frederick Pulman. Although there is a large archive of surviving photographs held in museums, particularly of their

Maori portraits, as the photographs were identified under the studio name it is difficult to assign whether the photographer was George, Elizabeth, or Frederick Pulman. However due to their flattering and sympathetic style of portraiture that allowed the personality and individuality of the sitter to come through, it appears that they were commissioned by a large number of Maori clients. To emphasise the Maori identity of individuals the studio owned and used cloaks, hei tikis (pendants), meres (clubs), taiahas (spears), and huia feathers so that they could enhance the 'Maoriness' of those portrayed. The Pulman Studio was sold shortly before Elizabeth Pulman's death in 1900, including a selection of landscape negatives that were purchased and subsequently reprinted by the New Zealand Government Tourism Department.

JOCELYNE DUDDING

PUMPHREY, WILLIAM (1817–1905)
English photographer

Born on February 4, 1817 in Worcester, the son of a Quaker glove-maker, William Pumphrey held the daguerreotype licence for York from 1849—only the second photographer to operate in the city—having acquired the photographic interests of Samuel Walker the licensee since 1844.

Before taking up the new profession of photography, Pumphrey had trained as a science teacher, and taken up a teaching position in York in 1845. When William Henry Fox Talbot relaxed his calotype licensing terms in 1852, Pumphrey started to exploit the process producing and publishing portfolios of views of the architectural heritage of York and its environs. The earliest dated examples of this aspect of his work date from October of that year.

Throughout 1853, he published a sixty-image part work of these views, but by the following year he is believed to have sold his studio and taken up a position as superintendent of an asylum.

Thereafter his enduring interest in photography appears to have been as an amateur. In 1866 he organised an exhibition of art and industry in York, including a number of his own stereoscopic views. A second exhibition in 1879 was also successful.

He retired to Bath in 1881, and moved to Bristol in 1895 where he died ten years later on 28th March.

JOHN HANNAVY

PUYO, ÉMILE JOACHIM CONSTANT (1857–1931)
French photographer

Émile Joachim Constant Puyo was born in Morlaix in 1857 and died in 1931. He was a French Army officer, serving first in artillery, being after promoted to commander (Commandant was sometimes used as his nickname). He served in Algeria them returned to Paris to the commanding office. He practiced photography from 1887 and ended leaving the army in 1902 to pursuit a photographic career.

Entered the *Photo-Club de Paris* in the mid 1890's. This association published the *Revue Française de Photographie* were he published many photographs as well as technical articles. In these texts he promoted pictorialism, as an aesthetic, was well as a *technically* based movement. In 1896 Puyo wrote *Notes sur la Photographie Artistique*, the first of many articles and books on equipment and processes that he would publish throughout his career.

Along with Robert Demachy he was one of the best known French pictorialist photographers photographing folk types, landscapes and mostly the female figure. He was a pioneer of several painterly processes, mostly bromoil, used by their ability to create an unrealistic rendering, closer to painting than to photography. He used soft-focus lens in order to achieve the same goal. His work was widely successful and he was published in many countries outside of France including Alfred Stieglitz's *Camera Work*. He participated in many exhibitions, including a group show promoted by Stieglitz in 1906 and a 1931 Paris retrospective with Demachy.

He continued to practice pictorialist photography after World War I, after his friend Demachy abandoned photography and the Photo-Secession in New York ended.

His work is now present in many collections, including 160 images in the French *Médiathèque de l'architecture et du patrimoine*.

NUNO PINHEIRO

Q

QUINET, ACHILLE LÉON (1831–1900)
French photographer and studio owner

Born in 1831, Achille Quinet was a successful photographer who operated a studio at 320 rue St Honoré, Paris from about 1869 to 1879. Although Quinet made photographs of the moments and architecture of Paris as well as a series of views of Italy, he is best known for his landscape, animals and figure studies, many of which were made in or around the town of Barbizon and the forest of Fontainebleau. These photographs, which were likely intended as aids to painters, are generally albumen prints mounted on blue card stock, with the stamp "Étude d'Après Nature' as well as a red rubber stamp of his name. Some images are mounted on white stock with the blind stamp "A le. Quinet fils."

A member of the Sociéte Française de Photographie from 1876 to 1894, Quinet exhibited his work at the universal exhibition of 1878. Most of Quinet's work is housed at the Bibliothèque Nationale, Paris, where he deposited his *Etudes* at the Depôt Légal in 1868, 1875, and 1877. Quinet's work is occasionally confused with that of his contemporary, Constant-Alexandre Famin. While the pair made photographs with similar subject matter, general stylistic differences distinguish the two. It is possible that Quinet, acting as a publisher or distributor, placed his own stamp on works made by Famin. After 1879, Quinet moved to Cély, near the Forest of Fontainebleau, where he died in 1900.

SARAH KENNEL

R

RAMON Y CAJAL, SANTIAGO (1852–1934)

Santiago Ramon y Cajal (1852–1934) is famous in Spain as its sole Nobel Prize winner. He shared the prize in Medicine in 1906 with Golgi. His professional practice was a principal but not sole driver of his interest in photography.

His passion for photography dated back to his childhood, with his introduction to the amazing detail of daguerreotypes. He practiced many of the various process advances as they came along, including 'inhaling the delicious aroma of collodion' and then the beautiful gelatine-bromide emulsions.

He was important for photography in Spain and internationally as he experimented with and published papers and books on numerous processes in the late 1800s and early 1900s, especially in stereo and in the new color technologies as they emerged, and in his pursuit of color images of microscopic subjects. He promoted photography in Spain, and when the Photographic Society of Madrid was founded in 1899 (later the Royal Photographic Society) he was named honorary President.

He experimented with many processes, especially the Autochrome process, and contributed to getting consistent results with the Lippmann process. With his skills as a microscopist it was easy for him to section his Lippmann images and directly show their internal layered structure (others who published such sections included Edgar Senior, Richard Neuhauss, Herbert Ives and Hermann Krone). Some of his conventional images, including a beautiful autochrome self-portrait, are in the collections of the Instituto Cajal in Madrid. His draft for his book on color photography (1912), held at the National Library, is hand illustrated in color. A view of it is reproduced in Sougez's *Historia de la Fotografía* (1991).

Besides the book, which received wide use in Spain, and his articles in technical journals all over Europe, he published a number of articles on photography, stereo photography and color photography in popular Spanish journals.

His Nobel was for his pioneering efforts in the development of contrast-enhancing stains for microscope slides and for his drawings of the microscopy of the human nervous system, including the delineation of neurons and their connections. These drawings still set a standard for accuracy in current medicine, and his stains are still in use. He and Golgi were at odds over the nature of the neuronal system. Cajal's viewpoint is more in line with the modern one.

WILLIAM R. ALSCHULER

See also: Daguerreotype; Spain; and Neuhauss, Richard.

Further Reading

Ramon y Cajal, S., *La Fotografía de los Colores*, Madrid: Moya, 1912. (reprinted: Madrid: CLAN, 1991)

——, *Las placas autocromos de Lumiere y el problema de las copias multiples* [*Lumiere Autochrome plates and the problem of multiple copies*], in *La Fotografía*, Madrid: no. 73, October 1907.

Sougez, M.-L., *Historia de la Fotografía (History of Photography)*, (4th ed.), Madrid: Catedra, 1991.

RAOULT, JEAN (IVAN PETROVICH) (active 1860s–1880s)
Professional photographer

French by birth, Jean Raoul was owned a photographic studio in Odessa in 1860-1880s. He created ethnographic photographic studies in many areas of Russia. In late 1870s Raoul published the album "Collection de

1183

types des Peuples de Russie, Roumanie et Bulgarie," a collection of "folk types," shots of everyday life and surroundings, mostly from Russia's south, which consisted of more than 200 photographs. Raoul's photographs of 1880s depicting landscapes, the people and the antiques of the Caucasus, the Crimea and the Volga river were also assembled into albums. In 1877–1878, during the Russian-Turkish War, Raoul travelled to Romania and Bulgaria where he photographed the military actions of the Russian forces. In 1879–1882 during the expedition to the Northern Caucasus, Georgia and Armenia and later to Athos and Palestina devoted to the searching for the Christian antiques Raoul was a photographer accompanying Prof. N. P. Kondakov. In 1884 staying in Constantinople after one of Kondakov's expeditions, Raoul decided to returne to France. In 1890s he owned a photographic studio in the south of France. He won prices at the Paris Geographic Exhibition (1875) and at the World Exhibition in Paris (1878) for photographs of people of Moldavia, Bessarabia and Odessa.

ALEXEI LOGINOV

RAU, WILLIAM HERMAN (1855–1920)
American photographer

William Herman Rau, a successful commercial photographer, was born in Philadelphia, Pennsylvania on January 19, 1855 to German and Swiss immigrant parents Peter and Mary Elizabeth Witschi Rau. He began his photographic career at thirteen as an assistant to Philadelphia photographer William Bell, and in 1874 served as a photographer with the United States government's Transit of Venus expedition in the South Pacific, the first of many photographic journeys. In 1881 he and Philadelphia photographer Edward L. Wilson embarked on a photographic trip through the Middle East, and Rau made subsequent photographic journeys to many other countries including Belgium, Germany, France, the Netherlands, Italy, England, and Mexico. In 1891 and in 1893 he received the important commission of photographically documenting the Pennsylvania Railroad's lines for promotional purposes, and in 1895 received a similar commission from the Lehigh Valley Railroad. Rau also served as the official photographer for the 1904 St. Louis World's Fair and the 1905 Louis and Clark Exposition. From 1886 until his death he operated a busy commercial studio in Philadelphia with an extensive stock of lantern slides. Rau was active in photographic associations including the American Lantern Slide Interchange and the Photographic Society of Philadelphia. William Rau died in Philadelphia on November 19, 1920.

SARAH J. WEATHERWAX

READE, JOSEPH BANCROFT (1801–1870)
English chemist

The Reverend Joseph Bancroft Reade was born in Leeds, Yorkshire, and was ordained as a deacon in the Church of England at the age of twenty-four.

His interests in chemistry date from an early age, and interests in science and microscopy endured for most of his life. He served as President of the Royal Microscopical Society in 1869 and 1870.

Of particular interest in considering his engagement with photography is a letter he wrote in 1839, quoted by Sir David Brewster in 1847, describing a photographic process involving the use of silver nitrate and gallic acid, and which was fixed with 'hypo.' Brewster asserted that Reade's successful experiments may have predated Talbot's calotype patent by up to two years. It was later claimed that, having lectured on his process in 1839, Reade had 'published' his process before Talbot's patent was granted.

Research has demonstrated, however, that the reports of Reade's lecture and letter were partial and the dates incorrect. His process was a modification of Talbot's *photogenic drawing* process, and his reference to hypo post-dated Herschel's publication of his researches on the chemical.

Notwithstanding that, Reade's 'priority' was quoted by lawyers for Martin Laroche in the court case *Talbot v Laroche* in 1854, in an attempt to undermine Talbot's legal position.

JOHN HANNAVY

REEVE, LOVELL AUGUSTUS (1814–1865)
English publisher of photography

Through his many publications Lovell Reeve advanced public expectation of the photographically illustrated book.

Born in London, Reeve was apprenticed to a grocer, but his interests quickly focused on natural history and his first book, *Conchologia Systematica,* was published in 1842 or 1843. His interest in shells and natural history in turn led to an engagement with stereoscopic photography.

His first book as publisher, in 1858, was Charles Piazzi Smyth's *Tenneriffe: An Astronomer's Experiment,* the first book to be photographically illustrated with stereographs. It presented twenty pairs of prints mounted on the octavo pages of the book, and Reeve initially commissioned Negretti & Zambra to design and manufacture a stereo viewer especially for viewing book-mounted images.

The Stereoscopic Magazine first appeared in July 1858, and continued until early 1863, publishing three stereo images per month, by Fenton, Howlett and others, with accompanying texts 'by Writers of Eminence.' Reeve also published periodic sets of stereo cards under the umbrella title *The Stereoscopic Cabinet*.

The Conway in the Stereoscope with text by James Davidson and twenty stereographs by Roger Fenton, was published in 1860, and additionally contained advertisements for other proposed publications and sets of images, several of which are presumed never to have been published. Many of the images from the book were re-published in *The Stereoscopic Magazine*.

<div style="text-align: right">JOHN HANNAVY</div>

RÉGNAULT, HENRI-VICTOR (1810–1878)
French photographer and scientist

Henri-Victor Régnault was born on 31 July 1810 in Aix-la-Chapelle (now Aachen, Germany). Régnault, who used the given name "Victor," was the only son of André Privat Régnault, a military geographic engineer in Napoleon's Imperial Corps, and Marie Thérèse Massardo. His father died on the Russian campaign in 1812 and his mother died six years later, leaving the eight-year-old Victor and a younger sister without family or means. In 1830, Régnault won entrance to the prestigious École polytechnique. Graduating third in his class, he continued his training as an engineer at the École des Mines, where he studied with the celebrated chemist L.-J. Gay-Lussac. After his election to the Chemistry section of the Académie des sciences in 1840, Régnault turned his interest to the emerging field of experimental physics. His major research topics were patently useful to the state's plans for industrial development, and brought him lucrative government research commissions. Régnault also received multiple academic appointments, including Gay-Lussac's coveted chair in chemistry at the École polytechnique (1840), and the chair in physics at the Collège de France (1841).

Like many of his academic colleagues, Régnault was captivated by the promise of photography as a tool of empirical science. Known as a master of precise scientific method and measurement, Régnault would apply this talent to refining the inexact practices of early photography. In 1841, when William Henry Fox Talbot sent Jean-Baptiste Biot samples of his photographic paper, Biot passed them on to Régnault, who was already experimenting with daguerreotypy. Régnault soon adopted Talbot's paper negative process and in 1843, Richard Calvert Jones wrote to Talbot from Paris, telling him he had been making calotypes with Régnault and Hippolyte Bayard. Little else is known of Régnault's photographic activities prior to 1847, when Louis-Désiré Blanquart-Evrard devised improvements to the English process that circumvented Talbot's patent restriction in France. Régnault was charged with examining Blanquart-Evrard's process for the Académie in April of 1847. He subsequently became one of the most avid practitioners of paper negative photography and contributed at least fourteen images to Blanquart-Evrard's Imprimerie Photographique editions in the early 1850s.

In January of 1851, Régnault joined a diverse group of artistic, literary, and scientific figures in founding the Société héliographique, which precipitated a sudden increase in his photographic activities. Always worried that he was not devoting his full energy to his scientific career, Régnault claimed that did not take up photography for pleasure, but because he intended to illustrate a physics textbook with photographically derived illustrations, for which he invented a method of chemically reducing photographs to line drawings. This project, while never realized, may be connected with ten photographs of staged acoustic experiments Régnault made in 1851. Two substantial portrait series also date from this time: portraits of his colleagues in science and academe, and a large group of intimate portraits of his family. He also contributed two methods to the technical discouse: the use of pyrogallic acid (which quickly superceded gallic acid as the premier developing agent) and the use of a vacuum pump in uniformly sensitizing photographic paper.

In 1852, Régnault's photographic and scientific careers came together with his role as a government arts administrator when he was appointed to the prominent directorship of the state-owned Manufacture Impériale de porcelaine de Sèvres. At Sèvres, he found another devoted calotypist in Louis Robert, the head of the painting atelier, who had begun working in photography around 1850. Both men frequently photographed the factory environs in the early 1850s. Régnault also took advantage of the pastoral scenery around Sèvres to create his most artistically ambitious images: large format (approximately 35 × 44 cm), atmospheric landscapes of the Seine and woodlands around Sèvres. Several of these lush landscapes were exhibited in London in 1852 and 1853, courtesy of Régnault's friend John Stewart. These appear to have been the only public exhibitions of Régnault's work in his lifetime. His photographic practice was essentially private, notwithstanding his role as a central figure and technical expert in photographic circles of the 1850s.

Régnault accepted the presidency of the newly formed Société française de photographie (S.F.P.) in 1855. With their unanimous vote, the new society's members recognized Régnault's ability to bridge the concerns of science, art, and industry, a goal that would

be precisely served by Régnault's involvement in the highest circles of power in the Académie des sciences, Académie des beaux-arts, and the Second Empire government. With his ties to British photographers such as Sir John Herschel and Sir David Brewster, Régnault would also serve as a link between the British and French photographic worlds. His scientific expertise and faith in empirical method, moreover, made him a superior technical expert, and he duly focused his efforts for the S.F.P. on extracting rational methods and practices from the informational disorder surrounding the nascent medium. In this way, he presided over the field of European photography for nearly fifteen years, guiding discussions of technical, professional, and occasionally aesthetic concerns and serving as arbiter of all debates presented to this most influential photographic organization on the Continent.

Although he is known to have practiced wet plate photography and other process variants as they appeared in the late 1850s and 1860s, Régnault's principal photographic work was confined to his paper negative photography of the early 1850s. Increasing professional obligations and poor health curtailed his leisure photography after 1855, but he continued to serve actively as president of the S.F.P. until his resignation in 1868. Crushed by the death of his son, the celebrated painter Henri Régnault, in the Franco-Prussian War, he withdrew from public life and died in 1878, on the seventh anniversary of Henri's death.

Without exhibition reviews or other discussions of his work in the photographic press of his day, Régnault's photography was overlooked by historians until the late 1970s.

LAURIE DAHLBERG

Biography

Victor Régnault was born on 31 July 1810, in Aix-la-Chapelle, France (present-day Aachen, Germany). A devoted experimental chemist and physicist in the Académie des sciences, Régnault first experimented with daguerreotypy around 1840. Introduced to paper photography in 1841 by J.-B. Biot, who gave him samples of Talbot's sensitized paper, Régnault eventually became a serious practitioner of calotypy, which he applied to multiple purposes in the early 1850s, including scientific use, portraiture, still life, and landscape. He was a founding member of the Société héliographique in 1851, and the first president of the Société française de photographie (1855-1868). Appointed director of the state porcelain factory at Sèvres in 1852, Régnault also experimented with vitrifiable photography and convinced the state to allow photographic documentation of the Sèvres wares. A technical expert and authority, Régnault experimented with all photographic processes, but only his paper photography survives. He died in 1878.

See also: Calotype; Robert, Louis; Société héliographique; and Société française de photographie.

Further Reading

Bajac, Quentin, "La photographie à Sèvres sous le second Empire: du laboratoire au jardin," *La revue du Musée d'Orsay* 5 (Autumn 1997): 74-85.

Bulletin de la Société française de photographie, no. 1, April 1982 [special issue devoted to Victor Régnault]

Dahlberg, Laurie, *The Bull in the China Shop: Victor Régnault and the Culture of Photography, 1840–1870* (MS currently under review),

Jammes, André, "Victor Régnault, Calotypist." In Van Deren Coke, ed., *One Hundred Years of Photographic History: Essays in Honor of Beaumont Newhall*. Albuquerque, NM: University of New Mexico Press, 1975: 77–83.

Jammes, André and Eugenia Parry Janis, *The Art of French Calotype*, Princeton, NJ: Princeton University Press, 1983.

Musée des Arts Décoratifs, *Victor Régnault 1810–1878, Oeuvre Photographique*, essays by Romeo Martinez and Pierre Gassman, Paris: Musée des Arts Décoratifs, 1979.

REID, CHARLES (1837–1929)
Scottish

Charles Reid was born at Turriff, Aberdeenshire in 1837 and operated a photographic studio in Wishaw, North Lanarkshire.

Reid specialised in animal studies and it is for these small albumen and large carbon prints that he is known today, producing a large quantity of high-quality studies of sheep, cattle, birds, horses etc. The resulting prints are usually monogrammed C.R. and numbered in the negative. Many were printed and published by G.W. Wilson and Company.

Reid's pictures are always well composed and show good technique and many examples of his small studies were purchased by artists as reference for their paintings and sculptures. His large carbon studies of Highland cattle and sheep graced many late Victorian parlours.

Reid travelled extensively around Scotland and the North of England finding suitable animal subject matter and he showed considerable patience in working with a wide range of creatures and producing such good quality work, which rarely shows a hint of blur. He exhibited his photographs in the 1880/90's and also gave lectures to the Edinburgh Photographic Society during this period. He published an article 'Some Notes on Animal Photography' in The Practical Photographer in 1895.

His sons continued his business well into the 20th Century.

IAN SUMNER

REJLANDER, OSCAR GUSTAV
(c. 1813–1875)

Oscar Gustav Rejlander was born in Sweden. Little is known about his early years, but as a young man he studied painting on the continent, where he became familiar with the work of the old Masters, whose influence is apparent in some of his best known photographs. His career as a photographer began when he was thirty-nine, and was centered in Wolverhampton and London. Rejlander was an ingenious photographer who produced a highly diverse body of work that included portraits, genre scenes, figure studies, allegories and literary illustrations. His versatility is a reflection in part of the difficulties he and other photographers of the period encountered as they tried to earn a living from this fledgling medium.

Rejlander is most often remembered for inventing combination printing, a process in which different plates are painstakingly combined into a single, integrated image. Beyond making good exposures and prints, issues of scale and consistent lighting (and shadows) were essential in creating convincing final prints. Rejlander's successful combination prints are remarkable considering the complexity of the wet plate process, long exposure times, and fleeting lighting conditions. Combination printing required careful conceptual work of the final image, along with a good deal of skill and patience in its execution, and Rejlander's background as a painter no doubt were helpful in both regards.

Rejlander's best-known photograph, *The Two Ways of Life* (1857), was a combination print painstakingly

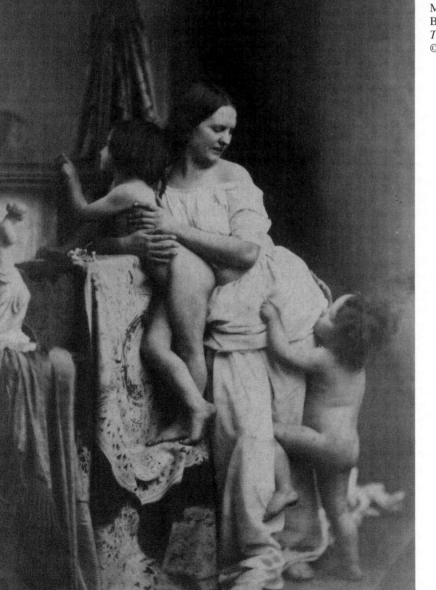

Rejlander, Oscar Gustave. The Madonna and Child with St. John the Baptist.
The J. Paul Getty Museum, Los Angeles
© *The J. Paul Getty Museum.*

assembled from over thirty separate plates. The final print evokes after Rafael's *School of Athens,* but Rejlander's allegory had an expressly Victorian flavor, with one side representing virtuous activities like reading and tending to the sick, while the other side depicts several deadly sins. The inclusion of languorous, bare-breasted nudes provoked a fair amount of controversy when it was first shown, even though Queen Victoria found sufficient merit in *The Two Ways of Life* to purchase a copy for Prince Albert, who reportedly kept it on his wall for the rest of his life.

Many of Rejlander's other photographs are equally innovative. Rejlander grasped in prescient ways the potential of the photographic medium to capture an unfolding scene or even stop action long before such images were technically possible. In many of his genre studies he conveys a sense of spontaneity in a scene, despite the cumbersome wet collodion process and slow exposure times. In a picture like *The Juggler* (c. 1855) he constructed an effective illusion of a man juggling several decades before such images were technically possible. Rejlander's accomplishment lay in his ability to *conceive* of such images as natural extensions of photographic seeing.

Many of Rejlander's genre pictures and portraits involve children, a photographic subject that was very popular with the masses as well as photographers like Hill and Adamson, Charles Dodgson, and Julia Margaret Cameron. Here again, he experimented with various moods, ranging from depictions of angelic children (again evoking Rafael) to poor waifs who could easily populate the novels of Charles Dickens. He photographed children at play, at rest, in the nude, and at their mother's breast. His most commercially successful photography, *Jinx's Baby*, depicted a small child in the midst of a howling cry. This photograph was one of roughly eighteen pictures which Rejlander produced as illustrations for Charles Darwin's *The Expression of the Emotions in Man and Animals* (1872).

Rejlander brought a sense of humor to photography, a rarity among 19th century photographers, who were a rather somber and serious lot. Only Nadar, among Rejlander's contemporaries, expresses a comparable *joi de vivre* in his photographs. In one combination print, *O. G. Rejlander Presents O.G. Rejlander* (c. 1871), he theatrically presented himself as an alter-ego militia man. In *Happy Times*, he and his wife, both well into middle age, smiled jauntily at the camera with unmasked good humor. Rejlander depicted scampish children being chastised by cranky, outraged elders. Rejlander also enjoyed satire: in *Did She? (c. 1862)*, two men gossip and snicker about some unsuspecting young lady, while *The Empress Nicotena (c. 1857)* depicted an old and weathered crone holding a mask of youth in front

of her face with one hand as she reached for tobacco with the other.

Some of Rejlander's studies convey a sense of sexuality that defy the typical Victorian stereotypes. Rejlander's approach was at times light-hearted, as in *Washing Day* (c. 1855), where a two older women washed clothes in the foreground while a younger woman hung hosiery on a line to dry while openly flirting with a young man. Some of his studies of paired, unclad women suggest lesbianism, and one light-hearted photograph featured two soldiers who flank a third man who is dressed as a woman. Masturbation was clearly implied in *The Bachelor's Dream* (c. 1860), where a sleeping man reclined beside a dress hoop populated toy female figures, his hand resting on his groin. Paintings or photographs that address issues such as these are extremely rare in Victorian England, or even on the Continent, where the underground traffic in photographic pornography was more developed.

Despite a lengthy and prolific career, which included several published essays on photography, Rejlander died impoverished and largely forgotten. The press complained about what they perceived to be shoddy technique, and others questioned some of his subject matter. Rejlander's positions on the artistic potential of photography were controversial in some quarters, and his adventuresome efforts to expand the range of photographic expression no doubt confounded some of his peers. Peter Henry Emerson's scathing review in 1890 of Rejlander's posthumous, four hundred print retrospective sealed his fate for several generations of Modernist photographers and historians.

In his published writings, Rejlander was a consistent champion of photography's legitimate role in the production of art by painters and, increasingly, photographers themselves. Like Arago and Talbot, he grasped reflexively some of the possibilities of photography, both in the ambitions of combination printing and naturalistic, "stop-action" scenes, and in his ability to achieve psychological insight in a broad variety of photographic genres.

DAVID L. JACOBS

See also: Cameron, Julia Margaret; Dodgson, Charles Lutwidge; Hill, David Octavius, and Robert Adamson; and Victoria, Queen and Albert, Prince Consort.

Further Reading

Jones, Edgar Yoxall, *Father of Photography: O. G. Rejlander.* Newton Abbot, Devon: David and Charles (Holdings) Ltd., 1973.

Oscar Gustav Rejlander. Stockholm: Moderna Museet, 1998.

Spencer, Stephanie, *O. G. Rejlander: Photography as Art.* Ann Arbor: UMI Research Press, 1981.

RELVAS, CARLOS (1838–1894)

Carlos Augusto de Mascarenhas Relvas e Campos (1838–1894), was the best know 19th Century Portuguese amateur photographer. He was a very rich farmer and a nobleman from Ribatejo in central Portugal. His enormous wealth allowed him the time and resources for an important photography practice, including the building of the exotic and magnificent House of Photography, entirely dedicated to his photography. He was initiated in photography, using wet collodium, most likely by W. CifKa in the early 1860's. During his life he experimented with most new photographic processes: Collotype, Gum, Carbon, and Gelatin.

As an amateur he was not constrained by the limitations of a daily portrait business and embraced most of the acceptable genres of 19th Century photography: Portraits of family and friends, including the royal family, landscapes and folk types. These were many times performed by his servants and employees, he photographed in the studio, many times with painted backdrops. One of the most important parts of his work consists in art reproductions, being the photographs he made of the tomb of the King Pedro I and his mistress Inês, he made in 1868, some of the first of that genre. He also made the 52 photographs of the decorative arts exhibition in Lisbon. His photographs where part of the Fine Arts Academy in Lisbon report on northern Portugal monuments. Carlos Relvas participated in many exhibitions in Portugal and abroad, including the Paris Universal Exhibition in 1876, and the Vienna Universal Exhibition were he won prizes.

In 1884 organizers of the Portuguese first national photography exhibition invited him has an honorary president and only after his refusal turned to the king Ferdinand. He died in 1894, after a horse accident.

Due to family quarrels most of his negatives were sold after his dead and many were lost. Even so a large amount of then are in Portuguese national institutions and a major exhibition was held in 2003 in Lisbon's Ancient Art Museum.

NUNO DE AVELAR PINHEIRO

Exhibitions

Carlos Relvas e a Casa da Fotografia, Museu Nacional de Arte Antiga, Lisbon, 2003.
Renjø, Shimooka; See Shimooka Renjø.

RETOUCHING

The retouching of photographs was a habitual and extensive practice. The aesthetics and practices of retouching can be separated into two broad periods. The first is from the early 1850s to the early 1860s. The second is from the 1870s onwards to the end of the century. Separating the two phases are differences in the practical process of retouching, and its impact upon perceptions of photography.

The reworking of photographs was a prominent concern as early as the 1857 Art Treasures exhibition. During the 1850s, retouching was a term covering various forms of manipulation, including colouring. Of the 240 portraits exhibited in Manchester, a large number had been altered. A review in the *Liverpool and Manchester Photographic Journal* drew attention to both the number of touched photographs and the extent of their alteration. It noted that, in some cases, "no trace of the original picture is visible, its only use apparently being to secure identity and truth, the visible picture being laid over the other in oil and water-colour" ("Exhibition of Art Treasures at Manchester," 126). At this stage, most manipulation would have been carried out on the positive print rather than on the glass-plate negative.

Coloured photographs were intended to alleviate the unflattering and mechanical harshness of the monochrome picture. The practice thereby made the resultant pictures more akin in appearance and status to miniature portraits. As such, colouring reflects photography's initial subservience to the dominance of fine art aesthetics. In 1862, the *London Review* claimed that coloured photographs approached more closely to oil paintings because they were the result of study and generalisation, which were qualities lacking in an ordinary photograph. On a more pragmatic level, miniature painters put out of business by photography found themselves employed by photographic studios. In 1857, Elizabeth Eastlake claimed that there was no photographic establishment that did not employ artists for finishing pictures, at salaries of up to £1 a day.

In order to counter the hybridity of coloured pictures, there were numerous claims that the realism of photography was its unique element. Manipulation of photographs was felt to undermine the most valuable quality of the medium. Efforts were consequently made by the Photographic Society of London to prevent any retouched photographs being shown at their annual exhibition. The rules of entrance for the 1857 exhibition at South Kensington, for example, included precise instructions regarding retouched photographs. They would be admitted only if accompanied by untouched copies of the same picture. Positive pictures from touched or painted negatives also had to be described accordingly. These instructions continued to be repeated but judging by the complaints of some reviewers they were far from being universally followed. In 1864, the Photographic Society of London debarred from their annual exhibition any coloured or touched pictures. Although the effect was a much reduced exhibition, the rules did enforce

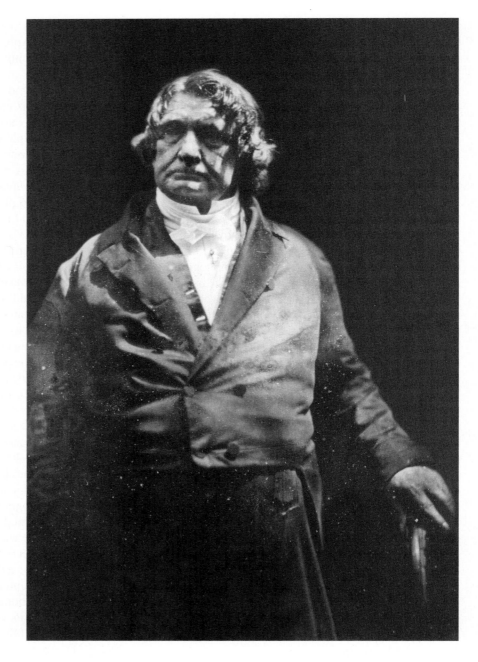

Southworth, Albert Sands and Josiah Johnson Hawes. Lemuel Shaw. *The Metropolitan Museum of Art, Gift of Edward S. Hawes, Alice Mary Hawes, and Marion Augusta Hawes, 1938 (38.34) Image © The Metropolitan Museum of Art.*

a pure photographic aesthetic where there was a clear demarcation between "real" and fabricated pictures.

Despite the efforts of some members of the photographic community, retouching, and debates upon its efficacy and honesty, were commonplace during the 1850s and 1860s. In the *carte-de-visite* era, methods could be as crude as the retouching of eyes by putting pinpricks in the negative. During the 1870s and 1880s, retouching continued to be prevalent. This second phase of retouching differed from the early years of photography though in that the dominant means of manipulation was through working upon the negative rather than painting upon the positive print. Photographic manipulation became particularly common after the introduction of the dry-plate

negative in the early 1870s because these were easier to rework than the existing wet-plate negatives.

In addition the technical ease with which retouching could now be carried out, the introduction of a larger format of cabinet photograph presented a greater threat to a sitter's vanity. Any blemishes or wrinkles were more likely to be evident. The value of producing of flattering pictures certainly encouraged the widespread use of retouching. As the *Photographic News* put it in 1872, photographers knew that "those portraitists who retouch most effectively secure the largest share of public patronage" ("Retouching and Photographic Truth" 25). An equally important reason for the practice, however, was the removal of technical imperfections

and the desire for greater realism. The amount of light used by photographic studios, for example, considerably deepened any wrinkles and accentuated the signs of age: retouching was argued to be a means of making a photograph into a better likeness.

The specialist photographic journals often contained advice on how to manipulate negatives, and there were numerous instruction manuals published. These suggest that, at its best, retouching was a complex practice that required a high degree of artistic skill and an intimate knowledge of facial physiognomy. All too easily, however, zealous retouching could give sitters' faces a waxdoll or billiard ball appearance. Many articles on retouching, although not against the practise *per se*, were concerned that too much unskilled work would destroy popular belief in photographic realism. As one manual put it, "The clever pupil of the celebrated Professor Scratchpaw took in other pupils until the scratchpaw aborigines flooded the market with *re* or *misre*-presentations of somebody or other, and the result was that the real retoucher has always been at a premium" (Hubert, 7–8).

Retouching was carried out using a variety of soft lead pencils upon a glass negative coated with a solution that allowed the pencil to bite. Elaborate professional equipment, including desks with inbuilt lights and reflectors, aided the task. Most manuals recommended the use of lines to accomplish any desired alterations, much in the way a steel or wood engraver would work. Retouching varied from the carefully precise work to the brutally extensive. As *The Art of Retouching* put it:

> Do not on any account forget to touch ladies' waists in a specially hearty matter, if you want to keep on good terms with them. You are always safe in cutting off an inch on each side, and in some cases, where corpulence is rather conspicuous, two or more inches will never be missed. (Hubert 49)

Instruction manuals contained far more information, however, than simply the removal of waistlines and double chins. They included details of how to soften the lines around the temples; how to remodel the furrows around and under the eyes where the studio light would cause dark shadows; and how to thicken and darken hair through careful manipulation. Necks, cheeks, jowls, all were subject to the retoucher's pencil. Carried out with skill and subtlety, retouching could add *gravitas* to a sitter's appearance as well as remove years.

JOHN PLUNKETT

See also: Rigby, Lady Elizabeth Eastlake; Photographic Exchange Club and Photographic Society Club, London; Cartes-de-Visite; and Photographic News (1858-1908).

Further Reading

Barrett, Redmond, "Methods of Retouching," *British Journal of Photography* 34 (1887): 71–72, 116–118, 150–151, 218–219.
Butt, Drinkwater, *Practical Retouching*, London: Iliffe and Sons, 1901.
Burrows and Colton, *The Art of Retouching*, London: Mann & Co., 1876.
Eastlake, Elizabeth, "Photography," *Quarterly Review* 101, June 1857–Sept. 1857, 442–468.
"Exhibition of Art Treasures at Manchester," *Liverpool and Manchester Photographic Journal* 1857: 126.
Hubert, J., *The Art of Retouching*, London: Hazell, Watson and Viney, 1891.
"The new Picture Galleries," *Photographic Journal* 15 February 1862: 380–381.
"Retouching and Photographic Truth," *Photographic News* 16, 19 January 1872: 25.
Young, Andrew, *The ABC of Retouching*, London: Memorial Hall, 1895.

REUTLINGER, CHARLES (1816–1881)
French photographer

Charles Reutlinger was founder of the highly successful eponymous Paris photographic establishment, in business from 1850 to 1937, which was known for its portraits, theatrical cartes de visite and cabinet cards, as well as erotica and, later, fashion and proto-surrealist photographs.

By the time Reutlinger was 18, he was already known to be practicing the art of silhouette portraiture, which his aunt, Madame la Conseiller Weiss, had been doing professionally since around 1820 in Karslrhue. He moved to Stuttgart around 1835, where he met Georg Friedrich Brandseph, an established silhouette artist, who was among the early adapters to the burgeoning field of daguerreotype portraiture. It may have been Brandseph who interested Reutlinger in the new art, but it is undoubtedly during that time that Reutlinger came to know about the work of Daguerre and Niepce, and he established his own photographic studio in Stuttgart at 8 Fürtbachstrasse by 1849.

Reutlinger certainly arrived in Paris with some amount of portrait photography business and technical acumen already, since, by 1851, his photographic advertisement was running in the publication *La Lumière*, offering, as well, to instruct others in the art of "daguerreotype on paper."

From the early 1850s, Reutlinger was a prolific producer of carte de visite portraits of the notable figures in cosmopolitan Paris, including politicians and royalty, musical celebrities, and theatrical stars. Among the portraits in the collection of the Bibliothèque Nationale are the Le Prince Napoléon-Bonaparte (ca. 1853) and Édouard Manet (1875). His atelier was decorated

elaborately, with the furnishings and decor serving as settings and props in the portraits. The cartes were stamped "Ch. Reutlinger" on the back, with a coat of arms and address, and sometimes "garantie d'après nature."

Portrait photography was an ideal symbiotic partner with the emerging cult of celebrity, especially the fascination with theatrical stars. Both were dependent on artifice and capitalized on fantasy, and photographers and performers were glad to cooperate to increase their profits.

Reutlinger's early style was somewhat distinctively archaic, in that it drew upon the formal conventions of the silhouette portraits by preferring to vignette bust portraits, rather than the full length portraits preferred by Disderi and other contemporaries.

The medium for Reutlinger's commercial production, the carte de visite, was a photographic process patented in Paris by André Disderi in 1854. They were albumen prints printed onto cards of standard sizes (4½ × 2½ in.), which had engraved labels on the back with the company's name, address and coat of arms. In the 1860s, a larger format (6¾ × 4½ in.) was introduced, the cabinet card, which replaced the bulk of Reutlinger's production for the remainder of the century, until supplanted by less expensive postcards.

Reutlinger became a member of the Société française de photographie in 1862, and his more beaux arts photographic works were included in their exhibitions throughout the 1860s and 1870s. The works shown were predominantly artistic portraits and studies "after nature," in keeping with the academic aspirations of that organization. In the 1874 exhibition Reutlinger exhibited six examples of what were labeled "aristotypes (silver gelatin prints)," and in 1876, a series of carbon prints.

Meanwhile, the increasing commercial demand for celebrity portraits was a boon to Reutlinger, who had, by 1873, a catalog of over 1,300 personalities available for sale. Their names, listed alphabetically and by genre or profession, were predominantly those of public figures and theatre stars, but also included members of the clergy (Catholic, Jewish and Protestant), visiting dignitaries, and great artists.

Reutlinger was by no means alone in capitalizing on the demand for theatrical stars, as his colleagues Nadar, Etienne Carjat, and others were highly successful in that regard. The great democratization of these images, available for a small price, allowed the public to select and repeatedly examine the likenesses of the famous. These, they mounted into albums, becoming, in effect, curators of their gallery of favorite portraits. Émile Zola's novel *La Curée* gives an indication of the entertainment value these provided, provoking passionate discussions by the collectors about the various merits and depictions of the personalities in their personal albums.

Ten albumen prints of his theatrical portraits were included in a 1875 publication by the Palais Royal-based firm Tresse titled *Foyers et Coulisses: Histoire Anecdotique des Théatres de Paris*. Many magazines also patronized Reutlinger and the other Paris firms for iconic images of everyone from statesmen to *demi-mondaines*, with a decided preference for the latter.

The costumed actresses, by far the most popular of the images produced in that era, naturally evolved into more and more erotic imagery, with an emphasis on actresses in the body stockings that were the theatrical facsimiles for nudity. This, in turn, gave way to Reutlinger photographing nudes and beauties in their underclothes, and making them available as a series called "des petites femmes de Paris." The fact that this was a thriving industry initially particular to Paris during the period is evident by the fact that erotic pictures continued to be referred to as "French postcards" well into the 20th century.

It is not clear how many of these nudes were made by Charles and how many were by his younger brother, Émile, who succeeded him as director of the business in 1880. It is certainly known that the catalog of existing images continued to be marketed and added to in Émile's era, and that Charles Reutlinger passed away in Paris in 1881.

The Reutlinger firm continued well into the twentieth century under a succession of family members, but the cartes continued to be stamped "Ch. Reutlinger" until 1895, when the stylized signature of Léopold, the son of Émile, became the label. Today, the bulk of the Reutlinger archives are housed in the Bibliothèque Nationale de France in Paris.

Reutlinger's legacy was as a pioneer in the commercial business of photography and creating a niche business in the great photographic metropolis that was Paris in the 30 years he was active there, recognizing and cultivating the uncharted territory of celebrity mania, then in its formative years.

DEIRDRE DONOHUE

Biography

Reutlinger was born 26 February 1816 in Karlsruhe as Carl Reutlinger, the eldest of four siblings. His brother Émile, who would succeed him as head of the firm, was born in 1825. Their father Léopold was a wine wholesaler and former military officer.

In 1850, upon moving to Paris, he changed his first name to Charles, and began to work in his home at 33 boulevard Saint-Martin (in a building which no longer exists). Charles Reutlinger, photographic artist, appears in the Bottin Paris business directory of 1853 at 112 rue de Richlieu on the corner of boulevard Montmarte. That is the address of the firm until 1864, when the

street number for the entrance around the corner, on the boulevard, is given.

Reutlinger's first award, a medal of London, was not noted on the backs of his photos, but he won a succession of honors during the next two decades, including first prize medals in the *Exposition internationale de Berlin*, 1865; the *Exposition universelle de Paris*, 1867; the *Exposition photographique de Hambourg*, 1868; and medals from the *Société Photographique à Paris*, 1870; the *Exposition universelle de Lyon*, 1872 and the *Exposition universelle de Vienne*, 1876. These medals were reproduced on the backs of the firm's cartes.

See also: Cartes-de-Visite; Cabinet Cards; Daguerre, Louis-Jacques-Mandé; Bonaparte, Roland, Prince; Zola, Emile; Nadar (Gaspard-Félix Tournachon); and Carjat, Etienne.

Further Reading

Bourgeron, Jean-Pierre, *Les Reutlinger: Photographes à Paris 1850–1937*, preface by Jean-Pierre Seguin, Paris: J.-P. Bourgeron, c. 1979.
Darrah, William C, *Cartes de Visite in Nineteenth Century Photography*, Gettysburg, Pennsylvania: W.C. Darrah, c. 1981.
Frizot, Michel (Ed.), *A New History of Photography*, Köln: Könemann, c. 1998.

REY, GUIDO (1861–1935)
Italian photographer

Guido Rey was born in Torino in 1861, to Giacomo Rey and Lydia Mongenet de Resencourt. In 1879 he attended the Academy of Fine Arts in Torino. He worked in the family textile business for which he traveled quite often. He took his first photographs during mountain climbs in 1883–85 with the Sella family and started his pictorialist works only in 1892–93. He was active in organizing the Universal Exposition of Visual Arts in 1902 where Stieglitz, Demachy, C. White and Annan presented their works. He died in 1935.

Rey participated in the cultural life of his city but more importantly in the debate—at the European level—about photography as an art. He had a great passion for painting and he was the only European pictorialist to create sets with minute historical attention in Nipponic, Roman, Flemish and Neoclassic style, without manipulating the photographs. His intent was to describe the past in the every day scenes by having his models wear costumes that he designed. His book on alpinism was published in 1904 (*Il monte Cervino*). More appreciated abroad, his work was published on "The Studio" review and he was the only Italian to be published on "Camera Work" (1908).

CARLO BENINI

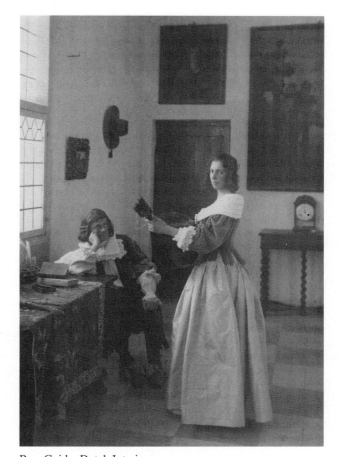

Rey, Guido. Dutch Interior.
The J. Paul Getty Museum, Los Angeles © The J. Paul Getty Museum.

REYNAUD, CHARLES-EMILE (1844–1918)
French inventor, artist, showman

Charles-Emile Reynaud was born at Montreuil-sous-Bois on December 8, 1844. An experienced creator of educational images for the magic lantern, in 1877 Emile Reynaud invented the Praxinoscope. This ingenious moving image toy featured a central circle of mirrors set in a shallow cylinder, opposite colour-lithographed sequence drawings on paper strips. The Praxinoscope Theatre followed; the cylinder set in a box with glass-covered viewing aperture, which reflected a card with a colored background. The animated subjects appeared superimposed on the scenery. A further development for projection, the domestic Projection Praxinoscope, used figures on glass. This led to the Théâtre Optique, a large-screen version. Long perforated bands, bearing characters painted onto squares of transparent material, were wound horizontally back and forth from reel to reel in the mirror-drum projector. The background was projected from a separate lantern. Shows commenced at the Musée Grevin, Paris, in 1892. By 1896 Reynaud was shooting photographic motion picture

films; subjects included clowns Footit and Chocolat. The individual film frames were mounted as perforated bands in the same manner as the painted strips. These presentations were eventually superseded by competing cinematograph shows; the last performance was in 1900. Between 1903 and 1907 Reynaud worked on a motion picture viewer for brief stereoscopic sequences. Emile Reynaud died at Ivry-sur-Seine, January 9, 1918.

STEPHEN HERBERT

RICHEBOURG, PIERRE AMBROISE (1810–1872)

Pierre Ambroise Richebourg was born in Paris in November 1810. Of his childhood and his formation few elements are known, except that he was trained in optics with Vincent Chevalier, father of Charles Chevalier, supplier of instruments of Daguerre. He seemed to have followed the lessons of the latter, of whom he created a portrait with daguerreotype in about 1844.

He was one of the first to exhibit daguerreotype portraits in Paris in late 1839. He was also, according to his own statements, the first to have carried out a series of daguerreotype images taken under the solar microscope for the course of Alfred Donné at the College of France, in 1840, from which he presented examples in front of the Academy of Science in Paris. The following year, following the death of Vincent Knight, he again took up Knight's trade and installed his shop and workshop not far from the Town hall, at 69 quai de l'Horloge (which will become, following a change of classification in 1851, number 29) where he made photographic portraits, sold photographic material, and gave lessons. In 1843, he published an instruction manual, *Nouveau manuel complémentaire pour l'usage pratique du daguerréotype* [the New Complementary Handbook for the Practical Use of the Daguerreotype]. The following year, his name appeared under the heading "daguerreotypist" and he presented in the "optical" section of the images at the exposure of the l'exposition des Produits de l'Industrie, where he received a favorable acknowledgement of the panel.

From the very beginning of the 1850s, he was one of the first French photographers to be interested in the new technique of the collodion, for which he developed, about 1851–52, a protective varnish for the negative plates. From this date he used this technique, to which he devoted a booklet in 1853, *New Handbook of Photography on Collodion*, in which he carried out the essence of his production. During the years 1850-1860, he entered many exhibitions, Paris (1855 (medal), 57 (medal), 59, 62 (medal), 64, 65, 67), Brussels (56, 57), London (58, 63), and Oporto (66). In 1855, he became a member of the Société française de photographie. Ten years afterwards, indicative of

his fame, he appeared in the *Dictionnaire des Contemporains* of Vapereau.

His abundant production, often of excellent technical quality with some exceptions, is worthy primarily due to the diversity of the addressed subjects, characteristic of the multitude of the fields of applications of photography under the second Empire. The various mentions of the photographer one finds on the seals and publications are indicative of this eclecticism. In the years 1860, his name in organizations was frequently followed by the description " Photographe des Palais Nationaux " then, from 1864 as "Photographe de la Couronne." In 1858, he was described as a "photographer of the contests, the official albums, and the artists" and since 1864, as a "the photographer of Town hall" and "photographer of the Ministry for the Art schools."

One of his fields of interest was the reproduction of works and objets d'art, which he explicitly mentioned as one of his specialties since 1847–48. It is known that he made reproductions for various artists, painters (Billhook, Leroux), sculptors (Préault), and goldsmiths (Wheat-Meurice). He also made photographic copies of the paintings in the Salon, in particular those of 1857, 1861, and 1865. The work of Theophilus Gautier appeared at Gide and Baudry in 1859, *Trésors d'Art de la Russie ancienne et moderne*, decorated with sixty photographs chosen from more than two hundred created by Richebourg in Russia since 1857.

On this occasion he developed a system that enabled him to reproduce images of a whole cupola with a high geometrical degree of accuracy. With this production a certain number of remarkable series devoted to the interiors of various palaces and imperial residences were added: the castle of Fontainebleau (about 1860), the palace of Luxembourg (about 1859), that of the Elysium (1864), the Pompéienne Villa of Prince Napoleon (about 1865).

Parallel to this activity Richebourg expressed a taste for what one can describe as topical photography. Introduced in the mid-1850s, in the imperial milieu, he successively photographed the reception of Queen Victoria at the Town hall of Paris (1855), which he reproduced, for the people of Paris. He then documented the ceremonies of the birth and baptism of the Prince Impérial (1856), and the festivals of Cherbourg (1858). During this period Richebourg announced that on request he would travel around France. It is likely that a number of engravings made from his photographs and used in *L'Illustration*, emanate from such commissions. This continued until the beginning of the 1870s, through the series made by Richebourg containing images of various inaugurations (le palais du Luxembourg (1858), the chantier de l'église saint (1861), Arc de Triomphe de l'actuelle place de la Nation. In 1871, he created some

pictures during and after the events of the Commune, some of which were again interpreted in engravings.

A commercial portraitist, he was also interested from the early 1850s in passport photos and identity cards, and in January 1853 establsihed a program for passports with photographs in front of the ministry for Justice. Thereafter he seemed to have worked sporadically for the Prefecture of Police force: in 1869, in particular, he made and marketed negatives of the victims of the Troppmann assassin. In addition, as a photographer on behalf of the Ministry for Agriculture and the Trade, he regularly created images of the animals of the annual agricultural shows of Poissy, Paris, and Chartres. Several of these images were presented at the time of the various expositions in which it took part. He also left stereoscopic images, in particular some daguerreotypes of nude females. The last mention that one finds of Richebourg dates to 1872, in *Moniteur de la Photographie*. One does not know with certainty his date of death. His abundant body of work is found in public collections in France and abroad.

QUENTIN BAJAC

Further Reading

Michèle et Michel Auer, *Encyclopédie internationale des photographes de 1839 à nos jours*, Hermance, éditions Camera Obscura.

Janet E. Buerger, *French Daguerreotypes*, Chicago and London: The University of Chicago Press, 1989.

Anne Mac Cauley, Industrial Madness, Commercial Photography in Paris, 1848–1871, New Haven and London: Yale University Press, 1994.

Bernard Marbot et Weston Naef, *Regards sur la photographie en France au XIXe siècle*, catalogue d'exposition, Petit Palais, Paris: Berger-Levrault, 1980.

RIGBY, LADY ELIZABETH EASTLAKE (1809–1893)
English artist, writer, and critic

Elizabeth Rigby, Lady Eastlake was born in Norwich on November 17th 1809, daughter of the obstetrician and gentleman farmer, Dr. Edward Rigby. After spending extended periods of time abroad in Germany and Estonia she settled in Edinburgh between 1842 and 1849, where her tenancy of the city coincided almost exactly with the photographic partnership of Hill and Adamson. In Edinburgh, she became one of Hill and Adamson's early and most frequent sitters, sitting for about twenty portraits. She married Charles Lock Eastlake in 1849 and moved to London where she continued to publish reviews for the periodical press, mainly in the area of the visual arts and to translate and edit art-historical texts. She died at her London home in 1893.

Elizabeth Rigby sat for her first calotype portraits in Hill and Adamson's studio in the summer of 1843 and formed opinions of the process to which she remained faithful throughout her life. She expressed her thoughts on photography to her friend John Murray, publisher of the *Quarterly Review*, soon after this first sitting: '... I venture to send you a few specimens, being assured that you will appreciate their truth and beauty, though few do. It appears to me that this is the only line of photographic drawing which can at all assist an artist—it was absurd to think that any would supersede him. I send you various specimens of the subjects to which it has been turned here ... I have enclosed three of myself, not the best impressions ... I *admire* myself very much, but cannot get the world to agree with me. The downcast eyes were a necessary consequence of the most brilliant sun which prevented their being raised the least higher. With old faces it is most successful—producing the most exquisite Rembrandt effect. ...'

Fourteen years later, in April 1857, Eastlake wrote one of the earliest critiques on photography, an article in the *Quarterly Review* reviewing seven related publications. In large part the piece is a history of photography distilling the information from the listed texts into a reliable, chronologically arranged account of the development of the processes collectively contributing to a history of photography. Eastlake gives a lucid account of the various chemical experiments in photography up to 1857, 'when the scientific processes on which the practice depends are brought to such perfection that, short of the coveted attainment of colour, no great improvement can be further expected.' (459) The more discursive portions of Eastlake's essay articulates mid nineteenth-century debates about the status and rôle of photography. Granting 'Photography' the upper case and making it a feminine noun, like Art and Nature, Eastlake proceeds to measure the artistic successes and shortcomings of the photographic process in conveying nature. She first draws and then preserves a distinction between photography as an art and photography as a popular past time, the latter owing more to 'the hunger for facts.' She is thus untroubled by claims that photography will supersede art or supplant the work of artists, convinced that 'Photography is intended to supersede much that art has hitherto done, but only that which it was both a misappropriation and a deterioration of Art to do' (466). She therefore views photography as a means of relieving the artist of a 'burden' of 'literal, unreasoning imitation' (466), arguing that 'what she [photography] does best is beneath the doing of a real artist at all' (467).

Eastlake was herself an amateur artist, skilled in drawing portraits of friends and family and adept at producing topographical views of cities and landscape [4]. Eastlake sees photography as another form of drawing, 'the solar pencil' (445), capable of communicating

an objective account of appearances although, in her opinion, somewhat limited in its formal properties. She is most critical of photography in respect of its deadening effect on form and failure to represent the full tonal range of its subject, what she refers to as 'the falling off of artistic effect' (462). She observes: 'If the cheek be very brilliant in colour, it is as often as not represented by a dark stain. If the eye be blue, it turns out as colourless as water; if the hair be golden or red, it looks as if it had been dyed, if very glossy it is cut up into lines of light as big as ropes' (461) In landscape too, she finds that photography fails to properly convey the 'breadth and gradations of nature': 'The finest lawn turns out but a gloomy funeral-pall … trees, if done with the slower paper process, are black, and from the movement, uncertain webs against the white sky.' (463).

Eastlake's essay appeared in the wake of the wet-collodion process and she is ambivalent about the fine detailing that the process afforded. Eastlake acknowledges the 'pictorial feats' achieved by wet-collodion, for example in its precise rendition of 'Alpine masses' but she retains an aesthetic preference for the soft papers and gentler outlines of the calotype, setting up an opposition between the former's assertion of 'facts' and the latter's facility for the picturesque. The picturesque is an important and recurring motif in Eastlake's essay, used specifically to mean the opposite of descriptive. She presents picturesque conventions such as imprecise outline, broad suggestion and pleasing irregularity in the representation of nature as a benchmark of artistic practice, stating: 'If the photograph in its early and imperfect scientific state was more consonant to our feelings for art, it is because, as far as it went, it was more true to our experience of Nature. Mere broad light and shade, with the correctness of general forms and absence of all convention, will, when nothing further is attempted, give artistic pleasure of a very high kind; it is only when greater precision and detail are superadded that the eye misses the further truths which should accompany the further finish.'(p. 460) It is not only the fine detailing that Eastlake finds objectionable in the improved 'scientific state.' She also laments the lack of 'mystery' in the wet collodion print and she sees portraiture as its chief casualty: 'Every button is seen—piles of stratified flounces in most accurate drawing are there,—what was at first only suggestion is now all careful making out,—but the likeness to Rembrandt and Reynolds is gone! (p.461) Her repeated references to Rembrandt in the essay reiterate her preferences for the picturesque, where character studies are suggested rather than the descriptive where physiognomy is minutely told.

In reading Lady Eastlake's *Quarterly* review her connection to both the Royal Academy (her husband was its President) and to the Photographic Society (her husband had been its chair) should be borne in mind. It is quite plausible that Eastlake's essay was as much an iteration of Victorian academicism as it was a critique of photography. In her comparison of the 'free-will of the intelligent being' to the 'obedience of the machine' she is ostensibly distinguishing between the artist and the camera but she may equally well be referring to the very contemporary fashion for Pre-Raphaelitism. Knowing that Eastlake frequently used the *Quarterly Review* to settle old scores it is quite possible to read her reference to the artist's '… power of selection and rejection, the living application of that language which lies dead in his paint-box' (466) as a further public rejection of the strictures of John Ruskin.

JULIE SHELDON

See also: Hill, David Octavius, and Robert Adamson; Eastlake, Charles Lock; Calotype; Wet-collodion; and Ruskin, John.

Further Reading

Stevenson, Sara, *David Octavius Hill and Robert Adamson: Catalogue of their calotypes taken between 1843 and 1847 in the collection of the Scottish National Portrait Gallery*, Edinburgh: National Galleries of Scotland, 1981.
Letter to JM Saturday October 7 1843. By permission of the John Murray Archive.
'Photography,' *Quarterly Review*, vol. 101, April 1857, 442–468.
Smith, Charles Eastlake (ed.), *Journals and Correspondence of Lady Eastlake*, 2 vols. London: John Murray, 1895.

RIIS, JACOB AUGUST (1848–1914)
Dannish photographer

There are not many examples of photography changing societies perception so as to render significant social and political change, indeed some would argue that photojournalism simply sells newspapers. One exception would be Jacob Riis, (born Ribe, Denmark, emigrated to USA 1870) who used photography to provide evidence of the appalling conditions of the slums of New York City which he photographed in the 1880s for 10 years, often at night, and with an early use of magnesium powder, culminating in the most famous of his books, the first of its kind: *How the Other Half Lives* (1890). Packed 522 to the acre of mainly immigrants, New York had the worst disease ridden slums in the world. In 1877 Riis became a police reporter for the *New York Tribune* but found that his words, and indeed the printed woodblock illustrations made from his photographs, had little impact. But as a result of publishing his night photographs, the flop houses and police '5 cents a spot' lodgings were abolished and a new era of treating the poor and homeless began in the USA with Riis at the forefront of the campaign. Known as the 'Emancipa-

tor of the Slums,' esteemed by Theodore Roosevelt, Riis proved that photography could be an active agent of change. "I had a use for it, and beyond that I never went" became the touch stone for many a campaigning documentary photographer thereafter.

ALISTAIR CRAWFORD

RIVE, ROBERTO (active 1860s–1880s)
Italian photographer and studio owner

Roberto Rive worked as a photographer in Naples from the beginning of the 1860s, with a studio in Palazzo Serracapriola, Vico Carminello, 38, Riviera di Chiaja. In 1865 he moved to Palazzo Lieti, Via Toledo, 317 and, from 1886 until 1889, he had a studio in Salita San Filippo, Riviera di Chiaja, 15. In 1867 Rive took part at the Exposition Universelle Paris. He became very well-known for his portraits and views, some of which were in stereoscopic size. He took photographs of all the famous monuments in the South of Italy, in Naples, Pompeii, Paestum, Sorrento, Capri, Amalfi, and of the most important towns and archaeological sites in Sicily, as well as other historical towns such as Florence, Pisa, Siena, Rome, Genoa and Venice. He was also an inventor and he patented a special photosensitive paper which was used above all in Southern Italy. Outstanding photographers, such as Luigi Borlinetto (1827–1904), who was a very well—known scientist in Padua, used the paper invented by Rive (Borlinetto used it in a variant form, with the addition of potato flour, water and alcohol). Roberto Rive continued to practise as a photographer until the end of the 1880s.

SILVIA PAOLI

RIVIÈRE, HENRI (1864–1951)
French

Benjamin Jean Pierre Henri Rivière is primarily known as a printmaker. He was also an engraver, theatre director, collector, painter, and writer, and in the late twentieth century his skill in photography was acknowledged. Rivière did not sign or mark his photographs. Yet despite the obscurity surrounding his photographic work, photography was integral to Rivière's oeuvre. The main collection in the public realm at the Musée d'Orsay, Paris reveals that Rivière was one of the most original amateur photographers in France at the end of the nineteenth century.

Born in Montmartre, Paris in 1864, Henri Rivière grew up in this artistic milieu, spending summers within Aix-les-Bains in the Pyrenees where he experimented with watercolour and studied nature. These trips, along with early travels to St Briac in Brittany where he would return again and again, shaped his art. Rivière was taken

on by an academic and art teacher, Emile 'Père' Bin, a period of formal training lasting only a year due to Bin's unforeseen death.

Rivière was inspired by the pull of modernity, engrossed in the journal *La Vie Moderne*, and the work of Puvis de Chavannes and the Symbolists, the Impressionists, the Nabis and other contemporary artists. He was to be self-taught for the rest of his life, and generally progressed through solid periods of time using a particular medium. He produced etchings from 1881 to 1885 and then again in 1906; photographs largely from 1887 to 1912; large format wood engravings from 1890 to 1894 and watercolours from 1910 to 1950. He was to be both respected and criticised for making large format prints in large editions, which were controversially destined as much for the wall as for the collector's portfolio.

Rivière leapt adeptly into the Paris art scene of the 1880s, strengthening friendships with his childhood friend Paul Signac and other artists, including the painter and entertainer Rudolphe Salis, who ran a cabaret, the Chat Noir. The cabaret was a hotbed of political mockery, creative fervour and fun, and as a result was very popular with avant-garde artists. In 1882, Rivière became the assistant secretary of the associated journal, *Chat Noir*. At this time he began to make etchings of the countryside from the sketches he had made in Brittany.

The Chat Noir produced spontaneous plays using shadow puppets. Rivière, realising how popular it was, formalised the production. By 1886 until the end in 1896 when Salis died, Rivière was stage director of these unique performances, 43 in all, that pre-empted cinema in their screen-like movement and light effects. Rivière cut characters and images out of zinc, and created a sense of perspective in the design. In 1890 he introduced coloured lights to simulate day and night in his production of *La Marche à l'Etoile*. He documented his work at the Chat Noir with photographs, encouraged by his friend there, Charles Clos. Many of these images are of his colleagues at work, taken close-up from a range of perspectives, and often obscured by flash or the surreal floating effect of electric lights. The photographs never accompanied articles about the Shadow Theatre—George Redon's illustrations were commissioned for magazines. Rivière used his images to help him when designing new sets and to record the complicated machinery involved. His photographs sometimes preceded/inspired a theatrical story, such as his 1887 show, "La Tentation de St Antoine."

Rivière began to teach himself photography from 1887 and practised it for about twenty-five years, by which time photography was over popular in his eyes. He used a wooden camera with bellows and a (printing) frame, identical to the one Degas was to use a few years later. His glass plates were far larger than the film

negatives used by Bonnard and other artists. He was a skilled technician, mastering the cyanotype for images with shadows requiring contrast and the gelatin-silver print on matt paper to achieve luminous greys.

The Chat Noir photographs reveal Rivière's fin-de-siècle fascination with light, shade and silhouettes. Rivière described the lantern of the theatre as "the soul of the retreat," in an article in *Le Temps*, 1894, underlining the importance of light in his work and explaining in part his attraction to photography. These images fit a time when photographers such as his acquaintance Edgar Degas was experimenting with the effects of artificial light, reversing shades of light and dark. The abstract compositions and unusual perspectives pre-empt the later works of the Bauhaus photographer Laszlo Moholy-Nagy and modernists Ilse Bing and Man Ray.

Alongside the Chat Noir photographs, Rivière photographed other motifs that he used in his engravings. He focused on modern scenes of Paris around 1889, echoing Impressionist paintings of street life, with peoples' heads or feet cropped and shadows protruding into the frame from all corners. He concentrated on intimate scenes of family life in the 1890s, and his photographic portraits reveal silhouettes reminiscent of his shadow theatre days, and a fluid style recalling Degas' pastel outlines. Rivière focused on Breton ports and countryside from 1885 to 1900 and then miscellaneous subjects for the next twelve years. He covered topics beyond the pictorialist visions of outdoor nature in his prints, and used photography to record personal portraits and interior views of his home, restricted, or inspired, by the space and light in the apartment. By 1886 he and his wife Eugenie had a summer house in Loguivy, Brittany, and a large Parisian apartment on the Boulevard de Clichy.

Rivière combined classical, modern and decorative styles to produce elegant compositions, heavily influenced by the Japonaism popular at the time. Although Rivière was opposed to overt stylisation in art and examined nature fervently, his wood block prints reveal stylistic techniques from Japanese artworks—high perspective, unusual crops and large flat expanses of colour. Amassing one of the largest collections of oriental objects in nineteenth-century Paris, Rivière became close friends with a dealer, Florine Epstein-Langweil, and worked with his patron Tadamasa Hayashi, who imported Japanese woodblock prints to France.

His photographs of Paris reveal the modernist steep perspectives and sharp angles, stemming from Japanese influences. From 1899 Rivière used photographs and sketches to document the building of the Eiffel tower. He used these preliminary studies for a set of woodblock prints, after Hokusai, *Les Trente-Six Vues de la Tour Eiffel*, published as lithographs in 1902. He was the first person to image the Eiffel Tower and both his photographs and his resulting prints present radical abstract views. The prints were well received, Roger Marx writing in the *Revue Encyclopedique* ten years later that since producing them, Rivere 'has a cult of admiration long overdue' (Toudouze, 135).

Although Rivière did not intend his photographs to be "art," today they have been lifted from obscurity. Technically competent and aesthetically daring, Rivière's photographs bare witness to the nineteenth-century fascination with the effects of light and shade, steep perspectives and modern scenes and are both documentary and artistic. They pre-empt the modernist movement that gripped Paris in the 1920s and '30s and despite the self-effacing nature of the artist, are important proof of the fast pace of nineteenth-century Paris and the changing role of photography.

SOPHIE LEIGHTON

Biography

Benjamin Jean Pierre Henri Rivière was born in Montmartre, Paris, in 1864. He spent much time in Brittany and Aix-les-Thermes, in the Pyrennes. His father died in 1873 and his mother remarried in 1875. A friend of his step-father, Emile "Père" Bin, academic painter and teacher, accepts Henri Rivière into his studio in. Rivière met Rudolpe Salis in 1882 and discovered the Chat Noir, an artistic cabaret. From 1886 to 1896 Rivière ran the Shadow Theatre at the Chat Noir. He participated in his first exhibition in 1886, of works by Chat Noir artists. He met Eugenie Estelle Ley in 1888 and they married in 1895. In 1888 Rivière taught himself to make woodblock prints. From 1888–1902 Rivière worked on a series of lithographs of the Eiffel tower. Andre Antoine, friend of Rivière, formed the Theatre Libre and in 1888 commissioned Rivière to produce a program, co-produced with Eugene Verneau, a commercial lithographic printer who collaborated with Rivière on prints. In 1896 the Rivières bought a summer house in Loguivy, Brittany. Rivière produced his first major lithograph edition *L'Hiver* in 1896 and continued with engraving, photography and watercolour painting. His wife died in 1943. Rivière died in 1951, aged 87.

See also: Artificial Lighting; Degas, Edgar; France; Impressionistic Photography; and Societies, groups, institutions, and exhibitions in France.

Further Reading

Cate, Phillip Dennis, *Henri Rivière: A retrospective exhibition,* The Jane Voorhees Zimmerli Museum, New Jersey, 1983 (exhibition catalogue).

Fields, Armond, *Henri Rivière,* Salt Lake City: Peregrine Smith Books, 1983.

Fossier, François, Heilbrun, Françoise and Néagu, Philippe

Henri Rivière, graveur et photographe, Paris: Musee d'Orsay, 1988.

Loyerette, Henri, *Gustave Eiffel,* Paris, 1986.

Jeanne, Paul, *Les Théâtres d'ombres a Montmartre de 1887 à 1923,* Paris, 1937.

Toudouze, Georges, *Henri Rivière: Peintre et Imagier,* Paris: Librarie Editeur, 1907.

Exhibitions (photography—for printmaking exhibitions, see Fields, 1983).

1983, Rutgers, The State University of New Jersey *Henri Rivière (1864-1951), A Retrospective Exhibition.*

1983, Paris, Palais de Tokyo *Le Fonds Gustave Eiffel au Musee d'Orsay,* Petit Journal, no. 130, mai 1983.

1988, Musée d'Orsay, Paris *Henri Rivière, Graveur et Photographe.*

Publications

L'Estampe Originale 1893.

ROBERT, LOUIS RÉMY (1810-1882)
French photographer

Louis Rémy Robert was born in Paris on 3 October 1810, the eldest child of two artists, Pierre Rémy Robert and Anne Caroline Demarne. In 1813, Pierre Robert moved his young family to Sèvres, where his father-in-law, Jean-Louis de Marnette Demarne, a Belgian landscape painter, had secured him a job at the Manufacture Nationale de porcelaine de Sèvres. As a boy, Louis Robert assisted in his father in the *atelier de peinture sur verre* (glass painting studio) and was groomed to take a permanent place at Sèvres, but the Robert family intended that Louis would be more than an artist or artisan. Following his secondary studies, Robert studied chemistry with the illustrious chemist Jean-Baptiste Dumas, probably at the École centrale des arts et manufactures, a new school of industrial engineering in Paris. When his father died suddenly in 1832, Robert returned to Sèvres to assume the role of family breadwinner, and he ultimately spent the rest of his life at the manufacture in a series of increasingly important positions. With commissions for stained glass windows waning in the 1840s, the glass painting studio was phased out, and Robert ascended to the post of *chef de peinture* in 1847. In 1871, Robert became the first employee from the factory ranks to attain the position of Director of the Manufacture de Sèvres.

Robert began experimenting with photography around 1850. Material conditions made the Sèvres factory a natural place for photography to appear, where there were laboratories, chemical stocks, and the camera obscura already in use. Technical advice would have been available from Robert's former professor J.-B. Dumas, who also happened to be an early photographic expert living in Sèvres. In some early trials, Robert utilized outdated stationery bearing the old "Manufacture Royale" letterhead for making paper negatives, probably following Louis-Désiré Blanquart-Evrard's modifica-

Robert, Louis-Remy. Alfred Thompson Gobert.
The Metropolitan Museum of Art, Purchase, Joyce and Robert Menschel, Mrs. Harrison D. Horblit and Paul F. Walter Gifts, and Rogers Fund, 1991 (1991.1044) Image © The Metropolitan Museum of Art.

tions to William Henry Fox Talbot's calotype process. Robert was soon experimenting freely with both wet and dry paper processes. He eventually became a recognized expert in all the period's methods, and from 1858 to 1872 he enjoyed a state appointment teaching photography to engineers at the École des ponts et chausées and the École du génie maritime.

Raised in an environment filled with art and artists, Robert was already an accomplished portraitist who had exhibited pastels in the Salon (1848, 1849, 1850) when he took up the camera, and he may have initially approached photography with a view to creating *aides memoire.* By 1851 he was frequently posing his family members and colleagues at the Manufacture for portraits, many of which are remarkable for their animation and warmth, notwithstanding their lengthy exposures. A few images made of his colleagues in the laboratory are among photography's earliest images of workers in the workplace.

Robert's photographic activity increased steadily in the early 1850s. This was encouraged in part by the arrival in 1852 of the new factory director, Victor Regnault, who was an avid amateur photographer. Although the two men surely shared their interest, experience,

and expertise in calotypy, they practiced independently and cannot be called collaborators. Thus, while Robert and Regnault's relationship was never close—unlike Robert's friendship Count Olympe Aguado, with whom he made photographic outings—it did strengthen the place of photography at the manufacture. He may also have taught photography to others at the factory. Moreover, Robert's quasi professional photographic activities in the fifties leave no doubt that photography virtually became his second career. He was particularly active as a landscape and architectural photographer, beginning first by photographing in the nearby Parc de Saint-Cloud with his small portrait camera (approximately 27 × 22 cm), and later acquiring a larger camera (approximately 33 × 38 cm) for views. His invention of a negative holder that could be loaded with up to fifteen dry paper negatives allowed greater ease photographing in the field. In 1853 he published a portfolio of thirteen architectural views in Blanquart-Evrard's edition *Souvenirs de Versailles*, and his photographs of medieval architecture in Brittany were copied in lithography for publication in the first volume of *Anciens évêhés de Bretagne* (atlas and first volume, 1855). Traveling in Normandy in the early 1850s, he also made a series of large views on the grounds of the Chateau d'Eu. These muted pictures, which feature rustic, timbered sheds, barns, hay wagons, ancient, massive beech trees, and the architecture of the 18th-century glassworks on site, are indebted to the model of the Barbizon painters, who were in turn indebted to Robert's grandfather Demarne, who had been instrumental in introducing French painters to naturalistic Flemish landscape painting. Robert in fact maintained close friendships with two of the principal painters associated with Barbizon: Camille Corot, a family friend who lived adjacent to Sèvres, and Constant Troyon, an intimate friend since boyhood.

Robert's most well known photographic work, however, was in still life, and from the beginning of his photographic career he had envisioned using photography to document the extensive Sèvres output and historical collections. He photographed a few arrangements of ceramic vases, statuettes, glassware, and artist's props using paper negatives, but expanded and refined the project for the 1855 Exposition Universelle. The Manufacture de Sèvres was to be France's showcase institution for this international exhibition, and Robert thought to make photographic reproductions the factory's showpieces. Seeking a more subtly detailed image, he learned the albumen-on-glass process from Hippolyte Bayard, and produced a group of salted paper prints from glass negatives of Sèvres wares that was offered for sale at the exhibition. Robert won critical notice with these pictures in several photographic salons and exhibitions in the early 1850s and 1860s. In 1863, Robert proposed the funding of a photography studio at Sèvres for the purpose of cataloging the factory output, which was approved in 1865 after much ministerial resistance.

A member of the Société française de photographie from 1855 on, Robert was involved in the society's activities until the end of his life in 1882. His personal photographic production is estimated at some 600 paper negatives, but most of his later work on glass (outside of the factory catalog) has not survived.

LAURIE DAHLBERG

See also: Calotype and Talbotype; and Régnault, Henri-Victor.

Biography

Louis Robert was born on 3 October 1810, and was raised beyond the western edge of Paris in Sèvres, where his parents were employed by the Manufacture de porcelaine de Sèvres. Raised to take his place as a factory artist but trained also in chemistry, he directed the atelier of painting on glass from 1832 until 1847, when he was promoted to *chef de peinture*. He began working in paper negative photography around 1850 and turned the camera to portraiture, landscapes, architectural studies, and still life arrangements. His photographic activity at Sèvres was encouraged by factory director Victor Regnault, a fellow amateur photographer who assisted Robert in establishing a photography studio in the factory to record Sèvres' output and museum collection. Some of Robert's architectural work was published in the early 1850s, including thirteen views that comprised Blanquart-Evrard's 1853 edition, *Souvenirs de Versailles*. A technical expert in all the period's processes, he taught photography from 1858 to 1872 at the École des ponts et chausées and the École du génie maritime. He was active in the Société française de photographie from 1855 until his death in 1882.

Further Reading

Bajac, Quentin, "La photographie à Sèvres sous le second Empire: du laboratoire au jardin," *La revue du Musée d'Orsay* 5 (Autumn 1997): 74–85.

Dahlberg, Laurie, *The Bull in the China Shop: Victor Regnault and the Culture of Photography, 1840–1870* (MS under review).

Jammes, Isabelle, *Blanquart-Evrard et les Origines de l'Édition Photographique Française*, Genève-Paris: Librairie Droz, 1980.

Jammes, André and Eugenia Parry Janis, *The Art of French Calotype*, Princeton, NJ: Princeton University Press, 1983.

Stourdzé, Sam (ed.), *Louis Robert, l'alchimie des images*. Paris: Baudoin Lebon, NBC editions and Musumeci Editore, 1999 (exhibition catalog).

ROBERTSON, JAMES (c. 1813–1888)

James Robertson was trained in London under William Wyon, the Chief Engraver at the Royal Mint. In 1841,

Robertson, James. A Turkish Lady. From the "Hickes Album" 1855–1860.
The J. Paul Getty Museum, Los Angeles © The J. Paul Getty Museum.

he himself accepted an appointment as Chief Engraver at the Imperial Mint in Constantinople (present-day Istanbul), and held that position for forty years, until his retirement on October 29th 1881. Within days he sailed with his family to Yokohama, to join his brother-in-law and business partner, Felice Beato. He died in Japan on April 18th 1888.

The move to Constantinople, which may have begun for Robertson as a young man's light-hearted adventure, proved to be a step which changed the course of his life. Highly respected for his work, a senior officer of the Mint, and honoured several times for exemplary service, he still found time to open another avenue of artistic achievement. At some stage in 1852, possibly inspired by the example of another expatriate, the French engineer Ernest de Caranza, he took up photography, and for the next fifteen years devoted considerable time and effort to mastering the new art, and establishing a new business.

Conditions conspired to favour his ambitions. Constantinople itself was a prize for any photographer, exotic, picturesque, still little known but much dreamed of by westerners as the epitome of oriental mystery and romance. The recent, ever-expanding network of regular rail and steamship services throughout Europe and the Mediterranean basin had also put within easy reach

of the city regions held in special honour: Greece, the cradle of Western civilization, and also Egypt and the Holy Land, the settings for hallowed events in the Old Testament and the New. Besides these places of timeless significance, there was one other which achieved great topical importance for a short time. The Crimean Peninsula, site of the war fought between Russia and the Allied Forces of Britain, France and Turkey in 1854–1856, lay just one full day's voyage from Constantinople.

Each of these territories was tapped for treasure by Robertson during his photographic period. Permanent residency in Constantinople made it possible for him to record at leisure the city's splendid buildings and characteristic street life. Images from other places were gathered in short, concentrated camera forays. His first album of Constantinople views was published in London in December 1853; his first sample of Grecian antiquities followed in 1854. As a pioneer war reporter, Robertson paid several brief visits to the Crimea between June 1855 and late spring 1856. On his way from the Crimea to England that summer, he stopped for a while in Malta, to take and sell photographs there as well, before continuing on his journey. With his two Beato brothers-in-law he made an excursion to Egypt and the Holy Land in the spring of 1857, and re-visited Greece later that year. After this flurry of activity the pace slowed, but a number of albums filled with assorted views of Constantinople, Athens and Jerusalem were issued at intervals until the autumn of 1867, when the end of his photographic adventure was announced by the sale of his business premises and all their contents.

Robertson's career had developed along logical and harmonious lines. In his days he was not only an engraver by profession, but also an amateur enthusiast who made charming, lively watercolours and sketches of the daily life around him. For such a young man, with an artist's training and an artist's eye, who was also making a home for himself in a strange, exciting world, it was natural to pick up a new toy, the camera, and play with it. Very soon he realized that he was ideally placed to derive profit as well as pleasure from the hobby. He tried many ways to bring his pictures to the attention of the public, and his enterprise provides an insight into the workings of the early photographic market.

By the end of 1854 he had established a studio in Constantinople, from which he sold prints to Western residents of the city, and to travellers passing through. From 1856 he expanded his business by working for a few years with Felice Beato, a photographer who went on later to an adventurous career in the Far East.

Robertson's pictures could be bought in London and Paris, and viewed there in photographic exhibitions. They were to be found in ports of call, like Malta, on the Mediterranean route, or purchased at a military camp in the Crimea. Engravings based on his work appeared in

books and on the pages of the illustrated press. Professional organizations like the Architectural Photography Association marketed his images, and so did commercial ones like the steamship companies, which offered engraved versions of his photographs as souvenirs.

Robertson's eye was caught by buildings, monuments, structures, the play of light on carved and modelled surfaces. His photographs of Grecian antiquities and scriptural sites in the Holy Land presented objects which may not have been seen before by his viewers, but which were already steeped for them in a thousand associations. As far as possible he tried to isolate the venerated subject matter from the distractions of contemporary life, with just a few small human figures to give a sense of scale. Even before he set foot in Athens or Jerusalem, he knew well what his camera must do. Its task was not to startle or surprise but to pay homage.

In the Crimea, Robertson was constrained by no such expectations. One of the first war reporters, he had to establish tradition, not to follow it. The pictures for which he is famous are silent witnesses to the cost of conflict. No dead bodies are shown, but the devastation of military fortifications and civilian buildings tells its sobering story. In Constantinople also, Robertson was free to tell a new tale, not to illustrate an old one. The city was fascinating to Westerners but occupied no special place in the collective consciousness. His camera could show both the architectural marvels of the place and the mundane life swirling around them. His record of the city earned him the title by which he is best known, "Robertson of Constantinople."

BRIDGET A. HENISCH
HEINZ K. HENISCH

Biography

James Robertson, born in 1813–1814, in Middlesex. was the son of Thomas James Robertson, and he was christened in the Church of England. In 1855 he married Matilda Beato, and they had three daughters. Trained in London as a coin engraver, he spent forty years in Constantinople at the Imperial Mint. On his retirement there in 1881, he and his family went to Japan, where he died in 1888. Active as a photographer from 1853 to 1867, he exhibited examples of his work in Britain throughout that period, at the Royal Society of Arts (1854), the Photographic Society of London (1855–1858), the Manchester Art Treasures Exhibition (1857), etc. His Crimean photographs were on display in London and some provincial cities from December 1855 to December 1856. His first published album of views appeared in 1853, his last in 1864. Engraved versions of his pictures were shown from 1853 onward in several illustrated journals, in Britain and continental Europe.

See also: Beato, Felice.

Further Reading

Henisch, B.A. and H.K., "James Robertson of Constantinople," *History of Photography*, vol. 8, no. 4, 1984, 299–313.

Henisch, B.A. and H.K., "James Robertson of Constantinople, a Chronology," *History of Photography*, vol. 14, no. 1, 1990, 23–32.

Henisch, B.A. and H.K., "James Robertson's Crimean War Campaign," *History of Photography*, in print for Autumn 2002.

Lawson, J., *James Robertson, Photographer of Istanbul*. Catalogue of an Exhibition organised by The British Council in association with the Scottish National Portrait Gallery, Edinburgh, 1991.

Osman, C., "The Later Years of James Robertson," *History of Photography*, vol. 16, no. 1, 1992, 72–73.

Öztuncay.B., *James Robertson, Pioneer of Photography in the Ottoman Empire*, Eren, Istanbul, 1992.

Öztuncay, B., "James Robertson; A Scottish Artist in the Ottoman Capital," *Scottish Photography Bulletin*, vol. 2, 1991, 3–10.

ROBINSON, HENRY PEACH (1830–1901)
British photographer

Robinson was born in Ludlow, Shropshire, on 9 July 1830. He was the first child of John, a Master of the National School of the Church of England, and Eliza Robinson. Young Robinson had artistic ambitions, but as there was no formal art education available in Ludlow, he taught himself to draw and paint. Robinson's father, however, was unconvinced of his ability to make a living as an artist, so Robinson went to work for various printers and booksellers in Ludlow, London and Leamington for the years 1844–1856. Nevertheless, Robinson continued to draw and paint during these years, and he produced hundreds of watercolors, pen and ink drawings, and etchings. The acme of his artistic achievement came in 1852 when the Royal Academy accepted his painting *View of the Teme near Ludlow* for their annual exhibition.

In 1851 Robinson learned the daguerreotype process from a visiting photographer, and he experimented with photogenic drawings and calotypes, and then later with the collodion process. Dr Hugh Diamond visited Robinson in 1854 and enthusiastically encouraged Robinson's photography. Robinson continued to refine his photographic techniques, and in 1856 he decided to pursue commercial photography as a profession. With a loan of £100, Robinson opened a photography studio in Leamington on 12 January 1857.

Robinson is most well known for his attempt to create artistic compositions through photography. Basing his photographic art technique and compositional style upon principals of academic painting, Robinson produced large prints for the annual exhibitions of the Photographic Society. In 1858 Robinson exhibited *Fading Away*, which was controversial for two reasons: its subject matter and its compositional technique. Some critics felt that its subject, a young middle-class lady

dying of consumption, was too painful to depict with the realistic medium of photography. To compose the narrative image, Robinson used combination printing, a technique in which a photographer created a picture by printing parts of several negatives together. Robinson used this technique to make up for the technical short-comings of the collodion process and because it allowed him to carefully compose an aesthetic picture. Whereas Robinson felt that photographers should be able to use any technique that furthered the aesthetic appearance of the image, Alfred H. Wall and other critics felt that combination printing was dishonest. Undeterred, Robinson continued to use combination printing for the remainder of his photographic career. In 1861 Robinson exhibited another controversial combination print of a young woman doomed to die—*The Lady of Shalott*. This photograph was based on the title character from Alfred, Lord Tennyson's allegory of artistic creation. In effect, Robinson's *Shalott* staked a claim that photography could illustrate and even interpret poetry, or in other words, it could depict the imaginary. Some critics had harsh opinions, saying that the subject went beyond the appropriate boundaries for photography.

After the two controversial subjects of *Fading Away* and the Pre-Raphaelite *Lady of Shalott*, Robinson vowed to stick to themes of "the life of our day," but he still wanted to create a type of photography that would be accepted as art. For the next fifty years, Robinson produced photographs that almost exclusively imitated British genre painting, depicting rustic maidens and old cottagers. This subject matter allowed him to explore the creative principles of photography while still permitting him to picture a conservative and familiar type of reality.

Robinson was an active member of the Photographic Society of London, to which he was elected in 1857. He was elected to the Society's Council in 1862, and he was elected Vice-President in 1870. In 1891, however, he withdrew from the Society after he was censured for allowing the late entry of George Davison's photographs into the annual exhibition. The following year he helped to form the Linked Ring, an association of photographers dedicated to developing their medium as an art.

Throughout his career, Robinson was a prolific writer, publishing nine books and over 150 articles in various photographic journals. His most popular book, *Pictorial Effect in Photography: Being Hints on Composition and Chiaroscuro for Photographers* (1869), went through four English and American editions and was also published in French and German. These books were mostly aimed at other commercial photographers, and Robinson encouraged these photographers to create pleasing images by following compositional and lighting principals of Fine Art.

Robinson operated commercial photography studios for the majority of his artistic career. His initial studio in Leamington fared well, and he offered portraits on paper, glass or ivory, plain or colored, as well as hand-colored art reproductions, landscapes, documentation of public buildings and residences, and printing of amateurs' negatives. Robinson suffered from ill-health, largely due to the hazards of photographic chemistry, and he halted commercial practice in late 1864. After more than three years of rest, Robinson opened up a commercial studio in 1868 with a partner, Nelson K. Cherrill, in Tunbridge Wells, Kent. Robinson and Cherrill collaborated on many artistic combination prints during their partnership, which lasted until 1875. Their lavish studio featured prominent displays of studio portraiture and also many examples of Robinson's artistic exhibition photographs. It also exhibited nearly fifty medals Robinson had won at various exhibitions throughout Europe and America. Robinson retired from commercial practice in 1888.

Although he had retired from commercial photography, Robinson was still very as an artist and writer. In 1889 began a brief, but very heated, public debate with the British photographer Peter Henry Emerson, who had implicitly criticized Robinson's oeuvre in his book *Naturalistic Photography for Students of the Art*. (Emerson disdained combination printing, for example, saying that it was "the art of the opera bouffe" and that Oscar Rejlander was the only artist he knew who had used it.) Robinson negatively reviewed Emerson's book, concluding that Emerson's theories were symptomatic of a recurrent "disease," for which Robinson's views were the "disinfectant." This prompted a heated and insulting reply from Emerson that concluded, "I have yet to learn that any one statement or photograph of Mr. H.P. Robinson's has ever had the slightest influence upon me, except as a warning what not to do." Their public debate effectively ended with Robinson's assessment of Emerson's retraction of his theories as "a petulant jeremiad."

Robinson died in 1901, survived by his wife, Selina, and their five children: Edith, Ralph Winwood, Maud, Ethel May, and Leonard Lionel.

DAVID COLEMAN

See also: Photographic Exchange Club and Photographic Society Club, London; and Wet Collodion Negative.

Further Reading

Coleman, David. *Henry Peach Robinson: Victorian Photographer*. Austin, Texas: Harry Ransom Humanities Research Center, The University of Texas at Austin, 2001.

Handy, Ellen, ed.. *Pictorial Effect, Naturalistic Vision: The Photographs and Theories of Henry Peach Robinson and Peter Henry Emerson*. Norfolk, Virginia: Chrysler Museum, 1994.

Harker, Margaret. *Henry Peach Robinson: Master of Photographic Art, 1830–1901*. Oxford, UK: Basil Blackwell, 1988.

Smith, Lindsay. "The Elusive Depth of Field: Stereoscopy and the Pre-Raphaelites." In Marcia Pointon, ed. *Pre-Raphaelites Reviewed*. Manchester: Manchester University Press, 1989.

Smith, Lindsay. *Victorian Photography, Painting and Poetry: The Enigma of Visibility in Ruskin, Morris, and the Pre-Raphaelites*. Cambridge: Cambridge University Press, 1995.

Taylor, John. "Henry Peach Robinson and Victorian Theory." *History of Photography* 3 (October 1979): 295–303.

Weaver, Mike. "Artistic Aspirations." In *A New History of Photography*, edited by Michel Frizot. Cologne: Könemann, 1998.

ROBINSON, RALPH WINWOOD (1862–1942)
English photographer

Ralph Winwood Robinson, son of the eminent pictorialist Henry Peach Robinson (qv), took over the family portrait studio in Tunbridge Wells, Kent, in 1885 when his father's failing health forced his retirement. The business became known subsequently as H. P. Robinson & Son, and had a considerable reputation for child portraiture. He later took over the Rembrandt Studio in Redhill, and another in Croydon. He was a highly respected pictorialist in his own right, and his enthusiasm for exploring the unique aesthetics of the photograph led him to become a founder member of the Linked Ring Brotherhood in 1892.

Ralph W. Robinson also developed a ground-breaking approach to location portraiture, producing a highly acclaimed series published as Royal Academicians and Associates. These studies showed the artists at work in their studios, and sitters included Alfred Waterhouse, George Frederick Watts and others.

Like many professional photographers in the closing years of the 19th century, Robinson found his livelihood being eroded by offers of cheap portrait photography in return for coupons being offered by soap manufacturers and tobacco companies. As a direct result of this, Robinson and others banded together and established the Professional Photographers' Association in London in 1901.

JOHN HANNAVY

ROCHE, RICHARD (1831–1888)
Canadian photographer

Richard Roche was born on June 16, 1831 in England. He joined the Royal Navy in 1851, setting sail in October 1856 as a third lieutenant on HMS *Satellite* for British Columbia, which was reached via Cape Horn on June 7, 1857. He likely carried a camera with him, as a scrapbook at Yale University Library (call number WA MSS S-1817) contains photographs documenting portions of the vessel's voyage and the joint military occupation of San Juan Island in which Roche took part. Roche served on the ground as a member of the Northwest Boundary Commission in 1858 and 1859, who included among its members Royal Engineers trained as photographers, until he was recalled to assist in the joint occupation of San Juan Island by British and American troops. Early in 1860 just prior to the *Satellite*'s departure, he struck up a friendship with Francis George Claudet who lived aboard the vessel for a time. After Roche's retirement, he settled on the Isle of Wight where he died in 1888. Roche's name is commemorated by place names in BC and Washington. Less than three dozen prints identified or attributed as his work survive in Canadian and American public collections.

DAVID MATTISON

RODGER, THOMAS (1833–1883)
English photographer

As a 'boy assistant' in Dr. John Adamson's St. Andrews lecture room, Thomas Rodger could truly claim to have been in at the birth of photography in Scotland. He became interested in photography at an early age, being taught by Adamson and eventually assisting him.

Thomas Rodger was born in St Andrews. His father, also named Thomas, was a painter, but Thomas Jr. chose to study chemistry and later medicine rather than art. Nonetheless, by 1849, at the age of sixteen, he had opened a photographic studio in the city. He lived and worked at his studio, in St. Mary's Place, for his entire professional life.

Amongst his early calotype subjects—exhibited at the Aberdeen Mechanics Institute exhibition of 1853, were portraits of Dr. John Adamson himself, views of the ruins of St. Andrews Cathedral, and several of the city's colleges.

Rodger exhibited his pictures in London, Edinburgh and Glasgow over a period of several years, but all the images exhibited from 1854 were by the wet collodion process rather than the calotype.

Rodger's friendship with John Adamson endured for many years, and accounts of the 1857 Exhibition of the Photographic Society of Scotland report a series of posed studies of the game of golf—then enjoying a considerable resurgence of interest—credited jointly to the two men.

JOHN HANNAVY

RODRÍGUEZ, MELITÓN (1875–1942)
Colombian photogrpaher and studio owner

Melitón Rodríguez was born in Medellín, Colombia and worked at his craft between 1892 and c.1939. He may

have received some training from artist Francisco Cano but was primarily self-taught. He worked in partnership with his brother Horacio until 1897, after which he continued on his own. Although the Colombian coffee industry grew significantly during his lifetime and brought prosperity to the Medellín area, in general Rodríguez struggled to support his wife and nine children, three of whom later worked with him in the studio.

His images recorded a variety of subjects in both studio portraits of individuals and groups and in outside views. He photographed modern developments such as railroads, trolleys and automobiles; urban monuments, buildings and events; rural scenes, locations and people, and ethnographic "tipos." He is remembered for recording the opening of the Amaga Railroad line in 1914.

Rodríguez was passionate about his craft, painted his own backdrops and for several years kept a diary in which he recorded his attempts to develop his skills and abilities as a photographer. He received a number of local awards for his work and in 1895 received a silver medal at a New York show sponsored by the photography journal, *Light and Shadow*. The image was that of "Los Zapateros" ("The Cobblers"). His archive of over two hundred thousand negatives is considered the official record of the Province of Antioquia during the first half of the twentieth century. The archive is preserved in Medellín at the Biblioteca Pública Piloto.

YOLANDA RETTER VARGAS

ROENTGEN, WILHELM (1845–1923)

Wilhelm Roentgen wrote or co-wrote fifty-eight scientific papers, but only the three he published on X-rays, which he discovered and named, are now well known. Among other subjects he investigated were the ratio of the specific heat of gases, the polarisation of light in gases, pyroelectricity and piezoelectricity, refractive indices of fluids, and the compression of liquids and solids. At the time of his discovery of X-rays in 1895, he was looking at electrical discharges through gases at low pressure.

Roentgen began studying cathode rays generated in a Crookes tube in the autumn of 1895. To detect them, he used paper coated with barium platinocyanide, which fluoresces when struck by cathode rays. On 8 November 1895 he noticed that one of the sheets, lying some distance away from the covered tube, was glowing. Photographic plates fogged in similar circumstances had been observed previously, but Roentgen was the first to investigate further. Since the range of cathode rays in air had been shown to be only a few centimetres, he deduced that the glow must be caused by some other form of ray. Placing his hand in the path of the rays caused the outline of his bones to appear on the coated paper.

X-rays are produced when cathode rays strike the wall of the tube and Roentgen experimented with a range of materials to determine their properties. He found that interposing materials varying in density affected the brightness of the rays by different amounts. A magnetic field did not deflect them as it did cathode rays but neither did they exhibit reflection, refraction or polarisation. It was because of these unusual characteristics that Roentgen characterised them as "X-rays," X standing for unknown as he could not determine their nature, although they were soon also known as Roentgen rays in his honour. The theory behind the phenomenon was unclear to him—he thought that they might be longitudinal vibrations in the ether. Later research showed that they were electromagnetic waves with a very short wavelength.

On 22 December 1895 he took the emblematic image of his wife's hand wearing a ring. He sent a paper entitled *On a New Kind of Ray* to the Würzburg Physical-Medical Society six days later and on New Year's Day 1896 sent copies, with samples of X-ray images, to a number of European colleagues. The story was published in Vienna on 5 January and was soon widely disseminated, bringing Roentgen instant fame. He followed his first paper with two more, in March 1896 and May 1897, which mapped the properties of the new ray.

The phenomenon was easily replicated, with unambiguous results; and unlike the increasingly abstruse details of laboratory science, the results were obvious to the layperson. Popular international interest too was immediate and paralleled scientific dissemination through the academic press. Awareness was stimulated by reproductions in illustrated magazines of X-ray images of a wide range of objects. They became the subject of an enormous quantity of commentaries as well as fiction, poetry and cartoons, though the satirical edge of many betrayed fears over loss of privacy and possible immorality.

The nature of X-rays raised the difficulty of fitting them into a conceptual framework, hence the alignment with photography which, despite the efforts of a number of early commentators to point out the obvious differences, glossed over the method by which each was achieved. As the images created by X-rays could be recorded on photographic plates, it was a natural assumption that they shared other characteristics. X-rays were seen as analogous to photography except that they captured information not visible to the naked eye.

Despite these differences the label "New Photography" caught on quickly, and had a certain validity. Photography had already extended the capabilities of perception, with its ability to freeze motion, take images of stars invisible to the naked eye and record microscopic organisms. At the same time Roentgen was announcing his discovery, moving images, which could reproduce motion, were being projected for the

first time, though at first X-rays received by far the greater coverage. X-rays appeared to be another method by which reality could be analysed with a permanent image as the result. The association was reinforced as photographers, realising the commercial possibilities, took up X-ray portraits as a side line. It was not long, however, before the negative side effects of uncontrolled use were appreciated.

Wild claims were made initially, for example one in March 1896 that X-rays were being used to transmit anatomical diagrams directly into the brains of medical students. Two months later a young farmer was reported to have used X-rays as an updated Philosopher's Stone to transmute cheap metal into gold. More reasonably, they were touted as an alternative to vivisection, their non-invasive character contrasting positively with the scalpel. The temperance movement too felt that they would have an educative effect by demonstrating the deleterious physiological effects of alcohol and tobacco.

X-rays also slotted into the discourse around spirit photography, with their shared emphasis on photographing the invisible, phenomena that could not be seen with the naked eye. The early terminology used to describe X-rays (notably ether and vibrations) was similar to that used by spiritualists, and the figure of Sir William Crookes, both inventor of the 'Crookes tube' that was an essential component in producing X-rays, and a figure strongly associated with Spiritualism, reinforced the link. Darget and Baraduc's thoughtographic experiments were conducted using a device called a 'radiographer,' showing a clear debt to Roentgen. The ability to see what was otherwise hidden was used to legitimate the claims of clairvoyants, who maintained that they did the same.

The medical and metallurgical applications of X-rays were quickly appreciated, assisted by Roentgen's refusal to patent the discovery so that humanity would benefit from it. Familiarity with the new technology, and appreciation of its limitations, soon caused a loss of interest among the general public. There was also an increased appreciation of the differences with photography during the second half of the decade, and "New Photography" faded away.

TOM RUFFLES

Biography

Wilhelm Conrad Roentgen was born 27 March 1845 in Lennep, Rhine Province but grew up in the Netherlands. He obtained his PhD on the properties of gases from the University of Zurich in 1869. In 1870 he moved to the University of Würzburg, the first of a number of academic posts in the next decade. After spells at Strasbourg, Württemberg and back at Strasbourg, he took the Chair of physics at Giessen University in 1879.

Würzburg offered him the Directorship of its Physical Institute in 1888 and he became its rector in 1894. After a demonstration of X-rays to the Kaiser he was awarded the Prussian Order of the Crown, Second Class, and was made an honorary citizen of Lennep. He was appointed professor of physics at Munich in 1900 and accepted the first Nobel Prize for physics in 1901. He died of cancer on 10 February 1923 and was buried with his wife Anna at Giessen.

See also: Spirit Photography; and Crookes, Sir William.

Further Reading

Crangle, Richard, "Saturday Night at the X-Rays—The Moving Picture and the 'New Photography' in Britain, 1896." In Fullerton, John (ed.), *Celebrating 1895: The Centenary of Cinema*, Sydney/London: John Libby, 1998.

Chéroux, Clément, "Photographs of Fluids: An Alphabet of Invisible Rays." In Chéroux, Clément, Andreas Fischer, Pierre Apraxine, Denis Canguilhem and Sophie Schmit (eds.), *The Perfect Medium: Photography and the Occult*, New Haven/London, Yale University Press, 2005.

Dam, H. J. W., "The New Marvel in Photography," *McClure's Magazine*, vol. 6, no. 5, April 1896, 403–415.

Glasser, Otto, *Wilhelm Conrad Röntgen and the Early History of the Roentgen Rays*, London: John Bale, Sons and Danielson Ltd, 1933.

Grove, Allen W, "Röntgen's Ghosts: Photography, X-Rays, and the Victorian Imagination," *Literature and Medicine*, vol. 16, no. 2, Fall 1997, 141–173.

Keller, Corey, "The Naked Truth or the Shadow of Doubt? X-Rays and the Problematic of Transparency," *Invisible Culture: An Electronic Journal for Visual Culture* (www.rochester.edu/in_visible_culture/Issue_7/Keller/keller.html), 2004.

Nitske, W. Robert, *Wilhelm Conrad Röntgen: Discoverer of the X Ray*, Tucson, Arizona: The University of Arizona Press, 1971 (reprints the three X-Ray papers and provides a list of all of Roentgen's scientific papers).

Schedel, Angelika, "An Unprecedented Sensation—Public Reaction to the Discovery of X-rays," *Physics Education*, (part of feature issue on X-ray centenary) vol. 30, no. 6, November 1995, 342–7.

"The Photography of the Invisible," *Quarterly Review*, vol. 183, no. 366, April 1896, 496–507.

Trowbridge, John, "The New Photography by Cathode Rays," *Scribner's Magazine*, vol. 19, no. 4, April 1896, 501–506.

ROLL FILM

From the early 1850s, experimenters had been looking for an alternative to glass as a support for light-sensitive emulsions. The weight and bulk of glass plates added greatly to the photographer's burden, added to which, of course, was the constant danger of breakages. Talbot's caloytpe process had shown that paper could be used satisfactorily as a negative support. Paper could be used either in sheet form or as a long band. The first practical proposal to use a band, rather than a sheet, of sensitised paper came in a British patent of 1854 by Joseph Blakey

Spencer and Athur James Melhuish. They described a camera attachment called a roller slide or rollholder containing a band made by gumming together sheets of sensitized paper. The paper was attached at each end to a pair of rollers and could be wound from one roller to another in order to take several exposures in succession. Several similar devices were patented during the 1850s and 1860s, including one designed by the famous portrait photographer Camille Silvy, in 1867. None of these early devices, however, were widely used. The first rollholder to enjoy a modest degree of commercial success was designed in 1875 by Leon Warneke, a Russian living in England. Warneke's rollholder contained a one hundred exposure roll of tissue coated with a film of gelatine or dry collodion emulsion that could be stripped from the paper for processing. Warneke's design was the inspiration for the first commercially successful rollholder, designed by George Eastman and William H Walker in 1884. The Eastman-Walker rollholder used strips of sensitised paper or stripping film, sold under the name "Eastman's American Film." Such was Eastman's faith in the future of film photography that he changed the name of his company from The Eastman Dry Plate Company to The Eastman Dry Plate *and Film* Company. At this time, 'film' effectively meant "paper," used either as a negative material in its own right or as a support from which a negative-bearing emulsion layer could be stripped during processing. Eastman was not alone in realising the disadvantages associated with paper and the need to develop an alternative support for film photography. However, any substitute would have to fulfil a number of criteria—it would have to be light, tough, flexible and transparent. Many flexible film supports were tried in the 1880s, including the idea of using several layers of collodion emulsion, but the answer was eventually found in one of the most important synthetic materials developed during the nineteenth century—celluloid.

Celluloid has its origins in the work of an Englishman, Alexander Parkes. In 1855, Parkes was granted a patent for a substance which he called *Parkesine* produced using a mixture of oils and gums as a solvent for nitrocellulose. In America, brothers John and Isiah Hyatt discovered that camphor under heat and pressure acts as a nitrocellulose solvent. They called their new material *celluloid* and in 1872 they founded the Celluloid Manufacturing Company which made a range of products from celluloid, such as dominoes and billiard balls. As celluloid became better known, its qualities recognised and its use as a substitute for other materials widened, photographic experimenters became increasingly interested in its possibilities. A number of people attempted, unsuccessfully, to promote the use of sheets of celluloid as a substitute for glass plates, including David and Fortier in France and Waterhouse in England.

The breakthrough came in 1888 when John Carbutt, an Englishman born in Sheffield who had emigrated to America as a young man, put on the market the very first commercially produced gelatin emulsion-coated celluloid sheet film. Although marketed as "flexible negative film," Carbutt's celluloid sheets were, in fact, relatively stiff and unsuitable for production in long strips for use in rollholders.

In 1887 Hannibal Goodwin, a relatively unknown clergyman and amateur photographer in Newark, New Jersey, filed an application in the U.S. Patent Office for a 'transparent sensitive pellicle better adapted for photographic purposes, especially in connection with roller-cameras.' Goodwin was a self-taught chemist and his patent application was broad and somewhat ambiguous in its wording. For two years, the application remained unissued, undergoing several amendments, but by this time other inventors, most notably George Eastman and his chemist Henry Reichenbach had entered the field. In 1888, the year that he introduced the Kodak camera, George Eastman began to seriously explore the possibility of manufacturing flexible rolls of sensitised celluloid. He set his young research chemist, Henry Reichenbach on the task and the following year both Eastman and Reichenbach filed patent applications for flexible celluloid film. These interfered with Goodwin's application, filed two years earlier, setting in motion a legal battle that would drag on for over twenty years. Eastman's celluloid film went on sale in the autumn of 1889 and was available in a range of sizes to fit the various rollholders and the growing range of Kodak cameras (four different models by this time). The commercial potential for rollfilm was enormous, as Eastman quickly realised. In March 1889 he had written to his business partner William Walker: "The field for it is immense… If we can fully control it, I would not trade it for the telephone."

Eastman did not enjoy a monopoly of film manufacture but his company did come to dominate the market. Throughout the 1890s, boosted by the rapid growth of amateur photography and its use in cinematography, transparent celluloid rollfilm was produced in ever increasing quantities. All this time, Goodwin's patent application remained under consideration. It was not until 1898, eleven years after his original application had been filed, that Goodwin was finally granted a patent. After his death in 1900, Goodwin's patent was sold to the American firm of Anthony and Scovill, who took out a suit against Kodak for patent infringement in 1902. The case dragged on for over ten years and, finally, in August 1913 it was ruled that Goodwin's patent had indeed been infringed, "not on the ground that Eastman had copied the process, but that Eastman's process, though an improvement, came within the Goodwin patent claims." The following year, Eastman paid

his competitor five million dollars as compensation. A huge amount, but tiny when compared to the profits that Eastman had earned from sales of celluloid film in the intervening years.

COLIN HARDING

See also: Camera Design: 5 Portable Hand Cameras (1880–1900); Camera Design: 6 Kodak (1888–1900); Carbutt, John; Eastman, George; Kodak; Melhuish, A J; and Parkes, Alexander.

Further Reading

Jenkins, Reese V, *Images and Enterprise: Technology and the American Photographic Industry, 1839 to 1925*, Johns Hopkins University Press, 1975.

ROOT, MARCUS AURELIUS (1808–1888)
American photographer

At the height of his career in the 1850s, Marcus Aurelius Root was one of America's preeminent daguerreotypists, renowned for the elegance of his portraits, the eminence of many of his sitters, the flawless finish of his plates, and the size and opulence of his studios. Root was also one of the most prolific and influential writers on photography of his era, contributing numerous articles on both the art and profession of photography to the journals of the period. He supposedly coined the term "ambrotype." Root's book, *The Camera and the Pencil or The Heliographic Art* (1864), remains a major source on the theory and practice of photography in America in the 19th century. Finally, Root was a pioneering photographic historian and collector: *The Camera and the Pencil* includes the first the history of American photography ever written, and Root assembled a collection photographic original works spanning 1839–1876 for display in the Philadelphia Photographic Society's pavilion at the 1876 Centennial Exposition in Philadelphia, which resents the first exhibition surveying the history of photography. (This collection remained largely intact and forms the core of the collection of early Philadelphia photography held by the Library of Congress.)

Marcus Aurelius Root was born and grew up in Ohio, where he took art lessons and worked briefly as a portrait artist while studying penmanship (ornamental copperplate writing). Root moved to Philadelphia in 1832 to study portrait painting with Thomas Sully, but finding he lacked talent as a painter, began teaching penmanship, then a very lucrative profession. He opened a writing academy in Philadelphia in 1835, and devoted most of the next decade to running his school, teaching penmanship, and authoring manuals on its philosophy and practice.

In 1839 and into the early 1840s, Philadelphia—then the home of American science—was the major center of daguerreian activity and experimentation in the United States. Root naturally became interested in the process and by 1843 had learned it. His teacher was Robert Cornelius, one the first Americans truly to master the daguerreotype. (Cornelius, who introduced using bromine to increase the sensitivity of daguerreotype plates in 1839, opened the first portrait studio in Philadelphia 1840. He also invented the superior plate polishing compound used by many of the top American daguerreotype studios, including South and Hawes—and Marcus Root.) Deciding to practice daguerreotypy professionally, Root learned the business by becoming a partner in galleries in Mobile, Alabama, New Orleans, Louisiana, and St. Louis, Missouri, 1844–1845. In 1846, he returned to Philadelphia, bought out John Jabez Edwin Mayall, whose studio at 120 Chestnut Street was one of the city's leading daguerreian establishments, and within a short time had established a reputation for the superior artistic and technical quality of his portraits. In 1849, Root opened a studio in New York in partnership with his brother Samuel, but sold his share to his bother in 1851. In the meantime, Root consolidated his reputation by exhibiting his work at the annual fairs sponsored by Franklin Institute in Philadelphia (1844, 1846–1849), the American Institute in New York (1846–51), and at the international expositions at Crystal Palace in London (1851) and the Crystal Palace in New York (1853), where he won a bronze medal. In 1851, when the first American professional photographic journals were founded, Root became a frequent contributor, and by the time a serious injury suffered in a railroad accident caused his premature retirement from gallery work in 1856, he was recognized as one of the major figures in the profession in the United States.

Marcus Root wrote the *Camera and the Pencil* during his recovery. Conceived as a comprehensive two-volume theoretical and practical manual for practitioners, Root's magnum opus promotes photography as a legitimate aesthetic medium and as a significant form of American cultural expression. The first volume (1864), is one the major documents of 19th century photographic literature: it includes the first history of photography, chapters on aesthetics and art appreciation, and offers an extended discourse promoting the high standards of artistic and technical proficiency in the practice of the photographic profession of which Root was an ardent advocate. When the second volume, a handbook of processes and practical photographic technique, was destroyed in the presses when the printers burned to the ground, Root retired from the field.

Root's final contribution was the exhibition surveying the history of photography, 1839–1876, which he

organized for the Philadelphia Centennial Exposition in 1876. Granted only a small panel at the end of a dividing panel instead of the 12-foot wall he requested, Root was able to display only a fraction of the collection of original early material he had assembled, much of it obtained directly from Philadelphia's pioneer daguerrians. This collection—which included some of the earliest and most important examples of American daguerreotypes—remained largely intact after the Centennial and afterwards, and was eventually acquired by the Library of Congress, where it represents one of the great treasures in the Library's collection of photography.

When Marcus Root died in 1888 as a consequence of injuries received in a streetcar accident three years earlier, he was remembered as "one of the first daguerreotypists in America"—meaning one of the best and most successful. Indeed, portrait plates by Marcus Root typify and epitomize American studio daguerreotypy at its best, and good examples of his work are prized by collectors. In the end, however, Root's real importance lies not in his art, but in his writing and in his prescient understanding of the importance of preserving the story and the artifacts of photography's history.

WILL STAPP

See also: Cornelius, Robert; and Mayall, John Jabez Edwin.

Further Reading

Dilley, Clyde H., "Marcus Aurelius Root: Heliographer," *TheDaguererian Annual 1991*, Eureka, CA: The Daguerreian Society, 1991, 42–47.

Foresta, Merry A., and John Wood, *Secrets of the Dark Chamber: the Art of the American Daguerreotype*. Washington, D.C.: The Smithsonian Institution Press for the Nationaml Museum of American Art, 1965.

Johnson, William S., *Nineteenth Century Photography: An Annotated Bibliography, 1938–1879*, Boston: G.K. Hall & Co., 1990.

Newhall, Beaumont, *The Daguerreotype in America*, New York: Dover Publications, 1976.

Rinhardt, Floyd, and Marion Rinhart, *The American Daguerreotype*. Athens, GA: University of Georgia Press, 1981.

Root, Marcus Aurelius, *The Camera and the Pencil or the Heliographic Art*, Philadelphia: M.A. Root, 1864. (Facsimile edition, Pawlet, VT: Helios, 1971)

——, *Philosphical Theory and Practice of Penmanship... In Three Parts...Each Part in Four Books*, Philadelphia: A.W. Harrison, 1842.

Rudisill. Richard, *Mirror Image: The Influence of the Daguerreotype on American Society*, Albuquerque: Universiry of New Mexico Press, 1971.

Stapp, William F., *Robert Cornelius: Portraits from the Dawn of Photography*, Washington, DC: Smithsonian Institution Press for the National Portrait Gallery, 1983.

Welling, William, *Photography in America: The Formative Years, 1839–1900*, New York: Thomas Y. Crowell Company: 1978.

Wood, John, ed., *America and the Daguerreotype*. Iowa City: University of Iowa Press, 1991.

ROSLING, ALFRED (1802–1882)
English

Alfred Rosling was a London timber merchant from a Quaker family who, as early as 1846, made large-scale stereo still-life calotype studies for use in a Wheatstone viewer. He was a founder member of The Photographic Society, becoming its treasurer in 1859, and The Photographic Exchange Club. He exhibited 20 landscapes from paper negatives plus four microphotographs from collodion negatives, in the first photographic exhibition, at the Society of Arts in 1852. Like George Shadbolt, who was also a timber merchant, Rosling was an early experimenter with microscopic photography.

He used calotype, waxed-paper ,as well as collodion negatives, favoring the French chemist Dr .J.M. Taupenot's dry collodion process.

In 1859 Rosling and his family moved to Reigate where they became neighbors of the famous photographer Francis Frith and in 1860 Rosling's 22 year-old daughter, Mary Ann, married fellow Quaker Frith, 38, who had recently returned from his travels to the Middle East. Rosling's landscape and tree studies were later published by Frith and many of his views taken throughout Britain were used in early photographically illustrated books.

Rosling's work, which is mainly known through his Exchange Club studies, as well as the views published in the 1860's by Frith, is always technically accomplished and carefully composed.

IAN SUMNER

ROSS, ANDREW & THOMAS (1798–1859)

Of all the British photographic lens manufacturers the firm of Ross was the most significant and long-lasting with an involvement in photography's British origins, innovations in optical design throughout the nineteenth and twentieth centuries and a history which only ended in the third-quarter of the twentieth century.

Andrew Ross was apprenticed to John Corless an optician and instrument maker in 1813, and worked with the optician Gilbert until 1829. By 1830 he had established his own business as an optician, mathematical and philosophical instrument maker and by 1839 was trading under the name of Andrew Ross & Co. Ross remained involved in the business until his death in 1859 training his son, Thomas (1818–1870), who was to succeed to the business and John Henry Dallmeyer (1830–1885). Dallmeyer married Andrew Ross's second daughter Hannah, and was left one-third of Ross's fortune of over £20,000.

Thomas Ross and Dallmeyer separated and Dallmeyer established his own optical business in 1860. The

Ross business became Thomas Ross & Co, then from 1871 Ross & Co and finally from 1898 Ross Ltd. During the second half of the twentieth century the firm became associated with the Houghton-Butcher photographic business. It was last recorded as a manufacturer c. 1970 making binoculars before it was dissolved in c. 1975.

From 1830 Andrew Ross quickly established a high reputation for his microscopes and he was responsible for a number of significant improvements in microscopy design some in conjunction with Joseph Jackson Lister (1786–1869). Both were founder members of the Microscopical Society of London. Ross was a supplier of lenses and optical apparatus to William Henry Fox Talbot from at least 1838 and Talbot also visited his Regent Street shop. During one such visit on 30 March 1839 it is likely that Ross mentioned the work of the Reverend J. B. Reade and his use of gallic acid when preparing sensitized paper. Reade had previously spoken to Ross about this, a fact which emerged in the 1854 *Talbot v Laroche* lawsuit.

Ross acted as an intermediary between Talbot and the Parisian optician of Alphonse Giroux, the maker of Daguerre's camera, ordering two daguerreotype cameras with lenses for 320 francs on 7 October 1839 following two months of experimenting with the daguerreotype and communication on the matter with Talbot. Talbot was later to recommend Ross's services in securing such apparatus to Walter Trevelyan in 1842.

The Petzval lens was one of the first lenses designed specifically for photography being announced in 1841. The lens worked at f/6 and Ross was immediately able to improve it to work at f/4. Ross's son, Thomas, working in his father's factory made a novel lens for Henry Collen on 2 June 1841 being a double made of two cemented achromatic lenses. It was not a commercial success being unable to compete with the superior definition of the Petzval. Ross made other lenses for Talbot.

Henry Collen, a professional calotypist in London, ordered a camera from Ross but by March 1842 was complaining to Talbot that Ross had not delivered it and probably never would as he was having difficulties with the curved paper holder made to correct the focus of the lens. In August Collen was complaining to Talbot that Ross had not delivered a large lens of wide aperture he had ordered. This was never made. In 1848 Talbot was recommending Ross's enlarging camera to Thomas Malone, another professional photographer.

This involvement with the British early photographers gave way to more commercial activities including in c1860 a mammoth lens with a focal length of 6 feet (*sic*) producing an image of 44 × 30 inches for John Kibble of Glasgow. The camera to which it was attached was mounted on wheels and drawn by a horse.

Aside from optics the firm also sold and made a range of cameras and photographic equipment. An ex-tant catalogue from 1855 records Ross's success at the 1851 Exhibition for lenses and 'the best camera in the Exhibition' and it details a range of portrait and landscape lenses, cameras, stands and accessories, together with chemicals and equipment required to operate the Calotype, Daguerreotype and collodion processes. From 1861, Ross was also responsible for making Thomas Sutton's camera for panoramic photography and continued making it's distinctive water-filled lens. Ross's Universal Binocular camera of 1862 was a particular success.

From 1864 Thomas Ross developed a range of lenses called Doublets and based on his father's Collen lens. After Ross's death in 1870 the firm brought in a series of managers and lens designers including some from Germany who continued to produce new photographic lenses alongside the firms other optical products. In 1874 the firm brought out their portable and rapid symmetrical lens calculated by F. H. Wenham. Ross was the first firm to employ a scientist as a lens mathematician and Wenham was with the company from 1870 until 1888. He was followed by Hugo Schroeder.

Ross was awarded various medals and diplomas for their optics and claimed a list of the leading photographers of the period as users of the their lenses including: Henry Barraud, Francis Bedford, Henry Dixon & Son, Elliott & Fry, Thomas Fall, Robert Faulkner, Francis Frith, Frank Good, Hills and Saunders, Payne Jennings, Lock and Whitfield, J. E. Mayall, George Washington Wilson and Frederick York.

In 1890 the firm became Zeiss's London agents and made many Zeiss lenses, including the Protar (from 1 April 1892), the Planar, Unar and the Rudolph-designed Tessar, all under licence. Ross also made a version of a Meyer lens under it's own name as the Homocentric from 1902 which was a popular and long-lived design.

When Schroeder left Ross he was succeeded by J. W. Hasselkus whose first lens design was issued in 1898. The firm established a large factory at Clapham Common in 1899.

During the last years of the nineteenth century Ross issued several new designs of camera to supplement their traditional wooden field and studio cameras. The first of their twin lens reflex cameras the Portable (Divided) camera was launched in 1890 and a single lens reflex camera launched in 1905 which was made by Kershaw of Leeds. Other photographic optical equipment such as optical lanterns was also sold.

Throughout the nineteenth century photographic optics was just one part of the Ross company's wider optical manufacturing activities. While its involvement in photographic optics was maintained well in to the twentieth century cameras and associated photographic equipment was increasingly being bought in from other manufacturers and sold under the Ross name. Unlike

Dallmeyer which did develop some truly original lens designs the Ross company after Andrew Ross's death relied more on refining optical designs from Germany and selling its own version as well as manufacturing well-known German designs under licence. It introduced few original optical designs of it's own.

MICHAEL PRITCHARD

See also: Dallmeyer, John Henry & Thomas Ross; Talbot, William Henry Fox; Giroux, André; Daguerre, Louis-Jacques-Mandé; Petzval, Josef Maximilian; Henry Collen, Henry; Exhibition of the Works of Industry of All Nations, 1851: Reports by the Juries; and Calotype and Talbotype.

Further Reading

The Correspondence of William Henry Fox Talbot. http://www.foxtalbot.arts.gla.ac.uk/.

Rudolf Kingslake, *A History of the Photographic Lens*. London: Academic Press, 1989.

R. S. Clay, "The Twenty-fifth Annual Traill-Taylor Memorial Lecture: The Photographic Lens from the Historical Point of View," in *The Photographic Journal*, LXII, 11, (November, 1922), 458–476.

Michael Pritchard, "The Houghton-Butcher/Ensign Company Tree," in *The Photographic Collector* 5 (2), 204–205.

W. Taylor and H. W. Lee, "The development of the photographic lens," *Proceedings of the Physical Society*. 47 (1935), 502–518.

ROSS, HORATIO (1801–1886)

A talented marksman and athlete, Horatio Ross was also an important figure in the history of early photography in Scotland. He was born at Rossie Castle, Forfarshire Scotland on 5 September, 1801, the son of Hercules and Henrietta (Parish) Ross. He joined the 14th light dragoons in 1819 and retired as a Captain in 1826. Ross then embarked on a political career as a member of parliament for the Aberdeen and Montrose boroughs but did not seek re-election after 1834. An avid hunter, Ross wrote the introduction to a book titled *Deer Stalking and Forests*, in 1880. He lived at his family home, Rossie Castle until 1853, when he purchased the estate of Netherley in Kincardineshire. In 1834 he married Justine Henriette Macrae. Their marriage lasted over fifty years and produced five sons, Horatio, Edward, Hercules, Colin and Robert.

One of Ross's earliest photographs is thought to be a quarter plate daguerreotype, made in 1847, that depicts his eldest son and a friend, fishing. Although it is unusual for a amateur photographer to tackle the complexities of the daguerreotype process, eight plates at the Victoria and Albert Museum attest to Ross's perseverance and skill with this technique. Two years later, in 1849, Ross learned the rudiments of the paper negative process from a professional photographer from Edinburgh, James

Ross (no relation). Several of his albumen prints (often measuring 11 × 14 inches) were made from waxed paper negatives but even by about 1856 Ross was also using the wet-plate collodion process. A photograph from about 1858, made by his wife Justine, shows him preparing a plate in his home studio.

Ross's primary subjects were his family and other deer stalking enthusiasts. He also made "trophy" photographs the spoils of his activities as a deer-stalker as we can seen in photographs such as *Stag in Cart*, c. 1858 (Gilman Paper Company Collection). Set against the rugged landscape of the Scottish Highlands, the fallen stags are often arranged in a manner meant to produce the best pictorial effect. The branch-like antlers of the deer are silhouetted against a blank sky or massive boulder in order to highlight their spiky form. He worked within the English Picturesque tradition, photographing views of shepherds' huts, winding streams, waterfalls and rocky outcrops. Some writers have even suggested that the frequent use of a screen of trees or rocky crevices is the result of Ross's expertise as a consummate hunter. He is also known for his views of Edinburgh and various estates (and private hospitals) from around the Scottish countryside.

One of the founders of the Photographic Society of Scotland in 1856, Ross was the vice-president at the time of the society's first exhibition and held that position until 1863. Ross was a forceful advocate for the place of the amateur photographer within the society. He even went as far as delineating which fields of photography were suited to amateurs and which should be left to the professionals in a paper he read to the February 10th 1857 meeting of the PSS, where he argued that the "proper field for the Amateur's labor is in the open air. Portraiture he should leave in the hands of the professional gentlemen." He later defended the position of the amateurs at a special meeting of the society in 1858, when the professional members sought to establish a greater presence on the on the hanging committee. His motion to reject a proposal that would limit the number of amateurs in the society was supported by the majority of members.

Although Ross's work was exhibited frequently during his lifetime it is not as well known today. There are several known albums of his work and his picturesque views are often compared to the work of his contemporaries Roger Fenton and Benjamin Brecknell Turner. As a gentleman-amateur photographer Ross was typical of many of photography's early inventors and experimenters. While his hunting scenes can be seen as the product of the particular class and generation, they, along with his landscapes and architectural views, and portraits of friends and family, form a unique picture of life in Scotland in the mid-19th century.

Horatio Ross died at Rossie Lodge, Invernesshire, on the 6th of December, 1886. The *Dictionary of National*

Ross, Horatio. Tree.
The Metropolitan Museum of Art, Gilman Collection, Purchase, Harriette and Noel Levine Gift, 2005 (2005.100.17) Image © The Metropolitan Museum of Art.

Biography emphasizes Ross's accomplishments as a politician, athlete and marksman. His versatility with various photographic processes and his enthusiasm for recording the life and landscape the surrounded him, have also left an indelible mark on the early history of photography in Britain.

LORI PAULI

List of Exhibitions

1856 Edinburgh, Photographic Society of Scotland.

1857 (September) Birmingham, *First Annual Exhibition of Photographs, Stereoscopes, Apparatus and Etc.* Birmingham Photographic Society.

1858 (February 18) London, *Supplemental Exhibit, 5th Year, Exhibition of Photographs and Daguerreotypes at the South Kensington Museum*, Photographic Society of Great Britain.

1858 Edinburgh, *Photographic Society of Scotland.*

1859 Aberdeen, British Association Meeting in Aberdeen, 1859 Exhibition of Photographs, Hen and Chicken Hotel.

1859 (April) Glasgow, *Glasgow Exhibition of Photographic Works*, Glasgow Photographic Society.

1859 (December 1858) Edinburgh, *Scottish Exhibition of the Photographic Society of Scotland*, Photographic Society of Scotland Exhibition Rooms, 90 George Street.

1860 (December 1859) Edinburgh, *Scottish Exhibition of the Photographic Society of Scotland*, Photographic Society of Scotland Exhibition Rooms, 90 George Street.

1861 (January) Edinburgh, *Fifth Scottish Exhibition of the Photographic Society of Scotland*, Photographic Society of Scotland Exhibition Rooms, Mr. Hay's Rooms.

1867 (January) Paris, *Exposition Universalle*, Palace of the Champ des Mars.

1874 (October–5 November) London, *19th Annual Exhibition of the Photographic Society of Great Britain*, Suffolk Street Gallery, Pall Mall.

Collections

J. Paul Getty Museum, Los Angeles, California, United States.

Detroit Institute of Arts, Detroit, Michigan, United States.

Metropolitan Museum of Art, New York, New York, United States.

Harry Ransom Humanities Research Center, University of Texas, Austin Texas, United States The Science Museum, London.

See also: Wet Collodion Positive Processes.

Further Reading

Stein, Donna, (with an introduction by Sam Wagstaff), *Horatio Ross Presentation Album: Justine H. Ross, 1870,* vol. 7, no. 3 and 4, March 1986. New York: Janet Lehr Inc.

Titterington, Chris, *Photographs by Horatio Ross, 1801–1886.* New Haven: Yale Center for British Art, 1993.

ROSSE, LADY (1813–1885)
English photographer

Lady Rosse was born Mary Field in Yorkshire in 1813 to Anne Field and John Wilmer, a wealthy landowner. Her mother died shortly after her birth and she was raised by a governess. In 1836, she married William Parsons, Lord Oxmantown, and they took up residence at his family's seat at Birr Castle in Ireland. He became the 3rd Earl of Rosse after the death of his father in 1841. Lady Rosse took up photography in 1854 following the lead of her husband, who began experimenting with the daguerreotype process in 1842. Among her photographs that survive are group portraits, single portraits and landscapes, as well as many pictures of telescopes built by her husband. Lady Rosse was closely involved in the Earl's construction projects, and some of her first photographs portray his telescopes. The Photographic Society of Ireland awarded Lady Rosse their first Silver Medal in 1859. She was an elected member of the Dublin Photographic Society and the Amateur Photographic Association. Lady Rosse moved to London in 1870 following the death of her husband in 1867. She died in London in 1885 and was buried in the family vault at Birr Castle in Ireland.

ANDREA KORDA

Further Reading

Davison, David H., *Impressions of an Irish Countess: The Photography of Mary Countess of Rosse.* Dublin: The Birr Scientific Heritage Foundation, 1989.

ROSSETTI, DANTE GABRIEL (1828–1882)
English painter and photographer

Pre-Raphaelite painter and poet Dante Gabriel Rossetti was born in 1828 in London. Son of an Italian intellectual, Rossetti was the second of four children, including the art critic William Michael Rossetti (1829–1919) and poet Christina Rossetti (1830–94). Rossetti briefly trained as a painter at the Royal Academy schools and with Ford Madox Brown. He formed the Pre-Raphaelite Brotherhood in 1848 with other key members John Everett Millais and William Holman Hunt. Rossetti's relationship to photography was limited. He loosely used a group of photographs as the basis for many of his later portraits and studies of Jane Morris, the wife of designer, poet, and socialist William Morris. These albumen prints were taken in 1865 in the garden of Rossetti's home in Chelsea, London, by the photographer John Robert Parsons, but it is assumed that Rossetti posed Jane Morris himself. In the series of portraits, Jane Morris is posed against a cloth tent or a fabric-covered, patterned screen, wearing the loose-fitting clothes she adopted. She appears in several of the languid and flowing poses that Rossetti would make characteristic of her in his paintings. These photographs are housed in an album now in the collection of the Victoria & Albert Museum. Rossetti also posed with his siblings for a notable group of photographs taken in 1863 by Charles Lutwidge Dodgson (Lewis Carroll). Rossetti died in 1882 in Birchington-on-Sea after several years of illness.

DIANE WAGGONER

ROSSIER, PIERRE (1829–c. 1898)
Swiss photographer

Pierre Joseph Rossier was born on July 16, 1829, into a farming family in Grandsivaz, Switzerland. A passport issued to Rossier in October, 1855 listed his profession as photographer and indicated that he was to travel to France and England in order to practice his trade. Sometime between 1855 and 1858, Rossier was hired by the London photographic firm Negretti and Zambra. They sent him to Asia from 1859 to 1861, where he was among some of the first to produce commercial photographs (primarily stereographic views) of Japan and China. While in Japan, he trained Ueno Hikoma and other first-generation Japanese photographs in the collodion wet-plate procedure. His employment with Negretti and Zambra seems to have ended sometime in 1861. Rossier then traveled to Thailand, where he assisted the French zoologist Firmin Bocourt by taking ethnographic portraits of local people. He returned to Switzerland in 1864, operating a photography studio in Freiburg until at least 1876 that produced stereograph and cartes-de-visite views of local scenes as well as portraits. Captions on the mounts indicate that Rossier also had a studio in the Swiss city of Einsiedeln, although no dates of operation are known. He died in Paris sometime before 1898.

KAREN FRASER

ROUCH, WILLIAM WHITE (1833–1871)

The business of William White Rouch & Co began in 1854 as a partnership trading under the name of Burfield & Rouch as operative chemists, philosophical and photographic instrument makers, at 180 Strand, London. By 1864 it was trading as W. W. Rouch & Co under which name it remained until it ceased actively trading in photographic equipment around 1914.

William White Rouch was a chemist and appears to have been the driving force behind the business. The firm was the wholesale agent for T. Frederick Hardwich's negative and positive collodion from the late 1850s and commenced dry plate manufacture from an early date. It was also active in the manufacture of photographic equipment advertising various forms of camera for amateur and professional photographers. Rouch also manufactured lenses and was an agent for the principal British and European lens makers and it offered a range of accessories for photography, chemicals and prepared collodions and papers. W. W. Rouch registered a design of portable camera with separate processing chamber in 1858 and the following year registered a portable dark tent which was still being advertised in the 1880s. An improved dark tent design was registered in 1861 and a photographic shutter in 1862. W. W. Rouch died at Mentone on 18 February 1871 aged 39.

A relation, Samuel White Rouch (died 1898) continued with the business. The Patent Portable camera of 1878 was based on S. W. Rouch's patent and proved very popular. It was improved in 1885 and in 1891 and the firm announced that it was being widely used by travellers and explorers including Henry Morton Stanley.

Rouch also introduced a hand camera to meet the demand for smaller, more portable cameras. The Eureka was one of the most popular magazine plate cameras of the later nineteenth century. It was based on Rouch's patents of 1887 and 1888 and the model was sold until at least 1910. The rear section of the camera held a number of plates (one model also made this interchangeable) allowing multiple exposures to be made before reloading.

Hand cameras aside, Rouch continued to offer older designs of cameras and photographic equipment and, increasingly, cameras from other makers. Its importance consequently decreased and the firm traded mainly as a retailer. After Samuel's death in 1898 his son William Albert Rouch continued to manage the business but his interests lay more as a photographer and he built up a successful career as a horse photographer illustrating several books during the 1930s.

By 1914 the manufacturing and retailing business had largely ceased and after the first world war the W W Rouch name continued as W. A. Rouch's photographic studio and remained in existence until at least the mid-1980s.

MICHAEL PRITCHARD

Further Reading

Channing & Dunn, *British Camera Makers. An A–Z Guide to Companies and Products*, Claygate: Parkland Designs, 1996.

ROUSSEAU, LOUIS (1811–1874)
French photographer

Born on February 23rd, 1811 in Paris (France), Louis Pierre Rousseau pursued a lifetime career in the Museum of Natural History, mainly as assistant naturalist in the department of Malacology. He also took part in three scientific journeys.

His talent for preparing and drawing specimens contributed in the development of his interest in the publication of scientific illustrations. After the project of publishing a large number of engravings failed, he eventually turned to photography in 1853.

With Achille Devéria, assistant curator in the French national library, he undertook the publication by installments of *Photographie zoologique*, sixty photographs showing rare specimens from the Museum collections (salted paper prints- negatives by Louis-Auguste and Auguste-Rosalie Bisson and prints by Lemercier, and later plates made by the photomechanical process of Niépce de Saint-Victor). Despite constant praise for its accuracy and beauty the project was never completed. In 1854, Louis Rousseau took a series of portraits and photographs of skulls for the anthropological gallery.

A founding member of the *Société française de photographie* (November 15th, 1854), he received its instructions for his journey to the North Seas in 1856, where he made portraits of Inuit and Icelanders (collodion). He is not known to have taken photographs thereafter.

He died of an illness caught during one of his journeys on October 14th, 1874 in Paris, after a long career as a naturalist and a brief one as a photographer.

CAROLINE FIESCHI

ROYAL COLLECTION, WINDSOR

Members of the British Royal Family have collected photographs since the 1840s. By 2005 these amounted to hundreds of thousands of images, but it had not been until the late 1960s that certain of them were classed as a photograph collection, which was subsequently kept in the Round Tower at Windsor Castle in England. By 2005 it numbered at least 350,000 images, of which about a tenth had been acquired in the nineteenth century.

The first members of the Royal Family known to have been aware of photography were Queen Victoria, and more particularly her husband, Prince Albert, who took a keen interest in the new medium. Both had artistic skills and tastes, and were intrigued by new inventions. In March 1842, while the Court was at Brighton, the Prince had himself photographed by William Constable. The Queen and the Prince soon recognised photography's potential uses, whether for recording people and places,

for instruction and inventory purposes, or as an art form in its own right.

By the early 1850s, the Royal couple had commissioned photographers such as William Kilburn and Brunell to take pictures of their family. These were at first intended solely for private use, but within a few years the Queen and her husband had begun to realise how photography could be used to make the Royal Family better known to the public; this was to lead to the expansion of Royal photographic portraiture throughout the nineteenth century and beyond. By 1900, such images were as much an appanage of Royalty as painted State portraits had ever been.

In 1853 Queen Victoria and Prince Albert became patrons of the Photographic Society (later the Royal Photographic Society). When they visited its first exhibition in January 1854, the Honorary Secretary, Roger Fenton, showed them the latest developments in the art through his own work and that of other photographers. As a result he was given the first of his royal commissions, which included photographing the Royal children taking part in a series of tableaux to celebrate their parents' fourteenth wedding anniversary in February 1854.

Work by other photographers, including William Lake Price, Alfred Rosling, and Oscar Rejlander was also purchased by the Queen and the Prince. George Washington Wilson, Adolfe Disderi, and J.J,E. Mayall were commissioned for specific purposes: Mayall's *Royal Album*, produced in 1860, made photographs of the Royal Family available to the general public for the first time.

By the time of the Prince Consort's death in December 1861, he and the Queen had collected several thousand images. These included British and foreign Royalty, Royal Household officials and staff, friends, acquaintances, politicians, actors, artists and musicians and the armed forces. In addition there were views of Royal residences, scenes at Coburg and Gotha (made in 1857 and 1858 by Francis Bedford as birthday presents from the Queen to her husband); military, topographical, art and genre photographs, and reproductions of works of art.

Queen Victoria continued to collect photographs in memory of the interest which she and her husband had shared, but her preference was less for art and genre photography and more for portraiture; one series of 44 albums, *Portraits of Royal Children*, showed her descendants from 1848–1899. Many photographers, including Dr. Ernst Becker (Prince Albert's German librarian), T.R. Williams, William Bambridge, Leonida Caldesi, Camille Silvy, Hughes & Mullins, Hills & Saunders, Mendelssohn, Alexander Bassano, Charles Bergamasco, George Piner Cartland, Professor E. Uhlenhuth, Backofen, W. & D. Downey and others were employed to produce this record. Many were granted the Royal Warrant.

The Queen also collected photographs of her relatives, staff, and people she had met, or was unable to meet except through the medium of photography. Among the portrait photographers whose work she purchased was Julia Margaret Cameron. Other material showed military campaigns, ceremonial occasions, such as the Queen's Jubilees in 1887 and 1897, or historic buildings, such as J. Benjamin Stone's photographs of the Tower of London in 1898. Views taken in Europe, Australia, India, the Andaman Islands, Africa and elsewhere enabled the Queen to see foreign countries and parts of the British Empire which she herself was never able to visit.

Queen Victoria and Prince Albert had encouraged their children's interest in photography and several of them, including the Prince of Wales (later King Edward VII) and Prince Alfred (later Duke of Edinburgh and of Saxe-Coburg-Gotha) learnt how to use a camera in their youth. During the nineteenth century all nine Royal children, by this time adults with their own families, collected photographs and many of these, formerly kept in their separate residences, had by the late twentieth century become part of the Royal Photograph Collection. They included property belonging to Prince Alfred, Princess Helena (Princess Christian of Schleswig-Holstein) and Prince Arthur (Duke of Connaught) and his wife, as well as Queen Victoria's grandchildren, such as the future King George V and Queen Mary.

The most significant collection belonged to Albert Edward, Prince of Wales, who by the time of his marriage in 1863 had assembled at least 1,000 images, mostly documentary or topographical, such as Roger Fenton's Crimean War series, or the views taken by Francis Bedford during the Prince's Tour of the Near East in 1862. From an early age the Prince also collected photographs of works of art. During the1860s he assembled a number of volumes of views of foreign cities, important buildings and other material which interested him, including some genre photographs by R.P. Napper. The Prince and his wife, (later Queen Alexandra), kept photographs of themselves, their family and their residences, and by the 1880s had lent their support to a new development. Simplified cameras, for amateurs, were newly available, and George Eastman presented one to the Prince and Princess in 1885. Within a few years the Princess had become a skilled and enthusiastic practitioner.

The last decade of the nineteenth century saw the various collections expanding as the Princess of Wales, her daughter, Princess Victoria, the Duchess of York, the Duchess of Connaught and others began compiling albums which contained not only work by professional photographers but also their own snapshots. When members of the Royal Family openly supported photography by exhibiting some of their own work at

a Kodak exhibition in 1897, they gave considerable encouragement to the general public to take up the medium as a popular hobby.

FRANCES DIMOND

See also: Victoria, Queen and Albert, Prince Consort; Royal Photographic Society; Fenton, Roger; Rejlander, Oscar Gustav; Price, William Lake; Rosling, Alfred; and Mayall, John Jabez Edwin.

Further Reading

Gernsheim, Helmut and Alison, *Queen Victoria. A Biography in Word and Picture*, London: Longmans, Green & Co. Ltd., 1959.

Gernsheim, Helmut and Alison, *Edward VII and Queen Alexandra. A Biography in Word and Picture,* London: Frederick Muller, 1962.

Happy and Glorious. Six Reigns of Royal Photography. Edited by Colin Ford. London: Angus & Robertson, 1977.

Dimond, Frances and Taylor, Roger, *Crown and Camera: The Royal Family and Photography. 1842–1910*. London: Penguin Books Ltd., 1987.

Dimond, Frances, "Photographers, Royal"; "Royal Photograph Collection." *The Royal Encyclopedia*. Edited by Ronald Allison and Sarah Riddell. London: Macmillan Press, 1991.

Dimond, Frances and Taylor, Roger, "Photographic Portraits," *The Royal Encyclopedia*, edited by Ronald Allison and Sarah Riddell. London: Macmillan Press, 1991.

Dimond, Frances, *Presenting an Image*. London: Merrell Holberton, 1995.

Dimond, Frances, *Developing the Picture. Queen Alexandra and the Art of Photography*. London: Royal Collection Enterprises Ltd., 2004.

ROYAL ENGINEERS

The British Army's Corps of Royal Engineers was probably the first military unit to receive formal instruction in photography. Between 1854 and 1855 a small number of Sappers were trained on an ad hoc basis by civilian photographers in order to capture scenes of the Crimean War and to reduce maps and plans for the Ordinance Survey. In 1856 the War Department appointed Charles Thurston Thompson (1816–1868), Superintendent of Photography at the South Kensington (later Victoria and Albert) Museum, to train the Corp's non-commissioned officers in the wet-plate process. On receiving their certificate of competency, they were despatched to companies stationed overseas, from Greece to India and China, to document work in progress and make topographical and ethnographical pictures. Often working under inhospitable conditions they produced the earliest significant bodies of photographs of many little known places and cultures. They painstakingly recorded from the crest of the Rocky Mountains westwards along the 49th Parallel to the Pacific coast for the US/Canada Border Survey from 1858–62, and the 400 mile journey inland from Zula, Eritrea to Magdala during the Abyssinian expedition of 1868. By the 1860s photography was offered as an optional course at the School of Telegraphy at the Royal Engineers Establishment at Chatham. Captain (later Sir) William de Wiveleslie Abney (1843–1920) established a separate Chemical and Photographic School there in 1874 which was absorbed into the Survey School in 1904.

ANNE-MARIE EZE

ROYAL GEOGRAPHICAL SOCIETY
The world through a lens

No expedition ... can be considered complete without photography to place on record the geographical and ethnological features of the Journey.
John Thomson RGS Official Instructor in Photography 1885.

Photographs of Exploration

Today the Royal Geographical Society is today home to a remarkable collection of over 500,000 19th and early 20th century photographs. This collection was built up through the donation of photographs taken by many travellers, geographers and explorers. In addition, the growing importance the Society attached to photography during the Victorian period is in part due to John Thomson who in 1886 became the RGS's Instructor of Photography. He has recently undertaken photographic travels in China and Cambodia (alongside his celebrated collaboration with the journalist Adolphe Smith Street life in London 1878) and it was under his instruction that many RGS Fellows set of to photograph the furthest reaches of the known world.

Such work helped to underpin the use of the camera—alongside the sextant, compass and sketchpad—as an essential part of any explorer's equipment. While the aesthetic nature of photography was ever present there was burgeoning interest in its application for the scientific documentation and recording of the world. As Thompson noted *"the faithfulness of such pictures affords the nearest approach that can be made towards placing the reader actually before the scene which is represented."*

Photography's New Place in Exploration

Throughout the Victorian period expeditions continued to be documented both through existing forms—such as the sketch pad and oil paints—alongside the recent introduction of the camera. The tensions between these two forms can in part be seen in David Livingstone's Zambezi expedition 1858–64.

Livingstone was accompanied by his brother Charles—who was the expedition's photographer—

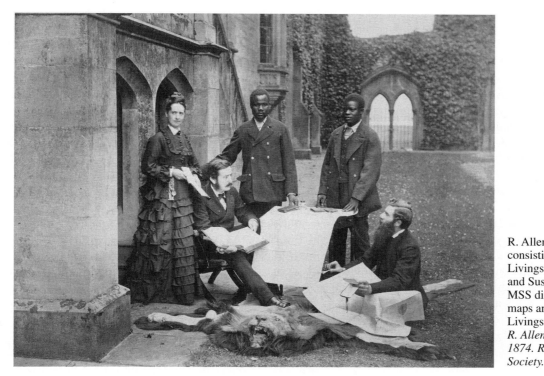

R. Allen & Sons. A group consisting of T. S. and Miss Livingstone, James Chumah and Susi and the compiler of MSS discussing the journals, maps and plans of the late Dr. Livingstone.
R. Allen & Sons (Nottingham) 1874. Royal Geographical Society.

alongside Thomas Baines an accomplished artist. Bain's and Charles Livingstone soon argued, and following a contrived story of the theft of a bag of sugar Baines was expelled from the expedition.

The animosity between these two visual professional is reflected in Baines's painting of the rapids on the Zambezi River in 1859. Baines is pictured centrally, striding purposefully across the scene sketch book in hand. However, the expedition's photographer is depicted as a diminuative, shrouded figure isolated and seemingly of little consequence.

Records of Hidden Histories

The photographic archive of exploration also reveals the hidden histories of individuals whose lives may have so easily been lost to history. For example, many may be familiar with the story of how after Livingstone's death the African members of his expedition carried his body, alongside his equipment and papers, back to the coast for where it was returned to England, However, what do we know of these Africa individuals?

Much is revealed in the following photograph showing James Chuma and Abdullah Susi (centre left and right) both members of Livingstone's expedition. As Dr Caroline Bressey notes, in a rereading of this image, it illustrates an uncommon scene of a white Victorian man—Rev Horace Waller (the editor of Livingstone's papers) looking up at two Black African individuals who are centre stage in the scene's composition. It was Waller who, when the RGS presented Chuma and Susi

with medals recognising their contribution said; *"These faithful companions of Livingstone were able to give an intelligible account of every river and mountain and village in the regions they had passed through; and such aid as they could give was of the first importance to Mr. Livingstone in preparing the work on which he was engaged."*

It was only with some trepidation that the Society embraced the new technologies of lenses, blackout tents, chemicals and glass plates. For example, Hugh Mill wrote, in commenting of the use of images projected by lantern slides in the 1880's, that *"the proposal to illustrate papers read at the evening meetings by lantern slides was scoffed at by some who said it would lower the Society's discussion to the level of a Sunday School treat with a magic lantern."* However, the Society's growing enthusiasm for this new technology resulted in its purchase—albeit under the guise of how the images enhanced the 'scientific' value of lectures—of its own lantern in 1890.

In addition, a chapter on photography appeared in the second edition of the Society's *Hints to Travellers* (1865)—alongside sections on 'Outfits for an Explorer,' and 'Latitude and Longitude.' Professor Pole the author wrote that, *"any traveller or tourist, gentleman or lady may, by about a quarter of an hour's learning, and with the amount of apparatus that would go into the gentleman's pocket or lady's reticule, put him or herself into the position (to take a picture)."*

148/9 "the Society by degree added instruction in photography, geology, natural history and other subjects so that the traveller who took the whole course and

profited by it could start on his exploration with a full scientific equipment"

Conclusion

Today we may marvel at the lengths to which our Victorian ancestors toiled to gather photographs of their world. The Royal Geographical Society was central to the promotion, use and collection of photographs that recorded the global reach of Victorian Britain. Indeed, it was the Society's central concern—that of geography—than underpinned how it promoted photography. As James Ryan has argued, *"much Victorian colonial photograph, from travel and topography to natural history, was broadly about geography."*

Time may not have diminished the beauty of these photographs and we can continue to revel in their aesthetic qualities. However, perhaps of greater importance is that in their glass plates and sepia tones these 19th century photographs have captured an irreplaceable record of the world' people, places and environments.

STEVE BRACE

Further Reading

Mill, Hugh, *The Record of the Royal Geographical Society 1830–1930*, 1930.
Ryan, James R., *Picturing Empire: Photography and the Visualisation of the British Empire*, 1997.
Proceedings of the Royal Geographical Society, Anniversary Meeting, 22 June 1874.

ROYAL PHOTOGRAPHIC SOCIETY

The world's oldest national photographic society, the Royal Photographic Society of Great Britain, formed in 1853 as *The Photographic Society*, was not the world's first photographic organisation. That distinction goes to *The Edinburgh Calotype Club* established by a group of amateurs in 1841. Like the *Société héliographique française* founded in France ten years later, the Edinburgh club was a relatively informal grouping, and survived until 1856 and the formal establishment of the Photographic Society of Scotland. The *Société héliographique française* was disbanded in 1854, its place taken by the more formal structure of the *Société française de photographie* which still exists today.

The genesis of the *Photographic Society* can safely be traced back to the discussions in 1851–52 which prefaced the organisation of the world's first exclusively photographic exhibition at the Society of Arts in London in December of that year. By that time, surprisingly in advance of London, a photographic society had already been established in Leeds, and friendships developed through the informal *Calotype Club* in London in the 1840s had also surely underlined the value of such groupings.

The pivotal moment in the organisation of photography in 1852 brought together the leading amateurs and professionals of the day, under the leadership of Roger Fenton, to organise and mount a huge international showcase for the new medium. Seven hundred and eighty four exhibits from seventy-six named photographers and several more un-named were displayed at the Society of Arts from December 22nd 1852 until the end of January 1853. Significantly that event brought together most of those who would figure centrally in the first meetings of the new photographic society.

One figure surprisingly missing from the list of 1852 exhibitors was Antoine Claudet, a key figure in the establishment of the Photographic Society of London. Despite the widespread published attribution of the idea of forming a photographic society in London to Fenton, researches have significantly raised the importance of Claudet's input into the project.

An undated document exists in the National Museum of Photography, Film & Television, Bradford, England, titled *Photographic Society* which can tentatively be dated to some time in 1851. Recent researches (Kamlish 2002) strongly suggest that this document—which significantly predates Fenton's involvement with the idea—was written by Claudet.

The document opened

> It is proposed to establish, in London, a Photographic Society on the same principles as the Heliographic Society which has just been formed in Paris by a number of Gentlemen.
>
> The Object of this society is the advancement of the Science of Photography, and the diffusion of all the improvements made in the different countries where the art is practiced with some success.
>
> Every particular branch of science has in London a centre of action, a place of meeting where its followers can be brought in contact one with another, where they may be helped in their private research by the research of others where they can learn new discoveries as soon as they are published. It is time after ten years of unconnected and separate labours that Photography should take a rank among the most important Sciences. It is time to erect its temple.

Kamlish argues that Claudet's motivation was not entirely altruistic, that he had recently acquired premises at 107 Regent Street which were too large for his immediate needs, and that the establishment of such a centre for the promotion of photography would be an appropriate and profitable use for that space.

For whatever reason, Claudet's proposal remained unpublished, and probably circulated only to a very few people. Thus, no action was taken for at least a year. Claudet's right to be recognised the originator of the idea seems well made. Certainly, in Fenton's obituary (*Photographic Journal*, Sept 15 1869, 126) he, Fenton,

is recognised only as "one of the early promoters of the Photographic Society."

Fenton's enthusiasm for such an organisation was fuelled after he had become directly involved with members of the *Société héliographique française* during a visit to Paris in late autumn 1851—meeting with Gustave le Gray and others—and had been impressed both by the society itself, and its pioneering publication *la Lumière*. He published an account of his visit in *The Chemist*, February, 1852, making a particular point of praising the vision of the French in establishing their society—and using the readership of the journal as a conduit for promoting the idea more widely in Britain. In the following issue, March 1852, he published his "Proposal for the formation of a Photographical Society."

Kamlish postulates that Claudet—who had by 1852 become a near neighbour of Fenton's with a home in Gloucester Road—may have passed his proposals to Fenton in the hope that Fenton would be better able to promote them. That would be at odds with the relative photographic status of the two men at that time—Fenton a newcomer to the medium, and Claudet already recognised as one of the major players with ten years experience, a thriving London business, several important published papers on the science of photography, and a number of patents to his name. In any event, in his address to the inaugural meeting of the society in spring 1853, he reflected on the original ideas which had been mooted "in the winter of 1851–52."

Whatever the circumstances, Fenton's published proposal was pivotal, and was doubtless translated into a practical proposition during the preparations for the Society of Arts exhibition. In it he set out many of the tenets that drove the society for the following century and a half—many of them also contained within the Claudet document of a year earlier. Only a few of his proposals proved short-lived.

> As the object proposed is not only to form a pleasant and convenient photographic club, but a society that shall be as advantageous for the art as is the Geographical Society to the advancement of knowledge in its department, it follows necessarily that it shall include amongst its members men of all ranks of life; that while men of eminence, from their fortune, social position, or scientific reputation, will be welcomed, no photographer of respectability in his particular sphere of life will be rejected.
>
> The society, then, will consist of those eminent in the study of natural philosophy, of opticians, chemists, artists, and practical photographers, professional and amateur. It will admit both town and country members.
>
> Despite that proviso, and although the name adopted was *The Photographic Society*, it was often referred to as *The Photographic Society of London* reflecting the predominantly metropolitan make-up of its founding membership.

Like Claudet, Fenton believed the society should have 'appropriate premises fitted with laboratory, glass operating room, and salon in which to hold its meetings. It would be some considerable time before that was achieved, the ordinary meetings throughout the early years being held at The Society of Arts.

Again, like Claudet, Fenton also proposed the regular publication of the society's proceedings, and the establishment of a library, but while Claudet proposed the establishment of a Permanent Collection and a Museum of Photography, Fenton's paper proposed an annual album of members' work. Despite annual albums being produced in the early years, it was Claudet's idea for a permanent collection which endured and which grew into the huge world-class RPS Collection which is now housed in Bradford at the National Museum of Photography Film & Television.

At about the time the proposal appeared in *The Chemist* in March 1852, Fenton and others met and formed a Provisional Committee to drive the idea of a society forward. They met frequently throughout the spring and autumn, and in an unusual choice of words, these meetings were reported as being held "with a view of organising a Society of those to whom such a *re-union* would be acceptable." Fenton became honorary secretary of the provisional committee, and his role was pivotal in spreading news of the new initiative as widely as possible. Throughout that period he was also actively involved in the proposed exhibition at the Society of Arts, the two parallel engagements giving him regular access to like thinkers.

The provisional committee, which had met regularly at the offices of the *Art Union* journal in the spring, suspended its activities in the summer, as one of the stumbling blocks in the formation of the society, which they had to consider and deal with, was the existence of William Henry Fox Talbot's calotype patent—the restrictions it placed on the development of photography was seen as incompatible with an independent photographic society. After representations by Sir Charles Eastlake and Lord Rosse, Talbot's agreement was reached to relax the patent, at least for amateur users, and progress towards the establishment of the society was restarted with a further series of meetings in autumn 1852.

The Inaugural Meeting of the new Society was held on January 20th 1853 at the Society of Arts—a few days before the exhibition closed—with Sir Charles Eastlake in the Chair, who opened his address by confirming that the chairmanship had initially been offered to Talbot, but that the inventor had declined.

The inaugural Council of the new society included, amongst others, such luminaries as Charles Wheatstone, Sir William Newton, Hugh Welch Diamond, Fenton as Secretary, Peter le Neve Foster, Peter Fry, Robert Hunt, John Dillwyn Llewelyn (whose name was recorded

as 'Lewellyn'), the Count de Montizon, Hugh Owen, Alfred Rosling, Charles Vignoles, several of whom had also exhibited at the Society of Arts at the end of the previous year. In his eloquent introduction to the catalogue for that exhibition, Fenton had written that the society "will be the reservoir to which will flow, and from which will be beneficially distributed, all the springs of knowledge at present wasting unproductively."

The first issue of the *Journal of the Photographic Society* was published on March 1st 1853, and with only minor interruptions, has been published ever since. Despite having a membership a little shy of four hundred by the mid 1850s, the popularity of the journal amongst the entire photographic community meant that it was producing four thousand copies per issue. Its founding premise—that it would serve as a conduit for an interchange of ideas and successes amongst photographers in all countries—has held good ever since.

The topics covered in early editions of the journal ranged from transcripts of lectures given at meetings, and in-depth discussions on the chemical composition of sensitising and developing baths, to the rolling controversy over whether photography was an art of a science. Reprints of articles published in *la Lumière* were also included, as were reports on the proceedings of regional photographic societies, and transcripts of key lectures given in Liverpool, Manchester and Edinburgh. A thriving letters column soon became a mainstay of the publication, allowing both town and country members to share their experiences, their difficulties, and their discoveries.

Within six months of the formation of the society, Queen Victoria and Price Albert had agreed to become patrons, initiating a Royal association with the society which has endured to this day and which, in 1894, culminated in the change of name to the *Royal Photographic Society of Great Britain*. It was Prince Albert who, unwittingly, resurrected Claudet's idea of a permanent collection of members' works in 1854, but several years passed before the idea was acted upon. In the meantime, infrequent albums of members' work were produced and circulated by groups within the society, operating under the names of *The Photographic Club*, and *The Photographic Exchange Club*.

One of the initiatives contained within both Claudet's and Fenton's proposals was the mounting of an annual exhibition, and the first such display opened at the Society of British Artists, on London's Suffolk Street, with an evening soirée on 3rd January 1854. The Annual Exhibition remains a focal point of the Society's year today. In those Victorian exhibitions, the majority of the works were for sale, the society augmenting its funds by taking a 10% commission off the sale price.

By the end of the first year, with professional photographers assuming a greater influence over the proceedings of the society, the first Annual General Meeting in February 1854 voted, by show of hands, to exclude all professional photographers and photographic dealers from sitting on Council of holding office within the society. Fenton, at the end of his first year as secretary of the society he had helped form, informed the meeting that were this to be implemented, he would feel obliged to resign—he was at the beginning of his own eminent career as a professional photographer. After further discussion, the meeting was persuaded of the folly of such a move, and the vote reversed. The Photographic Society was not unique in having to learn to live with the uneasy marriage of amateurs and professionals.

But it was the presence and the influence of the scientists and the professionals who drove much of the important early work undertaken by the society's various ad hoc committees.

Most significant amongst those committees was what became known as the 'Fading Committee' chaired by Fenton in 1855, and set up to investigate the apparent impermanence of both salted prints and albumen prints. Under the chemical direction of T. F. Hardwich, the committee came up with sound recommendations for the avoidance of the problem—specifically using fresh hypo, and gold toning. Hardwich had correctly identified that sulphur compounds in the prints, caused by over-used fixer were a primary cause of the problem—eliminated by using fresh fixer—and that sulphur in the atmosphere exacerbated fading, a factor reduced by toning with gold chloride.

Other committees played important roles in the further understanding of the chemistry of the collodion process, and very significantly, in moving towards the establishment of realistic copyright protection for photographs and photographers.

These scientific and legal engagements did much to raise the public profile of the society, but beneath the surface, the ongoing debate about the status of photography within the worlds of art and science continued. The uneasy marriage of photographic artist and photographic scientists continued throughout the society's first forty years until, in 1892, the Vice President Henry Peach Robinson, frustrated by what he saw as a lack of recognition of the art of photography, led a breakaway group to leave the society and establish what became known as the Brotherhood of the Linked Ring. Their manifesto stated that the breakaway group had been established "as a means of bringing together those who are interested in the development of the highest form of Art of which Photography is capable," and was a direct response to their belief that the society's direction was biased against them. The recently elected President, Sir William de Wiveleslie Abney was one of the leading (and most opinionated and widely published) photographic scientists of his day, with a declared lack of interest in

the creative side of photography. He remained President until 1894, was re-elected again in 1896, and again in 1903, serving until 1905.

The society, in its first half-century had been led by a succession of eminent scientists, and clearly the photographic artists felt they were not receiving equal recognition, and that the society's leadership showed little sympathy towards their aspirations. Sir Charles Eastlake had been succeeded in 1855 by Sir Jonathan Frederick Pollock MP, barrister and mathematician, who held the presidency until 1869. He was immediately followed by James Glaisher, one of the society's founder members, who remained in office until 1892. Then came Abney, and all three had emphasised in their various presidential addresses that they saw the advancement of photographic science as being a far more important pursuit than the development of the art. Indeed, going back to Claudet's original proposal, he suggested only that the society's primary object should be "the advancement of the Science of Photography." It was Fenton who first broadened the brief and Sir Charles Eastlake whose introductory address first embraced the value of photography "both to Science and to Art."

In the 20th century, the recognition of disparate groups within the society, each focused on a specific aspect of photographic art or science, defused such potential minefields and ensured that the broad diversity of photography proposed by Fenton almost a century earlier were equally and individually represented.

Over the first seventy years, the society's collection of photography developed in an unstructured manner, dependent upon gifts from members rather than a focused gathering together of a representative cross section of the images produced. Thus, when John (J) Dudley Johnston decided to focus on the society's history in his Presidential Address in 1923, he found few examples of past members' work with which to illustrate his lecture. Roberts (2001) notes that he was able to find only about one hundred images in the attic of the society's house, many of the early works having either been damaged or, simply, lost. It is thanks to Johnston's zeal—as Honorary Curator from 1927 until 1955—that the society developed its unique collection, retrospectively acquiring prime examples of 19th century work as well as gathering the best contemporary work available. Roberts notes that over 70% of the work in the collection was produced by members of the society.

It was, therefore, towards the middle of the twentieth century before Antoine Claudet's 1851 suggestion—that the society should gather "specimens of the art contributed by members or procured from different countries"—became a valuable reality.

JOHN HANNAVY

See also: Bridges, George Wilson; Claudet, Antoine-François-Jean; Fenton, Roger; Talbot, William Henry

Fox; Wheatstone, Charles; Diamond, Hugh Welch; Foster; Fry, Peter Wickens; Hunt, Robert; Llewelyn, John Dillwyn; Montizon, Count de; Owen, Hugh; Rosling; Vignoles, Charles Black; Robinson, Henry Peach; and Brotherhood of the Linked Ring.

Further Reading

Hopkinson, Tom, *Treasures of the Royal Photographic Society 1839–191*, London: Heinemann, 1980

Henfrey, Arthur (ed.), *Journal of the Photographic Society (Volume 1 1854)*, London: Taylor & Francis, 1854, reprinted by the RPS, 1976.

Kamlish, Marian, 'Claudet, Fenton and the Photographic Society,' in *History of Photography*, vol. 26, no. 4, Basingstoke: Taylor & Francis, 2002.

Roberts, Pamela, *Photogenic—from the Collection of the Royal Photographic Society*, London: Scriptum Editions, 2001.

Taylor, Roger, *Photographs Exhibited in Britain 1839–1865*, Ottawa: National Galleries of Canada, 2002

ROYAL SOCIETY, LONDON

The Royal Society of London for Improving Natural Knowledge was founded in 1660 and established by Royal Charter in 1662. It is the world's oldest scientific society in continuous existence and today acts as the UK's national science academy. It is an organisation of Fellows, currently numbering around 1300 of the world's leading scientists.

The Society and its Fellows had a longstanding interest in the component parts of what in the 19th century became photography: light, optics and chemistry. Early opportunities to develop photographic technique occurred on the fringes of the Society: for example, in solar printing experiments by Thomas Wedgwood and Humphry Davy (a future Royal Society President). J.N. Niepce approached the Society, apparently with the intention of submitting a paper on his work, but did not do so. These episodes in photographic pre-history led to no practical Royal Society involvement in scientific research on the subject.

However, from 1833, the problem of recording an image from life by camera was being considered in a serious if intermittent way by William Henry Fox Talbot FRS (1800–1877). Talbot had already written on mathematical and optical subject, thus earning election to the Royal Society's Fellowship in 1831. He had early contact with intellectually sympathetic Fellows such as John Herschel and David Brewster and the former would provide crucial support following the first announcement of Talbot's research interests in his paper 'Some account of the art of photogenic drawing' which was read to the Society on 31 January 1839.

Remarkably, Talbot's paper was not published in full in the Royal Society's *Philosophical Transactions*, but was abstracted. However, it, and news of L.J.M.

Daguerre's work in France generated a wave of interest in photographic science, particularly on the part of Sir John Herschel FRS, who had followed newspapers and other printed accounts of the new inventions. Herschel quickly provided his own important contributions to both Talbot and the wider world, most importantly on the use of sodium thiosulphate as a fixing agent. His photochemical experiments were published by the Royal Society in three major papers as were basic coinages such as 'photography,' 'positive' and 'negative.' These terms were in circulation amongst the Fellowship well before their first appearance in print. Herschel himself developed several novel photographic processes which were communicated to the Royal Society, notably the chrysotype and cyanotype and remained for some time an unofficial consultant and prime mover on matter concerning photography.

As knowledge of the new images gained currency among Britain's scientists, other important photographic researches were relayed to the Society, often encouraged or mediated by Herschel. Thus, Robert Hunt FRS (1807–1887) published not only in the *Philosophical Transactions*, but also produced the first important popular digest on photographic technique. Joseph Bancroft Reade FRS (1801–1870), meanwhile, investigated and to an extent repeated his peers' work on the usefulness of gallic acid in developing latent images, reporting on his work to the Society. In addition to improving elements of processing, Fellows also looked almost immediately for applications of the photograph to scientific work. As early as 1839, the use of sensitized paper as a recording medium for barometric and meteorological instrument observations was being discussed by the circle of Robert Were Fox FRS (1789–1877).

It was not just the scientific elite who were caught up in the excitement of photography. The formal development of photographic science was accompanied by popular interest, the general currency of which owed much to the personal networks of the Society's Fellows. Thus, for example, the first serially-published photographic book (and one with serious natural history intent) was Anna Atkins' *British algae*. Atkins (1799–1871) adopted Herschel's blueprinting technique for the purpose; her father was John George Children (1777–1852) a Fellow of the Royal Society and chairman of the 1839 meeting of the Society at which W H F Talbot had described his process for the first time.

That Royal Society's scientists themselves played a role in popular photography is evidenced by the work of Sir Charles Wheatstone FRS (1802–1875) and Sir David Brewster FRS (1781–1868) on stereoscopic photography, a popular offshoot of a development which had serious scientific merit. In the aftermath of the Great Neapolitan Earthquake of 1857, for example the Society (via Robert Mallet FRS) financed the gathering of dam-age evidence and earth movement using, in part, stereo photographs and these were also used for astronomical purposes. However the greatest single contribution of the Society and its Fellows in this respect was in the relaxing of Fox Talbot's calotype patents. Many of the Society's principally-concerned Fellows provided evidence on the merits of the patents and on the history of Talbot's researches, while the Society's then-President, William Parsons 3rd Earl of Rosse (1800–1867) cowrote a crucial letter to Talbot in 1852 which had significant impact on his relenting in aspects of his claims.

The Society continued to be interested in scientific applications of photography in the 1850s and 1860s. Many of these are very well-known. Warren de la Rue FRS (1815–1889) took important steps in astronomical photography. His initial work on the moon was privately conducted, inspired by daguerreotypes he had seen at the Great Exhibition of 1851 and such images proved more useful than the human eye in resolving lunar features. His solar work, particularly the cost of producing regular photo-heliograph images at Kew, was underwritten by the Royal Society and results were the subject of a Royal Society Bakerian Lecture by de la Rue in 1862. At the opposite scale, the Society provided research support to the physician Richard Leach Maddox (1816–1902), then producing photo-micrographs as illustrative material for paper submissions to the Society. Maddox would later perfect lightweight gelatine plates for photographic use.

An under-researched aspect of the Royal Society's role in promoting photography lies in the organisation's regular use of images at its annual exhibitions of science. In the 19th century these were known as soirees or conversaziones. At these events the latest developments in scientific research were (and still are) presented to invited audiences and in their earliest incarnations, photographs were themselves the subject of display. One famous later Victorian participant was the photographer Eadweard James Muybridge (1830–1903) who in 1889 presented his instantaneous photographs of animal motion. The event concealed an episode that reflected very badly on the Society. Muybridge had submitted a paper on 'Animal locomotion' for publication by the Society in 1883 but its author was quite unfairly suspected of plagiarism and it remained unpublished, thereby temporarily damaging Muybridge's reputation as the originator of motion photography.

As the 19th century drew to a close, the use of standard photographic methods in support of scientific work and publication became a matter of routine and the Society's immediate involvement in photography waned in favour of more specialist organisations. To put this into perspective, photography was a relative novelty in scientific travels of the 1850s, such as Mallet's work in Naples and that by Charles Piazzi-Smyth FRS

(1819–1900) in Teneriffe in 1856. But even by the time of the pioneering oceanographic expedition undertaken by HMS *Challenger* in the years 1872–1876, initially championed by the Royal Society and led by its Fellows William Benjamin Carpenter FRS (1813–1885) and Charles Wyville Thomson FRS (1830–1882), things were changing. The expedition had its share of 'firsts' (including images of iceberg) but more important were the large numbers of photographs taken as an integral part of the expedition scientific record, in the same manner as note-taking, specimen collection and instrument readings.

KEITH MOORE

See also: Wedgwood, Thomas; Davy, Sir Humphry; Niépce de Saint-Victor, Claude Félix Abel; Talbot, William Henry Fox; Cameron, Henry Herschel Hay; Brewster, Henry Craigie; Daguerre, Louis-Jacques-Mandé; Hunt, Robert; Maddox, Richard Leach; and Muybridge, Eadweard James.

Further Reading

Gleason, Mary Louise. *The Royal Society of London: years of reform 1827-1847*, New York: Garland, 1991.

Mallet, Robert. *The Royal Society of London's photographs of the 1857 earthquake (in Naples) [facsimiles of the originals, some stereoscopic, in the archives of the Royal Society]*, Bologna: SGA, Storia Geofisica Ambiente, 1987.

Matthew, H.C.G. and Harrison, Brian (eds). *Oxford Dictionary of National Biography* [for articles on individual scientists cited] 60 vols. Oxford: University Press, 2004.

Schaaf, Larry J. *Out of the shadows: Herschel, Talbot, & the invention of photography*, New Haven: Yale University Press, 1992.

Schaaf, Larry J. *Sun gardens: Victorian photograms by Anna Atkins*, New York and Oxford: Aperture, Phaidon, 1985.

Thomas, Ann (ed) *Beauty of another order: photography in science*, New Haven and London: Yale University Press in association with National Gallery of Canada, 1997.

Tucker, Jennifer. *Nature exposed: photography as eyewitness in Victorian science*, Baltimore: John Hopkins University Press, 2005.

Ware, Mike. *Cyanotype: the history, science and art of photographic printing in Prussian blue*, London: Science Museum, 1999

Ware, Mike. *Gold in photography: the art and history of chrysotype*, Brighton: ffotoffilm publishing, 2006.

RUDGE, JOHN ARTHUR ROEBUCK (1837–1903)
English photographer

Born in Bath, England, 26 July 1837. His father Henry Rudge, a wood carver, and his mother Christiana, were middle-class reformers. By 1861 Rudge was lecturing on electricity, experimenting with an electric model train and an electric boat, and in 1863 was listed as a "philosophical instrument maker." In the 1860s or 70s he projected simple silhouette moving images with a "Wheel of Life" lantern slide. In 1875 Rudge created the Biophantic Lantern. A carousel with seven slides moved intermittently around the lamphouse. Rudge became associated with portrait photographer William Friese-Greene, and probably initiated Friese-Greene's interest in motion photography. They produced various motion effects with glass slide sequences.

Rudge's "Jumbo Funniosities" (c.1882), projected on a more developed machine, featured sequentially posed photographs of a toy elephant; a precursor of stop-motion motion picture animation. Another device featured four converging lenses to project a static slide bearing four portrait photographs. A rotating shutter directed the light to each one in turn, creating a limited movement effect. About 1887 he screened with his last machine, the Biphantascope, a motion series of 12 photographs of 'A Boy in an Eton Collar.' A lifelong bachelor, Rudge died in Bath on 3 January 1903.

STEPHEN HERBERT

RUSKIN, JOHN (1819–1900)
Art critic and social commentator who took a keen interest in photography

John Ruskin was, and still remains, best known for his art criticism and social commentary. His many artistic pursuits including drawing and watercolour painting, designs of various kinds, poetry and other literary works, have been assimilated into a cannon that reveals the breadth and depth of Ruskin's originality. His first four major publications, volumes one and two of *Modern Painters* (1843 and 1846), *The Seven Lamps of Architecture* (1848) and *The Stones of Venice* (1852), established his reputation as a writer of powerful intellect and rare ability to convey both the experience and the significance of the act of seeing. These publications also demonstrated Ruskin's commitment to the social responsibility of art. Ruskin was a prolific writer as the 39 volumes of his 'Works' testify but he was also an eloquent public speaker who lectured on a dazzling array of subjects, both before and after he became the first Slade Professor of Fine Art at Oxford in 1869. Writing almost a century later in 1964, Kenneth Clark pronounced that merely to read Ruskin was accepted proof of possession of a soul and, from the numerous editions of his publications, he was read extensively. His legacy extends to such different individuals as Oscar Wilde, Alfred Milner, Arnold Tonybee, Cecil Rhodes and the numerous realist landscape artists of the second half of the nineteenth century. Ruskin's importance to the history of photography is that he made many references to it during a period of over sixty years, he employed it intermittently in his publications and lectures, he recommended it as a drawing aid, he purchased photographs and, during the

late 1840s, 1850s and possibly beyond, he was closely involved in their production. Over 200 daguerreotypes mainly of Alpine subjects and architectural details are attributed, directly or indirectly, to Ruskin. 125 of these are extant and have been connected to Ruskin for some time. A further 121, possibly dating from Ruskin's visits to Venice in the late 1840s up to 1852, together with 14 salt prints, which surfaced in 2006.

John Ruskin was born on 18th February 1819 at 54 Brunswick Square, London. He was the sole offspring of a wine merchant father and an Evangelical mother. As a youth he was privately tutored at home, visited a number of art masters, developed a passion for the works of Turner and travelled in Britain and Northern Europe with his parents. In 1836 Ruskin became a Gentleman Commoner at Christ Church, Oxford, which considerably extended his education and social circle. He won the prestigious Newdigate Prize for Poetry but poor health delayed his graduation. However by 1843, the first volume of *Modern Painters* had been published by "A Graduate of Oxford."

Ruskin had an extraordinarily large and varied network of associates and followers, a significant number of whom were involved in photography. One of these associates was John Henry Parker, an antiquarian who sold photographs of archaeological investigations in Rome to Ruskin in 1874, which subsequently featured in Slade lectures. For a substantial period Dante Gabriel Rossetti, a founder member of the Pre-Raphaelite Brotherhood, was an ardent follower of Ruskin. Rossetti, similarly to Ruskin, used photographs as visual aids and, at his family home in Chelsea, posed with Ruskin and the artist William Bell Scott for William Downey on 29th June 1863. Despite the appearance of relaxed conviviality suggested by many of the photographs from this sitting, Ruskin expressed his dissatisfaction with his appearance and Scott later candidly revealed his dislike of Ruskin in his 1892 autobiography. Some of the many others whom Ruskin knew included Jemima Blackburn (née Wedderburn) who conducted early experiments with photography and Richard Calvert Jones who, like Ruskin, was taught drawing by James Duffield Harding.

In large part because Ruskin was passionate about art and traditional crafts and turned his visually attuned mind towards mineralogy and botany among other subjects, he had an aversion to the idea of progress expressed in Thomas Macaulay's *History of England* (1843–60), the geological revelations in Charles Lyell's *The Principles of Geology* (1830–33) and the ideas of history contained in Charles Darwin's *Theories of Evolution* (1859). Although early photography was a fundamental breakthrough, Ruskin was able to embrace it because it was tangible rather than theoretical and, above all, it captured the kind of singular detail that Ruskin craved in art, architecture and landscape scenery.

In a letter to his father in October 1845, Ruskin described the daguerreotype as a blessed invention. He was purchasing daguerreotypes by the end of his Normandy tour in 1848 and took his own photographic equipment to Switzerland in 1849 and, with his new wife Euphemia (née Gray) to Venice in 1849–50. On 24th February 1850 she described Ruskin in St. Marks's Square "with a black cloth over his head taking daguerreotypes" (Mary Lutyens, *Young Mrs Ruskin in Venice*, New York: Vanguard Press, 1965, 146). At this time Ruskin was assisted by his factotum John (known as George) Hobbs (later Hobbes) who was in Ruskin's service until 1854. In Hobbs' notebook entry for 1st May 1849, there is a suggestion that he not only carried the photographic equipment for Ruskin but also prepared and developed the plates. This may have been a pattern that Ruskin continued with his new factotum, Frederick Crawley, who was photographing with Ruskin in the Alps in 1854. This would have freed Ruskin to select viewpoints, consider compositional matters and check focus. However it is possible that Ruskin was more involved in photography than this interpretation allows.

Typically these dDaguerreotypes are 6" × 8" and there is at least one example, Richard St. John Tyrwhitt's painting *Mer de Glace* of c. 1859, that was almost certainly based on a Ruskin daguerreotype. Whether Ruskin was the first to photograph the Matterhorn, as William Gershom Collingwood claimed in 1884 is debatable but in *Praeterita* (1885–89) Ruskin stated that he was among the first. Looking back over almost forty years he discovered that his daguerreotypes recorded the ebbing of glaciers. In a similar vein, the 1883 Epilogue to *Modern Painters* contains Ruskin's observation that photographs of St. Mark's in Venice demonstrated that his own "careless" sketch for plate VI of *The Stones of Venice* had omitted the entasis of the tower.

Ruskin recommended photographs as an aid to drawing and cited Charles Thurston Thompson's reproduction of Raphael's *St. Catherine* as a model. He also included photographic reproductions in some of his publications such as the Autotypes in the 1890 edition of *Val D'Arno* and Carlo Naya's photographs of paintings in the 1890 edition of *Giotto and his Works in Padua*. However Ruskin could be critical of photography, remarking in *The Elements of Drawing* (1857) that shadows were rendered much darker than they should be. He was also concerned that colour photography would also bring further distortions.

The 1870s brought Ruskin joys and sorrows. He moved to Brantwood, an idyllically situated house in the Lake District. However the deaths of his mother in 1871 and, in 1875, the death of Rose La Touche, the young woman he had hoped would become his second wife, signalled Ruskin's gradual retrenchment from intellectual life. Between these two bereavements, in September

1873, Frank Meadow Sutcliffe photographed Ruskin, followed by Lewis Carroll in 1875. William Jeffrey captured an early Ruskin portrait in 1856 and Ruskin sat for Caldesi in 1862. By the time John McClelland photographed him in the 1890s, Ruskin had been broken by a legal battle with Whistler but had completed his autobiography. Ruskin died in 1900 and was buried at St. Andrew's in Coniston. He is commemorated in Poet's Corner, Westminster Abbey.

JANICE HART

Biography

Ruskin was born in London in 1819, the sole offspring of a wine merchant father and an Evangelical mother. As a youth he was privately tutored in art and a wide range of subjects and travelled widely in Britain and Europe with his parents. He went on to Christ Church Oxford in 1836, won the Newdigate Prize for Poetry but sat for his degree much later than expected because of ill health. In 1843, inspired by the works of Turner and the new generation of Pre-Raphaelite artists, he produced *Modern Painters*, the first of five volumes of art criticism inflected, like most of his later writing, with social commentary. He was a prolific writer, eloquent lecturer (both before and after he became the first Slade Professor of Fine Art in 1869) a productive artist and an occasional designer. He also took a keen interest in photography producing (or overseeing the production of) upwards of 200 Daguerreotypes, many taken in Italy during an 1849–50 a tour with his new wife Euphemia (née Gray). The trajectory of Ruskin's interest in photography began with the Daguerreotype and, over a period of sixty years encompassed photography's numerous technical, artistic and social transformations. Ruskin's early enthusiasm for photography's ability to render singularity of detail, particularly architectural and landscape detail, gave way to a criticism of photography's tonal rendition and later, a questioning of photography's capacity for artistry and an apprehension concerning the likely distortions of colour photography. These shifts in opinion give considerable interest to Ruskin's various references to photography because he can be seen as a barometer, if an idiosyncratic and sometimes aberrant one, of changing public attitudes. Ruskin occasionally included photo-mechanical prints in his publications such as the Autotypes which appear in the 1890 edition of *Val D'Arno*. Ruskin also sat for a large number of photographers including William Jeffrey, William Downey and Frank Meadow Sutcliffe. The ill health that troubled him whilst an undergraduate student developed into a number of physical and mental complications, particularly from the 1870s following the deaths of his mother and the woman he had hoped would become his second wife, Rose La Touche. Ruskin went into semi retirement in the last decade of his life at Brantwood, the house he purchased in the early 1870s. He died there in 1900, one of the indisputable sages of the nineteenth century. He is buried at St. Andrew's at Coniston and commemorated at Westminster Abbey.

See also: Dodgson, Charles Lutwidge (Carroll, Lewis); Daguerreotype, Jones, Calvert Richard; Downey, William Ernest, Daniel, & William Edward; Naya, Carlo; Parker, John Henry; Rossetti, Dante Gabriel; Sutcliffe, Frank Meadow; and Thompson, Charles Thurston.

Further Reading

Complete Works, edited by Edward Tyas Cook and Alexander Wedderburn, 39 volumes, London: George Allen, 1903–1912.

Heather Birchall, 'Contrasting Visions: Ruskin: the Daguerreotype and the Photograph' in *Living Pictures*, vol. 2, no. 1, 2003, 88–92.

Susan Casteras and Anthony Lace Gully et al., *John Ruskin and the Victorian Eye*, New York: Harry N. Abrams in association with Phoenix Art Museum, 1993. Publication commemorates the exhibition *The Art of Seeing: John Ruskin and the Victorian Eye*, 1993. Also shown at the Indianapolis Museum of Art, 1993.

Michael Harvey, "Ruskin and Photography," in *Oxford Art Journal*, no. 7, 1985, 25–33.

Mary Lutyens, *Young Mrs Ruskin in Venice*, New York: Vanguard Press, 1965.

Jeremy Maas, *John Ruskin and His Circle,* London: Maas Gallery, (exhibition catalogue) 1991.

Lindsay Smith, *Victorian Photography, Painting and Poetry: the Enigma of Visibility in Ruskin, Morris and the Pre-Raphaelites*, Cambridge: Cambridge University Press, 1995.

Frank Meadow Sutcliffe, "A Day's Sunshine at Brantwood," in *Amateur Photographer*, 9th February 1900, 107–108.

RUSSELL, ANDREW JOSEPH (1832–1909)
American photographer

The building of the first transcontinental railroad by the Union Pacific and Central Pacific Railroads generated an enormous interest among the American public creating both a market for photographic images of Western America and a means for photographers to transport bulky equipment to remote regions. Andrew Joseph Russell was the official Union Pacific photographer in 1868 and 1869 and one of many to follow who took advantage of this interest in the railroad and the sights along the line. He took over 250 large-format glass-plate negatives and 500 stereo-view negatives mostly in Nebraska, Wyoming, and Utah. Some of these images are classics of 19th Century American photography including one of the best-known images in American history (for years misidentified as a C.R. Savage photograph) of the two

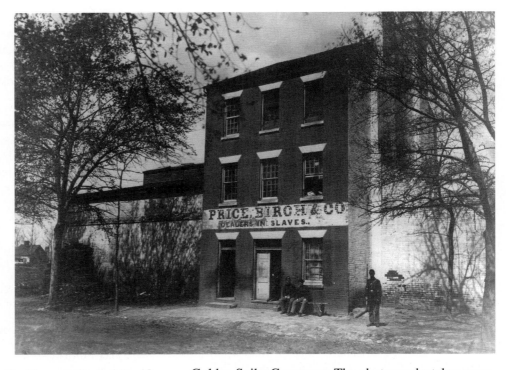

Russell, Andrew Joseph.
Slave Pen, Alexandria,
Virginia.
*The Metropolitan Musuem
of Art, Gilman Collection,
Purchase, The Horace W.
Goldsmith Foundation Gift,
2005 (2005.100.91) Image
© The Metropolitan Museum
of Art.*

locomotives of the Union Pacific and Central Pacific Railroads coming together at Promontory, Utah at the Golden Spike Ceremony.

Russell was the natural choice when the Union Pacific decided to photographically document, The Work of the Age. Russell was a New York State native who moved from Nunda, New York to New York City in 1859 where he was a painter and portrait photographer. During the Civil War he was assigned as a special assistant to the Military Railroad Construction Corps for the Union Army. Most of his images documented the construction of military railways and his photographs were often rushed by special messenger to Secretary of War Edwin M. Stanton in Washington D.C. Russell as well photographed the battle of Fredericksburg and took a few stereo-views, and some Russell photographs have mistakenly been attributed to Matthew Brady.

After the war Russell returned to New York City to resume his work as a portrait photographer and artist. For whatever reason, Russell was not hired immediately after the war and the Railroad used the Chicago, Illinois photographer John Carbutt instead. Given, however, Russell's background in railroad photography and the fact that most of the Union Pacific executives were former Union Army officers, he must have seemed a better fit. Russell began photographing the Railroad headquarters in Omaha, Nebraska in early 1868 and he caught up with the construction crew in Cheyenne, Wyoming. He followed its frenzied pace across Wyoming, into Utah, and finally to the site where the Union Pacific and Central Pacific lines came together at Promontory, Utah on May 10, 1869. There were three photographers (the other two being C.R. Savage and Alfred A. Hart) at the

Golden Spike Ceremony. The photographs taken were, not surprisingly, mostly devoid of the workers who built the railroad (Irish-Americans for the Union Pacific and Chinese-Americans for the Central Pacific). Instead they show the railroad officials, financiers, and dignitaries who were invited to the event. Afterwards Russell traveled to Sacramento along the Central Pacific line taking a handful of images as he went. Before returning to New York City, he photographed across Utah and Wyoming again, but this time at a more leisurely pace.

Russell showed a great deal of flexibility as a photographer. The twenty-three large-format images published by the Union Pacific in *The Great West Illustrated in a Series of Photographic Views Across the Continent* (only a handful of which exist today) portray the builders of the railroad in heroic terms. They evoke awe of the work done and convey both movement and power. The thirty images utilized in a book published by geology professor Ferdinand Hayden one year later entitled *Sun Pictures of Rocky Mountain Scenery*, however, are not dramatic images but instead are scenes of geological interest. Hayden was in charge of the U.S. Geographical and Geological Survey and wanted to promote the study of geology in Western America. Most of these photographs were taken after the joining of the rails when Russell had more time to pick and choose his subjects. In these photographs nature is not an obstacle to be overcome, but a source of interest to the traveler. Neither of these books, however, had a wide distribution and the general public viewed the building of the transcontinental railroad through stereo-view series published by Russell initially and later without attribution by Stephen Sedgwick and O.C. Smith. These images are surprisingly mundane.

Taken as a whole, however, the stereo-views create a visual catalog of the workers, tunnels, bridges, buildings, railroad engines, and new towns of the Union Pacific and satisfied the demand by the public for photographs instead of artwork (whose accuracy was suspect to many Americans) of the American West.

Russell's artistic background is shown in his large-format views by the careful composition and thoughtful placement of the railroad within its natural surroundings. The images provide a human perspective on what for Russell must have seemed an impossibly forbidding landscape. A number of photographs show figures contemplating the railroad from a high vantage point. These views reinforce the idea of the railroad as conquering the great distances of the American West, but also in a precarious balance with the natural forces surrounding it. Russell was, as well, a pioneering photographer. Although his equipment did not allow him to stop action, he did attempt to set up scenes as if he were capturing the daily work of the laborers. Many of his photographs were, as well, made into wood-cut illustrations and printed in weekly magazines.

Russell was the first of many photographers, including William Henry Jackson, Charles Roscoe Savage, Carleton Watkins, and Eadweard Muybridge who photographed both the Union Pacific and Central Pacific Railroads. Russell provided scenes which were bought by an Eastern audience eager for images of what was still then considered an exotic and romantic place. Surprisingly, however, there is no evidence that Russell ventured to Western America again in his lifetime.

DANIEL M. DAVIS

Biography

Andrew Joseph Russell was born on March 20, 1829 and grew up in Nunda, New York. As a young man he was a painter and a teacher at the Nunda Literary Institute before moving to New York City in 1859 where he worked as a panorama painter and a portrait photographer. During the Civil War, Russell became the official railroad military photographer for the Union Army. He returned to New York City after the war, but soon thereafter traveled west to start documenting the construction of the Union Pacific Railroad through Nebraska, Wyoming, and Utah. He is best known for the 250 large-format images he took of the building of the transcontinental railroad in 1868 and 1869 including one of the most famous images in American history, that of the two railroad engines of the Union Pacific and Central Pacific coming together at Promotory, Utah. He also took over 500 stereographic negatives during these two years that were actually seen by a larger audience at the time. Russell earned a good salary from the Union Pacific for over two years, yet others gained more materially from

his images as his stereo-views were later issued without attribution. In the 1960s a cache of glass-plate negatives were discovered at the American Geographical Society and his large-format views became better known. After photographing the railroad, Russell returned to New York City and worked as a portrait photographer as well as an artist for the magazine *Leslie's Illustrated*. He died on September 22, 1902.

See also: Savage, Charles Roscoe; and Watkins, Alfred.

Further Reading
Bain, David Howard, *Empire Express: Building the First Transcontinental Railroad*, New York: Penguin, 1999.
Current, Karen & Current, William R., *Photography and the Old West*, New York: Abradale Press, 1986.
Mautz, Carl, *Biographies of Western Photographers: a Reference Guide to Photographers Working in the 19th Century American West*, Nevada City, Calif.: Carl Mautz Publishing, 1997.
Naef, Weston J. & Wood, James N., *Era of Exploration: The Rise of Landscape Photography in the American West, 1860-1885*, Buffalo, New York: Albright-Knox Art Gallery, 1975.
Richards, Bradley W., *The Savage View: Charles Savage, Pioneer Mormon Photographer*, Nevada City, Calif.: Carl Mautz Publishing, 1995.
Wadsworth, Nelson B., *Through Camera Eyes*, Provo, Utah: Brigham Young University Press, 1975.

RUSSIAN EMPIRE

The first information about the invention of Daguerre reached Russia already on 4th January 1839 (according to the Julian calendar). It was followed by active discussions in the press of the future perspectives of photography. A special emphasis common for all participants to these discussions was made on the documental character of daguerreotypes. But the evaluations were in fact different. The new invention did not fail to interest the scientists from St. Petersburg Academy of Sciences. In April of 1839 academicians (biologists) Karl-Ernst Bar (1792–1876) and Fyodor Brandt (1802–1879) asked the corresponding member of the Academy of Sciences, Josef Hamel (1788–1862) to get acquainted with the new invention in the course of his business trip abroad.

First Hamel went to London and got acquainted with Talbot and his invention. In May of 1839 Hamel sent to the Academy the description of Talbot's method and a couple of photos, which were of bad quality. The Academy Assembly therefore committed a task to Julian Frizshe, an academician (1802–1871) to survey the calotype method. The academician informed on the results of his research work on the 23rd of May of 1839 and demonstrated the picture of herbarium, which he made by using the method of photographic recording (photogram). In the course of his work on these pictures

he streamlined the method. This was the first scientific research of photography made in Russia.

Meanwhile, Hamel moved from London to France and got acquainted with Daguerre. He sends to the Academy the description of daguerreotype method along with the equipment necessary for making photos, including the camera, before the sale of these things started. The discussion devoted to this technology in the academy of sciences was held on the 6th of September of 1839. In 1839–1841 Hamel recurrently sent to St. Petersburg new photos, including those made by Isidore Niepce—these were the views Louvre and other buildings. Later in 1850 Hamel received from Isidore Niepce the originals of documents (168 in number) on the history of inventing photography, which after Hamel's death in 1862 were transferred to the Academy Archive.

In Russia, like everywhere in the world, daguerreotypes gained great popularity. The first daguerreotypes brought to Russia were exposed in shop-fronts and attracted the interest the of public at large. In 1839 the first booklets by Nickolai Stepanov appeared describing the methods of Daguer and Talbot, the cameras, and other necessary photographic equipment went on sale. One of the first photographic amateurs to appear was Franz Teremin (1802–?), a lieutenant colonel of the Ministry of Lines of Communication, was interested in daguerreotypes, and made a photograph of the Isaac Cathedral in St. Petersburg with 25 minutes time-exposure in October 1839. In 1840s Count Alexei Bobrinski made a photograph of the conservatory in his house in St. Petersburg. In 1843 Sergey Levitski (1819–1898) being on a trip made photographs of views of the Caucus. In mid-1840s an unknown photographer recorded the sculptures by Ivan Vitali before they were mounted onto the facade of the Isaac Cathedral.

Since 1840s professional daguerreotype studios for making portraitphotographs started to appear. The style of these works was predetermined by the style of painted miniatures, which were very popular at the time. The latter was imitated in daguerreotypes decoration and in by-hand colouring of the black and white photos. The genre of photo-portraits formed the commercial basis for future development of photography.

The first professional daguerreotype specialists working in Russia came from abroad. All of them had already worked in various cities of Europe. They were, Josef Weninger from Wien, the Schneider brothers and Carl Dautendey from Germany and among others.

Some of them set up permanent studios, while others traveled round the country. For instance, D'Avignon made several trips to far away cities of Russia in 1843–45s. In 1845 he made photo-portraits of insurrectionists against the emperor in December of 1825 who spent their life banishment in the suburbs of Irkutsk in Siberia. As this information reached the Third Department of the Emperor's Office (dealing with state crimes and prisoners) the photographer was arrested for making photographs of state criminals. Soon afterwards the photographer was released, the daguerreotypes were confiscated and destroyed and since then taking photographs of criminals was strictly prohibited. However some of the daguerreotypes preserved by some miracle are now part of the collection of the Historical museum. Thus, the authorities estimated the documentary value of photography very high right from the beginning.

Among the first Russian professional photographers one could name Alexei Grekov, who opened a studio in 1840. He made and sold self-constructed daguerreotype apparatus, he employed Boris Yakobi's method for silver-plating copper and brass photo-plates. Such photo-plates were cheaper than the ones completely made of silver. At the meeting of Paris Academy of Sciences in November of 1840 Arago made a report on his method of producing photo-plates.

Most of the Russian professionals in daguerreotype started to work in 1850s and by 1860s they fully replaced the foreigners. Many of the Russian daguerreotype masters were graduates of the Emperor's Academy of Fine Arts, which produced high artistic value of the works. The industry of the studio portrait actively developed in Russia.

In 1850s the wet collodion photo-process started to be widely used in Russia and soon enough it ousted daguerreotype although this was the way people continued to call it: a daguerreotype on paper. In 1850s Andre Disderi started to make cartes de visite, which made this genre extremely popular with the public. It became popular in Russia to have an album of photographic family portraits.

In 1850 Andrei Denier (1820–1892), a graduate of St. Petersburg Academy of Fine Arts opened his famous studio. He became a true master of photo-portraying; the artists Ivan Kramskoi and Petr Sokolov worked in his studio for some time as retouchers. In 1865–1866s Denier publishes photographic albums of portraits of famous people (Russian writers, artists, scientists, etc.) 12 photographs in each and this was one of the first photographic editions in Russia. The aesthetics of painting, which was then applied to photography, called for a soft optical image. In order to achieve it Denier worked out an original technique of printing from two negatives of different density. He patented this technique in 1873 for three years. Recent researches made it clear that this method had been employed by foreign photographers earlier (which proves that Denier's invention was not the original) but nevertheless Russian photographers keep calling it "Denier's effect"and prominent Russian masters of photography, such as Sergei Levitski (1819–1898), Andrei Karelin (1837–1906), used the method successfully.

The thing of particular interest at present is the early outdoor works. Despite the considerable technical problems accompanying outdoor photography, photographers were often asked to join scientific expeditions to do the job previously assigned to artists. They were to record the results of research, photograph the nature, the nationalities inhabiting the region, to work in the combat area documenting the ongoing events.

Widely known are the photographs made by Roger Fenton: he photographed the Russian fortifications being destroyed during the Crimean War of 1854–1855s. The Russian photographers also made photographs of the aftermath of the battles, scenes in the camps. C. Kolpaktchi, for instance, made a panorama of destroyed Sevastopol consisting of several photographs.

The work which attracts much attention is the one by an unknown photographer who made a photography of a church procession in Moscow Kremlin in 1858. In this work there was something of a photo-report—a recording of an interesting event.

The main task of outdoor photography was to record the scene or object as closely to the reality as possible. The photography was a assigned the auxiliary role of a scientific document. In 1850–1860s Nikolai Vtorof, an ethnographer, applied photography to create an ethnographic map of Voronezsh region (he invited Michail Tulinof (1823–?)to do this job for him). Vtorof presented the results of this work at the meeting of Russian Geographic Society in 1857. In 1867 The Natural Science Society of Moscow Emperor's University organized an all-Russia Ethnographical Exhibition. This exhibition housed more than two thousand photographs of different nationalities, scenes of their life and views of the region. Photographers joined expeditions and missions were recording of the events was needed.

In 1858 in the course of the diplomatic mission to Khiva and Bukhara second lieutenant Anton Murenko (1837–1875) made photographs that composed a unique album "From Orenburg through Khiva and to Bukhara." Here were the scenes of life of the mission on trip, scenes of life of local people and the surrounding landscapes. For this work Murenko was awarded a silver medal of Russian Geographic Society and afterwards he became a professional photographer. Then Murenko got a task from Russian Geographic Society to compose albums of ethnography and views of different regions of Russia. On opening a studio in Saratov in 1861 he was the first to start purposefully making photographs of Povolzshje.

In the second half of the 1860s a Russian photographer Michail Nastjukof made lots of photographs of the Volga region and in 1866–1867s he issued an album "Views of Volga from Tver and up to Kazan."

More and more photographers started to make outdoor photos. An interesting ethnographic photo-work was carried out by W. Carrick (1827–1878) in 1870s. In the 1870s ethnographic photography was also practiced by J. Raoult, a photographer from Odessa. He worked in Simbirsk region, made photographs of inhabitants of Moldova and Ukraine. A huge photographic collection of valuable material on Central Asia was composed under the supervision of A. Kun, a researcher, in 1874. The album comprised four volumes and contained over 1200 photographs. For this album the author won one of the highest awards at an International Geographic Exhibition in Paris in 1875.

All these works were applied in science and their value depended on the exactness of rendering of this or that object or scene by means of photographing. The emergence of association for mobile exhibitions (the so called peredvizhniks trend in art) in 1870 conduced to finding artistic value in documental photography as these artists in the majority of their pictures recorded some moments of real life as if fixed down with a photo-camera.

Thus photographs made in 1869 by Josef Migurski a fellow member of French photography society, the author of the first textbook on photography in Russian in 1859, made photographs of construction in Odessa, which echo the paintings by Konstantin Savitski "Repairs at the railway," 1874.

Nevertheless it should be mentioned that artistic photography is a term more applicable to studio photography (including studio photographic portraits). The photographer arranged the setting in accordance with the laws of painting, achieved the desired lighting through a complex system of reflectors, used a variety of studio accessories, strived for the ways of making the image softer at the expense of documental exactness, and at times just copied famous paintings.

A widely acknowledged master of Russian pictorial photography of the second half of the 19th century is A. Karelin. His followers and students, like for example Stepan Solovjov (?–1908) and others searched for the expressive means in photography taking the aesthetics of painting as a starting point.

The static character of studio photography had to be overcome. The attempts to do it were made by Konstantin Shapiro (1840–1900). In his photo-series devoted to the novel by Gogol "Notes of a madman" he recorded performance by Vasili Andreev-Burlak. Each photography in the series corresponded to a definite moment in the context of the monologue. The album was published in 1883, it consisted of 30 photographs and today we perceive it as a set of expressive shots from a silent film with titers.

A considerable progress in the development of photography, the documentary photography in particular, was prompted by the emergence of dry bro-gelatine plates in late 1870s. The events of the Russian-Turkish war of 1877–78s were recorded by such photographers

as A. Ivanov, M. Revenski, D. Nikitin, V. Barkanov and others. In the 1880-s photo-recording of various events became quite frequent. Alexei Ivanitski made a photographic document of the crash of the Tzar train in 1888. But these works were a long cry from the real photographic reports. Photographers kept concentrating on static scenes. Their attempts to reflect the dynamics of the event were still rather shy.

Lieutenant N. Apostoli made marine photographs with the help of a double camera he constructed in 1890. Apostoli outlined his experience in the "Guidance for studying practical photography for naval officers and tourists."

The documentary photographs were badly needed by the illustrated. At that time they still published photographs engraved by artists. But even in the copies made by artists one could easily trace the photographic basis. The demand for such photographs went steadily up. The photo-images were often used by artists involved in battle painting: they introduced some of the documental details rendered by photographers into their works.

In the 19th century painting in Russia the peredvizhniks were obviously domineering. This surely told on photography: the leading tendency consisted in rendering the surrounding world realistically by purely photographic means. The concept of free photographic setting kept gaining weight. The plots were often taken from regular life of common people, not necessarily some extraordinary scenes but also a most routine ones.

One of the prominent proponents of realistic photography was Maxim Dmitriev (1858–1948). The most outstanding of his works was the album "Year of Poor Crops of 1891–1892 in the Nijnij Novgorod Province." The woes of people suffering of severe drought and epidemics of typhoid and cholera were the center of the first photo-publicist report in Russia.

The method similar to photo-documentary was also employed in literature. It helped to transmit the realistic message and make the plot more close to reality. Thus, for example, the famous Russian writer Anton Chekhov (1860–1904) visited Sakhalin in 1890 and in his literary work "The Island of Sakhalin" first published in 1895 the writer rendered with photography-like exactness all the details of the way of life of convicts and exiles. The basis for this description was laid down by his observations and a series of photos.

In 1890s Alexei Kuznezov (1851–?) a convict confined to ten years in the Zabaikalje region for revolutionary activities, created an album called "Views and Types of the Nerchinsk Servitude." Documentary photographs of the late 19th century made Dmitri Jermakov (1845–1916) one of the first photographers of Georgia. His diverse photographic legacy included landscapes, architectural monuments, scenes of life of different nationalities from Georgia, Armenia, Persia. His studio on Tiflis (at present Tbilisi) one might consider a prototype of a photo-agency of today. In 1896 Jermakov issued his "Catalogue of photographic views and types of the Caucus, Persia, The European and Asian parts of Turkey." It comprised over 18 thousand images and anyone could order the view he liked for a fee. Jermakov made studio ethnographic photos: the sitters dressed in the national costumes played the moments of their real life. The photographer admired both the picturesque moments and the routine situations and fixed them down in a short period of time.

In all these works one could trace the starting point of the contemporary understanding of photography. According to this understanding the realistic rendering is an artistic document, which does not simply reflect but influences the reality. Masters like that were the ones who predetermined the concept of specifics of photography.

A considerable part of photographic legacy is constituted by landscape city shooting. Many photographers especially from 1870s on recorded the sights of the home town. The photographers were particularly attracted by large cities such as St. Petersburg, Moscow, Nizhni Novgorod and some others.

A large-scale shooting of Moscow and its suburbs was carried out by Albert Meighm in 1870–1880s under the task of one of the Moscow leading bourgeois, Nikolai Naidenov. As a result an album appeared, which comprised the photographs of architectural monuments and vies of the streets in the city. It should be mentioned that these works were not aimed at rendering the city's life. In 1890–1900s Petr Pavlov carried out a shooting of Moscow; he focused primarily on genre and view photography. In his works architectural monuments were recorded on the background of the vigorous city life.

In the 19th century photography was actively used to solve scientific problems and execute applied tasks. The first Russian photographer who made photographs of Russian style buildings and period pieces was Ivan Barschevski (1851–1948). He made a great number of photographs of architectural monuments, archeological objects and different ancient pieces from museums for the purpose of future scientific research.

Another vivid example of applied use of photographs is the research works by Jevgeni Burinski (1849–1912), who employed photography in court litigation. In 1886 he worked out a method of layer by layer restoration of image (colour-separating method), which allowed to read spoiled manuscripts and inspect the documents if there is a doubt in their authenticity. In 1894 he used this method in his work in the Emperor's Academy of Sciences—he studied leather documents of the 14th century.

Pictorial photography in Russia was also pushed forward by amateurs (first amateurs appeared already

in 1839). The number of photo-amateurs went up rapidly in the 1880–1890s, which is connected with wide spreading of brom-gelatine plates and simplification of the process of photography. Since 1890s lots of societies of photo-amateurs of different levels emerged in Russia. By 1917 they amounted to over a hundred.

Many of the amateurs were also keen on music, painting, literature, which had an impact on their creative work as photographers and formed the basis for a homogeneous cultural environment of the nation.

One of the first and the most respected photo-amateurs was Ivan Nostits (1824–1905), count and lieutenant general. He started to go in for photography in 1839; he later made photo-portraits of the Emperor's family, ships, landscapes, architectural monuments. In 1859 he made the photographic portrait of the famous prisoner, the Chechen imam Shamil. He tested photo-apparatus and published the results of his research works in special journals. In 1896 he issued an album "Photographs by count Nostits." The earnings he donated to the fund of the Penkov orphanage in Yekaterinaslav region.

The problems of photography were the topic of several works by an outstanding Russian scientist and evolutionist Kliment Timiryasev (1843–1920). He drew parallel between photography and the process going on in leaves o plants. Besides he was among the first ones to realize how important foe physiology was the invention made by Hermann Wilhelm Vogel—his optical sensibilizators. Timiryasev used to say that the most fascinating photo-process is the decomposition of carbon dioxide and the formation organics in the plants under light and the sensiblizator—chlorophyll. The scientist was also a passionate photo-amateur, he was knowledgeable in the theoretical as well as in practical achievements of photography. He pictured landscapes and was a master of the genre. By the best of his works he proved that photography is an art.

Among Russian photo-amateurs Alexei Mazurin(1846–?) is most widely known in Europe. In 1890s his works were published in journals of Germany, Great Britain and other countries. He was one of the Russian pioneers of pictorialism, the leading trend in photography on the verge of the 20th century. He learned how to perform positive printing, got acquainted with the gum dichromate and the pigment method.

There were women photo-amateurs, for instance Natalia Nordman-Severova (1863–1914), the wife of a famous Russian artist Iliya Repin. She was the head of the Ladies' photographic society. Her amateur photographs were used by Repin in creating the great painting "The State Council."

Leo Tolstoy's wife Sophia was an amateur photographer, so she made a photographic chronicle of the writer's life.

The thing that contributed to the spreading of knowledge of photography was the photo-periodicals. This can be subdivided into issues of public photographic organizations, independent editors, journals of trading firms, non-photographic journals, which published materials on photography.

The majority of articles tackled the technical problems of photography. The question of the artistic value of photography was less widely discussed also there were several declarative publications stating that photography was a form of art.

The aesthetics of photography started to gain prominence in the end of the 19th—the beginning of the 20th century especially as soon as pictorialism spread in the country.

Photography was first used as an illustration by an artist Vasili Timm (1820–1895), who published from 1851 to 1862 the so called "Russian Pictorial Gazette," although the photographs were copied by hand. In Russia there were photo-journals: "Svetopis" (Photography) issued in 1858–1859s; "Fotograf" (Photographer) issued in 1864–1866; "Fotograficheskoje obozrenije" (Photography review) issued in 1865–1870s.; the "Fotograf" journal (1880–1884s) was an organ of the fifth department of the Emperor's Russian Technical Society (ERTS; there was also "Fotograficheski Vestnik" (Photography Gazette) issued in 1888–1897s; "Fotograf Ljubitjel" (Amateur photographer) issued in 1890–1909. The best artistic and theoretical journal, "Fotograficheski Vestnik" was a press organ of Russian Photography society in Moscow in 1907–1918s. The journals housed publications on new achievements of photographic process, events in the life of Russian and foreign photography, reviews on photographic literature, information on exhibitions and other important things. The journals not only unified the Russian photographers, they also kept society informed on culture-specific questions.

In 1890s photography started to be actively used in periodicals, which entailed the emergence of photographers oriented on making reports. The considerable sums of money they got as honorariums allow them to go in for this kind of photography.

The title of the king of report is best suited to Karl Bulla (1853–1929). Together with his sons he made photographs for journals and news-papers rendering the events that were taking place in St. Petersburg. Over 100 thousand negatives made by the Bulla family reflect the way Russia lived in the end of the 19th—the beginning of the 20th century. They did not lie in the advertisement that ran as follows: "An experienced photographer-illustrator, K.Bulla, St.Petersburg, Nevsky 48. Makes photographs for illustrates on the current events. Makes photography of anything you might need, anywhere, feeling free in any surroundings be that a region, a build-

ing, be it in the day-time or at night." The exactness of a photographic report was socially relevant and more convincing than a verbal description. That's why the public kept demanding for more and more photographic information.

The 19th century is the time of emergence and maintenance of photography all over the world and in Russia in particular. Besides it is the time when photography gained the status of a form of art.

In the end of the 19th century and the beginning of 20th century (up to the revolution of 1917) there were two trends for development of photography in Russia. The bulk of photographers believed in the principles of realistic photography, employing the latest achievements of photographic technology. The proponents of the trend, and Sergei Prokudin-Gorski most active among them, called to stay documental and use natural colours. The latter worked on a large project—a series of coloured photographs of Russian sights. The results of the work were used for studies as well as for research.

Another trend especially active in the beginning of the 20th century was the pictorial photography. Within the framework of this trend the photographers studied the problems of creating an artistic image, worked on such matters as composition and lighting. The photography developed on the background of changing priorities in Russian painting, These trends formed the basis for the Soviet photography of the 1930s, which combined expressive imagery and documental exactness.

Russia before the revolution of 1917 was integrated into the world economy, politics and culture and carried out one of the leading functions in the development of the world. That is why Russia had a worthy position in the global process of photography development.

ALEXEI LOGINOV

Further Reading

Horoshilov, P. and A. Loginov, *The Masterpieces of the Photography from Private Collections. Russian Photography 1849–1918*, /M., Punctum 2003, 176 pp.

Morozov, S., *Artistic Photography*, /M., Planet, 1986, 416 pp.

Rakchmanov, N. (ed.), *Russian Photography*, /M., Planeta, 1996, 344 pp.

Russische Photographie 1840–1940, Ars Nicolai GmbH., Berlin, 1993, 256 pp.

RUTHERFURD, LEWIS MORRIS (1816–1892)

He was born in New York City and graduated in Laws from Williams University in 1834. Between 1837 and 1849 he practiced as a lawyer. He was a passionate amateur in astronomy, and has a special place in both histories of photography and astronomy as a pioneer of the photography as a tool of the astronomer. The begin-

ning of spectroscopy (1830) and photography (1839) opened the horizon of astronomy, that traditionally studied the position of the stars. From that moment a new branch was inaugurated, the physical astronomy, or more commonly known as astrophysics.

With this starting point, chemists and physists began to point instruments at the stars searching for new data and the photography was called to play a fundamental role, when allowing a faithful, reliable and lasting registry of the celestial phenomena. Today this period of astronomy is known as "New Astronomy"; and Rutherfurd was one of its pioneers, together with Norman Lockyer (1836–1920) in England, Jules Janssen (1824–1907) in France, father Angelo Secchi (1818–1878) in Italy and Hermann W. Vogel (1834–1898) in Germany. Rutherfurd developed special lenses, altogether with the optician and daguerreotypist Henry Fitz. This allowed to focus on the wavelengths involved in the photochemical process of the humid collodion plates, that is the blue, the violet and the ultraviolet.

In 1860 he established in New York an observatory with a great equatorial refractor telescope, with an objective of 33 cm of diameter and a camera for humid colodion plates. He obtained photographic images of the solar disc, as well as of the Moon, some planets, stars and constellations. His images of the Moon became famous at the Universal Exhibition of Paris, in 1867. Some were reproduced in stereoscopy and in woodburytype, illustrating treatises of astronomy or photography (Flammarion, 1878 and Vogel, 1875) and a few in albumen paper, in great size—approx. 42 cm × 57cm—which were distributed to the main scientific centers and to celebrities and astronomers of the world.

When the American astronomer Benjamin A. Gould (1824–1896) accepted the invitation of the President of Argentina, Domingo F. Sarmiento to direct an observatory in the mediterranean city of Cordoba, Argentina, Rutherfurd trained the future Gould' assistant, a German scientist, Carl Schultz-Sellack to obtain photographs with his system, and gave Gould the first compound lens that were used in that observatory. (Ferrari, 2001).

Rutherfurd donated his instruments and photographs to the University of Columbia, of which he was a benefactor (1858–84).

ROBERTO FERRARI

References

The South Carolinian Library Archive, (Document 10437) Letter from Leiber to Rutherfurd, Nov. 2nd, 1868.

Ferrari, Roberto A., *Carl Schultz-Sellack (1844–1879) y los orígenes de la fotografía astronómica en la Argentina.* In: Saber y Tiempo (Buenos Aires), vol. 5, Enero-Junio 2001, 71–101.

Poggendorff, J.C., *Biographisch-Literarisches Handwörterbuch der Exakten Naturwissenschaften.* Berlin: Akademie-Verlag, 1960.

Montserrat, M., "Sarmiento y los fundamentos de su política científica." In *La Ciencia en la Argentina—Perspectivas Históricas*, edited by Miguel de Asúa. Buenos Aires: CEAL. 1993.

Flammarion, Camilo, *Las tierras del cielo*. París-México: Bouret, 1878.

Vogel, Hermann, *The Chemistry of Light and Photography*. New York: Appleton, 1875.

RYDER, JAMES FITZALLEN (1826–1904)
American photographer

James Fitzallen Ryder, an American photographer for most of the second half of the 19th century, learned the daguerreian process in his hometown of Ithaca, N.Y. from a self-styled "Professor" Brightly, who "assured me that I was a promising subject and would make a mark as a daguerreotypist," Ryder wrote in his memoir.

In partnership with Brightly, Ruder operated daguerreian rooms in Ithaca, then became a traveling daguerreian in southwestern New York, Pennsylvania and Ohio. He opened a gallery in a vacant Mormon temple in Kirtland for a time, and worked in Elyria, Ohio during the winter of 1850. He then settled in Cleveland, where he introduced the ambrotype to the city in 1855.

In 1862, under the commission of the Atlantic and Great Western Railway, Ryder produced a two-volume album of 129 photographs of the landscapes, towns, stations and sheds, bridges, cuts, and tracks associated with the company. By the late 1860s, Ryder was Cleveland's leading photographer.

In 1868 he helped introduce negative retouching to the United States when he brought a retoucher from Germany to the United States. Ryder was a founding member of the Photographers Association of America and became the group's first president in 1880.

BOB ZELLER

S

SABATIER-BLOT, JEAN-BAPTISTE (1801–1881)
French painter and photographer

Appearing among the most famous portraitists of the Parisian daguerreotype of the 1840s, Jean-Baptist Sabatier is still today a poorly known figure among the historians of photography. There was a burst of production, accompanied by the absence of sources of files relating to him, and a scarcity of his name in the press, which make writing on him difficult.

He was born on January 31, 1801 in Lassur in Ariège. His parents wanted an ecclesiastical career for him, but his fragile health obliged them to withdraw him from seminary. Afterwards, he developed his artistic talents and became a miniaturist, located in Paris at 50 Palais Royal, exhibiting to the Salon on several occasions since 1831 (1835, 1837, 1839, 1841, 1843), always showing portraits of women. In 1838 he married Miss Blot and in 1839 their only daughter, Maria, was born; throughout the years of the 1840s, both were his favored models for daguerreotype portraits.

From the beginning of the 1840s he seemed to become part of the many painters of miniature attracted by the new medium of daguerreotype. During this period he became the pupil of the friend, Daguerre with whom he created at least two portraits, around 1844 (Rochester, George Eastman House and Société française de photographie). It is from 1842 that we find the name "Sabatier-Blot" on the reverse side of a plate of daguerreotype. The following year this name appeared for the first time under the heading "painter-artist," with "Palais Royal, 137." It was probably then that, assisted by his wife, Sabatier simultaneously practiced the two techniques, daguerreotype and miniature, even if the latter had become less favored. That year, Sabatier presented miniatures to the Salon for

the last time however, he continued to be presented as "a painter in miniature, making portraits with the daguerreotype" until the 1850s.

Sabatier-Blot presented daguerreotypes at "l'Exposition publique des Produits de l'Industrie" ("Public exposition of Products of Industry") the following year and, according to its publicity, was awarded an honorable mention. The same year, "Sabatier-Blot" appeared for the first time with the heading "Daguerreotypes" and a different address (Palais Royal 163). He was explicitly mentioned as specialist in portraits.

He seemed to have been one of the most sought after portraitists of the capital in the second half of the 1840s. His works, abundant and scattered, are difficult to locate in their totality. They reveal a good technician, famous for perfectly polished plates, which were obtained using a machine of his own invention. Also demonstrated is a certain skill of composition which sometimes distinguished him from his competitors. Sabatier-Blot had access to the traditional accessories of the portrait studio of this period such as the pedestal table covered with a tablecloth or a carpet. The plain backgrounds made it possible to center the attention on the character and to cut out its silhouette more significantly. Perhaps the naturalness of the poses, often less stiff than in the majority of the works of this period, is particularly noticeable in the series of portraits which he left to his daughter and his wife and can explain the success of his studio.

At the end of the 1840s, Sabatier-Blot was still located at the Palais Royal but at a different addresses: Palais Royal 137 and Valois 27 (1848) then Palais Royal 129 (1849–58). The other addresses however appear on the back of various plates signed with his name: Palais Royal 43 or Palais Royal 132. In 1849 he presented portraits at the exposition of the Products of

Industry. His production was rewarded, even though the jury mentioned that the effects of light were too complicated, which harmed the simplicity and the clarity of the images.

The last exposition in which he seemed to have taken part was that of the Hook Deluxe hotel of 1851 where he presented only one portrait. The same year, he became a member of the new Société heliographique. At the time when the technique of collodion was established, his name was rarely mentioned: three years later, he appeared among the first members of the Société française de photographie although he did not take part thereafter in any of its expositions. He seemed nevertheless to continue to express interest in the photographic medium, and its technical aspects in particular. In 1857 he acquired a patent for an instrument that was easier to manipulate as it was "so simple that one hour is enough to learn photography." Then in 1863, he developed another apparatus to operate in the open air. Moving once again, his studio from to 1861 was located at 25 rue Neuve des Bons Enfants (25 street Neuve of the Good Children), and then from 1863 to 1871, at Valois 37. He continued to make portraits, in particular calling cards, and ended his activity at the beginning of the 1870s. He died in 1881.

Since his large body of work is very scattered today, the most substantial collection consists of a little less than thirty plates belonging to the George Eastman house in Rocheste. These images came from the collection of Gabriel Cromer, a member of family of Sabatier-Blot's daughter who married, in 1865, to another photographer, Victor Laisné. With the study of this collection, it appears that the best of his work was carried out in margin of his commercial activities such as a portrait of the chemist Jean-Baptist Dumas, probably from 1849–1850, and the many portraits, sometimes with the format full plate, which he created of his daughter and his wife starting from the middle of the 1840s. Sticking more to the expression and the character of his models than with their social status, these images are among the greatest successes of the portrait to the French daguerreotype portraits.

QUENTIN BAJAC

Further Readings

Auer, Michèle, and Michel Auer, *Encyclopédie internationale des photographes de 1839 à nos jours*, Hermance, éditions Camera Obscura.

Buerger, Janet E., *French Daguerreotypes*, The University of Chicago Press, Chicago and London, 1989.

Mac Cauley, Anne , *Industrial Madness, Commercial Photography in Paris, 1848–1871*, Yale University Press, New Haven and London, 1994.

SACHÉ, ALFRED (c. 1853–1885)
India-based photographer

Commercial photographer, eldest son of John Edward Saché by his first wife, Alfred joined his father's photographic studio at Nainital in 1872, where he worked as an assistant till 1874. Working on a seasonal basis, he also opened his own premises in Benares in 1874, which he managed for one season till March 1875. The following month, he established another studio in the hill station of Kasauli, where he also became agent for the sale of his father's photographs. Between 1876 and 1881, Alfred's professional activity remains uncertain; the birth of his first child in March 1876 in Amballa and his second child in 1880 in Lahore suggests he may have worked as a photographer in both cities. In 1881, he opened a studio in Dalhousie, which he ran for a few years before traveling to Lahore again, where he possibly established the firm A. Saché & Co before he died in 1885. The firm continued till 1895, possibly run by his half brother John, who was John Edward Saché's son by his second wife Annie, and managed a studio in Lahore between 1886 and 1895. From 1896, the business A. Saché & Co was renamed Saché & Co and remained in activity till 1900.

STEPHANIE ROY

SACHÉ, JOHN EDWARD (1824–1882)
Prussian-born, Indian photographer and studio owner

Commercial photographer, born in Prussia as Johann Edvart Zachert, Saché arrived in Calcutta from the United States in late 1864, and entered into partnership with W. F. Westfield. Member of the Bengal Photographic Society, the firm Saché & Westfield won the silver and bronze medals at the annual exhibition of the Society, respectively in 1865 and 1866. While in partnership with Westfield, Saché opened his own independent studio at Nainital in 1867. He subsequently went into a brief partnership with a Mr J. Murray in Bombay in 1869. The same year, he made an expedition into the Himalayas, following Samuel Bourne's example. By 1870, Saché had ended his association with Westfield and concentrated on the running of season-based studios until his death in 1882: Mussoorie (from 1876) and Nainital during the hot months, Lucknow (from 1871) during the cooler months. In 1873–74, Saché made a series of views of Kashmir, which was to be the last group of topographical images he produced. Between 1874 and 1876, additional seasonal studios were opened in Meerut, Cawnpore and Benares, the latest being

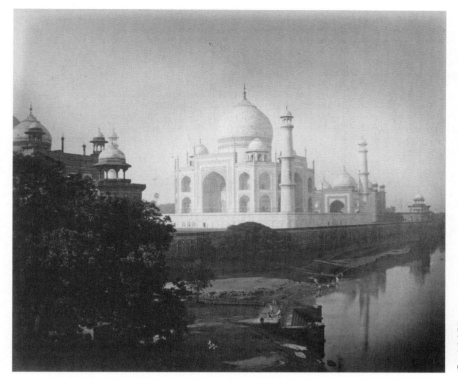

Sache, John. The Taj Mahal, Agra, India.
The J. Paul Getty Museum, Los Angeles
© The J. Paul Getty Museum.

managed by his eldest son Alfred. A number of talented photographers worked in Saché's studios, including G. W. Lawrie, with who he went into partnership as Saché & Lawrie between 1880 and 1882. During his twenty years in India, Saché traveled extensively throughout northern India, covering major sites and towns, and produced an accomplished collection of images, proving himself a master of the picturesque composition.

STEPHANIE ROY

SALTED PAPER PRINT

More concisely known as the salt print, the name implies the method of its preparation: fine quality paper was soaked in a dilute (ca. 1–2%) solution of common salt (sodium chloride) and dried. One side was then brushed over with a concentrated (ca. 20%) solution of silver nitrate, thus precipitating light-sensitive silver chloride within the paper fibres. Exposure to sun- or daylight through a contact negative caused a positive image in silver to print-out as minute particles of the metal trapped within the fibres of the paper surface. Such photographs on plain paper therefore carry no significant layer of colloidal binder; their matte surface distinguishes salt prints from those coated with glossy layers of hardened colloid, such as albumen, gelatin, or collodion, to bind the silver particles in suspension. Between these extremes there also exist intermediate examples of lightly colliferized prints.

The light sensitive chemistry of salt prints is essentially that of the first successful photographic process on paper: the photogenic drawing paper (q.v.) invented by William Henry Fox Talbot in 1834. The term 'salt print' is a later neologism (Hardwich 1855). Talbot originally stabilised his photogenic drawings with fixing agents—either saturated (ca. 32%) sodium chloride, or (ca. 2%) potassium iodide—but rather ineffectively, because the residual silver chloride remained slightly light-sensitive. Fixation with these halides was soon displaced by 'hyposulphite of soda' (still used today as 'hypo,' but properly, sodium thiosulfate), Sir John Herschel's innovation of 1839, which completely removed the excess silver chloride.

Salt prints fixed in a fresh hypo solution have a reddish- or yellowish-brown color that is affected by the paper sizing agent: the animal gelatin used for British papers afforded warmer image tones than the starch sizing of French papers. Such colors were commonly considered unpleasing, but with continuing use any hypo fixer bath was seen to yield more satisfying print colors of rich brown, as silver salts accumulated within it. This observation, publicised by Louis-Désiré Blanquart-Evrard in 1850, caused photographers to age their hypo baths artificially, by deliberately adding silver nitrate. The same effect was discovered in some cheaper substances: nitric acid, iodine, and iron(III) salts—all are oxidising agents that convert thiosulfate into polythionates, capable of *partially* sulfiding the silver image, to good effect. However, the optimum point of this procedure was very critical: if the paper were not fully washed free of excess fixer, it slowly converted the entire image to silver sulfide, with consequent fading

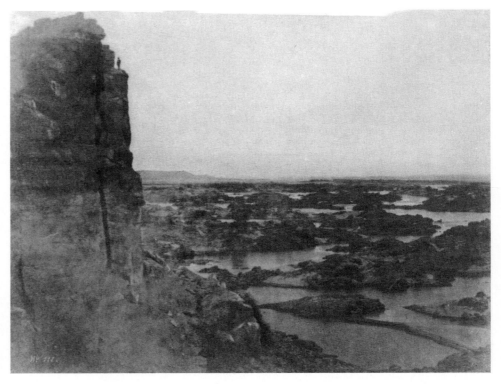

Benecke, Ernest. Vie de Gebel Mousir & Il Cataract du Nil regardant au nord-Nubie 72.
The J. Paul Getty Museum, Los Angeles © The J. Paul Getty Museum.

to dull ochre. The enthusiastic but careless employment of these inexpensive "old hypo fixing and colouring baths" proved disastrous for the permanence of many salt prints.

A better procedure for toning salt prints had already been proposed in 1847 by P. F. Mathieu, who employed *sel d'or*—a complex thiosulfate of gold(I)—to protect the silver image with a deposit of gold metal, as used for gilding daguerreotypes since 1840. Encouraged by Gustave Le Gray's recommendation in 1850, many French photographers took to gold-toning, but its benefits were only publicised in Britain much later in 1855, by Thomas Sutton. His energetic advocacy in the *Photographic Journal* won over the leading photochemist Thomas Hardwich, who repudiated his earlier recommendation of the 'old hypo bath,' in the second edition of his *Manual of Photographic Chemistry* in 1855. In the same year, the Photographic Society set up a committee with the remit "to take into consideration the Question of the Fading of Positive Photographic Pictures upon paper." This so-called "Fading Committee" recommended—though not unanimously—that gold toning be employed. The 'old hypo bath' was not finally discredited until *ca.* 1858. By then, the fading of salt prints had become a chronic problem; for instance, those printed by Nicholaas Henneman from 1844 onwards, for Talbot's publication *The Pencil of Nature,* suffered from the use of 'old hypo' at the Reading Establishment, where inadequate washing procedures were occasioned by the intermittent and impure water supply.

Greater success with salted paper printing was en-joyed by the circle of Scottish amateur photographers based in St. Andrews, and by their professional brethren in Edinburgh, David Octavius Hill and Robert Adamson. Between 1843 and 1847 this uniquely fruitful collaboration produced thousands of salt prints of rich color that survive well today. Edinburgh Old Town was then affectionately known to the Scots as "Auld Reekie" and the ingress of the sulfur-polluted atmosphere sometimes caused fading at the margins, but the body of the print was usually unattacked. The stability of Hill and Adamson's salt prints may be attributed to their use of dilute fixer and very thorough washing—24 hours was usual—to ensure complete removal of residual thiosulfate.

Three other improvements to Talbot's original formulation for photogenic drawing paper have proved worthy of note:

1. The 'ammonio-nitrate of silver paper' devised by Alfred Swain Taylor in 1839, which yielded a more neutral print color, and was easier to fix.
2. The inclusion of sodium citrate in the salting solution to absorb the chlorine produced photochemically, which otherwise reversed the reaction by re-oxidising the silver image; this became a standard additive to all later printing out papers.
3. Immersion in dilute sodium chloride before the hypo fixation bath, to precipitate any remaining soluble silver nitrate, which could otherwise cause brown stains of silver sulfide by oxidising the thiosulfate.

Salted paper was the principal medium for photographic printing throughout the 1840s and 1850s; but it was slowly displaced by a shift in public taste towards albumen paper, which had first emerged around 1853, and achieved commercial dominance by the end of the decade. From an esthetic viewpoint, the salt print was seen as the positive complement to Talbot's calotype paper negative process, thus sustaining the artistic ethos of 'photography on paper' as the medium of the gentleman-amateur. The fibrous paper substrate had the optical effect of diffusing the image to a softened 'impressionistic' look, much favoured for landscape. On the other hand, the sharp albumen print was the ideal positive counterpart to the highly resolved wet collodion negative on glass, and the medium of choice for portraiture by professional photographers. The artistic sentiments attaching to plain paper photography may also have stimulated the temporary revival of the salt print between 1895 and 1912, contemporaneous with the newly-perfected platinotype process and its perfectly matte 'engraving-like' surface, which was challenging—as one detractor put it—the "sharp and slimy" albumen print.

MIKE WARE

See also: Light-Sensitive Chemicals; Albumen Print, Dry Plate Negatives: Gelatine; Dry Plate Negatives: Non-Gelatine, Including Dry Collodion; Photogenic Drawing Negative; Talbot, William Henry Fox; Blanquart-Evrard, Louis-Désiré; Toning; Daguerreotype; Le Gray, Gustave; Sutton, Thomas; Photographic Exchange Club and Photographic Society Club, London; Henneman, Nicolaas; Hill, David Octavius and Robert Adamson; Taylor, Alfred Swain; Calotype and Talbotype; Wet Collodion Negative; and Wet Collodion Positive Processes.

Further Reading

Crawford, William, *The Keepers of Light*, New York: Morgan & Morgan, 1979.

Hardwich, T. Frederick, *A Manual of Photographic Chemistry*, London: John Churchill, 1855.

Jammes, André, and Janis, Eugenia Parry, *The Art of French Calotype*, Princeton, NJ: 1983.

Reilly, James M., *The Albumen & Salted Paper Book,* Rochester: Light Impressions, 1980.

Sparling, Marcus, "The Theory and Practice of the Photographic Art." In *The Circle of the Sciences, Volume VII. Practical Chemistry*, London: Griffin, Bohn, & Co., 1856.

Sutton, Thomas, *The Calotype Process. A Handbook to Photography on Paper*, London: Joseph Cundall, 1855.

Taylor, Roger, *Impressed by Light: British Photographs from Paper Negatives 1840–1860*, New York: Metropolitan Museum, 2007.

Ware, Mike, *Mechanisms of Image Deterioration in Early Photographs*, London: Science Museum and National Museum of Photography, Film & Television, 1994.

Ware, Mike, "On the Stability of Robert Adamson's Salted Paper Prints." *History of Photography* 27, 1, (Spring 2003): 35–39.

Ware, Mike, *Gold in Photography: The History and Art of Chrysotype*, Abergavenny: ffotoffilm publishing, 2006.

SALZMANN, AUGUSTE (1824–1872)
Archaeologist and painter

Impassioned by the early East, Auguste Salzmann went to Italy (1844) and Algeria (1847) with his friends Gustave-Henri Salzmann (a homonym) and Eugene Fromen-

Salzmann, Auguste. Jerusalem, Saint Sepulcre, Details de Chapiteaux. *The Metropolitan Museum of Art, Gilman Collection, Gift of The Howard Gilman Foundation, 2005 (2005.100.373.86) Image © The Metropolitan Museum of Art.*

tin. The company Schoengauer de Colmar provided the financial assistance for them stay in Egypt at the time of the excavations of Mariette (1851). This environment stimulated Salzmann's learning for archaeology, so he documented the architecture by means of photography. At the end of 1853, he left for the Holy Land to photograph the monuments studied by archaeologists two years earlier. In June 1854, he brought approximately 150 negatives from Jerusalem although his partner Durheim remained there after his departure, and produced around fifty more, which he published in 1856 in the form of album that he dedicated to Saulcy.

The *Jérusalem, époques judaïque, romaine, chrétienne, arabe; explorations photographiques* contains 174 prints obtained using paper negatives and 92 pages of text (Museum of Orsay: donation Robien de Bry; BNF; private collection). This work, printed by Blanquart-Evrard and published by Gide and Baudry, constitutes a luxurious album published in the early years of photography. The print quality gave the images relief and a particular intensity.

At the end of 1857, Salzmann left for Rhodes where he remained for several years, in particular to excavate the necropolis of Camiros (1858–1865). In 1863, he set out again for the Holy Land with Saulcy to undertake more thorough research. He brought back from this second campaign a set of salted paper prints on (approximately 26 × 32 cm) which were then reproduced in the form of photolithographies, in the workshops of Joseph Lemercier. These images were intended to illustrate the articles of Félicien Caignart de Saulcy.

These two voyages made Salzmann an occasional photographer who seized the appropriateness of the new medium to serve his scientific goal. He fully explored the malleable possibilities of photography just as well as other photographic professionals. Salzmann took part in the very first exposition organized by the Société française de photographie in 1855, with a panoramic view of Jerusalem, which was noted for the skill of execution (however, he was never a member of the SFP).

The views of the first voyage were among the most beautiful images of Jerusalem, and of a very poetic range, in spite of the scientific approach that inspired them. Salzmann studied ruins according to a rigorous approach, similar to that of Henri le Secq for Mission Héliographique. Le Secq's countryside images of Alsace was perhaps what inspired Salzmann to photograph the general and in contrast, the individual as well, creating overall sweeping images of the Valley of Josaphat, juxtaposed to images of enclosing walls, and drains. Salzmann photographed whole monuments as well often finding focus in the details. The project emphasized the closer details (apparatuses, ornaments) and points of view, namely all that the traditional artist did not have time to draw. The strongest images were indeed those which favored the large layout, which were unusual at that time.

In the foreword of the album, Salzmann wrote: "the photographs are not any more of the accounts, but of many gifted facts of a brutal conclusiveness." From this point of view, the Jerusalem album offers a successful application of the paper negative to the challenge of illustrating archaeological remains. Salzmann's images were used as a way to report and testify to the reality of the archaeological vestiges. In that, these views fulfilled the goal of photography assigned by Arago, which was to reproduce testimonies of the history of humanity. However these images go well beyond mere representation, glorifying the stones and the architectural and sculptural reliefs in a controlled play of light and shade. By their character of immediacy, the images acquired a great effectiveness. With the effects of the subject matter, Salzmann perceived with acuity the possibilities of the photographic medium. The power of certain images is accentuated by the fact that the town of Jerusalem was in ruins, and therefore uninhabited.

With the photographs of 1854, Salzmann takes his place in the role call of eminent travelers in the east, consisting of painters and draughtsmen, then photographers. From 1840, Egypt in particular and then other regions were regularly visited by the followers of the new medium. In the known body of photographs taken in the East between 1840 and 1855, Salzmann occupies quite a particular place, which one could consider a personal esthetic. Surpassing simple representation, his work offered a fresh vision in the field of archaeological photography.

HELENE BOCARD

Further Reading

F. de Saulcy et la Terre Sainte [texte de Françoise Heilbrun], Paris: Musée du Louvre, Paris, Réunion des musées nationaux, 1982.

N.N. Perez, "An Artiste in Jerusalem: Auguste Salzmann," *The Israel Museum Journal*, vol. 1 (Spring 1982).

André Jammes, and Eugenia Parry-Janis, *The Art of french calotype*, Princeton, NJ: Princeton University Press, 1983.

SAMBOURNE, EDWARD LINLEY (1844–1910)

Edward Linley Sambourne was one of the most eminent British cartoonists and illustrators of the late nineteenth century. For over forty years, from 1867 onwards, his work appeared in nearly every issue of *Punch* magazine, where he succeeded Sir John Tenniel as chief cartoonist in 1901. A gifted and skilful draughtsman, some of

his best work appeared as book illustrations, such as his drawings for Charles Kingsley's *The Water Babies* (1885). Sambourne was also an enthusiastic and prolific photographer, relying heavily on photographs to support his draughtsmanship and building up a reference collection of around 30,000 images.

Sambourne first took up photography in the early 1880s, attracted like many others by the increased ease and convenience offered by the recently introduced gelatin dry plates. However, unlike the vast majority of these new amateur photographers, Sambourne's motivation for becoming a photographer was primarily pragmatic and utilitarian rather than recreational. Over the years, Sambourne had amassed a huge collection of commercial photographs and magazine cuttings to use as visual references for his drawings. However, the tight deadlines he had to work to meant that it was often impossible for him to find commercially produced images which exactly matched his needs. Photography provided Sambourne with the perfect means of obtaining precisely the image he required, exactly when he needed it. Many artists, of course, have made extensive use of photographs, but most were reluctant to admit the debt that they owed to photography. Sambourne, to his credit, was refreshingly candid and open about his working methods. In two interviews he gave in 1893 he explained: 'I do not agree with those artists who codemn the aid of photography altogether. On the contrary, I consider it a very useful and valuable adjunct to art.' and, more revealingly, 'You see, I don't believe in drawing out of my head, as people call it. I go to Nature herself, and that must be better art than working from mere recollection—at least, that is my opinion. I'm always on the look-out for people, objects and scenery to photograph...' Soon, rather than being merely a 'valuable adjunct,' photography became an indispensable tool which came to dominate his working practice. Indeed, a fellow *Punch* cartoonist, Harry Furniss, later described Sambourne as 'a slave of the camera and mere copyist'—a charge which Sambourne fiercely refuted. Even a superficial study of Sambourne's photographs and cartoons, however, reveals just how dependent on photography he became.

At his home in Stafford Terrace, Kensington, London, Sambourne photographed himself, members of his family, friends and servants in poses and attitudes reflecting the requirements of his weekly cartoon for *Punch*. He also made frequent use of a huge variety of props and costumes. The resulting negatives were processed by Sambourne in his home darkroom which he converted from a bathroom and contact printed to produce cyanotypes or platinum prints. These prints were then traced to form the outline of the cartoon. Indeed, many of

Sambourne's drawings are direct transcriptions of his photographs down to the smallest detail.

In 1893 Sambourne joined the Camera Club—a sign of his growing interest in photography that now transcended his work-related activities. The Camera Club had recently moved to new well-appointed premises on Charing Cross Road and Sambourne made full use of the facilities offered, attending meetings and lectures and using the darkrooms and studio. Many of his photographs taken at the Camera Club reflect Sambourne's main area of photographic interest—the female nude. Whilst some of these studies were genuine *aides-memoire* for his drawings, the sheer volume of nude photographs, combined with the nature of the poses implies that their motivation was primarily private rather than professional. They can be viewed as both artistic and erotic with many transcending the boundary into the fetishistic and mildly pornographic. For his nude photography Sambourne used professional models and usually worked at the Camera Club. On rare occasions, however, he would invite the models into his home—making sure that his wife was safely out of the way, staying at the family house in Ramsgate.

In 1905 the Camera Club closed temporarily. This coincided with a change in direction for Sambourne's photography. Whilst continuing to photograph nudes as well as the tableaux which formed the basis of his work for *Punch,* he now began to devote time to exploring the possibilities of the snapshot. He had bought his first hand camera in 1892 and relished its potential for 'candid' photography. Sambourne's favourite subjects were schoolgirls that he photographed in the streets of Kensington, using a detective camera disguised as a pair of binoculars that took a photograph at right angles to the direction in which it appeared to be pointed. Despite the unpleasant connotations clearly implicit in these photographs, there is no denying their freshness, vitality and spontaneity and they represent some of his most interesting work.

It is, perhaps, significant that this, the last expression of Sambourne's continuing and at times all-consuming enthusiasm for photography, should also embody an element of subterfuge and secrecy. In his photography, as with so many aspects of his personal life, Sambourne seemed able to keep the various strands of his public and private persona detached and separate. He remained a public figure with very private passions—a man of contrasts and contradictions, a man who despite the huge amount of time and energy he devoted to it, could still reply, when asked if he was fond of photography: 'No, I can't honestly say that I am.'

Sambourne died in 1910. His house is Stafford Terrace is preserved and is open to the public as a unique

example of a late Victorian townhouse. The family archive, including Sambourne's photographs, is held at Kensington Central Library.

COLIN HARDING

Further Reading

Shirley Nicholson, *A Victorian Household*, Sutton Publishing Limited, 1988.

Mary Anne Roberts, *Edward Linley Sambourne (1844–1910)*, History of Photography, Vol XVII, Summer 1993.

Robin Simon (ed.), *Public Artist, Private Passions: The World of Edward Linley Sambourne*, The British Art Journal, 2001.

SANDERSON, FREDERICK H. (1856–1929)
English photographer and inventor

Frederick Sanderson was born in July 1856 to a long established Cambridge family. He started work as a cabinet maker and as a wood and stone carver and became interested in photography in the 1880s. He took a leading role in his local photographic society. Photographic retailing was added to his cabinet making business.

Sanderson had a particular interest in architectural photography and, unable to find a camera to meet his needs, he set about designing one. The outcome of his work was the subject of British patent number 613 of 10 January 1895. The patent described a method of supporting the front or back of a camera which allowed them to be fixed at any angle. In practice the design was incorporated into a double strut on each side of the front standard which could be locked into any position. The patent also referred to a rotating lens panel into which the lens was mounted eccentrically and bellows which tapered on their lower side to aid the extreme movement available with the strut arrangement.

Sanderson licensed the design to George Houghton and Son of London who initially had the camera made for them by Holmes Brothers. Holmes Brothers were incorporated into Houghtons Ltd in 1904 and the camera was subsequently made and sold by them or their selling company Ensign Ltd until its demise in 1940. The camera was popular and the original field camera model, made in a variety of plate sizes. A hand and stand model was offered from 1899. The hand camera underwent a process of continual improvement with further patents from Sanderson and others. It was last listed in Ensign's 1938 catalogue by which time upwards of 26,000 examples of the sixty distinct models of Sandersons had been made.

Frederick Sanderson does not appear to have made any further significant contribution to photography. He

died on 9 July 1929 leaving an estate valued at £1887 12s 3d.

MICHAEL PRITCHARD

SARONY, NAPOLEON (1821–1896) AND OLIVER FRANÇOIS XAVIER (1820–1879)

The Canadian brothers, Napoleon and Olivier Sarony, earned their respective reputations on opposite sides of the Atlantic—Napoleon becoming New York's pre-eminent 19th century theatre photographer while his older brother operated the most successful portrait studio in the north-east of England.

The sons of an officer in the Austrian army who had moved to Canada after Waterloo, the brothers moved to New York with their parents in 1831, and by 1841, both had become enthused by photography, with Oliver operating daguerreotype studios briefly in both New York and Quebec. Napoleon, however, initially trained as a lithographer and worked for a time with the eminent American print-maker Nathaniel Currier before setting up his own lithographic business in partnership with James Major in 1843. By 1857 the company had acquired another partner and traded as Sarony, Major & Knapp. Despite his later success with photography, he retained a profound interest in lithography.

In 1843, the year Napoleon established Sarony & Major, Oliver had emigrated to England, and spent several years as an itinerant daguerreotypist in eastern England. Early advertisements list him in the 1840s and early 1850s operating studios in towns and cities in Yorkshire, Nottinghamshire, and Lincolnshire. Given the attempts by Richard Beard to retain tight control over the use of the daguerreotype in England in the 1840s through his patents and licences, it can be assumed that Oliver was using the process unofficially.

By 1854, he was operating a mobile studio throughout Cambridgeshire and Norfolk, eventually opening a permanent studio in Scarborough, Yorkshire, in 1857. This represented a complete change of direction for Oliver, as itinerant photographers were usually at the lower end of the market, while advertisements for the Scarborough studio emphasised the quality of his work, and were priced accordingly. Before the end of that year he briefly opened another studio in Newcastle, and returned to Scarborough in July 1858 to open Gainsborough House, a custom-designed studio built to his own specification at South Cliff, and he remained at that address until his death in 1879. Many of the studio's cartes-de-visite bore the address 'Sarony Square, Scarborough.'

Oliver Sarony was not only a fine photographer, he was an innovator as well, with a keen business eye. Several of his innovative ideas were patented—with two

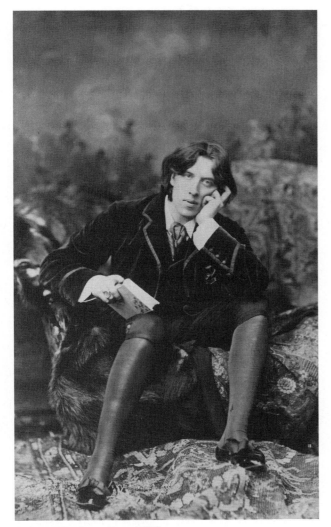

Sarony, Napoleon. Oscar Wilde.
*The Metropolitan Museum of Art, Gilman Collection,
Purchase, Ann Tenenbaum and Thomas H. Lee Gift, 2005
(2005.100.120) Image © The Metropolitan Museum of Art.*

patents (1858 No. 725, and 1858 No. 1501) covering aspects of studio practice and the coloring of prints, and another in 1862 for an improved combined posing chair and head restraint.

He employed painters and colourists to produce large portraits from his photographs, and opened and developed an art gallery selling paintings, lithographs, and his own photographs of royalty and celebrities. His fame drew a visit by the Prince of Wales in 1869, resulting in a sitting which further extended Sarony's.

In his obituary (*Anthony's Photographic Bulletin*, September 1879, 287) his Scarborough operation was described, at its height, as having 98 rooms and employing 110 staff.

By the late 1860s, Sarony & Co. was offering for sale a range of studio backdrops—reportedly painted by his brother Napoleon who had, by that time, opened a photographic studio in New York.

By 1864 he had been joined in England by Napoleon, whose Birmingham studio, Sarony & Co., operated from premises in New Street from 1864 until after 1880. The *British Journal of Photography* in its issue of April 28 1865, 222, reported Napoleon's patent 'Improvements in the Production and Treatment of Photographs.' A few weeks earlier, the *American Journal of Photography and the Allied Arts & Sciences*, Feb. 1 1865, 351–352, had commented on Napoleon's new techniques for vignetting being used in the Birmingham Studio, and in May 1866, The *Art Journal* reported that he "is one of the best photographers [working] in Birmingham" and that he "uses the 'rest' invented by his brother, of Scarborough."

But the Birmingham venture was not his first. Napoleon Sarony's first studio is believed to have opened in Yonkers in 1857, where he was listed as a daguerreotypist, at which time he was still involved with the lithographic business of Sarony Major & Knapp. The fact that Knapp joined the partnership at that time may have been as a result of Napoleon's decision to change professions. The studio is not listed after 1858, and he is believed to have left for a tour of European lithographic companies some time before 1860, arriving in England in 1863. With the Birmingham studio established, however, he returned to America, and his New York in Union Square studio opened in 1866 or 1867. Over the following thirty years he is reputed to have photographed every major star on the New York stage.

Napoleon was a major influence in the emerging use of publicity photographs in the theatre. In addition he photographed many writers and celebrities. By the time of his death in 1896, the studio is believed to have amassed an archive of over forty thousand negatives.

Napoleon was at the centre of a celebrated court case in 1883, over the unauthorized duplication and publication of one of his portraits of Oscar Wilde. The case of *The Burrow-Giles Lithographic Company against Napoleon Sarony* was heard first in a District Court, and subsequently argued in the US Supreme Court in December 1883. It centered on whether or not the copyright protection granted to photographers under the US Copyright Act of July 1870 was constitutional. The question related to whether or not the photograph existed separately from the person it portrayed—and as Oscar Wilde's physical appearance was not copyright, nor could be a photograph of him. In 1884 the Supreme Court found in favor of Sarony, but conceded that all photographs might not necessarily be thus protected. Central to this definition of copyright was the ideal that the photograph should be *"entirely from his own mental conception"* and that the photographer must be responsible for *"arranging the subject so as to present graceful outlines, arranging and disposing the light and shade,* [and] *suggesting and evoking the desired expression."* Thus, this ruling constitutionally defined a

photograph was being the work of an author, as original as the written word—a major milestone in copyright protection.

The character of Julius Bianchi in the 1902 novel *The Fortunes of Oliver Horne* is believed to have been based on Napoleon Sarony.

JOHN HANNAVY

See also: Daguerreotype; Cartes-de-Visite; and *British Journal of Photography*.

Further Reading

Sarony's Living Pictures: Photographed from Life, New York, Chasmar, 1894–95.

Bassham, Ben L, *The Theatrical Photographs of Napoleon Sarony*, Kent, OH: Kent State University Press, 1978.

Johnson, William S, *Nineteenth Century Photography: An Annotated Bibliography 1839–1879,* London, Mansell Publishing, 1990.

Bayliss, Paul, and Anne Bayliss, *Photographers in Mid-Nineteenth Century Scarborough—The Sarony Years*, Scarborough, Bayliss 1998.

SAUNDERS, WILLIAM THOMAS (1832–1892)
English photographer

William Saunders, one of the finest nineteenth-century photographers of China and Japan, operated a studio in Shanghai from around 1861 until at least 1887. Like Felice Beato in Japan, Saunders' success was built upon the production of souvenir albums of Chinese scenery and *genre* studies for foreign residents and visitors. Much of this work has survived and his talent is self-evident. His Chinese landscape portfolio of Shanghai, Ningpo and Foochow was supplemented by views of Peking and Japan. He made his first photographic tour to Japan in 1862, accumulating some 90 images but, surprisingly, only a few of these have so far been identified and are in the Worswick Collection, Tokyo. In May, 1863 Saunders offered handcolored photographs and may well have been the first commercial studio in the Far East to do so. Apart from his larger-format work, which also included multi-plate panoramas of Chinese and Japanese towns and cities, Saunders also sold *cartes de visite* and stereoviews.

Having enjoyed considerable commercial success, he sold all of his stock and equipment in 1871 and returned to England to marry. Perhaps his marriage failed because, by the following year, he was back operating his studio in Shanghai. His wife died in England in 1887 and shortly afterwards he decided to retire and went home. Returning to Shanghai on a visit in 1892, he caught bronchitis and died.

TERRY BENNETT

SAUVAIRE, HENRI (1831–1896)
French photographer

Henri Sauvaire was born in Marseille. Raised by his Uncle Marius, a merchant who often dealt with the Near East, he soon became familiar with Orient. As Henri de Clercq (1836–1901) or Gustave de Beaucorps (1825–1906) he was among those talented amateur photographers fond of Orient. He certainly learned photography in France in the mid-fifties and practiced it during thirty years along with a successful diplomatic carrier started in 1857 in Lebanon, as a *drogman* in Beyruth, and ended in 1885 in Morocco as the French consul. He then came back to France, near Marseille, where he died.

Unfortunately only some of his photographs are still kept today (the Musée d'Orsay received in 1995 from René and Bernard Sauvaire a very important gift of 160 prints, both from paper and glass negatives). Most of the remaining prints have been taken between 1860 and 1866 in Lebanon, Syria and around the Bosphorus. Henri Sauvaire was a fine observer of oriental life and landscapes. He revealed his sense for artistic composition as well as his technical abilities in large Beirut panoramas, sad views of the Christian quarter in Damas burnt down after the civil war in 1860 as well as in beautiful prints of the famous Damas Omayad mosque.

Familiar with occidental circles in Lebanon he also did several photographs of Camille Rogier (1805–1870) studio. Painter and illustrator—he has illustrated the first French edition of Hoffmann's tales; Rogier was close friend to Théophile Gautier, Gérard de Nerval and Gustave Flaubert. Even if he almost left his artistic carrier for a more lucrative position in postal administration, Rogier stands in front of Sauvaire's camera as a painter, before a white canvas, surrounded by friends. The *tableaux vivants* Sauvaire composed in the eccentric French man studio show the photographer sense of humor as well as his mastery of lightening. His soft portraits of women whose beauty is enhanced by the sumptuous fabrics of their Turkish clothes underline Sauvaire's delicacy.

In 1866, Sauvaire traveled with Christian Edouard Mauss around the Dead See thanks to an archeological expedition supported by the Duc de Luynes. He took there almost one hundred prints to be published by Melchior de Vogüé in 1875. The views of the ruined crusaders castles gave him first rank, along with Auguste Salzmann (1824–1872), as masters of early archeological photography. Fine scholar, experienced numismatist, Sauvaire then published and translated several books on Oriental civilization.

DOMINIQUE DE FONT-RÉAULX

SAVAGE, CHARLES ROSCOE (1832–1909)
American photographer

Charles Roscoe Savage's beginnings were modest. He grew up in a poor Southampton neighborhood and as the son of a gardener received very little schooling and was expected to contribute to the family finances at an early age. He did, however, have an interest in religion and in 1848, despite his family's objections, he converted to the Church of Jesus Christ of Latter-Day Saints (the Mormons). In 1855 Savage left England for New York City. Although he was interested in photography while still in England, only when he reached New York did he begin his study in earnest. He found the trade to be very secretive and had difficulty in receiving training of any kind. Eventually, through reading, experimentation, and paid lessons he became quite competent.

In 1860 he arrived in Council Bluffs, Iowa (then the main departure point for the Overland and Oregon Trails) where he set up a crude darkroom and gallery. He was able to earn enough money to buy and outfit a wagon for his small family for the trip westward. On August 28, 1860, Savage finally reached the Mormon Zion in Utah. At first his business was almost exclusively devoted to portraiture, but Savage soon went outdoors by photographing the buildings of Salt Lake City as well as the mountains and small towns of Utah. After several years, though, Savage felt more and more isolated from other progressive photographers and from the latest developments in the art. In 1866 he came up with a daring plan to travel 9,000 miles from Salt Lake City to San Francisco to New York and then back to Utah that would plunge him deeply in debt, but which began his rise to national prominence as a Western photographer.

Savage left Salt Lake City for San Francisco, California by stagecoach. He visited with a number of photographers while in the city including Carleton Watkins. He then took a steamer down to Panama, crossed the Isthmus and took another boat north to New York City. In New York he bought photographic supplies from the E. and H.T. Anthony Co. and visited with several publishers before traveling to Philadelphia to pick up a wagon similar to the darkroom wagons used by Civil War photographers. He shipped the wagon by boat and rail to Nebraska City, Nebraska. He then traveled across the Plains, into the Rocky Mountains, and back to Salt Lake City (of course photographing the more famous places on the Oregon Trail as he went). Savage made a number of contacts on this voyage and soon after his images started showing up as lithographs in *Harper's Weekly* and *Leslie's Illustrated* and were marketed on the East Coast through the New York firm of Fowler and Wells. Savage also subsequently published articles in *The Philadelphia Photographer* and *Humphrey's Journal of Photography and the Allied Arts and Sciences*.

In 1869 when the Union Pacific and Central Pacific Railroads were scheduled to come together at Promontory, Utah, Savage was asked to join Andrew Joseph Russell and Alfred Hart to photograph the final drama of "The Work of the Age." This event opened doors among the railroad companies and for the next 30 years Savage enjoyed free passes and sometimes even private luxury cars on several lines. Savage's photographs encouraged tourism for the railroads while providing him the means to travel about the West photographing the landscape and its diverse peoples. Savage also benefitted from interest in the Mormons of Utah. Americans had a morbid curiosity about polygamy (Savage himself would eventually marry four women), with the worship of a living prophet, and with the Mormon theocratic government. After the railroad was completed, greater number of tourists visited Salt Lake City and a stop at Savage's studio became almost mandatory.

In 1869 Savage also met (presumably for the first time) two of the best known photographers of the American West, William Henry Jackson and Timothy O'Sullivan. Although at the time they could not know it, these three would introduce the country to the scenic Western landscape long before Buffalo Bill peddled the mythic West of cowboys and Indians. Whereas O'Sullivan and Jackson would travel to the most remote areas of the West, Savage stuck to the more traveled byways, using wagons and trains rather than mules and makeshift boats. And although Savage had an appreciation for wilderness, he did not embrace it as did O'Sullivan and Jackson whose photographs celebrate the breathtaking landscape and majestic scale of the West. In comparison with these two, Savage's photographs focus on development. Upon first seeing what would later become Zion National Park Savage wrote, "From a picturesque point of view, it was grand, sublime, and majestic, but as a place of residence, lonely and unattractive, reminding one of living in a stone box; the landscape, a skyscrape; a good place to visit, and a nice place to leave" (Richards, 66).

In part due to this ambivalence towards nature, Savage's images have never received the critical attention of Jackson and O'Sullivan. Certainly he is not put in the same category as Carleton Watkins or Edweard Muybridge whose subtle experiments with unconventional views and composition are lacking in Savage's work. He did, however, document an important sub-culture (the Mormons) and his relentless travels around the West ensured that he would be remembered among the major names of nineteenth-century Western photographers.

Savage was also a savvy businessman, one who did not succumb to the bleak financial fate of so many other Western photographers. He was successful in part because his photographic studio was also a general art store that sold various photographic and artistic supplies, periodicals, books, craft goods, and miscellaneous novelties. He had a variety of contacts on the West and East coasts through which he could market his photographs and stereo-views and who would, in turn, provide him with merchandise to sell at his "Art Bazar." Despite a few setbacks (his gallery burned down in 1883) his business continued to grow over the years. As amateur photography grew increasingly popular in the 1880s and 1890s, Savage moved into photo finishing and camera sales. After the turn of the century, Savage devoted more and more of his time to various philanthropic events and to the Mormon Tabernacle Choir. In fact, when he died of a heart attack on February 3, 1909, he was almost as well known for his generosity as for his photography.

DANIEL DAVIS

See also: Watkins, Alfred; and O'Sullivan, Timothy Henry.

Biography

Charles Roscoe Savage was born on August 16, 1832. He grew up in a poor Southampton neighborhood but moved to New York City in 1855. Savage began his study of photography in New York and opened his first gallery in Salt Lake City, Utah in 1860. He started with portraiture, but quickly branched out to photograph buildings, towns, mines, newsworthy events, and landscapes in Utah. In 1866 a trip to New York and Philadelphia brought attention to the young photographer, but it was not until he attended the joining of the Union Pacific and the Central Pacific Railroads at Promontory Point in 1869 that Savage became a recognized name. After 1869 he would travel throughout the West (with free passes from the railroads) shooting scenes of interest along the lines. In comparison with his peers such as Carleton Watkins, Timothy O'Sullivan, and William Henry Jackson, Savage was not as ambitious about seeking out new photographic opportunities, nor did not embrace the western landscape as they did. He did, however, document an important sub-culture (the Mormons) and he was one of the first photographers to provide images of the American West to eager Eastern audiences. Savage was also a savvy businessman whose profits from a successful art store in Salt Lake City allowed him to continue his photographic career. Unfortunately, only a few original Savage negatives exist today because of two devastating fires in 1883 and 1911.

Further Reading

Pamquist, Peter E., and Kailbourn, Thomas R., *Pioneer Photographers of the Far West: A Biographical Dictionary, 1840–1865*, Stanford, California: Stanford University Press, 2000.

Richards, Bradley W., *The Savage View: Charles Savage, Pioneer Mormon Photographer*, Reno, Nevada: Carl Mautz Publishing, 1995.

Stern, Madeleine B. *A Rocky Mountain Book Store: Savage and Ottinger of Utah, BYU Studies*, 9/2 (Winter 1969).

Wadsworth, Nelson B., *Set in Stone Fixed in Glass: The Great Mormon Temple and Its Photographers*, Salt Lake City, Utah: Signature Books, 1992.

Wadsworth, Nelson B., *Through Camera Eyes*, Provo, Utah: Brigham Young University Press, 1975.

SAVILLE-KENT, WILLIAM (1845–1908)
English naturalist and photographer

Saville-Kent (also known as Kent) was born in Sidmouth in Devon, England, on 10 July 1845 to Samuel Savill Kent and Mary Ann Kent. After studying at King's College, and the Royal College of Science under T.H. Huxley, he initially pursued a career in natural history museums, including the British Museum. In 1873, he accepted the position of resident naturalist at the recently opened Brighton Aquarium. Similar roles followed at other public aquaria until he was appointed Superintendent of Fisheries in Tasmania, Australia, in 1884. Saville-Kent's research into marine life and its commercial applications, including pioneering work in pearl culture, earned him a number of advisory roles for the Victorian, Queensland and Western Australian colonial governments from 1887. These provided him with opportunities to travel to some of the farthest regions of the continent and adjacent islands. During this time he took up photography and produced remarkable coral reef views and studies of natural history specimens. Saville-Kent published numerous scientific studies throughout his career, however he is best known for two, more popular, natural history monographs from that latter period in Australia—*The Great Barrier Reef of Australia*, 1893, and *The Naturalist in Australia*, 1897—both extensively illustrated with his photographs. He developed various techniques for photographing natural history subjects and experimented with colour processes, exhibiting his photographs at the Royal Society in 1891 and the Royal Photographic Society (RPS) in 1906. The latter, shown by invitation of the RPS Council, included over eighty natural colour transparencies prepared by the Sanger-Shepherd trichromatic process with modifications, and were presented as lantern-size plates, half and quarter-size plates and stereos. Following a sudden illness and bowel surgery, Saville-Kent died in Bournemouth, England, in 1908.

KATE DAVIDSON

SAWYER, JOHN ROBERT MATHER (1828–1829) AND CHARLES (1861–1914)
English photographers

John Sawyer was born in Sheffield, but started his career as an optician in Norwich. He opened a studio on Regent Street, London in 1871 with Walter Strickland Bird (1828–1912), later admitting Edward William Foxlee (1832–1913) to the partnership. At the same time, the partners took an interest in the recently established Autotype Company, operating out of Ealing.

In January 1873 John Spencer (manager of the chemical department), and Bird bought out the Company together with its London Gallery at 36 Rathbone Place, St. Marylebone. A modification by Sawyer of the carbon process was patented in 1874, as "flexible temporary suppor,t" paper coated with gelatine rendered insoluble by means of chrome alum, followed by a second coat in soda and borax. Sawyer's son Charles joined the Company shortly before his father's ill health forced a premature retirement. John Sawyer died at sea in sight of Naples harbour January 21 1889, while on a health cruise.

Charles was sole manager of the Autotype Company after Bird's mental health deteriorated, forcing him to retire in 1900. Sawyer, whose main interest had always been with the technical manufacture of the carbon printing, himself died prematurely after a long illness September 22, 1914.

DAVID WEBB

SAWYER, LYDDELL (1856–c. 1908)
English photographer

When the photographer Lyddell Sawyer joined the Brotherhood of the Linked Ring in November 1895, he took the pseudonym of 'Sheriff.' Despite having been one of the original 'secessionists' from the Photographic Society of Great Britain (today the Royal Photographic Society) in 1891, the association which became known as the Linked Ring was three years old before he formally became a 'link.'

Originally from the north east of England—he is believed to have been born in Sunderland, and to have worked in a professional studio in Newcastle before establishing his own studio in the town in 1885—'Lyd' Sawyer had quickly earned for himself the reputation as one of the finest 'art photographers' in late Victorian England, and was a friend of such other eminent practitioners as Frank Meadow Sutcliffe and Henry Peach Robinson. From 1896 he operated a portrait studio in Regent Street, London.

Given the importance of his contribution to the development of photography as an art, surprisingly little is known of his life and work. A staunch advocate of the idea that a photographer should 'make' rather than 'take' pictures, his images have a lyrical narrative quality.

His images appeared in several influential publications, including *Sun Artists* (vol. 4), 1890, and *Photographs of the Year,* the published catalogue of the Photographic Society's 1891 exhibition, with a text by H P Robinson.

He left the Linked Ring in 1901, and continued to operate a studio in Maida Vale until at least 1908.

JOHN HANNAVY

SAXTON, JOSEPH (1799–1873)
American Photograper

Joseph Saxton is credited with creating the oldest extant American-made photographic image. Taken from his window at the Philadelphia mint where he served as curator of weights and measures, the daguerreotype captured the cupola of Central High School and a portion of the State Armory building on a silver plate used to cut coin blanks. The actual date of the image has been disputed as several accounts of the Daguerre's process were available in the United States in September and October of 1839. The earliest published reference to Saxton's daguerreotype is a description that appeared in the *United States Gazette* on October 24, 1839. Best known as a talented machinist, instrument maker and inventor, Saxton constructed and improved upon a wide variety of scientific and practical devices. He was a member of the American Philosophical Society, the Franklin Institute, and the National Academy of Sciences. Born in Huntington, Pennsylvania on March 22, 1799, Saxton spent his early career in Philadelphia employed as a clock and watchmaker. He lived in London for nearly a decade where he was affiliated with the Adelaide Gallery of Practical Science before returning to Philadelphia in 1837 to accept the position at the mint. He served as chief mechanic in the Office of Weights and Measures of the U.S. Coast Survey from 1843 until his death on October 26, 1873 in Washington, D.C.

JENNY AMBROSE

SAYCE, B. J. (1837–1895)

The name of B.J Sayce first came to national prominence within the photographic community with the publication of the paper 'Photography Without a Silver Nitrate Bath' in *The British Journal of Photography* on September 9th 1864. That article effectively marked the end of the wet collodion era and prefaced the dawn of modern photographic materials.

Although his name usually follows that of William Blanchard Bolton in histories of photography—'Bolton and Sayce' being given joint credit—Bolton himself acknowledged that it was Sayce's understanding of chemistry which drove the development of photography's first true emulsion.

Sayce's quest for an emulsion which could simply be poured on to a plate and then exposed clearly places the genesis of the idea in the wet collodion era. From initial experiments in 1859, it took five years of development before the announcement of a working collodio-bromide emulsion in 1864.

The emulsification of silver bromide in collodion removed the need for the separate silver nitrate bath, and was the forerunner of all the dry plate emulsion technology which followed. For several years, Sayce's discovery was known as the Liverpool Process.

Always an amateur photographer, Sayce was a founder member of the Liverpool Amateur Photographic Association, and one of the instigators of the first International Photographic Exhibition held in Liverpool in 1888.

JOHN HANNAVY

SCHAEFER, ADOLPH (c. 1820–1853)
Dutch photographer

Started original as a painter and according an advertisement in the Journal of The Hague in the Netherlands he worked there as a photographer from January 1st until the 14, 1843. He was befriended with Philipp Franz von Siebel who wrote at Leiden on May 1, 1843, a letter of recommendation to King William II of the Netherlands to ask the King if Schaefer could work in the Indonesia to work for the Ministry of Colonies to photograph the historical buildings and places for the government. In 1844 he traveled to Indonesia to replace Jurriaan Munnick, as the Dutch Government was not pleased with the results of Munnick's work.

Before he left he bought on November 3, 1843, photographic equipment from Hottinguer & Comp. in Paris for for 8882 Dutch guilders.

After his arrival Schaefer made more then 5000 pictures of many Indonesian monuments and geological places in the West Indies in order of the Dutch Government. He used daguerreotype and later albumin types. Most of his work in preserved at the Tropical Institute of Amsterdam, some is preserved in the collection of art at the Rijksmuseum in Amsterdam. In 1849 Schaefer opened a studio in Semarang on the Isle of Java and also gave lessons in photography.

After this time Schaefer disappeared. It could be the result of his debt of 6073,53 guilders to the Dutch Government.

In Dresden a men named Schaefer died in 1853, leaving behind a widow and a son.

PETRA NOTENBOOM

SCHEELE, CARL WILHELM (1742–1786)
Swiss chemist

The chemist Carl Wilhelm Scheele was born in Stralsund, then part of Sweden, now Germany, and was one of a number of eminent scientists whose work predicted and laid the foundations for photography. His research in 1777 into the blackening effect of light on silver salts confirmed the earlier findings of Johann Heinrich Schultze, and progressed scientific understanding of what would become photographic chemistry.

Scheele's significant discovery was that the blackening effect of light on silver chloride—he had isolated and identified the element chlorine in 1774—was due to chemical reduction, and that the result of that reduction was black silver metal. His recognition that silver chloride blackened more quickly when exposed to light at the blue and violet end of the spectrum was a significant contribution toward understanding that spectral sensitivity.

In so doing, he coined the expression 'chemical rays' to denote those wavelengths of light which has actinic properties.

That ammonia dissolved silver chloride was already known to chemists, but Scheele's application of that knowledge to remove the silver chloride which had not been affected by exposure to light predicted the 'fixing' process upon which permanent photography would later depend.

He is credited with the identification of citric, malic, oxalic and gallic acids—the last also a key chemical in early photography—and was the first to recognise that air is predominantly made up of two gases, oxygen and nitrogen.

JOHN HANNAVY

SCHLAGINTWEIT, HERMANN (1826–1882); ADOLPH (1829–1857) AND ROBERT (1833–1885)
German explorers and scholars

The five Schlagintweit brothers—Hermann, Adolph, Eduard (1831–1866), wrote an account of the Spanish expedition to Morocco in 1859–60, Robert and Emil (1835–1904), and specialized in Tibetan studies—also worked in Europe and Asia. Hermann's first scientific mission, in association with his brother Adolph, was conducted in the Alps between 1846 and 1848. Subse-

quent expeditions in the same region, in which Robert took part, confirmed their reputation as scientific explorers. In 1854, the East India Company commissioned the three brothers to pursue a magnetic survey of India on the death of surveyor Charles Elliot. During 1854–57, they traveled throughout the Deccan and the Himalayas, and at some occasions, beyond the frontiers of the Company's territories. Hermann and Robert were the first Europeans to cross the Kunlun Mountains in China, for which Hermann received the title *Sakünlünski*. During these travels, Robert took a number of ethnographical and topographical photographs. Upon their return in Europe in 1857, the two brothers published *Results of a Scientific Mission to India and High Asia* (4 volumes, 1860–66). Adolph pursued his research in Central Asia and was put to death by the Amir of Kashgar on 26 August 1857. Hermann settled in Jägesburg and devoted himself to writing. Robert was appointed professor of geography at Giessen in 1863 and traveled widely to America between 1867 and 1870, where he lectured and traveled along the Pacific coast, publishing his research between 1870 and 1876.

STEPHANIE ROY

SCHNAUSS, JULIUS KARL (1827–1895)
German photographer, photo-chemist, and photographic writer

Julius Karl Schnauss was born in Weimar on 7 July 1827 to the court advocate Carl August Constantin Schnauss. Being deaf since his childhood he primarily received a private education. From 1847 to 1849 Schnauss studied physics and chemistry at the University of Jena but experimented mainly in his own laboratory. After gaining his doctorate in chemistry, Schnauss began photographing, opening a portrait studio in Jena in 1852. In the same city, he founded one of the first photographic schools in Germany, the *Photographisch-Chemische Institut* in 1855 where he taught photo-chemistry and practical photography and also sold photographic equipment. Schnauss also tried to establish photography as a discipline at the local university, but without success. In 1858 he was co-founder of the Allgemeiner Deutscher Photographen-Verein [General German Photographers' Association]; in conjunction with this initiative he became editor of the professional journal *Photographisches Archiv* [*Photographic Archive*], together with one of his pupils, Paul Eduard Liesegang. Schnauss closed his school and the studio in the midst 1860s, concentrating on his career as a writer. He published a number of popular manuals and treatises and regularly in photographic and chemical journals. Schnauss also made important contributions to photo-chemistry. He died in Jena on 6 December 1895.

STEFANIE KLAMM

SCHNEIDER, TRUTPERT (1804–1988), HEINRICH (1835–1900), AND WILHELM (1839–1921)
German daguerreotypists

Trutpert Schneider was born 13 March 1804 in Bollschweil (then Bollschweil-Kukucksbad) . Like his namesake, St. Trudpert, the seventh-century Catholic missionary who settled in Baden, he called the scenic and multi-lingual area around Freiburg his home. He was trained to be a cabinet maker by his father Mattäus Schneider, and in 1831, married Regina Locherer and established his workshop in her parents' house in Ehrenstetten. Schneider's fine woodwork and elaborate designs won him an excellent reputation and and a loyal circle of customers including the local landed gentry as well as wealthy residents of the city.

Early in 1847, an itinerate daguerreotypist named Joseph Broglie arrived in Freiburg, having lost his plate holders in transit. He was sent to Trutpert Schneider who fashioned the replacement holders to Broglie's exacting specifications. Broglie, in thanks, made a daguerreotype of the family Schneider: Trutpert, his wife Regina, and three sons, Karl (b. 22 December, 1833), Heinrich (b. 9 October 1835), and Wilhelm (b. 10 October 1839). Trutpert Schneider was instantly captivated by the daguerreotype process and assisted Broglie for a very short time, learning the methods of polishing, fuming, exposing, and developing daguerreotypes. He sketched the dimensions of the camera, the fuming and developing boxes, and all that was necessary to construct his own daguerreotype apparatus. Plying his new trade among his enthusiastic customers, Schneider began his career as a daguerreotypist, offering not only photographs, but boxes adorned with daguerreotypes.

Rather than setting up a studio, Schneider decided to follow the model of an itinerate photographer. Unlike most itinerate photographers, however, Schneider and later his sons Heinrich and Wilhelm travelled from one lucrative city location to another, stopping in the country only to photograph estates and castles, usually by invitation. By 1848, Trutpert and his middle son, the 13 year old Heinrich, had embarked on perhaps their first daguerreotyping tour. It followed a path which they would often take, through Donaueschingen, Heiligenberg and Karlsruhe. Although many of the daguerreotypes made by Schneider and his sons have been dispersed or lost, it is apparent that even in this very early stage, they were much in demand. Trutpert himself and both his sons Heinrich and Wilhelm spoke German, English, Italian, and French, and could accomodate not only tourists, but travel and work easily to the North, South, East, or West.

These small tours continued for several years, during which Trutpert Schneider refined his technique

and began to make stereo daguerreotypes, filling the demand for photographs in three dimensions. It was one of several distinctive characteristics of the Schneiders' photography that they not only made such a large quantity of stereo daguerreotypes, but that they appear to have refused to make any 'studies,' the usual title for nude and often pornographic stereo daguerreotypes. Having begun to daguerreotype at the height of the industry, Trutpert Schneider and his sons adhered to their successful medium, only occasionally making Ambrotypes, and much later, learning the wet plate and dry plate processes. Their lack of novel innovation does not appear to have injured their business or slowed the demand for their photographs.

In 1852, Trutpert and Heinrich Schneider began a much longer tour, on foot, through Switzerland, and over the mountains to the region of Lombardy, which was under Austrian control at the time. It was here that the Schneiders first met the Prince Karl von Baden, whose acquaintence would aid their later work in Russia. The sitting calendar shows that father and son travelled and photographed in Como, Brescia, Verona, Venice and Vicenza. They kept a tight schedule, moving from one place to another, but still there were times when no appointments were made, and to fill the time and his purse, Trutpert offered instruction in his own method of penmanship. In 1854, they were again on the road, this time to Vienna, where they remained a year. This pattern of travel was followed by the brothers Wilhelm and Heinrich when they succeeded their father in the business.

It may have been as late as 1856 that Wilhelm first joined his brother and father in photography. The Atelier of T. Schneider & Sons was firmly established from the year 1858 onwards, when the Schneider brothers kept an orderly record of their portrait sittings. Trutpert, who would live to very advanced age, continued actively in the partnership but more and more remained at home in Ehrenstetten while Wilhelm and Heinrich widened their circles of travel and their fame. They would establish themselves in a city for a certain time, taking rooms that would be made into a temporary and often luxurious studio, and photograph until it was time to move on to the next city. In this way, they daguerreotyped in Cologne, Frankfurt, Bonn, Hamburg and Berlin.

It was in Berlin in 1859, that Wilhelm and Heinrich plied their daguerreotyping skills to great effect, achieving a level of fame that was previously unknown to them. They photographed notables from His Majesty the Prince Regent (preparing and developing the plates in his highness's bedchamber, much to the titillation of the press) to the Lord and Lady Bloomfield. They would return to Berlin several times, documenting not only the wealthy and famous people, but the architecture as well—of which beautiful examples exist in stereo. After their success in Berlin, the Schneider brothers never

wanted for work, and indeed they earned enormous sums of money in each city they worked.

In late May 1861, the brothers arrived for their first daguerreotyping tour of Russia. St. Petersburg, still in the grip of winter, was only a short layover before they continued on to Moscow. In Moscow, they were treated like visiting dignitaries, allowed access to the royals, given transportation and an escort, and housed in the Kremlin. On this first visit, the brothers remained less than a month, returning to St. Petersburg, where they stayed a year. They returned to Moscow again in the summer of 1862, and photographed in Königsberg and northern Prussia on their way back to Berlin, returning home finally in 1863.

Although the brothers continued to travel the length and breadth of Germany for several years, they were thinking of settling back near their hometown. They finally opened a newly built photographic studio near the train station in Krozigen in 1867. Trutpert Schneider lived on until 27 December 1899, long enough to see his sons turn first to wet plate, then to dry plate photography. Wilhelm Schneider outlived Heinrich, who died only six months after their father. But when Wilhelm also died in 1921 the era of T. Schneider & Söhne came to an end.

KELLEY WILDER

Biography

Trutpert Schneider (13 March 1804–27 December 1988), and his two sons Heinrich (9 October 1835–13 May 1900), and Wilhelm (10 October 1839–21 January 1921), from near Freiburg in Breisgau, operated a daguerreotype and photographic studio from 1848–1921. For many of these years it was a travelling studio, not only within Germany, but in the neighboring lands of Austria, Italy, and Russia. They refined the art of the itinerate photographer, however, and created an event of their arrival in each city, often photographing the most famous and wealthy inhabitants. From 1859–1863 the firm enjoyed considerable success, spending a great part of the time in Berlin, Moscow and St. Petersburg. Most distinctively, the Schneider Atelier continued to make daguerreotypes and stereo daguerreotypes long after the invention of the wet plate. The daguerreotypes were often hand colored, and the stereos were famous for their plasticity. In 1867 the brothers opened their first fixed studio in Krozigen, incorporating first the wet plate and later dry plate for their photography.

See also: Daguerreotype; and Wet Collodion Positive Processes.

Further Reading

Geiges, Leif, *T. Schneider & Söhne 1847–1921. Vom Dorfschriener zum Hofphotographen*, Freiburg: Schillinger Verlag 1989.

SCHOTT, FRIEDRICH OTTO (1851–1935)
German glassmaker and chemist

Born in Witten, near Essen, Germany, Schott came from a family of glassmakers. After studying chemistry at Aachen and Wurzburg, he graduated at Leipzig in 1875 with a thesis on 'Defects in the manufacture of Window Glass.' He experimented with new types of glass, using previously unemployed elements such as lithium, boron and phosphorus. In 1879 Schott sent some samples to Ernst Abbe at the Zeiss factory in Jena. Abbe was so impressed that the pair began to collaborate and, in 1882, Schott moved his laboratory to Jena in order to continue his experiments. In 1884, Schott set up the Schott and Genossen glass factory with Abbe, Carl Zeiss and Roderich Zeiss. This glassworks specialised in new forms of optical glass, many of which were previously unknown. Their first catalogue, published in 1886, listed no fewer than forty-four different types of glass. In 1889, along with Abbe, Schott formed the Carl Zeiss Foundation. He succeeded Abbe as the foundation's manager, a post he held until 1927.

COLIN HARDING

SCHRANK, LUDWIG (1828–1905)

Ludwig Schrank was born on August 24th, 1828 in Vienna. He studied chemistry, physics, mineralogy and geology at the technical university and was in the service of the "K.K. Bergwerksprodukten Verschleiß-Direktion." Until his retirement he remained busy in government service. His interest in electroplating led him to photography. In 1854 he established a studio, in which he worked part time as a portrait photographer. After the doors of his first studio were closed, he established another studio in 1868 with Franz Xaver Massak, which was successful from 1870 to 1873. In 1861 Schrank was one of the first establishing fathers of the "Photographische Gesellschaft" Austrias first photographic association. In 1864 he and photographic dealer Oskar Kramer, established the "Photographische Correspondenz." This magazine was appointed the organ of the "Photographische Gesellschaft" a while later. Schrank remained the publisher and editor of the magazine, imtermittently during the years 1870 to 1885 up to his death. By the mid 1870s, Schrank ended his very active career as a photographer, however, he continued his publishing and editorial activity for decades. Beside numerous articles in domestic and foreign technical periodicals on topics such as practical and aesthetic topics, he also wrote a practical manual for photographers and a publication discussing copyright in photography. Schrank died on May 20th, 1905, in Vienna.

ASTRID LECHNER

SCHULTZE, JOHANN HEINRICH (1687–1744)
German chemist

Johann Heinrich Schultze, born in Colbitz, Magdeburg, was a German chemist and polymath, a Professor of Chemistry and Anatomy—and later also Greek and Arabic—at the University of Altdorf near Nuremberg. He was also one of a number of eminent chemists whose work predicted and laid the foundations for photography.

While engaged in chemical experiments in 1725 seeking to produce phosphorus, Schultze discovered that chalk—which by chance also contained traces of silver—impregnated with nitric acid, turned dark under the action of sunlight. Further investigations confirmed that it was silver nitrate—produced by a reaction between the acid and the silver—which had had that effect, and his continued experiments resulted in the creation of impermanent photograms of stencils, letters and other objects laid on the chalk.

His significant discovery was that it was light rather than heat which was creating this effect—a point picked up by his 1907 biographer Josef Maria Eder, who, with an almost apostolic zeal, declared him the true 'inventor of photography.' While Schultze recognised the purely scientific importance of his discovery and communicated his findings to the Imperial Academy at Nuremberg, he did not, however, recognise its future as the basis of an imaging system. That step would be made almost three quarters of a century later by, amongst others, Thomas Wedgwood.

Schultze died in Halle in 1744.

JOHN HANNAVY

SCIENCE
Towards the science of photography

Until the advent of today's digital age, the science of photography has predominantly been concerned with harnessing, exploiting, and controlling the effect of light upon silver salts. The science of photography, as it emerged throughout the nineteenth century, was concerned with expanding the understanding of both the physics of light and optics, and the chemistry of sensitive materials and their processing, maximizing the effect of light upon those salts. That photographic materials progressed, by 1900, from experimentation by enthusiastic individuals to mass production my multi-national companies, underlines both the importance of the medium, and its commercial value. It also stands as a testament to the commitment of the early pioneers to share information, exchange ideas, and offer innovative suggestions to move scientific understanding forward.

For practical photography's first four decades, the picture-maker was also manufacturer and chemist, seeking to produce photographs using homespun chemistry which by its lack of consistency, introduced an almost infinite range of variables. Yet in so doing, the great photographers of the mid-Victorian era overcame major difficulties, and applied their limited technical and chemical understanding to the production some of the medium's most beautiful and enduring images.

In seconding the motion "That a Society now be established to be called 'The Photographic Society'" at the Photograph Society of London's inaugural meeting on 20th January 1853, Robert Hunt accurately summarized the importance of a forum for the exchange of scientific knowledge in the development of photography. His comments were reproduced in the first issue of the *Journal of the Photographic Society*:

> Mr Hunt, in seconding the motion, dwelt at some length on the importance and even the necessity of a Society to ensure the future progress of photography. He considered such an Association of practical men would be the best and most efficient mode of publishing and comparing the results of their numerous mutual trials, and pave the way for new discoveries. However rapid and satisfactory may have been the improvements in this science, much yet remained to be done. Reference was made to several phenomena, hitherto unexplained and still obscure, attendant on the results of photographic operations; for instance, it is known that the prepared paper is not acted upon by the yellow rays, while these rays do act upon glass prepared with collodion.

Hunt's account, while correctly identifying that the science of photography was, as yet, in its infancy, underlined that lack of understanding by incorrectly suggesting that the wet collodion plate had some sensitivity to yellow. Yellow sensitivity would, in fact, not be achieved until the early years of the 20th century when the introduction of dye sensitizers finally made a truly panchromatic emulsion possible. What Hunt was probably observing was limited green sensitivity manifesting itself as fogging under an imperfect yellow glass in the darkroom.

If the experiments of Thomas Wedgwood between 1795 and 1802 are taken as a starting point, photography, at the time Hunt was writing, was already more than half a century old—yet an understanding of the underpinning science was only in the very earliest stage of emergence. Wedgwood's inability to fix his pioneering images is often cited as an early example of poor photographic research—given that the ability of a range of chemicals to arrest the darkening effect of sunlight on silver salts had been identified by Carl Wilhelm Scheele and others much earlier. So, from photography's earliest days, an organized dissemination of relevant scientific knowledge would have been beneficial.

Robert Hunt was, himself, one of the leading figures in the advancement of the science of photography. His *Popular Treatise on the Art of Photography* had first been published in 1841, and he had completed work on the third edition of his *Manual of Photography*, first published in 1851, by the time of the Photographic Society's inaugural meeting.

The early years of photography were punctuated by a number of radically different approaches—independent inventors pursuing their shared goal by seeking to exploit fundamentally different chemistries.

Wedgwood and Davy opened the century with their experiments—reported in June 1802 in the *Journal of the Royal Institution* and later recounted by Henry Snelling in his groundbreaking 1849 book, *The History and Practice of the Art of Photography* (New York: G.P.Putnam, reprinted New York: Morgan & Morgan 1970).

> A piece of paper, or other convenient material, was placed upon a frame and sponged over with a solution of nitrate of silver; it was then placed behind a painting on glass and the light traversing the painting produced a kind of copy upon the prepared paper, those parts in which the rays were least intercepted being of the darkest hues. Here, however, terminated the experiment; for although both Mr. Wedgwood and Sir Humphrey Davey (sic!) experimented carefully, for the purpose of endeavoring to fix the drawings thus obtained, yet the object could not be accomplished, and the whole ended in failure.

While that report mentions that Wedgwood and Davy experimented with several different materials on which to brush their chemistry, only paper is specifically cited. Their other experimental surfaces included leather, and they noted that

> White paper, or white leather, moistened with solution of nitrate of silver, undergoes no change when kept in a dark place; but, on being exposed to the day light, it speedily changes colour, and, after passing through different shades of grey and brown, becomes at length nearly black ...

and indeed their experiments proved markedly more effective with leather than with paper, due in part to chemicals contained within the tanned leather about which they knew nothing at the time. It would be a further thirty years before William Henry Fox Talbot demonstrated the practical application of their ideas, by recognizing the initial production of a 'negative proof' from which a 'positive proof' could be made by contact.

In 1816, Joseph Nicéphore Niépce, experimenting with silver chloride, got no further than had Wedgwood and Davy, again due to an inability to arrest the darkening effect of light. He too got within touching distance of producing the first photographic negative. Silver nitrate—the chemical Niépce abandoned—would later play a crucial role in the evolution of photographic materials. A decade later he turned his attention to a range of

chemicals which were physically hardened by the action of light and so, eschewing silver salts about which so much was already known in favour of bitumen of Judea, coated on to a sheet of glass, hardened by long exposure to light, and the unhardened areas then dissolved with oil of lavender. By 1826 he had moved to a pewter base and had announced his findings and produced what survives as the world's oldest photographic image.

By 1828 he had migrated from pewter to the silvered copper plate which would later become the base of the daguerreotype, and had returned to exploring the effect of light on silver salts—in this case silver iodide. Niepce's process, however, used iodine to darken the areas of silver where the bitumen had not been hardened by the action of light.

The daguerreotype evolved directly from the collaboration between Niépce and Daguerre, and after Niépce's death in 1833, between Daguerre and Isidore Niépce. Since Isidore's first attempts in 1840, many in the history of photography have sought to clarify the importance of Joseph Nicéphore Niépce's role in the evolution of the process which would help make photographic portraiture ubiquitous.

While the daguerreotype bears the Frenchman's name, the process which achieved such worldwide popularity progressed well beyond its inventor's achievements. The science of the daguerreotype was advanced significantly by many practitioners and scientists. Experiments by Antoine Claudet, for example, increased the sensitivity of the plate considerably, while arguably the most significant advance was John Frederick Goddard's discovery of the accelerating effect of employing bromine—reducing exposures for portraiture from the impractical to the practical. Despite the significance of his discovery, Goddard did not profit from his scientific breakthrough, and unlike Daguerre who received a French government pension, Goddard lapsed into poverty, saved only by a public appeal—promoted by John Werge and Jabez Hughes—which raised enough money to sustain him into old age.

In the 1840s, scientific innovation had no commercial value without the protection of a patent, and Goddard had not sought such protection, although arguably it was his innovation which ensured the daguerreotype's long popularity.

In a series of parallel developments, Talbot's experiments had taken him first to photogenic drawing and then to the calotype, establishing the negative/positive process as the ideal foundation for the development of photography as a low-cost and easily duplicated medium. Talbot's chemistry was simple, but by the early 1850s, albumen-on-glass, waxed paper and wet collodion had all brought both new refinement to the production of the negative, and a widening range of chemicals being used.

There was often little understanding of the role of each additional chemical—just a belief that adding them improved the reliability of the negative medium, and the consistency of the results.

Thus, in the first issue of the *Journal of the Photographic Society* for 1854, Washington Teasdale from Leeds published a comparison chart showing the differences and similarities between eight different versions of le Gray's Waxed paper process. The chart demonstrated the huge variations between the strengths of the chemicals employed by the process's main proponents—including Vicomte Vigier, Sir William Crookes, Roger Fenton, and le Gray himself. Teasdale's table and accompanying notes showed there was huge variation in the chemical composition and chemical strength of the different versions, the recipes ranging from a single chemical—potassium iodide on its own—in Crookes' version, to eight in Teasdale's, while the iodide in Fenton's published account was three times the strength of le Gray's original formulation. Such variations go a long way towards explaining why some users found le Gray's process unreliable and slow while others found Fenton's to be almost assured of success.

Variations in the chemistry of the waxed paper process was by no means unique. Every process had its advocates and its critics. With Frederick Scott Archer's wet collodion process, there were ultimately almost as many versions as there were users! As long as the manufacturing of the negative material was in the hands of the user, such wide variation in formulae was inevitable, as was the vigorous support each user gave to his 'improvement.'

In addition to claims about the performance of individual chemicals, there was often significant debate over who had prior claim to a particular process. Niépce's claim in France for a share of Daguerre's fame was mirrored in Britain by the Rev J. B. Reade's claim for priority over Talbot in the invention of the paper negative. At the time of Frederick Scott Archer's publication of the wet collodion process, Gustave le Gray, himself the inventor of the waxed paper process, claimed to have proposed—and used—a wet collodion process at least a year before Archer. (Like Goddard, Archer's generosity in seeking no financial reward for his process left him penniless, and after his untimely death in 1857 a fund had to be established to raise money for his widow.) Talbot, for good measure, claimed his patents gave him control over any process in which a negative was created from which prints could be made.

By the mid-1850s, however, photographic science entered a period of calm, with most patents being allowed to lapse, and the photographic community showing increasing altruism in sharing ideas and experience.

Many photographers soon appreciated the need for a measure of consistency in their chemistry, and

initiated self-imposed quality control and testing in their manufacture. In the 1850s, after preparing a new batch of waxed paper negative papers, the British photographer Samuel Smith, of Wisbech, Cambridgeshire, for example, would use the front of his house as a test subject to determine the sensitivity of the new material, and thus the exposure required. Collodion users would go through a similar routine to test the rapidity of each new mix of chemicals.

Despite the primitive chemistry and unsophisticated technology of the day, the quality of surviving imagery from the mid-Victorian period is a testament to the skill of the early photographers, despite the lack of sound scientific underpinning.

However, a widespread lack of understanding of the relationship between the colour temperature of the exposing light source, the spectral sensitivity of the emulsion, the exposure given to the negative, and the processing to which it was subsequently subjected, resulted in a range of visual phenomena in the negatives and resulting prints for which photographers had no ready explanation.

In the absence of simple measuring devices which would aid the estimation of accurate exposure, development was, invariably, continued 'until the image was brought out fully,' however long that might take.

An appreciation of the importance of consistent developer temperature, did not gain widespread acceptance until the end of the century. Despite recognition in the 1860s that the activity of the developer changed with the seasons, no connection was made between that and the importance of temperature consistency. Instead, it was suggested (Towler 1864) that a stronger developer was needed in the winter than in the summer, and that a more acidic developer was preferable in the summer, as the acid slowed the developer action down.

The combination of lower actinic values in winter daylight—causing under-exposure—and cold and under-active developers, resulted in many negatives which required considerably extended development until a printable density was achieved. This introduced increased fog levels, significant loss of shadow detail, and a loss of the subtle tonality which those same photographers could produce in summer.

Perhaps surprisingly, failure to recognize the cause of the problem persisted into the closing years of the century with Wall (1897) noting that 'speaking very generally, it may perhaps be estimated that development takes about twice as long in winter as in summer." Wall did, however, observe correctly that "under-exposure should always be avoided, as with these plates or films a considerable amount of over-exposure can be controlled in development, but if the light has not acted sufficiently on the plate no process of development can possibly make a good negative of it." In Wall's 1897 dictionary,

he devoted several pages to 'Thermometers and Thermometry,' but included nothing of their application to photographic processing! The chemical composition of the developer, its strength and its rate of activity were all issues about which individual practitioners held strong views.

In many instances, good science emerged from heated debates between practitioners with opposing points of view, conducted in the meetings of photographic societies and literary and philosophical societies, or in the pages of the emerging photographic press. Often deteriorating into very personal attacks, these very public spats helped to progress scientific understanding, with the protagonists returning to their experiments to test and re-test their theories. The gentleman scientist—the enthusiastic amateur—seemed willing to endure the opprobrium of his peers in the cause of defending his point of view. There was little tangible benefit to the protagonists, except by being proved correct, but their perseverance eventually led to significant progress and enhanced understanding.

It was only with the advent of industrialization in the manufacture of photographic materials that good science acquired a commercial value. Once the manufacture of emulsions and materials moved from kitchen-sink to manufactory, consistency and reliability assumed a greater importance.

Amongst the first to produce ready-to-use gelatin-bromide dry plates were Wratten & Wainwright in London. Along with several other manufacturers, their 'repaid' dry plates went on sale in the late 1870s, and were initially met with 'scepticism and conservatism by the most eminent photographers' used to preparing their own materials from start to finish (Werge 1890). Initial reluctance, on the part of photographers, to abdicate their responsibility for emulsion preparation and coating to industrial concerns, was only overcome when those emerging manufacturers could demonstrate that their products offered benefits which the homemade preparations could not. Those benefits—initially more promised than actual—only really came to be understood and appreciated once the many chemical and physical components of photography were recognized as a single system rather than a number of disparate and unrelated elements.

Key to persuading professional users of the benefits of pre-coated plates was the introduction of scientific control over emulsion preparation, and the design of coating machines to ensure batch-to-batch consistency. Manufacturers such as Cadett & Neal, Marion & Company, and others, quickly recognized the commercial value of emphasizing the high quality of their materials and the consistency of results which their careful use brought to the user.

In working towards an understanding of the holistic

nature of the photographic process, the pioneering work of Ferdinand Hurter and Vero C. Driffield in England was pivotal. Their work on the relationship between development rate and temperature led them to recommend that 65°F be adopted as the optimum standard, thus removing, at a stroke, the idea that development time should be extended in cold weather. Intriguingly, their recommendation was published in the journal *Photography* in 1893, four years before Wall's *Dictionary of Photography* perpetuated the idea of doubling time in winter!

But Hurter and Driffield's most significant and enduring contribution was the recognition that photography needed to be considered as a *system* where each component and each action was interdependent—that a deviation in any one aspect had an impact on the character of the final negative. While their proposal was not widely accepted or understood at the time, the various suggestions they made about standardisation, consistency, accuracy and repeatability established the foundation not only for the science of sensitometry, but also for a much wider appreciation of the physical and chemical inter-relationships upon which photography depends.

Their H&D speed system, based on the placing of the full tonal range of the subject on the straight line portion of the *characteristic curve*, came at the same time as a range of devices for estimating the actinic value of the illuminating light source. Thus, as the century came to a close, improved consistency in plate manufacture, coupled with reasonably accurate estimation of exposure and accurate processing, took photography into a whole new realm of consistency.

A number of actinometers were on the market by the 1890s, most using albumen printing-out-paper, and basing exposure on the time taken for the paper to darken to a pre-determined tone. The importance of such instruments as Green and Fuidge's Actinometer, Wynne's Exposure Meter, Watkins' Exposure Meter, and similar devices by Reid, Stanley, and Watt, cannot be underestimated—despite the fact that they used a blue-sensitive printing-out-paper to estimate the exposure required for orthochromatic emulsions—a problem noted by Werge without explanation.

The introduction of the Kodak camera in the late 1880s marked the birth of modern photography—with, for the first time, the science of manufacture and processing effectively separated from the art of photographic picture-making.

JOHN HANNAVY

See also: British Journal of Photography; Scheele, Carl Wilhelm; Hunt, Robert; Royal Photographic Society; Wedgwood, Thomas; Davy, Sir Humphrey; Daguerre, Louis-Jacques-Mandé;, Niépce, Joseph Nicéphore; Talbot, William Henry Fox; Hurter, Ferdinand, and Driffield, Vero Charles; Abney, William de Wiveleslie; and Wratten, Frederick Charles Luther.

Further Reading

Brayer, Elizabeth, *George Eastman—a Biography*, Baltimore & London: John Hopkins University Press, 1996.

Ferguson, W. B. (ed.), *The Photographic Researches of Ferdinand Hurter & Vero C. Driffield*, London: Royal Photographic Society, 1920 (reprinted New York: Morgan & Morgan, 1974).

Snelling, Henry H, *The History and Handbook of the Art of Photography*, New York: G.P.Putnam, 1849, reprinted New York: Morgan & Morgan 1970.

Towler, J., *The Silver Sunbeam*, New York: Joseph H. Ladd, 1864 (reprinted Morgan & Morgan, 1969).

Wall, E. J. *The Dictionary of Photography*, London: Hazell, Watson & Viney Ltd, 1897,

SCIENTIFIC PHOTOGRAPHY

"Magnificent," declared *The Photographic News*, referring to Professor Owen's opening address to the British Association in 1858:

> Photography is now a constant and indispensable servant in certain meteorological records. Applied periodically to living plants, photography supplies the botanist with the easiest and best data for judging of their rate of growth. It gives to the zoologist accurate representations of the most complex of his subjects, and their organisation, even to microscopic details. The engineer at home can ascertain …the most complex works on the Indian or other remote railroads. The physician can register every physiognomic phase accompanying the access, the height, decrease, and passing away of mental disease.

The speaker had been very prescient and within a few years, other writers echoed his words. In 1860, F.F. Statham referred to "the handmaid of the sciences," and four years later, a reviewer described photography as "the child of science," emphasising the freedom from fallibility in observations. Praise continued because of photography's ability to preserve a faithful image. "The sensitive photographic film is the true retina of the scientist," declared the eminent French astronomer, P.J.C. Janssen at a meeting of the Société Française de la Photographie in June 1888. The potential of photography to the scientific disciplines had been present from the beginning. In 1839, William Henry Fox Talbot had anticipated future developments by challenging his "photogenic drawing" to capture the image within his solar microscope. Many other investigators soon exploited the advantages of photography, and their research benefited from sharing reliable results with other practitioners.

In France, the daguerreotype process was also used with the microscope and, in spite of the lack of rapidity in the plate, Alfred Donné obtained satisfactory images

for demonstration to the Academy of Sciences in 1840. His philosophy was summarised: "… we shall let Nature reproduce herself … with all her details and infinite nuances." The poor response of his plate to daylight, however, prompted him to develop alternative lighting forms, and he successfully adapted the oxy-hydrogen torch as a light source for his microscope. By 1845, Donné and Léon Foucault had published an illustrated atlas of histological photomicrographs intended for teaching—"it is so to speak the object itself which will be placed before the eyes and in the hands of the audience."

There was no formalised programme for developing photography as a tool of the sciences. Whilst others accepted photography as an art form, the scientific practitioners welcomed photography as an aid to their work, and used it in different ways. Some realised that emulsion sensitivity extended beyond the boundaries of human vision and that it was possible, for example, to probe the night sky and secure ocular proof of their observations. At times, it was possible to dispense with lenses and optics, but instead, to build equipment designed to "write" direct to sensitive plates. At an early stage, analyses of solar and other spectra benefited by having images for comparison with other versions.

Practitioners in medicine, natural history and crime recognised the potential for creating standardised records, records that provided an image, which was adequate to serve as the original. Botanists were prompt to recognise the advantages over drawing, and when Anna Atkins made cyanotypes in 1843, she overcame difficulties "in the interest of the botanical value." Robert Hunt declared, "Specimens may be copied with a fidelity which cannot by any other means be obtained." At Surrey County Asylum Hugh W Diamond believed photographic evidence of his suffering patients would contribute to improvements in treatment. Staff at London Zoological Gardens undertook to compile a catalogue of "type specimens" from the animals in their collection and in 1871, unwittingly created a photograph of the last surviving quagga. Police services recognised the merits of "the rogues gallery" when a police sergeant from Bristol was able to identify "a hardened offender" in Birmingham.

Other disciplines of a scientific nature also annexed photographic techniques for recording aspects of their pioneering work. Liberated from free-hand drawing, archaeologists utilised photographic prints in lectures, in exhibitions and in publications. Space saving was welcomed by travellers. Prior to the use of photography, expeditions had relied on casting plaster images of the faces of native tribes. Photographic prints would serve ethnology just as well, stated *The Photographic News*. On any Arctic voyage, space was at a premium, but the merits of securing permanent records of the explorations were seldom overlooked, in spite of the hardships to be endured by the photographic officer, who was obligated to work in difficult conditions.

In astronomy, photographic recording became such an asset, that many of the astronomers made important contributions to photographic science. Janssen advised on good laboratory practice for photographing with the telescope, and valued photography—"[it] gives us today images of the sun in such perfection that they permit us to employ them in work of the greatest precision." For twenty years, he had cherished a belief that "a photograph … offers for purposes of measurement and examination such previous details that they surpass in value the observations of the most skilful astronomer."

At the observatory in Bonn in 1894, the first assistant, Dr. Julius Scheiner, devised a sensitometer for establishing reliable plate speeds for his photographic exposures, which subsequently evolved as the Scheiner speed system. Regular adjustments to equipment and techniques sometimes revealed the need for improvements to sensitised materials. For example, in 1884, Josef Marie Eder proposed a formula for orthochromatic plates, colour-corrected to improve rendition of yellow-greens. Early in the twentieth century, further improvements delivered the panchromatic emulsion.

The single astronomical record was valuable, but photography was a tool that could be applied to a constructive purpose. In 1882, some observers agreed to document stellar positions, but by 1891, eighteen worldwide observatories were working in co-operation to assemble a comprehensive dossier of the night sky. Such was the authority of the assemblage that the undertaking was not repeated until 1949. Similarly, in medicine, the compilation of an "atlas" of conditions often provided confidence to diagnostic procedures.

The applications of photography multiplied for two reasons. It provided results in a permanent form, and some techniques could be adapted to reveal data that were otherwise undetectable. Talbot's use of the solar microscope in 1839 had been successful, but within three years, he was demonstrating polarising microscopy, and showing its potential for crystallographic studies. In combining his enthusiasm for pictorial photography with his studies in crystallography (1853), Sir William Crookes admitted his motive had been to "retain in a more tangible form the well-known beautiful figures observed…" (That is, the distinctive ring structures that permitted identification of crystals.) However, Crookes' results provided a welcome surprise; his photographic plate revealed more than four times what he had expected from his visual observations, which, in turn, initiated further enquiries within the scientific community, and the evolution of standardised techniques.

The possibility of recording beyond the limits of the human eye was considered possible. Sir John Herschel had succeeded in identifying infrared radiation

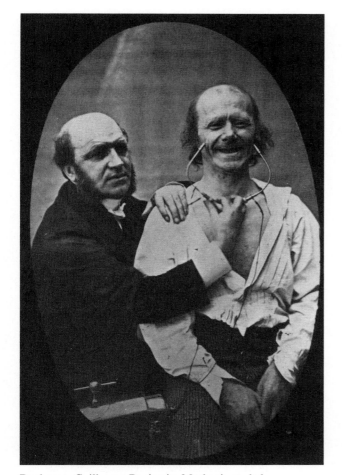

Duchenne, Guillaume-Benjamin. Mechanisme de la Physionomie Humaine ou Analyse Electro-Physiologique de *l'Expression des Passions.*
The J. Paul Getty Museum, Los Angeles © The J. Paul Getty Museum.

by observing temperature change, and he forecast the likelihood of detecting energy in the "lavender" region of the spectrum (i.e., ultra violet radiation.). When the ultra violet spectrum was eventually recorded in 1864, it was the precursor for twentieth-century studies in atomic structure ... and later, in 1935, ultra violet radiation was supplanted by the electron beam and a new style of microscopy evolved.

In 1851, Talbot demonstrated "an instantaneous photogenic image" to the members of the Royal Institution by exposing a page of *The Times* (which was fastened to a rotating drum) to the light from an electric spark. The relationship between photography and time now developed in different ways. High-speed photography had its derivation in the pistol camera of Thomas Skaife who made modifications that allowed him to capture what he termed the "epochs of time, inappreciable to our natural unaided organ of vision ..."

Advances to the dry plate fulfilled the specification for recording shock waves. In 1888, Ernst Mach adapted August Töpler's schlieren layout and succeeded

in preserving the distinctive patterns of currents that surrounded a bullet in flight. In 1893, CV Boys was engaged in studies intended to demonstrate the effects of a projectile (bullets) striking different materials, such as glass and metal. Photography was now providing a range of ideas on which to base experiments, to record sequences, and to compare results, all with certainty and confidence.

Photography offered other ways of capturing time. Experiments, which preceded the development of cinematography, exploited the ability to capture movement, and Eadweard Muybridge used photography when he set up a series of cameras in 1872 to study the motion of a horse. Success encouraged him to reduce exposure times and thus eliminate blur, by improving his chemistry and equipment. By 1878, he had secured sequences of horses walking, trotting, and galloping, men running and leaping, women dancing, doves in flight, water splashing and sufficient experience to synthesise his multiple images into an apparent single moving picture.

In France, Etienne Jules Marey, a physiologist, improved the idea and designed cameras for recording sequences on a single plate. His "chronophotography" was applied to many motion studies—locomotion, aerodynamics, vibration, blood circulation and heartbeats. When the Englishmen, William Frieze Greene, modified a magic lantern around 1886, he introduced a rotating shutter and four lenses to capture images, which gave the impression of movement.

Subsequent improvements to emulsions, to lighting and to timing equipment provided the basis of scientific techniques that continued into the heart of the next century, but some nineteenth-century investigators struck out in a different direction. They had realised the merits of using sensitised photographic material as a "self-recording" method, which would automatically indicate changes to the quality of light and other phenomena. Captain William de Wiveleslie Abney equipped a "sunshine recorder" with a discrete hole through which sunlight smeared its image on slowly-moving piece sensitive paper. To analyse the quality of daylight, Vero Charles Driffield modified the actinometer patented by his colleague, Dr. Ferdinand Hurter, and collected "daily diagrams of light" for twelve months during 1885 and 1886. From the mass of data, now accumulated on bromide paper, the two men designed the Actinograph exposure calculator.

Anxious to explore the solar spectrum (and improve the characteristics of dry plates for solar photography), Abney registered evidence of infrared radiation by directing sunshine, *via* the spectroscope, onto his photographic plate (1880). He had been confident "there are some faint rays which lie below the limit of the red." Eventually (1930), special plates were sensitised for infrared photography.

The x-ray, possessing unusual properties but detectable on conventional plates, was discovered by Wilhelm Röntgen in 1895. Working with a luminescent screen and a cathode ray tube, the hitherto unrecognised rays revealed themselves "by making darkness visible," when Röntgen placed his hand in the ray's path and revealed the internal bone structure. X-ray techniques opened the way to non-invasive probing of the soft tissues of the human body, teeth, fractured limbs, Egyptian mummies, precious stones, machinery and metal castings. The applications in medicine alone prompted *The Lancet* (1896) to describe the technique as "the searchlight of photography." It was seen as "photography of the invisible." Relishing the chance to photograph the invisible, Josef Maria Eder teamed up with Eduard Valenta in 1896 to produce a series of radiographic studies, that were acclaimed for their artistic content as much as the scientific disclosures.

Once the value of x-radiography was accepted, progress was swift. Exposures of quarter an hour were reduced to a few minutes and the nineteenth-century pioneering efforts contributed substantially to the twentieth-century techniques of ultra-sound, pulse echo recording, and tomography based on positron emission. Radiotracers were employed on cadavers in 1896 but by 1927, the technique of angiography had become an *in vivo* procedure. The first autoradiograph emerged in 1904, and in 1912, x-rays were used to produce diffraction patterns of crystals.

Not all the applications of photography were successful and many ideas for taking advantage of photography either failed to materialise, or did not fulfil the requirement. In a review of progress in 1888, Dr. C.H. Bothamley deplored the lack of "scientific method." His thesis was that few people had the ability to plan satisfactory experiments, and some research failed to establish "the existence of a given set of phenomena." In his opinion, investigators sometimes drew incorrect conclusions from their data, and Bothamley criticised results that did not distinguish between "that which is actually established and that which is only rendered probable or possible." His remedy was "systematic and somewhat severe training."

He recommended the photographic literature of the day, and accepted "progress must necessarily be slow until a better knowledge of the art of experiment ... become more widely diffused...." The journals fulfilled their responsibility by publishing papers from the universities, academies and institutes in Europe and America. Just as important were the abstracts and reprinted texts from overseas journals, such as *La Nature* (France), the *Bulletin de la Société Françoise de Photographie, the American Journal of Photography,* and the *Philadelphia Photographer* (USA). *The Photographic News* included regular features from correspondents in Germany and France, and *The British Journal of Photography* maintained a column of continental notes and news.

Photography made satisfactory contributions to nineteenth-century science for three reasons:

- It was welcomed as a means of securing reliable proof that had a degree of permanence and could be distributed among colleagues
- It documented phenomena and scientific events in ways that replaced the need for human observations
- It could be allied to existing optical equipment, and could be incorporated in the design of new apparatus.

In making use of photography for constructive purposes, progress was never in doubt and a secure nineteenth-century foundation provided confidence for twentieth-century investigators, who then achieved advances as new materials, methods and techniques were introduced.

RON CALLENDER

See also: Société Française de la Photographie; Talbot, William Henry Fox; and Muybridge, Eadweard.

Further Reading

Abney, W. de W., "On Photographic Operations in the Recent Arctic Expedition." *The Photographic News*, XX, 614, (1876).

Darius, J, (1984), *Beyond Vision*, Oxford: Oxford University Press.

Hunt, R., "Photography Considered in Relation to its Educational and Practical Value." *The Photographic News, I*, 242, (1859).

Jones, B.E., (ed.), (1974), *Encyclopedia of Photography*, (reprint of 1911 edit.), New York: Arno Press.

Janssen, M. J., "Photography and Astronomy." *The Photographic News*, XX, 614, (1876).

"Photography in and out of the studio." *The Photographic News*, XX, 529, (1876).

The British Association for the Advancement of Science, *The Photographic News* I (8th October 1858).

Thomas, A. (ed.), (1997), *Beauty of Another Order*, New Haven & London: Yale University Press.

SCOVILL & ADAMS
Photographic apparatus and supply firm

Scovill & Adams, a photographic apparatus and supply firm, succeeded the photographic division of the Scovill Manufacturing Company in 1889 with Washington Irving Adams (1832–1896) serving as President, Treasurer, and Secretary. The firm, which evolved from a company with a diverse history, originated as a gristmill on the Mad River in Waterbury, Connecticut in 1680. The mill, converted in the early 19th century to the gilt and brass button manufactory of Abel Porter & Co., was purchased by James Mitchell Lamson

Scovill (1789–1857), Frederick Leavenworth, and David Hayden in 1811. In 1827, Hayden and Leavenworth retired and James's younger brother, merchant William Henry Scovill (1796–1854), purchased the men's interest in what had become one of the two most prominent button factories in the country. Under the brothers' leadership, the firm, renamed J.M.L. & W. H. Scovill, grew in success and divisions, including an expanding auxiliary business of rolled brass and plated metal.

In 1842, J.M.L and W.H. Scovill became the first and largest manufacturer of daguerreotype plates in the United States after perfecting a plate that was flat and of a better quality than the popular French imports. According to the company papers at Harvard University, the company supplied such prominent daguerreians as Samuel Broadbent, Jeremiah Gurney, and A. Southworth & Co. To remain competitive over the next decade, the company expanded their photographic products line to include gilded metal mats, preservers, and cases. The New York City salesroom established in 1846 made over $60,000 a year in sales on mats and preservers alone. By 1851, the firm was advertised as a dealer of daguerreotype materials and promoted such novelties as a folding case for family portraiture and a case for sepulchral daguerreotypes.

In 1850, all the company interests, including the photographic division, were incorporated under the Scovill Manufacturing Company, which continued to grow in market outlets, production plants, and profits. In 1851, company agent Samuel Holmes established Western markets as far away as California. In 1857, the firm bought the factory of S. Peck & Co. in New Haven, Connecticut, which produced plastic photograph cases and camera parts, and in 1867 acquired the American Optical Co., a manufacturer of cameras and other photographic apparatus in New York. By 1873, company growth had led to the establishment of a branch of the photographic division in Birmingham, England and the completion of a new warehouse in New York City at 419–421 Broome Street containing offices, salesrooms, storage, and a darkroom for customers. By 1874, the profits of the photography division totaled over $1,000,000.

In 1868, Frederick J. Kingsbury accepted control of the company following the deaths of the Scovill brothers and the retirement of Scovill Buckingham, the Scovills' nephew. Under Kingsbury's administration, the photographic division of the firm prospered through the ingenuity of company upstart Washington Irving Adams. Adams, a former daguerreotypist, entered the employ of the Scovill Manufacturing Company as an entry clerk in 1858 and quickly acquired increasingly influential roles and responsibilities. Between 1870 and 1871 Adams assumed the leadership of the American Optical Co. and founded the company periodical, *Pho-*

tographic Times. In 1875, Adams became president of the S. Peck & Co. and in 1878 became the company agent in charge of the New York business. Adams also served as the first Vice-President of the Centennial Photographic Company and was a Chairman of the Executive Committee of the National Photographic Association.

Throughout the 1870s and 1880s, under Adams's guidance during the peak of a rivalry with E. & H.T. Anthony & Co., Scovill's interest in the photographic market diversified even further. In the early 1870s, prolific advertisements in the company periodical and the *Philadelphia Photographer* promoted apparatus and materials for every aspect of photography, including tripods, lanterns, developers, rollers, trays, negative frames, and studio props. The company also introduced the Scovill Photographic Series of training manuals. With the introduction of a multiplying camera in 1878, Scovill became synonymous with cameras as well. The company's cornering of the market in competition with Anthony & Co. progressed even further when around 1881 Scovill became the sole distributor of Carbutt dry plates, a move that signaled Adams's business savvy in anticipating the growing amateur market. Consequently, in 1882 the Scovill Manufacturing Company began advertising cheap amateur outfits that included camera, dry plate holder, tripod, and lens. In 1885, the Waterbury view camera was introduced as a part of the profusely advertised outfits and quickly became an American classic. During this time, the company also displayed its photographic equipment at several exhibits, including annual exhibitions of the National Photographic Association and the Photographic Association of America as well as the Centennial Exhibition of 1876, where the company received an award for photographic apparatus.

Given the success of the photographic department and following George Eastman's 1887 rejection of a Scovill offer to consolidate photographic businesses, Scovill Manufacturing Co., opted to form an independent firm, Scovill & Adams, which manufactured, sold, and acted as agents for photographic equipment and supplies. With the creation of the new firm in 1889, Scovill & Adams became a leading innovator in camera design and earned several patents related to camera construction. Between 1891 and 1898, the company introduced the Henry Clay folding camera, one of the first self-casing, folding bellows cameras; the Solograph folding plate camera; a spy camera; and a panoramic camera equipped with a swinging lens. The new firm continued to publish the *Photographic Times* and the renamed Scovill & Adams Photographic Series of training manuals. It also remained a leading supplier of photographic equipment and apparatus nationally and internationally, including Central and South America.

Adams ran Scovill & Adams until his death in 1896, whereupon his son Washington Irving Lincoln Adams, editor of *Photographic Times*, assumed operation of the company. Under the younger Adams, the firm entered into the manufacturing of roll film in 1899.

On December 23, 1901, Scovill & Adams and their main competitor of fifty years, E. &H.T. Anthony & Co., merged and formed Scovill & Anthony with a joint capital stock worth $2,500,000. In 1902, the firm relocated principal operations to Binghamton, New York, and, in 1907, changed its name to Ansco. In 1928, Ansco merged with the film company Agfa, and the new company focused on the manufacture of film. In 1939, General Aniline & Film Corp, known as GAF, merged with Agfa-Ansco and the company, later renamed Anitec, continued operation until 1998.

ERIKA PIOLA

See also: Camera Accessories; Camera Design: 5 Portable Hand Cameras (1880–1900); Carbutt, John; Daguerreotype; Dry Plate Negatives: Gelatine; and Eastman, George.

Further Reading

"A Tribute to the Memory of Washington Irving Adams." *Wilson's Photographic Magazine*, (February 1896) 63–72.
"James Mitchell Lamson Scovill," In *History of Waterbury and the Naugatuck Valley Connecticut*, edited by William. J. Pape, vol. 2, New York: S.J. Clarke Publishing Company, 1918.
Marder, William, *Anthony, the Man, the Company, the Cameras: An American Photographic Pioneer: 140 Year History of a Company form Anthony to Ansco, to GAF*, Plantation, FL: Pine Ridge Pub. Co., 1982.
"Our Founder Gone." *The Photographic Times*, February 1896, 65–66.
Scovill Brass. Buttons, Cameras, and Cartridge Cases. Westport, CT: Historical Perspectives, 1997
Scovill Manufacturing Company. *Scovill Manufacturing Co.* (s.l., s.n., n.d.)
"The Scovill & Adams Company." *Wilson's Photographic Magazine* (February 1889): 97–98.
"William Henry Scovill." In *History of Waterbury and the Naugatuck Valley Connecticut*, edited by William. J. Pape, vol. 2, New York: S.J. Clarke Publishing Company, 1918.
Rinhart, Floyd, and Marion Rinhart, *The American Daguerreotype*, Athens: The University of Georgia Press, 1981.

SCOWEN, CHARLES T. (active 1873–1890)
English, photographer and publisher, active in Ceylon

Charles Scowen arrived in Kandy, Ceylon (Sri Lanka) in early 1873. He worked as a clerk for some period of time but by 1876 he had opened a photographic studio. In 1885, the firm which bore his name, Scowen & Co. had studios in Kandy and Colombo. Scowen & Co. of-fered an extensive catalogue of sensitively photographed studies of native people, as well as the antiquities and landscapes of Ceylon. During its existence, there appear to have been several Scowens involved in the operation of the studio—Charles T. Scowen returned to England in 1885, and C. Scowen was listed as proprietor until 1891, M. Scowen was proprietor in 1893 when the firm changed hands and the companies stock, including negatives, was taken over by the Colombo Apothecaries Co. Photographs credited to Scowen & Co were used as illustrations in a number of books about Ceylon and the tea trade.

KATHLEEN HOWE

SEARS, SARAH CHOATE (1858–1935)
American photographer and painter

Sarah Choate Sears was born in Cambridge, Massachusetts, in 1858 to Elizabeth Carlisle and Charles Francis Choate, a lawyer. In 1877, she married the wealthy real estate magnate Joshua Montgomery Sears and became a prominent member of Boston Society. She studied painting at the Cowles Art School and the Museum of Fine Arts School in Boston during the 1870s. She began to receive recognition for her watercolors by the 1890s. In the next decade she turned her attention to photography, producing portraits and still lifes in the pictorialist style. She became active in promoting photography as an aesthetic medium along with Frederick Holland Day and was influential in ensuring photography's inclusion in Boston's Society of Arts and Crafts inaugural show in 1897. She was granted a solo exhibition at the Boston Camera Club in 1899. She was also a member of the British pictorialist association, the Linked Ring and the Photo-Secession. After her husband's death in 1905, she abandoned her work as an artistic photographer and dedicated herself to collecting contemporary art and supporting the work of other photographers, particularly the photographers of the Photo-Secession. She died in West Gouldsboro, Maine, in 1935.

ANDREA KORDA

SEBAH, JOHANNES (JEAN) PASCAL (1823–1886) AND JOAILLIER, POLICARPE (1872–1947)

The Constantinople-based photographic studio Sebah & Joaillier—formed from a partnership between Johannes (Jean) Pascal Sebah and Policarpe Joaillier which dates only from 1890, but from its establishment, took over the marketing of the catalogue of fine images produced in Turkey and Egypt by Pascal Sebah. Sebah operated a studio in Constantinople from the 1860s, and also worked in Egypt from 1873. The same images, therefore,

have been marketed by the studio at various times as being the work of P. Sebah, J. P. Sebah, or Sebah & Joaillier.

Folowing Pascal Sebah's death in 1886, the Turkish studio was operated by his brother Cosimi for a time, who also trained Pascal's son in the art of photography. Johannes, known as Jean, reputedly joined the business aged 16, took it over at aged 18, and immediately entered into a partnership with Policarpe Joaillier. Joaillier returned to France in 1910, but with subsequent partners, Jean Sebah remained actively involved with the studio until 1943.

From the 1870s, Sebah, and later Sebah and Joaillier, were major suppliers of evocative imagery to the increasing number of people who to undertook the Victorian Grand Tour. Their studio images of Egpytians and Nubians in 'traditional' costumes and undertaking 'traditional' tasks were highly popular, and indeed had been Pascal Sebah's *Les Costumes Popularies de la Turquie* published to critical acclaim in 1873.

JOHN HANNAVY

SEDGEFIELD, WILLIAM RUSSELL (1826–1902)
English photographer

William Russell Sedgefield was born in Wiltshire, England, in 1826, and by the age of sixteen had applied to Talbot for a licence to practice the calotype as an amateur, while at the same time pursuing his training as an engraver. He progressed from calotype to waxed paper and both wet and dry collodion, and in a lifetime devoted to the medium, became one of the most critically acclaimed photographers of his generation. His acquaintances included the great publishers of photographic views Francis Frith and Francis Bedford.

Amongst his publications were *Photographic Delineations of the Scenery, Architecture and Antiquities of Great Britain and Ireland*, published in several parts in 1854, and *The Thames Illustrated with Photographs*, also in several parts (1866). He contributed works to several photographically illustrated books, most notably William and Mary Howitt's *Ruined Abbeys and Castles of Great Britain* in 1862 where his images appeared together with contributions by Bedford, Roger Fenton, George Washington Wilson, and others.

Sedgefield exhibited his work at many exhibitions from 1854, and from 1859 his many series of stereoscopic views were widely distributed. He continued in professional photography until his retirement c.1890, with premises in various locations in the London area, but the topographical nature of his most important work took him all over England and Wales.

JOHN HANNAVY

SELF-PORTRAITURE

The first photographic self-portrait was made just weeks after Arago announced Daguerre's invention in the French Council of Deputies in 1839. Like Niepce, Daguerre, and Talbot, Hippolyte Bayard had labored for some time at inventing a permanent photographic image. He was on the verge of success when Arago made his dramatic announcement, which conferred fame, as well as a sizeable monetary stipend, upon Daguerre. Bayard's response was a remarkable self-portrait in which he depicted himself in the nude as a drowned man. On the back of one print he wrote a note explaining that the drowned man had ended his life in despair after learning that Daguerre had beaten him to the acclaim and the money. He pointed out that the discoloration in his face and hands were signs of the flesh's deterioration, and warned the viewer of the corpse's odor. This first self-portrait was groundbreaking in several respects. It is the first known self-portrait in the nude by any artist since Durer (Durer's 1503 drawing is full frontal nudity, while Bayard's groin is covered.) Moreover, there is a self-directed humor in Bayard's image that many subsequent photographers would echo. To our eyes, Bayard's picture seems prophetic not just regarding the images that other 19th century photographers would produce, but for the performance art that emerged later in the twentieth century.

Many photographers, including Bayard, made more conventional self-portraits in which they presented themselves as serious people deserving of respect. Photography was revolutionary in its ability to make likenesses of people that would outlive them, a privilege that had previously been reserved for those very few who could afford to commission their own portraits. Photographers were no less prone to desires for immortality than anyone else, and accordingly self-portraits flourished. In addition, photographers, like painters, seized upon the genre as a way of advertising their abilities, often posing themselves beside their cameras or photographs. Photographers presented themselves as serious image-makers, and adopted the head and shoulders, direct gaze conventions of formal portraiture. Self-portraits became one mechanism through which photographers presented themselves as deserving the status of artists.

However, the self-dramatizing and playful elements that Bayard introduced also recurred throughout the 19th century. One is tempted to suggest that there is something in the photographic process itself that encourages this kind of plasticity and role-playing. These behaviors were not, of course, the exclusive prerogative of photographers, as they predated the birth of photography by many centuries. Rembrandt's self-portraits, for example, portrayed a man moving through a variety of social stations, as signaled by his amazing array of hats,

gold chains, and cloaks. Jan Steen portrayed himself as an anti-hero, often occupying the central position in paintings that depicted the chaos of unruly households, taverns, and debauchery in general. And when Caravaggio depicted David holding Goliath's decapitated head in triumph, he modeled the ogre's head after his own. But photographers of the 19th century approached the genre with an exceptional degree of freedom and experimentation. Among others, Charles Negre, Roger Fenton, Antoine Samuel Adam-Salomon, and Francis Frith enjoyed donning costumes and posing as various Romantic and exotic figures.

Nadar's and O. G. Rejlander's self-portraits are especially notable cases in point. Nadar made numerous self-portraits throughout his lengthy career, including straightforward head and shoulders images and family portraits with his wife and son. He sometimes donned outrageous costumes and wigs, probably chosen from the compendious wardrobes he kept in his studio. Nadar also photographed himself as part of two of his many entrepreneurial projects. He made at least one self-portrait in the Paris catacombs as part of a series on the expansive underground network in Paris. These photographs represented the first underground photographs as well as one of the earliest successful efforts to use artificial light in photography. The process of sitting for the catacomb self-portrait, which among other things provided a sense of scale for the unfamiliar underground setting, proved to be an especially arduous undertaking because of the very long exposure time and the cool and damp conditions. In a subsequent picture, Nadar spared himself the inconvenience and used a dummy rather than himself. Nadar was also an investor in the development of hot air ballooning, which became something of a passion for him. He used it as an opportunity to make the first aerial photographs, and also to pose himself (looking not entirely comfortable) in the gondola of one the balloons.

Across the English Channel, O. G. Rejlander was no less eclectic and eccentric in his interests. He posed himself in various guises, ranging from Greek philosophers to Garibaldi. He included himself in several humorous tableaus. In one scene, Rejlander scratches his head in confusion as a gypsy peddler tries to con him with an array of products, while in another image he whispers gossip into another man's ear about an unseen young woman. In several of the illustrations for Darwin's *On the Expression of the Emotions in Man and Animals* (1872), Rejlander used himself as a model, histrionically posing in images that supposedly represented indignation, surprise and other emotions. He used the combination printing technique that he pioneered in the mid 1850s to create a self-portrait of himself presenting an alter-ego version of himself as a militiaman. In *Happy Days*, Rejlander and his wife Mary smile broadly as they embrace one another, an unusually upbeat depiction of middle-aged love. There is a *joie de vivre* in Rejlander's self-portraits that is rare not only in 19th century photography, but in the entire history of the genre. Both Rejlander and Nadar in large measure reject the melancholic and self-important postures that many self-portraitists adopted, in part, one senses, because they were simply having too much fun playing with the photographic possibilities.

Some of the same elements continue through memorable American self-portraits near the turn of the century. In a dizzying photograph, William Henry Jackson posed himself at the edge of a high and precipitous rock outcropping in Yosemite (c.1895). The legs of the tripod are spread to the extreme edges of the small rock as Jackson studies the canyon on the ground glass. In dramatizing the considerable risks that many landscape photographers undertook in the practice of their art, such images valorized the courage of the photographer.

In 1898, F. Holland Day took different kinds of risks when fasting for several weeks in order to depict himself as Christ in a crucifixion series. The series includes close-ups of Day's head, topped with a crown of thorns, as well as photographs of his emaciated, nearly naked body nailed to the cross. These self-portraits are extraordinarily realistic, which accounts for some of the controversy that they occasioned when first exhibited in Boston.

Two other pairs of self-portraits are emblematic of how the genre developed in the late nineteenth century. Edward Steichen made numerous self-portraits throughout his long career, but two of his earliest are among the strongest in the medium's history. In one, made in Milwaukee in 1898, a young, casually dressed Steichen stands near the edge of the picture's frame, peering rather uncertainly into the camera. Beside his head hangs a small empty frame on an otherwise blank wall. The picture has a tentative quality to it, suggesting a young man who is just beginning to emerge as a distinct personality. The other self-portrait was taken four years later, after Steichen had moved to Paris. Now Steichen depicts himself as a painter (which in fact he was at the time), applying a brush to a palette in a beautifully composed and heavily worked photograph. He is dressed in sumptuous clothes worthy of a Rubens self-portrait. In this picture, Steichen presents himself as the very picture of success and self-assurance. Whether these two photographs represent an actual metamorphosis in Steichen's personality is open to question, but there is little doubt that the two *projected* selves could not be more different.

Similarly, Frances Benjamin Johnston constructed two very different selves in 1896. In *The Proper Victorian*, Johnston, in her early thirties, poses herself as a society matron, a genre in which she had developed

a considerable reputation amongst political and high society women in Washington. She is decked out in furs and an elaborate hat, her head resting on an elegantly gloved hand as she peers directly into the camera with an expression combining haughtiness, intelligence, and perhaps just a hint of vulnerability. Her expression is accentuated by the carved human head on her chair, which glares at something beyond the picture's edge. In the other self-portrait, Johnston is the "Proper Victorian's" polar opposite: she sits before a fireplace holding a beer stein in one hand and a cigarette in the other. Her legs are casually crossed, prominently displaying petticoats and an ample sweep of calves. She looks away from the viewer with a strong, unsmiling mien. The lack of eye contact reinforces the impression of a tough, no-nonsense woman making her way in a man's world. There's nothing seductive or feminine about her. This woman is fully self-contained, breaking the rules without a hint of apology.

Steichen's and Benjamin's self-portraits at the dawn of the twentieth century may be seen as efforts not just to reflect or project themselves through self-portraits but also to construct multiple selves using the photographic medium. From the first self-portrait of Bayard onwards, photographers were often drawn to the plastic and theatrical possibilities that they discovered in photography. Photographers during the nineteenth century increasingly used the medium to examine and portray the multiplicity of selves that would come to preoccupy psychologists, sociologists, historians, and countless artists in the century to come.

DAVID L. JACOBS

SELLA, VITTORIO (1859–1943)
Italian photographer

Vittorio Sella was born on 28th July 1859 in Biella, where his father, Giuseppe Venanzio, a scientist and photographer, founded one of the most important Italian woollen manufactures. In 1856 he published *Il Plico del Fotografo*, the first Italian treatise on photography. Vittorio's uncle, Quintino, a government minister, founded the Club Alpino Italiano in 1863. Vittorio attended a scientific high school and afterwards he worked in the family firm. He learned photography from his father and thanks to him he also became interested in exploring and mountaineering. In the course of his life he took thousands of photographs of the Alps. From 1879 he worked with scientific rigour on many extraordinary photographic *reportages*, taken while climbing in the Italian Alps. He also travelled abroad; in 1889, 1890 and 1896 he was in the Caucasian mountains; in 1897 he took photographs during an ascent of the mountains of Alaska with the Duke of the Abruzzi. In 1899 he was

in Sikkim in Nepal, and in Africa with the Duke of the Abruzzi again. He made ascents in the Himalayas (1899, 1909) and took photographs during a trip to Morocco. His photographs were widely circulated for their quality and variety and they were found useful by geographers, topographers and alpinists. Vittorio Sella died in Biella on 12th August 1943.

SILVIA PAOLI

SENSITOMETRY AND DENSITOMETRY

When Hubert Davy repeated the experiments of Thomas Wedgwood in 1802, he attempted to convey the rapidity of his photosensitive preparations and stated, "… the part concealed by it *[the light]* remains white, the other parts speedily become dark." Some years later, William Henry Fox Talbot also found the need to indicate the speed of his materials, and he quantified an experiment by combining the intensity of the light ("I employed the full sunshine") and the time of exposure—"*half a second*" (Talbot's italics).

In the same year (1839), Mungo Ponton drew attention to a "cheap and simple method" that relied on the behaviour of light on potassium bichromate to form an image. He claimed his material was "equally sensitive with most of the papers prepared with salts of silver" but admitted, "it is not sufficiently sensitive for the camera obscura …" He had already identified that "the active power of the light … resides principally in the violet rays" by an experiment using light filtered to violet, yellow and red.

Antoine Claudet initiated experiments in 1848 that he hoped would increase the sensitivity of the daguerreotype process to daylight. In order to quantify the response of his plates, he built a device that he called the Photographometer, and which provided controllable conditions of exposure. Like other workers, Claudet relied on assessing his results by eye.

Unwittingly each of the early practitioners had provided the basis for the subsequent study of sensitised materials. Sensitometry became particularly important when photographers no longer prepared their own materials but relied on plates manufactured by a third party. The introduction of dry plates brought a need for reliable testing in the factories, and a means to audit the claims for improved speed. Consequently, the role of sensitometry took on an importance that led to continuing improvements in the practice of photography. For example, an understanding of the behaviour of sensitised materials contributed to the design of actinometers to improve exposures during carbon printing, and to the accuracy of exposure calculators, which replaced exposure tables.

As a rule, three requirements were required for a sensitometric study:

- Equipment for making a consistent exposure to a plate,
- Implementation of an agreed development protocol,
- A means of accurately measuring the ensuing densities.

The designs of the first sensitometers incorporated ingenious exposing devices. Leon Warnerke relied on an energised phosphorescent block of calcium sulphide for his exposing source. James Spurge (working with J.D. Mucklow) proposed a system of tubes that channelled controlled amounts of daylight onto the test plate. Exposing through "a screen" (a step wedge) impressed a set of numbers on the negative and, after development, the first identifiable number established the rapidity of the plate. For example, in 1890, Marion & Company advertised their Ordinary dry plates as "Averages 19–20 Warnerke's Sensitometer" and advised users to "double the exposure of the Instantaneous," which had an average rapidity of 24–25 (on Warnerke's scale).

Before then, however, some workers had encountered conundrums, which were not resolved until sensitometry improved. In 1874, William de Wiveleslie Abney noticed a disparity between time of exposure and intensity of light whilst examining the opacity of his negatives. By the time he had solved the riddle, he had developed his own method for measuring the deposits on negatives and was confidently testing photographic materials objectively.

To measure the transparency (or the opacity) of a negative, Abney used the shadow photometer that Benjamin Thompson (Count Rumford), had designed to compare the strength of different forms of artificial lighting in 1793. Although Abney introduced improvements to the instrument by inserting rotating sectors (i.e., a system of variable apertures), which were positioned in front of one of two light sources, he retained Rumford's principle of balancing the intensities of the two shadows projected on a screen. The amount of adjustment that was necessary to achieve the match indicated the opacity of the deposit.

A limitation of the method when applied to photographic work was the need to use relatively large specimens. Warnerke's sensitometer and Abney's photometer for measuring density (that is, a densitometer) were pragmatic solutions devised to solve specific questions as they occurred. When practitioners appreciated the value of sensitometry and densitometry, the techniques improved and evolved as an important branch of photographic science.

By 1888, Ferdinand Hurter and Vero Charles Driffield had begun to collaborate on experiments in photographic chemistry. The initial work had been undertaken with a view to improving the calculation of camera exposures, but their investigations were later directed towards understanding the action of light on photographic emulsions. To make their studies comprehensive, Hurter and Driffield standardised their tests by exposing plates to the light of a standard candle, modulated by a rotating disk designed to control the amounts of light reaching the plate. They also specified a standard developer (ferrous oxalate) and described apparatus they had made for making measurements.

Hurter and Driffield also introduced the word "density" to describe the individual amounts of silver that were produced during development, and by plotting density measurements against the given exposures, they constructed a curve, which displayed the characteristics of the sensitised material being examined. Hurter and Driffield formed their conclusions from a range of density readings, (instead of the single number obtained by Warnerke), and their technique was consequently more reliable. From their characteristic curve, they were able to determine the sensitiveness of plates, and by the end of the 19th century their method was recognised and accepted as the H & D Speed System.

A contemporary of Hurter and Driffield, Henry Chapman Jones, described his densitometer in 1895, which he claimed as an improvement on other designs because he had been "desirous of getting a more simple arrangement." His achievements were to eliminate the need for two light sources (the reference beam and the measuring beam), to reduce the loss of light in the optical system and to measure in "one simple movement.." Jones's densitometer remained popular until improved designs were introduced in the 20th century.

RON CALLENDER

See also: Ponton, Mungo; Warnerke, Leon; Marion & Son, A.; Abney, William de Wiveleslie; and Hurter, Ferdinand, and Driffield, Vero Charles.

Further Reading

Abney, William de Wiveleslie, *A Treatise on Photography*, 8th ed., London: Longmans, Green and Co., 1893.

——, "Photometry, The Royal Society of Arts' 3rd Cantor lecture." *Photographic News*, 38, 499, 521, 542, 547, 1894.

——, *The Action of Light in Photography: Evening talks at The Camera Club*, London : Sampson Low, Marston and Company, 1897.

——, *Instruction in Photography*, (11th edit.), London : Iliffe and Sons Limited, 1905

——, "On the opacity of the developed photographic image." *The Philosophical Magazine* (September 1874): 1–5.

——, "Chemical Action and exposure; or, a failure in a photographic law." *Photographic Journal*, XIX, (1894), (Complimentary reprint).

Brown, S C, *Benjamin Thompson, Count Rumford*, Cambridge, MA: The MIT Press, 1979.

Davy, Humphrey, "An Account of Copying Paintings upon Glass, and of Making Profiles by the Agency of Light upon Nitrate of Silver." *Journals of the Royal Institution*, 1, (1802): 170–174.

Ferguson, W. B. (ed.), *The Photographic Researches of Ferdinand Hurter and Vero C.* Driffield, London: The Royal Photographic Society, 1920.

Jones, Henry Chapman, A new form of apparatus for measuring the densities of photographic plates, *Photographic Journal*, 20, (1895), 86–90.

Mucklow, J D, and Spurge, J B, "An improved sensitometer." *Photographic Journal*, VII, (1881), 44–47.

Ponton, Mungo, "Notice of a Cheap Method of Preparing Paper for Photographic Drawing …" *The London and Edinburgh Philosophical Journal*, XXVII, (1839):169–171.

Sterry, J., *Photography by Rule*, London: Iliffe and Sons Limited, 1903.

Talbot, William Henry Fox, "Some Account of the Art of Photogenic Drawing" *The London and Edinburgh Philosophical Magazine* XIV (1839): 29.

Warnerke, Leon, "On Sensitometers." *British Journal of Photography* 28 (1881): 96–97, 108–109.

SEVASTYANOV, PETR IVANOVITCH (1811–1867)
Archeologist, traveler, photographer

Petr Sevastyanov was born in 1811 to the family of merchants who were honorary citizens of the town Krasnoslobodsk in the Penza province. In 1831 he graduated from the Moscow University. Commissioned by the Ministry of Justice he worked in Perm, Tiflis (T'bilisi), and St. Petersburg. In 1852 he was honored with the title of the Full Secret Counselor. While staying in Paris in 1858, Sevastyanov took lessons in photography for a month from the photographer Belloni preparing himself for an expedition to Athos.

Sevastyanov organized two expeditions to Athos. The first important series of photographs devoted to the Holy Mountain was taken during the first expedition in 1857; the second expedition lasted for 14 months (1859–1860). Painters, architects ,and photographers took part in these expeditions. Sevastyanov photographed the rare manuscripts and icons of the Athos monasteries. He brought 1300 negatives back with him. Sevastyanov's prints made it possible to read the manuscripts' faded ink texts. This was the first instance where photography aided the restoration of such rare documents.

In February 1858 Sevastyanov made a report "On photograpy in application to archeology" in Paris on the basis of the first Athos expedition. In 1861 and 1862 Sevastyanov's prints were a success in St. Petersburg and Moscow exhibitions. Sevastyanov was the first to use photography to the document research on Athos monasteries.

Sevastyanov died in St. Petersburg in 1867.

ALEXEI LOGINOV

SHADBOLT, GEORGE (1819–1901)
English

North London timber merchant George Shadbolt was an early experimenter in micro-photography and a leading figure of the Microscopic Society.

He was a founder member of the Photographic Society and exhibited many subjects at its 1854–1857 exhibitions using wax-paper, wet-collodion and his own 'collodion honey process' to produce his favored matt salt prints—he disliked the 'glare' of albumen paper. He was also a member of the Photographic Exchange Club.

Shadbolt's earliest exhibits were portraits, some enlarged from small negatives (he appears to have used his camera as a form of enlarger, using gaslight to make the prints). His later studies were all views made in and around Hornsey, North London, which then was then quite rural.

Shadbolt contributed several articles to the *Journal of the Photographic Society* and the *Liverpool & Manchester British of Photographic Journal* which later became *The British Journal of Photography*. He was also vice president of the North London Photographic Association and a member of the Amateur Photographic Association.

He seems to have retired from photography around 1864, however, his son Cecil became a pioneer aerial photographer, taking vertical pictures from a balloon in 1883. C.V. Shadbolt also photographed the Holy Land, illustrating H. A. Harper's *Walks in Palestine,* published in 1888. He was killed in a ballooning accident in 1892, his father died nine years later.

IAN SUMNER

SHERLOCK, WILLIAM (1813–1889)
English

Sherlock was born at Lambeth, South London, in 1813, his father, also William, was a solicitor and William junior followed his father's profession. In 1843 Sherlock wrote to William Henry Fox Talbot requesting permission to open a London photographic portrait studio. After several exchanges, Talbot offered the concession for Bristol, but Sherlock declined.

Sherlock contributed over 40 photographs to the 1852 Society of Arts London Exhibition, all but one from paper negatives. The subjects depicted rural scenes: A Group of Peasants, Pollard Willows and Rustic Bridge were typical titles. By 1855 he was using wet-collodion to produce his negatives, printing on salted paper.

Sherlock's large body of work was originally attributed to John Whistler but as Ken Jacobson has shown in his 1996 work *Etude d'Apres Nature*, this was an incorrect assumption due to a large number of his works in the collection of the Whistler family.

In exhibitions between 1852 and 1859 Sherlock showed almost 200 rustic studies, many entered by the print seller J.Hogarth. His work has also been confused with that of the French master Humbert de Molard and much of his work is in the French style. He gave up his profession as an attorney and became a full-time photographer in the late 1850s and moved from London to South Devon, where he lived until his death in 1889.

IAN SUMNER

SHEW, WILLIAM (1820–1903)

William Shew first made his mark as a daguerreian artist and case maker in Boston before moving to California, where he took photographs for more than 50 years.

Born near Watertown, New York, he began making daguerreotypes there in 1841 with his three brothers after learning the process directly from Samuel F. B. Morse. The four brothers moved from Watertown to Ogdensburgh to Rochester and to Geneva, New York, establishing galleries in each city, before settling in New York City.

From 1841 to 1844, Shew managed John Plumbe, Jr.'s Boston gallery. Around 1844, he began making miniature cases and continued in that line of work for several years. From 1849 to around 1851, he resumed taking daguerreotypes in Boston.

Shew arrived in San Francisco by ship around 1851 and established a portable gallery that he operated until moving into more permanent quarters on Clay Street. He was burned out of this location and moved to another on Montgomery Street, where he remained for 20 years. He was also active in local politics and served on the local Board of Education. In 1901, more than 50 years after settling in San Francisco, Shew was still operating a photo gallery on Kearny Street.

BOB ZELLER

SHIMOOKA RENJØ (1823–1914)
Japanese photographer

Shimooka Renjø is generally thought of as one of the "two fathers of Japanese photography," along with Ueno Hikoma. Shimooka was born as Sakurada Hisanosuke in Shimoda in 1823. His father was an official shipping agent for the Tokugawa military rulers. Shimooka moved to Tokyo at the age of thirteen to seek training as an artist. He later served an apprenticeship with a master of the traditional Kanø painting school, Kanø Tøsen. He may have first seen foreign daguerreotypes while serving as a guard at the Shimoda artillery battery in the 1850s. He was so impressed by their realism and detail that he decided to learn photography. Shimooka acquired his first formal training in the medium around 1860 from an American photographer in Yokohama named John Wilson. When he left Yokohama in 1861 or 1862, Wilson also gave Shimooka his first camera in exchange for a painting. In 1862 Shimooka opened a studio in Yokohama, one of the first Japanese-run photography businesses. He produced studio portraits primarily for foreign tourists, as well as staged photographs of locals that also appealed to foreign tastes. He later managed a number of studios in both Yokohama and Tokyo, and trained many of Japan's early photographers. By 1877, Shimooka no longer worked as a photographer, though he continued to paint photographic backdrops and panoramas. He died in 1914.

KAREN FRASER

SIDEBOTHAM, JOSEPH (1824–1885)
Calico printer, botanist and entomologist, pioneer photographer

He was involved with several early experiments in the search for stable dyestuffs for textile printing and had an enduring interest in microscopy. Sidebotham was a prime mover in the establishment a 'microscopical section' in the Manchester Literary & Philosophical Society in the late 1850s (becoming its Vice-President), and a photographic section in the 1860s. Through the 'Lit & Phil,' he became acquainted with John Benjamin Dancer (qv)—from whom he purchased microscopes and developed an interest in micro-photographs—James Mudd (qv), Alfred Brothers (qv) and many other early photographers. He was a long-serving member of the Manchester Photographic Society, and a regular speaker at the society's meetings. One of the earliest demonstrations of the workings of a rotary camera shutter was that given by Sidebotham in 1856. He served as the society's Vice-President from 1861 until 1865. With James Mudd, he experimented with variants on the waxed paper process in the 1850s.

Sidebotham lectured and wrote extensively on photography and his essays on the collodio-albumen process, and on contemporary printing processes published in *Recreative Science: A Record and Remembrance of Intellectual Observation, Vol. II.* (Groombridge and Sons, London, 1861), were considered important contributions to the published account of photography.

JOHN HANNAVY

SILVESTER, ALFRED (UNKNOWN)

Alfred Silvester's blindstamp can be found on some of the most elaborate and beautifully tinted genre stereocards of the 1850s and 1860s, yet the only record of his studio at 118 New Bond Street, London is from an 1864 trade directory. No personal details have yet been located.

His exhibition record comprises two portraits by wet collodion shown at the 1855 Exhibition of the Photographic Society, and forty of his celebrated stereographs at the 1858 Edinburgh exhibition of the Photographic Society of Scotland.

Silvester's stereos were usually produced in small sets of three or four cards, or in much larger series, with a strong moral theme and narrative character, and they could be purchased either card mounted for viewing by reflected light in the drawing room stereoscope, or as tissues for viewing by transmitted light. Themes like *The Hero's Wife* and *The Dream of the Wedding* were popular entertainment. *Look Before You Leap* linked sound advice with a strong Masonic theme, and depicted aspects of Masonic ritual, while his most celebrated genre card, *Guardian Angels* was one of his most overtly religious. Similar treatments of many of the themes in Alfred Silvester's stereographs were published by his major rivals John Elliot, and the London Stereoscopic Company.

JOHN HANNAVY

SILVY, CAMILLE-LÉON-LOUIS (1834–1910)
French photographer

Camille Silvy was born at Nogent-le-Rotrou, a market town to the west of Chartres, on May 18, 1834, to Marie Louise and Onésipe Silvy, descendents of a notable Provençal family with possible Italian roots. When his father, mayor of Nogent, was appointed director of a Paris bank in 1835, he moved his family with him.

As a child, Silvy was taught drawing by Hippolyte Lalaisse, a teacher, lithographer, and painter of portraits, genre scenes, and animals. Silvy studied law and graduated in 1852 taking up a minor diplomatic post. He took up photography when he took a trip with Lalaisse to Algeria in 1857 and realized his inadequacy at obtaining exact views of the places he traveled through. He made photographs and drawings on this trip, particularly of Kabylia, newly conquered by France.

Silvy joined the Société française de photographie in 1858 and exhibited at the Salon the following year. Silvy was one of a number of photographers who donated prints to be sold to raise funds for the organization. Most of the views he exhibited at the Salon were taken close to his birthplace, at Gaillard at La Croix-du-Perche or in Nogent-le-Rotrou. Like those of many of his contemporaries, Silvy's photographs were made from large, wet collodion glass negatives which most likely processed his plates in one of the family's houses in the area.

Silvy's most well known photograph was taken near Nogent-le-Rotrou of the river Huisne in 1858, and is known today as "River Scene, France." The version in the Société française de photographie, where Silvy exhibited the print for the first time in 1859, was originally given the title "Vallée de l'Huisne."

Although it was made just a few years following the inauguration of the Grande Ligne de l'Ouest from Paris that passed through Nogent, "River Scene, France" gives no indication of this new industrial access to Paris. The scene is one of quiet, picturesque contemplation where one's eyes can explore the intricate and carefully composed details in the middle ground where riverside houses, boat docks, and trees are reflected in the smooth mirror-like surface of the river. The glass negative allowed a greater sharpness as well as faster exposure speed. The people positioned along the riverbank in *River Scene*, though staged, did not have to stand stiffly in order to be rendered. The composition is reminiscent of topographic prints of the time, aimed at creating picturesque views of leisuring tourists in a landscape. However because Silvy's photograph lacks picturesque monuments such as the nearby Romanesque castle and a church, he seems to be more interested in the scene as that of local residents, enjoying their own beautiful spot.

Because clouded skies were challenging in early photographs, Silvy used a method first invented by Hippolyte Bayard and made famous by Gustave Le Gray that is to take a separate negative of a cloudy sky and splice it with the negative of landscape in the printing stage. In addition, Silvy had to paint in parts of the main cluster of poplar trees as well as along the horizon in order to blend the two negatives. Because of his success with these techniques as evident in "River Scene," Silvy is recognized as one of the great craftsmen of photographic printing.

In a review of the exhibition at the Société française de photographie, Ernest Lacan praised Silvy's landscapes: "These are ravishing *tableaux* which have the merit of being as true as nature herself, while borrowing from art a glamour which gives poetry to the most ordinary places" (*Photographic News*, July 9, 1859, 1). Such critical acclaim along with the writings of Louis Figuier, a well-known science journalist, who declared Silvy's photographs to be ". . . true pictures in which one does not know whether to admire more the profound sentiment of the composition or the perfection of the details . . ." (L. Figuier, *La Photographie au Salon de 1859,* Paris, 1859, 9) placed Silvy at the head of the modern French landscape school.

In addition to landscapes, Silvy also made still-lifes, such as *Trophées de chasses* of rabbits, game birds, and fish hanging symmetrically like realist still-life paintings of the time. In 1859 a wood engraving for the weekly *L'Illustration* was made after his photograph of a group of citizens in Paris gathered around a posting put up by Napoleon III before his departure for Italy to join the

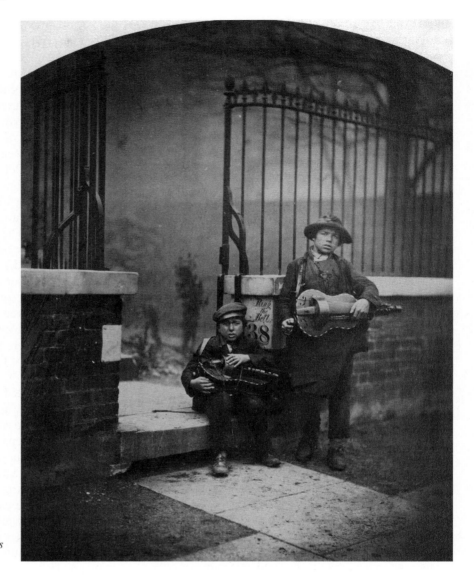

Silvy, Camille. Les Petits Savoyards
(Street Musicians).
The J. Paul Getty Museum, Los Angeles
© *The J. Paul Getty Museum.*

fight against Austria. The image combined reproductive technology, politics, and a moment of history in the making. Silvy was also meant to travel with the Italian campaign to make photographs but the French army succeeded in their mission before Silvy could receive his papers to go.

In 1859, Silvy moved to London and established a portrait studio. There he made carte de visites, recently patented by the Frenchman Disderi, which makes him most likely the first *carte-de-visite* photographer in London. Soon Silvy moved to a large and spacious portrait studio in Porchester Terrace, Bayswater. Within two and a half years he had taken close to seven thousand portraits of famous and upper class citizens. He photographed individuals and groups in elaborate studio settings as well as arrangements of figures in landscapes.

Beyong the studio, Silvy continued to be inventive with the medium. In the late 1850s he created a series of studies of light and weather as well as a series of

street scenes. Silvy made photographic reproductions of early manuscripts, particularly the "Sforza Manuscript" in which he discovered that photography, because it could capture yellow ink and render it as black, could also play a restorative role as well as a documentary one. When a major controversy over whether photography could be exhibited in the Fine Arts section of the 1862 International Exhibition occurred, Silvy, who was a member of both societies, stood in favor of photography's industrial classification. Silvy was also an inventor of machines, such as a cylindrical camera body that could house a rolled waxed-paper negative and in 1867 he made a panorama of the Champs Elysées to demonstrate his invention. He invented the idea of a tripod that could keep a lens horizontal to the ground for surveying. Silvy experimented in making print runs of photographs in ink and worked in photoceramics and photographed tombs in the Dreux chapel in Normandy by magnesium light.

As the *carte-de-visite* phenomenon died down, Silvy ended his portaiture studio in London in 1868 and moved back to France. He took up the post of *agent consulaire* of the French government at Exeter from 1868 to 1870 but returned again to France when the Franco-Prussian War broke out, and served as a lieutenant in the Eure-et-Loir department. He later published two pamphlets describing the campaign. Like many workers in photography in the nineteenth century, Silvy's life was ended prematurely by cyanide of potassium poisoning. Silvy entered an asylum in 1881 and died there in 1910.

KAREN HELLMAN

Biography

Camille Silvy was born at Nogent-le-Rotrou, France, on May 18, 1834. Silvy studied law and graduated in 1852 taking up a minor diplomatic post. He took up photography during a trip to Algeria in 1857. Silvy joined the Société française de photographie in 1858 and exhibited at the Salon the following year. Like those of many of his contemporaries, Silvy's photographs were made from large, wet collodion glass negatives. Silvy was known primarily for his landscape scenes taken around his native town in France but he also made still life studies. In 1859 he moved to London and established a portrait studio where he was possibly the first carte de visite photographer in London. In the late 1850s he created a series of studies of light and weather, a series of street scenes, and several photographic reproductions of early manuscripts. In the 1860s Silvy invented a cylindrical camera body that could house a rolled waxed-paper negative and in 1867 demonstrated his invention with a panorama of the Champs Elysées. He also invented the idea of a tripod that could keep a lens horizontal to the ground for surveying. In 1868 Silvy closed his studio and moved back to France. He took up the post of *agent consulaire* of the French government at Exeter from 1868–1870 but returned again to France when the Franco-Prussian War broke out, and served as a lieutenant in the Eure-et-Loir department. Like many workers in photography in the nineteenth century, Silvy's life was ended prematurely by cyanide of potassium poisoning. Silvy entered an asylum in 1881 and died there in 1910.

See also: Société française de photographie; Wet Collodion Negatives; and Cartes-de-Visite.

Further Reading

Hales, Andrea, "The Album of Camille Silvy," *History of Photography* 19 (Spring 1995): 82–7.
Haworth-Booth, Mark, *Camille Silvy River Scene, France,* Malibu, California: The J. Paul Getty Museum, 1992.

SIMPSON, GEORGE WHARTON (1825–1880)
Editor and writer

George Wharton Simpson succeeded Thomas Sutton and Editor and Proprietor of the fortnightly journal *Photographic News* in 1861, a position he held until his death in 1880.

A prolific writer, he contributed essays, in addition to his own journal, to *Photographic Notes, The Photographic and Fine Arts Journal* and the *British Journal of Photography*. His writings were reprinted extensively in *The Philadelphia Photographer, The American Journal of Photography and the Allied Arts & Sciences, Humphreys Journal* and *Photographic World* amongst others.

He wrote two important books—*The Photographic Teacher: or What to do in photography, and How to do It: a Clear and Concise Compendium of the Collodion Process* was published in 1858 by H Squire & Co of London, and *On the production of Photographs in Pigments: containing Historical Notes on Carbon Printing and Practical Details of Swan's Carbon Process* was published by T Piper in London in 1867.

He became Vice President of the Photographic Society of Great Britain, and was also elected to the same post at the South London Photographic Society.

In his obituary, (*BJP*, January 15 1880) his early career as Editor of the *Darlington & Stockton Times* is mentioned, as is the fact that he practised as a professional photographer 'for some years' before taking over the editorial chair at *Photographic News*.

JOHN HANNAVY

SKAIFE, THOMAS (1806–1876)
English photographer and studio owner

Thomas Skaife was born in 1806, marrying circa 1829 and having one son, Wilfred (1830–1862). He operated photographic studios at various addresses in London from 1860 until 1867 and exhibited as a miniature painter at the Royal Academy from 1846 to 1852.

He took up photography in early 1856 and in June patented a rubber-band powered flap shutter to facilitate instantaneous photography. He became increasingly attracted to instantaneous photography and he produced a series of stereo photographs for the War Department showing the trajectory of the shell from a mortar.

His most prominent contribution to photography was the introduction of his Pistolgraph camera in 1859. Skaife, inspired by a suggestion made by Thomas Sutton in the *Photographic Journal* of July 1858, designed a camera fitted with one of his own flap shutters. He re-designed the camera in 1859 to make use of 1 inch

square glass plates. The camera was called the Pistol-graph. Skaife's camera was sold with several types of lenses including a wide aperture Dallmeyer f/1.1 portrait lens. The plates could be enlarged successfully 10 to 15 times by projection, by enlarged negative or by use of a solar camera.

Skaife's camera attracted much interest in the photographic press and Skaife licensed the use of the camera to other photographers to produce 'pistolgrams' or 'pistolgraphs.' It was deemed particularly applicable for taking portraits of children, old people, and animals.

Skaife died on 18 November 1876 at Preston, near Steyning, Sussex, aged 68.

MICHAEL PRITCHARD

SKEEN, WILLIAM LOUIS HENRY
(d. 1903)
English, photographer, publisher

William Louis Henry (W.L.H.) Skeen was the proprietor of a large commercial photographic company active in Ceylon (now Sri Lanka) from the late 1860s through 1903, with studios in Colombo and Kandy. His father William Skeen, the first official government printer for Ceylon, purchased a studio for his son after he his return from photographic training in London. During its existence, W.L.H. Skeen & Co was the premier photographic firm in Ceylon. The company offered an extensive catalogue of views of landscapes, studies of tribal peoples and ethnic groups, and documented the tea plantations and spice works. Skeen & Co. held commissions to record many of the major construction projects—railway projects and the construction of the Colombo Breakwater in the 1880s. The company published J.W.W. Birch's photographs of Polonnaruwa around 1876. Skeen & Co. received the coveted "photographers by appointment to the Duke of Edinburgh" during his tour of 1870. In addition to views of Ceylon, in the 1890s the firm offered a series of views of India—Bombay, Jaipur, Delhi, Agra, Darjeeling—probably acquired through purchase or trade with another commercial studio. Skeen & Co. photographs were exhibited at major international exhibitions from 1870 to the end of the century and its operations. It appears the Platé & Co. acquired its negatives when it closed in 1920.

KATHLEEN HOWE

SKY AND CLOUD PHOTOGRAPHY

Photography was invented as the meanings and uses of sky and cloud in art were in flux. In paintings, skies were once typically conveyed as the realm of gods; cloudless, infinite and timeless, often blocked out with celestial gold. If a cloud was present, it was a symbol of divine wrath. From the early Renaissance artists began to fill images of skies with clouds and birds, seeking to evoke a specific space and time. By the nineteenth century, sky and cloud in art could be romantic, evoking emotional states or spirituality, but could also be scientific or realist, used to image atmospheric effects, highlight the time of day or document nature.

At a time when the West was surveying unknown lands, it was also exploring the infinite, daunting sky. Photography played a role in the demystification of sky and cloud, providing what was considered objective evidence of natural processes. In 1896, the *International Atlas of Clouds* was published, incorporating photochromatypes of different types of cloud, by the international meteorological committee—a concern thus spanning the entire century. However, it was actually in the early 1900s Jean Baptiste Lamarck and Luke Howard worked on classifications for clouds.

The night sky was also documented. Lunar daguerreotypes of George Philips Bond and John Adams Whipple were shown at the 1851 Great Exhibition at Crystal Palace, London, and were so popular that they went on tour in Europe. The subsequent wet-plate collodion prints by Warren De La Rue, along with Lewis Morris Rutherford's albumen print 'The Moon, New York' (1865) continued to spark the interest in lunar photography. As well as looking to the skies from Earth, Gaspard Félix Tournachon, or Nadar, famously took his camera up in the hot-air balloon, attempting 'aerostatic photography' from 1858 to record the earth from the sky.

Cloud and sky were aesthetic as well as scientific subjects. In nineteenth-century art the empiricist doctrine of depicting a specific place at a specific time, and aiming to show atmosphere, was pursued by artists such as Claude Monet, John Constable, Joseph Mallord William Turner and James McNeil Whistler. Images recording 'effect' gained scientific value and appeared more 'truthful' and desirable. Summing up mid-nineteenth-century art, Ruskin stated in 1856, that 'if a general and characteristic name were needed for modern landscape art, none better could be invented than "the service of clouds".' Photographs were used as an aid to drawing and painting natural landscapes. Many people considered them equivalent to a sketch, although less subjective and less artistic. In the 1870s for example, the French artist Gustave Courbet was concentrating on skies and seas, making photographs on which to base his paintings.

Skies could be cloudless for both technical and aesthetic reasons. From the 1840s skies in photographs were often blank due to the fact that the material's sensitivity was selective and restricted, which prevented the photographer to acquire detail in a dark foreground (for example 'At Compton, Surrey, 1852–54' by Ben-

jamin Brecknell Turner). Often photographers tried to achieve an empty sky for stylistic reasons. Japanese photographs were closely linked to the woodblock tradition that made use of large single-tone spaces: Kusakabe Kimbei's 'Fujiyama' (c.1880) is a coloured albumen print with a flat sky. The empty sky in Carleton E. Watkin's 1860s photographs (of the type to be disseminated as artistic prints and postcards), highlights the sublime in the iconic landscape of the American west at Yosemite. In the 1890s, the British photographer Peter Henry Emerson sometimes used a white, blank sky to evoke distance and fin-de-siecle emptiness (for example 'The Bridge,' a photo etching from *Marsh Leaves*, 1895).

J. M. W. Turner, discussing paintings, breached the artistic concern of making an opaque two-dimensional surface reflect light. In photography, the appearance of the sky depended on the characteristics of the methods and paper used, and how light would reflect off the surface. The mirror surface of the daguerreotype reflected light and added interest to void skies (Horatio Ross's daguerreotype 'Craigdacourt,' 1848, for example). Watercolourists and calotypists both used Turkey Mill paper to render the sky mottled and interesting. Hill and Adamson's work reveals the blurred effect, creating texture and shape, caused by the way in which the paper absorbed chemicals. Journals suggested improving blank, white skies when using a paper negative by blackening the verso with ink, and when using a glass negative by painting the verso red or yellow.

Imaging clouds demanded technical skill and astounded viewers, who were unused to seeing romantic symbols in such a scientific context. It was a technical challenge until photographic papers became more reactive than the early albumen papers of the 1850s, and so alternative methods were used. Clouds were often painted onto the backs of negatives. Farnham Maxwell Lyte revealed in 1861 that tufts of cotton could be placed the glass negative and the printing frame to achieve clouds. Alternatively, the part of the negative showing the sky could be covered during exposure in the darkroom, so that the detail was not lost.

It became common practice to superimpose one negative of clouds onto a negative of a landscape, creating a photomontage to achieve detailed sky and land in one photograph. Frenchmen Camille Silvy and Gustave Le Gray, and Englishmen F. M. Lyte and Roger Fenton were amongst the nineteenth-century photographers who used this innovation. Silvy's 'River Scene, France' (1858), is an early example of this technique, and was praised in *The Photographic Journal* (5, 1859) for its 'exquisite and varied detail,' although Silvy was also criticised for using 'artifice to make picture, not take a picture" (Paris review by Louis Figier, 1859).

Roger Fenton's study 'September Clouds' (1859),

emulating Constable's paintings of clouds, was used in a number of different landscapes to give a model sky to each image. His photographs were first shown in Britain and sold well to an international market. The blatant manipulation of superimposing negatives to artistic ends was a concern for Le Gray, who insisted that photographs preserve the 'truth' but who also used photography as an artistic printmaking process, as in 'The Solar Effect—Ocean' (1857). Sky and cloud made Le Gray famous; his many seascapes selling well.

Nineteenth-century photography of sky and cloud was caught between the contemporary concerns of art and science. Echoing the painterly obsession with imaging the atmosphere, it acted as a catalyst for technical innovations in the 1800s, and the development of scientific skill and artistic taste. Photographs of sky and cloud sold brilliantly to a large market as fine art prints, postcards, or stereoscopic views. The subject was used to varying effect in different situations: highlighting majesty of mountains, emphasising vastness of land or sky, contributing to propaganda of empire, documenting new theories and discoveries, aiding explanations of natural processes, and advancing photography as an art.

SOPHIE LEIGHTON

See also: Aerial photography; Fenton, Roger; Le Gray, Gustave; Lunar photography; Night Photography; Pictorialism; Silvy, Camille.

Further Reading

Weaver, Mike (ed.), *British Photography in the Nineteenth Century: The Fine Art Tradition*, Cambridge, Cambridge University Press, 1989.

Clair, Jean, *Cosmos: From Romanticism to the Avant-Garde*, Munich, Prestell, 1999.

Coe, Brian, and Haworth-Booth, Mark. *A Guide to Early Photographic Processes*, London, V&A Museum, 1983.

Ruskin, John, *Modern Painters*, London, 1843.

Quand Passent Les Nuages, Galerie de Photographie 1988, Paris, Bibliotheque Nationale.

Hamblyn, Richard, *The Invention of Clouds: How an Amateur Meteorologist Forged the Language of the Skies*, London, Farrar Straus Giroux, 2001, and 'A Celestial Journey' in *Tate Etc* Issue 5 (Autumn 2005).

SLINGSBY, ROBERT (d. 1895)
English photographer

Robert Slingsby was a professional photographer working in Lincoln from circa 1859 where he was also described as a stationer and dealer in artistic supplies. He joined the Photographic Society in 1869 and was a regular exhibitor of work in the Society's annual exhibition from 1863 initially showing examples of his portrait work and local views but gradually showing more staged genre and art studies.

Slingsby contributed a number of articles to the British photographic press usually addressing portraiture and matters of interest to the professional studio photographer. In his 1873 piece entitled 'A few notes on portraiture,' he described his method of sensitising plates, his studio and posing methods and later pieces commented on backgrounds and the need for an orderly routine in the studio, all based on his own experiences. He had two patents granted in 1875 and 1876 relating to the use of skylights in photographic studios.

In 1880 H. Baden Pritchard visited Slingsby's Lincoln studio and reported on the visit in detail for the *Photographic News*. He noted that Slingsby's photograph *Alone* which had been exhibited at the Photographic Society's exhibition had earned him £450 and was continuing to sell. The article described Slingsby's studio and working methods in some detail.

Slingsby's more important contribution to photography was his work on the development of flash light for photography. As early as 1869 he had a photograph reproduced in the *Illustrated London News* that had been produced using artificial light and between 1890 and 1891 he was granted four patents relating to the use of magnesium for flash photography one of which related to a shutter that could be synchronised to the discharge of magnesium.

Robert Slingsby died in Lincoln on 16 August 1895 leaving an estate totalling £1552 13s 10d.

MICHAEL PRITCHARD

SMEE, ALFRED (1818–1877)

The scientist, ophthalmic surgeon, and metallurgist Alfred Smee was an important and prolific writer on electricity and electro-biology, and was an early pioneer in the understanding of the electrical stimulation of nerves and muscles.

Smee, a fellow of the Royal Society, was co-founder of the London Opthalmic Hospital, and ophthalmic surgeon to the Bank of England, and a friend and collaborator with Charles Babbage. Recent researches have confirmed him as an early pioneer of the concept of artificial intelligence.

He was also interested the potential value of batteries in the electrolytic preparation of chemicals, and, in 1842, supplied Sir John Herschel with some of the potassium ferricyanide—a key chemical in Herschel's cyanotype process—which he had made from potassium ferrocyanide by what he termed 'electrolytic oxidation.' Several surviving letters from Smee to Herschel attest to his wide interest in the chemistry of early photography.

An article by Smee "Photogenic Drawing" was published in *The Literary Gazette and Journal of Belles Lettres* on May 18, 1839 (314–316). In that article Smee recognised the future value to photography of gallic acid,

and also predicted the importance of iron proto-sulphate, observing that "photogenic paper may be blackened" by a dilute solution of the chemical. Iron proto-sulphate, or ferrous sulphate, was later recognised, by Robert Hunt in 1844 as a developer.

In his book *Elements of Electro-Metallurgy* (Longman, Brown, Green and Longman, 1841), Smee included a chapter 'On Multiplication of the Daguerreotype' (134–135).

JOHN HANNAVY

SMILLIE, THOMAS W. (1843–1917)
American photographer

Washington, D.C., photographer Thomas W. Smillie served as the Smithsonian Institution's first photographer when hired part-time beginning in 1869. Educated in chemistry, Smillie pursued his passion for photography at the Institution while continuing to work as a commercial stereo photographer. By 1871, Smillie's position was made full-time with responsibilities to photograph and document museum collections, buildings, and scientific research. He developed traveling exhibitions, the first for the Ohio Valley Centennial Exposition at Cincinnati in 1888. Smillie arranged for this display by acquiring or borrowing historic and contemporary photographs and camera equipment, such as Samuel F. B. Morse's daguerreotype camera and accessories, and the 1888 No. 1 Kodak camera. He continued to correspond with working professional and amateur photographers, and manufacturers to record the history of the science, technology and art of photography. In 1896, Smillie was named the first honorary custodian of the newly formed Section of Photography at the Smithsonian, the first such unit in an American museum. Smillie maintained an active collections and exhibitions program while remaining staff photographer. As a mentor, he taught photography to many apprentices preparing them for work with U.S. government agencies. In 1913, Smillie opened the first Hall of Photography in the Smithsonian's U.S. National Museum. He remained at the Smithsonian until his death in 1917. Today, this important collection is housed in the Smithsonian's National Museum of American History, Photographic History Collection.

MICHELLE ANNE DELANEY

SMITH, BECK & BECK

The firm of Smith, Beck and Beck dates from 1857. Its origins lie with James Smith (died 1870) an optician and optical turner working from 1826–1847 who had made the brass work for Joseph Jackson Lister's (1786–1869) achromatic microscope. Smith took Lister's nephew

Richard Beck (1827–1866) as an apprentice and they commenced a formal partnership in 1847 which continued until 1857 when they were joined by Beck's brother Joseph Beck (1829–1891), who had been apprenticed to the important optician and instrument maker William Sims.

The Smith, Beck, and Beck company was primarily an optician and optical instrument maker with microscopes being a particular speciality. As Smith and Beck the firm introduced stereoscopes to the range of goods it produced including a top-loading hand-held model. The firm's most successful viewer was based on Joseph Beck's patent number 2112 of 15 September 1859 which described a viewer designed for viewing paper stereo pairs either mounted on card or in books. The open-body viewer was sold as the Patent Mirror Stereoscope.

A refined version was produced with solid sides which inverted into it's own box and was sold as the Achromatic Stereoscope in either walnut or mahogany. Various designs of cabinets to hold the viewer in its box and stereographs were produced. The viewer was very effective and consequently became very popular with over 3000 being produced. It was still being advertised in 1890.

Alongside the stereoscopes Smith, Beck and Beck was also publishers and retailers of photographs including cartes-de-visite portraits and they claimed to keep in stock 'some thousands' of stereoscopic views with others readily obtainable. The most notable of the stereographs published by the firm was Warren de la Rue's celebrated series of lunar photographs taken on his reflecting telescope and enlarged by Robert Howlett. These were sold as both paper and glass stereographs.

Smith retired from the partnership in 1865 and c1867 the firm began trading as R and J Beck, becoming a limited company in 1895. Joseph's son, Conrad, was apprenticed to the firm in 1879 and later ran the company and published several books on optics. Thomas Smithies Taylor was also apprenticed to the company in 1879 and in 1886 he founded his own firm which was to become Taylor, Taylor and Hobson of Leicester, another successful photographic lens manufacturer.

By the 1880s R. and J. Beck's photographic lenses were mainly being exported to the United States and by the end of the decade they had doubled manufacturing capacity to meet the demands of the home market. The company was the first to fit an iris diaphragm on a regular basis to its rectilinear lenses from 1887. Although the firm manufactured some Voigtländer lenses under licence and a limited range of its own quality lenses it increasingly produced lenses directly for camera makers such as W Butcher & Sons, Newman and Guardia and others.

The company made several distinctive cameras. The first true twin lens reflex camera was made by R. and J.

Beck for G. M. Whipple (1842–1893), superintendent of the Kew Observatory to his own design, in 1880. It was designed for cloud photography. A later cloud camera was made by Becks to Robin Hill's patent in 1924. From 1892 Beck introduced a successful range of cameras under the Frena name with the third thousand being supplied in 1894. The camera was based on Joseph Thacher Clarke's patents and held one or two packs of twenty cut-films, specially made for them by Ilford Ltd, which were changed by rotating a handle on the outside of the camera. Further models were made through to the early 1900s.

During the twentieth century, the firm increasingly focused on supplying lenses and specialist optical instruments before moving away from photographic optics. It underwent several mergers but remains in existence as Coherent Ealing (Europe) Ltd producing specialised high precision opto-mechanical assemblies.

MICHAEL PRITCHARD

Further Reading

Channing, Norman, and Mike Dunn, *British Camera Makers. An A-Z Guide to Companies and Products*, Claygate: Parkland Designs, 1996.

Clifton, Gloria, *Directory of British Scientific Instrument Makers 1550–1851*. London: Zwemmer, 1995.

Coe, Brian, *Cameras. From Daguerreotype to Instant Pictures*, London: Marshall Cavendish Editions, 1978.

Wing, Paul, *Stereoscopes. The First One Hundred Years*. New Hampshire: Transition Publishing, 1996.

SMITH, JOHN SHAW (1811–1873)
Irish amateur calotypist

John Shaw Smith belonged to the Anglo-Irish landed gentry, born in Clonmuth, County Cork, South Ireland, on October 18, 1811, the fifth of eight sons of John and Mary Richardson Smith. He settled in the family's house of Fairy Hill in Blackrock, on the seaside north of Dublin, and in 1839 he married his first cousin, Mary Louisa Richardson, from whom he had two children, John Augustus (born in 1840) and Florence (born in 1844). His life ended tragically on January 29, 1873, when he shot himself.

His work with the calotype process stands out in the early history of photography in Ireland for the extensive photographic tour that he took along the Mediterranean shores, between December 1850 and September 1852. Before taking this trip, he practiced the calotype process in Ireland, documenting the ruined landscape scenery of his surroundings—the Celtic Graveyard at Blackrock, the monastic settlement at Glendalough—and taking a short trip to Paris, in August 1849. It is not documented whether he had any personal contacts with the French calotypists, but his Parisian views reveal his awareness

of their work, as well as of Lerebours' *Excursions Daguerriennes* (1842–1843). It is likely that Shaw Smith was exposed to photography from its beginnings, as the new invention was announced in 1839 in the "Proceedings of the Royal Irish Academy." Possibly, he knew the work by Scottish calotypists Captain Henry Brewster (Sir David Brewster's son), in Dublin in 1842, and John Muir Wood, in Ireland in the late 1840s. The work of Irish gentleman William Holland Furlong, corresponding with Talbot in the early 1840s, might have also come to his attention.

John Shaw Smith mastered the calotype process, reading a paper about his modification of Blanquart-Evrard's wet-paper process for use in hot and dry climates, at the Dublin Photographic Society in April, 1857 (published in the *Journal of the Photographic Society* on April 21, 1857, and in the *Liverpool and Manchester Photographic Journal*, on May 15, 1857). His modification consisted in adding "bromure d'iode" to the iodizing bath in preparation of the calotype negative (using Whatman's paper and, for higher temperatures from 70 to 85 degrees, Canson's paper). The addition of "bromure d'iode" caused the time exposure to be longer but allowed the paper to remain in good condition for a whole day in high temperatures. The paper was excited in the morning and developed the same evening. The geography he toured along the Mediterranean shores elicits comparison with similar itineraries taken by Calvert Jones (1841, 1845–1846), George Wilson Bridges (1846–1852), and the French calotypists in Egypt, beginning with Maxime Du Camp in 1851.

He photographed the monuments and sceneries of Italy, Greece, Turkey, Egypt, the Sinai peninsula, Palestine, the ruins of Petra, Lebanon, Syria, Malta, and, on his way back, Switzerland. He carefully documented this trip, writing date and location on each negative, organizing each group with geographical headings, and keeping also a travel diary. After 1861, he printed his calotype negatives of Egypt as albumen prints in a two-volume album of seventy-two views with autograph text pages. The photographs of Shaw Smith's tour were not published, and were exhibited only once in his lifetime, in the photographic section at the Dublin International Exhibition in 1865, together with works by Antoine Claudet, Julia Margaret Cameron, O.G. Rejlander, Thomas Annan, Francis Frith, Francis Bedford, where Shaw Smith was awarded an honorable mention for "good productions from paper negatives."

The Grand Tour of John Shaw Smith began in December 1850 in Rome, where he made eighty-one photographs (the largest group in his trip together with those made in Egypt), which followed a preconceived iconography of the Catholic-Roman capital, and sought for picturesque sceneries along the Tiber River, and the surroundings of Tivoli. He was one of the last amateurs who yielded to the lure of Italy with the paper negative, and it is likely that he gathered with the international group of artists and photographers at the Caffe' Greco. He continued the trip south, reaching Naples and Pompeii, taking pictures of the ruined landscape with the Vesuvius in the distance, which echo Calvert Jones' earlier calotypes as well as Charles Dickens' literary observations.

He traveled by steamboat between Naples and Athens, with a stop in Malta, quarantine station between Europe and the Eastern countries. The photographs of Athens reveal his political involvement with the romantic figure of Lord Byron, searching for the house where this hero lived and died during the Anglo-Greek war, and looking for traces of British power over Greece. He continued to Constantinople and Alexandria, stopping in Smyrna, Cairo, and taking a boat-trip along the Nile. He approached the Egyptian ruins in a similar way he photographed the Roman sites, visiting the monument in its architectural context and making progressive sequences that presented each structure and views from a variety of perspectives.

Many photographs taken in the Eastern countries (Petra, Jerusalem, Baalbec) recall his work in Ireland, where ruins are enmeshed in a quiet and deserted landscape, with atmosphere of spiritual and natural decay. The aesthetic rendering of the texture of the stones into the fibers of the paper negative reached its peak in the records of the tombs of Petra, where he arrived as earliest calotypist in history. As for many early photographic travels, the one by the Irish John Shaw Smith raises questions about his own personal engagement with the sites, his cultural and political background, and a growing tradition of organized itineraries, guidebooks, and architectural documentation.

The whole extent of John Shaw Smith's calotype work (346 calotype negatives and 191 salted paper prints) is conserved in two major photographic collections—the Harry Ransom Humanities Research Center at the University of Texas at Austin (from the collection of Helmut Gernsheim) and the George Eastman House in Rochester (from the collection of Alden Scott Boyer)—and, in minor part, in the Photographic Society of Ireland in Dublin.

MARIA ANTONELLA PELIZZARI

Biography

John Shaw Smith is the only known Irish calotypist who took an extensive trip along the Mediterranean, in Italy, Greece, Turkey, Egypt, the Sinai peninsula, Palestine, Lebanon, Syria, Malta, and Switzerland, between 1850–1852. A smaller body of work documents Irish Celtic ruins, and a trip to Paris. He was born in Clonmuth, County Cork, South Ireland, on October 18,

1811, and was part of the Anglo-Irish landed gentry. His relationships with Scottish, Irish, and French calotypists of his time are possible but not documented. He used Blanquart-Evrard's wet-paper process, improving it for the use in hot and dry climates, and he was a member of the Dublin Photographic society, founded in 1854. His work was not published and was exhibited only once, at the Dublin International Exhibition in 1865. He ended his life tragically, when he shot himself, on January 29, 1873. His large body of work reveals an amateur skilled at the early photographic process, with a good knowledge of other calotypists' works in Europe and the Near East.

See also: Calotype and Talbotype; and Travel Photography.

Further Reading

Nancy C. Barrett, *Catalogue of the Photographs of John Shaw Smith: Annotated and with Description and Analysis*, MA thesis, University of New Mexico, 1981.

Maria Antonella Pelizzari, "The Inclusive Map of John Shaw Smith's Photographic Tour (1850–1852)," *Visual Resources*, vol. XVI (2000): 351–375.

Roy Flukinger, *The Formative Decades: Photography in Great Britain 1839–1920*, Austin: The University of Texas Press, 1985.

Richard R. Brettell, *Paper and Light: The Calotype in France and Great Britain, 1839–1870*, Boston: David R. Godine, 1984.

Nissan N. Perez, *Focus East: Early Photography in the Near East (1839–1885)*, New York: Harry N.A brams, 1988.

Helmut Gernsheim, *Masterpieces of Victorian Photography 1840–1900 from the Gernsheim Collection*, London: the Arts Council of Great Britain, 1951.

Helmut and Alison Gernsheim, *The History of Photography from the Camera Obscura to the Beginning of the Modern Era*, London: Thames and Hudson, 1969.

Edward Chandler, *Photography in Dublin during the Victorian Era*, Albertine Kennedy, 1983.

SMITH, SAMUEL (1802–1892)
English

Samuel Smith, known locally as 'Mr. Philosopher Smith' on account of his amateur enthusiasm for all things scientific, lived much of his life in Leverington near Wisbech, Cambridgeshire, England, where he 're-tired' in the late 1840s after a short but successful career as a timber merchant. He was an amateur astronomer, geologist, microscopist and microscope-maker, and photographer.

He developed his interest in photography c.1851, and between 1852 and 1864, produced a remarkable body of work using le Gray's waxed paper process, sometimes working with Thomas Craddock. His subjects were the ships, buildings and industry of Wisbech, and despite the challenges of the slow waxed paper process, his im-

ages present an evocative picture of the Cambridgeshire town.

He prepared his waxed paper negative materials in batches, testing each new batch by photographing Malvern House, his Leverington home. Several of Smith's negatives bear annotated exposure details, confirming exposure times of between ten and fifteen minutes. Thus, for his many views of sailing ships on the River Nene, low tide was the only time photography was practicable.

There is no evidence that Smith ever used wet collodion. He stayed with the waxed paper process until the mid1860s—making him one of the last photographers in the country to employ paper negatives. After 1864, he abandoned photography to pursue his other interests.

JOHN HANNAVY

SMITHSONIAN INSTITUTION

The Smithsonian Institution was established by act of the United States Congress in 1846. Although this legislation provided for scientific and cultural research with a library, a museum and an art gallery proposed, much of the research and collecting for the first decades of the Institution focused on the scientific interests of Secretary Joseph Henry. Photography was first displayed at the Smithsonian during an 1869 exhibition documenting Native American delegations visiting Washington, D.C., Ferdinand V. Hayden of the U.S. Geological Survey and William Blackmore were influential in supporting the exhibition. Alexander Gardner and Antonio Zeno Shindler of Washington photographed many of the nearly four hundred portraits which became part of the Natural History collections. In the same year photographer Thomas W. Smillie was hired as an independent contractor to document buildings and specimens in the Smithsonian. By 1871, Smillie was appointed the first photographer for the Smithsonian and given a staff position to run the photography unit in the Department of Preparation.

Smillie, with the support of Smithsonian officials like Secretary S.P. Langley, Assistant Secretary G. Brown Goode, and Graphic Arts Curator Sylvester R. Koehler, expanded the scope of his work to include preparing Smithsonian traveling exhibitions related to the history of photography. The first of these exhibitions was sent to the Ohio Valley Centennial Exposition in Cincinnati in 1888. Smillie sought examples of photographs and apparatus from individual photographers (both professional and amateur) and commercial manufacturers to illustrate the technical history of the field and contemporary advances. With a broad vision for the newly formed U.S. National Museum (1881), Assistant Secretary G. Brown Goode supported collecting efforts documenting present and past technologies as well as cultural artifacts

from everyday life. Objects for display in 1888 included Samuel F. B. Morse's daguerreotype camera, the first in America; a portrait of Morse, a plate holder, and a fuming box purchased from the National Photographic Association. William Bell and S.R. Seibert donated additional pieces of apparatus for display. Commercial contributors included George Eastman and the Eastman Dry Plate Company, William Kurtz and the Scovill Manufacturing Company.

Following the close of the Cincinnati exhibition, some of photographic items were retained by the Smithsonian as the start of its photography collection. Work on traveling exhibitions and collecting artifacts for a history of photography collection continued over the next decade. Friends to the collection like John Wesley Powell, of the U.S. Geological Survey and later the Smithsonian's Bureau of American Ethnology, and photographer Frances Benjamin Johnston, who apprenticed with Smillie, were influential in bringing significant acquisitions to the growing collection. In 1896, a Section of Photography was recognized within the Division of Graphic Arts, and established as the first unit of its kind in an American public museum. Smillie was given the title of "honorary custodian" of the photography collection while continuing his work as official Smithsonian photographer; he retained both titles through long career. He died in 1917 while still supervising the photography collection.

The 1896 Washington Salon and Photographic Art Exhibition, sponsored by the Camera Club of the Capital Bicycle Club, presented an opportunity to for Goode and Smillie to expand the national collection of photography to include its first examples of the pictorialist, or art photography. Fifty of the 345 works on exhibit at the Washington Salon where purchased for the Smithsonian's new Section of Photography. The selection of platinum and carbon prints represented work of notable photographers such as Philadelphia photographers Alfred Clements, Clarence Moore, and Henry Troth; New York photographer Charles I. Berg; female photographers Mary Bartlett, Sarah Eddy, Emma Fitz, Emma J. Farnsworth, and Frances Benjamin Johnston; and many amateur photographer members of the Washington Camera Club. Alfred Stieglitz did not submit any of his own photographs to the 1896 Salon but acknowledged the effort of the U.S. National Museum as a step forward in the acceptance of photography as art. Smillie's later correspondence with Stieglitz result in a purchase of twenty-seven photographs from Stieglitz's personal collection of his own work and that of his contemporaries for the installation of the first Smithsonian Hall of Photography in June 1913. The exhibit presented to the visiting public the history of the science, technology and art of photography, select inventors,

professional and amateur photographs and equipment, and the beginnings of the motion picture.

Only four men have followed Thomas Smillie as custodians to the unit: Loring Beeson (1917–1920), A.J. Olmsted (1920–1946), Alexander Wedderburn (1946–1960), and Eugene Ostroff (1960–1994). Wedderburn and Ostroff held the title of curator. Important materials accessioned reference the various processes and formats of photography and significant collections of individual photographers William Henry Fox Talbot, J.W. Osborne, Dr. John W. Draper, Peter Neff, Eadweard Muybridge, H.H. Bennett, Frederic Ives, Ansel Adams, Victor Keppler, Richard Avedon, Elliott Erwitt, and Edward Weston. Works by Washington, D.C. photographers are collected, such as Mathew Brady, Alexander Gardner, William Henry Jackson, William Towle, the Bell and Scurlock families, and Fred Maroon. Strengths in the apparatus collection are the U.S. Patent Model collection, stereoscopic cameras and viewers, the GAF collection and still camera collection, the printing and processing collection, and early motion picture apparatus dating from 1895–1915.

More than one hundred years have past since the inception of the Smithsonian's collections pertaining to the history of photography. Now referred to as the Photographic History Collection within the National Museum of American History, the unit's mission focuses primarily on American photography encompassing social history, technical innovation and aesthetic values. Yet, the Collection has maintained a holistic approach to document the history of the field, study the effects of time, and collect best works of both professional and amateur photographers. The Collection has increased to 150,000 photographs and 10,000 pieces of photographic apparatus.

The Smithsonian Institution now administers sixteen museums each with photograph collections pertaining to its holdings. The African Art Museum, Cooper-Hewitt Museum of Design, Freer/Sackler Gallery of Asian Art, Hirshhorn Museum and Sculpture Garden (modern art/international scope), National Museum of American History, National Museum of American Indian, National Museum of Natural History, National Portrait Gallery, Smithsonian American Art Museum, and Smithsonian Archives all offer rich research opportunities in the study of photography.

MICHELLE ANNE DELANEY

See also: Smillie, Thomas; Scovill & Adams; Eastman, George; Bell, William; Morse, Samuel Finley Breese; Stieglitz, Alfred; Art Photography; Talbot, William Henry Fox; Draper, John William; Brady, Mathew B.; Gardner, Alexander; Jackson, William Henry; and Stereoscopy.

Further Reading

Brown, Julie K., *Making Culture Visible*, Amsterdam: Harwood Academic Publishers, 2001.

Delaney, Michelle Anne, "The 1896 Washington Salon and Art Photography," *American Art Review*, vol. IX, no. 1 (February 1997): 110–115.

Haberstich, David E. "Photographs at the Smithsonian Institution: A History." *Picturescope*, (Summer 1985): 5–20.

O'Connor, Diane Vogt, (ed.), *Guide to Photographic Collections at the Smithsonian Institution*, 4 vols, Washington, D.C.: Smithsonian Institution Press, 1989–1995.

Smithsonian Institution Annual Reports. Washington, D.C.: Smithsonian Institution, annual from 1846.

Wright, Helena, (Guest ed.), *History of Photography*, National Museum of American History, Smithsonian Institution, vol. 24, no. 1 (Spring 2000). Most of the issue was devoted to collections of the National Museum of American History.

SNAPSHOT PHOTOGRAPHY

Before it acquired the photographic meaning with which it is now primarily associated, the word 'snapshot' was originally a hunting or shooting term describing a shot taken quickly, without careful aim or preparation. In 1850, for example, *Blackwood's Edinburgh Magazine* wrote of intrepid African explorers pressing on 'without pausing in their route, even to take a snap-shot at a crocodile basking on a sand-spit' (*Blackwood's Edinburgh Magazine*, August 1850, 231). During the 1850s, when 'instantaneous' photography first became a technical possibility, the term seems to have first begun to be used in a photographic context. Certainly, by 1859, a report of a demonstration of Thomas Skaife's Pistolgraph camera in *The British Journal of Photography* describes how the camera operator 'was directed to snap his camera at the skylight' (*BJP*, 1 July 1859). In this case, of course, the link with firearms is implicit in the name Skaife chose to give his camera. However, the term was also open to a broader interpretation. The following year, for example, writing in *The Photographic News*, Sir John Herschel referred to 'the possibility of taking a photograph, as it were, by a snap-shot—of securing a picture in a tenth of a second of time' (*The Photographic News*, 11 May 1860). On the basis of this remark, Herschel is usually credited with coining the term 'snapshot' to describe a photograph taken with a very brief exposure. However, it is quite possible, that he was simply echoing what was already current usage.

Herschel's comments, whilst prophetic, did not reflect photography's capability at the time. Although 'instantaneous' photographs were indeed produced during the 1860s—often as stereoscopic pairs—it was not until the introduction of much more sensitive gelatin dry plates in the late 1870s that the practice became widespread. Dry plates not only made possible the pioneering chronophotography of Muybridge, Marey and Anschutz but also profoundly affected the work of amateur photographers by extending greatly the range of subjects available to them. Their introduction also had a radical effect on camera design. For the first time, exposures were now brief enough to allow cameras to be held in the hand when taking a photograph. Freed from the need for a tripod, a new generation of hand-held box-form cameras appeared in the 1880s. Because of their comparatively inconspicuous appearance and speed of operation, which made 'candid' photography possible for the first time, these were popularly known as 'detective' cameras—a term coined by Thomas Bolas in 1881. Most were simple wooden boxes, sometimes covered in leather or brown paper, so as to resemble bags or parcels. Some were disguised as books or watches, hidden in ties, hats or walking sticks or intended to be worn, concealed beneath a waistcoat. Most 'serious' photographers rejected the term 'detective' since they felt that it damaged both their individual reputations and that of photography as a whole. They felt that it encouraged the popular notion of the 'camera fiend' who took people's photographs without their knowledge or consent. Henry Peach Robinson, for one, considered that: 'There is something in the sound of the word so mean, sneaking and unutterably low-down that it quite choked me off having anything to do with the whole concern' (*The Amateur Photographer*, 27 March 1896, 270). Robinson's preferred term was the less sensational and more accurate 'hand' camera.

The idea of hidden cameras, of observing without being observed and of being photographed unawares, certainly caught the imagination of the general public. The ubiquitous 'camera fiend' turns up frequently in contemporary cartoons, newspapers and popular magazines. In 1895, *The Amateur Photographer* magazine (founded in 1884 and a manifestation of the rapid growth of photography as a hobby) complained: 'We are gradually beginning to think that when a man gets hold of a hand-camera he loses some of his moral balance, and he does things which otherwise he would not think of doing; and unless he recognises this and pulls himself up short, he degenerates into that worst of all types—the snap-shot fiend' (*The Amateur Photographer*, 19 July 1895, 34). Three years later, when hand cameras were a little less of a novelty, *The British Journal of Photography*, could still write: 'One often hears and reads of the 'hand-camera fiend' who 'snap-shots' (sic) ladies as they emerge from their morning dip at the seaside, or loving couples quietly reading under a shady rock' (*BJP*, 23 December 1898, 818). By the 1890s, then, the term 'snapshot,' whilst still referring to a photograph taken with a brief exposure, had acquired a second and more widely-used meaning as a 'candid' photograph taken without the subject's knowledge or permission. The lure

of covert photography was deemed to be so tempting that even members of reputable clubs and societies had to be warned about succumbing to its attractions. In 1892, a speaker at a meeting of the West Surrey Photographic Society hoped that members of his audience 'would not at any time bring discredit upon hand-camera work by 'snap-shotting' (sic) persons under conditions which might cause unpleasantness' (*BJP*, 11 November 1892, 732). The appropriate choice of subject was not the only cause for concern. The convenience, flexibility, cheapness and comparative ease of use of hand cameras challenged photography's status both as an 'art' and as a 'craft' requiring skill and dedication. As *The Amateur Photographer* observed in 1894: 'The hand-camera has not exercised a most salutary influence on the status of photography; the use of the instrument, the cheapness of some forms too, tending to produce a careless haphazard style of working in which 'flukes' are sure to be occasionally successfu.' (*The Amateur Photographer*, 5 January 1894). Alfred Stieglitz, despite being an early advocate of the hand-camera as a creative tool, concurred: 'The placing in the hands of the general public a means of making pictures with but little labor and requiring less knowledge has of necessity been followed by the production of millions of photographs. It is due to this fatal facility that photography as a picture-making medium has fallen into disrepute' (*Scribner's Magazine*, November 1899, quoted in Nickel, Snapshots, 11). Indeed, since snapshots are usually taken by people with little or no technical knowledge or aesthetic sensibility—with predictable results—the word has also acquired a pejorative association. This seems to be a comparatively recent interpretation. Paul Martin, for example, usually described his photographs as 'snapshots' or even 'snaps' and even called his 1939 autobiography *Victorian Snapshots*.

Confused and threatened by such rapid change, some photographers looked back at what they perceived as a lost 'golden age': 'In the good old time of collodion and silver baths, amateur photographers were comparatively few, and they were looked up to by their friends as being far above ordinary mortals, owing to their knowledge of the black art…They had to do all the work themselves…and felt rewarded for all their trouble by their intense pride in the result. Now, alas! All that is changed, the amateur photographer is everywhere; he knows nothing of the troubles of his predecessors and has no respect for the old amateur…who often finds that he has to take a back seat to make room for the man who, only last week, bought a 'complete outfit' for a guinea, 'directions for use' included' (*BJP Almanac*, 1890,p446). Some die-hard conservatives refused to compromise. Colonel Joseph Gale, for example, when asked whether he would consider doing some hand-

camera work, replied, 'I have not descended to level yet.' (*The Photographic Journal*, July 1934, 345). Others, however, such as Paul Martin, actively embraced the new and exciting possibilities offered by the dry plate and hand-camera, capturing the world of the 1890s with his trusty 'Facile' camera, tucked under his arm. Discovering the delights of candid photography, he later enthused, 'It is impossible to describe the thrill which taking the first snap without being noticed gave one' (Paul Martin, *Victorian Snapshots*, 22). George Davison, who as well as being a leading pictorial photographer was also a director and assistant manager of the Eastman Photographic materials Company, managed to persuade several of his photographic friends, including Eustace Calland, J. Craig Annan and Frank Meadow Sutcliffe, to try out Kodak rollfilm cameras so that the results could be used for advertising or promotion. In 1897, in another initiative to promote the legitimacy of the hand-camera, Davison organised the first public exhibition of snapshot photography. As well as amateur work received as entries for an international competition, the exhibition also included an invitation section of work by leading pictorial photographers and a selection of work by Royal photographers, including Princess Alexandra. The exhibition was a great success and after its three-week run at the New Gallery in London's Regent Street transferred to the National Academy of Design in New York.

The success of the Eastman Exhibition was a measure of the extent to which snapshot photography had caught the interest of the public. Whilst the debate about snapshot photography rumbled on in the photographic press and in club and society meetings, the public had, it seemed, already made up its mind, knowing little and caring even less about the opinions of the likes of Colonel Gale or Alfred Stieglitz. Events had conspired to overtake matters. For in the wider world a revolution was taking place. A revolution that was to fundamentally alter the nature of amateur photography; A revolution that had been triggered in 1888 by the appearance of a 'detective' camera named *The Kodak*.

Marketed with the famous slogan 'You press the button, we do the rest,' the Kodak was simple enough for anyone to use. Eastman claimed: 'We furnish anybody, man, woman or child, who has sufficient intelligence to point a box straight and press a button…with an instrument which altogether removes from the practice of photography the necessity for exceptional facilities, or in fact any special knowledge of the art. Significantly, the camera formed merely part of a complete system of amateur photography that was to revolutionise photography. The Kodak camera was pre-loaded with film. After this had been exposed, the entire camera was returned to the factory for the film to be developed and

printed. The camera, reloaded with fresh film, was then returned to its owner with their negatives and a set of prints. For the first time, the act of picture-*taking* was separated from that of picture-*making*. Contemporary observers soon realised the significance of the Kodak System. Reviewing the Kodak, *Scientific American* magazine concluded that 'it promises to make the art of photography well nigh universal.' Ironically, of course, in making photography universal it also directly challenged its claim to be regarded as an 'art.' How could such a democratic and quotidian medium whose subjects were largely drawn from the trivial and banal have any pretensions towards 'Art'?

Crucially, the Kodak was not aimed at existing photographers but at a vast new untapped market that Eastman had created for photography. As *The Photographic News* was quick to realise: 'The Kodak is intended…to bring into the ranks a new class—those who do not wish to devote the time and attention which is necessary to really practice photography, but who desire to obtain records of a tour, or to obtain views for other purposes' (*The Photographic News*, 14 September 1888, 578). Eastman's own advertising copy put it more succinctly—'Anybody can use it. Everybody will use it.' With cameras placed in the hands of people who were not perceived to be 'photographers,' the word snapshot took on its third and current definition, meaning a photograph taken by an unsophisticated amateur, using a simple camera. Today, it is the intent of the photographer rather than the exposure time or choice of subject that best serves to define the snapshot. Whilst the majority of snapshots are taken with comparatively brief exposures, some are not. Moreover, whilst the word also implies a degree of spontaneity, many snapshots are the result of considerable preparation and arrangement of the subject. The fundamental characteristic of the snapshot is that it is a 'naïve' document motivated solely by a personal desire to create a photographic record of a person, place, or event with no artistic pretensions or commercial considerations.

Following the success of the Kodak, the rapid introduction of ever-cheaper camera models, culminating in Eastman's introduction of the Brownie camera in 1900, removed many of the financial as well as the technical constraints that had delayed the popularization of photography. For the first time, photography became truly accessible to millions of people. In 1896, even before the appearance of the Brownie, the writer, J. Ashby Sterry, wrote about 'these days of the universal Kodak and perpetual snap-shooter' (J. Ashby Sterry, *A Tale of The Thames*, 1896). In 1899, *The New Penny Magazine* in an article entitled 'Snap-Shot Photography' could confidently claim that 'Almost everyone now has some idea of the taking and making of a photographic picture'

(*The New Penny Magazine*, 1899, 282). The snapshot had come of age.

COLIN HARDING

See also: Davison, George; Eastman, George; Herschel, Sir John Frederick William; Kodak; Camera Design: 5 Portable Hand Cameras (1880–1900); Camera Design: 6 Kodak, (1888–1900); and Instantaneous Photography.

Further Reading

Coe, Brian, and Paul Gates, *The Snapshot Photograph: The Rise of Popular Photography, 1888–1939*. London, Ash & Grant, 1977.

Green, J. (ed.), *The Snapshot*, Aperture, 19, 1974.

Ford, Colin, and Karl Steinorth, *You Press The Button, We Do The Rest: The Birth of Snapshot Photography*, London, Dirk Nishen Publishing, 1988,

King, Graham, *Say Cheese: The Snapshot as Art and Social History*, London, Wiliam Collins Sons & Co Ltd, 1986.

Martin, Paul, *Victorian Snapshots*, London, Country Life Limited, 1939.

Nickel, Douglas R., *Snapshots: The Photography of Everyday life,1888 to the Present*, San Francisco, San Francisco Museum of Modern Art, 1998 (exhibition catalogue).

SNELLING, HENRY HUNT (1817–1897)

The History and Practice of the Art of Photography, published in 1849, was the first book from the pen of Henry Hunt Snelling, who would go on to establish, edit, and publish the influential *Photographic Art Journal* in 1851.

A writer, editor and photographer, Snelling was born in Plattsburg, New York, on November 8, 1817, where his father, a colonel in the US Army, was stationed. He spent much of his childhood travelling to new postings with his parents, eventually settling in Detroit with his mother in 1829 after his father's death.

After a number of generally unsuccessful business ventures, Snelling, in 1847, took up a position with Edward Anthony, then the major manufacturer and supplier of photographic materials, equipment and accessories. Questions about technique from customers reputedly encouraged Snelling to believe that there was a market for instruction manuals, and *The History and Practice of the Art of Photography* appeared within two years.

It was, however, the monthly publication of *The Photographic Art Journal*, renamed in 1854 *The Photographic and Fine Art Journal*, which established Snelling as perhaps the most authoritative voice on the development of American photography at the time. Two further books, *A Dictionary of the Photographic Art* (1854), and *a Guide to the Whole Art of Photography* (1858) further cemented his reputation.

JOHN HANNAVY

SOCIÉTÉ FRANÇAISE DE PHOTOGRAPHIE (SFP)
French organization, 1854 to present

The Société française de photographie (SFP) was founded November 15, 1854, by seventeen former members of the Société heliographique (SH) (1851–53) and a number of prominent figures in the sciences, the arts, government, and society—non-photographers as well as practitioners. The character of the earlier Société heliographique, a rather relaxed, genteel group with meeting rooms in the home of its president, Colonel de Montfort, intimate photographic soirees in private homes, and a self-described identity as an organization for "those looking in their leisure time for the charm of a noble interest and the attraction of an elevated preoccupation" (Janis 1983, 42) was that of an exclusive group of enlightened amateurs. The SFP adopted a more formal structure appropriate to a learned society organized on the model of the French Academies. The precise connections between the earlier organization and the SFP have yet to be traced. Although many former SH members became members of the SFP, the SFP was not a continuation of the earlier organization. In fact, prominent members of the earlier group are notable in their absence, for example, Henri LeSecq and Ernest Lacan, while others, such as Eduard Baldus only joined later.

The Société française de photographie defined itself under its organizing statutes as "an artistic and scientific association of men studying photography." Membership was limited and exclusive. By charter there would be two hundred regular members, and an additional two hundred corresponding members from outside Paris; a membership number no doubt based on the model of the two hundred member Institut de France. Ten of the founding members of the SFP were members of the Institut de France, including the first president Victor Regnault. They also counted among their founders, members of the nobility, i.e., Count Aguado, Baron Gros, and Baron Humbert de Molard. Included among the ninety-three founders were representatives from the arts—Eugène Delacroix, Vallou de Villeneuve, Louis Robert, Eugène Durieu and Eugène Cuvelier—and sciences—the botanist Brébisson, naturalists Geoffrey-Saint-Hilaire and Louis Rousseau, and physicist Léon Foucault. Several members came from the mid and upper ranks of the Second Empire bureaucracy. And, of course, a number of photographers associated with the Société Heliographique—Hippolyte Bayard, Gustave LeGray, Charles Nègre, Blanquart-Evrard, Léon de Laborde—were also founding members. Victor Regnault, a physical chemist, director of the Imperial Porcelain Manufactury at Sèvres, and a photographer, served as the SFP's first president, a position he held

until 1868. By 1855 membership had grown to 165 members. The aspirations of the organization were defined in the first issue of the *Bulletin de Société Français de Photographie* (January 1855) which explicitly denied "any consideration foreign to purely scientific and artistic goal[s]…[other than] the pure love of the photographic art and science" (McCauley 1994, 41). McCauley identified a strong anti-commercial bias in the membership and program of the SFP and notes that during a period characterized by the explosion of commercial photography studios and the firms serving them (1850–1870), relatively few commercial operators were to be found in its membership rolls.

The SFP's administrative committee comprising fifteen members and officers organized regular bimonthly meetings which were conducted under formal rules of order like those governing the Academies. Committees were established to investigate reports, review scientific submissions—generally to do with innovations in processes and equipment—and to vet technical communiqués. Meetings and the work of the committees were reported in the *Bulletin de Société Français de Photographie,* which also announced competitions, almost exclusively of a scientific or technical nature, and published the prize-winning submissions. The secretary carried on lengthy correspondence with a number of foreign photographic societies excerpts of which appeared in the *Bulletin*. The *Bulletin* quickly settled into a dual role as the means of communicating the work of the SFP and its members, and a journal devoted to the scientific and technical aspects of photography. Issues that might have been of interest to commercial photographers—laws governing photographic rights, or advances specifically geared to commercial interests in the rapidly industrializing practice of photography—were not addressed. It was no doubt due to the lack of support for commercial interests that in 1859 Ernest Mayer, of the firm Mayer frères et Pierson, founded the Union photographique as a mutual aid society for photographic workers.

Within months of its founding, the SFP began to organize photographic exhibitions; the first opened in September 1855 and coincided with the Paris Universal Exposition which featured a remarkably strong showing of photographic work. Between 1855 and 1876, the SFP organized eleven photographic exhibitions—1857, 1859, 1861, 1863, 1864, 1865, 1869, 1870, 1874, and 1876—a continuous program of exhibitions which roughly coincided with the Paris painting salons. Exhibitions were open to members and non-members, and to foreigner practitioners. The SFP's exhibitions quickly achieved the status of the photographic salon on the order of the official paintings salons. The 1859 SFP exhibition was held in the Palais des Champs-Elysées in rooms adjacent to the Salon, the government sponsored

painting exhibition. Subsequent exhibitions opened on the same day as the *Salons,* which rejected all submissions in photography. The Société's exhibition committee also organized French representation in exhibitions in other countries. SFP members exhibited as a group in Brussels in 1856, in a large space dedicated to French photographic achievement. This was also the case in reciprocal arrangements the SFP entered into with the Royal Photographic Society (RPS) of England; in the RPS exhibitions of 1858 and 1863, SFP members were accorded their own section or rooms.

By far the most press recognition and critical attention accorded to photography was directed to the exhibitions of the SFP. With the exception of the 1855 exhibition, every later exhibition was accompanied by a catalogue which listed photographers by name and nationality, described the subject of submitted images, and identified both negative and print processes. They constitute an invaluable resource for researchers. In addition, the *Bulletin* devoted extensive coverage and detailed reviews to all of the SFP exhibitions, as well as the photography sections of the Universal Expositions of 1855 and 1867, and international exhibitions of photography in Brussels, London, Edinburgh, etc.

The scientific focus came to dominate the SFP to the exclusion of the arts towards the end of the nineteenth century. Within the *Bulletin* there are fewer references to artistic projects by members; discussions of issues of aesthetics, never prominent, disappear. The criteria for evaluating work presented in the SFP exhibitions increasingly focused on technical competence. As the nineteenth century drew to a close, the SFP came more and more to function as a scientific academy in which scientific and technical issues could be presented and debated, and as a repository for technical examples. Prizes for technical innovation were offered under the aegis of the Société and a number of technical challenges were posed by the Société with awards determined by committees made up of members with scientific backgrounds. This insured that important innovations were presented first to the SFP for publication in the *Bulletin.* Scientific and technical submissions ranged from that of Edmund Becquerel, a founding member, who published the results of his experiments with heliochromy, or recording the colors of the light spectrum on daguerreotype plates, to Alphonse Poitevin's presentation of a photolithographic printing process. But the SFP's preoccupation with scientific and technical questions created an increasing sense of disenfranchisement for members who aspired to artistic photographic practice. Ultimately, although some maintained membership in what was clearly the most prestigious photographic organization in France, they and others formed organizations that reflected more closely their interests. Such an organization was the Photo-Club de Paris, founded

in 1894 by SFP member Robert Demachy and others, to address the interests of artistic photographers. The Photo-Club's first exhibition (1895) was titled the First Exhibition of Photographic Art, a rather heavy-handed effort to distinguish their program from the exhibitions of the SFP. This division of artistic practice from the overwhelmingly scientific and technical bent of photographic organizations, such as the SFP, was echoed by similar organizations in London—Linked Ring Brotherhood—and Vienna—Das Kleeblatt (The Clover Leaf)—and New York—The Photo-Secession.

Société française de photographie continues to this day as a research center. Their holdings include superb collections of images—contemporary and historic, examples of rare photographic processes and types of equipment, as well as members' archives which include papers and photographic prints and negatives. The Société maintains a library devoted to historic and contemporary photography. In 2006, they list their holdings at 10,000 books and five hundred photographic journals from twenty-four countries. This includes extensive holdings of early photographic journals from around the world. The collection of early photographs can be counted among the most important of French photographic collections. Publication of the *Bulletin* continues, and is joined by a journal devoted to historical and critical research, *Études photographique.* The SFP continues to promote the study of photography—both its history and contemporary use—through lectures and its collection.

Société française de photographie (www.sfp.photographie.com), 71, rue de Richelieu, 75005 Paris, France.

KATHLEEN STEWART HOWE

See also: Société héliographique

Further Reading

Buerger, Janet E., *French Daguerreotypes*, Chicago and London: University of Chicago Press, 1989.

Bulletin de Société Français de Photographie, Paris, 1855–.

Janis, Eugenia Parry, and Andre Jammes, *The Art of French Calotype with a Critical Dictionary of Photographers, 1845–1870,* Princeton, NJ: Princeton University Press, 1983.

McCauley, Elizabeth Anne, *Industrial Madness: Commercial Photography in Paris, 1848–1871*, New Haven and London: Yale University Press, 1994.

Poivert, Michel, "La SFP rejoint la BnF." *Revue de la Bibliothèque Nationale de France,* 2, 1994.

SOCIÉTÉ HÉLIOGRAPHIQUE

In the early stages of the history of photography, many people were experimenting with the new medium. The calotype process, which is a paper negative process, was one of the most important techniques of the time.

In 1851, a group of artists, writers, and photographers got together and formed the first photographic society in the world: the Société héliographique française. The creation of this photographic society was a landmark moment in the evolution of photography and important for its history. It was a network of people excited about the possibilities of the calotype and interested in exchanging both chemical and artistic skills, which contributed to the expansion and development of photography through exhibitions, members' projects such as La Mission Héliographique, and the review, *La Lumière*.

The 1850s was a time when many different groups were being established and efforts were being made to legitimize the new medium. The objective of the society was to unite those involved in the new process and to exchange ideas. The Société héliographique was an important development for the growth and recognition of photography because it promoted the medium.

The society was formed by Baron de Montfort in January of 1851 in Paris, France and its first president was Baron Gros, a diplomat and photographer. The group was made up of mostly photographers, amateur and advanced, as well as painters, writers, scholars, and public figures. The society's board included Hippolyte Bayard, Edmond Becquerel, Benjamin Delessert, Eugène Durieu, Mestral, Léon de Laborde, Claude-Marie-François Niépce of Saint-Victor, Jules-Claude Ziegler and Baron de Montfort himself. Many of master photographer Gustave Le Gray's students, as well as students of painter Eugène Delacroix's, were members; both of these artists were also members. Additional members included Olympe Aguado, Arnoux, Aussandon, Edouard Baldus, Barre, Champfleury, Charles Chevalier, Cousin, Desmaisons, Fortier, Count of Hassounville, Horeau, Lemaître, Henri Le Secq, Noël-Marie-Paymal Lerebours, Leisse, Frédéric Bourgeois de Mercey, Montesquiou, Prince of Montléart, Emile Peccarère, Viscount Adolphe of Poncéau, Peuch, Puille, Victor Regnault, Schlumberger, FrançoisAuguste Renard, Viscount Joseph Vigier and Francis Wey.

The headquarters of the society was at Baron de Montfort's home, 15 rue de l'Arcade in Paris. The top floor of the building contained meeting rooms as well as rooms closed off for developing and experimenting in the new medium and an outside terrace for members' use. The building also had a shop, owned by Mr. Peuch, which sold photographic materials.

Members were united with a common cause which was to endorse photography through exhibitions, share technical information, publish reviews and more. They met frequently to work on developing the technique. Lengthy discussions took place and served as a way to pass along skills and knowledge of the technique. Beyond the regular informal get-togethers, the society had "photography soirées" at the Baron de Montfort's home or at other members' homes.

The society also held exhibitions, notably an opening exhibition in January of 1851 as well as an exhibition which included a portfolio "intended to illustrate the best French photography" by Charles Nègre titled *Little Ragpicker* (Pare, 228). The society also assembled a collection of photographs in the form of albums.

The weekly magazine, *La Lumière*, was a significant part of the society and prospered even after the society ended. Under the direction of both Francis Wey, who served as head of the society for part of its existence, and Ernest Lacan, *La Lumière* reviewed exhibitions as well as members' work and even recorded the society's meetings. While reporting on photographic projects of the time, *La Lumière* expressed the great enthusiasm for the medium that the members shared in the Société héliographique. The magazine existed from 1851 to 1860 and remains a very important document for the medium's history of the time period, and certainly for the history of the Société héliographique.

Since the 1850s was an important time for the advancement of photography, the Société héliographique played an important role in its progress. For example, five members of the society—Gustave Le Gray, Mestral, Édouard Baldus, Hippolyte Bayard and Henri Le Secq—became the group that formed the Mission Héliographique, commissioned by the government's Commission of Historical Monuments. One of the leading members of the Commission, Léon de Laborde, was also a member of the Société héliographique. The mission's goal was to send these five photographers across France to document important French architectural structures. This effort, a large proportion of which was produced by using le Gray's waxed paper process, was an attempt to record French cultural heritage and began shortly after the foundation of the Société héliographique. *La Lumière* reported with great fervor and praise for the project.

British photographer, Roger Fenton who had studied in Paris under painter Delaroche from 1841–1843, went back to France in 1851 to study the structure and organization of the newly created Société héliographique. The following year he drafted a proposal for a photographic society back in Britain and eventually founded the London Photographic Society in 1853.

The Société héliographique française dissolved in 1854 and became the Société française de photographie which still exists today. As for the end of this group, photography historian Michel Frizot explains in "Calotypists circles," that "this "secession" may be related to the change in technique from paper to glass negatives and the need for better organization of meetings, which remained informal and friendly" (*A New History of Photography*, Frizot, 70). The group was informal

but then as the medium became more complex, it was necessary for a more disciplined approach to exploring its complexities. The Société héliographique published reviews, held discussions and exhibitions related to promoting the technique, and served as a model for future organizations. The society still remains an important step in the evolution of the photographic medium.

KRISTEN GRESH

See also: Calotype and Talbotype; Société héliographique Française; *La Lumière;* Mission Héliographique; Montfort, Benito de; Gros, Baron Jean-Baptiste Louis; Bayard, Hippolyte; Becquerel, Edmond Alexandre; Delessert, Edouard and Benjamin; Durieu, Jean-Louis-Marie-Eugène; Mestral, Auguste; de Laborde, Henri; Niépce de Saint-Victor, Claude Félix Abel ; Ziegler, Jules; Le Gray, Gustave; Delacroix, Ferdinand Victor Eugène; Wey, Francis; Le Secq, Henri; and Fenton, Roger.

Further Reading

De Mondenard, Anne, *La Mission Heliographique: Cinq photographes parcourent la France en 1851*, Paris: Centre des monuments nationaux/Monum, Editions du patrimoine, 2002.

Frizot, Michel (ed.), *La Nouvelle Histoire de la Photographie*, Paris: Bordas, 1994 (translation: *A New History of Photography,* Cologne: Könemann, 1998).

Jammes, André and Janis, Eugenia Parry, *The Art of French Calotype with a Critical Dictionary of Photographers, 1845—1870*, Princeton: Princeton University Press, 1983.

Pare, Richard, ed., *Photography and Architecture: 1839–1939*, Montréal: Canadian Center for Architecture, 1982.

SOCIETIES, GROUPS, INSTITUTIONS, AND EXHIBITIONS IN ASIA (EXCLUDING INDIA)

The photographical technique was a blend of various inventions stemming from diverse origins. Soon after its first public circulation in August 1839, photography freely entered the commercial field. The ability, open to everyone, to daguerreotype was the key to success. Photography then spread through Europe, America and few years later throughout the world. The spread of photography in Asia, as elsewhere, does not only come from the novelty of the process. It also benefited from the commercial expansion of western countries through eastbound sea routes and first appears in Asia in coastal towns open o foreign trade.

Photography also reached the orient with the various diplomatic or military expeditions, as they often included an amateur or a professional photographer.

Soon, many adventurers, attracted by the chance of fortune, would try to establish photographic studios in Asia. Singapore—first trading post in 1819, then crown colony in 1867—had its first documented photographer in 1843. The economic growth of the colony attracted many studios such as August Sachtler, 1863, and G.R. Lambert & Co, 1867. The enthusiasm of the foreign community both drew new photographers to Singapore and urged them to get organized. The first official society was the Strait Photographic Association, created in 1887 at Hill Street. The first president was D.C. Neave, founder o the F&N Company. As soon as 1894, members of this association took part in international photographic competitions and won prizes in Jakarta.

In the same period, China was compelled to open Canton (Guangzhou), Amoy (Xiamen), Foochow (Fuzhou), Ningpo (Ningbo), and Shanghai to foreign trade and cede Hong Kong, following the signature of the Treaty of Nanking on 29 August 1842. It allowed British merchants to establish "spheres of influence" in and around the ports and permitted the installation of occidental newcomers (merchants, soldiers, traders, diplomats, adventurers etc.) and with them along came photography. Jules Itier took the first documented daguerreotypes of Macau and Canton in 1844. He was a member of the French embassy of Théodose de Lagrenée, who signed the treaty of Whampoa (24 October 1844) between France and China.

The arrival of photography depended on the opening to foreign trade of the coastal owns of southern China. However the first photographers society was founded only in 1937, it was The Photographic Society of Hong Kong. It also followed the route of military expeditions, as the armies took photographers along. Felice Beato would go further in land in 1860, taking pictures in the trail of the Anglo-French force, which invaded Peking and burnt the famous Summer Palace.

Photography reached Japan in much the same way. From 1853 onward, Japan, closed to all foreign trade since 1639, started to open its ports under the pressure of western countries. Ports as Yokohama, Nagasaki, or Kobe were then open to westerners. The first known daguerreotype of Japan dates from 1857, but professional studios appear only a few years later. Charles Wirgman, sent to Japan as a correspondent of *The Illustrated London News* as soon as 1861, invited Felice Beato to join him in 1863. Together, they founded in 1865 their first commercial venture, a studio in Yokohama. It is significant that when the second owners of this firm were still westerners, Stillfried & Andersen, the next one was a Japanese, Kusakabe Kimbei.

The further improvement of photographical techniques increasingly mastered by Japanese would foster amateur practice. The first society, the Nihon Shashinkai was created in 1889 by William Burton, a professor at Tokyo's imperial university, Ogawa Kazumasa, and other native and foreign photographers. Ogawa's friend, Japanese Viscount N. Okabe was an amateur

photographer too and through his wealth and position could help the development of photography in Japan. As a president of this society Enomoto Takeaki, an influent member of the Meiji government, tried to promote photography as an artistic medium. Other photographic societies emerged at the turn of the century, such as the Tokyo Shayu –kai, founded by Osaki Koyo, or the Toyo Shashin-kai, by Miyauchi Kotaro.

In south-east Asia, the lead of Thaïland in the adoption of photography must be noted. It is due first and foremost to the implication of King Rama IV. The king created a royal department of photography in his government and had the queen and himself portrayed. The French bishop Pallegoix, leader of Siam's Catholic Church, introduced daguerreotype a mere few years after its invention. According to a 1905 edition of the Sayam Prabhet newspaper, the country's first native photographers were Pallegoix's students, Phraya Kasapkijkosol, Phra Preechakolkarn and Luang Akaneenaruemitr, who is best known today as Chit Chitrakanee or Francis Chit.

In other parts of south-east Asia, the British colonial administration sent various archeological or artistic surveys, often with a photographer, such as the one sent to Burma in 1855 to document the ancient town of Ava.

Photographers reached Indochina and other French colonies or protectorates following the progression of troops in Cochinchina. Emile Gsell was the first to settle in Saigon and have his studio there from 1866 to 1879. The progression of the troops in the north—Annam and Tonkin—allowed photography there too. Hocquart, a military doctor, illustrated through his photographs the progress of French colonization. But no real organization dedicated to photography was established before the beginnings of twentieth century. The EFEO—French school of far-eastern studies—established in Hanoi in 1900, was the first body to launch extensive photographic campaigns.

Documentation about societies, groups and exhibitions of photography in far-east Asia is very scarce and few historians have so far had either the ability or the will to search through the subject. The broad outline as it appears today is that of a parallel progression of photography, trade, military conquests, religious missions and industry. The countries where a strong political system, and the social elites, were willing to adopt the new technologies brought from the west, such as Siam and Japan, were the ones where amateur and professional photographers first got organized in societies or government bodies. Many foreigners were also probably members of photographic societies in their home countries. Elsewhere the societies seem to appear only in the twentieth century. It is likely that the exhibitions or fairs dedicated to industry and trade also played a role in the diffusion of photography but they are yet to be studied. It would be interesting to compare the case of far-east Asia to that of India, where photography rose fast and strong in the nineteenth century.

JÉRÔME GHESQUIÈRE

See also: Lambert & Co., G.R.; Beato, Felice; von Stillfried und Ratenitz, Baron Raimund; Chit, Francis; and Gsell, Emile.

Further Reading

Falconer John, *A vision of the past, a history of early photography in Singapore and Malaya, the photographs of G.R. Lambert & Co., 1880–1910*, Singapore, ed. Times Editions, 1987.

SOCIETIES, GROUPS, INSTITUTIONS, AND EXHIBITIONS IN AUSTRALASIA (INCLUDING NEW ZEALAND AND PACIFIC)

Nineteenth-century Immigrants from Great Britain who chose to settle in Australasia may have been surprised to find that once they'd settled into their new homes, they had on their doorstep some refinements which hitherto may have been denied them because of their status in society. These were learned institutions which went under a multiplicity of names like the Philosophical Society or the Mechanics Institute. Some of these may have been fostered by those who were responsible for organising their passage in the first place. For instance, the New Zealand Company, largely responsible for the settlement of Port Nicholson, saw to it that a consignment of books was dispatched to the colony. For an annual membership fee, immigrants could join these groups and participate in the exchange of information on a myriad of topics, especially the arts and sciences.

Wellingtonians for instance, were able to boast a Mechanics Institute in a temporary dwelling which was purchased for £30 in 1842, barely two years after the settlement was established. This housed a library and a selection of (unspecified) scientific instruments which had been purchased in London prior to the departure of the first immigrant ships that left England in September 1839.

Institutions like this became a conduit which saw the dissemination of knowledge including the virtues of the daguerreotype and other photographic improvements which followed at a rapid pace. It may come as a surprise to known that Australians and New Zealanders were more than familiar with the theoretical workings of the daguerreotype and the calotype well before a decade had elapsed after their discovery. Wellington's Mechanics Institute represents just one of many fledgling institutions that developed throughout Australasia.

Of course anyone involved in the arts and sciences in mid-Victorian times was eagerly sought to give ad-

dresses to its members. In August 1848, the daguerreotypist H.B. Sealey was invited to become a member of the Mechanics Executive Committee after he had presented an address on the daguerreotype.

Elsewhere in the South Pacific, with smaller centres of population, it would be difficult to maintain anything approaching a society or an institution.

However, as missionaries were very active with cameras, it may have occasioned an instance whereby one of their party may have given a talk or demonstration of their skills. Their audience may have included land owners, government employees and traders. For instance, the French settlement in New Caledonia saw a number of photographers from 1848.

After the discovery of gold in payable quantities, some cities like Melbourne in Australia and Dunedin in New Zealand's South Island, demonstrated their wealth with trade exhibitions. These colonial events attempted to follow that which had been established in London in 1851 with The Great Exhibition. They were ideal platforms for displaying photographs and elicited great attention whenever they were staged. Dunedins' first exhibition was in 1865 and it was repeated again in 1889/90, when it carried the more impressive title of title of the New Zealand and South Seas Exhibition.

Gradually, as some of the wrinkles were removed from photography an ever growing number of educated people began to take up the craft as a recreational pursuit. Some of these amateurs formed themselves temporarily into groups like those who met on 8 December 1858 in Sydney under the auspices of the Philosophical Society of New South Wales.

This may well have been the first such group in Australasia. As amateurs tended to push the boundaries of photography, there eventually came a need to show their handiwork to a wider audience. The amateur photographer Rev. John Kinder (1819–1903) exhibited a selection of his photographic views at two exhibitions run by the Auckland Society of Arts in 1870 and again in 1873. Despite these developments, photographers in Australasia had to wait many years before anything resembling a photographic society of some significance got off the ground.

In New Zealand the first photographic organisation to appear on the scene was the Amateur Photographic Association of 1882, which met on a monthly basis and had its base in Wellington. A prominent member of this Association was Arthur Thomas Bothamley (1836–1948), a civil servant who played an important role in New Zealand's exhibit at the 1876 International Exhibition in Philadelphia. Also active about this time in the Association was an amateur who went on to become a member of the New Zealand's Parliament, William Thomas Locke Travers (1819–1903). In 1871, Travers read an important paper to the Wellington Philosophical Society on "Out-door photography," a report which drew attention to some photographic characteristics peculiar to this part of the world, like the effect of ultra violet light on photographic emulsions which had been devised mainly for use in the northern hemispheres.

The 1890s witnessed a period of tremendous expansion as easy-to-use cameras of all description became available at low cost. Photographic clubs and societies were formed in nearly every major settlement. A highlight in their annual calendar of events was the Intercolonial Exhibitions which saw entries from both sides of the Tasman Sea gathered together where they were judged and awarded medals and certificates.

Attempting to bond these widely spread groups into a united front fell unwittingly into the lap of several publications which were established in the early 1890s. Two of these were Australian journals. They were *Harrington's Photographic Journal* which, though printed in Australia, was also released in New Zealand. It was founded in 1892. Similarly, the Australian Photographic Review also found its way across the Tasman from 1894. In New Zealand, *Sharland's New Zealand Photographer*, also commenced publication in 1892. This was edited by Josiah Martin, (1843–1916) a commercial photographer who amongst other things opposed soft focus photography and actively campaigned for a number of matters which identified injustices to photographers when it came to government agencies who were undercutting professionals who were involved in supplying prints for the lucrative tourist market.

As the nineteenth century came to a close, New Zealand photographers were able to measure themselves for the first time against their overseas counterparts. A British annual called *Photograms of the Year*, which published a yearly survey of fine art prints from around the world, despatched a folio which included examples by H.P. Robinson. These were toured in Australasia by photographic clubs and societies in 1896.

WILLIAM MAIN

See also: Daguerreotype; and Photograms of the Year (1888–1961).

Further Reading

Dunn, Michael, *John Kinder: Paintings & Photographs,* SeTo Publishing 1985.

Newton, Gael, *Shades of Light—Photography and Australia,* Colins 1988.

Kakou, Serge, *Découverte Photographique de la Nouvelle-Calédonie 1848–1900.* Actes Sud 1998.

——, *International Exhibition Catalogue 1865.*

——, New Zealand and South Seas Exhibition Catalogue 1889–1890 Hocken Library, Otago University, Dunedin New Zealand.

Main, William, *Wellington Through a Victorian Lens,* Millwood Press, 1972.

——, Wellington Philosophical Society Archives,Te Papa Tongarewa, Museum of New Ze, and Turner, John, *New Zealand Photography—from the 1840s to the present*,PhotoForum 1993.
——, Wellington Philosophical Society Archives,Te Papa Tongarewa, Museum of New Zealand,
——, Wellington Camera Club Archives, Alexander Turnbull Library Wellington, New Zealand.
——, *Sharland's New Zealand Photographer 1892–1911*, Alexander Turnbull Library, Wellington, New Zealand.
Ward, Louis E., *Early Wellington*, Whitcombe & Tombs, 1928.

SOCIETIES, GROUPS, INSTITUTIONS, AND EXHIBITIONS IN AUSTRIA

Among the most important places and proliferation of early photography in Austria is Physikinstitut der Wiener Universität, das Polytechnische Institut in Wien (1815 an engineer created academy, which is called today the University of Vienna) and the Niederösterreichische Tradesman's Union (which was a 1839 union of the industrial middle class with financial support from Viennese aristocracy circles, and is known today as the Austrian Tradesman's Union). Andreas von Ettingshausen was chair of physics at the Viennese university since 1834, and was a reader of the publication of the Daguerreotype in Paris 1839. Von Ettingshausen and his nephew William Burger gave lectures on photography between 1863 and 1867. From 1896 to 1930 these types of lectures were given by the photographer Hugo Hinterberger who specialized in photomicrographs. Johann Joseph Prechtl (supervisor from 1815, and until 1849 was the director of the school) and the chemists Anton von Schroetter and Joseph Johann Pohl were the main figures responsible for supporting photography at the polytechnic institute. On Prechtls suggestion Anton George Martin (initially an assistant at physical Institut, starting from 1843 as the librarian of the polytechnic institute) and the others began to experiment with photography.

Under Anton of Schroetter general guidance, the school's own Chemistry institute developed a laboratory equal to that of several photographic pioneers, under the direction of Andreas Groll and Johann Natterer, and particularly Joseph Johann Pohl, who became coworkers of Anton George Martin in 1846. He also, in 1858, gave relevant lectures on photography and micro photography at the polytechnic institute and became a professor of chemical technology (1862–1895) and later a teacher of Josef Maria Eder.

Among other famous photographers was Wilhelm Horn, who before he opened his studio in Prague in 1841, was the publisher of the first photographic technical periodical in German-speaking countries (photographic journal) from 1854 to 1865, and the founder of the first Central European photography wholesale business.

Andreas von Ettingshausen, Johann and his brother Joseph Natterer, and August Artaria were considerable representatives of the Niederoesterreichi Tradesman's Union who represented Simon Ploessl and Wenzel Prokesch, the art dealer and publisher. The association secretary, William Horn, who had been in this postion since 1841, traveled to Paris to establish an exchange between Austrian and French photographers and was a general manager of the world exhibition of 1873 in Vienna. From the Niederoesterreichi Tradesman's Union, various initiatives proceeded for the establishment of public technological-historical collections after 1873 in addition to the efforts started in 1908 of the establishment of the Gründung des Technischen Museums Wien, which opened in 1918. In its exhibition contents among other things, valuable photographic historical pieces from the collection of the poly-technical institute were displayed.

The earliest association which centered on the application of photography in Austria has traditionally been the Fürstenhofrunde, which existed from 1840 to 1842. At first this organization was more informally a club of photographic pioneers consisting of Josef Berres, Anton George Martin, Josef Maximilian Petzval, Joseph Johann Pohl, Wenzel Prokesch, Peter Wilhelm Friedrich von Voigtländer, and August Artaria, which met at the Naturwissenschaftlern, Technikern und Medizinern, Künstlern und Gewerbetreibenden zusammengesetzter Klub von Fotopionieren. They also met at the house of the painter Carl Schuh zu Fachgesprächen or in the building of the Fürstenhofs in Vienna to discuss common experiments. The testing of Petval's revolutionary lens design of 1840 is probably the group's most significant experiment.

An outstanding instance of the early paper photography in Austria embodied the photographic studio of K.K. Hof and the state of printing, which increased in 1841 under the direction of Alois Auer who was the director until 1866. In the 1850s and 1860s one of the best innovations created were the print manufacturing plants of Europe. Many aspects of public research and development focused on visual presentation because these plants were able to produce large sized architecture and panorama photographs, expedition reports, photomicrographs and first photo-mechanical pressures through unusually systematic and effective production lines, allowed the variety of reproduction methods and picture documentation to be widely distributed with relative ease and conformity.

Legal restrictions concerning copyrights were introduced to Austria in 1861, which led to the establishment of a photographic copyright association. The photographic society in Vienna remains today the oldest and most long-lived interest agency of photography in German-speaking countries. This association at first was

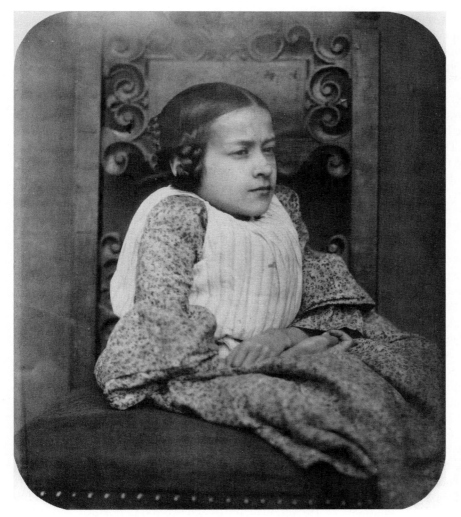

Antoine, Franz. Hermine Antoine.
The Metropolitan Museum of Art,
David Hunter McAlpin Fund, 1948
(48.83.21) Image © The Metropolitan
Museum of Art.

mainly modelled after the Société française de photographie, however the state-conformed civil organization nevertheless was somewhat dominated by the same stucture existing in the country's government.

The first president of the society however was Anton George Martin (elected in 1861 until 1865, then again from 1868 to 1870). He was followed by the chemist and school teacher Emil Horing (president 1866 to 1867 and 1870 to 1883) and the officer and reproduction technician Ottomar of Volkmer (president 1885–1901). Furthermore among the group's members were Ludwig Angerer, Rudolf Eitelberger, Josef Maximilian Petzval, Joseph Johann Pohl, Ludwig Schrank, Anton von Schroetter and Wilhelm Schwarz-Senborn. The society pursued commercial goals and offered advertisements in their association magazine *Photographische Correspondenz* (from 1864 to 1971 since from 1956, the official scientific organ came from the Sektion der Deutschen Gesellschaft für Photographie in Cologne) however, *Photographische Correspondenz* was always also a current, supraregional and effective forum for the broader proclamations of scientific-technological innovations. In addition it was prominent in the orga-

nization of exhibitions in 1864, in Vienna as the first specialized photographic exhibition in German-language countries. This exhibition provided a historical sample and apparatus collection as well as a library of relevant international specialized publications, recently located at Graphischen Lehr- und Versuchsanstalt but today, on loan to the Fotosammlung der Albertina in Vienna). The purpose of Österreichischern Museums für Kunst und Industrie (1864 opened; first director: Rudolf Eitelberger) was to provide a platform for central discussions reagrding modern visual culture, similarly fashioned after that of the larger model of the South Kensington Museum. The integration of photography into this discussion was helped along through the establishment of the museum's own photographic studio, led by the renowned photographer Ludwig Angerer. Further support of photography within the museum included comprehensive photograhic exhibitions, one of which took place in 1871 and was called grafische, reproduktionstechnische und fotografische Sektion im Rahmen der Eröffnungsausstellung im Museumsneubau am Wiener Stubenring; then in 1875 consisting of the internationale Ausstellung der Photographischen

Gesellschaft; and in 1888 with erste Ausstellung des Clubs der Amateur-Photographen in Wien, and again in 1891 with the Club der Amateur-Photographen in Wien—Internationale Ausstellung künstlerischer Photographien.

The opening of Eröffnung der K.K. Lehr and Versuchsanstalt für Photographie und Reproductionsverfahren in Vienna, today Höhere Graphische Bundes-Lehr- und Versuchsanstalt (GLV) was in 1888. This fully equipped technical school worked in Austria to maintain the tradition of photography as a discipline of civil buergerlich-gediegener handicraft and engineer art. The establishment of the GLV was known world-wide and received their international reputation for the work completed during the term of photo chemist Josef Maria Eder who was the first director from 1888 to 1923. Industrial magnates of photographic production did not develop in Austria as dynamically as in other countries. In the last quarter of the 19th century however from 1882 to 1918 and still under the monarchy, the very active protogewerkschaftlichen initiative came into being, which later became Verein photographischer Mitarbeiter.

Finally in 1887, the earliest association of moderately active photographer collectives in Europe was the Club der Amateur-Photographen in Vienna (renamed Camera Club in 1893,) stressed and aimed for an artistic dynamic. The first large exhibition in the Austrian museum for art and industry was organized by the "club." In 1888 they held a show, the first of which was for amateurs only. Doing this was enough however to shake up some members of the established photographic community in Vienna. More specifically, in exhibiting their photographs in this unusually, selectively arranged international exhibition, the amateur photographers challenged the aesthetic guidelines established by the contemporary painters and commercial artists. Most notable were the images that came from English photographers such as Peter Henry Emerson and George Davidson. It was from their design principles in the "Paysage Intime" that the idea was had to minimize the hole though which light came, later becoming known as small apertures and extended depths of field. The most consistent representatives of these techniques were Hans Watzek, Hugo Henneberg and Heinrich Kühn as well as the American art photographer, Alfred Stieglitz all of whom crucially changed the international photography scene circa 1900.

MAREN GRÖNING

See also: Burger, Wilhelm Joseph; Eder, Joseph Maria; Natterer, Johann and Joseph; Petzval, Josef Maximilian; von Voigtländer, Baron Peter Wilhelm Friedrich; Société française de photographie; Emerson, Peter Henry; Davidson, Thomas; Kühn, Heinrich; Watzek, Hans; and Stieglitz, Alfred.

Further Reading

Eder, Josef Mari,. *Geschichte der Photographie* (Ausführliches Handbuch der Photographie, Band 1, Teil 1), 4, Auflage, Halle: Verlag von Wilhelm Knapp, 1932.

Auer, Anna u.a., *Geschichte der Fotografie in Österreich*, Bad Ischl: Verein zur Erarbeitung der Geschichte der Fotografie in Österreich, 1983.

Starl, Timm, *Biobibliografie zur Fotografie in Österreich 1839 bis 1945*, 1998ff. (wird regelmäßig aktualisiert) http://alt.albertina.at/d/fotobibl/einstieg.html.

Starl, Timm, *Lexikon zur Fotografie in Österreich 1839 bis 1945*, Wien: Album, Verlag für Photographie, 2005.

SOCIETIES, GROUPS, INSTITUTIONS, AND EXHIBITIONS IN BELGIUM

The multiple and potentially protean nature of photography is clearly reflected in the broad range of institutions which assisted the introduction of the new medium to Belgium—artistic, technological, and learned. the patrons of the fine arts were the first to witness a public display of daguerreotypes in Belgium at the triennial exhibition held in Brussels in September 1839. the crowded walls of competing portraiture, landscapes, and history paintings also welcomed five daguerreotype plates—two by Daguerre (who had presented them to King Leopold I), and three local views by rival Brussels pioneers Jean Baptiste Jobard (1792–1861), inventor and journalist, and Antoine Dewasme (1797–1851), lithographer and director of the Société des Beaux-Arts.

Simultaneously, the country's leading learned society, the Académie royale des Sciences et Belles-Lettres (Royal Academy of Science and Literature), was called upon to evaluate a paper process invented by Albert Breyer (1812–1876), a medical student, whose Breyerotype was a form of reflectography or photocopy enabling direct positive prints of engravings, drawings, and written documents. the Académie would reprise this role in the 1840s and 1850s, when work by W.H.F. talbot, Abel Niépce de Saint-Victor, Guillaume Claine and Edmond Fierlants was submitted for opinion, in the latter two cases within the context of grant applications made to the Belgian government. Furthermore, photography featured in one of the prize essays set by the Académie in 1847, on a topic covering "les avantages et les inconvénients de la découverte des procédés purement mécaniques" (advantages and drawbacks of the discovery of purely mechanical processes).

Another semi-official body to take a sustained interest in photography in the early decades was the Musée de l'Industrie, headed by Jean Baptiste Jobard in the 1840s. Despite its name, the Musée was more a technology centre and forum for the dissemination of inventions. As such, the progress of the new medium was monitored by the institution, a process culminating in the association of Gustave De Vylder (1824–1895),

engineer and teacher at the Ecole industrielle de Gand (Ghent Industrial College), where he gave public courses in photography for over thirty years, beginning in 1862. One of his pupils, Léonce Rommelaere (1839–1887), was appointed chemist at the Musée de l'Industrie in 1870, where he too instituted the practise of free public lessons in photography.

Very soon after its foundation in 1854, the Société française de photographie, pre-eminent in France, became a natural focus for the aspirations Belgian photographers eager to prove themselves on an international level. Many leading practitioners joined, such as Chevalier L.Pt. Dubois de Nehaut, Edmond Fierlants, and the great specialist in micro- and astronomical photography Adolphe Neyt (1830–1892). And it is thanks to membership of the Société française de photographie that the work of Louise le Ghait, the only significant woman calotypist in Brussels, has been saved from oblivion.

The French body also contributed to the success of the earliest photography exhibitions held in Belgium in 1856 and 1857. Photography had previously occupied a minor place in the state-sponsored trade fairs run under the aegis of the Association pour l'encouragement et le développement des arts industriels en Belgique (Association for the promotion and development of industrial arts in Belgium). Fearing that local production was lagging behind the international competition, Edouard Romberg, director-general for fine arts in the interior ministry, took the initiative to transform the event into a full-fledged photography exhibition for two years running. The 1856 exhibition, at which the Sociéte française de Photographie exhibited collectively, had a considerable impact. The purpose of stimulating local production was implicit in the nature of the trade fair, as one commentator observed: "Belgian photographs have been far surpassed by those from other countries… Belgium will derive most benefit with regard to photographic progress, from the lessons given by her neighbours" (Thomas Phipson, "Universal Exhibition of Photography, Brussels," *Journal of the Photographic Society [of London]*, 3 (21 October 1856): 146, reprinted from *Cosmos*, 9 (3 October 1856): 345).

Belgium had to wait nearly twenty years and the creation of its first photographic society before an exhibition of equal significance would be organized. The Association belge de Photographie was founded in 1874 as a national and official body with King Leopold II as patron. The initiators were De Vylder and Rommelaere, who were appointed respectively first president and general secretary, and two young engineers, Paul Davreux (1845–1905) and Léon Laoureux (1845–1915). A founding membership of 143 grew steadily decade by decade, from 200 in 1880 and 381 in 1890 to 650 in 1898 and 727 in 1905. It would remain a strong (if latterly less predominant) force in the domain in Belgium

until the outbreak of the second world war, when its collections and library were dispersed.

Throughout its existence, the Association belge de Photographie remained true to its twin purpose of acting as a springboard for artistic creation and scientific advance. Article 2 of the articles of association reads: "Son but est purement artistique et scientifique. Elle poussera au développement des progrès scientifiques par des réunions périodiques, des communications, l'essai des nouveaux procédés, des expositions, et si les ressources le permettent, par la publication des faits les plus intéressants" (Its purpose is purely artistic and scientific. It will promote the development of scientific progress by means of regular meetings, communications, experimenting new processes, exhibitions, and, if resources allow, by the publication of news reports.) Despite the explicit disavowal of commercial interest, the Association was a broad church, counting many professional photographers and owners of supply houses amongst the membership and officers, such as Joseph Maes, president from 1889 to 1895. Its breadth of membership and scope proved an advantage, enabling many functions to be delegated and practical work to be carried out at monthly meetings of the regional sections—initially Brussels, Liege, and Ghent, followed by Antwerp in 1890, Namur in 1893, and Mons in 1901. Given the centripetal force of the Association, the few independent local clubs set up in the wake of the growth in amateur photography in the 1880s made little impact. Exception may be made for the Cercle Photographique de Bruges, founded in 1887 as an offshoot of the Excelsior literary society, in a part of Belgium which failed to produce a regional section of the Association, and the Photo-Club de Belgique, founded in 1895, an amateur body of excursionist tendencies and a total membership of around 100.

The Association belge de Photographie, in fulfilment of its mission, organized international exhibitions of photography, both images and material, in 1875, 1883, and 1891. It was also present at the jubilee fair held to celebrate fifty years of nationhood in 1880 (and at which Désiré Van Monckhoven was honoured with a display of his publications) and the international exhibitions held in Antwerp in 1885 and 1894, and Brussels in 1888.

With its presiding spirit of internationalism, the pictorialist movement quickly gained ground in Belgium, influenced both by proselytising of the Linked Ring and by adherents of the Photo-Club de Paris, where Edouard Hannon (1853–1931) regularly exhibited. the Linked Ring counted two Belgians among its members—the multi-talented Brussels professional Alexandre Drains (1855–1925), and textile merchant Hector Colard (1851–1923), whose international outlook made him an ideal intermediary for interpreting and presenting, to a Belgian audience, the diverse intellectual and aesthetic

currents of the so-called French and English schools. the Association belge de Photographie, having hosted a well-received exhibition of British pictorialists in 1892, briefly lost the initiative when an independent Salon photographique was co-organized by Hannon at the Cercle artistique et littéraire [Artistic and Literary Circle] in Brussels in 1895, at which prints by leading lights of French pictorialism such as Demachy and Puyo featured alongside Belgian work. Henceforward, the Association belge de Photographie regained and maintained momentum, organising major salons in 1896, 1898, and 1902. Its size in Belgium and reputation abroad enabled it to overcome with ease the threat posed by the small secessionist movement L'Effort, active 1901–1905 around interior designer Léon Sneyers (1877–1949) and photographic supply-house owner Léon Bovier (1865–1923). Other leading pictorialists in Belgium, notably Gustave Marissiaux and Léonard Misonne, remained loyal to the Association.

The increase in the medium's popularity and profile at the turn of century gave rise to two very different institutional initiatives in photograph collecting. As a sign of pictorialism's social acceptance, a photography section was established within the Musées royaux des arts décoratifs et industriels [Royal Museums of Applied Arts] in Brussels in 1896. the Musée photographique, as it was known, purchased a total of 68 exhibition prints shown at pictorialist salons in Brussels between 1895 and 1901, 27 of which remain in the holdings of the Cinquantenaire Museum up to the present day. With the waning of pictorialism, the will to pursue the acquisition of photographic prints as artworks dissipated in Belgium. A Musée belge de Photographies Documentaires (Belgian Museum of Documentary Photography) was founded in 1901 as an offshoot of the Photo-Club de Belgique, along the lines of Léon Vidal's Musée Documentaire in Paris. It was reported shortly afterwards that the Museum possessed 23,000 items. Renamed the Institut International de Photographie in 1905, the fate of this body's collection is unclear.

STEVEN F. JOSEPH

See also: Daguerre, Louis-Jacques-Mandé; Niépce de Saint-Victor, Claude Félix Abel; Claine, Guillaume; Fierlants, Edmond; Société française de photographie; Chevalier L.Pt. Dubois de Nehaut; Maes, Melchior Florimond Joseph; van Monckhoven, Désiré Charles Emanuel; Photo-Club de Paris; Puyo, Émile Joachim Constant; Demachy, (Léon) Robert; Marissiaux, Gustave; Misonne, Leonard; and Vidal, Léon.

Further Reading

Association belge de Photographie, sous le protectorat du Roi. XXVe anniversaire de la fondation 1874–1898. Album jubilaire [Association belge de Photographie, under the King's patronage. 25th anniversary of its establishment 1874–1898. Jubilee album.], Brussels: Emile Bruylant, 1898.

Claes, Marie-Christine, *La collection des Pictorialistes*, Brussels: Musée du Cinquantenaire (MRAH), 1998.

Coppens, Jan, Laurent Roosens and Karel Van Deuren, *"Door de enkele werking van het licht": introductie en integratie van de fotografie in België en Nederland* ["By the sole action of light": Introduction and Integration of Photography in Belgium and the Netherlands], Antwerp: Gemeentekrediet, 1989.

Joseph, Steven F., tristan Schwilden and Marie-Christine Claes, *Directory of Photographers in Belgium 1839–1905*, Antwerp and Rotterdam: Uitgeverij C. de Vries-Brouwers, 1997

Leblanc, Claire, *"L'Effort,',' cercle d'art photographique belge (1901–1910)* ["L'Effort," Belgian photographic art circle (1901–1910)], Brussels: Editions La Lettre volée, 2001

Vercheval, Georges (ed.), *Pour une histoire de la photographie en Belgique* [Contributions to a History of Photography in Belgium], Charleroi: Musée de la Photographie, 1993.

SOCIETIES, GROUPS, INSTITUTIONS, AND EXHIBITIONS IN CANADA

Professional Organizations

Given Canada's small population spread out over a large geographic area and the existence of only a handful of professional photographers in any one urban centre up until the 1890s throughout the country, many Canadian professional and amateur photographers took out memberships in United States and international associations such as the National Photographic Association (founded 1868) and its successor the Photographers Association of America (established 1880). Montreal's Alexander Henderson in 1859 was the first member from North America of England's Stereoscopic Exchange Club. Lacking a local social or business outlet other than newspapers and short-lived magazines, commercial photographers regularly communicated information about their business (and sometimes personal) issues. Montreal's William Notman started in the 1860s with *The Philadelphia Photographer* and *Anthony's Photographic Bulletin*. Victoria's Hannah Maynard submitted samples of her own and her husband Richard's work in the 1880s and 1890s to the *St. Louis and Canadian Photographer*.

Many commercial photographers worked in isolation and, except for the most successful, appear to have mistrusted one another. Some of the newspaper advertising was extremely vitriolic. One of the initial attempts at a formal organization for professionals, the Toronto Photographic Society, lasted about a year from its start around March 1869. The society formed to battle price cutting. The St. John Photographers' Association made an even briefer appearance on the scene; its president, Carson Flood, is listed in an 1871 national business directory. The Photographic Association of Canada, centred in Ontario, organized on

24 January 1884 and was later known as the Ontario Society of Photographers; among its first leaders was Toronto photographer S.J. Dixon. The PAC's first president was R.D. Bayley, who as president of the Huron Photographic Association helped initiate the PAC. It survives today as the Professional Photographers of Ontario which is part of the Professional Photographers of Canada.

Amateur Associations

The earliest formally organized associations of Canadian amateur photographers, generally known in 19th century Canada as camera clubs, were established in the 1880s. The first independent camera club in Canada was the Quebec Amateur Photographers' Association located in Quebec City (1884–1886). The Quebec Camera Club, also in Quebec City, was founded 8 February 1887 and disbanded in May 1896. The Montreal Camera Club, preceded by the Montreal Amateur Photographic Club (1886–1889), organized in 1890 and incorporated two years later. The Montreal Camera Club still operates. Rivalling the province of Quebec as an early centre of amateur associations is Ontario. The Toronto Camera Club began on 23 February 1887 as the Photographic Section of the Royal Canadian Institute. The club went its own way on 17 March 1888 as the Toronto Amateur Photographic Association, then changed its name on 7 December 1891 to the Toronto Camera Club, followed by incorporation in 1893. The club celebrated its official centennial in 1988 and continues to exist. The Hamilton Camera Club started as the Hamilton Scientific Association, Photographic Section on 18 April 1892, and was followed by the Camera Club of Ottawa in 1894 and both are into their second century. Several other camera clubs in Ontario are noted in Koltun (1984).

Attempts to organize amateurs in other urban centres did not fare as well as Quebec and Ontario where the bulk of the Canadian population resided and still does. Sprange's *Blue Book for Amateur Photographers* (1895) reported the Winnipeg Camera Club, begun on 27 September 1892, as defunct. The Saint John Camera Club was organized on 9 June 1893 and lasted at least into the mid-1910s. The Halifax Camera Club was organized in March 1896. There were two efforts to create camera clubs in Vancouver, the first in 1895, the second in 1897. The later Vancouver Camera Club had 56 members in March 1897, but appears to have disbanded by 1899 or 1900. One of the last Western Canadian amateur associations to organize in the 19th century was the Associated Photographers of Manitoba and Northwest Territories which met on 13 July 1899 in Winnipeg, Manitoba, for its first annual meeting. When women applied for membership in the camera clubs, only the Toronto Camera Club is known to have debated the issue and agreed to admit them in November 1895.

Associations composed primarily of artists or those broadly interested in the arts, especially after the Kodak revolution, such as the Vancouver Art Association (founded 1890) and Vancouver Arts and Crafts Association (established 1900) also included amateur photographers and exhibited their works. The Canadian Lantern Slide Exchange (1893), centred around Toronto, Hamilton and Montreal in Ontario and Quebec, was modelled on the American Lantern Slide Interchange (1885). The amateur clubs often included professional photographers among their membership. William James Topley maintained a membership in the Camera Club of Ottawa, likely from its start in 1894 until 1921, three years before his death. Other professional photographers such as Les Livernois firm in Quebec City, Quebec, and the Edwards Brothers in Vancouver, BC, played an important role in helping manage the amateur revolution in photography brought about by Kodak roll film. They rented or sold cameras and supplies, helped process dry plates or film, and, most importantly, offered space and darkroom facilities for amateur organizations to meet and hone their technical skills.

Public and private art galleries, museums, libraries, religious organizations (chiefly in Quebec), private societies, companies such as the Canadian Pacific Railway, and academic institutions all played a significant role in preserving Canada's early photographic history before the establishment throughout the 20th century of government-operated archives by provincial and local jurisdictions. Some camera clubs, such as the Toronto Camera Club, maintained their own records back to their origins and only deposited these with national or other archives in the 20th century well after their founding. Several major collections by 19th century Canadian professional photographers such as William Notman, however, were preserved as business records and donated or sold in the 20th century to public institutions. Some studio collections by 19th century photographers, primarily in the Maritime Provinces (New Brunswick, Prince Edward, Nova Scotia and Newfoundland), continue to remain in private hands into the 21st century. Prints from Isaac Erb's (1846–1924) negatives, a New Brunswick landscape and industrial photographer beginning in the 1870s, are sold on the Internet through the collection owner Vintage Photo & Frame Ltd.

Of the provinces which were a part of the Confederation of Canada in the 19th century, only British Columbia and Nova Scotia appear to have had publicly accessible government archives prior to 1901. While all the provinces and their colonial predecessors had records-keeping operations, these were mainly paper-based. Historic photographs, where still used in the course of a government agency's work, such as the

Geological Survey of Canada, may not yet be transferred to an archives. The Canadian Archival Information Network or CAIN is a national database describing archival records, including photographs, at the fonds or collection level. All 13 provincial and territorial archival computer networks are linked to CAIN.

The National Archives of Canada (formerly the Public Archives of Canada, founded 1872) did not establish its Picture Division until 1907, but had acquired photographs a decade earlier. As of March 2002, the National Archives holds over 21 million of photographs dating back to the earliest days of photography. About 400,000 online descriptions of photographs preserved by the National Archives are linked to nearly 4,000 digital images in its online, Web-based research tool Archivi-aNet. The National Archives also issued research guides to its photographic collections and published the *Guide to Canadian Photographic Archives* (1984), a union list describing publicly accessible photo collections across the country.

The National Gallery of Canada (founded 1880 and officially opened 27 May 1882) contains an international collection of around 20,000 photographs dating back to 1839, descriptions of which, along with selected digital facsimiles, are available through its CyberMuse Web site. Although the NGC exhibited photographs as separate art forms beginning in 1934, its own Photograph Collection was not established until 1967.

As of March 2002, provincial and territorial government archives in Canada with active photograph digitization programs containing 19th century photographs (not for online exhibits) are, in chronological order, the British Columbia Archives (1993), the Archives of Ontario (1998), the Northwest Territories Archives (ca. 2000), and the Nova Scotia Archives & Records Management (2001).

First established in 1894 as part of the Legislative Library, the BC Archives began collecting historical records, including photographs, in 1898. Today it preserves the largest number of 19th century photographs of the province. Some of the significant 19th century photographers represented in its holdings are Frederick Dally, Francis George Claudet, Richard and Hannah Maynard, and Edward Dossetter. As of March 2002, the BC Archives Web site describes over 110,000 photographs linked to over 65,000 digital images.

The Notman Photographic Archives, operated within the McCord Museum, McGill University, Montreal, provides Web-based access to 24,000 digital photographs from among the 1,000,000 photographs by the William Notman firm and other photographers.

The other significant public collection of 19th century digital photographs is available through the privately funded Glenbow Library and Archives Web site. Part of the Glenbow Museum, the Glenbow Library and Ar-chives collection of online photographs (nearly 60,000 digital images and descriptions) are also searchable through the Images Canada Web gateway. The Glenbow Library and Archives preserves over one million photographs.

Canadian photographers, like their counterparts around the world, used their own business spaces from the very beginning of photography to exhibit their work. The first daguerreotypes of Canada taken in early 1840 by Hugh Lee Pattinson may have been exhibited the same year in London or Paris by Antoine-François-Jean Claudet and Noël Marie Paymal Lerebours. Works by Canadian photographers were formally exhibited at international world's fairs in Paris, London and other European urban centres, as well as the United States. The first international exhibition at which Canadian photographers were represented was the 1855 Paris Exhibition. Thomas Coffin Doane (1814–1896) from Montreal, Quebec, and Eli J. Palmer from Toronto, Ontario, the only two Canadian photographers exhibiting, received honourable mention for their work. At the 1862 London International Exhibition, William Notman was awarded a medal and Francis George Claudet, the youngest son of Antoine-François-Jean Claudet, received an honourable mention for his landscape photographs of New Westminster, BC. Claudet's father was one of the judges, but whether he excused himself is not known. Some of the portraits on patent leather exhibited by George Robinson Fardon at the 1862 world's fair were discovered late in the 20th century by the Victoria and Albert Museum and their identity verified by the author in 1999 as Fardon's work. Examples of other international exhibitions at which Canadian photographers were represented are the 1865 Dublin International Exhibition (J.B. Livernois of Les Livernois), the 1867 Paris Exposition Universelle (Wellington Chase; J.B. Livernois of Les Livernois; William Notman), the 1876 United States Centennial (International) Exhibition (J.S. Climo; Alexander Henderson; William Notman), the 1878 Paris Exposition Universelle (J.E. Livernois of Les Livernois [ed. Note: this is J.B. Livernois' son]; William Notman), the 1886 Colonial and Indian Exhibition London (Mrs. R.E. Carr; Richard Maynard; William Notman), the 1888 Barcelona World's Fair (S.H. Parsons), and the 1893 World's Columbian Exposition Chicago (W.H. Boorne; Les Livernois). Governments, both national and provincial, also commissioned photographs or purchased existing images which were incorporated into international exhibition displays as a means of illustrating and promoting their regions.

At the national level, there were no competitive exhibitions consisting solely of photographs as an art form until 1934 when the National Gallery sponsored the Canadian International Salon of Photographic Art. Prior to this time, the camera clubs and photographers

such as Vancouver's John Vanderpant organized open and invitational photography salons. The first Canadian camera club exhibit was staged by the Toronto Camera Club in 1891. Prior to this, industrial or agricultural fairs at the provincial or local level were the primary venue for the competitive exhibition of photographs by professionals and amateurs. Possibly the earliest such instance in Canada was the display of daguerreotypes at the Nova Scotia Industrial Exhibition in October 1854. Among the first Canadian art exhibitions which included photography was one hosted by the Art Association of Montreal (now the Montreal Museum of Fine Arts) in 1865. Works by William Notman and Alexander Henderson were on display that year and by the latter in 1867. The Royal Canadian Academy of Art (established 1880) did not begin to recognize photography as an art form until at least the 1960s when it awarded Ottawa's Yosuf Karsh its RCA Medal (1964). Some of the founders of the RCA, however, utilized photography in their landscape painting.

All Canadian societies and groups who sponsored exhibitions saw steady growth and interest in photography in the first decade of the 20th century as the Pictorialism tradition blossomed. As noted by H. Snowden Ward, co-editor of *Photograms of the Year*, based upon his 1899 visit to a Toronto Camera Club meeting:

> The Canadian amateurs … feel their somewhat isolated position … but by means of careful study and discussion of the articles and reproductions in the journals, as well as by very frank, breezy criticisms at their own lantern-slide evenings, they are doing all that lies in their power to remedy these deficiencies.

DAVID MATTISON

See also: Notman, William & Sons; Topley, William James; Livernois, Jules-Isaïe and Jules-Ernest; and Claudet, Antoine-François-Jean.

Further Reading

Greenhill, Ralph, and Birrell, Andrew, *Canadian Photography, 1839–1920*, Toronto: Coach House Press, 1979.

Koltun, Lilly, (ed.), *Private Realms of Light: Amateur Photography in Canada, 1839–1940*, Markham: Fitzhenry & Whiteside, 1984.

Lansdale, Robert, "Canadian Photo Magazines, 100 Years Ago," *Photographic Canadiana*, vol. 18, no. 3 (1992): 4–10.

Lessard, Michel, *Histoire de la photographie au Québec*, 3rd ed., Montreal: Université du Québec, 1987.

Lessard, Michel, *The Livernois Photographers*, Quebec: Musée du Québec, 1987.

Mattison, David, *Camera Workers: The British Columbia, Alaska & Yukon Photographic Directory, 1858–1950*, electronic edition, http://collection.nlc-bnc.ca/100/200/300/david_mattison/camera_workers/index.html.

Oliver, Andrew, *The First Hundred Years: An Historical Portrait of the Toronto Camera Club*, Gormley: Aurora Nature on behalf of the Toronto Camera Club, 1988.

Photographic Canadiana, various issues.

"Photography in Canada." *The Archivist*, vol. 16, no. 3 (1989): 2–15.

Reid, Dennis, *"Our Own Country Canada": Being An Account of the National Aspirations of the Principal Landscape Artists in Montreal and Toronto, 1860–1890*, Ottawa: National Gallery of Canada, 1979.

Schwartz, Joan M. (guest ed.), "Canadian Photography." *History of Photography*, vol. 20, no. 2 (1996).

Seifried, Christopher, (ed.), *Guide to Canadian Photographic Archives*, Ottawa: Public Archives Canada, 1984.

Sprange, Walter, *The Blue Book for Amateur Photographers*, Massachusetts: W. Sprange, 1893, 1894 and 1895.

Thomas, Ann W., and Strong, David Calvin, "The Exhibition of Photography in Canada: An Overview," *Muse*, vol 6, no. 4 (1989), 74–78.

Selected Canadian Web Sites With Descriptions of and Digitized 19th Century Historical Photographs:

Archives of Ontario, Toronto, http://www.archives.gov.on.ca; British Columbia Archives, Victoria, http://www.bcarchives.gov.bc.ca; Canadian Archival Information Network (CAIN), Web: http://www.cain-rcia.ca; Images Canada, http://www.imagescanada.ca

National Archives of Canada, ArchiviaNet: On-line Research Tool, Photographs Database, Web: http://www.archives.ca; National Gallery of Canada, CyberMuse, http://cybermuse.gallery.ca/ng; Notman Photographic Archives, McCord Museum, McGill University, Web: http://www.mccord-museum.qc.ca; Nova Scotia Archives & Records Management, http://www.gov.ns.ca/nsarm; Prince Edward Island, Public Archives and Records Office, On-Line Exhibits, http://www.edu.pe.ca/paro/exhibits/default.asp

SOCIETIES, GROUPS, AND EXHIBITIONS IN FRANCE

The birth of the French photographic institution followed the development of the scientific and historical academies in the country. The same cultural phenomenon took place in all European countries as well as in their colonial territories.

The photographic societies were associations whose purpose was to ameliorate photography and diffuse it to the majority.

During the 19th century, "in science, if the lonely genius make the most important discoveries, the scientific societies (…) make them understandable, propagate and improve them." ("Si c'est le seul génie qui fait dans les sciences les grandes découvertes, ce sont les sociétés savantes (…) qui éclaircissent les découvertes, qui les répandent et les perfectionnent," Dictionnaire de la langue française, Littré, 1863–1871)

This century has been considered as the century of technical discoveries. Diffused by specialized newspapers, Expositions universelles and academies, sciences became a new subject of interest, the beginning of their democratization.

The photographic academies were very different by their members' type, their research field, even their philosophy. The technical societies were the most important by the number of their members because they

were opened for all amateurs and professionals. Almost all artistic societies were dedicated to amateurs. The professional associations considered themselves as genuine companies union.

Most organizations developed themselves after 1875, following the simplification of the photographic techniques, particularly the introducing of the gelatin-silver bromide. As Jean-Pierre Chaline, the French historian, exposed, in France, academies grew up between 1875 and 1884. The expansion of the photographic associations' foundation took place later than the development of classic academies. For the photographic societies, this happened above all between 1887 and 1896.

These societies or associations established the scientific or artistic studies like a bond of the nation. Upper classes people gathered themselves to exchange on scientific or artistic experiments and knowledge. The first photographic society was called the Société héliographique, created in 1851 to develop photography and its applications but dissolved in 1853, the same year the Royal photographic Society was founded in Great Britain. One year later, in 1854, a new society, also based in Paris, called the Société française de photographie, replaced it.

Founded on the Académie des Sciences exemplification, this society was much more science-oriented: its aim was to ameliorate and diffuse photographic techniques (See Articles of association, *Bulletin de la Société française de photographie*, January 1855). They met each month to talk about both little improvements and important discoveries. As its model, practice was the only way to recognize a new technique. Researchers came to present their invention before the Society. Then, a little group (five or six people) formed a commission to experiment the novelties. One month later, they had to give their conclusions and judge them in a report. This account was published in the Bulletin de la Société française de photographie, the Society's journal released every month for the members since January 1855. Most of them were amateurs: they did not live of their passion but had enough time to experiment and devoted their life to photography.

At this time, knowledge was freely diffused and scientists offered to the community the results of their researches, based on common exchange. Transmission was the main way to evolve. This society became the pattern for all others. The Société boulonnaise de photographie located in Boulogne, in North of France, in 1856, even asked to use its status as a model.

The centralized organization of French politics probably influenced the creation of the photographic sociability: the most important of them, and the first, was located in Paris. Each town wanted to have its own scientific or historical academy. In the French countryside, photographic associations have been principally founded by a member of this main society: opened to every kind of members, often with a library, a laboratory and a newspaper dedicated to the photographic news and the life of the association.

As time went by, the addressed subjects evolved. At the beginning, before the 1870s, the different techniques—the collodion process, the negative albumen process, the collodio-albumen process—and the different cameras were the most important questions. With the gelatin-silver bromide's arrival, new topics appeared, such as picture quality, snapshot speed, and above all the recognition of the photography as an art and not only as a scientific help.

More than the professional photographers, the amateur members of these groups contributed to ameliorate and diffuse the techniques. The photographic societies organized courses and lectures—notably from the 22 November 1891 to the 10th of April 1892, at the Conservatoire national des Arts et Métiers, in Paris—explaining the processes, the best way to choose the camera, and how to use the best technique at the best moment.

Most of the members used to write books and articles to spread photography to the general public. One of the best known popularizer in France was Albert Londe, publisher of The snapshot photography (La photographie instantanée) in 1886 and The modern photography (La photographie moderne) in 1888. The will of the French photographic society was to give a status to photography, between science and art.

In the 1890s, the French society changed: entertainment became part of life not only for the upper classes, but for middle classes as well. With the gelatin-silver bromide and the reducing size of the camera—the most known, but not the only one, was probably George Eastman's Kodak box, photographic democratization was on its way. Photography was used during a jaunt, a trip, or to capture the most important life times of the families.

Following these changes, appeared a new kind of association led by Albert Londe, Maurice Bucquet, and Gaston Tissandier. Its name was the Société d'excursions des amateurs photographes created the 4th August in 1887. Its purpose was to "organize excursions and practical lectures for the development and the diffusion of the photographic knowledge" ("Société ayant pour but d'organiser des excursions et des conférences pratiques en vue du développement et de la diffusion des connaissances photographiques," in the first article of association). Several societies of this kind were created in France, in almost every department.

At the same period, another type of photographers' group appeared. Their members were also amateurs, but with a different aim. These artistic societies, the photo-clubs, existed since 1888, date of the Photo-club de Paris birth. One more time, this association was the

pattern for the others. The photo-clubs were associations where the members were strictly amateurs. Principally, these associations requested the recognition of the photography as an art.

First, members of the Photo-Club de Paris and the Société d'excursion des Amateurs photographes were almost the same, including Maurice Bucquet, Albert Londe and Jules-Etienne Marey. Quickly, theses societies' respective positions became diametrically opposed. The Excursion society lauded photography as a healthy entertainment—it was most of time combined with sports like bicycle or walk—when the Photo-club exalted photography as an aesthetic and conceptualized art. In fact, the Photo-club recommended the pictorial photography.

In 1892, they presented in the "first international photographic exhibition and the linked arts" (Première exposition internationale de photographie et des arts qui s'y rattachent) a new aesthetic. They showed staging images, playing with lens aberrations to give an ethereal and vaporous touch similar to drawings, mostly printed with gum-bichromate. Pictorial photography was an international movement first represented by British photographers like Peter Henry Emerson or Julia Margaret Cameron. This photographic practice was known in France thanks to universal exhibitions and books, notably "Naturalistic photography for students of the Arts" written by Emerson and published in 1889.

In France, the photo-club members had a particular position because they struggled for the photographic recognition as art, and also for the amateur status. According to Paul Gers in 1889, the 12th December, concluding on the Exposition universelle in Paris, "the artistic value of their (the amateurs) works, (could) compete with the specialist's one, the professional's one ("la valeur artistique de leurs travaux, lutter avec succès contre les spécialistes, les professionnels," in Photo-Club de Paris, Séance du 12 décembre 1889, Journal des Sociétés photographiques 1890–1892, 31).

Then, the amateur could have been considered as a better artist than the professional, whose sole purpose was to make money with his practice. They refused little camera boxes, choosing the camera obscura, refusing the instant photography and choosing the staging photography, in fact refusing technical progress.

These pictorial photographers proposed to consider a kind of hierarchy in photographs: their practice would have been the most important, as the noble one, whereas the excursionist's practice would have been seen as an entertainment able to give travel impressions and the professional practice would have been despised because of making money.

In France, particularly in Paris, photographers had to choose their side: excursionist or pictorialist. However, the splitting was not that strong in the countryside

where some associations like the Photo-club rouennais, located in Normandy, belonged to both sides. Created in November 1891, its presidents were scientists like the naturalist Henri Gadeau de Kerville (1891–1892) or the physician Abel Buguet (1893–1900) but the association was opened to "excursionists and pictorialists" (See articles status of the Photo-Club rouennais, 1891).

However, these organizations had a common fight, and to give them coherence, the Union Nationale des Sociétés photographiques de France was created in 1892. Every year, a congress was organized by the Union in a different city, working on technical, artistic or juridic subjects.

From the very beginning of the photography, the pictures display, especially during the Expositions universelles, was considered as the best way to introduce techniques' newness. Actually, photography was held as a scientific technique, so processes were the most important distinctiveness.

To present their researches, the societies and the photo-clubs used the same methods: the exhibition. The societies proposed to the spectator a presentation copied on the fine arts Salon. Another pattern was probably the exhibition of the Society of Arts in 1852 (or 1851) in London composed by Joseph Cundall, member of the Calotype Club with the help of Roger Fenton, active member of the future Photographic Society of London.

The first exhibition was organized by the Société française de photographie in 1855, from the 1st August to the 15th November. The photographs were divided in sections: the different processes as salted paper print, albumen paper print, daguerreotype, and then by subjects like portrait, landscape and scientific photography. The foreign photographers were accepted for the second show, in 1857. Several countries were represented and a jury awarded some of the photographers, like the Universal exhibitions did.

For the first edition, the amateurs were more important in numbers, but two years later, professionals were represented almost as much as the amateurs. The Société française de photographie made these shows approximately every two years.

The Expositions universelles were the occasion to show the new photographic techniques and processes. There were also exhibited ancient techniques as a kind of summary. One of the great wills of the societies and the photo-clubs was to give credibility to the photography as an art. They all tried to make the government understand the importance to give them an exhibition place in the fine arts section, not in the techniques' one: this request provoked a great scandal in 1900. Foreign photographers—principally pictorialists—refused to come and expose their production at the exhibition in Paris because it was scheduled in the Education palace and not in the art one.

Societies and photo-clubs in France, as well as their lectures and publications, have been prevailing in the fight of the photography's recognition. They allowed the grouping of different kind of people in the same purpose. The photographic institution, which had been divided in the 1890s, recovered its unity after 1900 and gave birth to the first section dedicated to the photography in a museum in 1926, in the Conservatoire national des Arts et Métiers, a technique museum, in Paris. At last, one of the ultimate purposes was accomplished.

MARION PERCEVAL

See also: Londe, Albert; Marey, Etienne Jules; Tissandier, Gaston; Wet Collodion Negative; Wet Collodion Positive Processes; Société française de photographie; Photo-Club de Paris; Pictorialism; Gum Print; Emerson, Peter Henry; and Cameron, Julia Margaret.

Further Reading

Chaline Jean-Pierre, *Sociabilité et érudition. Les Sociétés savantes en France, XIXe-XX siècles*, Paris: Editions du Comité des Travaux Historiques et Scientifiques, 1995.
Gunthert André, L'institution du photographique, *Etudes photographiques*, no. 12, November 2002, Paris: Société française de photographie.
Poivert Michel, Le sacrifice du présent, *Etudes photographiques*, no. 8, november 2000, Paris: Société française de photographie .
La photographie pictorialiste en Europe 1888–1918, Le point du jour éditeur/Musée des Beaux-Arts de Rennes, 2005.
Journal des sociétés photographiques, Paris, 1890–1893.

SOCIETIES, GROUPS, INSTITUTIONS, AND EXHIBITIONS IN GERMANY

Throughout the 19th century the German speaking countries hosted more than 100 photographic societies, mostly on a local basis but aiming at a greater public, too. The first group of practitioners met regularly as early as 1840 in the studio of Carl Schuh in Vienna but there were no significant implementations until 1857 when three German photographers called for the foundation of a Society of German Photographers (Allgemeiner Deutscher Photographen-Verein) following French and English examples. Formally founded by more than 40 participants the society seemed to flourish within the next years, including the initiation of its own journal *Photographisches Archiv* edited by the founding fathers Julius Schnauss and Eduard Liesegang. But in 1863 the society ceased to exist and was basically replaced by the freshly inaugurated Berlin Society for Photography (Photographischer Verein zu Berlin) which was founded by Hermann Wilhelm Vogel. He split this society into a German Photographic Society (Deutscher Photographen-Verband) by 1867 which existed—due to political

as well as internal reasons—only for another year on a national basis. For the next 30 years, all attempts to organize an annual conference of German photographers or found another society for the interests of all photographers were condemned to fail. Only in 1897, the newly released copyright law forced 2500 photographers to constitute a Law Protection Committee of German Photographers (Rechtsschutzverband Deutscher Photographen) which finally turned into a Central Committee of German Photographers (Centralverband Deutscher Photographen) in 1902. The Austrian history is different as the Photographic Society of Vienna (Photographische Gesellschaft in Wien), installed in 1861, gradually grew into the official function of uniting all Austrian photographers and industries of the field.

There were numbers of smaller societies and interest groups among photographers, too. Besides local groups, of which those in Berlin, Hamburg, Frankfurt on Main, Weimar, and Chemnitz were the most active ones there were groups of theater-playing photographers, of photographic industries, of suppliers of photographic materials, and of photographic assistants. Although 10% of all photographic employees in the late 19th century were female there has been no group or society to pursue their interests. As early as the 1850s there were smaller local groups in amateur photography but there were societies in amateur photography before the foundation of Society for the Improvement of Amateur Photography (Verein zur Förderung der Amateur-Photographie) in Berlin in 1869. The German Society of Friends of Photography (Deutsche Gesellschaft von Freunden der Photographie) set up in 1887 had to prepare the big exhibition for the celebration of photography's 50th anniversary, and a Free Photographic Society (Freie Photographische Vereinigung) was the first attempt in the creation of a pressure group in Fine Art Photography.

Setting up institutions in photography seemed a lot more complicated. In 1853, Hermann Krone in Dresden launched his first school of photography offering more than the average basic courses as given by nearly every daguerreotypist before. This private institute was converted in 1869 into a part of the Dresden polytechnicum, and Krone became the first official instructor in photography on a technical basis. The first class and laboratory in photochemistry was installed at the Berlin University in 1884, Hermann Wilhelm Vogel the first to hold the seat being followed by Adolf Miethe, Otto Mente, and Erich Stenger. By 1888, Joseph Maria Eder had founded the Higher Institute of Graphic Arts (Hoehere Graphische Lehr- und Versuchsanstalt) in Vienna which was to be followed in 1900 by a similar institution in Munich; the Lette school in Berlin specializing in teaching women created a class in photography in the same year. In 1885, the architect Albrecht Meydenbauer had set up the Prussian Institute for Photogrammetry

(Preussische Messbildanstalt) in Berlin to produce and catalogue photogrammetric data of buildings to be preserved.

Exhibiting photography started with its own birth: In fall 1839, there were a number of exhibitions showing Daguerreotypes from Paris in all big cities of the German speaking countries. The first one-man travelling show was installed in 1840 by Johann Baptist Isenring from the Swiss Schaffhausen but shown mainly in Southern Germany. Although the Germans were slow in presenting themselves at the World Fairs of 1851 and 1855 in London and Paris, photography had been present in both apparatus and images at all of the German industrial fairs from 1840 onwards. Permanent exhibitions in showrooms common in the USA since the 1850s only appeared irregularly in Vienna and Berlin in the 1860s. A special form of exhibiting stereo photographs was patented and installed by Ernst Fuhrmann in 1877 named the Emperor's Panorama (Kaiserpanorama).

Exhibitions of photographc images flourished for a relatively short time after photography's 25th anniversary in 1864. The same year, Anton Martin from Vienna had curated an exhibition on early photography and shown some work of his contemporaries; the German photographers concentrated on having a banquet with a burlesque comedy accomanying it. In 1865, Hermann Wilhelm Vogel and his Berlin society tried to establish an annual show of photography but these efforts ceased within three years. But by 1889, photography's 50th anniversary was the occasion for installing huge exhibitions of both images and apparatus in Berlin and Vienna. The Berlin exhibition held in the Prussian War Academy was the first to show the greater importance of amateur photography over the average craftmenship practised so far; the best featured exhibitor was a 25-year-old student of Hermann Wilhelm Vogel: Alfred Stieglitz. By this time Alfred Lichtwark had already been established as head of the Hamburg Art Hall (Kunsthalle); he started the annual exhibition of Fine Art Photography in 1893. A last instauration of the year 1895 combined all efforts described here: The South German Association of Photographers (Sueddeutscher Photographen-Verein) was founded to hold annual exhibitions for the sake of photographic art and artists in a Secessionist manner, it helped to instigate the Munich school of photography, it collected a large number of images to set the ground for a National Museum of Photography, and by a pilgrimage to Pope Leo XIII. in Rome, it installed Saint Veronica as the holy guardian for all photographers and their necessities.

ROLF SACHSSE

See also: Vogel, Hermann Wilhelm; Stieglitz, Alfred; and Lichtwark, Alfred.

Further Reading

Hoerner, Ludwig, "Allgemeiner Deutscher Photographen-Verein." Gründung und Werdegang 1858–1863. In: *Fotogeschichte. Beiträge zur Geschichte und Theorie der Fotografie*, 3–12, Frankfurt am Main, 1984.

——, *Das photographische Gewerbe in Deutschland 1839–1914*, 105–113, Düsseldorf 1989 .

Pohlmann, Ulrich, "Harmonie zwischen Kunst und Industrie"—Zur Geschichte der ersten Photoausstellungen. In Bodo von Dewitz, Reinhard Matz (eds.), *Exh.cat. Silber und Salz, Zur Frühzeit der Photographie im deutschen Sprachraum 1839–1860*, 496–513, Heidelberg 1989.

Sachsse, Rolf, Daguerre-Büste, Photographenmarsch und Werbetonfilm, Jubiläumsausstellungen und Geburtstagsfeiern für die Photographie. In Bodo von Dewitz, Reinhard Matz (eds.), *Exh.cat. Silber und Salz, Zur Frühzeit der Photographie im deutschen Sprachraum 1839–1860*, 584–597.

Exh.cat. Silber und Salz, Zur Frühzeit der Photographie im deutschen Sprachraum 1839–1860, Heidelberg 1989.

SOCIETIES, GROUPS, INSTITUTIONS, AND EXHIBITIONS IN ITALY

At the beginnings of photography, in 1839, Italy was not yet a unified state. In the months following the Arago announcement, daguerrotypy was presented in a number of the most prestigious scientific institutions and rapidly spread through the various states of the country, with different outcomes according to the different cultural influences. Even in unified Italy, however, the Italian photographic associations continued to maintain strong local characteristics.

The first photography associations were established primarily around the practice of calotypy, and were often also composed of foreign artists traveling in Italy on the classic grand tour. One of the first was the Circolo di calotipisti set up in Rome (1850–52) on the initiative of Count Frédéric Flachéron. The meetings were attended by Prince Giron des Anglonnes, Eugène Constant, Henri Peach Robinson, and Giacomo Caneva.

In March of 1888, the Associazione degli Amatori di Fotografia was established in Rome, presided over by the Duke of Artalia. The founders included Enrico Valenziani and the engineer and architect Giovanni Gargiolli. The latter, who had already founded the Società Amici della Fotografia in Naples in 1887, subsequently played an important role in the debate on the use of photography in an area traditionally covered by engraving, i.e. the reproduction of works of art, a sector in which Italian photography would always be extremely prolific. Obstructed in his project to create a photogravure laboratory at the National Copper-engraving Institute in Rome, he set up the Royal Photography Laboratory at the Ministry of Education (1892), which definitively established the use of photography in art reproductions.

Another active center was the city of Turin, which was particularly favorable to the diffusion of photography

also because of its geographical and cultural vicinity to France. Here the Unione Fotografica Italiana had been in existence since 1879, a longstanding association, whose activity was widely known.

The work of these first associations was mainly geared toward promoting meetings and information exchanges, particularly regarding technical innovations, as well as the dissemination of treatises and publications and the organization of training courses. The latter activity turned out to be essential, especially due to the absence of any official photography schools. Apart from some sporadic private initiatives, such as the Photographic Institute of Brindisi founded by Antonio Montagna, the teaching of Antonio Chimenti at the University of Rome (as of 1842), Semplicini in Florence (around 1850), and Ottavio Baratti at the Technical Institute of Milan in 1865, and the "Municipal evening school in chemistry for factory workers" in Turin, an authentic School of Photography was only established in Florence in 1905, following more than two decades of discussion, supported by the Società Fotografica Italiana.

The year 1887 was decisive: in Florence, during the works of the jury of the 1st Italian Photography Exposition, the foundations were laid for the constitution of the first national association. The Società Fotografica Italiana (SFI) was officially inaugurated two years later. The founders included many professional photographers, including Vittorio Alinari, Carlo Brogi (member of the Board of Directors), and the senator Paolo Mantegazza—known for his use of photography in a series of studies in anthropology and ethnology—who became its president. In October 1889, the SFI began publishing its own Bulletin, which continued until 1914.

One of the most important activities of the SFI was the organization of annual conferences, where participants discussed topics related to the history and technique of photography, its applications in a broad range of disciplines, and its relationships with art and custom. Both at the central level and through local groups, the SFI organized "photographic walks" and projections, and systematically collected Italian and foreign publications dedicated to photography. One of its most ambitious projects was to create a national museum of photography. Success came in 1902, with the opening of a Photography Archive at the Royal Uffizi Galleries in Florence, promoted by Corrado Ricci and encouraged by the Touring Club Italiano.

Around the SFI, many amateur photography clubs began to appear, often frequented by professional photographers as well.

In 1890, the *Circolo* Dilettanti Fotografi was set up in Turin, and many of its members were present at the photography exhibit in Venice in 1891. In 1892, the club participated in the organization of the Exhibit for the Promotion of the Fine Arts in Turin, in which over fifty photographers participated. The following year, in conjunction with the Turin branch of the Club Alpino Italiano (CAI), the association opened an exhibit of the works of amateur photographers, members of the CAI and other touring clubs from various Italian regions. In this regard, it should be underscored that photography assumed growing importance in the life of this type of association (CAI, Touring Club, Unione Escursionisti, and so on), and that these organizations, through the creation of thematic archives, expositions, and particularly magazines with a wide circulation, made a substantial contribution to the creation of a new image of the Italian landscape. No traces remain of the activity of the Circolo Dilettanti Fotografi after 1895, but it is known that many of the members converged, together with a group of professionals, in the more important Società Fotografica Subalpina. Founded in Turin in 1898 during the 1st National Congress of Photography, the Society was composed of about fifty members.

A branch of the SFI, composed of amateurs and professionals, was established in 1892 in Bologna, followed in 1896 by the Società dei Dilettanti Fotografi. The dissolution of these associations spawned the Circolo Fotografico Bolognese in 1900, the oldest body still in existence today.

Similarly, in Milan, the Circolo Fotografico Lombardo (1889) was established, as well as the *Associazione Lombarda*, which in 1893 numbered as many as four hundred members. In Milan, an important industrial and commercial center, the first national journal of photography, *La Camera Oscura*, began publication in 1863, directed by Ottavio Baratti and subsequently by Luigi Borlinetto. The journal published essays by Italian and foreign scholars, with a prevalently technical-scientific orientation, though often included topics of a political-cultural nature as well. But the experience that left the greatest mark on photography in Milan in the second half of the 19th century, in terms of both technical research and interest in the new creative languages, was *Il Progresso Fotografico*, a periodical created by Mario Gandini and Rodolfo Namias. By 1894, Namias had published more than thirty manuals and in 1895 he organized the Laboratory School of Applied Photochemistry.

In all the major expositions and conferences dedicated to photography in the last two decades of the century, the Istituto Geografico Militare was a constant presence. Its Photography Department was set up only in 1896, but the collections made by the military contained a large number of photographs made prior to that date, added to which was a large quantity of documentary material of geographic and ethnographic interest.

The involvement of Italian photography in exhibition events began with a sporadic presence in the general expositions, in which photography was initially exhibited

as a technical "marvel" rather than as a possible means of artistic expression.

In the pre-unification period, Bologna, the second most important city in the Papal state, could offer an emblematic example. In the 1850s, while the first studies and stable photographic production were beginning, the local administration attempted to foster the participation of local artisans in the Universal Expos of London and Paris. In parallel, exhibitions of a regional nature were promoted—occurring for the first time in the Agricultural, Manufacturing, and Industrial Exposition of 1856—in which photography was one of the products on display. In 1857, the official regulations of the exposition included a section of "Examples of Photography and Daguerrotypes," shown separately from the copper engravings and lithographs.

At the first Italian Exposition, held in Florence in 1861, all the important names in local photography participated. Most of the images displayed were portraits, while the large studios took the first steps in the sectors in which they would subsequently specialize: landscape photography and art reproduction.

Within important traditional events, such as the Italian General Exposition of Sacred Art in Turin, photography was not only widely present but the subject of a lively debate centered mainly on its artistic potentials (1898), leading to the creation of the important journal *La fotografia artistica* (1904–1917). In the General Exposition of Turin of the same year, "Photographic Art" appeared among the "Liberal Arts" and attracted a large number of visitors. At the end of the 19th century, Italian photography periodicals bore witness to the fact that discussions within the associations centered on issues analogous to those confronted in the other European countries: artistic photography, its definition as a cultural heritage, the genres, and the relationship with the applied arts, academy cultures, and the cultures of the secessionist movements.

CLAUDIA CAVATORTA

See also: Flachéron, Count Frédéric A.; Constant, Eugène; Robinson, Henri Peach; Caneva, Giacomo; Brogi, Giacomo, Carlo and Alfredo; and Alinari, Fratelli.

Further Reading

Atti del primo Congresso Fotografico Nazionale, Torino, Ottobre 1898 [Acts of the 1st National Photography Congress, Turin, October 1898], Torino: Tipografia Roux Frassati, 1898.

Atti del Secondo Congresso Fotografico Nazionale tenuto in Firenze dal 15 al 20 maggio 1899 [Acts of the 2nd National Photography Congress held in Florence from May 15–20, 1899], Firenze: Tipografia di M. Ricci, 1901.

Becchetti, Piero, *Fotografi e fotografia in Italia 1839–1880 [Photographers and Photography in Italy 1839–1880]*, Roma: Edizioni Quasar, 1978.

Becchetti, Piero, *La fotografia a Roma dalle origini al 1815 [Photography in Rome from the Origins to 1815]*, Roma: Colombo, 1983.

Bertelli, Carlo, and Bollati, Giulio, *L'immagine fotografica 1845–1945, Annali 2* della *Storia d'Italia [The Photographic Image 1845–1945, Annals 2 of The History of Italy]*, Torino: Einaudi, 1979.

Galassi, Peter, *Before Photography: Painting and the Invention of Photography*, New York: The Museum of Modern Art, 1981.

Gilardi, Ando, *Storia sociale della fotografia [Social History of Photography]*, Milano: Feltrinelli, 1976.

Miraglia, Marina, *Culture fotografiche e società a Torino: 1838–1911 [Photographic Cultures and Society in Turin: 1838–1911]*, Torino: Umberto Alemanni, 1990.

Quintavalle, Arturo Carlo, *Gli Alinari [The Alinari]*, Firenze: Alinari, 1993.

Quintavalle, Arturo Carlo, *Il territorio della fotografia [The Territory of Photography]*, Milano: Fratelli Fabbri, 1979.

Zannier, Italo, Costantini, Paolo (eds.), *Cultura fotografica in Italia. Antologia di testi sulla fotografia (1839–1949) [Photography Culture in Italy. Anthology of Texts on Photography (1839–1949)]*, Milano: Franco Angeli, 1985.

Zannier, Italo (ed.) *Segni di luce. La fotografia italiana dall'età del collodio al pittorialismo, [Traces of Light. Italian Photography from the Age of Collodium to Pictorialism]*, Ravenna: Longo Editore, 1993.

SOCIETIES, GROUPS, INSTITUTIONS, AND EXHIBITIONS IN RUSSIA

Photography became very popular in Russia in the 19th century. Thus, in St. Petersburg alone, according to the population census of 1881, photography involved 382 out of 668,000 citizens, and according to the census of 1890 it involved 443 out of 954,400 citizens. Such large cities as Moscow, Kiev, Odessa and others also functioned as photography centers. Fairs housed mobile photo studios in which the technology of ferrotypes was primarily used.

The first photo amateurs were often rich or born noble. As the photo technology became simpler and cheaper, many middleclass amateurs became involved, often using photography as a means of self-expression. The self-expression through photography is why the amateur photographical societies appeared. Studying and analyzing the achievements of contemporary photographers and exchanging experiences were especially valuable for the provincial amateur photographers. Before the revolution of 1917 the number of photographic societies, although varying in size and cultural significance, amounted to more than 100.

The first decades of the development of photography were marked by a specific emphasis on the equipment. The first photographic societies were technical societies. The basis for the first large photographic society was formed by the Russian Emperor Technical Society (RETS) established in St. Petersburg in 1866. The RETS consisted of several branches. It comprised such

departments as chemistry, electricity, air-drifting, etc., which facilitated the inclusion of the use of other scientific findings in photography. The RETS established a fifth department in 1878, it was called the Photography Department. This initiative was headed by outstanding scientists like D. Mendeleev, photographers like L. Levitsky, I. Boldyrev, V. Carrick, and even artists like landscape-painter I. Shishkin and other prominent figures in Russian culture.

RETS' goals included the development of the technical, scientific and artistic aspects of photography, the establishment of theoretical and practical lecture courses the organization of nationwide photo exhibitions, and the establishment of a museum for photographic pictures. RETS had over thirty affiliates in various cities, including Moscow, Nizhni Novgorod, Odessa, Vyatka, Kiev, and others.

The leaders of the photography department in RETS, S. Proskudin-Gorski being one of them, believed that photography was documental by nature. In fact, he published articles on pictorial photography in *Fotograf Lyubitel* (*Amateur Photographer*) of which he was the chief editor. He stated that photography functioned as a way to fix surroundings in natural colors. After the revolution of 1917 the organization changed its name to Russian Technical Society (RTS). RTS organized a couple of photographic events and it fell apart in 1929.

In 1872 another special department for photography within a technical society was established in Moscow. The Society for Technical Ideas Dissemination (STID) developed out of need, a photographic society. The department's activities became obvious in 1883 due a general increase of interest in photography. The photo department of STID fostered the development and dissemination of artistic and technical ideas related to photography. The department was formed by such outstanding figures in Russian photography as E. Mattern, D. Yezuchyevski, and V. Vulfert. As the members of the society grew in number and the scale of activities became larger, it became clear that an independent photographic society was needed. So, in 1894 Russian Photographic Society (RPS) was established. It played a great role in the development of photography in Russia. As of the 1st October 1901 the number of its members amounted to 1,113. In 1899 a famous Moscow Photographer K.Fisher was elected the chairman of the society. The society set up a charity fund for those photographers who could no longer work due to an illness or a tragic accident. The meetings of the society were held in the Polytechnical Museum. At these meetings the members of the society used to discuss not only organizational matters and the latest photography related news but also scientific issues that were of general interest. Members of the society also used to demonstrate new photo equipment. Those who were interested, but not members of the society gladly

visited the meetings, often totaling hundreds at times. The RPS organized out-of-town photo sessions in the beautiful suburbs of Moscow and nearby small towns. Often, this was followed by exhibitions and contests. The meetings of the society, as well as the journals, were full of heated debates on photography, its place in culture, and the direction of further development of photography. N. Petrov, a person knowledgeable on foreign photography and various theoretical and practical issues of photography, was a vigorous advocate of pictorial photography. He kept promoting the aesthetic concepts of pictorial photography in his speeches and articles for *Vestnik Fotografii* (*Photography Magazine*). He also tried to familiarize the Russian readers with the works by western masters. By 1930 the RPS had become dislocated and ceased to meet further.

The Photographic Society of Odessa (PSO) was founded in 1891. By January 1, it had 192 members. PSO studied theoretical as well as practical aspects of photography and gave an opportunity for the amateur photographers to travel for artistic and scientific purposes. The society members provided opportunities to photograph rare antiques and remarkable pieces of architecture. The PSO also held many of photo exhibitions. Additionally, the PSO established a commission for photo inspections that were needed for litigations.

There were also, among other societies, the Tiflis Society of Photo Amateurs, the Baku Photo Coterie, the Artistic and Photographic Society of Moscow, and the Saint Petersburg Photography Society.

The societies' major activities included the organization of photo exhibitions and providing support for members' participation in exhibitions held by other societies. Russian photographers took part in lots of international exhibitions, like the World Exhibition in London in 1863 and the International Exhibition in Berlin in 1865. Their works were an organic part of the world's art of photography. The works of Russian photographers were often prize-winning. The All-Russia Photographic exhibition in Moscow in 1867 housed over two thousand photos of typical Russian characters, scenes of folk life, and landscapes. Photography formed a large part of the International Polytechnic exhibition in Moscow in 1872. In 1882 a remarkable event in the history of Russian photography took place in Moscow, an All-Russia exhibition within the framework of a RETS session was held. Naturally the session included the photography department as well, thus setting into existence the first photographer's session in Russia. The exhibition prodded and worked to understand photo activity. The first specialized exhibition was held in Saint Petersburg in 1888 with 138 photographers participating and 820 photos exhibited. To mark 50 years since the invention of photography in 1889 the RETS organized exhibitions in Saint Petersburg and in Moscow. At the

St Petersburg exhibition there were some participants from abroad were invited by a commission of experts, such as F. Nadara.

Maxim Petrovich Dmitriev presented some of his works that later became a sensation of the Moscow exhibition. These photographs were some of his Volga sights, portraits, and genre scenes. In the 1890s international photographic exhibitions were no longer something extraordinary. At the Moscow International exhibition of 1896, organized by RPS, the foreign participants claimed all four contest nominations. Photographers from Denmark, Germany, France and other countries won gold and silver on equal terms with their Russian colleagues. Russia came to be fully integrated into the international photography process. The Session of Russian photographers and other specialists in the field synchronized to this exhibition a study of the key issues of Russian photography. The most salient question was of copyright for photographic works and products of photographic and mechanical processes. The law was proposed to the State Duma in 1908. Before the revolution of 1917, large photo-exhibitions took place in Russia like the International Photo Salon of Photography in Kiev in 1911, and a full-scale exhibition in St. Petersburg in 1912.

The societies and the exhibitions fostered the process of theoretical conceptualization of the artistic abilities of photography. The articles on this theme started to appear in Russia in the later half of the 1850s. The photographers and art critics wrote about the artistic potential of photography. However, these articles were not numerous and did not influence the world's photographic process.

During meetings of photographic societies, the question or problem that photography influenced life, or that life influenced photography was frequently discussed. For example, M.Dmitriev's album The Year of Poor Crops of 1891–1892 in the Nijnij Novgorod Province caused much influence on the public opinion and contributed to the activation of the government's aid to the ones who suffered from drought, typhus and cholera. It was this album that caused many photographers to begin to emphasize social problems in their work more often.

Many more heated debates on the specific features of photography, its language, the aesthetics of the art of photography, and the analysis of the achievements of world photography. In the beginning of the 1900s, a sharp debate arose in the photographic sphere regarding pictorial photography. This debate grew into an analysis of the nature of the artistic photographic image in general. Even though the works of the Russian photographers could not already influence the world's pictorial photography, it played an important role in the development of the Russian photography.

After 1932, all the artistic societies ended to create a space for the style of "soviet" realism.

ALEXEY LOGINOV

See also: Dmitriev, Maxim Petrovich.

Further Reading

Awards of the exhibitioners at the photography exhibition and practices, *Fotograficheski Vestnik*, 1889, no. 6, 121–129.

Barchatova, E., "Photography: A Science? A Craft? An Art!" *Russian Photography*, (1996) 5–22.

Boltyanski, G., *Essays on History of Photography in the USSR*, Goskinoizdat, 1939, 225.

Loginov, A., *Russian Pictorial Photography./ Pictorial Photography in Russia. 1890s–1920s* 10–29, M., Art-Rodnik, 2002.

"Moscow Photography exhibition," *Fotograf Lyubitel* [*Amateur Photographer*], no. 4 (1896): 150–153.

Podluzski, B., "The Activities of Russian Photographic Society." *Sovetskoye foto* [*Soviet Photography*] no. 1 (1927): 26–27.

SOCIETIES, GROUPS, INSTITUTIONS, AND EXHIBITIONS IN THE NETHERLANDS

The first encounters the Dutch had with photography probably took place in Paris where they went in the 1840s for equipment, or in London where they visited the International Exhibition of 1851. A few years later, in 1855 the Dutch for the first time had the opportunity to attend an exhibition of international photography in their country. It was the Exhibition of Photography organized by the prestigious Vereeniging voor Volksvlijt (Society for Industry), initiated by amateur photographer Jan Adriaan van Eijk, which was held in the center of Amsterdam in the building of the artists' society Arti et Amicitiae on the Damrak. It was quite similar to the exhibitions held this same year and a year later in Paris and Brussels, with more or less the same photographers and comparable contributions. 65 contributors send more than a seven hundred photographs to Amsterdam—photographers, societies and publishers alike—mainly from France, but also from England, Germany and the Netherlands itself. Photographs by the Dutch photographers Eduard Isaac Asser and his friend the chemist Eugene Bour were hung next to contributions by Charles Nègre, Henri Le Secq, Charles Marville, Edouard Baldus and the Comte the Montizon. The same exhibition was held a second time, two months later in The Hague, inaugurated by the king.

In 1858, 1860, 1862, and 1865 similar exhibitions, the first three also in the building of Arti and Amicitiae in Amsterdam followed: showing photographs by Gustave Le Gray, Philip Delamotte and Nièpce de St. Victor alike. The Dutch were a little more oriented towards France than towards Britain. It must have been the same mixture of art, experiment and industry as

elsewhere. The photographs were offered for sale and the catalogues mention ' import duties' and names of dealers as well. Benjamin Brecknell Turner's views of Amsterdam for instance were not exhibited in 1858 by the photographer himself but by the Amsterdam publisher W. Kirberger. The 1865 International Exhibition for Arts and Industry took place in the newly built Dutch Crystal Palace, the Paleis voor Volksvlijt in Amsterdam. Nadars mammoth photograph of a Japanese was being shown to the Dutch public, as well as his images from the Paris' catacombs. Maxwell Lyte for instance presented his landscapes from the Pyrenees and Wilhelm Hammerschmidt Egyptian views.

In those first 26 years since photography was introduced, the Dutch didn't have proper photographic societies, nor organized groups of photographers. Manuals and treatises from everywhere were translated for the amateurs who were interested in the new technique of image making. Some magazines for fine arts or industry translated articles from European origin and off course many read journals from France, Great Britain and Germany. The Dutch periodicals *Algemeene Konst- en Letterbode* as well as *Album der Natuur* regularly mentioned exhibitions, technical innovations and details in the field of photography. The 1860s saw the rise and spread of commercial and professional photography. This took place on a far smaller scale however than in the larger European countries. The first magazine exclusively concentrating on photography, *Tijdschrift voor Photographie*, was introduced in this period, again initiated by J.A.van Eyck, and leaded by a captain in the army L.P. van Beek. In 1864 it appeared for the first time and it lasted until 1866. Another photographer needs to be mentioned here. The German Julius Schaarwachter emigrated from Berlin to Nijmegen and started his De *Navorscher op het gebied der photographie, Tijdschrift voor photographie en aanverwante wetenschappen* between 1865 en 1876. He was a strong protagonist of the founding of a society or union for professional photographers, which he however never effectuated. In general the journals mainly had a 'technical' character. Other known platforms for exchange were the gentlemen's societies of art, architecture and antiquities.

It lasted until 1872 before the first *photographic* society, the 'Amsterdamsche Photographen-Vereeniging,' was founded with A. Haakman as its president. The society had its own journal, like the first Dutch journal also mentioned *Tijdschrift voor Photographie*. Only 45 photographers joined the club. The members exchanged photographs and technical details and held lectures, as we can read in its minutes in the *Tijdschrift voor Photographie*. In 1887 this rather subdue society was dissembled. Within a year a new society for *amateur* photographers—for 'dilettantes'—under the name of 'Helios,' with a journal with the same name

was founded in Amsterdam. Pioneer photographer Asser was one of its active members. In 1889 or 1890 the 'Nederlandsche Fotografen Vereeniging' was founded, which however didn't last long and of which we virtually know nothing.

The Amsterdam society was the first in a long row of local amateur photographer societies which were based in virtually every city, from Groningen to Arnhem, from The Hague to Maastricht. In the 1890s throughout the country a vast amount of international exchange took place by means of international exhibitions of the pictorialists. Foreign publications such as *Die Kunst in der Photographie, Camera Work,* and *The Studio* were well known. The work of British, American and German photographers, among them Alfred Stieglitz and Heinrich Kühn was often shown to the Dutch photographers and public. *Lux* (1889–1927) was an important monthly photography journal. Little known—only two numbers survive—was the journal *Lumen*, 'Magazine for Photography, Projection and Cycling,' founded by the Amsterdam photography firm Ivens & Co in 1897. The beginning of the 20th century saw the founding of two long lasting and important societies Nederlandse Fotografen Kunstkring (NFK) in 1902 as a real trade union and the Nederlandse Club voor Foto-Kunst (NCvFK) in 1907.

MATTIE BOOM

See also: Asser, Eduard Isaac; Baldus, Edouard; Kühn, Heinrich; LeGray, Gustave; Le Secq, Henri; Lyte, Farnham Maxwell; Marville, Charles; Montizon, Count de; Nadar; Nègre, Charles; Niepce de St. Victor, Claude Félix Abel; Stieglitz, Alfred; and Turner, Benjamin Brecknell.

Further Reading

Boom, Mattie, "De Amsterdamse fotografietentoonstellingen van 1855, 1858 en 1860." In *Geschiedenis van de Nederlandse Fotografie in monografieën en thema-artikelen, Alphen aan den Rijn*, edited by Ingeborg Leijerzapf, Amsterdam: Samson/Voetnoot, 1984.

Catalogus der Tentoonstelling van Photographie en Heliographie, Amsterdam 1855.

Catalogus der Tentoonstelling van Photographie en Heliographie, Amsterdam, 1858. Catalogus der Tentoonstelling van Photographie en Heliographie, Amsterdam, 1860. Catalogus der Tentoonstelling van Photographie, Enz., Amsterdam, 1862.

de Klerk, Liesbeth, "De Navorscher op het gebied der photographie: een platform voor de denkbeelden en aanbevelingen van Julius Schaarwächter." In *Geschiedenis van de Nederlandse Fotografie in monografieën en thema-artikelen, Alphen aan den Rijn*, edited by Ingeborg Leijerzapf: Amsterdam, Samson/Voetnoot, 1984.

de Ruiter, Tineke, "De Nederlandsche Fotografen Kunstkring, 1902–1948." In *Geschiedenis van de Nederlandse Fotografie in monografieën en thema-artikelen, Alphen aan den Rijn*, edited by Ingeborg Leijerzapf: Amsterdam, Samson/Voetnoot, 1984.

Leijerzapf, Ingeborg Th. (ed.), In *Geschiedenis van de Neder-landse Fotografie in monografieën en thema-artikelen, Alphen aan den Rijn*, Amsterdam: Samson/Voetnoot, 1984 [a series still being published].

Rooseboom, Hans, *De schaduw van de fotograaf. Status en posi-tie van Nederlandse beroepsfotografen, 1839–1889*, Leiden: Primavera 2006/2007.

SOCIETIES, GROUPS, INSTITUTIONS, AND EXHIBITIONS IN THE UNITED KINGDOM

The material infrastructure of nineteenth-century British photography has received remarkably little attention, yet exhibitions, societies and journals provided the framework for practice and theory. For a period, the social organisation of photography in Britain revolved around gentlemen amateurs. However, the category of the amateur requires scrutiny. Historians of photography have seen amateurs as synonymous with landed aristo-crats, engaged in the disinterested pursuit of knowledge: Talbot is the paradigmatic example. An oversimplified distinction is often made between landed gents and middle-class industrialists: in reality, no strong barrier separated these class fractions. However, a drift towards the professionalisation of photography is discernable during the period.

At the outset, photography was organised through bodies associated with the 'men of science': William Henry Fox Talbot exhibited his photogenic drawings at the Royal Society and at a meeting of the British Association for the Advancement of Science. These organisations provided 'men of science' with social networks and models of authority. Typically, early papers appeared in the *Proceedings of the Royal Society* or in the journals of the bourgeois public sphere: *Edinburgh Review, North British Review, Athenaeum, Art Journal, Notes & Queries*—even *Household Words* was a general-ist magazine. By the 1860s, the *Athenaeum* showed little interest in photography and *Notes & Queries* had been supplanted by the 'Notes and Queries' section of the *Photographic News*. As in everything else, the capitalist division of labour produced increased specialisation in photography.

The earliest recorded organisation dedicated to pho-tography was the Edinburgh Calotype Club, possibly in operation as early as 1841. This amateur organisation had a small membership (mainly legal men) who met over dinner to look at calotypes and socialise. Similar organisations soon sprouted in England: the Photo-graphic Club (sometimes called the Calotype Society), existed by 1847. As a contributor to the *Athenaeum* noted, the Photographic Club consisted of 'a dozen gentlemen amateurs associated together for the purpose of pursuing their experiments in this *art-science.*' The model for these groupings was based on networks of print connoisseurs. Members were to play a prominent role in British photography; among them were artists such as Sir William Newton, and 'men of science' like Robert Hunt. (P. Roberts, 212).

The Great Exhibition of 1851 initiated a transforma-tion in the structure of British photography. An extensive collection of British photographs, and related equip-ment, were shown; reviews appeared and medals were awarded. However, it was the foreign photographic displays (particularly the French) that drew praise. Many commentators claimed that French photographers outstripped their British counterparts. This argument needs to be treated with caution, because an established discourse suggested that British manufacturers—par-ticularly in the luxury trades—had slipped behind their French competitors. The account of photography circulating around the exhibition meshed with this argu-ment and was, in part, the product of self-serving taste-mongers. Nevertheless, combined with the simultaneous foundation of the French *Société héliographique* in 1851 the exhibition provided an impetus to the formation of British photographic societies.

The earliest British photographic society was estab-lished in Leeds in 1852. Crucially, in 1853 the London based Photographic Society came into being. The mem-bers of the Photographic Club played a significant role in creating this body, with Roger Fenton playing a leading role. The inaugural meeting took place, in 1853, at the Society of Arts—a venue that suggests the Society was modelled on the learned societies. The first Council was made up of twenty-four prominent gentlemen. By June of 1853 Queen Victoria and Prince Albert had agreed to act as patrons (though, it was not until 1894 that it assumed the title of Royal Photographic Society).

During the preparations for the Society, Joseph Cundall proposed an exhibition. Described by Pam Roberts as the first purely photographic exhibition, it opened at the Society of Arts on December 22nd 1852 and ran until January 29th 1853 (Roberts, 215). The first official exhibition of the Society took place in 1854. Thereafter, the Society's exhibition was an important annual event (with the exception of 1862, when it was suspended in favour of participation in the International Exhibition, and 1866). Held at a number of venues over the years, the entrance fee was set at one shilling, though on certain evenings—designated for the 'working classes'—it was reduced to 3d. The pictures were selected by jury and the display mimicked exhibitions of watercolours or prints—photographs in elaborate frames were stacked on the wall; a catalogue was published and extensive reviews appeared in both the national and the photographic press. These reviews provide important sources for judgements on particular images and assumptions about photography.

At least three amateur organisations existed during the

1850s: the 'Photographic Exchange Club' and two groups inside the Photographic Society: the 'Photographic Society Club,' founded in 1856, and the 'Exchange Club of the Photographic Society' (sometimes called the 'Photographic Club'). These organisations existed to facilitate exchanges of images and information between members, but they also provided networks of allegiance and identity. Founded 'to promote friendly feeling amongst members of the Photographic Society,' the Photographic Society Club was restricted to twenty-one members and met five times a year. (Seiberbling, 9–10) In a period when the Society mushroomed, this inner caucus provided the 'amateur' elite with a base for their hegemony. Grace Seiberling has estimated that only forty or so individuals were involved in these clubs. Membership overlapped and those involved were friends and acquaintances; some were relatives. A few of these people were engaged in photography on a professional basis, but these were amateur organisations imitating learned societies and dining clubs (where gentlemen socialised over a meal). According to Seiberling, the rules of the Photographic Exchange Club stipulated two photographic exchanges a year, but only four exchanges took place between 1855 and 1858. (Seiberling, 12) The Exchange Club of the Photographic Society issued two bound albums of members' photographs. The subjects of these pictures—antiquarian images of ancient buildings and monuments, picturesque views, landscapes, and so forth—typify the social vision of the gentleman amateur (Seiberling, 11).

From the outset tensions existed in the Photographic Society between amateurs and professionals. Talbot stressed the organisation should be founded on 'respectable' principles, unsullied by commerce. However, Fenton included professional or 'practical' photography in his vision for the Society. At the first anniversary meeting a motion advocated excluding those who practiced photography for profit. This proposition fell because it would have applied (among others) to Fenton who was Honorary Secretary ('Anniversary Meeting,' 165–66). According to Seiberling this tussle for control continued until 1858 (Seiberling, 73).

Nevertheless, a change was underway. The number of professional photographers in the Society increased substantively as did the range of commercial firms participating in the annual exhibitions. By the middle of the 1860s those involved in the exchange clubs had died or were no longer active in photography. This is not to suggest that there were ever rigid barriers demarcating amateur from commercial work: Talbot patented his inventions and attempted various commercial ventures; in 1853 early amateurs, including Philipe Delamotte and Cundall, instigated the 'Photographic Institution,' which charged for lessons, and sold equipment and prints; in 1856 Fenton, along with others from the Exchange Club, left the Council of the Society to found the com-

mercial 'Photographic Association,' when it flopped he returned to the Society and again played an active role as Vice President. Some early amateurs made the transition to professional photography; others tried to do so but failed.

Shortly after the foundation of the Photographic Society regional groupings appeared. The Liverpool Photographic Society was founded in 1853; the Manchester Society in 1855. Men professionally engaged with photography played a significant role in instigating these organisations in these industrial and commercial cities. But, even in these Northern bastions of capitalism, the key representative roles were filled by local notables. This should come as no surprise: this representative structure mirrors the British state and its colonial extensions. Some societies were short lived (In each case dates are for foundation of the society.): Devon and Cornwall (1854), Norwich (1854), Brighton and Sussex (1855), Birmingham (1856) reformed in 1885, Chorlton (1857), Blackheath (1857), Greenwich (1857) and Macclesfield (1858). The North London Society (1857) and the South London Society (1859) were more stable; as were the Nottingham (1858) and Bradford Societies (1860). With the rise of regionally active groups—the 'parent society'—became known as the Photographic Society of London; then the Photographic Society of Great Britain in 1874.

Special mention must be made of 'British' Societies situated beyond England's borders. Preceded by the Glasgow Photographic Society (1854), the Photographic Society of Scotland was formed in Edinburgh in 1856. Sir David Brewster was elected President; George Moir, previously involved with the Edinburgh Calotype Club was elected a Vice President (though, he stepped down the following year), as was Horatio Ross, a keen amateur and former M.P. for Aberdeen. Prince Albert agreed to act as Patron a month after foundation. The Society held regular meetings at which photographs and items of equipment were displayed and lectures presented; some papers along with the minutes of proceedings appeared in the *Journal of the Photographic Society*. The first annual exhibition was held in December 1856: 1,050 photographs were seen by 8,000 people. The Scottish Society's exhibition was to become a significant annual event. At the second AGM in 1858, membership stood at 151 and was said to include all prominent amateur and professional photographers in Scotland. However, following the establishment of the Edinburgh Photographic Society in 1861, the Photographic Society of Scotland declined, finally folding in 1873. Other Scottish societies included the short-lived Dumfries and Galloway Society (1856) and the Paisley Society (1857). The Glasgow Society became the Glasgow and West of Scotland Photographic Society in 1860.

In Ireland—at this time a part of the British state—

two societies emerged during the 1850s: the Dublin Photographic Society, founded at the premises of the Royal Dublin Society in 1854, and the Belfast Photographic Society, founded 1857, but probably defunct by 1860. The participants in the Dublin Society resemble the figures that made up the London Society: unsurprisingly, many of these people were part of the Anglo-Irish establishment. In a significant move, it changed its name to the Photographic Society of Ireland in 1858. In an empire over which the 'sun never set,' photographic societies were also active in Bombay (1855), Calcutta and Madras (both 1856). Journals were published by the first two societies, but appear not to have survived; the latter published proceedings in the *Madras Journal of Literature and Science* and also held some exhibitions. The social role of these organisations and the images produced by their members were inevitably shaped by this colonial context.

As the South London Society's Honorary Secretary A.H. Wall put it, the range of subjects discussed at meetings:

> are such as, until the introduction of photography, were seldom associated together. The rules of art, the laws of chemistry, the principles of optics, and the secrets of certain mechanical crafts, seem in the non-photographic mind to possess so little in common, that strangers wonder when they hear each, or all, of these dissimilar subjects blending in a discussion following some paper on one or other of the processes of photography. (Wall, 'A Few Thoughts about Photographic Societies,' 487)

Although some of the smaller societies were referred to as 'Gossiping Clubs,' the South London Photographic Society was extremely active and gives an indication of proceedings. Less formal than the London Society, 25 to 30 members gathered to discuss papers or matters of interest. A 'Question Box' allowed issues to be raised 'without writing a paper.' It was suggested that papers should be submitted in advance to the committee in order to prevent presentations that were 'foolish,' 'unsuitable' or in bad taste ('Photographic Societies, Papers, and Discussions,' 147). Evidently, some effort had to be exerted to establish norms of middle-class decorum.

What we know about the societies comes, in large part, from the journals, which carried the minutes of their proceedings and published papers. From the 1850s, numerous photographic journals appeared, often with a short life span. Three stand out: *The Journal of the Photographic Society of London* founded in 1853 (subsequently *The Photographic Journal* from 1859); *The British Journal of Photography* established 1860, but emerged from journals issued in the North West from 1854; and *The Photographic News* (1858–1908). *The Photographic News* was independent (though it was closely allied to the London groupings) and it easily achieved the highest circulation figures. These journals provide indispensable source material, but they need to be read carefully: these are partisan forums for personalities, trends and coteries; all were dedicated to elevating the social status of photographers.

From the outset, photographs were exhibited in a wide range of contexts, including: the British Association for the Advancement of Science, The Society of Arts, The Royal Scottish Academy, The Royal Polytechnic Association, The Photographic Institution, Mechanics Institutes; even the Yeovil Mutual Improvement Society. As we have seen, the Photographic Society and Photographic Society of Scotland mounted annual exhibitions: local photographic societies also held exhibitions on an intermittent basis. Photographs featured in the Great Exhibition of 1851 and in 1857 the Manchester Art Treasures Exhibition included an important collection of photographs selected by Delamotte. Exhibitions of novel subjects began to take place during the 1850s: Fenton's Crimean pictures, for instance, were shown widely around Britain. The 1862 International Exhibition was probably one of the most significant the exhibitions of the period. Following the pattern established in the Great Exhibition of 1851, the commissioners responsible proposed exhibiting photographs and equipment together in the Machinery Court. Photographers were repelled by this suggestion and demanded that their images be exhibited with the Fine Arts. A campaign for reclassification, led by the Photographic Society, was instigated and the national press took note of the argument. As *Punch* observed, the commissioners:

> [h]ave thought fit to pass an insult upon Photographic Art, by classing its productions with railway plant and garden tools, small arms and ship's tackle, big guns, and new omnibuses, donkey carts and corn extractors.... (Silver, 'Fair Play for Photography', 221)

The Society organised a boycott of the exhibition, but eventually accepted the compromise of a 'separate apartment' offered by the commissioners. When the exhibition opened it became apparent that this 'separate room' was a purely notional category in the catalogue; photographs were situated alongside cameras and chemicals amongst an array of educational devices. Despite photographers' evident dismay this exhibition was pivotal, because it pushed photographers to argue on a scale previously unknown that their art was one of the Fine Arts. No doubt, the need to claim invention in copyright law played an important role here, but the existence of networks of professional societies and journals was also significant (in this dispute the *Photographic Journal* received communications from at least nine societies). However, it would be another ten years, before photography was admitted to the category of Fine Art in the International Exhibition of 1872, where it was situated with engraving and lithography.

If the amateur exchange clubs provided one kind of alternative to photographic societies, other organisations also contested for hegemony. Mechanics' Institutes and Literary and Philosophical Societies gave time and attention to photography. During the 1860s James Mudd was a member of both the Manchester Photographic Society and the Manchester Lit and Phil (Photographic Section) were he rubbed shoulders with prominent industrialists and men of science. In 1863 and 1864, responding to the economic crisis in the carte trade, the editor of the *Photographic News*—George Wharton Simpson—advocated the establishment of a 'relief fund' or 'provident society' for photographers ('A Photographers' Relief Fund,' 589). Though little is known of it (probably because historians have been overly preoccupied with the doings of amateur gentlemen) the Solar Club, organised by Simpson, played an important role in the 1860s. Restricted to 25 members, it brought together the '*elite* of the metropolitan photographers*'* for dinner once a month along with guests from the arts and the press. The model may have been the gentlemanly dining club, but this was no longer an amateur binge. The members of the Solar Club were key figures in professional photography: editors, proprietors of grand studios and writers for the trade journals. At one such meeting the alliance between Alfred Wall and Oscar Rejlander was cemented. There were, of course, also attempts to unionise the industry, though nothing concerted seems to have happened until the early 1890s when Arthur G. Field, Eleanor F. Field and John A. Randall made a determined push for an operatives' organisation.

In his report on the International Exhibition of 1862, published in 1864, Dr Hugh Diamond suggested that there was 'scarce a branch of art, of science, of economics, or indeed of human interest in its widest application, in which the applications of this art have not been made useful.' He offered a list of those who employed photography in their professional pursuits, including: people from medicine, law, architecture and engineering, manufacturers, ethnology, natural history, archeology and antiquarian pursuits. (Diamond, 'Report of Jurors,' 339–46) Lists like this were part of the professional claim to status and shouldn't be taken literally. Nevertheless, photographers increasingly found forms of institutional support by providing the State and private organisations with documents. For example: Fenton, along with the brothers Thurston and Stephen Thompson, worked for the British Museum during the 1850s and 1860s documenting its holdings; penal photography was established during the 1870s and came increasingly to feature as evidence in the law courts; it also came to play an important role in anthropology and colonial administration.

As early as 1859, the need for a permanent collection of photographic portraits was mooted. Lachlan McLaclan took up the idea of a national collection of portraits in 1863. Three years later the Corporation of Manchester adopted his plan and appointed him Honorary Curator. Solicitations for pictures appeared in the photographic press, but, to my knowledge, nothing further happened. In 1882 the South Kensington authorities announced their intention to hold an exhibition surveying the history of photography. The exhibition was to form the basis of a permanent collection at the museum and appeals were again issued in the photographic press soliciting donations of apparatus and pictures. Organised in less than a month and accompanied by a series lectures, this exhibition provided the foundation for the Science Museum collection, and subsequently the nucleus for the National Museum of Photography, Film and Television.

Pictorialism represented both a break and continuity with the established organisations and procedures. The Linked Ring Brotherhood seceded from the Photographic Society in 1892 in order to pursue an untrammelled vision of photographic art. Initially, 28 members were listed on a 'Roll,' rising to 75 at the height of activity. The organisation assembled monthly at a 'Union' for dinner and published *Linked Ring Papers* for circulation amongst the membership. From 1893 it also organised an annual exhibition, or 'Photographic Salon,' which was first held at the Dudley Gallery, Piccadilly, and then at the Pall Mall premises of the Royal Society of Painters in Water Colours. The Linked Ring retained many of the existing organisational forms, but infused them with the imagery and values of the Aesthetic Movement and the Arts and Crafts Guilds. However, Pictorialism was not confined to the elite associated with the Linked Ring: *Amateur Photographer,* a journal peddling a softer version of the Symbolist aesthetic, appeared between 1884 and 1918, and Pictorialism permeated the new amateur hobbyists clubs that developed during the later years of the century. It has been suggested that the number of photographic societies had declined substantially by 1880; in 1885, H. Baden Pritchard listed 17 societies in England and Scotland. (Pritchard, *Photography and Photographers*, 101) By 1900 this figure has risen spectacularly to 256. As Peter James has noted, attention to Pictorialism has largely overshadowed the emergence, around 1890, of the Record and Survey Movement. (James, 'Evolution of the Photographic Record and Survey Movement,' 205). Instigated by Sir Benjamin Stone and W. Jerome Harrison a local survey was initiated to document disappearing monuments, traditions and old buildings in Warwickshire. Other local surveys were undertaken and Harrison attempted to found a national organisation, but he ran foul of the Photographic Society. Stone, by this time Conservative M.P. for Birmingham, established the National Photographic Record Association in 1897, which produced

thousands of images. Despite their divergent aesthetic approaches, Pictorialists and the survey groups pursued a largely anti-urban vision.

STEVE EDWARDS

See also: Talbot, William Henry Fox; *Notes and Queries; Photographic News (1858–1908)*; Edinburgh Calotype Club; Hunt, Robert; Société héliographique; Victoria, Queen and Albert, Prince Consort; Photographic Exchange Club and Photographic Society Club, London; Delamotte, Philip Henry; Rejlander, Oscar Gustav; Royal Photographic Society; Fenton, Roger; Great Exhibition 1851; Cundall, Joseph; Royal Society, London; Brotherhood of the Linked Ring; Photographic Salon, London; Wall, A.H.; South Kensinginton Museum.

Further Reading

Anon., "Anniversary Meeting." *Journal of the Photographic Society* (February 21, 1854): 165–166.

Anon., "Photographic Societies, Papers, and Discussions." *The Photographic News* (March 29, 1867): 146–147.

Barton, Ruth,, "'Men of Science': Language, Identity and Professionalization in the Mid-Victorian Scientific Community.," *History of Science*, vol. 41, part 1, no. 131,(March 2003): 73–81

Berman, Morris, "'Hegemony' and the Amateur Tradition in British Science.," *Journal of Social History* vol. VIII (Winter, 1975):.30–50.

Chandler, Edward, Photography in Ireland: The Nineteenth Century, Dublin: Edmund Burke, 2001.

Cooper, Harry. *The Centenary of the Royal Photographic Society of Great Britain 1853–1953: a Brief History of its Formation, Activities and Achievements*, Royal Photographic Society, 1953.

Diamond, Dr Hugh. "Report of Jurors." *The Photographic Journal* (August 15, 1863): 339–346.

Eastlake, Lady Elizabeth, "Photography." In *Photography: Essays and Images*, edited by Beaumont Newhall, 81–95, Secker and Warburg, 1981.

Edwards, Steve. *The Making of English Photography, Allegories*, University Park: Penn State University Press, 2006.

Fenton, Roger, "Proposal for the Formation of a Photographical Society," 1852, Pam Roberts, "'The Exertions of Mr. Fenton': Roger Fenton and the Founding of the Photographic Society,' Gordon Baldwin, Malcolm Daniel & Sarah Greenaugh, with contributions by Richard Pare, Pam Roberts, and Roger Taylor, *All the Mighty World: The Photographs of Roger Fenton, 1852–1860*, New York: The Metropolitan Museum of Art, 2004, 214.

——, "Upon the Mode in which it is advisable the Society should conduct its Labours." *Journal of the Photographic Society* (March, 3, 1853): 8.

Gernsheim, Helmut. *Incunabula of British Photographic Literature 1839–1875*, John X. Berger ed., London & Berkeley: Scolar Press, 1984.

Hamber, Anthony J., *"A Higher Branch of the Art": Photographing the Fine Arts in England, 1839–1880, Documenting the Image*, vol. 4, Amsterdam: Gordon and Breach Publishers, 1996.

Harker, Margaret, *The Linked Ring: The Secession Movement in Photography in Britain 1892–1910*, London: Heinemann, 1979.

James, Peter. "Evolution of the Photographic Record and Survey Movement, c.1890–1910." *History of Photography*, vol.12 no 3 (1988):.205–218.

Morrell, Jack, and Arnold Thackerey, *Gentlemen of Science: The Early Years of the British Association for the Advancement of Science*, Oxford University Press, 1981.

Pritchard, H. Baden, *Photography and Photographers: A Series of Essays for the Studio and Study*, (1885), Arno Press reprint, 1973.

Roberts, Pam, "'The Exertions of Mr. Fenton": Roger Fenton and the Founding of the Photographic Society,' Gordon Baldwin, Malcolm Daniel & Sarah Greenaugh, with contributions by Richard Pare, Pam Roberts, and Roger Taylor, *All the Mighty World: The Photographs of Roger Fenton, 1852–1860*, New York: The Metropolitan Museum of Art, 2004, pp.211–220

Seiberling. Grace, and Carolyn Bloore, *Amateurs, Photography and the Mid-Victorian Imagination*, Chicago: The University of Chicago Press, 1986,

Sekula, Allan, "The Body and the Archive." *October* no. 39 (1986): 3–64.

Silver, Henry, "Fair Play for Photography." *Punch, Or The London Charivari* no. 1038 (June 1, 1861): .221.

[George Wharton Simpson], "A Photographers' Relief Fund." *Photographic News* (December 11, 1863): 589.

Tagg, Joh,. *The Burden of Representation: Essays on Photographies and Histories*, Houndmills: Macmillan, 1988.

Taylor, Roger, *Photographs Exhibited in Britain 1839–1865*, Ottawa: National Galleries of Canada, 2002.

Thomas, G., "The Madras Photographic Society 1856–61." *History of Photography*, vol. 16, no. 4 (1992): 299–301.

Wall, Alfred H., "A Few Thoughts about Photographic Societies." *Photographic News* (October 9, 1863): 486–489.
Website
http://www.edinphoto.org.

SOCIETIES, GROUPS, INSTITUTIONS, AND EXHIBITIONS IN THE UNITED STATES

The development of photography in the United States has often been described as a "pell-mell rush," to quote Albert Sands Southworth's 1871 evocation of the beginnings of American photography: a spontaneous competition, in which academic institutions and formal organizations played little role. Although this characterization is to some extent true, the organizational history of American photography deserves attention, especially since it reveals, throughout the 19th century, a consistent ambition to elevate the status of photography.

During the 1840s, the development of the daguerreotype was largely autonomous and uncontrolled, as trade organizations did not yet exist and academic institutions played only a limited role. In the United States, the first announcement of Daguerre's invention was not carried by a scholarly publication, but rather by dozens of newspaper reprints of a letter by Samuel F.B. Morse, describing from Paris the "results" of the daguerreotype. The decentralized structure of the United States was

mirrored in the way daguerreotype experiments and then businesses popped up in virtually every settled area, the main economic and cultural centers merely leading the way. For most of the 19th century, and despite some important exceptions, federal departments and especially Congress were quite timid in promoting the use of photography, and were even more so in creating conservation and evaluation instruments. Yet the contrast that some historians have drawn between an "academic" Europe and an "entrepreneurial" America must not be overestimated. No existing American institution in 1839 would have had the power, the authority or the design to influence the course of photography in any way comparable to European policies of protection and promotion. An exception may be made for the U.S. Patent Office, which granted between 1842 and 1862 at least fifty patents concerning mostly minor improvements on the daguerreotype, but whose action was of necessity limited to the realm of technology and even then was often contested or disregarded. Beyond this, however, many academic institutions participated in their own way in the development of the daguerreotype. In many parts of the United States, universities and medical schools served as the first centers for information and experimentation, and this was no less true in the major cities. In Philadelphia—America's old capital —, the Franklin Institute was called upon to evaluate Daguerre's process, and shortly published an "explanation" and then an English translation of Daguerre's manual, while in May 1840 the American Philosophical Society was shown portraits of its members, produced through technical improvements on Daguerre's instructions which, based on experiments by chemists from the University of Pennsylvania, came to be known as the "Philadelphia method." In New York, the leading role that Morse and John W. Draper played in the first months reflected their connections to both New York University and Morse's National Academy of Design, the latter a mutual aid society, rather than a formal tribunal of art. Although other groups existed in New York without any such affiliation, and although the Morse-Draper group was short-lived and mostly informal, it was Morse's authority that drew many apprentices to his studio for lessons in daguerreotypy (among whom were Mathew B. Brady and several other future photographic greats). Finally, associations in the larger cities often held fairs where daguerreotypes were exhibited, the most important of these being the American Institute's fair in New York, which awarded medals for daguerreotype from 1840 on, Mathew Brady receiving his first medal there in 1844 and his first gold medal in 1849.

Between 1850 and 1855, increasing competition, signalled by price wars and various attempts at controlling the market through patents, and compounded by the emergence of the new negative processes, caused a great deal of tension in the profession and led to the formation of "protective" or "mutual" organizations. The most famous of several patents that were awarded, with little or no justification, for secondary improvements on the glass processes was the "bromide patent," covering an accelerating formula for collodion on glass, which was one of three granted in 1854 to James A. Cutting, and which virtually enabled him to control the entire sector of glass photography, causing bitter corporative feuds. Along with the anti-patent and price wars, another concern that initially and durably underlay trade organizations was the desire to "elevate" photography, which meant both to expand its uses and to legitimize it as a form of art. These factors merged in the formation in 1851 of the first two American photographic societies: the New York State Daguerrean Association, which aimed primarily at setting floor prices and creating a "fraternal" spirit in the profession; and the American Daguerre Association, whose first secretary was Samuel D. Humphrey, editor of the world's first specialized periodical, *The Daguerrean Journal* (founded 1850). Humphrey's goal was to promote taste in photography and counter its "humbug" reputation. Neither one of these early photographic societies survived for more than a couple of years, and, by 1852, a third one appeared in New York on a similar platform of mutual aid. In these early efforts to organize the profession and more generally to "elevate" photography's dignity one must also include the photographic competition at the New York Crystal Palace Exhibition in 1853, the first World Fair in the United States, where daguerreotypes still dominated in numbers but were outraced for the top award by photographs on paper.

In the decade between 1859 and 1869, as the daguerreotype was definitively supplanted by glass photography, several more attempts at organization betrayed the same protective impulse. In New York in 1859 the American Photographical Society (APS) was founded; it was later renamed the Photographic Section of the American Institute. Among its founders were some of American photography's pioneers, such as Henry Hunt Snelling, Charles A. Seely, John Johnson and Joseph Dixon, but relatively few active photographers. Indeed, this society aimed at placing American photography "in a position equally as elevated as in Europe," as Seely put it, and therefore it called rather on scientists (such as John W. Draper, Lewis M. Rutherford, Robert Ogden Doremus), and, in William Welling's words, "some of the foremost business, professional and social leaders of the day." The APS discussed technical novelties and scientific discoveries, but also various applications of photography and even photography's past, some members tossing around the idea of a photographic museum in New York. In these various aspects, the APS echoed changes in the social and cultural status

of photography in the United States. This was indeed the period in which, thanks to collodion photography, large organizations, especially federal departments and services, but also railroad conglomerates, museums and academic or scientific bodies, started to devise large-scale undertakings of documentation, archiving, map-making and illustration : hence the role of photography in the Civil War, and especially the connection of the Union's Army of the Potomac with Mathew Brady's staff of war photographers, but also Joseph Henry's precocious organization of photo-ethnographic collections at the Smithsonian Institution, and the systematic inclusion of photographers in federal surveys of the West after 1867. Another trend was the emergence of amateur photographers (or amateurs of photography) and local photographic societies. The most important of these was the Photographic Society of Philadelphia, which was founded in 1862, and which drew amateurs and professionals, including major figures such as Coleman Sellers and Edward L. Wilson, editor from 1864 on of the *Philadelphia Photographer*. This periodical continued the goal of "elevating" photography by promoting serious technical innovation and artistically informed discourse and practices. The strength of the Philadelphia connection was reflected in the Centennial Exhibition of 1876, whose large photographic section displayed in Philadelphia what Robert Taft called "the highwater achievement of the American wet plate photographer," as well as the first large-scale confrontation of American and European photographs in the United States before 1895.

Meanwhile, the protective spirit of the earlier daguerrian societies was far from extinct in the profession itself. The ongoing battle against patents was topmost on the agenda of the Photographers' Protective Union, which convened several times in the 1860. The matter finally came to a head in 1868, when in an effort to fight an application to renew the Cutting patent, a National Photographic Convention was held at the Cooper Institute. At this important event virtually all the great names of professional photography and the photographic industry were gathered (including Mathew Brady, John A. Whipple, Henry T. Anthony, Alexander Hesler, James F. Ryder, John Carbutt, etc.), united in a drive to obtain the repeal of the patent renewal. The patent was indeed revoked, and there ensued a new, "fraternal" organization, the National Photographic Association (NPA), which convened for the first time in 1869 in Boston, inaugurating a period of greater stability in the profession. At this convention a large exhibition displayed the state of the photographic art, including photographs made from retouched negatives, and announcing a trend that might be labeled "professional art photography," and which would characterize NPA exhibitions and American professional photography in general until 1900. In

1870, in the same protective spirit, the NPA defended a copyright for photographers, obtaining a provision in the 1870 law that granted copyright to photographs on the condition that two copies be sent to the Library of Congress (the single most important source of that institution's photographic collection). In the 1870s the NPA became the principal photographic organization; its membership exceeded 1,000 and included such prestigious figures as Samuel Morse, Oliver Wendell Holmes, and Hermann Vogel; it held large annual conventions and exhibitions, and pursued a very eclectic agenda, from patent discussions to artistic retouching to the esthetics of landscape to the historiography of early American photography. Although the NPA came to an early death in 1876 as a result of internal dissent, it was more or less revived in 1880 by the Photographers' Association of America (PAA), which essentially continued the former society in its membership, its "fraternal" ambition to elevate taste and quality and to combat price-cutting—a goal that became vital in the face of growing dry-plate companies and nascent popular photography—and in its genteel commitment to art, which as Sarah Greenough has noted, may have been innovative in theory, but was rather conventional in practice. Thus, it could be argued that from the first daguerrian associations to the PAA's continuing fight for "art photography," the mainstream of American professional photography consistently upheld the same agenda of resisting the more brutal forces of business and industry and promoting photography as art.

After 1880 and even more so after 1890 the structure of American photography changed, in response to the advent of popular photography and perhaps more directly to the growing ranks of self-conscious amateurs, whose clubs and societies numbered over 50 in 1890 and over 150 in 1895. This evolution was also reflected in the increasing number of photographic exhibitions and galleries. A Society of Amateur Photographers of New York held its first annual exhibition in 1885, and in 1887, along with its Boston and Philadelphia counterparts, it started holding Annual Joint Exhibitions that gathered vast amounts of photographs, still with a view to raise standards of taste and quality. In 1896 a photographic salon was held in Washington, D.C., at the Smithsonian Institution, and the following year this was enlarged into a "National Photographic Salon," with the Smithsonian Institution pledging to buy the best photographs. Also in 1897 a large salon was held in Pittsburgh. The National Academy of Design housed its first exhibition of photographs in 1898, and the same year a full-fledged European-style photographic salon was staged at the Philadelphia Academy of Fine Arts, which displayed over 200 photographs by 100 photographers. The Eastman Kodak Company itself created clubs and exhibitions for the promotion of artistic ambition within the

ranks of popular photographers. Thus, when Alfred Stieglitz formed the Photo-Secession in 1902, the institutionalization of fine art photography (and pictorialism) in the U.S. was so advanced that the issue was no longer to "elevate" photography, but rather to strip it of both its professional and amateurish connotations, which over half a century had jointly and consistently amounted to a code of photographic correctness.

FRANÇOIS BRUNET

See also: Southworth, Albert Sands, and Josiah Johnson Hawes; Daguerreotype; Daguerre, Louis-Jacques-Mandé; Brady, Mathew B.; Cutting, James Ambrose; Great Exhibition of the Works of Industry of All Nations, Crystal Palace, Hyde Park (1851); Snelling, Henry Hunt; Whipple, John Adams; Kodak; and Pictorialism.

Further Reading

Greenough, Sarah, "'Of Charming Glens, Graceful Glades, and Frowning Cliffs': The Economic Incentives, Social Inducements, and Aesthetic Issues of American Pictorial Photography, 1880–1902." In *Photography in Nineteenth-century America*, edited by Martha A. Sandweiss, 259–281.

Rinhart, Floyd, and Marion Rinhart, *The American Daguerreotype*, Athens (Ga.): University of Georgia Press, 1981.

Sandweiss Martha A. (ed.), *Photography in Nineteenth-century America*, Fort Worth and New York: Amon Carter Museum, Harry N. Abrams, 1991.

Southworth, Albert Sands, "The Early History of Photography in the United States" (1871), repr. in Beaumont Newhall, *Photography: Essays and Images*, 37–43, New York: The Museum of Modern Art, 1980..

Taft, Robert, *Photography and the American Scene: A Social History 1839–1889* (1938), repr. New York: Dover, 1964.

Welling, William, *Photography in America, The Formative Years 1839–1900* (1978), Albuquerque: University of New Mexico Press, 1987.

SOMMER, GIORGIO (1834–1914)
Italian photographer

Giorgio Sommer was born at Frankfurt am Main on the 2nd of September 1834. His parents were Georg and Anna Margaretha Gauff. His father had been the proprietor of a famous hostelry since 1826 and was able to give his growing family a certain measure of comfort. Later, however, he lost everything because of gambling and was forced to put his eldest sons to work to support the family. Thus Giorgio Sommer, the ninth of a very large family, served his apprenticeship in the firm of Andreas and Sons in Frankfurt until 1853. Immediately afterwards he started working professionally as a photographer.

In 1857 he went to Italy, first to Rome and then to Naples, where he chose to take up permanent residence. He went back to Rome in 1859 to keep up his acquaintance with his fellow-countryman Edmondo Behles (1841–921), with whom he had formed an association as soon as he had arrived in Rome. This acquaintance lasted until about 1866. Behles was the most brilliant and most qualified cameraman in Sommer's firm, and even today it is difficult to tell his work from that of Sommer's, since the earliest photographs of both do not indicate copyright.

Behles remained in Rome when Sommer set up in Naples, and worked independently until 1878 in Via Mario dei Fiori 28. Both Sommer and Behles in their new premises sold photographs taken in Rome under their own names while they were working together. This made the attribution of the studio's first photographs very difficult. The years spent in Rome were very fruitful ones for Sommer however and it was there that he put his experience to the test and he made contacts that helped him to consolidate and enlarge his own visual capacity. Rome was the meeting place of artists and intellectuals from all over Europe, the goal of a cultured elite of travellers, and the seat of academies and cultural institutes of different countries. There gathered some of the most eminent photographers, such as James Anderson (1813–1877), Angelo (1793–1858) and Giacomo (1819–1891) Luswergh, Robert MacPherson (1811–1872), the calotypists who gathered around Frédéric Flachéron (1813–1883) of the "Roman school of photography." Of these the most famous were Eugène Constant and Giacomo Caneva, who were often to be found at the famous "Caffè Greco" in Via Condotti. Also in Rome at that time there were many other German photographers, such as Wilhelm Osvald Ufer, Gustav Reiger, Michael Mang and Alfredo Noack. In Rome, Sommer and his fellow-countrymen pursued their interest in archaeology and the ancient world, and often met at the Deutscher Künstlerverein or in Palazzo Caffarelli. They loved the beauties of the Italian countryside and of Italian art, thanks to the return of Classicism and its myths, which were much transformed and "revisited" at a symbolic level. Such a passion for antiquity was nourished at the time by the finds at the excavations around Rome and Naples.

Of Sommer's work at Rome there remain several views and his complete set of photographs of the works of art in the Vatican, especially of the ancient statues of Braccio Nuovo, the Museo Chiaramonti, the Museo Pio Clementino, the cabinet of Pope Pius the VIth, the Rooms of the Muses, the Rotonda and the Candelabra. When he was at Rome, his preference was for stereoscopic formats and *carte de visite*, which he abandoned after the 1860s, and for "Medium" (21 by 27 cms) and "Large" (28 by 38 cms) photographic apparatus.

At Naples there were many foreign photographers and artists, such as George Conrad, Roberto Rive, Alphonse Bernoud, and Wilhelm Weintraub. Here Sommer set up

his studio most strategically in the centre, although he changed his address several times. Once his association with Behles had come to an end, between 1873 and 1874 he established himself finally in a palazzo in the piazza della Vittoria, where he stayed until he died on the 7th of August 1914. At the end of the sixties his studio was one of the foremost in Naples, which enabled him to live in considerable ease.

Of the photographs he took while at Naples there remain some extraordinary views of ancient ruins, of the excavations at Pompeii and Herculaneum, of the beauties of nature and of monuments, as well as some pictures of Neapolitan dress. Thus he continued to produce the type of work he had experimented with at Rome. He worked for commission, and free lanced at the same time to increase his own individual collection.

In 1862 he abandoned portraiture and began looking at the everyday life of the people of Naples, took photographs of their costumes and of produced genre scenes. From the numerous photographs of trades at Naples which he produced in his studio from the end of the sixties a fine cultural connection can be seen with the tradition of engraving and the eighteenth century Neapolitan tradition of the crib. However, he did not portray the real miseries of man's existence, but by restoring a degree of humanity gave somewhat picturesque view of life and sold his photographs as souvenirs to middle-class and aristocratic tourists who were looking for traditional scenes of a Neapolitan popular character. Indeed, there is no hint of the social conflicts that were typical of the period. In the nineties Sommer began to specialize in instant photography, using the new gelatine silver bromide process. These photographs, which show ordinary people in an everyday context, have an immediacy that reveals the changed priorities of the photographer, and can be seen as the forerunners of social reportage.

Perhaps at the commission of the great archaeologist John Henry Parker he photographed ancient works of art, in particular those at Pompeii and those in the Museo Nazionale at Naples. His views of landscape, both in Italy and in other European countries, are distinguished by their descriptive clarity and precision of detail. Their extremely high quality is due to the use of gold toning, which gives the prints fine gradations of tone from red and purple to violet. His great skill in composition is shown by the fact that, through a slight deviation from frontal and symmetrical shots, his photographs of monuments and architecture are always dynamic and never static.

His studio became very well-known also abroad, thanks to clever distribution and advertising techniques that gave him sales outlets at Vienna, Genoa, Venice, Florence and Palermo. He also had prestigious commissions in the world of art publishing, such that for the work by Domenico Benedetto Gravina published in 1859 *Il Duomo di Monreale illustrato* [*Illustrations of Monreale Cathedral*]. His remarkable entrepreneurial and organizational skills helped him to set up a strong network of collaborators, and his versatility of character and gifts enabled him to interpret successfully the different roles of photographer, printer, publisher, and distributor. Exploiting the growing taste for antiquities, he also started producing objects of art in bronze, terracotta, and marble, copying in particular originals of Pompeii. He won prizes for this, in addition to prizes for photography, at the international exhibitions at London (1862), Paris (1867), Vienna (1873), and Nuremberg (1885). In 1865, together with Behles, he received a signal honour from Vittorio Emanuele II, and from then on his style and title was that of Photographer of His Majesty the King of Italy.

He made many journeys abroad, especially to Switzerland, where, thanks to his reputation, he gained from 1880 to 1890 a commission from the Swiss government to photograph the mountains in connection with the extension of the railway network. Thus his last years were ones of flourishing activity, affluence, and fame also beyond the Alps. However, the extraordinary quality of his photographs mark him out as the photographer who above all definitively captured the life, the monuments, the natural and artistic beauties of Naples, Pompeii, Herculaneum, Amalfi, and all the region of Campania, rich in history, art, and tradition.

Sommer's firm was officially wound up in 1916, two years after his death. The plates were given by a nephew to Bruno La Barbera and were then destroyed.

Today there are many of Sommer's photographs in public and private collections, both in Italy and elsewhere.

SILVIA PAOLI

Biography

Giorgio Sommer was born at Frankfurt am Main on the 2nd of September 1834. His parents were Georg and Anna Margaretha Gauff. He was the ninth of a large family, and had to earn his own living from an early age because of economic difficulties. He was apprenticed to the photographic studio of Andreas and Sons and at the end of his apprenticeship he decided to work professionally. He began to work in Italy in 1857, at first in partnership with Edmund Behles, and from 1866 on his own. His first studio was in Rome, but almost immediately he decided to settle in Naples, where he changed his address several times (Strada di Chiaia 168, Via Monte di Dio 4 and 8, Piazza della Vittoria). He travelled widely in Italy and abroad, either for his own private work or on commission. His main interests were photographing views of archaeological sites and

of the natural and artistic beauties of Naples and its bay, of Pompeii and Herculaneum, and of the Amalfi coast, and taking photographs of Neapolitan costumes. For a short time he did portraits, but stopped in 1862. In 1861 at Naples he married Antonia Schmid, the daughter of a piano maker; they had two children, Edmund and Carolina. Edmund worked in his father's firm and on the 21 of January 1889 became a partner. The firm won prizes at international exhibitions: London (1862), Paris (1867), Vienna (1873), and Nuremberg (1885). In 1865 Sommer was honoured by Vittorio Emanuele II as Photographer Royal. He died on the 7th of August 1914 after having achieved great affluence and European fame. Nothing remains of his archive of plates. Today there are only some of his photographs in public and private collections.

See also: Behles, Edmondo.

Further Reading

Afeltra G., Di Pace U., Portoghesi P. et al., *Giorgio Sommer viaggio nel ricordo*, Ercolano, Produzione Segno Associati, 1986.

Baum P., *Giorgio Sommer (1834–1914). Photographien aus Italien*, Linz, Neue Galerie der Stadt Linz, 1985.

Becchetti, Piero, *Fotografi e fotografia in Italia 1839–1880*, Rome, Quasar, 1978, 86–87.

Cova, Massimo, *Due professionisti dell'epoca del collodio: Pietro Poppi e Giorgio Sommer*, in *Alle origini della fotografia: un itinerario toscano 1839–1880*, edited by Falzone del Barbarò, Michele, Maffioli, Monica and Emanuela Sesti, 145–147, , Florence, Alinari, 1989,.(exhibition catalogue).

Hillebrand R., *Giorgio Sommer. Romantische Nostalgie*, in *Professional Camera*, 2, maggio, 1979, 50–55, 96.

Miraglia, Marina, *L'immagine tradotta dall'incisione alla fotografia*, Naples, Studio Trisorio, 1977, 28–29.

Miraglia, Marina, *Giorgio Sommer*. In Miraglia, Marina et al., *Fotografia italiana dell'Ottocento*, edited by Marina Miraglia et al., 178, Milan and Florence, Electa/Alinari, 1979.

Miraglia, Marina, *Giorgio Sommer*. In *Cultura figurativa ed architettonica negli Stati del Re di Sardegna 1773–1861*, edited by Castelnuovo, Enrico and Marco Rosci, 1487–1488, Torino, 1980.

Miraglia, Marina, *Note per una storia della fotografia italiana (1839–1911)*, in *Storia dell'arte italiana*, 9, , 483–484, Turin, Einaudi, 1981.

Miraglia, Marina, *Giorgio Sommer's Italian Journey. Between Tradition and the Popular Image. History of Photography* vol. 20, no. 1 (Spring 1996): 41–48.

Miraglia, Marina, and Ulrich Pohlmann (eds.), *Un viaggio fra mito e realtà. Giorgio Sommer fotografo in Italia. 1857–1891*, Neaples, Carte Segrete, 1992 (exhibition catalogue).

Palazzoli, Daniela, *Giorgio Sommer fotografo a Napoli*, Milan, Electa, 1981

Paoli, Silvia, *Giorgio Sommer*, in Miraglia, Marina and Matteo Ceriana (editors), *1899, un progetto di fototeca pubblica per Milano. Il ricetto fotografico di Brera*, Milan, Electa, 2000, 170–171(exhibition catalogue).

Petagna, G., *Napoli e dintorni: Album di Giorgio Sommer fotografo del Re*, Neaples, Raffaele Irace Editore, 1980.

Van Deren Coke, "*Giorgio Sommer.*" in *Bulletin of the University of New Mexico* 9 (1975–1976): 23–24.

von Dewitz, Bodo, Siegert, Dietmar and Karin Schuller-Procopovici (eds.), *Italien sehen und sterben. Photographien der zeit des Risorgimento (1845–1870)*, Heidelberg, Braus, 1994, 283 (exhibition catalogue).

Weinberg, A.D., *The photographs of Giorgio Sommer*, Rochester, New York, Visual Studies Workshop, 1981.

SOUTH KENSINGTON MUSEUM

The museum was actually located in the London district of Brompton, where it opened its doors in 1857. However, its founding director, Henry Cole, thought that the made-up name of 'South Kensington' possessed more social tone. The museum was based on an earlier one which was originally part of the Government School of Design and went by various names in the early 1850s, such as the Museum of Ornamental Art. These earlier manifestations were much enlarged in physical plant and intellectual ambition in the form of the South Kensington Museum. This was created out of the cultural impetus provided by the Great Exhibition of Works of Industry of All Nations, held in London's Hyde Park in 1851. The Commissioners of the Great Exhibition spent some of its enormous profits buying 86 acres of land south of Hyde Park. Prince Albert saw this as the site of a new cultural quarter. Henry Cole (1808–82), a prime mover in organizing the Great Exhibition, took control of the Schools of Design and the newly formed Department of Practical Art at the Board of Trade in 1852. The South Kensington Museum became a model for many other museums around the world. The new institution embraced the arts of everyday life and developed vigorous teaching programmes to improve design, craftsmanship and taste. Cole did several important things for photography. In 1852 he began a collection of documentary photographs representing works of art and architecture. Among the earliest acquisitions was Maxime Du Camp's *Egypte, Nubie, Palestine et Syrie,* bought by instalments from 1853 onwards. Secondly, from 1853, Cole commissioned photographs of the museum's temporary exhibitions, so that a record would be available for study when objects had been returned to their owners. Francis Bedford (1816–94) and Charles Thurston Thompson (1816–68) photographed An Exhibition of Decorative Furniture in 1853. In 1856 Thompson was appointed Superintendant of Photography and, assisted by soldiers seconded from the Royal Engineers, established the world's first museum photographic service. The purpose of the service was to record works of art with the new authenticity provided by photography and to make these photographs available at modest prices to the designers and others who needed them. Photographs were often used to illustrate the Museum's catalogues in the era before accurate photo-mechanical printing. Cole's third innovation was to begin a collection of the art of photography. He saw

the medium as a tool of education and scholarship, but also as a creative medium in its own right. (His enthusiasm for photography led him practise it as an amateur in 1856.) On 22 January 1856 Cole and Thompson visited *An Exhibition of Photographs and Daguerreotypes,* the third annual exhibition of the Photographic Society of London. Cole bought 22 photographs from the exhibition, thus founding the earliest collection of the art of photography in the world. His selection included examples of the principal subjects of fine art, such as the nude (an "Academic Study" by John Watson), still life ("Christmas Fare" by V.A. Prout and William Lake Price's "The First of September") and landscape (most notably views taken in the Valley of the Mole by Robert Howlett). Cole's fourth initiative was to host a photographic exhibition—the first in any museum—in 1858. This was a combined show involving the Photographic Society of London and its Parisian counterpart, the Societé Française de Photographie. There were almost 1000 exhibits, including contributions from some of the greatest practitioners of the time, such as—on the British side—C.L. Dodgson (Lewis Carroll), Roger Fenton, J.D. Llewelyn, Oscar Gustave Rejlander and Benjamin Brecknell Turner and—from France—Edouard Baldus, Gustave Le Gray, Nadar and Charles Nègre. Queen Victoria and Prince Albert, both keen collectors of the art of photography, attended the private view of the exhibition held on 12 February 1858. The installation of the exhibition was admired by critics and was recorded in a photograph by Thompson. Unfortunately, none of the exhibits were acquired by the museum. However, Cole was to make a significant acquisition in 1865 when he bought 80 photographs from Julia Margaret Cameron (1815–79). He sat for her at Little Holland House on 19 May 1865. Cameron produced a striking portrait of Cole, resembling a Renaissance grandee (a print is in the Royal Society of Arts), and gave the museum 34 more of her photographs. Cole showed a selection of Cameron's works at the museum in autumn 1865. He also provided her with studio space for her portraiture practice at the museum—this was (his fifth innovation) a precursor of the idea of the artist-in-residence. Her marvellous letters to Cole are in the National Art Library at the South Kensington Museum's successor, the Victoria and Albert Museum (which it was renamed by Queen Victoria in 1899, now popularly called the V&A). Cole's sixth innovation was to send Cameron's photographs to regional centres as part of the museum's circulating exhibitions programme. He was the first, and unfortunately the only, museum director to buy and exhibit Cameron's work in her lifetime. The works she gave Cole and his wife personally were given to the museum by their son, Alan S. Cole, in 1913. Thanks to the various photographic initiatives introduced by Cole at South Kensington, his colleagues were sufficiently sensitized to the art of photography to accept the photographic element when the Chauncy Hare Townshend Bequest was offered in 1869. The photographs were kept alongside other kinds of prints in the Art Library—perhaps the earliest 'museum without walls.' The museum's scientific experts also arranged important exhibitions which presented photography from a technical point of view, notably The S.T. Davenport Collection (1869) and the Special Loans Exhibition (1876). These exhibitions displayed an impressive range of photographic processes, print types and equipment such as lenses. Items from the 1876 exhibition became part of the Science Museum collections when the South Kensington Museum was divided and renamed in 1899 and are now in the National Museum of Photography, Film and Television.

MARK HAWORTH-BOOTH

See also: Great Exhibition of the Works of Industry of All Nations, Crystal Palace, Hyde Park (1851); Du Camp, Maxime; Thompson, Charles Thurston; Bedford, Francis; Royal Engineers; Societé Française de Photographie; Dodgson, Charles Lutwidge; Fenton, Roger; Llewelyn, John Dillwyn; Rejlander, Oscar Gustav; Turner, Benjamin Brecknell; Baldus, Édouard; Le Gray, Gustave; Nadar; Nègre, Charles; Victoria, Queen and Albert, Prince Consort; Cameron, Julia Margaret; and Cole, Sir Henry.

Further Reading

The Victoria & Albert Museum, National Art Library Public Access Catalogue

Burton, Anthony (et al.).*Vision & Accident: The Story of the Victoria and Albert Museum* London: V&A Publications, 1999.

Conforti, Michael, Haworth-Booth, Mark, and McCauley, Anne, *The Museum and the Photograph.* Williamstown, MA: Sterling and Francine Clark Art Institute, 1998.

Hamber, Anthony, *A higher branch of the art": photographing the fine arts in England, 1839–1880.* Amsterdam: Gordon and Breach, 1996

Haworth-Booth, Mark. *Photography, an independent art: photographs from the Victoria and Albert Museum 1839–1996,* London: V&A Publications, 1997.

Physick, John, *Photography and the South Kensington Museum.* London: Victoria and Albert Museum, 1975.

——, *The Victoria and Albert Museum, the history of its building.* London: The Victoria and Albert Museum, 1982.

Thomas, David. The Science Museum photography collection. London: H.M.S.O., 1969.

SOUTH-EAST ASIA: MALAYA, SINGAPORE, AND PHILIPPINES

Malayasia in 2006 comprises in the west: the southern Malay Peninsula (former Straits Settlements of Penang, Province of Wellesley and Malacca), Singapore and in the east, the states of Sarawak and Sabah on Borneo and the Philippines.

Early photography in the British Straits Settlements was concentrated around Singapore the prosperous port built in 1819 by the English East India Company. Munshi Abdullah in his 1849 narrative *Hikayat Abdullah* reports seeing a daguerreotype view of the city—possibly as early as 1841—made by a doctor aboard a visiting American warship. The first resident photographer in the region was the undistinguished French portrait painter Gaston Dutronquoy (c.1800–c.1857) who set up his 'London Hotel' in Singapore in March 1839, installed a photography studio and in December 1843 advertised his services as 'complete master of the newly invented and late imported Daguerreotype' in the *Singapore Free Press*. His practise may have continued till 1849 but may also have been an occasional activity. French customs expert Jules Itier (1802–1877) did succeed in making daguerreotypes in Asia between 1843–1846 while on a business mission to China. Some plates survive including portraits and views from Singapore, Borneo, and Manila made in 1844–1845. Eliphalet Brown Jr. (1816–1886) official photographer on the U.S .Perry Expedition to Japan, seems also likely to have made plates in Singapore in 1853.

The first generation of photographers in Asia were itinerant and the few established studios lasted only a few years; daguerreotypist H. Husband operated in Singapore in1853 then C. Düben from Batavia who had also visited Hong Kong, Shanghai, Macao and Manila, offered superior improved portraits from 1854 until his return to Batavia in 1857 and in May 1855 daguerreotypist L. Saurman also from Batavia, briefly worked out of the London Hotel. Calotype work popular in British India, is unknown in the Straits and Manila.

In the first decades most photographers in the Asia-Pacific region were European but J. Newman based in Singapore from 1856–57, advertised many refinements and "permanence" for the products of his American Photographic Rooms. He made a side trip to Malacca—the first photographer to work on the Malay mainland.

It seems likely that across the Asia-Pacific hundreds even thousands of daguerreotypes were made even in the 1840s. Englishman J.W. Newland for example, travelled west to east from South America via Australia to India and claimed to have made over 200 daguerreotypes on the way. The number of extant daguerreotypes however, is tiny. This paucity appears to apply equally to the succeeding format of cased ambrotype portraits and views.

By February 1858 Edward A. Edgerton was the first professional to introduce photographs on paper to Singapore but moved on to work as an editor by 1861. He was followed by Thomas Hermitage and O. Regnier offering the new wider range of products; both views and portraits and places. The quest for images to send back to Europe where they would be widely disseminated redrawn as graphic illustrations propelled the growth of the views trade. Stereographs led the way and in 1860 Negretti and Zambra in London pioneered publication of Southeast Asian stereographs. They took the bold step of dispatching Swiss photographer Pierre Rossier to China in 1859 and instructed him to go to Manila where he made images of the Taal volcano. The ease of making multiple prints facilitated the production of albums and panoramas extolling the progress of colonial cities. The earliest panorama in the Straits region was a view of Singapore in ten parts made in 1863 by Sachtler and Co. The firm also made one of the first published albums; *Views and Types of Singapore*. From 1864 the firm was run by August Sachtler and Danish- born Kristen Feilberg (1839–1919) and they built an extensive stock of views from across the region including images from an expedition to Sarawak in 1864. Feilberg, operating alone from 1867, had a feel for picturesque views which he exhibited in the Paris International Exhibition in 1867. J.M. Nauta, operated in Penang and Singapore and had branches in Medan, Achin and Sumatra between 1868–1888. He exhibited Penang scenery at the *Colonial and Indian* exhibition in London in 1886.These shows enabled the public to see large format Asian images first hand.

With improvements in exposure times portraiture continued to grow and Royal courts in Asia were in often enthusiastic and discerning users of photography exchanging images with their foreign counterparts. Views trade work soon merged into reportage and Feilberg also recorded events such as the Penang riots in 1867 and later the visit of the British Duke of Edinburgh in 1869. Other events particularly the increasingly fashionable Royal tours by European and non-European rulers and Vice Regal residents were a stimulus to photography in the Asia-Pacific but more strongly it seems in Hong Kong than in Singapore and Malaya.

The outstanding figure of the period for breadth of coverage in the 1860s and model of the 'travel photographer' was Scot John Thomson who set up a studio in Singapore in 1862 with his brother William but spent most time travelling to Penang as well as Sumatra before departing in 1865 for Thailand and Cambodia. He returned briefly to Singapore in 1867 and published his first book *Cambodian antiquities* before settling in Hong Kong where he illustrated a publication on the Visit of the Duke of Edinburgh in 1869.

John Thomson used Indian assistants on his Straits journeys in 1862 as the Chinese would not go near the processing. Chinese (and a few Japanese) photographers however were among the earliest non-European photographers at work in Southeast Asia mainly, Sun Qua in 1867 and Yuk Lee a portrait painter from Canton, who advertised briefly in Singapore in 1861–1862, and Koon Hin had a studio there in 1880. Hand-colouring

however, a distinctive genre in 19th century India and Japan played only a small role in Southeast Asia.

Photography associated with expeditions and government agents was a factor in the 1870s. Professional photographer and painter Austrian Wilhelm Burger (1844–1920) was part of the Austrian mission in Asia from 1869–1870 and later marketed rather prosaic stereoviews of Borneo, Singapore, Sulu and the Philippines. James W.W. Birch (1826–1875) the first British Resident in Perak in 1873 an amateur photographer, who sent views of his tours in Perak and Selangor to the colonial office in 1874 was murdered in 1875. British Major J.F.A. McNair used illustrations drawn from photographs in his 1878 book on Perak and the Malays. His countryman Civil Servant Leonard Wray (1852–1942) a prolific amateur also documented Perak peoples and places in the 1880s–1890s and was much valued for his efforts. In 1883 J.F. Stiehm in Berlin published their "Marine" series including views of Singapore and the Philippines made by Gustav Riemer the purser on the Austrian S.M.S.*Hertha* expedition of 1880.

Established studios become more common in the late 1870s and expanded their inventory of views and also trained a new generation of professionals. Henry Schuren worked for Woodbury and Page in Batavia before settling in Singapore in 1874 and was soon after appointed official photographer to King of Siam, settling there in 1876. From 1883 August E. Kaulfuss (1861–c.1909) worked for J.M. Nauta studio then became a travelling photographer gathering views from all over and was also official photographer to Sultan of Kedah.

The opening of the Suez Canal in 1869 increased trade and tourism through Asia which benefited firms such as that established by G.R. Lambert 1846–after 1886) a professional from Berlin who advertised his services in Singapore in 1867 but effectively commenced in 1877. During 1879–1880 Lambert was in Bangkok taking over Henry Schuren's stock and his position as official photographer to the King of Siam. Lambert left the business operations by around 1886 and the work was continued under Alexander Koch who recorded such ceremonies as the Kuala Kangsar durbar in 1897 to mark the creation of the Federated States of Malaya.

GR Lambert and Company built the most extensive inventory of views of the Malay Peninsula, Borneo and Sumatra including making the earliest images of Kuala Lumpur and covering all major Malayan ceremonies and events and also kept up with new developments in instantaneous and dry-plate photography. The dominance of such large and mass production studios in Asia as elsewhere was checked by the emergence of the snapshot family photographers including the amateur photographic societies of the 1880s–1890s (Singapore Photographic Society was established in 1887) but compensated for in the new century by the profitable postcard craze.

Images of the Philippines were regularly reproduced in British and French magazines such as *The Illustrated London News* from the 1860s but relatively little is known of the earliest photographers. A Spanish Government agent Sinibaldo de Mas took up portrait work in 1841 to earn extra income. Jules Itier was in the Philippines from December 1844–January 1845 (where he surprisingly records buying 25 new plates in Manila) then in Mindanao, Sulu and Basilan until March. A daguerreotype of the Intramuros is the earliest extant Philippine view. Daguerreotypist C. Düben is known to have been in Manila before 1853.

The GBR museum at Cavite holds a daguerreotype portrait of William W. Wood an American who worked in China as a clerk and newspaper editor from 1827–33 before relocating to Philippines in 1833 where he later operated a photography studio in Manila by the 1870s. His own work in daguerreotypy is unclear. The earliest surviving Philippine images on paper include a cdv of two Indio musicians in La Union by Pedro Picon circa 1860; a group of stereographs from an *Oceanie* series with French captions of the Tinguian people of Northern Luzon made in 1860 and a later group of stereos by an unknown photographer of the 1863 earthquake. Swiss born Pierre Rossier was sent to Manila by Negretti and Zambra to photograph the volcano but would have taken other subjects. T.W Bennett also marketed an early stereograph series of views under the Spanish title *vistas filipinas*.

Studios were established in the 1860s benefiting from the increased commercial activity in the region. From the mid 60s until his death in Manila in 1874 the British photographer Albert Honiss sold a wide range of well-composed views to magazine publishers in Europe; any connection to W.H. Honiss in Singapore in 1862 is unclear. The Dutch photographer Francisco Van Kamp who had exhibited in Amsterdam, took over the Honiss studio in 1874 and later produced a set of views of the 1880 earthquake.

Ethnographic subjects were a staple for resident and visiting photographers. The photographers aboard the British Challenger Expedition of 1872–1876 made or gathered a number of photographs of ethnographic and scenic photographs in Manila and the archipelago in 1875. William Wood made ethnographic cdvs and examples with similar backgrounds appear in Belgian author Jean de Man's 1875 photographically illustrated book *Souvenirs d'un voyage aux Iles Philippines*. In 1881 French ethnologist Alfred Marche (1844–1898) photographed Negritos on his Philippines expedition of 1879–1885 and the photographs were used for illustrations in the journal *Tour du Monde* in 1886. One of the most extensive ethnographic records was

undertaken by German A. B. Meyer (1840–1911) on his own and by use of other photographers work. His *Album von Philippinen-Typen* of 1885 included Luzon and Mindanao people in a mixture of studio set ups and natural settings.

The turbulent revolutionary years at the close of the century also inspired the growth of reportage. Spaniard Manuel Arias y Rodriguez (1850–1924) took up photography in 1892 and ran the Agencia Editorial bookshop at Escolta with his brother Vincente. The firm sold a wide range of photographs of urban and landscape views of the regions but was quietly subversive selling under the counter banned books by nationalist Dr Jose Rizal whose execution in 1896 Manuel photographed. Afterwards Arias took on the role of war correspondent of the Philippine Revolution against Spain 1896–1897 and supplied images to the Barcelona journal *La Ilustración Artística* from 1897–1900. Arias ended up as Spanish ambassador to Tokyo and died there in 1924. Documenting war proved perilous for Francisco Chofré y Olea and Augusto Norris y Olea who were killed in 1896 while photographing during the Philippine Revolution. Their portraits and their photographs were included in two albums on the war *Tristes Recuerdos1896* and *1897* published posthumously by their firm Chofre and Co. in Manila.

The Spanish-American war resulted in American rule in the Philippines from 1898 prompted a flood of illustrated publications including, F. Tennyson Neely's *Fighting in the Philippines: authentic original photographs* 1899, many stereograph series and distinctive solder-portraits wearing their scout-style outfits and striking poses reminiscent of the Old West. James Ricalton (1844–1929) an American teacher who photographed for Underwood and Underwood recorded grisly images of the 1899 casualties (the greater death toll of locals from starvation and disease however, going largely unrecorded).

<div align="right">GAEL NEWTON</div>

See also: Woodbury, Walter Bentley; Itier, Jules; Castro Ordóñez, Rafael; Lambert & Co., G.R.; and South-East Asia: Thailand, Burma and Indochina (Cambodia, Vietnam, Laos).

Further Reading

Falconer, John, *Vision of the past: a history of early photography in Singapore and Malaya: the photographs of G.R. Lambert & Co., 1880–1910*, Singapore: Times Editions (1987), reprint 1995.

Groenveld, Anneke, Falconer, John, and Wachlin, Steven, *Van Bombay tot Shanghai/ From Bombay to Shanghai*, Amsterdam: Fragment Uitgeverij, 1994.

Liu, Gretchen, *Singapore—A Pictorial History 1819–2000*, Singapore: Archipelago Press, imprint of Editions Didier Millet, Ministry of Information and the Arts, National Heritage Board, 2005 reprint of the 1999 original.

Moore, Wendy Khadijah, *Malaysia: A Pictorial History, 1400–2004*, Singapore: Butterworth-Heinemann, 2004.

Perez, Christian, *Catalogue of Philippine Stereoviews*, Quezon City: Christian Perez, We-Print, 2002.

Silva, John, *Colonial Philippines: Photographs, 1868–1910*, Lowie Museum of Anthropology, University of California, Berkeley, May 9–July 11, 1987 (exhibition catalogue).

Silva, John L., 'Remembering a Glorious Past: The GBR (Geronimo Berenguer de los Reyes, Jr.) Museum, Philippines, Photographic Collection,' *Arts of Asia*, Jan–Feb. 1998.

Tristes Recuerdos Manila (Manila: Chofre and Co, 1896–97): reprint, Manila: National Historical Institute, 2004.

Feito, Mario López, webpage of 14 June 2006, 'Los primeros y últimos de Filipinas' Fotógrafo de Baler: Manuel Arias Rodríguez: una aproximación al fotógrafo del 98 español en Filipinas' http://baleria.com/?page_id=60 accessed 19 August 2006.

SOUTH-EAST ASIA: THAILAND, BURMA, AND INDOCHINA (CAMBODIA, VIETNAM, LAOS)

In his memoirs French trade negotiator Jules Itier (1802–1877) describes making two daguerreotypes at the French military fort at Tourane (Da Nang), South Vietnam, in 1845 while on a trade mission to China. Activity by other daguerreotypists in Burma or Indochina is as yet unknown. The response to photography in Thailand (Siam) was however, precocious due to the enthusiasm for the medium in the Royal Court.

In Bangkok in July 1845 French Bishop Jean-Baptiste Pallegoix (1841–1862) received an apparatus he had ordered from France and he and his confreres became adept enough to take Royal portraits and train others. With no tradition of Royal portraiture in the late 1840s and 1850s King Mongkut (Rama IV) had many photographs of himself and court made to mirror European portrait photographs received as gifts and which he returned in-kind. A practise continued even more assiduously by his son Rama V, King Chulalongkorn. Locals and members of the court also acquired photography skills (details are in various Thai histories as yet not available in English). Luang Wisut Yothamat (Mot Amatyakun) the Director of the Siam Mint, made portraits of the Royal couple using a daguerreotype camera sent by Queen Victoria to the King in 1856.

Access to the Thai Royals was granted to foreign photographers including Swiss Pierre Rossier (on assignment in Asia for Negretti and Zambra of London) who was in Bangkok in 1861 and made ethnographic studies and a Royal portrait for Firmin Bocourt a French zoologist and illustrator in Thailand on a naturalist expedition.

Bishop Pallegoix or French priests probably trained the Thai-Christian Khun Sunthonsathitlak (1830–1891) who began photography in the late 1850s, worked for the technologically-minded dual monarch Phra Pinklao, before opening his own studio in 1863 under the name

'Francis Chit & Co' (later & *Sons*). He was skilled in wet-collodion work and made numerous portraits, views and records of events including a large panorama of Bangkok in 1864. In early 1862 Isidore van Kinsbergen (1821–1905) the official photographer accompanying a Dutch delegation visiting from Batavia, made a range of views, portraits and studies of antiquities. Wilhelm Burger (1844–1920) a professional photographer attached to the Austrian diplomatic and trade mission was briefly in Bangkok in May 1869. He later marketed stereoviews of his travels to Vietnam and Japan. Francis Chit & Co photographs were regularly bought by visitors but most ended up uncredited when shown or reproduced in Europe.

A number of ambitious artists also went to Southeast Asia;. John Thompson (1837– 1921) after his first few years as a photographer based in Singapore in 1861–1864, transformed into a freelance 'travel' photographer and set off for Bangkok where in 1865 he photographed King Mongkut and his court as well as other subjects before travelling to his real goal—the fabled Angkor Wat temple complex in Cambodia in early 1866.

Chit and Co outlasted foreign competitors attracted to Bangkok such as Henry Schuren who visited from Singapore in 1874 and gained a Royal 'Appointment' (it was never an exclusive honour) then set up in Bangkok in 1876 but was replaced in 1879 by G.R. Lambert from the flourishing Singapore firm, who made a lengthy visit to Bangkok that year. British photographer William K. Loftus worked in Bangkok from 1887–1891 but his work was rather dull.

Increasingly from the 1860s illustrated magazines used photographs as the basis for illustrations and received images and stories from 'world tours' undertaken by a broader range of travellers facilitated by the improved travel routes and methods, modelled in some cases on the new 'Royal tours' undertaken by European and Asian kings and courtiers. Populist illustrated traveller's tales also flourished. The buoyant young French attaché Ludovic, Comte de Beauvoir for example, collected photographs assiduously in 1865–1867 on a tour with a French Royal, and used these as the basis for illustrations in his best selling books which began in 1869, with *Java, Siam, Canton : voyage autour du monde*.

Burma [Myanmar]

After three Anglo-Burmese Wars beginning in 1824, from 1886 north and south Burma were conquered and administered as part of British India. The last Burmese Kings, Mindon and Thebaw (prior to his exile in 1886) were photographed and later had court photographers but no daguerreotypes are known and the earliest extant photography in Burma is connected to British military expeditions. In 1853 East India Company Surgeon John MacCosh (1805–1885) an experienced amateur photographer, made views and ethnographic portraits while on duty in Burma during the Second Anglo-Burmese War but his work had limited circulation. By contrast, in 1855 Captain Linnaeus Tripe (1822–1902) posted from Madras as the official photographer to the well equipped Indian Government diplomatic mission to King Mindon's remote northern court at Ava. Tripe executed some 200 large paper negatives which concentrating on structures and topography, have an eerie empty stillness and were used as the basis for illustrations in the official *Narrative* of the expedition of 1858. More impressive and influential were the massive 120 image portfolios of original prints published under Tripe's authority in 1858 by the Madras Government. Major Williams an engineer and amateur photographer, accompanied the Edward Bosc Sladen expedition through Burma to China in 1868.

Military training in photography was also the path to a new vocation for J. Jackson (with fellow Private Bentley) who established a long running and prolific studio in Rangoon in 1865. Not all newcomers were British. The German professional photographer Philip Klier (1845–1911) began work in 1871 in Moulmein, lower Burma then at Rangoon where he was in partnership with J. Jackson in 1885–1890. His output was high in quality and extensive and represents the consolidation of the mass-market views trade over the 1880s–1890s—a world wide trend.

Lieutenant-Colonel Willoughby Wallace Hooper (1837–1912) on the British Expeditionary Force during the Third Burmese War produced a set of one hundred images in 1887 which he declared 'were taken entirely for his own amusement and from love of the art' as did Colonel Robert Graham (1838–1918) with his photographically illustrated book on the War released in 1887. Captain-Surgeon Arthur George Newland (1857–1924) published his *The image of war, or Service on the Chin Hills* with fine gravures in 1894.

Perhaps the earlier Burmese War publications scotched the plans of the Italian born Felice Beato (1825–1907) who arrived in Rangoon in 1886. He had made a name in war photography in India in 1858 and China in 1860 and for his prolific Japanese scenes and types over his long years there in the 1860s–1870s. Beato stayed on and set up a studio in Mandalay producing some war related scenes and studio tableaux of Burmese Beauties. He also travelled into the inner region and produced a substantial but now lesser-known body of work. By 1895, Beato had expanded into a quite large photography, furniture and artefacts manufacturing and postcard business. He employed a number of local photographers including in particular H.N. Samuels who wife and daughter apparently modelled local costumes in the Beato studio portraits of local 'types.'

The boom in Burma induced regional studios to set up branches; Frederick Skeen of Skeen and Co in Ceylon (Sri Lanka) arrived in 1887 to set up a branch and worked as Watts and Skeen. The work of the 1880s generation benefited from the introduction of the faster and more convenient dry-plate which allowed for more varied and lively subjects and atmosphere. The firm may have sold Beato material in Ceylon and their inventory seems to have been taken over by Beato after Skeen returned to Ceylon in 1903. Studios based in India also sent representatives including the well-known firm of Bourne and Shepherd.

Anthropology a new science also became codified and politicised in the 1860s and a number of uncredited photographers provided ethnographic images from Burma to the multi-volume *Peoples of India* publication of 1868–1875. Guidelines for scientific anthropometric studies were developed in the late 1860s following strict guidelines but these were rarely implemented. Some ethnographic studies were in fact more like early forms of pin-up girls and the fine-looking Burmese women in their restrained elegant costume proved especially appealing to European taste. A more sympathetic eye and ethnographic interest came from Sir George Scott who took up photography in 1888 and published a set of volumes on the Shan States.

Cambodia

The great abandoned temples of Cambodia, at times under Siamese control, were to become the 'pyramids' of Asia. John Thomson was inspired to visit Cambodia after reading the 1864 English edition of French explorer Henri Mouthot's *Travels in the Central Parts of Indo-China (Siam), Cambodia, and Laos, during the Years 1858, 1859, and 1860* which popularised the ruins. Illustrations after photographs in that (posthumous) book and the *Tour du monde* accounts of Muhout's travels 1868 were not by Mouhot but local photographers including Francis Chit. Thomson was not the first photographer at Angkor; his companion in 1867 British consular officer W.G. Kennedy had visited and taken photographs in 1856, but none are known to survive. Thomson was the first skilled technician and superior camera artist to make images there. His lively accessible prose ensured the success of his own first book of 1867 *Antiquities in Cambodia* illustrated with 16 original prints. His later publications were more widely disseminated as they had photomechanical illustration. The Cambodian work was also Thomson's entrée to the learned societies of his homeland. Thomson returned to Saigon and photographed the Royal family there before returning to Britain.

Soon after Thomson's work at Angkor French military trained photographer Émile Gsell (1838–1879) was at work there in late 1866 with the French Mekong Exploring Expedition initiated and later led by Francis Garnier.

Typical of the many French military come civil servants and administrators who became passionate advocates for Asian culture was naval officer Louis Delaporte (1842–1925) on the French Government Mekong expedition which visited Angkor in 1866. He sought help from Thomson and Gsell and perfected his own photography for his later 1873–1874 expedition to Cambodia with F.C. Faraut, seeking constant improvement in architectural work through use of aplanar lenses and gelatin processes. He exhibited at the 1878 Exposition Universelle in Paris His interest came from his passion for archaeology and Khymer culture for which he helped found a Musée Indochinois du Trocadéro .

The French tradition of the centralised grand scale cultural and scientific 'mission' meticulous and methodical was exemplified in the Mission Pavie teams of photographers.Delaporte sent Louis Fourneau on expeditions 1886–88 in which Captain Malgraive and Riviere also where made plates successfully at Angkor. The remarkable Jean Marc Bel and his wife an engineer made many voyages 1893.

International and local exhibitions formed a significant platform in the later 19th century to promote the colonial endeavours and as self promotion for photographers.

Vietnam and Laos

The French had a presence from the 1840s in Vietnam then known as Cochin China in the south and Tonkin in the north, and, as with the British in Burma, their control extended from the mid-1860s through various conflicts until effective control of Tonkin as well as the south came in 1885. Not surprisingly, French photographers were first to appear in Saigon (Ho Chi Minh City): Charles Parant in 1864–1867 and Clément Gillet in 1865–1866. After his Mekon Expedition work, Emile Gsell went private and set up a studio in Saigon in 1866 becoming first long-term commercial photographer in Vietnam. Gsell however, also left Saigon in 1873 to join Louis Delaporte's expedition in Cambodia revisiting Angkor Wat. Gsell Angkor Wat pictures and panoramas earned him a medal at the Vienna International exhibition of 1874 where he also Cambodian and Vietnamese ethnographic studies. In 1876–1877 Gsell was also able to travel in north adding images of Tonkin to his stock which passed to other studios in Saigon after his early death in Saigon in 1879.

John Thomson returned to Asia in 1867 spending some months in Saigon and surrounds even trying to capture clouds without montage suggesting he may have been using a new process. He sent articles to *The China Magazine* but his Saigon work was not included

in his 1875 book covering his *The Straits of Malacca, Indo-China and China, or, Ten years' travels, adventures and residence abroad.*

As elsewhere in Southeast Asia, photographers migrated to new markets opned up by colonisation. M. Martin from Singapore was noted for fine landscape views in the 1880s. The Chinese diaspora reshaped many communities in Southeast Asia; Pun-Ky marketed cdv portraits of Annamite (Vietnam) types probably from the 1870s as did Pun-Lun who had worked in Hong Kong had a studio in Saigon (opposite that of Gsell) from 1869–1872. A rare Vietnamese name appears; Dang Huy Tru, a retired Mandarin who learnt photography while in China, had a studio in Hanoi from 1869 until the French occupation of 1873. He is claimed to have attracted Vietnamese clientele and developed a style of pose based on ancestor portraits but such posing was common to costume portraits and types across Southeast Asia. Other Vietnamese names do not appear although in 1896 Cam Ly was in business in Hanoi. By the 1880s Chinese-born photographers were at work in most regions chiefly in portrait work. Few of their archives are identifiable but some more substantial commissions survive such as the photographs of the French railway constructed from 1889–1897 between Hanoi and Lang Son which executed by Tong Sing. Yu Chong had a studio in Hanoi in 1893–1900.

A number of Europeans in service in Asia became interested in not only the culture of the past but had a feeling for the life of the contemporary peoples. Like so many men attached to the military abroad, Doctor Charles-Édouard Hocquard (1855–1911), who was on service in Tonkin in 1884–1885 in the Franco-Chinese War, published his photographs officially and privately. His field report on the war illustrated with Woodbury types was subtitled '*customs and beliefs of the Vietnamese*, and was, serialised as 'Trente mois au Tonkin,' in *Le tour du monde,* 1889–1891. Aurélian Pestel (1855–1897) took up photography in Saigon in 1892 having arrivied in Vietnam in 1883. He was also noted for showing the customs of the country beyond studio enactments.

The new generation rising in the late 19th century but coming most to the fore after 1900 in the early decades of the 20th century, looked beyond hard objects to lifestyle and customs, including Sub Lieutenant Étienne Francoise Aymonier (1844–1929) in the French Marine infantry in Saigon who learned the Cambodian and Vietnamese languages.

The image of Southeast Asia was shaped and defined by early photographers and the legacy inherited revolved around a nostalgia as well as scholarly pursuit of antiquities. Photomechanical reproduction in photogravure, carbon, and woodburytpe created a new industry at the turn of the century of which a former soldier sent to Hanoi in 1885, Pierre M. Dieufils of Saigon, is one of the best knownt. His distinctive landscape folio publications were typical of the late 19th and early 20th century mass-produced works.

GAEL NEWTON

See also: Burger, Wilhelm Joseph; Chit, Francis; Itier, Jules; Thomson, John; and Expedition Photography.

Further Reading

Anek Nawikkamun, *Tamnan nai phap kao / `Anek Nawikkamun. Phim khrang raek* Krung Thep: Samnakphim Matichon, 1998. (Anake Nawikkamun is author of a number of detailed histories of photography in Thailand which await translation.)

Aubenas, Sylvie et al., *Photographes en Indochine: Tonkin, Annam, Cochinchine, Camboge et Laos au XIX Siècle,* Marval and Réunion des Musées Nationaux, Paris, 2001.

Pongrapeeporn Pipat. *The Panorama of Bangkok in the Reign of King Rama IV: A New Discovery by Pipat Pongrapeeporn, Photographs by Francis Chit.* Bangkok: Muang Boran Publishing House, 2001.

Peleggi, Maurizio, *Lords of Things,* Hawaii: University of Hawaii Press, 2002.

Moeshart, Herman J., "Daguerreotypieren unter der Tropensonne. Adolph Schäfer in Niederländisch-Indien," In *Silber und Salz. Zur Frühzeit der Photographie im deutschen Sprachraum, 1839–1860,* edited by Bodo von Dewitz and Reinhard Matz, Cologne: Edition Braus, 1989.

Falconer, John, "Photography and ethnography in the colonial period in Burma." In *Frontier Photography Burma,* 29.

Singer, Noel F., *Burma a photographic journey 1855–1925,* Stirling:Paul Strahan-Kiscadale Ltd, 1993.

Singer, Noel, and Felice Beato's, "Burmese Days," *Arts of Asia* (September–October, 1998): 96–107.

Moeshart, Herman. "Daguerreotypes by Adolph Schaefer." *History of Photography* 9 (July–September 1985): 211–218.

Jehel, Pierre-Jérôme, *Photographie et anthropologie en France au XIXe siècle.* Mémoire de DEA 'Esthétique, sciences et technologie des arts' UFR 'Arts, Philosophie et esthétique.' Université Paris VIII. Saint Denis.

SOUTHWORTH, ALBERT SANDS (1811–1894) AND HAWES, JOSIAH JOHNSON (1808–1901)

In 1840, the daguerreotype exploded onto the American social scene. Thousands took up the business and even more the sitter's chair. Yet with primitive technology, erratic rewards and intense competition, professional survival was difficult. Albert Sands Southworth and Josiah Johnson Hawes epitomized the talents needed to succeed in the chaotic early years of photography. Coupling ingenuity and expertise with great patience and hard work, their partnership was exemplary. Their studio was among the most distinguished and influential in America and their achievement ranks among the most important in nineteenth-century photography. Southworth was a natural promoter and salesman whose restless nature and financial cupidity drove him

to improvement and invention. By contrast, Hawes was a proven artist whose mastery of light, composition, mood and expression was unparalleled. Together, their technological innovations considerably improved the adaptability, application and clarity of the new medium. Likewise, their commitment to art enhanced the standing of the profession and significantly advanced the aesthetics of portraiture and the realism of documentary. Given the daguerreotype's fragile and singular nature, the partnership's legacy is equally remarkable, comprising over 1,500 existent images.

Albert Southworth was born in West Fairlee, Vermont, on 12 March 1811. After attending the Phillips Academy in Andover, Massachusetts, he tried teaching before establishing a drugstore in Cabotville, Massachusetts in 1839. Unhappy with his trade, he attended a lecture early in 1840 on the principles and practice of the daguerreotype. Delivered by François Gourand, a pupil of Louis-Jacques-Mandé Daguerre, the lecture stimulated Southworth and persuaded him to contacted Joseph Pennell, his friend and former roommate at Phillips. Pennell was, at the time, assisting Samuel Morse with his early photographic research and he invited Southworth to New York to participate. Southworth's first-hand experience of Morse's experiments convinced him of the value of the new medium. Displaying the restless enthusiasm and financial ambition that would mark his career, he wrote his sister Nancy late in May:

> You have read of the daguerreotype, an apparatus for taking views of buildings, streets, yards, and so forth. I had an invitation to join Mr. Pennell and in getting one, and partly to gratify my curiosity, and partly with the hope of making it profitable, I met Mr. Pennell and I cannot in a letter describe all the wonders of this apparatus. Suffice it to say, that I can now make a perfect picture in one hour's time, that would take a painter weeks to draw.
> (Robert Sobieszek, and Odette M. Appel, *The Daguerreotypes of Southworth and Hawes*, New York: Dover, 1980 (1976): xi)

Barely four months later, Southworth and Pennell opened a daguerreotype studio in Cabotville. Utilizing Alexander Wolcott's patented wooden-box camera, they produced commercial portraits while developing and perfecting the daguerrean process. Although their experiments proved successful—"we have very far surpassed anybody in this country, and probably in the world, in making miniatures"—Southworth and Pennell floundered financially. By the spring of 1841, the partnership was in serious debt and Southworth decided to relocate to Boston. With its prominent families, commercial wealth and large population, Boston seemed to Southworth the solution to the partnership's main financial difficulty: balancing commercial income with the rising costs of invention.

By June 1841, the Southworth and Pennell studio—now operating under the name of A. S. Southworth and Co.—was ensconced atop Scollay's building in Boston. In addition to portrait work, the company sold equipment, provided instruction and contracted for the manufacture of cameras, lenses, plates and cases. They prospered temporarily in their new environment and by 1842 had moved into a more permanent location on Tremont Row, the heart of Boston's artistic community. Yet despite these small gains, the new industry's financial landscape remained fickle. In 1843, Pennell left the company to take up a teaching position at a private school in the South. His place in the partnership was filled shortly afterwards when Southworth made the acquaintance of Josiah Hawes.

Josiah Hawes was born in East Sudbury, Massachusetts on 20 February 1808. After working on his family's farm, he apprenticed as a carpenter. In 1829 took up painting:

> Happening one day to come across an ordinary oil painting which I was admiring, a friend of mine asked me to close one eye and look at the picture through my hand with the other eye. The surpassing change which took place, from its being an ordinary flat canvas to a realistic copy of nature with all its aerial perspective and beauty so affected me, that from that time I was ambitious to become an artist. ("Stray Leaves from the Diary of the Oldest Professional Photographer in the World," *Photo-Era*, 16 (1906): 104–107)

For the next twenty years, he traveled New England as an itinerant portrait painter. Quite by chance, Hawes was in Boston in 1840 and attended the same Gourand lectures as his future partner. Unlike Southworth, Hawes was cautious. Unwilling to give up the steady income he received on his travels, Hawes continued to paint until 1841, when he became an itinerant daguerreotypist. In November 1843, Hawes was invited to join A. S. Southworth and Co. (whose name was changed to Southworth and Hawes in 1845). His financial prudence and artistic bent would perfectly complement Southworth's eye for the main chance.

While failing to shake its precarious financial state, the studio continued to achieve great artistic and social success. They attracted such luminaries as Charles Dickens (who, unfortunately, did not sit for a portrait), Ralph Waldo Emerson, Edward Everett, Charles Goodyear, Oliver Wendell Holmes, Henry Wadsworth Longfellow, Lola Montez, Lemuel Shaw, Harriet Beecher Stowe, Zachary Taylor and Daniel Webster. In addition, they produced important visual documents of such locations as the Boston Athenaeum, Niagara Falls, the operating room of the Massachusetts General Hospital, Mount Auburn Cemetery, the Boston Navy Yard and Docks, the Boston Common and the Emerson School for Girls. Unlike their Boston contemporary John Plumbe Jr., neither Southworth nor Hawes saw their studio as a potential

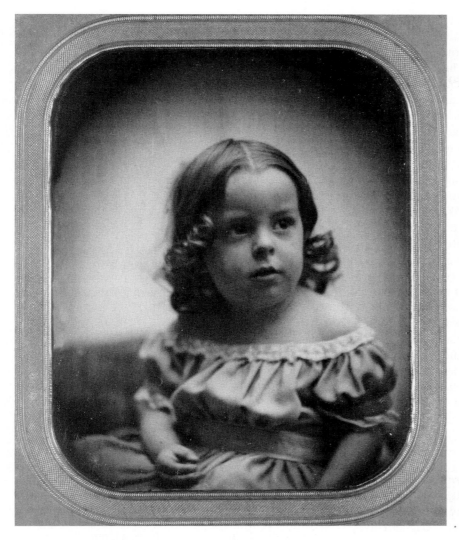

Southworth & Hawes. Portrait of a Young Girl.
The J. Paul Getty Museum, Los Angeles
© The J. Paul Getty Museum.

franchise. They utilized only the best equipment, did not hire outside journeymen and refused to lower their prices in the face of stiff competition. They shunned the conventions of standardized portraiture and sought to communicate a simple yet resonant representation of the sitter's personality:

> What is to be done is obliged to be done quickly. The whole character of the sitter is to be read at first sight; the whole likeness, as it shall appear when finished, is to be seen at first, in each and all its details, and in their unity and combinations and in the result there is to be no departure from truth in the delineation and representation of beauty, and expression, and character. (Albert Sands Southworth, "An Address to the National Photographic Association of the United States," *The Philadelphia Photographer*, 8 (1871): 315–323)

Dissatisfied with the meager income he derived from the studio, Southworth caught the Gold Rush fever and departed for California in 1849. He spent twenty-two months prospecting, yet his returns were minimal and he returned in poor health. The more practical Hawes stayed in Boston, and the studio continued in business.

Southworth returned in 1851, and began to focus his attention on the invention and patenting of technical equipment. In 1853, the firm's "Grand Parlor Stereoscope" won a gold medal at the Fair of the Massachusetts Charitable Mechanics Association. Significantly larger and more complex than any previous stereoscope, the device was put on show in the studio and patented in 1854. The first image presented was the Greek statue *Laocoön*: admission was 25¢, a season ticket 50¢ and for those wishing to buy the stereoscope itself, the price was an enormous $1,160. Commenting on the technical marvel, *To-day* magazine found "the illusion and absolute and the effect of the *Laocoön* in this stereoscope is really finer than one often gains in looking at the statue" (Beaumont Newhall, *The Daguerreotype in America*, third revised edition, New York: Dover, 1976 (1961): 46). Further patents followed, most notably for a "plate-holder for cameras" which many thought evidenced no significant technological advance over those currently in use. In 1854, the studio ceased the production of daguerreotypes and took up the collodion glass plate process.

After twenty-one years of financial struggle, Southworth's exasperation reached its limit and he dissolved the partnership in 1862. He returned to the family farm in West Fairlee to settle his late father's estate and stayed to run it with his brother. He continued to practice photography, write for leading journals and address the National Photographic Association of the United States. In later life he became a handwriting expert and died in 1894. Hawes continued to run the Tremont Row studio for a further thirty-nine years and his late nineteenth century images of Boston are regarded as some of the finest documents of life in the city at that time. In the post-Civil War period, Hawes occasionally returned to his earlier itinerant career hawking Stereoscopic views of Boston around the New England countryside in a traveling wagon. Still active in the profession, Hawes died while on vacation in 1901. In tribute, *Photo-Era* magazine praised the achievement of "the oldest living professional photographer in the world": "he was the last link in the long chain connecting the past and the present of photography and he sat at the cradle of photography and helped to rock it into life" ("Stray Leaves from the Diary of the Oldest Professional Photographer in the World," *Photo-Era*, 16 (1906): 104–107).

RICHARD HAW

Biographies

Albert Sands Southworth was born in West Fairlee, Vermont, on 12 March 1811. Attended lecture on daguerreotypy by François Gourand in Boston, 1840; established the A. S. Southworth and Co. daguerreotype studio with Joseph Pennell, 1841; traveled in California prospecting for gold, 1849–1851; developed the Grand Parlor Stereoscope, 1853; left the firm of Southworth and Hawes, 1862. Gave keynote address to the National Photographic Association of the United States, 1871. Died Charlestown, Massachusetts 3 March 1894.

Josiah Johnson Hawes was born in East Sudbury, Massachusetts, on 20 February 1808. Attended lecture on daguerreotypy by François Gourand in Boston, 1840; joined A. S. Southworth and Co., 1843; developed photographic back-lighting and perfected the use of studio skylights, 1843–1845; married Nancy Southworth, 1847; continued to operate out of the Tremont Row studio as an independent photographer, 1862–1901. Died Crawford Notch, New Hampshire 7 August 1901. The Hawes daguerreotype collection distributed to the Metropolitan Museum of Art, New York, the Boston Museum of Fine Art and independent collectors, 1934.

See also: Daguerreotype; Daguerre, Louis-Jacques-Mandé; and Wet Collodion Negative.

Further Reading

Appollo, Ken, "Southworth and Hawes: The Studio Collection." Iin *The Daguerreotype: A Sesquicentennial Celebration*, edited by John Wood, 79–90, Iowa City: University of Iowa Press, 1989.

Homer, Rachel Johnston, *The Legacy of Josiah Johnson Hawes: 19th Century Photographs of Boston*, Barre, MA: Barre Publishers, 1972.

Isenburg, Mathew R., "Southworth and Hawes: The Artists." In *The Daguerreotype: A Sesquicentennial Celebration*, edited by John Wood, 74–78, Iowa City: University of Iowa Press, 1989.

Newhall, Beaumont, *The Daguerreotype in America*, third revised edition, New York: Dover, 1976, originally published 1961.

Sobieszek, Robert, and Odette M. Appel, *The Daguerreotypes of Southworth and Hawes*, New York: Dover, 1980, originally published 1961.

Southworth, Albert Sands, "An Address to the National Photographic Association of the United States." *The Philadelphia Photographer*, 8 (1871): 315–323

——, "On the Use of the Camera" in *The Photographic News* (London), 18 (1874): 109–111.

——, "Photography, Painting and Truth." *The Photographic Times*, 29 (1877): 510–511.

Stauffer, John, "Daguerreotyping the National Soul: The Portraits of Southworth and Hawes, 1843–1860." *Prospects*, 22 (1997): 69–107.

Stokes, I. N. Phelps, *The Hawes-Stokes Collection of American Daguerreotypes by Albert Sands Southworth and Josiah Johnson Hawes*, New York: The Metropolitan Museum of Art, 1939.

"Stray Leaves from the Diary of the Oldest Professional Photographer in the World." *Photo-Era*, 16 (1906): 104–107.

SPAIN

When François Arago publicly announced the invention of the daguerreotype at the Académie des Sciences (Academy of Sciences) in Paris on 7 January 1839, Spain was immersed in a dynastic conflict between Carlists and Liberals that was to determine whether absolutism would continue or give way to allow the consolidation of a constitutional monarchy. In the first third of the 19th century, Spanish society was still primarily agrarian and anchored in the structures of the past. The new photographic technology, however, was to illustrate how the most progressive intellectual and scientific circles committed to modernising Spain immediately learned about and became involved in the initial development of this invention, in spite of their country's economically and socially underdeveloped context. This fact, the lack of government support and the absence of any commercial backing or stimulus characterise the introduction of photography in Spain.

The main figures involved in the earliest introduction of photography into Spain all belonged to the same progressive cultural and scientific elite. Many of them were doctors associated with Barcelona's Academia de Artes y Ciencias (Academy of Arts and Sciences),

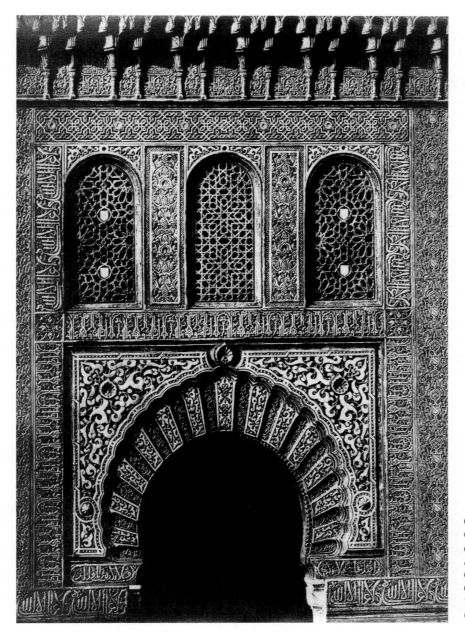

Clifford, Charles. The Alhambra, Granad. One of 58 prints in an album entitled: Eighteen architectural studies & city views of Spain by Charles Clifford plus other veiws of Spain and Canada by others.
The J. Paul Getty Museum, Los Angeles
© The J. Paul Getty Museum.

and several happened to be in Paris during the first weeks of 1839 (Pedro Monlau, Joaquín Hysern, Pedro Mata, Ramón Alabern) and were among the privileged few to see the first daguerreotypes and even Daguerre himself at work. Pedro Monlau was to act as the Paris correspondent for the Barcelona Academy. Shortly after the invention was announced, he issued a very detailed report, which was later published by the magazine *El Museo de Familias*. Once back in Barcelona, an enthusiastic Monlau introduced the daguerreotype process to his fellow academicians at a session held on 6 November 1839 and presented the view of the church of the Madeleine that Alabern had taken in Paris. He suggested that the Academy purchase Alabern's equipment at cost price. This was agreed, and the Academy then decided

to convene the citizens of Barcelona so that they could witness a demonstration of the process in what was to be the first known recorded use of the daguerreotype in Spain. This public presentation of the daguerreotype took place on Sunday 10 November, as announced by the *El Constitucional* newspaper and the *Diario de Barcelona* in its entertainment section. The exterior view of the Lonja building was the subject of this first, no longer extant, daguerreotype, again produced by Alabern after a 22-minute exposure.

The origins of photography in Madrid were also linked to Barcelona's Academia de Ciencias (Academy of Sciences) through a group of liberal scientists who worked in the capital and were also members of Madrid's Liceo (Lycée). A few days after the event

in Barcelona, on 18 November 1839, professors Juan María Pou y Camps, Mariano de la Paz Graells and José Camps y Camps, still unaware of the Catalan experiment, made their first daguerreotype—the second made in Spanish territory—which required a longer exposure (60 minutes) due to poor light conditions. This time the subject, a view of the Royal Palace from the right bank of the Manzanares River, was probably related to the interest shown by the Queen-Regent María Cristina [Maria Christina], who agreed to watch the demonstration.

The role played by the aforesaid liberal circles in developing the new invention is also demonstrated by the translation into Spanish and publication, in that very same year, 1839, of up to five different versions, varying in scope, of Daguerre's manual. One interesting example was prepared by Joaquín Hysern and Juan María Pou y Camps and titled *Exposición histórica y descripción de los procedimientos del daguerrotipo y del diorama*. This version includes a preface on photography and its relationships to the arts and sciences, with notes on the authors' own experiences. It offered two innovative theoretical photometry methods, which were surely the first of their kind in the field of photography, but they did not have the recognition they deserved outside Spain. *El daguerrotipo. Manual para aprender por sí solo tan precioso arte y manejar los aparatos necesarios* by E. de L. (Eduardo de León y Rico), published in 1846, stands out amid the second generation of publications on the invention, which appeared from that year onward.

With no apparent contact among cities, this type of non-professional circle continued to practice and disseminate the first advances in this new technology until well into 1841, with no financial backing from any institution and supported only exceptionally by private investors. The press played a very active role in spreading news of the invention and from the outset reported the major international developments in this field.

The year 1842 undoubtedly marks the start of a new era in photography in Spain, characterised by very different objectives and new key players. In a less confrontational political context characterised by greater economic development, the foundations were laid for photography to be launched as a business and for its professionalisation, in much the same way and at about the same time as in the rest of the Western world. Now the protagonists were travelling foreign daguerreotypists who came mainly from France (Mr. Constant, Etienne Martin, Mr. Anatole, Rousson, Jean Gairoard); Great Britain (Charles Clifford); Germany (Taylor and Lowe, Joseph Widen, Madame Fritz); Switzerland (Woelker, Schmidt); and Poland (Count of Lippa). These photographers, most of whom had been unable to cultivate a steady clientele in their own countries, came to Spain to exploit a totally virgin market. Their commercial strategy was to boast artistic or academic credentials, or

claim links with Daguerre's circle or dubious aristocratic titles. They usually travelled over wide areas of the peninsula, promoting themselves by placing advertisements in the local press upon arriving at each new town. They often had to combine their trade with other activities such as selling photographic products and teaching the new techniques. Their didactic efforts were indeed crucial to the development and definitive implantation of photography in Spain, because they provided technical knowledge to future Spanish daguerreotypists, who at first were also itinerant and mainly anonymous. From the 1850s onward, some of these itinerants would become fairground photographers, who followed specific routes and worked in standard settings in a profession that survived little changed until the latter part of the 20th century. The majority, however, began to set up professional studios. Mauricio Sagristá opened his establishment in Barcelona in 1842, only a year after the first studios were inaugurated in Philadelphia and London; José Beltrán opened one in 1843 in Madrid, and Francisco de Leygonier started his in Seville in 1845. From 1846 onward, photographic studios were established in numerous urban centres.

Very soon, certain figures began to stand out, including the French photographers Eugenio Lorichon and Franck (François-Alexandre Gobinet de Villecholles) as well as the Spaniards José Albiñana, who successfully took part in the Paris Exposition Universelle of 1855, and Napoleón (Fernando and Anaïs Fernández Napoleón, the latter one of Spain's first professional women photographers). By mid-century hundreds of portrait photographers were already plying this new trade, mainly in the major cities, although they simply recorded their subjects and seem to have had little in the way of aesthetic pretensions, as elsewhere. The most popular daguerreotype formats were 1/4 (10.8 × 6.3 cm.) or 1/6 (8 × 7 cm.) of a plate. Their high prices, although lower than those for paintings, still limited sales to members of the affluent classes. Few daguerreotypes were made of streets or monuments, and those that have survived are usually of major attractions such as Granada, for which there was a ready market among travelleres. In fact daguerreotypes were not used for long. In the 1850s they coexisted with the new photographic techniques that began to appear on the market, such as paper and glass negatives, and in the 1860s they began to be definitively replaced by the new processes.

Long before the invention of photography, southern Spain was a must for foreign travellers, literati and draughtsmen, who were attracted by the exoticism of its Moorish past, still visible in its monuments, and by the local colour of its inhabitants. The late onset of industrial development allowed Spain to continue to provide inspiration for the romantic, orientalist spirit that was a

prevailing characteristic of Western culture at the time. Photography immediately became a tool for this tradition and fulfilled its original goal of obtaining images of the world's most beautiful monuments and places. To cite an early example, in 1840 the writer Théophile Gautier and Eugène Piot travelled with daguerreotype equipment to record mementos of their trip through the Iberian peninsula. But above all, the large European publishers of illustrated publications began to send their own employees to obtain images on which to base engravings. This was true of the series on Spain made by Edmond François Jomard for the famous *Excursions daguerriennes* by Noël-Marie Lerebours, which included two views of Granada (the Patio de los Leones and the Albaicín) and one of Seville (the Alcázar). This series is particularly important as an iconographic reference for the numerous photographs made of the country from then on. Initiatives similar to these foreign publications also began to appear in Spain itself, such as *Recuerdos y Bellezas de España* (1839–1865), published by Francisco Javier Parcerissa y Boada.

The development of calotypes, with their ability to be reproduced, definitively spurred the foundation of the first photographic publishing houses. Starting in 1845 with Nicolaas Henneman's contributions to the *Talbotype Illustrations to the Annals of the Artists of Spain*, many travellers, mainly British and French, arrived in Spain, often on their way to the Middle East, and took photographs that were later marketed in their own countries. These travellers included: Louis-Auguste and Auguste-Rosalie Bisson (c.1848), Claudius Galen Wheelhouse (1849), Louis-Alphonse Davanne (c.1850), the Mayer brothers (c.1850), Vicomte Joseph Vigier (1850, 1851, 1853), Hugo Owen (1851), August F. Oppenheim (1852), Edward King Tenison (c.1853), John C. Grace (c.1854–56), Charles Piazzi-Smyth (1858), aided by his wife Jessie Duncan, Gustave de Beaucorps (1858), Jakob August Lorent (1858), Francis Frith (c.1856–59), Warren de la Rue (1860), Claude-Marie Ferrier (1861), R. P. Napper (c.1863), Louis de Clercq (c.1863), Charles Thurston Thompson (1868), George Washington Wilson (c.1889), and Paul Nadar (c.1895). Likewise, some of the foreigners settled in Spain began to use calotypes, including Clifford, Franck and Leygonier (who opened Seville's first studio and sold calotypes), as did Spaniards such as Pascual Pérez y Rodríguez in Valencia.

Most of these photographers busied themselves producing images—views and popular characters—of typical locales, such as Madrid (El Escorial, the Royal Palace and the Puerta de Alcalá) and Andalusia, the places visited frequently by the romantic travellers who were also devotees of calotype prints.

The presence in Seville of a figure such as Antonio María Felipe Luis d'Orléans, Duke of Montpensier, who was a patron and collector of photography, surely attracted some of these travellers too. In general, there was a certain thematic homogeneity, although some photographers, who were usually anonymous, recorded scenes of everyday life for local sale. Images of Spain's colonies overseas, taken by Mouton y Villar and Juan Buil, among others, also departed from this idealised repertory.

But the true counterpoint to this romantic representation of an idealised Spain came from another series of images: industrial photographs linked to the technical and scientific modernisation process carried out during the liberal monarchy of Isabel II (1843–1868). On another level, however, they could also be understood as an exaltation of what was sublime within the technological landscape and therefore as a continuation of a certain romantic aesthetic. During this period, the Crown used this new form of representation both as a symbol of technological modernity and to legitimise and promote a different view of the country more in line with the development of the industrial revolution. Major public works, such as the bridges and railways that were radically transforming Spanish territory, were documented. Two of the best in this field were Charles Clifford, and the Frenchman Jean Laurent, who were undoubtedly the most important foreign photographers in 19th-century Spain. Clifford was Isabel II's court photographer from 1858 onwards, and accompanied her on royal visits; much of his work was used as a powerful political propaganda tool favouring the monarchy and the progress it promoted. Apart from his more picturesque series, Clifford documented the construction of the Canal de Isabel II (1855–56 and 1858), which has continued to provide water to Madrid ever since. He also documented one of the era's great urban renovations, that performed in Madrid's Puerta del Sol (1856–1862), a square conceived by liberals as a new monumental and central public space. These photographs of the Puerta del Sol recall Marville's work on Paris during Haussman's remodelling. At the time photography in Spain was clearly in the service of government institutions, as was confirmed in Spain's capital city by the Royal Order of 8 May 1869 requiring all public works to be photographed and copies sent to the main institutions.

J. Laurent, who had lived in Spain since 1843 and who began to take photographs in 1857, created the 19th-century's most important commercial enterprise and photographic archive of Spain (Laurent y Cia.), which employed hundreds of professionals. Its Paris branch distributed work throughout Europe for over 50 years. Laurent's company documented all sorts of subjects, ranging from cities, monuments and reproductions of masterpieces of Spanish painting to celebrities and popular characters. His photographs of railways left and invaluable record, like those he made in collaboration

with José Martínez Sánchez of public works in 1866–67, a group of photos that was chosen for the Paris Exposition of 1867, together with Clifford's views of the Canal de Isabel II.

Topographical photography documenting industrial architecture gave way to some of the most interesting pictures from a compositional viewpoint due to their adoption of innovative spatial concepts and a new iconography devoted to modern buildings and the landscapes resulting from human interaction with nature. This was made easier because photography had finally overcome the greatest technical disadvantages limiting outdoor images. Works by José Rodrigo, Pau Audouard, William Atkinson and Pérez y Rodríguez should be added to those mentioned previously. Train images by J. Laurent, José Spreáfico, Auguste Muriel and Martínez Sánchez documented the birth of the many railway lines that, together with new roads, began to cover the peninsula. This increase in transport facilities was spectacular and a boon to photographers because it reduced distances and stimulated the penetration and dissemination of new ideas.

With new advances in photomechanical printing and the spread of the use of collodion and albumen paper, the 1850s also brought the initiation of a Spanish photographic industry. These factors enabled the marketing and mass production of large catalogues, albums and the popular "Photographic Museums," which offered all kinds of images for sale, most of them produced by stereoscopy. In addition to all the Spanish producers of stereoscopic views, at this time large foreign companies, such as the London Stereoscopic Company or Frith & Co., also sent their photographers to capture the country's most typical images.

In the Spanish market it was in the 1860s that the preponderance of foreign photographers was finally reversed in favour of Spaniards. This decade inaugurated the era of large studios and of *carte-de-visite* portraiture, which spread by means of the family album. In Spain, as in the rest of the world, the introduction of *carte-de-visite* meant a certain democratisation of photography, since they were within reach of a much wider public due to their being priced much lower than daguerreotypes. This development created a domestic market and a national photography that was able to fulfil the aspirations of the liberal bourgeoisie, who after the revolution of 1868 needed a way to reflect its growing power and associate itself with a technology that symbolised modernity. Consequently, large galleries of celebrities, consisting of portraits of all sorts of famous people, became the rage and were displayed in the show-windows of studios, usually located in the nerve centres of cities such as Madrid's Puerta del Sol. The most prestigious studios during this period belonged to Pau Audouard, Moliné y Albareda, A. Espulgas and

Napoleón in Barcelona; Laurent, José Albiñana, José Martínez Sánchez, Eusebio Juliá, Julián Martínez de Hebert, Alonso Martínez, Edgardo and Fernando Debas, Manuel Compañy, Christian Franzen and Bois-Guillot in Madrid; Antonio Cosmes and Antonio García Peris in Valencia; Xasajús, Leygonier, Lorichon, Enrique Godínez, Julio and Emilio Beauchy, and Barthe-Boyer in Seville; H. Otero and M. Aguirre in San Sebastián; José García Ayola in Granada; Spreáfico in Malaga; and Francisco Zagala in Pontevedra. As elsewhere, many painters and miniaturists decided to adopt the new medium and became photographers, retouchers or lighting technicians, using their artistic skills to win new clients and improve photographic craftsmanship.

If scientists played a vital role in the initial dissemination of photography in Spain, photography, in turn, was to become an indispensable tool for science as technology continued to develop. It was applied in myriad fields, from taxonomy to the analysis of animals, plants and insects, etc. By 1862, Rafael Castro y Ordóñez, a member of the Comisión Científica del Pacífico (Scientific Commission of the Pacific), was already making a photographic record of the Commission's expedition to South America. In astronomy, José Monterrey and Warren de la Rue shot a solar eclipse in 1860, and a decade later in Cadiz, John Spiller and William Crooks recorded the transit of Venus. Photography entered the medical world in 1874, when some doctors in Barcelona were authorised to photograph their patients or use images of patients for teaching purposes. From the mid-1860s onward, photography was also employed as a new tool for social control to document delinquents or condemned prisoners. One extant example of this practice is the series of photographs of bandits that the police commissioned from J. H. de Tejada in 1870.

The relationship between photography and the press in Spain dates from the 1850s, when the first newspapers and illustrated magazines began to use photographic images as the basis for their engravings. From the 1860s onwards, with the improvement of printing techniques, they were able to include photographs directly. The introduction of wet collodion, which enabled shorter exposure times, was a key event in this field, although photography had to wait for the silver bromide gelatine era to achieve real instantaneity. From 1858 noteworthy photographers, including Clifford and Laurent, were asked to contribute regularly to magazines like *El Museo Universal* and *La Crónica* respectively. *La Ilustración Española y Americana*, the most popular illustrated magazine in the 1880s, enlarged its staff with a wide network of regional photographer-correspondents, among whom Juan Comba García, considered one of the founders of Spanish photojournalism, stood out. Nonetheless, the full integration of photography into the press did not occur until the 1890s, when modern illustrated journals

such as *Blanco y Negro* (1891) appeared, and marked the birth of the 20th century. One of the regular contributors to *Blanco y Negro* was the Danish diplomat Christian Franzen, the other great figure in photojournalism and official photographer for Madrid's high society. Franzen also introduced the use of magnesium in Spain, which made it possible to photograph in poorly lit areas. This new market, which provided reporters with an outlet for their work, encouraged photographic testimonies of current events and wars. For instance, Carlist prisoners in Valencia were photographed by Antonio García Peris in 1869, and the bombing of Durango and San Sebastián was recorded by H. Otero and M. Aguirre in 1873. Photographs of the Moroccan War of 1859 taken by painter Mariano Fortuny y Madrazo, among others, and commissioned by General O'Donnell, were clear examples of reportage requested by political authorities for propaganda purposes. The work of Alfonso (Alfonso Sánchez García) should also be mentioned, as he was probably the most important Spanish photojournalist of the generation that started to work at the end of the century documenting a poor and depressed Spain after the crisis of 1898, when the country lost its last colonies overseas.

Apart from the importance of these press reports, Spain also had a series of photographers, often amateurs, whose work constituted a valuable anthropological record, as shown in the Mallorca photographs taken by Tomás Montserrat, those of Holy Week in Lorca by José Rodrigo, the Museo fotográfico (Photographic Museum) and Toledo series by Casiano Alguacil Blázquez, the views of Valladolid taken by Bernardo Maeso, and even the photographic records of Ramón y Cajal's trips to the United States and Antoni Amatller i Costa's journey throughout Northern Africa and the Near East.

At the end of the 1880s, the evolution in photographic reproduction methods and a new demand for print jobs caused the expansion and transformation of many studios into phototype workshops and establishments, and a range of specialised photographic trades appeared. This enabled more flexible ways for professional photographers to market their images and turned the sale of albums, limited editions of scenic views, collectible series, postcards and posters into a lucrative business. These images covered everything, from aerial views of Barcelona to public executions (Isidro Montpart), sports themes (the Debas brothers), to popular views of Madrid (Hauser y Menet). These photographers, and Laurent himself, were just some of many who set up this type of workshop.

As regards photographic products (plates, cameras, paper, etc.), at the end of the century the industry remained almost completely dominated by foreign companies, with the sole exception of Manufactura General Española de Productos Fotográficos S.A., a company founded in Murcia in 1893 to manufacture the *Victoria* bromide gelatine plates and aristotype (citrate) paper. Because of this dependence on foreign sources, important establishments opened in Spain and joined other shops like pharmacies as distribution centres, selling all kinds of photographic materials and systematically advertising their wares in the press. There are very few Spanish contributions to the development of photographic techniques, with exceptions like the leptographic paper patented by Laurent and Martínez Sánchez and research on colour photography, a matter of interest for many amateurs and scientists, including Nobel Prize winner Santiago Ramón y Cajal.

Professional studios reached their height of popularity during the last third of the 19th century, in the era of the Restoration of the Monarchy. This was due to the widespread acceptance of stereoscopy and to the introduction of new portrait formats (*Cabinet, Victoria, Promenade, Boudoir, Imperial*), now added to the already well-established *carte-de-visite*. In terms of photographic processes, the ambrotype was not very successful in Spain, but ferrotypes became quite popular from 1880 onwards; at about the same time both bromide gelatine dry plates and hydroquinone developers first began to be used.

The phenomenon of the expansion of these studios is also marked, however, by an increase in clients that paralleled the epoch's rapid demographic growth, particularly in large cities, which had doubled and tripled their population and had become poles of attraction for the rural exodus. Every urban centre of importance had its photographic studio, and by 1900 there were 439 legally registered establishments concentrated in major cities. Nevertheless, this proliferation took place at the cost of portrait quality, which progressively declined due to the limited technical expertise and low cultural level of photographers who began to work during this period.

The end of the golden age of photographic studios coincided with the turn of the century, marked by the serious economic crisis of 1898, which had repercussions in all financial and industrial sectors and forced a crucial change in the photographic industry. But the seeds of this deep transformation in Spanish photography had been sown previously by the great technical strides represented by bromide gelatine dry plates and the introduction of the first Kodak box cameras in 1888. The number of amateur photographers rapidly grew, reaching more than a thousand in Madrid and almost three thousand in Barcelona. It was now mainly these amateurs, not the studios, who sought and achieved better quality in their photographs. The market soon focused on them, for example with the first specialised magazines, which responded to their interests and technical needs, and organised activities, contests and prizes.

The first photographic societies, clubs and associations also grew up around these magazines. In general, members of such groups still came from the more prosperous social classes. The pioneer magazine was *La Fotografía*, founded in Barcelona in 1886. Figures as vital for the future development of Spanish photography as Luis de Ocharán, Antoni Amatller i Costa and Antonio Cánovas began to stand out among these enthusiasts. Cánovas, known as Kaulak, was one of the instigators of the photographic section in Madrid's Círculo de Bellas Artes (Circle of Fine Arts) (30 December 1899), which a year later became the Sociedad Fotográfica de Madrid (Madrid Photographic Society). This group, as well as other new societies and associations, very soon became the stronghold for the new form of Pictorialism that would develop in Spain after being imported from Europe at a very late date, and which was to continue well into the 20th century.

DIANA SALDAÑA

See also: Pou and Camps, Juan Maria Franck (François-Marie-Louis-Alexandre Gobinet de Villecholles); Piot, Eugène; Noël-Marie Lemercier, Lerebours & Bareswill; Henneman, Nicolaas; Bisson, Louis-Auguste and Auguste-Rosalie; Wheelhouse, Claudius Galen; Davanne, Louis-Alphonse; Vigier, Vicomte Joseph; Owen, Hugh; Oppenheim, August F; Tenison, Edward King; Piazzi Smyth, Charles; Lorent, Jakob August; de La Rue, Warren; Leon, Moyse & Levy, Issac, Ferrier, Claude-Marie, and Charles Soulier; de Clercq, Louis; Thompson, Charles Thurston; Wilson, George Washington; Calotype and Talbotype; London Stereoscopic Company; and Frith & Co.

Further Reading

Alonso Martínez, Alonso, *Daguerrotipistas, calotipistas y su imagen de la España del siglo XIX* [*Daguerreotypists, Calotypists and Their Image of 19th-century Spain*], Girona: CCG Ed., Centre de Recerca i Difusió de la Imatge (CRDI), 2002.

Coloma Martín, Isidoro, *La forma fotográfica. A propósito de la fotografía española desde 1839 a 1939* [*The Photographic Form. Concerning Spanish Photography from 1839 to 1939*], Málaga: Universidad de Málaga y Colegio de Arquitectos de Málaga, 1986.

Fontanella, Lee, *La Historia de la fotografía en España, desde sus orígenes hasta 1900* [*The History of Photography in Spain from its Origins through 1900*], Madrid: Ediciones El Viso, 1981.

Formiguera, Pere et al., *Introducción a la historia de la fotografía en Catalunya* [*Introduction to the History of Photography in Catalonia*], Barcelona: Lunwerg Editores; Museu Nacional d' Art de Catalunya (MNAC), 2000.

Garófano Sánchez, Rafael, *Fotógrafos y burgueses. El retrato en el Cádiz del siglo XIX* [*Photographers and the Burgeois. Portrait in Cadiz in the 19th Century*], Cádiz: Quórum Libros Editores, 2001.

González Cristóbal, Margarita Ruiz Gómez, Leticia, *La fotografía en las colecciones reales* [*Photography in the Royal Collections*], Madrid: Patrimonio Nacional, Fundación "la Caixa," 1999 (exhibition catalogue).

Huguet Chanzá, José and Aleixandre, José, *Memoria de la luz: fotografía en la comunidad valenciana, 1839–1939* [*Light's Memory: Photography in the Community of Valencia, 1839–1939*]. Barcelona and Valencia: Lunwerg Editores; Conselleria de Cultura, Educació i Ciencia de la Generalitat Valenciana, 1992 (exhibition catalogue).

King, Carl. S., *The Photographic Impressionist of Spain. A History of the Aesthetics and Technique of Pictorial Photography*, Lewiston, Edwin Mellen Press, 1989.

Kurtz, Gerardo G. and Ortega, Isabel, *150 años de fotografía en la Biblioteca Nacional. Guía-inventario de los fondos fotográficos de la Biblioteca Nacional* [*150 Years of Photography at the Nacional Library. An Inventory of the Photography Collections of the Nacional Library*], Madrid: Ediciones El Viso, 1989.

López Mondéjar, Plubio, *Las fuentes de la memoria. Fotografía y sociedad en España durante en siglo XIX* [*The Sources of Memory. Photography and Society in Spain during the 19th Century*], Barcelona and Madrid: Lunwerg Editores, 1989.

López Mondéjar, Publio, *Crónica de la luz: fotografía en Castilla-La Mancha (1855–1936).* [*All aboard: One Hundred Years of Photography and Railways*], Madrid: Ediciones El Viso, 1984.

López Mondéjar, Publio, *Madrid. Laberinto de memorias. Cien años de Fotografía* [*Madrid Laberyth of Memories. One Hundered Yers of Photography*], Madrid: Lundwerg Editores, 1999.

Muro Castillo, Matilde, *La Fotografía en Extremadura: 1847–1951* [*Photography in Extremadura: 1847–1951*], Badajoz: Junta de Extremadura, Consejería de Cultura, 2000.

Naranjo, Juan et al., *La fotografía en la España del siglo XIX* [Photography in 19th Century Spain], Barcelona: Fundación "la Caixa," 2003 (exhibition catalogue).

Pérez-Montes, Carmen et al., *Catálogo CD-Rom de fotografías de la Comisión Científica del Pacífico (1862–1866). Colección del CSIC.* [A CD-Rom Catalogue of Photographs by the Scientific Commission of the Pacific (1862–1866)]. CSIC Collections, Madrid: Museo Nacional de Ciencias Naturales, 2002.

Piñar Samos, Javier, *Fotografía y fotógrafos en la Granada del siglo XIX* [*Photography and Photographers in the Granada of XIXth Century*], Granada: Caja General de Ahorros de Granada, Ayuntamiento de Granada, 1997.

Riego, Bernardo, *Impresiones: la fotografía en la cultura del siglo XIX (Antología de textos)* [*Impressions: Photography in 19th-century Culture (An Anthology of Texts)*] Girona: CCG Ed., Centre de Recerca i Difusió de la Imatge (CRDI), Ajuntament de Girona, 2003.

Riego, Bernardo, *La construcción social de la realidad a través de la fotografía y el grabado informativo en la España del siglo XIX* [*Social Construction of Reality through Photography and News Engravings in 19th-century Spain*], Santander: Universidad de Cantabria, 2001.

Riego, Bernardo, *La introducción de la fotografía en España: un reto cultural y científico* [*The Introduction of Photography in Spain: A Cultural and Scientific Challenge*], Gerona: CCG Ed., Centre de Recerca i Difusió de la Imatge (CDRI). Ajuntament de Girona, 2000.

Rubio Aragonés, Juan Carlos et al., *Retrato y paisaje en la fotografía del siglo XIX. Colecciones privadas de Madrid.*

[*Portrait and Landscape in 19th Century Photography: Private Collections from Madrid*], Madrid: Fundación Telefónica, 2001 (exhibition catalogue).

Sánchez Vigil, Juan Miguel (ed.), *Summa Artis. Historia general del Arte. La fotografía en España. De los orígenes al siglo XXI* [*Summa Artis. General History of Art. Photography of Spain. From its Origins through the XXI Century*], Madrid: Espasa-Calpe, 2001.

Sougez, Marie-Loup, *Historia de la fotografía* [*History of Photography*], Madrid: Cátedra, 1981.

Teixidor, Carlos, *La Tarjeta Postal en España* [*Postcards in Spain*], Madrid: Editorial Espasa-Calpe, 1999.

Vega, Carmelo, *La voz del fotógrafo. Textos y documentos para la historia de la fotografía en Canarias (1839–1939)* [*The Photographer's Voice. Texts and Documents for the History of Photography in the Canary Islands (1839–1939)*], Santa Cruz de Tenerife: Gobierno de Canarias, Viceconsejería de Cultura y Deportes, 2000.

Yáñez Polo, Miguel Angel, *Historia General de la Fotografía en Sevilla* [General History of Photography in Seville], Seville: Ed. Nicolás Monardes & SHFE, 1998.

SPARLING, MARCUS (1826–1860)
Irish photographer

Marcus Fitzell Sparling was born in Ireland, and at age 20, enlisted in the 4th Light Dragoon Guards on March 17th 1846. After five years of service he was awarded a 'Good Conduct Chevron.' He was discharged from the army on September 6, 1853, and left with the honorary rank of corporal.

By then he was already a member of the recently formed Photographic Society of London, participating in the Society's second meeting, where he introduced a variation on Major Halkett's folding field camera. Reports of the meeting by Sir William Newton referred to him as 'Corporal Spalding,' to which he took exception, fearing that the attribution of a rank to which he was not entitled would earn him the disrespect of his regimental colleagues. His protest was published in the Society's Journal as being from M. N. Sparling.

Also present at the meeting was Roger Fenton with whom Sparling developed a lasting professional relationship. Indeed, he was living at Fenton's address by the end of 1853, giving his occupation as 'chemist,' and presumably already employed as his assistant.

He accompanied Fenton on his autumn photographic journey to Yorkshire, and in 1855 he worked as his assistant in the Crimea.

In 1856 he published his manual *Theory and Practice of the Photographic Art*, 'drawn from the author's daily practice,' this time identifying himself as 'W. Sparling, assistant to Mr Fenton in the Crimea.'

He was just 34 years old when he died in Liverpool on August 19, 1860, of hepatitis.

JOHN HANNAVY

SPENCER, WALTER BALDWIN (1860–1929)

British-born Professor of Biology at the University of Melbourne, he is better remembered as an anthropologist. Following formative work amongst the Arrernte people during the 1894 Horn Expedition to central Australia, he made other field trips to remote areas of central and northern Australia. With his collaborator, Frank Gillen (d. 1912), he made many hundreds of photographs and also pioneered the use of film in anthropological fieldwork. Their collaboration was so close that it is not always possible to attribute authorship to individual images. They developed and printed much of their own work and wrote to each other constantly on matters photographic. Spencer was also friendly with the distinguished Australian photographer J.W. Lindt who advised him on occasion. Whilst the photographs were made with scientific intent, many are both culturally engaged and aesthetically aware. The photographs were broadly disseminated. Not only were many of them published in Spencer's ethnographic monographs, such as *The Native Tribes of Central Australia* (1899), but he gave popular lantern lectures on aboriginal culture to packed halls throughout his career. His photographs are now in Museum Victoria, Melbourne, where they are curated with careful attention to the needs of the descendants of the indigenous communities with whom Spencer worked.

ELIZABETH EDWARDS

SPILLER, JOHN (1833–1921)
Chemist

Spiller was born on 20 June 1833, the son of an architect, and attended the City of London School where he showed a particular aptitude for science. He continued his studies at the private Royal College of Chemistry, (RCC), joining in 1849. The RCC had been founded by public subscription in 1845 with the purpose of training chemists to help the economic growth of the country. The training was practical and laboratory based. After two years the best students could become research assistants. Spiller was following this route until the RCC ran into financial difficulties and in 1853 merged with the Royal School of Mines, (RSM), whose Head was Dr Percy, a distinguished metallurgist and a photographer. Spiller transferred to the RSM, where, under Dr Percy's tutelage, he and two colleagues completed an important and comprehensive series of chemical analyses of British iron ores.

The state of photography at the time was such that although many basic principles had been established, there were real problems with the reliability of processes

and the reproducibility of results. This was an ideal and fertile ground for a chemist to delve into. Spiller was one such chemist, and a year ahead of him at the RCC was another, William Crookes, with whom Spiller was to forge a deep friendship. They both appear to have devoted much of the summer of 1852 experimenting at home with the waxed paper process. In 1853 Spiller's emphasis switched to the wet collodion process, and he had his first "Letter to the Editor" published in the *Journal of the Photographic Society* (*JPS*). It concerned the use of the pronitrate of iron for developing collodion images.

In May 1854, Spiller and Crookes published a paper in the *Philosophical Magazine* (*Phil Mag*), which really brought Spiller's name before the photographic community. It was on a method for extending the "life" of wet collodion plates well beyond the normal few hours. This necessitated the retention of a moist surface, which they achieved by putting the sensitised plate into a bath of fused zinc nitrate for about five minutes and then drying. The plate showed no sign of deterioration in sensitivity after a week. They had searched for a deliquescent material that would maintain the plate in its "pappy" state. It seemed a neat chemical solution to the problem. The method attracted much attention but had limited success. A few months later another paper in the *JPS* and the *Phil Mag* proposed using fused nitrate of magnesia. Further experimentation was promised and was revealed, in 1856, in a third paper in the *Phil Mag* (see Further Reading). The possibility of using glycerine was raised in the first article. Now they claimed priority for the suggestion, and developed a workable process. They also looked into other deliquescent materials, but still recommended glycerine. This was fine work by the two young chemists, but it was overtaken by the invention of the dry collodion plate.

During 1856 Dr. Percy invited Spiller on a photographic holiday in Devon. Percy was an active photographer who participated in the Exchange within the Photographic Society of London, (PSL), which produced the Photographic Albums for 1854 and 1857. The latter Album contains the photograph entitled "The New Mill near Lynton North Devon" by Percy and Spiller, taken, (not surprisingly), on collodion, September 1856. It is the only known published photograph by Spiller.

It was in 1856 that Spiller left the RSM and joined Woolwich Arsenal as an assistant chemist. In 1861 Spiller founded the Photographic Department there and lectured on photography at the Royal Artillery Institute and the Royal Military Repository. He continued to produce an impressive stream of articles on the chemistry of photography, and became well known as a knowledgable practitioner, particularly on collodion. He also devised Spiller's Reducer, using copper chloride to thin down negatives. Some of the articles owed their existence to

his continuing close friendship with Crookes. Crookes was successively editor of three photographic journals, and at times he was glad to have a friend he could turn to for an article to publish. In 1860 Spiller and Crookes were able to join forces to photograph the partial solar eclipse of the sun, using the telescope at Woolwich. They produced a good set of photographs, of which Spiller was especially proud. Spiller also took pride in being something of a champion of the Woodburytype process. He had been at the first demonstration of the process in London in 1865. At a British Association meeting in Dundee in 1867, he devoted most of a paper about new processes in photography to the Woodburytype.

In 1868, at the invitation of his brother, Spiller left Woolwich and joined the firm of Brooke, Simpson and Spiller as Chief Chemist. They were manufacturers of synthetic dyes, and Spiller was to remain with them for the next twenty years. Spiller's interest in photography remained undiminished, as the flow of articles, mainly on the chemistry of photography, testifies. Of particular significance was a paper, "On the action of chloride of gold upon certain salts of silver" in 1869. This has been regarded as the true invention of the self-toning principle. Spiller himself acknowledged that, although he proposed the idea independently, he was not the first. Surprisingly, he did not join the PSL until 1867, but eventually he occupied, at various times, every office. He was President in 1874–75 at a time of great crisis, when a separate Society might well have been formed. Spiller played a great part in holding the PSL together. Alas, the friendship with Crookes did not hold together. Crookes had become interested in spiritualism and Spiller attended a séance with him. They had different versions of events, which led to a spectacular row in the press in 1871 and the end of their friendship. However, Spiller attended the Golden Wedding celebrations of Sir William and Lady Crookes in 1906, having been their "best man." Spiller remained a member of the, by then, Royal Photographic Society, until his death in 1921, aged 88.

JOHN SAWKILL

Biography

John Spiller was born in London on 20 June 1833, the son of an architect. He attended the City of London School and then moved to the Royal College of Chemistry in 1849. He transferred to the Royal School of Mines in 1853 and analysed British iron ores. He then became an assistant chemist at Woolwich Arsenal in 1856, setting up the Photographic Department there. After twelve years at Woolwich, and at the invitation of his brother, Spiller joined the firm of Brooke, Simpson and Spiller as Chief Chemist. They manufactured colour dyes and Spiller was to stay with them for twenty years. In 1859

Spiller was elected a Fellow of the Chemical Society. He joined the Photographic Society of London in 1867, occupied every office and was President in 1874/75. He married twice, first to Caroline Ada Pritchard and then to Emma Davenport. He died in London on November 8, 1921.

See also: Crookes, Sir William; Percy, John, Wet Collodion Negative; Wet Collodion Positive Processes (Ambrotype, Pannotype, Relievotypes); Waxed Paper Negative Processes; and Woodburytype, Woodburygravure.

Further Reading

The Spiller Collection. 106 letters from Crookes to Spiller in the period 1850 to 1868 and a few later. Wellcome Institute for the History of Medicine, London.

Spiller, John and Crookes, William, "On a Method for preserving the sensitiveness of Collodion Plates for a considerable time." *Philosophical Magazine* vol. 7 (1854): 349–351.

Spiller, John, and Crookes, William, "Further researches on the methods of preserving the Sensitiveness of Collodion Plates." *Philosophical Magazine* vol. 8 (1854): 111–113.

Spiller, John and Crookes, William "Researches on the Methods of preserving the Sensitiveness of Collodion Plates." *Philosophical Magazine* vol. 11 (1856): 334–339.

Spiller, John "On the action of chloride of gold upon certain salts of silver." *Photographic Journal* vo. 114 (1869): 91, 92.

Spiller, John, "On the gold printing process." *The Year Book of Photography and Photographic News Almanac*, 63, 64, 1883.

SPIRIT, GHOST, AND PSYCHIC PHOTOGRAPHY

The nineteenth century saw the science and rationalism of the previous century emerge as an even stronger force of change further empowered by the mercantile thinking of a growing middle class. There was an almost frenetic quest for knowledge that rode on the surge of the industrial revolution. The growth of evolutionary and progressive science such as for example Charles Darwin's theory of evolution were perceived to challenge ideas of established belief systems particularly undermining the fundamentalist structure of 19th century Christianity. That the origin of mankind may have been a slow selective development from primates as opposed to a divine creationist intervention was considered both blasphemous and, as the argument developed, increasingly calamitous.

With these changes in perception a battle emerged between the desire or need to continue to believe in the numinous—and as its antithesis an increasingly empirical, materialist vision of creation. The middle ground was indeed growing treacherous underfoot. In his poem *Dover Beach*, the 19th century poet Mathew Arnold described how faith, like the tide, was retreating;

But now I only hear, Its melancholy, long, withdrawing roar" revealing the, "naked shingles of the world. (Trilling, p.594)

The process of photography is a familiar presence in contemporary life. The photograph has become our ubiquitous shadow and like a shadow is with us in many forms everyday of our lives. Yet when Louis Jacques Mandé Daguerre's process of photography was announced to the world in January 1839 those who examined the new image making process saw the medium not only as a scientific marvel but also as a miraculous aid to drawing that would revolutionise recording and effect an irreversible change in human perception. The photograph has not only altered the way in which we interpret the world around us, it has also affected the manner in which we perceive ourselves (Webster, 1).

As a form of representation of external reality the photograph played a powerful role in helping to establish concepts of order and interpretations of a shrinking world. As images were constructed subjectively they were (often it seems unwittingly) used to confirm what was already understood rather than as a cipher of new knowledge.

The apparent veracity of the photographic image lent it an unprecedented (and often unquestioned) credibility. The camera's ability to accurately reproduce the world on a two-dimensional surface stood as proof that the manner in which a subject was recorded was definitive and unquestionable. The photograph was held in a position of unparalleled importance as a piece of factual evidence.

As a device of moralising and comparison the photograph was unsurpassed—for as it was so closely linked to reality belief followed.

When discussing Roland Barthe's posthumously published text *Camera Lucida* John Tagg highlighted these points:

The camera is an instrument of evidence. Beyond any encoding of the photograph, there is an existential connection between the 'necessarily real thing which has been placed before the lens' and the photographic image': every photograph is somehow co-natural with its referent.' What the photograph asserts is the overwhelming truth that 'the thing has been there': this was a reality which once existed, though it is a reality one can no longer touch. (Tagg, 1)

In the nineteenth century the photograph seemed to affirm that science could transcend the confines of raw nature and that through man's ingenuity science would be the medium that allowed nature to record itself.

One extreme example of this was the case recorded in *The Photographic Times* of 1863 where a murder victim's iris was photographed, the negative enlarged and when viewed under the magnifying glass the

outlines of a human face (the murderer's imprint) could be made out.

> So exaggerated then was the efficacy of the all-seeing mechanical eye and so readily was its recorded image acceptable that those present had no difficulty in seeing the details of the face of the murderer. They saw what they wanted to see: long nose, prominent cheekbones, black moustache and other sinister distinguishing features. (Nickell, 146)

The revolution of photography democratised vision in the same way that the printing press revolutionised the dissemination of learning and knowledge. Although photography did in itself create a window on a smaller shrunken world, its effect was one of enlarging the life experience of the huge mass of avid viewers. And still the perception remained that the camera could not lie—its basis was in optics and chemistry.

It may seem slightly ironic then that the camera and the process of photography—very much a result of a time of innovation and upheaval—should become the tool for those whom wished to prove the existence of an incorporeal afterlife. Yet the belief in the camera's veracity as objective machine of record would ultimately lend credence to the claims of proof when photographic evidence was produced of supernormal phenomena.

When we view a photograph from the early period of portraiture there is an inherently poignant quality about these images. These are the shades of the dead, their actual reflection in silver, recorded as the light was reflected from the skin in darkening silver. Perhaps the irony of these early images of the then living is that they serve to confirm mortality rather than ensuring immortality.

For the Victorians it surely was secure the shadow ere the shadow fade. In industrial centres there were swiftly changing demographics and high mortality rates. The child mortality rate in cities, stable in the smaller decentralised centres, rose alarmingly. Death became a more pronounced cultural aspect of society.

This nineteenth century involvement with mortality, its possible antecedent the afterlife, and new questions of belief, resulted in an intricate relationship with photography, where families celebrated death in albums that included photographs of clocks recording the time of death as well as the post-mortem photographs themselves.

So where rationalism and Darwinian theory challenged belief, the photograph provided at least one place of seeming permanence and an afterlife. Where belief was accentuated the rise of new spiritual movements and spirit photography provided another.

Communication with the dead was not a new phenomenon that arose in the medium's parlour of the nineteenth century. However this occult practice gained new momentum through the growing desire for assurance that there was indeed an afterlife.

Spiritualism itself began as a movement in the United States in 1848 with the séance activity of Margaretta and Katie Fox, sisters from a family in the village of Hydesville, Wayne County, New York. Not only could these sisters apparently communicate through rapping's with the spirit world but also the ability could be passed on. The experiments spread widely from the eastern seaboard of the United States to Britain.

This movement drew its strength in effect from the reactionary beliefs of the 18th century where figures such as the Swedish philosopher Emanuel Swedenborg had begun his counter revolution of belief in a time of scientific rationalism and religious latitudinarianism. Although Swedenborg was influential he had a limited following in the United States. It was another movement, Mesmerism, which, having been far more popular in this country, provided the major basis from which Spiritualism had its origins. Mesmerism was primarily the creation of Franz Anton Mesmer, a German healer who used therapeutic hypnotism and the laying on of hands as part of his healing processes. It was the visions of the so-called spirit world that many of Mesmer's patients or *somnambules* experienced which generated a widespread fascination with Mesmerism. Spiritualism grew from the seeds of such occult attempts at re-enchanting spiritual activity. Within twelve years of the advent of Spiritualism the first photograph claimed to depict a spirit was produced in New Jersey (Guiley, p. 568).

It was the New Jersey commercial photographer W. Campbell who produced the first recorded case of a spirit photograph apparently without his intervention in 1860. He showed his remarkable photograph to the American Photographic Society at their twentieth annual meeting. The image was a test photograph of a chair in which the trace picture of a small boy had mysteriously appeared. Campbell was at a loss to explain the appearance and was never able to reproduce such images again (Permutt,12). This would suggest that the appearance of the boy was not a staged effect. Curiously the rational answer should have been apparent to any practising photographer of the time. This was the period of the wet plate process where glass plates were coated with a photographic emulsion and exposed in the camera whilst still wet. As glass was not inexpensive plates were often cleaned and reused. The result might be the residue of a non-actinic (i.e. yellowish) image that though faint would produce a ghostly image if the plate were re-exposed. But according to Campbell the boy was unknown to him (Nickell, 148).

Far more famous a personality as spirit photographer was the Boston photographer William H. Mumler. Mumler was an engraver by training who worked for the jewellers Bigelow Brothers and Kennard. He appar-

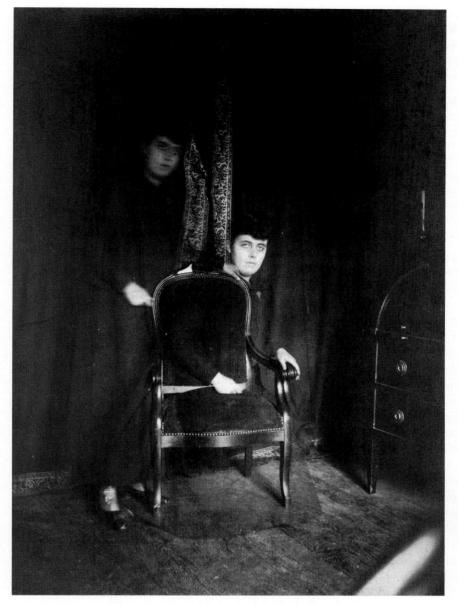

Henry Mathouillot Archive Partial Dematerialization of Medium M. Buettinger.
The Metropolitan Museum of Art, Gilman Collection, Gift of The Howard Gilman Foundation, 2005 (2005.100.383.4) Image © The Metropolitan Museum of Art.

ently discovered photographic extras on some amateur photographs he had taken of a fellow workman. This together with the popularity of Spiritualism seemingly provided Mumler with the impetus for exploring the idea of making such spirit photographs as a lucrative business venture. His Psychic self-portrait of 1862 as he accounted:

> was taken by myself, on a Sunday, when there was not a living soul in the room beside me, so to speak. The form on my right I recognise as my cousin who passed away about twelve years hence. (Nickell, 149)

Mumler's business venture thrived and he regularly obtained ghostly extras on the photographs he took of his customers in Boston. At the height of his career he could charge up to $10 per sitting. Nor did his popularity end when a Boston Spiritualist, a doctor Gardner, recognised some of the extras as living Bostonians.

Although it damaged business Mumler was able to continue. On one occasion around 1865 Mumler even produced a manifestation of Abraham Lincoln. Mumler maintained that the woman who sat for him retained her veil until the moment of exposure when she removed it for the photograph. He did not he said, realise that she was in fact Lincoln's widow Mary Todd Lincoln (Permutt, 13).

The practice of spirit photography attracted its critics as well as those who were believers. Gradually a realisation that fakery was quite possible in the apparently immutable photographic image crept in. In 1869 Mumler was working in New York where he survived an accusation of fraud through lack of evidence. The accusations however were public notice that belief did not naturally follow the production of a plate. Despite producing a likeness of Beethoven in 1871 Mumler eventually died in obscurity around 1884 (Nickell, 149).

English spirit photographer Frederick Hudson on the other hand convinced his critics with his ability to produce spirit-extras with his own daughter as a medium. Publishing in the British Journal of Photography, July 11, 1873, one investigator John Beattie stated;

> If the figures standing by me in the pictures were not produced as I have suggested [i.e. real spirits appearing through the medium's presence], I do not know how they were there; but I must state a few ways by which they were *not* made. They were not made by double exposure, nor by figures being projected in space in anyway; they were not the result of mirrors; they were not produced by any machinery in the background, behind it, above it, or below it, nor by any contrivance connected with the bath, the camera or the camera inside. (Permut, 17–18)

As convinced as Beattie was, it is interesting to note that Beattie himself had successfully experimented with spirit photography prior to his investigation of Hudson,

Whatever the merits of each individual case what is truly fascinating is not the argument whether or not the works were fakes—most of them almost certainly were, but rather that there was such a huge desire to have this link with the deceased even when the evidence would indicate that the images provided no such thing. The sitters wanted the images to be real and the desire was enough to remove overwhelming doubt. When viewing the images themselves this becomes apparent.

Sometimes fuzzy, of varying scale, technical skill and unconvincingly dressed in shrouds it would seem almost impossible to believe that anyone could accept these images. However it would be wrong to project our own more sophisticated media scrutiny back upon these sitters. The photograph represented the real; there upon the plate where nothing had been before was a trace, a certainty of life beyond life. It was this photographic veracity this machine's verdict, that helped convince his sitters that this was a scientifically recorded truth.

The report of the fraud inquiry into Mumler's work suggested:

> A number of good recognitions were claimed from time to time by sitters, and these can only be accounted for in the light of subsequent events by the long arm of co-incidence, and the will to believe that lies in all of us." (Nickell, 149). Especially, it might be added, when the evidence of a machine reinforces the will.

Importantly there was again the encounter between the Victorian understanding of the truth, i.e. the photograph, and the challenge of the unreal, "As visual spectacles and entertainment, such manifestations opened the way for the enjoyment of appearances whose very fascination came from their apparent impossibility, their apparent severance from the laws of nature" (Petro, 68). This type of photograph now offers clues not to the evidence of the afterlife but rather an insight into the Victorian mind and the complex puzzles of representation and implicit belief that the act of making a photograph evokes. As photographic knowledge progressed people were more and more convinced of the ability of the photographic 'medium' to access visual realms the eye could not see. The invention of the X-Ray by Karl Wilhelm Röntgen in 1895, understandings about the visible and invisible spectrum such as infra-red photography and the development of spectroscopy, reinforced such beliefs.

Sir Arthur Conan Doyle, Spiritualist and believer, defended the growth of this belief in paranormal activity. Doyle was himself convinced by the evidence he had seen over the course of his investigations.

> Victorian science would have left the world hard and clean and bare, like a landscape in the moon; but this science is in truth light in the darkness, and outside that limited circle of definite knowledge we see the loom and shadow of gigantic and fantastic possibilities around us, throwing themselves continually across our consciousness in such ways that it is difficult to ignore them. (Doyle, 13)

CHRIS WEBSTER

See also: Daguerre, Louis-Jacques-Mandé; and Mumler, William H.

Further Reading

Cohen, D., *Encyclopedia of Ghosts,*. New York: Dorset, 1984.

Doyle, A. C., *The Coming of the Fairies*, New York: Samuel Weiser, 1979.

Gettings, F., *Ghosts in Photographs*, New York: Harmony Books, 1978

Mulholland, J., *Beware Familiar Spirits*, New York: Scribner, 1979

Nickell, J., *Camera Clues*, Lexington: University Press of Kentucky, 1994.

Permutt, C., *Beyond the Spectrum*, Cambridge: Patrick Stephens Ltd., 1983.

Petro, P. (ed.) *Fugitive Images—from Photography to Video*. Bloomington: Indiana University Press, 1995.

Tagg, J., *The Burden of Representation*. London: Macmillan, 1988.

Trilling, L., and Bloom, H. (eds.), *Victorian Prose and Poetry*. New York: Oxford University Press, 1973.

Webster, C., *Memory of the Fall*, Aberystwyth: School of Art Press, 1998.

SQUIER, EPHRAIM GEORGE (1821–1888)

American poet, engineer, archaeologist, and photographer

Born June 17, 1821 in Bethlehem, New York, to Joel Squier, an itinerant Methodist minister, and Katherine Kilmer Squier, Ephraim George gained two half brothers—Charles Wesley and Frank— when his father mar-

ried Maria Kilmer, Squier's own mother's sister after Katherine's death when Ephraim was twelve.

As a young man he wrote poetry and edited several poetry journals. His literary interests switched from poetry to social issues when he became involved with a publication, *The New York State Mechanic*, which supported "...the interests, rights, and social advancement of the laboring classes of America," according to his biographer, Terry Barnhart. Squier went on to obtain an M.A. and a degree in Civil Engineering.

Squier's interest in archaeology began in 1845 with his writings about the Indian mounds in Chillicothe, Ohio, and culminated in one of his most important works *Peru: Incidents of Travel and Exploration in the Land of the Incas*, published in 1877. This extensive record includes 295 engravings based on drawings and photographs—using the wet-plate process—made under Squier's supervision by the Lima based photographer Augustus Le Plongeon, who also probably taught Squier basic photography, a photographer named only as "P," and even Squier himself. His use of photography served him well because the renderings of architectural plans and monuments remain accurate even today.

Some of Squier's other significant works include *Nicaragua: Its People, Scenery, Monuments, and the proposed Inter-Oceanic Canal*, published in 1852, and *Observations on the Uses of the Mounds of the West, With an Attempt at their Classification*, published in 1847.

Ephraim George Squier died April 17, 1888 in Brooklyn, New York. The Library of Congress, the New York Historical Society, the Indiana Histroical Society, and the Latin American Library of Tulane University, are some of the institutions that hold Squire materials and photographs.

MICHELE M. PENHALL

STAHL, THÉOPHILE AUGUSTE (1828–1877)

Born in Bergamo, Italy, on May 23, 1828, Théophile Auguste (Augusto) Stahl came from an Alsatian family. His father was a Lutheran pastor. Stahl arrived in Pernambuco, Brazil in 1853, and in 1862 moved to Rio, where he and Germano Wahnschaffe became Photographers of the Imperial House. A renowned landscape photographer who sold multiple copies of his prints, he portrayed remote parts of Pernambuco, documented the Recife and São Francisco Railway works and recorded Emperor Pedro II's visit to Recife in 1859. The resulting album, "Memorandum Pittoresco de Pernambuco," is considered a pioneering example of photojournalism. Stahl also produced anthropological and anthropometric pictures of "Brazilian types" for the Agassiz expedition (1865–1866), published in *Journey in Brazil*, by Louis

and Elizabeth Agassiz (1868). He participated in the First and Second National Exhibitions in Rio (1861 and 1866), the Great London Exposition (1862) and the Exposition Universelle, Paris (1867). He died in Alsace on October 30, 1877.

Collections: Brazilian Historical and Geographic Institute (IHGB), National Library (Brazil); Peabody Museum of Archaeology and Ethnology, Cambridge, Massachusetts (USA). Also published in *Augusto Stahl. Obra completa em Pernambuco e Rio de Janeiro*, by Bia Corrêa do Lago (2001), and *O negro na fotografia brasileira do século* XIX, by George Ermakoff (2004).

SABRINA GLEDHILL

See also: Exposition Universelle, Paris; and Expedition and Survey Photography.

STANHOPE

A Stanhope, sometimes called a peep, is a microphotographic image on glass attached to its own small magnifying lens. The construction allows a person to see the image clearly. Stanhopes were produced from the 1860s to the 1970s, primarily in France. They can be found in a variety of decorative, souvenir, and utilitarian objects that were manufactured and distributed around the world.

Microphotography is nearly as old as photography. In 1839 John Benjamin Dancer produced some of the first microphotographs on slides. After collodion came into use in the 1850s, microscope slides became more popular, but people needed an easier way to see the images. Sir David Brewster used the more portable Coddington lens, invented about 1820, but suggested microphotographs could somehow be mounted into jewelry. René Prudent Patrice Dagron was issued a French patent in 1859 involving the use of microfilms and lenses to be placed in novelty items. He produced Stanhopes as we know them today, referring to them as microscopic jewels. He also used the term "Stanhope."

Stanhope is named for Charles, Third Earl of Stanhope (1753–1816), an inventor who lived prior to the era of photography. He did not invent the Stanhope, but he had developed a hand-held lens on which the Stanhope is based. Charles Stanhope's lens had two rounded ends, but Dagron made one end flat so that he could attach the image directly to it. In this way he was able to place the units into holes in novelties so that people could carry them in a fashionable manner.

The images were produced by using a camera with microscope lenses. Although the first cameras had one lens, the later ones had as many as twenty-five. Through these lenses photographic images were made onto a microscope slide by using the collodion on glass process.

By moving the lenses horizontally and vertically it was possible to produce 450 images on one slide. These were then cut into individual square parts with a diamond tool creating images about 1/30 inch square. Onto each image was glued a tiny lens, 1/4 to 1/3 inch in length, and then the corners of the glass unit were ground off making the unit cylindrical. The glue used was Canada balsam which was clear when it dried. The finished piece is usually about 1/10 inch by 1/3 inch, though some Stanhopes were made in larger sizes.

The focal length of the lens equals the length of the lens, so to be in focus, the image must be in direct contact with the flat end of the lens. To view the image, it is necessary to hold the curved end very close to your eye and direct the flat side of the lens toward a light source. Sometimes this is best with direct light, but in other instances diffused light or light reflected off a white surface is best. Since the Stanhope contains its own magnifying lens, most people find it easier to view without the aid of eyeglasses. Often many scenes will appear in a Stanhope, but if there is a single lens it is still only a single Stanhope image. In a real multiple Stanhope item there will be different lenses for each Stanhope.

Today the term refers to both the images and the items containing them. Images can be souvenir sights, religious locations or prayers, political personalities, advertising information or nudes. Certain types of items tend to be from specific geographic regions. Satin spar barrels or similar objects have Niagara Falls images. Items of bog oak come from Ireland. Hoof or horn objects come from Austria or Switzerland and have mountain scenes. The age of many Stanhopes can be determined because the images commemorate datable events. These include celebrations, famous exhibitions and world's fairs. Political Stanhopes also can be dated by establishing election years for the people pictured.

Stanhopes appear in a great variety of articles. Most abundant are crosses, which always have some type of religious image. Common, too, are dip pens and letter openers made of carved wood or bone. The images included are usually locations since these were travel souvenirs. Miniature bone binoculars and telescopes, with nearly every type of image, also are frequently found. Less common are sewing and needlework implements, smoking items, jewelry, writing instruments, bookmarks, grooming tools, knives and assorted other trinkets. Canes, beer steins, and violin bows are among the larger items one can find with Stanhopes. Although some museums have a few Stanhopes, none permits viewing the images. It is possible to do this only in private collections.

The largest and most valuable Stanhopes are dolls.

Fewer than twelve are known to exist, all in museums or private doll collections. These dolls are all attributed to Antoine Edmond Rochard, who gained a French patent for them in 1867. They were produced through the 1870s. Most of them have multiple Stanhopes which appear in the bisque bodice. Some of the Stanhope lenses in these dolls are larger than those usually found. The known dolls are all different, varying in looks, height and necklace design. The number of Stanhopes in the dolls ranges from a single one to the thirty in Miss Jewel, owned by the Margaret Woodbury Strong Museum in Rochester, New York.

Several problems can occur in Stanhopes. The lenses sometimes fall out of their housings or the plate with the collodion image separates from the lens. This can be due to the deterioration of the Canada balsam which can dry out. If an item is washed the image will usually be lost because of separation. Sometimes the Canada balsam darkens. At other times bubbles appear in the image, but this probably happened in the production of the unit.

Stanhopes are no longer made, partly because the entire process was labor intensive. The last known Stanhope lens factory, in France, closed in 1972. For awhile they were produced in parts of Eastern Europe. In the twenty-first century people are fabricating images that they call Stanhopes, but they are not traditional Stanhopes.

BOBBI LONDON

See also: Brewster, Sir David; Dancer, John Benjamin; Photographic Jewelry; and Microphotography.

Further Readings

Dagron, René Prudent Patrice.,*Cylindres Photo-Microscopiques: Montés et Non Montés Sur Bijoux* [*Microscopic Photos: Mounted and Unmounted In Jewels*], Paris: Dagron & Cie, 1862.

Kessler, Mike, "Stanhopes: Collecting Photographic Jewels," in *The New York-Pennsylvania Collector*, Volume XXI, No. 8, October, 1997, pp. 8A–12A.

London, Bobbi, "A Visit With a Stanhope Doll" in *The Photographist*, Number 104, Winter 1994–95, pp. 4–5, 23.

Luther, Frederic, *Microfilm: A History 1839–1900*, Annapolis, MD: The National Microfilm Association, 1959.

Scott, Jean. *Stanhopes: A Closer View*, Essex, United Kingdom: Greenlight Publishing, 2002.

White, William. *The Microdot: History and Application*, Williamstown, NJ: Phillips Publications, 1992.

STEICHEN, EDWARD (1879–1973)

Edward Steichen, born Eduard Jean, Luxembourg, immigrated to the United States in 1881. At 16 he took up photography in 1895 while studying painting at the

Milwaukee Art Students League and on his apprenticeship in lithography, first exhibiting photographs in 1899 at the Second Philadelphia Salon. While few have achieved so many different careers in photography, he seems no longer to be accorded the status he had in his lifetime. The accusation that he kept changing horses for financial reasons may have stuck to his reputation: it is indeed hard to image that his fashion and advertising photography of 1923 onwards for Condé Nast is the same person as the painter and photographer protégé of Alfred Steiglitz, as the man who persuaded Steiglitz to open the 291 gallery in New York; the same photographer (more and more esteemed today) of those Whistler diffused images when he was a member of the Linked Ring (1901) and the Photo-Session (founder member 1902); the exclusive aesthetic interpreter of Rodin, one of the first photographers involved with colour, using autochromes as early as 1904. Pictorialist Steichen, still a painter then, also depicted brooding landscapes. These early Steichen's, essentially developed out of 19th century aesthetics, may well turn out to be his golden period rather than his conversion to 'Straight,' then to 'commercial art,' or that he became curator at the Museum of Modern Art in New York (1947–62), and of the most successful photography exhibition ever held: *The Family of Man* (1955). He was also a successful breeder of delphiniums, an equal art, he would have maintained.

ALISTAIR CRAWFORD

STEINHEIL, RUDOLPH (1865–1930)
Lens craftsman

Rudolph, the son of Adolph Steinheil, was the third and last member of the famous dynasty of lens makers. An accomplished lens designer in his own right, he took over the management of the business in 1893, when he was just twenty-eight, following his father's sudden death.

Rudolph became responsible for the scientific direction of the firm at a time when photographic optics were undergoing enormous changes following the introduction of new optical glasses such as those produced by Schott and Abbe at Jena. He designed a new anastigmat lens and two different types of orthostigmat lens, followed by a number of other lenses, including the Unofocal in 1901. Perhaps his greatest achievement was in the design of lenses for astronomy. He constructed several large telescopes for observatories in Germany and other parts of the world. In 1910, he collaborated with Carl Goerz in setting up the Sendlinger Glassworks in Berlin.

COLIN HARDING

STELZNER, CARL FERDINAND (1805–1894)

Carl Ferdinand Stelzner was born in 1805 in Flensburg and adopted by Carl Gottlob Stelzner in Flensburg. He married this man's daughter Caroline Stelzner in 1834. Both were successfully working in Hamburg since 1830 as miniaturists and portrait painters. In 1842 he opened a photographic studio together with Hermann Biow but the partnership was dissolved in 1843. When the city of Hamburg burnt down in 1842, the studio of Biow & Stelzner produced a series of photographs showing the ruins. Carl Ferdinand Stelzner's fame was for being the first and, for a long time, the best photographic portraitist in Hamburg. A noted miniaturist before taking up photography he knew how to find the moment of expression in his clients' faces, and even today his portraits are a lot more vivid than those of his contemporaries, Hermann Biow included.

His specialities included group pictures which he managed to arrange in very lively settings. For the 15 years Carl Ferdinand Stelzner practised photography he was virtually unsurpassed as a portraitist in the German countries; even as a blind man he remained a well heard spokesman in Hamburg's photography. Due to being blind since 1854, Stelzner's studio was sold in 1858 to Oskar Fielitz from Braunschweig, a year later to Heinrich Gustav Siemsen. Carl Ferdinand Stelzner died on October 23, 1894.

ROLF SACHSSE

STEREOGRAPHIC SOCIETIES

The history of any society or organization is also a history of the people and times within which it exists. Stereographic societies make particularly interesting reading, as their members have proved to be amongst the most active and multi talented of all photographic groups.

The Stereoscopic Club, formed in 1891, was the earliest stereographic group in the world. It was founded by Mr W.I. Chadwick, and it survived until 1905. Its remaining members then moved into The Stereoscopic Society, originally formed in 1893 as The Stereoscopic Postal Exchange Club.

This society offered a wider variety of opportunities and activities, such as meetings and distributing folios of stereo view cards, by post. In 1896, it changed its name to The Stereoscopic Society so as to better represent its members overall interests in Stereoscopic imaging. Its Founder/Secretary was Mr Charles Berti DiVeri. Its first President was Mr W.A. Whiston, followed by the illustrious Dr W.W. Stainforth.

Today, The Stereoscopic Society thus remains as the

oldest extant stereographic society in the world, with a thriving international membership.

In 1894, it became affiliated to The Photographic Society of Great Britain, later called The Royal Photographic Society, and over the next 100 years, they organised many exhibitions and published many articles.

No other independent stereographic societies existed until 1903, when the 'Stereo Club Francais' (SCF) was formed by Monsieur Benjamin Lihou. The club still exists.

Various stereo view card manufacturers, such as Underwood and Underwood, The Keystone View Company- and later ViewMaster- also had enthusiast stereographic groups within their own manufacturing organisations, but were little known outside their own companies.

Meanwhile, The Stereoscopic Society, based in England, encouraged international membership, and so, in 1919, The American branch of The Stereoscopic Society was the first overseas branch to be created, with Mr W.S. Cotton as secretary. Formation of the Australian branch (Secretary H.A. Tregallas), and New Zealand branch followed in 1924/5.

Other overseas branches followed, with autonomous international, national and local and independent societies, growing along the way. Some major national photographic organisations included stereographic groups within their edict. These included The Royal Photographic Society, and the Stereo Division (founded 1951, Chairman Dr Frank Rice) within the Photographic Society of America. Famous local stereographic societies included The Beverly Hills (California) Stereo Club (founded Sept. 1952), which had many Hollywood film star members.

Meanwhile, independent but countrywide stereographic groups formed, often in demand to a local need. These included The Third Dimension Society (founded 1963, Chairman James Milnes), The National Stereoscopic Association (1974). Also, The International Stereoscopic Union (1975) which encompasses many other societies as its members.

The Stereoscopic Society remains typical of the societies, with 15 specialist groups distributing folios of stereo view cards, slides and information to its members. Over a century since its formation, it runs regular meetings, projection sessions, training sessions, conventions, library service and advice.

DAVID BURDER

See also: Royal Photographic Society.

Further Reading

Symons, K.C.M *Time Exposure,* 1985.
Whitehouse, Pat, and David Burder, *Photographing in 3D,* 1987.

STEREOSCOPY

A stereoscope is an optical device used for viewing images in three-dimensional depth.

Two photographs are taken of the same scene but from a slightly different angle. This recreates the illusion of depth in the same way as the human eye. Our eyes are set about 2.5 inches (6.5cm) apart. Each eye sees a slightly different field of vision. When these views are combined an affect of binocular vision is created, giving depth height and distance to our view. If the lenses of a camera are set 2.5 inches (6.5cm) apart when taking two photographs, the same illusion can be created when these images are placed 2.5 inches (6.5cm) apart, and viewed simultaneously through a combination of lenses and prisms called a stereoscope.

It may come as a surprise that stereoscopy pre-empted the invention of photography. The concept for the stereoscope was first discovered by Sir Charles Wheatstone (1802–75). Wheatstone was a physicist and professor of experimental philosophy. Among other things, he discovered how to send the electric telegraph and helped create the modern dynamo. He started his career working as a musical instrument maker. It was in 1832 that he first invented the Stereoscope and presented these findings in 1838, a year previous to Daguerre's photographic discovery of the daguerreotype. Describing his instrument he said:

> I propose that it be called a stereoscope, to indicate its property of representing solid figures.

Wheatstones's, *Reflecting Stereoscope* is demonstrated in the diagram. Two pictures were fixed vertically at the end of a bar facing mirrors at right angle to each other. The images were usually of a large size and one could view the images simultaneously with each eye seeing one image. The instrument was successful in showing geometric drawings but not in showing portraits, landscapes and architecture. This original stereoscope remains at the Science museum, London. In c. 1841, Wheatstone approached the early photographers of the time Richard Beard, Henry Collen, Antoine Claudet and H.Fizeau in Paris and requested that they use his apparatus to view daguerreotype photographs. This was unsuccessful as the metal surface created too many reflections. Calyotypes were more successful especially with pictures of large objects. Good large examples were taken by Fox Talbot, Dr Percy, BB Turner, Alfred Rosling and Roger Fenton, some examples of which were on sale in 1846 in the shop of James Newman, Soho Square, London. Wheatstone's process was both expensive and time consuming. In March 1849, Sir David Brewster (1781–1868), presented his invention of the Lenticular Stereoscope to the Royal Society of Edinburgh. This was a modification of the second stereoscope plan by Wheatstone. Two images were viewed in a box

through a pair of prisms, which magnified the binocular image. The height of the images was usually limited to three inches. Brewster exhibited the first model made by Andrew Ross at the British Association Meeting in 1849, and suggested it should be applied to photography. It was slow to catch on at first and he struggled in vain to attract several English opticians to manufacture the instrument. In 1850, Brewster took his stereoscope to Paris where, the author Abbe Moigno was very impressed by the idea and presented it to Jules Dubosq, an optician who suggested producing transparent pictures on glass and replacing the solid bottom with a glass screen. At the Great Exhibition, The Crystal Palace, 1851, a number of stereoscopes made by Dubosq were shown as well as a set of stereo daguerreotype. The effective illusion of the instrument caught the attention of Queen Victoria. This prompted Dubosq to make an elaborate stereoscope for the Queen.

The fascination with this novel instrument soon spread to the general public. Dubosq had many orders and opticians in England started to manufacture stereoscopes. Among the photographers who worked with stereo daguerreotypes were Claudet, Beard, Mayall, Kilburn and Williams. They all took pictures of the Crystal Palace and its exhibits. One of the figures most responsible for the popularity of the stereoscope and for its scientific improvement was A. Claudet (1797–1867. Claudet showed a collection of stereo daguerreotypes at the Great Exhibition, which greatly impressed the Queen. In 1852, Claudet published his first paper on the subject: *On the Stereoscopometer and on a Manifold Binocular Camera* (British Association for the Advancement of Science reports 23 no.1 1852,. 6). The stereoscopometer was an instrument used to measure the position of the two cameras, relative to the subject, in order to achieve a good stereo effect. The *binocular camera* was a special camera for taking stereo daguerreotypes, which had two lenses. Unlike many others photographers Claudet adapted stereo daguerreotypes to portraits and even groups with great success and achieved a very a life like quality. Claudet's portraits were taken with painted backdrops, as this was thought to give the stereoscope a more dramatic three-dimensional affect.

An example of Claudets portrait stereos is *The Geography lesson c 1853* which was referred to in the *Illustrated News* as a charming part of the Gernsheim Collection. The complex composition is made up of a group of figures at differing heights, around a globe in the centre. There is a balance of all elements of the composition. The figures are lower in the foreground and raised in the background. Claudet used this formula for many of his elaborate stereo group portraits, which he called his 'conversationals.' The depth of such a complex portrait can only be fully appreciated when seen through a stereoscope, where the characters are brought to life

and given three-dimensional form. Before the invention of the binocular camera, Claudet produced his stereos by setting up two cameras side by side, which accounts for the exaggerated roundness of the figures.

In 1852 J.F. Mascher from Philadelphia invented a miniature case which had on one side the folding stereoscope and on the other a stereo image. In 1853 Claudet gave a lecture at the Society of Arts entitled 'The History of the Sterescope and its photographic Applications.' For the promotion of this area of photography he received the Society medal from the President Prince Albert.

In March 1853 claudet patented a folding pocket stereoscope, in which one stereoscopic daguerreotype was fitted in a case with two lenses. When opened it formed a stereoscope.

A drawback of Brewster's and Dubosq's design was that eye pieces were not adaptable to different eye widths or to different sight. In 1855 Claudet patented an instrument where the lens was set in adjustable tubes. This patent also covered a *large revolving stereoscope*, where one hundred slides could be rotated on a band.

In 1858 Claudet presented his *stereomonoscope* to the *Royal Society*. The instrument combined stereo images on a large glass screen which allowed several viewers to watch at a time, pre-empting cinema.

Before the invention of moving image, at the beginning of the nineteenth century, stereoscopy provided a new and exciting way of seeing the world. This was an ideal medium for travellers to present scenes of places that most people had never seen and to re-create a visual illusion of such scenes. The stereoscope was as common in American homes as the TV is today. People who had never been able to travel could escape to far away places. Stereoscopic pictures were used as travel guides and educators. People could sit in their own homes whilst touring the world with views of the countryside, ancient Egypt, sights from New York or San Francisco. Great events were brought into peoples living rooms. Natural desasters such as the Johnstown flood or the San Franscisco earthquake could be recorded for the first time. Both the Chicago Worlds Fair in 1892, and the St Louis Worlds fair in 1904, could be enjoyed by those who were not even there. A. Claudet described the stereo daguerreotype:

> The general panorama of the world. It introduces to us scenes known only from the imperfect relations of travellers, it leads us to the ruins of antique architecture, illustrating the historical records of former and lost civilisations; the genious, taste and power of past ages with which we have become as familiarised as if we had visited them. ('Photography in its Relation to the Fine Arts,' *The Photographic Journal*, vol. Vi, 15 June 1860)

The invention of the stereoscope marked an important step towards the invention of moving image and for many years Dubosq, Claudet and other pioneers worked

to combine the stereoscope with the zoetrope to create 'moving photographic figures.' Claudet created an instrument where a slide was adapted to the eye piece of the stereoscope. This moved backwards and forwards opening and closing each eye piece. One view shows a man with a cigarette in his hand and the other with the cigarette in his mouth. Moving the slide backwards and forwards across the eye piece, gives the impression that the sitter, A.Claudet, is smoking. Claudet explained this as 'an uninterrupted perception of an object in motion.' This experiment was based on the understanding of how the eye works. Arthur Gill described this as the first photographic device specifically giving an illusion of movement. Arthur Gill 'Antoine Claudet Photographer,' *Modern Camera Magazine,* Nov. 1961 462. Said:

> together with Dubosq his is the honour of having laid an important foundation stone on the edifice of motion pictures.

Claudet knew that the retina retained some of the previous image after viewing. The eyes were able to supply the in between images by the persistence of vision. Claudet elaborated on this idea, showing an arrangement of a series of pictures on blades on a rotating band. This gave an illusion of movement when looked at through the stereoscope. He applied this idea to Plateau's Phenakistoscope in 1865, but failed to achieve a smooth illusion of moving image.

In America daguerreotype photography and stereo daguerreotypes experienced a long duration of success. By the 1850s a town called Dagurreville had appeared in America around a factory which produced three million daguerreotype plates a year. In fact, there were more studios in New York than in the whole of Europe this was due to the more relaxed licensing laws. 'Southworth and Hawes were a successful American studios who produced many stereo daguerreotypes. In an article by the Philadelphian daguerreotypist Marcus A.Root, August 1855 for the *Photographic and Fine Art Journal,* 'A trip to Boston—Boston Artists,' he wrote that:

> Mr Southworth explained the wonders of the stereoscope very clearly, and he takes his pictures of this class without distortion or exaggeration. I think his principle correct, for his specimens were stereoscopically beautiful, and exempt form the many faults witnessed in those of others…They have also invented and patented a beautiful instrument, by which 24 or 48, or even more (stereoscopic) pictures-taken either upon plate, or paper, or glass,- are exhibited stereoscopically; and so perfect is the illusion, as to impress the beholder with the belief, that the picture is nature itself!

Many stereos were sold in sets, and most were of buildings and scenery. The size varies but the most common viewers were 7 × 3.5 inches (18 cm x 9 cm), the images were both about 3inches square (7.6cm square).

Stereoscopy became the first in a line of photographic crazes. Within the first three months after Albert and Victoria had taken a shine to the new phenomena, a quarter of a million stereo viewers were bought in London and Paris. The stereoscope experienced its peak of popularity in the 1850s and 1860s. It was estimated that by the mid-1850s over a million homes had one. By 1860 almost every Victorian family of the middle classes had a stereoscope and a collection of photographs to go with it. Many beautiful stereo daguerreotypes were produced in the 1850s but the metal plate was fragile and heavy and not suited to the medium. The plates were expensive to make and the reflections on the surface often interfered with the three-dimensional effect. Once the collodian photographic process was established stereoscopic photography received a boost in popularity. Paper prints could be mass produced and were much cheaper than their daguerreotype predecessors.

The most common process for making stereos was the stereocards with the Albumen process. The number of stereo daguerreotypes produced was relatively rare. In 1854 George Swann Nottage set up the London Stereoscopic Company, manufacturing sterescopes and binocular pictures and was one of the largest manufacturers in England. He had 10.000 stereocards on offer in 1854. By 1858 he had increased this to a stock of 100,000 stereos of places of interest in both England and abroad. Within two years they had already sold half a million instruments. His ambition was for there to be no home in England without a stereoscope. With his fortune George Nottage became the mayor of London. Magazines were started up which had stereo images and clubs were formed where people got together and showed swapped and collected stereos. The stereoscope was to Victorians what the television is to us today. Stereo cards were the cheapest type sold at half a crown for three. By the late 1850s there was a trend for dioramas where thin paper could transmit light. Even mundane objects fascinated people by the the apparent reality viewed through the lens. Stereos could be sold of all sorts of subjects, ghost pictures freaks and risque nudes. Paris was one of the biggest exporter of stereos in this genre. Most were taken by photographer who kept their identity anonymous. Due to the strict moral climate in England and America at this time such photographs were considered pornography and were not thought of as acceptable as nude painting.

Soon a variety of viewers became available. The cabinet viewer could store up to 50 positives. Eventually one of the widest used stereoscopes was that invented by American writer Oliver Wendell Holmes designed in 1860. It was cheap to produce and easy to use. The structure which was like a mask, was held in front of the eyes by a handle below, like a lorgnette. There was a piece going across on a runner to support the cards.

This could be moved up and down until the picture was in focus. More elaborate models were mounted on a stand. This type of stereoscope continued to be used into the twentieth century. By the 1920s the stereoscope lost its charm and went out of favour as the most popular form of entertainment. Stereoscopes were eventually eclipsed by the introduction of *carteomania*, the craze for the *carte de visite*, small portraits on cards 2.25 × 3.5 inches, an invention which had been developed by the French photographer Andre Disderi in 1854. Despite this stereoscopy continued to have revivals in popularity well into the twentieth century. Present day stereo cameras can be bought and modern stereoscopes consist of a plastic box with two viewing holes. *The Sterescopic Society* was formed in 1893 and continues to promote stereo photography today. Stereoscopy is still used for aerial surveys to map out land elevations and for astronomers to view small planets.

LAURA CLAUDET

See also: Wheatstone, Charles; *Illustrated News*; and Daguerreotype.

Further Reading

Allwood, John, *The Great Exhibition*, Studio Vista, London, 1977.

Briggs, Asa, *From Today Painting is Dead The beginnings of Photography*, The Arts Council, London, 1972.

Buerger, J. E, *French Daguerreotypes* Chicago, 198.

Coke, Joan, *Dissertation on A. Claudet*, University of New Mexico.

Ford, Colin, *Portraits The Library of World Photography*, Thames and Hudson,

Freud, Gisele, *Photography and Society*, Gordon Fraser, London, 1980.

Gernsheim, Helmut, *The Origins of Photography*, Thames and Hudson, 1982.

Gernsheim, Helmut, *A History of Photography*, Dover, London, 1986.

Hannavy, John, *The Victorian Professional Photographer*, Shire Publications Ltd.

Heyert, Elizabeth, *The Glass House Years (Victorian Portrait Photography 1839–1870)* Montclair and London, 1979.

Hayworth-Booth, M., *The Golden Age of British Photography 1839–1900*, New York Aperture, 1984.

Hillier, Bevis, *Victorian Studio Photographs*, Ash and Grant Ltd, 1975.

Jay, Bill, *Cyanide and Spirits An inside-out View of Early Photography*, Nazraeli Press, Germany, 1991,

Lassam, Robert, *Portrait and the Camera Studio* Editions, London, 1989.

Macdonald, Gus, *Camera Eye Witness*, BT Batsford Ltd, London, 1979.

Newhall, Beaumont, *The Daguerreotype in America*, New York, Dover, 1976.

Newhall, Beaumont, *Photography Essays and Images*, The Museum of Modern Art, New York, 1980.

Pols, Robert, *Understanding Old Photographs*, Robert Boyd Publications, 1995.

Richter, Stefan (Introduction by Helmut Gernsheim), *The Art of the Daguerreotype*, Viking, 1989.

Thomas, Alan, *The Expanding Eye Photography and the Nineteeth Century Mind* Croom Helm, London, 1978.

Wade, N.J., *Brewster and Wheatstone on Vision* London, 1985.

Wood, John, *The Daguerreotype (A Sesquentenial Celebration)*, University of Iowa Press, 1989.

STEWART, JOHN (1800–1887)

John Stewart lived and worked for many years in Pau in the Pyrenees from 1847 and for a time in the 1850s, was associated with an informal grouping of photographers who referred to themselves as the 'ecole de Pau.' That group included Stewart's frequent photographic companion Maxwell Lyte.

The group produced impressive and often romantic landscapes, sometimes placing people strategically within the frame to counter the spectacular mountain scenery.

He was one of the exhibitors at the 1852 photographic exhibition at the Royal Society of Arts in London, and an early member of both the Photographic Society of London, and the Societé française de photographie. Stewart was brother-in-law to Sir John Herschel, and Herschel wrote about his work in the 'Atheneum' in 1852, alongside Stewart's own account of his experiences.

He exhibited work at the Photographic Societt of London's 1855 exhibition, but with one exception, he thereafter appears to have exhibited only in France. That date coincides with him joining the Societé Française. The exception was a portrait of his brother-in-law exhibited at the 1857 Manchester Art Treasures Exhibition.

In 1853 and 1854 he published accounts of a 'new photographic process,' and it was examples of his 'wet paper process' which he exhibited in 1855.

JOHN HANNAVY

STIEGLITZ, ALFRED (1864–1946)
American photographer, creator and editor of Camera Notes, *and founder of the 291 Gallery*

Alfred Stieglitz is remembered through his remarkable photographic work, his involvement in the photo secessionist movement, and his pivotal involvement in the fostering of an academicization of photography in America. His work made great strides to promote the symbolic in American art and elevate the position of photographer to that of fine artist, as opposed to a skilled craftsman who is merely technically proficient.

Stieglitz, the first son of four children, including two male twins, was born in Hoboken, New Jersey, on 1 January 1864 to hard-working Jewish parents. Alfred's mother, Ann Werner, who moved to the United States in 1852 and married Edward Stieglitz, Alfred's father, on 21 December 1862, was an educated woman fond of literature and the arts. Alfred's father made it a point

not to mix home life with business life; he preferred to have his home filled discussions of the arts. As a result, Alfred enjoyed a home environment full of discussions of literature and the arts as well as meetings with well-known artistic and literary figures.

Alfred grew up next to the Elysian Fields in Central Park, home to the invention of modern baseball and inspiration for a lifelong love of the game. Stieglitz identified with his subject, a notion that traced back to his childhood experience of bringing food to an organ grinder because Stieglitz identified with the organ grinder. During the 1870s, Alfred saved money and brought a sandwich to an Italian organ-grinder and his monkey, who played outside Stieglitz's house every Saturday. Years later, Stieglitz confessed to his mother that "I was the organ-grinder." Stieglitz often affirmed that whenever he took a photograph he was photographing himself—regardless of its ostensible subject—so that all his photographs were, in effect, self-portraits that conveyed symbolic representations of his and the symbolic representations of his feelings. Alfred would cultivate intense jealousy of the twin boys.

For a good part of the beginning of his career, Stieglitz believed in what is called "straight photography," as opposed to unusual visual effects achieved, among other means, by the manipulation of negatives and chemicals. This later proved seemingly ironic as Stieglitz became one to rely heavily on manipulation of photographic images. However, at the heart of his photographic creations, Stieglitz never wavered from sticking to the fundamental emulsion, lens, and camera qualities. Throughout his career, Stieglitz photographed primarily in the open air.

Lake George, near the Finger Lakes in upstate New York, was a favorite haunt of both Stieglitz and his family, where they often spent their summers, and also the site of many of his photographic images. New York City was an equally important focus of Stieglitz's work. Works such as "Winter on Fifth Avenue" (alternately referred to as "Fifth Avenue, Winter") and "Spring Showers" captured the atmospheric environment of the inner city in a way that previous mediums had been (lacking)/wont to do/capture. Other works, such as "Spiritual America," depicting a gelded or castrated horse captured the spiritual void being created by modern American commercialism and manifested in a crisis in American masculinity. Stieglitz's work, "The Steerage" (1907), on the other hand, dealt alternately with geometric forms constructed in spatial planes within a photographic frame and issues of social class and gender differences.

In 1905, Stieglitz established the famous gallery 291 named for its location at 291 Fifth Avenue in New York City. The gallery was designed to be a location for the exhibition of photography as a fine art in America. Yet, soon after opening, the gallery broadened its scope to include the works of the modern French movement and introduced to the United States the work of Cezanne, Picasso, Braque, Brancusi, and many others. It also made known the work of such American artists as John Marin, Charles Demuth, Max Weber, and Geogia O'Keeffe, whom Stieglitz married in 1924.

Stieglitz moved freely from these works into his photographs of his second wife, painter Georgia O'Keeffe. The nude photographs Stieglitz composed of O'Keeffe's hands, face, chest, and body were the content of a one-man show at his 291 gallery. Ironically, these photographs of O'Keeffe's body, not her body of work, are what brought her attention.

With the demolition of the building 291 occupied, the Photo-Secession ended in 1917. However, the most of its members had already effectively left the group either as a result of personal conflicts with Stieglitz or new ideas about where the movement should be headed.

Never one to tolerate a seeming imperfection in his past, Stieglitz, who maintained a near-obsessive passion for his body of photographic work, attempted to destroy all of the material he produced for Camera Work. However, after Stieglitz happened to communicate with the director of the Metropolitan Museum of Art, the MET decided to collect all of Stieglitz's remaining works from the Camera Work era. This collection would later be incorporated into a separate library within the MET.

Retouching portraits had been common in the collodion era, but after 1917, new art critics were calling for a "straight photography." Straight photography came to refer to art critics desire for an art that relied on the photographer's eye, instinct, knowledge of composition and inherent good taste as opposed to special effects such as retouching. While retouching was necessary procedure for the majority of daguerreotype images as they were fragile, it was not a requisite for modern photography that could now be produced on sturdy papers and could withstand less cautious handling.

Stieglitz sought to produce an art free from the pressures of rampant commercialism. He felt that, unlike in Walt Whitman's era, the then-current day presented a world where advertising and commercials took the place of American imagination. Throughout his life, He tried to spread the idea that art is not property and should be accessible to all.

In 1922, Stieglitz began a series of abstract photographs entitled "Equivalents," or abstract works composed primarily of clouds, atmosphere, and light, in which cloud formations create various moods and textures. He referred to them as his attempt to "put down my philosophy of life—to show that photographs were not due to subject matter" (Newhall, 171). Stieglitz always saw these photographs as a reflection of himself in some way.

Stieglitz's circle, a group of artists who all had exhibited at 291 before the gallery's demolition, combined the Whitmanian notion of nature as health-giving and unifying with an aesthetic philosophy taken from the socialism of William Morris and the Arts and Crafts movement. Stieglitz's determination for high-quality art photography to reach an international audience was proven in his correspondence with Lewis Mumford, the editor of the international art journal with a socialist slant, the *Dial*. Stieglitz desired to have photographs entered into the *Dial* and thereby have well-produced photographs reach an international audience.

From 1917 until approximately 1925, Stieglitz produced some of his best known works including the extraordinary portraits of O'Keeffe, studies of New York, and the "Equivalents," or great cloud series. From 1925 until 1930, he operated the Intimate Gallery (1925–1930) and An American Place (1930–1946), which both sought to further the conceptual advance gained by the exhibitions that occurred with the photo secessionists with 291.

SARAH B. WHEELER

See also: Art photography and aesthetics; Daguerreotype; Frank, Eugene; Kasebier, Gertrude; Photography as a profession; Portraiture; Printing and contact printing; Sky and cloud photography; Steichen, Edward J.

Biography

Alfred Stieglitz was born on 1 January 1864 in New York City. He took up photography in the early 1880s while living in Berlin, Germany. In 1901, he founded a society of American pictorial photographers, the Photo-Secession, based firmly in New York, and he created the journal *Camera Work* in which to display the work of the Photo-Secessionists. Stieglitz was one of the founders of the pictorial movement and an advocate of straight photography, or photography that strove not to alter the photographic image after the image was captured. Stieglitz, who first displayed works of Brancusi, Braque, Rodin, and Matisse in his 291 gallery, is credited with awakening the American public and critics to modern European movements in the visual arts. Often claiming that truth was his obsession, Stieglitz sought not to alter the image after it was captured by the camera. He began a series of photographs of Georgia O'Keeffe, American painter and feminist, who would later become his wife, and launched a one-man show in his 29' gallery entirely of portraits of O'Keeffe. After the closing of 291 and the termination of *Camera Work*, Stieglitz opened the Intimate Gallery, consisting of rooms "at the Anderson Galleries to promote the work of a circle of American modernists in painting and photography that comprised, besides himself, Arthur Dove, Marsden Hartley, John Marin, O'Keeffe, and Strand" and ran the space from 1917 and 1925. Beginning in 1913, he made a series of abstract photographs entitled "Equivalents," the majority of which focused on clouds and atmosphere, to illustrate what he felt were nature's equivalents to his philosophy of life. A number of these "Equivalents" were photographed at Lake George—a site of interest to the Hudson River School painters such as Thomas Cole, Albert Bierstadt, Frederic Edwin Church, and Thomas Moran—where Stieglitz summered. His work in this later period includes portraits, hundreds of studies of Georgia O'Keeffe, photographs of Lake George, clouds, and New York City views. Stieglitz ran *An American Place*, in which he exhibited principally painting, sculpture, and graphic work, and occasionally photography, from 1929 until his death on 13 July 1946.

Further Reading

Connor, Celeste, *Democratic Visions: Art and Theory of the Stieglitz Circle, 1924–1934,* Berkeley: University of California Press, 2001.

Frank, Waldo (ed.), *America and Alfred Stieglitz: A Collective Portrait*, New York: Octagon Books, 1975.

Greenough, Sarah, *Modern Art and America: Alfred Stieglitz and His New York Galleries,* Washington: National Gallery of Art and Boston: Bulfinch Press, 2001.

Homer, William Innes, *Alfred Stieglitz and the Photo-Secession*, Boston: Little, Brown, 1983

Kornhauser, Elizabeth Mankin, *Stieglitz, O'Keeffe and American Modernism*, Catalog of an exhibition held at the Wadsworth Atheneum, Hartford, Conn., 16 April–11 July 1999.

Newhall, Nancy Wynne, *P. H. Emerson: The Fight for Photography as a Pine Art*, New York: Aperture, Inc., 1975.

Peterson, Christian. *Alfred Stieglitz: Camera Notes.* New York: W. W. Norton and Company, 1993.

Phillips Collection, *In the American Grain: Arthur Dove, Marsden Hartley, John Marian, Georgia O'Keeffe, and Alfred Stieglitz: The Stieglitz Circle at the Phillips Collection*, Washington, D.C.: Counterpoint, 1995.

Stieglitz, Alfred, *Camera Work: The Complete Illustrations 1903–1917*, Köln and New York: Taschen, 1997.

Szarkowski, John, *Alfred Stieglitz at Lake George*, Catalog of an exhibition held at the Museum of Modern Art, New York, 14 September 1995–2 January 1996; also shown at the Kunst- und Ausstellungshalle der Bundesrepublik Deutschland, Bonn, 9 February–14 April 1996, and the San Francisco Museum of Modern Art, 20 June–22 September 1966

Whelan, Richard, *Stieglitz on Photography: His Selected Essays and Notes*, New York: Aperture, 2000

STILL LIFES

Still life was a popular theme for photographers during the nineteenth century for a number of reasons. Technologically, the long exposure times required to capture an image on a light-sensitive surface meant that moving subjects were impossible to register until at least the 1860s. Still lifes, however, allowed photographers the greatest degree of control over their subject. In the

early years of the medium, the emerging photographer could experiment with lighting, timing, tonal qualities, texture and subject arrangement without interruption or complaint from a live subject.

The natural world was also of great interest to nineteenth-century photographers. One of the principal inventors of photography, William Henry Fox Talbot had a scientific interest in nature and natural phenomena, including botany. For Talbot, photography was a physical manifestation of the wonders of nature, a working tool, a unique recording system and an art. In his first book of photographs, *The Pencil of Nature* (1844), he hoped to show how nature might 'draw' or 'fix' itself on paper. The term 'photography,' literally means 'light drawing' or 'light writing' and in *The Pencil of Nature* Talbot gives an account of photography in relation to painting and its traditions.

Talbot hoped that photography would be an aid to scientists and to artists in their attempts to represent the world. From this time, the extent to which photography continued to be understood in relation to the arts was hotly debated. During the second half of the century, painting exhibitions were often reviewed and discussed in photography publications. Photography's role was frequently a central focus of photographic societies' meetings and discussion centred on what constituted acceptable themes for photographers in order to legitimise their work as Art. In the earliest years after the medium's invention, the acknowledged topics included landscapes, cityscapes, portraiture and still lifes.

Historically, still life is an ancient genre, traditionally associated with the medium of oil painting. By definition, still lifes are an arrangement of inanimate artefacts, often food (especially fruit and dead game), plants and textiles, for example. The composition of still lifes can range from highly elaborate displays to simple arrangements, posed within a domestic setting. While still lifes are most often a subject of painting, throughout history other media have been used, including mosaics, watercolour, collage and, of course, photography. Some of the earliest known images that can be described as still lifes have been found in ancient Egyptian funerary painting.

Despite the existence of still lifes in Greek, Roman and Renaissance art, the form emerged as an independent subject in the West only in the sixteenth century. The genre was highly regarded by artists such as Carravaggio, who elevated still life to a status that was more than merely decorative. Still lifes flourished in seventeenth century Dutch painting where sumptuous arrangements of food, flowers and objects celebrated nature as well as Christian, philosophical and metaphysical ideas. The flora and fauna of exotic places was also a popular still life subject. As historians such as John Berger note, still lifes embody a moment in the history of art where merchandise becomes subject matter in itself.

Frenchman Jean-Baptiste-Siméon Chardin is celebrated as the most notable early still life painter during the peak of the genre's popularity in Europe, in the eighteen century. Still lifes were especially popular in France, Spain and Italy at this time and were often included in *tromp l'oeil* paintings. By the early nineteenth century in Europe there was little demand for still life painting. However, it received a boost in the region through the still lifes of much-famed artists such as Gustave Courbet, Francisco de Goya and the Impressionist Paul Cézanne who pushed the field toward non-representational art. The term 'still life' became accepted in the seventeenth century but there remained a diverse vocabulary for this type of imagery up until then including, *nature morte* in French and *vanitas* in the Netherlands, for example.

Little has changed in style or iconography in still life photography from these prototypes in painting. Nineteenth century photographic still lifes are most often tabletop arrangements of materials traditionally found in still life precursors: fruit, crockery, flowers, shells, statues and dead game. This type of image making attracted a number of photographers, notably the inventors of photography, Louis Jacques Mande Daguerre and Talbot. Other photographers, like Adolphe Braun and Jules Dubosco, also used props such as skulls to make visual connections with painting and its capacity for symbolism, which was also a High Victorian interest and widely understood.

In a letter to his short term partner Daguerre, photography pioneer Nicéphore Niépce refers to two Heliographs, only one of which has been identified. The image, known as *La table servie*, shows a set table, laid with a tablecloth for a meal with bowls, cutlery and a goblet. The date of the image has been disputed, but historians suggest it was taken somewhere between 1823 and 1829, with most dating it around 1827. Produced years before the medium had even been officially invented, Niépce's image is considered the first still life photograph.

Daguerre's first successful daguerreotype was also a still-life, taken in 1837, in a window sill. Entitled *Still life*, it shows a group of plaster casts, a framed print and a wicker wrapped bottle. Daguerre's interests reflect both the technological limitations of the earliest daguerreotypes and the nineteenth-century desire to collate and categorize, as seen in the establishment of museums and their impulse to catalogue the world around us. His famous *Shells and Fossils* of 1839, is also suggestive of this interest in classification and evokes painterly still lifes devoted to meticulously reflecting earthly existence. This tradition continues throughout the history of nineteenth-century still life photography by photographers such as Adolphe Bilordeaux, who created teeming, allegorical compositions that refer-

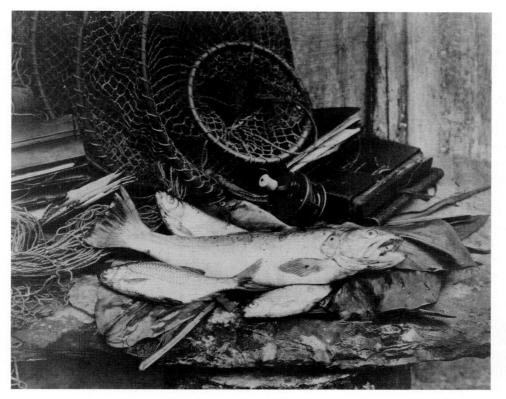

Bailey, Henry. Trout Roach etc.
The J. Paul Getty Museum, Los Angeles © The J. Paul Getty Museum.

ence a cabinet of curiosities. Other key early examples include Hippolyte Bayard's compositions of garden implements, domestic objects and plaster casts, such as *In the Garden* of 1842 and Talbot's image of fruit published in *The Pencil of Nature*.

The best-known photographers to produce still lifes are Roger Fenton and Adolphe Braun. Both created still lifes during the genre's peak in the 1850s and 1860s. Fenton's photographs are some of the most opulent still lifes made in Britain at the time and joined a vogue for this genre already proliferating Paris (Frenchman Henri Le Secq had produced a successful series of still lifes known as *Fantasies* around 1855). Fenton's photographs, such as *Fruit*, 1860, have a great sense of texture and light, drawing on Flemish and French pictorial traditions. Photography historians Helmut and Alison Gernsheim suggested that the painter George Lance used Fenton's photographs as studies for his paintings, even though Fenton was the one accused of plagiarism at the time. Fenton's still lifes are indeed painterly in their formal qualities and reflect the highly privileged lifestyle of those to whom such exotic foods and flowers were available. His compositions regularly include either shot game or exotic fruits and sometimes mirrors and rich fabrics. His subjects are highly symbolic and explore themes such as Christian faith and the transience of earthly life.

Frenchman Adolphe Braun had worked in Paris as a textile designer, and after discovering an interest in photography, set up a large commercial studio, creating images such as *Flower study*, 1854. He later exhibited images of flowers and flower arrangements at the Exposition Universale in Paris in 1855. Braun's work was enthusiastically received and he won a gold medal for the sensuality of texture, softness of tone and the play of reflections in his images. So influential were these photographs and so great was the demand for them, that he and his many assistants produced a collection of studies intended for artists using flowers in decorative motifs. The set consisted of 300 plates of floral arrangements and natural flowers to serve as 'designs' for painters but Braun's principal market were the fabric designers employed by the local mills. In 1864, another French photographer, Charles Aubry, who also worked as a designer, formed a Paris-based company to manufacture plaster casts and photographs of plants and flowers, such as *Leaves*, 1864. Although unsuccessful in his business, he continued to sell the photographs to drawing schools throughout the 1870s.

Braun's still life images that incorporate shot game and hunting equipment, like *Still life with Deer and Wildfowl,* c. 1865, can be seen as modern versions of the work composed by the painters of Northern Europe. Scenes capturing the 'bounty of the hunt' were extremely popular with still life photographers, as they had been during the eighteenth century with painters. Photographers including Fenton, Charles Phillipe Auguste Carey, Dr. Hugh Welch Diamond, Louise Laffon, William Lake Price and Victor Albert Prout all created still lifes on this theme.

Still lifes could sometimes be treated unconventionally, as in Dresden photographer, Hermann Krone's

Still life of the Washerwoman, 1853. Krone's image does not depict a woman at all and instead uses the visual signs of her trade: washing tubs, buckets, pitchers and cloths positioned in a studio setting. Krone was celebrated for his daguerreotype still lifes of scientific instruments and equipment, amongst other subjects, and his stated ambition was 'to make photography useful to all areas of science.' Henri-Victor Régnault also created a number of still lifes with a scientific outlook. His *Laboratory Equipment, Collège de France, Paris*, c. 1852, shows a tabletop arrangement of test-tubes, measuring equipment and other devices, literally reflecting photography's bonds with science.

Similarly, Scottish photographer and writer John Thomson included images of flowers and fruit to an ethnographic end in his *Illustrations of China and its people* (1873–74). Thompson's images draw on the tradition established by European painters who recreated the bounty of the worlds outside England and America in luscious settings. Unlike some still lifes which visually describe such cornucopia as a feast for the senses, Thompson illustrated his subjects in even greater detail by including their botanical classification and descriptions of their texture and taste; intensifying the viewer's experience. He preferred the wet collodion process, a then cumbersome method, and produced large-format negatives and stereographs that are noted for their clarity of detail and richness of tone, securing their 'scientific' status.

The market for still life photography during the nineteenth century was both commercial and domestic. It was a time of art patronage by the fashion-conscious bourgeois when relations between photography and painting were as close as they would ever be and both photographers and painters aimed to service the same picture collectors. Nineteenth century still lifes are now seen in a category of photography that includes genre scenes, allegories and composite images as each attempted to speak the language of 'high art.' One of the first museums to collect photography, the South Kensington Museum (later the Victoria and Albert Museum) included still lifes by Prout and Lake Price in their first purchase of art photographs for the collection in 1857.

Nineteenth century still life photography can be understood through terms of reference drawn from painting, where everyday objects assume a particular monumentality through their meticulous description and often dramatic lighting. The imaging of objects is part of a tradition of probing the external world through its close depiction. Lavish displays of affluence and abundance can also be found at the heart of the still life tradition. It is perhaps photography's ability to radically transform everyday objects, through its peculiar temporal qualities, however, which anticipates the experimental work of the best known still life photographers of the twentieth century, namely Irving Penn and Paul Outerbridge. The tradition of still life scrutinizes everyday existence around the table where simple objects symbolise the decay and mortality associated with life. Still lifes exalt the banality of the subjects they depict through technical virtuosity and they offer a sharp reminder of the materiality of our existence.

KATE RHODES

See also: Talbot, William Henry Fox; *The Pencil of Nature;* Courbet, Gustave; Daguerre, Louis-Jacques-Mandé; Braun, Adolphe; Niépce, Joseph Nicéphore; Bayard, Hippolyte; Le Secq, Henri; Diamond, Hugh Welch; Price, William Lake; Prout, Victor Albert; and Régnault, Henri-Victor.

Further Reading

Bajac, Quentin. *The Invention of Photography: The First Fifty Years*, London: Thames and Hudson, 2002.

Gernsheim, Helmut, and Alison, *The History of Photography 1685–1914*, New York: McGraw-Hill Book Company, 1969.

Fizot, Michel, *The New History of Photography*, Koln: Konemann, 1998.

International Center of Photography, Encyclopedia of Photography, New York: Pound Press, 1984.

Lucie-Smith, Edward, The *Invented Eye: Masters pieces of Photography, 1839–1914*, New York: Paddington Press, 1975.

Rosenblum, Naomi, *A World History of Photography* (rev. ed.), New York: Abbeville Press, 1989.

STILLMAN, WILLIAM JAMES (1828–1901)
American photographer, painter, journalist

William James Stillman was born in Schenectady, New York in 1828. Despite his strong passion for an artistic career, his family sent young William to the Union College of his birthplace from where he graduated in 1848. His ambition, however, to become a notable painter, dominated his early life. He took lessons and made the acquaintance of well-known artists including William Page and Edward Ruggles. He travelled to England and France where he met J. M. W. Turner, John Ruskin and Dante Gabriel Rossetti. Stillman's career as a landscape painter did not last long despite his recognised work for which he earned the title of the 'American Pre-Raphaelite.' Soon the necessity for a more profitable occupation led him to the practice of journalism. The absence of an American periodical devoted to art prompted him to establish an art journal entitled *The Crayon: A Journal Devoted to the Graphic Arts, and the Literature Related to Them* in 1855. The journal was very successful but the long working hours that the editorial work required soon exhausted him and led to his resignation in 1861.

Stillman, William J.. Relief of Nike from the Temple of Athena Nike, Athens. Figure of Victory, fromt eh Temple of Victory-High Relief. One of 26 prints ina book entitled: "The Acropolis of Athens."
The J. Paul Getty Museum, Los Angeles
© *The J. Paul Getty Museum.*

During the American Civil War, Stillman volunteered to join the Massachusetts troops. His poor health, however, was an obstacle and he was offered the position of the American Consul in Rome. Three years later, in 1865, he was transferred to Crete which at the time was excluded from the new Greek state and was still part of the Ottoman Empire. During the three years of his stay on the island, Stillman and his family (he had married Laura Mack in 1860 and had two children) experienced the Cretan Insurrection. Their personal safety was at risk, so Stillman was advised to leave Crete for Athens where a few months later his wife committed suicide. His son Russie was suffering from a fatal disease which forced Stillman to return to England where he became engaged in journalistic and literary pursuits for the rest of his life. In 1871 he married the daughter of the Greek consul in England, Marie Spartali, with whom he appeared to have lived happily until his death on the 6th of July 1901.

Stillman was introduced to the medium in 1857. As he mentions in his autobiography '[he had] bought a photographic apparatus, and learned photography as it was practised [at that time], a rude, inefficient, and cumbersome apparatus and process for fieldwork, of which few amateurs nowadays can conceive in inconvenience.' At first Stillman took up photography as 'a means to bring back records of vegetation.' Two years later he published his first photographic album entitled *Photographic Studies by W. J. Stillman, Part 1. The Forest, Adirondack Woods.* The existence of Stillman's late 1850s Italian views testify that he took up photography once again whilst appointed consul in Rome, since his official duties left him plenty of time. However, his serious involvement with the medium came when he was transferred to Crete. During his stay, Stillman photographed even the most remote parts of the island and conducted a number of experiments on the chemical development of images and photographic equipment.

The latter resulted in the construction of an apparatus that he called the 'universal camera' and which was an improvement on his 8 × 10 Kinnear camera.

Stillman's most significant contribution to the history of photography is a body of work of the antiquities of Athens. These photographs were taken in 1869 when he was forced to leave the island of Crete and advised to stay in the capital of the Greek State. The series of images taken that year resulted in the publication of an illustrated album entitled *Acropolis of Athens, Illustrated Picturesquely and Architecturally in photography* published privately by F. S. Ellis, in 1870. This large format album is bound with a red maroon leather cover and contains a total of twenty-six carbon prints. The photographs are mounted separately on individual sheets of card and most of them are numbered, signed and dated. Each image is accompanied by a descriptive text, printed on the opposite page, identifying the site of the precise geographic orientation. Copies of Stillman's Acropolis album can be found at the British Library, the J. Paul Getty Museum and the Gennadius Library of Athens.

Stillman's 1869 photographs of the Grecian antiquities are characterised by sharp detail and extreme depth of field made possible by the sharpness of the Dallmeyer lens used. They demonstrate the choice of an original viewpoint, which reveals the architectural structure of Classical temples with precision and the sculptural details with accuracy. Furthermore, Stillman's originality of visual expression is favoured by his extended knowledge of the technical aspects of photography. The excellent use of his technical skills, in the domains of choosing his photographic equipment and processing techniques, result in a unique clarity within a wide range of focus. Additionally, the realistic representation of ancient ruins reflects Stillman's influence from his artistic background and contemporary aesthetic tendencies.

As the years went by, his involvement with photography became even more diverse. He continuously experimented and improved upon photographic processes. In 1874, he published a handbook entitled *The Amateur's Photographic Guide-Book, Being a Complete Resume of the Most Useful Dry and Wet Collodion Processes* dealing with the problems of working with early processes, especially in difficult terrains and climates. Additionally, Stillman published, in various journals such as *The Nation, The Photographic Times* and *The Photographic News*, a number of articles dealing with technical issues, commenting on the use of particular lenses and giving examples of contemporary photographic works which met his criteria for good practice.

In 1876, during a visit to the United States, Stillman published another photographic album entitled *Poetic Localities of Cambridge*. The album is illustrated with heliotypes depicting the houses of Henry W. Longfellow and Olivier W. Holmes, Harvard College and Washington E.L.M.. The images are accompanied by a text written by Holmes and poems by Longfellow and Lowel. Original copies of this volume can be found at the Union College Library at Schenectady along with Stillman's personal correspondence.

Stillman never considered himself a gifted painter, nor a talented photographer. His introduction to the medium was almost an accident and there is evidence to suggest that his photographic work was a financial necessity. This aspect of his career never seemed to be of importance to him since it went almost unmentioned in his autobiography, which he compiled just before his death. His involvement, however, with photography was not restricted to simple topographical documentation. Stillman's significant contribution to the medium consisted of experiments with chemical processes, improvements to standard photographic equipment and the publication of articles in photographic journals of the period on a variety of subjects from the analysis of technical processes to the theoretical aspects of the medium.

ALIKI TSIRGIALOU

Biography

William James Stillman was born in 1828 in Schenectady, New York. A naturalist, a painter attracted to the Pre-Raphaelite circle, a diplomat and a journalist (he published numerous articles and books covering a wide range of subjects such as archaeology, photography and art criticism), he took up photography in 1857. From 1855 to 1861 he published the art journal *The Crayon: A Journal Devoted to the Graphic Arts, and the Literature Related to them*. During the American Civil War he was offered the position of American Council in Rome and three years later he was transferred to Crete. His involvement with photography was not restricted to simple topographical documentation. Stillman's significant contribution to the medium consisted of experiments with chemical processes, improvements to standard photographic equipment and the publication of articles in photographic journals of the period on a variety of subjects from the analysis of technical processes to the theoretical aspects of the medium. In 1859 Stillman published his first photographic album entitled *Photographic Studies by W. J. Stillman, Part 1. The Forest, Adirondack Woods*. However, Stillman's most significant contribution to the history of photography is the publication of an illustrated album entitled *The Acropolis of Athens, Illustrated Picturesquely and Architecturally in photography* (F. S. Ellis, 1870). Stillman died in England on the 6th of July 1901.

Further Reading

Ehnenkranz, Anne, *Poetic Localities: Photographs of the Adirondacks, Cambridge, Crete, Italy, Athens by William James Stillman*, New York: Aperture, 1988.

Lindquist-Cock, Elizabeth, *'Stillman, Ruskin and Rossetti: The Struggle Between Nature and Art,'* in *History of Photography*, volume 3 (1979), pp 1–18.

Miller, Frances, *Catalogue of the William James Stillman collection.* Schenectady: Friends of the Union College Library, 1974.

Stillman, William James, *The Acropolis of Athens, Illustrated Picturesquely and Architecturally in Photography.* London: F. S. Ellis, 1870.

——, *The Amateurs Photographic Guide Book, Being a Complete Resumè of the Most Useful Dry and Wet Collodion Processes.* London: C. D. Smith & Co, 1874.

——, *Poetic Localities of Cambridge.* Boston: James P. Osgood & Co, 1876.

——, *Autobiography of a Journalist.* London: Grant Richards, 1901.

STIRN, RUDOLPH AND CARL (active 1880s–1890s)

The Stirn brothers were manufacturers and retailers of cameras and photographic equipment with their best known camera being the Concealed Vest camera which was patented in the United States, Germany and Britain in 1886.

Stirn's camera was based on a design by the American R. D. Gray which he showed in December 1885 and had refined by May 1886. It was patented in July 1886. C. P. Stirn of the American firm Stirn & Lyons purchased the rights to the camera from Gray and with his brother Rudolph in Germany began manufacturing the camera and selling it in October 1886. The camera made six exposures on a round plate and was hidden behind a vest or waistcoat with the lens peeking through a buttonhole. The camera was an immediate success with 18,000 sold by December 1890. A second model was made larger to hold more exposures and that appeared in 1888. The cameras were sold under several different names.

In 1889 Rudolph Stirn made a 360-degree panoramic camera called the Wonder Panoramic camera designed by an American J. R. Connon, and patented in that year. Rudolph Stirn also patented and sold a range of other camera designs none of which saw the success of the Concealed Vest camera.

MICHAEL PRITCHARD

STODDARD, SENECA RAY (1843–1917)
American photographer, guidebook writer, and lecturer

Stoddard was born 13 May 1843, to Julia Ray Stoddard and Charles Stoddard of Wilton, New York, nine miles north of Saratoga Springs. In the late nineteenth century he was recognized as an outstanding photographer of the Adirondacks in northern New York State, and late 20th century critics have compared him to famous early photographers of the American West.

A job from 1862–1864 with the Eaton and Gilbert Car Works near Troy, New York, taught him landscape painting in decorating rail cars. From there he moved to Glens Falls, strategically located between the fashionable tourist spots of Lake George and Saratoga Springs. He learned *wet plate collodion* photography from a Glens Falls photographer, and soon began photographing the Adirondack scenery and selling *stereographs* and large mounted *albumen prints* to tourists.

Complementing his photography were his various guide books about the Adirondack region. *The Adirondacks: Illustrated* first appeared in 1874, and went through various editions until 1914. Wood engravings based on his photographs were included along with his own maps. Later editions incorporated photo engraving. His first wife. Augusta Potter Stoddard, managed the studio with the help of female relatives, while his brother-in-law Charles Oblinis accompanied Stoddard as an assistant.

Hotels and transportation companies, including the Delaware & Hudson 'Railroad and the New York & Canadian Railroad, used Stoddard's photographs for promotion. In 1878, he headed the Photographic Division of Verplanck Colvin's State Survey of the Adirondacks. Travel involved stage coach, steamboat, railroad, and sailing canoe. He hiked trails and climbed mountains to make thousands of photographs of what became the Adirondack Park in 1892. His slide lecture using oxygen-hydrogen projectors at the New York Assembly in Albany on 25 February 1892, was a lobbying effort to securing legislative backing for the park.

In *Adirondacks Illustrated,* 1874, Stoddard wrote of his own stereographs on sale at Ausable Chasm: "The kind universally acknowledged best are known as the 'Crystal,' and sold at $2.50 per dozen..." There was justification in such a claim, for the E. & H. T. Anthony & Company of New York distributed these images widely.

Stoddard generally used cameras ranging from 5 × 8 inches to 16 × 20 inches, and in the 1880s he turned to the more convenient dry plate process. He was particularly adept at arranging people within a landscape or architectural setting, and his images form a visual history of middle and upper class vacations. With some ability in drawing and painting, expert photographic technique, along with an awareness of art and literature, he revealed the natural setting with careful framing, sensitivity to light, form, and detail.

Historians, including Weston Naef and John Wilmerding, have linked Stoddard's work to the category of

Luminism. The term Luminism was coined to define landscape painting from around 1850 to 1875 or later. The characteristics apply to photography: small scale, depiction of crystalline light, often the inclusion of a small figure, a feeling of silence and the suggestion of a transcendent nature. Many of Stoddard's views of Adirondack lakes and streams fulfill such a 'definition, but it should be noted that the small aperture and long exposures required for overall sharpness tended to render water as a smooth, glassy surface.

Other Stoddard photographs do not fit the luminist category. This would be true of some of his fine architectural photographs of hotels like the Fort William Henry at Lake George or night photographs of tourists around a campfire. The night photographs required magnesium flash powder and with this dangerous substance, Stoddard proved himself a master with a noteworthy photograph of the Statue of Liberty in New York harbor. He used magnesium flash to illuminate the vast spaces of Howe Caverns near Albany, New York, and published an illustrated article, "Photographing Bats" for *The American Annual* of *Photography and Photographic Times Almanac,* 1889.

Photographs for William West Durant, developer of the "Great Camps" in the western Adirondacks provide an impressive record of those rustic estates in the wilderness. Stoddard produced an elephant folio album of silver prints showing Durant's Sagamore and Camp Pine Knot on Raquette Lake.

This Adirondack photographer turned his camera on other aspects of this region which included photographs of lumbering and of large, conical kilns for making charcoal for the tanning industry. Both industries showed little concern for the environment, and this led Stoddard to publish a short-lived periodical, *Stoddard's Northern Monthly,* (1906–1908) in which he took on the lumber interests which were denuding large swaths of forests.

While thought of primarily for his Adirondack photographs, Stoddard photographed in many other areas. In 1892, he traveled to the West Coast via Canadian railroad. He photographed indigenous people as well as scenery and continued his journey to Alaska, where he made photographs that would be used successfully as lantern slide lectures. A mammoth panoramic camera for negatives 20 × 49½ inches, especially made for this excursion, failed to function.

In 1895, he was a ship's photographer covering a Mediterranean cruise. Here, he used a roll film camera to illustrate his text for the self-published *In Mediterranean Lands: The Cruise* of *the Fries/and,* 1896. On June 26,1897, he sailed as ship's photographer for a cruise to northern countries including Russia. Surreptitious snapshots taken with his "kovered kodak"-a Kodak # 4 taking 4 x 5 inch negatives- were a departure from luminist images and glass plate photography. The resulting self-published book for the passengers on the northern European cruise appeared in 1901, as *The Midnight Sun: Being the Story* of *the Cruise* of *the Ohio.*

In the early 1900s, Stoddard experimented with new textured printing papers, cyanotype, and soft focus effects suggestive of the Photo-Secession. Most of his late activity involved writing, revising his guide book, and recycling earlier photographs. He also sold cameras and supplies to a burgeoning amateur photography market.

Stoddard's wife died in 1906, and two years later he married Emily Doty. In 1908, he purchased an qautomobile and was among the first to drive into the Adirondacks. He had early affiliations with the Methodist and Baptist denominations, was an active member of the Temperance movement, and later embraced Spiritualism. Stoddard died on May 3, 1917, in Glens Falls.

JOHN FULLER

Biography

Seneca Ray Stoddard was born 13 May 1843 in Wilton, New York. He acquired art technique as a railroad car decorator in Troy, New York, 1862–1864, and then moved to Glens Falls, New York, where he learned photographic skills from a commercial photographer. The area from Saratoga Springs, New York, northward to the Adirondack mountains was already a tourist attraction, and Stoddard's photography of landscapes and hotels were purchased as stereographs and larger mounted albumin prints. In 1874, he published *Adirondacks Illustrated,* which included his adventures in the wilderness along with his maps and descriptions of accommodations. He was a successful lecturer who showed lantern slides before the State Assembly in 1892, as a lobbying effort for creating the Adirondack Park. He photographed such distant regions as Alaska and part of Russia as well as Mediterranean countries. He published extensively. He exhibited at the Philadelphia Exposition of 1876, and received widespread acclaim .for his multiple magnesium flash photograph of the Statue of Liberty. Since a monograph on Stoddard appeared in 1972, his work has attracted renewed attention, and he is often considered the Eastern counterpart of the noted photographers of the Western United States. Stoddard died in Glens Falls, 3 May 1917.

See also: Wet Collodion Negative; Albumen Print; Dry Plate Negatives: Gelatine; and Artificial Lighting.

Selected Works

Lumbering in the Adirondacks. The Choppers, albumen print @1890, Adirondack Museum.
Avalanche Lake, Adirondacks, albumen print, @1888, Adirondack Museum.

Raquette River, At Sweeney Carry, albumen print @1888, Adirondack Museum. *Horicon Sketching Club* [Lake George], albumen print, Adirondack Museum. *Liberty Enlightening the World,* multiple magnesium flash, albumen print @1890, Chapman Historical Museum of Glens Falls-Queensbury Historical Association. Inc.

Further Reading

Adler, Jeanne Winston, *Early Days in the Adirondacks: The Photographs of Seneca Ray Stoddard,* New York: Henry N. Abrams, 1997.

Crowley, William, *Seneca Ray Stoddard: Adirondack Illustrator,* Blue Mountain Lake, New York: The Adirondack Museum, 1982.

De Sormo, Maitland C., *Seneca Ray Stoddard: Versatile Camera-Artist,* Saranac Lake, New York: Adirondack Yesteryears, 1972.

John Fuller, "The Collective Vision and Beyond-8eneca Ray Stoddard's Photography, *History of Photography,* vol. II, no. 3, July-September, 1987, 217–227. John Fuller, "Seneca [Ray] Stoddard and Alfred Stieglitz: The Lake George Connection," *History of Photography,* vol. 19, no. 2, Summer 1995, 150–158.

Stoddard, S. R., *The Adirondacks: Illustrated* (1874), Glens Falls, New York: Chapman Historical Museum, 1983.

Stoddard, Seneca Ray, *Old Times in the Adirondacks,* edited by Maitland C. De Sormo, Saranac Lake, New York: 1971.

Welling, William, *Photography in America: The Formative Years 1989–1900,* New York: Thomas Y. Crowell, 1978.

Wilmerding, John, *American Light: The Luminist Movement, 1850–1875,* Princeton, New Jersey: Princeton University Press, 1989.

STONE, SIR JOHN BENJAMIN (1838–1914)

In the seemingly casual context of the life of a Victorian gentleman, John Benjamin Stone was a wonder and perhaps the most prolific photographic recorder of his generation. He dealt with the way things looked and has left us with a huge archive of 25,000 images. The work is simply remarkable. That Stone is not more celebrated should be a national shame for he presented England with its history, perceived from a Victorian standpoint. He also showed the world to England—he was a great traveller.. In short, Sir Benjamin was a man of means and a great character.

The means came from inheritance and his own abilities as an industrialist, the character from a sense of duty. Stone was first a member of Birmingham City Council, later a Tory member of Parliament for East Birmingham, a seat he held for 15 years.. Stone came from a well-to-do Midlands family and was knighted in 1886. In hindsight we can mark his career as one of power and service to the community, but he excelled in his passion—photography.

His interest began through collecting the works of others and later developed into his own practice as an enthusiastic taker of photographs. Stone's zeal can be judged by his output. In the City of Birmingham library sit 19,174 contact prints from his whole plate negatives, 3,045 enlargements, 14,000 negatives and 2,500 lantern slides. They were given in 1921 by the Trustees of Stone's estate. During his lifetime Stone had made a handsome gift of 1200 prints to the British Museum. and various Midland's institutions. Given his combination of wealth and industry, Stone chose three paths. The paths were crucial to his work at and away from Parliament, because he chose to picture the evident, not the incidental. His was a sense of history which he saw vanishing as Britain became increasingly industrialised He could be placed as a late taker of the spirit of William Morris and the 'Art & Craft' movement. He pictured the look of things but avoided what was obvious. One strand lay in compiling a 'National Photographic Record' which documented English customs and traditions, another was a visual account of his time in Parliament and the third was aan extended photographic journal of his travels—he was adventurous and visited North and South America, most of Europe, China, India, Ceylon (as Sri Lanka was then known), the West Indies, South Africa and Japan. And all over Britain. One can only be impressed at how prolific he was. Stone was a visual sociologist, though not in a systematic sense, and tried to gather up an individual analysis of the world. That said, he did not underestimate his worth; he amassed 38 albums of press cuttings, now in the Birmingham library, which give a good view of his abilities as a self-publicist.

The 'National Photographic Record' was originally proposed by Jerome Harrison in 1892. Stone knew Harrison through his involvement with the Warwickshire Photographic Survey; Sir Benjamin was the first President of the Birmingham Photographic Society and the Warwickshire project gave rise to grander ambitions which were nothing less than an audit of 'Life and History' made clear in pictures. It should be said, however, that he took up photography quite simply because no one else was taking pictures of the things he thought to be of value, so he was unable to buy them. Thus he learned how to make them for himself and history. It was to become a work of stature. He stored his glass plates carefully in two specially built out-houses in his back garden because of a personal conviction that the past might inform the future. Sir Benjamin planned three books to cover his work as a photographer. Two were published by Casssell, London. No date appears in the books though 1903 might be close. In typical style they were called 'Sir Benjamin Stone's Pictures." They covered his images of the enactments and ceremonies of British folklore and his documents of the people of Parliament. These two volumes were very handsomely produced. The third, on his travel pictures, was not published, which is a shame as he was an acute observe

of what made the ordinary extraordinary. It has been estimated that Stone spent £30,000 on his photographic exploits—which could be multiplied by 25 to gain a contemporary value.

PETER TURNER

STORY MASKELYNE, NEVIL (1823–1911)
British photographer, chemist, mineralogist and MP

Born on 3 September 1823, in a large Wiltshire country house, Nevil Story, as he was then called, was the eldest son of Anthony Story, a squire and barrister, and had three sisters and a brother. Nevil's mother, Margaret, was daughter of Nevil Maskelyne, an Astronomer Royal of the previous century. Nevil Story became interested in science while still at boarding school, through reading a book by Mary Somerville, which he won as a school prize, later claiming that this book had turned him into 'a man of science.' In the summer holidays of 1840, George Dolland, a family friend, visited the Storys house and showed them how to make photograms, or 'sun pictures,' which awoke Nevil's enthusiasm for photography. Besides trying out photograms, which required perhaps half an hour of exposure to sunlight, he experimented with his grandfather's camera obscura, and constructed himself a second camera from an old cigar box. He became frustrated by the erratic results of his photographic attempts, but this only increased his interest in chemical reactions and the properties of light. In 1842, Nevil went up to Wadham College, Oxford, to read mathematics, but his energies centred on attending lectures on scientific subjects such as chemistry and optics, which were outside the Oxford examination syllabus at that time. To his father's dismay, he also spent substantial sums of money on photographic equipment and chemicals, and evidently passed much time experimenting with them. When Nevil reached his twenty-first birthday, his father changed the family name to Story Maskelyne, ready for the time when Nevil would inherit the estate—a Maskelyne property.

After graduating from Oxford in April 1845, young Maskelyne set up a laboratory in a thatched farmhouse on his father's land and experimented with calotype photographic images. He was particularly concerned at his own failure to record the foliage of trees in sunlight, believing it to be due to 'extreme red,' now known as infra-red, and to their green colour, (ultra-violet radiation from leaves in sunlight was not then understood). He experimented with both chemicals and filters, until he achieved better results with tree photography. In the autumn of 1845, Maskelyne was sent to study for the Bar in London, but the law held no appeal, so he read the latest European scientific articles rather than law-books. As a result of this and of his frequenting Faraday's laboratory, he was thinking deeply about the properties of light and chemicals, and wrote a perceptive manuscript scientific paper concerning light-waves and their relationship to light and electricity. He became a member of the Committee of Visitors at the Royal Institution in London, alongside William Henry Fox Talbot, William Grove, Faraday, and Wheatstone of the electric telegraph. In 1847 he could have applied for a professorship in scientific subjects at St Andrew's University in Scotland, but his father, who felt a professorship was socially beneath the family status, forbade it.

Later the same year, Sir Benjamin Brodie, an eminent chemist, sensing Maskelyne's despair at a lost scientific opportunity, invited him to work in his private laboratory in London. This time, Maskelyne defied his father and turned to chemistry. In 1848 he was experimenting with albumen—egg-white—which had recently been introduced as a medium for attaching photographic chemicals to a glass base, and became involved with the London Christian Socialist movement, a group of young intellectuals aiming to help working men improve their lot. By 1849, Maskelyne was lecturing in mineralogy at Oxford from time to time, to help out Professor William Buckland, whose health was failing. In 1850, he was offered the post of Deputy Professor in Mineralogy, for which he prepared in London, with Faraday's help.

Back in Oxford, Maskelyne lived for the next seven years in rooms in the basement of what was the old Ashmolean Museum in Broad Street. During those years he taught analytical chemistry in his basement laboratory, which was innovative in that chemistry was normally taught as a theoretical, rather than a practical, subject. At this time, Maskelyne was experimenting with mica as a stable base for photographic negatives, and was taking interesting and lively portraits of his own Oxford circle, using chemicals to achieve better contrast than usual for the time. He was successfully using collodion on glass soon after the process was invented and lived a sociable life, entertaining young like-minded Oxford friends in his basement. They were almost all involved in the struggle to improve the status and recognition of science at Oxford. In 1857 Maskelyne met Thereza Llewelyn, herself a keen amateur photographer, whose parents were both photographic enthusiasts, and the couple soon became engaged. While staying with her family in South Wales, whose wealth derived from coal mines and land-ownership, he was invited to a house-party at Charlton Park, Malmesbury, where he took some fine photographic studies of the fashionable assembled company.

Marriage necessitated leaving Oxford for better-paid employment, and he found himself back in London, this time as Keeper of Minerals at the British Museum. Maskelyne tried to establish a small chemical and pho-

tographic laboratory in the museum basement, but fire regulations prevented its use. His career as Keeper of Minerals was successful and lasted for twenty years, during which time he retained his professorship at Oxford, but his photographic contribution was finished now that chemical experiments were impossible. In the British Museum years, Maskelyne wrote numerous scientific papers and counted great numbers of contemporary scientists among his friends. When at last it was time for him to leave the museum in 1879, the year his father died, he returned to Wiltshire to manage the family estate. He became Member of Parliament for Cricklade in Gladstone's Liberal government, and helped to prepare bills on technological matters like electric lighting or the ventilation of London's underground railways. Even though Nevil Story Maskelyne was not among the great artistic photographers of the nineteenth century, he created some interesting and sometimes lively images. His enthusiasm and scientific ability are the attributes which earn him his place in the history of the earliest era of photography.

VANDA MORTON

Biography

Nevil Story Maskelyne was born on 3 September, 1823, at Basset Down in the parish of Lydiard Tregoz, North Wiltshire. An enthusiast for photography and chemistry from his teenage years, he experimented first with photograms and then with calotype negatives and prints. While a student at Worcester College, Oxford, he exploited chemical elements to produce sharper images and to record the growing foliage of trees in sunlight. He experimented with mica as a stable base for negatives, and was an early user of the albumen and collodion processes on glass. He was deeply interested in the properties of light and chemicals, and published numerous scientific papers. Maskelyne later became Professor of Mineralogy at Oxford, Keeper of Minerals at the British Museum and Member of Parliament in Gladstone's government.

See also: Faraday, Michael; Talbot, William Henry Fox; and Wheatstone, Charles.

Further Reading

Allison, D. 1981, Nevil Story-Maskelyne: Photographer. *The Photographic Collector* 2, 2. 16–36.

Kraus, H.P., and Schaaf, L.J., undated. *Sun Pictures*, 1 and 2 (dealer's catalogues).

Lassam, R.E., 1980. Nevil Story Maskelyne 1823–1911, *History of Photography* 4, 2. 85–93.

——, 1981. Britain loses a family connection. *British Journal of Photography*, 17 July 1981, 720–721.

Morton, V., 1987, *Oxford Rebels: the life and friends of Nevil Story Maskelyne 1823–1911*. Alan Sutton, Gloucester.

STUART-WORTLEY, COLONEL HENRY (1832–1890)

Archibald Henry Plantagenent Stuart-Wortley was born 26 July 1832 at Wortley, Yorkshire. His father Charles James Stuart-Wortley died in 1844. His mother Lady Emmeline née Manners, was a poet and travel writer and his sister Victoria, as Lady Welby, became a pioneer in the field of semantics. Henry joined the army in 1848 as a lieutenant and served as a Captain during the Kaffir Wars 1850–53 in Africa and in the Crimea in1854–55 Deputy-Assistant Quarter Master as a Brevet-Major. It was while in Africa in1853 that Stuart-Wortley took up photography and later observed Roger Fenton in action in the Crimea in 1855. After his mother died while travelling to Beirut in October 1855 Stuart-Wortley escorted his sister back to England where he remained on half-pay during 1856, briefly pursued a career in politics in 1858–59 and retired by sale of his commission in February1862 being granted the honorary rank of Lieutenant-Colonel.

Photography became a vocation for Stuart-Wortley by 1860 and he sought advice from photographic innovators, particularly in the new 'dry 'collodion processes, including Thomas Sutton and George Wharton Simpson, respectively editors of *Photographic Notes* and *Photographic News* who looked to the leisured amateurs to advance photography. Of particular interest in these years was the search for a means to capture motion in photographs, i.e. with exposures under about a second and the development of various "dry" processes to preserve the sensitivity of wet-plates for use outdoors and over the decade the development of dry- collodion plates and developers.

Stuart-Wortley took a trip to India in 1860 where he practiced his craft but it was on his Mediterranean travels in 1861 that he began to apply methods of his own for securing the desired "instantaneous" photography. He must have been familiar with the work of pioneer marine photographer of the 1850s John Dillwyn Lewellyn and the secret of Gustave Le Gray's dramatic "moonlit" effects achieved by photographing directly into a cloud-covered sun at mid-afternoon. Stuart-Wortley however, used a fast wide aperture and learned to whip his cap over his Dallmeyer triplet achromatic lens-in under a second. He used a version of a dry collodion process in the field, a light-tight carrying box of his own design, fixed the negatives at night and then intensified the thin plates on his return. On his return to England his atmospheric Italian pictures showing the belching Mt Vesuvius, waves and rich cloud effects gained him membership in 1862 of the Photographic Society of London and an honourable mention as at the Society's International Salon. As referenced from "9th Annual Exhibition of the Photographic Society London," *British Journal of Photography,* January 15 1863 p.31, his

cloud studies were described as "gems" of the 1863 salon and these and his portraits up to 10 × 12 inches were noted for their size.

By 1863 Stuart-Wortley was on the Council [of the Photographic Society] and later served as Vice President at various periods over the next twenty years. From 1863 he exhibited regularly at the Photographic Society of London and received medals there, at the Royal Polytechnic Society of Cornwall, and the Manchester Photographic Society as well as at the Société française de photographie in Paris where his "A Wave Rolling in" was praised. He also began lecturing and contributing papers to the *Photographic News* and the *Photographic Journal* of the Photographic Society of London where his long article "On Photography in Connection with Art" appeared in October 1863. In it he describes how the beauty of a sunset serves as a respite from the vexations of life and an inspiration. He thus recommended amateurs get "life" in their pictures with some form of rapid process and told of his own success with adding bromide to collodion and liberal nitric acid in the bath. This was Stuart-Wortley's only manifesto; his succeeding articles were mostly concerned with plate sensitivity. His quest to capture the ephemeral beauty of seascapes was not mere rising to a technical challenge but embodied deeply felt belief that spiritual comfort and values could be expressed in photographs of fleeting natural phenomena.

In 1864 Stuart-Wortley settled in Rosslyn House, St John's Wood, London where he built a studio, and in 1865 married Augusta Vershoyle—the couple divorced in 1878. He also turned professional in 1864 forming the United Association of Photographers, an ambitious multifaceted commercial franchise company; His brother-in-law Sir William Welby, was a shareholder and Director. The Association aimed to specialize in upper class and royal portraiture and over the next few years registered 82 portraits in the Copyright Office. They promoted new products in various formats—chiefly the German Jacob Wothly's 1864 uranium and silver process; an early but ultimately unsuccessful form of collodio-chloride printing-out paper—and released art reproductions in the new carbon process. The venture and was not as successful as hoped and in 1866 Stuart-Wortley took on a position as Secretary to his uncle, Lord John Manners, at the Department of Works. The United Association of Photographers company was liquidated in 1867.

Through the late 1860s Stuart-Wortley continued exhibiting and publishing unusually large portraits and art reproductions in carbon including a series old master drawings in the collection of his relative the Duke of Rutland at Belvoir Castle In 1869 James Sheldon Wholesale Publishers of London released a series of card mounted albumen prints "Photographed from Nature by Colonel Stuart-Wortley." His "moonlit" seascapes also developed new scale and drama in the late 1860s and came with poetic titles.

In 1872 Stuart-Wortley again tried business when he founded the Uranium Dry Plate Co. to market his own urano-bromide dry-plate negatives. Despite energetic promotion, further demonstration in 1873 that a strong alkaline developer considerably increased the sensitivity of his plates and endorsement of the plates by Captain William Abney, the business was sold in 1875. A year before the Lord Chancellor appointed Stuart-Wortley as Head of the Patents Museum at South Kensington. This position evolved into that of Keeper of Machinery and Inventions, which he held until retirement in 1889.

Wortley turned his enthusiasm in the late 1870s to further the cause of carbon printing and then later gelatine dry-plate processes. He exhibited widely, winning a medal for large figure studies in 1875 at the Royal Cornwall Polytechnic and medals at Philadelphia Centennial in 1876 for large portraits and his new almost abstract large seascapes. He returned as a Vice President at the Photographic Society from 1875–1888 and served as a Trustee of Photographer's Benevolent Society formed in 1874 with Lord Hawarden, whose late wife the amateur photographer Clementina Hawarden, had also won medals for "instantaneous" prints at the Photographic Society of London exhibition in 1863. In 1879 he discovered that gelatine emulsions kept at a high temperature could be made sensitive over a few hours rather than days.

Stuart-Wortley travelled during and after his military service to Africa, Turkey, Ceylon, India, Greece, Turkey, Europe and the Mediterranean. In 1880 he undertook a world tour with his new wife Lavinia, neé Gibbons. The couple travelled via Australia and New Zealand to Tahiti and on to New York. He carried his own gelatine dry-plates especially modified to withstand the heat of the tropics and a mechanical shutter of his own invention to cater for the shorter exposures needed for the bright light of the Pacific. In 1882 he published a book illustrated with collotypes titled *Tahiti: a series of photographs taken by Colonel Wortley with letterpress by Lady Anne Brassey*. In addition to his photography Stuart-Wortley was an expert in marine fauna and maintained a large collection of British specimens in aquaria. He called on ethnographic collector William Macleay in Sydney in February 1880 and a photograph of the latter's collection of native artefacts appears in the Tahiti book ascribed to that of Mr Flockton.

Stuart-Wortley continued to exhibit until the mid-1880s and resigned from his position at the South Kensington Museum in 1889 due to ill health. He died 30 April 1890 in London. In 1898 a group of fifty prints were exhibited for sale at the International Exhibition of the Royal Photographic Society. The fate of the bulk

of his personal archive is not known; the Huntington Library and Art Gallery, California holds 27 seascapes that were found within Lady Annie Brassey's travel albums and were acquired in 1923, and the J.Paul Getty Museum holds 35 seascapes—31 of which were collected by Sam Wagstaff in the late 1970s.

GAEL NEWTON

Biography

Archibald Henry Plantagenet Stuart-Wortley was born on 26 July 1832 in Wortley, Yorkshire. He first took up photography in Africa in 1853 while in the army and began exhibiting portraits and dramatic 'instantaneous' seascapes in 1862 the same year he was elected as a member Photographic Society of London later serving on the council and as Vice-President on and off until 1884. He contributed papers to the *Photographic News* and *The Photographic Journal*. In 1864 Stuart-Wortley formed the United Photographers Association, a commercial franchise liquidated in 1867and from 1871–74 marketed his own plates through his Uranium Dry Plate Company. He is recognised as the author of one of a number of "dry" collodion processes in the 1860s and 70s. Simultaneously with his photographic work, he held several paid positions. He died in London 30 April 1890. Stuart-Wortley is best known aesthetically for his large "moonlit" seascapes with poetic titles. A series of his nature studies published by James Sheldon, London in 1869 and proved popular with artists. His 1882 book *Tahiti: A Series of Photographs...with letterpress by Lady Brassey* was illustrated with collotypes from images made in 1880.

See also: Sutton, Thomas; Dry Plate Negatives: Non-Gelatine, Including Dry Collodion; *Photographic Notes (1856–1867)* and *Photographic News (1858–1908);* Dallmeyer, John Henry & Thomas Ross; Le Gray, Gustave; Abney, William de Wiveleslie; and Hawarden, Viscountess Clementina Elphinstone.

Further Reading

DiGiulio, Katherine, *Natural Variations: Photographs by Colonel Stuart-Wortley*, San Marino, California: Henry E. Huntington Library and Art Gallery, 1994 (exhibition catalogue).

Fluckinger, Roy, *The Formative Decades: Photography in Great Britain 1839–1920*, Austin, Texas: Harry Ransom Humanities Research Center and Archer M. Huntington Gallery, University of Texas Press, 1985.

Jacobson, Ken & Jenny, *Étude D'Après Nature: 19th Century Photographs in relation to Art*, Petches Bridge, Essex, England, 1996 (catalogue).

Jacobson, Ken, *The Lovely Sea-View: A Study of the Marine Photographs Published by Gustave Le Gray, 1856–1858*, Petches Bridge, Essex, 2001.

Stuart-Wortley, Lieut.-Col, "On Photography in Connection with Art," *The Photographic Journal*, no.138 (October 15, 1863): 365–368.

Stuart -Wortley, Colonel Henry, *Tahiti: A series of photographs taken by Colonel Stuart-Wortley with letterpress by Lady Brassey*, London: S. Low Marston Searle and Rivington, 1882

Tower, John, *The Silver Sunbeam*, New York: Joseph H. Ladd, 1864.

Titterington, Christopher, "Llewellyn and Instantaneity," *The V&A Album 4*, London: Victoria and Albert Museum, 1986, pp.139–145.

Wagstaff, Sam, *A Book of Photographs*, New York: Gray Press, 1978.

STUDIO DESIGN AND CONSTRUCTION (1840–1900)

George Cruikshank's 1842 cartoon showing Richard Beard making a daguerreotype at the Royal Polytechnic Institution in London is believed to be the earliest illustration of a photographic studio. The cartoon was created as an illustration to accompany S. L. Blanchard's poem "The New School of Portrait-painting." In that woodcut we see a surprisingly sophisticated studio design, considering that portrait photography had only recently been introduced, and that Beard's studio was the world's first.

Daylight was the exposing light source, supplied through a glass ceiling. A system of calico blinds could be drawn or opened to control the direction and intensity of the light. The subject sat on a raised dais, with a moveable screen overhead—to reduce glare on the top of the head. The dais could be moved at will around the circular walls of the studio, to ensure that the subject was lit as well as prevailing daylight conditions permitted.

Cameras were fixed on a platform suspended from rails around the walls of the studio, ensuring that the camera to subject distance remained fixed, eliminating the need for the camera to be focussed before each exposure. In the Cruikshank cartoon, two cameras—presumably offering two different plate sizes—can be seen on the platform while the photographer, standing on a set of steps, times the exposure.

With exposures running into minutes on dull days, and still very long even in the brightest of light, the subject was held in place with a head clamp.

Top lighting on its own was found to result in deep shadowed eyes unless reflectors were used to direct more light directly into the subject's face. A more satisfactory answer was a studio where side lighting light could also be introduced—the top floor of a building with large windows as well as skylights being one of the options. The alternative was a large greenhouse-like glasshouse structure, fitted with screens and blinds.

That basic idea of a glasshouse studio where light could be controlled by blinds remained the guiding principle of studio design for several years. In today's studio, the photographer starts off in a black room with

no light, and introduces light where required. The early practice of starting off with diffuse even lighting and removing light where it was not needed arguably yielded a much more natural effect.

It had its drawbacks, however. The more the photographers used baffles and shutters to create special visual effects, the longer the exposure times became. Julia Margaret Cameron's sitters frequently complained about exposures running into several minutes as the great portraitist sought to create dramatic effect.

Many early studios were built on the roofs of tall buildings, ensuring even and consistent lighting. According to a newspaper report in the *Glasgow Herald* in 1843, the location of the studio was to ensure that 'the light of day which acts to him [the photographer] the part of a pencil, may have free and uninterrupted access.' But, of course, in cities, that high position surrounded by chimneys brought with it soot and smog from coal-burning fires.

Before the end of the 1840s, converting the upper floor of a building to give good window space—facing north if possible—and a large skylight, offered the ideal combination of top and side or front light. Those walls not replaced with glass were painted white or light blue, to ensure the highest actinic value of the reflected light.

In 1849, Henry Hunt Snelling writing in his book *The History and Practice of the Art of Photography* (New York: G. P. Putnam) noted

> In choosing your operating room, obtain one with a north-western aspect, if possible; and either with, or capable of having attached, a large sky-light. Good pictures may be taken without the sky-light, but not the most pleasing or effective.

That advice was echoed in manuals throughout the 1850s. Keeping the glass clean, however, posed a considerable challenge. Dirty glass, polluted by smoke not only increased exposure times by acting as a filter, but also radically altered the actinic value of the light. The blue content of the daylight to which the daguerreotype and wet collodion processes were sensitive was considerably reduced by having to penetrate the yellow tar stain which smoke and rain overlaid on to the roof glass. Writing in his 1868 *Manual of Photographic Manipulation,* William Lake Price observed that

> Thus the light cast on the sitter traverses a villanous compound of concentrated coal smoke and the victim, impaled on the head rest, is made to suffer double the requisite amount of "exposure."

To alleviate this suffering, he outlined an ingenious and semi-automatic system of pipes and pumps for washing and cleaning the skylight. An added bonus of this system, he noted, was the cooling effect on the studio itself by the periodic flushing of the roof with cold water during hot days.

The head clamp remained a part of studio portraiture into the 1870s, with a wide variety of devices being invented and marketed. Some were free-standing on heavy cast-iron bases, whilst others were built into chairs. All were designed to reduce the instances of a portrait being ruined by the subject inadvertently moving his or her head during exposure.

The idea of painted studio backgrounds was first mentioned in Antoine Claudet's 1841 British patent No. 9193 'Daguerreotypes' although there is no evidence that his rights to such an 'invention' were ever upheld in any court of law. In his patent he stated that

> When the daguerreotype process was originally applied to portrait taking it was necessary to place behind the sitter some plain background or neutral tints in order that the outlines of the figures should be delineated and brought out. I have now improved this by applying behind the sitter some backgrounds of painted scenery representing landscapes, interiors of apartments, and other representations adapted to the taste and habits of the sitter or to his profession.

The studio portrait was further embellished by the balustrades, potted plants and other ephemera which continued to be used throughout the *carte-de-visite* and cabinet portrait eras. The earliest known daguerreotype of a photographer at work (in the collection of the National Museum of Photography Film and Television, Bradford, UK)—showing Jabez Hogg making a daguerreotype portrait of William Johnson in 1843—depicts a curtained window-frame with trees beyond, ornate trellis work, a classical sculpture, stools and chairs, and a caged bird above the camera (watch the birdie).

With pitched glass roofs, the photographic studio was much prone to leakage, and manuals and journals offered wide ranging advice on how to render the 'operating room' watertight. Ingenious seals were suggested—the most elaborate being the 'Philadelphia Sash' which, it was claimed, guaranteed that any leakage would be carried away by internal drainage ducts. The dual problems of waterproofing, and of minimising the impact of framing bars which might cast soft uneven shadows, brought suggestions that the thick plate glass be cut in such a way that each sheet slotted into a groove on the next.

As photographers became more concerned with the creative exploitation of light, a number of major figures started to break away from the tradition of using north light. Significant amongst these were O. J Rejlander, and Valentine Blanchard whose south-facing studio in London's Camden Town (1866) used a series of movable opaque screens to diffuse and reflect the lighting. This approach permitted much greater variety of contrast

and direction, permitting the photographer more control over visual effect.

As late as 1911, in the *Encyclopaedia of Photography* (Bernard Jones, Editor), and despite the fact that various forms of artificial light had been readily available for more than two decades, the daylight studio is still given prominence.

The daylight studio, while allowing photographers considerable control over lighting effects, limited the hours they could work. On dull winter days, low light levels resulted in over-long exposures. Several portrait photographers in the 1860s and 1870s advertised their studio opening times as 'weather permitting.'

With the widespread availability of gelatin dry plates from about 1880, with their considerably increased sensitivity, exposure times in daylight studios were reduced to only a few seconds, allowing photographers to refine the lighting techniques they had used for three decades without unnecessarily inconveniencing their sitters.

Thus the introduction of artificial lighting in the 1850s was, at first, not widely taken up by portraitists. For those who did embrace the new technology, it considerably extended working hours. John Moule's patented 'Photogen' light source—burning a powdery mixture of antimony, sulphur and potassium nitrate—was advertised in 1857 as a "rival to the sun," but was not adopted by many portraitists. Perhaps the noxious smoke it generated had a significant impact on its popularity.

Credited with the first successful use of flash was Manchester photographer Alfred Brothers in May 1864, although initially on location rather than in the studio. By the end of that year, however, he was using magnesium ribbon to create a sustained high-intensity light for studio portraiture.

Amongst those to embrace the possibilities of artificial lighting were itinerant photographers, who took their caravan studios to villages, towns and fairgrounds throughout the country.

A writer for the journal *Photographic News* (Vol. 30, no.1434, February 26 1886), described such a photographer's caravan. Attracted by a notice offering photographic portraits in five minutes by electric light, the writer entered the caravan just before the studio's closing time of 11pm remarking that "The desire to witness this astonishing advance in photographic science could not be resisted."

So I ascended the wooden steps to the caravan…The studio was certainly no more than five feet by three. It was painted a light blue, and in the left-hand corner, fronting the sitter, was a sort of glass cupboard placed diagonally. The glass was blue, and its use I was presently to see. The studio was wholly devoid of "properties; its solitary article of furniture was a common Windsor chair, behind which was a well-worn head-rest…The head-rest was applied in half-a-second, and in a second more the artist had his head beneath the focussing cloth, and a camera with four lenses was protruded towards my face…… ……he was profoundly indifferent as to my expression…All he said was: "Now don't be afraid, it won't hurt you," and up blazed an intense light in the blue-glass cupboard. I must confess that the sensation of the blinding blaze was not pleasant. The exposure was probably five or six seconds.

The lighting was generated by a device known as the Luxorgraph, patented in Britain in 1878 by Alder and Clark, and described in E. J Wall's 1897 *Dictionary of Photography* (London: Hazell, Watson and Viney) as 'A large lantern-like device with tissue paper front in which pyrotechnic or other compounds can be burned to give artificial light for portraiture.'

The photographer stressed that this was not a magnesium wire or ribbon light source (which was covered by patents), but "Luxorygraph powder." As to the exact composition of the powder, he did not elaborate. The combustible powder was flared by a gas jet which was in turn ignited by an electric spark. The device produced a very flat lighting effect especially when used in such confined spaces.

Credited with being the first studio in the United Kingdom to offer portraits by electric light was that of Henry Van der Weyde, an American photographer who had opened premises in London's Regent Street as early as 1877. To power what he advertised as "The Van der Weyde Light" he generated his own electricity using a gas engine—another first. It was not until the late 1880s, that portraiture studios generally started to embrace the new lighting technology, and several changed their names to incorporate 'Electric' or 'Electric studio' into their names. Thus, for example, Thomas Charles Turner, who had been in business since c.1875, started to advertise his "electric and daylight" studios in 1891, and celebrated that fact on the backs of his cartes-de-visite. Electric lighting came in a variety of forms—gas lamps as well as acetylene and arc lamps.

Once artificial light became commonplace, photographers were able move their studios from the top floors of buildings to ground floor locations, offering easier access to their customers. Many, however, used electric light to augment or partly replace daylight, simply extending their ability to work independently of weather conditions. Many daylight studios continued in use well into the twentieth century.

JOHN HANNAVY

See also: Cameron, Julia Margaret; Snelling, Henry Hunt; Daguerreotype; Wet Collodion Negative; Wet Collodion Positive Processes; Price, William Lake;

Claudet, Antoine-François-Jean; Carte-de-Visite; Cabinet Cards; and *Photographic News (1858–1908)*.

Further Reading

Anon, "Five Minutes in a Photographic Caravan" in *The Photographic News,* vol. 30 No.1434, February 26 1886, 133–134.

Henisch, Heinz K., and Henisch, Bridget A., *The Photographic Experience 1839–1914,* University Park: The Pennsylvania University Press, 1994.

Wall, E. J., *Dictionary of Photography,* London: Hazell, Watson and Viney, 1897.

Jones, Bernard E (ed.), *Encyclopaedia of Photography* New York: Arno Press (reprint of 1911 edition, London: Cassell) 1974.

Price, William Lake, *Manual of Photographic Manipulation,* London: John Churchill and Sons, 1868.

Tissandier, Gaston, *A History and Handbook of Photography,* London: Sampson Low, Marston, Searle and Rivington, 1878,

STURMEY, JOHN JAMES HENRY (1857–1930)

Henry Sturmey, born in the Somerset village of Norton-sub-Hamden February 28, 1857, started a career in the burgeoning late Victorian leisure industry through a passion for cycling. An early promoter of the Bicycle Touring Club (later Cyclists' Touring Club), Sturmey teamed up with the publisher William Iliffe to edit the "Cyclist," after his compilation of the "Indispensable Bicyclist's Handbook in 1877. In the early 1880s, Sturmey moved into photography, joining forces with the journalist Walter Welford to produce *Photography* (1888), later absorbed into *Amateur Photographer* (founded 1884).

Sturmey's collaboration with Welford led to the publication of their two major encyclopaedias, *The Photographer's Indispensable Handbook* (1887), on photographic apparatus, and the *Indispensable Handbook to the Optical Lantern* (1888). Sturmey also edited the *Photographic Reference Book* (1897; 2nd ed. 1904), as well as the first volumes in the series *Photography Annual*, from 1891.

By the mid 1890s, however, Sturmey's main area of interest had passed to the automobile. He founded and edited Autocar (1895), and invested heavily in the Great Horseless Carriage Company; in 1900 he became one of the early victims of an automobile accident. Sturmey's later career is entirely linked to the car industry, founding Sturmey Motors and launching the Lotis car range, which went into liquidation in 1911.

In later life, Sturmey concentrated on the design and patent of a five—hub cycle gear, but this never reached the manufacturing stage. He became something of a recluse in his final years, dying in Coventry January 8 1930.

DAVID WEBB

SUN ARTISTS JOURNAL

The *Sun Artists Journal* is a significant example of photogravure in the history of the photographically illustrated book. *Sun Artists* was published in eight parts by Keegan Paul, Trench and Trübner, London between October 1889 and July 1891. Each Issue was devoted to the work of a single British photographer, illustrated by four hand-pulled photogravures, together with an introductory descriptive essay. Laurence Housman was commissioned to provide the cover design for the series, the letterpress being by the Chiswick Press.

Particular care was taken by the publisher of *Sun Artists* to identify the individuals who prepared the gravures for publication, all leading exponents of photogravure at the time. Mr Dawson of the Typographic Etching Company, himself an acclaimed photographer, made the etchings for Issue 1. Mr Cameron Swan of Messrs Annan and Swan made those for Issues 2, 3, and 4 while the etchings for Issues 5–8 were made by Mr W.L. Coll.

Issue number 1 featured the work of Colonel Joseph Gale (d. 1906) (essay by George Davison): *Sleepy Hollow, A foggy day on the Thames, Brixham trawlers, Homewards from the plough.*

Issue 2, Henry Peach Robinson (1830–1901) (essay by Andrew Pringle): *Carolling*
A merry tale, Dawn and Sunset, When the day's work is done.

Issue 3, James Booker Blakemore Wellington (1858–1939) (essay by Graham Balfour): *Eventide, A tidal river, East Coast, The broken saucer, A study of sheep.*

Issue 4, Lyddell Sawyer (1856–1900) (essay by Rev. F.C. Lambert): *Waiting for the boats, The castle garth, In the twilight, The boat builders.*

Issue 5, Julia Margaret Cameron (1815–1879) (essay by P.H. Emerson): *The kiss of peace, Sir John Herschel, Lord Tennyson, The day dream.*

Issue 6, Benjamin Gay Wilkinson (1857–1927) (essay by Rev. F.C.Lambert):
Sand dunes, Prawning, A pastoral, A windy corner.

Issue 7, Mrs F.W.H. Meyers (1856—1937) (essay by John Addington Symonds):
Robert Browning, Right Honourable W.E. Gladstone, M.P., Rebekah at the well, The summer garden. Myers, née Eveleen Tennant, was a highly regarded portrait photographer.

Issue 8, Frank Meadow Sutcliffe (1853–1941) (essay by Charles N. Armfield):
Water rats, Dinner time, Excitement, Sunshine and shower. The six man editorial board for *Sun Artists*, headed by W. Arthur Boord, announced in the introduction to the first issue that they sought to "emphasize the artistic claims of photography by reproducing the best work of the best photographers in the best possible manner"

and noted that previous efforts in this direction "have almost invariably had a basis personal to the artist reproduced." The board made clear that the members were themselves amateurs,"corporately unassociated with any particular phase of photographic endeavour" and expressed the hope that the whole series would form a true representation of modern photographic photography. They provided no indication that the series would be restricted to British photographers nor any criteria for the selection of artists or of individual images.

They were, however, were at pains to state that they would provide no prediction on the nature or extent of future issues, especially the single artist single issue format. Perhaps more importantly in view of their objective, they gave a clear undertaking that all hand work on the plates "would be scrupulously avoided."

Significant changes occurred during the life of the series. Issue 7 was advertised as featuring the work of J. E. Austin but he was replaced, without comment, by Mrs Meyers. Similarly Mr Seymour Conway was advertised for Issue 8 but replaced by Frank Sutcliffe, again without comment.

The editorial board closed the series at Issue 8. Responding to criticism that younger photographers had not been represented, they stated that the series was "a monument to great British photographers who had brought honour to the Art.," a significant change in direction and emphasis from their originally stated aim. One can infer that the series was initially a commercial success with the first Issue going to reprint and the publishers offering a premium on behalf of a subscriber for an undamaged copy of that issue. Similarly, the published excerpts of reviews might indicate some critical success both for the series and the original concept. Using either the citerion of "best photographer" or that of "great British photographers," it is difficult to understand the selection of some of the artists represented and the omission of others. While Emerson was a noted author on the aesthetics and practice of photography, the omission of his photographic work is highlighted by his appearance as critic for the Cameron images. Similarly the inclusion of Meyers appears to say more about the social context of the editorial board than its commitment to the best in photography. While John Addington Symonds is laudatory in his comments on Meyers portraiture, other critics found the figure "amateurish" and as Fletcher noted in the *RPS Journal*, December 2004, "the art does not hide the art." On the other hand it must be noted that Symonds essay represents one of the first attempts to address photography in critical language with a vocabulary other than that of painting or drawing. *Sun Artists* appeared at a critical time in the history of photography. George Davison (1854—1930), the author of the essay in Issue 1 was to launch the Pictorialist movement with the exhibition of his image

The Onion Field at the annual exhibition of the Royal Photographic Society in 1890. Davison later became one of the founding members of The Brotherhood of the Linked Ring. During this time Peter Emerson recanted his original view that photography should seek to reflect human vision, stating in 1890 that photography lacked the capability to render a natural subject accurately. It is more likely that the fundamental change that was occurring in photography at that time, already represented by Davison's *Onion Field* and anticipated by Sawyer's *The Castle Garth* had rendered both the style and substance of *Sun Artists* no longer representative of the cutting edge of contemporary art photography. At a different level, *Sun Artists,* appears to be the first attempt to showcase the work of individual artists using the best available technologies to faithfully represent the work to a wider audience. As such it might be seen to anticipate Alfred Steiglitz' *Camera Work*. Photogravure represented the fourth and most significant development in nineteenth century efforts to develop an efficient method of faithfully reproducing the photographic image on the printed page in continuous tone. Karl V. Klič, a Czechoslovakian residing in Vienna, utilised the Swan/Poitevin gelatinised carbon tissue technique to produce an intermediate image on a copper plate coated with an asphalt resin. Following exposure, the plate was etched in acids of varying strengths to capture the tonal range of the original. The plate was then inked, wiped and then printed. The resultant print was a faithful copy of the original image with the fine particles of ink providing a grainless, continuous image. Klič subsequently licensed the Thomas and Craig Annan of Glasgow to use his process in England and Scotland.

While dust grain photogravure had replaced collotype as the preferred method of reproducing photographic images on the printed page, it was replaced in the early 1890's by a further Klič development, half-tone. By 1890 the introduction of the halftone process had made photogravure virtually redundant for all but the highest quality reproductions of photography. Peter Henry Emerson's *Wild life on a tidal water*, (1890) used the new half-tone process for the reproduction of his images, although his later *Marsh leaves* (1895) is regarded as the finest example of photogravure in a printed book. Perhaps the best and final examples of dust grain photogravure for the reproduction of the work of the artist photographer are found in Alfred Steiglitz' *Camera Work* (1903 –1917).

A facsimile edition of *Sun Artists* was published by Arno Press, NY, in 1973.

ROBERT DEANE

See also: Klič, Karel Vaclav; Annan, James Craig; Annan, Thomas; and Emerson, Peter Henry.

Further Reading

Buchanan, William, "Relationship between the Annans and Karol Klic." *The PhotoHistorian*, no.148 (June 2005):.5.

Cox, Julian, and Ford, Colin, *Julia Margaret Cameron. The complete photographs*, Los Angeles CA: Getty Publications, 2003.

Farnham, Roger , and Magee, Harry, "Photogravure & the representation of continuous tone in printmaking." *The Photo-Historian*, no.148, (June 2005): 18–21.

Fletcher, Jan, "Faking it: between art photography and advertising, 1850–1950." *RPS Journal*, (December 2004): 454–457.

Ford, Colin, *Julia Margaret Cameron. A critical biography*, Los Angeles, CA: J. Paul Getty Museum, 2003.

Goldsmith, Lucien, and Naef, Weston J., *The truthful lens. A survey of the photographically illustrated book, 1844–1914*, New York: The Grolier Club, 1980.

Hammond, Anne Kelsey, "Aesthetic aspects of the photomechanical print" in *British photography in the nineteenth century*, ed. Mike Weaver, London, Cambridge University Press, 1989.

Harker, Margaret A., *Henry Peach Robinson. Master of photographic art*, Oxford: Basil Blackwell, 1988.

Hiley, Michael, *Frank Sutcliffe, photographer of Whitby*, London: Gordon Fraser, 1974.

Frank Meadow Sutcliffe, 1853–1941, London: British Council, c.1981 (exhibition catalogue).

Horsley Hinton, A. "The influence of the half-tone process." *The Penrose Annual,*(1899): pp. 89–93.

Krüger, Gary, Photogravure, historical notes, http://www.gary-krueger.de/english/helio1.html and helio2.html (Accessed 16 February 2006).

Kolb, Gary P., *Photogravure. An illustrated handbook*, Southern Illinois University Press, 1986.

Krüger, Gary, Photogravure, historical notes, http://www.gary-krueger.de/english/helio1.html and helio2.html (Accessed 16 February 2006)

Moorish, David, *Copper plate photogravure. Demystifying the process*, Boston: Focal Press, 2003.

Petersen, Christian A., *Camera Work: Process and image*, Minneapolis: Minneapolis Institute of Arts, 1985 (exhibition catalogue).

Zoete, Johan de, *A manual of photogravure: a comprehensive working guide to the Fox Talbot Klič dustgrain method*, (translated by Christopher Harrison), Haarlem: Joh Enschedé, c.1988.

SURVEY PHOTOGRAPHY

As a means of gathering visual evidence of the world, photography became useful in the 19th century to a number of activities associated with the idea of the survey. To survey generally means to ascertain and delineate the physical scope and specific characteristics of an entity or related entities, usually places or areas relative to their position on the earth's surface and often including people and objects. Though the activity of surveying can be traced back to antiquity, its significance with respect to developments in the modern world including the adoption of photography in its practice can be understood in light of scientific inquiry and exploration and the formation of national identities in the previous century; the geographical and geological survey and civil engineering were both practical outgrowths of eighteenth-century scientific advancement and political ideology. Surveying as a form of engineering and geographical demarcation emerged in order to articulate boundaries, topographical contours, and to establish zones of operation and the structures necessary for resource development, transportation, and commerce. It would then seem reasonable for photography to have joined preexisting representational and symbolic strategies ideal for conceiving geographical space: drawing and map and model-making procedures.

By the middle of the eighteenth century Britain and France had become absorbed with the lands and major features within their own borders, including distinctive monuments that were thought significant in the construction of a national patrimony. The Ordnance Survey of Great Britain began in 1747 as a military defensive measure to map the borders of England, but soon became an official government department to map the entirety of the United Kingdom. In the same year, France started a school in Paris for specialized training in public engineering projects, the *École des Ponts et Chaussées* (School of Bridges and Roads). That photography had come of age in this enterprise is witnessed by its having become part of the training of engineers in both of these rival countries almost concurrently: in 1856 at the school for Royal Engineers at Chatham, England, and the following year at the École. This civilian effort thus served to give momentum to the systematic use of photographs as a form of documentation of expanding industrial infrastructures and resource development in Europe and regions subject to colonialist expansion. Further, as national institutions took on more responsibility for the improvement of urban conditions, pictures of older streets or areas in decline became central to the demonstration that governments were attending to social need through new construction and civil engineering projects.

In France, sentiments toward educating the public in the past glories of its medieval history had been signaled early in the nineteenth century. *Voyage pittoresques et romantiques dans l'ancienne France* (1820–1878), a multi-volume work illustrated with lithographic plates, set a precedent for a growing "preservationist" movement that fed the collective imagination of the people. The *Mission Héliographique* was commissioned in 1851 by the Commission des Monuments Historiques, a group of authorities on the culture of France, to survey the country's architectural heritage with the camera. Photographic documentation for the purposes of preservation and restoration of selected monuments was the main thrust of the program, but the effort was not systematic nor did it appear to have the full authority of government behind it. Several of the photographers who were affiliated with the Mission Héliographique,

Watkins, Carleton E.. Cape Horn near Celilo. *The Metropolitan Museum of Art, Gilman Collection, Purchase, The Horace W. Goldsmith Foundation Gift, 2005 (2005.100.109) Image © The Metropolitan Museum of Art.*

including Gustave Le Gray and Henri Le Seq, had been formally trained in the studio of the painter Paul Delaroche; many of the several hundred images produced for the mission were thus endowed with a pictorial artistry and a marked skill with the variant paper processes of the period. Though the photographs were not utilized in any official capacity, this tentative embrace of the medium was soon to change. From the late 1850s to the end of the century the engineering school had amassed an enormous collection of pictures of public works, railways, bridges, and other constructions taken within France as well as other countries. Some of the photographers who had been affiliated with the earlier *Mission* and contributed to this and other archives, including Édouard Baldus, who produced views in the early 1860s of railway bridges for civil engineers who had worked on these projects. Charles Marville, who had also engaged in earlier documentary projects published by Louis Désiré Blanquart-Evrard's printing establishment *Imprimerie Photographique*, was commissioned by Georges Haussmann's *Travaux historiques* in 1865 to photograph the city streets while undergoing modernization under the latter's supervision.

As the major industrial powers extended their reach into other parts of the world, photography was employed to extract visual evidence from lands of scientific, archeological, architectural, and ethnological significance, economic promise, and political importance to probing western nations. In this respect, the medium was found useful by officers in the British army and

the Government Civil Service. India especially was the site of an emergent economy of British intelligence and imperialism in which the camera was adopted readily enough for specific activities that may fall under the broad rubric of surveying: of reconnaissance, surveillance, and exploration of places and their inhabitants. One Philip Henry Egerton, for instance, was Deputy Commissioner of Kangra in the western Himalaya when he made a photographic excursion through the rugged mountain environment near the Tibetan border in 1863. His *Journal of a Tour through Spiti, to the Frontier of Chinese Thibet*, illustrated with thirty-six of his views of particular ethnographic and geological interest, was published by Cundall, Downes and Company the following year. Egerton's intentions to stimulate further exploration and encourage trade in the region were clear. British enterprise "would bring manufactures into the heart of Central Asia, extending civilisation to the barbarous hordes which people those vast tracks, and enriching the manufactures, exporters, and carriers of European produce, as well as Tartar Shepherds." (Egerton, 1864, pp. iv–v) More systematic efforts were to come almost immediately thereafter, with increased use of the camera for surveying the antiquities of the subcontinent in conjunction with the establishment of the Archaeological Survey of India. Photographs by various military and civilian operators would also be selectively acquired by professional and government agencies. Such collections as formed in the 19th century at the South Kensington Museum (which became the

Victoria and Albert Museum), the India Office Library and Records (acquired by the British Library), and the Royal Geographical Society (acquired by Cambridge University), testify to the robust application of the medium to the knowledge base of empire.

Having already achieved recognition for his explorations in charting the little known recesses of Africa, David Livingstone's Zambezi Expedition of 1858–64 sought to incorporate photography into the quest for knowledge of the principal features and natural resources of the eastern and central regions of the continent. The expedition was launched by Sir Roderick Murchison, geologist and President of the Royal Geographical Society, who aside from scientific interests also aimed to encourage agriculture and commercial activity among the inhabitants, thus remaining true to the colonialist project. The navigation of the Zambezi River was essential to the enterprise, and was consequently photographed in an effort to record the terrain along the water body. The expedition's botanist Dr John Kirk realized some success with the camera; his work provided images of the land that were useful in the study of disease and plant life. Such wilderness views could seem neutral enough on the surface as empirical data for scientific argument, yet they also literally and symbolically enacted a form of dominance over the native environment (consider the naming of indigenous places after British explorers or individuals of political distinction). Close ties existed between the British War Department's Topographical Department and the Royal Geographical Society, whose maps were employed for gathering information about foreign regions, including Africa. In 1867 Sir Robert Napier led a political rescue operation into Ethiopia, generally known as the Abyssinian Campaign of 1867–68, which is purported to have yielded 1500 photographs taken by a corps of Royal Engineers. The fact-finding, scientific contingent of the expedition was directed by Murchison once again, thus bearing further witness to the importance of the medium with regard to the survey in the double sense of the term: a coordinated effort to articulate of boundaries and landmarks and to ascertain features of scientific and political significance in the overall geophysical and ethnological comprehension of an environment.

The Abyssinian expedition was one of several geographical campaigns in which the Royal Engineers participated and included the camera as a survey instrument. Already in 1857, they had begun to work with photographs to assist in North American Boundary Survey. This was a joint enterprise between the United States and Canada to mark the boundary along the forty-ninth parallel to avoid possible contention over gold. Though the Americans had tried their hand at the medium, only the British engineers trained in photography seemed to have success. Their work, mostly produced in the Pacific northwest, comprised an official photographic record that made its way to the Secretary of State for Foreign Affairs in 1863. A corps of Royal Engineers was also hired to undertake extensive mapping and documentation of the Holy Land—Jerusalem, Palestine, and the Sinai Peninsula. Ordnance Surveys were conducted of Jerusalem in 1864, and of the Peninsula in 1868. These were chiefly geographical and scientific in nature, in part privately funded, and especially significant for strengthening the religious ties of Britain with the Judaic and Christian past of the region through the pictorial and cartographic identification of biblical sites. Thus, in the linking of picture with site, and the coordination of pictures with the procedures and symbolic meanings of mapmaking and the topographical survey, the survey became a process that was clearly more than a mere exercise in measurement and pictorial documentation.

While one could cite further cases related to expeditionary enterprise and ideology beyond the few examples discussed thus far, the survey as a projection of a larger vision of expansion is especially well evinced by the grand surveys of the American west between 1867 and 1879. These were geologist Clarence King's US Geological Exploration of the Fortieth Parallel, launched under the auspices of the US Geological Survey; Lieutenant George Montague Wheeler's US Geographic Surveys West of the One Hundredth Meridian; the US Geological and Geographical Survey of the Territories, led by the geologist Ferdinand Vandiveer Hayden; and John Wesley Powell's US Geographical and Geological Survey of the Rocky Mountain Region. The civilian and military men who were the leaders of the surveys recruited photographers to augment the communication of their findings to the scientific community, and to persuade government that additional expenditures for further campaigns were worthwhile. Among the best known of the operators were William Henry Jackson (with the Hayden survey), Timothy H. O'Sullivan (King and Wheeler), Carleton Watkins (King), E.O. Beaman (Powell), and John K. Hillers (Powell). Their works were distributed in stereographic form, single prints, and albums, and reproduced in print media both in the reports of the expeditions and in popular illustrated journals.

Survey activity during the nineteenth century was aligned with the growth and spread of modern institutions. In this period of positivist reliance on observable phenomena for knowledge of the world, photographic images were increasingly accepted as visual evidence of domestic and foreign places and public works important to cultural legacy and national determination. Photographs also began to meet the requirements for pictorial accompaniment in geophysical and anthropo-

logical study. The findings of scholarly, scientific, and government sponsored enterprises as well fostered a demand from the mid-century on for illustrated accounts of these activities in the popular journals. Overall, the quest for new knowledge verifiable through the agency of photography, among other systems of recording, has been characterized as a "compulsive visibility" (Marien, 2002, 79)—a double quest for knowledge, one related to an ideology of power, the other to a democratic idealism that attempted to bring cultural enlightenment to those accorded a place within the domains of western economies.

GARY D. SAMPSON

See also: Royal Engineers; Mission héliographique; Le Gray, Gustave; Le Seq, Henri; Delaroche, Paul; Baldus, Édouard; Blanquart-Evrard, Louis-Désiré; Marville, Charles; Royal Geographical Society; Watkins, Carleton Eugene; and Pictorialism.

Further Reading

Boyer, M. Christine, "*La Mission Héliographique:* Architecture Photography, Collective Memory and the Patrimony of France 1851," in *Picturing Place: Photography and the Geographical Imagination*, edited by Schwartz, Joan M., and James R. Ryan, London and New York: I.B. Tauris, 2003.

Daniel, Malcolm, *The Photographs of Édouard Baldus*, New York: The Metropolitan Museum of Art, and Montreal: Canadian Centre for Architecture, 1994.

Edwards, Elizabeth (ed.), *Anthropology and Photography, 1860–1920*, New Haven and London: Yale University Press, 1992.

Egerton, Philip Henry, *Journal of a Photographic Trip through Spiti, to the Frontier of Chinese Thibet, with Photographic Illustrations*, London: Cundall, Downes and Co., 1864.

Frizot, Michel, ed. *A New History of Photography*, Köln: Könemann, 1998.

Howe, Katherine, "Mapping a Sacred Geography: Photographic Surveys by the Royal Engineers in the Holy Land, 1864–68," in *Picturing Place: Photography and the Geographical Imagination*, edited by Schwartz, Joan M., and James R. Ryan, London and New York: I.B. Tauris, 2003.

Jammes, André, and Eugenia Parry Janis, *The Art of French Calotype: with Critical Dictionary of Photographers, 1845–1870*, Princeton, N.J.: Princeton University Press, 1983.

Kelsey, Robert, "Viewing the Archive: Timothy O'Sullivan's Photographs for the Wheeler Survey, 1871–74," in *Art Bulletin*, vol. 85 no. 4 (December 2003): 702–23.

Marien, Mary Warner, *Photography: A Cultural History*, New York: Harry N. Abrams, 2002.

Pinney, Christopher, and Nicolas Peterson (eds.), *Photography's Other Histories*, Durham: Duke University Press, 2003.

Ryan, James R. *Picturing Empire: Photography and the Visualization of the British Empire*, Chicago: University of Chicago Press, 1997.

Sandweiss, Martha. *Print the Legend: Photography and the American West*, New Haven and London: Yale University Press, 2002.

Trachtenberg, Alan. *Reading American Photographs: Images as History, Mathew Brady to Walker Evans*, New York: Hill and Wang, 1989.

SUTCLIFFE, FRANK MEADOW (1853–1941)
British photographer

Frank Meadow Sutcliffe was born at Headingly on October 6, 1853, the son of Thomas and Sarah Lorentia Sutcliffe. He was the oldest of eight children. As a child Frank slept in his father's studio surrounded by painting equipment, plaster busts of classical sculpture, and a printing press. Thomas Sutcliffe was an artist working in oils and watercolors. He was also an etcher, lithographer and amateur photographer although none of his images appear to have survived. To encourage his children Thomas painted a diorama in one end of his studio complete with lighting and sound effects.

One of Frank's first creative works was achieved on the printing press. It was an etching of two ships used to create a letterhead for himself. The design survives in a letter Frank wrote to his brother Horace in 1869. He also worked as printer of his father's small books of stories written under the pseudonym of Jossy Hullarts. He was also the occasional illustrator of these stories. He had this to say about his childhood:

> I spent much of my childhood running up and down narrow lanes only wide enough for one carriage…The boy who has lived the country life and whose eyes and ears are open to every movement in hedge or bank or tree, is much more likely to have his eyes and ears around him than one who has lived among tram cars and smoke.
>
> When not out of doors my childhood was spent with tiles and bricks. This I believe was a capital education, give a child a heap of squares and triangles, and let him puzzle with them till he makes a picture or at least an ornamental design. He will not be at a loss to know how to place a group of figures afterward. (Frank Meadow Sutcliffe. "Factors in My Success." *The Photogram*, April 1902, 107)

In 1865, at age 14, Frank was apprenticed as a clerk at the offices of Tetley Brewery on Hunslett Lane in Leeds. He lasted eighteen months as an apprentice. This apprenticeship was during a period of his father's illness. While recuperating from his own experience with the city Sutcliffe discovered Lake Price's *A Manual of Photographic Manipulation* published in 1858 on the family bookshelf. His first camera was a 24x18 that he modified to an 8.5x6.5 with a 24" lens. It was John William Ramsden, a portrait photographer and founder of the Leeds Photographic Society who introduced him to the learned photographic journals whose articles covered the latest in scientific and technical matters relating to photography. His early work included portraits and still life studies. He also attempted an image of birds in flight before the use of stop motion photography was common knowledge.

In 1870 Thomas Sutcliffe moved his family to Ewe Cote approximately a mile from Whitby. Thomas died in December of 1871 and by the summer of 1872 Frank is photographing for a client in the Lake District. In 1872–1873 he photographed for Francis Frith a series of views of Yorkshire's abbeys and castles. It was from Frith that he learned to use tracing paper masks to achieve the proper tonal range in prints. He was also advised not to include people in the views since the customer was only interested in the view. During his work for Frith he makes an image called *Sunset after Rain* shot above Rievaulx Abbey. A family friend sent a copy to John Ruskin who invited Sutcliffe to visit him at Brantwood in September 1873 where he photographed Ruskin and the surrounding countryside.

He married Eliza Duck in 1874 and they moved to Tunbridge Wells in 1875 to establish a photographic studio. It was a financial failure and he returned to Whitby in 1876 to establish a studio in Waterloo Yard. It was a one man operation specializing in portraiture. On the verso of a carte mount c 1883 he advertised himself as photographer to Mr. Ruskin, a member of the Photographic Society of Great Britain and prize medals in photographic show in 1881 and 1882. In 1894 he moved the studio to 25 Skinner Street, Whitby where he was able to pursue his portrait work in a state of the art studio. He became a familiar sight in Whitby and developed a rapport with the fishing community. It was the rather rambunctious children of the fishermen who became his water rats. The "Water Rats" is the most famous of his photographs winning a medal at the 1886 Photographic Society Show in London. From his return in 1876 until he sold his business in 1922 Sutcliffe photographed in and around Whitby. His photographs show an understanding of the people and the community of Whitby that is unsurpassed. He began with the collodion wet plate switched to dry plates and then to cameras and roll film provided by Kodak.

In 1892 he joined the Linked Ring whose purpose was to promote photography as an art. He exhibited at the annual Photographic Salon of the Linked Ring from 1893–1904. In 1888 he had a one man show at the Camera Club in London and in 1891 he has a one man show at the Royal Photographic Society. However, it is not until 1935 that he is made an Honorary Fellow of the Royal Photographic Society.

He began writing journal articles in 1875 and went on to become an editorial contributor to *Photography* and between 1895–1913 he regularly wrote for *Amateur Photographer* and contributed to *The Practical Photographer, The Photogram* and *Camera Notes*. He also wrote a weekly column "Photography Notes" for the *Yorkshire Weekly Post* from 1908–1930. In 1922 he became curator of the museum of the Whitby Literary and Philosophical Society and continued in that posi-

tion until March 1941. He died at his home in Sleights on 31 May 1941.

PAULETTE E. BARTON

Holdings: Royal Photographic Society, Bath; Sutcliffe Gallery, Whitby, Yorks; George Eastman House, Rochester, New York; J.P. Getty Museum, Los Angeles, California; California Museum of Photography, Riverside, California; Museum of Contemporary Photography, Chicago Art Institute, Chicago, Illinois; Boston Museum of Fine Arts, Boston, Massachusettes; Yale University Art Gallery, New Haven, Connecticut.

See also: Frith, Francis; Ruskin, John; Wet Collodion Negative; Camera Design: 6 Kodak (1888–1900); Brotherhood of the Linked Ring; and Royal Photographic Society.

Further Reading

Armfield, Charles N., "Mr. F. M. Sutcliffe," *Sun Artists*, no. 8, July 1891, pp.55–60.

Hankey, J.L., "The Frank M. Sutcliffe Memorial Lecture." *The Photographic Journal*, (August 1942): 280–291.

Hiley, Michael, *Frank Sutcliffe Phographer of Whitby*, Boston: David R. Godine, 1974.

———, *Frank Meadow Sutcliffe* Aperture History of Photography 13, New York: Aperture, 1979.

Shaw, Bill Eglon, "Sutcliffe of Whitby." *Creative Camera* (March 1968): 100–103.

———, *Frank Meadow Sutcliffe, Photographer, A Selection of His Work*. Whitby: The Sutcliffe Gallery, 1985.

———, *Frank Meadow Sutcliffe, A Second Selection*. Whitby: The Sutcliffe Gallery, 1985.

Warren, W.J. "F.M. Sutcliffe of Whitby. An Appreciation and Some Examples of His Work." *The Amateur Photographer*, (June 15, 1900): 470–473.

SUTTON, THOMAS (1819–1875)
English technical writer and photographer

Thomas Sutton was born in London's Kensington district on 22 September 1819. Very little is known about his early life. In 1846, he received a Bachelor of Arts degree from Caius College, Cambridge.

Sutton's first experience with photography was in 1841, when he posed for a portrait in Antoine Claudet's daguerrian portrait studio. At the time he was planning to continue his education in the direction of art, and some advice from Claudet made him consider becoming a photographer. A few weeks later, on a holiday in Jersey, he met an amateur daguerreotypist and started to pursue photography as a hobby; however, his first attempts were unsuccessful.

From 1842–50, study at Cambridge and the demands of married life seem to have prevented him from continuing with photography.

In 1850, he and his wife settled in Jersey, buying some land and building a cottage at St. Brelade's Bay. There he received some lessons from a calotype photographer known only as Mr. Laverty.

From 1851–53, during an extended voyage to Italy and Switzerland with his wife and son, Sutton made the acquaintance of two photographers based in Rome, Frédéric Flachéron and Robert MacPherson. Flachéron gave him further lessons in the calotype process, showing him the wet-paper technique he was using. MacPherson initiated him in the albumen-on-glass negative process. After trying both methods, Sutton settled upon the paper negative process.

Following his return to England in 1853, Sutton was commissioned by the London publisher Joseph Cundall to make twelve prints each of one hundred of his best negatives from Italy. Dismayed by the task, Sutton attempted to arrive at a developing-out printing process similar to the one used by Louis Désiré Blanquart-Évrard—whose photographic printing facility in Lille, France had published several impressive photographic albums. Failing at this, he sent Blanquart-Évrard some negatives he had made since returning to Jersey, asking him to print them. These were published by Blanquart-Évrard in 1854, under the title *Souvenirs de Jersey* [Souvenirs of Jersey]. Sutton also offered to pay Blanquart-Évrard one hundred pounds for the details of his developing-out printing process, but was politely refused.

In 1855, Sutton published a technical treatise titled *The Calotype Process: A Hand Book to Photography on Paper*, which attempted to cover all facets of the photographic process on paper known at the time. This was immediately followed by treatise titled *A New Method of Printing Positive Photographs, By Which Permanent and Artistic Results May be Uniformily Obtained*, in which Sutton outlined the steps for a developing-out printing process using whey, or milk-serum. The success of this procedure induced Prince Albert to suggest that Sutton set up a photographic printing facility.

Aware that he lacked experience with full-scale industrial printing, Sutton again contacted Blanquart-Évrard, asking for his assistance in establishing the printing facility. Blanquart-Évrard—at this point suffering from financial difficulties and realizing that Sutton's published procedure was a serious rival to his own—accepted the offer, and invited Sutton to tour his printing facility in Lille. There he showed Sutton his industrial printing methods without reservation, which Sutton later described in an 1862 article. Blanquart-Évrard's printing facility was then shut down; and in September 1855, the two men launched a new printing facility at Jersey, the Establishment for Permanent Positive Printing.

Sutton's business partnership with Blanquart-Évrard lasted about two years. During this time they published, at irregular intervals, a series of installments to a larger work titled *The Amateur's Photographic Album*. Each installment contained three to four photographs and sold for the price of six shillings. In January 1856, they also launched a photographic journal titled *Photographic Notes*, which ran as a monthly journal at first, then becoming fortnightly from September 1856. Blanquart-Évrard's contribution to either of these undertakings has yet to be fully determined.

As the editor of *Photographic Notes*, Sutton proved himself to be a venomous and opinionated writer. The journal was used for launching personal attacks and new photographic innovations were often treated with derision and scorn—only to be accepted in a contradictory, face-saving manner once Sutton's initial reactions had been proven wrong.

Largely overlooked, but nevertheless important, are a number of articles Sutton wrote and published in *Photographic Notes* during the years 1856-61, in which he expanded upon his earlier, 1855 developing-out treatise. Here he outlined a method of developed-out salt printing that yielded results virtually indistinguishable from ordinary, printed-out salted paper, while at the same time requiring much less exposure to light.

In 1858, Sutton published *A Dictionary of Photography*, which featured encyclopedic articles on every aspect of the photographic process, mostly written by himself.

By the late 1850s, Sutton's interests appear to have moved away from the chemical operations of photography and more towards optics. In 1859, he wrote that a triplet lens he had made from two opposing, achromatic plano-convex elements, with a small, bi-concave quartz element in between, corrected curvilinear distortion and curvature of field. But the lens was never manufactured. This was followed in 1860, by the introduction of a ball-shaped water lens, capable of a 100 angle of view. The lens was formed by two opposing positive meniscus elements, with water in between also acting as an optical component. The lens reached a limited scale of production and was capable of producing fine images, but was never widely used—in part because it required a curved ground glass, curved negative plates, and a curved contact printing frame.

In 1861, Sutton was appointed lecturer on photography at King's College, London, where he succeeded T. Frederick Hardwich; but within a few months he had resigned from the position, citing domestic problems caused by repeated travelling between Jersey and London.

In 1867, Sutton terminated his involvement with *Photographic Notes*, it then being absorbed by *The Illustrated Photographer*. Sutton and his family moved to Redon, in Brittany. There he lived in semi-retirement, contributing articles to the *British Journal of*

Photography, most notably his "Reminiscences of an Old Photographer," which was published under a pseudonym.

In 1874, Sutton moved to Pwllheli, in North Wales. He died very suddenly, allegedly from stomach cramps, on 19 March 1875.

ALAN GREENE

Biography

Thomas Sutton was born on 22 September 1819 in London. After studying at Caius College, Cambridge, he and his family moved to the island of Jersey. In the early 1850s, he made a number of calotype views of Rome, aided by lessons obtained from Frédéric Flachéron. Wanting to print his negatives from Rome, he became interested in the industrial, developing-out printing process of Louis-Désiré Blanquart-Évrard. This led him to devise a developing-out process of his own, the details of which he published in 1855. In 1855–1857, Sutton and Blanquart-Évrard founded an industrial titled photographic printing facility at Jersey. During this time they also started a journal *Photographic Notes*, which Sutton continued to edit until 1867. A prolific writer, Sutton wrote a number of technical manuals, contributed articles to different photographic journals, and compiled a photographic dictionary. He also was interested in optics, designing a triplet lens and a wide-angle duplet lens filled with water. He died on 19 March 1875 in Pwllheli, North Wales.

See also: Blanquart-Évrard, Louis Désiré; Calotype Process; Claudet, Antoine; Flachéron, Frédéric; Lenses: 1. 1830s–50s, MacPherson, Robert; and Wet-Collodion Process.

Further Reading

Auer, Michel et Michèle Auer, *Encyclopédie internationale des photographes de 1839 à nos jours* [International Encyclopedia of Photographers from 1839 to the Present], 2 vols., Hermance, Switzerland: Editions Camera Obscura, c.1985.

Gautrand, Jean-Claude, and Alain Buisine, *Blanquart-Évrard*, n.p.: Centre Régional de la Photographie Nord Pas-de-Calais, 1999, pp.32–35, 43–44, 47–49.

Gernsheim, Helmut, "Cuthbert Bede, Robert Hunt, and Thomas Sutton." In *One Hundred Years of Photographic History: Essays in Honor of Beaumont Newhall*, edited by Van Deren Coke, 64–67, Albequerque: University of New Mexico Press, 1975.

Sutton, Thomas, *The Calotype Process: A Hand Book to Photography on Paper*, London: Joseph Cundall, 1855

———, "Description of a New Photographic Lens, Which Gives Images Entirely Free from Distortion." *Journal of the Photographic Society*, no. 90 (15 October 1859): 58–59.

———, *A Dictionary of Photography*, London: Sampson Low, 1858.

———, *A New Method of Printing Photographs, By Which Permanent and Artistic Results May be Uniformily Obtained*, St. Brelade's Bay, Jersey: [self-published], 1855.

———, "A New View-Lens." *Journal of the Photographic Society*, no. 78 (5 February 1859): 169–73.

———, "On Positive Printing without a Toning Bath." *Photographic Notes*, vol. 1, no. 1 (15 November 1856):.237–43.

———, "On Printing by Development." *Photographic Notes*, vol. 1, no. 1 (1 January 1856): pp.vii–viii.

SUZUKI SHINICHI STUDIOS

The Japanese photographers Suzuki Shinichi I (1835–1919) and Suzuki Shinichi II (1855–1912) were simultaneously apprenticed to Shimooka Renjo. The connection was that Suzuki II married Suzuki I's daughter. Suzuki I was born Takahashi Yujiro in Izukuni. In 1854 he married into a Suzuki family, adopted the family name, and moved to Shimoda. That year he lost everything in a tidal wave and moved to Yokohama. In 1866 he became apprenticed to Shimooka and then left in October 1873 to set up his own Yokohama portrait studio which also sold souvenir albums to foreigners. That year he also changed his given name to Shinichi and saw his daughter married to Okamoto Keizo, also apprenticed to Shimooka. Okamoto changed his name to Suzuki Shinichi II. Suzuki I pioneered a technique for printing photographs onto porcelain and authored the *shajo* series which realistically documented the life and customs of rural communities. Retiring in 1892, his son Izaburo changed the studio name to I.S. Suzuki.

Suzuki II was born in Izu. Originally intending to be an artist, he switched to photography and in 1870 apprenticed to Shimooka for seven years. In 1876 he opened his own studio in Nagoya. Although successful, in 1879 he decided to improve his technical knowledge by studying for one year with the famous Isaiah West Taber in San Francisco, becoming the first Japanese photographer to study abroad. Returning to Japan he built an extensive studio complex in Tokyo which was known as the 'branch studio' to Suzuki I's Yokohama premises. Suzuki II won prizes at Japanese and European exhibitions, and he photographed many famous statesmen and members of the Japanese royal family. His success peaked in around 1896 and shortly afterwards he lost everything after speculating in the shipping business. He died in relative poverty and obscurity in 1912. Examples of work from the Suzuki studios can be found in the Tokyo Metropolitan Museum of Photography, Tokyo.

TERRY BENNETT

See also: Shimooka Renjo.

SWAN, JOSEPH WILSON (1824–1914)
British scientist and inventor

Born in Sunderland on October 31,t 1824, the physicist and electrical visionary Joseph Wilson Swan originally

trained as a chemist. Earlier in his career he was appointment as an assistant, and later partner, to the Newcastle chemist John Mawson. The company later became Mawson & Swan.

Swan is most widely remembered as the inventor of the incandescent filament electric light bulb in 1860. Due to the poor quality of vacuum pumps at the time, it took a further twenty years before he was able to demonstrate a lamp with sufficient luminance to be practical. By 1880 he had set up the Swan Electric Light Company.

In photography, Swan is credited with the introduction of the first practical carbon printing process in 1862—based on Alphonse Louis Poitevin's 1855 patent. He is also credited, in the 1870s, with the introduction of the gelatine bromide dry plate which evolved into the mainstay of the photographic industry and, a few years later, with the introduction of bromide printing papers.

With the chance discovery—while investigating materials to make electric light bulb filaments—of how to make fibres out of nitro-cellulose, he is credited with the creation of one of the first man-made fibres, later used widely in textile manufacture.

Swan was knighted in 1904, and died in Surrey on May 27, 1914.

JOHN HANNAVY

SWEDEN

News of the invention of photography reached Sweden with the speed of the stage-coach. Three weeks after Daguerre's invention had been briefly announced in Paris, a newspaper in Stockholm was able, on 28 January 1839, to report "one of the most important inventions of the century." More details became available during the autumn, after Arago's big introduction, and at Christmas that year, the bookseller Adolf Bonnier published a Swedish translation of Daguerre's manual.

Among those who bought the book were, naturally enough, the scientist Jacob Berzelius and his circle. He, as well as Carl Wilhelm Scheele before him, had been responsible for some of the chemical findings which made photography possible. The Swedish Academy of Science published continuous reports on the advances made in photography.

The pioneers, however, were to be found elsewhere. *G. A. Müller*, stage designer at the Royal Opera, acquired photographic equipment together with *U. E. Mannerhjerta*, once a pioneer in lithography and at this time a translator of French plays. Müller had learned his craft as an assistant of Gropius in Berlin, the stage decorator who had built his own Dioramas as direct copies of Daguerre's stage designs.

This was early in 1840, when another lithographer,

the young Liutenant *L. J. Benzelstierna*, received an apparatus from the Swedish ambassador in Paris. In September 1840, these three men exhibited their views of Stockholm at the Royal Museum.

At the same time the visting French merchant Neubourg exhibited his Daguerreotypes in the Old Town, a few blocks away from the castle. One year had passed since the official announcement of the new invention, and four photographers were already exhibiting.

Müller and Mannerhjerta soon abandoned the daguerreotype. Müller followed Daguerre and built a Diorama in Stockholm. Benzelstierna became our first professional photographer, although not by selling his images: He choose instead to demonstrate, for an admission charge, the entire complicated process involved with the slivered copper plates. For almost two years he travelled Sweden, photographing and exhibiting.

While Benzelstierna toured the countryside with his rapidly ageing technique, new daguerreotypists were appearing in larger towns and cities. Many of the itinerant photographers during the first decades were Danish and German. Some of them took their time to train assistants and apprentices.

The greatest portraitist of this era was *J. W. Bergström*, whose life began in poverty and ended in riches: After ten years as a daguerreotypist he turned his interest to industry and made a fortune as a manufacturer. He left behind him a large work of masterly portraits, but it is his pictures from the sphere of his private life that attract our greatest interest.

Gradually, the itinerant daguerreotypists introduced new methods as the ambrotype. The style remained however the same. From the glass plates were also made positives on salt or albumen paper. Paper was also tried as negatives. The pioneers appear to have been *David Gibson* in Gothenburg 1851 and the painter *C G Carleman*, who was later to be one of the inventors of the halftone block. His first halftone blocks were printed in Swedish magazines in 1871.

The introduction of better negative-positive processes and the *carte-de-visite* format created a boom. The number of professional photographers increased from 12 in 1860 to 65 in 1865. Among them, an elite of about 20 organised themselves in a professional association.

The most legendary studio of the era was established by *Johannes Jaeger*, a German who after a few iterant years settled in Stockholm in 1863. In Gothenburg his equivalent was *Aron Jonason* The artistically inspired photographers included *Frans Klemming*, closely related to the school of national romanticism.

While studio photography developed technically, the first amateurs appeared with a freedom to choose their motifs. *Carl Curman* was a doctor, and the pioneer of the Swedish bathing resort. As a photographer he emphasised the greatness of nature in a romantic style. Painter

SWEDEN

Severin Nilson was his opposite, using his camera to document the poor and urban slum areas.

August Strindberg tried photography during a few intensive periods. A journey through the French countryside aimed to create a social documentation in a new way, but his disregard for established techniques made the material unusable. Another project to photograph clouds failed for similar reasons. But the existing body of around 60 pictures consists mainly of strong portraits and auto portraits.

Several of Sweden's best photographers have been immigrants. To a greater extent, a number of Swedish photographers have produced their most important work in other countries. The most famous was *Oscar Gustav Rejlander*, who studied painting in Rome before moving to England. His "art photography" attracted a wide audience in the 1850s.

Otto Wegener, from the south of Sweden, opened in 1883 an elegant studio in Place de la Madeleine in Paris, competing with Nadar the Younger and Reutlinger. He signed his works simply by using his Christian name Otto. His period of fame lasted until the end of the century but the body of his work seems lost. Hence, he is overlooked by photo historians, except for a few footnotes in connection with his apprentice Edward Steichen.

John A. Anderson photographed lumberjacks and railroad workers in California, *Eric Hägg* documented the Gold Rush in the Klondike and *Gustaf Nordenskiöld* explored the ancient rock dwellings in Meza Verde, Colorado.

The Swedish tourist Association was formed in 1885 as a part of a nationalist movement. To help Swedes discover their own country, photographers were invited to portray landscape, wildlife an people in their home regions. A generation of versatile professionals found a reason to get out of the studios and deliver coherent portfolios of cities and countryside.

The signals of pictorialism were rapidly registered in the 1890s. Amateur *Gunnar Malmberg* and the professional *Herman Hamnqvist* were the first to introduce the gum bichromate process. The pictorialist era was dominated by photographers as *Ferdinand Flodin*, *John Hetzberg* and *Henry B. Goodwin*, but their main oeuvre was created after the turn of the century.

PÄR RITTSEL

See also: Wegener, Otto.

Further Reading

Söderberg, Rolf, and Pär Rittsel, *Den svenska fotografins historia*, Bonnier Fakta, Stockholm 1983. (*History of Swedish Photography*, in Swedish with an English summary Sidwall, Åke & Leif Wigh, Bäckströms Bilder. Prints from the Helmer Bäckström Collection in Fotografiska Museet, Museum of Modern Art, Stockholm, Sweden 1980.

Jacobson, Anderson, John, Claes-Håkan, Rosebud Sioux: A Lakota People in Transition , C-H Jacobson produktion, Sweden 2004.
(Ericson, August William) Palmquist, Peter E, Fine California Views: The Photographs of A.W. Ericson, Eureka, California 1975.
Hägg, Eric A, The Alaska Gold Rush 1897–1901. Photographs by E. A. Hegg, International Center of Photography, New York 1976.
Jones, Rejlander, Oscar Gustav, and Edgar Yoxall, *Father of Art Photography*.
O.G. Rejlander 1813–1875, Newton Abbot: David & Charles, 1973.
Rejlander, Oscar Gustav) Spencer, Stephanie, O.G. *Rejlander Photography as Art*, Ann Arbor, UMI Research Press, 1981.

SWITZERLAND

The first announcement of Daguerre's discovery appeared in the Schweizerischer Beobachter on the 19th January 1839 and the first specimens of the new process were shown in St-Gallen and Zurich as early as October of the same year. In 1840, the French itinerant photographer named Compar was touring the country, followed by many others introducing the daguerreotype to an interested public and teaching its technique.

Even though the physicist and professor of veterinary surgery at the University of Bern Andreas Gerber (1797–1872) claimed in February 1839 to have been able to fix microscopic prints on silver chloride paper as early as 1836, one of the most important pioneers of early Swiss photography remains Johann Baptist Isenring (1796–1860), a landscape painter and engraver from St-Gallen. He succeeded in obtaining excellent portrait daguerreotypes already in November 1839. And in August 1840 he showed in his first photographic art exhibition ever examples of his art in St-Gallen, and later in Zurich. As an itinerant photographer, he worked and traveled with a "sun-wagon" in Switzerland, Southern Germany, and Austria.

During the 1840s, daguerreotype studios appeared in many cities. Beginning in 1841 the sculptor Antonio Rossi (1823–1898) ran a Kabinett in Locarno.

The optician and precision mechanic Friedrich Gysi (1796–1861) in Aarau added another branch to his business by producing daguerreotypes from 1843 onward, while in 1847 another optician, Emil Wick (1816–1894), decided to change profession and became the first daguerreotypist in Basle. Franziska Möllinger (1817–1880) began taking daguerreotypes views of main cities and landscapes around 1844. She published 15 of them as an edition of lithographs but only one original daguerreotype by this first Swiss woman photographer has come down to us. The lithographer Carl Durheim (1810–1890) in Bern produces daguerreotypes since 1845.

In the French-speaking part of Switzerland the diffusion of the new medium happened differently. Sev-

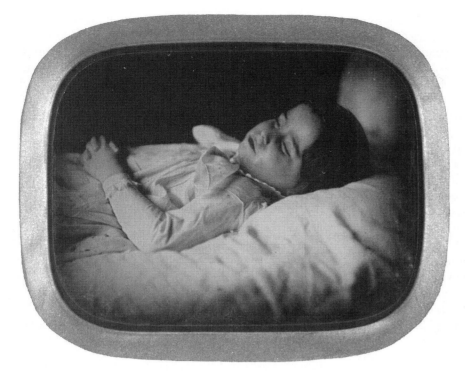

Durheim, Carl. Postmortem of a Child.
The J. Paul Getty Museum, Los Angeles
© *The J. Paul Getty Museum.*

eral aristocratic families enjoyed close relationships to France and its scientific milieu and it is rather through this network that photography was introduced. A banker in Geneva, Jean-Gabriel Eynard Lullin (1775–1863) produced as an amateur daguerreotypist a remarkable photographic oeuvre depicting his relatives, his friends and his mansions. The mathematician and astronomy professor in Lausanne, Marc Secretan (1804–1867) published his ³Traité de photographie² in Paris in 1842. At the same time Les Excursions daguerriennes were issued by Lerebours, for which the painter, engraver and collaborator of Secretan, Frederik von Martens (1806?–1885?), engraved a few plates. In the early 1840s, the tinsmith Samuel Heer-Tschudi (1811–1889) provided them both with metal plates for their daguerreotypes, before he himself turned daguerreotypist in the mid 1840s. Despite the several mentions in the newspapers of views of cities, buildings and landscapes, the daguerreotypes which have survived are almost exclusively portraits.

Adrien Constant Delessert (1806–1876) who entertained close links with international photographic circles and was recognized as a photographer as well as a scientist, was instrumental in transmitting the technique of the Calotypes. Paul Vionnet (1830–1914), Secretan's nephew, learnt it from him in 1845 and was to use it as a means of documenting old buildings, monuments and landscapes. The tradesman Jean Walther (1806–1866) in Vevey, also taught by Constant Delessert in 1850, worked locally but took a series of remarkable views of Athens. Around 1855–60, Charles de Bouell produced a series of salt prints representing Basle and the archeologist, historian and politician Auguste Quiquerez (1801–1882, perhaps together with his son Edouard)

documented the Canton of Jura with more than a hundred pictures of monuments, ruins and landscapes. In 1852/53, Carl Durheim created one of the most interesting group of Calotypes, the first large body of police photographs: about 220 portraits of itinerants without citizenship, vagabonds and criminals, commissioned by the new Federal Government. The use of photography for police purposes was introduced on cantonal levels soon after that. Many daguerreotypists began offering salted prints in the early 1850s, like Durheim in Bern, Christian Müller in Zurich or Wick in Basle.

Around 1860 large family businesses began emerging, most of them devoted to portrait photography and the production of local views. The Taeschler studio, founded by the watchmaker, painter, and later itinerant photographer Johann Baptist Täschler (1805–1866) was established in St. Fiden (near St. Gallen) in 1850 and forced to close after WWI. The German Jakob Höflinger (1819–1892) settled down in Basle in 1857. His firm did not flourish however, until the introduction of the *carte-de-visite*. His son, Karl Albert (1855–1936), and his nephew, August (1867–1939), took up the business in 1885 and managed it until the 1910s. The inventor of the Pinacoscope (a projector for colored slides), Johannes Ganz (1821–1886) opened a store in Zurich in 1859. His son Rudolf (1848–1927), a great portraitist, sold the company to Camille Ruf (1872–1939) in 1902. Another German, Johann Linck (1831–1900) arrived in Winterthur in 1863 and opend his own studio a year later. Apart from portraits, Linck specialized in exterior and interior views of the plants and factories in town documenting the booming industrial growth beginning in the 1870s.

Henri-Antoine Boissonnas (1833–1889) active in Geneva in the clock-making industry started a new business in 1864–65, succeeding the photographer Auguste Garcin (1816–?). First taking landscape and city views, he specialized in children portraiture. After his death his sons took over, Edmond-Victor (1862–1890) inventing ³Orthochromatic² plates, for which he received a silver medal in the Vienna photographic exhibition of 1882. Fred (1858–1946), the most famous of the family, was a successful businessman and a great artist at the same time, creating refined studio portraits and impressive tableaux vivants. He experienced with a large variety of printing techniques and became one of the only internationally recognized Swiss Pictorialists. Since the 1860s, the most important portrait atelier for the Lausanne bourgeois society was run by the De Jongh family. After working with Niepce de St-Victor in France, Alphonse Dériaz (1827–1889) established himself in Morges in the 1870s taking studio portraits and occasional industrial views. His son Armand (1873–1932) opened a business for postcards and alpine panoramas.

Early examples of Swiss landscape photography are scarce: Durheim took a few pictures of the Bernese Oberland as early as 1849, Samuel Heer even earlier, but no trace of the latter's pictures survive. However, Swiss landscapes became well known through the work of foreign photographers, artists, scientists, alpinists and travelers like Adolphe Braun, Francis Frith, William England, Giorgio Sommer, who produced large corpuses covering the whole country, or like Aimé Civiale, F. Donkin, G. Roman, the Bisson brothers. who focused on the Alps. Around 1860, it was Garcin from Geneva who provided Swiss views for tourists. Johann Adam Gabler (1833–1888) in Interlaken did the same in alpine areas beginning in the 1860s just as Romedo Guler (1836–1909) in Davos would do in the Grisons a decade later.

Carl August Koch's (1845–1897) alpine photographs attracted attention in the National Exhibition of 1896 in Geneva.

Even if the Charnaux brothers took pictures in the Alps, they are better known for the very broad selection of views of Switzerland they offered in the 1870s and 1880s, thus anticipating the industrial ventures of the firms Schroeder & Cie, Photochrom (later Photoglob after the fusion with Schroeder in 1895) and Gebrüder Wehrli, which merged into Photoglob in 1924. These tree companies flooded the market with commercial images of all areas of the country. Whereas the brothers Wehrli produced only black and white pictures, Photochrom specialized in polychrome photolithographs taken by its anonymous operators all over the world and sold to an increasingly picture-hungry international audience.

SYLVIE HENGUELY

See also: Bisson, Louis-Auguste and Auguste-Rosali; Braun, Adolphe; England, William; Niépce de Saint-Victor, Claude Félix Abel; Sommer, Giorgio; Frith & Co, Photoglob Zurich /Orell Fussli & Co; Itinerant Photographers; Tourist Photography; Civiale, Aime; Delessert, Edouard and Benjamin; Isenring, Johann Baptist; Martens, Friedrich; and Rossier, Pierre.

Further Reading

Im Licht der Dunkelkammer. Die Schweiz in Photographien des 19. Jahrhunderts aus der Sammlung Herzog, Basel: Christian Merian Verlag, 1994.

La photographie en Suisse. 1840 à nos jours, Berne: Benteli, 1992.

René Perret, Frappante Aehnlichkeit. Pioniere der Schweizer Photographie. Brugg: Bilder der Anfänge, BEA + Poly Verlag, 1991.

Switzerland, History of Photography, Guest Editor Martin Gasser, vol. 22, nr. 3, Autumn 198.

Du, June 1952, Nr. 6, 12. Jhg, Frühe schweizerische Photos

Industriebild. Der Wirtschaftsraum Ostschweiz in Fotografien von 1870 bis heute, Hrsg. Giorgio Wolfensberger und Urs Stahel, Werd Verlag, Zürich 1994

Bréguet, Elisabeth. 100 ans de photographie chez les Vaudois 1839–1939, Lausanne: Payot, 1981.

Il Ticini i suoi fotografi. Fotografie dal 1858 ad oggi, Berne: Benteli, 1987.

Auer, Michèle. Catherine Santschi, Jean Gabriel Eynard. Au temps du daguerréotype, Genève 1840–1860, Ides et Calendes, Photoarchives 4, Paris: Neuchâtel, 1996.

——. Gilbert Coutaz, Samuel Heer. Au temps du daguerréotype, Lausanne 1841–1860, Ides et Calendes, Photoarchives 9, Paris: Neuchâtel.

——. Alain, Fleig, Paul Vionnet. Au temps du calotype en Suisse romande, Ides et Calendes, Photoarchives 15, Paris: Neuchâtel, 2000.

Marianne Blattner-Geissberger, Gysi. Pioniere der Fotografie, 1843–1913, Baden: Hier + Jetzt, 2003.

Wider das Leugnen und Verstellen. Carl Durheims Fahndungsfotografien von Heimatlosen 1852/53, Hrsg. von Martin Gasser, Thomas Dominik Meier, Rolf Wolfensberger, Fotomuseum Winterthur und Offizin Verlag, Zürich, 1998.

Basel. Archiv Höflinger, Edition Schmid, Ennetbaden 1987 mit Text von Bruno Thüring.

Girardin, Daniel; Anne Leresche, and André Schmid (1836–1914), Lausanne: Musée de l'Elysée/Musée historique de Lausanne, 1998.

La famille Deriaz. Five generations of Swiss Photographers, Edition Stemmle, Schaffhausen 1988, with a preface by Charles-Henri Favrod.

Boissonnas, Nicolas Bouvier. Une dynastie de photographes 1864–1983, Lausanne: Payot, 1983.

SZATHMARI, CAROL POPP DE (1812–1887)
Romanian portrait photographer

The Romanian photographer Carol Popp de Szathmari was born in Transylvania and moved to Bucharest by the age of eighteen. He trained in art, and embarked

on a career as a court painter before taking up the daguerreotype c.1844 and establishing himself as a portrait photographer. By 1848 he was using albumen-on-glass. By the early 1850s, he was working with collodion.

Szathmari took his camera to war a full year before Fenton, photographing the early months of the Crimean conflict along the River Danube. He also reportedly had a horse-drawn darkroom van with him, and, like Fenton, found himself under fire.

Unlike Fenton and others, whose photography was unashamedly partisan, Szathmari's political contacts enabled him to photograph the war from both sides. Thus his images showed the Russian troops and their fortified positions as well as Turkish units, field hospitals and military leaders. It was while working at a Russian field hospital that he came under fire from the Turkish artillery.

After the war, Szathmari compiled albums containing 200 images from the campaign which were widely acclaimed throughout Europe. Amongst the reported recipients of copies of the album were Napoleon, Queen Victoria, the Emperor of Austria, and the pianist Franz Joseph Liszt. The images were exhibited at the Exposition Universelle in Paris in 1855.

He also photographed the Turkish-Russian-Romanian War of 1877 at age 65.

JOHN HANNAVY

T

TABER, ISAAC WEST (1830–1912)

Isaac West Taber was born in New Bedford, Massachusetts on August 17, 1830. In 1854, Taber opened a daguerrotype studio in the town, and with his brother Freeman Augustus Taber, subsequently ran a studio in Syracuse, New York, 1857–1864. Taber then moved to San Francisco, operating on behalf of Bradley & Rulofson until opening his own gallery in 1871. He took over Carleton Watkins Gallery in 1876.

Taber exhibited prominently in the 1877 San Francisco Art Association show, and the Mechanics' Institute Exhibition in 1880. In 1880, he published *Photographic Album of Principal Business Houses, Residences and Persons*, as a promotional venture, and photographed Kalakaua, King of Hawaii during a Pacific cruise. In 1885 Taber developed a method for enlarging and printing fingerprints, and opened a factory for dryplates. In 1894 Taber obtained exclusive rights to photograph within the grounds of the San Francisco Midwinter Fair, and in 1897 opened a branch of the Taber Bas Relief Photographic Syndicate in London.

Taber's studio was totally destroyed in the San Francisco earthquake of 1906, including 80 tons of portrait negatives. He died at his home in San Francisco on February 22, 1912.

DAVID WEBB

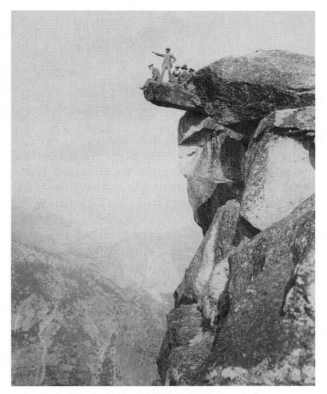

Taber, I. W. Glacier Point 3,201 feet, Yosemite, Cal.
The J. Paul Getty Museum, Los Angeles © The J. Paul Getty Museum.

TABLEAUX

The tableau is a combination of visual and theatrical arts, consisting of costumed figures arranged in static poses so as to create the effect of a picture. In the nineteenth century, the tableau vivant, or living picture, imitating a well-known work of art or literary passage, was tremendously popular both as a private amusement and as public entertainment. In their most elaborate form, carefully posed and lit tableaux were staged behind large gilt frames, covered with a layer of gauze that imitated the effect of varnish on an old painting (Stevenson, 45). Tableaux flourished during photography's first half-century, especially in Britain, where the two phenomena, tableaux and photography, often coincided. Not only did figures holding still in a tableau lend themselves to being photographed, but to make an artistic or pictorial photograph with figures, one in effect had first to construct a tableau.

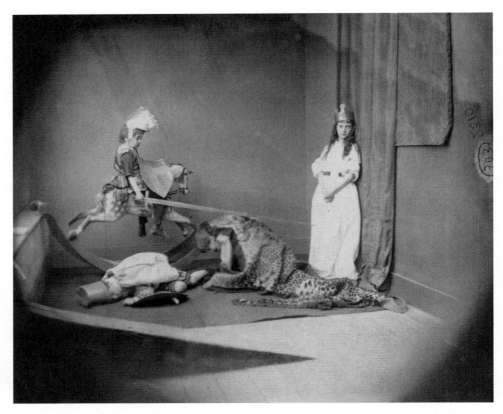

Carroll, Lewis. Tableau with Xie Kitchin as the Damsel in distress with St. George and the Dragon.
The J. Paul Getty Museum, Los Angeles © The J. Paul Getty Museum.

With roots in medieval and Renaissance pageants, the modern tableau emerged in the eighteenth century. In his writings on the theater of the 1750s and 1760s, Denis Diderot argued that stage productions should create emotional and moral effect like the best painting of the day by presenting deliberate tableaux at critical moments in the drama. In Naples in the late eighteenth century, Lady Emma Hamilton famously assumed frozen "attitudes" after figures on Greek vases and ancient statues. This activity would soon be echoed in a music hall entertainment, the *pose plastique*, where partially dressed figures assumed positions suggesting classical statuary (Stevenson, 57). In 1809, Goethe prominently featured the practice of staging tableaux vivants in his novel *Elective Affinities*. Tableaux vivants became especially popular in Great Britain when the Scottish painter Sir David Wilkie, having witnessed in a German theater a tableau after a painting by David Teniers, began arranging figures after famous paintings and literary works. In his most well known examples, based on the stories of Sir Walter Scott, Wilkie constructed elaborate scenes requiring weeks' preparation, all for brief performance (Stevenson, 46). The amusement of staging tableaux was enjoyed among the highest classes of British society, including the royal family.

In 1845 David Octavius Hill and Robert Adamson photographed a number of tableaux after Scott featuring medieval costumes, using as models friends who were practiced in the art of assuming characters and holding poses from having enacted tableaux. These works related both to literary painting of the day and to the contemporary craze for tableaux vivants. They also helped to initiate a trend of fictional photographs in which groups of two or more figures enact a scene for the photographer. As with tableaux, such images might refer to historical or allegorical themes, or to recognizable moments from everyday life.

William Lake Price, who created elaborate costume photographs after literary sources such as *Don Quixote* and *Robinson Crusoe* in the mid-1850s, noted the difficulty of photographing figure groups, attempts at which marked much ambitious art photography in the Victorian era. When O.G. Rejlander produced his intricate composition photograph *The Two Ways of Life* in 1857, he was trying to exceed the limitations of photography in rendering complex figural arrangements, by combining a number of discrete tableaux into a larger scene that itself resembled an elaborate tableau vivant. It has often been noted that Rejlander employed professional models from a troupe of *pose plastique* actors, accustomed to partial nudity and long poses, for *The Two Ways of Life*, and it has been suggested that some of the negative criticism directed toward the work may have derived from the picture's associations with the "debased art form" of commercial tableaux vivants and *poses plastiques* (Daniel, 15).

Rejlander more directly copied specific paintings in a number of studies, made after the old masters, in which, wrote the critic A.H. Wall in *The Photographic News* of 31 December 1886, "he selected models, illuminated,

and posed them in imitation of some of the grandest masterpieces in the public galleries, and then photographed them" (Wall, n.p.). Wall recommended this practice as the best training for an aspiring art photographer, who, like Wilkie with his tableaux, needs to know how to make pictures out of living models. The problem of the imperfect model as opposed to the idealized figures of painting was often noted in mid-century photographic criticism, suggesting that photographs of pictorial or literary subjects were tainted by the intermediate step of needing to construct a tableau with real people as actors. At the same time, however, there was quite a vogue in British photography for just such images among professionals and amateurs alike.

Both Henry Peach Robinson and Lewis Carroll frequently staged scenes that were meant to conjure up paintings or that made literary reference. Whereas Robinson's efforts are professional in the extreme, using hired models and carefully constructed scenarios, Carroll's tableaux involving children, such as *St. George and the Dragon*, ca. 1874, are notable for their playful, amateurish quality. For her *Studies* of the 1860s, Viscountess Clementina Hawarden, while spurning period costumes and props, posed her figures in attitudes reminiscent of paintings as well.

A new dimension was added to the photographic tableau with the advent of stereoscopic photography. From the 1850s through the 1880s and beyond, narrative tableaux became a staple of commercially published stereographic cards internationally. This hugely popular form came to involve extensive story-telling sequences of photographic tableaux, common at the turn of the century (Henisch and Henisch, 70–77).

Among art photographers, perhaps the work of Julia Margaret Cameron most consistently and ambitiously incorporates the tableau. Her Madonnas and saints, allegorical figures, and subjects from poetry involve servants, family, or friends costumed and arranged in sometimes quite elaborate mises en scène. These works, enacted wholly for the camera, often allude to the amateur theatrical, with spare, makeshift stages and distinctly non-professional actors. For one of her last and most involved projects, Cameron in 1874 spent several months, and enlisted dozens of models, to produce twelve large-scale photographic images of Arthurian subjects to illustrate a volume of her friend Alfred Lord Tennyson's *Idylls of the King* (Bajac, 5). Critics and historians in the mid-twentieth century would condemn such works of the Victorian art photographers as misguided attempts to produce "imitation paintings," preferring, in the case of Cameron, her simple and direct portraits to her fanciful literary scenes. With the shift to a postmodern aesthetic in the late twentieth century, however, the practice of staging fictional scenes again came into prominence in photography, and with

it a renewed appreciation for the role of the tableau in nineteenth-century photography.

STEPHEN PETERSEN

See also: Art photography; Cameron, Julia Margaret; Dodgson, Charles Lutwidge (Carroll, Lewis); Genre; Hawarden, Viscountess Clementina Elphinstone; Hill, David Octavius, and Adamson, Robert; Rejlander, Oscar Gustav; and Robinson, Henry Peach.

Further Reading

Bajac, Quentin., *Tableaux Vivants: Fantaisies Photographiques Victoriennes (1840–1880)*, Paris: Éditions de la Réunion des Musées Nationaux, 1999 (exhibition catalogue).

British Photography in the Nineteenth Century: The Fine Art Tradition, edited by Mike Weaver, Cambridge: Cambridge University Press, 1989.

Daniel, Malcolm, R., "Darkroom Vs. Greenroom: Victorian Art Photography and Popular Theatrical Entertainment." *Image* vol. 33, no. 1–2 (Fall 1990): 13–20.

Henisch, Heinz K., and Bridget A. Henisch, *The Photographic Experience, 1839–1914: Images and Attitudes*, University Park, The Pennsylvania State University Press, 1984.

Meisel, Martin, *Realizations: Narrative, Pictorial, and Theatrical Arts in Nineteenth Century England*, Princeton, NJ: Princeton University Press, 1983.

Sieberling, Grace, and Carolyn Bloore, *Amateurs, Photography and the Mid-Victorian Imagination*, Chicago: University of Chicago Press, 1986.

Stevenson, Sara, "Tableaux, Attitudes and Photography" in *Van Dyck in Check Trousers: Fancy Dress in Art and Life, 1700–1900*, 45–63. Edinburgh: Scottish National Portrait Gallery, 1978..

Wall, A.H., "Rejlander's Photographic Studies—Their Teachings and Suggestions (Reprinted from *The Photographic News*, vols. 30–31), London, July–February, 1886–1887" in *The Photography of O.G. Rejlander: Two Selections*, edited by Peter C. Bunnell, New York: Arno Press, 1979.

TAFT, ROBERT (1894–1955)

Born of missionary parents in Japan in 1894, Robert Taft grew up in the U.S. After receiving a B.A. in history in 1916 and a Master's in 1919, he joined the University of Kansas where he obtained a Ph.D. in chemistry (1925) and taught chemistry until his death in 1955. An amateur of art and history, Taft was drawn to photographic history upon realizing, around 1932, that no existing book would satisfy his curiosity about early photography in the American West. He started amassing information by exploring the 19th-century press and writing old-timers and local historical societies. Out of this enormous personal effort came a series of articles in Kansas and other Western magazines, followed by his masterful *Photography and the American Scene: A Social History 1839–1889* (1938), the first comprehensive history of American photography, which has become a classic of the socio-cultural history of the medium. Along with many lesser publications on photographic history he also

made a major contribution to Western American cultural history with his Artists and Illustrators of the Old West (1955). The extensive collection of Taft's papers at the Kansas State Historical Society is a major resource for further understanding of this often underestimated photo-historian.

FRANÇOIS BRUNET

TALBOT, WILLIAM HENRY FOX (1800–1877)

William Henry Fox Talbot, photographic inventor, mathematician, etymologist, Assyriologist, and botanist, was born 11th February 1800 at Melbury in Dorset, the home of his maternal grandfather, Henry Thomas Fox-Strangways, the 2nd Earl of Ilchester. His father, William Davenport Talbot (1764–1800), was a Captain in the 88th Foot Regiment. His mother, Lady Elisabeth Theresa (née Fox Strangways) (1773–1846) was the daughter of the 2nd Earl of Ilchester and his first wife Mary Theresa.

When Talbot was five months old his father died leaving him the Lacock Abbey estate and over £30,000 in debt. In order to pay back these debts, Lacock Abbey had been let out to the Countess of Shrewsbury starting in 1795, and after her death in 1810 to John Rock Grosset, the local Member of Parliament. Talbot spent his youth living in a variety of relative's homes or away at boarding school. It wasn't until Talbot reached the age of 27 that he finally took possession of the Abbey and began to make it his home. In 1804, Talbot's mother married Captain Charles Feilding (later Rear Admiral). His attention both to the Lacock estate and to his stepson brought stability to both. Talbot's mother and Feilding had two daughters, Caroline Augusta (1808–1881, later Lady Mt Edgcumbe), and Henrietta Horatia Maria (1810–1851, later Henrietta Gaisford), who both showered affection on Talbot and influenced him with their artistic interests and talents.

Education

Talbot's earliest educational experiences were, certainly, at his mother's knee. Her knowledge of languages and the essentials of the classics, frequently presented in the form of games, was the foundation of Talbot's tutelage. Long periods during his childhood spent at Penrice, his aunt's home in the Welsh countryside, collecting shells, stones and plants initiated Talbot's life-long interest in the natural sciences, especially botany. His mother and stepfather's frequent trips on the continent also gave the young Talbot a broader view of life and put him in contact with important people.

From the age of eight, Talbot was a boarding student of the Reverend Thomas Hooker's school at Rottingdean in Sussex. Here he expanded his knowledge of Latin and French while reading and translating literary works, also continuing his interest in botany.

From age 11, Talbot attended Harrow, living in the Head Master's House under the watchful eye of the Reverend George Butler, a man he highly respected. This seemed a most satisfactory time for Talbot who made many friends, took part in sports and, with his friend Walter Calverley Trevelyan, went in search of botanical specimens culminating in a handwritten book on the 'Flora of Harrow.'

After leaving Harrow at the top of his class, but still too young to enter university, Talbot was tutored first by the Reverend Theophilus Barnes at Castleford, Yorkshire, and second by the Reverend Thomas Kaye Bonney at Normanton in Rutlandshire.

Talbot's years at Trinity College Cambridge (1817–1821) were centred on a passionate interest in mathematics, which, at that time, was seen as one of the consuming interests of Cambridge itself. In order to get a first class BA, a student had to sit for the 'Tripos,' then the most demanding and prestigious examinations in the country. Talbot received his first class BA and was named 12th Wrangler, disappointing his mother who had hoped he would be named Senior Wrangler. Talbot proceeded MA in 1825.

> Far from excelling only in mathematics, Talbot also received the Porson prize for his Greek Iambic translation of Macbeth, and the second Chancellor's Classical Medal.

Family Life

In December 1832, Talbot married Constance Mundy of Markeaton Hall in Derby. Their marriage took place at All Souls Church in Langham Place, London. They had four children: Ela Theresa (dsp), Rosamond Constance (dsp), Charles Henry (dsp) and Matilda Caroline who married John Gilchrist Clark of Scotland.

First Experiments

In the first fascicle of Talbot's Pencil of Nature published in 1844, he writes of the epiphany that led him to the discovery of photography. In the opening pages he relates:

> One of the first days of the month of October 1833, I was amusing myself on the lovely shores of the Lake of Como, in Italy, taking sketches with Wollaston's Camera Lucida, or rather I should say, attempting to take them: but with the smallest possible amount of success. For when the eye was removed from the prism—in which all looked beautiful—I found that the faithless pencil had only left traces on the paper melancholy to behold.

He considered using the camera obscura for drawing, as he had on earlier trips to the continent, but this too

Talbot, William Henry Fox. The Open Door. *The Metropolitan Museum of Art, Gilman Collection, Purchase, Joseph M. Cohen and Robert Rosenkranz Gift, 2005 (2005.100.498) Image © The Metropolitan Museum of Art.*

required some previous drawing skill on the part of the amateur artist.

> It was during these thoughts that the idea occurred to me... how charming it would be if it were possible to cause these natural images to imprint themselves durably, and remain fixed on the paper!

Talbot's first experiments, beginning in the spring of 1834, involved coating common writing paper with silver nitrate both alone and in combination with sodium chloride. Too slow for use in a camera obscura, his first images were sunprints created by placing botanical specimens onto the sensitive paper and exposing it to the sun. The greater challenge he faced was that once the paper had been made sensitive to light and an image was formed, it was necessary to somehow halt this sensitivity so that the image would remain. Although creating paper sensitive to light was straightforward, and was known to have been achieved as early as 1800 by Thomas Wedgwood, the inability to halt the sensitivity meant that images would continue to print out until the paper was black.

In examining early prints, Talbot noticed that some areas appeared more light sensitive than others. He attributed this to varying proportions of sodium chloride to silver nitrate. Further experiments showed that less sodium chloride made the paper more sensitive to light. He reasoned from this that if a light coating of sodium chloride made sensitive paper, it could then be desensitised or stabilised by soaking the finished print in a bath of saturated sodium chloride.

Sciagraphs or Photogenic Drawings

To make the paper sensitive enough to be used in the camera obscura, he found that multiple coatings of silver nitrate and sodium chloride would increase the sensitivity to an extent that exposures could be made in one of several small, crude box cameras fitted with microscope eyepiece lenses that were made for Talbot and his experiments. Exposures were long as he was still relying on the action of light alone to bring out the image. He had not yet discovered the latent image.

He began writing up his results in late 1838 for presentation to the Royal Society. However, in January 1839 word came from Paris that a Frenchman named Louis Daguerre had also created a photographic process, although no details were published on the actual process itself. Fearing that his labour in developing this process might be in vain should Daguerre's process turn out to be identical to his, Talbot pulled together the samples that he had made previously and on 24th January, Michael Faraday exhibited them at the Royal Institution. On the 31st of January, Talbot's paper 'On the Art of Photogenic Drawing' was read to the Royal Society in London. He then revealed the full working method of the process in a letter read to the Royal Society on the 21st of February. When Daguerre's process was disclosed in August of 1839, it revealed that there was no overlap between the two processes. The strong support for Daguerre by the government of France and the French scientific community, combined with the fact that the daguerreotype was made to be used in a camera, meant that Talbot's process was obscured in the press and public discourse.

Calotype Process

Talbot continued with his experiments attempting to make the paper sensitive enough to be easily used in a camera and trying different methods for fixing the image after exposure. His friend, Sir John Herschel, recommended the use of 'hyposulphite of soda' as the best fixing agent and after some months of experiments, Talbot began to use that for the vast majority of his work. The photogenic drawing process was successful as far as it went, but Talbot took a large leap forward in his work when he discovered in September 1840 that a short exposure to light was enough to create a latent image on the paper which could then be brought out by chemical development. This single change brought exposure times down from minutes or hours to seconds.

More than an improvement on Photogenic Drawing, the Calotype was virtually a new process. Although he had given his Photogenic Drawing process free to the world, through the urging of his mother and his friend Sir David Brewster, Talbot took out a patent on the calotype. The restriction of this patent, along with the widespread public delight about the daguerreotype, was blamed for slowing further development of photography on paper during the 1840s. Frederick Scott Archer's introduction of photography on glass in 1851 was the first serious commercial challenge to the daguerreotype and was quickly taken up by photographers in England. Talbot believed that the basic concept of Archer's process differed little from his calotype process. In 1852, at the urging of the Royal Society and the Royal Society of Arts, Talbot relinquished his patent rights for all amateurs, scientists and artists with the exception of commercial portraiture, which he felt he had to retain to protect the business of those who had already taken out a license from him.

In 1854, Talbot brought suit against a photographer named Martin Laroche (real name William Henry Sylvester) claiming that Laroche's use of the collodion process violated his patent rights. Although Talbot had the support of Sir John Herschel and Sir David Brewster, the judgment assigned Talbot credit as the inventor of the photographic process on paper, but ruled that Archer's process was outside his patent and was therefore available for public use.

Photoengraving

Talbot's desire to create images that were both reproducible and permanent was not to be found in silver printing processes. Talbot made his last photograph in 1846. His mother's death in 1846 and his prolonged illness throughout the late 1840s brought an end to his experiments using the calotype process. Although Talbot's experiments with photography ended in 1845, in the early 1850s he picked up his earlier researches on printing photographs by way of a printing plate and ink. By 1852 he had created his first successful photoengraving process, which he patented. Later changes brought about a greatly improved process, which he called Photoglyphic engraving, taking out a patent on it in 1858. These two photographic engraving processes were the foundation for photogravure printing.

Talbot's Later Years

From the mid 1850s until his death in 1877, Talbot turned much of his intellectual energy to deciphering Assyrian cuneiform tablets held by the British Museum. Along with Sir Henry Rawlinson and George Smith of the British Museum, Talbot was one of the major translators of this previously unintelligible script.

In 1863, Talbot was awarded an honourary Doctor of Laws degree from Edinburgh University for his "pre-eminence in literature and science, and the benefits that his discoveries have conferred on society.

Talbot died in his study at Lacock Abbey on the 17th September 1877 and was buried in the cemetery at Lacock. His entire estate, including all of his photographs and scientific notebooks, were left to his son Charles Henry. When Charles died in 1916 he left everything to his niece Matilda Gilchrist Clark who then changed her name to Talbot. She was a great promoter of her grandfather's work and it was through her that large collections of his work were lodged with the Science Museum (now at the National Museum of Photography, Film and Television) and the Royal Photographic Society with smaller collections given to the Smithsonian. In 1944, Matilda donated Lacock Abbey and its estates to the National Trust. The contents of the house, including his photographs and papers remained with the family and are now in the William Henry Fox Talbot Trust collection.

Although usually referred to as Fox Talbot in both contemporary and modern texts, he preferred Talbot and usually signed himself Henry F Talbot or HF Talbot. The use of H Fox Talbot Esq. on the title page of *Pencil of Nature* is probably the origin of this use of the family name.

In addition to a number of published articles and pamphlets on mathematics and other subjects, Talbot also published seven books: *Legendary Tales in Verse and Prose* (1830); *Hermes or Classical and Antiquarian Researches* (vol. 1 1838, vol. 2 1839); *The Antiquity of the Book of Genesis—Illustrated by Some New Arguments* (1839); *The Pencil of Nature* (published in fascicles from June 1844 to April 1846); *Sun Pictures in Scotland* (1845); *English Etymologies* (1847).

ROGER WATSON

See also: Archer, Frederick Scott; Brewster, Sir

David; Daguerre, Louis-Jacques-Mandé; Faraday, Michael; Herschel, Sir John Frederick William; Wedgwood, Thomas; Royal Photographic Society; Societies, groups, institutions, and exhibitions in the UK; Illustrated Books illustrated with photographs: 1840s; Books and manuals about photography: 1840s; Great Britain; Developing; Exposure; Fixing, Processing and Washing; Latent Image; Light-Sensitive Chemicals; Paper and Photographic Paper; Calotype and Talbotype; Photogenic Drawing Negative; Wet Collodion Negative; Daguerreotype; Salted Paper Print; Camera design: 1. 1830s–1840s; Court Cases and Photography; History: 1. Antecedents and proto-photography up to 1826; History: 2. 1826–1839; History: 3. 1840s; History: 4. 1850s; Patents; Laroche, Martin; and Wollaston, William Hyde.

Further Reading

Arnold, H. J. P., *William Henry Fox Talbot: pioneer of photography and man of science,* 177.
Buckland, G., *Fox Talbot and the invention of photography,* 1980.
Schaaf, L. J., *Out of the shadows: Herschel, Talbot and the invention of photography,* 1992. (From Original Manuscript material belonging to the William Henry Fox Talbot Trust.)
Dictionary of National Biography, entry by L.J. Schaaf, 2003.

TAUNT, HENRY WILLIAM (1842–1922)

Henry Taunt was born in Oxford, and at the age of 14 was apprenticed to portrait photographer Edward Bracher. When Bracher sold the business in 1863, the new owners retained Taunt as manager, but four years later he left to establish his own studio.

One of his first publishing ventures in the late 1860s was the first photographically illustrated guide to the River Thames—later to be followed by over fifty other publications. The second edition of his *New Map of the River Thames,* published in 1873, was illustrated with eighty original photographs and hand tipped onto the pages. Talented at self-promotion, he generated demand for his work by giving lantern-slide lectures throughout the area.

Using wet collodion during the early years of his career, he is reputed to have carried all his equipment, materials, and darktent on a small boat as he explored the river.

In addition to illustrated books, Taunt & Co. published many albums of views of the Thames and the surrounding areas.

Taunt was politically active throughout much of his career, and in 1880 became involved in a campaign to improve Oxford's water supply, at a time when it was reportedly possible for live shrimp to be delivered through the cold water tap. He participated in this cause by threatening to photograph the shrimp and publish the images.

JOHN HANNAVY

TAUPENOT, JEAN MARIE (1822–1856)

Originally from Givry, in Burgundy, Jean Marie Taupenot was born the 15th August 1822. He studied physics and biology. His work about Montpellier and the Cevennes's geology (south of France) gave him the doctor graduate in natural science in 1850.

He became professor of physics, first in Romans (in the south of France), then in Chaumont (in the Champagne area).

Eventually, he was named professor of physics and chemistry in the military high school of La Flèche, the Prytanée Impérial Militaire in 1853. There began his interest in photography: he setted up in this school the laboratory where he worked the next three years.

He invented and revealed to the Société française de photographie a dry collodion process in 1855, to which he gave his name. At this time, he became involved in this society.

The same year he presented to the French Academy of Sciences a little photographic device called "chercheur photographique" or a photographic view finder.

After his wedding in 1856, he carried on his researches in geology and natural sciences, inventing a wind gauge.

Jean Marie Taupenot died the same year, at the age of thirty-two, the 15th October, in La Flèche.

Jean Marie Taupenot was not a professional photographer, he was a scientist involved in photography by passion.

The photographic process invented by Taupenot gave to the unknown professor a world-wide acknowledgement. At this time, the best photographic technique was the Wet-plate or collodion process, an invention of several persons, especially Frederick Scott Archer, an English photographer, and Gustave Le Gray, in 1851. The negative was on a glass plate coated with collogion, a mixture of guncotton and ether. It was quite fast (only a few seconds to pose), but all the process had to be fulfilled before the complete drying of the glass plate. Practical for photographic studios, it was very complex to take photographs outside.

For this kind of photographs, another useful process was the negative albumen process proposed by Niepce de Saint-Victor in 1847. The glass plate was coated with iodide and bromide of potassium.

Jean Marie Taupenot used to employ both processes, wet collodion and albumen, but "he was impatient of the slowness of the albumin and perhaps more of the defect of solidity of collodion" ("il était impatienté des

lenteurs de l'albumine et plus encore peut-être du défaut de solidité du collodion," extract from the *Bulletin de la Société française de photographie,* 1855, 234). The unique solution the photographer had found, was to put varnish on the negative plate poured with wet collodion to give them stability. However, this result was expensive and not easy for people who were living in the countryside as was Taupenot (la Flèche is about 300 km far from Paris).

That is the reason that he had the idea to combine both techniques. As the main principle, he substituted the varnish with albumen, a nitrogenous substance found in egg white, making it less costly and easier to obtain.

As an amateur photographer, Taupenot's research was a great help to other photographers. He did not patent his process, making it freely available to all, but he was aware of its importance. He created an album of photographs that he presented and offered to the emperor Napoleon the Third, who decided to add his pictures to the Exposition Universelle in Paris the same year. The scientist even won a bronze medal for his work.

In this album, the photographs presented the procession of the Fête-Dieu (in June), in the Prytanée: the students in the gymnasium, the chapel of the School, the Library, the Laboratory, the garden and the park. As a matter of fact, he had to prove that his process could be used inside as well as outdoor.

A professional chemist and physician, he was looking for the acknowledgement of his colleagues: that is the reason he presented his discovery to the French Academy of Sciences. One of the most important scientists of this time, Michel Eugène Chevreul (1786–1889), made the report about it.

At the same time, he described his process before the members of the Société française de photographie, in September 1855. He brought with him several samples of photographs made with his technique in order to show the good quality of images he obtained. A commission constituted of MM. Bayle-Mouillard, Bayard, Humbert de Molard, Fortier and Fierlants, was gathered to test the invention.

The Taupenot process consisted of a classical collodion preparation sensitized with iodide of ammonium, to which he added a mix of fermented albumen, honey, iodide of potassium, and water with brewer's yeast.

Taupenot coated the glass with the collodion, as the photographer used to do, and he washed it with water. Then he poured the collodion glass with the albumen and drained it off until the albumin was dry. To sensitize the plates and use them, the photographers had to put them in a bath of aceto-nitrate as used for the classical albumen process. The scientist used the gallic acid, a classic modus operandi in the 1850s, to reveal his negatives.

With this process, the glasses could be exposed more than one month after their preparation.

The most important problem with the collodio-albumen technique was the exposure. It required a longer time exposure than the collodion-based one (sometimes eight times more). The photographs he showed at the French Photographic Society were obtained with an exposure time between six seconds and one minute, making this technique perfectly suitable for representing still life, landscapes and architectures, but not fast enough to be used for portraits. The quality of the photographs was as subtle and delicate as with the albumen process.

The notice of this discovery was spread all over the world, relayed by the newspapers specialized in photography and the photographic societies. This process has been used by many photographers particularly from Austria, the French Louis Alphonse Davanne and Alphonse François Jeanrenaud, among others. Several names were given to the Taupenot's technique: collodio-albumen process, dry plate process, Taupenot process, albumenised collodion.

The apex of the Taupenot process was between the middle of the 1850s and the 1870s. By these times, different people were looking for a better technique than the wet collodion process and tried to dry the coated mix. Such attempts include Fothergill's process invented in 1856, the tannin process of Major Russel in 1861, and Bolton & Sayce's process, which added silver-bromide to collodion. However, Taupenot's walked away the support of the amateur photographers.

In the same spirit of this first invention, the simplification of the photographic technique, Jean Marie Taupenot also presented to the French photographic society, in January 1856, a little device everyone could realize, that he named "chercheur" (researcher). It looked like a small cork tube pierced with a round hole at one extremity and a square hole at the other extremity. This last hole should have the same ratio as the negative glass. In fact, it had the same purpose that the "iconometer": finding the best position to give to the camera.

Taupenot's photographs were not particularly worthy for their aesthetics: he was an amateur and his practice was mostly a validation of his chemistry research on photography. Unlike other chemists, he never advertised his work by publishing books, and these pictures are the sole testimony of his studies. They are conserved in the Bibliothèque Nationale de France and the French Photographic Society.

MARION PERCEVAL

See also: Wet Collodion Negative; Archer, Frederick Scott; Le Gray, Gustave; Niépce de Saint-Victor, Claude Félix Abel; Chevreul, Michel-Eugène; Bayard, Hippolyte; Humbert de Molard, Baron Louis-Adolphe; Krone, Hermann; Davanne, Louis-Alphonse; Expositions Universelle, Paris (1854, 1855, 1867 etc.) and Sayce, B.J.

Further Reading

Modification apportée au procédé de photographie sur collodion, *Comptes-rendus hebdomadaires des séances de l'Académie des sciences*, vol. 40, 1153, 1855.

Rapport sur deux procédés photographiques de M Taupenot, Rapporteur M. Chevreul, *Comptes-rendus hebdomadaires des séances de l'Académie des sciences*, vol, 41, 383, 1855.

Bulletin de la Société française de photographie, Paris: Société française de photographie, vol, 1 (1855): 233–253.

Bulletin de la Société française de photographie, Paris: Société française de photographie, vol. 1 (1855): 279–282.

Lacan Ernest, *Esquisses photographiques*, 111–113, Paris: Grassart, 1856.

TAYLOR, A. & G.
Company

Andrew and George Taylor founded a highly successful string of photographic studios which capitalized upon the 1860s craze for collecting and commissioning portrait photographs. They were previously engaged in the production of miniatures and like many others in this trade they made the transition to photography. Their first photographic studio was opened in London around 1864 with an address at 11 Cannon Street West. They were soon to establish branches outside London and numbered the following locations among their outlets: Birmingham, Carnarvon, Glasgow, Leeds, Liverpool, Manchester, Newcastle and Dublin. They also opened further studios in America including New York, Boston, Pittsburgh, Philadelphia, Chicago, and Newark. A Paris studio was opened some time after 1879. In adevertisements and upon the reverse of photographs they regularly claimed to be the 'Largest Photographers in the World.'

In 1882, a detailed account of their central operations at Forest Hill, London was given by H. Baden Pritchard in his publication entitled *The Photographic Studios of Europe*. Here a large number of staff, many of them female, were engaged in processing and printing the images which were sent to London from the firm's branches throughout England. The account took the form of a guided tour given by the works manager, Mr Smith. This factory demonstrated a strict division of labour with entire floors of the immense building being designated to particular tasks, for example, the Enlarging Room. Daily targets were set for the employees who worked on assembly lines. Taylor's success may have stemmed from their centralized approach to production which utilized high quality equipment such as lenses by Dallmeyer. In Dublin they were the first photographic studio to establish an instalment method of paying for photographic portraits. It is probably through the introduction of such shrewd business methods that they were able to sustain successful studios in a multitude of locations.

It is also thought that the basis of the company's success was the sale of many copies of a carte-de-visite of Queen Victoria and Princess Alexandra. The publication in 1860 of a set of royal portraits started a fashion in Britain for collecting carte-de-visite portraits of famous people. Though the validity of Taylor's claim to royal patronage may be in question as the company lost a court case in 1884 for illegally representing themselves as photographers to the Queen, which was a matter widely reported in the photographic press of the time. Like other portrait studios they utilized the verso of carte-de-visites and cabinet portraits to name royal customers and to boast of medals awarded at the many international exhibitions which took place during this period. Taylor's exhibited at numerous exhibitions including the Edinburgh Photographic Society's show of 1890.

The firm was also engaged in the production of photographic furniture. This consisted of the many studios props that appeared in the background of carte-de-visites and cabinet cards. Their advertisements offered items such as posing chairs, ornate cabinets and head rests. The need for such a service was indicative of the increased popularity of the studio portrait. It also explains the sameness that was found in studio portraits of the era, where every sitter appeared in a refined middle-class setting. There was also evidence that they were involved in the production of postcards from 1901. Their premises at Hastings was used for this purpose from 1914 onwards where processes such as the Collotype, Albertype and the 'Lichtdruck' which was a variation on the Woodburytype, were employed.

During the period between July and October 1869 Andrew left the firm. However he is listed as the manager of the Head Office in Regent Street, London, in the 1880s. Throughout this period they employed a network of managers and the whole business seems to have been run somewhat on a franchise basis. Although George Taylor died in 1911, branches were to continue in business for many years afterwards.

ORLA FITZPATRICK

See also: Dallmeyer, John Henry & Thomas Ross; Cartes-de-Visite; Collotype; and Woodburytype, Woodburygravure.

Further Reading

'G Taylor, Obituary.' *British Journal Photographic Almanac 1913*, 571–572.

Matthews, Oliver, *The Album of Carte-de-Visite and Cabinet Card Portrait Photographs 1854–1914*, London: Reedminster Publications Ltd, 1974.

Osman, Colin, 'The Studios of A & G Taylor—The largest photographers in the world' in *PhotoHistorian Supplement*, March, 1996.

Pritchard, H. Baden, *The Photographic Studios of Europe*, London: Piper & Carter, 1882, 37–42.

TAYLOR, JOHN TRAILL (c. 1827–1895)

John Traill Taylor, born in Scotland's Orkney Islands, and the son of a watchmaker, went on to become one of the most influential figures in the emerging photographic press in Great Britain.

Moving to Edinburgh c.1845, initially working as an optician and watchmaker, he is believed to have written for several daily newspapers, and to have contributed to a number of scientific and optical journals.

In 1856 he founded a manuscript journal entitled *The Photographer* and three years later began his long association with *The Photographic Journal*, formerly the *Liverpool & Manchester Photographic Journal*. This became *The British Journal of Photography* (*BJP*) in 1860 and which he edited from 1864 until 1879, and again from 1886 until his death in 1895, also editing *The British Journal of Photography Almanac* during that latter period.

Taylor's interest in the practice of photography had started with the daguerreotype in the 1840s and continued throughout his life. He regularly communicated with William Henry Fox Talbot in the 1860s both on scientific issues, and in preparing an account of Talbot's life and work for the *BJP*. He resigned his editorship in 1879 intending to take up photography professionally, but by 1880 he had moved to the United States where he spent five years as Editor of *The Photographic Times*.

His influential writings on photography were reprinted in several journals in both Britain and America. Having purchased land in Florida planning to live there in his retirement, he died there suddenly in November 1895.

JOHN HANNAVY

TENISON, CAPTAIN EDWARD KING (1805–1878)
Irish

Tenison was a wealthy Irish landowner who was an early pioneer of the calotype and waxed-paper negative. He married the eldest daughter of the 1st Earl of Lichfield, Lady Louisa Anson, in 1838 and lived at Kilronan Castle, Roscommon. Tenison and his wife travelled to France and Spain in the early 1850s and in her 1853 journal *In Castile and Andalucia* Lady Louisa gives a humorous account of the interest her husband's suspicious 'Talbotype Apparatus' aroused amongst the locals.

Tenison exhibited various studies at the 1853 Dublin exhibition and joined the newly formed Dublin Photographic Society the following year. He showed four Spanish architectural studies from waxed-paper negatives in the 1854 Photographic Society's London exhibition and in 1855 ten views of chateaux, priories

and churches in Normandy. His large Spanish pictures were generally well received at the Dublin exhibition, the Photography Section Report jurors remarking on the prints' unusual warm-yellow and violet tints (from gold-toning), however it was suggested that they had too much contrast and could perhaps be improved by printing with the Blanquart-Evrard process. Tenison seems to have taken this advice on board and many of his later French views were produced by the French process.

IAN SUMNER

TERRIS, ADOLPHE (1820–1900)
French photographer

Adolphe Terris is best known for his photographs of the large-scale public construction projects that occurred in and around Marseilles, France in the early 1860s. Terris was born in 1820 in Aix-en-Provence to a family of craftsmen. Terris' first known commercial venture was a book store, which he opened in Marseilles in 1845. His interest soon turned to photography, however, and by 1856 he was working in a local photography studio in the port city. Terris was a founding member of the Société Marseillaise de Photographie in 1860, and in 1861 he had organized a photographic exhibition in his studio. In 1861 Terris also received his first commission to photograph the large civil engineering projects underway in and around Marseilles, on this occasion his subject was the extensive renovation of the Rue l'Imperiale. Between 1861 and 1875 the city commissioned Terris to document other aspects of their construction and modernization program, including the rehabilitation of the public roads and buildings, the harbor and waterfront. Terris' photographs serve as an important historical record of the transformation of the city of Marseilles. Several of his photographs were included in *Les Travaux Publics de la France*, which was published through the French Ministry of Public Works. Terris died in 1900.

MAXIM WEINTRAUB

TEYNARD, FÉLIX (1817–1892)
French, active in Egypt 1851–1852, photographer, civil engineer

Félix Teynard, a provincial civil engineer, completed an extensive photographic survey of Egypt during the course of a Nile voyage beginning in late 1851 and concluding in 1852. Working with the calotype process, Teynard made more than 160 paper negatives along the Nile from Cairo to the level of the Second Cataract. He completed what to date was the most thorough documentation of the recently cleared site of Abu Simbel, as well as extensive and systematic records of Karnak, Luxor, and Philae. Publication of Teynard's work began in 1853

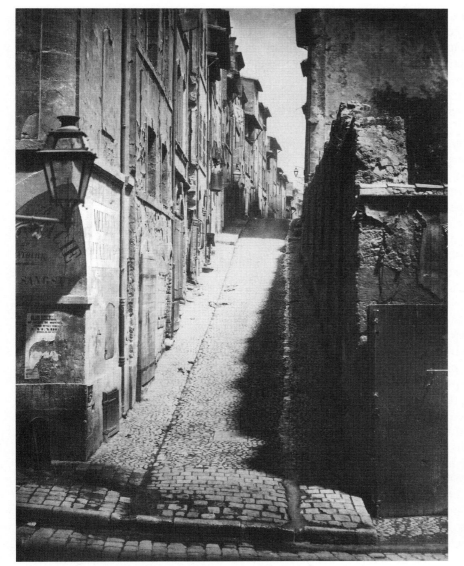

Terris, Adolphe. Rues des Grands
Carmes, Marselles.
*The Metropolitan Museum of Art,
Purchase, The Horace W. Goldsmith
Foundation Gift, 1995 (1995.171)
Image © The Metropolitan Museum
of Art.*

and culminated in 1858 with the two volume *Egypte et Nubie* containing 160 photographs. It is considered one of the masterworks of early travel photography. However, Teynard's project was not the first sustained photographic record of Egypt, nor was it the first lavish photographic publication based on the ruins along the Nile. Maxime DuCamp, traveling with Gustave Flaubert, had photographed along the same route in 1849–51. It was DuCamp's photographs, brought out by Gide et Baudry in 1852, that received attention and accolades as the first and extensive photographic record of the sites of ancient Egypt and the first photographically illustrated travel book. In January 1853, before Goupil began printing Teynard's photographs for distribution, DuCamp received the Legion of Honor in recognition of his photographic work.

Teynard's photographs epitomize the tensions inherent in early expeditionary photography: on the one hand, the acceptance of photography as the newest tool in the long effort to create accurate visual records of the world, the latest technological innovation in the long tradition of drawn and printed topographic views; and, on the other, a growing appreciation of the photograph's unique ability to capture and convey the sense of a place as experienced at the moment the photograph was made. In short, the tension between neutral record and the evocation of experience. Teynard's project must be seen as part of the drive to apply the new technology of photography to record the physical world, in this case the sites of ancient Egypt. From this perspective, photography, rather than a radical break with the past, was part of the continuum of strategies in the ongoing project to replicate and reproduce for publication views of the world, a project which began with the printing revolution of early modern Europe. Teynard embraced this view of photography as a complimentary technique to earlier modes of recording when identified his project in the subtitle of *Egypte et Nubie* as a "photographic atlas complementing the great *Description de l' Egypte*"—the massive multi-volume publication of

Napoleon's scholars. Yet he recognized the inherent difference in mediums—the engraved illustration as an idealized summation of multiple sketches and measurements versus the photograph as carrying the impress of the physicality of a place at a specific moment. He offered his photographs to his readers as the "records of his sensations" as he experienced the ancient sites of Egypt.

Both formally and intellectually, Teynard's work is connected to pre-photographic projects to order and record ancient Egypt. His work rests squarely on French scholarship begun by the cadre of scholars who accompanied Napoleon's Army of the Nile in 1798. The *Description de l'Egypte*, which included ten volumes of highly detailed engravings based on sketches and measurements made by the over 100 scholars and engineers, was the summation of the work of Napoleon's scholars. It offered an encyclopedic treatment of Egypt and became the foundational text in the developing discipline of Egyptology. Teynard's engagement with the *Description* was not perfunctory. His approach to complex sites such as Karnak and Philae was modeled on that in the *Description*. He provided site plans upon which he indicated camera positions and angles. Captions of photographs related the images to the site plan. Where possible, he photographed structures from vantage points that replicated the illustration in *Description*. Napoleon's teams of scholars had not ascended the Nile into Nubia; there he turned to Gau's *Antiquités de la Nubie*, published in 1822 and conceived by the author as the continuation of the work of the earlier scholars. Again, Teynard photographed, almost exclusively, the structures and sites illustrated by Gau, choosing vantage points which yielded views which corresponded to Gau's illustrations. While Teynard's debt to earlier models can be seen in choice of subjects and viewpoints, the startling immediacy of photographs made in the shadowed recesses of colonnades and across the desolate sweep of desert reinforce his description of the photographs as the record of sensations. The tension between positivist record and romantic experience distinguishes his work from that of others practicing in Egypt at the time.

After his return, Teynard's photographic activity was confined to scientific and technical experimentation. In 1862, he submitted the winning solution to the problem posed by the Academie des Sciences for the Prix Bordin, a problem on optical focus. He continued to investigate the focusing properties of lens and submitted work to the Academy. In 1869 he was among the invited guests of the Khedive at the opening of the Suez Canal. He died outside of Grenoble in 1892.

The publication history of Teynard's photographs is complicated. His work was first issued as *Voyage en Egypte et en Nubie: Sites, Monuments, Bords du Nil* in thirty-two livraisons of five prints beginning in 1853 by Maison Goupil et Compaigne, Paris. It was only in 1858 that the complete book was published by Goupil et Cie in two volumes under the title *Egypte et Nubie: Sites et Monuments les plus interessants pour l'etude de l'art et de l'histoire*. The 160 prints were accompanied by his short descriptive texts. The two volume set commanded a very steep price, 1000 Francs. The size of the edition is unknown but fewer than 15 complete copies of the two volume work are known to exist.

KATHLEEN STEWART HOWE

See also: Calotype and Talbotype; Du Camp, Maxime; and Goupil & Cie.

Further Reading

Howe, Kathleen Stewart, *Félix Teynard: Calotypes of Egypt. A Catalogue Raisonné*. New York, London, Carmel: Kraus, Hershkowitz, and Weston, 1992.
——, *Excursions along the Nile: The Photographic Discovery of Ancient Egypt*. Santa Barbara, California: Santa Barbara Museum of Art, 1993.
Perez, Nissan, *Focus East: Early Photography in the Near East, 1839–1885*. New York: Harry N. Abrams, 1988.

THOMAS, JOHN (1838–1905)

Born Glan-Rhyd, Cellan, West Wales, John Thomas left his draper's assistant post in Lampeter in 1853 and walked to Liverpool to start a similar post. Ill health prompted an outside job and he became a 'Town Agent on Commission' for a firm trading in stationary and photographs of famous personalities along the North Wales route, from Liverpool to Holyhead. It was the absence of any Welsh personalities that prompted him to take up photography in 1863. He became the manager for Harry Emmens Studio in Liverpool, photographing mainly non-conformist ministers. In 1867 he launched his own business, producing *carte-de-visites*, also *-in memoriam*, under such titles as bards, poets, musicians, singers, missionaries, church dignitaries and ministers. While he spent most of his time tramping round North Wales his wife ran the mail-order business from the Cambrian Gallery, Liverpool, which lasted for around 40 years. Before his death, he selected 3113 plate negatives which were bought by Sir O. M. Edwards who used them to illustrate articles in his *Cymru* magazine. This collection is now in the National Library of Wales. Along with his depictions of tradesmen, working women, town characters, the almshouses, farm yard and market streets, the coming of the railways, building the reservoirs, he accomplished the most important depiction of life in 19th century Wales, and one of the earliest sustained documentary projects in the history of photography.

ALISTAIR CRAWFORD

THOMPSON, CHARLES THURSTON (1816–1868)

British photographer, official photographer to the South Kensington Museum and Department of Science and Art

Charles Thurston Thompson was born in 1816, the son of a wood engraver, John Thompson. Charles took up his father's profession under his tuition. With his father he drew and engraved many of the illustrations for William Yarrell's *A History of British Birds* (1843). In his early thirties he turned to photography and began practising the wet collodion technique around the time it was introduced in 1851. The same year, Thompson assisted Henry Cole, civil servant and Chairman of the Fine Arts Committee of the Society of Arts, with the arrangements for photography at the Great Exhibition in London. Thompson worked with the photographer Robert Bingham on the production of the photographic prints for the *Reports by the Juries of the Great Exhibition* (1851) and in 1852 worked with him in his studio in Paris.

Out of the proceeds of the Great Exhibition and with government help, land was purchased in the area south of Hyde Park, for the establishment of the new South Kensington Museum (later renamed the Victoria and Albert Museum). Henry Cole, later to become Thompson's brother-in law, was appointed first director. The Museum officers were keenly aware of the possibilities that photography could play in the development and promotion of museum activities and collections. Thompson was called upon by the Museum as a freelancer to produce photographs of objects on loan to an exhibition of decorative furniture held at the Museum's temporary accommodation at Gore House in 1853. In the gardens he photographed the *Venetian Mirror c.1700 from the Collection of John Webb* (1853, V&A collection), along with other studies of mirrors, showing himself reflected in the glass. Usually, such photographs had the mirror glass obscured during exposure or blacked out in the printing to remove the reflection. Thompson's images of mirrors reveal the processes of early object photography and suggest that he was consciously showing himself at work in the new-founded profession of Museum photographer.

In 1855 Thompson was appointed superintendent of the British photographic contributions to the Paris Exposition Universelle and travelled there to work with Bingham on photographing the exhibition and its buildings. While there he was granted special permission by the French government to photograph art objects in the Louvre. On his return to London in 1856 Thompson submitted works for the exhibition of the Photographic Society of London. That same year he was appointed official photographer to the South Kensington Museum and the Department of Science and Art thus establishing the earliest Museum photographic service in the world. Thompson photographed not only Museum objects but also made pictures of the construction of the new museum. Non-commissioned military officers of the Royal Engineers, or 'sappers,' contributed to many aspects of the Museum's operations and were enlisted to assist Thompson in photography as they had done previously during the Great Exhibition. Thompson was formally appointed by the War Department to teach photography to the Royal Engineers in 1856 for which he was paid ten guineas when each soldier was granted a certificate of proficiency. Their photographic skills were subsequently of great use to the military in documenting terrain in many corners of the world and in reproducing Ordnance Survey maps.

On the completion of its main buildings the Museum re-opened at South Kensington in 1857 and Thompson's studio was set up at the site. In July he returned to Paris to purchase a lens suitable for photographing the size-able Raphael Cartoons then housed at Hampton Court Palace prior to their removal and display at the Museum. A special camera was constructed to accommodate large glass negatives measuring 30 × 48 inches (76 × 122 cm). Only full daylight was sufficient to obtain the correct exposure so a method of photographing the fragile works on paper in the outdoors was devised: they would be hung out of the windows at the Palace on fine days. This work continued throughout 1858. The prints were offered for sale to the public but they also proved useful to the Museum staff who marked the prints with diagrams to identify areas of the original cartoons requiring treatment—possibly the first use of photography for conservation purposes. The negatives and marked prints remain in the V&A collection.

The same year Thompson photographed the Exhibition of the Photographic Society of London and the Société française de photographie held at the South Kensington Museum (V&A collection). This image is an important record of the appearance of early photographic exhibitions with stereoscopes on tables and pictures hung floor to ceiling, frame to frame. A figure seated is likely to be Thompson himself. Three of his works, tree studies made in Surrey probably taken in 1857 or 1858, are visible in the exhibition. His systematic representation of trees was intended to be of use to the Museum in its capacity as a source of inspiration for artists and designers. They served as studies from which students could copy, much like Edward Fox's *Anatomy of Foliage* acquired by the Museum for the same purpose in 1865. Thompson's tree studies survive, along with many of his other works, pasted into the Museum's 'guard books'—bound volumes containing one print from every negative made for the Museum photographic service (V&A Archive).

In April 1859 Thompson became a full employee of the Museum on a retainer of an annual fee of one hundred pounds. Although obliged to be at the call of the Museum, he was not prohibited from engaging in private work. Partly in order to keep up with demand, he concentrated on making negatives only at the Museum. In addition to his retainer he received 3d for every square inch of negative. A further reason for Thompson's concentration on making negatives only was as a reaction to a debate brewing between the Museum and the private trade. Objections were raised that the Museum was undercutting the general trader by selling exclusive reproductions of works of art that were financed by public funds. Furthermore, because of Thompson's official employment, private photographers were discouraged from working in the Museum. The issue of safety to Museum objects complicated the issue. At the British Museum, where Roger Fenton had worked as a freelancer, an accidental fire caused by another photographer had led the trustees to prohibit anyone but the photographer approved by them to work on the premises. This, and the fact of the existence of an established negative store and printing establishment at South Kensington, led to the British Museum's arrangement with Fenton being discontinued and all photography for both Museums being transferred to South Kensington.

A Select Committee of the House of Commons was set up to enquire on the issues. The minutes of evidence published with the Committee's report in 1860 give a fascinating insight through photographers' testimonies. It was decided that the appointment of an individual or firm to the Museum was necessary for the smooth running of a Museum photographic department. However, A Committee on Education passed a minute on 10 January 1862 stating that photographs from negatives produced from objects of art being public property should be sold through channels of trade.

Thompson was industrious photographing a huge variety of objects at the Museum. It is estimated that he produced in the region of 10,000 negatives. A *Price List of Mounted Photographs printed from negatives taken for the Science and Art Department by the Official Photographer C. Thurston Thompson* (London: Chapman and Hall) dated 1864, lists nearly one thousand different photographs. These include categories such as Italian sculpture, arms and armour, engraved ornament, cartoons and drawings of Raphael, portraits by Holbein in the Royal Collection at Windsor Castle, Limoge enamels, ivory carvings, objects in crystal in the Louvre, Turner's *Liber Studiorum*, and trees studies. Prints could be obtained through the photographic firms of Chapman & Hall, P. & D. Colnaghi, Scott and Co. and Cundall, Downes & Co. The public could also request images to be made of objects in the Museum not already photographed.

In 1866, Thompson left on a tour of Spain and Portugal to photograph works of art and architecture. John Charles Robinson, curator of the South Kensington Museum, had visited the Cathedral of Santiago de Compostella in Spain the year before. He singled out the cathedral's Romanesque doorway, the Portico de la Gloria, for special treatment commissioning a gigantic plaster cast of the whole structure to be shipped to the Museum. He also asked for Thompson to photograph the site, so that the photographs could be shown alongside the plaster cast, showing the context of the doorway. Robinson left precise instructions for Thompson down to placing the camera 'betwixt the 9th and 10th trees at the roadside.' However, Thompson went beyond his brief, photographing the crypt, and the tribune above the Portico de la Gloria and views of the Puerta de las Platerias. In 1868 the Arundel Society published a volume of the photographs that brought the hitherto largely unknown cathedral to the attention of scholars and played a central role in raising interest in Spanish antiquities in the later 19th century. His photographs of Portugal were exhibited in the Portuguese section of the Universal Exhibition of Paris, 1867 and the Arundel Society published, *The Sculpted Ornament of the Monastery of Batalha*, 1868.

Thompson was described as "a man of extensive and varied art culture, possessing a most discriminate taste and judgement; but, withal, modest and unassuming. As a private friend he was a rarely amiable man, possessing and unusually winning and conciliatory deportment" (*The Photographic News*, Vol. XII, no.490, 24 January 1868, 38.). Late in 1867 he stayed in Paris to assist with the photographic section of the British portion of the exhibition. While there he suffered severe attacks of jaundice and died on 20 January 1868 aged fifty-two.

MARTIN BARNES

Biography

Charles Thurston Thompson was born in 1816 and trained with his father as a wood engraver. In his early thirties he turned to photography and began practising the wet collodion technique around 1851. The same year, Thompson assisted with the arrangements for photography at the Great Exhibition in London. He worked with the photographer Robert Bingham on the production of the photographic prints for the *Reports by the Juries of the Great Exhibition* (1851) and in 1852 worked with him in his studio in Paris. On returning to London in 1853 Thompson was employed by the newly founded South Kensington Museum (later renamed the Victoria and Albert Museum) first as a freelancer and from 1859 as official photographer, the first post of its kind. He made thousands of negatives of objects in the Museum and of artworks in other public and private col-

lections including the Royal Collection and the Louvre. Thompson was an active organiser and exhibitor of the Photographic Society throughout the 1850s and early 1860s. In 1866, at the direction of the Museum, Thompson left on a tour of Portugal and Spain and produced fine architectural photographs, among them views of the Cathedral of Santiago de Compostella, Spain. Late in 1867 he stayed in Paris to assist with the photographic section of the international exhibition. While there he suffered severe attacks of jaundice and died on 20 January 1868 aged fifty-two.

See also: Wet Collodion Negative; Cole, Sir Henry; Great Exhibition of the Works of Industry of All Nations, Crystal Palace, Hyde Park (1851); South Kensington Museums.

Further Reading

British Sessional Papers, 1860, vol.XVI, 527 ff, *Report from the Select Committee on the South Kensington Museum.*

Fontanella, Lee, *Thurston Thompson*, Xunta De Galicia, Spain: 1996.

Hamber, Anthony, *A Higher Branch of the Art: Photographing the Fine arts in England, 1839–1880*, London: Gordon and Breach Publishers, 1996.

Haworth-Booth, Mark, *Photography: An Independent Art. Photographs from the Victoria and Albert Museum, 1839–1996*, Victoria and Albert Museum/Princeton University, 1997.

Haworth-Booth, Mark, and McCauley, Anne, *The Museum and the Photograph: Collecting Photography at the Victoria and Albert Museum, 1853–1900*. Sterling and Francine Clark Art Institute, 1998.

Physick, John, *Photography and the South Kensington Museum*, London: Her Majesty's Stationery Office, 1975.

THOMS, WILLIAM JOHN (1803–1885)

The writer William John Thoms was born in Westminster, London, and initially trained as a clerk, working for over twenty years at Chelsea Hospital before moving to the House of Lords as Clerk around 1845. He eventually held the post of Deputy Librarian there from 1863 until his retirement.

In addition to his clerical posts, Thoms was a prolific writer, and in 1849, founded the subsequently influential journal *Notes & Queries*. The journal first carried an essay on photography in September 1852, and in the following issue, Thoms explained his decision to include the new art:

> The shadow of a doubt that we once felt as to the propriety of introducing the subject of Photography into our columns, has been entirely removed by the many expressions of satisfaction at our having done so which have reached us.

and thus embarked on an engagement with the medium which continued for many years. Amongst his early

contributors were Dr Hugh Diamond, who would later edit the *Journal; of the Photographic Society* and George Shadbolt, later editor of *The Liverpool & Manchester Photographic Journal*. Thoms, himself a keen amateur photographer, continued to edit *Notes & Queries* until 1872.

In the wider world of literature he is remembered for his 1879 book *The Longevity of Man: Its facts and Its Fictions* (London: F Northgate) and for the invention of the word 'folklore' in 1846.

JOHN HANNAVY

THOMSON, JOHN (1837–1921)

John Thomson was born in Edinburgh in 1837. While little is known of his early years, the intellectual breadth of his writings suggests that Thomson was well educated. He was a versatile photographer whose work ranged from portraiture, landscape and architecture to studies of urban life. Thomson was a keen observer of his various subjects, a skill that led him well beyond the conventions of travel photography.

Thomson traveled to Asia in 1862, at the age of twenty-five, settling first on the island of Penang in Malaysia. With brief interruptions, Thomson lived in Asia for the next decade, photographing in Siam, Viet Nam, Cambodia, Formosa, and vast stretches of China. It is difficult to overstate the challenges that Thomson confronted during his travels in Asia. Traveling with the paraphernalia involved in the wet collodion process was arduous, what with the weight and fragility of the cameras, lenses, glass plates, chemicals, trays, and material sufficient to make portable darkrooms. He transported himself and his equipment to high mountain ranges, jungles, swamps, and the upper reaches of the Yangtze River. But just as formidable were the challenges of negotiating different languages and cultures. Thomson must have been a man of considerable charm and persuasion, since he repetitively connected with powerful, well-placed people in these countries who sat for his portraits and then enabled him to gain access to other people and remote areas. The King of Siam, for example, provided support for Thomson to photograph, for the first time, the extraordinary ruins at Angkor Wat.

Thomson was not immune from ethnocentrism and cultural bias in his images and writing, but in the main he expressed a genuine respect for native customs, and he took evident pleasure in explaining these differences to his European readers. When traveling, Thomson took extensive notes which he later used for the essays he published along side his photographs, in which he explained in considerable detail a wide range of local customs. On occasion he made pointed comments about how Europeans could learn could learn from the comparisons. When writing about Cantonese merchants, for

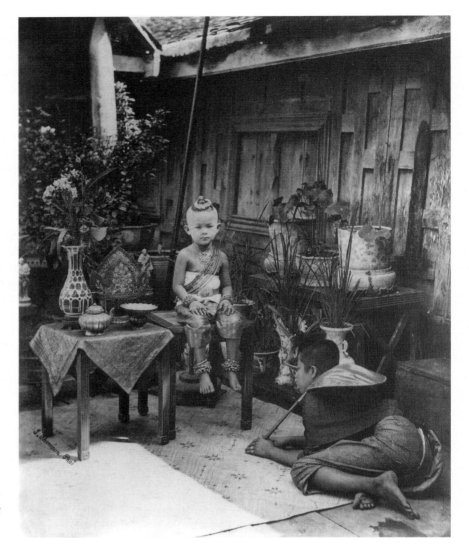

Thomson, John. A Young Prince.
*The Metropolitan Museum of Art,
Gilman Collection, Purchase, Cynthia
Hazen Polsky Gift, 2005 [2005.100.583
(33b)] Image © The Metropolitan
Museum of Art.*

example, Thomson suggested that, "Here we find none of the display, none of those desperate efforts to secure the lion's share of custom, which competition has fostered in European towns." Thomson photographed and wrote about the full spectrum of society from Kings, politicians, and traders to peasants, street people, beggars, and even criminals. To appreciate the achievement of Thomson's Asian work, we should bear in mind that most of the people who posed for him had never seen any picture of themselves, much less a European who brought with him this odd collection of equipment that somehow produced miraculous images. Thomson clearly had the ability to put people at ease and gain their trust, which in turn allowed him to convey a sense of unforced naturalness in his portraits.

Thomson also made outstanding photographs of the various terrains that he traveled in Southeast Asia and China. His photographs of mountains, for example, compare favorably to the Bisson Frere's studies of the Alps and Samuel Bourne's images of the Himalayas, and he was no less successful in photographing jungles, farmlands, rivers, and seacoasts. He also made accomplished

architectural photographs of pagodas, houses, temples, and other structures. Like many great photographers, Thomson's visual versatility allowed him to find unique solutions to challenging subject matter.

When Thomson married his wife, Isobel, in 1868, they settled in Hong Kong. When she returned to England after the birth of their son, Thomson continued photographing in Asia, but he finally returned to England for good in 1872. He published four volumes on his travels in China entitled *Illustrations of China and its People* (1872–74). These ambitious books contained over two hundred photographs, which were published along side his detailed and entertaining commentaries. In 1875 he published a lengthy memoir of his travels in Asia, *The Straits of Malacca, Indo-China and China,* which were illustrated with engravings based on his photographs. Taken together, these books comprise the most complete photographic and ethnographic record of China and Southeast Asia made during the 19th century.

Thomson applied the skills he had honed in Asia to his native culture when he began photographing street people of London. The resulting book, *Street Life of*

London (1877), combined his Woodburytypes with detailed essays on the images. His collaborator, Adolphe Smith, wrote most of the texts, although Thomson wrote some of them, and in all likelihood they collaborated on many of the rest. The authors stated their intentions in the Preface:

> we have sought to portray [the] harder phases of life of bringing to bear the precision of photograph in illustration of our subject. The unquestionable accuracy of this testimony will enable us to present true types of the London Poor and shield us from the accusation of either underrating or exaggerating individual peculiarities of appearance.

Street Life of London represents a major breakthrough in street photography, which until that time had been a minor sub-genre of photography. While photographers like Charles Marvill, Charles Negre, and Henry Mayhew had occasionally ventured into the streets, the bulkiness of the cameras and slow exposure speeds were obstacles. But the obstacles extended considerably beyond technical limitations: with few exceptions, art and literature before the mid-nineteenth century seldom dealt with the common man, much less the impoverished or the homeless. However, a combination of political, intellectual, and cultural factors had developed since the late eighteenth century that led writers and artists to begin to pay attention to the under classes. Thomson's extensive experience in Asia made him uniquely suited to take on the poverty in his own back yard. Thomson's London photographs are beautifully rendered, but they also function as moving documents of people who were living on the edge of society.

Unfortunately, this was not the kind of work that could sustain Thomson's stillgrowing family. Accordingly, in 1879 Thomson set up a studio in London where he specialized in portraits and took on various commercial assignments. He continued his studio work until around 1910, when he finally retired.

Thomson's legacy lies in his extraordinary versatility as a photographer and his ability to capture in his photographs and writing the salient features of a broad range of subject matter. He photographed and wrote about individuals from all walks of life with remarkable equanimity. His work can be seen as a precursor to much ethnographic and anthropological work that developed in the twentieth century. Thomson brought to his photography a rare combination of visual virtuosity and keen intellectual curiosity.

DAVID JACOBS

Further Reading

Judith Balmer (ed). *Thomson's China: Travels and Adventures of a Nineteenth Century Photographer,*. Hong Kong: Oxford University Press, 1993 (a reprint of the part of John Thomson's original book, *The Straits of Malacca, Indo-China, and China* (1875), dealing with China).

Judith Balmer (ed). *The Straits of Malacca, Siam and Indo China.* Oxford: Oxford University Press, 1993 (a reprint of the part of John Thomson's original book, *The Straits of Malacca, Indo-China, and Chin* (1875) dealing with Indo-China).

John Thomson, *China and Its People in Early Photographs.* New York: Dover, 1982 (a full reprint of the original four volumes of John Thomson's *Illustrations of China and Its People,* 1873–74).

John Thomson, *Street-Life in London,* Dortmund: Harenberg, 1981 (a full reprint of the entire English text; Dover Publications has also published the full version (1994), and the British Arts Council has published excerpts).

Stephen White, *John Thomson: A Window to the Orient.* New York: Thames and Hudson, 1986 (paperback version printed by University of New Mexico Press, 1989).

THORNTON, JOHN EDWARD (c. 1865–1940)

John Edward Thornton was born around 1865 and started his photographic career in 1885 when he was twenty. By the end of 1886 he was trading under his own name in Manchester selling photographic equipment. By then he had also been granted several photographic patents.

He started the Thornton Manufacturing Company and introduced several cameras and his patent roller-blind shutter which proved popular. A need for capital to expand the business seems to have been required and by 1887 Thornton was working with Edgar Pickard and a formal partnership, under the name The Thornton-Pickard Manufacturing Company commenced in January 1888. The success of Thornton's roller-blind shutter which had sold 12,000 units within three years allowed the firm to build a new factory in Altrincham. The factory, which was mechanised, produced shutters and an extensive range of cameras starting with the Ruby field camera. Thornton-Pickard became a significant British volume manufacturer of cameras in the period 1890–1914.

Edgar Pickard died in 1897 and his brother George Arthur Pickard joined Thornton as joint managing director. The same year Thornton reported that shutter sales had shown an increase of 11 percent and camera sales 264 per cent with profits of £7255. The company began to concentrate on producing cameras where greater profits were to be had. In 1898 after an Extraordinary General Meeting Thornton was forced out of the company the result of him trying to respond to increased competition by developing new products, notably sensitised film, in the face of the opposition of Pickard who wanted to maintain the company's existing product range. Over the long term Thornton's strategy was shown to have been the correct one.

Under Pickard the Thornton-Pickard company initially continued to expand. The factory was increased

to 20,000 sq ft and employed 250 employees in the pre-1914 period. The company mass-produced a range of cameras from traditional mahogany field cameras to amateur hand, box and folding cameras and, from 1908, reflex cameras. During the war it developed aerial cameras for the government but after 1918 it failed to innovate its consumer and professional products and despite attempting diversification into toys in the 1920s with Picabrix it gradually declined as a photographic manufacturer. TP ceased trading in 1959 by which time it was only undertaking photographic repairs.

After 1898 Thornton continued to patent a range of devices relating to photography and other subjects and he tried, unsuccessfully to expand into film production and undertook other business ventures before he moved to the United States. He seems to have had some success with cinematography and was earning royalties from Kodak during the 1920s.

Thornton returned to Britain and died on 5 October 1940 forgotten by the photographic industry that he had been part of fifty years previously.

MICHAEL PRITCHARD

Further Reading

Douglas Rendell, *The Thornton-Pickard Story*, Prudhoe, Photographic Collectors Club of Great Britain, 1992, from a series of five articles originally published in the *British Journal of Photography* between December 16, 1983, and January 13, 1984.

TILBROOK, HENRY HAMMOND (1848–1937)

Tilbrook was born in Llandudno, Wales, and arrived in Adelaide, South Australia, with his family aboard the *Albermarle* in 1854. He worked as a compositor for the *Register* newspaper and after other work including a stint in New Zealand looking for gold he established the *Northern Argus* newspaper in Clare in 1870. He became a keen amateur photographer in the dry plate era, making numerous trips into the surrounding countryside and beyond. After retiring in 1891 he moved to East Adelaide and he made a number of lengthy photographic (and hunting) excursions including visits to the Flinders Ranges in 1894, Mount Gambier in 1898, Mount Bryan in 1899, Mount Gambier to Robe in 1900 and Mount Gambier and Portland, Victoria in 1905. He created albums of prints, stereoviews and enlargements but did not make a commercial venture of this although some of his enlargements were supplied to the Railways Dept to decorate train carriages in 1901. Tilbrook made detailed notes of his travels in diaries and a collection of his photographs and glass negatives was acquired by photographic historian R. J. (Bob) Noye and is now in the State Gallery of South Australia. An exhibition of his work was held there in 2001.

MARCEL SAFIER

TINTYPE (FERROTYPE, MELAINOTYPE)

A process first introduced in the mid-1850s, the collodion and later gelatin-based images on thin metal sheets were customarily sent through the mail to sweethearts and family. Though popularly called "tintypes," they were never made of tin. Tintypes have been produced in the studio, by itinerant photographers and by the general amateur. Tintypes became the vacationers' keepsake, the Sunday strollers' memento. Ironically, the tintype, which so permeated the lower working class of society, rarely outlined its social problems and other struggles. Rather the tintype image, largely through the use of studio props, created an ersatz lifestyle and does little to further our understanding of the working-class life. This suggests that it is wise to remember that photographs cannot stand alone as interpretative statements about the past, any more than can other primary sources.

The tintype was immensely popular in North America from late-1850s onward and, to a much lesser degree in Europe and elsewhere. The use of collodion chemistry eventually gave way to gelatin emulsion manufacture by the early-1890s. This genre survives even today and noticeably practised by street photographers in Central and South America and India.

Ferrotypy is the proper technical name for the process. The words "ferrotype" and "tintype" are often used interchangeably to describe the light-sensitive plates, and "tintypist" to describe the photographer. These and other terms proliferated throughout the popular language and in commercial and technical publications (see Appendix).

The tintype was the particular application of Frederick Scott Archer's wet-collodion process. A japanned (i.e., blackened) sheet of thin iron was substituted for the ambrotype's glass support. The plates were coated with collodion, quickly sensitized and immediately exposed in the conventiona "wet plate" manner. The "tintypist" would develop and fix the plate, and cut it apart with tin shears. Formats ranged from postage-stamp size "gem" tintypes (approximately 1.5×2 cm) to the large "double whole" plates (21.5×33 cm). (Though technically inaccurate to classify a tintype by "plate" dimensions, popular nomenclature prevails.) Tintypists enhanced the image by applying assorted water- or oil-based colours and protective shellacs to its surface.

Collodion Ferrotypy

By 1853 Parisian college professor Adolphe Alexandre Martin presented to the Société d'Encouragement and to

the French Academie des Sciences two *Compte Rendus* which outlined processes to make direct positives on glass and on tinned plate or galvanized iron. His reports had little impact on a nation still enamoured with the daguerreotype and certainly with the new albumenized paper processes. Apparently unaware of Martin's work, Hamilton L. Smith, professor of natural science from Rambier, Ohio, carried out similar work with a seminary student, Peter Neff Jr. during 1853–54 and then independently in 1855. In 1856, on the advice of Neff, Smith obtained U.S. Patent 14,300 (February 19, 1856), to make "ferrotypes." The patent suggested that black japan needed to coat the metal plate (before one can make it light-sensitive) could also be applied to "leather, fibrous materials and rubber." William Kloen and Daniel Jones Enlgand also patented the "ferrotype" that same year. Europe, with its predilection for social classes, showed no interest in the "lowly" process. Peter and William Neff eventually purchased the patent rights for the manufacture of the plates.

In spring 1856 Peter Neff promoted the new process through a pamphlet entitled *The Melaintotype Process, Complete*. By October, American innovator Victor Moreau Griswold applied for two patents to improve the process. Soon-to-be-competitor Griswold criticized the name "tintype," calling it "senseless and meaningless." He sarcastically pointed out that "not a particle of tin, in any shape is used in making or preparing the plates, or in making the pictures …, unless it be, the *tin* which goes into the happy operator's pocket after..." In 1863, tintypes were purchased for as little as two cents each and still proved profitable! Oliver Wendell Holmes pushed to have 'the 'tin-types' "properly" renamed 'stannotypes.' (Ironically, Holmes' "stannotype" might refer to iron-black colour but its root *stannous* refers to any compound containing tin.)

By early 1857, continued experimentation resulted in improved resistance and assorted hues (blue, green, red and chocolate) to the japanned surfaces. The japan or varnish was made with linseed oil, asphaltum and sufficient umber or lampblack to give the desired shade, boiled, then tested for consistency—thinned with turpentine if necessary—and eventually brushed onto the metal, and oven-dried. Other possible ingredients included mastic, lac or copal varnishes and other shades of colouring matter. The reported manufacture of white enamalled plate susceptible to produce a negative image never materialized.

From mid-1850s to early-1860s, Neff and Griswold were the sole manufacturers of tintype plates in North America. Through pettiness or excessive competitiveness, each threatened the other with lawsuits. Griswold cut his prices as he improved production of his plates. Neff countered by freely making available the necessary licenses to practise ferrotypey, since patents forced the photographic fraternity not only to buy the plates at monopoly prices, but also to buy the right to use them. Fees ranged from $25 to $300 for a "room-right license." Both failed to recognize early the weakness of their geographical location that eventually saw the manufacture of japanned collodion plates switch from their Ohio bases to the increasingly industrialized cities of Newark, New Jersey, and New York. By 1868 several companies had joined the fray: Holmes, Both & Hayden; Willard & Co.; and Anthony & Co. acting as distributing agents to several manufacturers. The Chadwick Leather Manufacturing Company of Newark, New Jersey, manufactured tintypes, but no evidence exists of its pannotype, i.e., the manufacture of photo-sensitized leather.

Horace Hedden or his son H. M. Hedden, of the Ph[o]enix Plate Company, Newark, New Jersey, created the "Chocolate" plate after obtaining a patent on March 1, 1870. This plate would temporarily renew the interest in ferrotypy. By August 1871, an English patent had been obtained.

The More Rapid Gelatin Dry Processes

While producing astounding results, collodion photography, by its shortfalls (i.e., the need to immediately prepare, sensitize and photograph), encouraged the search for a more convenient means of capturing an image. The new, consistent and reliable, gelatine dry plate of the 1870s would some twenty years later give rise to commercially manufactured gelatin-silver tintypes.

In 1871 Richard Leach Maddox invented and published the first practical formula for gelatin-silver halide emulsion. By 1873 prepared *gelatine dry* plates were being marketed in England. The following year Richard Kennett introduced the "high speed" pelllicle and subsequently offered prepared dry plates. The manufacture of the gelatin tintype however only came into existence in 1890. Basic emulsion manufacture ("ripened" emulsion) was cooled to a jelly; cut into noodles, washed of excessive chemicals and by-products; reheated (altering the chemistry) and finally coated onto a continuously moving roll of sheet metal support (i.e., the plates) and cut into standard sizes and packaged. In England's post-industrialized social climate, ferrotypy gained popularity, especially with the introduction of dry "ferrotype" plates by Ladislas Nievsky in 1891. Dependable development time varied from eight in hot climates to sixty seconds in polar temperatures. After fixing (1:5 ratio hyposulfite/water) for ten to thirty seconds, the plate was quickly rinsed, dried and then varnished.

The advent of the "street" camera, with built-in processing facilities removed the need for a portable darktent and contributed to the third and final resurgence of the tintype, especially in North America. By 1894 The Bosco Automatic (booth) Camera manufactured by

Bernitt, Hamburg, Germany, produced a small tintype shaped like a shallow tray. The recessed shape sequentially held developin /processing and fixing chemistry. Patrons entered the booth, paid their fee, and exited with a tintype self portrait within three to five minutes.

Appendix: Known Commercial and Popular Names

Adamantean [1863+]
Adamantine [from c. 1861–63]
American instantaneous photography [Europe c. 1860]
American novelty [Europe c. 1870]
American Photography [Berlin, Germany 1878+]
American process [Europe, c. 1858?]
Anchor (mid-1860s–1870s, British, unsensitized plates exported to North America)
Atrograph [British, c. 1900–1950, technically a gelatin-based "ferrotype" on black paper]
Bon-Ton pictures [may refer to mounted ferrotypes or albumen prints; uncertain]
Cambria (mid-1860s–1870s, British, unsensitized plates exported to North America)
Celebrated Chocolate Tint [1871]
Champion
Chapman celebrated O.K. plate [?—1867] "from Charcoal Iron" [refers to the high-quality English sheet iron used by U.S. Manufacturers]
Chocolate tintype [1871+]
Chromo-Ferrotype [1871+]
Columbia
Diamond [may relate to protective varnish for Adamantean plates]
Egg-shell Ferrotype [c. 1858–1900, considered industry standard]
Eureka [c. 1861–1870]
Excelsior
Fallowfield [c. 1910–1915, British commercial plates "collodion emulsion" ferrotype dry plates]
Ferrograph [first mentioned 1856 in *Photographic Notes*]
Ferrotype [1857–1867, with a resurgence ca1891]
Ferrotype [1856– present]
Gartle (mid-1860s–1870s, British, unsensitized plates exported to North America)

GEMS

Glossy Ferrotype [c. 1858–1900, considered industry standard]
Helion
Imperial ferrotype
Iron plates
Lettergraphs
Lettertypes

Letter-types

LITTLE GEMS

Melainotype [1856–1870; especially prevalent in Canada]
Melaneotype
Melanograph [1854; early wet-collodion experiments on paper; see Atrograph]
Phoenix [c. 1857–1870+]
Pontimeister (mid-1860s–1870s, British, unsensitized plates exported to North America)
Portraits sur zinc/Portraits on zinc; de tôle/on sheet metal [c. 1900 to 1930s, Quebec, Canada]
Sheet iron photographs [ca1898, Maryland, USA]
Silvertype [c. 1860, H.P. Moore (mfr), New Hampshire, USA; trademark for copied daguerreotypes]
Star Ferrotype
Sunplate [1870–1872, Scovill Mfg. Co., USA]
Tagers Iron, also Taggers Iron [c. 1856, unsensitized plates, American, often stamped]
Tinplate portraits [c. 1900–1930s, eastern Canada]
Tintype [1856–present]
Tintype on paper [c. 1900–1950, atrograph]
Tiny Gem
Union
Vernis [c. 1861–1862]
Wonder Photo-buttons [1900+, sold in England and USA; gelatin emuslion plates

PHILLIPE MAURICE

See also: Wet Collodion Negative; Archer, Frederick Scott; and Maddox, Richard Leach.

Further Reading

Coe, Brian, and Mark Haworth-Booth, *A Guide to Early Photographic Processes*, London, Hurtwood Press, 1983.
Estabrook, Edward M., *The Ferrotype and How To Make It*; Hatchel & Hyatt, Cincinnati & Louisville, 1872, reprinted by Morgan & Morgan Inc., Hastings-on-Hudson, NY, 1972.
Jenkins, Reese V., *Images and Enterprise. Technology and the American Photographic Industry 1839 to 1925*, Baltimore, Johns Hopkins University Press, 1976.
Maurice, Philippe, "History, Identification, Deterioration characteristics and the Preventative Care of Collodion and of Gelatin-emulsion Ferrotypes" in *Environnement et conservation de l'écrit, de l'image et du son. Actes des deuxièmes journées internationales d'études de l'ARSAG, Paris, May 16–20*, 1994.
——, "Snippets of History: The Tintype and Prairie Canada." *Material History Review*, National Museum of Science & Technology, Ottawa, Canada, vol. 41 (1995): 39–56. (mid-1860s–1870s, British, unsensitized plates exported to North America)
Catching the Sun: *A Catalogue of Photography Studio & Photographica Advertisements & Notices published in Prairie Canada between 1850 and 1900 [photographic compilations 1850—1900]* vol. 1 and vol. 2, Calgary, Philmsearch, 1996, 1998.

TISSANDIER, GASTON (1843–1899)

It was as a scientific scholar, a public educator and writer, and an enthusiast for new inventions that Gaston Tissandier's major contribution to photography in the nineteenth century was made. His formative influences were in science, journalism and ballooning. Having completed studies at the Lycée Bonaparte, Tissandier studied in the chemistry laboratory of P.P. Dehérain at the Conservatoire des Arts et Metiers, Paris, before taking courses at the Sorbonne and the Collège de France. By the time he was only twenty-one (1864), he became Director of the Laboratoire d'essais et d'analyses chimique de l'Union nationale. Within three years he co-authored, with Dehérain, the 4-volumed *Elements of Chemistry* (Hachette, 1867–70) and was commissioned by Hachette to write four books for the series Bibliothèque des Merveilles (Library of Marvels), beginning in 1867 with *l'Eau* (*Water*) and progressing through to 1874 with monographs on Coal, Fossils and Photography. The first of these was certainly indebted to Dehérain, but the fourth in the series, *Les Merveilles de la photographie* (*Handbook and History of Photography* (1878)), reflected the young scholar's own interests. Tissandier continued to write many books on science, including those on dust particles in the upper atmosphere and on the construction of electrostatic dirigible balloons.

If science was his first love, writing was a close second. Aged twenty-three he began contributing to Edouard Charton's illustrated weekly on the arts, literature, history and sciences, *Magasin Pittoresque* (established 1833 to "instruct and moralise the new generations"), awakening in the young man a lifelong belief in education through the popular press. In 1873 Tissandier established his own illustrated scientific journal, *La Nature*, attracting the publishing support of Hachette after the first year. Tissandier wrote innumerable articles on all branches of the sciences for this journal, and as editor was able to attract the support of leading scientists. Much of the material that first came to light in *La Nature* was collated and expanded into one of his most influential tomes, *Les Récréations scientifiques* (1880), which presented science as knowledge attained through wonder and fun-filled experiments, most of them amenable to the home enthusiast. As a fluent writer and eloquent public lecturer, many of his books went into multiple, revised editions, and were translated into many languages.

A third formative influence was ballooning. Having made his début ascension on 16 August 1868, Tissandier went on to make many aerial voyages. Most of his ascensions were to further meteorological knowledge (e.g. analysing dust particles in the upper atmosphere) and the science of aeronautics (leading he and his architect brother and lifelong companion, Albert, to devise electric and propeller-driven balloons). Indeed, it is as a balloonist that Tissandier is now best known.

To these formative influences should be added patriotism, for Tissandier's ballooning expeditions over enemy lines during the Siege of Paris by Germany (1870–71) was not only rewarded with his being made a chevalier of the Legion d'honneur on 15 November 1872, but predisposed him to embrace the philosophy of the newly-formed French Association for the Advancement of Science which stood 'for country and for science.' According to his biographer, Le Cholleux, *La Nature* and his many other publications were driven by a desire to enhance the quality of science in France.

Tissandier's interest in photography is best revealed in three texts, *Les Merveilles de la Photographie* (1874); segments in *Récréations* (1880); and *La Photographie en ballon* (1886).His photography has its roots as much in popular entertainments of illusionism, as in painstaking scientific experimentation. 'Admirable photographs,' he argued in *Photographie*, reflect the 'skill of the physician and the taste of the artist,' and have 'colour, relief, delicacy and truth,' their 'rigorous precision' making them invaluable to the artist, architect, archaeologist, geographer, explorer, and those maintaining criminal and juridical archives. For Tissandier, aerial panoramas could assist surveying as much as military reconnaissance. Indeed, *Photographie en ballon* includes an albumen print frontispiece of the port of the Hôtel de Ville, Paris, 'taken at 600m. altitude by messieurs Gaston Tissandier and Jacques Ducom,' where the strongly intersecting diagonals of streets and bridges, remarkably modernist in composition, are delineated on a transparent overlay, to demonstrate its value as a map. This and other crisp aerial images, in fact taken by Ducom, were indebted to successful efforts to minimise shudder in the basket, and the use of M. Bacard's plates enabling exposures at 1/50 sec. He also collaborated with Paul Nadar, who photographed Versailles and Sevres from 800m. Tissandier wrote lucidly of the history, chemical processes and applications of photography. His enthusiasm for 'that sublime and beneficent art' rested on the camera's ability to accurately reproduce the human face, distant lands, and all the sciences from laboratory-based micrography to astronomy. Writing in a clear and accessible narrative style, often complemented by the inclusion of abundant images, his books and articles were written to inform and enthral young and old.

Tissandier was an amateur photographer, serving at various times as president and vice-president of the Société d'excursions des amateurs de photographie (founded 1887). He was a member of the Société française photographie, as well as societies of aerial navigation, meteorology, chemistry, and served on government commissions of military aerostations and civil aeronautics.

His prodigious publishing activity ensured that Tissandier was well known to his contemporaries in France and abroad. During his life he was included in national dictionaries of biography. Few authors in the twentieth century have referred to his work, and most only in passing and by reference to aeronautics.

CATHERINE DE LORENZO

Biographical

Gaston Tissandier was born in Paris on 20 November 1843, the second son of Paul Emmanuel Tissandier and Caroline Agathe Decan de Chatouville. Interestingly enough, all contemporary accounts give Tissandier's birth date as 21 November 1843, but the copy birth certificate at the Service des Archives départementales, Paris, clearly states his birth as 20 November 1843. The original birth certificate was destroyed during the Siege of Paris in 1871 when the Hôtel de Ville was set alight. Following his studies at the Lycée Bonaparte, he worked as a chemist at the laboratory of the Conservatoire des Arts et Métiers, before being named director of the Laboratory of Tests and Chemical Analysis of the Union Nationale in 1864. He published more than two dozen books, jointly authored nine more, presented more than ten major papers to learned societies, and wrote innumerable articles, especially on hot-air ballooning and popular science. He was the founding editor of the illustrated popular science journal, *La Nature*, His death certificate notes he was predeceased by his wife, Louise Anne Arbouin, and his brother noted that he had two children. Tissandier died 30 August 1899 in Paris.

See also: Nadar, Paul.

Further Reading

Tissandier's writings on photography include:

Les Merveilles de la photographie, Paris: Hachette, 1874, [later *La Photographie*, 3rd ed., Paris: L. Hachette et Cie, 1882, and translated as *A history and handbook of photography*, edited by J. Thomson, London: Sampson Low, Marston, Low & Searle, 1876].

Les récréations scientifiques, ou, L'enseignement par les jeux, 2e éd. entièrement refondue, Paris: G. Masson, 1881 [*Popular scientific recreations, in natural philosophy, astronomy, geology, chemistry, etc., etc., etc.* Translated and enlarged from 'Les recreations scientifiques,' of Gaston Tissandier; New York: Ward, Lock, 1885].

La Photographie en ballon, par Gaston Tissandier. Avec une epreuve photoglyptique du cliché obtenu par MM. Gaston Tissandier et Jacques Ducom, à 600 mètres au-dessus de l'ile Saint-Louis, à Paris... Paris: Gauthier-Villars, 1886.

Contemporary biographies include entries in:

Dictionnaire générale de biographie contemporaine, etc. edited by Adolphe Bitard, Paris, 1878.

Dictionnaire générale de biographie contemporaine, etc., edited by Adolphe Bitard, 3rd ed. Paris, 1887.

Biographie nationale des contemporaines: rédigée par une société de gens de lettres, edited by Ernest Glaeser, Paris, 1878.

Dictionnaire universel illustré biographique et bibliographique de la France contemporaine, edited by Jules Lermina, Paris 1884.

R. Le Cholleux, (ed.) [pseud. of Brissy, René Alphonse] 'Gaston Tissandier,' *La France Biographique: Galerie des Notabilités contemporaines*. Paris: France Biographique, 1891.

R. Le Choleux [sic], 'Gaston Tissandier, biographie,' Delivered at a general meeting of the *Société d'encouragement*, 9 June 1893], Paris: Imprimerie générale Lahure, 1894.

R. Le Cholleux, 'Gaston Tissandier,' *Revue biographique des notabilities françaises contemporaines*, 3 vols. Paris: Rédaction et administration, 1896–1898.

Dictionnaire universel des Contemporains contenant toutes les personnes notables de la France et des pays étrangers, edited by G. Vapereau, Paris: Librairie Hachette et Co. 1893.

Henri de Parville, 'Gaston Tissandier,' *La Nature*, No. 1372, 9 Sept. 1899, 225–7.

Albert Tissandier, 'Gaston Tissandier: Sa vie intime,' *La Nature*, No. 1373, 16 Sept. 1899, 248–50. For more recent accounts see *Dictionnaire des inventeurs français*, edited by Marie Fernande Alphandéry, Paris: Éditions Seghers, 1963.

Index Biographique Français, 2nd edition, compiled and revised by Tommaso Nappo, 7 vols. München: K.G. Saur, 1998.

Aaron Scharf, *Art and Photography*, rev. ed., Harmondsworth, Pelican, 1974.

James R. Ryan, *Picturing Empire: Photography and the Visualisation of the British Empire*, Chicago: University of Chicago Press, 1997.

TONING

Armand-Hippolyte-Louis Fizeau—the French physicist best known for being the first to develop a reliable method of calculating the speed of light—was responsible, in August 1840, for proposing some significant advances in the daguerreotype process. The most enduring of these was the use of gold chloride as a final chemical treatment after fixing—most recipes employed dilute solutions of both 'hyposulphite of soda' and 'chloride of gold' mixed just before use. This had several effects, marginally raising the contrast of a daguerreotype, slightly intensifying the image, and most significantly, increasing the stability and permanence of the delicate image. It also slightly changed its color, imparting a warm tinge to the darker areas of the image.

Despite the fact that this process changed the color of the daguerreotype image, it was invariably described in contemporary journals not as 'toning' but as 'fixing' or 'gilding.' The term 'toning' would not come into general use until well into the ascendancy of the paper albumen print. Gold chloride remained the basic building-block of the majority of toners throughout the remainder of the 19th century.

Writing on the subject in *The Dictionary of Photography* in 1897, Edward John Wall noted that "If a silver print is placed directly into the fixing bath, an

unpleasant brick-red color is the result." That brick-red color, and the wide range of other reds and sepias which could be produced when making both salt prints and albumen prints had long been considered unpleasant.

It was probably Louis-Desiré Blanquart-Evrard, the originator of albumen printing paper, who first proposed the application of the gold chloride toner to the paper print. Fortuitously it had the same preservative and stability effects which had been experienced with the daguerreotype, but also brought about a dramatic color change. The albumen image was, in its un-toned state, both reddish-brown, and unstable—neither of them desirable qualities. Relatively quickly the image deteriorated and the highlights—always a pale cream and less brilliant than had been previously experienced with the salt print—darkened and yellowed. The gold toner not only produced a rich purple/brown hue to the shadows, but also acted as an effective barrier to the yellowing of the highlights, as well as reducing image fading. The richness of many of the Victorian images preserved today attests to the effectiveness of the gold toner to an otherwise correctly processed print.

As understanding of the chemical processes deepened, it became clear that the acidity or alkalinity of the gold chloride bath had a significant impact on its effect. By the closing years of the nineteenth century, over twenty recipes for gold chloride toning baths were available in contemporary manuals—each offering a slightly different effect dependent upon its pH. An acidic solution was found to produce a reddish hue in the print, a neutral solution created the purple/brown colors so fashionable from the 1850s, and an alkaline solution tended towards the blue/black shadows, creating a much colder image.

With the introduction of the bromide print, and a broader understanding of chemical effect, a much wider range of print colors could be achieved by the end of the century—platinum toners produced a rich sepia, copper a bright red, vanadium a deep muted green, and iron toners offered a range of blues.

JOHN HANNAVY

See also: Albumen Print; Blanquart-Evrard, Louis-Désiré; Bromide Print; Fizeau, Louis Armand Hippolyte; and Wall, Edward John.

Further Reading

Jones, Bernard E., *Encyclopedia of Photography*, London: Cassell, 1911. Reprinted New York: Arno Press, 1974.

Lerebours, N. P., *A Treatise on Photography*, London: Longmans, Brown. Green and Longmans, 1843, reprint New York: Arno Press, 1973.

Wall, E.J., *The Dictionary of Photography*, London: Hazel, Watson & Viney, 1897.

TOPLEY, WILLIAM JAMES (1845–1930)
Photographer and businessman

William James Topley, was born 13 February 1845 at Saint John, near Montreal, Canada East, now Quebec and died 16 November 1930 in Vancouver, British Columbia.

Topley began his career as an independent tintypist but from 1864 apprenticed with William Notman, Montreal. At age 22, Topley took charge of the new Notman studio in Ottawa, the first established outside Montreal; by 1872 Topley was "proprietor" of the Notman studio, and in 1875 set up independently as The Topley Studio with a staff of fourteen. By 1880 he had vice-regal patronage, being appointed photographer to Governor General the Marquis of Lorne; this confirmed his reputation but did not appear to increase his income. The Topley Scientific Instruments Company, established in the 1890s, specialized in the repair and sale of optical and survey instruments and photostat machines; at the same time the Topley Studio started selling cameras and film and provided developing and printing services for amateurs.

While the studio specialized in portraits, including those of most of the leading politicians, it also did scenic work for the tourist trade and a great deal of commercial, industrial and government work, in Ottawa and Quebec, Ontario and the west. Some of Topley's work has been used on Canadian currency and postage stamps. Approximately 150,000 negatives are located at Library and Archives Canada.

Topley and his son William de Courcy managed the Studio from 1868 to 1923, successfully negotiating major changes in photographic methods and materials, accommodating business cycles and the advent of the snapshooter, but finally closing it because there was no family successor.

ANDREW RODGER

TOPOGRAPHICAL PHOTOGRAPHY

Dependence on a long history of pictorial and landscape conventions means that topographical photography inherited ways of seeing which precluded the sort of objectivity and inclusiveness which the medium was capable of delivering—much that was feasible from 1839 is absent but the reasons for these absences are complex. Processes were unwieldy, image permanence problematic, but, above all, demand hardly existed. The depiction of buildings, townscape and the human environment does of course occur—but the earliest evidence is frequently visible at one remove: daguerreotypes were employed as the source for line illustrations. This indirect application of photography is most evident in N.

P. Lerebour's *Excursions Daguerriennes* [1842]. In the United States the advanced development of daguerreotype technology meant that the depiction of topography is a little more common.

Only in France was there any form of official attempt to record the cultural landscape but even the Mission Heliographique proved to be a premature model for the systematic use of photography in a topographical or architectural manner. Depiction of isolated cultural treasures and picturesque landscape precluded many representations of personal and public spaces. A recent pioneering photographic survey of Antwerp acknowledges these visual absences but also noting that the smells, sounds and urban historical context necessary to allow proper interpretation. Apart from the work of a few photographers such as Charles Marville in Paris and Thomas Annan in Glasgow who were commissioned to record redevelopment or slum clearances there is only weak or indirect visual evidence for the reality of Victorian culture: the objective eye of the camera was simply not pointed in directions we now want to explore.

The daguerreotype quickly became ubiquitous—much is known of work in Egypt, Palestine, Jordan, India and North Africa and South America but it is significant that in Canada the earliest known topographical views are recorded as late as the mid-1850s. Unlike the sophisticated application in the United States, topographical daguerreotypes in many other countries were never taken or do not survive. This absence is directly related to absent markets—especially in tourism. Viable marketing and distribution conditions are necessary for photographic production but even when both the technology and the incentive existed, prevailing fashion dictated specific 'polite' forms of coverage avoiding whole sectors of the society in question: all topographical 'records' and 'views' are clearly limited by both social and market forces.

It is only very recently that some of the earliest topographical collections have surfaced at auction (Gilbert de Prangey) and the extent of knowledge and image survival is still fragmented. Much of what we know has only developed since the 1970s and is dependent on haphazard factors—in the market, in academia and in the variable criteria applied to digitisation. The archaeology of photography and the genealogy of image generators remain undeveloped discipline but an emerging global outline of topographical collections means that key figure like Russell Sedgefield (born in Devizes, Wiltshire) is best known through family sources in New Zealand and Australia, Gustave le Gray's later Egyptian life can now be linked with his earlier fame in France, and the surviving archives of key Scotish topographical companies (James Valentine, George Washington Wilson) are being made available online (in Scotland) It can also mean that more is known about the North American

work of a mobile photographer like William England than any of the rest of his English or international work he mostly executed for the London Stereoscopic Company, whose remit was by no means restricted to London or even England.

Sophisticated marketing and distribution systems and the dispersal or amalgamation of collections means that interpretation of apparently national concerns may require international context. 'Local' views may indeed be generated by local photographers but many similar views were produced by major commercial companies so that an understanding of business history starts to become necessary. In particular the huge market for stereoscopic views confirms the need for a global overview. Negretti and Zambra consciously sought the views created by Francis Frith in Egypt which they knew they could sell in key locations where there was domestic demand for tourist views such as the Crystal Palace at Sydenham. Later Underwood and Underwood operated on an international basis and competed with European companies for the lucrative stereo market. However, the massive educational and tourist output of such companies was still constrained by the landscape and fashion conventions. The reach of individual photographers like Felice Beato could extend beyond the Mediterranean basin as far as Japan—indeed his complex nationality and extended travels illustrate the sheer breadth that one photographer could encompass. In a cultural sense, however, barriers still existed: for much of the century topographical views signally avoided social realities allowing images to be culturally integrated in historical terms.

In France, Britain and the United States the combination of industry, commerce, empire and antiquarianism succeeded in producing a global photographic era. John Thomson is famous for work in the Far East yet his extensive operations in his home country (apart from his famous publication on London street life) are little known: as the chosen photographer for the English branch of the Rothschild dynasty he may have been better remunerated for his opulent English architectural commissions than for his views of Japan. Based in Alsace Adolph Braun dominated European tourist views as well as creating a monopoly for tourists intent on acquiring or appropriating gallery images associated with the Grand Tour. Braun and Frith represent the new industrial application of photography which before the advent of wet collodion was pioneered by Blanquart-Evrard in Lille: the first mass production of topographic views occurs in limited form in the early 1850s but was succeeded within a decade by the massive printing operations by Francis Frith in Reigate, Surrey and by Adolph Braun in Dornach. By the 1860s the beginnings of huge national branch empires are evident such as A & G Taylor of London who combined chains of portrait

studios with topographical work using the full industrial printing techniques. Such mass production (often mixed with portraits) means that the study of such photographic concerns has be merged with knowledge of printing or lithograph companies if we are to understand the first generation of mechanical processes driven by the increasing audience for topographical images for the burgeoning tourist market. So all images from the 1860s need to be assessed in such a light: Fratelli Alinari in Florence dominated the Italian tourist market, William Lawrence of Dublin dominated Ireland, Notman becomes a major producer in North America based in Montreal, and Matthew Brady signals the advent of the photographic combine in the United States. Careful distinction needs to be made between these 'super-companies' who with others must be seen as a distinct category quite separate from individual photographers or small firms such as F M Sutcliffe of Whitby who also undertook more mundane commissions like recording the Whitby branch of the Woolworths chain store. The same photographer could equally embrace both the picturesque and romantic as well as the more practical or commercial aspects of the same region.

It is only later in the century with the availability of cheaper equipment and processing that a demand appears for nostalgic delineations of the lost national cultures now dominated by industry. Yet the very industrial and urban environments which had helped to create and popularise photography are often the very elements least evident in topographical views.

IAN LEITH

See also: Lemercier, Lerebours & Bareswill; Mission Héliographique; Marville, Charles; Annan, Thomas; de Prangey, Joseph-Philibert Girault;; Le Gray, Gustave; Valentine, James and Sons; Wilson, George Washington; England, William; London Stereoscopic Company; Negretti & Zambra; Frith, Francis; Underwood, Bert, Elias & Elmer; Beato, Felice; Thomson, John; Braun, Adolphe; Blanquart-Evrard, Louis-Désiré; Frith, Francis; Braun, Adolphe; Taylor, A. & G.; Alinari, Fratelli; Notman, William & Sons; Brady, Mathew B.; and Sutcliffe, Frank Meadow.

Further Reading

Aubenas, S., *Gustave Le Gray 1820–1884*, Los Angeles: The J Paul Getty Museum, 2002.

Baldwin, G., Greenough, S., *All the Mighty World: The Photographs of Roger Fenton, 1852–1860*, New Haven: Yale University Press, 2004.

Bartram, M., *The Pre-Raphaelite Camera: Aspects of Victorian Photography*, London: Weidenfeld & Nicholson, 1985.

Daniel, M., *The Photographs of Eduard Baldus*, New York: Metropolitan Museum of Art, 1994.

Galassi, P., *Before Photography: Painting and the Invention of Photography*, New York: Museum of Modern Art, 1981.

Greenhill, R., *Early Photography in Canada*, Toronto: Oxford University Press, 1965.

Ferrez, G., and Naef, W. J. *Pioneer Photographers of Brazil 1840–1920*, New York: Centre for Inter-American relations, 1976.

Goethem, H., Van. *Photography and Realism in the 19th Century. Antwerp: The Oldest Photographs*, Antwerp: Ronny Van de Velde, 1999.

Hales, P. B. "American Views and the Romance of Modernization" in *Photography in Nineteenth-Century America*, edited by M. A. Sandweiss, Fort Worth: Amon Carter Museum, 1991.

Leith, I. "Amateurs, Antiquaries and Tradesmen: A Context for Photographic History in London," in *London Topographical Record v. XXVIII*, edited by A L Saunders, London: London Topographical Society, 2001.

Leith, I., *Delamotte's Crystal Palace: A Victorian pleasure dome revealed*, Swindon: English Heritage, 2005.

Lyons, C. L., Papadopoulos, J. K., Steward, L. S., and Szegedy-Maszak, A. *Antiquity & Photography: Early Views of Ancient Mediterranean Sites*, London: Thames & Hudson, 2005.

Nickel, D. B., *Francis Frith in Egypt and Palestine: A Victorian Photographer Abroad*, Princeton, NJ: Princeton University Press, 2004.

O'Brien, M., and Bergstein, M. *Image and Enterprise: The photographs of Adolphe Braun*, Providence: Thames & Hudson, 2000.

Perez, N. N., *Focus East: Early Photography in the Near East 1839–1885*, Jerusalem: The Domino Press, 1988.

Pelizzari, M A., *Traces of India: Photography, Architecture and the Politics of Representation, 1850–1900*, New Haven: Canadian Centre for Architecture, 2003.

Seiberling, G., and Bloore, C., *Amateurs, Photography and the Mid-Victorian Imagination*, Chicago: University of Chicago Press, 1986.

Simpson, D., and Lyon, P., *Commonwealth in Focus: 130 Years of Photographic History*, Melbourne: International Cultural Corporation of Australia, 1982.

Taylor, J., *A Dream of England: Landscape, Photography and the Tourist Imagination*, Manchester: Manchester University Press, 1994.

Trachtenberg, A., *Reading American Photographs: Images as history Mathew Brady to Walker Evans*, New York: Hill and Wang, 1989.

Zannier, I., *Le Grand Tour in the Photographs of the 19th Century*, Venice: Canal & Stamperia Editions, 1997.

Zeri, F., *Alinari: Photographers of Florence 1852–1920*, Milan: Fratelli Alinari, 1978.

TOURIST PHOTOGRAPHY

Travel and travel reports have been associated with each other since ancient times. The Greek Odyssey is no more than a travel report; the same for Gulliver's Travels and many other more or less fantasy tales and 19th Century photography was able to provide more reliable information about far away places.

Nineteenth century travel was marked by an earlier 18th century idea that travelling was a "grand tour" in which any well born, young, rich gentleman should take, seeing historical places, like Italy, in order to see ancient sites, architecture and art. Travelling and enlightenment

were typically closely linked. With the advent of photography, tourists, with the help of the *Camera Lucida,* or from other optical devices commonly photographed monuments and anything of interest, including William Henry Fox Talbot as he did during his 1830s travels.

By the mid 19th century this kind of travel was well established, however, difficulties with using cameras prevented most travellers and novice photographers to have to purchase images from independent professional travelling photographers. At the same time large commercial photographers started to see an important market in photographing distant or exotic places. Not surprisingly, the locations appearing in early travel photography were similar or the same places considered worthwhile to "grand tour" travellers such as Italy and Greece for the classical travellers and the Holy land and the Middle East for the biblical and exotic travellers.

During the19th, century new means of transportation allowed travelling large distances to be made with greater speed and comfort. Photography, since the mid 19th century was an important travel companion. Coincidentally, the train and camera were invented almost at the same time, and technological progress in photography paralleled the growth of railway lines in most developed countries, suggesting perhaps a symbiotic relationship. Both however answered the needs of industrial society and middle class aspirations. In the late 19th century, lighter cameras and dry plates, made travel photography more widely available to the well-heeled traveller and to middle classes. From the 1890s onward, travel was to be one of the most important genres for photography.

Mid-19th century travel photographs were mainly produced by professionals such as Francis Firth, Antonio Beato, Felix Bonfils and the Zangaki brothers in the Middle East; the Bisson brothers for the alpine mountains; the Alinary brothers in Italy; Charles Clifford or J. Laurent in Spain, John Bourke in India, Felice Beato in China and Japan, Carleton Watkins and Eadweard Muibridge in the North-American west or Cunha Moraes in Portuguese Western Africa. These professional photographers travelled on photographic expeditions using whatever transportation they could to take pictures. Then, they produced their images and sold them in both small and large formats, as well as in stereograms. Generally the images taken on these trips were for those who could not travel, often serving as a substitute for travelling.

Often travellers would carry their photographic souvenirs with them when they returned home. These were typically studio portraits that had been taken abroad and served as proof of travel. Also, these images were representative of affluent classes and linked the owners to high society as represented by the fashionable photographer. This idea of having one's likeness taken at a major travel destinations came early in History of Photography. Daguerreotypists had been active at Niagara Falls since the late 1840s where they targeted the tourists who travelled to this important destination in American. Many 19th Century people had their picture taken for the first time at other vacation or tourist destinations as well like beach or other tourist spots.

Even though there were great difficulties involved in travelling and photographing with mid 19th cntury cameras and processed, there were quite a few amateurs among the travelling photographers such as George Moir (1800–1870), a founding member of the Edinburgh Callotype Club, college professor and latter Sheriff of Ross-shire, and photographer of Ghent; Sir James Dunlop (1830–1858), photographed Malta and Italy in the course of a "Grand tour" in the late 1840s; another Scot, Robert McPherson (1811–1872) photographed Rome and its surroundings, as did Giacomo Caneva (1813?–1865) from Padua. Since the 1850s every major European country had its gallery of amateur travelling photographers, including the Germans even if they seemed to be less active than others.

Later, local photographers understood the potential of the tourist market selling views and images of local or indigenous people to travellers. Even if this was a worldwide practice, Samuel Bourne took a good part these types of images especially in India, the most striking example of tourist photography however came from photographer Christiano Júnior, who produced and sold studio pictures of slaves as a souvenir to those visiting Brazil. Even ambulant photographers understood the new market potential, placing themselves close to main tourist attractions in order to make visitors "instant" photographs.

With late 19th century technical progresses in photography there was a bigger place for one of the most popular photo motivations, travel. Newer cameras that were smaller in size and easier to operate were created as were dry plates, which did not needed to be sensitised before exposure, making travelling with a camera painless. Travelling itself also became much easier as trains were able to go farther distances in smaller amounts of time, and because of this the travel industry was developing, catering not only to the upper classes, but to a middle class as well, which began to take part in tourism.

It the late 19th century, the photographic industry saw the emergence of cameras that were smaller and lighter which made hand held exposures possible. This innovation created a new market potential for tourist photography. This practice was compatible with not only simpler and cheaper Kodaks, but also for the more expensive hand cameras like Ernemman; Voigtlander; Contessa and Goerz. Furthermore, some inventors even developed a special type of camera for the tourist mar-

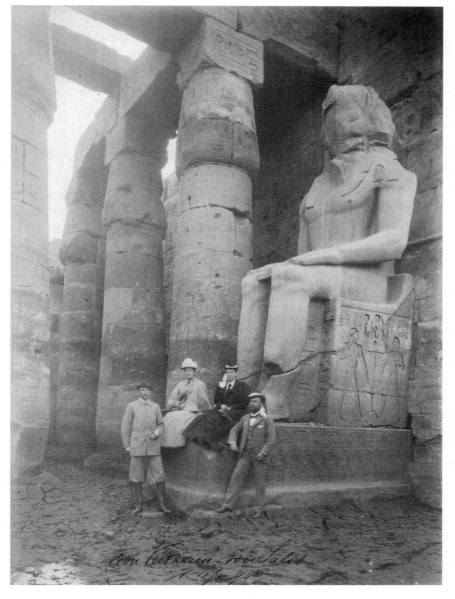

Beato, Antonio. Group at Abydos.
The J. Paul Getty Museum, Los Angeles
© The J. Paul Getty Museum.

kets like tropical cameras which were made to deal with warm, humid climates and a special bike cameras was invented to allow people to carry a very light camera while cycling.

To further develop people's interest, photographic societies were started allowing people to pursue both photography and travel, or even sometimes, photography and cycling. The train and the bicycle were the two main travel companions for the 1890s photographers, replacing the mule cart used by photographers of the daguerreotype and wet plate decades.

Besides travelling to new places an increasingly large group of society was enjoying parts of the summer at seaside resorts. Even though these resorts were mostly class segregated, photography played an equal part in the summer for all classes, starting from the small trade of ambulant photographers to the high-class studios from the large cities migrating with his well-heeled clients.

This usually local summertime tourism meant that a good amount of tourist photography from the later 19th century was made in the photographer's own country. Some spots with a special aura would evoke that country's history and meaning. Some figures, like Shakespeare in Great Britain, and others that were seen as particularly important would have their lives as imagined by photographers explored and photographed, not only by a large number of amateur and professional photographers, but images of their houses would appear in photographically illustrated books and tourist guide books. Each country created its own photographic stereotypes, one for instance was that England was magic and small, and another was one where Spain exotic and grand.

With mass travel and mass tourism came the distinction between the tourist and the traveller, the former being unable to grasp below the surface of things, being

the second able to enjoy aesthetically the pleasures of the landscape. This means that there was a complete social set of what deserved to be photographed and what did not, the landscape, coming from 18th century painting was a socially constructed one. Some of these conventions are still important in today's tourist photography.

This need for tourism to the most significant parts of a country came, also, from the idea that the countryside was soon to disappear under the huge wheels of the industrial society. To photograph what was about to disappear, creating a link between past, present and future, was a duty to photographers. Sir Benjamin Stone even proposed this to be done systematically, being the resulting photographs deposited at the British Museum; some other such attempts were made locally, or in other countries.

Nationalism, the need for History and the 19th century obsession with classification, is all associated with tourist photography. Tourist photography can be loosely defined as a class experience and one that is dictated by convention. The socially constructed landscape of 19th century tourist photography came from 18th century painting and picturesque notions which continued through into 20th century tourist photography. Photography became an important part of travel and, for some, the only way of seeing far away places. Perhaps though, the success of tourist photography came instead from the need of creating memories of special moments and the proof of status it gave.

NUNO DE AVELAR PINHEIRO

See also: Great Britain; Spain; Júnior, Christiano; and Instantaneous Photography.

Further Reading

Adler, Judith, "Origins of sightseeing." *Annals of Tourism Research*, 16: 7–29.

Andrews; Malcolm, *The Search for the Picturesque*, Scolar Press, London, 1989.

Bailey, Peter, "'A mingled mass of perfectly legitimate pleasures": the Victorian middle class and the problem of leisure,' *Victorian Studies*, 21: 7–2.8

Bate, David, "The occidental tourist: photography and colonizing vision." *Afterimage* (Summer 1992): 11–13.

Bourdieu, Pierre. 1965, *Un Art Moyen*, Minuit, Paris.

Briggs, Asa, 1989, *A Victorian Portrait*, Harper and Row, New York.

Cadenas, Carlos Teixidor, 1999. La Fotografía em Canarias y Madeira, La época del Daguerroptipo, el Colodión y la Albúmina, 1839–1900, Madrid.

Coe, Brian, and Gates, Paul, 1977, *The Snapshot Photograph: The Rise of Popular Photography 1888–1939*, Ash and Grant, London.

Crary, Jonathan, 1990, *Techniques of the Observer, On Vision and Modernity in the Nineteenth Century*, MIT Press, Cambridge Massachussets.

Fabri, Annateresa, Fotografia, usos e funções no século XIX, Edusup, São Paulo.

Sousa, Vicente de; Jacob, Neto. 1998, Portugal no 1º Quartel do Sec. XX documentado pelo Bilhete Postal Ilustrado, Câmara Municipal de Bragança, Porto, 1991.

Taylor, John, 1994, *A Dream of England: Landscape, Photography and the Tourist's Imagination*, Manchester University Press, Manchester and New York.

TOURNACHON, ADRIEN (1825–1860)
French photographer

Alban-Adrien Tournachon was born in Paris in 1825 to Victor Tournachon and Thérèse Maillet. He was the younger brother of Gaspard-Félix Tournachon, better known as Nadar, a name he adopted in 1838 as his *nom de plume*. By the 1840s, Nadar was famous for his caricatures and his incendiary writings for leftist Parisian journals. Nadar let Adrien work at his studio, where he learned caricature. He soon decided that Adrien should learn photography and opened a studio that he would partially own and Adrien would run as the principle operator. For training, Nadar placed Adrien with Gustave Le Grey, a photographer known for his landscapes and his technical skills. Nadar's friend Louis Le Prévost funded the studio, which opened in early 1854 at 11 boulevard des Capucines, a fashionable area filled with photography studios. Adrien soon claimed exclusive credit for the studio, which he decided to run alone.

Like Nadar, Adrien photographed artists, although he never achieved his brother's level of success. He is best known for the physiognomic studies made for Dr. Guillaume-Benjamin-Armand Duchenne (also known as Duchenne de Boulogne), a French physiologist and psychiatrist credited as the founder of electrotherapy, between 1853 and 1854. The photographs represented the 19th century obsession with mental illness, a subject of great scientific and artistic study. Adrien photographed patients at the Parisian hospital, Salpêtrière, where Duchenne worked and Géricault created his studies of psychological problems. Featured in Duchenne's 1862 book, *Mécanisme de la physionomie humaine, ou analyse élector-physiologique de l'expression des passions applicable à la pratique des arts plastiques* (*Mechanism of Human Physiognomy, or Electro-physiological Analysis of the Expression of the Passions Applicable to the Practice of the Figural Arts*), the photographs illustrated various emotional states that Duchenne achieved through electric shocks that stimulated muscles. Adrien mainly photographed an elderly male patient, who expressed reactions including terror, fear, amazement and displeasure. The photographs reflected the influence of Positivism, a philosophy based on the Enlightenment principles of scientific analysis and classification that sought truth through observation and study. Visually

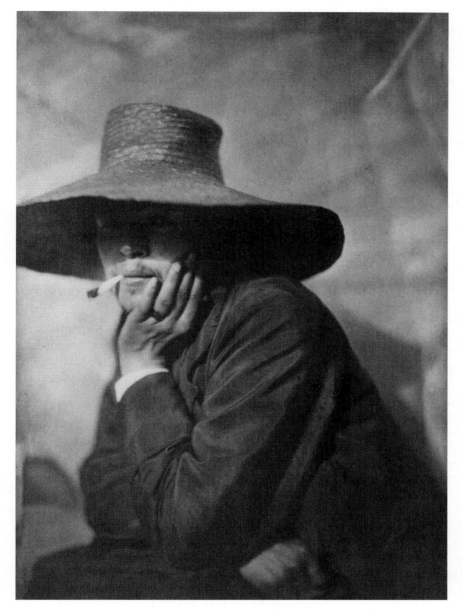

Tournachon, Adrien. Self-Portrait. *The Metropolitan Museum of Art, Gilman Collection, Purchase, The Horace W. Goldsmith Foundation Gift, 2005 (2005.100.44) Image © The Metropolitan Museum of Art.*

interesting, the works show chiaroscuro and a baroque use of space. Attribution is generally given exclusively to Adrien, who signed the works "Nadar jeune," as historians are unable to find evidence that Nadar worked on these images. Two works signed "Nadar jeune" were found in Duchenne's own collection and in his text, Duchenne wrote "Monsieur Adrien Tournachon, whose skill as a photographer is known to all the world, kindly contributed his talent by shooting a few of the pictures in this scientific portion."

Yet despite this commission, Adrien's studio was not successful. By mid-September 1854, Nadar returned to the studio and the brothers worked together. By this time, Nadar was trained in photography and had access to supplies, chemicals and studio equipment, in addition to celebrated and wealthy clients. During the period of 1854–1855, the brothers collaborated on portraits of

Ernesta Grisi (the wife of Théophile Gautier), Alfred de Vigny, Edmond and Jules de Goncourt, and Gérard de Nerval. Although the subjects were photographed in Adrien's studio, the photographs have a psychological dimension more associated with Nadar.

The most famous images the brothers made were the series featuring the character Pierrot, as played by Nadar's friend, the mime Charles Deburau fils. It is unclear what each brother contributed to the photographs. In one image, Pierrot is shown holding pieces of paper that said "ad. Tournachon" and "nadar j," both in reference to Adrien, as was the stamp "TOURNACHON 11 Boule. des Capucines," Adrien's first signature and the studio where he and Nadar worked. The photographs also reflected Adrien's physiognomic studies, printing technique and his larger, 12 × 9½ inch plates. However, their expressive, theatrical quality connects the works

to Nadar, who was more familiar with the work of Charles Deburau and his father, Baptiste. Nadar used his influence to have the series, submitted under the name "Nadar jeune," exhibited at the 1855 Exposition universelle where it won a first-class medal. In a review published in 1856 in *Photographic Sketches (Esquisses photographiques)*, Ernest Lacan praised the works for the emotional quality of the mime's body and face. Like most critics and historians, he saw the works as a collaboration and attributed the works to "Messrs. Tournachon and Co."

Yet this collaboration was not to last. Nadar left the studio by mid-January 1855 and in October, Adrien, with two new backers, opened a studio, Tournachone Nadar et Companie, at 17 Boulevard des Italiens. Because Adrien was working as *Nadar jeune*, often minimizing the *jeune* to "*jne*" written in small type and in Nadar's celebrated script, Nadar was forced to exhibit under the name *Nadar aîné*. Despite Nadar's repeated requests and financial incentives, Adrien refused to stop using *Nadar jeune* until Nadar sued him to claim the name exclusively for himself and his family. Nadar also claimed authorship of their photographs and attempted to recoup money invested in their studio. By January 1856, Nadar opened a studio and signed works *Nadar et Cie/Nadar Société de Photographie Artistique* 113 R. St. Lazare" and "Nadar/113, rue St. Lazare, *pas de succursale*" (Nadar/113 rue St. Lazre, no branches) in reference to Adrien. Although Adrien won the first suit in 1856, he lost the December 12, 1857, appeal, with the court declaring Félix "the only, the true Nadar."

Adrien's new studio was initially successful and in 1855, he became a member of the *Société française de photographie*. However, by 1858 his studio was bankrupt. He tried to appeal the court's ruling, but was denied in June 1859. Later that year, the estranged brothers were reunited due to their mother's illness. She died in February 1860 and, as a last wish, asked Nadar to help Adrien with his floundering career. Nadar settled some of his debts and purchased Adrien's photographic equipment, even though he had paid for most of it six years earlier.

Between 1862 and 1864, Adrien ran a new studio with J.P. Johannes at 124, avenue des Champs-Elysées, where he created portraits of animals, such as angora goats and horses. In April 1867, Adrien opened a firm dedicated to photographic enamels, which failed and was closed by 1872. He continued to produce work and exhibited with the Société des Artistes Françaises at the Salon of 1884. In 1893 Adrien entered the retirement home at Sainte-Perrine, then the pension Galignani at Neuilly, where he was treated for mental illness. He spent his last decade in mental institutions before dying on January 24th, 1903.

Since the late 1970s, historians have reevaluated Adrien's photographic legacy. Comparing photographs made by the two brothers reveals both their differences and the extent of their collaboration. While Nadar's role has been acknowledged in works signed exclusively by Adrien, it is also clear that Adrien significantly contributed to works made by the two.

JENNIFER FARRELL

Biography

Alban-Adrien Tournachon born 1825 to Victor Tournachon and Thérèse Maillet in Paris. Younger brother of Gaspard-Félix Tournachon, known as Nadar. Adrien studied photography with Gustave Le Grey. Between 1853 and 1854, Adrien created physiognomic studies for Dr. Guillaume-Benjamin-Armand Duchenne, known as the founder of electrotherapy. In early 1854, Adrien opened a studio at 11 Boulevard des Capucines, partially funded by his brother, Nadar. They worked together for four months between until December and produced portraits of artists, friends, and clients. Their celebrated photographs were of the mime Charles Deburau as Pierrot, which were exhibited at the Exposition universelle in 1855. The brothers acrimoniously split and Nadar left the studio in January of 1855. In 1856, the brothers went to court over Adrien's use of the name "Nadar jeune" and financial issues. Adrien won the initial trial, Nadar eventually gained exclusive rights to the name. Adrien received acclaim for his animal portraits, yet his subsequent studios failed. In 1893, Adrien entered a retirement home for mental illness. He died on January 24, 1903.

See also: *Société française de photographie*; and Nadar (Gaspard-Félix Tournachon).

Further Reading

Hambourg, Maria Morris (ed.), *Nadar*, New York: The Metropolitan Museum of Art, 1995 (exhibition catalogue).

Jammes, André, "Duchenne de Boulogne, La Grimace Provoquée et Nadar." *Gazette des Beaux-Arts* 6,17 (1978): 215.

McCauley, Elizabeth Anne, *Industrial Madness, Commerical Photography in Paris, 1848–1871*, New Haven, CT: Yale University Press, 1994.

TOWLER, JOHN (1811–1889)

Born in Yorkshire, England, on 20th June 1811, Towler was educated in Yorkshire, Germany and Cambridge. He migrated to the United States in 1850.

The Silver Sunbeam: A Practical and Theoretical Text-Book on Sun Drawing and Photographic Printing: Comprehending all the Wet and Dry Processes at present Known, with Collodion, Albumen, Gelatine, Wax, Resin, and Silver; first appeared in 1864, from the New York publishing house of Joseph H Ladd. It became one of

early photography's 'best sellers' with sales exceeding nine thousand copies over a fifteen-year period in America alone. Several thousand more copies were sold in Britain, and yet more in three Spanish-language editions. It was the comprehensive nature of the book, and the accessibility of Towler's text, which attracted such significant sales. In nine editions, new discoveries and inventions were appended as they were introduced, and by the 1879 edition, the 351 pages of the first edition had swelled to 599. He went on to write several other important books and manuals on photography, but none captured the imagination, or achieved the sales enjoyed by *The Silver Sunbeam*. Towler edited *Humphreys Journal of Photography* from 1864 until 1867.

Other publications included essays on dry plate processes (1865), photography on porcelain (1865), and the production of high quality prints (1866, 1870), and several translations of works from the original German.

From 1882 until 1886 he served as US Consul in Trinidad.

JOHN HANNAVY

TOWNSHEND, CHAUNCY HARE (1798–1868)
British art collector, writer, and poet

Townshend was born on 20 April 1978 at Busbridge Hall, Godalming, England, the only son of a landed gentleman, Henry Hare Townsend and his wife, Charlotte. (Chauncy Hare Townshend added the letter 'h' to the family surname in 1827 when he succeeded to the family estates.) From an early age Townshend was encouraged to take an interest in the arts. He was educated at Eton College and Trinity Hall, Cambridge where he won the Chancellor's medal for his poem *Jerusalem*. In 1826 he married Eliza Frances Norcott.

Townshend took holy orders but felt unable to pursue this vocation due to a nervous complaint –a combination of melancholia and hypochondria to which he succumbed during the 1820s or 30s—that was to plague him for the rest of his life. However, his passion for travel and collecting, his contacts with distinguished friends, and his enormous personal wealth allowed him to lead an active and fascinating life. The experience of Townshend's journeys in Britain fed into his first published prose work, *A Descriptive Tour in Scotland* (1840). He was an accomplished amateur painter and draughtsman, musician and composer and an ardent advocate of mesmerism, aspects of which are now known as hypnotism. He published *Facts in Mesmerism* (1840) and *Mesmerism Proved True* (1854) and also practised the technique on others. He moved in the highest social and literary circles in London hosting musical evenings at his house at 21 Norfolk Street, (now Dunraven Street) looking on

to Hyde Park. Among the many guests were the poet Laureate Robert Southey and the novelist Wilkie Collins, much of whose description of "Mr. Fairlie" in *The Woman in White* is modelled on Townshend. Charles Dickens is said to have taken Townshend as his inspiration for the character of 'Cousin Feenix' in *Dombey and Son* and became a close friend, dedicating *Great Expectations* to him. He acted as literary executor after Townshend's death and edited his posthumous *Religious Opinions* (1869). After separating legally from his wife in 1843, Townshend spent his winters in Switzerland at his villa near Lausanne on the Lake of Geneva.

Townshend's wide-ranging interests in the 1840s and 50s informed his taste in his large, eclectic collection of pictures including oil paintings, watercolours, prints and photographs. Many of his acquisitions adorned the walls of his houses or would have been kept in portfolios and presses for viewing. He remains one of the few identifiable British private collectors of early photographs, on any significant scale, apart from Albert, the Prince Consort. After his death in London on 25 February 1868, *The Times* described Townshend as "a collector of rare judgement and exquisite taste." A bequest of porcelain, glass, watches, geological specimens, curios and the bulk of his library was made to the Museum at Wisbech, Cambridgeshire, near his country estates. The bequest to the South Kensington Museum (later renamed the Victoria and Albert Museum) was instigated at the suggestion of one of the curators, G.F. Duncombe, who put the idea to Townshend while accompanying him on a tour of the Museum. This bequest contained some of the finest treasures in his remarkable collection including photographs, paintings, prints, drawings, books, gemstones, coins, cameos and intaglios. This bequest ensured the rare survival of a key group of art photographs from a 19th century private collection.

An inventory of his collection made at his London home shortly after his death (V&A Archive) reveals how Townshend grouped and housed his collection. It also gives a valuable insight into his taste in photography that encompassed many of the major French and British names of the 1850s. He had visited the Exposition Universelle, Paris, 1855 and may have noticed works by Gustave Le Gray and André Giroux there but could have purchased fine photographs such as these at London dealers such as Murray and Heath. Townshend's photographs fall into three groups: those he kept carefully housed in presses also containing his watercolours and print collection old master etchings and engravings, (including Rembrandt) topographical and architectural views, drawings, zoological plates and leaves of dried plants; books illustrated by photographs which were shelved with the other books of his library; and stereoscopic photographs and daguerreotypes kept in cases in the "Front Room" or study. The stereographs and

daguerreotypes remain untraced, as does one photograph of a waterfall by an un-named photographer which is listed as being framed and hung among the paintings.

Of the holdings of Townshend's photographs still extant in the Victoria and Albert Museum the greatest group are twenty by Le Gray, comprising mainly his Fontainebleau forest pictures and celebrated seascapes, considered today to be among the finest selections of his surviving prints in the world. Among the other important photographs are a number by Camille Silvy, including his masterpiece *River Scene, France*, (1858), André Giroux's landscape *The Ponds at Obtevoz (Rhône)* (c.1855) and architectural studies by Édouard Baldus and the Bisson Frères. Among Townshend's photographically illustrated books is *The Sunbeam*, (1859)—edited by Philip H. Delamotte, including photographs by him and others such as Joseph Cundall, Francis Bedford, George Washington Wilson and John Dillwyn Llewelyn—William and Mary Howitt's *Ruined Abbeys and Castles of Great Britain* (1862) and photographic reproductions of J.M.W. Turner's compilation of drawings, the *Liber Studiorum*, photographed by Cundall, Downes & Co. (1862). Like many of his Victorian contemporaries, Townshend was also fascinated by popular and eccentric figures. The collection contains portraits of such people Mr. Rarey the famous American horse trainer with the stallion "Cruiser" by Caldesi and Montecchi (1858) and the champion boxers, John C. Heenan, "The Benicia Boy," and Tom Sayers, by George Newbold (1860). Townshend's interest also extended to pictures of topical interest at the time shown in Roger Fenton's Crimean war images and some remarkable scenes of ruined houses in the aftermath of the "Clerkenwell Explosion" taken by Henry Hering. On December 13th, 1867, a hole was blown in the prison wall at Clerkenwell House by Fenians attempting to release one of their group. The photographs record the extent of the resulting damage to buildings. These were some of the last objects collected by Townshend before his death.

<div align="right">MARTIN BARNES</div>

See also: Expositions Universelle, Paris 1854, 1855, 1867, etc.; Le Gray, Gustave; Giroux, André; Victoria, Queen and Albert, Prince Consort; Silvy, Camille; Baldus, Édouard; Bisson, Louis-Auguste and Auguste-Rosalie; Delamotte, Philip Henry; Cundall, Joseph; Lemere, Bedford; Wilson, George Washington; and Llewelyn, John Dillwyn.

Further Reading

A Diversity of Gifts: Four Benefactors of the National Art Library, National Art Library booklet, 1995.

Chauncy Hare Townshend 1798–1868, Wisbech and Fenland Museum Library exhibition leaflet 1998.

Haworth-Booth, Mark, "The Dawning of an Age, Chauncy Hare Townshend: Eyewitness," in *The Golden Age of British Photography, 1839–1900*, Victoria and Albert Museum/Aperture, NY, 1984.

Haworth-Booth, Mark, "A Connoisseur of the Art of Photography in the 1850s: The Rev. C.H. Townshend." In *Perspectives on Photography: Essays in Honour of Beaumont Newhall*, edited by Peter Walch, and Thomas Barrow, University of New Mexico Press, 1986

Reverend C. H. Townshend Bequest Registered File, Victoria and Albert Archive.

TRAVEL PHOTOGRAPHY

The link between photographic practice and the activity and experience of travel was forged before Louis Jacques Mandé Daguerre's process was announced to the Parisian public in 1839. The symbolic meeting of activities occurred at the meeting in 1838 of two principals when the eminent geographer and explorer Alexander von Humboldt visited Daguerre in his studio. Humboldt met with Daguerre in the geographer's role as member of the committee appointed by the Academie des Sciences to evaluate Daguerre's claim that he had perfected a process to record and fix through chemical means the images produced in the *camera obscura*. As Schwartz argues: "at a time when travel was embraced as a way of seeing and knowing the world, photographs offered a new means of acquiring, ordering, and disseminating geographical information" (Schwartz, 1996, 16). Travel was the primary means of gathering the empirical knowledge of the world; travelers' accounts supported by printed illustrations based on sketches, topographic views, and maps produced during the course of travel disseminated that knowledge. The emphasis on travel as a mode to acquire knowledge is part of the nineteenth-century emphasis on collecting, categorizing, and possessing the world associated with the sciences of geography, anthropology, and archaeology. After the introduction of photographic processes, whether as permanent image on metal plate or paper print, photography became the preferred and trusted mode of creating and presenting the visual records of travel because it was derived from the "neutral" operations of chemistry and optics. Later, travel as a method of empirical knowledge pursued by a relatively small cadre of explorers gave way to travel as part of the burgeoning activity and industry of tourism—the organized consumption of place as leisure activity. Photography participated in the change to touristic consumption as a record and validation of leisure travel and by creating and amplifying the desire to participate in leisure travel activities.

The first practitioners of travel photography were amateur enthusiasts who pursued their interests in the new technology of image making as they undertook travels for official, commercial, or personal interests. Joly de Lotbinière and Frederic Goupil-Fesquet sepa-

rately came to be photographing the Sphinx on the same day in November 1839, scant weeks after Daguerre's public demonstration. Lotbinière went on to make an extensive daguerreotype record of his travels over the next year. Jules Itier (1802–1877), a government functionary in the French trade ministry, was an early adopter of Daguerre's technique and made daguerreotypes on trade missions to Senegal (1842) and China, Singapore, the Philippines, Borneo, and India (1843–1846). Baron Louis Gros, a French diplomat, made and exhibited daguerreotypes of the monuments and landscapes he encountered on extensive travels in the Americas, Greece, and England. While yachting in the Mediterranean in 1845, Christopher Talbot, William Henry Fox Talbot's cousin, and Reverend Calvert Jones made a number of calotype views, including early two part panoramas of Naples. The Reverend George Bridges (active 1846–1852) photographed extensively during a tour of the Mediterranean and North Africa. Ernest Benecke (active 1851–1853), the son of an Anglo-German banking family, also compiled an extensive calotype record of travels perhaps undertaken to familiarize himself with family business interests in the region. In most of these cases, the work was shared privately or had limited exposure in exhibitions organized by the newly formed photographic societies. Lotbinière is the exception in that his work was reproduced in some of the first books to feature illustrations derived from photographs—those by Lerebours and Horeau, for example.

Excursions daguerrienes, representant les vues et les monuments les plus remarquables du globe (1840–44), published by the Parisian optician Nicholas Lerebours, was the first book of travel images derived from daguerreotype images. *Excursions* eventually comprised 100 plates of views of Egypt, Italy, Greece, Russia, France, and other countries provided by a number of early daguerreotypists. In this first use of the photographic image as document of travel, images were reproduced as engravings derived by tracing the outlines of the daguerreotype image and then laboriously adding by hand the exquisite detail which the daguerreotype was capable of rendering. Although a very few plates were printed directly from the daguerreotype plate using Fizeau's process, the plates were engraved copies after daguerreotypes. While *Excursions* was the largest and earliest photographic entry into the travel book market, it was rapidly followed by others that reproduced either daguerreotypes or calotypes through engraving, aquatint, or lithography—see for example, Hector Horeau's *Panorama d'Egypte et de Nubie* (1841) and Pierre Tremaux's *Voyage au Soudan oriental et dans l'Afrique septentrionale exécutés de 1847 a 1854* (1852–1854). The first travel book with direct photographic illustrations was Maxime Du Camp's *Egypte, Palestine et Syrie* (1852). Du Camp's book comprised 125 calotype prints derived from paper negatives nade during a lengthy journey in 1849 to 1851, printed by Blanquart Evrard, and accompanied by short texts supplied by Du Camp. Although the work was judged extraordinarily successful—Du Camp was awarded the Legion of Honor in recognition of his achievement—probably no more than 350 copies were printed.

These initial productions defined an elite market for deluxe photographically illustrated travel accounts for the scholar or arm-chair traveler. While amateurs continued to make photographs on their travels, entrepreneurial photographers realized that market demand could be better and more economically met by superior printing technology utilizing wet collodion glass plate negatives from which a large number of albumin prints could be made. Frances Frith should be credited with developing and refining marketing strategies for travel photographs by recognizing the existence of distinct market segments. Beginning in 1856 with his views of Egypt and the Holy Land, Frith produced photographs in a range of formats, including stereo-views, which were affordable to a growing middle class while appealing to Victorian ideals of self-improvement by offering direct visual knowledge of the world. After first working with established publishers, Frith formed his own photographic publishing firm—Frith & Co.—which continued to offer, throughout the nineteenth century, views of local and foreign destinations from a network of operators, as individual prints, collected in volumes, and in sets of stereo cards.

The photographically illustrated travel account, which paired text that reported incidents encountered en route and offered instruction in the history and culture of the region with photographs, functioned as both the document of a completed journey and the stimulus for journeys of the imagination. Frances Bedford accompanied the Prince of Wales' 1862 tour of Egypt and the Holy Land as the official photographer. On his return, prints were offered for sale through his Bond Street gallery and later compiled in *The Holy Land, Egypt, Constantinople, Athens, etc.* (1867). Both offered the British public vicarious participation in the royal journey and a record of the tour. The production of images of foreign or distant locales, ala Frith, Bedford, and innumerable other operators, was accomplished within a distinct set of practices associated with view photography, defined by expectations shared by maker and consumer. View or topographic photographs did not suggest or allude to a place, they delineated it precisely. Dramatic effects of light and shade that might confuse the presentation of a complete, spatially coherent, record of site were avoided. A well-executed view was as much a map as it was a picture, offering a clear understanding of the disposition of structures, access into and within the space, and relative scale and distance. Indeed, the fine detail

of glass plate negative/albumin print could provide an almost tactile registration of the materiality of physical space—the grit of masonry and sand, the smoothness of plastered walls, or subtle texture of wood.

As the industry of leisure travel grew, a development which can be dated to the first package tours to the Crystal Palace exposition in 1851, photography and the activity of travel became ever more intimately entwined. Travel views at once satisfied a demand for views of the world to those who would never visit the places shown, as they encouraged the consumption of places which were becoming more broadly accessible through organized tourism. Thomas Cook was one of the earliest, but by no means the only operator, offering package tours; Cook's Tours brought a growing number of middle class travelers to the Universal Exposition in Paris in 1855, to holiday destinations in Great Britain and Continental Europe by 1860, and to Egypt and the Holy Land in 1869. Expanded access to leisure travel altered the point of purchase of travel photographs but not the standards for the way in which place was inscribed as view. Travelers could purchase photographs of the sites they visited along their route. Commonly loose prints were purchased and arranged in elaborate photographic albums which served as the recapitulation of the journey, although local photographers did offer commercially printed albums dedicated to the particular area. While these albums operated as souvenir and proof of status for a traveler, they also retained the earlier connections between travel, photographic record, and nineteenth-century knowledge making. A number of photographic Tour de Monde albums were placed in public reading rooms or libraries, as a source of instruction for those who could not travel (Mickelwright, 2003. Local photographic studios were common at major sites after the late 1850s and nineteenth-century travel guides listed the best local sources for photographs. Commercial photographers offered photographs specifically for the visitor wishing to preserve the sights he or she encountered in the course of travel, including a variety of staged photographs of local life which had more apparent than real connection to his or her experience as tourist. Native "types" photographed in cafes, dimly lit courtyards, or "domestic" surroundings offered the illusion of connection with the foreign other that was seldom provided by the protected experience of the package tour arranged and managed to cause the least discomfort to western travelers. Maison Bonfils and Abdullah Freres in the Middle East, Bourne and Shepherd, and John Burke in India; Georgio Sommer, Fratelli Alinari, Tommaso Cuccionni, and Robert Macpherson in Italy; Muybridge, Watkins, and Jackson in the American West; Jakob Laurent and Charles Clifford in Spain; Felice Beato and his successors in the Far East; Baldus in France; and George Washington Wilson, Francis Frith, and Roger Fenton in the United Kingdom, to name just a few—were photographers with large commercial offerings of travel views available both on-site and through publication and distribution networks in European and American cities. Views of the Alps by the Bisson brothers (1860) and Charles Soulier (1869) recorded mountaineering, another form of leisure activity that developed as tourism expanded. Rail journeys were recapitulated by photographers in France (Baldus) and the United States (Rau and Jackson), as rail travel accelerated access to distant places. Increasingly railroad companies, who understood that leisure travel passengers offered a significant potential market, enticed those travelers by photographs which celebrated the engineering accomplishment embodied by the railroad and offered the inducement of miles of unfamiliar landscape to delight a passenger's eye. In the United States, the Santa Fe Railroad Company commissioned both painters and photographers to provide images calculated to whet the public appetite for the visual attractions of the American Southwest. Commercial photographers—initially subsidized by the railroad company—set up shop at rail stations and tourist destination hotels, also subsidized by the railroads.

Stereo photography was particularly well suited to travel images, offering as it did an immersive experience of place through the combination of the three-dimensionality of the image and the restricted field enforced by the viewer (Schwartz 1996). The effect of "knowing" the place seen through the stereoscopic viewer was reinforced by the inclusion of didactic text on the reverse of the card. A number of major publishers of stereo images—Underwood and Underwood, Kilburn Brothers, Frith and Co.—dispatched photographers to locations, events, and the aftermath of disasters around the world to feed the extensive market for entertainment and instruction. Realistic Travels Publishers offered stereo views of the far reaches of the British Empire from offices in London, Delhi, and Cape Town; views that reinforced imperial possession while providing instruction to future colonial officers. Stereo series of foreign and exotic locales continued to be widely marketed through the 1930s. Touted as an entertaining form of armchair travel and an educational tool, they could be found in parlor as well as classroom.

Perhaps the last manifestation of commercial photographic practice associated with travel in the nineteenth century was the development and rapid proliferation of the picture postcard industry at the end of the nineteenth century. By the 1890s, travel views sized to meet new postal codes and reproduced in collotype (also known under a number of proprietary names such as Phototype, Heliotype, Albertype, and Lichtdruck) or photolithography became a standard accompaniment to travel. By 1888, the halftone process and later a chromo-halftone

process, which provided rudimentary colored images, made picture post cards ever more available and less expensive. The picture postcard—mailed to friends and family or collected as souvenir—reigned as the commercially produced photographic marker of travel for the next century (Geary and Webb). After 1885 and the introduction of the Kodak, a unitary system of camera, film and processing that reduced the complexity of the photographic act to "You push the button and we'll do the rest," the commercial image was paralleled by the personal, informal, traveler's snapshot. Kodak advertising connected "Kodaking" to the modern pursuit of leisure—outdoor activities such as biking and automobile touring, and, of course, travel—and ads featured prominently the Kodak woman as tourist with camera in hand (West, 40). The personal snapshot and the commercial picture postcard dominated travel views throughout the twentieth century, only to be supplanted at the end of the century by digital images posted on users' spaces and accessed electronically from any computer.

Photography and travel, including the transformation of individual travel through the burgeoning tourism industry, are central and distinct elements of modern life from the nineteenth century forward. The centrality of these linked phenomena has been the focus of critical analysis from a variety of theoretical positions. Analysis of the cultural formations of travel and its associated imagery have addressed the economic and social implications of consuming the world as image and mediated experience (Osborne, Gregory, Taylor)The experience of travel, the visual record of distant locations, and the dissemination of that visual record were recognized as important elements of the social and political structures that reinforced imperial and/or colonial control of distant lands. Thus travel photography has been viewed through the lens of post-colonial critiques of power and resistance (Ryan, Nordstrom, Micklewright, Gregory). Ryan argues that photographic practice was an essential tool in the formation and maintenance of British imperial rule. Taylor focuses on the use of photographs of the British Isles to construct national identity through a shared tourist experience. Gregory defines the production of personal travel photographs by the amateur as one of the central acts in the performance of touristic explorations of the world.

In all of the critical discourse surrounding travel and photography are cores assumptions relating to the value of knowledge production in the nineteenth century and the power of the photograph, by virtue of its perceived transparency and veracity, to transmit knowledge of the world. Prior to the advent of photography, extensive travel was considered the ultimate source of knowledge of the world. Travel books might offer the traveler's journals expanded with observations and field notes, buttressed by research and citations from other authorities,

perhaps accompanied by reproductions of sketches and plans, but these were partial and mediated experiences of direct knowledge—valuable but inherently flawed. As Schwartz (2003) argues, the photograph became the surrogate for the direct experience of the world, acting as a neutral, impassive eye in distant places. Not a pale substitute for direct experiential knowledge but a form of knowing that offered advantages over physical travel because it permitted careful and repetitive examination of place, and facilitated comparison between distant places. The assumption that photography functioned as a technologically based system which mechanically produced direct observations of the natural world ensured that photography wielded the intellectual power that allowed it to operate as a tool of imperial and colonial control, a means of structuring national identity through shared place, the underpinning of commercial tourism, and ensures that it continues to provide proof of experience to modern day travelers, despite our understanding of the suspect nature of photography's claim to truth.

KATHLEEN STEWART HOWE

See also: Daguerre, Louis-Jacques-Mandé; von Humboldt, Alexander; Itier, Jules; Gros, Baron Jean-Baptiste Louis; Daguerreotype; Talbot, William Henry Fox; Jones, Calvert Richard; Africa, North (excluding Egypt and Palestine); Benecke, Ernst; Calotype and Talbotype; Lemercier, Lerebours and Bareswill; Italy; Greece; Russia; France; Egypt and Palestine; Du Camp, Maxime; Blanquart-Evrard, Louis-Désiré; Frith, Francis; Topographical Photography; Expositions Universelle, Paris (1854, 1855, 1867 etc.); Underwood, Bert and Elmer; Half-tone Printing; and Kodak.

Further Reading

Faber, Paul, Anneke Groeneveld, and Hein Reedijk, *Images of the Orient: Photography and Tourism 1860–1900*. Rotterdam: Museum voor Volkenkunde, 1986.

Fabian, J. Rainer, and Hans-Christian Adam, *A Vision of the Past: Masters of Early Travel Photography*, London, 1983.

Geary, Christraud M., and Virginia-Lee Webb, *Delivering Views: Distant Cultures in Early Postcards*, Washington and London: Smithsonian Institute Press, 1998.

Gregory, Derek, "Emperors of the Gaze." In *Picturing Place: Photography and the Geographical Imagination*, London: I.B.Taurus, 2003.

Hambourg, Maria Morris, "Extending the Grand Tour." In *The Waking Dream: Photography's First Century*. New York: Metropolitan Museum of Art, 1993.

Hershkowitz, Robert, *The British Photographer Abroad: The First Thirty Years*, London, 1980.

Micklewright, Nancy, *Victorian Traveler in the Middle East: The Photography and Travel Writing of Annie Lady Brassey*, London: Ashgate Pub., 2003.

Nordstrom, Alison Devine, *Picturing Paradise: Colonial Photography of Samoa, 1875–1925*, Daytona, Florida: Southwest Museum of Photography, 1995.

Osborne, Peter D., *Travelling Light: Photography, Travel, and Visual Culture*, Manchester and New York: Manchester University Press, 2000.

Ryan, James, *Picturing Empire: Photography and the Visualization of the British Empire*, Chicago: University of Chicago Press, 1997.

Schwartz, Joan, "The Geography Lesson: Photographs and the Construction of Imaginative Geographies." *Journal of Historical Geography*, 22, 1 (1996): 16–45.

——, Light Impressions: Travel, Writing, and Photography (working title). Manuscript in preparation.

Schwartz, Joan, and James Ryan (eds.), *Picturing Place: Photography and the Geographical Imagination*, London: I.B.Taurus, 2003.

Taylor, John. *A Dream of England: Landscape, Photography, and the Tourist's Imagination*, Manchester: Manchester University Press, 1994.

West, Nancy Martha, *Kodak and the Lens of Nostalgia*, Charlottesville, VA: University Press of Virginia, 2000.

TRÉMAUX, PIERRE (ACTIVE 1853–1868)
French, photographer, architect, architectural historian

The architect Trémaux was a member of the Académie des Beaux-Arts and Société de Géographie, and winner of a second place Prix de Rome in 1845. He was born in 1818, and is known for a extensive, profusely illustrated, three-part publication on the architecture of Africa and Asia Minor: *Voyage au Soudan oriental et dans l'Afrique septentrionale exécutés de 1847 a 1854* (1852–1854); *Une parallèle des édifices anciens et modernes du continent africain* (1861); *Exploration archéologique en Asia mineur* (1862–1868). Trémaux explored the use of photography for illustration, initially using photographs, as well as drawings, as source documents for lithographic plates. In 1853–54, he made calotypes in Egypt which were bound into volumes in addition to lithographs. The photographic prints deteriorated rapidly and he replaced them with lithographs. For the third part of the series, he turned to Poitevin's photolithographic process. Despite the technical shortcomings of his photographic work, Trémaux's calotypes are recognized as some of the earliest photographs of the people of Egypt.

KATHLEEN HOWE

TRIPE, LINNAEUS (1822–1902)

Working in India and the East in the mid 1850s the photographs of Linnaeus Tripe, along with those of his contemporaries John Murray and Samuel Bourne, rank amongst the finest of the period. Tripe, an accomplished amateur, was amongst several army officers seconded from military duties to record antiquities, architecture and ethnography of the continent and created a body of work which, though highly regarded by his contemporaries, has until recently been sadly overlooked.

Born in 1822 in Devonport, England, Linnaeus Tripe was the ninth of Cornelius and Mary Tripe's twelve children, his siblings including Theophilus, Octavius, Lorenzo, Septimus and Algernon. Tripe studied mathematics and the classics and at seventeen he joined the East India Company as an ensign. By the early nineteenth century, the East India Company itself had evolved from a small trading company to control much of India, employing both political and military rule to protect its commercial interests. The 'Government' was organised into three Presidencies of Bombay, Madras and Bengal respectively. Tripe was stationed with the Madras Establishment, rising from humble ensign in 1839 to honourary Major General by his retirement in 1875.

Tripe's first known photographs were taken between 1853 and 54 around his hometown of Devonport towards the end of a three and a half-year furlough. On his return to India he continued with his new hobby and while on leave in December 1854 took a series of photographs around Halebid and Belur. These prints were greatly admired when shown at the Madras Exhibition of 1855 and Tripe was awarded the first class medal. At this time the Government of India was already showing interest in photography as a more cost and time efficient method to document and record antiquities than commissioning traditional artists. In 1855 they sent a mission to Ava to persuade the King of Burma to recognise the British annexation of Lower Burma following the Second Anglo-Burmese War of 1852. Captain Tripe, probably as a result of his success in the Madras Exhibition, was appointed official photographer and during the three and a half-month trip he produced nearly 220 calotype negatives. In truth, due to sickness and bad weather, Tripe had only 36 working days in which to photograph the region. This was indicative of the problems of the 19th century photographer in India: heat, dust, and flies in summer, damp humid conditions and sickness during the monsoon months, the rapid deterioration of chemicals, and difficulties procuring and transporting the bulky equipment were regular complaints. For many of these reasons Tripe preferred the calotype, modifying Le Gray's waxed paper process to suit his needs. However even this method was not without its difficulties and Tripe complained that the wax often melted in the heat leaving spots on the first prints "so as to spoil them."

On his return to the photographic department in Bangalore Tripe began the labourious task of printing 50 boxed sets from 120 negatives selected from the trip for The Government of India—a total of over 6,000 prints. The skies of these Burmese views have a pronounced granular texture and lack of definition, a fault typical of early negatives since different exposures were needed to record sky and solid objects. Tripe blacked out the sky on his negatives completely so it printed white,

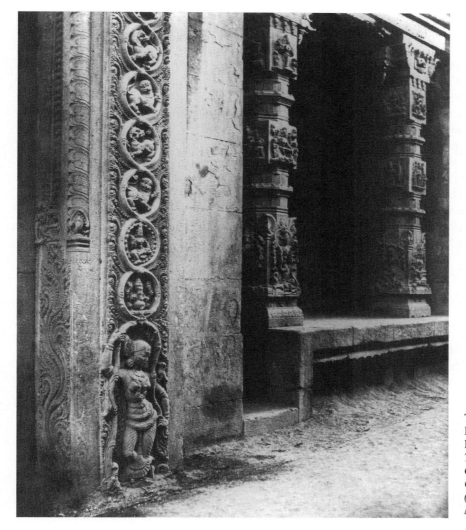

Tripe, Linnaeus. Basement fo a Monolith in the Raya Gopuram, Madura.
The Metropolitan Museum of Art, Gilman Collection, Purchase, Cynthia Hazen Polsky Gift, 2005 (2005.100.381.1.9) Image © The Metropolitan Museum of Art.

dubbed artificial clouds or settled for the grainy 'salt and pepper' effect. Tripe had begun printing when the Madras Establishment again requested his services as Government Photographer but printing the Ava views prevented him from taking up the post until the beginning of the following year. The aims of his new post were to photograph the southern states of the province, recording important items of interest to historians, antiquaries, and architects, to document different races, and to initiate other photographic projects.

The post also required Tripe pass on his knowledge and he taught the calotype process to employees of the public works department of Madras and the collodian process to pupils of the Madras school of Industrial Arts that spring. While teaching in Madras Tripe photographed the exhibits of the 1857 Madras Exhibition (and a number of prominent Madras civil servants) using the collodion negative process. On his return to Bangalore he printed around 1,800 prints for the government and a further 1,000 for public sale. Printing again delayed the start of his next project: a photographic tour of the Southern States of the Presidency. He finally set out in

December 1857 taking four bullock carts to transport his equipment on a trip that lasted seven months—much of it during the troublesome hot season. Tripe produced 275 paper negatives, 16 collodian glass negatives and 160 stereographs on glass. His subjects included the temples of Madura, Seringham and Tanjore, the palaces of Madura, Tanjore and Poodoocottah, the forts at Trichinopoly and Trimium, landscapes around the beautiful Salem district, and the Elliott Marbles in Madras. This body of work is considered to be his best and once more the Government ordered many sets of the prints. Back in Bangalore, Tripe and his assistants began printing once again, however a new problem faced the department. As a result of the Indian Mutiny the British government had taken over the rule of India from the East India Company in late 1858. The new Governor of the Madras Presidency viewed that in such difficult times the Photographic Department was "an article of high luxury" and soon ordered its closure on grounds of excessive costs. Tripe was to be allowed to finish work in hand, but there would be no new commissions. Tripe argued strongly against the decision, but to no avail and

on completion of printing and finalising the accounts in 1860 he left for England on a two-year furlough disappointed and in poor health.

Tripe returned to military duties in 1863 and his last known photographs were taken in 1870 while stationed in Burma. In 1873 he returned to Devonport, England, retiring from the army in 1875. During the 1880s he was active in local charities, and indulged a passion for collecting shells and corals, some of which were acquired by British Museum after his death in 1902. His photographic record shows not only diligence and determination to carry out his commission well, a technical mastery of his medium, especially the calotype process, but also a great visual awareness and sympathy for his subject, producing some of the finest architectural studies of the period.

SARAH MCDONALD

Biography

Born in Devon, England on 14 April 1822. Educated in classical and mathematical studies at Devonport Classical School. 1839 joined the Madras Establishment of the Army of the East India Company as a Cadet of Infantry. First documented photographs taken around hometown of Devonport 1853—54. Photographs taken on leave around Bangalore 1854 received the first class medal in the Madras Exhibition of 1855.

Appointed Official Photographer to the Government of India Mission to Ava (Burma) in 1844 and following year appointed as government photographer to the Madras Presidency taking up post in 1857. Photographed exhibits in the Madras Exhibition and Madras residents followed by a photographic tour of the Southern Districts of the Presidency. Published various volumes in 1858: *Photographic Views in Madura; Photographic Views of Poodoocottah; Photographic Views of Ryakotta and other places in the Salem District; Photographic Views of Seringham; Photographic Views in Tanjore and Trivady; Stereographs of Madura; Stereographs of Trichinopoly.* 1860 Photographic Department of Madras Presidency closed. Last known photographs taken in 1870. In 1873 returned to England, retiring from the army in 1875 with honourary rank of major general. Died 2 March 1902.

Exhibitions

1855 Madras Exhibition of Raw Products, Arts and Manufactures of Southern India. Awarded First Class Medal.
1857 Madras Exhibition of Raw Products, Arts and Manufactures of Southern India.
1857 Photographic Society of Bengal Exhibition (Calcutta)
1859 Madras Photographic Society Exhibition

See also: Murray, John; Calotype and Talbotype; Le Gray, Gustave; Waxed Paper Negative Processes; and Wet Collodion Negative.

Further Reading

Falconer, John, *India: Pioneering Photographers 1850–1900,* The British library. London, 2002.
Falconer, John, Satish Sharma, and Brett Rogers, *A Shifting Focus: Photography in India 1850–1900,* The British Council, 1995.
Dewan, Janet, *Linnaeus Tripe: Photographs of Burma and Madura in the 1850s,* Toronto: Art Gallery of Ontario, 1988.
Dewan, Janet, and Sutnik, Maia-Mari, *Linnaeus Tripe: Photographer of British India 1854 –1870,* Toronto: Art Gallery of Ontario, 1986.
Desmond, Ray, *Photography in India in the Nineteenth Century,* London: India Office Library and Records Report. 1974.
Hershkowitz, Robert, *The British Photographer Abroad: The First Thirty Years,* London, 1980.

TUMINELLO, LUDOVICO (1824–1907)
Italian photographer

Along with the painter Giacomo Caneva (1813–1865) from Padua, Tuminello represents outstanding, aesthetic Italian photography at the beginning of the introduction of the process to Italy. Although not always consistent in quality, at his best in landscape topography and architecture, he conveys, by control of tone, especially the use of strong contrasts, of dark shadow and bright light, and an expert selection of composition and viewpoint, the grandeur and emotional experience, the melancholy that is Rome. In this he mirrors the monumentality caught by both Caneva and Robert McPherson, the foremost photographer of the period. Born Rome, Tuminello started photography around 1842 but moved to Turin in 1849 for political reasons during the revolutionary upheavals in Rome. He returned in 1869 and commemorated in a panorama (three photographs) the siege of Rome by the Italian troops in 1870, including the breach of the walls. He also visited Sardinia, Egypt, Sudan and Tunisia on expeditions led by the Marchese Orazio Antinori. Tuminello persisted in using the calotype (along with glass negatives) after the sweeping success of the new wet plate process post 1851 when the market then became flooded with often nondescript images made exclusively for those on the Grand Tour: their success was to deny the photographer's personality. Tuminello bought and distributed Canova's picture library produced for the artists of the French Academy at the Villa Medici (and may have used some of his negatives as his own, not uncommon). In 1903 his archive was auctioned but some paper negatives are preserved in the Gabinetto Fotografico Nazionale in Rome. We still await a serious study of this remarkable photographer.

ALISTAIR CRAWFORD

TURNER, BENJAMIN BRECKNELL
(1815–1894)
British photographer

Benjamin Brecknell Turner was born on 12 May 1815 at 31–32 Haymarket, London, the eldest son of Samuel Turner and Lucy Jane Fownes. He attended Queen Elizabeth's Old Palace School, Enfield, London, until 1831. At sixteen he was apprenticed to his father as a tallow chandler in the family firm Brecknell, Turner Ltd., which made and sold candles and soap from their premises at Haymarket. In 1836, the family moved to live in Balham, South London. In 1840, Turner travelled to Belgium, Switzerland, and Paris. At his father's death the following year he took over the family business. He continued his continental tour in 1845 with visits to Switzerland, Munich, Salzburg, Vienna, Prague, Dresden, Berlin, and Hamburg. In 1847 he married Agnes Chamberlain with whom he had eight children. The family lived above their shop at Haymarket. In 1849, at the age of thirty-four, Turner took out a licence for one guinea from Talbot to practice calotype photography as an amateur.

Turner's earliest surviving photographs were taken in and around the location where the family spent holidays at Bredicot, a farm four miles outside Worcester bought by Turner's father-in-law, Henry Chamberlain, in 1840. These pictures were made with a modestly sized camera, taking negatives of about 7½ × 5½ inches (19 × 14 cm). By 1852 he had acquired a larger camera taking impressive negatives of about 12 × 15 inches (30 × 40 cm). In this format in March that year he photographed the interior of the Crystal Palace in Hyde Park, London. It was probably the display of photographs held there at the Great Exhibition of 1851 that spurred him to greater ambition. His photographs, taken after the Exhibition had closed, capture the scale and elegance of engineering of the light-filled structure.

Two views of the Crystal Palace open his sequence from a unique album of sixty photographs—his major extant body of prints—entitled *Photographic Views from Nature. By Benjamin Brecknell Turner. Taken in 1852, 1853 and 1854, on paper, by Mr. Fox Talbot's Process*, now in the Victoria and Albert Museum. Unlike nearly all other British photographers, Turner remained faithful to Talbot's calotype paper negative process for most of his career. The collection of some 250 negatives made by Turner between about 1852 and 1860, preserved by the Royal Photographic Society, demonstrate that he occasionally doctored them by adding pencilled foliage details or blacking out skies with Indian ink. However, he chose mostly to use the newer albumen (rather than salted paper) print process. This results in an image that successfully combines the grainy quality of the negative with the depth and clarity characteristic of the print.

Apart from its opening images, *Photographic Views from Nature* contains examples of the kind of subjects which Turner would favour and excel at throughout the 1850s: English churches, abbeys, castles, cottages and farms—rural scenes and ancient architecture—especially in the counties of Worcestershire, Surrey, Sussex, Kent and Yorkshire. His choice of canonical Picturesque subjects—rustic scenes, ivy-clad ruins and trees—was drawn from the English water colourist tradition of the pre-photographic generation. Updating his subjects for the photographic art, Turner understood the power of the medium to capture both broad handling of light and shade and to render minute, textural detail. Typical examples include, *At Compton, Surrey* (c.1852–4 showing an ancient barn and farmyard with thatched hayricks, *Whitby Abbey, Yorkshire, from the North East*, (c.1852–54) capturing the brooding ruins and *Hawkhurst Church, Kent* (1852) remarkable for its almost perfectly symmetrical reflection in the village pond. *Scotch Firs, Hawkhurst* (1852) was his most frequently exhibited photograph. The 1850s was one of the last decades before mechanised farming and the expansion of the rail network changed the landscape irrevocably. Turner's works contain a reverence for the disappearing older order. Because of their long exposure times (documented as up to half an hour) his photographs are largely unpopulated. This lends his work a timeless, meditative quality.

Turner's work was highly regarded in its day and constantly praised by reviewers. He exhibited regularly, beginning at the world's first ever purely photographic exhibition at the Society of Arts in London, 1852 and participated in photographic society shows throughout the 1850s in London, Norwich, Manchester and Glasgow. He exhibited at the Exposition Universelle held in Paris in 1855—the French follow up to the Great Exhibition—and was awarded a bronze medal. In 1862 he contributed nine photographs at the London International Exhibition.

Turner was a founder member and later a Vice President of the Photographic Society of London (founded 1853). He was also an honorary secretary and treasurer of the Photographic Club, within the society, which produced albums of photographs in 1855 and 1857. Members used the albums as a means of exchanging their works. Turner contributed a print of his own for both volumes and organised the 1857 album. At a glass-house studio, which he constructed above his London business, he took portraits in collodion of fellow photographers, friends and family. He also experimented with collodion negatives for landscape subjects in 1856 but the results lacked the charm of his works

from paper, to which he immediately returned. In May 1857 he travelled to Amsterdam to make some of the earliest photographs of the city. His sixteen surviving images from this journey concentrate exclusively on the canals. In 1860 he volunteered as an ensign in the Queen's Westminster's regiment but resigned in 1862. He moved from Haymarket to Tulse Hill, London in 1864. From 1873 he became concerned about the decline of his tallow chandling business and moved to a smaller house in the area but continued photographing until the 1880s, keeping pace with technology by making large carbon prints but showing much the same picturesque subjects he had explored in the 1850s. Agnes Turner died in 1887; her husband who passed away at Tulse Hill on 29 April 1894.

MARTIN BARNES

Biography

Benjamin Brecknell Turner was born on 12 May 1815 at 31–32 Haymarket, London, the eldest son of Samuel Turner and Lucy Jane Fownes. He attended school at Enfield, London until 1831. At sixteen he was apprenticed to his father as a tallow chandler in the family firm Brecknell, Turner Ltd., which made and sold candles and soap from their premises at Haymarket. In 1836, the family moved to live in Balham, South London. In 1840, Turner travelled to Belgium, Switzerland, and Paris. At his father's death the following year he took over the family business. He continued his continental tour in 1845 with visits to Switzerland, Munich, Salzburg, Vienna, Prague, Dresden, Berlin, and Hamburg. In 1847 he married Agnes Chamberlain with whom he had eight children. The family lived above their shop at the Haymarket. In 1849, Turner took out a licence from Talbot to practice calotype photography. Throughout the 1850s he excelled in photographing rural scenes and ancient architecture in England and participated in photographic society exhibitions around the country. At a studio above his London business, he took portraits in collodion of family, friends, and photographers. He travelled to Amsterdam in 1857 to make some of the earliest photographs of the city. In 1860 he volunteered as an ensign in the Queen's Westminster's regiment but resigned in 1862. He moved from Haymarket to Tulse Hill, London in 1864. From 1873 he became concerned about the decline in the tallow chandling business and moved to a smaller house in the area. He continued photographing until the 1880s. Agnes Turner died in 1887 followed by her husband who passed away at Tulse Hill on 29 April 1894.

See also: Expositions Universelle, Paris (1854, 1855, 1867 etc.); and Great Exhibition of the Works of Industry of All Nations, Crystal Palace, Hyde Park (1851).

Further Reading

Barnes, Martin (with introduction by Daniel, Malcolm and biography by Haworth-Booth, Mark), *Benjamin Brecknell Turner: Rural England through a Victorian Lens*. London: V&A Publications 2001.

TURNER, SAMUEL N. (active 1880s–1890s)
Camera manufacturer

Samuel N. Turner owned the Boston Camera Company which he started in 1884 and by the late 1880s the Blair Camera Company was acting as both his purchasing and sales agent.

In 1888 Turner designed and introduced a roll film camera called the Hawk-Eye which incorporated a roll film holder. This attracted the attention of George Eastman as it appeared to infringe the Eastman-Walker patent. In June 1889 Eastman and Thomas Blair agreed that the Eastman Company would supply the roll holders for the Hawk-Eye camera taking a royalty on each one sold.

In 1894 Eastman sought an injunction against the Boston Camera Manufacturing Company and their Bulls-Eye camera which had been designed by Turner and incorporated a daylight-loading film system. Turner's patent described using a flanged spool with sensitized film protected by opaque paper at each end to form a light-tight roll. He had developed a new system of roll film photography which did not infringe Eastman's patents.

The injunction was denied and Eastman began to develop a camera to compete called the Bullet which he introduced in March 1895. By June, after Eastman had been advised he was infringing Turner's patents, he negotiated a sole and exclusive license except for the Boston Camera Manufacturing Company to use Turner's system. Eastman introduced the Pocket Kodak in July and in August he bought the Boston firm outright and Turner's agreement not to manufacture cameras for five years. Turner was put on a $100 per month retainer in return for his ideas.

Eastman's activities with roll film opened a flood of litigation with Thomas Blair, Anthony & Scovill and Hannibal Goodwin which was to drag on into the early twentieth century.

MICHAEL PRITCHARD

TYTLER, HARRIET CHRISTINA (1827–1907) AND ROBERT CHRISTOPHER (1818–1872)

The son of an officer in the Bengal Medical Service, Robert Tytler was born in Allahabad on 25 September

1818 and entered the Bengal Army in 1834. During the Indian Mutiny of 1857 he played a conspicuous part in the re-taking of Delhi, his wife Harriet (born in Sikora on 3 October 1827) being one of the few European women present throughout the siege. After the Mutiny, having received tuition from both John Murray and Felice Beato, the couple undertook an extensive photographic documentation of sites associated with the recent events. In the space of some six months in 1858, the couple produced nearly 500 large-format calotype negatives of Delhi, Cawnpore (Kanpur), Lucknow, Benares, Agra and other locations, which, when shown to the Bengal Photographic Society in 1859, were considered 'perhaps the finest series that has ever been exhibited to the Society.' While many of their photographs bear the clear compositional influence of both Murray and Beato, these images remain one of the most remarkable of the various photographic records of the mutiny, additionally impressive in the light of the couple's photographic inexperience. The Tytlers subsequently settled in Simla, Robert establishing a museum, with which he was involved until his death on 10 September 1872. His wife set up an orphanage in the hill station in 1869, where she also lived for the remainder of her life, dying there on 24 November 1907.

JOHN FALCONER

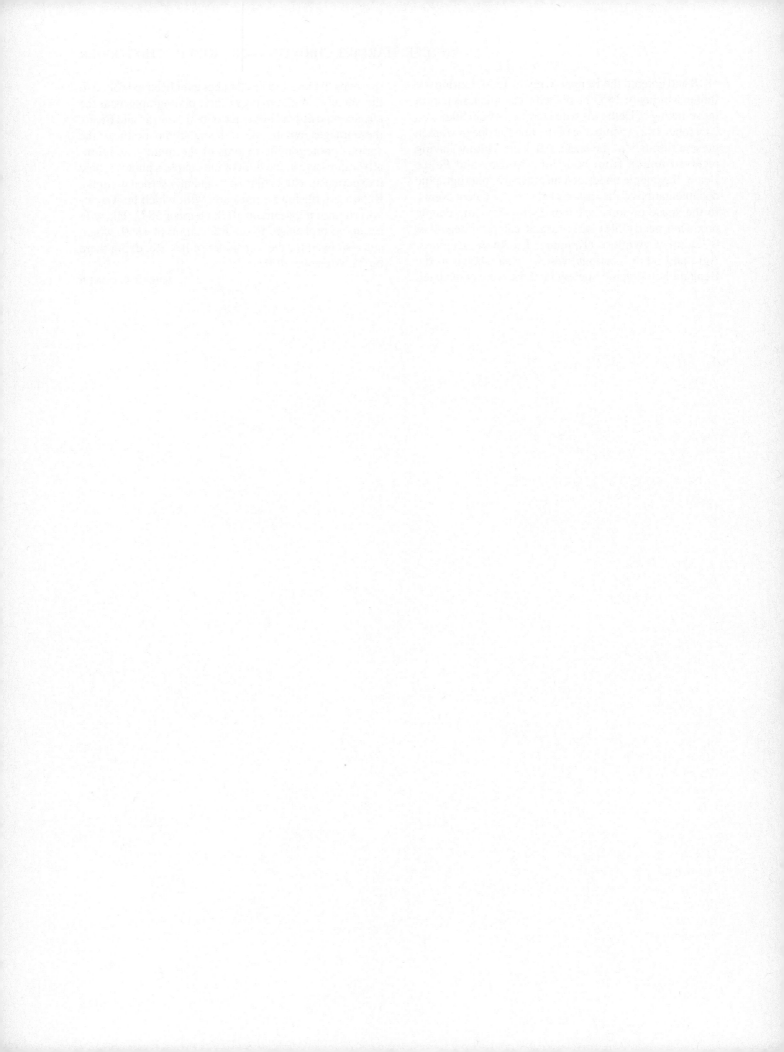

U

UCHIDA KUICHI (1844–1875)
Japanese photographer

Uchida Kuichi was born in 1844 in Nagasaki, Japan. He may have first encountered photography through contact with the Dutch physician Johannes Pompe van Meerdervoort at the naval training school there. Uchida studied photography with Ueno Hikoma in the early 1860s. In 1865 Uchida and Morita Raizø opened the first photography studio in Osaka. Uchida moved his business to Yokohama in 1866, and then to Tokyo in 1869. Over the next several years he established a reputation as the finest portrait photographer in Tokyo. His fame resulted in a commission from the Department of the Imperial Household in 1872 to make the first official photograph of the Emperor Meiji. Uchida photographed the young emperor wearing traditional court dress. State authorities believed the image fed negative stereotypes of Japan as a regressive country, and commissioned another photograph in 1873 to show a more updated look. The later image, depicting the emperor in a Western military-style uniform and with a new short haircut, was widely distributed as the official imperial portrait. Uchida also traveled with the emperor throughout Japan in 1872, where he photographed the various locations visited as well as the public's response to the imperial entourage. Uchida's successful career was cut short when he died of tuberculosis in Tokyo in 1875.

KAREN FRASER

UENO HIKOMA (1838–1904)

Ueno Hikoma was born in Nagasaki, Japan in 1838. His merchant father, Ueno Toshinojø, imported Japan's first camera in 1848. Ueno's interest in photography did not stem from this event, however, but from studying chemistry at the naval training school in Nagasaki under Johannes Pompe van Meerdervoort, a Dutch naval doctor. Ueno was an intrepid student, constructing his own cameras from old telescope lenses and experimenting with various ways to make photographic chemicals, which were not yet readily available. In 1859 Ueno learned collodion wet-plate photography from the Swiss photographer Pierre Rossier, sent to Nagasaki by the London firm Negretti and Zambra. In 1862 Ueno published *Seimikyoku hikkei* (Chemist's Handbook), co-authored with Horie Kuwajirø. It included an appendix describing collodion wet-plate photography, Japan's first manual on the process. Later that year, Ueno opened a studio in Nagasaki, one of Japan's first, and he also began importing cameras and photographic supplies. Ueno became well known for both landscape and portrait photography. He photographed a number of important nineteenth-century figures, including former U.S. president Ulysses S. Grant. Other highlights of his career included assisting a team of Americans who came to Nagasaki in 1874 to photograph the transit of Venus across the sun, and photographing the battlefield during the Satsuma Rebellion in 1877. Ueno was one of Japan's most successful early photographers, later opening branch studios in Vladistock, Shanghai, and Hong Kong in 1890 and 1891. He died in Nagasaki in 1904.

KAREN FRASER

UKAI GYOKUSEN (1807–1887)
Japanese photographer

Ukai Gyokusen was the first Japan-born professional photographer, operating a studio in Edo (Tokyo) from 1860 or 1861 until 1867. Until recently his reputation has been overshadowed by Shimooka Renjo and Ueno Hikoma's who nevertheless did not open their studios until 1862. It is strange that Ukai's significance was

forgotten since biographical details are carved on his gravestone in Yanaka Cemetery, Tokyo. Born into a wealthy samurai family, in Ishioka-shi, Ibaraki Prefecture, Ukai worked as a merchant in the sake business until 1831 when he decided to become a full-time artist. Nothing is then known until he decides to move to Yokohama in 1859 or 1860 with the intention of studying photography. His gravestone inscription confirms he consulted the American, Orrin Freeman, who had opened an ambrotype studio and was giving lessons. It then seems that he purchased, for a considerable sum, Freeman's camera, equipment, and a series of lessons before opening a portrait studio in Edo. At his studio, named Eishin-do, he photographed over 200 members of the aristocracy. In 1879 he was employed by the Government to photograph antiquities in western Japan. In 1883, Ukai unaccountably buried several hundred glass negatives adjacent to his final resting place in Yanaka Cemetery. (One of his ambrotypes is held by the *Yokohama Archives of History*, Yokohama.)

TERRY BENNETT

UNDERWATER PHOTOGRAPHY

Nineteenth century interest in utilizing the power of photography in all forms of scientific endeavour led the Englishman, William Thompson (1822–1879), to speculate on the use of photography as an inexpensive method of assessing the damage to bridge piers in time of flood. In February 1856 Thompson succeeded in making a weak collodion negative of the sea floor of Weymouth Bay at a depth by lowering a box containing a 5 × 4 inch plate camera on a rope some eighteen feet to the bottom. Thompson described his methodology in a paper "On Taking Photographic Images Under Water," published in the *Journal of The Society Of Arts*, May 9th, 1856, which is reproduced in *Historical Diving Times*, 19 (Summer 1997).

In 1866, the Frenchman, Ernest Bazin claimed to have made underwater photographs at his marine observatory. Bazin used a form of diving cylinder to enable him to descend below water with electric lights to illuminate his subject. However none of these images have survived and it appears that none were ever made public. While there are reports of photographs taken from a submarine by the German Wilhelm Bauer and various experiments by the Swiss F. A. Forel to determine the penetration of daylight through water by photographic means, the first major publication to utilise photography for the illustration of marine specimens was William Saville-Kent's *The Great Barrier Reef of Australia, its products and potentialities* published in 1893. However Saville-Kent's specimens were not photographed with an underwater apparatus.

The first systematic approaches to underwater photography were commenced in 1886 the Frenchman

Louis Boutan (1859–1934) and his assistant Joseph David (1869–1922). Born in 1859, Boutan obtained his doctorate of science from the University of Paris in 1879. In 1880, at the time of the Melbourne Exposition, he was sent by the French Government to Australia to study the embryology of marsupials. He was appointed maître de conference at the University of Lille in 1886 before undertaking a mission to the Red Sea in 1890. In 1893 Boutan was appointed professor at the Arago Laboratories at Banyuls-sur-Mer, part of the University of Paris. By the end of that year Boutan had established the fundamentals of underwater photography.

Writing in *The Century Illustrated Monthly Magazine* in 1898, Boutan recalled that he was fascinated by the underwater landscape he found at Banyuls-sur-Mer when invited to use the Laboratory's diving suit. He wrote "why, I asked myself, could I not succeed in making a photograph at the bottom of the sea?" In a note in *Archives de Zoologie expérimentale et générale*, Boutan described the principal features of his underwater photographic apparatus, the plans for which had been devised by his brother Auguste, an engineer and manufactured by the firm of Alvergniat in Paris with anastigmat lenses by Darlot. These had the form of a rectangular metal box fixed to a metal tripod having adjustable legs, external controls for adjusting the shutter and diaphragm and changing the specially varnished Lumiere plates and a rubber balloon with which to adjust the buoyancy to the whole. One of these cameras was illustrated in the Century Magazine article together with several of Boutan's underwater images.

Initially Boutan found that back-scattering of light and the lower contrast gave unsatisfactory images on his "isochromatic" plates. After considerable experimentation he was able to obtain more satisfactory images by interposing a blue filter in front of the camera lens.

Several ingenious methods were employed by Boutan to illuminate his underwater scenes. In 1893 he collaborated with a French electrical engineer, M. Chaffour, to make the first flash bulb. Chaffour used a thick glass bottle, some 10cm in diameter, mounted with the neck down. He placed a coil of magnesium ribbon inside the jar before replacing the air with pure oxygen. An electric current was used to ignite the magnesium ribbon, producing a very intense flash of light. This system was not without its disadvantages. When ignited, the magnesium produced a dense cloud of magnesium oxide vapour which not only reduced the light output but also coated the inner surface of the bottle. Moreover the high temperature produced at ignition frequently caused the bottles to explode, even underwater. Although only an experimental model, the Chaffour flash established the principles for all future flash bulbs while Boutan had produced the first underwater image made with flash.

A more reliable, if cumbersome, system of illumination

was built by David for Boutan. An alcohol lamp was placed in a glass bell-jar secured to the top of a wooden barrel. An external reservoir of magnesium powder was connected to a metal tube placed just in front of the lens flame. Using a rubber bulb, Boutan was able to blow the magnesium powder into the flame to produce his flash illumination. A scale model of Boutan's camera and the "barrel" flash is on permanent display at the Musée de la Plongée, Sanary-Sur-Mer, France. A later system utilised carbon-arc lamps power by banks of batteries.

Boutan described in some detail his methodology for making underwater images. Descending to the bottom in a diving suit, he selected the area to be photographed, then signalled to the dive boat for the apparatus to be sent down, stand first then on signal the camera box and illumination source. Once set up, Boutan then signalled that he had commenced the exposure and waited for a signal from the boat to tell him when the required time had elapsed.

In 1898 he published the first book on underwater photography: *Photographie sous-marine et les progrès de la photographie*, Schücher Frères, Paris. The following year Boutan obtained sharp images of underwater vegetation at night and, using battery-powered arc lamps, images of a plaque at a depth of 50 metres. The exhibition of slides of his underwater photographs at the Expositions Universelle, Paris in 1900 and publication by Charles Mendel of more images in *La Photographie sous-marine*, with text by Pierre Guichard, served to further Boutan's reputation as the foremost underwater photographer of the time.

ROBERT DEANE

See also: Saville-Kent, William; and Expositions Universelle, Paris (1854, 1855, 1867 etc.).

Further Reading

Auer, Michèle and Michel Auer, *Photographers encyclopedia international, 1839 to the present*, Editions Camera Obscura, Hermance, Switzerland, 1985.

Baker, Nick *William Thompson—The world's first underwater photographer*. [cited 2 February 2006] Available from World Wide Web: www.thehds.com/publications/thompson.html.

Bron, Pierre and Philip L. Condax, *The photographic flash. A concise illustrated history*, Bron Elektronik AG, Allschwil, Switzerland, 1998.

Boutan, Louis, "Memoire sur la photographie sous-marine" ["Note on underwater photography"], in *Archives de zoologie expérimentale et générale* [*Archives of experimental and general zoology*], 3eme series, vol. 1, (1893), 286–289.

Boutan, Louis, "Submarine photography" in *The Century Illustrated Monthly Magazine*, The Century Company, vol. 56, May 1898, 42–49. [cited 8 February 2006]. Available from World Wide Web: http://cdl.library.cornell.edu/moa/browse.journals/cent.1898.html.

Boutan, Louis, *La photographie sous-marine et les progress de la photographie* [Under-water photography and photographic advances], Paris, 1898.

Chenz, Christian Peteron and Claude Rives, *La prise de vue sous-marine* [The underwater snap-shot], Paris: Edition Denoel, 1978.

Gernsheim, Helmut and Alison, The history of photography, 1865–1914, New York: McGraw-Hill, 1969.

Lenman, Robin, *The Oxford companion to the photograph*, New York: Oxford University Press, Inc., 2005.

Saville-Kent, William, *The Great Barrier Reef of Australia: Its products and potentialities,* London: W. H. Allen & Co. Limited, 1893.

Weinberg, Steven, Phillipe Joseph Dogue, and John Neuschwander, *100 ans de photographie sous-marine* [100 years of underwater photography], Edition Alain Schrotter, 1993.

Un peu d'histoire [A little history][cited 2 February 2006]. Available from World Wide Web: http://www.cinemarine.net/Abode/historique.pdf.

The antique camera collection of Sylvain Hagland. [cited 7 February 2006] Available from World Wide Web: (www.collection-appareils.com/avoscrayons/html/photosm.php.

UNDERWOOD, BERT (1862–1947) AND ELMER (1858–1943)
Manufacturer of ten million stereo cards and 300,000 stereo viewers a year (1901)

The Underwood brothers built a Stereoscopic production and sales organization that surpassed all that had preceded them. By learning the door to door selling techniques of B. W. Kilburn of Littleton, New Hampshire, the Underwoods took the lead in the creation of the world's largest stereo view business. Even The Stereoscopic Company in Great Britain could not match their success.

Elmer and Bert Underwood, sons of the Reverend E. Underwood, were born in northern Illinois Elmer in 1859 and Bert in 1862.

Elmer started a publishing business there in 1879 whilst Bert worked in a grocery and then for the White Sewing Machine Company in Kansas City before becoming a sales agent for a medical book which he peddled from door-to-door throughout his assigned area on the edge of Indian Territory. A natural salesman, Bert became known among the farmers as "that boy who sells a book to everyone:' During his book selling trips in 1881, he met an agent for stereoscopic views and became convinced that if the merits of the then "out-of-date" stereoscopic views could be properly presented to the public they would prove to be fast sellers. Ordering a stock of views and a stereoscope he began to formulate a system for selling them that proved immediately successful.

Bert's sales grew so fast that within a few months he persuaded his brother to sell his publishing business and join him in expanding the stereo view business into other areas. At that time, the Underwoods were selling the stereo views published by Charles Bierstadt (Niagara Falls), J. F. Jarvis (Washington, D.C.) and the Littleton

View Company (one of B. W. Kilburn's competitors) in the sparsely settled areas west of the Mississippi. (Some of these early views have been found inscribed on the back "Sold by Underwood and Underwood, Ottawa, Kansas:') In a year's time the brothers had established their own group of sales agents (all trained in the Underwood method) working in Missouri and Kansas.

The Underwoods directed this sales force from a small office in Ottawa, Kansas. Many of these agents were recruited from colleges and universities. Some earned enough during the summer months to pay their entire college expenses for the year.

As their business grew, they documented the system in a manual that taught their agents how to successfully sell stereo views. To learn just how these agents plied their craft, a copy of their Sales Manual for 1890 was examined at the Oliver Wendell Holmes Stereoscopic Research Library.

The Underwoods divided their sales effort into two parts—the canvassing and the delivery. Canvassing included gaining a hearing, creating a desire to buy and obtaining a small order for a stereoscope or views. Upon delivering the original order a week or two later, they made their major pitch to sell more views.

The manual took the new agent, step by step, through a typical sales call, telling them what to say and how to handle all objections. The agent was instructed to greet the person answering the door with: "I have something very beautiful I want to show you. It will take just a minute:'

No mention was made of the product they were selling. If the prospect hesitated, they added: "It is something new in this line, and I can show you much better and easier than I can tell you:' If told there was no interest in buying anything they countered with: "Oh, I am only showing now and I have something so interesting I do like to show it. You can spare just a minute:' After gaining entrance, the agent laid his case down and removed the stereoscope saying: "Of course you have a stereoscope:' If the customer did not, the agent stated that they have never seen views through this type of glass. "Everyone says it is the finest lens they ever looked through:' The important thing was to get the customer seated and to hold the scope. The manual advised the agents to insert each view into the scope before taking the preceding one out so the customer was always looking at something, the better to hold their attention.

They made each view as interesting as possible by pointing out the objects of value, beauty or novelty in each. For example, "Phoebe's Arch, Palmer Lake, Colorado. Notice how far through that arch, across the landscape you can see. That farthest mountain is thirty miles from the arch. Isn't it something wonderful to cover such distance in a view" Remember, the manual advised the agent, "your customer will often see, in the views you show him, only what your words have the power to make him see. They credited the glass for the beautiful details and distances brought out in perfect relief. They dwelt on the power of the glass as a sale of the scope obviously produced a demand for views.

They attempted to close the sale by saying: "If I will bring you just as good a lens as this is in about two weeks, you will want one of them won't you? This scope is only ninety cents and if the one I bring is not as good as this, don't take it." Price was only mentioned after they had shown a number of sample views.

The agent then advanced numerous reasons the customer should have a stereoscope in their home—they cost very little and yet are so interesting; if company comes they can help entertain themselves with a stereoscope and a collection of views; children read, hear people talk then study about places in the views; they can never visit all these places as it would cost hundreds of dollars to visit only a few and the stereoscopic views, as seen through a good glass, will give them a better idea than they can get in any other way.

The agent concluded with: "Well, I shall put you down for the glass, shall I not, as it's only ninety cents:' The order was written up for "Scope and Views" and the customer was told: "You see, 1 have put you down for a scope and left the views indefinite. When I bring around your scope I will have a fine collection of views and our $2.00 per dozen views are the finest in the country."

If the customer already had a stereoscope, the agent switched the emphasis away from the lens, crediting all the fine effects to the superior quality of the clear sharp views, all from original negatives taken by the best view artists in the country. The agent worked prominent names into the sales pitch to influence the customer: "Dr. Jones liked that view very much. I have his order for a collection. The agents were told that local personal influences of this kind are impossible for anyone to resist entirely.

The experienced agents carried a small folder containing a list of prominent local people and their avocation who had purchased views. These were shown to the prospect with the comment: "Here is the Mayor you see, the Minister, the Postmaster, and of course, these Doctors, who have all purchased views for their collection:' The great secret of moneymaking with views, it was emphasized, was to canvass their territory thoroughly—exhaustively. It was easier to build up the order if many of the customer's neighbors were taking views. They were advised not to be easily put off as "NO, is not always an answer in canvassing any more than in courting. Persistence wins the day.

The manual also offered advice on how the agent should conduct himself while on the road. They 'were admonished to find a good boarding place, keep the

best of company and not talk politics and if a Christian, to go to church Sunday and make themselves at home in prayer-meetings or the Y.M.C.A. rooms. To be neat and clean in attire, to dress well and never boast of his business, only talking about his views when actually canvassing. (No mention of female agents has been found.)

When delivering the scope, it was important to once again get the customer seated to try it out. Views were shown in the same manner as when canvassing, having the customer decide on each view separately, laying aside those they wanted to keep. If the customer protested: "Oh, I have more than I can take now;' the agent replied: "Why this is only a start—you have an opportunity to obtain the finest views that have ever been made and it will pay you to take advantage of it and get a good collection. Your scope is not so interesting without a nice collection. The more you get the better:' The agent was reminded not to lower prices as that lowered the value of the goods in the minds of the patron. However, to clinch a large sale, the agent would offer a free stereoscope with an order for six dozen or more views!

In addition to their first class views, the agents carried a small number of copied views that they sold for three cents each. The purpose was to counter the customer's objections that they could buy views cheaper elsewhere and to prove the superiority of their more expensive views. By downgrading these views with the comment: "These are copies. We carry them only for a cheap class of trade;' they seldom had to show them. They also carried hand painted views and French transparencies with them that sold for 25 cents each.

Using these successful methods, Bert expanded their sales force into western Iowa, Nebraska, Dakota and Minnesota throughout 1884. At the same time, Elmer built the business in eastern Iowa, Illinois and Wisconsin. By the end of the year, they covered Kentucky Tennessee, Arkansas and Louisiana with their agents.

The following year, Elmer worked his way east into Pennsylvania and in a year and a half built the foundation of an immense business through the populous eastern and southeastern section of the country. Meanwhile, Bert crossed the Rockies, covering the Pacific Coast, from San Diego to Puget Sound, with agents.

The Underwoods claimed to have sent out 3,000 college students in one summer. Agents traveled by bicycle, or horse and buggy in farm country, and were sometimes invited, to spend the night with their last customer, paying for their room and board with stereo views. A few agents used their experiences with the Underwoods to go on to bigger and better things. One was James M. Davis, who became the exclusive Sales Agent for Kilburn stereo views. Another was B. L. Singley, founder of the Keystone View Company of

Meadville, Pennsylvania. Keystone, in time became a strong competitor to the Underwoods.

Outgrowing their single supply house in Ottawa, Kansas by 1887, they opened an office in Baltimore to supply all the territory east of the Mississippi. That same year they also secured control of the stereo views produced by Strohmeyer & Wyman. The combined capacity of their four suppliers, Bierstadt, Jarvis, Littleton Views, and Strohmeyer & Wyman was ten million stereo views per year. A Canadian office was opened in 1888 to handle the large sales there.

Underwood and Underwood expanded into Europe in 1890 when Bert opened a branch in Liverpool, England. He personally ran the office for three years, creating a renewed interest in stereo views there. They moved their Baltimore office in 1891 to New York to better serve their growing sales overseas.

By 1894, they were selling their views wholesale or through agents in all European countries, Australia, New Zealand, South Africa, India, Japan, Cuba, Mexico and nearly every country in South America. In that year, the Underwoods shipped three million views to England retailing them for $2.00 a dozen. 160,000 stereoscopes were also sold there for $1.00 each.

Gradually the Underwood firm began to publish their own original views to supplement already established trade lists of their four suppliers. In 1891 Bert took lessons in photography from M. Abel in Mentona, France. The excellent travel views of Italy Greece, the Holy Lands and Egypt, published under the U&U label, all were produced from Bert's negatives.

While in Rome, Bert arranged to photograph Pope Pius X in stereo, producing a 12 card set on "The Pilgrimage to St. Peter s and the Vatican:' After presenting a set to His Holiness, the firm received the following note from a Cardinal at the Vatican:

> His Holiness Pope Pius X., wishes me to tell you how much He had admired the stereoscopic views which Messrs. Underwood & Underwood have kindly presented to Him. As a token of His special appreciation of these very interesting photographs, His Holiness bids me send you in His name a silver medal together with His thanks.

It was not until 1897 that the company supplemented Bert's work by employing their own full-time photographers and using free-lance operators for specific assignments.

By 1901, the firm had finalized the design of the U&U logo on their stereo views and were publishing over 25,000 views a day of their own. They also sold 300,000 stereoscopes a year—a prodigious output that made the firm the largest of its kind in the world. Their stereoscope supplier was Henry E. Richmond, a native of Bennington, Vermont, who had established a

stereoscope factory for the trade around 1890, in the small town of Westwood, New Jersey, population 838. The factory was just fifteen miles from mid-town Manhattan and employed about thirty people. His factory ground the lenses, cut out the wooden parts, stamped and shaped the aluminum hoods, binding the edges with velvet. Those he made for the Underwoods were stamped on the hood with the words "Sun-Sculpture" surrounded by their rising sun trademark. The factory was a two-story building with a water tower that supplied water to the town of Westwood. U&U apparently bought the factory around 1901 and retained Richmond as their Manager through at least 1914.

They also purchased a factory from Strohmeyer & Wyman in Arlington, New Jersey, eight miles from Manhattan, that produced both stereoscopes and views. Seventy persons were employed there in 1906. One of the Underwoods' more famous staff photographers, James Ricalton, was from Maplewood, New Jersey, just a few miles from their factory in Arlington. Their Westwood factory produced stereoscopes exclusively, employing 10 men and 20 women the same year.

At the turn of the century the Underwoods introduced their unique boxed set of views—a sequence of views that simulated a tour of the country depicted. Some views had captions in six languages printed on the back. A descriptive guidebook accompanied the views which included a map showing the exact location and boundaries of the views in the set.

U&U Guide Books were edited by some of the most eminent scholars of the day. The popularity of these travel sets and guidebooks made it difficult for smaller companies to compete and was responsible for some of them closing up shop and selling their negatives to the Underwoods, which grew even bigger as a result. Their boxed sets and books became immensely popular, forming the bulk of their output for the next 15 years. Their sales literature pointed out—"The Underwood Travel System is largely mental. It provides Travel not for the body, but for the mind- but travel that is none the less real on that account. It makes it possible for one to see as if one were present there in body—in fact to feel oneself present—and to know accurately famous scenes and places thousands of miles away without moving his body from his armchair in his comfortable corner; indeed, it enables him to take up one standpoint and then another with reference to them and so see them as a whole, and to study them minutely just as one would on a visit to the places in the ordinary expensive way."

By 1910 they had 300 different stereo view sets for sale and had diversified into the new field of News photography. As stereo views declined in popularity their News Division grew. They ceased production of all stereo views in 1920, selling their stereo negatives to the Keystone View Company which continued to produce Underwood inspired travel sets, primarily to schools. Shortly after the Underwoods retired, the company was reorganized as Underwood & Underwood News Photos, Inc. In 1943 Bert Underwood died in Arizona. Four years later, Elmer died in St. Petersburg, Florida.

Since 1978, much of the Underwood and Underwood archives have been housed within the University of California Riverside (UCR). This is as part of a 30 ton collection of 350,000 original stereoscopic negatives, 140,000 cards, record books, and salesman catalogues, primarily from Underwood and Underwood, The Keystone View company, B.W. Kilburn, H.C. White, and The American Stereoscopic company.

Underwood & Underwood images are a vast and invaluable resource showing the modernization of the world, brought to life by the power of Stereoscopic viewing.

DAVID BURDER

See also: Markets, Photographic; Stereoscopy; and Topographical Photography.

Further Reading

Breasted, Charles. *Pioneer to the past*. New York. Charles Scribner& Sons, 1943.

Brey, William, *Stereo World*, 1990.

Burder, David and Pat Whitehouse. *Photographing in 3-D*, The Stereoscopic Society, 1989.

Darrah, William C., *The World of Stereographs*, 45–56.

Hamilton, George E. (President of Keystone View Company), *Oliver Wendel Holmes—His Pioneer Stereoscope and the Later Industry*, 1949.

Industrial! Directory of New Jersey—1901, 1905, 1906, 1912, 1915, 1918.

The Keystone Mast collection. The University of California Riverside. Museum of Photography.

Mabie, Roy W., *The Stereoscope and Stereograph*, 1942. 36–37.

Manual of instruction for View Canvassers from Underwood & Underwood, 1890.

Photographica. October 1978, 2.

Topeka Capital Journal, Undated article by Zula Greene.

Underwood and Underwood. *A trip around the world*. New York. 1897.

Wilson's Photographic Magazine, vol. XXXI, 1894. 66–69.

Wing, Paul, *Stereoscopes: The first 100 years*. Nashua: Transition Publishing 1996.

UNION CASES

Union cases are plastic photographic cases made during the 1850s and 1860s primarily in the New England section of the United States and used to house daguerreotypes and later, ambrotypes. Made from the earliest form of plastic, or composition, the case material consisted of shellac and pulverized wood fibers (sawdust) which, when thoroughly mixed and sufficiently heated, resulted in a thick-flowing malleable substance. This substance

was pressed into molds which had die-engraved designs. The lid and bottom of each case were held together with metal hinges. "Union" cases were so named because of the combining of materials to produce a new substance, the earliest plastic.

From its inception daguerreotype was immediately popular in the United States and the demand for these portraits was overwhelming. In order to protect their delicate surfaces, daguerreotypes were, at first, placed under glass and fitted into wooden frames. A much more popular and portable method of protecting daguerreotypes was the use of the jewelry case, following the fashion established for portrait miniatures. As the production of daguerreotype images dramatically increased, so did the demand for cases to house them. Throughout the 1840s and early 1850s photographic cases were generally designed as shallow wooden boxes covered with thin sheets of leather or pressed paper to simulate leather.

The plastic photographic case industry began with the Scovill Manufacturing Company of Waterbury, Connecticut, and the daguerreotypist, Samuel Peck. The Scovill Company, a partnership between brothers James M.L. Scovill and William H. Scovill, was one of the earliest brass manufacturing companies in America. They had experience in making rolled plate metal, including silver plated copper sheets. One early supplier for cases to the Scovills was Samuel Peck of New Haven, Connecticut who began his career as a daguerreotype artist in 1844. By 1850 he was manufacturing cases and soon began a co-partnership with the Scovills that was named Peck and Company. In addition to leather and paper cases, Peck began creating "fine cases" including those made from papier-mâché. Perhaps it was the technique used in making these cases which inspired Peck to his greatest innovation. By May of 1852 Samuel Peck and his brother-in-law, Halvor Halvorson began producing daguerreotype cases molded from plastic.

Another important early plastic case manufacturer was Alfred P. Critchlow, a button maker from Haydenville, Massachusetts. Critchlow moved to Florence, Massachusetts and soon began experimenting with steam presses to mold shellac and gutta-percha compounds. He was producing plastic daguerreotype cases as early as 1852, soon after Peck began his work. Critchlow entered into partnership with Samuel L. Hill and Isaac Parsons in 1853; this new company issued a line of standard size cases, from which dozens of different designs have been identified. Beginning about 1857 the photographic supply firm of Holmes, Booth and Hayden in New York City were also actively engaged in plastic case manufacturing.

Great Britain was an early market for American made union cases, especially those with a distinctly British appeal such as "Sir Henry Havelock," "The Calmady Children," "Sir Roger de Coverly," and "The Highland Chief." Peck cases were being used there soon after their introduction in America. John Atkinson and Elisha Mander were two importers of these cases based in Liverpool and Birmingham. Some union case examples found in Great Britain have labels which read, "Patent American Union Cases." These were sold by Mander and were probably re-labelled for his market in cases made by Littlefield, Parsons & Co. or Critchlow. At least one firm manufactured union cases in Britain in the early 1860s—John Smith of Birmingham. The rare ninth-plate case, "Amazon on Horseback Being Attacked by a Tigress," was probably created by his firm, although none of the known examples carries a trade label. The dramatic design was based on the sculpture of the same name by Auguste Kiss which was a major attraction at the Great Exhibition at the Crystal Palace, Hyde Park, in 1851. Brookes and Adams were two die engravers who created case designs for the British market. Of major significance are two British patents made by John Smith for a thermoplastic mixture "...capable of being used for jewel cases, photographic cases, and 'horn' buttons in a variety of colours." The influences of this relatively small group of British dealers and manufacturers were important to a market which had been exclusively American.

Union case designs range from traditional subjects, such as patriotism and religious sentiment, to scenes from romantic literature, children's stories, mythology, and classical allusions, as well as vignettes of Victorian domestic life. Patriotic designs include "Shield with Flags, Cannons, and Liberty Cap," "Union and Constitution," "The Eagle at Bay," and "Constitution and the Laws." Religious motifs decorate "The Lord's Prayer," "Daniel in the Lions' Den," "The Holy Family," "Rebekah at the Well," and "The Church Window." Children's stories and Victorian sentiment were especially popular design themes with titles such as "Bobby Shafto," "See Saw, Margarey Daw," and "The Faithful Hound." American history theme cases include "The Landing of Columbus," "The Sweet Potato Dinner," "The Capture of Major André," "The Warning at the Green Spring," and "The Washington Monument, Richmond, Virginia." Many of these designs were based on prints, paintings, sculptures, and other works of art. Some die engravers were completely faithful in their translations for case designs, such as Smith and Hartmann, who copied Emanuel Leutze's epic painting "Washington Crossing the Delaware" in almost precise detail. Geometric, scroll, and floral designs were also used extensively on union cases—about 70 percent of all case designs. Plastic, or union, cases were manufactured in several standard sizes from the largest whole plate size (7 3/8" x 9 3/8"), half plate (5" × 6 3/8"), quarter plate (4" × 4 7/8"), sixth plate (3 ½" × 3 ¾"),

ninth plate (2 ½" × 3"), sixteenth plate (2" × 2 1/8"), and "sweetheart" (1 ¾" diameter) and came in several shapes, rectangular, octagonal, oval, and circular. Colors were at first limited to black and brown, ranging from a very light, almost tan shade to a dark, lustrous chocolate brown. Not until the late 1850s did union cases appear in colors other than these standard two. Small cases, usually ninth, sixteenth, small ovals, and the circular "sweetheart" cases were produced in a variety of colors including orange, red, and green.

Between 1853 and the mid-1860s, hundreds of thousands of union cases were produced to meet the demands of the rapidly growing photographic market. By 1857, with the advent of paper photographs which did not need to be protected in cases, the union case industry suffered its decline. The 1870s witnessed the disappearance of the cased image—both the daguerreotype and ambrotype processes were obsolete. Case manufacturers found new uses for thermoplastic and manufactured buttons, belt buckles, jewelry, combs, knife handles, chessmen, mirrors, gun cases, brush handles, picture frames, and lids for men's collar boxes, some using union case designs.

Union cases were America's first plastic products—the very beginning of a significant industry. Used as a protective device for the popular daguerreotype, union cases became artful objects in their own right and are collected today for their wonderful and intricate designs.

MICHELE KRAINIK

See also: Mounting, Matting, Passe-Partout, Framing, Presentation; Daguerreotype; Scovill & Adams; and Great Exhibition of the Works of Industry of All Nations, Crystal Palace, Hyde Park (1851).

Further Reading

Berg, Paul K., *Nineteenth Century Photographic Cases and Wall Frames.* Huntington Beach, California: Huntington Valley Press, 1995.
——, *Nineteenth Century Photographic Cases and Wall Frames.* Second Edition. Paul K. Berg, 2003.
Hannavy, John, "The Union Case in Great Britain." The Daguerreian Annual 1995. The Daguerreian Society, 1995, 1–13.
Hannavy, John, *Case Histories: The Presentation of the Victorian Photographic Portrait,* Antique Collectors Club: Woodbridge, and Easthampton MA, 2005.
——, John Smith and England's Union Cases, "A Resumé of Recent Researches." The Daguerreian Annual 1997. The Daguerreian Society, 1998, 47–62.
Kenny, Adele, *Photographic Cases: Victorian Design Sources, 1840–1870.* Atglen, Pennsylvania: Schiffer Publishing, Ltd., 2001.
Krainik, Clifford and Michele, with Walvoord, Carl, *Union Cases: A Collector's Guide to the Art of America's First Plastics.* Grantsburg, Wisconsin: Centennial Photo Service, 1988.
Rinhart, Floyd and Marion, *American Miniature Case Art.* South Brunswick and New York: A.S. Barnes and Company, 1969.
——, *The American Daguerreotype.* Athens, Georgia: The University of George Press, 1981.

UNIONS, PHOTOGRAPHIC

The need for a 'photographic union'—an association designed specifically to offer support to professional photographers—manifested itself in some regions of the world much earlier than others. Despite early photographic societies and groups declaring themselves to be open to all who had the interests of photography at heart, it very quickly became apparent in some countries that the needs, motivations and intentions of the amateur and the professional were distinctly different.

Though the initial spread of the daguerreotype in the United States was largely spontaneous and unorganized, after 1850 various factors such as increased competition, questionable patenting of minor improvements (such as a bromide coating of glass plates) and the rise of the negative processes led to several attempts at uniting professional photographers on a "protective" or "fraternal" basis. In 1851 were formed the first two American photographic societies, which were closer to being unions than their French and British counterparts: the New York State Daguerrean Association thus aimed at setting floor prices, while the American Daguerre Association sought to vindicate the profession from its "humbug" reputation. These short-lived organizations, and their immediate followers, also resembled earlier artistic unions in providing for "mutual aid." This professional concern was less prominent in the formation of the American Photographic Society in 1859, which emphasized larger, social and cultural goals. Hence the creation of a Photographers' Protective Union in 1860 and the ongoing battle, in the 1860s, to repeal the infamous "bromide patent," a goal that was finally achieved in 1868. In 1869 was formed the National Photographic Association, the first "fraternal" organization of professional photographers to remain stable and to combine mutual aid and a concern for the elevation of pictorial standards, as shown in its annual exhibitions until 1900. The 1870s and early 1880s were thus a period of relative stability, though early photographic giants such as the Anthony and Scovill companies had come to control large sectors of the photographic market, bypassing professional organizations. After 1890, the rise of popular photography, embodied in the phenomenal growth of the Eastman Kodak Co., threatened to relegate the old professional and fraternal pattern to marginal status, while a new industrial framework emerged that had little tolerance for workers' unions.

In Europe, Julius Schnauss founded the *Allgemeiner Deutscher Photographen-Verein* in 1858, and went on to edit its journal, *Photographisches Archive*, while Ernest Mayer of Mayer Freres et Pierson in Paris, founded the

Union photographique in 1859 as a mutual aid society for the protection of workers engaged in all aspects of professional photography.

Very little is known about the situation of the majority of photographic workers in 19th century Europe. Most photographers were artists or craftsmen, and their studios employed just a few assistants in setting up chemicals, carrying equipment, or retouching the results. Larger studios began to employ women for greeting the clients when entering the rooms. Social problems arose with the establishment of larger companies and studios after the introduction of the carte-de-visite and stereo cards.

Workers at lithographic establishments such as Hanfstaengl in Munich or Roemmler & Jonas in Dresden organized themselves in printers' unions but because of the nature of their operations, photographic workers had little or no access to such organisations. Membership of many of the early mutual aid societies was restricted to studio principals—the photographers themselves—with little or no protection available to their workers.

About 1865, twenty Danish professional photographers formed themselves into a professional association—the first such organisation in that country—but like so many early attempts at the formation of trade associations, it was relatively short lived.

In 1870, there was an "Association of Photographic Operators" (Photographischer Gesellenverein) founded in Berlin, and in 1885 there was a branch set up in Dresden, in 1887 as well in Chemnitz and Munich. In 1891, authors of a meeting's report hastened to tell the public that they had 'eliminated all socialist elements' from their organisation, and in 1898 a Viennese association of operators had similar problems in distinguishing themselves from workers' unions.

As many photographic assistants worked in large printing offices they found themselves organized as printers by the late 1860s in Italy, France, Switzerland, and Austria, to be followed by Germany in the late 1870s. Lithographers became well organized after the invention of the autotype process both in Germany and Austria, and it is likely that numbers of practitioners went under the shelter of their union by this time.

Britain was very slow to adopt the idea of a trade association or union for photographers and photographic workers. From the 1850s, organisations such as the Photographic Society and the Architectural Photographers Association (later the Architectural Photographic Society) were open to amateurs and professionals alike—the criteria for membership focusing on the 'gentleman photographer' rather than the staff who worked behind the scenes. So the negotiations with Talbot over the restrictions imposed by the calotype patents were conducted through the Photographic Society rather than by any professional grouping.

It was the 1880s before an exclusively professional association was first mooted in Britain, and 1890 before a trade union for photographic assistants came into being—the same year that the Photographic Manufacturers Association was formed. A busy year for the formation of specialised groupings, 1890 also saw the establishment of the Society of Professional Photographers (quickly renamed the National Association of Professional Photographers) towards the year-end. None of these groupings endured—the NAPP folding by 1898—and a Master Photographers Association enjoyed only a very brief existence during the 1890s. It was 1901 before the Professional Photographers Association (now the British Institute of Professional Photography) came into being. That association continues today.

In the southern hemisphere, the distances which separated areas of photographic activity dictated that local rather than national associations were established.

The earliest professional photographic group in Australia was the Photographic Society of Victoria, formed in 1860, which held meetings at the studio of Batchelder & O'Neil at 57 Collins St. Melbourne. The secretary was Charles Hewitt. In 1894, the Professional Photographers Association of Sydney formed, meeting in the Sydney School of Arts with J. Hubert Newman as Chairman, and a state-wide group, the New South Wales Professional Photographers Association formed in the same year, holding meetings at the Baker & Rouse Warehouse in George St, Sydney.

The Photographic Association of South Australia was formed late in December 1882 and the first meeting was held at George Freeman's studio in King William Street, Adelaide where it was reported that twenty-four persons had sent in their names for enrolment, but the group was short lived.

The South Australian Photographic Society first met 14 August 1885 at Chairman Aaron Flegeltaub's office in Freeman Street, Adelaide, catering for both professional and amateur photographers, while in Queensland the Professional Photographers Association formed in Brisbane in 1893 with Gustave A. Collins, operator at the studio of Albert Lomer & Co, as president.

FRANÇOIS BRUNET, JOHN HANNAVY, ROLFE SACHSSE, MARCEL SAFIER

See also: Daguerreotype; Anthony, Edward, and Henry Tiebout; Scovill & Adams; Kodak; Cartes-de-Visite; and Calotype and Talbotype.

Further Reading

Jenkins, Reese V., *Images and Enterprise, Technology and the American Photographic Industry 1839 to 1925*, Baltimore: The Johns Hopkins University Press. 1975.

Rinhart, Floyd and Marion, *The American Daguerreotype*, Athens, Ga.: University of Georgia Press, 1981.

Welling, William, *Photography in America: the Formative Years,*

1839–1900, Albuquerque: University of New Mexico Press, 1987 [1978].

Alfred Eberlein (ed.), Die Presse der Arbeiterklasse und der sozialen Bewegungen: von den dreißiger Jahren des 19. Jahrhunderts bis zum Jahre 1967; Bibliographie und Standortverzeichnis der Presse der deutschen, der österreichischen und der schweizerischen Arbeiter-, Gewerkschafts- und Berufsorganisationen (einschließlich der Protokolle und Tätigkeitsberichte, Archivalische Forschungen zur Geschichte der deutschen Arbeiterbewegung Bd.6, Frankfurt am Main: Sauer & Auvermann, 1968 passim.

Ludwig Hoerner, *Das photographische Gewerbe in Deutschland 1839–1914,* Düsseldorf: GfW, 1989, 55–57.

Hannavy, John, *Images of a Century—the Centenary of the British Institute of Professional Photography,* Ware: British Institute of Professional Photography, 2001.

McCauley, Anne, *Industrial Madness—Commercial Photography in Paris 1848–1871,* New Haven, CT and London: Yale University Press, 1994.

UNITED STATES OF AMERICA

In view of photography's extraordinary development and deep assimilation in the United States, it has been suggested that although it originated in Europe, it should really have been invented in the U.S. Such a claim could hardly be justified on mere technological grounds, since by all accounts there were few, if any, serious precursors in the U.S., and since the American contribution to photographic technologies was minor, at least until the emergence of dry plates and popular photography after 1880. Similarly, the artistic achievement of 19th-century American photographers, at least until the 1890s, has often been regarded as secondary in comparison to that of leading European countries, although since 1975 or so a few American "masters," such as Edward S. Curtis or Carleton E. Watkins, have received increasing attention. If one is to uphold the idea of a special success of photography in the U.S., then it must be understood less in the traditional categories of science and art, and more in terms of social, economic, and cultural development, as was already made clear in Robert Taft's pioneering history of American photography, published in 1938 under the significant title *Photography and the American Scene: A Social History, 1839–1889.*

Social history, in a broad sense, has been a continuing trend in the ever-increasing historiography of 19th-century American photography since Taft, and it has been important not only in unveiling previously unknown or underestimated American photographers and pictures, but more generally in stressing social patterns of practice, use, and appreciation. These patterns were doubtless more pronounced or more noticeable in the U.S. than elsewhere, but they were by no means unique to the U.S. In that sense, the social bend of much of American historiography has served in recent years as a model for other areas, especially Europe, where the social dimension of photography had often been eclipsed by a more narrowly academic historiography. The following presentation, while arranged in broad chronological fashion, will focus on the connections between photography and society, which in the case of the U.S. determined the course of photography as a medium of culture and memory, rather than a mere form of art.

Most accounts of the beginnings of photography in the U.S. have emphasized the sweeping enthusiasm of Americans for what Oliver Wendell Holmes called "the mirror with a memory," i.e., the daguerreotype, which was the sole process being practiced in the 1840s and which was dominant until 1855 at least. This enthusiasm was reflected in countless press articles and other records, starting with Samuel F.B. Morse's famous description of Daguerre's "results" in a letter he sent his brothers from Paris in March 1839, and which was subsequently published in dozens of American newspapers. According to the American painter-inventor, Daguerre's plates were "Rembrandt perfected," and "their exquisite perfection almost transcend[ed] the bounds of sober belief." A few months later, Edgar A. Poe hailed the daguerreotype as "the most important, and perhaps the most extraordinary triumph of modern science," while Ralph W. Emerson, noting the sobering effect of a daguerreotype sitting, wrote in his journal that "a Daguerreotype Institute is worth a National Fast." Many more examples of this enthusiasm could be adduced, especially from the scientific, literary and artistic milieus, which almost unanimously embraced the daguerreotype and in many cases kept abreast of improvements. What was perhaps most distinctive about the American response, however, was not its superlative and sometimes fantastic character, but its primarily social and technical dimension, which quickly transformed the foreign invention, its use and its practice, into a booming profession and something of a national pastime. It would be exaggerated to claim that the beginnings of photography in the U.S. amounted to a rush of entrepreneurs and fortune-seekers, as opposed to the genteel world of *savants* and *artistes* supposedly typical of European countries. Many of the early practitioners and promoters of the daguerreotype in the U.S., notably in New York, Philadelphia and many other cities, were artists, such as Morse, whose studio served in 1840 as a school for many a future great of American photography, including Mathew B. Brady, Edward Anthony, and Albert S. Southworth. Most American painters of the mid-century would experiment in one way or another with the daguerreotype and then with other processes. One must not overlook either the initial role of professional scientists, such as the leading chemist and colleague of Morse at New York University John W. Draper, the University of Pennsylvania chemist Paul Beck Goddard, and the future president of Columbia University

Frederick A. P. Barnard; in addition, the development of the daguerreotype in smaller cities, such as in the South, was often led by local academics or physicians. It is clear, however, that these beginnings were less academic and more professional than in Europe, and that they took place mostly outside established institutions, or rather that those academic institutions that did play a role (such as the American Institute, the Franklin Institute, or even the American Philosophical Society) were at the time too insignificant or too weak to exercise any kind of control or even any major influence over the course of events. Thus, what is striking about Morse's letter of March 1839 is not just its fantastic style, but rather the fact that this private letter, full of emotional marvelling, and necessarily devoid of any proof or illustration, was reproduced in hundreds of newspapers and served as the nearest equivalent of an official annoucement of the daguerreotype in the U.S. In contrast to the ceremonious and centralist rituals that surrounded the invention in France, the spontaneous and diverse beginnings of photography in the U.S. were auspicious for an invention that was to become a "mirror image," in Richard Rudisill's phrase, of political and cultural democracy—so much so that by the 1850s many an American journalist would claim that "photography was born in the U.S."

The fact that Daguerre did not take out a patent in the U.S. was a major factor in the daguerreotype's long domination; its development, however, took almost immediately a decisively technical and professional turn. Virtually every effort of the pioneers centered on the drive to make portraits and to make a business out of them, and this soon led to the registration of many patents for technical improvements. Whatever the answer may be to the much-debated question of the "first photographic portrait," and while European experimenters were also involved in 1839–40 in research aimed at reducing exposure time and increasing light input and chemical sensitivity, such research mobilized more energy and ingenuity, and yielded quicker positive results, in the U.S. than anywhere else. A classic example of this American specialization is the short career of the Wolcott-Johnson partnership, which in October 1839 created and soon patented, for the purpose of making portraits, a simple design of a camera without a lens, and used its superior luminosity to open in New York, in May 1840, the world's first studio for photographic portraiture. While Wolcott also designed many recipes for "accelerating" silver salts and more generally reducing exposures, many more examples could be adduced of early and continuing American experiments that almost always touched upon the technique of making portraits, including its more artistic aspects such as lighting, background, and the expression of the sitter. Between 1839 and 1845 at least, portrait-making was virtually the sole photographic activity practiced in the U.S., and after that it remained both the most important and the most prestigious branch of daguerreotypy, as illustrated by many an enterprising "daguerreotype institute" (such as the network of studios owned by the Bostonian John Plumbe), and, most famously, by Mathew Brady's Broadway studio. Brady's "Gallery of Illustrious Americans," which became something of a household word in the 1850s, especially exemplified the link between photography and the building of a national identity, as well as the connection that the portrait always suggested between one's image and the public image of celebrities functioning as models. Well beyond the daguerreotype era, indeed for the entire 19th century, portrait-making would remain the dominant use of photography, feeding a profession which, as early as the 1840s, emerged as unrivalled in size, dynamism, and business.

The unique success and durability of the daguerreotype process in the U.S. can be measured by the fact that both in quantitative and qualitative terms it reached its climax after 1850, rather than before, and that it remained dominant until 1855 and widely practiced until the early 1860s, thereby departing radically from the general course of development observed in Europe. Thus in 1851 at the London Crystal Palace Exhibition, Americans showed nothing but daguerreotypes and indeed won several prizes for them: a first prize to Martin M. Lawrence for stylish and allegorical portraits, a second prize to Mathew Brady for his portraits of celebrities, and another second prize to John A. Whipple for his daguerreotypes of the moon. At the 1853 New York Crystal Palace Exhibition, daguerreotypes were still largely dominant, although for the first time the top award went to paper photographs. The years 1850–1853 were the peak of a kind of Daguerrian cult in the U.S., with the publication of the world's first specialized journal under the title *The Daguerreian Journal* (founded in November 1850 by Samuel D. Humphrey); the creation of the first two professional associations, namely, the New York State Daguerrean Association and the American Daguerre Association; and, in the same year, 1851, which saw the death of Daguerre and an emotional homage from the American profession to the "French master," the building of a huge photographic manufacturing complex on the Hudson under the name Daguerreville. According to sources quoted by Taft and other historians, in 1853 the number of daguerrian establishments in New York exceeded one hundred, which is twice as many as the figure known for Paris in 1848, and the annual production of daguerreotypes in the U.S. was estimated at three million; between 1850 and 1860, the national census recorded an increase from 938 to 2650 daguerreotypists, while the 1860 census also registered a new category of "photographists" with a population of 504, probably an underestimation since by this date

many daguerreotypists were also practicing photography on glass. By 1855–1860, every town of any significance and many a tourist spot or place of passage had at least one resident photographer, and the itinerant "dag'typist" with his wagon and chemicals had become a familiar feature of the countryside.

The daguerreotype boom of the 1840s and early 1850s was sustained by a climate of "near-perfect competition" (Reese V. Jenkins) that was facilitated by the quasi-absence of commercial restrictions on the practice. This situation changed with the advent of negative-positive processes, which made it possible for some individuals, notably one James A. Cutting, to take out patents on minor improvements with a view to controlling the entire market of glass-plate photography. The "Cutting patent" or "bromide patent," awarded in 1854 for the use of potassium bromide in combination with collodion on glass, enabled its holder to exert durable financial pressure on many practitioners, until it was repealed in 1868 upon an application to renew it. More generally, the 1850s and 1860s witnessed a greater diversity of processes, as well as the emergence of cheaper variants (such as the "ambrotype" and its more popular version, the tintype, which as a pseudo-positive process on a dark metal base continued the daguerreotype model in the U.S. and remained hugely popular throughout the 19th century) and mass-market picture products (such as the carte-de-visite and then stereophotographic views). These cheaper, more common types of pictures gradually transformed an activity that had been largely a craft into a more industrial and more aggressively commercial business. Thus, this period was marked on the one hand by the rise of larger suppliers or brokers and a few dominant picture-making firms (the most important being the Anthony brothers' company in New York), and on the other by a spirit of suspicion and bitter rivalry among the more isolated individual photographers, leading to countless efforts, between 1850 and 1870, to organize the profession (see entry "Societies, groups, institutions, and exhibitions in the United States"). The atmosphere of defiance and the absence of a strong organizational framework was illustrated by the famous affair of the "hillotype," an alleged process for color daguerreotypes which the Reverend Levi Hill claimed to have invented, but which could never be either proved or disproved, despite a protracted investigation and major turmoil in the photographic profession in the 1850s.

Meanwhile, by 1860, it can be said that photography had become part of American culture at large. Even though the prices of full-plate daguerreotypes had remained too high for most people to afford them, the carte-de-visite, the tintype and the stereoview gradually turned the experience of photography into a common one, and allowed large segments of the population to own at least a few pictures. These would of course be portraits for the most part, and the more privileged individuals and families who had started accumulating daguerreotypes in the early 1840s were already, by 1860, enjoying the later popular ritual of viewing the growth of children, family resemblances and more generally family history through the photo-album. This photographic construction of family memories was already commented on by Oliver W. Holmes in his famous articles on stereoscopic photography, which appeared between 1859 and 1863 in the *Atlantic Monthly*, and which also indicated the emergence of a cultural consumption of images of the world in the upper, educated classes. For indeed, besides portraits, an increasing share of photographic production in the 1850s illustrated aspects of public life and national culture, from portraits of statesmen and artists that were reproduced as engravings to views of prominent buildings, city scenes, and some already well-established tourist sites (such as Niagara Falls), which would be made popular mostly by stereo-views. Many burgeoning American cities of the antebellum period were illustrated by photography, sometimes in a very self-conscious way, as in the case of Cincinnati (a stunning multi-plate daguerreotype panorama of which, by Charles Fontayne and William Porter, had won a prize at the Franklin Institute in 1849) or especially San Francisco, which almost from its very inception as a city cultivated a kind of photographic narcissism (with views by George Fardon, Charles L. Weed, and then Carleton E. Watkins and others) that would only expand in the 1860s and 1870s; in later years, the rise of Chicago as a metropolis was similarly documented almost day to day by photography. The 1850s and early 1860s also saw the first significant examples of landscape and survey photography, in California especially, but also in the Philadelphia area, although this trend really picked up force only after 1868 or so. Although still timidly, some Federal and state institutions, such as the Department of Treasury for instance, started to use photographers, as did also some large-scale expeditions such as Colonel John C. Fremont's fifth expedition across the Rocky Mountains in 1853 (daguerreotypist Solomon N. Carvalho) and Commodore Mathew Perry's inaugural voyage to Japan in 1852–53 (daguerreotypist Eliphalet Brown). The idea that photographs carried a memorial and documentary value, and therefore could produce a new kind of archive, was making its way into many corners of society. Although American scientific institutions were typically slow and reserved in this process, the 1850s and 1860s saw some attempts at building up collections of ethnographic photographs, in a few cases of African-American slaves and, through the practice of some Washington, D.C., photographers (such as Zeno Shindler), of Indian representatives on delegation visits. Thus, the earliest significant bodies of images of minority groups in the U.S. came into being

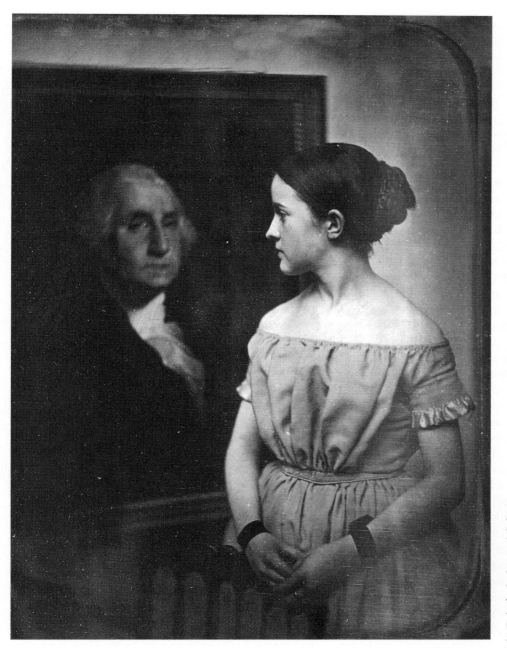

Southworth, Albert Sands and Josiah Johnson Hawes. Young Girl with Portrait of George Washington.
The Metropolitan Museum of Art, Gift of I.N. Phelps Stokes, Edward S. Hawes, Alice Mary Hawes, and Marion Augusta Hawes, 1937 (37.14.53) Image © The Metropolitan Museum of Art.

as a function of archival projects. The political world itself began during the 1850s to realize the impact of photography as a means of publicity and emotional effect; this is how, during the 1860 Presidential campaign, Mathew Brady became "Mr. Lincoln's camera man." Finally, the new cultural role of photography in American society was recorded in much writing of the time, from Nathaniel Hawthorne's *The House of the Seven Gables* (1851), the first major piece of fiction probably anywhere in the world to stage a photographer (in this case a daguerreotypist) as a protagonist, to dozens of more popular novels, tales and stories exploiting the supposed "mysteries of the darkrooms" and the magic powers of the camera, and to the more philosophical reflections of Emerson, Holmes, and others; around

1860, Walt Whitman had become the first major public image of a writer through photography.

These various trends truly gained full force during and immediately after the Civil War, as the glass-plate, negative-positive processes finally superseded the daguerreotype, now making the multiplication of prints a defining aspect of photographic practice and business. The Civil War itself provided direct and decisive impetus for the suddenly accelerating spread of photography in American society and institutions. What is most obvious and most often mentioned in this connection is the outstanding and unprecedented body of thousands of photographs of the war that were produced by the hundreds of photographers associated with the Union army, many of them in the employ of Mathew Brady (such as

Alexander Gardner, Timothy H. O'Sullivan, George N. Barnard): camp scenes, army group portraits, but also the first "straight" photographs ever of war casualties and destruction, among which the most famous one is probably O'Sullivan's "A Harvest of Death," a view of Union soldier corpses left lying at the battlefield of Gettysburg. Here were, to quote Gardner's words in his *Photographic Sketch Book of the Civil War* (1865), the "dreadful details" and the "blank horror" of war: these pictures indeed clashed with the traditionally staid pictorial representation of war, and inaugurated a tradition of war reportage, and of reportage in general, that would be durable and especially strong in American photography. The unique photographic documentation of the war that was thus collected—mostly, once again, from the Union side—has become a major document of American history. Along with various technical uses of photography for map-making, reproduction and filing that the military itself promoted, it has often been cited as one of the illustrations of the Civil War's "modern" dimension. But there were other aspects as well, although often overlooked. First, the war affected virtually every American family, and it tragically strengthened the desire of relatives to remain linked to their boys by getting their pictures, and of soldiers to keep a remembrance of home, peace and family ties through the carte-de-visite portraits of loved ones they kept in their wallets. The production of photographic portraits during the war was enormous, and it was one of the immediate reasons why the armies—especially on the Union side—decided to allow and then to invite photographers among their ranks. Although from its inception photography had been especially linked with the keeping of family portraits and especially the commemoration of the dead, the Civil War more than any other single event made photographic portraits a part of American life. And it was after the Civil War that increasing numbers of ordinary American citizens, including a large number of women (who have more recently been brought to our attention), took up photography either as a business or as a hobby. Second, the Union Army's involvement with photography and photographers precipitated, in the wake of the war, its inclusion in virtually every sector of scientific, museal, documentary and more generally institutional activity in the U.S. It was after the war, and often as a direct result of Army staff connections with photographers, that many new or preexisting institutions started to use photography and to hire photographers on a more or less permanent basis. This was true with a number of medical, police, and other public institutions. But the most striking example of this phenomenon was the widespread use of photography and photographers in Federal surveys of the West between 1867 and 1880, which involved several veterans of war photography, such as

O'Sullivan—who remained in Federal hire from 1867 to his death in 1881, and who is now the most valued and scrutinized of the survey photographers—and Andrew J. Russell, who after serving with the Quartermaster Corps went on to document the building of the Union Pacific Railroad line. Along with the spirit of conquest and colonization that characterized the post-war years, the Army's involvement with photographers thus paved the way, somewhat paradoxically perhaps, for the exceptional flourishing of documentary and landscape photography that took place in the West, under Federal direction mostly, around 1870. Beyond O'Sullivan, the survey photographers included, among others, William H. Jackson, another "grand old man" of American photography who recorded the first views of Yellowstone, the Mountain of the Holy Cross, Mesa Verde and many another of the "wonders of the West," and Jack Hillers, the photographer on Major John Wesley Powell's survey of the Colorado who almost singlehandedly created the photographic archive of Indians in the Bureau of American Ethnology. When looking at the sublime landscapes of California, Colorado, Wyoming, Idaho, etc., which were taken by these photographers in large, sometimes gigantic, collodion-coated glass-plates, one cannot but be struck at their magnitude as well as technical and artistic excellence. At the same time, however, one cannot either avoid the supposition that the Federal Government, by 1870, had found in the photography of the West's grand landscapes a perfect visual and even artistic expression for its policy of "reconstruction," i.e., a means of replacing the wounds of the war with visions of both a pristine Nature and a grandiose future in the imagination of Americans.

Many of these photographs, including especially hundreds of landscape pictures that basically defined the contours of the American imagination of the West and its great sites, were exhibited and rewarded in several important exhibitions, including the World Fairs of Paris in 1867 and Vienna in 1873, as well as the Centennial Exhibition in Philadelphia in 1876. They were also distributed, along with many other similar pictures of private or corporate origin, in the form of stereoviews, which by 1870 had become the most important popular medium of visual information and entertainment. The railroad companies were especially active in promoting and selling landscape photography. The business of landscape views was between 1865 and 1890—aside from portraits—the primary channel of popularization of photography and photographs in American society, and it continually reemphasized the connection between the new medium—for photography was still considered such by the general public—and the new perspectives of American society. But it also served, although somewhat paradoxically, the recognition of photography as an art form. Because these views obsessively staged

the spectacular landscape forms of the West, and because their authors in general tended to underplay or perhaps to hide their stylistic input in them, they were generally regarded as anonymous "views of the West," notwithstanding the specialized interest of a small "photographically literate" community in their makers' idiosyncrasies. For that reason especially, as well as because of increasing acts of piracy and underselling, the more culturally conscious segment of American photography fought after 1865 for a legal recognition of their authorship, which resulted in 1868 in a modification of the copyright laws that provided some protection for authors. Thus, the same moment that witnessed the true popularization of photographic images in American society was also the time when the idea of photographic authorship gained a measure of recognition. This dual pattern was to maintain itself for several decades, as the social distribution of views expanded into the business of chromolithographs and then (after 1890) postcards on the one hand, and as more demanding artist photographers on the other hand devised stylistic and publishing means of distancing themselves from the mainstream. William H. Jackson, who after his survey years went into partnership with the railroads and then with the Detroit Publishing Company, was an example of the "commercial" model, as were also, in the last years of the century, Frank Jay Haynes and Adam Clark Vroman (although all three of these photographers at the same time practiced more advanced or formally innovative photography). Conversely, more sophisticated or more artistically ambitious individuals, such as Peter Henry Emerson, the founder of "naturalistic photography" in the 1880s, and his followers illustrated a more formally and intellectually demanding perspective, although they learned immensely, if not always admittedly, from the "view" or "business" photographers.

This latter trend, which led to the differentiation of "professionals" and "artists," was also a reflection of broader patterns after 1880, among which the most significant was the emergence of amateur photography and the ensuing transformation of the older forms of practice. Until 1880 or so, there were few amateurs in the U.S., and those who existed were for the most part the learned, high-profile type, engaging primarily in documentary endeavours. While the French law of 1839 on the daguerreotype had implausibly announced that with the daguerreotype, every one could make a picture, the democratic promise of universal access to picture-making had remained until around 1880 a fairly abstract notion, even though the possession of pictures had already been democratized. In fact, in the U.S. even more markedly than in Europe, the business of picture-making had been, almost immediately and durably, the exclusive privilege of a professional class, which prided itself on its technical achievement, and which because of

its lack of reputation was especially prone to bar outsiders from entering the field. Photography until 1880 or 1885 remained, in Daniel J. Boorstin's phrase, "esoterical." But then after that things changed rather quickly, as dry plates, smaller formats, and the first attempts at providing photographic customers with technical services started to catch the fancy of the urban upper-middle class. By 1885 there were amateur photographic clubs in most leading American cities, and photography was becoming a fad along the same lines as bicycling or going to the beach. Then a new and decisive threshold was crossed with the introduction, by the Eastman Company of Rochester, of the first Kodak (1888–89), an easy-to-handle hand camera loaded with film (first mounted on paper, then on celluloid) for a hundred views, which after exposure the firm would take in and process for a relatively low cost : "you press the button, we do the rest," the slogan went, as if to materialize the promise of 1839. This slogan was successful enough to become a catchphrase of the 1890s, as thousands of Americans discovered the pleasures of snapshot-taking and thus constructing their own private memories, and as the Eastman Kodak Company kept introducing newer, simpler and cheaper models (such as the famous Brownie in 1900). The Kodak organization reflected the new potential of American industry for technological innovation, which around the same time was also embodied in the development of moving pictures. But the Kodak was primarily a concept, and although it had been preceded, and was largely imitated, by many competitors (such as Ansco, Carbutt, Cramer, etc.), it was a revolutionary one, just like its author George Eastman had intended it to be: for George Eastman had been perfectly explicit about his ambition to make "a Kodaker" of every American man, woman, and child, be it at the cost of displacing the former corporative privileges and organization of the professionals. Professional photography did not simply disappear around 1900, but it was progressively stripped of its basic functions and relegated to more specialized ones, such as ceremonial portraits on family occasions and the like. Meanwhile, much of the former public and commercial character of photographic practice was replaced by a new interrelation of industrial and domestic concerns, out of which, in addition, the amateur photographer now also started to evolve, at least in some cases, as a new type of artist. To be sure, serious amateurs and artist amateurs had been around, and had even formed clubs, for several decades before 1900, an early and important example being the Philadelphia Society, which starting in 1860 gathered around Edward L. Wilson and published a high-class periodical, *The Philadelphia Photographer*. But the boom of popular photography in the 1890s transformed the very concept of amateur, in the sense that being a popular photographer meant taking the kind of pictures

that a professional might have made before, although not necessarily with strong artistic consciousness. Finally, this process of popularization also coincided with, and in several ways underlay, the much more self-conscious efforts at distinguishing art photography from run-of-the-mill professional photography—as well as from "button-pressing"—by some advanced individuals, who since about 1885 had been advocating and practicing "pictorial photography," under the influence of P.H. Emerson, and British and other European artists and critics. The most notable example of the partition between "high-brow" amateur photography and popular photography was, of course, Alfred Stieglitz and his New York circle, which between 1892 and 1900 progressively broke away from the New York amateur clubs to create the Photo-Secession and the prestigious magazine *Camera Notes*. Stieglitz went on to found a distinctively American branch of photography—as well as modern art—on the premise that neither the limited, recipe-style, technical expertise of the professionals nor the haphazard and vulgar opportunism of the "button-pressers" constituted true photography. But at the same time, Stieglitz himself practiced the hand-held camera and other contrivances associated with popular photography, while also showing great meticulousness in his picture-taking choices, as well as in developing and printing procedures, and he thus served as the synthesis of the new diverging trends, and as an endpoint to several of the main traditions of 19th-century American photography. Ultimately, it may be argued that the American 19th century climaxed in the contradictory but complementary figures of Eastman and Stieglitz, who not only jointly revolutionized photography for the U.S. and for much of the world, but who paradoxically upheld some of the basic trends of the 19th century, most notably the profoundly political dimension that in the U.S. had attached itself to photography, making it the democratic art *par excellence*. This political dimension, indeed, was lost neither on Eastman nor on Stieglitz, both of whom viewed photography as the double expression of hard work and individual freedom.

FRANÇOIS BRUNET

See also: Daguerreotype; Southworth, Albert Sands, and Josiah Johnson Hawes; Draper, John William; Goddard, John Frederick; Brady, Mathew B.; Great Exhibition of the Works of Industry of All Nations, Crystal Palace, Hyde Park (1851); Wet Collodion Negative; Cutting, James Ambrose; Cartes-de-Visite; Stereoscopy; Watkins, Carleton Eugene; Weed, Charles Leander; and Fardon, George Robinson.

Further Reading

Gernsheim, Helmut and Alison, *The History of Photography from the Camera Obscura to Tthe Beginning of the Modern Era*, New York: Mcgraw-Hill, 1969.

Jenkins Reese V., *Images and Enterprise, Technology and the American Photographic Industry 1839 To 1925*, Baltimore: The Johns Hopkins University Press, 1975.

Newhall, Beaumont, *The Daguerreotype in America*, New York: Duell, Sloan & Pearce, 1961.

Newhall, Beaumont, ed., *Photography: Essays and Images*, New York: The Museum Of Modern Art, 1980.

Newhall, Beaumont, *The History of Photography*, 5th ed., New York: The Museum of Modern Art, 1982.

Rinhart, Floyd And Marion, *The American Daguerreotype*, Athens, Ga.: University Of Georgia Press, 1981.

Rosenblum Naomi, *A World History of Photography*, 3rd ed., London: Abbeville Press, 1997.

Sandweiss, Martha A., ed., *Photography in Nineteenth-Century America*, Fort Worth And New York: Amon Carter Museum, Harry N. Abrams, 1991.

Scharf Aaron, *Art and Photography*, New York: Penguin Books, 1986.

Taft, Robert, *Photography and the American Scene: A Social History 1839-1889* (1938), Repr. New York: Dover, 1964.

Trachtenberg, Alan, ed., *Classic Essays on Photography*, New Haven, Conn.: Leete's Island Books, 1980.

Trachtenberg, Alan, *Reading American Photographs: Images as History, Mathew Brady to Walker Evans*, New York: Hill and Wang, 1989.

Welling, William, *Photography in America, the Formative Years 1839–1900*, Albuquerque: University of New Mexico Press, 1987.

Wood, John, ed., *America and the Daguerreotype*, Iowa City: University of Iowa Press, 1991.

URIE, JOHN (1820–1920)

John Urie was born in Paisley, Scotland, in 1820, the son of a weaver, and was apprenticed in the printing trade. In the 1840s he operated his own business hand-carving wooden type for use in the printing industry, and later working as a wood engraver making printing blocks.

Urie's engagement with photography was reputedly initiated by a visit to the Great Exhibition, and by 1852 he had established himself as a photographer in Glasgow.

In December 1852 he was mentioned in *The Practical Mechanics Journal* in connection with the application of photography to wood engraving.

By 1854 he occupied premises in Glasgow's Buchanan Street, at Nos. 33 and 35, producing portraiture. The *Mechanics Journal*, May 1854, published an account of Urie's *Relievotype* variation on the collodion positive, or ambrotype, in which the image was presented emulsion side up, with only the background of the actual portrait backed with black shellac. The image was then placed on a light paper or card background. This had the effect of creating a three-dimensional effect.

He later advertised studios in Edinburgh, Glasgow, Leeds, Perth, Dundee and Belfast and that he had 'agencies' in all important cities.

In 1885 he invented a photographic printing machine which could produce two hundred prints an hour by gaslight (*Photographic Times*, Nov 27 1885).

JOHN HANNAVY

V

VACQUERIE, AUGUSTE (1819–1895)
French photographer and writer

Auguste Vacquerie was a very close friend of the Hugos, who considered him as a member of the family. His brother Charles married Leopoldine Hugo, the writer's elder and beloved daughter. The consorts both drowned in the river Seine near Villequier, in 1843.

After a classical education, he turned to critique and journalismHe co-founded in Paris the political newspaper L'Évènement, with Paul Meurice, his good friend from College Charlemagne, Charles, and François-Victor Hugo. On the 2nd of December 1851, threatened as a republican and opponent to Napoleon's dictatorial regime, he left France. Later he moved to Saint-Helier, Jersey Island, with the two Adeles, the wife and daughter of Victor Hugo, who joined them in August 1852. They stayed there till October 31 1855, when they had to move to Saint-Peter-Port, Guernsey Island.

In Jersey, Vacquerie had to adjust to his new condition of exile, as well as the Hugo family. Far away from his busy social life dedicated to political and journalistic activities, he mainly turned to literature. But along with Victor Hugo, Charles and François-Victor, he was part of the Jersey et l'Archipel de la Manche book, a project launched by Victor Hugo, supposedly in two volumes. The first one, rather inexpensive, included poetry written by Victor Hugo himself. The second volume, more luxurious, was to include texts on Jersey's history and institutions, and photographs taken by the Hugos sons and Vacquerie. For him, this book was a rather basic work, far from the interest he had at this time in theatre plays. He hoped it would be an opportunity to make money quickly.

Vacquerie greatly admired Delacroix aesthetic and was influenced by the latter's concept of photography. Vacquerie mostly worked with negatives on paper, which offered more delicate contours. Yet, he used glass plates as well. Positives were printed on salted paper, a technique he seems to have learnt from Charles Hugo. Not satisfied with his first attempts, he worked hard on improving his technical skills, as witnessed by letters to his friend Paul Meurice or to his family (see unpublished letters to his mother, sister (Mrs Lefèvre) and nephew Ernest Lefèvre, kept at Musée Victor-Hugo at Villequier).

Auguste Vacquerie usually used small size prints (roughly 10 × 7 cm.), organizing his pictures with great attention to harmony, according to curves, light and shadow balances. Although it is hard to discern Charles Hugo's or Auguste Vacquerie's authorship when not clearly established, Vacquerie's portraits end-up as a remarkable set.

Beside Victor Hugo's portraits, he shot pictures of many exiled people there (like the Le Flô children or Augustine Allix) or visiting friends (Paul Meurice and his wife) that the corresponding French colony in Jersey still looks very vivid. Focusing on details, he brings to life the daily routine of the exile, like Mrs Hugo reading Châtiments dressed in a peplum-like drapery, and the passing of the seasons, pictured in close-ups of the green house sofa with hanging roses above or the garden under the snow. In his images, Vacquerie never parted from his own sense of humor: he pictured his cat sleeping as a pendant to a portrait of Hugo, during a reading of Phèdre tragedy.

Vacquerie also made as many as 43 self-portraits. These images show a clear influence of Victor Hugo's portraits: the poses are strikingly similar. Many of Vacquerie's self-portraits are grouped along with portraits he did of his family (his mother, sister, nephew, etc.) in an album he gave them (now kept at the Bibliothèque nationale de France).

Lastly, Vacquerie developed a clear interest in still life, a genre that set him apart from the rest of the Jersey Atelier and the Hugos' photographic production.

Through photographs of casual objects (like Mrs. Hugo's purse, or her bracelet on her arm), or small compositions (including the reproduction of the Hugo's portrait or drawing done by the writer), Vacquerie gave a puzzling image of the family. This specific type of images, though, was never broadly circulated, and seemed to have stayed with the closest relatives the Hugos and Vacquerie had.

In 1854, 9 000 francs (in gold) had been spent already on the project mentioned above, without any return. No publisher could be found who was willing to issue the work. All were afraid of the cost, and of the possible censorship the volume might trigger.

Vacquerie's and Hugo's sons pictures were all taken in Jersey, except a very few number when they moved to Guernsey, in 1855. Then, although a lab was installed at their new place, Hauteville House, the photographic production slackened. The text Vacquerie had written to accompany the pictures in *Jersey et l'Archipel de la Manche* was published in 1856 and 1863, *Les miettes de l'Histoire*. Some of the reprints he had done later on were used by Vacquerie to illustrate his books (mainly *Profils et Grimaces*), in order to turn them into personalized gifts.

Dropping photography, he concentrated on journalism and literature, both of which he had never left behind.

MATHILDE LEDUC-GRIMALDI

Biography

Auguste Vacquerie (1819–1895), schoolmate and friend of Charles Hugo. After a classical curriculum, he was first a journalist and a literary critic, for French newspapers like *Le Globe*, *l'Époque*. Very early, he was introduced into the romantic coterie and became a devoted admirer of Victor Hugo. He became part of the family when his brother Charles Vacquerie married Leopoldine Hugo, the writer elder child. After their drowning, emotional ties grew even stronger between Vacquerie and the Hugos.

He joined Hugo's sons and friend Paul Meurice venture in publishing *L'Évènement* (1848) where he was more concerned in literature than politics. When, in 1851, this paper re-named *l'Avènement du Peuple* saw most of its staff jailed, Vacquerie took it over. Then the four of them were fined and jailed at the Conciergerie in 1851, and the Evènement was shut down under Napoleon's dictatorial regime (along with him was jailed his female cat Grise and again she was in Jersey where Vacquerie took a famous photograph of her). Sharing Hugos' political ideas, he fled from France, and lived in Jersey, Guernsey and Brussels. Part of his work, such as Profils et Grimaces (1856) or Les miettes de l'histoire (1863), and his many letters to his friends or sister in France depicted his life in Jersey with the Hugo family,

and showed his interest in photography. Yet, this hobby actually lasted just a few years.

In 1869, he founded Le Rappel with Rochefort, Paul Meurice, Charles et François-Victor Hugo, unrelentingly fighting against Napoleon III Empire. After the Empire fell, he backed the uprising of Paris (1871), as did V. Hugo and his sons.

He also wrote poetry (*L'Enfer de l'Esprit*, in 1840), a comedy (Souvent Femme Varie, in 1859) and dramas (Tragaldabas in 1848, Les Funérailles de l'Honneur, in 1861).

Back in France (around 1867), he continued his activities as a journalist, writer, and was chosen (along with Paul Meurice and Ernest Lefèvre, Vacquerie's nephew) by Victor Hugo to overlook the publication of the poet's entire work after his death.

See also: Bacot, Edmond; Wet Collodion Negative; Daguerreotype; France; Hugo, Charles and François-Victor; and Salted Paper Print.

Further Reading

Lacan, Ernest, "Vues de Jersey par MM. Hugo frères et Auguste Vacquerie", in *La Lumière*, no. 41, 8 Octobre 1853.

Vacquerie, Auguste, *Profils et Grimaces*, Paris: Michel Lévy, 1856.

Vacquerie, Auguste, *Les Miettes de l'histoire*, Paris: Michel Lévy, 1863.

Gaudon, Sheila, "Victor Hugo et la photographie: les débuts de l'atelier photographique de Jersey (1855)," *Bérénice*, no. 7, 1995, 11–23.

Robb, Graham, *Victor Hugo*, London: Picador, 1997.

Heilbrun, Françoise and Molinari Danielle, ed., *En collaboration avec le soleil, Victor Hugo, photographies de l'exil*, Paris: RMN, 1998.

Stevens, Philip, *Victor Hugo in Jersey*, Chichester: Phillimore & Co, [1985], 2002.

Prévost, Marie-Laure ed., *L'Homme Océan*, Paris: BNF, 2004.

VALENTA, EDUARD (1857–1937)

Valenta was a professor at the Hohere Graphische Bundes-Lehr- und Versuchsanstalt in Vienna from the late 1800s to 1909 where he codirected with Josef Eder, founding director and author of famously detailed The History of Photography (Geschichte der Photographie), and later succeeded him as the school's head in 1923. The school is one of the oldest and most important with a specialty in photography and graphic arts in the world.

Valenta and Eder carried out and published in journals and annuals numerous studies of the spectra of elements and compounds, including many of the dyes important for photographic emulsions. They experimented with emulsions and published a number of photographic studies, including one of the earliest and most beautiful collections of highly detailed X-ray images (1896).

Valenta studied and published on the Lippmann process (1894–1912). Many of his Lippmann plates were held in the collection at the "Graphische." Those were mostly in the nature of lab trials, and most were failures with poor or no color. These plates, along with 60,000 others in the Graphische's collections, were donated to the Albertina in Vienna where they are in process of being cataloged.

WILLIAM R. ALSCHULER

VALENTINE, GEORGE D. (1852–1890)
Scottish photographer

George D. Valentine (1852–1890) was a son of the famous Scottish photographer James Valentine. He came to New Zealand in 1884 with the hope that the climate would improve his health. It seems that in the remaining years of his life, he was unable to suppress his sheer enthusiasm for photography and despite his fragile condition he committed himself to compiling an extensive series of landscape photographs. Beginning with views of Nelson where he initially settled, he then turned his attention to views of the Pink and White Terraces and Lake Rotomahana, both pre and post eruption 1886–1887. Moving to Auckland he broadened his coverage by making a series based on a summer cruise in the Pacific Islands, photographing Tahiti, Tonga and the Cook Islands. In 1889 he was one of the first photographers to descend into the Waitomo Caves at Otorohanga, an exploit which would have tested the physical endurance of a very fit person. Surprisingly none of his 12 × 10 inch views seem to have found their way back Scotland for his father's firm to distribute. Two years after he died in Auckland, Valentine & Sons dispatched a photographer to New Zealand where he made a series which were used for tourist souvenirs and postcards. These were marked with the initials of J.V. as distinct from George Valentine's photos who signed his prints with the initials of G.V.

WILLIAM MAIN

VALENTINE, JAMES AND SONS
Company

James Valentine and Sons of Dundee, Scotland, were a successful photo-publishing firm who derived the bulk of their income from the sale of topographical views and postcards. The firm had its origins in the activities of John Valentine, a one-time weaver who commenced the production of wood-blocks for the linen industry around 1825. In 1832 John's son James, who had been trained in the art of portrait painting in Edinburgh, was summoned to assist in the running of his father's printing firm. For a time father and son worked together, however, local directories show that they had parted company by 1840. Before James expanded into photography he produced bill-heads, engraved notices, prints of local scenes and illustrated propaganda envelopes for the American social campaigner, Elihu Burritt. James also became interested in the daguerreotype and travelled to France to study photography under M. Bulot. He was listed in the 1851 trade directories as a professional photographic artist. From the mid 1850s he supplemented his income from photographic portraiture by selling stereographs and carte-de-visites created by other photographers.

The public appetite for scenic views was evident in the growing sales of topographical lithographs after 1820. This audience was augmented by souvenir -hungry tourists whose holidays were made increasingly possible through the expansion of the railways. In the early 1860s, another member of the family, James's son William Dobson Valentine, entered the firm. He had just graduated in chemistry from University College, London, and had also trained with the renowned professional travel photographer Francis Frith at his Reigate Studios. It is thought that William encouraged his father to produce photographic views similar to those with which the firm's Aberdeen rival, George Washington Wilson, was having great success. In 1867 James Valentine was commissioned to produce a series of forty Scottish highland views for Queen Victoria and was subsequently appointed as Photographer to the Queen. William's brother George Dobson Valentine also entered the business where he concentrated mainly on portraiture. William was a thorough photographer and his topographical views show careful attention to composition. Two negatives were made of each scene and by 1878 the company's numerous views necessitated the introduction of a number dating system thereby attaching a unique number to each image within the collection.

By the 1870s Valentine's views covered the whole of Britain and were being sold singly in several sizes or in finely bound albums. The pricing of these exquisitely bound volumes demonstrated that they were intended for the middle and upper-classes. The company also sold more moderately priced individual views and inexpensive stereographs which were cheap to produce and in wide demand. The company changed its name from James Valentine to James Valentine and Sons in 1878. Following the death of James Valentine in 1879 his two sons became sole partners in the firm. This arrangement lasted until 1884 when, due to ill health, George emigrated to New Zealand where he was to become one of the earliest landscape photographers in the country. William was also keenly interested in technological advances in photography and contributed articles to periodicals such as Art Journal and the Photographic News. During the 1880s he was to write on a variety

of subjects including underwater photography and the photographing of winter scenes.

In 1886 an article appeared in the *British Journal of Photography* outlining the extent of the Valentine's operation which by then employed over one hundred people. By 1888, their catalogue included over 20,000 views of Scotland, England, Wales, Ireland and Norway. At around this time another generation of the family entered the business, William's son Harben Valentine. He was also keen to use any technological innovation which would give the firm an advantage over its competitors. By the 1890s Harben was employing the collotype process which allowed the mechanical reproduction of photographic images which would previously have been printed by hand. This greatly increased the speed at which the firm could operate. He was also to experiment with the photocrome and photogravure processes.

In 1897 the British post office permitted private cards to be sent through the mail for the first time and it was in that year that the Valentine firm were to enter the postcard market. Valentine and Sons were able to compete in the rapidly expanding market due to the technological advances which had been instigated by Harben. The combined the collotype process with the bitumen process to add colour. An indicator of their success in the production of postcards was the number of staff employed by the firm which rose from over 100 in 1886 to almost 1000 in 1900. The firm's activities spread overseas with branches opening in Canada, the United States, South Africa and Australia. William Dobson Valentine handed management of the firm over to Harben in 1900 though he was to retain an avid interest in the firm until his death in 1907. The early years of the twentieth century saw increased competition from German postcard manufacturers and Valentine responded by placing an emphasis upon the production of realistic views undoubtedly utilising their immense collection of negatives and their knowledge of topographical photography. In 1908 they became the official postcard publishers for the International Franco-British Exhibition. It was at this time that they took on the twin globe logo and its accompanying motto 'famous throughout the world.'

From about 1901 Valentine began to extend and diversify their interests to include the production of greeting cards, children's books and calendars. The number of views commissioned by the firm began to shrink in the 1950s and family interest in the firm declined with the death of Harben in 1949. The firm was eventually taken over by John Waddington and Co. Ltd. in 1963. In 1971 the archive containing Valentine's topographical views was deposited with St. Andrew's University, Fife, Scotland. Whilst the 150,000 views in the archive constitute only a remnant of the half a million which were recorded

from 1878 to 1967 they provide a valuable record of popular taste and topographical photography.

ORLA FITZPATRICK

See also: Topographical Photography; Postcard; Daguerreotype; Stereoscopy; Cartes-de-Visite; Frith, Francis; Wilson, George Washington; Victoria, Queen and Albert, Prince Consort; Valentine, George Dobson; Photographic News (1858–1908); *British Journal of Photography*; Collotype; and Photogravure.

Further Reading

Hannavy, John, *A moment in time: Scottish contributions to photography, 1840–1920*, Glasgow: Third Eye Centre, 1983.

Sidey, Tessa, *Valentines of Dundee: photographs, postcards and greeting cards from the 1850s to the present day*, Dundee: Dundee Museums and Art Galleries, 1979.

Smart, Robert, 'Famous throughout the world: Valentine & Sons Ltd., Dundee,' in *Review of Scottish Culture*, no. 4, 1988, 75–89.

Stevenson, Sara and A.D. Morrison-Low (eds.), *Scottish photography: a bibliography 1839–1989*, Edinburgh: Salvia, 1990.

Taylor, John, *A dream of England: Landscape, photography and the tourist's imagination,* Manchester: Manchester University Press, 1994.

VALLOU DE VILLENEUVE, JULIEN (1795–1866)
French, artist, lithographer, and photographer

Vallou de Villeneuve was born in Boissy-Saint-Léger on 12 December 1795. From his début at the Salon of 1814 (to 1840) as a painter he regularly exhibited lithographed images of daily life, fashion, regional costumes and erotica, many done after the work of English and Dutch artists. Vallou, earlier a student of Millet and a lithographer of scenes of daily life, costume, and erotica, also published his own lithographed compositions, mostly 'female types.' From 1820 to 1830 he acquired great popularity for his engravings of fashions, costumes, every day scenes, and erotic images. Many lithographs based on his drawings were done by Raymond Noël and Régnier.

Despite a long artistic tradition and an obvious delight in the female nude, decorum in mid-century France, required that the subject be removed from the reality of the present—shown in mythological guise or as an exotic creature, distant and non-threatening. The need to provide a legitimate context for the depiction of the nude was particularly compelling in photography, and Vallou often appointed his models with the paraphernalia of the painter's studio (rugs, shawls, spears, beads, anklets, and turbans). His most successful pictures, however, are those least encumbered by artificial trappings; revealing more and borrowing less from painterly tradition,

de Villeneuve, Julien Vallou. Female Nude, #1940. Reclining, with arm raised.
The Metropolitan Museum of Art, Purchase, Lila Acheson Wallace Gift, 1993 (1993.69.1) Image © The Metropolitan Museum of Art.

these are the most poetic. While tantalizingly real in both weight and texture, Vallou's reclining nude seems nonetheless to float in an indeterminate and dreamlike space, a crescent moon in a starry sky.

In 1826 he showed at the Salon "Costumes des Provinces Septentrionales des Pays-Bas." He published in 1829 lithographs of "Types des Femmes," Souvenirs of an artist. In 1830 with Achille Deveria and Numas, Maurin and Tessaert, he contributed to the compendium of romantic erotica called Imagerie Galante (Paris, 1830), which provocatively updated an erotic mode found in 18th-century engravings. The subjects were pictorial versions of stock characters from popular novels and plays. Issued through several publishers. In 1839 he published the lithographs "Les Jeunes Femmes, Groupes de Têtes." He became interested in photography in 1842, shortly after the new medium's invention, as an aid to his graphic work. His subjects included fashion, costume, and daily life, as well as light erotica, sometimes published in conjunction with other artists. In 1850 he began to practice photography at 18 Rue Bleu, Paris (nudes, portraits of actors). He fixed prints with ammoniac after the process of Humbert de Molard. He liked to retouch his negatives. Durieu criticized him concerning this procedure. By 1850 Vallou de Villeneuve had begun to practice photography in his studio, primarily female nudes and portraits of actors.

In 1851 he became member of the Société héliographique. Between 1851 and 1855, Julien Vallou de Villeneuve, made a series of small-scale photographs of female nudes, which he marketed as models for artists.

Around the symbolism photography art in the 19th Century painters got already a rapid eye for the expressive possibilities of photography. Photographers ogled to the achievements of painted art. The photos mapped the wealth of this interaction. Already as from the first steps in the 19th Century photography had an enriching but also ambiguous link with painting art. Their respective histories were intertwined and revealed many similarities. The mutual teamwork formed the scope of the show, symbolism, as a result of the retrospective Fernand Khnopff in the Royal Museum for Fine Art in Brussels, Belgium.

In 1853-54 Vallou published a series of nude studies, Études d'après nature, which were sold as artists models and to the general public. Several were used for well-known works by Gustave Courbet. Vallou de Villeneuve's works are admired for their emotional restraint, as well as for their masterful orchestration of form. Gustave Courbet, Gustave Moreau and Eugène Delacroix inspired themselves on photograph's, which they let make the Villeneuve, Henri Rupp and Eugène Durieu by photographers such as Julien Vallou. Also the school of Barbizon brought painters and photographers closer to each other. Camille Corot and Théodore Rousseau, Eugène Cuvelier, Charles Famin and Paul Berthier literally walked the same paths at the Fontainebleau. Around the symbolism, the links between photography and painting art exposed the photographic penchant of symbolism in the painter by means of photographic portraits, studies to nature, mises-en-scène and tableaux vivants, and included as well was picturalism. Thanks to photography, artists discovered a totally new manner to capture reality. Vallou's nudes have long been associated with those of Gustave Courbet, who was known to have

used photographs in his painting process. Although no absolute one-to-one correspondence can be proven, the quality of Vallou's models is very close to Courbet's concept of the nude. J. Vallou de Villeneuve in his photographs organized zones of light and shade and worked in small formats intended for albums or "intimate" portfolios. His personages are without ornamentation in simple decors. His nudes are improved by studied lighting. Some accessories were placed within view to add simple graphics.

In his nude studies intended for artists, he was not content with habitual poses, but instead invented new ideas of attitudes.

From 1853 to 1854, he was a founding member of the Société française de photographie (S.F.P.) and in 1855 he gave his prints to this society.

On 4 May 1866, he died in Paris.

JOHAN SWINNEN

Biography

French lithographer, photographer and painter. Between 1851 and 1855 Julien Vallou de Villeneuve, a student of Millet and a lithographer of scenes of daily life, costume, and erotica, made a series of small-scale photographs of female nudes that he marketed as models for artists; evidence suggests that they were used as such by Gustave Courbet, among others.

See also: France; Lithography; Erotic Photography; Nudes; Portraiture; Société héliographique; Painters and Photography; Courbet, Gustave; Delacroix, Ferdinand Victor Eugène; Durieu, Jean-Louis-Marie-Eugène; and Société française de photographie.

Further Reading

Font-Reaulx, Dominique de, L'art de nu au XIXième siècle: le photographe et modèle, Hazan: Bibliothèque Nationale de France, 1997.

Frizot, Michel (ed.), Nouvelle Histoire de la Photographie, Paris: Bordas, 1994.

Gernsheim, Helmut and Alison, The origins of photography, London: Thames and Hudson, 1982.

Heilbrun, Françoise (ed.), L'invention d'un regard (1839–1918), Paris: Musée d'Orsay/Bibliothèque nationale, 1989.

Jay, Paul (ed.), Les calotypes du fonds d'Iray, Chalon-Sur-Saône: Musée Nicéphore Niépce, 1983.

Lemagny Jean-Claude and Sayag, Alain, L'invention d'un art, Paris: Centre Georges Pompidou, 1989.

Lewinski, Jorge, A history of nude photography, the naked and the nude, London: Weidenfeld & Nicolson, 1987.

Strauss, Victor, The lithographers manuel, vol. I & II, New York: Waltwim Publishing Company, 1958.

Turner, Jane (ed.), Dictionary of Art, vol. 8, London: Macmillan, 1996.

Witkin, Lee D. (ed.), The photograph collector's guide, London: Secker & Warburg, 1979.

VAN KINSBERGEN, ISIDORE (1821–1905)
Dutch-Belgian photographer and theatre maker in the Dutch East Indies

When Isidore van Kinsbergen arrived in Batavia in the Dutch East Indies (now Jakarta in Indonesia) on 26 August 1851, he described himself as an artist, lithographer, set painter and opera singer. Such a versatile background meant a great advantage in a small colonial town like Batavia where artists needed several skills in order to survive. Van Kinsbergen's leading role in the Théâtre Français de Batavia gained him support from the upper social classes of colonial society and through this interesting photographic assignments from the colonial government. "A capable and experienced photographer" was the opinion of the Amsterdam photographic pioneer Eduard Isaac Asser.

It is not known where and from whom Van Kinsbergen learned to photograph. However his background as a lithographer and his entrepreneurial spirit no doubt whetted his interest in the medium. His first photographic activities in Batavia date from 1855 when he briefly associated with the French photographer Antoine François Lecouteux.

Via his contacts in Batavia's artistic and scientific circles, it is certain that Van Kinsbergen was familiar with what was being published in Europe in the field of illustration. However, it is doubtful whether he saw there much photography of any kind of quality. In view of his links to the Parisian art world, it is well possible that he became acquainted with photography in the French capital when he resided there for a few months in 1854. Van Kinsbergen's sense of photographic monumentality evokes the work of his French contemporaries Edouard-Denis Baldus and Louis-Auguste and Auguste-Rosalie Bisson.

In 1844, the Dutch Ministry of Colonies, being far ahead of its time, commissioned the German photographer Adolph Schaefer to make daguerreotypes of Javanese antiquities including the Borobudur. When nearly twenty years later Van Kinsbergen picked up the thread where Schaefer left off, photography was already being used elsewhere for documenting ancient treasures and archaeological findings (Egypt, India etc.). He had come to the attention of the Dutch colonial government in September 1862 with photographs taken during a journey with the Governor-General on Java. These convinced the colonial government of his ability to make an extensive photographic survey of Javanese antiquities. Meanwhile the government was also aware of the photographs he had made of famous monuments and temples in Bangkok in Siam (Thailand), where he had been assigned as photographer to a diplomatic mission earlier that year.

In December 1862 the Batavian Society of Arts and Sciences (acting on behalf of the colonial government) drew up a contract with Van Kinsbergen. The Society did not give any directions as to how he should photograph the Hindu-Javanese and Buddhist antiquities. This was left entirely to his own technical and artistic insights. Between 1863 and 1867 Van Kinsbergen made more than 330 photographs which were published in the portfolio Oudheden van Java [Antiquities of Java] in a chronological and geographical order, commencing with the first photographs he made around Bogor on West Java and concluding with images of the Panataran temple complex on East Java.

Van Kinsbergen showed an immense interest in the antiquities he photographed. The Dieng Plateau was considered one of his personal rediscoveries. However, what he thought about the art of photography itself is not revealed. Information on his artistic motivation can only be gleaned by looking at the photographs themselves and from a few responses to his work by experts that specialized in antiquities or the East Indies. Apart from Eduard Asser, it is not known whether fellow photographers appreciated his work as it was hardly reviewed in photography magazines of the period.

Van Kinsbergen worked with different sized negatives (now preserved in the department of history and archaeology at the Ministry of Culture and Tourism in Jakarta) measuring 17 × 21 cm up to 30 × 40 cm. In as far as on-site conditions allowed, he always searched for a viewpoint that showed off the characteristic form of a building, sculpture or artefact to its best advantage. He often worked with images that filled the entire picture in order to do justice to the detailing of the reliefs on the richly decorated temples.

Van Kinsbergen worked deliberately with direct sunlight enabling him to give depth and liveliness to the sculpture he photographed. Often combined with a pitch-black background which he obtained by scratching away the layer of emulsion on the negative, this approach became his trademark. The highly contrasting tone and the theatrical effect that went with it, is typical of not only his archaeological photographs but almost all his topographical views as well. This characteristic makes his photographs easily distinguishable from those Woodbury & Page made for instance. This choice of lighting illustrates that Van Kinsbergen was not only interested in conveying detailed information, but wanted to bring out the dramatic, expressive powers of subjects he photographed.

Van Kinsbergen made a near complete documentation in more than 100 photographs of Candi Panataran, his tour de force of the Antiquities of Java series. However, Boro-Boedoer [Borobudur] is still considered the true pinnacle of his archaeological work. Supplementing the Antiquities of Java series, the Batavian Society had commissioned Van Kinsbergen in 1873 to photograph the Borobudur. The manner in which he immortalized the various Buddha types on this world famous monument enraptured the Dutch scholar G.P. Rouffaer: "If ever the concept of God, as we see it, has revealed itself to the Hindus in the language of sculpture than is it certainly in these depictions of the sitting Buddha."

Van Kinsbergen's assignment from the Batavian Society provided the artistic and financial opportunity to establish his reputation as a photographer with a diverse oeuvre comprising topographical photographs, portraits, peoples of the region, still lives and even nudes. Van Kinsbergen tackled these photographic genres with the same verve as the Javanese antiquities.

In his studio, the relaxed manner in which Van Kinsbergen had his models posing reveals the communicative skills of a theatre director. Each person or group that appeared before his camera offered him fresh opportunities to experiment with a range of poses and forms of expression. He saw the Javanese models who visited his studio more as objects of academic study rather than ethnographic curiosities. His portraits of rulers (Yogyakarta, Surakarta) also reveal how Van Kinsbergen tried not only to depict the symbolic function of a sovereign, but also to make a study of the person behind it. In 1865, he was the first photographer visiting Bali, where he made an exceptional portrait series of the Raja of Buleleng and his court representing all ranks of society.

In his object-oriented and monumental approach to his subjects Van Kinsbergen was closely allied to a photographer like Linnaeus Tripe, who worked in India under similar circumstances. Van Kinsbergen can be described as the only Dutch photographer working between 1850 and 1880 who internationally measures up to colleagues now counted among the top exponents of nineteenth-century photography.

Isidore van Kinsbergen acquired international acclaim with his work that was widely distributed to international institutions. Most of it is still being preserved in the collections of, among others, the KIT Tropenmuseum and the Rijksmuseum in Amsterdam, the National Museum of Ethnology, the Kern Institute and the KITLV in Leiden, the Royal Archives in The Hague, the British Library in London, the Bibliothèque Nationale de France and the Société Asiatique in Paris. His photographs were found in the legacy of the French painter Paul Gauguin, being a direct source of inspiration for several paintings and woodcuts. The French collector Prince Roland Bonaparte owned hundreds of Van Kinsbergen's photographs now kept at the Société de Géographie in Paris.

SASKIA ASSER
GERDA THEUNS-DE BOER

Biography

Isidore van Kinsbergen was born in Bruges in the southern Netherlands (now Belgium) on 3 September 1821, as the son of a Flemish mother and a Dutch father. In the 1840s Van Kinsbergen worked as an engraver in Ghent where he also studied Chant français at the Conservatory. In 1851 he moved to Batavia in the Dutch East Indies (now Jakarta in Indonesia), where he was appointed as a set painter for the Théâtre Français de Batavia. He would be closely involved in the theatre world until his death. In 1855 he took up photography, later opening a commercial studio in Batavia. Van Kinsbergen was one of the first photographers to visit Siam (Thailand, 1862), and to photograph the rulers of Yogyakarta, Surakarta and Bali (1862–1865). He became famous for his extensive photo series of Javanese antiquities commissioned by the Dutch colonial government and the Batavian Society of Arts and Sciences, published as the series Oudheden van Java [Antiquities of Java] (1863–1867) and Boro-Boedoer [Borobudur] (1873). He exhibited at the World Exhibitions in Vienna (1873), Paris (1878) and Amsterdam (1883). Van Kinsbergen died on 10 September 1905 in Batavia.

See also: Asser, Eduard Isaac; Edouard-Denis Baldus; Bisson, Louis-Auguste and Auguste-Rosalie; Schaefer, Adolph; Woodbury, Walter Bentley; Tripe, Linnaeus; and Bonaparte, Roland, Prince.

Further Reading

Falconer, John, *Photographs of Java, Bali, Sumatra, 1860s–1920s*, Paris: Les Éditions du Pacifique, 2000.

Lunsingh-Scheurleer, Pauline, "Isidore van Kinsbergen: Photographer of Javanese Antiquities," in *Toward Independence: A Century of Indonesia Photographed*, edited by Jane Levy Reed, San Francisco: The Friends of Photography, 1991.

Merrillees, Scott, *Batavia in nineteenth century photographs*, Richmond: Curzon, 2000.

Rouffaer, G.P., "Monumentale kunst op Java" [Monumental Art on Java] in *De Gids* 19 (1901), 225–252.

Theuns-de Boer, Gerda (research) & Saskia Asser (editor). *Isidore van Kinsbergen (1821–1905): Photo Pioneer and Theatre Maker in the Dutch East Indies*, Zaltbommel: Aprilis/Leiden: KITLV Press, 2005.

Wachlin, Steven, Woodbury & Page, *Photographers Java*, Leiden: KITLV Press 1994.

VAN MONCKHOVEN, DÉSIRÉ
(1834–1882)
Belgian photographic scientist, writer, and industrialist

Désiré van Monckhoven was born in Ghent on 25 September 1834, the only child of an unmarried mother. Despite these inauspicious beginnings, van Monckhoven proved to be a gifted child, showing a marked interest in physics and chemistry. His academic promise earned him a transfer from the Quanonne Institute, where he was training to be a clerk, to the Atheneum [high school]. Van Monckhoven briefly became a bank clerk, but pursued his passion for photography, which enabled him to turn his knowledge of science to commercial use.

Van Monckhoven received a thorough grounding in photographic practice from Charles D'Hoy (1823–1892), one of the first professionals in Ghent, and by 1853 or 1854 van Monckhoven had supplied a view of the local gothic town hall for the series Variétés photographiques published by Louis-Désiré Blanquart-Evrard. However, van Monckhoven's predilection was for research and writing, rather than running a studio. Barely 20 years old, he published the first edition of his Traité de photographie sur collodion [Treatise on collodium photography], Paris: A. Gaudin et frère, 1855. An initial printing in March 1855 of 1500 copies sold out, and was following by a second printing of 750 copies later in the year. This success persuaded his publishers to bring out a second, greatly expanded edition of the textbook. Van Monckhoven's Traité général de photographie [General treatise on photography], Paris: A. Gaudin et frère, 1856, in a print-run of 3000 copies, consolidated the author's reputation as a leading photographic scientist in continental Europe, an independent researcher able to analyse and arrive at accurate, fault-free formulae, and to disseminate these in clear and unambiguous language.

In order to legitimize his standing in the eyes of the broader scientific community, van Monckhoven enrolled as a student at the University of Ghent in 1857, where he was awarded a doctorate in natural science in 1862. In parallel, he continued his output of handbooks, collecting data from an array of sources and setting out his tried-and-tested conclusions in practical form. His work Méthodes simplifiées de photographie sur papier [Simplified methods of paper photography], Paris: Marion et Cie; A. Gaudin et frère, 1857, was followed by Procédé nouveau de photographie sur plaques de fer [New process of photography on ferrous plates], Paris: A. Gaudin et frère; A. Secretan, 1858, a third edition of his magisterial Traité under the title Répertoire général de photographie Paris et Londres, A. Gaudin et frère, 1859, and a simplified version of the latter as Traité populaire de photographie sur collodion, Paris: Leiber, 1862. Van Monckhoven was also a joint founder of the monthly Bulletin belge de la photographie in 1862, contributing a column on technical innovations.

Van Monckhoven turned his attention to photographic optics. He took out a Belgian patent in August 1863 for "an optical apparatus intended for enlarging by projection." Running counter to diurnal motion, the sun's rays were reflected uniformly by means of a mirror propelled mechanically by clockwork. Further patent

applications were made in France and England, and van Monckhoven set up as a manufacturer of heliostat enlargers under the name "appareil solar dialytique" [dialytic solar apparatus]. He received a bronze medal at the Paris international exhibition of 1867 for his innovation, and published the fruit of his research as Traité d'optique photographique, Paris: V. Masson et fils, 1866. The Traité général quickly ran to fourth and fifth editions also under the Masson imprint in 1863 and 1865 respectively.

Van Monckhoven moved to Vienna in January 1867 to form a partnership with the portrait photographer Emil Rabending, constructing a state-of-the-art studio in the Wieden district, at Favoritenstrasse 3 "in the courtyard of the imperial iron foundry." About two years later van Monckhoven dissolved the partnership to pursue scientific interests in his own laboratory. Returning to Ghent in the autumn of 1870, van Monckhoven established a factory for the production of carbon paper, and published two works on the subject: Historique du procédé au charbon [History of the carbon process], Ghent: Annoot-Braeckman, 1875 and Traité pratique de photographie au charbon [Practical treatise on carbon photography], Paris: G. Masson, 1876. He also published a sixth edition of the Traité général, Paris: V. Masson, 1873.

The introduction of dry-plate photography stimulated van Monckhoven to make his most significant contribution to photo-chemistry. Realising that Richard Leach Maddox's invention was poised to revolutionise photography thanks to its ease of handling, he had the factory diversify into emulsion production. Pursuing his research into the properties of silver halides in 1879, van Monckhoven discovered that the ripening of emulsion on gelatine-bromide plates could be improved by adding ammonia, thereby enhancing the tonal range. He wrote Introduction sur le procédé au gélatino-bromure d'argent [Introduction to the silver gelatine bromide process], Ghent: C. Annoot-Braeckman, which went into four editions between 1879 and 1882. A seventh edition of the Traité général, Paris: G. Masson, 1880, contained a chapter on dry-plate photography summarising the author's findings. The factory was expanded in 1880, employing thirty female workers for coating plates, and reached an annual turnover of one million gold francs that year.

Désiré van Monckhoven married Hortense Tackels (1839–1911) on 12 December 1872, and they had two daughters. In his spare time, he devoted himself to astronomy, and constructed a private observatory. A telescope, equipped with a 23 cm Steinheil lens, was custom-built in 1880, and van Monckhoven began work on a star atlas. This work went unrealised, as Van Monckhoven died suddenly of a heart attack on the evening of his forty-eighth birthday, at his home in Ghent on 25 September 1882.

Hortense Tackels headed the firm after her husband's death, and was followed by her son-in-law, the engineer and future senator Jean-Alfred de Lanier-van Monckhoven (born 1852). The firm successfully marketed dry plates under the D.V.M. label from around 1886, operating out of Boulevard d'Akkergem 74 until 1908. Two posthumous editions of the Traité général appeared under the imprint Paris: G. Masson, 1884 and 1889.

The Museum voor de Geschiedenis van de Wetenschappen [Museum of the History of Science], Ghent, houses a dialytic solar apparatus, some van Monckhoven manuscripts and a virtually complete set of his publications. The University of Ghent acquired the 23 cm telescope in 1904, which is still operational in the observatory. The Nadar papers in the western manuscripts section at the Bibliothèque nationale de France—Département des manuscrits contain a substantial and lively correspondence by van Monckhoven.

STEVEN F. JOSEPH

Biography

Désiré Carolus Emanuel van Monckhoven was born in Ghent on 25 September 1834, the illegitimate son of Francisca Maria van Monckhoven. The birth certificate declares "father unknown." Early clerical training was followed by studies at the University of Ghent, where he gained a doctorate in 1862. A renowned photo-chemist, van Monckhoven published his initial research on collodium in 1855, and wrote numerous works on photography and optics. Also a pioneer of the photographic industry in Belgium, his factory, founded in 1870, produced carbon tissue, and later emulsion for dry-plate photography. He married Hortense Tackels (1839–1911) on 12 December 1872, and they had two daughters. Van Monckhoven died suddenly of a heart attack on his forty-eighth birthday, at his home in Ghent on 25 September 1882. His widow continued to run the factory successfully, which operated in Ghent, Boulevard d'Akkergem 74, until 1908.

Further Reading

D. Van Monckhoven 1834–1882, Antwerp: Provinciaal Museum voor Fotografie, 1982 (colloquium held to commemorate the centenary of van Monckhoven's death, with texts by Steven Joseph, Laurent Roosens, and Paul Faelens).

Joseph, Steven F. and Tristan Schwilden, "Désiré Van Monckhoven (1834–1882). Son rôle dans le développement de la photographie" [Désiré Van Monckhoven (1834–1882). His role in the development of photography], Technologia, 5 (1982): 31-41 and 7 (1984): 29–32.

Joseph, Steven F., Tristan Schwilden and Marie-Christine Claes, Directory of Photographers in Belgium 1839–1905, Antwerp and Rotterdam: Uitgeverij C. de Vries-Brouwers, 1997.

Nadar, Quand j'étais photographe [When I was a Photographer], Paris: E. Flammarion, 1900 (reprint Paris: l'école des lettres/Seuil, 1994).

Roosens, Laurent, "Dr Désiré Van Monckhoven als Autor von fotografischen Lehrbüchern" [Dr Désiré Van Monckhoven as author of photographic textbooks], *Fotogeschichte*, 8 (1983): 3–12 and 10 (1983): 72.

Vercheval, Georges (ed.), *Pour une histoire de la photographie en Belgique* [Contributions to a History of Photography in Belgium], Charleroi: Musée de la Photographie, 1993.

Von Rohr, Moritz, "Contributions to the history of the photographic objective in England and America between 1800 and 1875," *The Photographic Journal*, 64 (1924): 349–359 (section 5 "D. Van Monckhoven (1865–1867), as mediator between A. Steinheil and English opticians").

VANCE, ROBERT H (1825–1876)

In 1849, gold was discovered in the workings of Sutter's Mill at Coloma, California, just ten years after the announcements of the inventions of photography in Europe. News of Daguerre's process travelled to America ahead of William Henry Fox Talbot's paper-based method; consequently, east coast practitioners soon began to specialise in daguerreotypes.

Robert H. Vance, who was born in Maine and inherited money from his father, learned about photography as a young man while working in portrait studios in New Hampshire and Boston. By February 1847, he had his own gallery in Valparaiso, Chile, and later opened a similar venture in Santiago. Much of Vance's commissioned work came from owners of the wealthy, silver mines of Atacama Province, but circumstantial evidence suggests he also documented landscapes for his own satisfaction, then a rare practice among professionals.

By 1850, Vance was 25 years old and the California gold rush was underway. He sold his South American studios and moved to San Francisco to take advantage of the commercial opportunities (of the gold rush). En route to America, he stopped at Cuzco in the Peruvian Andes, and one biographer (Abel Alexander of Buenos Aires) believes this body of work represented Vance's best photography whilst in South America.

Within twelve months of his arrival in northern California, Vance had opened portrait studios in Sacramento, Marysville and San José, and eventually expanded his interests to Nevada (Virginia City and Carson City), and Hong Kong. Declaring Vance's Sacramento location as the "finest Daguerreotype and Photograph Gallery in the world," the San Francisco Daily Times described the "magnificent chandeliers, lace curtains, orlet [bordered] carpets, and the richest style of furniture." There were "eight elegantly finished reception rooms, and twelve operating rooms [and] ladies sitting and toilet rooms, where family parties may go, with a perfect assurance of privacy, and the premises are so arranged that there are at least three distinct galleries, each separate from the other."

Vance was an expert practitioner of the daguerreotype process, but he advertised cartes-de-visite at his First Premium Gallery in San Francisco, very soon after they became popular in Europe. He also offered colour portraits, which used the photograph as a guide for an artist working via a solar camera, and marketed Ambrotypes by emphasising superiority over his rivals, because those "taken by me are upon thick glass, and are atmospherically sealed, and will stand forever." But Vance lost money by dabbling in the stock market, and sold his gallery in 1864. The following year, he returned to New York, where he lived for eleven years until a sudden death at the age of 51. He was buried in Augusta, Maine.

In an appreciation in 1946, Ansel Adams noted that "the photographers of earlier days were definitely unaware of being 'artists.' They worked as craftsmen, … and their comment was not concerned by conflicting influences of manner and style." Adams believed that Vance was not only a superb craftsman, but that he had other qualities—"careful thought and selection of viewpoint." That is, he combined technical ability with creativity.

Robert Vance excelled as an artist, but he must also be remembered for the twelve-month undertaking he began in 1850. Once settled in San Francisco, his entrepreneurial spirit reasoned that, beyond California, people were eager to learn about the gold rush and that he was well placed to provide a visual narrative of its people and the places. Leaving his studios to be run by managers, Vance secured over three hundred images of life in California, which were dominated by themes of the gold fields. He framed his work, arranged the layout, published a catalogue and, in 1851, opened the exhibition on Broadway, New York.

In the 8-page "Catalogue of daguerreotype panoramic views of California," Vance featured portraits of gold miners and native Americans, photographs showing aspects of gold prospecting, the gold mining camps and pictorial landscapes. The important segments illustrated the popular locations—the Stanislaus River, the Mokelumne Mines near Sonora, Sacramento, Nevada City, Yuba City and Coloma in El Dorado County. He included San Francisco—before the fire of May 1851, and afterwards. He also showed emerging styles of architecture and "almost every variety of scenery," said the editor of *Photographic Art Journal*, in a review which described the "three hundred daguerreotypes so arranged that a circuit of several miles of scenery can be seen at a glance." Vance had displayed "an exquisite taste for the sublime and beautiful."

From the outset of his career, Vance had favoured a large, whole-plate camera, although studios portraits were generally taken on a smaller format. (A portrait of Horatio G Finch in the Bancroft Library was taken on a "mammoth" plate measuring 32cm × 27cm.) That Vance was able to visit the mining camps of the gold fields and return with processed whole-plate images of excellent quality, speaks well for his mastery of the process.

In spite of Vance's abilities, and good reviews, the New York exhibition failed. There were three possible reasons:

The public had lost interest in West coast news
Vance set the admission price too high
Vance neglected to promote the exhibition adequately

In February 1853, Vance attempted to sell his collection, but it took five months before being auctioned to an entrepreneur from St Louis, Missouri, who exhibited them with his own work in the spring 1854. A review appeared in the *Photographic and Fine Art Journal* two years later, but by then, all three hundred images had disappeared.

Scholars argue that they may have been destroyed by fire, or sold for their metal content, and optimists maintain Vance's Views of California may yet re-emerge to receive renewed recognition. In 1946, Ansel Adams had already acknowledged the master's touch when he praised "the clarity of line and edge, the simple arrangement of mass, the beauty and richness of tonal values [and] above all, the integrity and forthright simplicity of Vance's photography and the evidence of his devotion to the enduring qualities of the world about him."

Vance's work is located at:

The Bancroft Library's California Heritage Collection
The Getty Museum
California State Library, Sacramento
Oakland Museum of California

RON CALLENDER

See also: Talbot, William Henry Fox; Daguerre, Louis-Jacques-Mandé; Cartes-de-Visit; and *Photographic Art Journal* (later *Photographic and Fine Art Journal*).

Further Reading

Hively, Wm. (ed.), *Nine classic California Photographers*, California: The Friends of the Bancroft Library, 1980.
Johnson, D.H. and M. Eymann (ed.), *Silver & Gold: Cased images of the California gold rush*, Oakland: University of Iowa Press, 1998.
Palmquist, P.E. and T.R. Kailborn, *Pioneer Photographers of the Far West: A biographical dictionary, 1840–1856*, Stanford: Stanford University Press 2000.

VARIN FRÈRES
Pierre-Amédée (1818–1883), Pierre-Adolphe (1821–1897), and Eugène-Napoléon (1831–1911)
French photographers and printmakers

Descendents of an old dynasty of tinsmiths and printmakers established in Châlons-sur-Marne, near Reims, Amédée, Adolphe, and Eugène Varin studied printmaking in Paris. They became very successful in the 1850's and created many reproductive prints after paintings from the Salon, mostly for the publisher Goupil. Amédée and Eugène worked collaboratively and often co-signed the prints. In the same vein, their photographs are difficult to attribute to one or the other brother.

Little is known about the Varin brothers' photographic activity, which began around 1845–46 (a few portrait daguerreotypes from this time have survived). During the 1850's, they produced salt paper prints: landscapes, family portraits and intimate scenes, and architectural views and cityscapes taken during travels in the provinces, especially in La Rochelle. Aesthetically, their photographs rely on a solid artistic education and are reminiscent of amateurs photography of this era. The Varin brothers were not involved in the photographic world, and their photographic practice appears disconnected from their careers as professional printmakers. They rarely used photography as an aid for printmaking, nor envisioned it as a publishing technique. However, Quentin-Dailly, a publisher in Reims, released a portfolio of their views of the city.

PIERRE-LIN RENIÉ

VEDANI, CAMILLO
(active 1853–1870)
Italian-born studio owner and teacher

An Italian photographer active in Brazil between 1853 and 1870, Camillo Vedani had two studios in Rio de Janeiro, first on Assembléia St. and later on Ouvidor St. He also taught drawing and Italian to make ends meet. He spent five years in Salvador, Bahia (1860–1865). The photographs he took there overlap with and complement views taken by Benjamin Robert Mulock (1859–1862). Vedani also photographed the Bahia and San Francisco Railway terminus after it was completed. He produced stunning images of the city of Salvador, characterized by a bold style and an esthetic that was ahead of its time. He returned to Rio in 1865 and put together two albums of views of Salvador and Rio dating from 1860 to 1870. A label on one album reads: "Landscape photographer…. Will travel anywhere to photograph views and establishments." Brazilian collector Gilberto Ferrez, the grandson of Marc Ferrez, discovered the albums in the 20th century, which are now at the Moreira Salles Institute, Rio de Janeiro. Vedani also produced an album of photographs of Rio taken between 1865 and 1875. Both Gilberto Ferrez and photographer Pedro Vasquez have published his photographs. His works have been exhibited in Rio and São Paulo.

SABRINA GLEDHILL

VERESS, FERENC (1832–1916)
Hungarian photographer

Ferenc Veress, the son of a civil servant reputedly of noble descent, was born in Kolozsvár, Transylvania, on 1 September 1832. At the age of 16, in 1848–49, he was a goldsmith's apprentice in Nagyenyed to Károly Budai, one of the first amateur daguerreotypists in Transylvania.

He reckoned his photographic career all started with the gift of a camera from his mother in 1850, when he mostly took talbotypes. From this point his career could have turned in two directions. He could have either taken photographs, made experiments similarly to the well-to-do amateurs of the age or could have chosen photography as a profession and taken commercial photographs in his studio. He took both ways and opened the first permanent studio of Transylvania in Klausenburg and never gave up experimenting. The money he earned from his studio portraits he spent on photographic experiments and his land- and cityscapes.

It was on April 21, 1852, that he contacted Elek Buda, the local squire who had tried out and modified all the photographic techniques of the age. Under him, Veress mastered the daguerreotype, and a year later, opened a studio in Kolozsvár, the first permanent studio in Transylvania. He used the wet collodion technique to make albumen prints of glass negatives. In the same year, he experimented jointly with count Zsigmond Kornis. The activity of this promising duo came to a halt in 1854, when the count died. Baron Károly Apor, who presided over the Marosvásárhely royal Court of Appeal, introduced him to Count Imre Mikó, a Transylvanian patriot. The three continued photographic experiments. Mikó helped him photograph the Transylvanian aristocracy and he compiled an album of the photographs he took, no original copy of which has survived.

In 1855, the aristocratic patrons made it possible for him to go on a tour of study to Munich and Paris where he visited several famous photo studios. As a result, his technical knowledge was well above the country's average, he could produce life-size portraits which were then coloured in watercolours or oils by his temporary partner György Vastagh. He made ferrotypes, pannotypes, but he could also create photos on leather and canvas. His cyanotypes have survived. In 1858, he married Josefa Stein, the daughter of a Kolozsvár publisher, who also owned the local press, book and stationery shop. The Veresses had seven children, five of whom survived to adulthood.

At the end of 1859, he was the first person in Hungary to use Disderi's 1858 Paris invention, the *cartes-de-visite*.

His first landscapes date back to 1859. He used the dry collodion process, which deviated form the generally-used wet process in that a cover protected the humidity of the collodion layer for a few weeks, keeping it ready for use at any time. Count Imre Mikó initiated and assisted in the establishment of the Transylvanian Museum Circle in the same year, with Veress as official photographer. He compiled several albums and series, such as the album "Kolozsvár in Pictures," in two volumes, now housed in the Sion Collection of Kolozsvár University Library. He took his stereo photographs, featuring fifty views of the city, at the same time. The technique he was the first to apply in Hungary, simplified the tedious tasks of landscape photography associated with the wet process.

In 1861, Veress built a new studio-cum-home in Kolozsvár, which was extended seven years later. He was to work there for 28 years without interruption.

In 1862, he photographed, and sold cartes-de-visite of the members of the Kolozsvár National Theatre. He published his call to all the country's photographers, who, at that time, numbered roughly 250, in the paper "Ország Tükre":

> Our photographers could do a great service to our homeland by photographing, and collecting pictures of, lesser and more important men in the sciences, arts, industry and trade, and submit their resulting albums to museums… Our photographers could also do a great service to our history by taking photographs of all our relics, fortresses, old castles and country seats, ruinous churches and caves, which, though still in existence at present, are doomed to perish within a brief decade.
>
> (Veress, "A fényképezés múltja, jelene, jövője hazánkban" [The Past, Present and Future of Photography on Our Country], Ország Tükre [Mirror of Our Country], 9, 1862, 132–133)

In 1869, he sent Queen Elisabeth an ornate album with pictures with the remark: "If only all historic sights of Hungary could be photographed and… stored in Her Majesty's special library, we should be doing future generations a great service."

In 1872, Veress took a hundred and fifty-six 25 × 30 cm glass negatives of Central Transylvania, and he exhibited 144 of them at the Vienna World Fair one year later.

Some of the above albums must have been realized. One of them belongs to the Vienna Höhere Graphische Lehr- und Versuchsanstalt. Seventy-eight of his landscapes and about the same number of pictures of Kolozsvár have survived in family archives, museums and in the collection of the Hungarian Museum of Photography.

His 1876 exhibition at the National Industry and Farm Produce Fair was the first to show the technique of porcelain decorated with photographs and, in 1879, he exhibited more than three hundred such pictures in Székesfehérvár and Deés.

In 1880, he published a work of fiction entitled "Álomképek" [Pictures in My Dreams], under the

pseudonym Ferenc Turul. He established also a model-farm, where he improved more than 800 different kinds of apple.

In 1881–1882 he taught photography as an associate of Franz Josef University, Kolozsvár.

He launched the journal *Fényképészeti Lapok* [Photographic Papers] on January 1, 1882, as its owner, editor, publisher and most industrious reviewer. This, the first professional photographic journal in Hungary was published regularly until December 1888, and extended 84 issues.

He is known above all for his experiments of heliochromy, the very first direct colour process. Five years of experiments to take colour photographs accelerated in 1884 when he first managed to fix a heliochrome image, which claimed due success at the Paris World Fair in 1892. He was the only Hungarian photographer of the time to acquire worldwide recognition. In 1891, he carried out his 2663rd colour experiment.

In 1890, he closed his studio, leased it to the photographer József Kató, and devoted the rest of his life to colour photography, slowly sinking into poverty. (The year 1811 saw his 6,056th experiment with heliochromy.)

His death on 3 April, 1916, came only months before Romania's declaration of war on the Austro-Hungarian Monarchy and the Romanian invasion of Transylvania.

KÁROLY KINCSES

Biography

Ferenc Veress was born on 1 September 1832 in Kolozsvár [Klausenburg, Cluj], Transylvania. He learnt to be a goldsmith, just like many of the early daugerrotype-photographers and obtained his first camera in 1850. In 1853 he opened a studio in Kolozsvár, the first permanent photographic atelier in Transylvania. In 1855, his aristocratic patrons made it possible for him to go on a tour of study to Munich and Paris where he visited several famous photo studios. As a result, his technical knowledge was well above the country's average. There is not a single process in photography that he left unnoticed, he tried out, corrected and improved them. (He made ferrotypes, pannotypes, but he could also create photos on leather and canvas. His cyanotypes have survived.) At the end of 1859, he was the first person in Hungary to use Disderi's 1858 Paris invention, the cartes-de-visite. According to his calculations he took the studio-photo of nearly 40.000 people. In the meantime he took fascinating land- and cityscapes. His first landscapes date back to 1859. He invented and applied a Taupenot-type semi-dry plate. He compiled several albums and series, some of them have survived in several museum's collections. He brought making photographs on porcelain

to perfection. His 1876 exhibition at the National Industry and Farm Produce Fair was the first to show the technique of porcelain decorated with photographs. He is known above all for his experiments of heliochromy, the very first direct colour process. Five years of experiments to take colour photographs accelerated in 1884 when he first managed to fix a heliochrome image, which claimed due success at the Paris World Fair. He was the only Hungarian photographer of the time to acquire worldwide recognition. He published the first regular Hungarian photographic journal: *Fényképészeti Lapok* [Photographic Papers] between 1882 and 1888. He taught photography at the University of Kolozsvár between 1881-82. In 1890, he closed his studio, leased it to the photographer József Kató, and devoted the rest of his life to colour photography, slowly sinking into poverty. He died on 3 April, 1916.

Further Reading

Kincses, Károly, *Levétetett Veressnél Kolozsvárt*, Budapest: Magyar Fotográfiai Múzeum, VIPress, 1993.

Kincses, Károly, A Photographer Without Limits, in Photography and Research in Austria—Vienna, the Door to the European East, The proceedings of the Vienna Symposium, Passau: Dietmar Klinger Verlag, 2002, 21–27.

Kincses, Károly, "Régi erdélyi emberek, tájak Veress Ferenc fényképein," in *A fénykép varázsa*, Budapest: Magyar Fotómüvészek Szövetsége, 1989, 53–74.

Miklósi Sikes, Csaba, Veress Ferenc, *Fotómüvészet,* 1985, 2, 19–24.

VERNACULAR PHOTOGRAPHY

The term "vernacular" literally means the ordinary and ubiquitous but it also refers to qualities specific to particular regions or cultures. Its attachment to the word "photography" is a recent development, part of an effort to devise a way of representing photography's history that can incorporate all of its many manifestations and functions. Although all photographs are potentially vernacular in nature, the phrase "vernacular photography" is generally used to encompass all those photographic practices and genres that fall outside the standard art history of the medium. This might include, for example, all sorts of typical commercial portraits or views, but also amateur practices where photographs were combined with other media and turned into hybrid objects. It would also include distinctive regional photographic practices, including those found in such places as Africa, Asia or Latin America. From this perspective, vernacular photography encompasses the vast majority of the world's photographs.

A few selected examples give some idea of vernacular photography's variety of forms and meanings. Although not given much attention by historians today, photographic jewellery was a staple product of the pro-

fessional portrait photographer of the mid-nineteenth century. The practice of carrying a small painted portrait of a loved one predates photography itself by quite a few years. It was logical that, following the invention of photography in 1839, calotypes, daguerreotypes, ambrotypes, tintypes and albumen prints would also find their way into the pins, rings, pendants, brooches and bracelets that were then so fashionable. By this means, photography allowed the middle classes to adopt a cheaper version (twenty times cheaper in most cases) of the visual habits of their betters. Photographic jewellery seems to have fulfilled a range of different functions (and, of course, the same piece of jewellery could signify affection at one moment and mourning at another, depending on the fate of its subject). A single necklace pendant might have portraits of husband and wife on either of its sides, lying back to back, never to be parted. For the object to be experienced in full, it has to be turned from side to side, a form of perpetual caress preordained by its designer. Other examples include photographic lockets containing two facing but separate portraits, such that the man and woman inside initially lie hidden, kissing each other in the dark until liberated into the light of a loved one's gaze. Pieces of human hair, sometimes elaborately woven into patterns, were frequently added to this jewellery, turning them into modern fetish objects.

A similar gesture can be witnessed in an embellished daguerreotype from the collection of Matthew Isenburg in Connecticut, USA. In this object we find a combination of daguerreotype and dress fabric inside a daguerreotype case, put together in about 1850. When we open this case we are invited to literally touch a piece of the cloth that, we can see from the photograph, once also touched the skin of this long-departed girl. We touch what she touched, turning this square of fabric into a membrane conjoining past and present, the living and the dead. By this creative contrivance, absence and historical distance are temporarily bridged by a moment of shared bodily sensation, making the remembrance of this girl into an experience at once optical and haptic.

Vernacular photographic practices frequently involve the elaboration of the photograph through the addition of other materials and iconography. It was common in the nineteenth century, for example, to surround a photograph with a wreath as a sign of both mourning and faith in the eventual resurrection of the photograph's subject. One example comes in a large timber frame, with an albumen photograph of a young woman in its center. Under this rather formulaic studio portrait are the words "At Rest," impressed into a sheet of copper and pinned to the board behind. At each of its two top edges are rosettes, woven out of human hair (probably hers). Around all of this rests an extravagant wreath of flowers made from wax, with similarly waxen butterflies flitting

decoratively amongst the petals. It was probably made in about 1890 by a group of women friends in memory of the departed. In another, similar example, a small tintype of a little girl sitting on what we take to be her father's knee has, after her death, been surrounded, first by some fancy metal edging and then by a lovingly embroidered garland woven into a background of black velvet. The labor of embroidery ensures that this act of mourning is a slow one, deliberated and extended through time. The same gesture was extended to a framed albumen portrait of General José Antonio Páez, a man centrally involved in securing the independence of both Colombia and Venezuela. In about 1873, after his death in New York, an official portrait of him in his uniform was surrounded by a wreath made out of one of his own shirts. Through this skillful act of remembrance, history is made personal, and an otherwise formulaic portrait is transformed into the equivalent of a sacred relic.

Framed and painted tintypes might also be described as vernacular. The research of American collector Stanley Burns has shown that these types of photograph were produced in large numbers from the 1860s through the 1890s in rural areas of the United States (indeed, this is a practice indigenous to that country), employing framemakers, photographers and 'folk art' painters whose portrait businesses had been driven into extinction by the cheaper and quicker tintype technology. The portraits that resulted have all the animation of a statue or wax effigy. This stiffness is not improved by the subsequent addition of paint, this being limited in colour range and usually covering whatever idiosyncratic detail may once have been present in the photograph. One consequence is that these portraits exhibit a certain sameness of expression, monotonous to a contemporary viewer but perhaps comforting to a clientele seeking familiarity of genre rather than artistic innovation. This clientele looks out at us from their standard gray backgrounds with the fixed stare of the blind, their facial and bodily comportment insisting above all on a dignified formality of presentation. Such formality is fitting for a procedure that may have only occurred once in a person's lifetime. In many of them the photographic base has been almost entirely covered by paint or, in the case of some of the backgrounds, erased through the application of a solvent. The resulting image was then often elaborately framed and matted, giving the final object both pattern and depth. This framing also allowed each example of an otherwise generic image-making process to take on a unique and distinctive appearance.

Painted photographs were also produced in India from the 1860s until the early twentieth century. Albumen and silver gelatin portraits were often covered in lavish and meticulous patterning and materials (including calligraphy and gold leaf) that transformed the perspectival space of the camera-picture into a flat, vertical surface.

Not much is known about the function of painted photographs in India, whether they were meant for the leaves of an album or a frame on a wall, for public or private space, although this form of portrait would seem to be an affectation adopted by the Indian ruling classes (similar pictures of Europeans living in India are unknown). If nothing else, their striking combination of local Indian painting traditions and a European image-form such as photography speaks to the tension generated when one culture seeks to accommodate the visual conventions, and political demands, of another.

We might look from India to Australia and find that paint was used to transform photographs there too. An albumen photograph was made to celebrate B.O. Holtermann's discovery of a gigantic gold nugget in 1873 after nine years of searching (he has helpfully added some relevant statistical information), a discovery which allowed him to go on to become one of Australia's most enthusiastic patrons of photography. What's strange about the addition of paint in this instance is that it turns what appears to have been a faithful record of Holtermann into an obviously fictitious scene, transporting him from the confines of a studio into a sweeping rural landscape. This landscape serves two functions: it claims to be the setting for Holtermann's discovery while also offering itself up as a prize that he can now acquire. Paint, it seems, helps overcome photography's obstinate realism, allowing fantasy full sway.

Memory and realism are uncomfortable bedfellows. Consider, for example, a cabinet card image of two sailors who worked on the Columbia River in Oregon in the 1880s, now held in the Stephen White Collection in Los Angeles. These sailors have obediently adopted the self-conscious poses one tends to adopt in a photographer's studio, each in uniform and with a hand in his left pocket, each gazing off over our right shoulder, as if looking out to sea, perpetually on watch for potential dangers. Anyone looking at this photograph in the 1880s would have known what we know—that these men are posing for a camera, pretending to be somewhere they aren't, sitting on an artificial rock in front of a painted backdrop. In this photograph, photography's realism is presented as an overt artifice.

What's interesting about this example, though, is that someone decided to play with this real artifice by adding a further bit of artifice of their own. For we can see that this someone has carefully painted in a piece of rope that starts from behind this photograph and then seemingly loops in and out of the right hand edge of the print, apparently puncturing it, before winding itself around a group of suitably nautical objects—a capstan, anchor and compass. This painted addition has a number of effects on the way we might read this picture. It merges the symbolic pictorial artifice of painting with the indexical reality of photography to produce a com-

posite image that repeats and enhances the occupational themes expressed by both components. At the same time it draws attention to the reality of the actual photograph, to the physicality of the print before us, pretending to penetrate that print but also to hide behind it. So there's all sorts of play going on here with this photograph—it's being asked to act as a window onto another world set in the past, and simultaneously to declare itself to be a touchable and opaque object that has an edge and a thickness right here in the present, an object that is glued on to this board but also somehow stands away from it (such that the rope could be both behind and in front of it). This otherwise flat pictorial scene is anchored at its edges by a rectangle of ordinary thumb tacks that jut out from the cardboard mat, casting shadows back onto it and thereby giving this object a real, as opposed to an illusory, depth. If nothing else, the making of this object points to a critical, or at least skeptical, attitude to the photograph. It also provides evidence of a willingness to intervene to make this photograph a more compelling memorial experience. Indeed, it implies that, for the owner of this object, the photograph by itself was not able to provide a powerful enough memory trigger without this added enhancement.

Photograph albums could also be described as vernacular. Many albums are relatively banal depositories of carte-de-visite family portraits and pictures of celebrities. Some, however, show evidence of a strong degree of creativity on the part of their compilers. The album pages produced by English upper-class women in the mid-1860s, for example, rely on a remarkable degree of visual invention. They often combine an artful collage of shaped albumen prints with ink and watercolour drawings, sometimes arranged in rigidly symmetrical patterns and sometimes in a seemingly careless profusion of forms which recall contemporaneous trompe-l'oeil paintings or even the visionary fantasies of Lewis Carroll. The mechanical exactitude of the photographic portrait is transformed and elaborated into a personal tribute to these women's friends and family, and the desires and dreams associated with them. As with all collage practices, attention is drawn to the edges of each page's constituent images, disrupting the seamlessness of photography's representational claims to fidelity and realism as well as its role as an inscription of the past—these photographs are harshly located in the here and now of the page itself.

In the case of the Cator album, produced by an unknown member of that family, we find approximately 156 albumen prints have been mounted on its forty-six pages. These pages are often further decorated with ink illustrations and watercolour paintings. The album's cover is made from deeply carved wood, based on a geometric design of oak leaves and nuts. This cover speaks of the album's importance, as well as of its own

Englishness; it also creates a very theatrical entry to the pages that lie inside. The decoration on those pages often repeats their cover's overt appeal to nature, displaying detailed depictions of entwined blackberries, strawberries and even exotic lychie fruit encircling their photographs. Apart from these signs of an eternally fertile spring, the album maker is keen to emphasise family genealogies (adding names as ink captions to many of the portraits we find within). One page shows a collage of Cator family members facing us in front of a huge painted glass window, suitably framed by red curtains. Through the window we get to see an idyllic seascape occupied by two sailing boats. Another page shows a similar gathering in front of another huge piece of interior architecture, a fireplace. This scene of domestic bliss features an equally huge elliptical photographic portrait of a young child hanging over the mantlepiece in an ink frame while a more suitably-scaled dog curls up in front of the hearth. Some scenes are drawn from a more whimsical imagination. In one, the album maker has a man and a woman, each cut from a separate photograph, occupying a row-boat headed out to sea. But perhaps the most unusual image centers on a large jester figure dressed in a striped red, yellow and blue costume. With a sardonic expression on his face, the jester tosses eleven thumbnail-sized albumen portraits from his gathered apron, scattering them over the surrounding landscape like so much seed.

Vernacular photographic practices often took place in the home. In the years around the advent of the twentieth century, for example, it was not uncommon for women to turn their family snapshots into cyanotypes printed on cloth and then to sew them into pillow slips or quilts. One such pillow slip in the collection of Eastman House in Rochester, New York, consists of thirty of these blue images machine-sewn together, all but one showing typical outdoor scenes of the kinds everyone has taken on family holidays. Some feature male and female portraits, while others depict landscapes; one shows the interior of a house with its own complement of photographs sitting on top of a bookcase. Each image no doubt prompted a happy memory for the members of this family. But the pillow as a whole was also a reminder within the home of the outside world that it refers to, a constant reference to a picturesque elsewhere. The production of these kinds of photographic domestic keepsakes was encouraged by women's magazines of this period, and was influenced more broadly by an Arts and Crafts movement concerned to preserve hand-craft traditions in the face of expanding industrialisation. So the apparent ordinariness of this object belies the deeper social and cultural complexities embodied in its making. The physicality of this pillow's fabric, signalled in the unpredictable play of its straight seams and crumpled edges, is also a significant aspect of its capacity to induce a memory experience, giving these photographs substance and texture, making them touchable and warm, and allowing past and present to permanently cohabit as part of everyday domestic life.

These few examples are but the tip of an iceberg of vernacular photographic practices not often considered or even acknowledged in standard histories of photography. Although the emphasis here has been on practices that elaborate or add to the photograph, we could have as easily chosen to look at groups of unadulterated images drawn from advertising, ethnography, religion, pornography, science, leisure, journalism, criminology, tourism, business, government, or a host of other fields. What vernacular practices all have in common is that their photographs are typical and generic, rather than exceptional or innovative. They represent the visual culture of everyday life, sometimes poignant and creative but more often banal and utilitarian. Whether made by identifiable professional photographers or unknown amateurs, these are mostly conformist kinds of photographs, reproducing established social and aesthetic conventions in an effort to fulfill certain specific functions. These functions, ranging from the sentimental to the commercial, have little connection to the interests of high art. Nor do vernacular photographs lend themselves to the usual art historical systems of evaluation, based as these are on originality and rarity, masterpieces and great masters. As a consequence, if vernacular practices are to be included in photography's history, a whole, new way of doing that history will have to be devised.

GEOFFREY BATCHEN

See also: Calotype and Talbotype; Daguerreotype; Mounting, Matting, Passe-Partout, Framing, Presentation; Wet Collodion Positive Processes; and Albumen Print.

Further Reading

Geoffrey Batchen, 'What is Vernacular Photography?: a collective discussion' (including Daile Kaplan, Douglas Nickel, Elizabeth Hutchinson, Bill Hunt, Elizabeth Edwards, André Gunthert), *History of Photography*, 24: 3 (Autumn 2000), 229–231.

Geoffrey Batchen, 'Vernacular Photographies,' *Each Wild Idea: Writing, Photography, History,* Cambridge, MA: The MIT Press, 2001, 56–80, 199–204.

Geoffrey Batchen, *Forget Me Not: Photography and Remembrance* (exhibition catalogue, Amsterdam: Van Gogh Museum & Princeton Architectural Press, 2004).

Michel Braive, *The Photograph: A Social History,* New York: McGraw Hill, 1966.

Stanley Burns, *Forgotten Marriage: The Painted Tintype and the Decorative Frame 1860–1910: A Lost Chapter in American Portraiture*, New York: The Burns Press, 1995.

Heinz K. Henisch and Bridget A. Henisch, *The Photographic Experience 1839–1914: Images and Attitudes*, University Park: The Pennsylvania State University Press, 1994.

Daile Kaplan, *Pop Photographica: Photography's Objects in*

Everyday Life 1842–1969 (exhibition catalogue), Toronto: Art Gallery of Ontario, 2003.

Christopher Pinney, *Camera Indica: The Social Life of Indian Photographs,* Chicago: University of Chicago Press, 1997.

Glenn Willumson, 'The Getty Research Institute: Materials for a New Photo-History,' *History of Photography,* 22: 1 (Spring 1998), 31–39.

VICTORIA, QUEEN AND ALBERT, PRINCE CONSORT

Victoria and Albert played an important role in the development of photography, most especially through being influential patrons during the 1850s. Upon the death of the Prince Consort in December 1861, Hugh Welch Diamond summed up their contribution to establishing the respectability of photography:

> As a manipulator in photography the Prince Consort was unsurpassed: in his practice of the art he was greatly assisted by his former librarian Dr Becker. . .Her Majesty is also a very good photographer. Certainly the art has no reason to complain of want of patronage and support from the Court; so extensive is the collection of negatives which have been taken by and for the Royal family, that it is necessary to have a private printer to keep them and print them when copies are wanted ("The Late Prince Consort and Photography," *Photographic News* 24 January 1862: 39).

Victoria and Albert's support existed firmly within the tradition of royal patronage of the arts. At the same time, though, as early practitioners, they epitomise the upper-class amateurs to whom photography was an affordable pastime. Royal support thereby stemmed from both a personal interest in the medium and a belief in its artistic and technological value.

The first ever photographs of the British monarchy were two daguerreotypes of Prince Albert that were taken by William Constable at Brighton on 7 March 1842. Later in the same month, Albert visited Richard Beard's daguerreotype studio in Parliament St., London. Other photographs taken during the 1840s included a series of daguerreotypes of the royal family by William Kilburn. Kilburn's success led to him being appointed "Photographer to Her Majesty and His Royal Highness Prince Albert." Many photographers subsequently went on to hold official warrants from the Court, including George Washington Wilson (1873) and André Disderi (1867), W. & D. Downey (1879), and Alexander Bassano (1890). Titles like "Photographer-in-Ordinary to Her Majesty" were attenuated versions of the appointments traditionally held by court painters: they demonstrate that traditional models of patronage continued to exist alongside the burgeoning mass market for royal photographs.

It was not until the early 1850s that Victoria and Albert became significantly engaged with photography. Prince Albert's interest in the union of art and manufacture fed naturally into his enthusiasm for the medium. Victoria's interest was more commemorative, founded around the camera's ability to record family occasions and events. Many early royal photographs were taken by Dr Becker, Prince Albert's librarian and a founding member of Royal Royal Photographic Society of London. Becker taught Victoria and Albert the calotype process and, although none of their photographs have survived, substantial amounts of photographic apparatus were supplied to Windsor Castle. A darkroom was built at Windsor in 1854 and, in 1857, the regular royal photographer, William Bambridge, was paid £643 3s 6d for his services.

The royal couple's association with Becker and Sir Charles Eastlake led to them becoming patrons of the Royal Photographic Society soon after its inception in 1853. They regularly visited its annual exhibition, purchasing pictures as well as aiding the society through their high profile presence. Notable photographs acquired for the Royal Collection include several copies of Oscar Rejlander's Two Ways of Life, and Henry Peach Robinson had a standing order from Prince Albert for a copy of every pictorial photograph he produced. In 1855, Albert also contributed £50 towards a study by the Royal Photographic Society into how to prevent the fading of photographs.

Victoria and Albert's patronage of the Photographic Society of London meant that they became acquainted with some of the most prominent photographers of the period. One typical example of the work carried out for the couple was a commission given to Francis Bedford by Victoria in 1857. Bedford was asked to travel to Coburg and take a series of pictures of Albert's homeland as a present for the Prince's birthday. Roger Fenton was another who took numerous royal photographs in the 1850s. These included a well-known set of Victoria's children in tableaux vivants in February 1854, and a series of pictures of Buckingham Palace, Windsor and Balmoral. Prince Albert also used his position to enable Fenton to obtain the necessary permission to take his Crimean war photographs. These were eventually published as *Dedicated by Special Permission to Her Most Gracious Majesty the Queen, Photographs by Roger Fenton Esq. M.A. of the Seat of the War in the Crimea* (1855). At the wedding of the Princess Royal in January 1858, T.R. Williams was requested to take a series of daguerreotypes. It is important to emphasise the photographs taken during this period were never intended for publication and were all private commissions by the royal family.

As well as Victoria and Albert's domestic use of photography, they continued to give public support to the medium. At the Art Treasures exhibition in Manchester, opened by Albert in May 1857, numerous photographs and paintings were lent from the Royal Collection. It

was also the first occasion that photographs of members of the royal family were put on public display. Pictures of both Albert and the Duke of Cambridge were amongst the exhibits. William Lake Price specifically took a portrait of Albert for the exhibition, probably as a sign of his approval and encouragement of the event. In 1852, Albert also initiated a project that would use photography to copy all the extant Raphael paintings and drawings, both in the Royal Collection and elsewhere. Photographers involved in the Raphael project included Rejlander, Philip Delamotte, and William Bambridge.

The death of Prince Albert coincided with the advent of the celebrity *carte-de-visite* and the growing market for celebrity photographs. These two events caused a fundamental change in the relationship between the monarchy and the camera. From being significant patrons, members of the royal family became valuable sitters who were much sought after by commercial studios. Patronage did continue in that the Prince of Wales, for example, became President of the Amateur Photographer's Association in September 1861. Victoria also maintained her strong personal interest in photography, particularly when it came to using pictures of the dead Prince as objects of mourning. She also accumulated many albums of pictures that document both her burgeoning extended family and the contents of the various royal palaces. However, after the early 1860s, royal photographs moved uneasily between being family pictures and media images. Photographers exploited the monarchy rather than relying on it for support.

JOHN PLUNKETT

See also: Diamond, Hugh Welch; Beard, Richard; Kilburn, William Edward and Douglas T.; Wilson, George Washington; Disdéri, André-Adolphe-Eugène; Photographic Exchange Club and Photographic Society Club, London; Downey, William Ernest, Daniel, & William Edward; Bassano, Alexander; Calotype and Talbotype; Eastlake, Sir Charles Lock; Robinson, Henry Peach; Rejlander, Oscar Gustav; Bedford, Francis; Fenton, Roger; Williams, Thomas Richard; Daguerreotype; Price, William Lake; and Delamotte, Philip Henry.

Further Reading

Dimond, Frances, and Roger Taylor, *Crown and Camera; the Royal Family and photography 1842–1910*, London: Viking, 1987.

Ford, Colin, ed., *Happy and Glorious: Six Reigns of Royal Photography*, London: Angus and Robertson, 1977.

Gernsheim, Helmut, and Alison Gernsheim. *Queen Victoria; A biography in word and picture*, London: Longmans, 1959.

Homans, Margaret. *Royal representations; Queen Victoria and British culture 1837–1867*, Chicago: Chicago UP, 1998.

Plunkett, John, "Queen Victoria: the monarchy and the media 1837–1867," Unpublished PhD, University of London, 2000.

Seiberling, Grace and Carolyn Bloore, *Amateurs, photography and the mid-Victorian imagination*, Chicago: Chicago UP & International Museum of Photography, 1986.

VIDAL, LEON (1833–1906)

Leon Vidal is not well known today but during the latter half of the nineteenth century was heavily involved with public photographic display, instruction in photography, promotion of photography and the development of photographically linked printing processes in France. He published numerous books that covered topics in all these areas.

Vidal was born near Marseilles. His parents owned a salt works at Port du Buc nearby. He was educated at the Lycee St. Louis and the Sorbonne in Paris, majoring in engineering. He moved back to Marseille and became active in photographic endeavors. He invented the Autopolygraph, one of the first automatic photographic plate-changing magazine-type cameras, in 1861. He met Poitevin and edited his works for publication. Also in 1861 in Marseille he founded, published and edited the journal "Le Moniteur de la photographie," which he continued to do for the rest of his life, taking it with him to Paris when he moved there in 1875.

Perhaps the most beautiful, if not the most influential work by Vidal was his devising of a color photographic printing process in the early 1870s he called "photochromie," a term unfortunately used for a number of other processes, and as a general term for color photography around that time in Germany. His process was a three-color separation process printed on a Woodburytype black layer. It was put into use in Paul Dalox's Tresor Artistique de la France, Musee National du Louvre, Gallerie d'Apollon (Imprimerie et Librarie du Moniteur Universelle, Paris). The first volume appeared in 1872, the second in 1875. Copies of these volumes are held, among other places, in the collection of the Getty Research Institute. They are folio size. The images, while not extremely high resolution, look quite sharp. They appear to have almost the look of lacquer in their finish. They reproduce colors very well, with a somewhat cold tone. They shine (literally) in their reproduction of metallic surfaces. Each object is posed in rather even illumination in front of a uniform background. Some of the most outstanding images are the Casque de Henri II (Helmet of Henry the Second) in volume I, and the Epee de Charlemagne (the Dueling Sword of Charlemagne), Boite de Evangeliaire (Box of the Evangelist), and the Statue Equestre (Statue of the Equestrian), in Volume II. Reproductions of decent quality are to be found in *Farbe im Photo*, 204 and 207. The colors are good, but the surface luster of the original is absent. Of course, the photographic three color separation process was demonstrated in a famous experiment using projected lantern slides by Maxwell in 1861, envisioned in various

forms by Ducos du Hauron in his papers and patents in 1867–9, and was tried by many people. However, Vidal's addition of black as a fourth color seems to have been an important contribution.

Vidal published frequently. His books include: *Calculation of Exposure Times* (*Calcul des temps de pose*, 1865, 1884), *The Art of Photography Considered from the Industrial Point of View* (*L'art Photographique considere au point de vue industriel*, 1868), *Practical Treatise on Carbon Photography* (*Traite pratique au photographie du charbon*, 1877), *Practical Treatise on Phototypie* (*Traite pratique de Phototypie*, 1879), *Photography Applied to the Industrial Arts of Reproduction* (*La Photographie appliquee aux arts industriels de reproduction*, 1880), *Practical Treatise on Photoglyptie* (*Traite pratique de photoglyptie*, 1881), *Practical Manual of Orthochromatism* (*Manuel pratique d'orthochromatisme*, 1891), *Color Photography* (*Photographie des Couleurs*, 1897).

He also sat on and wrote or edited reviews and jury results at a number of exhibitions and conferences. Some examples are: Rapport du Jury classe X, Exposition Internationale des Sciences et des Arts Industriels, 1886, La Photographie a l'exposition de 1889, Rapport du jury internationale, classe 12, Exposition Universelle Internationale de 1889, Discourse on photogravure and photochromographie at the Exposition Internationale de Photographie de 1892, Rapport du jury internationale, classe 12, at the Exposition Universelle in Paris, 1900, as well as a major portion of the Musee Retrospectif de la photographie a l'Exposition Universelle de 1900 (reproduced in Bunnell, P.C., ed., *The Universal Paris Exposition of 1900: Two Catalogs*, Arno Press, 1979).

In his book on Orthochromatism cited above Vidal reproduces opposite the title page three images of the same mixed-flower bouquet, taken with black and white film through three different color filters. In each one almost every bloom takes on a different shade from white to black, illustrating that the varied sensitivities of black and white film create an illusion of reality in the final image, which does not correspond to the truth. Only panchromatic film can capture the entire spectrum we see. Vidal quotes Hermann Vogel, the discoverer of photosensitizing dyes as his opening text. Vidal also provides one of the earliest compilations of sensitometry curves on pages 36 and 37, taken from the work of Josef Eder and others. There you can see the dyes with the farthest reach of sensitivity in the red are quinoline red and cyanine. These represent among the first of their chemical family, one that is still important in film sensitization.

Vidal taught at the Conservatoire des Arts et Metiers in Paris, in Limoges, and occasionally in Marseilles. He was an active member of the Societe francaise de photographie. He traveled to the International Photog-

raphy Congress held at the 1893 Columbian Exposition in Chicago. There he proposed an idea for a museum of documentary photography. Later that he year he founded the Association du Musee de Photographies Documentaires in Paris.

He was an officer of Public Instruction and made a Chevalier of the Legion of Honor (Chevalier de la Legion d'Honneur).

In the *Moniteur de la Photographie* he wrote (no. 23, Feb. 15, 1866, 178–180 and no. 24, March 1, 1866, 186–88) "We want photography, so useful to all branches of knowledge, to become the domain of everyone…Industry should aim to make photography for everybody as mechanical as possible in use." He certainly did all he could throughout his life to make this wish to come true.

WILLIAM R. ALSCHULER

See also: Poitevin, Alphonse Louis; Woodburytype, Woodburygravure; Expositions Universelle, Paris (1854, 1855, 1867 etc.); Vogel, Hermann Wilhelm; Eder, Joseph Maria; and Société française de photographie.

Further Reading

British Journal of Photography Almanac, 1907.

Johnson, W.S., *Nineteenth Century Photography: An Annotated Bibliography, 1839–1879*, Boston: G.K. Hall, 1990.

Focal Encyclopedia of Photography, London and New York, Focal Press, 1965.

Eder, J., *History of Photography*. Trans. Epstean, E., New York: Dover, 1972.

Bellone, R. and Fellot, L., *Histoire Mondiale de la photographie en couleurs*, Paris: Hachette Realities, 1981.

Vidal, L., La voie nouvelle en photographie, *Le Moniteur de la Photographie*. No. 23, February 15, 1866, 178–80, and no. 24, March 1, 1866, 186–8, quoted in Frizot, M. Editor. *New History of Photography*, Koln: Koneman, 1998, 236.

op ten Hofel, K. and Gohr, S., *Farbe im Photo*, Koln: Haubrich-Kunsthalle, and Leverkeusen: Agfa Foto-Historama, 1981.

N.A. *Photo-gazette*. Paris: 25 February 1892.

Konig, E. and Wall, E.J., *Natural Color Photography*, London: Iliffe and Son, 1906.

VIENNA INTERNATIONAL EXHIBITION AND VIENNA TRIFOLIUM (1892)

The Vienna International Photography Exhibition, Ausstellung Kunstlerischer Photographien, was held in Vienna from April 30 to May 31, 1891 [*The American Amateur Photographer*, Jan. 1891, 34] under the patronage of Archduchess Maria Theresia, and sponsored by the Club der Amateur-Photographien under the direction of Carl Srna, Dr. F. Mallmann, and Carl Ulrich.

Much of the event's importance revolved around the organizers' decision to limit the exhibition solely to artistic photography to the exclusion of technical

and scientific applications of the medium. Fittingly, it was juried by imminent members of Vienna's fine arts community who selected for display six hundred photographs by one hundred and seventy-six persons.

Among the eleven-member panel were Henry von Angeli, professor at the Imperial and Royal Academy of Arts, Vienna; John Benk, sculptor; Julius Berger, professor at the Imperial and Royal Academy of Arts, Vienna; K. Karger, professor at the Imperial and Royal School of Art-Industry, Vienna; Fritz Luckhardt, professor, imperial councilor, photographer to H.I. Majesty the Emperor; and Augustus Schaeffer, director of the Imperial Picture Gallery, Vienna. [*Am. Journal of Photography*, March 1891, 124] The preponderance of painters among the jury members drew criticism from the ranks of photographers who called for a more balanced representation.

The strategy initiated by the Vienna Exhibition established it as the first international group show dedicated to collecting the best aesthetic photographs, and one which recognized its creators without the use of traditional prizes and monetary awards that had come to be looked upon as undesirable methods of reward since the Pall Mall Salon in London. Underscoring the event was the Secession movement and its emphasis of art photography as opposed to scientific recording, leading to the formation of camera clubs devoted to advancing aesthetic production.

Its organizers carefully orchestrated the promotion and direction of the exhibition using considerable foresight to be the first to include the younger generation of photographers who were rising through the ranks. From America, there were ten appointees out of a field of forty. From New York City, the works of Alfred Stieglitz, James L. Breese, Miss Mary Martin and Henry B. Reid were represented. Others from New York State included John E. Dumont, Rochester and H. McMichael from Buffalo. Philadelphia's most promising young photographer, John G. Bullock, was selected along with George B. Woods, from Lowell Massachusetts, and Chicagoan Mary A. Bartlett [*Anthony's Photographic Bulletin*, June 27, 1891, 355].

The prominent British names were naturally given strong representation at the Vienna Salon. In fact George Davison was the star with eighteen pictures, followed closely by Henry Peach Robinson with fourteen works, suggesting that the eleven jurors were able to discern the key aesthetic currents—pictorialism and constructed art photography—and give them equal consideration. Frank M. Sutcliffe, although a seasoned professional, chose to be listed as an amateur and was exhibited beside the vast majority consisting of amateur ranking.

From Germany, a list of those photographers whose works were represented by fifteen or more photographs included Moritz Hahr and N. von Rothschild. Equally,

distinction was given to works by the then prominent Countess Loredana da Porto Bonin.

The Austrian photographers played an important role at the Vienna Salon and continued to advance the photography Secession movement throughout the 1890s. Begun the same year of the exhibition, the Wiener Kamera-Club (Vienna Camera Club) promoted the tenets of art photography and was the artistic counterpart to the technically oriented Photographische Gesellschaft in Vienna. During the decade, the Weiner Kamera-Club published two journals, *Photographische Rundschau* and *Wiener Photographische Blätter* featuring some of the most beautifully executed photogravures.

An early member of the Wiener Kamera-Club was Hugo Henneberg. Through his association with French photographer Robert Demachy and the English photographer Alfred Maskell, Henneberg brought the gum bichromate process to the attention of his Austrian colleagues, Heinrich Kühn, and Hans Watzek. Henneberg's work most closely resembled the pictorial style of George Davison, then the only British member of the Kamera-Club in Vienna. Henneberg was Alfred Stieglitz's first contact in Vienna and the two had corresponded since 1890. In 1894, Stieglitz became a member of the Wiener Kamera-Club presumably at Henneberg's suggestion. In subsequent years, Stieglitz featured works by the Austrian photographers at his Photo-Secession Galleries in New York.

Early in 1896, Henneberg, Kühn, and Watzek began experimented with colored gum-bichromate prints making remarkable creative color constructions using up to three colors. Influenced by Impressionism's rejection of the objective in favor of visual impression, and motifs and methods of composition shared by contemporary painters of the Munich Secession, the group transformed masses of light and shadow to make pictures whose eminent qualities of mood prevailed over realism.

Associated with progressive art theories of the late nineteenth century, the group's artwork was featured early in 1898 along with all the other innovative arts when the Vienna Secession published the first volume of its journal *Ver Sacrum*. Calling themselves the Trifolium, Henneberg, Kühn, and Watzek exhibited together in the photographic section of the Munich Secession international exhibition in the fall of 1898. By this time their association led them to sign their prints with a cloverleaf monogram near their signature to symbolize the Trifolium. In the subsequent years following the Vienna Salon, Henneberg, Kühn, and Watzek submitted their photographs to salons in Paris and London. The three also became members of the prestigious British photographic association, the Brotherhood of the Linked Ring.

The Vienna International Photography Exhibition was perhaps the most successful and influential force

for drawing attention to photography's aesthetic role and affecting a shift within the industry toward art photography. Ideas emanating from the landmark exhibition established a model for a long string of salons that admitted only art photography and excluded technical and scientific work.

The rigorously juried international exhibition set a higher standard that would be applied to subsequent international and regional exhibitions. The consideration of photography as an art form versus a scientific tool of reportage prompted the formation of separate camera organizations devoted solely to art photography. The following year, in 1892, the Linked Ring was formed in Great Britain. The Photo-Club de Paris began in 1894. In America, Alfred Stieglitz followed the movement of secession from traditional photography societies when in 1902 he formed the Photo Secession group in New York. Intrigued by the Trifolium's identity, Stieglitz arranged to present the three in America. Their work came to stand for what most Americans would know of Austrian Secession photography.

MARGARET DENNY

See also: Photographische Rundschau; Stieglitz, Alfred; Watzek, Hans; Kühn, Heinrich; Brotherhood of the Linked Ring; and Photo-Club de Paris.

Further Reading

An exhibition of One-Hundred Photographs by Heinrich Kühn, Munich: Stefan Lennert, 1981.

Buerger, Janet E., *The Last Decade: The Emergence of Art Photography in the 1890s*, Rochester, NY: International Museum of Photography at George Eastman House, 1984.

Naef, Weston J., *The Collection of Alfred Stieglitz: Fifty Pioneers of Modern Photography*, New York: Metropolitan Museum of Art, 1978.

VIEWING DEVICES

The origin of photographic viewing devices can be traced to the eighteenth century, when a 'show box,' or 'peep box' was employed to enhance the sense of depth within hand coloured engravings, thereby generating a more realistic viewing experience. Such devices tended to be of a basic construction where the viewer would look with both eyes through a single glass lens built into the front of a box which magnified the image. A similar effect was achieved using another eighteenth century device known as the Zogroscope. This consisted of an adjustable stand with a mirror and single large lens attached. The engraving to be viewed was placed upside down in front of the viewer. The Zogroscope was then placed alongside the engraving. The engraving would then appear reflected in the mirror, through the lens, the correct way up and hopefully with an added sense of realism. How effective such devices were is

debatable, but the use of viewing devices, in one form or another, continued with the advent of photography. Early photograph collectors were often also collectors of engravings, and some viewed their newly acquired photographs in the same way they had always viewed their engravings. Viewing devices therefore form a link from the pre-history of photography through to the advent of photography itself.

In time, viewing devices became more elaborate. In 1862 the photographer, Carlo Ponti (1823–1893) took out a patent in England for his Alethoscope. This had a single magnifying lens intended for the viewing of large photographic prints showing architectural views of Italy. Ponti's imposing optical devices later came to be known under a variety of names, including the Megalethoscope, Dioramascope and Pontioscope. Ponti also made the impossible claim that his devices were able to show single photographs with a stereoscopic effect.

It is important to acknowledge the sheer variety of viewing devices that were produced throughout the nineteenth century, some of which were more successful than others. For example, in the 1870s Francis Frith & Co produced a series of large format photographs on coloured transparent paper. Entitled, Photoscopic Pictures, these look, from their design, as if they were intended to be viewed in a device similar to Ponti's Megalethoscope, but little mention is made of them nowadays.

At the opposite end of the scale are Stanhope viewers. Named after the English politician and scientist, Charles, Earl of Stanhope (1753–1816), these viewing devices can be found embedded in a wide range of small novelty articles: from needle holders to letter openers. They consist of microphotographs fixed to the flat end of a tiny glass rod, while the other end of the rod is curved, so that when the one peeps through the Stanhope viewer the microphotograph appears much enlarged through the convex lens at the other end.

In 1864 Charles Rowsell produced a device capable of handling stereoscopic photographs as well as single prints. The Graphoscope's mainly wooden construction comprised of a moulded rectangular plinth which supported a hinged platform which could be adjusted to various angles to aid the viewing of images through either a pair of inset stereo lenses, or a larger single double convex lens glass. The double convex lens was said to produce an illusion of relief, rather than a fully realised stereo effect. In an advertisement for the photographic supplier, P. Meagher from 1875 the Graphoscope is described as a device 'For viewing photographs, drawings and stereoscopic pictures on glass or paper. By a simple adjustment of the easel the instrument is readily focused to suit any sight.'

Perhaps the most obvious example of a device designed to generate a realistic viewing experience is the stereoscopic viewing device, without which a

stereoscopic photograph stubbornly remains two-dimensional. However once seen though the correct viewing device the image is miraculously perceived in three dimensions. Such viewing devices therefore have the power to convert two separate, flat photographic images into one single three-dimensional image.

The first system capable of producing a photographic stereoscopic image is credited to Sir Charles Wheatstone (1802–1875). He successfully described the theory of stereoscopic vision and invented a device, known as a Wheatstone Reflecting Stereoscope, through which two large, separate photographic images could be simultaneously viewed in order to produce a single stereoscopic image. It was the first practical stereoscope, and because it was capable of accommodating large photographic prints (up to 27 × 40 cm each) it was particularly suited to the photographic connoisseur. Both Roger Fenton (1819–1869) and Benjamin Brecknell Turner (1815–1894) produced Wheatstone stereo images.

Stereoscopic photography was not introduced on a mass scale until the 1850s, when demand for images for use in Sir David Brewster's (1781–1868) Refracting, or Lenticular Stereoscope grew. Commercially produced by Louis Jules Duboscq in 1851, Brewster's system used two photographs taken of the same object from slightly different viewpoints at exactly the same time. This was an improvement on the stereo images created using Sir Charles Wheatstone's stereo pictures which were usually created using a single lens camera which had to be moved between two consecutive exposures. The difficulty in producing the stereoscopic image for Wheatstone's system was mirrored in the viewing device. The Wheatstone Reflecting Stereoscope was a rather insubstantial affair constructed from strips of wood and two mirrors set at an angle of 45° which resulted in an awkward and uncomfortable stereo viewing experience. Brewster's system, on the other hand, produced a handsome design which was much being better suited to a Victorian drawing room. It also produced a more effective, or pleasing stereoscopic effect.

Antoine Claudet's Folding Stereoscopic Viewer appeared on the market around the same time as Brewster's pattern for a Lenticular stereoscopic viewer. Claudet's design was the more limited of the two, as it came with a single stereo daguerreotype permanently built into the viewer. Its collapsible design meant it could be stored flat, however, Brewster's design proved to be more adaptable and formed the basis for most of the popular stereoscopic viewers that followed, and became the viewer of choice in the craze for stereoscopic images that was to continue into the latter part of the century.

Stereoscopic viewers based upon Brewster's pattern were popular throughout the 1860s and were known as Box Form stereoscopes. These simple hand-held devices, capable of holding one stereoscopic photograph at a time, were often highly decorated in keeping with the setting of the Victorian parlour. The stereo card fitted through a slot at the back of the device, while a mirrored flap could be raised and angled so that light was cast onto the stereo card thereby giving enough light for it to be viewed through the twin lenses at the front. The back of the stereo viewing device was often fitted with a ground-glass panel which allowed diaphanous stereo cards manufactured on hand coloured tissue paper also to be viewed, alternating between night and day, summer and winter, simply by raising and lowering the mirrored flap on top of the viewer.

In America, Dr Oliver Wendell Holmes devised a simplified stereo viewer in 1861 which is probably the design most people think of today when they imagine a nineteenth century stereoscope. It consisted of a wooden hood-like arrangement which covers the viewer's eyes, with a holder for the stereo card fixed at a set distance from the hood. This design was improved in 1864 by another American, Joseph L Bates of Boston, when he added an adjustable sliding holder for the stereo card, thereby making it possible for the instrument to be adjusted to suit the individual and maximise the three-dimensional effect.

More ornate 'pedestal' stereo viewers were manufactured by companies such as Negretti & Zambra. Although the actual stereo viewer was simple in design, and similar to the box form stereoscope described above, they were often constructed from high quality wood veneers and incorporated highly decorative figurative sculptural elements in the base. The third, and most substantial type of stereo viewer dating from this period and intended for use in the most lavish Victorian parlour setting was in the form of a cabinet. These cabinet stereo viewers were capable of accommodating a selection of up to twenty individual stereo view cards at the same time which moved through sequence on a carousel inside the cabinet.

The fact that companies such as Underwood & Underwood could produce up to ten million stereoscopic views a year in order to meet the Victorian parlour's huge demand for photographic images I order to ensure its viewing device was well stocked with photographic images is testimony to the importance of this sector of the photographic industry in the nineteenth century.

BRIAN LIDDY

See also: Ponti, Carlo; Frith, Francis; Stanhopes; Wheatstone, Charles; Turner, Benjamin Brecknell; Duboscq, Louis Jules; and Claudet, Antoine-François-Jean.

Further Reading

Norman Channing and Mike Dunn, *British Camera Makers: an A-Z guide to companies and products*, Esher: Parkland Designs, 1996.

Brian Coe, *The History of Movie Photography*, Westfield: East-view Editions, 1981.

Thomas H Court and Moritz von Rohr, "On Modern Instruments Both for the Accurate Depicting and the Correct Viewing of Perspectives or Photographs," *The Photographic Journal*, vol. LXXV (new series LIX), August 1935.

Bernard E Jones (ed.), *The Encyclopaedia of Early Photography*, Bishopsgate Press, London, 1981 (originally printed in 1911 under the title, 'The Encyclopaedia of Photography').

Laurent Mannoni, Werner Nekes and Marina Warner, *Eyes, Lies and Illusions*, Hayward Gallery Publishing/Lund Humphries, London, 2004.

The Year Book of Photography and Photographic News Almanac, 1875.

VIGIER, LE VICOMTE JOSEPH (1821–1894)

Louis Jules Achilles Vigier, known as Joseph Vigier, was Viscount, owner of the castle of Grand-Vaux à Savigny-sur-Orge. School-fellow of the duke of Aumale at the school Henri IV, he remained connected all his life to the family of Orleans. In 1872, after having sold his Grand-Vaux à Savigny-sur-Orge, he acquired the castle of Lamorlaye, close to Chantilly, where the duke of Aumale remained and where he could appease his passion for horses (developed with his training of thoroughbred racehorses of English origin).

Vigier was introduced to photography in the workshop of Gustave le Gray around 1848–1850. He first stayed in Seville in 1851, in the home of the duke of Montpensier; it is not known if he took photographs there. In September 1852, he went to England and took photographic portraits of the royal family in exile in Claremont: King Louis-Philippe, the queen Amélie, their children (duke of Nemours) and grandchildren

posed, each one sitting upright or close to a table, some in front of a fabric painted with the exuberant decoration of flowers; the prince of Condé is illustrated on a horse. In the summer of 1853, he voyaged to Spain while passing by the Pyrenees (Luchon, Cauterets, Pau), from which he brought back several hundreds of scenes on negative paper. At the end of the year, he published the Album des Pyrénées (Album of the Pyrenees), which was a collection of about thirty prints. In February 1854, he showed six of them in London, with the Exhibition of Photographic Society, which created enthusiasm in the public and queen Victoria.

Vigier was the founding member of the Société héligraphique in 1851, then of the Société française de photographie in 1854 (he remained there until 1862); he was also member of the board of directors of the SFP from 1857 to 1862. He took part in the first two Exhibitions that the Society organized, in 1855 (views of the Pyrenees) and in 1857 (views of Dauphiné of 1855 on negative paper, a castle of Savigny of 1856 on dry collodion, a horse according to nature on wet collodion). He also took part in several Exhibitions in London (in 1852, Society of Arts, and in 1854 in Photographic Society) and in Brussels in 1856 (views of the Pyrenees and views of Dauphiné, on negative paper; portraits, monuments, horse on collodion; monuments and views of France, England, Spain on albuminous paper and waxed paper). The birth of a son in 1859, the management of his grounds, voyages, passion for the horses, and especially the evolution of the photographic processes in the years from 1860 diverted him perhaps definitively from his practice.

A major figure of the photo hobbyists of the 1850s, the personality and oeuvre of the Viscomte Vigier are still

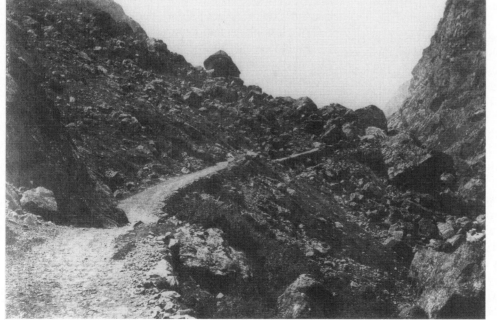

Vigier, Vicomte Joseph. Path to Chaos, Saint-Sauveur. The Metropolitan Museum of Art, Gilman Collection, Gift of The Howard Gilman Foundation, 2005 (2005.100.503.8) Image © The Metropolitan Museum of Art.

not well-known. His body of work is for the moment only partially identified: portraits of the family of Orleans went on public sale in 2000, and especially scenes of Spain (Seville, Grenade) and of the Pyrenees, preserved at the SFP, the BNF, the Museum of Orsay (this last preserves the album of the Pyrenees, and the views captured in the Brébisson album). Because of his participation in two London Exhibitions, Vigier was apparently better known by the English public. It may be also that he met English amateurs at the time of his stay in the Pyrenees. His affinities with England are perhaps at the origin of his interest for Talbot's calotype process, which he used in alternation with the process of Le Gray (waxed paper). He considered the two techniques complementary, finding it easier to use Talbot's in particular for the impression, whereas that of Le Gray's, which gave more definition, of transparency in the shades, of truth in returned space. He sought to improve the processes on paper and communicated with the SFP on this subject in 1856. Vigier used the collapsible darkroom of Koch and resorted, for his printings, to the photographic printing works of H. Fonteny, directed by Alexandre Lachevardière, in Paris, principal rival of the printing works of Blanquart-Evrard. He signed his tests with a dry seal with his monogram, JV, surmounted by a crown. Negative paper agreed well with the primitive aspects of certain landscapes like arid valleys and rocks, and captured the textures of the rock and stone because of those atmospheric effects. The tones are warm, of a beautiful colour varying from pink to brown. His images are often very composed, with sets of lines, right-hand sides or curves (road, bridge), introducing a movement, making space and giving to the spectator the feeling of being in the scene (Sentier du chaos allant de Gavarnie à Saint-Sauveur). The foreground is often released (road, river, way) and the background occupied by a thrust created by a mountain or a church (Bridge of Slate with Luchon).

With their public appearance, the photos of the Pyrenees achieved the unanimous acclaim. With the occasion of the Exhibition of London in February 1854, the critic Ernest Lacan devoted an article to the album of the Pyrenees, in which he emphasized the difficulties encountered in traversing the various sites; he underlined the transparency, the strength of the tone of these images as well. In 1855, Eugene Durieu admired those same views, and in 1857, Paul Perier remembered their "broad and severe character." With the Exhibition of 1857, in front of a sight of castle in Dauphiné, Perier spoke about smoothness and frankness from execution: "the light was so fortunately chosen, that water, of a curious transparency, has their value everywhere, and is harmonized very well with all the other parts of the table. The avenue of trees of the castle of Savigny is not less remarkable; the foliage is returned perfectly, and the table has much of depth without presenting the exaggeration of prospect

which often the avenues in photography give." By the masterly character of these tests, without anecdote nor picturesque, Vigier occupies a singular place in the production of the amateurs of the 1850s.

HELENE BOCARD

Further Reading

Michel Auer et Michèle Auer, *Encyclopédie internationale des photographes de 1839 à nos jours*, Hermance, Camera obscura, 1985.
André Bourgoin, *La dynastie Vigier*, Savigny-sur-Orge/Lamorlaye, 1995.
André Jammes et Eugenia Parry-Janis, *The Art of french Calotype*, Princeton, Princeton University Press, 1983.

VIGNES, LOUIS (1831–1896)
French, active in Morocco, Sicily, Lebanon, and Palestine 1859–1864, photographer, naval officer

Vignes was a distinguished naval officer whose photographic work is limited to his early service in the Mediterranean and North Africa. He entered l'Ecole navale in 1846 and remained in the French Navy, retiring as an admiral. It is unclear where he learned photography, but he made over 50 calotypes of sites in Morocco, Sicily, and Beirut during the Syrian campaigns of 1860. It was this experience that led to his assignment to the archaeological expedition mounted by the Duke du Luynes, an eminent biblical archaeologist with an interest in photography. The group traveled from Beirut south through Sidon, Tyre, Nablus, and Jerusalem to the Dead Sea which they explored by ship from March through May of 1864. Vignes photographed throughout the journey, initially with collodion on glass at du Luynes behest. He returned to the calotype process he had used in Syria on the return journey, perhaps because the supply of glass plates had been exhausted. While there is no complete tally of photographs from this expedition, it may be estimated at 400. Sixty-four photographs were published by Charles Negre using his photogravure process to accompany, *Honoré d'Albert, duc de Luynes, Voyage d'exploration à la mer Morte, à Pétra et sur le rive gauche du Jourdain*, Paris, 1875. In addition there are a number of albums in public and private collections that include material not found in the publication—in addition to archaeological subjects, panoramas, interior views in French residences, and landscape studies.

KATHLEEN HOWE

VIGNOLES, CHARLES BLACKER (1793–1875)

Charles Blacker Vignoles was born in 1793 at Woodbrook, Ireland. His parents were Captain Charles Henry

Vignoles and Camilla Hutton, daughter of Dr Charles Hutton of Woolwich. A Civil Engineer with a wide range of interests, he was engaged in Railway Engineering in England, Ireland and on the Continent of Europe.

Vignoles was a founder member of the Royal Photographic Society, and was an early advocate of the use of photography as a means of recording construction activities.

In 1848 he employed John Cooke Bourne and in 1852 Roger Fenton to take record pictures of the Tsar Nicholas I Chain Bridge which he was constructing at Kiev.

In 1859 he encouraged John Watson, the contractor on the Bahia and San Francisco Railway in Brazil to employ a photographer to record the progress of the works. From 1859 to 1862 this was carried out by Benjamin Mulock.

In 1860, while working in Northern Spain, he facilitated an expedition to view the Eclipse of the Sun, when Warren de la Rue photographed the Corona for the first time.

President of the Institution of Civil Engineers from 1870 to 1872, Vignoles died in Southampton in 1875.

JOHN VIGNOLES

VILLALBA, RICARDO
(active 1860–1880)

Ricardo Villalba (sometimes spelled Villaalba), was active in Perú and Bolivia, between 1860 and 1880. He may have been born in Corocoro Bolivia, but very little is known about his life. Villalba's images are found on cartes de visite and cabinet cards and his albumen prints include views of the Peruvian Southern Railroad, Lake Titicaca and the devastating 1868 earthquake of Arequipa and Arica. During the 1870s, Villalba had a studio in Arequipa and is thought to have been the first to photograph the city's famed volcano, El Misti. When Villalba left Arequipa, his studio and perhaps some of his negatives may have been acquired by the photographer Carlos Heldt. According to Dan Buck, Villalba relocated to Paris in the 1880s, where he was listed as a member of the Societe Francaise the Photographie. He also submitted several photographs for an exhibit sponsored by the Photo Club de Paris in 1894.

The Harvard Peabody Museum owns a Villalba album containing ethnographic cartes de visite of Bolivians. There are also over thirty Villalba photographs in the James Maxwell Collection at the University of Delaware. The ENAFER Corporation in Perú owns an album of images of the Ferrocarril del Sur (which ran from Mollendo to Puno). The William Darrah Collection at Penn State contains one carte de visite (c. 1872) of a sunken ship off of the port of Callao (near Lima). On this card the photographer's name is spelled Villaalba.

YOLANDA RETTER VARGAS

VOGEL, HERMANN WILHELM
(1834–1898)
German inventor, photographer

There are not many 'firsts' in the history of German photography but there is one man who collected most of them: he wrote the first thesis on photo-chemistry in German language; with the Photographische Mitteilungen, he founded one of the first and most lasting periodicals; he gave photography the "second half of light" (J.M. Eder, 1880) by finding the substances for the colour sensitisation of photographic plates. In the German speaking countries, he was the first to criticize an exhibition at length, and among the firsts to curate another one, dedicated to the aesthetic qualities of photography gained throughout the first 25 years of existence. Hermann Wilhelm Vogel was a remarkable thinker about photography whose interests were as wide-spread as the medium itself:

> Thus we see photography active into the most diverse directions. Animals, plants, minerals have to draw their images onto the light sensitive plate as well as the products of art and industry, and as the motions of the barometer and thermometer. The photographer directs his instrument into the icy regions of the North Pole as well into the thicket of the tropical jungle; into the gorges of our high mountains as well as into the depths of the endless universe. His art is applicable to all branches of human knowledge and wisdom. There is no field in the great world of the visible where it [photography] could not be introduced fruitfully; it is shaping the history of towns and countries, and when we will be no more existant, our photographs—more loquacious the all historical works—will tell the cultural history of our time to our successors. (Hermann Wilhelm Vogel, Die Photographie auf der Londoner Weltausstellung des Jahres 1862, Braunschweig 1863, 28)

Neither photography nor fame were laid in his cradle. Hermann Wilhelm Vogel was born in 1834 in the small town of Dobrilugk (today: Doberlug-Kirchhain) fifty miles southeast of Berlin. He was the son of a material merchandiser who wanted him to follow in his footsteps, and so young Hermann became an assistant sales agent at the age of fourteen. In 1850 he finally managed, according to records, with the help of some of his father's friends, to inscribe at the trade school in Frankfurt/Oder which had a technical department. From 1852 to 1858 Vogel visited the technical school at Berlin, then the best-known institute for all kinds of applied science. After finishing this institute with a diploma in 1858, he was installed as a scientific assistant at the Mineralogical Museum of the Berlin University. It was there that he finally met his life-long interest: photography.

Two influences can be reported for this determination: At the Museum he had to reproduce cuttings of rock with the aid of photography, and a friend from the technical school, the architect Albrecht Meydenbauer,

asked him to help with advice for the setting-up of a photogrammetic inventory of buildings ready for preservation and reconstruction. Besides his work at the Mineralogical Museum, Vogel managed to write a thesis on the behaviour of silver halides under conditions of light which was finished by 1863. Later in the same year, he was named head of a newly established photographic laboratory of the Berlin technical school where he had studied before. This laboratory was opened in 1864, and from then on Vogel unfolded a wealth of activities within all fields imaginable in photography. In 1879, the Berlin technical school and the building academy were unified to the Technical University where Vogel was made Professor in Photo-Chemistry, a position he held until his death in 1898. The chair gained world-wide fame, and Vogel was succeeded by Adolf Miethe, Otto Mente, and Erich Stenger, each of them outstanding in their own fields.

Hermann Wilhelm Vogel's most important contribution to photographic chemistry and industry was the sensitisation of the emulsion for larger parts of the spectrum. In 1873, he described the enrichment of photographic emulsions with eosin dye pigments for dry plates which were to be named orthochromatic. As a typical product of the science of its time, his findings were easy transferrable into industrial use, and the benefits of Vogel's plate sensitisation helped the German photographic industry to both develop and achieve world-wide acclaim. As orthochromatic emulsions lacked sensitivity for red colours, Vogel continued this part of his research until his death. Adolf Miethe, his successor in the Berlin seat, was lucky to announce in 1902, four years after Vogel's death, the introduction of the panchromatic sensitisation which not only gave black & white photography a perfect gray scale for all colours but set the foundations for today's colour photography as well.

As head of the only department of photo-chemistry in Prussia, Vogel was a major influence in the development of German photography. He set up the first comprehensive exhibition of photography in Berlin in 1865 and organized the medium's half-centennial in 1889. While setting up the first exhibition, he stimulated a legal debate on photographic copyrights, a law installed with his help in Germany by 1897. For a gathering of photographers at the exhibition in 1865, Vogel co-authored a dramatic comedy in two sets. As a member of the jury, he took part in the preparation of the photographic departments of the world exhibitions in Paris 1867, Vienna 1873, Philadelphia 1876, and Chicago 1893. He instigated not only the career of master scientists like Miethe and Mente but of photographers as the young Alfred Stieglitz alike. He wrote a number of books, among them a four-volume comprehensive handbook of photography whose fourth part is the first overview on the medium's aesthetics in German language—and contains a chapter on reproducing sculpture which changed the views of art history. Vogel led photographic expeditions to view solar eclipses and to archaeological sites all over the world, and he brought home not only masses of scientific results but landscape and travel photographs as well. His own photographic work has still to be unravelled from the huge amount of records he left behind at his untimely death in 1898.

ROLF SACHSSE

Biography

Hermann Wilhelm Vogel, born in Dobrilugk, Lausitz, March 26, 1834. As the son of a merchant, he had to leave school at the age of 14 and became the assistant of a sales agent. From 1850 to 1852 he visited the trade school at Frankfurt/Oder, from 1852 to 1858 the industrial school at Berlin. From 1858 to 1864 he worked as a scientific assistant at the mineralogical museum of the University of Berlin, in 1863 he finished his doctorate on the theory of photography which is considered the first scientific work in German photo-chemistry. In 1864 he founded the photographic laboratory at the Berlin industrial school which was transferred into the Technical University in 1879. From then until his death on December 17, 1898, in Berlin, he was Professor and head of the Department of Photo-Chemistry in this institution.

See also: Miethe, Adolf; and Stieglitz, Alfred.

Further Reading

Baier, Wolfgang, *Quellendarstellungen zur Geschichte der Fotografie*, Leipzig: VEB Fotokinoverlag 1977, 266–267.

Herneck, Friedrich, *Hermann Wilhelm Vogel*, Leipzig: Teubner 1984.

Lerche & Isaaksen (i.e., Vogel and Jacobsen), *Das Zukunftsatelier. Oder die Photographie als Eheprocurator, Dramatisch-photographischer Scherz in 2 Akten*, Berlin: Photographischer Verein zu Berlin 1864.

Vogel, Hermann Wilhelm, *Die Photographie auf der Londoner Weltausstellung des Jahres 1862*, Braunschweig: Neuhoff & Comp. 1863.

Vogel, Hermann Wilhelm, *Handbuch der Photographie*, vol. 1–4, Berlin: Oppenheim 1867–1891.

VON ETTINGSHAUSEN, ANDREAS RITTER (1796–1878)
Austrian mathematician and physicist

Ettingshausen was born on 25 November 1796 in Heidelberg, where his father was stationed during the first World War as a member of the Austrian general staff. After the relocation of the family to Vienna in 1809 and the completion of high school he turned to a career as

an officer. In 1815 he turned to a scientific career too. When he entered the scene of Austrian photo history in 1839. He was among the most renowned scholars of the Habsburger monarchy and enjoyed the special protection of the State of Clemens von Metternich, securing himself in his independent study of modern math and physics problems. In 1839 Ettingshausen was in Paris and participated with the publication of the Daguerreotype, and later lectured at the Académie of the Sciences of the Académie Beaux, which had arranged for François Arago on 19 August at Institut de France.

During his stay in Paris Ettingshausen was introduced personally to the new photographic procedure of Louis Jacques Mandé Daguerre and acquired a Giroux camera (No. 26). His own print series were taken after October 1839 on Johannisberg at Ruedesheim on the Rhine, the summer seat of the prince Metternich. Metternich, as well as the entire Austrian public, was completely informed about Ettingshausen. An exciting exhibition from Ettingshausen's daguerreotype at the Institut of the Viennese University took place on 22 November 1839. After this, a club of photographic pioneers in Vienna formed briefly, consisting of scientists, technicians, medical professionals, and artists, in which Ettingshausen also worked. Here he showed his first micro photographs and experiments with polarized light.

The result of Ettingshausen's photographic activity was limited to what he created during his membership in the 1861 photographic society in Vienna (since 1863, starting from 1875 as an honorary member) and to several photography courses, which he taught from 1863 to 1866 at physical Institut of the Viennese university. However, his contribution remained important to the fastidious scientific culture of photography in Austria during the nineteenth century.

MAREN GRÖNING

Biography

Andreas von Ettingshausen was born on 25 November 1796 in Heidelberg (Germany). His parents first intended that he have a military career, but he had already taken studies at the school to Vienna in higher mathematics. In 1817 he reached Adjunkt (assistant) for mathematics and physics at the University of Vienna. In 1819 he became a physics teacher at the High School Innsbruck and in 1821 became professor of higher mathematics in Vienna. Together with Andreas Baumgartner he published the magazine for mathematics and physics in 1826–1832. In 1834 he took over the chair for physics at the University of Vienna (1852 institute leaders). Temporarily he taught also at the engineer academy at the same time (1848 to 1852) and at the polytechnic institute (1852) in Vienna. In 1845 he took part in a petition by intellectuals to loosen the censorship in the

Habsburger state. In 1847 he was selected as the first Secretary-General (until 1850) of the founders' meeting of the Austrian sciences. From 1861 to 1862 he led the Viennese university as a rector. After his retirement in 1866 he was raised into baron status (knight of Ettingshausen). He died on 25 May 1878. As a practical photographer Ettingshausen might have been active only in the months of his participation in the publication of the Daguerreotypie in Paris in August 1839 up to his work in the circle of the Viennese " round court " in March and April 1840.

See also: Austro-Hungarian empire, excluding Hungary; Societies, groups, institution, and exhibitions in Austria; Daguerreotype; Microphotography; and Petzval, Josef Maximilian.

Further Reading

Auer, Anna. "Andreas Ritter von Ettingshausen (1796–1878). Der Mann, der die Daguerreotypie nach Österreich brachte," in Rückblende. *150 Jahre Photographie in Österreich, herausgegeben von der Photographische Gesellschaft in Wien*, Wien: Selbstverlag, 1989, 33–43 (englische Fassung p. 44-49; gekürzte englische Fassung in History of Photography, vol. 17, 1993, 117–120)

Starl, Timm. *Biobibliografie zur Fotografie in Österreich 1839 bis 1945, 1998ff* (wird regelmäßig aktualisiert) http://alt.albertina.at/d/fotobibl/einstieg.html.

Starl, Timm. *Lexikon zur Fotografie in Österreich 1839 bis 1945*, Wien: Album, Verlag für Photographie, 2005.

Faber, Monika. "Stallburg und Altes Burgtheater. Eine Daguerreotypie von Andreas von Ettingshausen aus dem Jahr 1840," in *Fotogeschichte*, Heft 77, Jahrgang 20, 2000, p. 15-24.

VON GLOEDEN, BARON WILHELM (1856–1931)

Born Volkshagen Castle, Wismar, Germany, Baron von Gloeden contracted tuberculosis and moved to Taormina, Sicily c. 1879 and indulged a life of leisure until the family lost its fortunes at the instigation of Kaiser Wilhelm II. Forced to find money, von Gloeden turned his interest in photography into a business in 1888. Reputedly taught by his cousin, Wilhelm Plüschow (1852–1930) who had a studio in Naples from the 1870s, and Francesco Paolo Michetti, tourist prints soon gave way to collectors photographs of the male nude set in the landscape of antiquity, but created out of fin-de-siécle aestheticism. For a society still devoted to the Greek Ideal, he brought the myth to life, although his depictions were more Arcadian than Homeric. He achieved critical and financial fame and his photography entered the mainstream of European society. Using local peasant youths to create his ephebes, he opened savings accounts for his models and allocated royalties. Il Barone Fotografico was much loved in Sicily, until

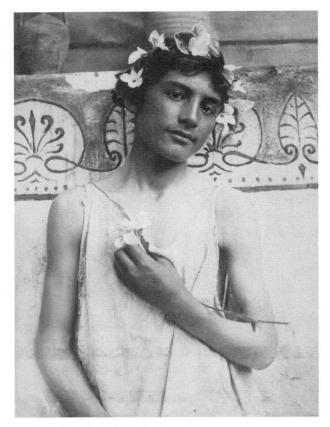

von Gloeden, Baron Wilhelm. L'Offerta.
The J. Paul Getty Museum, Los Angeles © The J. Paul Getty Museum.

Italian fascists, and then the War, destroyed many of his plates inspite of the attempts of his former model, go between, and heir, Pancrazio Bucini, to protect them. His influence was widespread: from his contemporaries Vicenzo Galdi, Gaetano D'Agata, Plüschow, to 1950s American Beefcake and David Jarmen's movie Sebastiane (1976). Post-Freud, post-1970s, and now regarded as the founder of male nude photography, Gloeden's homoerotic depictions have become part of contemporary gay culture.

ALISTAIR CRAWFORD

VON HERFORD, WILHELM (1814–1866)

Born in Soldin, Prussia (now Mysliborz, Poland), under the full name Friedrich Wilhelm Theodor von Herford, von Herford studied law in Berlin and Breslau and worked as a civil servant until 1846, at which time he began five years of travel and language study throughout Europe and the Middle East in preparation for a diplomatic career. While waiting for a post, von Herford traveled to Paris in 1853, where he sought out fellow Prussian Édouard Baldus for photographic instruction. Student and master traveled through Provence in September and October, working side-by-side as von

Herford made his first successful pictures. Frustrated by the dull winter light of Paris, he moved to Rome before year's end, and the following fall received further instruction from an unidentified German photographer, likely Jakob August Lorent. From Rome, he traveled to Sicily in late 1854, to Sardis, Trabzon, and finally Beirut for the long-awaited consular position in 1855, photographing along the way, notably at Baalbek. He photographed extensively in Jerusalem in May and June 1856 and in Egypt in 1856 and 1857. In 1944 Erich Stenger reported the survival of 185 paper negatives (60 of Rome and elsewhere in Italy; 27 of Jerusalem; 44 of other sites in Palestine; 27 of Egypt; 5 of buildings in other countries; and 22 of portraits and costume studies) and 200 prints; what now remains is preserved at the Agfa Foto-Historama, Köln.

MALCOLM DANIEL

VON HUMBOLT, ALEXANDER (1769–1859)

Friedrich Heinrich Alexander, baron von Humboldt, brother to philosopher and linguist Wilhelm von Humboldt, was born in Berlin in 1769 and died there in 1859. One of the 19th century's scientific giants, often described as the last universal scholar, baron von Humboldt is considered one of the founders of geography. His extensive travels in South and Central America (1799–1804), recorded in a long series of publications, made him the century's most influential explorer. His final, monumental treatise *Kosmos* (1845–1862) aimed at a synthesis of knowledge on the natural and human world, and emphasized methods of observation. Von Humboldt's involvement with the beginnings of photography was brief but significant. Early in 1839, when he was in Paris, his long-time friend François Arago, the French scientist who sponsored Daguerre's and Niépce's invention, called upon the Prussian scientist to examine Daguerre's plates and testify before the French Academy. Von Humboldt was impressed. His letter of February 25, 1839 to fellow-polymath Carl-Gustav Carus, describing Daguerre's views of Paris, is one of the most eloquent of such early statements. His testimony in favor of Daguerre, and more generally his endorsement of photography's descriptive powers, influenced the adoption of the invention by explorers, especially in the United States.

FRANÇOIS BRUNET

VON KOBELL, FRANZ (1803–1882)

In January 1839, the first news of Daguerre's invention spread over Europe and the Academies took notice. Many professors attempted to recreate the experiement

to reproduce the same results. Carl August Steinheil, the Munich-based physicist and his colleague Franz von Kobell were amongst the academics who were interested in what Daguerre invented. It virtually took them only days to find a method of keeping light on paper; Steinheil constructed a small metal camera with a self-calculated lens and Kobell found a comparatively sensitive chlor-bromide process which produced negative images; these were reproduced for positive results. On Feb., 1, 1839, they published the first notice on their findings, and when Talbot released his own invention in March 1839, the two felt the obligation to surpass him by producing a number of actual images. Both presented their results—which were of photographs from Munich, reproductions of graphic arts, and images of smaller objects—to the Bavarian Academy of Science on July 3, 1839 with much acclaim. Their images were small, mostly 4 cm in diameter, but clear and sharp. Both did not think of their invention as more than a scientific experiment and did not develop their ideas further. While Steinheil stuck to photographic optics, Franz von Kobell left this field completely and concentrated on his two careers as mineralogist and as a playwright. His "Brandner Caspar" is still on the playlist of every Bavarian folk theatre.

Franz von Kobell was born on July 19, 1803 in Munich as the grandson of the painter and copper etcher Ferdinand von Kobell. He studied mineralogy in Landshut and started his professional career in the mineralogical state collection of Bavaria in 1823. In 1827 he was honoured as a member at the Bavarian Academy of Science. In 1834 he became professor of mineralogy at the Munich university, and in 1849 he was made director of the named state collection. His main concerns were of practical questions of crystallography and anorganic chemistry. Besides his cooperation with Carl August Steinheil in the invention of photography he is named for a "stauroscope" which he patented in 1855. From 1839 on, Franz von Kobell published numerous books as an author in both Bavarian and Palatinate dialect as well as in the standard language. Prior to his death on Nov.11, 1882, in Munich he was honoured with knighthood. In 1896 there was a memorial dedicated to him. His daughter Luise, then a well-known author, wrote a comprehensive biography on him and his life's work.

ROLF SACHSSE

VON LENBACH, FRANZ (1836–1904)

Franz Lenbach was born on Dec. 13, 1836 in the village of Schrobenhausen in Bavaria. Following short studies at the Augsburg polytechnic school he became a student of Karl von Piloty in 1857 for a short time,

taught painting at Weimar in 1860, and began travelling to Italy and France for several years. From 1868 he devoted himself exclusively to portraiture. Within a short time, Lenbach had introduced photography as an aid to his work. There were a number of photographers working for him, most notably Karl Hahn. Lenbach gained enormous fame for his portraits of Otto von Bismarck for which he had more than 120 photographs made of the German chancellor; the result were more than 80 paintings. The use of photography in Lenbach's painting processes was threefold: first he had the heads of the photographs enlarged to copy them. Second he had slides made from the images which were then projected onto the canvas. And third, he used the Parisien method of "photo-peinture", a sensitively covered canvas with a faint images of the portraited over which he painted his picture. He believed in photography as an aid in the quick delivery of painting commissions. Only within the last two years of his life did he take photographs himself. He died in Munich on May 6, 1904.

ROLF SACHSSE

VON STEINHEIL, CARL AUGUST (1801–1870) AND HUGO ADOLF (1832–1893)
Astronomers and lens and camera manufacturers

Born in Rappoltsweiler, Alsace, Carl August Steinheil studied science and astronomy, obtaining a doctorate from Konigsberg University in 1825. In 1832 he became professor of mathematics and physics at Munich. In March 1839, after William Henry Fox Talbot had sent a copy of his paper, 'Some account of the art of Photogenic Drawing,' to the Bavarian Royal Academy of Sciences, Steinheil, together with a colleague, Franz von Kobell, conducted their own experiments in photography. Steineil designed a cylindrical camera, made from cardboard and resembling a telescope which produced circular negatives on paper sensitised with silver chloride solution. He later went on to make the first daguerreotypes in Germany.

Steinheil's son, Hugo Adolph, studied optics and astronomy in Munich and Augsburg. In 1854, father and son founded the Steinheil Optical Institute in Munich. Adolph designed a number of innovative lenses, including the Periskop in 1865 and the Aplanat the following year. In 1866 he bought out his father's interest in the Institute, which then became C. A. Steinheil Sohne, and he carried on the work of the Institute following his father's death in 1870. He continued to design lenses, writing an influential book on lens design in 1891, two years before his death.

COLIN HARDING

VON STILLFRIED-RATENICZ, BARON RAIMUND (1839–1911)
Austrian photographer, painter, soldier, diplomat, and restorer.

An adventurous aristocrat, Stillfried was one of the most important travel photographers of the Austro-Hungarian Empire. He was born at Komotau in Bohemia, Austria (now Chumotov, Czech Republic) on 6 August 1839, second of three sons of Baron August von Stillfried-Ratenicz, a decorated career soldier, and Countess Anna, née Clam-Martinicz. After spending most of his early childhood in the Austrian Military Frontier district (now Croatia), he began a formal education in 1851 at the prestigious Marine-Akademie in Trieste. During his five-year residence in the port, Stillfried received painting lessons from the accomplished Orientalist Bernhard Fiedler (1816–1904), who recognised his talent and attempted without success to convince his father to support the boy's artistic pursuits. After gaining a cadetship to the army's second Engineering Battalion, he moved to Linz in 1856 and attended the drawing classes of Joseph Maria Kaiser (1824–1893). Although rapidly promoted through the army ranks, he soon abandoned his military career "in order to satisfy his thirst for adventure and travel" [um seinen Durst nach Abenteuern und Reisen zu befriedigen] (A. Th.).

In January 1863, against his father's wishes, he voluntarily resigned from the Imperial army and travelled as a shipsboy to Callao, Peru. Financing his wanderlust through several odd trades, he eventually reached Nagasaki, probably in late 1863, where he worked for the Dutch silk firm Textor & Company, acquired some Japanese language skills, and met the Prussian landscape painter Eduard Hildebrandt (1818–1869). Although Stillfried later claimed to be self-taught, Fiedler, Hildebrandt, and to a lesser degree Kaiser, all built successful careers on the depiction of distant lands for the European market and their example perhaps inspired the young traveller towards a similar artistic vocation.

In mid-1865, Stillfried left Japan to join the volunteer forces of Emperor Maximilian of Mexico. A decorated officer, he remained in Mexico after the French withdrawal, serving in the beleaguered forces until the execution of Emperor Maximilian on 19 June 1867. After briefly returning to Austria, he travelled again to Japan and by July 1868 settled in Yokohama where he resided until 1881 (although he frequently travelled overseas). During the first two years, Stillfried worked for the North German Legation in Tokyo and sent regular reports on local affairs to the Austro-Hungarian Foreign Ministry. He also assisted the Austro-Hungarian diplomatic mission on their arrival at Yokohama in October 1869 (Wilhelm Burger acting as official photographer), for which he received the Franz Joseph Order on 15 March 1871. Aware of the booming local photographic market, Stillfried quit his diplomatic position in 1870 and opened a photographic supply shop in Tokyo. He obtained lessons in wet-plate photography from the experienced professional Felice Beato, before finally opening his own studio of Stillfried & Company at No. 61, Yokohama. Announcing the establishment of the new atelier, *The Hiogo News* noted on 9 August 1871: "A new photographer has started in Yokohama, Baron Stillfried was once a pupil of Mr. Beato and is now trying to undersell him." (Harold S. Williams Manuscript Collection, National Library of Australia, Canberra) As Beato's active interest in photography waned, Stillfried came to dominate the local market, catering for the influx of foreign tourists attracted to Japan during the 1870s. His work was widely reproduced in the overseas illustrated press and exhibited at several world exhibitions, including Vienna (1873), Philadelphia (1876), Paris (1878), Melbourne (1880) and Calcutta (1883). Although best known for his hand-tinted 'costumes' of generic Japanese 'types,' his first portfolio revealed a predilection for the landscape that brought a trained classical aesthetic to the Japanese views of Beato and Burger. A vastly underrated outdoor photographer, he further demonstrated his landscape capabilities in the later Hong Kong (1881–1882), Siam (1882–1883) and Balkan collections (1889).

Throughout his career, Stillfried's entrepreneurial ambition often led to scandal. In January 1872, he prompted a serious diplomatic affair after attempting to market an unofficial portrait of the Mikado taken during the emperor's inaugural public appearance at Yokosuka arsenal. The following year, he again courted controversy after transporting a seven-room teahouse to Vienna for the World Exhibition, accompanied by three Japanese women hired to serve tea to the prospective guests. The authorities refused to allow the building's reconstruction in the official grounds after reports associated the enterprise with Japanese prostitution. Despite losing a substantial amount in the venture and returning to Japan near bankruptcy, Stillfried quickly rebuilt his enterprise, now situated at No. 59, Yokohama, and soon promoted as the Japan Photographic Association. In November 1874 Josef Lehnert, a member of the Austrian expedition sent to Japan to record the Venus transit, pronounced in his travelogue: "As a photographer Baron von Stillfried achieves extraordinary things, really his atelier is the best and most important in the whole of East Asia." [Als Photograph leistet Freiherr von Stillfried Außerordentliches, thatsächlich ist sein Atelier das beste und bedeutendste in ganz Ostasien.] (Lehnert, Band II, 532) For his assistance photographing the astronomical event, Stillfried gained the title of court photographer on 25 April 1875 to the Austro-Hungarian Empire.

In 1875, Stillfried formed a partnership with a Prus-

sian accountant, Hermann Andersen, which allowed him to concentrate on his profession and leave the business operations to his associate. He travelled to Shanghai for a month in April 1876, returning to Yokohama with a large collection of Chinese genre images. Stillfried's products of the mid-1870s, most notably the albums generically entitled Views and Costumes of Japan were beautifully presented objects containing an equal number of hand-tinted studio 'types' and untinted 'views' (State Library of Victoria, Melbourne, Australia). Under his direction, the art of hand-tinting reached new standards rarely approached by subsequent studios, as he established select colours for each print chosen to highlight particular items of ethnographic interest. At its height, Stillfried claimed his studio employed thirty-eight full time Japanese workers, testifying to the firm's astounding popularity.

However, several business setbacks soon curtailed Stillfried's high standard Japanese work. On 14 January 1877, fire destroyed his studio and whilst most of his negatives were saved, at least some were probably destroyed. A week later Stillfried purchased Beato's entire stock, negatives and studio on the Yokohama waterfront, before departing on 6 June 1877 for a one-year international tour. He exhibited to considerable press attention at the annual salon of the Photographic Society of Great Britain in November 1877, before visiting several European cities, including Amsterdam, Berlin, Vienna, and Paris. In June 1878, he finally returned to Yokohama and promptly sold his share in Stillfried & Andersen to his business partner. In an extraordinary clause to the contract of dissolution, Stillfried agreed not to establish any future studio in Japan for a ten-year period. Andersen, however, continued to market albums under the Stillfried & Andersen banner containing an assortment of Beato and Stillfried reprints, as well as his own studio products, until 1883.

After a six-month Japanese government position teaching photography at the Department of State Printing, Stillfried opened a studio at his Tokyo residence in May 1879, but was forced out of business after Andersen issued a successful legal challenge for breach of contract. In response to the court decision, Stillfried invited his brother Franz to Yokohama, who shortly after his arrival on 25 October 1879 established the photographic studio of Baron Stillfried's Studio, No. 80. On 6 December 1879, Stillfried sold his remaining stock and photographic materials to Franz, prompting an acrimonious series of lawsuits between Andersen and the Stillfried brothers. Although Stillfried assisted his brother Franz in the studio's operations, his position was untenable and he soon left for continental Asia in search of new opportunities.

From September to December 1880, Stillfried operated a portrait studio in Vladivostock and produced a

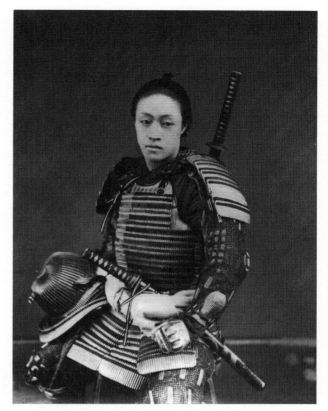

von Stillfried und Ratenitz, Baron Raimund. Actor in Samurai Armor.
The Metropolitan Museum of Art, Gilman Collection, Museum Purchase, 2005 [2005.100.505 (2b)] Image © The Metropolitan Museum of Art.

portfolio of Siberian studies, reputedly soon afterwards destroyed by fire. He returned to Yokohama for several months, before departing permanently on 4 May 1881, possibly once again for Siberia. He eventually arrived in Hong Kong on 15 October 1881, where he once again opened a portrait studio and gained a lucrative commission from the Governor-General, Sir John Pope-Hennessy, to document the decorations installed around the colony in preparation for the royal visit of Princes' Albert Victor and George of Wales. On 28 February 1882, Stillfried embarked for Siam (now Thailand) and remained thirteen months under the auspices of King Chulalongkorn, employed on several photographic commissions and the restoration of the royal oil painting collection until his permanent departure for Europe in April 1883.

Although at first little known in Vienna, Stillfried quickly established his reputation with an exhibition in February 1884 at the Österreichische Museum für Kunst und Industrie of around four hundred photographs, paintings, and sketches of Japan, China, and Siam. Perhaps due to Emperor Franz Joseph's personal attendance, Stillfried received exclusive permission the following year to visit twelve Habsburg estates, resulting in an important series of interior room photographs and

paintings exhibited in February 1886 at Vienna's Öster-reichischer Kunstverein. In 1889, Stillfried travelled through Bosnia-Herzegovina, Dalmatia and Greece producing a collection of three hundred landscape, eth-nographic, and archaeological studies, again exhibited in Vienna the following year. These exhibitions culminated in a large retrospective at Trieste in May 1891 compris-ing one thousand Asian and European images from the previous twenty years of work.

In the early 1890s, Stillfried established a large studio for the restoration of oil paintings at Feldsberg bei Lundenberg (now Czech Republic). He exhibited paintings regularly at several art societies, which some critics compared to the celebrated work of Rudolf von Alt. Although the Viennese city directory Lehmanns Adreßbuch continued to list Stillfried as an active pho-tographer until his death, by the early twentieth century he was primarily occupied as a painter of architectural interior scenes until illness hindered further activities in 1908. He died from a heart attack on 12 August 1911 at his apartment in Gentzgasse 9, Vienna.

LUKE GARTLAN

Biography

Baron Raimund von Stillfried-Ratenicz was born into an aristocratic family on 6 August 1839 at Komotau, Bohemia, in the Austrian Empire (now Chumotov, Czech Republic). From his early childhood, he devel-oped a penchant for maritime travel, art and distant cultures, nurtured in the thriving cosmopolitan port of Trieste. In broad terms, Stillfried's adult career can be divided into two periods. The first comprises the twenty years of travel between his resignation from the Austrian army in 1863 and his final return to Vienna. Eventually settling in Yokohama after five years spent in South America, Japan and Mexico, he established a photographic studio by August 1871, which soon gained international recognition for the hand-tinted genre scenes and untinted landscapes. He left the Japan Photographic Association in June 1878, and was later active in Siberia, Hong Kong and Siam. In the second period, from 1883 following his return to Vienna until his death in 1911, Stillfried continued to remain active, assembling important photographic portfolios of the Habsburg estates, the Balkan and Greek peninsulas, and numerous other European sites. His personal life, with separate families in Japan and Vienna, reflects these two phases in his career. A common aspect of treaty port life in Asia, Stillfried had a long-term liaison with a Japanese woman named Nishiyama Haru, with whom he had three daughters christened Mary, Anna, and Helen. After returning to Vienna, Stillfried married Helene Jankovich de Jeszenicze on 22 September 1884, with whom he had a further two children, Alice and Alfons.

He died in Vienna on 12 August 1911, a few days after his seventy-second birthday.

See also: Burger, Wilhelm Joseph; and Beato, Antonio.

Further Reading

Banta, Melissa and Taylor, Susan (eds.), *A Timely Encounter: Nineteenth-Century Photographs of Japan*, Cambridge, Mass.: Peabody Museum Press, 1988 (exhibition catalogue).

Boyd, Torin and Izakura, Naomi, *Portraits in Sepia: From the Japanese carte de visite collection of Torin Boyd and Naomi Izakura*, Tokyo: JCII Camera Museum, 2000.

Cortazzi, Hugh and Terry Bennett, *Japan: Caught in Time*, New York: Weatherhill, 1995.

Gartlan, Luke, "A chronology of Baron Raimund von Stillfried-Ratenicz," in John Clark, *Japanese Exchanges in Art, 1850s–1930s*, Sydney: Power Publications, 2001, 121–188.

Geschichte der Fotografie in Österreich, 2 Bände, Bad Ischl: Verein zur Erarbeitung der "Geschichte der Fotografie in Österreich," 1983 (exhibition catalogue).

Lehnert, Josef, Um die Erde. Reiseskizze von der Erdumseglung mit der S.M. Corvette "Erzherzog Friedrich" in den Jahren 1874, 1875 und 1876, 2 Bände, Wien: 1878.

Stillfried, Alfons, *Die Stillfriede: Drei Jahrhunderte aus dem Lebensroman einer österreichischen Familie*, Wien: Euro-paischer Verlag, 1956.

Th., A., "Freiherr von Stillfried-Ratenicz und sein japanisches Theehaus," *Allgemeine illustrirte Weltausstellungs-Zeitung* (Wien), 9 November 1873, S. 103.

VON VOIGTLÄNDER, BARON PETER WILHELM FRIEDRICH (1812–1878)
Viennese inventor and lens maker

Peter Wilhelm Friedrich von Voigtländer was born into a family of optical instrument makers in Vienna in 1812. His grandfather, Johann Christoph von Voigtländer (1732–1797) had established a small business in the Austrian capital in 1756 manufacturing microscopes, compasses and other optical instruments. Johann had three sons, the youngest of whom, Johann Friedrich (1779–1859), carried on the family business after his father's death in 1797. As a young man, Johann trav-elled to England to study optics and, after his return to Vienna, started to make lenses in about 1808. In 1823 Johann invented and patented the opera glass. In 1837, aged 58, Johann Friedrich retired and the management of the family business was taken over by his son, Peter Wilhelm Friedrich, then just 25 years old.

By this time the house of von Voigtländer had already gained a reputation of being one of the very finest Eu-ropean optical instrument makers. Peter, although still comparatively young, had a wealth of knowledge and experience. His early education and practical instruc-tion came from his father. For his more advanced and theoretical education he later enrolled at the Vienna

Polytechnic Institute. Peter's practical experience and knowledge was broadened by travelling and working in Germany, France and England.

His primary area of interest was optical theory, including calculating the refraction and diffusion characteristics of various types of glass. It was inevitable, therefore that he soon befriended and began to collaborate with the mathematician Josef Max Petzval (1807–1891) who in 1837, the same year that Peter took over from his father, had become professor of higher mathematics at the University of Vienna. In 1840, Petzval, who had not designed a lens before, mathematically calculated the optimum arrangement for a lens intended specifically for photography. Up to this time, camera objectives were simple lenses that had been designed for other uses. The slowness of these lenses exacerbated the lack of sensitivity of the earliest photographic processes. Petzval entrusted the construction of his, at the time still theoretical, lens to his friend von Voigtländer. The first sample Petzval lens was completed in May 1840. It was made up of two separate asymmetrical lens components, a front lens with a forward-facing convex surface and a rear component consisting of one planoconcave and one biconvex lens, separated by a space. Definition and illumination was excellent in the centre of the field but deteriorated gradually towards the edge of the picture. However, this was not seen as a problem for portrait photography and could even be regarded as beneficial since it tended to emphasis the actual portrait area and suppress unwanted background detail. Petzval's design became the standard lens for portraiture until well into the twentieth century.

The original Petzval Portrait lens had an aperture of f/3.6. This made it sixteen times faster than the simple meniscus lenses that were currently in use and reduced exposure times from minutes to seconds. In 1841, von Voigtländer fitted a Petzval lens into an all-metal daguerreotype camera that he designed and manufactured. Of distinctive and unusual design, von Voigtländer's camera consisted of a conical brass body with the lens at its apex. A shorter conical focussing attachment with a ground glass screen and a magnifying eyepiece could be screwed into the other end. The camera rested on a cradle on top of a telescopic pillar. After focussing, the camera was removed from the stand and carried to a darkroom where the focussing attachment was removed and replaced by a plate-holder containing a sensitised circular daguerreotype plate, 94mm in diameter. The camera was repositioned on its stand and the exposure made by removing and replacing the lens cap. It is estimated that von Voigtländer produced about 70 of these cameras in 1841 and around 600 the following year. Today, however, only about a dozen are still known to exist.

Despite their initial friendship and shared interests,

von Voigtländer and Petzval soon quarrelled, primarily because Petzval felt he had not received sufficient financial reward for his invention. By the end of the 1840s the two men had ceased to be on speaking terms. Petzval had taken out an Austrian patent for his lens but in 1849 von Voigtländer established a second factory in Braunschweig, Germany, which was his wife's hometown. Here, there were no legal restrictions and von Voigtländer continued to produce Petzval lenses in increasing numbers. In 1862 he produced his ten thousandth lens. In 1866 von Voigtländer closed his original factory in Vienna. That same year he was made a member of the hereditary peerage by Emperor Franz Joseph of Austria, which entitled him to use the prefix 'von' before his name.

Peter Wilhelm Friedrich von Voigtländer retired in 1876 at the age of 64, handing over the business to his son, Friedrich Ritter von Voigtländer (1846–1924), the last of four generations of von Voigtländers connected with the optical industry. Friedrich, a fine lens designer in his own right, ensured the continuing success of the company with the introduction of the Euryscope lens in 1886 and the Collinear lens in 1892. Around the turn of the century, von Voigtländer branched out into camera manufacture which was subsequently to become a major part of the company's business.

COLIN HARDING

Further Reading

Brian Coe, *Cameras: From Daguerreotypes to Instant Pictures*, Marshall Cavendish Editions, 1980.

Rudolf Kingslake, *A History of the Photographic Lens*, Academic Press Inc, 1989.

Louis Walton Sipley, *Photography's Great Inventors*, American Museum of Photography, 1965.

VUILLARD, ÉDOUARD (1868–1940)
French painter and lithographer

Édouard Vuillard, known primarily as a painter and lithographer, produced over 2000 photographs (1700 as original prints) during his lifetime. Vuillard began experimenting with a hand-held Kodak camera in the late 1880's along with fellow artists Pierre Bonnard and Maurice Denis. These photographs taken throughout his lifetime focused primarily on the artist's circle of family and friends, as was the case with his paintings. He used the camera as a witness, spontaneously asking those around him to "hold it please" when he wanted to record a casual everyday moment, as mentioned in "Vuillard et son Kodak."

Vuillard also utilized photography to experiment with spatial ambiguity often staging scenes he later recreated in his paintings. The artist composed many

scenes to place the women in his life on center stage. Either through foreground placement or by putting them in focus, numerous photos exist of the two infatuations of Vuillard's life: Misia Natanson and Lucy Hessel. The artist's mother, however, was the subject he shot most; it was also she, often more than the artist himself, who frequently developed his photographic works.

Vuillard did not exhibit his photographs during his lifetime. They have predominately been hidden from public view in family archives until over 80 were revealed in the international 2003 Vuillard exhibition. A catalogue raisonné of all photographs in the family archives is forthcoming.

DEBBIE GIBNEY

Further Reading

Easton, Elizabeth. "The Intentional Snapshot" and Catalogue 166–253 in Guy Cogeval, *Édouard Vuillard*, New Haven and London: Yale University Press, 2003 (exhibition catalogue).

Kahng, Eik. "Staged Moments in the Art of Édouard Vuillard," in Dorothy Kosinski, *The Artist and the Camera: Degas to Picasso*. New Haven and London: Yale University Press, 1990 (exhibition catalogue).

Easton, Elizabeth, "Vuillard's Photography: Artistry and Accident." *Apollo*, vol. 138 (June 1994), 9–17.

Easton, Elizabeth, *The Intimate Interiors of Édouard Vuillard*, Washington: The Museum of Fine Arts Houston, Smithsonian Press, 1989 (exhibition catalogue).

Daniel, Émilie, "L'Objectif du subjectif: Vuillard photographe," *Les Cahiers du Musée national d'art moderne*, no. 23 (Spring 1988), 83–93.

Salomon, Jacques and Annette Vaillant, "Vuillard et son Kodak," *L'Oeil*, no. 100 (April 1963), 14–25, 61.

W

WALKER, SAMUEL LEON (1802–1874)

Samuel L Walker was one of the earliest daguerreotype photographers in the United States and was widely regarded as one of the best photographers during the 1840s and 1850s. He lived and worked in Poughkeepsie, New York.

Walker was born in 1802 at New Salem, Massachusetts, and enjoyed careers as a daguerreotypist and photographer, writer and spiritualist. There is some evidence to suggest Walker was an assistant to Samuel F. B. Morse in New York; he then had a studio in Albany before moving to Poughkeepsie by 1847. He seems to have stopped photographing between 1854 and the early 1860s when wet collodion photography began to supersede the daguerreotype and poor health limited his activities. By May 1864 Walker had returned to photography and was practicing the collodion process in his Photographic Institute.

The only known collection of Walker's work is held by George Eastman House in Rochester, New York, and the twenty daguerreotypes there consist of portraits including studies of his own children which Sobieszek claims are 'some of the most exciting images created by the daguerrean artist.' His daguerreotypes of his daughters are reminiscent of the work of Lewis Carroll in their directness and latent sexuality.

He died on 25 April 1874 aged 72 years when he was described as a man of great artistic taste with a love for his profession.

MICHAEL PRITCHARD

WALKER, WILLIAM HALL (1846–1917)

William H. Walker began making a wooden pocket amateur camera in Rochester from 1880 and by 1883 he was successfully manufacturing dry plates. He gave up camera making, allowing his former partners to form the Rochester Optical Company which continued with the camera making side of the business.

George Eastman recognising Walker's skills as a chemist and experience with plate manufacturing offered him a job which he accepted from the beginning of 1884. He began work on developing what became the Eastman-Walker roll film holder which allowed a roll of film to be used with any plate camera. The roll holder was patented in Britain on 25 November 1884 and in the United States on 5 May 1885. Through its use of standardized parts it could be mass-produced and was made in Frank Brownell's works, being placed on the market in 1885. It was produced in eleven different sizes. The roll holder proved popular with the photographic press and with amateur photographers so that by 1888 35 percent of negatives at the London Camera Club's summer outings were made using it. Rival companies introduced their designs.

Walker, with Eastman, also designed a paper and film coating machine and this, with the roll-holder and the development of a film, was intended to give Eastman's company a complete system of film photography.

In 1884 Walker became Secretary to the Eastman Dry Plate and Film Company and in 1885 he was sent to London to supervise the company's European activities, leading to the establishment of the Eastman Photographic Materials Company Ltd which was incorporated in November 1889.

Walker's relationship with Eastman, which had always been testy, deteriorated and Eastman himself was forced to find a factory site rather than rely on Walker. The Harrow site was purchased, the first for the company outside of Rochester. Walker was not a businessman and Eastman found Walker's negative attitude and repeated threats to retire tiresome. He finally accepted such a threat and George Dickman was appointed to take over

from Walker from January 1893. Eastman soon forced Walker from the company completely.

Walker, a wealthy man from his Kodak stock, died in November 1917.

MICHAEL PRITCHARD

WALL, ALFRED HENRY (d. 1906)

According to his obituary, Alfred Henry Wall was born in London, date unknown, and had a childhood sufficiently unhappy that he ran away from home and went to work for a time for one of the earliest daguerreotype studios in the city before joining a theatre company—an activity he would return to for a period in the 1860s.

He opened his own studio in Cheapside c.1850, and another in the Strand (date unknown), but by 1851 was working as a photographic assistant at the Great Exhibition.

Photographic News reported in 1861 that he was working as an itinerant portrait painter under the name of R. A. Seymour, and coincidentally in that year he published *A Manual of Artistic Colouring as Applied to Photographs.* By 1862 he had returned to commercial photography and opened a studio in London's Westbourne Grove.

In 1864 and 1865 he published two annual volumes entitled *The Art Student* which discussed photography as an art form, a subject aired several times since 1859. From 1868 until 1870 he edited *The Illustrated Photographer*, which described itself as 'a weekly journal of science and art,' and his contributions to several contemporary journals did much to expand understanding of the photographic processes.

Wall's last photographic book *Artistic Landscape Photography* was published in 1896.

JOHN HANNAVY

WALL, EDWARD JOHN (1860–1928)

Edward John Wall was one of the leading writers on the theory and practice of photography in the closing decades of the nineteenth century. His 1889 *Dictionary of Photography* became a standard reference work and ran to many editions worldwide. Although not published until 1925, his *History of Three-Colour Photography* was the first reflective look at that subject, drawing on material he had first published in the *British Journal of Photography* in the early 1900s.

In the closing years of the 19th century he contributed a manual on carbon printing to *Amateur Photographer* magazine's *One Shilling Library* series of books, but one of his most significant contributions to the practice

of photography was his published 1907 suggestion for the technique which became known as bromoil printing. Wall himself did not fully articulate the mechanics of the process, but his initial suggestions as to how it might work were realised in a practical sense by C Welbourne Piper, who published a working process later that same year.

Trained as a chemist, Wall initially worked for the plate manufacturers B. J. Edwards & Co. in London, before embarking on a career which embraced camera manufacture in the United States with the Blair Camera Company, journalism, photography, and motion pictures.

JOHN HANNAVY

WALTER, CHARLES (CARL) (c. 1831–1907)
Botanist, photographer, journalist

Born in Germany, he emigrated from Mecklenberg, Tokheim, to Victoria, Australia, in c.1856 where he worked as a botanical collector for the Victorian Government Botanist, Baron von Mueller. In 1858, he worled as a photographer and botanical collector, accompanied R.L.J. Ellery's geodetic survey party into eastern Gippsland.

In 1865, he advertised himself as a "Country Photographic Artist" of 45, Bell Street, Fitzroy, Melbourne, and began supplying photographs and reports of his travels in the bush to *The Illustrated Australian News.* Much of his early work was concerned with recording portraits of aborigines and he documented the mission stations of Ramahyuck (Lake Wellington), Coranderrk (Yarra Flats) and Lake Tyers. In 1867, he sent portraits of *Natives of Victoria* to the Anthropological Society of London.

Walter was, perhaps, Australia's first photojournalist, for as early as 1865 he sent a report of the "Salmon Tanks in Badger Creek" to the *Illustrated Australian News.* In the following year, he describes a trip overland to "Falls on the Niagara Creek, Mount Torbreck" with his "apparatus and tent upon his back—the whole weighing about fifty pounds."

Walter used a stereoscopic camera for most of his work but also produced some half-plate and whole-plate negatives. He registered photographs with the Victorian Copyright Office in 1870 and in 1871 he advertised "A very large stock of Stereoscopic Views of Aboriginal Life, Mining, Scenery and other Australian Subjects." The earliest extant photograph by Walter is dated 1862; his work continued to be published until the early 1870s.

BILL GASKINS

WAR PHOTOGRAPHY

Introduction

The medium of photography was generally accepted as a reflection of reality in the nineteenth-century. In truth, many photographic war scenes were manipulatively staged. At times this was because the artist wanted to reflect what they had seen with their own eyes, but were unable to capture with the camera. The creation of photographs was also incredibly arduous on the battlefield. Lighting had to be ideal, photographic equipment was cumbersome, and plates had to be processed quickly necessitating portable darkrooms. In addition, the slow development of the medium itself made it impossible to produce action photographs.

Even with the assumed veracity of photographic works, photographs were seldom printed in newspapers in the nineteenth-century. More likely they were seen when displayed in galleries, sold in books, or copied by engravers for newspapers. However, often engravers invented scenes of battle that had not been captured by photographers. The development of half-tone printing, which enabled the combining of text with photographs, fueled a rise of photos in papers during the Spanish-American War and Second Boer War at the end of the century.

Early War Photography

The earliest photographs of wartime events come from the end of the Mexican-American War (1836–1848).

These images are not of battle scenes, but rather posed scenes of soldiers. "General Wool and Staff, Calle Real, Saltillo, Mexico," c. 1840, offers a good example of the kind of choreographed scene frequently produced. Wool's regiment paused for several minutes to accommodate the exposure time needed for the daguerreotype; one can see that the figures on the left are slightly blurred from having moved. The difficulties of obtaining photographic materials, the lengthy preparation time necessary, and the long exposure period for the daguerreotype, made photography rare in this period. Only around fifty photographs survive, and we have no record of specific photographers of the Mexican-American War images.

The first identifiable photographer who took pictures in a wartime environment was John McCosh. McCosh served as a British surgeon during the Second Sikh War (1848–1849) in India and the Second Burma War (1852). Using the calotype, McCosh photographed fellow soldiers, artillery, and ruins. Karl Baptist von Szatmari also exhibited some photographs of a battle between the Russian Army and the Turks in the Paris Exhibition of 1855; an engraving after one of these scenes survives, as do some of the photographs themselves.

1850s

Richard Nicklin had been hired by the British military to photograph government-sanctioned scenes of the Crimean War (1853–1856), but the photographer and his two assistants were caught in a hurricane and drowned

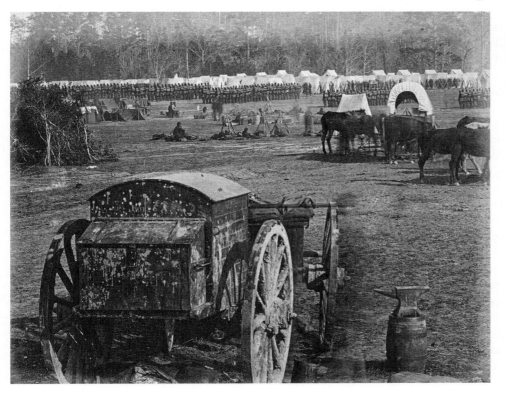

Wood and Gibson. Inspection of Troops at Cumberlanding, Pamunkey, Virginia.
The J. Paul Getty Museum, Los Angeles © The J. Paul Getty Museum.

in Balaclava Harbor in November of 1854. Photographs from other artists such as Gilbert Elliot, and two military officers, ensigns Brandon and Dawson, were also hired by the government to cover the war, but all of their works have since disappeared.

Roger Fenton produced over 350 images of the Crimean War during 1855. Thomas Agnew hired Fenton with aspirations of creating a profitable issue of photos similar to those that the military photographers had been hired to photograph but never produced. Roger Fenton wrote in letters of some of the horrors he witnessed during his time in the Crimean, but his photographs do not reflect the scenes he describes. Rather, Fenton mostly photographed heroic portraits of soldiers, positive scenes of life in the camps, and images of the surrounding landscape. Fenton may have felt compelled by Agnew, as well as Queen Victoria with whom the photographer had developed a warm relationship, to photograph encouraging images of the war to try and offset the negative impressions given to the British people by newspaper reporter William Howard Russell. Fenton was also limited by photographic materials of the time which did not yet enable spontaneous action shots. He was also challenged by the collodion wet plate process technique which required speed and virtuosity as he only had short time to develop the plates in his makeshift traveling laboratory after taking a scene.

Fenton's most recognized war image is one of the few in which he allowed a sense of sadness at the destruction of war to creep into his work. Arriving shortly after the brutal attack of soldiers of the British Light Brigade by the Russians on October 25, 1854, Fenton's "Valley of the Shadow of Death" showed the infamous valley as a desolate landscape filled with cannon balls. The exhibition of the photograph in 1855, and the popularity of Lord Tennyson's "Charge of the Light Brigade," written in 1864, marked this event in the memory of the British people.

James Robertson, Felice Beato, Charles Langlois, and Karl Baptist von Szatmari all photographed the final stages of the Crimean War. Of these, the sixty or so photographs taken by Robertson have become the most well known. Robertson's works showed more scenes of death, destruction, and violence, the kind of subject matter not in the work of Fenton. Although Thomas Agnew & Sons published both Fenton's and Robertson's Crimean photographs in 1856, Robertson does not seem restricted by Agnew to shoot only government-favored photos as Fenton had been, perhaps because of Robertson's other sources of income. In the end, Agnew's commercial adventure was not as successful as he had hoped. Fenton's and Robertson's photographs went on sale, both individually and as sets, as early as November 1855. However, the public had little interest in these images by the end of the war. By the end of

1856, Thomas Agnew & Sons sold all remaining prints and negatives from both photographers at auctions.

After photographing the end of the Crimean War, Felice Beato and James Robertson worked together in Calcutta and photographed the Indian Mutiny, of First War of Independence, of 1857. Beato's most striking images from this period are scenes of the execution of over 2000 Indian rebels by the British, and those of Secundra Bagh in which he recorded the devastation in the months that followed. In his photographs from the 1850s, Beato is often credited as the first to photograph corpses after a battle. Beato probably choreographed many of these scenes to heighten the dramatic effect, perhaps even excavating and arranging corpses. Beato became the most prolific photographer of war scenes of the Asian world in the nineteenth century including the recording of the Opium War in China (1860) and the Japanese attacks in the Simonaki Straights in September of 1864. Also during this decade, several photographers were sent to the battlefields during the War of the Triple Alliance in South America (1864–1870), in hopes for commercial success. Bate & Co. published Esteban García's work from this period in sets of ten titled La Guerra Ilustrada. However, it was the American Civil War (1861–1865) that was the first war to be extensively photographed.

1860s/American Civil War

It was the publishers' awareness of the public's desire for war scenes that caused the prolific photographic work produced during The American Civil War; at least five hindred photographers accompanied the soldiers of the North. Photographs were then made into engravings to be published in the papers, or sold to E. and H. T. Anthony and Co., who at times issued more than a thousand pictures a day. The photographs themselves would not be viewed by the public until they were displayed in galleries.

George S. Cook took images right after the fall of Fort Sumter, marking the beginning of the war between North and South. While Cook became one of the few photographers to shoot Confederate subjects, one of his most famous works is of a Federal troop leader, Major Robert Anderson who had been defeated at Fort Sumter. After the war, Cook collected over 10,000 photographs from the war; these are now in the collection of the Valentine Museum in Richmond, Virginia.

However, Matthew B. Brady is the name most synonymous with Civil War photography. He determined that he could make a profit organizing photographers to shoot the war and closed most of his galleries which had been highly successful portrait studios for the rich and famous. He had even done several sittings with President Lincoln who credited Brady with helping him win the

election with these fine portraits of the President. Brady claimed he was called to the war, "I felt I had to go. A spirit in my feet said 'go,' and I went."

Although suffering from poor eyesight, Brady initially went to the fields and was greeted with distaste from many of the soldiers who suspiciously saw his camera as some kind of weapon. Later, he organized other photographers to do most of the actual photographing. However, Brady managed to frequently place himself within photographs of military heroes. Throughout the course of the war, Brady hired over twenty photographers to shoot the troops, battle scenes, and the bodies after the massacres. He organized a complex system of equipping each of the photographers with a portable dark room and stocked chemicals and glass plates at the major battlefields. His team of photographers produced over 7000 negatives during the war.

One of Brady's best photographers was Alexander Gardner. Gardner followed the Army of the Potomac and captured most of their battles. His first war photographs were exhibited in Brady's studio in September of 1862 and captured the horrific results of the Battle of Antietam, the bloodiest battle of the war in which 26,000 soldiers were killed or wounded. The gallery received huge crowds desperate to see these first images portraying with veracity the costs of war. These photographs were dramatically realistic in contrast to heroic scenes that had been done of dead soldiers by painters in this period. Gardner showed the actual decay of the corpses and the inhumanity of their deaths. Eight of these photographs were also published in *Harper's Weekly* on October 18, 1862.

The *New York Times* praised the show, "Mr. Brady has done something to bring home to us the terrible reality and earnestness of war" and Gardner was disturbed by Brady's assumed ownership of these photographs. Each photograph was boldly marked with "Brady's Album Gallery" in contrast to Gardner's name written in small barely noticeable print. Gardner reacted by taking the negatives of his photographs along with Timothy O'Sullivan and James F. Gibson, some of Brady's best photographers, and opened his own studio. Once working for himself, some of Gardner's most intriguing works were those from his series on the execution of the conspirators who plotted the murder of President Lincoln.

Gardner clearly credited the photographers who worked for him in the publication of their work. For example, Timothy O'Sullivan, while working for Gardner, produced arguably the most famous war photograph, the "Harvest of Death" taken of the battlefield of Gettysburg. This scene shows a field covered with bodies, highlighting the numerous deaths from this battle. Yet O'Sullivan simultaneously shows the viewer one soldier's face, his contorted hand in the center of the

photo, bringing a large inconceivable number down to the reality of many individuals. Other soldiers have their clothes partly removed as thieves have already been searching their bodies. The scene achieves the kind of accurate reportage which Gardner supported when he remarked that this photograph by O'Sullivan "conveys a useful moral: it shows the blank horror and reality of war, in opposition to the pageantry."

Photography also filled a unique role for families who sent their loved ones to battle. Portraits of soldiers were often taken before leaving for the war and makeshift studios were set up in many battlefields enabling soldiers to send home images of themselves. The recently developed and inexpensive tintype photographs were particularly popular. It should be highlighted that although a few photographs of African-American troops and the treatment of slaves were taken, the photographic record of this period for African-Americans is minimal in comparison to the copious photographs taken of the war.

Some of the many photographers not discussed in depth in this essay who photographed scenes from The Civil War include: George Barnard, Bergstresser Brothers, Sam Cooley, James Gardner, James Gibson, S.A. Holmes, David Knox, Theodore Lilienthal, Royan Linn, A.D. Lytle, William Pywell, James Reekie, George Rockwood, T.C. Roche, John Scholten, William Morris Smith, Julian Vannerson, David Woodbury, and J. A. Young. Andrew J. Russell is the only photographer during the Civil War to have been paid by the government.

After the war, photographs of the battlefields were difficult to sell as the public preferred to forget their tragic losses. Alexander Gardner's Photographic Sketch Book of the Civil War published after the Civil War, which included O'Sullivan's famous Harvest of Death, had little response. While many photographers struggled, perhaps none suffered more than Brady who had bankrupted himself from his investments to photograph the war and ended up destitute and mostly blind. Also after the end of the war, Frank Leslie's *Illustrated Newspaper* published images of Southern war camps and malnourished prisoners. Mary Warner Marien discusses the role of the North's blockade of the South as a cause for the extreme neglect of the prisoners of the Confederacy.

The 1870s and 1880s

During the 1870s and 1880s numerous regional wars took place throughout the globe. However, few photographers recorded these events, as there was little interest in them for purposes of print illustrations. Rather, most newspapers hired artists to sketch dramatic battle scenes believing photography lacked the ability to capture the

action. Louis Heller shot images of prisoners which were used, however, for the cover of Frank Leslie's *Illustrated Newspaper*, July 12, 1873. Eadweard Muybridge produced some dramatic images of the battle between the Modac Indians and the American Cavalry on the border of Oregon and California in 1872–1873. Muybridge frames individual proud Native Americans as they fight to keep their land; in truth, most of the tribe would be hung when this battle was lost. Bismark's war against Schleswig-Holstein was photographed by a handful of artists showing mostly views of the destruction of the landscape and corpses. Only negligible photos survive from the Russo-Turkish War (1877–1888).

While James Burke photographed many struggles in Afghanistan, the best are of the Second Afghan War of 1879 in which the British were fighting in the area of Kabul. In one of the most successful battles in British military history, their troops numbering only 5000 fought off an attack by over 100,000 Afghans. Although he did not shoot the actual battle, Burke's photos of the confident British troops a day before the attack were published as engravings in London Graphic. Burke is known for his sweeping views of troop formations placed against the exotic Afghan backdrop.

Few noteworthy photographs survived from the Franco-Prussian War of 1870; however, photography played a crucial role in the siege of Paris. First, balloons marked "Daguerre" and "Niépce" were used to drop communications into the surrounded city. Later, photographically reduced text was hidden in small containers tied to the tails of homing pigeons enabling those under siege within the city to communicate with French officials outside. Once they realized the French's secret weapon, the Prussians used falcons to attack the pigeons.

The Paris Commune ended with Bloody Week (May 21–May 28, 1871), a period in which 25,000 Parisians were killed by the French government. Various Parisians took some particularly intriguing photos of the Communards posed prior to and after removing the Vendôme Column, an action that symbolized the removal of Napoleonic military barbarism. Bruno Braquehais published 109 photographs, which he personally photographed, in a bound album titled *Paris During the Commune*. Unfortunately, these photographs were later used to identify rebels who were then punished or murdered by the French government. Charles Soulier photographed the city in ruins after the end of the Commune. Eugène Appert fabricated photographs in which he hired actors to stage various scenes from the time of the Commune, and then he would paste in heads of the Communards and reshoot the pasted photo. This handful of contrived images, designed from the perspective of the government, was compiled into a book called Crimes of the Commune.

1890s

The Spanish-American War (April 25–August 12, 1898) is the first war in which photographs of war scenes were quickly disseminated to the public through publication in newspapers. Due to the images in papers owned by Hearst and Pulitzer, Americans saw the atrocities of the Spanish occupation, although often inaccurately reported, and support increased for the Cuban rebel forces. The sinking of the U.S. battleship *Maine*, on February 15, 1898, in the Cuban harbor of Havana was blamed on the Spanish and fueled the decision by the United States to enter the war on April 25. "Remember the *Maine*" became a rallying cry as numerous photography firms marketed stereographs of the event; Keystone View Company in particular made a profit from the selling of such images.

Despite the American public interest in this conflict, few photographers were hired to document the battles. However, Jimmy Hare began a career in which he would become known as the paramount photographer of war. Working for *Collin's Magazine* and later *Collier's* and *Leslie's Weekly*, Hare worked in the field during numerous twentieth-century wars including World War I. While few of his surviving photographs from this period are remarkable, later he would be credited with being the first modern war photojournalist for his courageous efforts in documenting times of war.

International public opinion on the Second Boer War (1899–1902) was also greatly swayed by photographs of the battles and conditions in South Africa. Much of Europe and the United States supported the seemingly simple people of the Boer republic initially in their battle against Britain. Once realizing the power of the medium, the Boers began taking numerous photos of every aspect of the war. The Boers encouraged photos of their weaponry, trenches filled with dead British soldiers, and their prisoners including then war correspondent Winston Churchill.

Through manipulation of these and other photographic images, the British used the media to try and persuade the national and international public to support their troops. Horace Nicholls can be credited with shooting some of the most sentimental images during this period, which engendered sympathy for British troops. Nicholls described his desire to shoot and compose "photographs which would appeal to the artist sense of the most fastidious, knowing that they must as photographs have the enhanced value of being truthful." Numerous other photographers were sent to shoot this war, Reinholt Thiele and H.C. Shelley for example, but many scenes were shot by British soldiers and volunteers who brought their own Kodaks to South Africa. The deplorable conditions of British concentration camps, in which 40,000 women and children died of disease and starvation, were undeniable due to the many photographs taken within the camps of the victims.

Conclusion

While many battles from the larger wars were more frequently photographed, photographs also evidence the colonization by Europeans and Americans around the globe. In many countries, photos of famous cultural sights and exotic locales were taken once an area was conquered. Many of these images were used to lure westerners to become settlers in a certain area and to romanticize the prowess of western cultures at exploration.

Photography was also utilized as a military tool throughout the second half of the nineteenth century. Most military expeditions had a trained photographer as part of their troops. Some armies maintained an entire unit of photographers. Photographic technology was also used to reproduce maps, study military maneuvers and the terrain, and to train servicemen.

In the majority of battles, photographers were successful at performing their role as observers of both sides. Yet in some cases photographers were taken as prisoners when suspected of spying for the enemy. In addition, photographers were frequently warned against photographing any military details and could be imprisoned if such images were ever published. Some soldiers felt uncomfortable with the new technology, as discussed above during the American Civil War. Native American warriors, in fact, frequently avoided the camera for fear that the strange contraption would somehow capture their soul.

The time needed to set up the equipment, the slow development time, and the simple fact that a photographer had to shoot something before them rather than creating it in their mind, made photography a challenging medium to work with in the nineteenth century. Yet, the camera's seeming ability to capture reality also made the desire to take photographs of battlefields and soldiers simply irresistible. By World War II, photographs would be the primary source of images for newspapers informing the public about the war.

DEBRA GIBNEY

See also: Half-tone Printing; Daguerreotype; McCosh, John; Expositions Universelle, Paris (1854, 1855, 1867, etc.); Fenton, Roger; Agnew, Thomas; Victoria, Queen and Albert, Prince Consort; Robertson, James, Beato, Felice; Langlois, Jean Charles, Brady, Mathew B.; Gardner, Alexander; Tintype (Ferrotype, Melainotype); and Nicholls, Horace Walter.

Further Reading

Anderson, *Glass Warriors: The Camera at War,* London: Harper Collins, 2005.
Armstrong, Jennifer, *Photo by Brady: A Picture of the Civil War,* New York: Atheneum, 2005.
Baldwin, Gordon, Malcolm R. Daniel, and Sarah Greenough, *All the Mighty World: The Photographs of Roger Fenton,* New Haven, Conn.: Yale University Press, 2004.
Burns, Stanley, *Civil War Medical Photography,* New York: Stanely Burns, 1983.
Clattenburg, Ellen Fritz, *The Photographic Work of F. Holland Day,* Wellesley, Mass.: Wellesley College Museum, 1975 (exhibition catalogue).
Fabian, Rainer, *Images of War: 130 Years of War Photography,* Norfolk: Thetford Press Ltd., 1985.
Fenton, Roger, Helmut Gernsheim, and Alison Gernsheim, *Roger Fenton, Photographer of the Crimean War, His Photographs and Letters from the Crimea,* London: Ayer, 1954.
Gardner, Alexander, *Gardner's Photographic Sketchbook of the American Civil War 1861–1865,* New York: Delano Greenridge Editions, 2001.
Harris, David, *Of Battle and Beauty: Felice Beato's Photographs's of China,* Santa Barbara, CA: Santa Barbara Museum of Art, 1999.
Howe, Peter, *Shooting Under Fire: The World of the War Photographer,* New York, NY: Artisan, 2002.
Kagan, Neil, *Great Photographs of the Civil War,* Birmingham, Ala.: Oxmoor House, 2003.
Kelbraugh, Ross, *Introduction to Civil War Photography,* Gettysburg, Penn.: Thomas Publications, 1991.
Knightley, Philip, *The Eye of War: Words and Photographs from the Front Line,* Washington D.C.: Smithsonian Books, 2003.
Lewinski, Jorge, *The Camera at War: A History of War Photography from 1848 to the Present Day,* New York: Simon and Schuster, 1978.
Marien, Mary Warner, *Photography: A Cultural History,* New York: Prentice Hall, and Harry N. Abrams, 2002.
Moeller, Susan, *Shooting War: Photography and the American Experience of Combat,* New York: Basic Books, 1989.
Palmquist, Peter, *Photographing the Modoc Indian War: Louis Heller versus Eadweard Muybridge,* London: Taylor and Francis, 1978.
Pare, Richard, Roger Fenton, New York: Aperture Foundation, 1987.
Russell, Andrew, *Russell's Civil War Photographs,* New York: Dover, 1982.
Sullivan, George, *In the Wake of the Battle: The Civil War Images of Matthew Brady,* New York: Prestel Publishing, 2004.
Weber, Eva, *Great Photographers of the Civil War,* North Dighton, Mass.: JG Press, 2003.
Wilson, Jackie Napoleon, *Hidden Witness: African-American Images from the Dawn of Photography to the Civil War,* New York: St. Martin's Griffin, 2002.
Zeller, Bob, *The Blue and Gray in Black and White: A History of Civil War Photography,* Westport, Conn.: Praeger Publishers, 2005.

WARD, CATHERINE WEED BARNES (1851–1913)

Born in Albury, New York January 10, 1851, Catherine Barnes traveled with her parents to Russia in 1872. Introduced to photography in 1886, she built her own studio in the attic of her home. She was appointed associate editor of American Amateur Photographer, wrote and lectured extensively on photography, and became known as an advocate for women in photography with her talk

"Photography from a woman's standpoint" (1890). Her appointment as editor was followed by a visit to England, where she was enrolled into the Photographic Society of Great Britain, and married the photographic journalist Henry Snowden Ward (1865–1911).

Together with her husband, Ward edited *The Photogram* (1894–1905), continued as *The Photographic Monthly*, and *The Process Photogram* (1895–1905), continued as *The Process Engraver's Monthly*. They collaborated on a series of topographical volumes, with photographs taken by Mrs Ward, including Shakespeare (1896, 1897), Dickens (1903), Chaucer (1904), and Lorna Doane (1908).

Snowden Ward died suddenly in New York in 1911, while on a lecture tour to promote the Dickens centenary. Catherine returned to England, but her health deteriorated, and she died in Hadlow, Kent July 31 1913.

DAVID WEBB

WARD, HENRY SNOWDEN (1865–1911)

Henry Snowden Ward was born in Bradford. In 1884 he became associated with the Bradford photographic publishers and stationers Percy Lund & Co, for which he founded and edited *The Practical Photographer* in 1890.

In 1893 he left Lund and with his new wife, Catherine, started *The Photogram* which became *The Process Photogram* in 1895 and *The Process Engravers Monthly* from 1906. American edition and deluxe editions were also published. An annual *Photograms of the Year* also appeared from 1894.

Although his activities as a photographic technical author were extensive Ward was also an active participant in the [Royal] Photographic Society and the Photographic Convention and he was in demand at photographic societies as a judge. He was important in disseminating new discoveries and improvements, particularly in the area of photo-mechanical printing. He was one of the first experimenters with X-rays and wrote a handbook on the subject *Practical Radiography* (1896) and was a founder of the Röntgen Society. Ward was an enthusiastic proponent of record photography and was one of the first to draw attention to the use of photography in press illustration. He established a bureau to supply photographs to the press.

Although Ward's work with his process journals continued until his death from the later 1890s he began increasingly to explore the application of photography to the illustration of literary works. He authored books dealing with Shakespeare (1896), Dickens (1904), Chaucer (1904) and an edition of *Lorna Doone* (1908). These were usually illustrated with Catherine's photographs. He undertook extensive lecture tours on liter-

ary subjects and during one to New York he died on 7 December 1911.

His American wife Catherine Weed Ward (neé Barnes) who was an accomplished photographer and photographic journalist in her own right died on 31 January 1913.

MICHAEL PRITCHARD

WARNERKE, LEON (VLADISLAV MALAKHOVSKII) (b. 1837)

A Russian-born civil engineer, Warnerke moved to London before 1870 where he established himself as a photographer and opened one of the earliest photographic laboratories. By 1880 he had business interests in both the United Kingdom and Russia, living periodically in both south-east London and St Petersburg, where he opened a photographic manufacturing facility.

He is credited with the discovery (c.1875) of the tanning effect of pyrogallic acid when used in the development of collodion and, in 1880, with the development of the Warnerke sensitometer, the first effective device for the measurement of plate speed. This he used for pioneering sensitometric investigations of gelatine dry plates and early silver bromide emulsions.

In 1875 he designed a roll-holder for 100-exposure silver bromide collodion stripping paper, predicting the development of Eastman's stripping films in the following decade, and in 1882 he was awarded the Progress Medal of the Royal Photographic Society. From 1889 his factory manufactured silver chloride printing papers.

Warnerke's interests extended beyond photography. He is remembered in monetary circles as one of the greatest banknote forgers of all time, having been responsible for the forgery of several eastern European currencies, most particularly Russian roubles. He was never caught, and supposedly died in 1900—at the age of 63—but it is likely that he faked his own death to escape arrest.

JOHN HANNAVY

WASHINGTON, AUGUSTUS (c. 1820–1875)
Daguerreotypist and teacher

Augustus Washington was born in Trenton, New Jersey, in 1820 or 1821 to a former slave and his South Asian wife. His father Christian ran an oyster saloon in Trenton. Washington's mother probably died shortly after Augustus was born, as records show his father married a woman named Rachel in October 1821.

Attaining a solid education and sharing this knowledge with others dominated Washington's early life. He attended private schools in Trenton alongside white

children until the mid-1830s, when the activities of free blacks were restricted. At that time, educational opportunities for black students were suddenly limited due to the white population's fears about plans that called for the immediate abolition of slavery. In reaction, Washington briefly ran his own school for local African Americans.

Washington was able to further his education at Oneida Institute in Whitesboro, New York, one of only a few private schools that accepted African American students. With the help of abolitionists, he studied there for over a year before a lack of money forced him to leave school and seek employment. Washington's financial woes would continue to interfere with his academic dreams.

In 1838 Washington accepted a teaching position in Brooklyn, New York, at the African Public School. For the next three years he taught in Brooklyn, contributing articles and serving as a subscription agent for *The Colored American*, a new weekly newspaper written by blacks for a black audience. He also attended anti-colonization society meetings and organized voting rights meetings in New York and New Jersey.

Washington furthered his education, first at Kimball Union Academy in Meriden, New Hampshire, and later in the fall of 1843 at Dartmouth College, where he was the only black student. During the winter school vacation, Washington learned the daguerreotype process while visiting family in Trenton. He returned to Dartmouth, making and selling portraits to help pay his school expenses. Unfortunately, he did not earn enough money to continue his studies.

For the next ten years Washington lived in Hartford, Connecticut, working initially as a teacher for black children at the North African School from the fall of 1844 to 1846. Later that year, he opened a daguerreotype studio in Hartford. After the studio had been open a few months, he moved his operation to the city's business district on Main Street. Surviving images from this period indicate that his studio catered to Hartford's white population, attracting many prominent citizens, including Connecticut author Lydia Sigourney and Eliphalet Bulkeley, a Hartford lawyer and judge.

One of Washington's earliest and best-known extant portraits depicts the abolitionist John Brown. Washington posed Brown in an unconventional manner that accentuates the subject's importance. Brown stands with his right hand raised as if taking an oath, while his other hand holds a flag that might symbolize Brown's "Subterranean Pass Way," his plan for an Underground Railroad.

Washington generally posed his customers seated, with the sitter's right arm resting on a table. Men usually faced the camera straight on, while women sat at a slight angle, holding a daguerreotype case, book,

or flowers. A broadside for Washington's daguerrean gallery published in July 1851 boasts that the studio "... is the only gallery in Hartford, that has connected with it, a Ladies' Dressing-Room, and has a female in constant attendance to assist in arranging their toilet." The broadside also mentions that Washington had just spent three months in New York,... and availed himself of all the latest improvements in the Art."

Washington's commercial success could not offset the racial problems he and other African Americans faced in the middle of the nineteenth century. In 1850 Congress passed the Fugitive Slave Act, which threatened the freedom of all African Americans. Washington expressed his dissatisfaction with life in America in a letter published in the *New York Times* writing, "Strange as it may appear, whatever may be a colored man's natural capacity and literary attainments, I believe that, as soon as he leaves the academic halls to mingle in the only society he can find in the United States, unless he be a minister or lecturer, he must and will retrograde."

In 1850 Washington married Cordelia Aiken. He searched for a better place to live with his family, and considered relocating to Canada, Mexico, the West Indies, British Guiana, or various countries in South America. In spite of his previous involvement with anti-colonization efforts, Washington ultimately decided to immigrate to Liberia under the auspices of the American Colonization Society. Since its founding in 1816, the American Colonization Society, a private philanthropic organization, had worked to relocate freeborn and emancipated blacks to Liberia on the west coast of Africa. In 1847 Liberia became an independent republic, run by many former African Americans.

In November 1853 Washington closed his successful daguerreotype studio in Hartford, Connecticut, and with his wife and two young children sailed for Liberia on the *Isle de Cuba*. He began making portraits shortly after he landed, and his business was an immediate success, selling roughly $500 worth of portraits during his first five weeks of operation. In a letter to John Orcutt, Traveling Agent of the American Colonization Society, Washington wrote: "I put my price down to what people consider cheap, $3 for the cheapest picture, and when I am able to work I go to my room and take some 20, 30, or 40 dollars worth of pictures in a day. I have hired boys whom I send to tell as many as I can attend to." Washington planned to spend six months of the year working as an artist and the remaining six months as a merchant.

Washington's Liberian work is more varied in both style and subject. For his portrait photographs, Washington used several different poses. He photographed Liberia's President Stephen Benson in a near profile. A series of portraits attributed to him, depicting members of Liberia's senate, are much less formal than traditional

studio portraits. The sitters are posed as if working in the Senate chamber. Liberian artist Robert K. Griffin used these images as studies for a watercolor painting of the Senate he created in the mid 1850s. Washington also worked outdoors, producing landscape views of Monrovia that were published by the American Colonization Society. Unfortunately, these images are known only through published engravings.

When business slowed in Liberia, Washington traveled to Sierra Leone, Gambia, and Senegal to ply his trade. Eventually, he exhausted his daguerreotype supplies. He placed orders with suppliers in the United States, but had to wait several months before he received supplies, causing disruptions in business.

Despite his early success as a daguerreotypist in Monrovia, Washington became convinced that the only practical means of securing wealth, prosperity, and political importance in Liberia lay in developing the country's agricultural resources. Washington established a farm on the St. Paul River, twenty miles from Monrovia, where he grew sugarcane and other crops. At its peak, his farm employed more than fifty workers. He also held various positions in Liberia's House and Senate, including speaker.

Washington died in Monrovia, Liberia on 7 June 1875. At the time of his death, he was the owner and editor of the *New Era* newspaper.

Approximately sixty-five portrait daguerreotypes by Augustus Washington are extant. His daguerreotypes are in the collections of the Library of Congress, the Connecticut Historical Society, and the Smithsonian Institution, as well as many private collections.

CAROL JOHNSON

Biography

Augustus Washington was born in 1820 or 1821 in Trenton, New Jersey. He married Cordelia Aiken in 1850. The couple had three children. Washington was one of a small number of African American photographers to work as a daguerreotypist in the middle of the nineteenth century. He initially pursued photography in order to finance his education, selling portraits while studying at Dartmouth College in Hanover, New Hampshire. In 1846 he opened a successful daguerreotype studio in Hartford, Connecticut, where his sitters included the abolitionist John Brown. In 1852 he was awarded a silver medal for his portraits from the Hartford County Agricultural Society. The following year, Washington and his family moved to Liberia, on the west coast of Africa, where he continued to make daguerreotypes until he established himself as a farmer, political figure, and businessman. Washington died on 7 June 1875 in Monrovia, Liberia.

See also: Daguerreotype.

Further Reading

Johnson, Carol, "Faces of Freedom: Portraits from the American Colonization Society Collection." *The Daguerreian Annual*, 1996, 264–278.

——, "Photographic Materials" in *Gathering History: The Marian S. Carson Collection of Americana*, Washington, D.C.: Library of Congress, 1999.

Kernan, Michael, "A Durable Memento." *Smithsonian*, 30, no. 2 (May 1999): 26–28.

Moses, Wilson Jeremiah, *Liberian Dreams: Back–to Africa Narratives from the 1850s*, University Park: Pennsylvania State University Press, 1998.

Shumard, Ann, "Augustus Washington: African American Daguerreotypist" in *Exposure*, 35:2 (2002) 5–16.

——, *A Durable Memento: Portraits by Augustus Washington African American Daguerreotypist,* Washington, D.C.: Smithsonian Institution Press, National Portrait Gallery, 1999.

Sullivan, George, *Black Artists in Photography, 1840–1940*, New York: Cobblehill Books, 1996.

Willis, Deborah, *Reflections in Black: A History of Black Photographers 1840 to Present*, New York: Norton, 2000.

WATERHOUSE, JAMES (1842–1922)

James Waterhouse was a career soldier who made significant contributions in a number of technical and historical areas of photography. He was an industrious writer who combined a desire to innovate with aesthetic awareness and an antiquarian's sensibility. His keenness to explore unusual avenues was tempered by a readiness to retract when they turned out to be cul-de-sacs. He showed a willingness to go back to first principles to learn lessons of contemporary relevance, as with his examination of the daguerreotype process. His reputation has not endured for a number of reasons: the specialised nature of the subjects he scrutinised; because many of his articles were published in India and did not achieve a wide circulation; and because his findings were often incorporated into the research of later historians without appropriate attribution.

Waterhouse began his military training at the East India Company's Addiscombe College, where he was probably introduced to photography. Most of his service was spent in India as Assistant Surveyor-General. Part of the work of the Survey of India was concerned with making the production of maps and engineering plans more efficient, and Waterhouse researched improved techniques of photo-mechanical reproduction, as described in Charles Black's 1891 overview of the work of the Indian Surveys.

In 1878 Waterhouse toured European photographic laboratories, notably the Military Geographical Institute in Vienna, augmenting his findings with his own experiments, as a result of which he introduced improvements in photo-collotype and photolithography. In 1882 he developed a heliogravure technique for producing halftone prints. In 1887, after another visit to Vienna, he introduced a photo-etching process that was a great im-

provement over photo-collotype because it had greater resistance to variations in temperature and humidity, and could make far more impressions.

He became an authority on photography under tropical conditions, making numerous chemical trials using ingredients available locally. After confirming Vogel's 1873 finding that the sensitivity of plates to red and green could be enhanced, he examined the efficacy of other dyes, notably eosine, which in 1875 he discovered had the effect of increasing the sensitivity of haloid salts of silver to yellow light. In his presidential review for the Asiatic Society of Bengal in February 1889 he was able to outline the usefulness of eosine in preparing orthochromatic plates for use in copying paintings and photo-spectroscopy. That year he also established the effect of alizarine blue in increasing the sensitiveness of gelatine dry plates to the red end of the spectrum.

As well as his scientific studies, Waterhouse undertook three trips around central India in 1862 during which he took large quantities of photographs under difficult conditions for the pioneering ethnographic study *The People of India*, published in eight volumes between 1868 and 1875. He participated in the observations of the total solar eclipses of 1871 and 1875. For the observation of the transit of Venus in 1874 he took 100 photographs at Roorkee in India, and was fortunate to take the only sharp image of all the expeditions.

In 1875 he published the results of experiments on the solar spectrum using an aniline blue dye he had obtained from a local market. This enabled him to record lines in the solar spectrum less refrangible than A, but reversed: absorption lines appeared opaque on the transparent body of the spectrum instead of the normal transparent on an opaque body. He amplified these findings in a paper read to the Royal Photographic Society (RPS) in 1898 in which he noted that the degree of reversal tended to be a function of length of exposure and varied according to the stain used.

In 1890 Waterhouse found that adding thiourea to an alkaline developer caused a reversal of the image on dry plates but without a significant increase in the length of exposure, and in the same year he examined guaiacol as a cheaper alternative to catechol as a developer for dry plates. The following year he examined the generation of electrical current during development of gelatine dry plates. He returned to guaiacol in 1893, reporting on chemical analyses of it and allied phenoloid compounds, and in an addendum noted that the Lumières in Lyon had found that guaiacol in its pure form was not a developer, and that any developing action was caused by impurities. He followed up a paper by the Lumères in 1899 on the efficacy of fatty amines as accelerating agents, establishing that dipropylamine was the best but of limited practical benefit because of its price.

In 1893 he published a paper on the effect of light on silver salts and devoted the 1899 Traill Taylor Memorial Lecture to an analysis of the daguerreotype process and the lessons it held concerning the action of light on silver haloid compounds. The theme was continued in a paper he presented to The Royal Society the following year on the degrees of sensitivity of metals to light, in which he reported a wide range of experiments conducted on different forms of silver surfaces, as well as other metals, in order to examine the chemical reactions involved.

During his retirement, Waterhouse engaged more in historical research, but always with an eye on contemporary relevance. He studied the early history of the telephoto lens, and his influential paper on the camera obscura gathered a large number of references, in the process demolishing Porta's claim to have invented the device. He surveyed the pre-history of photography in the Smithsonian Institution annual report of 1903. Significantly, his 1905 presidential address to the RPS was on "by-ways of photography."

As well as technical articles, he was happy to write for a more popular audience, for example contributing an article on Niepce's early photographic work with bitumen to *Penrose's Pictorial Annual* for 1913–1914. He organised the Victoria and Albert Museum's 1905 *Loan Exhibition of Process Engraving*, for which he wrote the catalogue's introduction. Waterhouse was awarded the RPS's Progress Medal in 1890 for his spectrographic work on dyes and the development of orthochromatic photography, and the Voigtländer Medal of the Vienna Photographic Society in 1895 for his contributions to scientific photography.

TOM RUFFLES

Biography

James John Waterhouse was born 24 July 1842 and joined the Royal Bengal Artillery at 17. From July 1866 he spent five months with the Great Trigonometrical Survey at Dehra Dun learning photozincography before becoming Assistant Surveyor-General in charge of the photography section in the Surveyor-General's Office in Calcutta. As well as writing on photography, he also published on general matters relating to the Survey. He retired in 1897 with the rank of Major-General, when he returned to England. He never married. Among other positions, he was President of the Asiatic Society of Bengal from 1888 to 1890, President of the Photographic Society of India from 1894 to 1897, and President of the Royal Photographic Society from 1905 to 1907. He became a Fellow of the Royal Astronomical Society in 1876. He died at Eltham on 28 September 1922.

A portrait of James Waterhouse appears in *The Photographic Journal*, vol. 27 (1903): 217.

See also: Heliogravure; and Daguerreotype.

Further Reading

Black, Charles E. D., *A Memoir on the India Surveys 1875–1890*, London: Her Majesty's Secretary of State for India in Council, 1891.

Falconer, John, "'A Pure Labor of Love': A Publishing History of The People of India." In Hight, (eds.), *Colonialist Photography: Imag(in)ing Race and Place*, edited by Eleanor M., and Gary D. Sampson. London: Routledge, 2002, 51–83.

Ryan, James R., *Picturing Empire: Photography and the Visualization of the British Empire*. Chicago: The University of Chicago Press, 1997.

Waterhouse, J. *Report on the Cartographic Applications of Photography as used in the Topographical Departments of the Principal States in Central Europe, with Notes on the European and Indian Surveys*, Calcutta: Office of Superintendent of Government Print, 1870.

Waterhouse, J., "On Reversed Photographs of the Solar Spectrum beyond the Red, obtained on a Collodion Plate" *Proceedings of the Royal Society of London*, vol. 24 (1875–1876): 186–189.

——, *The Application of Photography to the Reproduction of Maps and Plans; by the Photomechanical and Other Processes*, Calcutta: Baptist Mission Press, 1878.

——, "On Alizarine Blue." *The Photographic Journal*, vol.13 (1889): 81–82.

——, *Practical Notes on the Preparation of Drawings for Photographic Reproduction. With a Sketch of the Principal Photo-Mechanical Printing Processes*, London: K. Paul, 1890.

——, "Note on Some Curious Cases of Reversal of the Photographic Image in Solar Photographs." *The Photographic Journal*, vol. 22 (1898): 307–314.

——, "Teachings of Daguerreotype." *The Photographic Journal*, vol. 24 (1899): 60–76.

——, "The Sensitiveness of Silver and of some other Metals to Light." *Proceedings of the Royal Society of London*, vol. 66 (1899–1900): 490–504.

——, "Notes on the Early History of the Camera Obscura." *The Photographic Journal*, vol. 25 (1901): 270–290.

——, *The Beginnings of Photography: A Chapter in the History of the Development of Photography with the Salts of Silver*, Washington DC: Smithsonian Report for 1903, Government Printing Office, 1904, 333–361.

WATKINS, ALFRED (1855–1935)

Following practical experience with the wet-plate process in the 1870s, Alfred Watkins welcomed the arrival of the dry plate, and within a few years, his accumulated skills encouraged him to address some of the perceived complications of photography. In the 1880s, he worked as a commercial traveller in Hereford, and annexed an out-building to set up the Watkins Meter Company, where he devised instruments to control bakery processes, as well as meters to simplify photographic tasks. His background knowledge allowed him to compress a number of associated factors into one single function.

On the death of his father in 1889, Watkins declined to join the family firm, but concentrated on local history and photography. In 1890, he addressed the Society of Chemical Industry to launch his Standard Exposure Meter, which combined an actinometer and calculator, in a tubular form. By analogy, the actinometer related the time to darken a sensitised paper, to camera exposure. A chain served as a pendulum for counting the actinometric record (that is, the strength of the ambient light) as well as timing seconds (for the chosen plate), and the calculator expressed five variable factors as the exposure recommendation. By dispensing with his "subject factor," Watkins introduced the simpler Junior Meter in 1895, along with the New Standard Exposure Meter, which was "absolutely complete for all problems," including copying, enlarging and contact printing. The compact Watch Exposure Meter followed and the pendulum survived, but the movements were simplified to a single scale. Watkins' ideas on photometry kept pace with improvements in photography, and in 1902, the design of the Watkins Bee Meter anticipated interchangeable printed discs at a later date to cope with cinematography, colour and studio conditions. (The Queen Bee Meters of 1903 and 1908 were de-luxe versions in a silver case and complete with a ball and chain pendulum.) Other meters included the Focal Plane (1907), the Colour Plate (1909), the Hand Camera and the Chronograph (1910), the Indoor (1911), and in 1920, the Watkins Snipe Meter, a simple meter for avoiding under-exposed snapshots.

All designs were supported by practical tests and Watkins' five axioms ("the standard truths"), identified the essentials of exposure, from which he determined a protocol to determine emulsion speed. That is, "an object of average colour twenty-five feet from lens" became the "standard" for two seconds of' exposure to mid-day June sunlight in England; his basic plate speed (1). Using this criterion, he issued annual lists of speeds, until he was able to derive his required values from speeds determined by the Hurter and Driffield method. In 1894, he promoted a simple system for correct development, which applied a factor (the Watkins Factor) to the appearance of the negative image.

In 1910, Watkins received The Royal Photographic Society's Progress Medal for his "methods and applications" relating to exposure and development. In spite of his photographic achievements, in many circles Alfred Watkins was better known as an antiquarian, who surveyed churches, pigeon-houses and standing crosses, prior to announcing controversial studies of ancient track ways, and founding the Old Straight Track Club in the 1920s.

RON CALLENDER

See also: Royal Photographic Society.

Further Reading

Hallett, M, Watkins, A True Amateur, *The British Journal of Photography,* 12 (August 4, 1988).

Newham, D, The Ley of the Land, *The Guardian Weekend,* 20, 13 May 2000.

Shoesmith, R, 1990, *Alfred Watkins: A Herefordshire Man,* Woonton: Logaston Press

Watkins, A, 1911, *Photography: Its Principles and Applications,* London: Constable and Co Ltd.

——, 1919, *The Watkins Manual,* Hereford: The Watkins Meter Company

——, "The Mathematical Calculation of Exposures," *The British Journal of Photography* 37, 247(1890).

——, "Timing Development," *The British Journal of Photography* 41, 697 (1894).

WATKINS, CARLETON E. (1829–1916)
American photographer

Well-known photographers of the nineteenth-century American West such as Charles Roscoe Savage, Timothy O'Sullivan, Jack Hillers, Andrew Joseph Russell, and William Henry Jackson are all praised for a variety of reasons. They documented historical events, they traveled to the remote corners of the West and photographed its spectacular scenery, they furthered the budding science of geology, and they documented the natural resources of the West for the United States Congress and the American public. Carleton Eugene Watkins, however, in addition to doing all of the above also gained critical acclaim as an artist. Not only did Watkins win praise from his contemporaries in the Eastern United States and also in Europe, but he was also praised by subsequent generations of art historians and critics. Initially

Watkins was recognized mainly for his photographs of the area now known as Yosemite National Park. Despite the difficulties of taking mammoth-plate negatives in an incredibly remote area, these images were known for their composition, flawless character, depth of detail, and excellent use of light. Watkins, however, photographed up and down the West Coast (as far north as British Columbia and as far South as Mexico) and also in Arizona, Nevada, Utah, Idaho, Montana, and Wyoming. While it is true that throughout his life he pursued nature's "grand view," Watkins also sought to show the subtle relationships between man and nature.

C. E. Watkins was born on November 11, 1829, in Oneonta, New York the oldest of eight children. In 1851 he left New York for California with another Oneonta native, Collis Huntington. Huntington was destined to become one of the most wealthy and powerful men in California and throughout Watkins' life he received financial support from his friend. Watkins initially worked as a clerk in Huntington's Sacramento store, but after a fire destroyed the store in 1852 he became a clerk in a bookstore owned by George W. Murray. Murray and Watkins would relocate to San Francisco in 1853 and in the fall of 1854 well-established daguerreotypist Robert Vance asked Watkins to temporarily replace an employee who had suddenly left his job.

Watkins learned the job so well that Vance kept him employed taking studio portraits. In 1856 Watkins left Vance to run a studio in San Jose (specializing in ambrotypes of babies), but apparently Wakins left that job as well before the end of the year. Watkins's activities

Attributed to George Davidson. Pack Train-Resting. From the Mount Conness, Sierra Nevada.
The J. Paul Getty Museum, Los Angeles © The J. Paul Getty Museum.

between 1856 and 1860 are not entirely clear. In 1858 he took photographs of the Guadelupe Quicksilver Mine for a land fraud case. In 1859 and 1860 he was hired by John C. Fremont and Trenor William Park to photograph their Mariposa estate. Watkins also took photographs of the New Almaden and New Indria Mines and Washerwoman's Bay at San Francisco. In 1861 his photographs were used as evidence in *U.S. v. D. and V. Peralta*. It was this experience that prompted him to build one of the earliest mammoth-plate cameras in America, capable of taking eighteen by twenty inch negatives.

By 1861 Watkins had established a more or less permanent studio in San Francisco. Although by that time he had earned a reputation as a competent outdoor photographer, it was the 30 mammoth-plate negatives and the 100 stereo-view negatives Watkins took of the Yosemite area that brought him national and even international praise. Watkins was not the first photographer to visit Yosemite (C.L. Weed had taken pictures there in 1859). He was, however, the first to use a mammoth-plate camera to achieve incredibly detailed views. In 1862 Goupil's Art Gallery in New York City featured the Yosemite photographs in an extremely popular exhibit. Copies of his Yosemite images won praise from Oliver Wendell Holmes, Ralph Waldo Emerson, and from the leading American photographic magazine, the *Philadelphia Photographer*. Watkins's photographs also no doubt played a part with legislation passed by the United States Congress in 1864 declaring Yosemite to be "Inviolate." Watkins became the first American photographer whose prints were displayed as fine art.

Due to the widespread interest with his Yosemite pictures, Watkins's other photographic exploits have not received as much attention. For three decades he crisscrossed California photographing railroads, mines, different species of trees, private estates, old Spanish missions, the Sierra Nevada mountains, the coastline, the San Francisco Bay area, and, of course, Yosemite. In 1867 Watkins also took the first of many out-of-state trips, photographing Oregon's coastline, settlements, mountains, and the Columbia River. On later trips he photographed the Comstock Lode mines in Nevada (1871 and 1875), scenes along the Central Pacific and Union Pacific Railroads in Nevada and Utah (1873), the Southern Pacific Railroad route in Arizona (1880), the coastlines of Washington and British Columbia (1882), and scenes in Idaho, Montana, and Yellowstone National Park (1884 and 1885). His last major trip was to the mines in Butte Montana in 1890.

Despite widespread acclaim, poor business decisions and bad fortune hurt the aging photographer financially. In the early 1860s he failed to identify and copyright his work and consequently many of his views were pirated and reprinted. In the mid-1870s his studio and collection of negatives were seized by creditors and sold to a competitor, I.W. Tabor, who reissued many of the images without credit. As tourism increased in the late nineteenth-century, his artistic style did not work well with tourists who wanted cheap and predictable images. Watkins' had trouble paying his bills and was forced to change studio locations on a number of occasions. Furthermore he did not advertise, instead relying on word of mouth, which no doubt created confusion for his would be customers. At the brink of almost complete destitution in the 1890s, his old friend Huntington stepped in and gave Watkins a small ranch near Sacramento as a retirement home. He lived at the ranch for several years before moving back to San Francisco. Unfortunately for posterity, the 1906 San Francisco earthquake destroyed all of his negatives along with a priceless collection of early California daguerreotypes. Tragically, this material was about to be transferred to the state for safekeeping. After the earthquake Watkins's health and mind continued to deteriorate and he died in 1916 at the Napa State Hospital for the Insane.

DANIEL M. DAVIS

Biography

Carleton E. Watkins was born in 1829 in Oneonta, New York. He moved to Sacramento California in 1851 and worked as a clerk and as a carpenter before being trained by Robert Vance as a portrait daguerreotypist. He soon moved to outdoor photography and he took a variety of commissions around the San Francisco Bay area between 1856 and 1861. The images that would make him famous, however, were taken in 1861 of the spectacular Yosemite region. These photographs won praise throughout the United States and even in Europe and were probably the first photographs taken by an American to be considered fine art. Watkins was not only a technical expert at using a mammoth camera to produce incredibly detailed and flawless negatives, but he also had an eye for composition and light. Although Watkins is best known for his Yosemite images, he traveled throughout the West Coast and in other western states in the 1860s, 1870s and 1880s. These later views show a sensitivity to the relationships between the frontier American settlements and the natural resources that supported them. Although Watkins had a generous and warm personality, he was a poor businessman. He suffered a series of financial and personal setbacks, and at one point he and his family (he married Frances "Frankie" Henrietta Sneed in 1879) were living in a railroad car. He was fortunate though to have the support of Collis Huntington, Josiah D. Whitney and others who supported him fiscally and encouraged him artistically. He died in Napa, California in 1916.

See also: O'Sullivan, Timothy Henry; Russell, Andrew Joseph; Jackson, William Henry; Vance, Robert; Weed, Charles Leander; and Goupil & Cie.

Further Reading

Coplans, John, "C.E. Watkins at Yosemite." *Art in America,* vol. 66, no. 6 (November/December 1978).

Naef, Weston J., and Wood, James N., *Era of Exploration: The Rise of Landscape Photography in the American West, 1860–1885,* Buffalo and New York City, New York: Albright-Knox Art Gallery and The Metropolitan Museum of Art, 1975.

Nickel, Douglas R., *Carleton Watkins: The Art of Perception,* New York: Harry N. Abrams, 1999.

Pamquist, Peter E., and Kailbourn, Thomas R., *Pioneer Photographers of the Far West: A Biographical Dictionary, 1840–1865,* Stanford, California: Stanford University Press, 2000.

Palmquist, Peter E., *Carleton E. Watkins: Photographer of the American West,* Albuquerque: University of New Mexico Press, 1983.

Rule, Amy (ed.), *Carleton Watkins: Selected Texts and Bibliography,* Boston, MA: G.K. Hall & Co., 1993.

WATKINS, HERBERT (1828–C.1901)
English portrait photographer

George Herbert Watkins was born in Worcester, England, on July 12, 1828, and was still alive at the time of the 1901 census, aged 73, and living in the Kensington Workhouse. At the same date, his wife Augustin was listed as a widow living alone.

Watkins' first studio opened at No.179 in London's Regent Street in the mid 1850s, producing high quality portraiture, and by 1858 had moved to No.215. His first public display of his celebrity portraits was at the 1856 Exhibition of the Photographic Society in London. In the 1857 Exhibition he included portraits of Owen Jones, George Cruikshank, and others, and a fine portrait of Charles Dickens working at his desk.

His *National Gallery of Photographic Portraits* with accompanying texts by Herbert Fry, a ten-part 'photographic serial' was published in 1857 continued publication into 1858, each issue containing four or five portraits. By 1857 he was additionally producing still life images and, most particularly, microphotographs. Along with John Benjamin Dancer, George Shadbolt and Alfred Rosling, he was a leading figure in the production of these tiny images. Watkins marketed many of his portraits as cartes-de-visite throughout the 1860s and 70s, subjects including celebrated portraits of Wilkie Collins, Michael Faraday and many others.

The 1871 census listed him as living alone in St. Pancras.

JOHN HANNAVY

WATSON, WILLIAM (1815–1881) & SONS
Optician and optics manufacturer

William Watson established his business as an optician in 1837 in London. It moved to 313 High Holborn in 1862 and remained there until 1957 before moving to Barnet, Hertfordshire, where it had had a manufactory since 1906. In 1957 the firm was acquired by Pye and in 1967 it was taken over by Philips, finally closing in 1981.

Watson's son, Thomas Parsons Watson, was responsible for extending the firm's business into optical instrument manufacturing in 1876 when it began making microscopes, one of its most successful and long-lived product lines. A manufactory was established at Dyer's Buildings at the rear of the main premises. The manufacturing of cameras and photographic equipment commenced about the same time. By 1888 extra manufacturing capacity was acquired at Fulwood Rents in Holborn, and finally in 1906 all manufacturing was moved to High Barnet. The factory at Barnet was destroyed by fire in 1910, was rebuilt, and further extended in 1936 and 1950.

Although microscopes continued to be important, photography increasingly occupied an equal position within the firm and in 1878 Watson was appointed the exclusive selling agent for Charles Bennett's gelatine dry plates. The firm's cameras included traditional mahogany tailboard such as the Tourist of 1883 and field cameras for studio and outdoor use with the patented Acme of 1889 being one it's most successful lines. In 1886 their Detective camera was one of the earliest hand cameras available. A number of patents were taken out relating to various photographic improvements.

The firm was an early adopter of standardisation in camera manufacturing and in January 1888 announced that all their own cameras would be built to standard gauges with interchangeable fittings and dark slides. These cameras were identifiable with serial numbers from 6000 onwards starting from January 1, 1888.

Watsons introduced the Vanneck hand camera in 1890 which used an Eastman-Walker roll holder. The camera was still being made in 1902. The Alpa of 1892 was a popular drop-baseboard camera and the 1898 Gambier-Bolton camera was a specialist reflex camera for use with long focus lenses. It had been designed by F W Mills and named after a well-known nature photographer. A twin lens camera appeared in 1894. The firm retailed more complex mechanical cameras from other manufacturers, such as the stereo binocular and monocular models made in Germany.

Their own wood cameras were usually made up in batches of fifty. Watson sold directly in Britain and overseas, and made cameras for other companies to sell under their own name. An Australian sales office

was established in Melbourne in 1886 which operated semi-independently for many years.

It also made a series of portrait, rapid rectilinear, wide-angle and landscape lenses which were later fitted with iris diaphragms. Their Holostigmat Convertible of 1905 was computed by Alexander E Conrady (1866–1944) the firm's optical advisor who was later professor of optics at Imperial College.

Watson was active in areas allied to photography. In 1895 it entered the new area of Röntgen (or X-ray) photography making apparatus in its own works and giving demonstrations in London hospitals. In 1911 a separate branch was established to handle this field and Watson & Sons (Electro-Medical) Ltd was incorporated in 1915, eventually becoming part of GEC. It was briefly involved with cinematography, introducing in late 1896 its Motograph, a well-regarded compact 35mm camera/projector for amateur use. Films were also supplied.

During the early twentieth century until the Second World War, the firm continued to sell its Premier tailboard, Acme field and Alpha hand and reflex cameras but photography became secondary to the manufacture of scientific and optical instruments. One notable exception was the granting of a patent (current untraced) to the company with A C Edwards in 1909 for an antinous release, more generically known as a cable release. Watson was the sole licensee and had sales in the hundreds of thousand.

During the Second World War, it subcontracted the making of cameras to Gandolfi while it concentrated on producing optical munitions. After the war the last family connection with the firm was severed in 1949 when W E Watson-Baker sold his interest to Captain James Cook, a financier and other than the standard Premier camera only special purpose cameras were then advertised.

MICHAEL PRITCHARD

See also: X-ray Photography.

Further Reading

Norman Channing, and Mike Dunn. *British Camera Makers. An A-Z Guide to Companies and Products*, Claygate: Parkland Designs, 1996.

WATTLES, JAMES M. (B. 1812)

The only reference to James Wattles in contemporary accounts of the evolution of photography comes from a meeting between Wattles and Henry Hunt Snelling, recounted in Snelling's 1849 book *The History and Practice of the Art of Photography*.

According to Snelling, Wattles, of New Harmony, Indiana, claimed to have successfully made paper negatives with his camera obscura as early as 1828, at the age of only sixteen.

After meeting Wattles, who was 'wholly ignorant of even the first principles of chemistry, and natural philosophy,' Snelling became convinced of Wattles' claim to have produced 'solar picture drawings' on paper soaked in what Wattles described as 'caustic' and then 'common potash.' After exposures of 45 minutes, he then fixed them in a salt solution and assured Snelling that he 'plainly perceived the effect, in the gradual darkening of various parts of the view, which was the old stone fort in the rear of the school garden, with the trees, fences, &c.' Despite the imperfection of his efforts, Wattles reportedly persevered with his experiments and was increasingly satisfied with the results. He offered Snelling several names who could support his claim, but no further account of his experiments have been traced.

JOHN HANNAVY

WATZEK, HANS (1848–1903)
German photographer

Hans (Johann Josef) Watzek was born on December 20, 1848, in Bílina/Tschechien to a buyer. He visited the academies of arts in Leipzig and Munich and worked toward end of the 1860s as a freelance artist. In Vienna Watzek received training as an art teacher in 1872 at the college of arts and crafts. He taught in Boehmen and established himself starting from 1875 in Vienna. In 1891 he joined a group of amateur photographers in Vienna (the later Camera Club Vienna). By experiments with a simple pinhole camera and the "Monokel" (a simple achromatic eyeglass lens, which is used as a lens in a camera) he, began to consciously use Unschaerfe (blurring) as style means. He dedicated himself to the landscape of his immediate surroundingsof Vienna. In 1893 he was accepted as a member of the Linked Ring Brotherhood London. Together with Heinrich Kühn and Hugo Henneberg, Watzek developed in 1896 multiple gum prints. He was, with Kühn and Henneberg one of the Vienna trifolium from 1897, marking his work with a three-leafed clover symbol. Watzek is considered one the most important Austria Pictorialists. He published numerous articles on primarily technical topics in German-language technical periodicals. Watzek died on May 12, 1903, in Vienna after a long illness.

ASTRID LECHNER

WAXED PAPER PROCESS

When Gaspard Feix Tournachon called, Nadar (1820–1910) wrote in his memoirs "Photography whistled and Le Gray came running." He characterized the exuberant

spirit of one of the most zealous and creative artists to try their hand at photography. The painter Gustave Le Gray (1820–1882) began experimenting with the daguerreotype as early as 1847 and the following year was using variants of Henry Talbot's calotype process. Within three years, he had produced a highly innovative photographic system, the waxed paper negative process. Although the process is part of the paper negative family, it uniquely stands apart from the decade-old calotype announced in 1841.

The crucial difference between the calotype and the waxed paper process is in the preparation of the paper. In the calotype process, a sheet of high quality paper is sensitized with a combination of silver halides, exposed in a camera (either in a dry state or slightly damp), removed, developed, and fixed with sodium thiosulphate. After processing, the translucency of the paper negative could be increased by saturating with wax. This helped increase the contrast and shorten printing times.

In most respects, the preparation of the waxed paper negative parallels the preparation of the calotype, except for one important difference: in Le Gray's waxed paper negative process, the paper is saturated with wax *before* the chemical sensitization. This simple reversal of one step profoundly alters the qualities of the paper. First and foremost, saturating the paper with wax evens out the texture of the paper and fills the interstices of the paper fiber matrix. In its natural state, paper is an overlapping, random web of fibers, held together by chemical and physical interactions. Light can and will travel through this matrix, but will be reflected off of each paper fiber in its path, decreasing in intensity as it passes through. By filling in the interstices of the fiber matrix, the wax changes the sheet's refractive qualities, allowing the light to pass through in a more direct path. The treatment with wax renders the paper negative more homogenous then the calotype and the individual paper fibers will not be as visually pronounced in the final print. The wax, however, does not completely fill the paper, and the sensitizing chemistry is still able to bond and anchor to the cellulose.

A second advantage of the waxed paper process was improved wet strength. The time required to develop a paper negative could be considerable, an hour or more, especially if the photographer was trying to compensate for underexposure. This meant prolonged submersion in an aqueous solution, at the end of which the operator had to handle a water-logged sheet of paper. With the waxed paper negative, much thinner, machine made papers could be employed without the fear of tearing.

Finally, the most practical advantage offered by the new negative process was its impressive longevity. Because of the protective qualities of the wax, a week's supply of fully prepared paper could be stored, ready for photographic excursions. This was an incredible boon to travelling photographers who could prepare negatives ahead of time and consequently lighten the load of photographic equipment required for travel. There were, however, contradictory reports from those travelling in extreme climates. Some accounts suggest difficulty with the process, such as Maxime duCamp (1822–1894), who, despite being instructed by Le Gray himself, failed all attempts at the waxed paper process once he reached Egypt and turned to a variant of the calotype, the wet paper process.

Paper negatives are hand made objects, subject to variations at every stage of preparation, from the selection of paper to sensitizing, processing and printing. However, during the first decade of photography, the range of off-the shelf photographic supplies increased and by mid 1850, waxed paper negative devotees could purchase pre-waxed and pre-iodized papers. In some products, quality was suspect, as noted by the Scottish surgeon and photographer Thomas Keith (1827–1885):

> I have always waxed my own paper, as what I bought waxed was so bad that the half of it was generally useless. By doing it yourself you have it much better done, and it is much more economical then buying it waxed. (*Photographic Notes*, June 10, 1856)

Post-processing manipulations paralleled those of the calotype, including re-fixing, chemical intensification and even reheating the already waxed sheet in an effort to improve weak negatives. Flaws in the image such as spots and stains could be retouched, although the waxy surface made soft graphite stick and powder the media of choice: gouache and watercolor would not readily adhere. Like all other paper negatives, the substrate would easily tear and crease, but was considered robust and durable when compared to the breakable and heavy glass plate negative.

The final image can appear on both the recto and verso of the sheet, and a waxed paper negative can be much darker in normal reflected illumination than its sister process, the calotype. When viewed through transmitted light, however, the dark muddy sheet is transformed into a bright, glowing negative of astounding detail.

Le Gray's endless experimenting led to other innovations and fostered a school of followers who in turn promulgated numerous and unusual modifications to the photographic formulas of the day, such as the turpentine waxed-paper process. Most of the formulas altered the basic process by adding organic components such as gelatin, albumin, collodion, sugar, or lactose. Although the exposures times were reduced, the wax-saturated paper lengthened the processing times and in the hands of a skilled operator, the results were breathtaking.

Some of the greatest photographers of the 19th

century practiced the waxed paper negative. In France, Charles Negre (1820–1880) and Henri Le Secq (1818–1882) followed Le Gray from painting to photography. Victor Prevost (1820–1881) was also trained by Le Gray and traveled to New York. In England, Roger Fenton (1819–1869) was a key photographer in the development of the process, and the young American John Beasley Greene, distinguished himself ca 1856.

Le Gray practiced the wet collodion and waxed paper processes side-by-side throughout much of his photographic career, but by the 1870's he and the rest of the photographic community had completely turned to glass plate photography.

LEE ANN DAFFNER

See also: Calotype and Talbotype; and Daguerreotype.

Further Reading

Brettell, Richard, and Roy Flukinger et al., *Paper and Light: the Calotype in France and Great Britain, 1839–1870*. London: David Godine, 1984.

Crookes, William, *A Handbook on the Waxed Paper Process*. Great Britain: Crookes, 1857.

Delamotte, Philip Henry, *The Practice of Photography: A Manual for Students and Amateurs*. London: Joseph Cundell, 1853.

Jammes, A. and E. Parry Janis. *The Art of French Calotype With a Critical Dictionary of Photographers, 1845–1870*. Princeton, NJ: Princeton University Press, 1983.

Janis, Eugenia Jarry, *The Photography of Gustave Le Gray*, Chicago: The Art Institute of Chicago and the University of Chicago Press, 1987.

La Blanchère, Henri de, *Répertoire Encyclopédique de Photographie*, Paris: Bureau de la Rédaction D'Abonnement et de Vente, 1862.

Le Gray, Gustave, The *Waxed Paper Process*. London: George Knight and Sons, 1855.

Sparling, W., *Theory and Practice of the Photographic Art; Including its Chemistry and Optics*. London: Houlston and Stoneman, 1856.

WEDGWOOD, THOMAS (1771–1805)
English experimenter

Wedgwood, collaborator with Humphry Davy on the first published account of photographic experiments, was the son of the famous English potter and industrialist Josiah Wedgwood. Educated largely at home under the direction of his wealthy and doting father, Tom Wedgwood was given expert tutoring in almost every field of knowledge, from science to art, and counted as friends some of Britain's leading intellectual figures. Although handicapped by a lifelong illness that eventually was to take his life at an early age, he nevertheless worked on a number of projects that attracted the attention of his peers, some practical and some merely philosophical. However it is for his experiments towards a photographic process that he is best remembered today.

It is unclear when he began these experiments. In November 1790, for example, he was working with nitrate of silver at his father's ceramics business, leading to his invention of a 'silvered ware' in about February 1791. He also had essays on his observations of light read at the Royal Society, and wrote speculatively about optics and "Time, Space, and Motion." These last interests he shared with his close friend, the English poet Samuel Taylor Coleridge, whom he first met in 1797. So close were they that Tom and his brother granted Coleridge a lifetime annuity that enabled the poet to travel to Germany in 1798 and study German idealist philosophy at first hand. Exposure to these radical new ideas undoubtedly stimulated Tom Wedgwood's thinking during the period in which he experimented with photography.

Despite the existence of some undated letters referring vaguely to "Silver Pictures," the only noncircumstantial evidence of these experiments is an essay that appeared in the first issue of the *Journals of the Royal Institution of Great Britain* in June of 1802. Co-written with its editor, the twenty-four year old Davy, the essay was titled 'An Account of a Method of Copying Paintings Upon Glass, and of Making Profiles, by the Agency of Light Upon Nitrate of Silver,' and describes various experiments the two men had undertaken with white paper or leather moistened with a solution of silver nitrate and exposed to light.

> White paper, or white leather, moistened with solution of nitrate of silver, undergoes no change when kept in a dark place; but, on being exposed to the day light, it speedily changes colour, and, after passing through different shades of grey and brown, becomes at length nearly black...
>
> The condensation of these facts enables us readily to understand the method by which the outlines and shades of painting on glass may be copied, or profiles of figures procured, by the agency of light...
>
> The images formed by means of a camera obscura, have been found to be too faint to produce, in any moderate time, an effect upon the nitrate of silver. To copy these images, was the first object of Mr Wedgwood, in his researches on the subject, and for this purpose he first used the nitrate of silver, which was mentioned to him by a friend, as a substance very sensible to the influence of light; but all his numerous experiments as to their primary end proved unsuccessful.... Nothing but a method of preventing the unshaded part of the delineation from being coloured by exposure to the day is wanting, to render the process as useful as it is elegant.

Despite their inability to make their images permanent, in the space of five short pages Davy and Wedgwood describe an impressive range of photographic ideas and applications. Wedgwood apparently began by attempting to capture the image formed by the camera obscura, and only subsequently moved on to the problem of copying pre-existing images. Of these, the

two experimenters attempted to copy paintings on glass (such as those used for projection devices) and "profiles of figures" (perhaps a reference to silhouette portraits). They also made contact prints using leaves and insect wings as well as engraved prints. Davy tells us that he himself made images of small objects using a solar microscope and "prepared paper." Their friend Anthony Carlisle recalled in 1839 that he had also undertaken several experiments with Wedgwood in about 1799 "to obtain and fix the shadows of objects by exposing the figures painted on glass, to fall upon a flat surface of shamoy leather wetted with nitrate of silver, and fixed in a case made for a stuffed bird."

Amidst these creative variations on the basic idea, Wedgwood and Davy also undertook numerous comparative experiments using different materials, solutions and processes. They exposed both white paper and white leather moistened with a solution of nitrate of silver in direct sunlight and then in shade, as well as under red, yellow, green, blue and violet glass. They tried, unsuccessfully, to remove the delineations so produced with both water and soapy water, and attempted, equally unsuccessfully, to prevent further development by covering the image with a thin coat of varnish. Davy also experimented with different solutions of nitrate and water, and with muriate of silver (a chloride which he found to be less suited to the task than the nitrate). He even gives practical advice about how best to apply the resulting solution to one's paper or leather. Finally, he not only recognizes the lack of image permanency as a problem but also suggests a plausible theoretical answer to it—on which subject, he tells us, "some experiments have been imagined" (although, it seems, never undertaken). So, thirty seven years before Daguerre and Talbot were to announce their own discoveries to the world, the 'Account' gives us many elements of the concept of photography. Sadly, Wedgwood was to die only three years later, and Davy, then in big demand as an experimental scientist, went on to other projects and did no further work on photography. However their 'Account' was republished in numerous European and American journals and informed the later and more successful experiments of, among others, William Henry Fox Talbot.

GEOFFREY BATCHEN

See also: Gelatin Silver Print; Multiple Printing, Combination Printing, and Multiple Exposure; Davy, Sir Humphry.

Further Reading

Batchen, Geoffrey, 'The photographic experiments of Tom Wedgwood and Humphry Davy: "An Account of a Method",' *History of Photography*, vol. 17, no. 2 (Summer 1993), 172–183.

——, *Burning with Desire: The Conception of Photography*, Cambridge, MA: The MIT Press, 1997.

Davy, Humphry, "An Account of a method of copying Paintings upon Glass, and of making Profiles, by the agency of Light upon Nitrate of Silver. Invented by T. Wedgwood Esq. With Observations by H. Davy." *Journals of the Royal Institution*, vol. 1 no. 9 (London, 1802). Reprinted in Beaumont Newhall (ed.), *Photography: Essays & Images*, 15–16. New York: Museum of Modern Art, 1980.

Litchfield, R.B., *Tom Wedgwood: The First Photographer, an account of his life, his discovery and his friendship with Samuel Taylor Coleridge including the letters of Coleridge to the Wedgwoods, and an examination of accounts of alleged earlier photographic discoveries*. London: Duckworth and Co., 1903.

Meteyard, Eliza, *A group of Englishmen (1795 to 1815): being records of the younger Wedgwoods and their friends, embracing the history of the discovery of photography and a facsimile of the first photograph*, London : Longmans, Green, and Co., 1871.

Wedgwood, Thomas; Tremayne, Margaret Olivia; Boole, Mary Everest, *The value of a maimed lif : extracts from the manuscript notes of Thomas Wedgwood*, London: C.W. Daniel, 1912.

WEED, CHARLES LEANDER (1824–1903)
American photographer

Charles Leander Weed was born on July 17, 1824, in New York State. Raised in Wisconsin, he traveled to

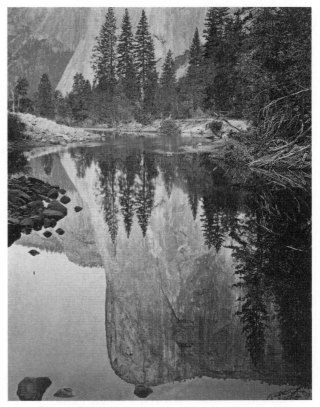

Attributed to Charles Weed or Eadweard J. Muybridge. Mirro View of El Captain. Yo-Semite Valley.
The J. Paul Getty Museum, Los Angeles © The J. Paul Getty Museum.

California at an unknown date. His photographic career began in 1854 as a daguerreotypist, and he later formed a partnership with Robert Vance between 1858–1859. Weed rose to prominence after his June 1859 trip to Yosemite Valley and publication of some of his photographs as engravings. Carleton Eugene Watkins was inspired by these images to create his own large prints of Yosemite. Both Weed and Watkins exhibited their prize-winning "mammoth-plate" prints at the 1867 Paris International Exposition. A remarkable aspect of Weed's career were travels to Hong Kong, China and Honolulu where he established four studios between 1860 and 1866, returning to California in 1861 before going back to Hong Kong via Honolulu in 1865. From 1864 to 1870 Weed associated himself with publisher Lawrence & Houseworth (later Thomas Houseworth & Co.), then operated his own studio or worked for other photographers and photo publishers in the 1870s. Married to Sarah P. Weed (born March 30, 1833) in the mid-1870s, they resided in Oakland, California, until his death on August 31, 1903. Weed's photographs survive only as prints in various formats, principally stereographs and albumen prints, with the Bancroft Library, University of California, Berkeley, and the New York Public Library, holding significant examples, including the 1864 Yosemite Valley mammoth-plate prints.

DAVID MATTISON

WEGENER, OTTO (1849–1922)

Otto Wegener was born in Helsingborg, Sweden, and moved to Paris, France, 1867. Nothing is known about his introduction to photography; all we know is that he opened his magnificient studio at the fashionable address 3, Place de la Madeleine in 1883, successfully competing with Nadar and Reutlinger for the elite audience.

He had then already simplified his name to Otto, a signature that gleamed in gold above the sixth floor on the building. He maintained contacts with the Swedish colony of artists and the writer August Strindberg dined in his house 1894.

A Swedish journalist wrote an appendix to a book about Paris and described him as the leading photographer in the capital, representing France at the Paris World Exhibition in 1900. Only one photographer made more money than Otto, and still did not have his aristocratic customers, nor his artistic merits. Visitors lined up outside his gallery on Rue Royale—where one of his apprentices, Edward Steichen, was given an exhibition. Otto even represented France in international photo exhibitions in Dresden 1908 and Leipzig 1914.

That year, 1914, the leading Swedish pictorialist

Henry B. Goodwin visited him and wrote a piece in a monthly photo journal describing his four storey combination of studios, parlours, dark-rooms and living quarters, all filled with antiques, paintings and the art noveau furniture he loved to design.

He had studied the new reproduction methods as oil transfers and gum prints with Robert Demachy and Constant Puyo, and he still photographed with an Eidoscope soft focus lens.

Despite this success, he is usually overlooked in major works on the history of photography, and only few of his negatives can be traced in French archives.

PÄR RITTSEL

WEHNERT-BECKMANN, BERTHA (1815–1901)

Bertha Beckmann was born January 15, 1815, in Cottbus; there is no knowledge about any training until she met the "mechanicus," Eduard Wehnert in 1839 at Dresden. He opened a photographic studio in Leipzig in 1842 which she operated until 1843 in Dresden. She married Eduard Wehnert in 1845 and carried on his business after his sudden death in 1847 under the name of Wehnert-Beckmann. From 1849 to 1851, Bertha Beckmann owned a studio in New York City, and around 1866 there seemed to have existed a branch of her businesses in Vienna. Bertha Wehnert-Beckmann seemed to be the female entrepreneur par excellence in 19th century photography, any business she founded had prospered within a year or two, mostly concentrating on hitherto unusual aspects of portraiture like children photography. Basically, her work was of very good quality but in no way different from typical work, with the exception that she had a sensitive approach to human beings. She never seemed to have aimed at any fate but fulfilling the needs of her clients; her historical importance lies in the fact that she successfully practised photography in a male world for nearly half a century. She practised photography until 1883, with the assistance of her brother Rudolf Julius Arnold Beckmann. Bertha Beckmann died in Leipzig on Dec.6, 1901.

ROLF SACHSSE

WELFORD, WALTER D. (d. 1919)

Welford was born in Newcastle, and began his career as a journalist for the newly established sport of cycling. He founded and edited *Cycling* (1878–82), and issued a pioneer annual *Wheel man's Yearbook* in 1881. In 1884, persistent ill health forced his move to London, where he quickly immersed himself in photography, starting as sub- editor on *Photography*, in the late 1880s.

In rapid succession, Welford founded and edited the *Photographic Review of Reviews*, later revamped as

Photographic Review (1892–1897); the *Junior Photographer*, later entitled *Practical & Junior Photographer* (1894–1903); and *Photographic Life* (1897, published for 3 months), a title which Welford then reorganised to combine his twin interests as "Cycle & Camera" (1897–1898, published for 9 months). None of them, apparently, was particularly successful.

Welford wrote a standard manual on the hand camera (1892, 6th ed., 1901), and compiled with Henry Sturmey, the pioneer cycle manufacturer and publisher, encyclopaedias on photographic apparatus (1887), and optical lanterns (1888).

Ill health blighted his later years, though he remained a member of the staff of *Kinematograph Weekly* throughout World War I, and wrote a number of plays for the cinema. He died at his home in Islington in July 1919. Welford's wife Jeanie (1855–1949) was a talented photographer in her own right, specialising in topographical views, many of which were published in her husband's journals.

DAVID WEBB

WELLINGTON, JAMES BOOKER BLAKEMORE (1858–1939)

J. B. B. Wellington was trained as an architectural draughtsman, but following an early association with George Eastman, his career was entirely concerned with photography and photographic manufacturing.

He first met Eastman in the 1880s, and became the first manager of Eastman's British factory in Harrow, England.

During a short but successful career with Kodak, Wellington was responsible for, amongst others, a popular printing-out paper, and, in 1889, one of the first intensifiers for photographic negatives—formulated from silver nitrate, ammonium thiocyanate and sodium thiosulphate.

In 1896, after a short period of time with Elliot & Sons of Barnet, Wellington and his brother-in-law H. H. Ward, established the company Wellington & Ward, manufacturing dry plates. Wellington was scientific and technical director of the company, with Ward taking responsibility for engineering. This company was eventually taken over by Ilford Ltd in 1929.

Wellington, however, was also a photographer of note, joining the Linked Ring Brotherhood in 1892 with the pseudonym of 'Duke.' Like all 'links' he was expected to perform the honorary role of 'Centre Link' for about a month—a presidential role with no authority whatsoever—and assumed that position for three weeks in February 1894.

His finest images, some printed in carbon, were produced in the early decades of the 20th century.

JOHN HANNAVY

WERGE, JOHN (unknown)

John Werge arrived in America from Scotland in June 1853. Whilst travelling in the United States, he became acquainted with the leading exponents of the daguerreotype, amongst them Samuel Root, Matthew Brady, Platt D Babbitt and Jeremiah Gurney. He used examples of his work to gain employment in the New York studio of the Meade Brothers as a colourist and 'teacher of colouring' and, in his 1890 book *The Evolution of Photography* recalled demonstrating his skills in colouring daguerreotypes to Gurney and others. He met Babbitt at Niagara Falls, and later recalled that his own photography at the falls had been lost when a fire destroyed the Glasgow exhibition to which he had loaned them. He eventually returned to Scotland.

Werge took over the Monteith Rooms in 1856, the Glasgow photographic studio which had been established in 1846 by John Bernard, and later operated by Bernard and (from 1848) Cornelius Jabez Hughes. He established himself as one of Glasgow's leading portrait photographers, operating the studio for three years.

He returned to America in 1859, and operated a photographic and publishing business at 805 Broadway until at least 1861. Moving to England, he served on the committee of the South London Photographic Society 1868–70, and managed London's Berners Portrait Company 1874/5. *The Evolution of Photography*, published in London by Piper & Carter 1890, offered a first comprehensive history of photography's first fifty years.

JOHN HANNAVY

WET COLLODION NEGATIVE

The wet-collodion negative process was developed in 1848 by F. Scott Archer (1813–1857) and first published in 1851. The process achieved popularity by the mid-1850s, dominating all other negative processes until 1881, gradually displacing both the daguerreotype and the calotype processes. The wet-collodion on glass negative process was desired both because the transparency of the glass yeilded high-resolution images, and because exposure times were shorter than for Daguerreotype or calotypes. Finished negatives were generally usually to produce albumen or salt prints.

The process derived its name from the use of collodion in liquid suspension to coat glass plates at the beginning of the sensitizing process before exposure. In the nineteenth century, the collodion used to coat glass plates was made from guncotton, a commercially-available medical dressing. Guncotton was derived from ordinary cotton that had been soaked in nitric and sulfuric acids, thoroughly washed, and dried. The guncotton was then dissolved the in a mixture of alcohol and ether to which potassium iodide had been added. The resulting collodion was a syrupy mixture. This mixture could be

prepared in advance in a shop or laboratory and transported into the field.

Immediately before the image was to be made, collodion was poured onto a clean glass plate, which was continuously tilted to produce an even coating. The size of the plate was dependent upon the required size of the finished print, and plates varied in size from under two inches square, to mammoth plates, measuring in excess of 20 × 24 inches. When the collodion had set but not dried (a matter of seconds), the plate was sensitized by bathing it in a solution of silver nitrate. During this bath, the silver nitrate reacted with the potassium iodide in the collodion to produce light-sensitive film of silver iodide. This sensitizing process could be carried out under yellow light.

While the plate was being sensitized, the camera operator finished composing the scene, set up the camera, and focused on the subject. After removal from the silver nitrate bath, the glass plate, now light-sensitive, was placed in a light-proof holder and transported to the camera while still wet. When the subject was ready and the film holder loaded into the camera, the "dark slide," a movable cover on the film holder, was moved to uncover the plate. The plate was finally exposed to the subject by removing the lens cap; exposure times ranged from less than one second to several minutes, depending upon the intensity of the light, and the age and quality of the collodion. When the proper exposure was made, the lens cap was replaced, and the "dark slide" returned to its closed position.

After exposure, the holder containing the plate was removed from the camera, returned to the darkroom and immediately developed in a solution of pyrogallic and acetic acids (a later refinement of the process used ferrous sulfate as a developer). The image became visible within a few seconds as the areas struck by light in the camera turn to metallic silver. When development was complete, the developing solution was removed by a wash of clean water. After fixing—usually in a tray of sodium thiosulfate (commonly called sodium hyposulphate in the nineteenth century)—to remove the unused silver halides, the plate was no longer sensitive to light, and could be removed from the darkroom and washed in fresh water. An alcohol lamp was then used to dry the plate. Once dry, and while still warm, the plate was coated with a protective varnish made from gum sandarac, alcohol and oil of lavender. The glass plate was then a negative, and could be used to make a wide variety of paper prints.

BRYAN CLARK GREEN

See also: Daguerreotype; and Calotype and Talbotype.

Further Reading

Archer, Frederick Scott, "The Collodion Process on Glass." *The Chemist* (March 1851).

Baldwin, Gordon, *Looking at Photographs: A Guide to Technical Terms.* Malibu, CA: The J. Paul Getty Museum, in association with the British Museum Press, 1991.

Barger, M. Susan (comp.), *Bibliography of Photographic Processes in Use Before 1880.* Rochester, NY: Graphic Arts Research Center, Rochester Institute of Technology, 1980.

Hardwich, T. Frederick, *A Manual of Photographic Chemistry, Including the Practice of the Collodion Process,* 4th ed. New York: H.H. Snelling, 1858.

WET COLLODION POSITIVE PROCESSES
(Ambrotype, Pannotype, Relievotypes)

The latest fashion in photographic portraiture, the wet collodion positive process on glass (also known in the United States as the ambrotype), was introduced in 1854. The images had a warm tone and did not have the mirror-like reflection that made daguerreotypes difficult to view. The images were the same standard sizes as daguerreotypes, and in Western countries and colonies they were usually presented in a similar manner, with hinged cases, and a glittering brass mat. "The closed, hinged case introduced the element of surprise, a sense of drama as one held it in one's hands, wondering what was going to be pictured inside. As the case was opened this sense of theater became part of the viewing experience."

The wet collodion positive process was derived from the collodion negative process described by English Frederick Scott Archer in1851. In the second edition of his manual (1854), Archer included a chapter, "The Whitening of Collodion Pictures as Positives." In the United States, the ambrotype process was patented by James Ambrose Cutting in 1854. Cutting's patents were largely ignored and had little effect in the rapid spread of this process across the United States.

The investment on the part of photographers to adapt their equipment and studios to the wet collodion positive process was inconsequential. The glass plates were the same standard size as the daguerreotypes; cameras were easily adapted to accommodate the glass plate and the investment in supplies and equipment was minimal. The chemicals required in preparing the collodion emulsion, and assorted paraphernalia including trays, beakers and funnels were readily available in cities and port towns.

The preparation and exposure of a wet collodion positive was a well choreographed dance that required timing and confidence in handling chemicals. The photographer prepared a collodion emulsion by dissolving gun cotton,

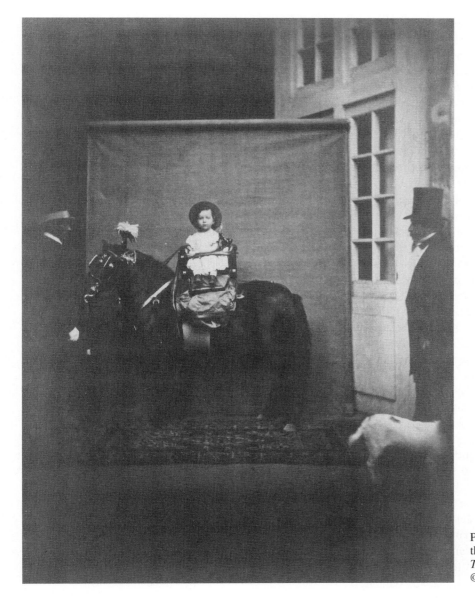

Pierson, Pierre Louis. Napoleon III and the Prince Imperial.
The J. Paul Getty Museum, Los Angeles
© *The J. Paul Getty Museum.*

and modifying its "glutinous" consistency so that it would remain viscous. A how-to-manual noted that "it is hardly necessary to caution the student when using Gun Cotton, as he is aware of its explosive nature; a single spark of fire in it might cause serious consequences." The collodion solution was then poured onto a glass plate and the trick was to evenly distribute the viscous solution on the plate surface allowing the collodion to "set" but not become completely dry. The photographer moved into a darkroom (or dark tent) to dip the plate in a silver solution, and load into a negative holder. After the plate was exposed, the photographer immediately returned to the darkroom to develop and fix the image before the collodion emulsion would dry and harden.

The ambrotype, like the daguerreotype, is a unique image. Photographers created a negative image (the darkest areas were transparent, and the lighter areas had a greater density of silver) by under exposing the plate in

the camera or under developing it in the final processing. A dark background was necessary to transform the image from a negative to positive before it was presented in a case to the patron. A variety of backings provided dark tones that brought out the image details and create the positive image: velvet fabric, black paper or "japanned black" paint either painted on the back of the case or the glass base of the image. Some photographers used opaque surfaces including ruby red glass, and leather as the base surface to prepare a wet collodion image. The images on leather were known as pannotypes. A more sophisticated process used by some studios in large cities, was the relieveotype process invented in 185 by Thomas C. Lawrence. In order to make the portrait stand out, the photographer removed the background and only blackened the area of the figure. The plate was backed with glass and a white background, to provide a greater illusion of depth.

The wet collodion positives, generally produced on glass, were introduced as ambrotypes in American cities. Itinerant photographers learned the process and moved across the United States. It was still faster to travel to the California by following well established shipping paths from New Bedford and other eastern port towns. In the October 1856, Hawai'i daguerreotypist Hugo Stangenwald, advertised that "having recently returned from a visit to San Francisco, [he] takes pleasure in informing the public that he has introduced, and is now prepared to execute, those splendid and permanent pictures on glass, well known as the improved ambrotypes."

In the Pacific, Andrew Garrett (a naturalist) earned his living by collecting, natural history specimens for individual scholars and U.S. and European institutions. In 1863, while living in Hawai`i, he "began to perfect himself in the relatively new art of photography, in order to go prepared to record the vegetation, flora, fauna, and inhabitants of these remote regions... An associate in San Francisco S. Hubbard... sent him a supply of photographic materials... and offered to act as his agent in San Francisco." An associate in San Francisco S. Hubbard purchased photographic materials for Garrett. Hubbard sent five boxes of photographic materials, and in his letter he requested that "if you should ever take any views I wish you would send me some and I will pay you for them, I should like a few pictures of the distinguished natives of the South Seas." By 1864, Garrett was collection images and specimens in the Tahitian, Marquesan, and Samoan Islands. A colleague in Honolulu wrote: "...not a day passes... without my dreaming over your fortune and success. I have imagined that the missionaries might decide that your photographs were a useless article of furniture and discourage the natives from patronizing you, and then again I think I see you surrounded by a crowd of natives dancing and shouting with pictures." Although not attributed, it is likely that Garrett made a beautifully hand colored ambrotype portrait of a native Tahitian man posed with a coconut in his lap, and a coconut frond artistically placed in the background.

The ambrotype process entered Japan through economic and political paths across the Pacific Ocean from San Francisco to the port of Yokohama. John Thomas Gulick, son of an American missionary in Hawai`i, was at loose ends in the winter of 1862, when he decided to learn photography in San Francisco from "Mr. [Carlton] Watkins" while waiting to find transportation to Japan. After arriving in Japan, Gulick noted that on May 2, 1862, he took his first successful picture: "After dinner took my first portrait. It was an ambrotype of Mr. Louder. It was taken when the sun was behind the hill and is therefore lacking in contrast of shades." Gulick left Japan in 1863, and noted in his recollections that "under my teachings a Japanese learned to take photo-graphs and ... I passed my camera and photographic material to him; and he became one of the first to spread the knowledge of that kind of picture taking among his countrymen." In Japan, ambrotype portraits were housed in specially made wood boxes, with a wood mat. This soft, light colored *kiri* wood (paulowina) was also used to make boxes to store scrolls and other valued items. Ambrotype portraits were common even after paper prints were available in Japanese studios, indicating the popularity of this style for family portraiture. The Meji period, beginning in 1868, was the height of the ambrotype process in Japan, although portraits continued to be made in rural areas until 1888.

Wet collodion positives were a transition process between daguerreotypes and paper prints. It was seldom used in the Western countries for portraiture after 1862, when paper prints made from wet collodion negatives became the latest fashion, and patrons collected carte-de-visite portraits to include in photographic albums. In addition, the U.S. Civil War (1861–1865) also contributed to a shift from wet collodion positives on glass to more durable carte-de-visite and the wet collodion image popularly known as the "tintype" (melainotype or ferrotype).

LYNN ANN DAVIS

See also: Archer, Frederick Scott; Daguerreotype; and Cartes-de-Visite.

Further Reading

Baldwin, *Looking at Photographs: A guide to Technical Terms*, Malibu, California: J. Paul Getty Museum in association with British Museum Press, 1991.

Cox Paul, (ed.), Heather Forbes, *Beautiful Ambrotypes: Early Photographs*, London: Travelling Light, 1989.

Crawford, William, *The Keepers of Light: A Historic and Working Guide to Early Photographic Processes*, Dobbs Ferry, NY: Morgan & Morgan, 1979.

Ellis, M.H., *The Ambrotype and Photographic Instructor or photography on glass and paper*, Philadelphia: Myron Shew, 1856, reprint by Peter Pamquist, Arcata, California: January 1990.

Florence Mann Spoehr, *White Falcon: The House of Godeffroy and Its Commercial and Scientific Role in the Pacific*, 112, Palo Alto, California: Pacific Books, 1963.

Gulick, Addison, *Evolutionist and Missionary John Thomas Gulick*, Chicago: University of Chicago Press, 1932.

Hirch, Robert, *Seizing the Light: A History of Photography*, Boston: McGraw-Hill, 1999.

Naoyuki, Kinoshita, "The Early Years of Japanese Photography," *The History of Japanese Photography*, New Haven and London: Yale University Press in association with the Museum of Fine Arts, Houston, 2003.

Scully & Osterman Studio, http://www.collodion.org/index.html (Acessed September 25, 2006).

Spoehr, Florence Mann, *White Falcon: The House of Godeffroy and Its Commercial and Scientific Role in the Pacific*, Palo Alto, California: Pacific Books, 1963.

Weinstein, Robert and Larry Booth, *Collection Use and Care of*

Historical Photographs, Nashville: American Association of State and Local History, 1977.

Whitaker, Robert, *A Freeman of the Frontier- The Story of a Modern Ministry... An account of the life of Dr. John T. Gulick Missionary, Scientist, and Sociologist. Typed manuscript by Gulick's brother-in-law*, n.d., Mission Houses Museum Library, Honolulu, Hawai`i.

WEY, FRANCIS (1812–1882)
French writer and critic

Francis Wey arrived in Paris from his native Franche-Comté in 1830 to prepare for a life of business at the Ecole des Arts et Manufactures. In 1832 he left his studies to become a writer. He began penning essays on Romantic topics such as the Abbey of Noirmoutiers, for journals such as *L'Artiste*. In the long career that followed, Wey covered almost every mode of writing available to an ambitious Parisian in the nineteenth century.

Around 1833, Wey came under the protection of Charles Nodier, fellow Franc-Comtois and friend of the Wey family. Nodier introduced Wey into the literary circle which gathered around him at the Bibliothèque de l'Arsenal; there the young writer encountered most of the major and lesser lights of the Parisian literary scene. In 1834, perhaps on the recommendation of Nodier, Wey entered the Ecole Royale des Chartes. Thereafter his writing was facilitated (and often generated) by his secure career as an archivist. He published novels, tales, and travel narratives, but also erudite studies of the French language, articles on history and archaeology, and literary and art criticism.

In 1851 Wey wrote often for the new photographic journal *La Lumière*. His involvement with the magazine ended with its dissolution and reformulation at the end of the year. In 1853 he wrote an essay on the history of photography for *Le Musée des familles*; he did not write about photography again. Wey's attention to the medium lasted little more than a year, and went unremarked by his biographers and bibliographers. Yet his twenty-three articles on various photographic matters constitute an early and self-conscious formulation of the terms for photographic criticism. His suggestions for photographic subjects and projects were taken seriously by his peers. And his critical project was inflected by his devotion to Realist and Naturalist painting, and his friendship with Gustave Courbet, another Franc-Comtois. Their alliance was perhaps at its height in 1851, the year Courbet's portrait of Wey was hanging in the Salon along with *The Stonebreakers* and *A Burial at Ornans*, among other works.

Wey wrote technical, scientific and historical articles for *La Lumière*, but the themes of his photographic criticism emerge in his reviews and his writing about art. Above all Wey wanted to elucidate photography's relationship to painting and printmaking, and to identify subjects and genres for which photography was well-suited. The clearest statement of his ideas appears in one of his last articles, "Photographes et Lithographes" (*Photographers and Lithographers*), which appeared on 19 September:

Art has already exercised a very notable influence on photography. It has taught it the science of effects, the manner of composing a picture, and diverse procedures for elevating itself, in its literal interpretation of nature, to the impression that results from the sentiment for color.

Wey was sympathetic to photography that took its cues from painting by the *coloristes*—whether the recent flowering of landscape, which he saw as one of the most important artistic developments of the day, or portraits by old masters such as van Dyck and Titian, who achieved pictorial unity through atmosphere and judicious use of highlights. In a 17 August review of photographic publications Wey praised the lines in calotype photography, "which leave the leading role to effect and the modeling of planes." So photography offered proof of color's dominance over line. But although photography was to follow painting's paradigm, it was only in order to establish one of its own. Further into "Photographes et Lithographes" Wey enumerates subjects for which photography is the superior medium to painting, engraving, or lithography: "Subjects swarming with details, monuments loaded with arabesques, the crossroads of old neighborhoods, birds-eye views of the great cities put [photography] above all rivalry." What is more, Wey finds photography capable of effects that would in turn nourish painting:

> We have watched landscapists in admiration before prints taken in winter forests, prints whose planes had been formed from a prodigious tangle of bare brambles, boughs, tree trunks, bristling patches of grass, and small branches. We have watched painters contemplate, amazed, certain effects that were reputed almost unattainable, yet which were rendered by photography with a clarity, a simplicity of means which art had not imagined.

Wey had introduced some of these ideas in his first article for *La Lumière*, "Sur l'influence de l'héliographie sur les beaux-arts" [On the Influence of Photography on the Fine Arts], and he developed them in other essays—"Du naturalisme dans l'art: de son principe et de ses conséquences" (On Naturalism in Art: Its Principle and Its Consequences), "Théorie du portrait" (Theory of the Portrait), "Album de la Société héliographique" (Album of the Heliographic Society). He repeatedly claimed that photography would "renew" painting through the fresh relationships it recorded in studies of landscape, the nude, and drapery. He also somewhat teasingly used

photography to establish grounds on which to appreciate Realist and Naturalist painting.

It is tempting to speculate about Courbet's influence on Wey's writing for *La Lumière*. In two novels, *Biez de Serine* (1850) and *Le Bouquet de cerises* [The Bouquet of Cherries] Wey had written descriptions of stonebreakers which are probably based on Courbet's painting. If his novels of that moment are an effort to work through the fresh example set by the painter, his defense of new painting often seems coached by Courbet. In *Du naturalism dans l'art* Wey writes about the exhaustion of the academic tradition, and he asserts that subject matter and canvas size no longer hold the importance they once did. Here and elsewhere he claims that the excesses of the Romantics and the coloristes were launched in reaction to the impoverishment of the classical school, with the dogmatism of Realism and Naturalism forming another reaction in turn. And photography? The new medium would introduce a necessary control on Realist and Naturalist tendencies, allowing the proper return of imagination to painting.

Wey also directed his criticism toward practical developments. In addition to the subjects listed above, he advocated photography as the best means to reproduce works of art, especially sculptures and bas-reliefs. In some cases he also thought it was superior to lithography for the reproduction of paintings. In "Un voyage héliographique à faire" [A Heliographic Voyage to Make], he extolled the painting of the little-known Flemish primitives, especially Memling and van Eyck. He wanted this art to receive more critical attention, and he also felt that the paintings' crisp linearity lent them to photographic reproduction. Louis-Desiré Blanquart-Evrard paid attention, and works by the early Flemish painters soon appeared in his albums. Wey often addressed Blanquart-Evrard in his writing, egging the publisher to finish his first album, which was late in appearing and which the writer needed for a critical touchstone, and subsequently offering tough assessments of individual photographs and categories of subject matter. Finally, Wey passionately promoted photographic journeys to record the sites and monuments of France and the world. He also advocated official patronage of such trips: he wrote a long review of Maxime Du Camp's Nile photographs made under the auspices of the Ministry of Public Instruction, and in several articles he praised the Mission Héliographique, still underway when his relationship with *La Lumière* ended.

PETER BARBERIE

Biography

Francis Alphonse Wey was born in Besançon in 1812, into a commercial family of German origin. The Wey family had suffered significant losses during the Revo-

lution and Terror, but maintained its business in Indian trade. In 1830, the eighteen-year-old Wey was sent to Paris to enter the Ecole des Arts et Manufactures. In 1832 he abandoned his studies against his family's wishes and turned to writing. In 1834 he entered the Ecole Royale des Chartes, graduating to become an archivist and paleographer at the National Archives in 1837. In 1853 he was named Inspector General of Departmental Archives, a post that he held until 1879.

Wey was a prodigious writer. Beginning in the 1830s he authored more than twenty novels and short stories, as well as two theatrical comedies. He also wrote over a dozen pieces of travel literature, which divide into distinct categories of light reportage and rather serious historical and archaeological accounts. Much of his writing appeared in popular journals such as *Musée des Familles* and *Revue de Paris*. In 1858, his biographer Eugène de Mirecourt characterized Wey as "the Christopher Columbus" of the *roman-feuilleton*: his skill with cliffhangers for his serialized novel *Les Enfants du Marquis de Ganges* [The Children of the Marquis of Ganges], published in 1838 in *La Presse*, had inspired dozens of imitators.

Wey also wrote reviews and philological and historiographical articles for learned societies. In his lifetime he was most honored for his studies of the French language, especially *Remarques sur la langue française, sur le style et la composition* [Remarks on the French Language, on Style and Composition; 1845] and *Histoire des révolutions du langage en France* (History of Revolutions of Language in France; 1848). In 1846 he was made a Chevalier of the Legion of Honor in recognition for the former work. Other books that were especially esteemed include *Le Bouquet de cerises* (1852) and his long travel book *Rome, descriptions et souvenirs* [Rome, Descriptions and Memories; 1871–1875].

Although Wey supported the politicized new painting of the 1850s, and even took up Courbet's subject of stonebreakers, he was himself a moderate Republican. He published two books related to the political upheavals of his period, *Manuel des droits et des devoirs, dictionnaire démocratique* [Manual of Rights and Responsibilities, Democratic Dictionary; 1848], and *Chronique du siége de Paris* [Chronical of the Siege of Paris; 1871].

In 1839 Wey joined the Société des Gens de Lettres, founded the previous year. He was the society's president from 1852–1854, 1857–1858, and again from 1861–1863. In 1864 he was made honorary president.

In 1858 Wey became a member of the Comité des travaux historiques, a national commission parallel to the Commission des monuments historiques, but dependant from the Ministry of Public Instruction. Like the Commission, the Committee had concerned itself with photography of monuments since 1849.

Francis Wey died in Paris in 1882.

See also: *La Lumière*; Courbet, Gustave; Blanquart-Evrard, Louis-Désiré; Du Camp, Maxime; and Mission Héliographique.

Further Reading

Beauge, Gilbert, "Un Monument de l'Archive Photographique: *La Lumière*" in reprint of *La Lumière*, Paris: Jeanne Laffitte, 1995.

Clark, T.J., *Image of the People: Gustave Courbet and the 1848 Revolution*, London: Thames and Hudson, 1973

Francis Wey 1812–1882: Discours prononcés à ses funerailles, bibliographie de ses oeuvres, Paris: 1882

Hermange, Emmanuel, "*La Lumière* et l'invention de la critique photographique 1851–1860." *Etudes photographiques*, vol. 1, no. 1 (November 1996): 89–108.

Janis, Eugenia Parry, and André Jammes, *The Art of French Calotype, With a Critical Dictionary of Photographers, 1845–1870*, Princeton, NJ: Princeton University Press, 1983.

La Mission héliographique, photographies de 1851, Paris: Inspection générale des Musées classés et contrôlés, 1980.

Mirecourt, Eugène de, *Francis Wey, Précédé d'une Lettre à Eugène Sue*, from the series *Les Contemporains*, Paris: Gustave Havard, 1858.

Mondenard, Anne de, "La Mission héliographique: mythe et histoire." *Études photographiques*, 2 (May 1997): 60–81.

Schor, Naomi, *Reading in Detail: Aesthetics and the Feminine*, New York: Methuen, 1987.

WHATMAN, JAMES & CO.

The *Whatman's Turkey Mill* watermark, which appears on many calotypes taken by Henry Fox Talbot and by Hill and Adamson, and on cyanotypes by Anna Atkins, dentifies a paper that was produced by a long-established manufacturer in Maidstone, Kent, England.

Turkey Mill, originally a fulling mill in which woollen fleeces were washed before spinning, was built in the 17th century, and was converted into a paper mill in the 1730s by Richard Harris.

On Harris's death, James Whatman, a tanner, married Ann in August 1740, just a few years after Harris had completed the mill conversion, and James and Ann determined to make their paper mill the finest in the country. At that time most of the finest papers for artists were imported into Great Britain from France and the Whatmans sought to change that.

James Whatman died in 1759, and his son, also James, took over the mill in 1763 aged only 21. In the following years, James introduced many innovations in paper-making—including discoveries which lead to improved whiteness in the papers—and built what he called his 'contrivance' to make paper which he named 'antiquarian size'—more than 50 inches by 30 inches—the paper-making process requiring a team of eleven men to operate it.

In the 1770s, James Jr. and his second wife took in William Balston, and Balston became his protégé and was groomed to become his successor. A stroke caused James to pass the operation of his mills—three by that time—to Balston, then 31, in 1890, and Balston remained with the business after it was sold to local businessmen in 1794.

In 1805 Balston left to form his own business, building a new mill at Springfield, and became the first to employ steam rather than water to power the processes of paper-making.

The Whatman name remained with the original company, and became enormously popular with artists of the day—amongst them J. W. M. Turner, for whom Whatman paper was a preferred choice claiming it gave particular qualities to his watercolours.

After 1840 Whatman's Turkey Mill paper also became the first choice of material for many pioneer British photographers, and the dated Whatman watermark can be seen in a few negatives produced by early calotypists, including Talbot, Hill & Adamson, Reverend George Wilson Bridges, Calvert Richard Jones, John Dillwyn Llewelyn and others.

Despite its popularity, however, Whatman's Turkey Mill paper was not ideally suited to photography. For a start there was the distinctive watermark, which intruded sometimes aggressively, into the composition. In the early days, this does not seem to have been seen as a serious problem, but later calotypes were made on paper specially cut from larger sheets to avoid it. The sheets bearing watermarks were retained for printing, where the watermark did not present such a problem. The paper had other drawbacks for photography as well—being largely made from rags, it was not uncommon for it to contain invisible traces of metal from buttons etc which had been introduced during the manufacturing process. While irrelevant in a writing paper, the chemical processes through which the calotype paper was passed caused those metal fragments to corrode and stain.

In 1857, an article in *The Liverpool and Manchester Photographic Journal* (vol. 1, 214) recounts a visit to see paper being made at "Hollingsworth's, formerly Whatman's Turkey Mill" and offers singular praise for the product stating that "the best paper ever made for the Talbotype process was made at Turkey Mill" and that "This paper was successfully used by the Rev. Calvert Jones, about 1844, at Malta, in very hot weather, and also in the East by the Rev. Mr. Bridges. It is strange to relate that such paper has *never* been obtained since, even from the same mill, and that is why I dwell so much upon it at this moment. Could we get such a paper again, with certainty the Talbotype would take a new start." Written at a time when the wet collodion process was in its ascendancy, that is quite a statement!

After a series of mergers—starting with Houldsworth and Balston in the early 1850s—the Whatman name was revived in the 20th century, and the company continues

papermaking today, and is one of the largest employers in Maidstone.

JOHN HANNAVY

See also: Atkins, Anna; Bridges, George Wilson; Hill; David Octavius, and Robert Adamson; Jones, Calvert Richard, Llewelyn, John Dillwynl; and Talbot, William Henry Fox.

Further Reading

Anon, "Paper for Photography." *Liverpool and Manchester Photographic Journal*, vol 1 (1857): 214.

Arnold, H.J.P., *William Henry Fox Talbot Pioneer of photography and man of science*, London: Hutchinson Benham, 1977.

Buckman, Rollin, *The Photographic Work of Calvert Richard Jones*, London: The Science Museum, 1990.

Gernsheim, Helmut, *The Origins of Photography,* London: Thames & Hudson, 1982.

Harris, Theresa Fairbanks, et al., *Papermaking and the Art of Watercolour in Eighteenth Century Britain: Paul Sandby and the Whatman Paper Mill*, Yale: Yale Center for British Art, 2006.

Schaaf, Larry, *The Photographic Art of William Henry Fox Talbot*, Princeton, NJ and Oxford: Princeton University Press, 2000.

WHEATSTONE, CHARLES (1802–1875)
English physicist and inventor

Sir Charles Wheatstone was born in Gloucester on 6 February 1802, the son of W. Wheatstone, a music seller. He attended a local private school, where he early manifested an interest in mathematics and physics. At the age of 21, he and his brother established a musical instrument-making business in London, a trade that allowed him to pursue his experiments with devices to measure and record sound. Wheatstone's first scientific paper, entitled "New Experiments on Sound," appeared in 1823, and his acoustical research continued with his invention of the concertina and a small form of accordion. In 1828 he presented the kaleidophone, a philosophical instrument that demonstrates the regularity of acoustic patterns by visual means. Although not intended to be a marketable device, the kaleidophone had utilitarian heirs in the photometer and the phenakistiscope, which likewise depend on the persistence of vision.

Wheatstone was part of a new generation of "natural philosophers" who believed in the value of practical research. For him, the construction of a functional device was both a means of working out an idea and an end in itself—a method that would prove central to the emerging discipline of physics. In 1834, still listed as a "musical instrument maker," he was appointed professor of experimental physics at King's College, London. He was only 32 years old. Hampered by acute shyness, Wheatstone seldom lectured after his first year in the post, instead using the institutional resources provided by his professorship to continue his research. Yet he was not socially or intellectually isolated. His publications in various scientific journals earned him immense respect (and election to the Royal Society in 1836); and he maintained close friendships with colleagues such as Michael Faraday and Sir John Herschel, and with artists including John Martin and George Cruickshank. Martin's son recalled that Wheatstone's home at 19, Park Crescent was "one of the most scientific and the most charming in the metropolis, and the resort of all distinguished in art, science or literature."

Wheatstone's importance for photographic history lies in his invention of the stereoscope. He apparently constructed prototypes as early as 1831, and presented it formally to the Royal Society in 1838. The stereoscope illustrated Wheatstone's revolutionary idea that the perception of solidity depends on the mental combination of the different images seen by the two eyes—the principle of binocular vision. The device itself is a symmetrical arrangement of mirrors (hence its common designation as a "reflecting stereoscope") and easels. In the center of a platform, two upright mirrors are placed at a 90° angle to one another, with two upright easels (to which images are affixed) placed at equal distances from the mirrors. The viewer places the eyes close to the vertical axis, where the mirrors are fixed together; looking at reflections of two flat pictures in the mirrors, one perceives a single, three-dimensional image about 6 to 8 inches away from the face. Wheatstone initially used pairs of simple line drawings—free of artistic conventions for indicating three-dimensionality—and predicted that more complex images might be introduced to even greater effect. The nearly simultaneous invention of photography immediately suggested itself as the ideal means of achieving such images.

The fact that Wheatstone did not comment on his own use of photography until 1852 has resulted in some confusion about the date and maker of the first stereoscopic photographs. Wheatstone's correspondence with William Henry Fox Talbot proves that the latter did make some experimental calotypes for use in the reflecting stereoscope by December 1840. During this initial period of trial and error, before the development of stereo cameras, successive exposures were made from slightly different positions with a single camera to produce a stereo pair. Wheatstone explained to Talbot that his photographs differed by too great an angle; he also pointed out that the two pictures must be taken under conditions when shadows would fall in exactly the same way in each. Experiments resumed in August 1841, when Henry Collen, under Wheatstone's direction, produced calotype portrait and still-life pairs. Earlier in the year, in the spring or summer, Wheatstone had gone with John Frederick Goddard to Richard Beard's

newly opened daguerreotype studio, where he had a pair of daguerreotype portraits of Beard's son taken to his specifications, and in 1842 Wheatstone commissioned Antoine-François-Jean Claudet in London and Louis Armand Hippolyte Fizeau in Paris to produce stereo daguerreotype pairs. However, he did not publicize any of these experiments.

By this time Sir David Brewster had devised an alternative stereoscope, somewhat similar to opera glasses in construction and employing lenses instead of mirrors. Brewster's highly marketable refracting stereoscope essentially determined the design parameters of stereo cameras and the standardized format of stereograph cards. Wheatstone had little involvement in the question of stereophotography once it became commercialized. In 1858 Brewster drew him into a dispute about the originality of the stereoscope, which the two scientists argued in letters to the *Times*. As this was not a patent dispute, no money was at stake; and the general consensus among commentators was that Wheatstone had proposed the theory and invented a device to prove it, while Brewster had refined the device so as to transform it from a philosophical toy into a viable commodity.

Wheatstone did not, in any case, need to earn money from the stereoscope. He had invested wisely in the Hammersmith Bridge Company and in various British and American mining concerns. Most significantly, he had taken care to patent (with William Cooke; 1860–1879) various improvements to the electric telegraph, the technology for which he is best known today. He carried out experiments with submarine telegraphy at Swansea Bay, in 1844, with photographic pioneer John Dillwyn Llewellyn. Other achievements include the Wheatstone Bridge (1843), which accurately measures electrical resistance; and the Playfair cipher, a cryptographic method based on digraph substitution.

Wheatstone married Emma West on 12 February 1847, and the couple had five children. He was named a chevalier of the French Legion of Honor in 1855 and became a foreign associate of the Academy of Sciences in 1873. He was knighted on 30 January 1868, and throughout his career earned some thirty-four honorary diplomas from a variety of institutions, including Oxford and Cambridge. Wheatstone died in Paris on 19 October 1875, leaving his collection of books and instruments to King's College.

BRITT SALVESEN

Biography

Charles Wheatstone was born on 6 February 1802, the son of a Gloucester music seller. He entered the musical instrument-making trade in London, but early made a name for himself in scientific circles by publishing his experiments on sound. In 1834, at age 34, he was appointed professor of experimental physics at King's College, London, where he conducted research on acoustics, optics, and electricity. He made an important contribution to photographic history with his invention, announced in 1838, of the reflecting stereoscope. In the early 1840s, Wheatstone called on various pioneers of photography to produce experimental pairs of calotypes and daguerreotypes produced for the stereoscope. Other technological innovations with which Wheatstone is associated include telegraphy, electric chronography, and cryptography. He was elected to the Royal Society in 1836 and knighted in 1868. He died in Paris on 19 October 1875.

See also: History: 2. 1826–1839; Philosophical Instruments; and Stereoscopy.

Further Reading

Bowers, Brian, *Sir Charles Wheatstone FRS 1802–1875*, London: HMSO, 1975.

"Charles Wheatstone." *Proceedings of the Royal Society* 24 (1875–76): xvi–xxvii.

Joseph, Steven F., "Wheatstone's Double Vision." *History of Photography* 3/4 (October/December 1984:.329–332

Wade, Nicholas J. *Brewster and Wheatstone on Vision*, London: Academic Press, 1983.

Wheatstone, Charles, "Description of the Kaleidophone, or Phonic Kaleidoscope: A New Philosophical Toy, for the Illustration of Several Interesting and Amusing Acoustical and Optical Phenomena," *Quarterly Journal of Science, Literature, and Art* 23 (1827): 344–351

——, "Contributions to the Physiology of Vision.—Part the First. On Some Remarkable, and Hitherto Unobserved, Phenomena of Binocular Vision," *Philosophical Transactions of the Royal Society of London* 128, pt. 2, 371–94, 1838.

——, "Contributions to the Physiology of Vision.—Part the Second. On Some Remarkable, and Hitherto Unobserved, Phenomena of Binocular Vision," *Philosophical Transactions of the Royal Society of London* 14, 1–17, 1852.

WHEELHOUSE, CLAUDIUS GALEN (1826–1909)

As a recently qualified doctor, Wheelhouse was the medical attendant on a cruise yacht in the Mediterranean in the late 1840s, and used the opportunity to produce one of photography's earliest travelogues, entitled *Photographic Sketches from the Shores of the Mediterranean*. One of the guests on board was Lord Lincoln, later the Duke of Newcastle and Minister of War at the time of the Crimean War.

In the three years in which he pursued photography as a hobby, he travelled to Greece, Egypt, Malta, and Spain, producing some of the earliest photographs of Thebes, and fine images of Cairo, Athens, and Seville. Using the calotype process, he photographed the greatest sites of Egypt, at the same time as, or even before, the better-known pioneers of early photography in the region.

The demands of calotype photography as a hobby soon outstripped the time available to the young doctor, who was destined to carve out a significant career for himself in surgery. He studied medicine at Leeds medical School in the 1840s, where he and his fellow students are reported to have experimented on each other to assess the anaesthetic effects of ether. He advocated the use of Lister's carbolic spray as an antiseptic and presented a major paper on surgery to the British Medical Association in Bath in 1878

Wheelhouse gave all his negatives to Lord Lincoln, and they were reportedly destroyed during a fire at Lincoln's house in 1879.

JOHN HANNAVY

WHIPPLE, JOHN ADAMS (1822–1891)
American photographer and inventor

Whipple was born in Grafton, Massachusetts, on 10 September 1822. As a boy he became interested in chemistry and attempted to reproduce the newly discovered invention of daguerreotypy. He came to Boston in 1840 and began manufacturing chemicals for daguerrean artists. When the fumes later caused him to abandon this practice he turned to the making of pictures although as his numerous inventions show, he always maintained an interest in improving the photographic process.

Whipple entered into partnership with Albert Litch in 1845, and they opened a studio at 96 Washington Street, a center of picture-making activity and industry in Boston. Litch left in 1847, and Whipple continued under his own name at the same address. Between 1856 and 1859 he partnered with James Wallace Black; the quality of work produced by their studio rivaled that of the well-known firm of Southworth & Hawes. Whipple's studio was located on the top floor so that he could take advantage of the natural light. Display cases at street level alerted passers by to the studio's presence. One of its special features was a "Miniature Steam Engine" that powered the buffing wheels used in preparing the plates and operated the revolving sign in the form of a sun that Whipple used to entice visitors. His portrait clientele included the highest of Boston society (he made a group of daguerreotype portraits of the Harvard class of 1852, the first class to be photographed, and continued to do so through 1860). Whipple was known for the psychological content of his portraits, for his ability to put clients at ease by telling little stories, and for his skill in arranging sitters.

Whipple was a pioneer in the field of astronomical photography. In the late 1840s and 1850s he collaborated with Professor William Cranch Bond and his son George Phillips Bond at the Harvard College Observatory. The first successful representation of the moon was taken on

March 14, 1851, by mounting the daguerreotype plate in the focus mechanism of the Great Refractor, one of the largest telescopes in the world at the time. Made by synchronizing the exposures with the pauses between the movements of the clockwork mechanism, the resulting image had an exposure time of thirteen seconds and measured three inches in diameter. A daguerreotype enlargement of the view exhibited at the Crystal Palace in London in 1851 awed audiences with the incredible details of the lunar surface and won a medal for excellence of production, "indicating the commencement of a new era in astronomical representation." Whipple and his partners, first William B. Jones and then Black, made about seventy exposures of different subjects, including the planet Jupiter. Whipple and Black worked again with the Harvard Observatory in 1857 producing over two hundred photographs of stars using the collodion wet plate process.

Whipple contributed many inventions that advanced the cause of photography. In 1846 he began experimenting with slides of microscopic insects and specimens, which a contemporary observer described as "the most delicate tissue of the tiniest animal." In 1849 he patented the crayon daguerreotype portrait, a technique he developed to create an effect of softness around the sitter as if the figure was floating in space. He achieved this by posing his subject against a light background and then placing in front of the lens a card with an aperture, which he moved in a circular motion during exposure so as to avoid any hard-edged lines.

Whipple's biggest contribution was the crystalotype process, which debuted in 1850. In 1844 Whipple, building on the experiments of early photographic pioneers, began exploring the possibilities of making paper photographs from glass plate negatives. On June 25, 1850, he and Jones patented the crystalotype process in which light sensitive materials were suspended in a mixture of egg white and honey, poured onto a glass plate, and exposed. In 1852 a writer for the *Photographic Art Journal* noted that the crystalotype presented "all the beauty of an actual painting with the unerring accuracy of the daguerreotype likeness." Indeed, the name crystalotype comes from the crystal clear transparency of the glass negatives.

Because of the long exposures, the crystalotype was first used for copying daguerreotypes. The process's reproductive capabilities enabled Whipple to produce prints for use in periodicals and book publications. His crystalotypes were mounted as frontispieces in the 1853 and 1854 issues of *The Photographic Art Journal* and the publication *Homes of American Statesmen* (New York, 1854), which has been described by one scholar as the first photographically illustrated book published in the United States. In 1852 examples of Whipple's process were on view at Root's Gallery of Daguerrean Art in

New York, and in 1853 his crystalotypes of the moon were awarded a silver medal at the Crystal Palace exhibition in New York. Whipple was generous in encouraging the use of the crystalotype and sold the rights to the process for $50; training was also provided for $50. The photographer Josiah Johnson Hawes and William James Stillman, a landscape painter, are said to have learned from Black, who was the principal instructor.

For unknown reasons Whipple and Black dissolved their partnership in 1859. Whipple kept the studio at 96 Washington Street and in 1865 moved to 297 Washington Street, establishing himself in rooms in three buildings with every modern convenience, including the largest skylight in the country according to one visitor. During this period he created a group portrait of the National Congregational Church Council at Plymouth Rock, a contact print measuring approximately 15 × 19 inches and containing over 1,000 figures. Whipple later photographed the aftermath of the Great Boston Fire of 1872.

Whipple retired from photography on June 1, 1874, after a family problem forced him into debt. Until his death from pneumonia on April 10, 1891, he was a bookseller and publisher of religious books. Whipple's photographs can be found in the following collections: Boston Athenaeum, Boston Public Library, Massachusetts Historical Society, Society for the Preservation of New England Antiquities, Harvard Observatory, International Museum of Photography, George Eastman House.

MICHELLE LAMUNIERE

Biography

Whipple was born on 10 September 1822 in Grafton, Massachusetts. Interested in chemistry as a boy, after moving to Boston in 1840 he began producing chemicals for daguerreotypists before beginning to take photographs himself. Whipple was instrumental in the development of the glass negative/paper positive process in America. He became known for his portraits, as well as views of the moon, buildings and ceremonial events in Boston. Whipple was married to a Boston-born woman named Elizabeth who bore a son William in 1861. By the time of his death, he had five children. Whipple exhibited frequently at exhibitions held by the Massachusetts Charitable Mechanic Association beginning in 1841 through the late 1860s, often receiving awards, and assisted in the formation of the National Photographic Association in 1868. After retiring from photography in 1874 he became a bookseller and publisher of religious books. Whipple died in Boston on 10 April 1891.

See also: Black, James Wallace; and Southworth, Albert Sands, and Josiah Johnson Hawes.

Further Reading

Ehrmann, Charles, "Whipple's Crystalotypes [sic]—The First Negatives Made on Glass in America." *Photographic Times and American Photographer* (April 1885): 216–217.
Grant, M., "John A. Whipple and the Daguerrean Art." *Photographic Art Journal*, (August 1851): 94.
"Obituary: John A. Whipple." *Photographic Times* (April 1891): 182–183.
Pierce, Sally, "Whipple's Dissolving Views." Daguerreian Annual for 2002–2003, the Daguerreian Society, 2004.
——, (with a chronological annotated bibliography by William S. Johnson) *Whipple and Black: Commercial Photographers in Boston*, Boston: The Boston Athenaeum, 1987.
Robinson, William F., *A Certain Slant of Light: The First Hundred Years of New England Photography*, Boston: New York Graphic Society, 1980.

WHITE, CLARENCE HUDSON (1871–1925)
American photographer

Born in Ohio, Clarence White was renowned both as a pictorialist photographer and as an inspirational teacher of photography. He is best known for his soft-focus photographs, often depicting women and children in domestic or natural settings.

After leaving school, White worked a book-keeper for a wholesale grocery business, taking up photography as a hobby in about 1893. Self-taught, he was a founder member of the Newark Camera Club in 1898. He met prominent figures in the photographic world, such as Fred Holland Day, who became a lifelong friend, and his work began to be shown at national and international exhibitions. He became a member of the Linked Ring in 1900 and was also a founding member of the Photo-Secession, having his work reproduced in *Camera Work* in 1905.

Increasingly involved in photography, he decided to give up his job and support his family through commercial photography and teaching. In 1906 he opened a studio on Fifth Avenue, New York and from 1907 until his death he lectured on photography at Columbia University Teachers College. In 1914 he founded the Clarence White School of Photography in New York, and his students included Dorothea Lange, Margaret Bourke White and Paul Outerbridge. He died suddenly, from a heart attack, in 1925, during a trip to Mexico with a group of students.

COLIN HARDING

WHITE, HENRY (1819–1903)
Henry White was born in 1819, the son of Richard Samuel White. He became a lawyer and went into practice with his father as White and Son. He took up photography and began exhibiting albumen prints

made from wet collodion negatives in 1855, and he showed his photographs at the various photographic societies in England and Scotland as well as the 1857 Manchester Art Treasures Exhibition and the 1862 International Exhibition. He also exhibited at the 1855 Paris Exposition Universelle and the 1856 Brussels international photography exhibition. A member of the Photographic Society, he served as its treasurer. In the late 1850s, his subject matter consisted of rural scenes, rivers and streams, fields of crops, and close-up views of vegetation, often in Surrey. He also exhibited some photographs of sculpture. In the early 1860s, his subjects included Welsh landscapes. His best-known photographs include "Hunford Mill";, " Surrey"; "The Lledr Bridge, near Bettws y Coed"; and "The Cornfield." His work is found at the Victoria & Albert Museum, the Metropolitan Museum of Art, and the Getty Museum, among others. He died in 1903.

DIANE WAGGONER

WHITE, JOHN CLAUDE (1853–1918)

John Claude White, Companion of the Indian Empire (CIE), was born on 1 October 1853 in Calcutta, the son of a British doctor in the Government of India. Educated at the Royal Indian Engineering College, Cooper's Hill, England, he entered the Government of India as a civil engineer; photography was his vocation. In 1883 he was assigned for a year to the British Residency in Kathmandu, Nepal, where he photographed Nepal's architecture and monuments. Named political officer in 1889, he moved to Gangtok, Sikkim where he oversaw British interests in Sikkim, Bhutan and Tibet for nearly 20 years. He carried his camera everywhere, photographing the Himalayan mountains, architecture and people. A member of the 1904 British invasion of Tibet, he was the only expedition member permitted to photograph Lhasa's monasteries. He made five trips to Bhutan, photographing its architecture and the 1907 coronation of its first king. His landscapes, glaciers, and architectural studies form a remarkably comprehensive documentation of important events in the history of the political development of the North-East Himalayan Frontier. His photographs were published by the studio Johnston and Hoffman: *Sikkim* (1902), *Bhutan* (1905–06), and *Tibet and Lhasa* (1908). His writings, including his memoirs *Sikhim and Bhutan: Twenty-one Years on the North-East Frontier 1887–1908* (London: Edward Arnold, 1909) and three articles in *National Geographic Magazine* illustrated by his photographs opened the window on the Himalayan region to the west. *In the Shadow of the Himalayas: Tibet-Bhutan-Nepal-Sikkim, a photographic record by John Claude White 1883–1908* (Mapin, 2005) contains over 100 of his photos, including his best known im-

age, a panorama of 1904 Lhasa. He died in London on 19 February 1918.

PAMELA DEUEL MEYER

WHITE, JOHN FORBES (1831–1904)
English photographer

A miller, art collector, and amateur photographer, John Forbes White was born in Aberdeen, the son of a flour miller, and was educated at Marischal College in the city, where he first met Thomas Keith with whom he would take many of his photographs in the 1850s. Between 1854 and 1858, the two men travelled extensively together with their cameras. They married sisters, Ina and Elizabeth Johnston, the cousins of Sir James Young Simpson.

Like Keith, from whom he had learned photography, White used Le Gray's waxed paper process for all his known output, and his subjects ranged from local views around Aberdeen and the Balgownie estate near the family's flour mills, to views in Central Scotland, Northern England, and North Wales. By the time of his interest in photography, he was running the family business, and it was the pressure of that responsibility which prompted him to abandon photography in 1859, the year of his marriage.

His photographic output consists of little more than eighty large paper negatives, many of them never printed until very shortly before his death.

White's work remained unseen for over forty years until James Craig Annan printed several of his negatives and displayed them to critical acclaim at the Glasgow International Exhibition of 1901 alongside images by Thomas Keith, and by Hill and Adamson.

JOHN HANNAVY

WHITE, MARGARET MATILDA (1868–1910)

Margaret Matilda White (1868–1910) emigrated to New Zealand from Belfast with her family in 1886. She was a friend of John Robert Hanna, a skilled Irish photographer who conducted a very successful portrait business in Auckland. It is thought that this friendship resulted in her acquiring skills as a photographer, which she demonstrated while working as a ward sister in a Mental institution. Her job provided her with subject matter that was very challenging because of the psychological undertones that the images invoke. She later married and moved to the West Coast of the South Island where she continued to use her camera to record her life and times. Because of her premature death in 1910, there isn't what one would call a very extensive files of negatives to draw upon

for an assessment of her abilities with a camera. Those that have been preserved are housed in the Auckland Institute and Museum. A study of these proves that she was capable of a lighter mode, photographing her workmates and friends in risqué situations, drinking and smoking in the company of men! There is also a very historically important reportage series on the funeral of the important Maori Chief Rewi Maniapoto, including a *morte* study.

WILLIAM MAIN

WILLÈME, FRANÇOIS (1830–1905)

Draughtsman, painter, and sculptor (he made models for the bronze manufacturers of art), François Willème also practiced photography. His various experiments gave him the idea of a new process, the photosculpture, which he developed beginning in 1859, and for which he registered several patents. The photosculpture consisted of producing a statue, a statuette, or a bust starting from a series of photographic negatives taken of a live person or a model in sculpture in the round. This involved a device that was comprised, as installed in a salon, of a circular platform ten meters in diameter, lit by a canopy; on the other side of the circular wall, in a corridor, were laid out 24 cameras (the lenses were concealed by carved busts), which made it possible to photograph the model at the same time from every angle possible (the shutters were connected and could be opened and closed at the same time). In the workshops, the negatives were then projected in a "lampascope" on a translucent screen, increased to the desired size; on the back of the screen, a workman traced the silhouette with a point fixed at a pantograph; at the other end, the pantograph was equipped with a knife which cut out the silhouette in a block of clay, poised on a revolving base; after each layout, the resulting image was projected and translated in the same way into three dimensions, and so on until the sum of the profiles was obtained. A sculptor completed molding and perfecting the image; the statue could then be cast. The resemblance was guaranteed, with proportions exact.

In 1861, François Moigno spoke about the process in his *Cosmos* review, but it was only in 1863 that the invention was made known to a larger audience. The Société générale de photosculpture was formed that year thanks to capital brought by different financiers; the first establishment opened on boulevard de l'Etoile, in a large building crowned with a cupola of glass, and with the facade decorated with statuettes; two years later, a branch opened on the boulevard des Italiens. To launch his company, Willème accepted the support of the press and writers. Willème's businesses were attended by the good company of the Second Empire, beginning with the imperial couple and its entourage, the personalities of the artistic and literary world, as well as society women. The vogue of photosculpture exceeded the French borders: similar establishments opened in London (Antoine Claudet introduced the process in England by proposing some improvements, and showed examples in 1864) and in the United States (branch opened in 1866 in New York by Huston and Kurtz). Willème went to Madrid to make the portraits of the royal family of Spain.

Willème showed specimens of photosculpture to the Société française de photographie in 1863 and 1864 (with his associate De Marnyac), and at the World Fair of Vienna in 1864, and to the exposition of the central Union of arts in Paris in 1865. Each time he had a great public success. The judgments of critics were divided. Ernest Lacan, always enthusiastic, compared a bust in terra-cotta with the "more charming oeuvres of the XVIIIe century" (*Monitor of Photography*, September 15, 1865), whereas Theodore Pelloquet spoke about "stiff figurines, gauche, of a soft design" and exclaimed: "All that is extremely ugly, all that feels mechanical and misses character and of life" (*Time*, August 13, 1865).

At the Exposition Universelle of 1867, Willème had a share of a house in the park. But the passion for photosculpture had already reached its end and the company collapsed; in 1868, Willème closed his workshops and returned to live in his native area of Sedan.

Even if it were transitory, the glory of Willème and his invention attests to the vogue of the photographic portrait under the Second Empire and of the inventiveness of the medium of photography; it also testifies to the entrepreneurship which could animate an even obscure artist, since he proposed a new idea and had effective support, in particular that of the press, which represented a true power then.

If it seems an invention without future, even like a salon entertainment for an avid society to contemplate its image, the photosculpture had at least the ambition to put sculpture, noble art, within the range of more modest purses; the duration of the sittings were short, the execution was fast and reduced the total cost. In that, it falls under the vast movement in favour of the industrial arts; but Willème undoubtedly failed insofar as there was never a true market for photosculpture, the victim of the competition of the more accessible photographic portrait, the format calling card. In addition to the portrait, Willème also made attempts at reproductions of old sculptures. The specimens of photosculpture now preserved are in plaster: portraits of personalities or unknown, adults and children (Rochester: collection Gabriel Cromer, SFP, Compiegne, Museum of decorative Arts, Museum of Arts and Trades).

HELENE BOCARD

Further Reading

Michèle Auer, and Michel Auer, *Encyclopédie internationale des photographes de 1839 à nos jours*, Hermance, Camera Obscura, 1985.

Wolfgang Drost, "La photosculpture entre art industriel et artisanat. La réussite de François Willème (1830–1905), *Gazette des beaux-arts* (Octobre 1985): 113–129.

Gillian Greenhill, "Photo-sculpture », *History of Photography*, no. 3 (1980): 243–245.

Raymond Lécuyer, *Histoire de la photographie*, Paris, Baschet, 1945.

Paris en 3D, Paris, Musée Carnavalet, 2001.

WILLIAMS, THOMAS, RICHARD (1825–1871)

British professional photographer

Thomas Richard Williams was a London-born professional photographer who was particularly known for the quality of his stereo-photography. Born in 1825, Williams was one of the few British photographers to make use of the daguerreotype process to produce news photographs. He specialised in making stereoscopic daguerreotype still-life studies and portraits. He also produced a large range of conventional stereocards from collodion negatives.

It is thought that Williams gained his professional experience by acting as assistant to pioneer daguerreotypists Richard Beard (1801–1885) and Antoine Claudet (1797–1867). Claudet was the first professional to use the stereo-daguerreotype in England and Williams was able to learn his trade from a skilled master and later go into direct competition with him.

Williams married Elizabeth in ca.1848–49 and went on to have nine children; his wife, three boys and three girls aged between five and twenty-one survived him at the time of Williams' death at his home, Sellar's Hall, in Finchley north London. Williams made a good living from his photography; as well as his large family there were several servants employed, including a coachman.

Williams' earliest photographic work seems to have been stereoscopic still lives produced by the daguerreotype and collodion processes. Many objects reappear in several of these elaborate set pieces. Musical instruments, stuffed animals, statuettes, fruit and vegetables, barrels, dead game, skulls and books all feature heavily, reflecting mid-Victorian taste.

A guitar, a table decoration within a glass dome and a Brewster pattern stereo-viewer all feature in one of his early tableaux, taken before his move to his Regent Street studio in the West End of London in around 1854. A small label on the reverse gives his early details: 'Mr. T.R. Williams, Photographic Artist, 35, West Sq. St. George's Rd. Lambeth.' At this time Lambeth was a poor area of London, an unfashionable district south of the River Thames.

If Williams was to make money from his photography he needed to move to a richer area of the capitol and Regent Street was the hub of fashionable photographers. Claudet was at number 107, Mayall (1810–1901), who also at one time assisted Claudet, was in the nearby Strand (and later in Regent Street) and W.E. Kilburn had a studio at number 234. Williams moved next door, to number 236 Regent Street.

At his portrait studio, which was patronised by royalty, aristocracy and the upper middle-classes, Williams also advertised views taken in and around the Crystal Palace (built originally in Hyde Park for the 1851 Great Exhibition and later moved to south London). He also offered a service to copy paintings, watercolors, crayon drawings, sculptures, and daguerreotypes.

Williams photographed Queen Victoria at the opening of the Crystal Palace Exhibition in June 1854 and again in 1855 when she was in the company of Napoleon III.

Williams went on to undertake several royal commissions including, in 1855, the launch of HMS Marlborough at Portsmouth and the return of servicemen from the Crimea. The following year he produced a few superb hand-colored stereo-daguerreotypes of the Queen's daughter, Princess Victoria, in her wedding dress.

Like Claudet Williams offered his stereo portraits with their own folding, leather viewing case, embossed with his name. He often subtly initialled his stereo-daguerreotypes 'T.R.W.' in pencil on the black paper surround, his earlier work was sometimes marked in the image itself.

Williams exhibited his commercial work at several London photographic exhibitions between 1855–1864. Stereo work was shown (from collodion negatives), along with a wide selection of carte de visite, and larger portraits.

Williams' reputation was largely built on the stereo-daguerreotypes and the wide selection of card-mounted stereos he produced at the Crystal Palace in 1854. Many of his views were distributed by the London Stereoscopic Company, as well as other publishers.

By Christmas 1856, a series of around sixty views (plus a few variations) entitled 'Scenes in Our Village' were available. This series showed life in a typical rural village in the English countryside and were accompanied by lines of poetic verse, probably penned by Williams himself.

Research by Brian May has shown the village photographed by Williams was Hinton Waldrist, just south of Oxford and about forty miles from London. May has also shown that Williams was, unusually, taking at least two pairs of negatives of the same posed rustic scenes, either using a single camera with two lenses mounted above each other, then moving the camera to one side and making another exposure, or by using two

identical cameras set up around six inches apart. There is evidence that this arrangement was used earlier, at the Crystal Palace in 1854, whether or not by Williams himself is unclear. The main reason was to produce two pairs of negatives of the same scene. William's strange arrangement made some sense; it allowed him to make two negatives, in case one became spoilt in processing or broken, also, it would also be possible to provide two different publishers with a negative each for printing. May argues that Williams found the 'sequential' effect of one image varying slightly from the other improved the three dimensional stereo effect.

Of course Williams might have used this unusual arrangement before; to produce both a glass stereo negative and a daguerreotype at the same time, in fact Williams is probably unique in offering photographs on metal and card of the same scene. This method of working was not necessary with still-lives or scenes with no figures, as Williams would have plenty of time to expose two or more plates. However, with the posed 'Village' scenes it was paramount to make the exposures quickly. The 'Village' series were taken with collodion on glass and there are a few known as glass positive transparencies, as well as conventional card-mounted examples.

Following this series of stereo views Williams concentrated on portraiture at his Regent Street studio, producing good quality cartes-de-visite and larger portraits. By the end of his career he was being assisted by his son Alfred, who was 18 at the time of his father's death in 1871.Williams was at one time in partnership with William Mayland, who appears to have taken over the Regent Street studio on Williams' death. Mayland went on to produce good-quality seascapes in carbon, in the style of Col. Stuart Wortley (1832–1890).

Williams died aged 46 on April 5, 1871 at his north London home from the effects of diabetes, which was at that time untreatable.

IAN SUMNER

Biography

T.R. Williams was a London commercial photographer mainly known for his stereographic work, often in the style of his mentor Claudet. He made an extensive series of photographs of the Crystal Palace exhibition of 1854, patronised by Queen Victoria. Williams produced 'news' photographs of the exhibition's opening ceremony and operated a successful studio and photographed many well-known personalities.

See also: Cartes-de-Visite; Stereoscopy; Daguerreotype; Wet Collodion Negative; Beard, Richard; Claudet, Antoine-François-Jean; Great Exhibition of the Works of Industry of All Nations, Crystal Palace, Hyde Park (1851); Victoria, Queen

and Albert, Prince Consort; and London Stereoscopic Company.

Further Reading

May, Brian, *Stereo World,* vol. 30, no. 1 (2004) and vol. 31, no. 4 (2006), National Stereoscopic Association, Inc.

Steel, Jonathan. *The Photographic Collector,* vol. 3, no. 1 (1982), Bishopsgate Press. London.

WILLIS, WILLIAM (1841–1923)
British inventor

His name is synonymous with the invention of platinotype—the finest process in the entire repertoire of 19th century photographic printing. Born in 1841 at St. Austell, Cornwall, the elder son of William Willis senior, engraver and inventor of the 'aniline' process, William junior was trained and employed in engineering and banking before devoting himself to tackling the problem of photographic impermanence. His prime choice of platinum as image substance achieved slight success in 1873, followed by many years of persevering research and development in his private laboratory at Bromley, Kent, which yielded five British patents and brought the process finally to perfection and universal acclaim by 1892. To market his invention, Willis had launched his Platinotype Company in 1879, and he remained continually responsive to public taste and commercial demand by inventing new variations: sepia platinotype, 'japine' paper, palladiotype, and 'satista' paper. He travelled widely, including the United States, and business interests notwithstanding, delivered instructive lecture-demonstrations to the Camera Club and the Royal Photographic Society, which awarded him its Progress Medal in 1881, and elected him to Honorary Fellowship in 1905. Willis's dedicated lifetime of research has endowed photographic history with a legacy of the most permanent and beautiful images. He died a bachelor, at Brasted Chart, Kent, in 1923.

MIKE WARE

WILSON, EDWARD LIVINGSTON (1838–1903)
Publisher, advocate, teacher

A tireless advocate for professional photographers' rights and a prolific author, Edward Livingston Wilson was born in Flemington, New Jersey, on March 4, 1838. He began his photographic career working in the studio of Philadelphia photographer Frederick Gutekunst in the early 1860s. In 1864 he established the first photographic magazine in America, the *Philadelphia Photographer*, later known as *Wilson's Magazine*, and

remained its editor until his death. He published other photographic periodicals and authored several books including *Wilson's Photographics* (1881), *Wilson's Quarter Century in Photography* (1887), and *Wilson's Cyclopaedic Photography* (1894). He also wrote and lectured extensively about his 1881–1882 Middle Eastern photographic journey. Throughout his career, Wilson worked to establish fair photographic practices and to elevate the profession. He led the fights against a photographic tax and many restrictive patents. As a founder of the National Photographic Association in 1868 and its successor organization the Photographers' Association of America, he helped organize exhibitions and conventions around the country. Through Wilson's efforts, a separate Photographic Hall was built at the 1876 Centennial Exposition to display photographs and equipment. In addition to his publishing and advocacy work, Wilson manufactured and sold photographic equipment and supplies. After almost a decade of ill health, Edward Wilson died in Vineland, New Jersey, on June 23, 1903.

SARAH J. WEATHERWAX

WILSON, GEORGE WASHINGTON (1823–1893)

This pioneering Scottish photographer trained as a miniature painter before taking up photography as a career. He was one of the first photographers to produce photographs on a scale large enough to operate in a mass-market capacity.

George Washington Wilson was the second of eleven children. His father was a crofter, George Wilson (1777–1848). His mother, Elspet Hurd (1798–1883), was his father's second wife.

From 1830 to 1835 George Washington Wilson was educated at the local Parish school.

At the age of twelve he was apprenticed to a local carpenter, but moved to Edinburgh to follow a career as an artist in 1846. Little is known about his time in Edinburgh.

In 1849 he moved to London and became a pupil of the painter, illustrator and sculptor, Edward Henry Corbould (1815–1905), who also tutored the royal family in History painting. When George returned to Aberdeen he set up business as a miniature portrait painter. At the time, photography was on the ascendance, and threatened the livelihood of portrait miniaturist painters. In 1853 George took the unusual, but sensible decision to combine his talents with those of his friend, the photographer, John Hay, and they set up a business which offered portraiture in both media. Furthermore, he established many relationships with other local studios and because of his commercial links with them,

published and disseminated their work as well. Always developing his connections with the photographic community, Wilson was a member of the Photographic Society of Scotland which met in Edinburgh in the 1850s and 1860s.

In 1855 Queen Victoria and Prince Albert commissioned Wilson and Hay to record the construction of their new residence which was being built at Balmoral. This was the start of a long association between Wilson and the royal family. He was granted a Royal Warrant in 1873.

In the late 1850s improvements in photographic technology allowed Wilson to use his Dallmeyer camera to become a pioneer in the field of instantaneous photography. This allowed him to capture landscape and sky without recourse to the artificial device of combination printing, which was standard practise at the time. In 1859 it was reported in the photographic press that Wilson had succeeded in taking the first 'instantaneous view' of Princes Street in Edinburgh. There is also a large print in the RPS Collection at the NmeN by Wilson which claims to be the first instantaneous photograph ever taken. Scotland had become a popular travel destination due to the success of Sir Walter Scott's romantic novels, combined with the growth of the railways, and Queen Victoria's patronage of all things Scottish. Wilson took the opportunity to provide photographic views of Scotland for the burgeoning tourist trade. Eventually he also began to provide topographic views of England and parts of Northern Ireland, to the extent where he rivalled the domain of the photographer, Francis Frith, who was also involved in the same business.

George Washington Wilson became a household name after he was able to take advantage of the craze for stereoscopic photography and produced an extremely popular range of stereoscopic views of the 1862 International Exhibition in London. In 1864 alone, Wilson's photographic business sold over half a million prints. The company continued to grow and became one of the largest photographic firms in the world. To accommodate this growth, larger premises were built in Aberdeen and Wilson embraced mass production techniques in order to meet the demand for his images. Despite such a high turnover, Wilson produced high quality, gold-toned prints. As a result it is not uncommon for his images to remain in excellent condition to this day.

Described as genial and good-natured, Wilson had two illegitimate sons with Isabella Johnstone in 1841 and 1844. Although they never married, Wilson did raise and educate the elder of his two sons, Alexander Johnson Wilson (1841–1921), who eventually became a well-known economist in London. In 1849 George Washington married Maria Ann Cassie, daughter of an innkeeper in Banff. They had five sons and four daughters together. Wilson died on 9 March 1893 at Queens

Cross, Aberdeen. He is buried at Nellfield Cemetery in Aberdeen.

The largest collection of George Washington Wilson's work was discovered in the attic of a house in Aberdeen in 1970, and is now held at the University of Aberdeen. Aberdeen Art Gallery and Museums now care for a second major collection of Wilson's work which was originally donated to Aberdeen Public Library by his son, Charles.

At the time of Wilson's death his photographic business employed forty staff. It continued for another nine years, until it was forced to close in 1902, primarily as a result from competition from less expensive, and easier to reproduce half-tone reproductions of photographs which became then became the standard format for postcards at that time. Even so, Wilson's negatives were purchased by Fred Hardie, a former employee of Wilson and used to produce postcards until 1920.

BRIAN LIDDY

Further Reading

Groth, Helen, *Victorian Photography and Literary Nostalgia*, Oxford University Press: Oxford, 2003.

Taylor, Roger, *George Washington Wilson, Artist & Photographyer,* Aberdeen: Aberdeen University Press, 1981.

WINTER, CHARLES DAVID (1821–1904)
French lithographer, painter, and photographer

Born in Strasbourg in 1821, Charles David Winter trained as a lithographer and painter before establishing a photographic studio at 1, rue des Calves, Strasbourg, that specialized in daguerreotype portraits. By 1851, he had adopted the paper negative process and by 1854, had mastered the wet collodion technique and was running a successful studio making portraits and *cartes de visite*. Winter's greatest accomplishments, however, are his photographs documenting the urban transformation of Strasbourg in the second half of the nineteenth century, including the building and demolitions in the city center (1855–80), the construction of a railroad bridge over the Rhine (1858–61), and the restoration of the Cathedral (1857–59). Winter exhibited at the Société française de photographie in 1857 and 1859. Striking for both their large size and their fine detail, his photographs revealed the formal beauty in new forms of architecture and engineering. Winter also recorded, in wrenching detail, the devastating destruction of Strasbourg following the Franco-Prussian war of 1870. After 1870, Winter illustrated and served as the editor of the *Bulletin de la Société de la Conservation des Monuments Historiques d'Alsace.* The largest holdings of Winter's photographs and albums are at the Municipal Library, Strasbourg,

and at the Museum of Modern and Contemporary Art, Strasbourg.

SARAH KENNEL

WITTICK, (GEORGE) BENJAMIN (1845–1903)
American photographer

Wittick established himself as a photographer in 1878 in New Mexico, working first for the railroad in the partnership of Wittick and Russell, later establishing studios in Albuquerque, Santa Fe, Gallup, and Fort Wingate, New Mexico, as well as in Arizona. Although he photographed the construction of the railroads and the growth of towns along the railroad route, he is best known for Native American subjects—both studio portraits and ethnographic studies of life and ceremonies. His portrait of Apache war chief Geronimo (Goyathlay) is one of the most famous images of a Native American. The portrait in which the chief poses against a studio backdrop with rifle in hand was made in 1887 after Geronimo's capture and was widely circulated. Wittick photographed many of the Apache and Navajo leaders as native groups were resettled. He was the first to photograph the Hopi snake dance ceremony, including the washing of the snakes and other rituals that took place in *kivas,* out of sight of observers. He died at Fort Wingate, New Mexico, in 1903, after being bitten by a rattlesnake which, it was reported, he had captured to transport to Hopi for the snake dance.

KATHLEEN HOWE

WOLCOTT, ALEXANDER SIMON AND JOHNSON, JOHN (active 1839–1844)

Both involved in mechanics before the advent of the daguerreotype, Alexander Simon Wolcott and John Johnson were among the few significant American inventors in daguerreotypy from 1839 to Wolcott's early death in 1844. In this short period, the two partners' research and strategy were focussed on two goals that more broadly characterized the daguerreotype era in the United States: to devise a practicable method of making portraits, and to use it towards creating a profitable business; in both directions, they reached a marked—if short-lived—success.

Wolcott and Johnson began experimenting around October 6, 1839, after learning about Daguerre's method. The more mechanically-inclined Wolcott set out to design a new camera—one with an internal mirror instead of a lens—and within twenty-four hours he was able to secure a small portrait of Johnson. Although it is regarded as the first daguerreotype portrait made

in North America, this picture is lost and was probably mediocre, but it testified to the potential of the new camera, which was and remains the duo's main claim to fame. "Wolcott's camera" or the "mirror camera," as it came to be known after an improved version was awarded the first U.S. patent in photography in 1840, was indeed revolutionary, in that it incorporated, in lieu of a lens, a small concave reflector at the back of the box, which reflected the light coming in through the front opening onto a small plate (2 × 2½ inches) fastened near the front and facing back. This crude design was intended not only to palliate the cost of quality lenses, but to maximize the amount of light reaching the plate, so as to render portraits feasible by reducing exposure times. Although the mirror design had the added (and culturally more significant) advantage of redressing the lateral inversion of early daguerreotypes, augmenting the available light was clearly the primary concern, as was also the case in the sophisticated system of studio lighting Wolcott invented by coupling mirrors outside of the room's bay windows, and in many other improvements intended to produce more horizontal, more even, or less brutal lighting. Indeed, the intensity of the light concentrated on the sitter's eyes was unbearable for any length of time, which explains why the early portraits produced by Wolcott's camera were profiles, and why various means were attempted to soften the impact. In spite of this problem, the mirror camera was the principal asset of the studio that the pair opened on Broadway in March, 1840, probably the first commercial daguerreotype portrait studio in the world, and one that presented a remarkable internal architecture, embodying precocious thinking on lighting and extending the structure of the camera to the room's organization. This was true technical thinking on photography, and significantly it originated in a concern for the control of lighting in portraiture, thus departing from the abstract bend of many early responses to the invention of photography. Thus, it is inconsequential that Wolcott's mirror design may have been predated by earlier European publications on the subject, as was in fact the case with some other methods developed by the tandem, such as Wolcott's "accelerator," a mixture of bromide and chloride for increasing plate sensitivity. Whether or not they were aware of such publications, Wolcott and Johnson were most efficient on a strictly technical level, for instance in developing various methods of polishing silvered plates (by grinding and, later, by buffing), which earned them a second U.S. photographic patent in 1841. In this consistent effort to make the daguerreotype a practical and artistic portrait process, they contributed to an important pattern in the U.S., where the application of ingenuity to the handling of light, as well as the perfecting of daguerreotype plate surfaces, were durable trends.

Similarly, the entrepreneurial drive of the pair was precocious and characteristic, although their commercial career was short-lived. Along with the New York studio, the two associates created an establishment in Washington, D.C. (where basic equipment was still very scarce in the summer of 1840), and one in Baltimore. More significantly even, as early as February 1840, the duo sent Johnson's father to England to secure a patent for the mirror camera (which could only be done by paying a fee to Daguerre's agent) and to develop a daguerreotype business in partnership with the investor Richard Beard, with whom they opened a studio in London in March 1841. Although the Wolcott-Johnson business in New York met with heavy competition and indifferent success (the studio being sold in the fall of 1841), in London the Beard studio was for a time the only one to compete with Antoine Claudet's, and thanks to the mirror camera it attracted a good deal of business and attention in 1841–1842, while in other British cities the Beard-Johnson partnership successfully operated subsidiaries until 1843–1844, to the extent that the associates engaged in local factory production of mirror cameras and polished plates. In fact, much of the pair's time was spent in England in the years 1841–1843, and in March 1843 they obtained a British patent for a method of copying and enlarging daguerreotypes, while letters that were published later show that by 1843 Wolcott was working on a system of coating glass plates with egg whites, subsequently hailed as a near-invention of the albumen process. Had Wolcott not come to an early death in 1844, he would likely have renounced his mirror camera, which produced mediocre images and painful effects on sitters, which never seriously threatened the classic lens camera, and which was definitively superseded after the new Petzval lens (coupled with a prism that reversed the image) was introduced in 1843. Nonetheless, its bold and simple design remains a major example of American technical ingenuity in the era of the "dag'type," while the partners' insistence on patenting their improvements and expanding their business announced the professional and commercial course of 19th-century American photography.

FRANÇOIS BRUNET

Biography

Born in 1804 in Connecticut, Alexander Simon Wolcott had, before 1839, been active as a mechanic in optics, dentistry, and steam engines; in October 1839, he went into partnership with John Johnson, who was born in 1813 in Maine and had previously been a "machinist." As early as October 6 or 7, Wolcott made the first daguerreotype portrait in the United States with a prototype of the "mirror camera," which was patented on May 8, 1840 (U.S. patent #1,582), and put into service on March 13, 1840, in a commercial studio on

Broadway in New York, as well as in branch offices in Washington, D.C., Baltimore (under Henry Fitz, Jr., a telescope maker who had collaborated in the design), and several cities in Britain (in partnership with Richard Beard). The duo obtained the second U.S. photographic patent for a method of polishing plates (December 14, 1841, #2,391), and sold an accelerator called "Wolcott's mixture." After Wolcott died in 1844 in Connecticut, Johnson turned to other mechanical activities, although he remained involved in photography and published documents on his partnership with Wolcott. He died in Maine in 1871.

See also: Daguerre, Louis-Jacques-Mandé; Daguerreotype; and Camera Design: 1 (1830–1840).

Further Reading

Barger, Susan M., and White, William B., *The Daguerreotype, Nineteenth-Century Technology and Modern Science*, Washington, D.C., and London: Smithsonian Institution Press, 1991.

Gernsheim Helmut, *The Origins of Photography*, Londres: Thames and Hudson, 1982.

Rinhart, Floyd, and Marion Rinhart, "Wolcott and Johnson: Their Camera and Their Photography." *History of Photography* (April 1977): 129–134.

——, *The American Daguerreotype*, Athens: University of Georgia Press, 1981.

Taft, Robert, *Photography and the American Scene: A Social History 1839–1889* (1938), repr. New York: Dover, 1964.

Welling, William, *Photography in America, The Formative Years 1839–1900* (1978), Albuquerque: University of New Mexico Press, 1987.

WOLLASTON, WILLIAM HYDE (1766–1828).

English chemist, natural philosopher, physiologist, inventor

Born August 6, 1766, in East Dereham, Norfolk, England to the Rev. Francis Wollaston (1731–1815) and Althea Hyde, he attended Cambridge University and, awarded a degree in medicine 1793. He became a Fellow of the Royal Society, 1793 and Foreign associate of the French Academy of Sciences. Wollaston published scientific papers in the 1790s. He gave up his London medical practise in 1800 to pursue scientific research and, with Humphry Davy, investigated physiology. Wollaston discovered the metals palladium and rhodium, and devised a lucrative process to produce malleable platinum. His electrical work included an improved battery. Wollaston's optical work included investigations of the solar spectrum. In 1806 he designed and patented the camera lucida, a glass prism on a support which enabled an artist to trace an impression of a view, ensuring accurate perspective. Fox Talbot's difficulty in producing

acceptable drawings using the camera lucida, which required artistic skill, spurred his chemical experiments in photography. In 1812 Wollaston produced a camera obscura with improved 'periscopic' (meniscus) lens. Niépce used one of these lenses, made by Chevalier, in his 1828 photographic experiments. A Wollaston-type lens was used in the 1839 Daguerre-Giroux camera. In 1806 Wollaston was elected Secretary of the Royal Society, and interim President 1820. He died in London, December 22, 1828. The mineral Wollastonite, a Canadian town, and a Geological Society (London) medal are named in his honor.

STEPHEN HERBERT

WOMEN PHOTOGRAPHERS

Historians have downplayed the role of women photographers even though they were among its earliest practitioners and took an active part in all areas of photographic endeavour during the nineteenth-century. The economic, social, and cultural constraints, which governed women's lives, were also to shape their choice of subject matter and the manner in which their photographic work was perceived. The Victorian emphasis upon the domestic role of women narrowed the range of experiences that were available to many women, however, this does not lessen the work of those amateurs who utilized photography to record and construct accounts of their lives and those of their families. Photography also provided women with a way of earning a living beginning with the pioneer studio owners and itinerant daguerreotypists of the 1840s and expanding to include the legions of women workers who were the preferred employees in certain sectors of the photographic industry.

On an artistic level, women perhaps benefited from the fact that the new medium of photography was not a subject for academic study. It was therefore freed from the hierarchy and regulations which were attached to the Fine Arts and which often precluded women's full participation within them. In some respects this freedom made it easier for women to play a notable role in international photographic movements such as Pictorialism.

A small number of women contributed to the pre-history of conventional photography and were engaged to a limited extent in the scientific experimentation which preceded the announcement of the Daguerreotype and paper negative processes in 1839. In the late eighteenth and early nineteenth century it was not altogether unusual for some wealthy women to have some popularized knowledge of science and to cultivate this interest on a limited basis. Elizabeth Fulhame, who published a book in London in 1749 outlining her attempts to create permanent images by light, could be numbered among

these women. So too could Friederike Wilhelmine Von Wunsch, a German artist who in 1839 claimed to have discovered a method for producing photographic portraits. Women also formed a substantial part of the growing middle-class clientele who commissioned silhouettes, miniatures and camera lucida drawings in the decades before 1839 thereby creating a demand for the production of likenesses which the photograph was to satisfy.

The earliest women amateurs who used the Calotype process belonged to the upper strata of society as only they were privy to the expertise and know-how required to master this difficult process. In England, they included the relatives and friends of the physicist William Henry Fox Talbot, who announced his positive/negative process in 1839. His wife, Constance Talbot, printed her husband's Calotype or Talbotype negatives whilst occasionally making her own exposures and prints. Her engagement with photography alongside that of Talbot's Welsh relations Emma and Mary Llewelyn typifies the elitist circle of friends who used the calotype process. In Ireland, Louisa Tenison and her husband of Kilronan Castle, County Roscommon and Mary, Countess of Rosse, Birr Castle, County Offaly, were amongst the first women to use the process. Due to the complicated nature of taking calotypes and printing negatives those who used the medium often worked with partners. For women, the societal emphasis upon the work of their spouses often meant that their role was unacknowledged. For example, Harriet Tytler worked with her husband to record the aftermath of the Indian Mutiny of 1858. Yet their work using large paper negatives has been attributed solely to her husband.

Debates concerning the nature of photography took place in journals throughout the nineteenth century. One of the earliest and most important commentators was Lady Elizabeth Eastlake (1809–1893) whose husband Sir Charles was the first president of the Royal Photographic Society. Among other aspects of photography, she explored its relationship with the fine arts. A piece by her which was published in the *London Quarterly Review* in 1857 revealed an astute understanding of the photographic medium. Eastlake decided that photography could not be considered as a true art, however, she astutely points to some of its possible uses.

> She (photography) is made for the present age, in which the desire for art resides in a small minority, but craving, or rather the necessity for cheap, prompt, and correct facts in the public at large. Photography is purveyor of such knowledge to the world. (Eastlake 1857, 93)

Frederick Scott Archer's invention of the wet collodion process in 1848 and Louis-Désiré Blanquart-Evrard's introduction of the albumen print in 1850 resulted in an increased number of women taking up photography on an amateur basis. Women amateurs were still chiefly drawn from aristocratic or well-to-do backgrounds and the wet plate process was far from straightforward. This was particularly so for outdoor work as the glass plates had to be coated and developed immediately. These lady amateurs added photography to other female hobbies such as sketching and needlework. That photography was considered a suitable pursuit for such genteel ladies is perhaps incongruous given the fact that they had to mix their own chemicals. They gained access to technical information through informal networks of friends and family or from the many technical manuals which were available by the 1850s.

The subject matter chosen by most women amateurs reflected their leisured lifestyles and confinement within the domestic sphere. They used photography as a form of personal biography and tended to make straightforward formal portraits of their children and family within domestic settings. Their domestic imagery provides a direct link to later women's snapshot photography. That they recorded their environment in a selective way is evidenced in the exclusion of the staff, who facilitated their lifestyles, from most photographs. Many were aware of their families special position within society and asserted their relationship with the land through photographs of the family home and its surrounding parkland. Their photographs were mostly destined for albums which were produced and circulated in a private environment. These albums had origins in the earlier keepsake or sentiment albums which contained poems, pressed flowers and water-colours. They were often intricately decorated and were shown to an audience of family and friends. Examples of this genre include the early work of Lady Clementina Hawarden (1822–1865), at Dundrum, County Tipperary, Ireland; Augusta Crofton Dillon at Clonbrock House, Ahascragh, County Galway, Ireland and the photographs taken by the sisters Lady Augusta Mostyn and Lady Caroline Nevill. They were also part of the Amateur Photographic Association whose members exhibited their work in London and also sold and exchanged prints. The work of Mary Paraskeva at Baranovka in the Crimea covered similar country house subjects.

The albums created by Lady Frances Jocelyn in the 1850s, and Charlotte Milles and Lady Mary Georgiana Filmer (1838–1903) in the 1860s, demonstrate the creative energy and inventiveness that could be invested in the production of photographic albums. These women produced photographic collages, a process which involved the cutting up of photographs and their insertion among painted backgrounds. The placing of images of different sizes and the use of different mediums such as watercolours subverted the realistic nature of photography. As careful consideration was given to the order and sequence of images within such personal albums,

it is important that institutions and collectors maintain the referential integrity of these volumes. Such albums should be considered as a single item rather than a series of unrelated images.

One woman who departed from the typical themes of amateur image making was Lady Clementina Hawarden (1822–1865). From 1857 until her untimely death, she created over eight hundred photographs mainly of her adolescent daughters caught in private moments of reflection or in fancy dress. Hawarden's atmospheric and sensual images were carefully constructed through the use of fabric and props and reveal an inner private world rather than a mere record of family life. Hawarden's original treatment of the domestic realm is in contrast to previous amateur practice. Although they utilised the same wet-plate process and albumen printing as Hawarden most amateurs chose more formal and stiff poses. The themes of the Pre-Raphaelite art movement are reflected in her photographs and she demonstrated a sensibility that is not visible in much of the amateur practice of this era.

In the mid-1860s another Englishwoman was to commence the production of distinctive photographs within her home. Julia Margaret Cameron's (1815–1879) romanticised portraits were influenced by the Pre-Raphaelite painters. She used family, friends, and servants to re-create biblical scenes and Arthurian legends. She also created idealised portraits of her many famous friends and acquaintances. . Like Hawarden she used the wet plate process and made albumen prints. She experimated with close-up shots and was not overly concerned about the precision of her images preferring to capture atmosphere and expression using a soft focus. Critics were divided as to the merits of her work mainly due to its lack of sharpness. Both Cameron and Hawarden entered their work into exhibitions held by the Photographic Society of London. Cameron also made money from her photography consequently blurring the lines between amateur and professional practice. Her pioneering artistic vision widened the notion of what constituted a good photograph. Another woman who interacted with the photographic medium in a unique and creative way was Virginia, Countesse de Castiglione (1837–1899). She commissioned over four hundred portraits of herself from the Mayer & Pierson studio in Paris. She chose elaborate costumes and backgrounds to create vibrant tableaux. These images, which she then hand-coloured, re-created scenes from her own life or from novels. Although she did not take the photographs her input represents an example of the use of photography as a tool for self-expression.

Lady Eastlake's exploration of the uses of photography included reference to its application within scientific research. Anna Atkins (1799–1871) was one of the earliest female botanists to use photography to illustrate their work. She worked with the Cyanotype contact printing process which was invented by Sir John Herschel. The brilliant blue cyanotype prints, which result from the action of light on paper sensitized by iron salts, were used by Atkins to accurately depict her collection of botanical specimens. She painstakingly illustrated her work *Photographs of British Algae; Cyanotype Impressions* over a ten year period from 1843. This work is considered to be the first photographically illustrated book and constitutes a formidable piece of research and contribution to scientific knowledge. Atkins's work demonstrated that women were capable of undertaking serious research within the natural sciences. It also reflects the Victorian preoccupation with the collection and classification of natural phenomena. Alice Le Plongeon (1851–1916) and her husband Augustus took photographs of archaeological finds from their excavations in the jungles of Mexico and these images which date from between 1873–1885 are amongst the earliest uses of photography in the field of archaeology. Both Atkins and Le Plongeon provide evidence of women's participation in a wide range of photographic practices.

The female members of several royal families promoted photography either through their patronage of certain photographic formats or by taking pictures themselves and compiling albums. In England, Queen Victoria precipitated the craze for stereoscopic photography by admiring a set at the Great Exhibition in 1851. By permitting the sale of royal portraits she started the trend in collecting cartes-de-visites of famous people. In Austria in the 1860s Empress Elizabeth collected and commissioned hundreds of portraits. Queen Victoria's daughter, Princess Victoria who married Crown Prince Friedrich in 1858, was a committed amateur photographer. Alexandra, Princess of Wales, acquired a Kodak roll-film camera in 1889 and created many images which she even exhibited. Several members of the Russian royal family also took photographs.

Women were also involved in the production of commercial portraits from its inception. A small number of women ran their own daguerreotype studios in England in the early 1840s. There is evidence of work undertaken by Marie Chambefort, an itinerant daguerreotypist, who was active in France around 1850. Some of these women may have been previously engaged in the production of miniatures and were merely combating the threat to their living posed by photography. Others had the role thrust upon them through the tragic event of widowhood or the death of their fathers. In the United States, where the daguerreotype attained the peak of its popularity, women were also establishing and managing studios during this formative period.

The number of portrait studios increased between the 1850s and the 1870s as tintypes and cartes-de-visites cut the cost of photography. During this boom, there was

naturally a rise in the number of women listed as proprietors of photographic studios in both the United States and Europe. It appears that societal constraints were lessened in the United States and that women were more likely to set up businesses and travel independently than in Europe. Hannah Maynard (1834–1918) set up a studio in Victoria, Vancouver Island in 1862 and proceeded to make a record of the landscape and people of Canada. She also embraced a wide variety of photographic techniques. These included montages, figures in motion, photosculpture, multiple exposures, composite images and the use of mirrors. She pioneered the use of these artistic techniques to investigate the notion of the self and her involvement with the spiritualist movement led to the creation of unconventional and surreal images.

An African American woman, Mary E. Warren, was listed in a Houston, Texas, directory for 1866 as a photograph printer. In 1867 Marie Lydia Bonfils and her husband Felix set up La Maison Bonfils in Beirut where they had relocated to from France. The studio was responsible for portraits and topographical views of the Middle East. Lydia took many of the studio portraits and continued to run the business after her husband's death. Clémence Jacob Delmaet was involved in the running of the Delmaet & Durandelle studio which specialised in architectural and engineering subjects and was active between 1854 and 1890. Geneviève-Elisabeth Disdéri worked separately to her husband to create views of the countryside in Brest between 1852 and 1872. Swedish studio photographers included Bertha Valerius (1824–95) and Rosalie Sjöman (1833–1919). From 1890 the Letter-Verein Photographic School in Berlin taught women a variety of photographic techniques. By the end of the century, there were several very successful society portrait photographers including Catherine Barnes Ward in the United States and Christina Broom in England. Broom was also considered to be England's first photo journalist taking photographs of suffragist events and specialising in photographs of London. Both women were advocates and role models for professional women within photography.

Women also found employment behind the scenes in portrait studios. They were involved in routine work on assembly lines where they were employed in activities such as the cutting of cartes-de-visite images. For example, the William Notman studio in Montreal employed a large number of women as retouchers and printers. Women worked as dressers attending to the hair and attire of female sitters. They were engaged at several levels within the studio either as receptionists or as hand tinters. Portraits printed on albumen were often over-painted in oils, watercolours or pastels. These over-painted photographs were reminiscent of the higher status portrait painting. Later women were to be employed in the processing and production of photographic materials in large scale factories, such as those run by the Lumière Brothers and Kodak.

Pictorialism which imitated the conventions of fine art, attracted American women such as Gertrude Käsebier and the Englishwomen Agnes Warburg and Emma Barton. This international movement whose tenets were debated by H.P. Robinson and Peter Henry Emerson sought to create photographs which rivalled painting in its expression of emotion and atmosphere. Some advocates manipulated negatives or used the gum bichromate process. American practitioners of the 1880s included Mary F.C. Paschall, Mary T.F. Schaeffer, Eva Watson, and Louise Deshong Woodbridge. The American Anne W. Brigman was a central figure in this movement photographing female nudes in the spectacular natural surroundings of the of the Sierra Nevada mountains of Northern California. She was a founder member of the Photo-Seccession and influenced later photographers such as Louise Dahl-Wolfe. Gertrude Käsebier opened her New York studio in 1897 and her work repeatedly explored the mother-child relationship and allegorical themes. The Brotherhood of the Linked Ring was founded in England in April 1892 and sought to advance the field of art photography, however, it did not admit women until after 1900. Käsebier was the first female to be elected and was also a founder member of the Photo-Secession. Her simple portrait style was widely emulated. She also succeeded in coupling her artistic ambitions with financial success. Zaida Ben-Yusuf was another successful fine art photographer who was active from 1897 to 1907. Pictorialism also had an impact on the work of the Dührkroop studios in Berlin and Hamburg where Mina Dièz-Dührkroop worked with her father.

Female documentary photographers included Alice Austen and Frances Benjeman Johnston in the United States. Alice Austen was an avid amateur photographer based in Staten Island. Her sharp focused images of upper-middle-class life and those of immigrants at the Hoffman Island quarantine station and on the Lower East Side of Manhattan prefigured later documentary styles. Johnston combined studio portraits of notable figures with prize winning documentary photographs of the Washington School system. Jessie Tarbox Beals worked in newspapers and as an itinerant photographer in Massachusetts. Geraldine Moodie (1854–1945) photographed the life of pioneers in the Canadian West. In addition to her mother and child portraits, Gertrude Käsebier photographed Native Americans in the Pictoralist tradition.

For the most part images of Africa, Australia, and Asia were constructed from a colonial viewpoint as women photographers tended to be the European wives or daughters of those employed in the maintenance of Empire. One such woman was Lady Hariot Dufferin (1843–1936), Vicereine of India, who recorded her ex-

perience in India between 1884 and 1888. She published a two volume account of her time in India and also photographed the Indian people and landscape. Whilst travelling in Iran in the 1880s, the Frenchwoman Jane Dieulafoy photographed everyday life and people. The detailed and informative descriptions which accompanied her images reveal a documentary rather than a tourist agenda.

The technological innovations which heralded the true popularisation of photography enabled millions of women to take up photography. George Eastman's famous advertising slogan 'You press the button, we do the rest' referred to his roll-film Kodak camera. From 1888, photographers could return their camera containing exposed films to Eastman's factory where the film would be developed and printed. Advertisers were quick to recognise that women were a large part of the market and many campaigns were aimed at the young mother or the independent young woman who was free to combine the new hobby of cycling with the taking of snapshots.

ORLA FITZPATRICK

See also: Albums; Amateur Photographers, Camera Clubs, and Societies; Atkins, Anna; Archaeology; Blanquart-Evrard, Louis-Désiré; Bonfils, Fèlix, Marie-Lydie Cabanis, and Adrien; Brotherhood of the Linked Ring; Calotype and Talbotype; History: 1. Antecedents and proto-photography up to 1826; Cameron, Julia Margaret; Cartes-de-Visite; Cyanotype; Daguerreotype; Rigby, Lady Elizabeth Eastlake; Eastman, George; Emerson, Peter Henry; Talbot, William Henry Fox; Great Exhibition of the Works of Industry of All Nations, Crystal Palace, Hyde Park (1851); Hawarden, Viscountess Clementina Elphinstone; Herschel, Sir John Frederick William; Jocelyn, Lady Frances (Fanny); Käsebier, Gertrude; Kodak; Lumière, Auguste and Louis; Potographic Exchange Club and Photographic Society Club, London; Pictorialism; Robinson, Henry Peach; Royal Photographic Society; Archer, Frederick Scott; Tintype; and Victoria, Queen and Albert, Prince Consort.

Further Reading

Apraxine, Pierre and Xavier Demange, *"La Divine Comtesse": Photographs of the Countess de Castiglione*, New Haven, CT: Yale University Press, 2000.
Batchen, Geoffrey, *Each WildIdea: Writing Photography History*, Cambridge, MA: MIT Press, 2002.
Judith Fryer Davidov, *Women's Camera Work: Self, Body, Other in American Visual Culture*, Durham, NC: Duke University Press, 1998.
Davison, David H., *Impressions of an Irish Countess: The Photography of Mary, Countess of Rosse 1813–1885*, Offaly, Ireland: Birr Scientific Heritage Foundation, 1989.
Dodier, Virginia, *Clementina, Lady Hawarden: Studies from Life, 1857 to 1864*, London: V & A Publications, 1999.
Ford, Colin, and Karl Steinorth, *You Press the Button, We Do the Rest: The Birth of Snapshot Photography*, London: Dirk Nishen Publishing, 1988.
Hirsch, Marianne (ed.), *The Familial Gaze*, Hanover, NH: University Press of New England, 1999.
Mavor, Carol, *Becoming: The Photographs of Clementina, Viscountess Hawarden*, London: Duke University Press, 1999.
Moutoussany-Ashe, Jeanne, *Viewfinders: Black women photographers*, New York: Writers and Readers Publishing, Inc. 1993.
Olsen, Victoria, *From life: Julia Margaret Cameron & Victorian Photography*. London: Aurum Press, 2003.
Palmquist, Peter E. (ed.), *Camera Fiends & Kodak Girls: 50 Selections by and about Women in Photography, 1840–1930*, New York: Midmarch Arts Press, 1989.
——, *Camera Fiends & Kodak Girls II: 60 Selections by and about Women in Photography, 1855–1965*, New York: Midmarch Arts Press, 1995.
Rosenblum, Naomi, *A History of Women Photographers*, London: Abbeville Press, 1994.
——, *A World History of Photography*, London: Abbeville Press, 1997.
Sandler, Martin W., *Against the Odds: Women Pioneers in the First Hundred Years of Photography*, New York: Rizzoli International Publications, 2002.
Seiberling, Grace, *Amateurs, Photography, and the Mid-Victorian Imagination*, Chicago: University of Chicago Press, 1986.
Smith, Lindsay, *The Politics of Focus: Women, Children and Nineteenth-century Photography*, Manchester: Manchester University Press, 1998.
Williams, Val, *The Other Observers: Women Photographers in Britain, 1900 to the Present*. London: Virago Press, 1994.

WOOD, JOHN MUIR (1805–1892)
Scottish pioneer of photography

John Muir Wood was a pianist, music teacher, musicologist, and impresario, who was educated in Paris and Vienna. Moreover, he had wide interests in recent developments in science and the visual arts, which he combined in his photographic experiments. Although he had no direct access to Talbot and was not an official member of any photographic societies, he undoubtedly had connections with British pioneers such as Hugh Owen, Joseph Cundell, Charles John Burnett and with scientists dealing with the chemical and optical aspects of photography. In addition, Wood had close contacts with artistic circles. Besides his affiliations in the music world, he was close friends with the painters James Eckford Lauder and Charles and Henry Cundell. As a photographer, he remained an amateur throughout his entire life. This, undoubtedly, gave him a far greater freedom than most professional photographers, who often had to specialize in portraits and tourist views that answered to stereotypical formulas determined by public demand. Wood's oeuvre, by contrast, was far-ranging in subject-matter. It included portraits, figure-compositions, studies of sculpture and architecture,

and, more importantly, townscapes and landscapes. In addition, he experimented abundantly with inventive techniques. However, this dilettantism, displaying the true spirit of the pioneer, did not imply a sloppy output. On the contrary, highly educated and sophisticated both in his knowledge of chemistry and in his experience and understanding of the visual arts, Wood made some exceptional photographs in the 1840s and 1850s. These pictures are original accomplishments, both on the scientific and artistic sides of photography. It still is a mystery why his name does not turn up in most general surveys of the history of the medium.

His portraits and group portraits, which sometimes depict his friends from art circles, are typical for the early years of photography. Showing some similarities with the work of David Octavius Hill and Robert Adamson, they can be considered as exercises in finding appropriate positions while dealing with relatively long exposure times. Some of his group portraits are situated in a garden setting, taking the photographic portrait away from the studio and insisting on giving the figures a context in which their lives and day-to-day existence could be suggested and felt. Nevertheless, his figures are often isolated and they show a frozen and oddly sculptural effect. Wood, for that matter, photographed sculptures as well, just as Daguerre and Talbot did. A bust of Bacchus, for instance, is photographed from different viewpoints and under different lighting conditions. This interest in rendering three-dimensional volumes by means of light and shadow is also present in some of his portraits, in which even a Caravagist *claire-obscure* is achieved.

In the summer of 1847, John Muir Wood made a trip to the continent. After a brief stopover in York and London, he visited Belgium, which was developing into an important tourist stop for English and Scottish travellers. Not only was it the inevitable first stop on a *Grand Tour* on the continent but the romantic predilection for the Middle Ages also stimulated the interest in the old Flemish cities with their belfries, cloth halls, cathedrals and castles. Muir, just like George Moir of the Edinburgh Calotype Club or Talbot, contributed to this tourist exploration by taking pictures of medieval city centres. He also wrote a kind of travel report, in which he carefully noted which pictures were taken on which day. His trip brought him to Bruges, Ghent, Mechelen, and Brussels. After Brussels, he did no longer include remarks on photography, but his diary indicates that he also visited the battlefield of Waterloo, and the cities of Namur, Charleroi, Huy, and Liège, where his report ends abruptly. Probably, this travel report is incomplete because his estate also contains pictures of Antwerp and Leuven. It is also possible that he continued his journey in Germany, where he photographed the cities of Cologne, Heidelberg, Nuremberg, and Munich—it is also possible that these pictures were made during another

trip since the dates are not indicated and probably prints were made years after the negatives were taken. His pictures of Flemish cities are both important historical documents and examples of an original photographical approach to the motif of the city. His depiction of the Groene Rei in Bruges is one of the oldest photographs of that city but also an example of Wood's consummate skill to make a balanced composition. Wood, playing with the diversity of tones, clearly had the photographic capacity to imagine the final result of his shooting. This is also the case in his Ghent pictures, which give us valuable information because they show the city before its major urban transformations of the later nineteenth century: the belfry has still its old wooden crowning and the castle is mostly hidden behind the houses built against it. The picture of the Ghent castle is a perfect example of Wood's response to the picturesque disorder of medieval towns. Unmistakably, he is more interested in the all-over pictorial effect than in architectural details or construction.

This aesthetic of the picturesque also turns up in his photographs of the ruins of Melrose Abbey and his evocations of the Scottish landscape, which was presented, both in the work of native and foreign artists and poets, as the ultimate romantic landscape. Wood also tried to register the sublime vagueness and freakishness of the Scottish scenery, answering to the romantic sensibility of his musical preferences. Often, he refers to traditional pictorial conventions, of which he had a sophisticated understanding. In other cases, he created remarkable unconventional and impenetrable compositions of woodlands without subject matter.

Throughout his career, Wood used the calotype instead of the highly polished metal daguerreotype or the later albumen process on glass. Even long after the introduction of glass negatives, he continued to use paper negatives. The calotype, of course, suited perfectly his picturesque way of seeing, which favoured the vivid all-over effect and subtle gradations of light over details and sharpness. His attention to light and hues lay also at the base of his experiments with different printing processes in the 1850s and 1860s, which resulted in an unparalleled chromatic intensity and vibrancy of color.

STEVEN JACOBS

Biography

John Muir Wood was born in Edinburgh in 1805. Being part of a family of piano-makers and music publishers, he became a pianist, music teacher, musicologist, and impresario. After an education in Paris and Vienna in 1826–1828, he set up as a music teacher and joined his brother George in the family business. He organized concerts for famous musicians including Chopin and Listz and did research on the history of Scottish music.

In 1848 he moved to Glasgow, where he married Helen Kenlo Stephen in 1851, who bore him thirteen children. Most of the pictures of his varied photographical oeuvre were taken in the late 1840s until mid 1850s but he continued to experiment with printing processes until the mid-1860s. He died in 1892 in Cove on the west coast of Scotland. His work is preserved in the Scottish National Portrait Gallery in Edinburgh.

See also: Amateur Photographers, Camera Clubs, and Societies; Hill, David Octavius, and Robert Adamson; Edinburgh Calotype Club; and Talbot, William Henry Fox.

Further Reading

Coppens, Jan,. 'Britse kalotypisten in Nederland en België.' In *Door de enkele werking van het licht: Introductie en integratie van de fotografie in België en Nederland 1839–1969*, edited by Jan Coppens, Laurent Roosens and Karel van Deuren, 179–193. Antwerp: Gemeentekrediet, 1989.

Stevenson, Sara, Julie Lawson, and Michael Gray, *The Photography of John Muir Wood: An Accomplished Amateur 1805–1892*, Scottish National Portrait Gallery, 1988.

WOODBURY, WALTER BENTLEY (1834–1885)
English photographer and inventor

Walter Bentley Woodbury, inventor of the Woodbury-type photomechanical printing process, was born in Manchester, England on 26 June 1834. He showed signs scientific tendencies and, as a youth, mastered the difficult wet-collodion process soon after it was published in 1851.

Woodbury arrived in Melbourne in October 1852, but instead of going to the goldfields as planned, he decided to put his photographic skills to use. He was one of the earliest wet-plate photographers in Australia and at the 1854 Melbourne Exhibition won a medal for a set of '9 views of Melbourne, taken by the Collodion process on glass.' A versatile photographer, he took panoramas and stereo photographs as well as conventional views, and even made his own collodion. He set up a studio in North Melbourne and for a time operated studios on the Victorian goldfields.

In 1857 Woodbury, with his associate James Page, travelled to Java. After Woodbury solved the problem of working the collodion process under tropical conditions their photographic business became highly successful. In addition to their commissioned work they travelled the country taking photographs for sale. Woodbury's stereo views, published by Negretti and Zamba, were favourably reviewed in the *British Journal of Photography*.

Shortly after returning to England in 1863 with capital from his Java business, he devoted himself to solving the serious problems which were inhibiting the sale of photographic books—the slow production rate of albumen prints and their tendency to fade. He moved from silver-based chemistry to the permanent but imperfect dichromate-based carbon process of Alphonse Poitevin, the main shortcoming of which was the poor rendering of half-tones. After much arduous work he was successful in combining Poitevin's process with aspects of Fargier's carbon process and innovations of his own. Woodbury arrived at an entirely novel solution to photomechanical printing for which he filed British Patent no. 2338 of 1864. He later improved the process by incorporating the technique of nature printing in which the hardened gelatin matrix was forced into a sheet of lead under high pressure. Prints in pigmented gelatin were then cast from the resulting lead mould. The salient features of the Woodburytype printing process were that it was suitable for high production rates of high quality images while avoiding the use of introduced grain or the half-tone screen. The half-tones and delicate detail were reproduced smoothly and precisely by the varying thicknesses of pigmented gelatin.

To publicise his process Woodbury himself printed several thousand images for an insert in *The Photographic News* of January 26, 1866, and enthusiastically promoted his invention by means of demonstrations to learned societies, entries in exhibitions and articles in the photographic press. In 1875 he produced a photobook *Treasure Spots of the World* as a demonstration of the superb quality of well-made Woodburytype reproductions. Although the cost of the necessary machinery put Woodburytype out of the reach of small operators, it became the process of choice for high quality illustrated books as well as being equally suited to the mass production of ephemeral items such as *cartes-de-visite* of stage personalities to be given away as advertising material. In one notable instance 30,000 prints were made in one day. Woodbury licensed the process in several countries. It was also adapted successfully for the production of lantern slides in large quantities.

Described as 'technically perfect' and the most beautiful printing process ever invented-it was, however, not without its problems. The afterwork on the prints was labour-intensive as each sheet had to be hardened in an alum bath, washed, dried, trimmed, and mounted. Furthermore, the prints could not be combined with letterpress.

In 1879 Woodbury patented the simplified Stannotype process but the modification came too late to compete with cheaper but inferior processes. The 1884 Woodburygravure process was more compatible with book production but also failed to gain acceptance. Woodburytype was highly successful in England and on

the Continent until about 1890 but was less adaptable to the extremes of temperature found in North America and Australia. Woodbury also adapted the process for watermarking paper.

When visiting the United States in 1871, Woodbury acquired the English rights to the popular Sciopticon lantern projector. He was a prolific and versatile inventor, holding more than twenty patents, including improvements to optical lanterns and photography from a balloon. His last patent was for a method of making paper transparent for use as a support for the emulsion.

Woodbury was awarded many honours including a gold medal at the 1872 Moscow Polytechnic Exposition and the 1883 Progress Medal of The Royal Photographic Society.

Although widely acknowledged and respected, he lacked the business acumen needed to capitalise on his inventions. Woodbury contracted diabetes and died on 5 September 1885 at Margate, England, from an accidental overdose of laudanum.

Woodbury's importance as a photographer lies in his photographs of Australia and Java which are now of historical value. His fame as an inventor is assured by the legacy of superb prints made by the process which bears his name. Time has proved that the claim to permanence of Woodburytype prints was essentially correct.

ALAN F. ELLIOTT

Biography

Walter Bentley Woodbury, born in Manchester UK in 1834, joined the Australian gold-rush in 1852 but turned to photography. In 1857 he opened a successful photographic studio in Java. Returning to England in 1863 he devoted his life to inventions including the Woodburytype photomechanical printing process. He died at Margate, UK, in 1885.

See also: Negretti and Zambra; Projectors; Wet Collodion negative; and Woodburytype, Woodburygravure.

Further Reading

Eder, Josef Maria (trans. E. Epstean), *History of Photography,* 397, 587–9, 600, New York: Columbia University Press, 1945.

Elliott, Alan F., 'Walter Woodbury: Pioneer Collodionist and Inventor.' *The Collodion Journal* (July 1998): 8–9.

Wachlin, Steven, *Woodbury and Page, Photographers, Java,* Leiden: Kitlv Press, 1994.

Wills, Camfield, and Deirdre Camfield, 'Walter Bentley Woodbury 1834–1885.' *The Photographic Journal* (December 1985): 551–4; (January 1986): 41.

Woodbury, Walter Bentley, *The Amateur Photographer,* (1884): 185–186; (1885): 334–355.

——, *The British Journal of Photography* (1885):167–168, 581, 596.

——, *The Photographic News* (1861): 78–79, 91–92, 126–127.

——, (ed. Alan F. Elliott), *The Woodbury Papers: Letters and Documents held by the Royal Photographic Society.* Privately printed, 1996.

WOODBURYTYPE, WOODBURYGRAVURE

Woodburytype is one of the finest of all photomechanical reproduction processes, producing continuous tone images that resemble carbon prints. Originally known as the photo-relief process (or, in France, *photoglyptie*), woodburytype was invented in 1864 by Walter Bentley Woodbury, although Joseph Wilson Swan's photo-mezzotint process, conceived earlier but published later, is virtually identical. The end product is a relief image in semi-transparent pigmented gelatin, thick in the shadows and thin in the highlights, giving excellent photographic gradation.

The process of making woodburytypes begins with the exposure and development of a positive relief image in a thick film of dichromated gelatin. Exposure through a negative differentially hardens the sensitized gelatin, which is developed by washing away the unexposed parts in warm water. This master relief is then used to produce a shallow negative intaglio printing mold with the highlights as hills and the shadows as hollows, usually by sandwiching the dried, hardened relief against a sheet of lead in a powerful hydraulic press, an idea Woodbury took from nature printing. Considerable pressure is required: about 4 tons per square inch, or 500 kilograms per square centimeter, depending on the thickness and hardness of the lead, and the size and nature of the image. In the early 1870s, a hydraulic press capable of 450 tons pressure cost £156, although a short time later, Tangyes of Birmingham began manufacturing a compact woodburytype hydraulic press with a short throw, suitable for 10×8 inch (25×20 cm) plates, which sold for about £60 (by way of comparison, an Albion press, suitable for letterpress printing, cost about £10).

Woodburytype prints are cast (rather than conventionally printed) using a special, less powerful, hand press capable of positioning paper perfectly flat against the mould. A small amount of warm pigmented gelatin "ink" is poured onto the center of the lightly greased, carefully leveled mould, and covered with a sheet of specially-prepared, waterproof paper. The top plate of the press is swung down and closed, forcing the gelatin into the contours of the mould. After about a minute (to allow the gelatin to set and adhere to the paper), the print is peeled out of the press, plunged into an alum bath to harden, rinsed, dried, and finally trimmed and mounted onto either a book page or printed card mount.

To increase productivity while waiting for the gelatin to set, printers usually worked a number of presses, either on a rotating turntable, or in the case of larger presses, lined up along a bench. However the extra work involved in trimming and mounting, necessitated by the excess colored gelatin squeezed out around the edges of the woodburytype image during printing (and a tendency for prints to curl), reduced efficiency, and mounting on thin text paper could produce an unattractive cockle.

The color used in woodburytype "ink" is generally Indian ink with a small amount of pigment added to suggest a gold-toned albumen print. Unusually colored woodburytypes, or prints on specially tinted paper (and even wood and ivory), are rare considering the ease with which they could be produced. However the woodburytype process is particularly well suited to glass, and firms such as John Carbutt's American Photo-Relief Printing Company and George Smith's Sciopticon Company marketed highly regarded lantern slides and stereo transparencies.

Woodbury's slightly simplified stannotype process, introduced in the early 1880s in an attempt to make woodburytype more attractive on a smaller scale, differed only in the method used to produce a printing mould. Stannotype eliminated any need for an expensive hydraulic press for the production of lead moulds by the expedient of printing directly from a tinfoil-coated negative dichromated gelatin relief. However stannotype was only a limited success, as most amateurs found the production of gelatin reliefs difficult and time consuming, and large scale professional woodburytype printers preferred the old method, as they already had the necessary equipment to produce multiple lead moulds from a single relief (limited by eventual crushing of the relief), in order to simultaneously print, for example, either eight cartes-de-visites or four cabinet cards, depending on the size of the press.

When justified over albumen for larger print runs, woodburytype offered the permanence of the carbon print and the productivity of traditional hand-inked printmaking. In 1877, the 8,500 prints needed for a frontispiece to the *British Journal Photographic Almanac* were run off in three days "with the *nonchalance* characteristic of a photographic portraitist whose transactions are on an extensive scale, when requested to furnish half-a-dozen prints from any particular negative." However maximum print size was limited: although 10 × 14 inches (25.5 × 36 cm) was achievable with special mammoth hydraulic presses, most woodburytypes are far smaller. Difficulties distributing the gelatin "ink" during printing further limited both size and the reproduction of highlights: although capable of rendering exquisite, luminous shadow details, unfortunately clear skies and other large white areas can appear mottled. These drawbacks forced practitioners such as Adolphe

Braun or Friedrich Bruckmann to adopt alternative processes for larger sizes or specific subjects.

Woodburytype flourished from about 1870 to 1900, although because of the initial patent restrictions (Woodbury took out patents in Great Britain, France, Austria, Belgium, Italy, Prussia, and the United States), large capital equipment costs, and its technically demanding nature, use was limited to a small number of specialist firms, mainly in Great Britain and France, and on a smaller scale, in Belgium, Germany, and the United States. In Portugal and Australia, the process failed to meet expectations. In France, Goupil & Cie and later Lemercier dominated, while in England, the then sole licensee, the Woodbury Permanent Printing Company apparently saw nothing remarkable in producing one and a half million prints in the first six months of 1876.

At its peak in the 1870s and 1880s, woodburytype was extensively used to photographically illustrate books and journals. Most were portraits, and appeared as book frontispieces, or supplements to periodicals such as *Galerie contemporaine* (1876–84) and *The Theatre* (1878–97), but additional applications included landscapes and architecture (*Treasure Spots of the World,* edited by Walter B. Woodbury, 1875; William de Wivleslie Abney's *Thebes and its Five Greater Temples*, 1876), social documentary (John Thomson's *Street Life in London,* 1877–78) as well as reproductions of works of art (*Tresor Artistique de la France,* 1877, contains some very large woodburytypes as well as examples of Léon Vidal's related photochromie process). However in 1890s, woodburytype seems to have been increasingly displaced in the high quality sector of the market by collotype and photogravure, both of which offered the advantage of being able to be directly printed onto plate paper suitable for binding into books.

Woodburygravure (so named because the matte-surfaced results resembled photogravure, although on close inspection the image appears slightly raised, especially in the darker areas) was a transfer process introduced in 1891. After printing on a temporary support given a special waxy coating to facilitate release, prints were trimmed, transferred to their final support, and the backing sheet peeled away after the application of a solvent. These extra steps were, however, expensive: Henry W. Cave's *The Ruined Cities of Ceylon*, first published in woodburygravure in 1897, cost 38 shillings, but a slightly smaller 1900 reissue in collotype cost only 12 shillings.

Other processes derived from woodburytype include Woodbury's photo-filigrane, which used a woodburytype relief to impress images resembling watermarks in already manufactured paper; Woodbury's photolithophane, which used a woodburytype relief to cast photographic intaglio transparencies in translucent porcelain; and Henri Rousselon's Goupil gravure, which used some form of granulation in a woodburytype relief

to create the grain for conventional intaglio printing. However photo-filigrane and photo-lithophane remained mere novelties (although Leon Warnerke apparently adapted photo-filigrane to forge Russian banknotes), and Goupil gravure, while producing beautiful velvet blacks, ultimately proved too costly even for the high end of the art market.

Around 1900 two German inventors, Paul Charles and Stephan Faujat, attempted to revitalize woodbury-type by automating the process (they also produced a few reportedly remarkable three-color prints), but it was too late. Despite its delicacy and beauty, woodburytype remained a transitional technology for publishing photographs, a labour-intensive means of mass-producing reproductions of carbon prints that partially replaced the pasted-in albumen silver photograph, but was itself replaced by faster, cheaper, type-compatible processes like the half-tone.

PHILIP JACKSON

See also: Carbon Print; Woodbury, Walter Bentley; Swan, Sir Joseph Wilson; Albumen Print; Carbutt, John; Stereoscopy; Cartes-de-Visite; Cabinet Cards; *British Journal Photographic Almanac;* Braun, Adolphe; Bruckmann Verlag, Friedrich; Goupil & Cie; Lemercier, Lerebours & Bareswill; *Galerie Contemporaine (1876–1884)*; Landscape; Architecture; Abney, William de Wiveleslie; Documentary; Thomson, John; Vidal, Léon; Collotype; Photogravure; Warnerke, Leon; and Half-tone Printing.

Further Reading

Bower, Peter, "Leon Warnerke (1837–1900): Master Forger and RPS Progress Medalist," *Photo Historian,* no. 114 (Dec. 1996): 7–15.

Bower, Peter, "Walter Woodbury and the Photo-filigrane Process," *The Quarterly: The Review of the British Association of Paper Historians,* no. 12 (Sept. 1994): 10–12.

Burton, W.K., "The Woodbury-type Process" and "Stannotype." In *Practical Guide to Photographic & Photo-Mechanical Printing,* 254–272, London: Marion, 1887.

Crawford, William, "Woodburytype." In *The Keepers of Light: A History and Working Guide to Early Photographic Processes,* 285–289, Dobbs Ferry, New York: Morgan and Morgan, 1979.

"Stannotype," *British Journal of Photography,* vol. 31 (1 Feb. 1884–25 April 1884):.71, 87, 102–103, 134–135, 149–150, 166–167, 182–183, 198–199, 214–215, 261

Vidal, Léon, *Traité Pratique de Photoglyptie,* (Annales de la photographie), Paris: Gauthier-Villars, 1881.

Wakeman, Geoffrey, *Victorian Book Illustration: The Technical Revolution,* Newton Abbot, Devon: David and Charles, 1973.

Wills, Camfield, and Deirdre, "Walter Bentley Woodbury, 1834–1885." *Photographic Journal,* vol. 125, no. 12 (Dec. 1985): 551–554 and vol. 126, no. 1 (Jan. 1986): 40–41.

"The Woodburytype Process." *Photographic News,* vol. 27 (1883):.582, 723; vol. 28 (1884): 177, 210–211, 226, 276

WORTHINGTON, ARTHUR MASON (1852–1916)
Physicist and scientific photographer

Born 11 June 1852, Arthur Worthington, FRS, became Professor of Physics and then Head Master of the Royal Naval Engineering College, Devonport. Having published papers in 1877 and 1882 on the physics of surface tension, especially the stretching of liquids, Worthington introduced photography into his experimentation in 1894, following in the footsteps of the stroboscopic work of C. V. Boys and Ernst and Ludwig Mach. Worthington and his assistant R. S. Cole established a method for taking individual frames of drops illuminated with a Leyden-jar spark, which they executed and exhibited at the Royal Institution in May 1894. Having decided that photography was a more practical method for the study of surface tension, Worthington conducted the full range of his experiments again, this time documenting each one photographically, one frame at a time. He was the first to make the experiment of the falling milk drop, which has since become the visual icon of fluid dynamics. Although Worthington's early work was more a comparison of one sort of drop to another, he carried on to track all phases of a single drop. In 1908, Worthington published his book, *A Study of Splashes,* which was used extensively by D'Arcy Wentworth Thompson in his extraordinarily influential *On Growth and Form* (1917). Arthur Worthington died 5 December 1916.

KELLEY WILDER

WOTHLY, JACOB (active 1850s–1860s)
Jacob Wothly's name is associated with a short-lived attempt to introduce a printing process based on uranium in addition to silver, as a method of overcoming the recognised impermanence of albumen paper. In the event, the Wothlytype, patented in 1864, proved to suffer from the same problems of fading, and fell out of use. One of the first to publish criticism of the process, William Henry Fox Talbot, shared photography's disappointment that the prints were not more permanent. The printing-out-paper was coated with a mixture of uranium ammonio-nitrate and silver nitrate in collodion, but was superseded by collodio-chloride papers before the end of the 1860s.

Wothly, originally a portrait photographer producing ambrotypes, with a studio in Theaterplatz in Aachen, appears to have been in business before 1853.

By the late 1850s, working with collodion negatives, he had developed an interest in making enlargements, and designed a significant improvement to Woodward's Solar Enlarger, simplifying the means of keeping the reflected light focussed on the back of

the equipment. He presented his ideas to the Societé Française de Photographie in early November 1860, and within a week *La Lumière* reported that he had sold his design to A. A. E. Disdéri for a reported 20,000 francs.

JOHN HANNAVY

WRATTEN, FREDERICK CHARLES LUTHER (1840–1926)

Very little is known about the life of Frederick Charles Luther Wratten, except that he initially embarked on a career as a school teacher, yet his legacy to the development of the modern photographic process was significant, and his name lives on in the industry eighty years after his death.

Wratten started his photographic career in 1861, aged twenty-one, as a clerk in Joseph Solomon's Photographic & Optical Warehouse in London's Red Lion Square, and by the mid 1870s, he had become convinced that the future of dry plates lay not with collodion but gelatin. In 1877 he established the company Wratten & Wainwright based in Great Queen Street, London, in partnership with Henry Wainwright. In their first year they marketed their own brand of collodion dry plates and in early 1878 they marketed their first gelatin dry plates—*London Ordinary Gelatin Dry Plates*—which were fifteen times as fast as their collodion equivalents. Four British companies pioneered the manufacture of gelatine dry plates, all launching products in that same year—Mawson & Swan in Newcastle (who had pioneered the process in 1877), The Liverpool Dry Plate and Photographic Printing Company, Samuel Fry & Co. of Kingston-on-Thames, and Wratten & Wainwright. In these early stages of mass-production, emulsion manufacture was beset by many problems, not least of which was batch-to-batch consistency.

Wratten's pioneering innovation in the preparation of the gelatine silver bromide emulsion sought to tackle those variations. Early attempts at manufacturing dry plate emulsions had failed to recognise the problems of effectively washing the emulsion to rid it of the excess bromides and other chemical impurities. Wratten introduced the idea of 'noodling' as an aid to cleansing the emulsion. By chilling and setting the gelatine silver bromide mixture, shredding the resulting jelly and then washing the shredded 'noodles'—resetting and re-noodling as required—Wratten's emulsions were thus washed much more effectively, resulting in their plates exhibiting enhanced purity and enhanced consistency from batch to batch. This in turn gave greater consistency in emulsion speed and therefore in exposure reliability.

Their plates were aggressively marketed throughout Europe, and Eder (1932) identified them as the first gelatine dry plates to be marketed in Austria. And yet, it was still a 'kitchen sink' business. According to Mees (1961), Mrs Wratten made the emulsion in her kitchen, and the emulsion was hand poured on to the plates. A batch of emulsion filled twenty teapots, and the pouring was done through the narrow teapot spout.

Wratten & Wainwright later advertised their 'London' brand dry plates as the oldest-established brand in the world, and their retail premises sold a wide range of photographic materials and accessories. By 1879 they had introduced their *London Instantaneous Plates*, with a sensitivity over forty times as great as collodion.

In the mid 1880s, Wratten 'Slow,' 'Ordinary' and 'Instantaneous' plates were amongst the first commercial brands to be subjected to rigorous testing by Hurter & Driffield. Driffield used Wratten Slow plates as the standard when testing the effectiveness of a range of developers, surely a tribute to their consistency.

From 1887 Wratten & Wainwright also marketed a range of own-branded cameras, and although there is no conclusive evidence that they manufactured the cameras themselves, they did advertise themselves as 'apparatus makers' in the London Post Office Directories between 1887 and 1894. Channing and Dunn (1995) list Wratten & Wainwright cameras as early as 1879—when they advertised their *New Double Camera* 'for instantaneous work' and four other designs between 1886 and 1895. Some researchers have suggested that the cameras may have been made for them by other London makers, including, perhaps, William Morley of Islington.

By 1896, their 'Photographic Depot' advertised that it supplied plates and chemicals, and photographic accessories. No mention is made of the 'Photographic Apparatus Department' which had figured in early listings.

A move to Croydon in 1890, to a factory in three converted houses in Canterbury Road, put emulsion manufacture and coating on to a proper commercial footing, with a coating machine made for them by Smith of Zurich. The company continued to develop improved emulsions and, in 1906, became the first company in Britain to manufacture and market panchromatic plates, incorporating the work on dye sensitisation which had been done by other researchers. The dye sensitisers used in their early pan plates were produced for them by Höhst in Germany.

At that time a young chemist had recently been appointed to the position of Joint Managing Director of Wratten & Wainwright Ltd, who by that time had expanded their manufacturing facility at Canterbury Road in Croydon. Dr. C. E. Kenneth Mees (1882–1860) had joined the company as a researcher, and within a few months had developed their first panchromatic plate. Attempts by earlier companies at dye sensitisation had involved bathing the coated plate in the sensitisers. Mees

was the first to propose sensitising the emulsion before coating, producing a much more reliable result.

Wratten's name, however, lives on in the working lives of present-day photographers in the classification code which he and Mees developed for the range of camera and safelight filters which Wratten & Wainwright introduced before 1909.

The rationale behind the numbering of his filter system seems somewhat arbitrary, but does have a basic structure to it. He started with low numbers applied to yellow filters, higher numbers for oranges, red and magentas, and higher yet for greens and blues. Numbered between 80 and 85, he listed filters which adjusted the colour temperature of the light reaching the film, with a range of miscellaneous filters occupying the range from 87 upwards. Of course, with the introduction of colour films, the Wratten filter list has been updated and expanded but, almost a century after their introduction, Wratten numbers are still the most commonly used to denote a filter's colour and character.

Wratten & Wainwright's plates so interested George Eastman that he visited Croydon to see the company's facilities in 1912, and was so impressed by Mees that he offered him a post in New York. The company was bought out by Eastman Kodak later that year—one of the specified conditions upon which Mees would agree to work for Kodak's new research department—and the workforce, including Wratten, transferred to the staff of Kodak Ltd. Mees ultimately became Kodak's Director of Research.

Frederick Wratten died in London on April 8, 1926 at the age of 86.

JOHN HANNAVY

See also: Eder, Joseph Maria; Fry, Samuel; Mawson & Co; Swan, Sir Joseph Wilson; Dry Plate Negatives: Gelatine; and Dry Plate Negatives.

Further Reading

Channing, Norman, and Dunn, Mike, *British Camera Makers*, Esher: Parkland Designs, 1995.

Collins, Douglas, *The Story of Kodak*, New York: Harry N Abrams, 1990.

Eder, Josef Maria, *History of Photography*, New York: Dover Publications, 1978.

Gernsheim, Helmut, *The Rise of Photography 1850–1880*, London: Thames & Hudson, 1988.

Mees, C.E. Kenneth, *From Dry Plate to Ektachrome Film*, New York: Ziff Davis, 1961.

Sipley, Louis Walton, *Photography's Great Inventors*, Philadelphia: American Museum of Photography, 1965.

WYNFIELD, DAVID WILKIE (1837–1887)
British painter and photographer

David Wilkie Wynfield was born in 1837 in India, the son of Captain James Stainback Winfield of the 47th Bengal Native Infantry, and Sophia Mary Borroughes. The family returned to England in the early 1840s, upon Captain Winfield's retirement. Wynfield's mother was the niece and adopted daughter of acclaimed Scottish painter of genre scenes Sir David Wilkie. Yet the young Wynfield did not immediately follow in the footsteps of his namesake (and godfather), initially intending to enter the priesthood.

In 1856, Wynfield decided to study art with historical painter James Mathews Leigh. Leigh's studio fostered the St. John's Wood Clique, a group of young artists—Philip Hermogenes Calderon, J. E. Hodgson, G. D. Leslie, Henry Stacy Marks, Val Prinsep, George A. Storey, Fred Walker, William Frederick Yeames, and Wynfield—who would meet weekly at each other's homes to sketch a set theme and critique the results. These men, many of whom had taken an initial study tour of Europe, had gravitated to London in the mid-1850s, where they formed a uniquely British, gentlemanly version of bohemia in which like-minded coteries of painters, illustrators, and writers dedicated themselves to establishing a "British School." Following Leigh's teaching, Wynfield adopted historical subject matter and highly illusionistic rendering. He first showed at the Royal Academy in 1859 and appeared regularly thereafter, gaining a modest reputation and a steady income as a specialist in subjects from English history, though never achieving the rank of Academician. He changed the spelling of his surname around 1860, probably to avoid confusion with the slightly older painter of historical genre scenes J. D. Wingfield.

A social group above all, the St. John's Wood Clique dabbled in amateur theatricals; they also participated together in the 38th Middlesex Corps of the Artists' Volunteer Rifles, one of many such companies that sprung up in the spring of 1860 in response to Napoleon III's expansionist policies. Most participants abandoned the Corps after a brief period, but for Wynfield (who never married) the comradeship was clearly important, for he remained in the Corps into the 1880s, rising to the rank of captain. It is not known exactly when or why Wynfield took up photography, but his friendship with Frederick Richard Pickersgill—painter, amateur photographer, and son-in-law of Roger Fenton—may have been influential.

Wynfield's most significant photographic project, begun around 1861, was a series of portraits of artists—not only painters, but also architects and graphic artists—in Tudor and Renaissance costume. He registered ten of these for copyright on 8 December 1863 and exhibited a selection at a meeting of the Graphic Society in mid-January 1864. Henry Hering of Regent Street published a series of the portraits under the title *The Studio: A Collection of Photographic Portraits of*

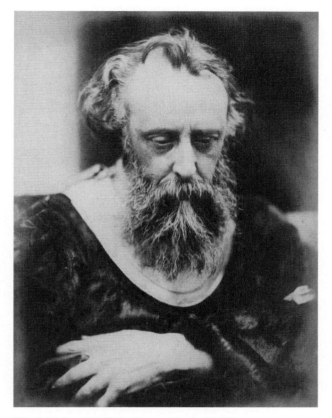

Wynfield, David Wilkie. George Grederick Watts.
The Metropolitan Museum of Art, Warner Communications Inc. Purchase Fund, 1977 (1977.537) Image © The Metropolitan Museum of Art.

Living Artists, Taken in the Style of the Old Masters, by An Amateur in the late spring of 1864; each issue sold for a guinea and included four photographs in the style of a continental school. *The Studio* attracted little notice in the photographic press, and two positive notices in more general periodicals, *The Reader* and the *Illustrated London News*, seem to have been insufficient to encourage future publication and indeed Wynfield withdrew the images from circulation about six months after their initial exhibition.

Wynfield's photographic portraits comprise a consistent body of work. All are albumen prints from wet-collodion negatives on 8 × 6-inch plates, and all except one are busts of male sitters (the exception is a head study of his sister Annie Yeames). The sitters occupy very shallow spaces, before backgrounds that function mainly as patterns of light and dark, setting off corresponding features in the heads or clothing. Most of the costumes refer to the fifteenth, sixteenth, or seventeenth centuries, and often bear some connection to the subject: for example Marks, painter of many Shakespearean subjects, appears in Elizabethan costume. Wynfield made many visual references to Holbein and Van Dyck, but did not re-create specific works and frequently combined elements from various styles and periods in a single image. Most sit-

ters were Wynfield's contemporaries and friends, many of whom had yet to make their reputations at the time they were photographed. Associating his fellow artists with the Old Masters, Wynfield projected their shared desire to be seen as humanists who could bridge past and present, soul and intellect, commerce and nobility, fame and its renunciation. He also expressed, much more clearly than in his paintings, the notions of breadth and idealism then attached to the Old Masters—qualities that stood in direct opposition to the focus, detail, and specificity that characterized most genre paintings and all commercial photographic portraiture. As seen from the perspective of a generalist art critic of the 1860s, David Octavius Hill was photography's Old Master, and Wynfield a worthy heir. The Photographic Society of London, meanwhile, was inhospitable to a practice they saw as insufficiently advanced technically and therefore unworthy of institutionalization. Wynfield never became a regular participant in the Society's annual exhibitions.

The relationship between Wynfield's painted and photographic production is far from straightforward. In appearance and construction they are totally different—and indeed Wynfield must have been concerned to avoid the charge that he relied on photographs when composing his paintings—but both were motivated by a vision of the literary and historical past. Assessment of Wynfield's achievement has been compromised by association with Julia Margaret Cameron, who approached him as a pupil in 1864 and later declared that "to his beautiful photography I owe all my attempts and indeed consequently all my successes." There is no doubt that Wynfield's photographs exhibit, in fact pioneered, many of the qualities now associated with Cameron's work, such as close-up format, soft focus, impressionistic atmosphere, and strong chiaroscuro. Historians—following the lead of nineteenth-century commentators—have applied the label of "amateur" positively to Cameron, using it to imply freedom from convention; with regard to Wynfield the term seems pejoratively to connote dilettantism, frivolity, and technical ineptitude.

Wynfield's abandonment of photography is as undocumented as his embrace of it. It is not known if he continued to make photographs into the 1870s and 1880s. He died of tuberculosis in 1887, at age fortynine. Examples of his portraits are found at the Royal Academy of Arts (given by his fellow artist and brother-in-law W. F. Yeames), the National Portrait Gallery, and the Victoria and Albert Museum.

BRITT SALVESEN

Biography

David Wilkie Wynfield was born in India in 1837, the namesake of his mother's uncle and adoptive father, the

renowned Scottish painter David Wilkie. After considering the priesthood, Wynfield decided to become an artist and entered the studio of James Mathews Leigh. There he learned to practice a style of historical genre painting and met the young artists with whom he would form the St. John's Wood Clique. Wynfield exhibited at the Royal Academy for the first time in 1859, and continued to do so regularly thereafter. Taking up photography around 1860, he produced a number of soft-focus, bust-length portraits of artists from wet-collodion negatives on albumen paper, some of which were published in 1864 under the title *The Studio*. Although Julia Margaret Cameron credited Wynfield as her major influence, he received little acclaim in Photographic Society circles. It is not known if he continued to make photographs into the 1870s and 1880s. Wynfield died of tuberculosis in 1887.

See also: Art photography; Historiography of nineteenth-century photography; Impressionistic photography; Portraiture; Hering, Henry & Co.; *Illustrated London News;* Wet Collodion Negative; and Photographic Exchange Club and Photographic Society Club, London.

Further Reading

"David Wilkie Wynfield." In *The Golden Age of British Photography 1839–1900*, edited by Mark Haworth-Booth, 120, New York: Aperture, 1984.

Garner, Margaret A. K., "David Wynfield: Painter and Photographer." *Apollo* 97, no. 132 (February 1973):158–59.

Hacking, Juliet, "David Wilkie Wynfield: 'The Great Amateur.'" *History of Photography* 19/4 (Winter 1995): 322–327.

Hacking, Juliet, *Princes of Victorian Bohemia: Photographs by David Wilkie Wynfield,* London/Munich: National Portrait Gallery/Prestel, 2000.

Lukitsh, Joanne, "Reminders of Titian and Van Dyck: *The Reader* Reviews the Portrait Photographs of David Wilkie Wynfield, 1864." *Victorian Periodicals Review* 24/2 (Summer 1991): 56–63.

Taylor, Tom, "English Painters of the Present Day: XXVI. D. W. Wynfield." *Portfolio* 2/13 (1871): 84–87.

X

X-RAY PHOTOGRAPHY

X-ray photography was one of the most important discoveries of the 19th century. Developed in November 1895 by German scientist Willhelm Conrad Röntgen (1845–1923), the x-ray thus straddles the cusp between two centuries. The phenomenon captured the public's imagination to an extent not experienced; its fascination was not to be eclipsed until the hydrogen bomb in 1945. The aesthetic and theoretical ramifications of x-rays also proved fertile ground for artists seeking new ways to picture inner realities. Röntgen won the first Nobel Prize in Physics in 1901 for his breakthrough, yet declined to seek a patent and remained modest about his remarkable discovery for the rest of his life. Interestingly, Röntgen disliked being photographed, therefore few images of him exist.

Röntgen, like many other researchers of his time, was interested in the nature of cathode rays. To accomplish his light experiments, he used vacuum glass tubes, commonly known as Crookes tubes after William Crookes, a British scientist who perfected them in the 1870s. Working in the Physical Institute laboratories of the University of Wurzburg, Röntgen studied emissions produced from an electrical current passed between the cathode (negative) and anode (positive) terminals. The cathode rays normally caused the walls of tube or other internal objects to glow, but did not seem to be able to penetrate the glass. Röntgen was astonished when his cardboard shrouded tube caused a barium platinocyanide screen across the room to fluoresce. Placing various objects between the tube and screen, he saw the bones of his hand through his flesh, which he subsequently captured on a photographic plate. What followed was seven straight weeks of intense experimentation. He remarked to a friend, "I have discovered something interesting, but I do not know whether or not my observations are correct."

On December 28 1895, Röntgen gave a preliminary report to the Physical-Medical society of Wurzburg, and by New Year's Day he sent copies of his report to colleagues across Europe. Newspapers and magazine quickly picked up the story and by January, the whole world was caught up in x-ray fever. Other non-existent rays were posited—including N-rays, black rays, and Becquerel Rays (later found to be the alpha, beta, and gamma rays produced by radioactive materials). Every imaginable substance, including animals and objects, were exposed. Eager for news of each new photographed organ, cartoonists and poets lauded the humorous new possibilities of seeing people's thoughts and peering through underwear. By 1896, over 60 articles had been featured in the popular press as well as the first angiography, cinematic x-ray, and military radiology performed.

The first generally-accepted x-ray photograph is that of Mrs. Röntgen's ringed hand from December 22, 1895. (After learning of the discovery, A.W. Goodspeed and William Jennings recreated one they had made by accident in 1890.) X-rays were seen as extension of the photographer's craft and were included in many manuals and journals. After Thomas Edison's invention of the fluoroscope in 1896 (a kind of hooded camera fitted with a screen), many x-rays were performed as demonstrations. People lined up at department stores, high schools, and other public venues to get "bone portraits." Dubbed "shadow photographs," X-rays soon after needed no camera, a capacity shared with some of the earliest forms of photography, and no film. Still, the evidentiary nature of a photograph proved irresistible, especially to photographers, scientists, and the press. Eadweard Muybridge made stop action photographs and films of frog's legs in motion in 1896. Edison even claimed that the rays would eventually show the activity of the human brain.

As x-rays are radiation, they can both diagnose and cure. Enthusiasts, not having a precedent, exposed themselves regularly to test strength and perform demonstrations. Reddening of the nose and hands of practitioners was common. The early decades of the 20th century saw the death of many early pioneers due to numerous amputations and burns resulting from overexposure. It was not until the death of Edison's assistant in 1904 that the spotless record of the rays began to wear thin. The novelty and pure aesthetics of the rays gave way to medical applications—both legitimate and illegitimate. Medical schools added x-rays to their curricula; likewise, correspondence courses offered programs for photographers and electricians to gain training in "Röntgenology." "Do-it-yourself" kits were even sold in popular magazines.

Röntgen initially described x-rays as "longitudinal vibrations in the ether". The ether was a commonly held scientific hypothesis that a mysterious substance occupied the air and was the media through which waves and a whole host of other as yet inexplicable phenomena moved. At the turn of the last century, science and occultism occupied a much closer range than they do today and x-rays were thought by many to give credence to extra-sensory perception and psychic ability. If such non-perceptible spectacles could be captured on a photographic plate, it was argued, so too could thoughts, auras, ghosts, and even the human soul. Philosophically, the discovery of x-rays caused a scientific sea change. No longer did the senses seem an adequate platform for analysis; scientific positivism was at a standstill.

Furthermore, these rays could also kill as well as cure, presenting a medical and moral conundrum.

It was not until the 20th century that x-rays were confirmed to be a part of the electromagnetic spectrum. Röntgen had covered his tube to keep the fluorescent effects contained; yet he found that the new rays could not be reflected, polarized, or refracted. It was later proved that x-rays have shorter wavelengths than visible light (around one billionth of a meter) and are related to radioactivity (discovered in 1896 and later studied by Marie and Pierre Curie). A trained glass blower, C.H.F. Muller was the first to construct commercially viable x-ray tubes and was later granted a patent in 1899. His firm expanded until another company took over in 1927, eventually setting the foundation for the new and improved x-ray apparatus we know today.

LESLIE K. BROWN

See also: Edison, Thomas Alva; Scientific Photography; and Photogrammetry.

Further Reading

Henderson, Linda Dalrymple, "X Rays and the Quest for Invisible Reality in the Art of Kupka, Duchamp, and the Cubists," *Art Journal* 47 (Winter 1988), 323–40.

Nitske, W. Robert, *The Life of Wilhelm Conrad Röntgen, Discoverer of the X Ray* (Tucson: University of Arizona Press, 1971).

Radiology Centennial, www.xray.hmc.psu.edu/rci/ss1/ss1_6.html, 1993.

Thomas, Ann with essay by Marta Braun, *Beauty of Another Order: Photography in Science*, New Haven: Yale University Press in association with the National Gallery of Canada, Ottawa, 1997.

Y

YEARBOOK OF PHOTOGRAPHY

The *Yearbook of Photography* was published by the weekly periodical *Photographic News* and was usually edited by that publication's editor. It was for many years the alternative to the *British Journal of Photography's Photographic Almanac* (1859–1963) but never quite grew in the same way or gained the same following. By 1894 the *Almanac* numbered 1336 pages against the *Yearbook's* 612 pages. It remains important as there were advertisers who only took space with one publication and the editorial content provides a useful alternative to the *Almanac*.

The *Yearbook* first appeared as the *Photographic News Almanac,* known as *Almanack* in 1859, *or the Year Book of Photography* in 1859 a title that it kept until 1863. The 1859 *Almanack* was published on 10 December 1858 at a cost of 6d and described in the *Photographic News* of 17 December 1858 (177). The intention is to 'disseminate useful and important information, alike to the practised operator and amateur... It will be found to be of the greatest assistance not only to the private amateur, but also to the professional photographer; to the former, on account of the numerous hints it contains, which if attended to, will ensure success under the most unfavourable circumstances; and to the latter, for the information on subjects which are so liable to escape memory.'

It became the *Yearbook of Photography and Photographic News Almanac* in 1864 and last appeared with the 1907/08 edition after which it's parent, the *Photographic News*, was absorbed by *Amateur Photographer*.

The original *Almanack* absorbed William Lay's *Photographic Almanac and Ready Reckoner for the Year of Our Lord 1859* which appeared for one year only. It was incorporated into the second volume of the *Photographic News Almanac* for 1860. Lay's *Almanac* and the first issue of the *Photographic News Almanac* lay claim as the world's earliest photographic almanacs.

The first editor was G. Wharton Simpson (1825–1880) who remained in that position until the 1880 edition; H. Baden Pritchard (1841–1884) edited the years 1881–1884; Thomas Bolas (1848–1932) edited 1885–1889; T. C. Hepworth (died 1905) edited 1892–1893; E. J. Wall (died 1928) edited 1897-1898; Percy R. Salmon (died 1959) edited 1901–1905 and F. J. Mortimer (1874–1944) edited 1906–1908. The missing years were not credited.

The content of the *Yearbook* was remarkably constant over its history from the 1859 *Photographic Almanac*. The editorial pages usually began with a calendar for the year and astronomical information, followed by a list of the principal photographic societies and their officers for Great Britain. A review of advances within photography for the previous year provided a useful survey of new processes, apparatus and survey of the profession as well as the principal deaths for the year. This was followed by an extensive list of photographic processes and formulae. A number of essays by noted amateur and professional photographers on practical aspects of photography completed the book. In, for example, the 1866 volume the essays included J. H. Dallmeyer on lenses, Jabez Hughes on constructing a photographic darkroom, Rejlander reflecting on photography and art, Thomas Richard Williams on portraiture and Henry Peach Robinson on managing sitters amongst others. All volumes contained substantial advertisement sections. In later volumes the amount of formulaic information was reduced to make way for surveys of new equipment and a trade directory. The essays during the 1880s and 1890s began to become more technical in nature reflecting the editors' own interests and the general editorial slant of the *Photographic News*.

MICHAEL PRITCHARD

See also: *British Journal of Photography*; *British Journal Photographic Almanac (1859–)*; Bolas, Thomas; Dallmeyer, John Henry & Thomas Ross; Rejlander, Oscar Gustav; Williams, Thomas Richard; Robinson, Henry Peach; and *Photographic News (1858–1908)*.

Further Reading

Koelzer, Walter, *Photographic and Cinematographic Periodicals*, Dusseldorf, Der Foto Brell, 1992.
Gernsheim, Helmut, *Incunabula of British Photographic Literature*, London, Scolar Press, 1884.

YOKOYAMA MATSUSABURO (1838–1884)
Japanese painter, photographer

The Japanese photographer Yokoyama Matsusaburo was born in Etorofu Island (now disputed territory with Russia), but spent his childhood in the port city of Hakodate. His lifelong love was painting, but when Commodore Perry's ships visited Hakodate in 1854, Yokoyama was intrigued by the photography of Eliphalet Brown. This interest was reinforced when, later that year, the Russian photographer Aleksandr Mozhaiskii took daguerreotypes of the streets of Hakodate. Thinking that mastery of photography would help him to become a better artist, he traveled to Yokohama and studied under Shimooka Renjo. Returning to Hakodate his technique was further refined by the Russian consul and amateur photographer, Iosif Goshkevich. In 1868, Yokoyama opened his own lavish studio in Tokyo. In 1871 he famously photographed the partially destroyed Edo Castle, and in 1873 Japanese art works destined for the Vienna Exposition. In the same year he began to concentrate on teaching art and photography students at his studio. In 1876 he gave up his studio and taught photography and photolithography at the Japan Military Academy until 1881. There he experimented with printing techniques and developed a form of photographic oil painting, shashin abura-e. In 1882 he contracted tuberculosis and spent the last two years of his life painting (particularly photographic oil painting) and immersing himself in a photolithography company which he founded. [Examples of Yokoyama's work can be found in the Tokyo Metropolitan Museum of Photography, Tokyo.]

TERRY BENNETT

YORK, FREDERICK (1823–1903)
Lantern slide manufacturer

York was born at Bridgwater, Somerset, England, in 1823. At 16 he was apprenticed to a Bristol pharmacist, where he came into contact with the new art of photography. He established and ran a photographic business in South Africa, 1853–1861. Returning to England, in 1863 he set up a stereoview and lantern slide business at 87 (later at 67) Lancaster Road, Notting Hill, London. The firm soon concentrated on photographic slides, and son William joined the business in 1877. York & Son's slides, by the 1890s over 100,000 per year, were manufactured in Bridgwater. Subjects included Travel, Comic, Science, Education, and Life Models. Travel scenes were produced with negatives 'bought-in' from other photographers. Life Model sets were photographed by the York company, whose only serious competition in this genre was Bamforth & Co. Costumed 'actors' posed in front of painted backdrops or, occasionally, exterior scenes to create a series of tableaux. Many scenes were photographed in a garden studio at Lancaster Road. Themes included temperance, popular songs, services of song, and 'tearjerker' stories. After Frederick York's death in 1903 William carried on, but the firm was dissolved in 1907. Newton & Co used the York name until the late 1940s.

STEPHEN HERBERT

YOUNG, THOMAS (1773–1829)
English physician and natural philosopher

Thomas Young is chiefly acknowledged for providing the decisive arguments against Newton's particle theory of light, leading eventually to widespread acceptance of the wave or undulatory theory. He also developed theories of interference and three-color composition of light which were important for the development of colour photography. Born 13 June 1773 to a Quaker family in Somerset, Young exhibited a prodigious intellect, studying literature, ancient and modern languages, engineering, chemistry, optics, mathematics and medicine. Having studied at both Edinburgh University and at the University of Göttingen, he became widely read in a number of Continental philosophers, including Leonhard Euler. Euler proposed that colors were created by the frequency of vibration in the ether, the longest wavelength corresponding to the red end of the spectrum. Young adapted his own analogies of light and sound to form a defence of a general wave theory of light in 1801. In his publication of 1804, *Experiments and Calculations Relative to Physical Optics*, Young published proof of the extension of the spectrum into the 'invisible' region beyond the violet. Like many investigators of light he employed the well-known sensitivity of silver nitrate, casting the image from a solar microscope on strips of paper soaked in the solution. Thomas Young died 10 May 1829 in London.

KELLEY WILDER

Z

ZANGAKI BROTHERS
(active 1870s–1900s)

The Zangaki brothers produced some of the finest images of late Victorian Egypt, yet so little is known about them. They were probably Greek Cypriots, although it has been suggested they may have come from Crete. Nothing is known of them before their first photographs were published in Egypt in the late 1870s, and even the names of the brothers themselves is unknown. It has been suggested their initials were 'C' and 'G,' and indeed early 20th century photographic postcards bearing the name 'C Zangaki' have been located.

Their photographs, however, were simply identified as 'Zangaki,' the letter 'Z' being frequently mistaken for a stylised 'L' in several books, resulting in their work being incorrectly ascribed to 'Langaki.' Indeed, until relatively recently, there was assumed to be one photographer with the name of 'A Zangaki' until the discovery of a signboard bearing the legend 'Adelphoi Zangaki' confirmed that the images were the work of brothers.

While their Greek—Cypriot or Cretan—roots are confirmed, the horse-drawn darkroom van with which they toured the length of the Nile bore the legend 'Zangaki Brothers,' and to further confuse matters, the majority of their images are titled (in the negatives) in French.

Amongst many fine images are photographs taken after the bombardment of Alexandria in 1882, and some eloquent commentaries on the popularity of the Grand Tour of Egypt in the 1880s.

JOHN HANNAVY

ZEISS, CARL (1816–1888)

The name of Carl Zeiss is synonymous with quality photographic optics, and has been for well more than a century and a half. Throughout the twentieth century, cameras fitted with Zeiss optics were used by the major figures in photography. But during Carl Zeiss's lifetime, the company made its name through the design and manufacture of the highest quality microscopes.

However, it is to Zeiss and his associates that we owe the emergence of the science of optical design and manufacture—a science which had a direct and enduring impact on the development of photographic lenses.

Carl Zeiss himself was born in Weimar on 11 September 1816, and apprenticed to Dr Friedrich Körner, a microscope and scientific instrument maker, before opening his own workshop in 1846, repairing optical and scientific equipment. After Körner's death in 1847, Zeiss took over some of his former employer's business interests, developing the first 'compound microscope' in that same year. It is recorded that in his first year of operation, he sold twenty-three microscopes! Twenty years later he sold his one thousandth, and a further twenty years later, 1886, saw the ten thousandth microscope sold!

1866 was a key year for Zeiss and marked the beginning of his working relationship with Dr. Ernst Abbe, then a physics lecturer at the University of Jena. With Abbe, Zeiss would become a major player in lens manufacture, and the Zeiss Optical Works, established in that same year, soon had Abbe as its Director of Research. The marriage of Zeiss's manufacturing experience, and Abbe's scientific understanding proved pivotal. Between them, the two men would develop the design and manufacture of high quality lenses into a precise science where, as Abbe noted, lens design was based on

'a precise study of the materials used, [and] the designs concerned are specified by computation to the last detail—every curvature, every thickness, every aperture of a lens—so that any trial and error approach is excluded.'

Within six years the company had developed a significant number of new microscope lenses, all based on Abbe's

theoretical research and mathematical modelling. They combined high quality, large apertures, colour accuracy and minimal distortion—all essential characteristics in a microscope lens.

In 1881, Abbe met Dr. Friedrich Otto Schott, who had achieved his doctorate in glass science a few years earlier. Combining Abbe's scientific approach with Schott's researches into the manufacture of high quality mineral-rich glasses—using phosphorus, lithium and boron—paved the way for the development a whole new generation of lenses, including the first apochromatic (or fully colour-corrected) lenses, eliminating chromatic aberration, the bane of microscope users. Before then, achromats had been corrected for only two of the three primary colours.

Schott and Associates Glass Technology Laboratory, a partnership between Zeiss and Schott, was formed in 1884. With Abbe's scientific approach applied to the manufacture of glasses, and the introduction of new and precisely computed ingredients, over a hundred new types of glass were developed. Zeiss lenses by the 1880s were recognised the world over for their optical purity and accuracy.

Carl Zeiss died in 1888 and control of the Zeiss Optical Works passed to Abbe, who had been a partner since the mid 1870s. In the following year Abbe transferred ownership of the company to the Carl Zeiss Foundation, together with their interests in Schott's glassworks. The purpose of the foundation was to fund research, and also to initiate social and workplace reforms. It is reported that by 1900, Zeiss workers enjoyed profit-sharing, an eight hour working day, paid annual holidays, a basic health-care plan, and retirement pension. A century ago such benefits was revolutionary.

The first years after Carl Zeiss's death saw the company develop a series of camera lenses which were to endure for a century and more. The Zeiss Planar (1896) and Tessar (1902) are perhaps the most long-lived lens designs in the history of photography.

JOHN HANNAVY

See also: Schott, Friedrich Otto, and Abbe, Ernst Karl.

Further Reading

Auerbach, *Das Zeisswerk und die Karl Zeiss-Stiftung in Jena,* Jena, 1907.

Kingslake, Rudolf, *A History of the Photographic Lens,* London: Academic Press, 1989.

Leonhardt, Ute, Haueis, Otto, and Wimmer, Wolfgang, *Carl Zeiss in Jena 1846 bis 1946,* Erfurt: Sutton Verlag GmbH, 2004.

ZIEGLER, JULE (1804—1856)

Jule Ziegler was a celebrated painter of the July Monarchy, ceramist, and photographer. His contribution to photography is manifold. Of an inventive spirit, Jules Ziegler performed many experiments on techniques, optics, and color. From the early 1840s, he was devoted to the daguerreotype and improved its coloring. In 1851, he was one of the first in France to use wet collodion. The same year, he joined the management committee of the Société heliographique and he was awarded a certificate for his photography at the Great Exhibition at the Crystal Palace, London 1851. He wrote many articles for *La Lumière* and a report on photography for the Paris Exposition Universelle of 1855. Ziegler's work exhibited similarities with that of his friend Hippolyte Bayard, who did his portrait with the daguerreotype in 1844 (SFP), as well as with the topics of the compositions: still lifes, sculptures, reproductions of antiques (*Venus de Milo*), and views of his garden. He used photography to emphasize his work as ceramist; sandstone vases of his manufacture are reproduced in several negatives (girl in front of the Vase with the twelve apostles). The museum of Langres preserved a set of his photographs, including compositions with sculptures and vases and the Pallet of the painter.

HÉLÈNE BOCARD

ZILLE, HEINRICH (1858–1929)

Heinrich Zille was a draughtsman and famous Berlin engraver, author of albums, and collaborator of satirical newspapers. In about 1887, he started photography as a way to aid. He initially photographed his family, then chronicled the proletariat with a series of the women at the market, men returning home from work, children in the streets, and fairs. He also took portraits of artists in their workshops and he completed nude studies as well. By 1914, he took hundreds of negatives on glass plates of gelatine-bromide. Zille never published his photographs, which he regarded as working tools. Discovered in the 1960s, they were appreciated for their modernity: instantaneous with the characters captured in full action, sometimes seen from the back, walking. His images also had a persistent flat spaces, inscriptions, and lines that created dynamic effects (crossroads, scaffolding).

Through his unique artistic eye, Zille drew attention to the grounds, the palisades, and the walls thought to be common. His images of the poor district, Krögel were described as having direct vision, without an aesthetic research or anecdote. Dependent on the Berliner Secession, Zille always remained outside of any aesthetic contemporary category. If his work is connected with naturalism, it is only because he approached the expressionists by simplifying the human form to the point of making a prototype of it. The originality of his vision on certain topics (shops) was pointed out by Eugene Atget. These images in fact are documents of great value on the social dimension of Berlin in 1900.

HÉLÈNE BOCARD

ZOLA, EMILE (1840–1902)

"In my view you cannot claim to have seen something until you have photographed it." This is a rather curious sentiment, since it came from its author, Emile Zola, after most of his incredible writing career, which was largely based on good old-fashioned visits, conversations, and note-taking, was over. Zola was virtually a writing machine who became famous by turning out mostly great and in any case best-selling novels at the rate of more than one per year for more than 30 years. He wrote many of them for serialization, keeping just ahead of their journal publication, and then they were published as books. The biggest project was *Les Rougon-Macquart*, a more than 20 volume set of familial and social disasters that ran from 1871-93. He novelized the urbanization and modernization of France. He also wrote many journal articles, essays, criticism, and plays. A number of his books were successfully put on stage.

Zola became friends with Cezanne as a youth, with many of the Impressionists, and with Nadar (Felix Tournachon), Petit, Carjat, and other photographers in the 1860s. Nadar took many portraits of him between 1876 and 1898. Zola apparently took up photography on a particular trip in 1888, but did not start taking photographs seriously until 1894, and took perhaps 5000 images up to his murder in 1902. He was passionate about photography in writing and in speaking. He collected about a dozen cameras, including large and small formats, stereo and panoramic equipment. He did his own darkroom work, from mixing his photochemistry to enlarging and printing. His subjects included portraits, mostly of his family, especially his paramour and their children; his wife; some friends, and then landscapes, railroad scenes, street scenes in Paris and London, and the Paris World's Fair of 1900. He considered himself a member of the naturalist (or realist) school in his writing, and that is reflected in his photographic compositions. One of his best photos of Paris, of Place Prosper-Goubaux on a rainy day, shows from its camera angle, mistiness, shadows, carriages, pedestrians and buildings strong similarity to Caillebotte's famous painting, *Rue de Paris, temps de pluie* (*Paris street in Rainy Weather*, 1877). It is extremely likely Zola had seen the painting and knew Caillebotte.

Zola also publicly and famously defended Capt. Alfred Dreyfus after he was unjustly and falsely accused of treason. In 1898 Zola wrote a front page open letter to the French President in the Paris newspaper *L'aurore,* under the banner "J'accuse...!" that ripped apart the Army's case. Zola was tried and convicted of slandering the Army, and fled to exile in England for 11 months, where he continued to photograph. Zola returned in 1899. Dreyfus was tried and convicted again, but almost immediately pardoned by the President and reinstated by the Army. In the 1920s a stove fitter confessed on his death bed to stuffing the chimney of Zola's country house one night. Carbon monoxide killed him in his sleep.

WILLIAM R. ALSCHULER

Further Reading

Brown, F., *Zola, a Life*, New York: Farrar Straus Giroux, 1995.

Emile-Zola, E., and Massin, *Zola Photographer*, New York: Seaver/Henry Holt, 1988.

Massin and Emile-Zola, F., *Zola Photographe*, Paris: Musee-Galerie de la Seita, 1987 (this and the above title are closely related, from a particular exhibition, but the text and pictures only overlap and the quality of reproduction differs).

Index

Page numbers in italics refer to illustrations.

INDEX

INDEX

INDEX